Encyclopedia of
American
Folk Art

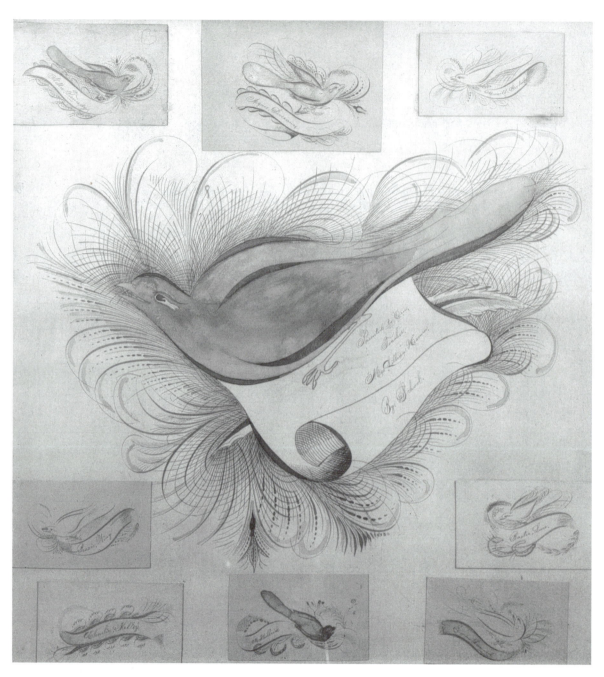

Spencerian Birds; Lillian Hamm and her Students (dates for Lillian Hamm unknown); United States; c. 1850–1900. Watercolor on paper. 19½ × 18¼ in. © Collection American Folk Art Museum, New York, 1883.29.4.

Encyclopedia of
American
Folk Art

GERARD C. WERTKIN, EDITOR

LEE KOGAN, ASSOCIATE EDITOR

In association with the American Folk Art Museum

Routledge

New York London

Published in 2004 by

Routledge
29 West 35th Street
New York, NY 10001-2299
www.routledge-ny.com

Published in Great Britain by
Routledge
11 New Fetter Lane
London EC4P 4EE
www.routledge.co.uk

Routledge is an imprint of Taylor & Francis Books, Inc.

This book was developed by
Cynthia Parzych Publishing, Inc.
P.O. Box 319
Planetarium Station
New York, NY 10024

Consulting Editor: Paul S. D'Ambrosio, Ph.D.
Copyeditor: Erikka Haa
Designer: Dorchester Typesetting Group, Ltd.

10 9 8 7 6 5 4 3 2 1

Printed on acid-free, 250-year-life paper
Manufactured in the United States of America

Library of Congress Cataloging-in-Publication Data

Encyclopedia of American folk art/Gerard C. Wertkin, editor; Lee Kogan, associate editor; in
association with the American Folk Art Museum.
 p. cm.
Includes bibliographical references and index.
 ISBN 0-415-92986-5 (hardback : alk. paper)
 1. Folk art—United States—Encyclopedias. I. Wertkin, Gerard C. II.
Kogan, Lee. III. American Folk Art Museum.
NK805.E6 2004
745'.0973'03—dc22

 2003018051

COVER ART

Top Left:

Cow Jump Over the Mone (1978). Nellie Mae Rowe (1900–
1982); Vinings, Cobb County, Georgia. Colored pencil,
crayon, and pencil on paper; 19½ × 25¼ inches. Collection
American Folk Art Museum, New York. Gift of Judith
Alexander, 1997.10.1.

Top Right:

Slipware Charger With Combed Decoration (c. 1800–1840).
Artist unidentified; Southeastern Pennsylvania. Glazed red
earthenware; 2⅞ × 15½ inches diameter. Collection
American Folk Art Museum, New York. Promised gift of
Ralph Esmerian, P1.2001.112.

Bottom Left:

Bed rug (1803). Attributed to Deborah Leland Fairbanks
(1739–1791) and unidentified family member; Littleton,
Grafton County, New Hampshire. Wool; 101 × 96 inches.
Collection American Folk Art Museum, New York. Promised
gift of Cyril Irwin Nelson in honor of Joel and Kate Kopp,
P1.1995.12.

Bottom Right:

Tigere (1977). Felipe Benito Archuleta (1910–1991); Tesuque,
Santa Fe County, New Mexico. Paint and gesso on
cottonwood with straw; 32½ × 71 × 17 inches. Collection
American Folk Art Museum, New York. Gift of George H.
Meyer, 2000.17.1.

CONTENTS

LIST OF ENTRIES

NOTES ON CONTRIBUTORS

Editor

Gerard C. Wertkin has been director of the American Folk Art Museum in New York City since 1991, having previously served as assistant director of that institution for eleven years. He is an adjunct associate professor of art and art education at New York University where he teaches courses in the history of American folk art, religious traditions in American folk art, and the material culture of American communal groups. Recognized as an authority on the art and culture of the Shakers, he is the author of *The Four Seasons of Shaker Life* and *Millennial Dreams: Vision and Prophecy in American Folk Art*. His essays have been published in many books and catalogs and he is a regular contributor to the journal, *Folk Art*. In 1996, Wertkin received the Annual Award of Distinction of the Folk Art Society of America.

Associate Editor

Lee Kogan is director of the American Folk Art Museum's Folk Art Institute and curator of special projects for the museum's Contemporary Center. She is an adjunct assistant professor of art and art education at New York University where she teaches courses in American folk painting and contemporary self-taught artists. Kogan contributes articles regularly to *Folk Art, Raw Vision, Folk Art Messenger*, and *Alabama Folklife*, and has written several books on American folk art, including studies of Nellie Mae Rowe and Jacob Kass.

Contributors

Ernest Albrecht is the editor and publisher of *Spectacle*, a quarterly journal of the circus arts and the author of several books on the subject including *A Ringling by Any Other Name* and *The New American Circus*. He has lectured on the subject at the Circus World Museum, The Ringling Museum of Art, and Lincoln Center for the Performing Arts.

Cory M. Amsler is curator of collections at the Mercer Museum of the Bucks County Historical Society in Doylestown, Pennsylvania, a position he has held since 1990. He holds an M.A. degree from the Cooperstown (New York) Graduate Program in History Museum Studies. Amsler has organized many exhibitions at the Mercer Museum, including "From Heart to Hand: Discovering Bucks County Fraktur" in 1997.

Brooke Davis Anderson has been director and curator of The Contemporary Center of the American Folk Art Museum in New York since 1999, following seven years as director of the Diggs Gallery at Winston-Salem State University in North Carolina, where she also held an appointment as assistant professor of art. At the American Folk Art Museum Anderson has organized several exhibitions, including "Darger: The Henry Darger Collection of the American Folk Art Museum." She holds an M.A. degree in American folk art studies from New York University.

Paul Arnett, an art historian, has been co-curator of The Arnett Collection in Atlanta for fourteen years. A recognized authority on the work of Southern vernacular artists, he served as co-editor of *Souls Grown Deep: African American Vernacular Art of the South* and was a contributor to *The Quilts of Gee's Bend*, among other publications.

Deborah Lyttle Ash, an independent scholar, is a graduate of the M.A. program in folk art studies at New York University.

Jacqueline M. Atkins, a textile historian, is an adjunct associate professor in the Department of Art and Art Professions, New York University. She was the recipient of a 1995-1996 Fulbright Research Award to study the history of quilting in Japan and has written and lectured extensively on Japanese quilting and American quilt and coverlet history for Japanese and American publications. She is author or co-author of a number of books including *Folk Art in American Life; Shared Threads: Quilting Together Past and Present;* and *New York Beauties: Quilts from the Empire State.*

Lois Avigad earned an M.A. degree in American folk art studies at New York University and has published essays in several publications, including *Folk Art.* She is preparing a biography and *catalogue raisonné* of the work of the artist Ruth Henshaw Bascom.

John Beardsley, an independent curator, is senior lecturer in landscape architecture at Harvard University Graduate School of Design. The recipient of fellowships from the Guggenheim Foundation, the Graham Foundation, and the National Endowment for the Arts, he was co-curator of "Black Folk Art in America, 1930-1980" and "Hispanic Art in the United States: Thirty Contemporary Painters and Sculptors." An authority on the idiosyncratic environments of visionary artists, he is the author of *Gardens of Revelation: Environments by Visionary Artists* and *Earthworks and Beyond: Contemporary Art in the Landscape.*

Janet Catherine Berlo is Susan B. Anthony Professor of Gender and Women's Studies and professor of art history at the University of Rochester, where she currently is serving as acting co-director of the graduate program in visual and cultural studies. The holder of a Ph.D. degree from Yale University, she specializes in the indigenous arts of the Americas. Her recent books include *Wild By Design: Innovation and Artistry in American Quilts* (with Patricia Crews), *Spirit Beings and Sun Dancers: Black Hawk's Vision of the Lakota World*, and *Native North American Art* (with Ruth Phillips). She has received grants from the John Simon Guggenheim Foundation, the Getty Foundation, and the National Endowment for the Humanities in support of her research on Plains Indian ledger drawings.

Avis Berman, who heads the oral history program of the Archives of American Art in New York, is an independent writer and critic in the arts. She has published many books and essays, including *Rebels on Eighth Street: Juliana Force and the Whitney Museum of American Art* and is a contributor to *Elie Nadelman: Classic Folk.*

Roderic H. Blackburn served as assistant director of the Albany Institute of History and Art, before becoming senior research fellow at the New York State Museum. A recognized expert on the early art and culture of the Hudson River Valley, he has organized several exhibitions devoted to the region's decorative arts, including "Remembrance of Patria: Dutch Arts and Culture in Colonial America: 1609-1776" (with Ruth Piwonka) and was co-author of the accompanying catalog.

Jenifer P. Borum has an M.A. degree in art history and criticism from the State University of New York at Stony Brook and is a Ph.D. candidate in art history at The Graduate School and University Center of the City University of New York, where the working title of her dissertation topic is "Concerning the Spiritual in Art: The Significance of Self-Taught Visionary Artists and Their Work." She frequently contributes articles and reviews on folk art topics to *Folk Art* and *Raw Vision.* She has taught courses on folk art at SUNY Stony Brook and the Folk Art Institute of the American Folk Art Museum in New York.

David R. Brigham is the Priscilla Payne Hurd Director of the Allentown Art Museum in Pennsylvania and was previously curator of American art and director of collections and exhibitions at the Worcester Art Museum in Massachusetts. He has published many articles on early American fine and folk art including an in-depth electronic catalog of the Worcester Art Museum's collection prior to 1830.

William F. Brooks Jr. is an independent scholar and a research and curatorial consultant in the field of American folk art. He received his master's degree in American folk art studies from New York University. He is the former executive director of the Frog Hollow Vermont State Craft Center and his research has assisted Intuit: the Center for Intuitive and Outsider Art in Chicago, El Museo del Barrio (New York), the American Folk Art Museum, the National Gallery of Art, and the Shelburne Museum.

David H. Brown is visiting fellow at Harvard University at the Afro-American Studies Center and an expert on Santería, a subject on which he has published many books and essays. The holder of a Ph.D. degree, Brown is the author of *Santería Enthroned: Art, Ritual and Innovation in an Afro-Cuban Religion.*

Johanna Brown is director of collections and curator of Old Salem, Inc. and the Museum of Early Southern Decorative Arts, Winston-Salem, North Carolina

Roger Cardinal, an art historian, is professor of literary and visual studies at the University of Kent at Canterbury, England. He publishes and lectures widely on the creativity of artists working outside the mainstream. *Outsider Art,* his pioneering study of *art brut,* introduced a new term to the field.

Annie Carlano is curator of the North American and European collections of the Museum of International Folk Art in Santa Fe, New Mexico.

Barbara Cate is professor of art history at Seton Hall University, co-director of the M.A. program in museum professions, and trustee of the American Folk Art Museum. She is also founder and first director of the Folk Art Institute (AMFA).

Deborah Chotner is assistant curator of American and British paintings at the National Gallery of Art in Washington, D.C.

H.E. Comstock is a researcher and consultant to museums, historical societies, and private collectors with an expertise in American folk pottery. He has written books and articles on the subject including *The Pottery of the Shenandoah Valley Region*.

Jeff Corey has been the executive director of Intuit: The Center for Intuitive and Outsider Art, since 1995.

Donald J. Cosentino is professor of African and diaspora literature and folkore at UCLA, where he also chairs the folklore program and co-edits *African Arts*. He has undertaken extensive fieldwork in Haiti and is the editor of *Sacred Arts of Haitian Vodou*. Among his other published works is *Voudou Things: The Art of Pierrot Barra and Marie Cassaise*.

Paul S. D'Ambrosio is chief curator of the New York State Historical Association at Cooperstown, New York, where he has organized many exhibitions, including "Empire State Mosaic: The Folk Art of New York." He is author or co-author of several books and catalogs, among them *Folk Art's Many Faces: Portraits in the New York State Historical Association* and *Ralph Fasanella's America*.

Harry H. DeLorme Jr. is senior curator of education at the Telfair Museum of Art in Savannah, Georgia. He served as curator of that institution's exhibition, "Savannah Folk: Self-Taught Artists from the Telfair Museum and Area Collections."

Linda Eaton is the curator of textiles at Winterthur Museum in Delaware. She has a B.A. (Hons) from the University of Newcastle upon Tyne and graduate diploma in Textile Conservation from the Courtauld Institute of Art.

William A. Fagaly has been associated with the New Orleans Museum of Art since 1966 serving in various positions including the curator of contemporary American self-taught art and twenty years as the assistant director for art. He is currently the Françoise Billion Richardson Curator of African Art at that institution. He has been the curator of over seventy art exhibitions including two at the American Folk Art Museum in New York, both focusing on the work of Sister Gertrude Morgan, one in 1973 and a major retrospective and book in spring 2004.

Jesse Lie Farber is an emeritus professor at Mount Holyoke College in Massachusetts, and co-founder of the Association of Gravestone Studies. Since the early 1970s she has lectured, photographed, and written on gravestones and is a widely recognized authority on the subject.

Helaine Fendelman is the former president of the Appraisers Association of America, Inc. with a specialty in American folk art. She writes a feature column on antiques and collectibles for *Country Living*, is a syndicated columnist for the

Scripps Howard News Service, and is co-host of the PBS television program "Treasures in Your Attic." Her publications include *Tramp Art: A Folk Art Phenomenon.*

Mia Fineman has a Ph.D. in art history from Yale University and is a research associate in the department of photographs at the Metropolitan Museum of Art. She is author of *Other Pictures, Anonymous Photographs from the Collection of Thomas Walther* and curator of the exhibition of the same title at the Metropolitan Museum organized in 2000.

Tobin Fraley is an expert on carousel art. He owned and operated a restoration company for carousel figures and has written many books on the topic including *The Carousel Animal* and *The Great American Carousel.*

Stuart M. Frank is former director of the Kendall Whaling Museum and currently senior curator and director of the Kendall Institute, the academic studies and publications division of the New Bedford Whaling Museum. An expert on maritime folk art, Frank has been widely published on the subjects of maritime art, history, literature, and music.

Laurel Gabel is a researcher, author, and lecturer in gravestone studies. She is a trustee and served as research coordinator for the Association for Gravestone Studies. She is also a member of the editorial board of that organization's annual journal *Markers,* where many of her articles on gravestones have been published.

Janet C. Gilmore is an independent folklorist with an M.A. and Ph.D. in folklore from Indiana University and three decades of experience researching folk cultural traditions. Her publications include *The World of the Oregon Fishboat: A Study in Maritime Folklife* that focuses on folk arts, foodways, and commercial fishing traditions, many of which bear Norwegian influence. She has worked with a variety of arts and historical agencies to produce exhibits, workshops, artist demonstrations, a video, and folklife festivals.

Christian Goodwillie is curator of collections at Hancock Shaker Village, Pittsfield, Massachusetts received a B.A. from Indiana University and M.A. from the school of the Art Institute of Chicago in historical education.

Lynda Roscoe Hartigan is chief curator of the Smithsonian American Art Museum in Washington, D.C. She has written extensively on the history of the contemporary folk art field, most notably the book, *Made with Passion: The Hemphill Folk Art Collection* (Smithsonian Institution, 1990). Hartigan has served on the national advisory board of the Folk Art Society of America since 1989, and received the society's annual Award of Distinction in 1998.

Kit Hinrichs and Delphine Hirasuna are co-authors of *Long May She Wave: A Graphic History of the American Flag.* Hinricks is a partner in the international design firm, Pentagram, and his collection of Star and Stripes memorabilia contains more than 3,000 items. Hirasuna is a writer and author of several books.

Stacy C. Hollander is senior curator and director of exhibitions of the American Folk Art Museum in New York City. The holder of an M.A. degree in American folk art studies from New York University, she served as curator of "American

Radiance: The Ralph Esmerian Gift to the American Folk Art Museum," and was author of the accompanying catalog. Among her many other exhibitions at the American Folk Art Museum are "Harry Lieberman: A Journey of Remembrance," "Every Picture Tells a Story: Word and Image in American Folk Art," and "A Place for Us: Vernacular Architecture in American Folk Art." Hollander lectures and publishes widely and is a frequent contributor to the journal, *Folk Art*.

Frank Holt is director of The Menello Museum of American Folk Art in Orlando, Florida.

John Hood is a graduate of the New York University graduate program in Folk Art and an independent scholar.

Alan Jabbour is a folklorist who received a M.A. and a Ph.D. from Duke University. He taught at UCLA before becoming head of the Archive of Folk Song at the Library of Congress, director of the Folk Arts Program at the National Endowment for the Arts, and director of the American Folklife Center at the Library of Congress. He has been widely published in the areas of folklore, folk music, and cultural policy.

Jane Kallir, an art historian, has served as curator of exhibitions at museums in the United States and abroad, including "Egon Schiele" at the National Gallery of Art and "Masters of Naïve Art," which traveled to four museums in Japan. Among her numerous publications are *Grandma Moses: The Artist Behind the Myth* and *The Folk Art Tradition: Naïve Painting in Europe and the United States*.

Helen Kellogg, an independent scholar, compiled information that identified the husband-and-wife team of Samuel Addison Shute and Ruth Whittier Shute as the artists of an important group of New England watercolor portraits. She was a contributor to *American Folk Painters of Three Centuries* and *American Radiance: The Ralph Esmerian Gift to the American Folk Art Museum*.

Arthur and Sybil Kern are independent scholars, reasearchers, and collectors in the field of folk art and have written many articles on a number of American folk artists. They have served as guest curators of exhibitions at the American Museum of Folk Art and the Albany Institute of History and Art.

William C. Ketchum is the author of *American Folk Art of the Twentieth Century*, which received the Ambassador of Honor Award of the English-Speaking Union; *All-American Folk Arts and Crafts*; and many other books. He is a recognized authority on American folk pottery.

Sojim Kim is associate curator at the Japanese American National Museum. She received her Ph.D. in Folklore and Mythology from UCLA.

Amy Kitchener is executive director of the Alliance for California Traditional Arts (ACTA), a statewide organization she co-founded in 1997. She is a public folklorist who has worked in California since 1989, first as project coordinator for the Los Angeles Public Library's "Shades of L.A." project, then as Folk Arts program director at the Fresno Arts Council where she developed the agency's first programs in folk and traditional arts. She holds a B.A. in Anthropology from the University of Arizona and an M.A. in Folklore and Mythology from UCLA. Her

book, *The Holiday Yards of Florencio Morales: "El Hombre de las Banderas,"* was published by the University Press of Mississippi.

Elizabeth Mankin Kornhauser is deputy director, chief curator, and Krieble curator of American painting and sculpture at the Wadsworth Atheneum Museum of Art in Hartford, Connecticut. An authority on American art, she is the author or co-author of many books and catalogs, including *Marsden Hartley: American Modernist* and *Ralph Earl: The Face of the Young Republic.*

Wendy Lavitt has written several books on dolls and was guest curator of an exhibition on the subject for the American Folk Art Museum.

Jack L. Lindsey, curator of American decorative arts at the Philadelphia Museum of Art, received his M.A. degree in American civilization and museum studies and his Ph.D. in folklore and folklife from the University of Pennsylvania. He has published and lectured extensively on American furniture and silver, Pennsylvania German decorative arts, African American material culture, and American folk art. Lindsey has organized many exhibitions including "Worldly Goods: The Arts of Early Pennsylvania, 1680-1758" and "Community Fabrics: African American Quilts and Folk Art."

Barbara R. Luck is curator of painting, drawing, and sculpture at The Colonial Williamsburg Foundation in Virginia. She has published and lectured widely in the field of American folk art. She was a principal contributor to *American Folk Portraits: Paintings and Drawings from the Abby Aldrich Rockefeller Folk Art Center* and *American Folk Paintings.*

Vincent F. Luti is professor emeritus, University of Massachusetts at Dartmouth. He has pursued twenty years of independent research on the Narragansett Basin gravestone carvers of the eighteenth century, has delivered many papers at the annual conferences of the Association of Gravestone Studies, and published many articles in their journal. He received the Harriet M. Forbes Award for distinguished scholarly contributions to the study of gravestones and his book on the subject, *Mallet and Chisel*, was published in 2002.

Marsha MacDowell is curator of folk arts, Michigan State University Museum and professor, department of art and art history, Michigan State University. MacDowell teaches as well as initiates and directs traditional arts projects, including those related to exhibitions, festivals, research, publications, collection development, and development of arts policy. Among her publications is, with C. Kurt Dewhurst and Betty MacDowell, *Reflections of Faith: Religious Folk Art in America*, issued in conjunction with an exhibition the three curated at the Museum of American Folk Art. MacDowell directs the Michigan Traditional Arts Program, is past president of the American Quilt Study Group, and serves on the board of The Alliance for American Quilts.

Michael McCabe is an expert on tattoo and has written several books on the subject including *New York City Tattoo: The Oral History of an Urban Art (1997).*

Susan McGreevy is the former director of the Wheelwright Museum of the American Indian and is currently a research associate there, at the School of American Research, at The Museum of Indian Arts and Culture, and at The Museum of International Folk Art, all located in Santa Fe. She is an anthropologist

with a special interest in American Indian arts and culture that spans twenty-five years of research, teaching, and lecturing. Her recent publications include the contribution of an essay on Charlie Willeto for the book, *Vernacular Visionaries: International Outsider Art in Context*.

George H. Meyer is a collector of American folk art, particularly walking sticks, figural pottery, and other three-dimensional folk art. He is a long-standing trustee of the American Folk Art Museum and president of the American Folk Art Society. In addition to lecturing and writing articles on folk art topics, Meyer has written two books: *Folk Artists Biographical Index* and *American Folk Art Canes: Personal Sculpture*.

Richard Miller is former associate curator and curator of sculpture and decorative arts at The Abby Aldrich Rockefeller Folk Art Museum and is a lecturer on various topics relating to folk art. He has contributed to catalogs on the folk art collections of the New York State Historical Association (Cooperstown, New York) and the National Gallery of Art. He is a contributor to *The Encyclopedia of New England Culture* and writes articles on American folk and decorative arts regularly for *The Magazine Antiques* and *American Furniture*.

Carol Millsom is a retired New York University professor of psychology, a graduate of the university's folk art program, and has published a paper on sewer tiles.

Angela Mohr is editor/writer for *FirstCut,* the Guild of American Papercutters' quarterly Publication and *The Gourd,* American Gourd Society's quarterly publication.

Charlotte Emans Moore earned an M.A. degree in folk art studies from New York University and is completing her Ph.D. in the American and New England studies program at Boston University. An expert in American folk portraiture, she was co-author of *Folk Art's Many Faces: Portraits in the New York State Historical Association* and *A Window into Collecting: The Edward Duff Balken Collection at Princeton*, among other publications.

William Moore is assistant professor in the department of history at the University of North Carolina at Wilmington, former excutive director of the Enfield Shaker Museum in New Hampshire, and former director of the Livingston Masonic Library and Museum in New York. He is a contributor to many journals and catalogs with a folk art focus including *Perspectives in Vernacular Architecture* and *Vernacular Architecture Newsletter*.

Dennis Moyer was director of the Schwenkfelder Library and Heritage Center in Pennsburg, Pennsylvania, from 1983 to 1996, having previously served that institution in several staff positions beginning in 1977. An expert on the arts and culture of the Pennsylvania Germans, he is the author of *The Fraktur Writings and Folk Art Drawings of the Schwenkfelder Library Collection*.

Richard Mühlburger, director for twelve years of the Museum of Fine Arts, Springfield, Massachusetts, was vice director for education at The Metropolitan Museum of Art from 1989 through 1992. Now teaching art and architectural history at Western New England College in Springfield, he headed the education departments of the Worcester Art Museum and The Detroit Institute of Arts

earlier in his career. He is an authority on folk marquetry, and has written *American Folk Marquetry: Masterpieces in Wood,* published in association with the American Folk Art Museum.

Carmella Padilla, an independent writer, has been published extensively in the field of Hispanic art and culture in northern New Mexico. From 1991 to 1997, she was a member of the Spanish Colonial Arts Society's board of directors. The Historical Society of New Mexico has awarded her its Ralph Emerson Twitchell Award for significant contributions to history. Among her publications are *Conexiones: Connections in Spanish Colonial Art; Spanish New Mexico: The Spanish Colonial Arts Society Collection;* and *Cuando Hablan Los Santos: Contemporary Santero Traditions from Northern New Mexico.*

Tom Patterson is an expert on contemporary self-taught artists. He is a freelance writer, critic, editor, and independent curator. He has written more than one hundred articles and critical essays on self-taught artists that have appeared in *ARTnews, Folk Art, Raw Vision,* and other magazines. He is the author of *St. EOM in The Land of Pasaquan* (1987), *Howard Finster, Stranger from Another World* (1989), *Reclamation and Transformation: Three Self-Taught Chicago Artists* (1994), and *Contemporary American Folk Art: Treasures from the Smithsonian American Art Museum* (2001).

Sally Peterson is a graduate of the University of Pennsylvania's Ph.D. program in folklore and folklife, has served as curator of folklife at the North Carolina Museum of History, and she has taught folklore courses in ethnicity, women and folklore, and material culture at the University of Pennsylvania and the University of North Carolina at Chapel Hill. She has published numerous articles on Hmong needlework artistry and lectures widely on the topic.

Ramon Ramirez has taught in the Florida school system and is currently on the staff of Coral Castle, Florida, where he is a tour guide.

Harley Refsal is a professor of Scandinavian Folk Art at Luther College in Decorah, Iowa. He is also an internationally recognized figure carver, specializing in Scandinavian-style flat plane carving. In addition to the carving classes he teaches in the United States, Refsal is also a regular traveler to Scandinavia, where he teaches classes, demonstrates and makes presentations. He is the author of *Woodcarving in the Scandinavian Style,* and has contributed to numerous books and magazines focusing on Scandinavian folk art and Scandinavian wood carving. In 1996 Refsal was decorated by the King of Norway, in the form of the Saint Olav Medal, for his contributions to Norwegian folk art and Norwegian folk art studies.

Cheryl Rivers is an instructor at the Folk Art Institute, American Folk Art Museum in New York. She works with American folk art, sources and documents, and folk art of the American cemetery.

John Sands is an expert on maritime art and is vice president and chief operating officer at Brookgreen Gardens, Pawleys Island, South Carolina. He worked for many years as a manager and director of various departments at Colonial Williamsburg. His publications include *Yorktown's Captive Fleet* and he has written many articles on other maritime topics.

Cynthia V.A. Schaffner, an independent scholar, earned an M.A. degree in American decorative arts from Cooper-Hewitt, National Design Museum. An expert on American painted furniture, she is co-author with Susan Klein of *American Painted Furniture 1790-1880*. She and Klein also collaborated on *Folk Hearts: A Celebration of the Heart Motif in American Folk Art*. A frequent lecturer on various aspects of the American decorative arts, Schaffner has served as a trustee of the American Folk Art Museum.

Mimi Sherman holds a M.A. from the Fashion Institute of Technology in New York and is a graduate of the Folk Art Institute at New York University where she has also taught courses on American textiles, needlework, costume, and folk portraiture. She has also given a series of lectures at the Institute on the history of American domestic technology. Ms. Sherman has been a regular contributor of articles to *Quilt Connection* and *Folk Art*.

Linda Crocker Simmons is curator emeritus of the Corcoran Gallery of Art in Washington, D.C. She has pursued research on the members of the Peale family and other early American painters, African American art, women artists and folk painters, and contributed essays to many catalogs. Among her publications are *American Drawings, Watercolors, Pastels and Collages in the Collection of the Corcoran Gallery of Art*, and *Jacob Frymire: An American Limner*.

Lynne Spriggs is curator of folk art at the High Museum of Art in Atlanta, a position she has held since 1997. The holder of an M.A. in art history and a Ph.D. in Native American art history from Columbia University, she previously was associate curator of American art at the Norton Museum of Art in Florida. She has organized several exhibitions at the High Museum of Art, including "Let it Shine: Self-Taught Art from the T. Marshall Hahn Collection" and "Local Heroes: Paintings and Sculpture by Sam Doyle."

Judith E. Stein, an art historian, is former curator of the Pennsylvania Academy of the Fine Arts, and a regular contributor to *Art in America*. In 1994, she organized the traveling exhibition and edited the catalogue for "I Tell My Heart: The Art of Horace Pippin." The same year, she received the Pew Fellowship in the Arts for literary non-fiction.

Lisa Stone is curator of the Roger Brown Study Collection of the School of the Art Institute of Chicago, and has worked on the documentation and preservation of folk art environments since 1983. Her publications include *Sacred Spaces and Other Places: A Guide to the Grottoes and Sculptural Environments in the Upper Midwest* and *The Art of Fred Smith*, each co-authored with Jim Zanzi.

Adrian Swain is curator and registrar of the Kentucky Folk Art Center at Morehead State University, Morehead, Kentucky.

Susanne Theis has been executive director of the Orange Show Foundation in Houston since it was founded in 1983. She has published widely on the subject of "folk art environments" and has been instrumental in the development of the Orange Show's education and outreach program, including the Art Car Parade.

Laura Tilden is the education assistant for the Folk Art Institute at the American Folk Art Museum in New York City. She has held the job since acquiring a post

graduate certificate in Folk Art Studies. Tilden has written for *Folk Art* and lectured on a variety of topics pertaining to the field.

Leslie Umberger is senior curator of exhibitions and collections at the John Michael Kohler Arts Center in Sheboygan, Wisconsin. Umberger received an M.A. in art history with a focus on contemporary American self-taught and folk art from the University of Colorado at Boulder. She has curated over thirty exhibitions, over half of which focused on work by self-taught, vernacular, or folk artists. Umberger has published writings on Loy Allen Bowlin, Levi Fisher Ames, Nek Chand, and Chris Hipkiss.

Maud Southwell Wahlman is Dorothy and Dale Thompson/Missouri Endowed Professor of Global Arts in the department of art and art history, University of Missouri-Kansas City and author of *Signs and Symbols: African Images in African-American Quilts.*

Don Walters, formerly a curator at the Abby Aldrich Rockefeller Folk Art Center in Williamsburg, Virginia, is an independent scholar and an authority on American folk art.

Frederick S. Weiser, editor of publications of the Pennsylvania German Society from 1966 to 1992, is a retired Lutheran pastor and a widely recognized scholar in the arts of the Pennsylvania Germans. The holder of B.D. and S.T.M degrees from Lutheran Theological Seminary, he has taught at Gettysburg College and lectured widely on Pennsylvania German culture. He is co-author, with H.J. Heaney, of *The Pennsylvania German Fraktur of the Free Library of Philadelphia.* In 1994, he was guest curator of "The Gift is Small, the Love is Great" at the American Folk Art Museum. Weiser has identified several important artists in the fraktur tradition.

Bruce and Doranna Wendell are national authorities on gameboards and have published many books and articles on the topic.

William Wroth, a widely recognized authority on Southwestern Hispanic cultural history and art, was curator of the Taylor Museum of Southwestern Studies of the Colorado Springs Fine Arts Center from 1976 to 1983. He is author and editor of numerous works on the Hispanic and Indian arts of the Southwest and Mexico. His publications include *Christian Images in Hispanic New Mexico, Images of Penance, Images of Mercy: Southwestern Santos in the Late Nineteenth Century*, and *Ute Indian Arts and Culture from Prehistory to the New Millennium.*

Charles G. Zug III is an emeritus professor of English and folklore at the University of North Carolina at Chapel Hill. The holder of a Ph.D. degree from the University of Pennsylvania, he is a well-known authority on Southern pottery traditions. Zug is the author of *Turners and Burners: The Folk Potters of North Carolina.*

INTRODUCTION

The *Encyclopedia of American Folk Art* is intended as a resource for researchers in American folk art and the categories of artistic endeavor that have become associated with it in recent decades through patterns of institutional collecting, museum exhibitions, and related publications and programs. As such it provides basic information about the American visual art forms that are variously described as "folk art" or as "non-academic," "naïve," "self-taught," "vernacular," "visionary," or "outsider" art. The proliferation of these terms, to which others might justifiably be added, demonstrates an ongoing struggle for precision and clarity in an aesthetic terrain that remains remarkably resistant to definition. It is also evidence of the growth of the field, the shifting nature of its parameters, and the passionate engagement of its participants.

Folk art is increasingly recognized as a vital element in the cultural history of the United States, but it remains a contested expression. Art historians, museum curators, folklorists, and cultural anthropologists assign varying discipline-based meanings to it. Divergent categories of cultural production are comprehended by its usage in Europe, where the term originated, and in the United States, where it developed for the most part along very different lines. Within the field, some American museums and organizations that emphasize the work of contemporary "self-taught" or "outsider" artists in their missions and programs use the expression "folk art" as an umbrella term, while other institutions reserve the expression for more traditional works of art. Not insignificantly, the politics of the marketplace have had an impact on the development of terminology in the field, with the use of "folk art" and other words moving in and out of fashion as a result of trends in buying and selling.

In compiling the *Encyclopedia of American Folk Art*, its editors and contributors have taken a broad-based approach to the subject. Many of us have ad-hered to the art historical perspective generally in place in American museums, but other viewpoints are represented, as well. Altogether 607 topical entries are explored. Intended for scholars, students, collectors and the general public, the encyclopedia offers for the first time in one volume quick and convenient access to a remarkably diverse body of information drawn from three centuries of American folk creativity in the visual arts.

A Brief History

To understand folk art requires some familiarity with the conflicting approaches to the subject and its definitions, beginning with the genesis of the term itself. It was in late nineteenth-century Europe that the very notion of folk art as a field was first articulated and where the ideas that shaped the subject first arose. Surprisingly, these significant antecedents to the scholarship of American folk art are rarely referred to in American studies of the field. Nevertheless, European ideas continue to have an impact on the way American folk art is classified and studied today.

The great Paris *Exposition Universelle* of 1878—with sixteen million visitors, the world's largest world's fair until then—was a watershed in the early history of the field. Artur Hazelius, who had assembled the comprehensive folk art collection of the Nordiska Museum in Stockholm beginning in 1872, exhibited a collection of Scandinavian folk objects at the Paris fair. Another Scandinavian pioneer, Bernard Olsen, founder of the Danish Folk Museum, visited Hazelius's display, and later exclaimed that it represented the emergence of an entirely new idea. The presentation of these objects was a "fresh museum concept," Olsen observed, associated with a "class" whose life and activities previously had been disregarded "by the traditional and official view of what was significant to scholarship and culture."

Olsen's reference to class is noteworthy because it provides a key to an understanding of the term "folk art" as it was first articulated in Europe. For European scholars, folk art is generally identified with the peasant class: rural communities with a deep connection to place, the members of which are bound together by ties of kinship, ethnicity, religious faith, common agrarian life patterns, and inherited or received traditions in the arts. Folk art, according to this view, is conservative in expression and local or regional in character; it is created within a communal environment, and its techniques are transmitted from generation to generation within small, related groups. In contrast to the machine-made products of mass culture, folk artists use simple, often handmade, tools, manual techniques, and readily available materials.

The developing ideas about folk art, with their emphasis on time-honored local traditions; continuity through the passage of years of cultural forms, ornamental patterns, and symbolic references; and the integrity of hand craftsmanship were consistent with the spirit of nineteenth-century European romantic nationalism and became significant in the quest for national identity. The authentic national culture was seen as residing in the countryside, away from the polluting influence of the cities, which had absorbed foreign ideas and ways of life. Folk art became a powerful symbol of the national soul.

Ernst Schlee, in his comprehensive study of German folk art, refers to an almanac that was published in 1845 to promote German nationalism in certain German-speaking territories then under Danish rule. The volume contains an essay on *Schnitzkunst* or the art of woodcarving. Its author argued that with an "awakening national awareness," the artistic element in "the spirit of our people" should be developed. He praises woodcarving as an art form "rooted in the soil of the fatherland, an instructive, holy art, in the true sense of the word, a *Volkskunst* [folk art]." He further argues that it is "in the nature of art that it does not belong . . . to the upper classes only."

If the use of the term *Volkskunst* is recorded as early as 1845, the subject itself was not more fully elucidated until much later in the century, with the work of art historians like the Austrian Alois Riegl, whose important *Volkskunst, Hausfleiss und Hausindustrie* was published in Berlin in 1894. Romantic nationalists had used folk art to help underpin the argument for distinct national identities in the second half of the nineteenth century, emphasizing its shared, tradition-bound nature, and occasionally theorizing about a mystical, collective creativity, in which the identity of the individual artist was lost in communal anonymity. Riegl, on the other hand, stressed that the individual hand and intentions of the artist were significant, even in folk creativity. To be sure, the artist may have been obliged by group expectations to work within the norms of transmitted forms and conventions, but individual creativity—which implied personal aesthetic choices and technical virtuosity—saved received or inherited traditions from stagnating and permitted them to be renewed in each generation.

By the end of the nineteenth century, a vast descriptive and theoretical literature existed in Europe devoted to the field of folk art, much of it unknown to American scholarship on the subject even to this day. In this literature, folk art is considered either from the perspective of art history or ethnography, or both. (The former, for example, might typically trace the relationship of folk ornament to earlier styles in "high art" or elite culture; the latter the symbolic role of a folk object in a specific peasant culture.) A wide variety of objects in various media had been collected, described, and analyzed: ceremonial or regional dress and articles of personal adornment, ceramic or wooden vessels, painted furniture and household decoration, ritual or symbolic objects, woodcarvings, woven and embroidered textiles, decorated Easter eggs, among many other forms. Moreover, museums from Ukraine to Norway had been established on the model of Skansen, the influential outdoor Swedish museum in Djurgården of vernacular culture that Artur Hazelius founded in 1891.

If anything, the advent of the twentieth century only accelerated the interest in folk art. In 1928, the first Folk Art Congress met in Prague. By 1932 it was estimated that there were 2,000 local folk art museums in Germany alone. Ironically, as the European interest in the subject began to grow, the production of folk art in Europe entered a period of sustained decline, the result of changing social conditions, mechanization, industrialization, education, emigration, and the consequent loss of traditional village life.

The Roots of American Folk Art

The interest in American folk art may be traced to the celebration of the nation's centennial in 1876, which helped awaken a widespread interest in American local history, genealogy, and material culture and spurred the Colonial Revival. It also fostered the establishment of hundreds of historical societies in small towns and villages throughout the country and the antiquarian pursuit and collection of objects—some of which would later be characterized as folk art—that were especially relevant to the history of

their respective regions and the people who resided there. Before the end of the nineteenth century, pioneers like Henry Chapman Mercer in Bucks County, Pennsylvania, had begun the methodical collection, classification and preservation of the everyday objects of early American life, approaching this endeavor from an anthropological rather than an aesthetic purview. Another Pennsylvanian, Edwin Atlee Barber, acquired folk pottery and fraktur for the Philadelphia Museum of Art in the 1890s, recognizing these Pennsylvania German objects as works of art.

Although these trailblazing efforts were highly significant to the development of the field, American folk art was not collected in earnest *as art* until the 1910s and 1920s, independently of the earlier European interest in the subject. European ideas about folk art, however, continued to affect American thinking, especially in the academic disciplines of folklore, folklife studies and cultural anthropology. Moreover, various forms of folk art were brought to the United States by recent immigrants or created, studied, and exhibited here. Between 1919 and 1932, for example, a series of popular exhibitions of immigrant arts and crafts, as described by Allen H. Eaton in *Immigrant Gifts to American Life* (1932), was presented to large audiences throughout the country.

Almost from the start, however, the collection, study, and exhibition of folk art in America took a radically different direction. At least in part this was because the social conditions supporting the creation of folk art in Europe did not exist in North America, except in relatively closed groups with fully integrated cultural traditions. Notable examples of these in the eighteenth and nineteenth centuries were the Pennsylvania German farming communities of southeastern Pennsylvania and the Hispanic villages of northern New Mexico.

The perspective through which many Americans came to know the field was defined by Holger Cahill, curator of several of the first exhibitions devoted to the subject in the United States. In a 1931 essay in *The American Mercury*, Cahill—who had visited folk art museums in Germany and Scandinavia—demonstrated how dissimilar his conception of the subject was by comparison to the earlier, European ideas. "Folk art," he wrote, "does not include the work of craftsmen—makers of furniture, pottery, textiles, glass, and silverware—but only that folk expression which comes under the head of the fine arts—painting and sculpture. By 'folk art' is meant art which is produced by people who have little book learning in art techniques and no academic training, whose work is not related to the established schools." This is not to suggest, however, that such creative endeavors were not without substantial aesthetic merit. "Much of it," Cahill observed, "was made by men who were artists by nature, if not by training, and everything they had to say in painting and sculpture is interesting."

As against the emphasis on *tradition* and *community* that prevailed in Europe (an emphasis, incidentally, that is accepted by American folklorists, although with expanded parameters that substantially extend the original narrow class-based focus of the terms), Cahill chose for his model an "aesthetic" or "fine arts" approach and stressed instead *the nature of the artist's training*. Through this approach, which to a considerable extent guides the field to this day, American folk art embraces many, generally unrelated, artistic expressions that flourish among gifted individuals who are inspired to create, but for the most part without formal academic training or sustained exposure to the fine arts. As understood by Cahill and his followers, folk artists may draw deeply from the wellsprings of community tradition or may be idiosyncratic in their creativity. Their paintings are often distinguished by deceptively simple but remarkably sophisticated and stylized compositions, flat picture planes and tonalities, and a tendency toward abstraction. Folk sculpture, often direct and vigorous, shares similar aesthetic qualities.

Cahill's exhibitions "American Primitives: An Exhibit of the Paintings of Nineteenth Century Folk Artists" (The Newark Museum, Newark, New Jersey, 1930–1931); "American Folk Sculpture: The Work of Eighteenth and Nineteenth Century Craftsmen" (The Newark Museum, 1931–1932); and "American Folk Art: The Art of the Common Man in America, 1750–1900" (The Museum of Modern Art, New York, 1932) established a pattern that would influence American thinking on the subject to the beginning of the twenty-first century. Unlike the categories of objects that Hazelius showed in Paris, Cahill exhibited portraits of prosperous nineteenth-century merchants and farmers and their families by itinerant professional painters, landscape and still-life paintings by young women in seminaries, weathervanes, ship figureheads, shop figures, tavern signs, wildfowl decoys, and other objects. Some of these objects were produced in small shops by trained artisans; others represented the work of talented amateurs. Some were utilitarian in nature, while others were examples of pure fancy. Folk art, according to this view, was not necessarily rural in origin, and it clearly cut across class lines, often developing from earlier, provincial adaptations of urban style. Indeed, if any class was predominantly represented in the field, it was the

middle class. In one sense, however, Cahill and the Europeans agreed. For the most part, they reasoned, folk art was a thing of the past. Having reached its full flowering in the late eighteenth and early nineteenth centuries, its production declined as a result of industrialization, mass communication, and the impact of popular culture.

It should be acknowledged here that neither Cahill nor the early collectors of American folk art ever articulated clear or comprehensive parameters for the field that they had helped establish. In fact, these parameters were flexible enough eventually to admit the very kinds of objects—pottery, quilts, hooked rugs and other textiles, furniture, and other objects from craft traditions—that Cahill originally rejected. (In these categories, the creator transforms an everyday object into a work of art through the highly skillful and inventive use of materials, the application of imaginative surface decoration or other non-utilitarian features of an aesthetic character, and excellence in form and design.) Nor did they generally attempt to understand folk art in the context in which it was created. Many of these collectors were themselves artists who were seeking, in the years following the influential 1913 Armory Show in New York, a paradigm for a new American art, with freedom from the conventions of the academy. For these modernists, folk art—by definition "non-academic" in nature—represented something of the free spirit of America itself.

Among the artists who collected American folk art early in the twentieth century and helped shape the field as it came to be developed in the United States, were several painters and sculptors who spent summers in Ogunquit, Maine, at an artist's colony and school established in 1913 by Hamilton Easter Field. A painter, critic, and teacher, Field was an influential proponent of modern art through his published essays, the gallery that he operated in his home in Brooklyn, and *The Arts*, a brief-lived journal of art criticism that he inaugurated in 1920. Modernism helped open the doors to an appreciation of American folk art in the 1920s and 1930s. Many of the institutions and individuals—artists, collectors, curators, dealers—who figure prominently in the development of modern art have significant places in the field of American folk art as well.

A History of Collecting

The artists associated with Field included Robert Laurent, Yasuo Kuniyoshi, Niles Spencer, and William Zorach, all recognized today as prominent modernists. They decorated the fishing shacks in which they spent the summer in Ogunquit with examples of folk art that they collected. Some of them lent objects from their collections to such pioneering exhibitions as Cahill's Newark Museum shows and "Early American Art," an even earlier presentation at New York's Whitney Studio Club that the painter Henry Schnackenberg organized in 1924 with the support of Whitney director Juliana Force. Marsden Hartley, Charles Sheeler, and Elie Nadelman were among other important American artists whose work was influenced by their exposure to American folk art. In fact, Nadelman, an immigrant from Poland, and his wife, Viola, established in 1926—in their home in Riverdale, the Bronx (New York City)—the first museum in the United States devoted wholly to the subject. As opposed to the art of the academy, the modernists considered folk art as direct, free from the constraints and posturing of academic realism, and, above all, authentic. Indeed, much of this early interest in folk art may be understood as a quest for authenticity, an effort to recover truths deemed lost in social conventions and cultural forms. On a parallel track with the European artists of the period whose experiments with primitivism transformed the very nature of their artistic expression, American modernists found a basis for their own creativity in folk painting and sculpture.

It would be impossible to consider the developing appreciation for American folk art without recognizing the pivotal role played by Edith Gregor Halpert, who opened her influential Downtown Gallery in New York after a period of residence in Ogunquit in the summer of 1925 with her husband, the painter Sam Halpert. Field had died in 1922, but Laurent, his heir, introduced the Halperts to folk art, and they in turn brought it to the attention of Cahill, who visited Ogunquit with them the following year. By 1929, Edith Gregor Halpert was selling eighteenth- and nineteenth-century American folk paintings and sculpture in her gallery together with the avant-garde work of contemporary artists. She sold to Abby Aldrich Rockefeller, one of the founders of New York's Museum of Modern Art, many of the important works of American folk art that today form the core of the collection at the Abby Aldrich Rockefeller Folk Art Museum at The Colonial Williamsburg Foundation in Williamsburg, Virginia. Many other prominent private and institutional collections were built with Halpert's assistance.

As observed previously in this essay, little if any attention was paid in Cahill's and other early exhibitions to the contexts in which the objects on display were created. On the contrary, folk paintings, sculp-

ture, and other objects were considered strictly on aesthetic grounds, depriving them of their place in history and culture. (Eaton's exhibitions of immigrant arts and crafts were notable exceptions.) In part, this approach resulted from the newness of the field and the fact that virtually no contextual research had yet been undertaken. In the decades following these early efforts, however, American folk art became institutionalized. The establishment of Electra Havemeyer Webb's Shelburne Museum in Vermont in 1947; the purchase in 1950 of the American folk art collection of Howard and Jean Lipman by Stephen Clark for the New York State Historical Association in Cooperstown, New York; the installation of the Rockefeller collection at Williamsburg in 1957; and the founding of the American Folk Art Museum in New York (then the Museum of Early American Folk Arts) in 1961 not only meant that the public had access on a regular basis to exhibitions of American folk art, but that research in the field would be encouraged.

As more became known about the richly gifted artisans and amateurs who produced works that previously were seen as anonymous, the full diversity of the contexts in which they created, their widely varied sources and techniques, the disparate methods of transmission and training, and the differing community traditions that they represented, the very notion of American folk art as a coherent field was questioned. A highly charged literature, sometimes rancorous in nature, developed in the last quarter of the century over issues of classification and terminology, some theorists holding more closely to European ideas about folk art. The debate was all the more frustrating because its participants often were not speaking about the same categories of cultural production.

Notwithstanding the raging of these debates, the proponents of American folk art continued to collect, study, and exhibit the objects comprising the field, however arbitrary the classification occasionally appeared, confident that these objects deserved the consideration accorded to mainstream art. As an increasingly reliable body of information was developed, it became clear that the field, however diverse and elusive its definitions, had shed light on a highly important aspect of the American heritage and warranted the serious consideration of scholars.

A History of Terminology

The advent of the 1960s and 1970s brought new challenges to the scholarship of American folk art. The term increasingly was used to refer to the paint-

ings, sculpture, and built environments of contemporary self-taught artists, although previously it had been generally accepted that folk art belonged to the past. Collector, curator, and tastemaker Herbert W. Hemphill Jr. used the expression in his "Twentieth-Century American Folk Art and Artists," an exhibition with wide-ranging parameters and influence at New York's American Folk Art Museum (then the Museum of American Folk Art) in 1970. Although Hemphill and others recognized that this usage substantially extended the scope of the subject, it continued to enjoy broad-based, if occasionally begrudging, institutional and popular acceptance in the United States to the end of the twentieth century and beyond. Thus "folk art" was the term chosen to describe Hemphill's eclectic collection when it was acquired by the Smithsonian American Art Museum in 1986; the term was used by the Milwaukee Art Museum to refer to the collection of Michael and Julie Hall, an assemblage similarly rich in twentieth-century materials acquired by that museum in 1989; and the curatorial department of American folk art at the High Museum of Art in Atlanta uses the expression in its departmental title despite its clear emphasis on the work of contemporary self-taught artists.

In Europe, however, a clear distinction was drawn between folk art—which continued to be understood as class-based and tradition-bound—and "naïve art." This expression had been used to describe the paintings of Henri Rousseau, whose work was exhibited for the first time in 1886 in the Salon des Independants in Paris, and other self-taught artists like him. "Naïve art" continues to be the term most commonly used in Europe for self-taught artists today. Interestingly, the distinguished collectors of eighteenth- and nineteenth-century American folk art, Edgar and Bernice Chrysler Garbisch, chose to use the term "naïve art" to describe their collection; this usage has been maintained by the National Gallery of Art in Washington, D.C., where the core of their collection now is housed.

The proponents of other concepts and categories competed for recognition during the late twentieth century. "Outsider art" was the name Roger Cardinal's publishers gave to his 1972 study of *art brut*, a concept that "embraces not only the art of the clinically insane but also other artists of an authentically untutored, original, and extra-cultural nature." This category of artistic expression was originated by the painter Jean Dubuffet, who founded the *Compagnie de l'Art Brut* in France in 1948. For Dubuffet, mainstream art had become a repetitive cultural exercise. He saw in *art brut* ("raw art") an unmediated expres-

sion of creativity: spontaneous and uncompromising. The term "outsider art" is now in use by at least one American institution—Intuit: the Center for Outsider and Intuitive Art in Chicago.

Although it is difficult to imagine the use of two such dissonant terms to describe the same artists and their work, this is precisely what occurred in the United States in the last two or three decades. The two expressions, after all, do share similarities in meaning; as expressions they are less parallel in nature than convergent. As we have seen, both terms refer to art created outside the institutional structures of the art world by individuals without academic training or sustained exposure to the fine arts. Hemphill had already opened the doors to the idea that the work of idiosyncratic self-taught artists could be contextualized as folk art, and "outsiders"—persons living in isolation or at society's margins—had been included in his exhibitions and publications.

The field was able to absorb this enlarged purview at least in part because of advances in the understanding of American folk art itself. Cahill's Newark exhibitions, in keeping with the thinking of the day, tended to characterize folk art as anonymous, as if the individual hand and intentions of the artist were beside the point. In the following decades, however, researchers had identified scores of American artists. As a result, it was possible to discern visual, contextual, methodological, thematic, and other continuities, if not direct lines of transmittal, between the earlier artists and those who worked in the twentieth (and now twenty-first) centuries, including artists described as "outsiders." To be sure, some of these continuities were accidental, rather than related to the essence of the art or its production, but sufficient similarities existed to provide a basis for considering this work together.

Increasingly, distinctions are being drawn between folk art, on the one hand, and such categories as outsider art, although they remain connected in most institutions. In fact, when the surface is scratched, the full complexity of each artist and his or her work becomes apparent. Facile and narrow labels that reduce the creative spirit to a single dimension are of little significance in the long run, especially when they obscure the multiplicity of intentions, ideas, meanings, influences, connections, and references inherent in every work of art. Whatever nomenclature is used, the art and artists presented in this reference work are essential to an understanding of the American experience in its fullness.

Scope of the Encyclopedia

The *Encyclopedia of American Folk Art* is not intended to be fully comprehensive in scope. Rather it has been designed to provide a representative but detailed sample of relevant subjects through capsule biographies and thumbnail sketches. The entries, which together cover over three centuries, address three broad areas: persons, institutions, and subjects of topical interest. The extensive use of cross-references demonstrates the interconnectedness of the entries and will suggest additional areas for research to the user. Bibliographies are provided to suggest other sources of information, and entries on major repositories of American folk art will offer further leads. Finally, the comprehensive index will provide access to information that may be found throughout this volume, even when it is not the principal subject of the entry.

Newcomers to the field may appropriately question the relative want of Native American topics in this reference work. In general, research and collecting patterns in American folk art developed independently from those of traditional American Indian art, and for the most part the two subjects do not share institutional homes, specialists or bodies of scholarly literature. (It is interesting, and perhaps not surprising, however, to observe that avant-garde modernists, with their enthusiasm for primitivism, collected and contextualized both American folk art and Native American art *as art* early in the early twentieth century.) While recognizing that Native American art is outside the scope of this volume, the editors nevertheless have elected to include a general entry on the subject and several specialized entries on topics that represent a fusion of Native and non-Native cultural influences, such as ledger drawings.

Artists and subjects have been selected for inclusion in the *Encyclopedia of American Folk Art* because of their general significance to the field, but the editors recognize that other specialists might well have chosen differently. The emphasis here is on artists, collectors, and others who have achieved widespread recognition, but relatively few living persons have been included. Given limitations in the size of this volume, it was thought appropriate to restrict the numbers of living subjects. The approach tends to be art historical rather than ethnographic or folkloristic, but these perspectives are also represented. Had the work been approached as a whole from the purview of another academic discipline, the contents of this book would have been substantially different. Nevertheless the editors hope that the information

provided in the encyclopedia will be of benefit to a wide range of inquiry. It was intriguing to observe the diversity of the entries—in content, approach, and style—as they arrived for inclusion in this volume. It is our hope that readers will share our enthusiasm for the absorbing process of discovery that the compilation of the *Encyclopedia of American Folk Art* represented.

Although the *Encyclopedia of American Folk Art* is the first encyclopedic reference work to approach the subject as a whole, valuable resources have been published that provide access to aspects of the subject. For many years, George C. Groce and David H. Wallace, *The New-York Historical Society's Dictionary of Artists in America, 1564–1860* (New Haven, Connecticut, 1957) has been a useful guide to America's early artists. Its brief entries and bibliographical references include artists of interest to the field of American folk art. For "naïve artists"—as that term is used in Europe—Oto Bihalji-Merin and Nebojsa-Bato Tomasevic, *World Encyclopedia of Naïve Art* (Secaucus, New Jersey, 1984) provides a colorful introduction. George H. Meyer, *Folk Artists Biographical Index* (Detroit, Michigan, 1987), which covers more American folk artists than any other compilation, does not contain entries of its own; rather it helpfully refers the reader to over two hundred sources of published information about the indexed artists. Especially valuable for its comprehensive coverage of 257 artists and widely acknowledged for the significant original research and fieldwork of its authors, Chuck and Jan Rosenak, *Museum of American Folk Art Encyclopedia of Twentieth-Century American Folk Art and Artists* (New York, 1990) is a pioneering work that remains an important resource. Another book by the same authors, Chuck and Jan Rosenak, *Contemporary American Folk Art: A Collector's Guide* (New York, 1996), while written from another perspective, contains detailed information about many artists not included in the first work, together with useful references to museum collections. More recently, Betty-Carol Sellen with Cynthia J. Johanson, *Self-Taught, Outsider, and Folk Art: A Guide to American Artists, Locations and Resources* (Jefferson, North Carolina, 2000) and *Outsider, Self-Taught, and Folk Art Annotated Bibliography: Publications and Films of the 20th Century* (Jefferson, North Carolina, 2002) offer much helpful data.

The compilation of information represented by this volume was accomplished by ninety-two specialists, including many distinguished scholars with impressive credentials in their respective fields of study and a talented group of newer students, who brought their own fresh perspectives to their entries. I am deeply grateful to all the contributors; their commitment to sharing the results of their research and their enthusiastic dedication to their subjects have truly animated the *Encyclopedia of American Folk Art*. I am especially beholden to my colleague, Lee Kogan, director of the Folk Art Institute, an educational arm of the American Folk Art Museum, and curator of special projects for that institution's Contemporary Center. Kogan, who served as associate editor of the encyclopedia, was my partner in every respect of the word. In addition to writing ninety-five entries of her own, she provided wise counsel and advice at every step of the project's development. She also assembled most of the illustrations that bring a striking visual dimension to the pages of this book. Paul S. D'Ambrosio, chief curator of the New York State Historical Association at Cooperstown, a contributor to this volume, kindly read its whole text. His critical comments and other suggestions were important to the realization of our goals. My gratitude to him is deeply felt and abiding. My warm appreciation is also due to Cynthia Parzych and John Turner, who first proposed the project to me, helped shape the book, and administered its development with aplomb and dedication. Final acknowledgments go to the publisher, Routledge, New York, an imprint of Taylor and Francis, London. The team at Routledge's reference department who diligently brought this book to fruition include Sylvia Miller, publishing director; Kate Aker, director of development; and development editors Sue Gamer, Kristin Holt, and Lynn M. Somers. They were ably assisted by production director Dennis Teston and Greg Nicholl, assistant production editor.

Gerard C. Wertkin, Director
American Folk Art Museum, New York

I wish to acknowledge with thanks colleagues, scholars, museum staff, and family descendants and friends of artists for generously sharing information and materials.

Lee Kogan, Director
*Folk Art Institute/Center of Special Projects
for the Contemporary Center*

AARON, JESSE J. (1887–1979) was a woodcarver of mixed descent (African American, European, and Seminole) who took up art in his eighth decade. The origins of the creative process are often ambiguous and baffling, but for Aaron they were clear and unmistakable: "Carve wood" were the words he heard at three in the morning in 1968, during a period when his wife, Lee Anna, was losing her eyesight. Compelled by a higher power to make art, the former cook, cabinetmaker, and nurseryman quickly became an accomplished carver of cedar rescued from the swamps and marginal terrain near his Gainesville, Florida, home. The income he earned during his first year of carving helped pay for an operation he credited with saving Lee Anna's vision.

Trees on the boundaries of Aaron's property were his first artworks; the faces carved into the wood changed and became distorted slightly as their living hosts added rings. Aaron gradually converted his side yard into a "museum" filled with freestanding carvings, ranging from a foot or so to seven feet tall, that he offered for sale. Aaron's artwork is part of a continuum, encompassing the work of conventional African American carvers such as Elijah Pierce and Ulysses Davis, and "root sculptors" such as Bessie Harvey and Ralph Griffin. Artists devoted to a single medium, especially wood, often develop an almost preternatural attachment to the act of identifying and selecting their raw material. Aaron preferred to salvage wood himself; the carving was virtually a translation of existing forms, or a negotiation between the natural world and his vision. By the mid-1970s his health began to fail, however, and he relied increasingly on having wood brought to him.

As with many sculptors of found wood, Aaron's subjects tend to be people and animals. Occasionally, hints of social observation and commentary appear, as in a carving of a sheriff restraining a chained, brown prisoner, but most of Aaron's efforts are true to their generally untitled status. Sometimes they are painted and embellished with other found materials, such as hats, jewelry, dolls' eyes, and antlers. Their formal strength emerges through a mixing of the cedar's prior textures and volumes with a virtuoso blunt carving style that can resemble brushstrokes. The tension between sinuousness and brutal technique lends classic Aaron sculptures an expressionist pathos that is both tender and anguished. Often the works are stiff and frontal, hallmarks of their former existence as stumps or limbs, but their powerful, semaphore-like movements pulse inside skins as complex as their maker's.

See also **African American Folk Art (Vernacular Art); Ulysses Davis; Bessie Harvey; Elijah Pierce; Sculpture, Folk.**

BIBLIOGRAPHY

Arnett, Paul, and William Arnett. *The Tree Gave the Dove a Leaf. Souls Grown Deep: African American Vernacular Art of the South,* vol. 1. Atlanta, Ga., 2000.

Livingston, Jane, and John Beardsley. *Black Folk Art in America, 1930–1980.* Washington, D.C., 1982.

PAUL ARNETT

ABBY ALDRICH ROCKEFELLER FOLK ART MUSEUM is built around the important American folk art collection of Abby Aldrich Rockefeller (1874–1948), the wife of John D. Rockefeller Jr. (1874–1960). Rockefeller's husband funded the restoration of Virginia's colonial capital, and the museum is one of five that compose Colonial Williamsburg. In 1935, Rockefeller loaned a portion of her collection to Colonial Williamsburg for exhibition in the Ludwell-Paradise House, an eighteenth-century building; she donated those objects to Colonial Williamsburg in 1939. The collection remained on exhibit in the Ludwell-Paradise House until 1956.

Two years earlier, Colonial Williamsburg had announced plans to construct a new museum bearing Rockefeller's name. With the support of David Rockefeller (1915–), Mrs. Rockefeller's son, fifty-four examples of folk art that she had given in 1939 to the Museum of Modern Art and the Metropolitan Museum of Art were reunited with the collection in Williamsburg. Funded by John D. Rockefeller Jr., with Nina Fletcher Little (1903–1993) serving as consultant and writing a catalog for the collection, the Abby Aldrich Rockefeller Folk Art Collection opened to the public in May 1957.

The four hundred and twenty four objects collected by Abby Rockefeller between 1929 and 1942 remain the foundation of the museum's collection, which nevertheless was envisioned to be expandable from the outset. In the museum's first year of operation, with the acquisition of the folk art collection assembled by J. Stuart Halladay (dates unknown) and Herrel G. Thomas (dates unknown), as well as objects acquired from Holger Cahill (1887–1960), Edith Gregor Halpert (1900–1970), and Mrs. John Law Robertson (dates unknown), the collection rapidly grew. Works from all regions of the United States and objects dating from the early eighteenth century to the present day are now represented in a collection of more than 3,000 objects. Particular strengths are in the areas of portraiture, Southern folk art, sculpture, fraktur, African American folk art, and textiles. The museum has in-depth holdings of representative works by Eddie Arning (1898–1993), Wilhelm Schimmel (1817–1890), Erastus Salisbury Field (1805–1900), Edward Hicks (1780–1849), Lewis Miller (1796–1862), and Ammi Phillips (1788–1865). Some of the museum's first exhibitions were about such diverse topics as The Beardsley Limner (Sarah Perkins, 1771–1831); Virginia decorated furniture; the portrait painters Zedekiah Belknap (1781–1858), James Sanford Ellsworth (1803–1875), and Asahel Lynde Powers (1813–1843); and the artists Eddie Arning and Henry Young (1792–1861).

The museum's name was changed in 1977 to the Abby Aldrich Rockefeller Folk Art Center, reflecting the institution's extensive archive of research materials, and in 2000 the center's name was changed again, to the Abby Aldrich Rockefeller Folk Art Museum.

See also **African American Folk Art (Vernacular Art); African American Quilts; Eddie Arning; Zedekiah Belknap; Holger Cahill; James Sanford Ellsworth; Erastus Salisbury Field; Fraktur; Furniture, Painted and Decorated; Edith Gregor Halpert; Edward Hicks; Nina Fletcher Little; Sarah Perkins; Ammi Phillips; Asahel Lynde Powers; Abby Aldrich Rockefeller; Wilhelm Schimmel.**

BIBLIOGRAPHY

Rumford, Beatrix T., ed. *American Folk Portraits: Paintings and Drawings from the Abby Aldrich Rockefeller Folk Art Center.* Boston, 1981.

Rumford, Beatrix T., and Carolyn J. Weekley. *Treasures of American Folk Art from the Abby Aldrich Rockefeller Folk Art Center.* Boston, 1989.

RICHARD MILLER

ADKINS, GARLAND (1928–1997) was a carver and painter of animals from the mid-1980s until shortly before his death in 1997. Adkins married Minnie Wooldridge in 1952, and the couple lived mainly in Ohio until returning to their home community of Isonville, Kentucky, in the early 1980s. Garland then began his work as an artist by helping his wife produce her pieces. Typically, he would do the initial work of obtaining, selecting, and preparing a suitable piece of wood, then marking it and sawing out the rough form of a piece with a chainsaw and other power tools. He would then give it to Minnie to carve. He was quick to assert that he participated primarily because this was the Adkins family's source of income, and he regarded Minnie's carvings not as works of art but as objects made for sale. Regardless of who spent more time working on a piece, most of the Adkinses' carvings produced between 1986 and 1997 were presented as collaborations, marked with their combined signature, "G & M Adkins." Garland's participation was a key factor in the Adkins's family cottage industry, but he and Minnie both produced pieces that quite clearly bore the marks of their separate, individual styles.

Garland's personal repertoire was much narrower than Minnie's, consisting almost entirely of the abstracted, standing horses for which he became best known in his own right, about 1990. In 1987 he sold a foot-high unpainted wooden horse to Morehead State University, and in 1988 he granted permission for the silhouette of this piece to be used as the basis for the organizational logo of the Folk Art Collection at the university. Adkins continued to develop and refine this form, retaining its legs, which lack detail, and its rectangular head, but further elongating the extended neck. Over the next ten years he produced many versions of this horse, either in plain wood or painted black all over. The standing horse came in two basic versions: one upright and alert, with its straight neck raised diagonally forward from the shoulders, and the other relaxed, with its neck curved

gracefully forward and downward, and its head close to the ground, as if grazing.

Adkins earned a significant place in twentieth century American folk art, not because his work exemplifies regional woodcarving traditions, but because the austere power of his horse form transcends identification, whether by geographic location, culture, or period in time.

See also **Minnie Adkins; Sculpture, Folk.**

BIBLIOGRAPHY

Moses, Kathy. *Outsider Art of the South.* Atglen, Pa., 1999.
Yelen, Alice Rae, ed. *Passionate Visions of the American South: Self-Taught Artists from 1940 to the Present.* New Orleans, La., 1993.

ADRIAN SWAIN

ADKINS, MINNIE (1934–) is a carver in wood who gained national attention as an artist in the late 1980s. She began to carve small animals and birds as a child in Isonville, Kentucky. Generally, she has produced, carved, and assembled sculptures of animals, particularly tigers, bears, foxes, and possums, but she has also created paintings, various assemblages, and ceramic collaborations with her cousin, Tess Little, a sculptor and ceramic artist. For many years, Adkins' best-known piece was a forked-twig rooster with a red-and-yellow painted comb and beak, and a split tail, but after interest in her work grew through her association with the Folk Art Collection at Morehead State University, her subject matter expanded to incorporate the human figure, including a series of self-portraits. From the mid-1980s until his death in 1997, her first husband, Garland Adkins, helped work on his wife's larger pieces, procuring the wood, rough-cutting the sculptures, and generally helping with production.

Adkins has initiated a cottage industry by selling commercially woven afghans and locally made quilts featuring her animal forms, and offering *The Blue Rooster,* a book and cassette collaboration with musician Mike Norris. Her second husband, Herman Peters, produces painted, welded steel-pipe versions of other animal forms. Adkins remains productive, with a reputation that extends beyond her own work, as a mentor and promoter of other self-taught artists in her own community and beyond. The existence of a network of folk artists based in Kentucky can be attributed largely to her promotion, friendship, and encouragement of others. An annual folk art fair is held at her home each June.

Adkins has received many awards, including the Jane Morton Norton Award from Center College in Danville, Kentucky; the Award for Leadership in Arts and Culture from the Eastern Kentucky Leadership Foundation; the Distinguished Artist Award from the Folk Art Society of America; an Al Smith Fellowship; a Governor's Award for the Arts from the Kentucky Arts Council; the Appalachian Treasure Award and an honorary doctorate from Morehead State University.

See also **Garland Adkins; Outsider Art; Sculpture, Folk.**

BIBLIOGRAPHY

Moses, Kathy. *Outsider Art of the South.* Atglen, Pa., 1999.
Yelen, Alice Rae. *Passionate Visions of the American South.* New Orleans, La., 1993.

ADRIAN SWAIN

ADVENTIST CHRONOLOGICAL CHARTS were a distinguishing feature of the religious movement founded in the 1830s by William Miller (1782–1849), a farmer-turned-preacher from Low Hampton, a village near the Vermont border in upstate New York. An intensive study of the prophecies contained in the biblical books of Daniel and Revelation convinced Miller that the long-awaited millennium, the 1,000-year period of peace on earth, would commence in 1843 or 1844, accompanied by the Second Coming of Christ. He gathered a substantial following in the Northeast and elsewhere in the country through tent meetings and the circulation of prophetic literature.

In 1842, two of Miller's followers, Charles Fitch and Apollos Hale, prepared a chart printed on linen panels that outlined Miller's calculation of the Second Coming in graphic detail. They exhibited their work at a conference of Millerites (followers of Miller's teachings) in Boston, and it was deemed so successful that the leadership of the movement resolved to have three hundred copies printed. *A Chronological Chart of the Visions of Daniel & John,* as the first version was titled, was published in 1843 by Miller's lieutenant, Joshua V. Himes, and printed in a large format by the Boston lithographer, E.W. Thayer. The charts measured nearly six by four feet. From then on, Millerite preachers carried a copy of the chart with them, using it as a visual aid to help audiences understand the complicated biblical chronology. The American folk painter William Matthew Prior (1806–1873), was an ardent follower of Miller. Although it no longer is extant, Prior painted a version of the chronological chart under Miller's direction; he was so moved by the preacher that he also painted his portrait.

Versions of the chronological chart were circulated widely in the periodicals of the Millerite, or "Adventist," movement, as it was also called (from the belief in the imminent second "advent" of Christ), and they provided an iconographic resource for efforts by other preachers and prophets to demonstrate in a visual format the timing of the millennium. In addition to the actual calculations, the charts generally contain fearsome, if fanciful, depictions of the beasts described in the Books of Daniel and Revelation; a large and imposing bearded figure symbolic of four ancient empires; the Four Horsemen of the Apocalypse; and several trumpeting angels, among other dramatic images.

After the failure of Miller's calculations, the Adventist movement revised its interpretive approach to biblical prophecy and, in turn, altered the chronological charts. Jonathan Cummings of Concord, New Hampshire, for example, published an untitled prophetic chart in the Adventist tradition in 1853, a copy of which is in the Firestone Library at Princeton University. A monumental late nineteenth century handdrawn and painted *Missionary Map,* formerly in the collection of Herbert W. Hemphill Jr., is now at the Smithsonian American Art Museum. It draws upon a similar stock of Adventist iconography. The twentieth century artist William Alvin Blayney (1917–1985) may have been familiar with the imagery of the Adventist chronological charts when he painted his impressive diptych, *Anti-Christ and Reign of the Gentile Kingdoms* and *The Sealed Book of the Revelation of Jesus Christ* (c. 1960).

See also **William Alvin Blayney; Herbert W. Hemphill Jr.; William Matthew Prior; Religious Folk Art.**

BIBLIOGRAPHY

Doan, Ruth Alden. *The Miller Heresy, Millennialism, and American Culture.* Philadelphia, 1987.
Nichol, Francis D. *The Midnight Cry.* Washington, D.C., 1944.
Wertkin, Gerard C. *Millennial Dreams: Vision and Prophecy in American Folk Art.* New York, 1999.

GERARD C. WERTKIN

AETATIS SUAE LIMNER: *SEE* NEHEMIAH PARTRIDGE.

AFRICAN AMERICAN FOLK ART (VERNACULAR ART) is defined here specifically as the visual art produced in various forms within the African American community beginning as early as the seventeenth century, when blacks were taken in large numbers from Africa and the Caribbean to work as slaves in the United States, primarily in the South. The study of black art forms has been dominated by deeply riven opinions about African American culture. In 1998, when the Museum of American Folk Art (now the American Folk Art Museum) mounted its major overview of self-taught art, "Self-Taught Artists of the Twentieth Century: An American Anthology," thirteen of the exhibition's thirty-two artists (40 percent) were African American, when only about one-tenth of the total United States population was black. The show made inescapable an obvious question: How did artists of African descent become so central to the field of self-taught art?

African American folk art, or vernacular art, has two histories: one of its production (the artists, their work, and its perspectives), and another of its reception (the ways the art is consumed, discussed, and positioned on cultural maps). The gaps between these two histories merit study, for the ways in which the art has been promoted point to conflicting American attitudes toward African American "folk" culture. Only in the last years of the twentieth century did it become apparent that, among a generation of vernacular artists who came of age during the period of intense civil rights struggles in the 1960s, the fissure between their art's creation and its welcome have become a part of their work's meaning. If vernacular artists have not fully entered any "mainstream" (a goal most do not pursue anyway), many have nevertheless brought under their control the terms on which their art is created.

African American folk art began everywhere Africans were forced, with limited resources and no organization, to cobble spiritual, aesthetic, psychological, and physical survivals amid the surrender of selfhood demanded by the institution of chattel slavery in the United States. The historical record remains hazy, but slaves and free blacks often became accomplished craftspeople within white workshops or patronage environments, as was the case with Harriet Powers (1837–1911), who created at least one of her quilt masterpieces as a commission for a group of college professors' wives in the 1890s; other important examples of needlework, pottery, and furniture were produced by African American artisans throughout the North and South, especially in antebellum times. During an era in which most of white society remained skeptical that even literate blacks were capable of creating written literature, the first forms of folk art (art produced for personal use or consumption by other blacks) were almost certainly not paintings and sculpture, nor works in any genre that would

have endangered the maker in a society threatened by displays of elevated black consciousness.

Nevertheless, tantalizing glimpses linger of independent veins of creation. Two signature objects from the mid- to late nineteenth century—a wooden walking stick carved by Henry Gudgell (c. 1826–1895) of Missouri, and a pair of pictorial, appliqué quilts made by Harriet Powers of Georgia—are remarkable for their individuality and formal assurance. Powers' appliqué quilts, divided into a panel-like grid, depict biblical stories and events, while Gudgell's relief-carved canes feature abstract as well as realistic motifs, such as humans, leaves, lizards, and tortoises. Despite the works' utilitarian functions, their elaborate iconographies imply the existence of highly developed systems for representing reality through the visual arts, oral storytelling, religious worship, or combinations of the three. Both artists' work hints at the fact that African mythologies endured the middle passage (the journey undertaken by many slave ships, from Africa across the Atlantic to the West Indies or the Americas) and became firmly established within African American life.

The unknown provenances of most craft objects of the nineteenth century muddy attempts to identify any traits particular to African American artisans. Moreover, two key categories of African American creativity are almost entirely unaccounted for in the historical record. The yard shows ubiquitous in the black South were seldom, if ever, documented, except obliquely in the descriptions of a few travelers and novelists. And few significant examples of studio painting or sculpture are known to have survived—if indeed conditions of material prosperity and personal leisure existed to support any widespread production of "gratuitous," or non-utilitarian artworks.

Black folk art did not exist, at least as far as the outside world was concerned, until the rise, in the 1930s, of interest in indigenous (as opposed to European) sources of American vanguard art. The key early figure in black folk art's public emergence was Nashville stone carver William Edmondson (1874–1951), the subject of a show at the Museum of Modern Art in 1937. A gravestone carver, Edmondson blurred the boundaries between stonemasonry and art with his limestone animals, angels, and popular heroes. Edmondson, like an artisan in pre-modern societies, worked within a circumscribed framework of inherited formal solutions, materials, and techniques; yet he was individually inspired by a divine vision, and his sculptures' stylistic resemblance to twentieth-century masters, such as Amadeo Modigliani (1884–1920) and Constantin Brancusi (1876–1957), seemed to confirm the universality of modernist aesthetic values. Edmondson's artistic renown helped establish an enduring historical pattern by which folk art and outsider art are treated as evidence of the investigations and stances of trained artists.

The work of other black artists, such as painter Horace Pippin (1888–1946), was looked at in a similar way, but few observers sought to make cultural distinctions among the panoply of folk artists that came to light before the 1960s. Broad dichotomies between Europe and the United States, those in the vanguard and those with more conservative views, and highbrow and lowbrow sensibilities dominated conceptions of folk art's place within the larger history of art.

The three signal artists of the pre-1960s era are Edmondson; Bill Traylor (1854–1949) of Alabama, with his elegant draftsmanship and opaque yet irresistible storytelling; and James Hampton (1909–1964), with his resplendent religious altar/throne/shrine produced in the 1950s to early 1960s in a Washington, D.C., garage, which he called *The Throne of the Third Heaven of the Nations Millennium General Assembly*. This work by Hampton epitomized the great migrations (the slow exodus of blacks from the rural South to major cities), and although the iconography of the work remains only partially understood, it seems to represent the blossoming of liberation struggles in the postwar decades.

The upheavals of the 1960s and early 1970s—including the civil rights, counterculture, women's, and antiwar movements—completed disruptions to class and racial structures first set in motion by the Great Depression of 1929 to 1939 and World War II. Social criticisms, previously unthinkable as manifest themes for most African American vernacular artists, became the norm, and "blackness" was represented with an open-ended set of possibilities, including Joe Light's (1934–) cartoon-influenced proclamations of his creolized heritage and adopted Jewish faith; Vernon Burwell's (1916–1990) equating of Sojourner Truth, a former slave and advocate for equality and justice, with Martin Luther King Jr. and Jesus in monumental concrete sculptures outside his North Carolina home; and Royal Robertson's (1936–1997) conception of himself, based on comic strips, as an intergalactic superhero/traveler exposing the hypocrisies and sins of his fellow earthlings.

While art underwent transformation during the civil rights movement in the 1960s as well as during the movement's percolation into the everyday lives of African Americans in the 1970s, new tools for art's evaluation were emerging throughout academia, primarily outside the narrow realm of the art world. The

establishment of a Black Arts movement, making claims for a black aesthetic, coincided with ground-breaking studies of black religion, slavery, folklore, and music, along with an interest in African American genealogy that permeated popular culture. This heady period culminated in two projects from the early 1980s: the 1982 exhibition "Black Folk Art in America, 1930–1980," curated by Jane Livingston and John Beardsley, at the Corcoran Gallery of Art; and the book *Flash of the Spirit: African and Afro-American Art and Philosophy* (1981), by Robert Farris Thompson. Both upended the aesthetic principles previously applied to black folk art. Livingston and Beardsley spotlighted works, for example, like Steve Ashby's (1904–1980) bawdily kinetic found-object sculptures, and James "Son" Thomas's (1926–1993) hair-raising ceramic heads that were, in Livingston's words, "crude" and "relentlessly coarse or repellent" (intentionally so, she posited) when considered through existing standards of taste. Partisans of European *art brut* had long championed disturbing rather than congenial forms, but Livingston turned prior debates on their head by proclaiming such styles as culturally specific values often consciously sought by African American artists. Meanwhile, Thompson placed the same art at the New World end of clusters of cosmological beliefs and religious rituals originating in Africa. "Black Folk Art in America" challenged received notions of beauty and artistic skill; Thompson implicitly attacked the designation of the art as *art*—not because it was in any way inferior to art proper, but because he saw it as sidestepping almost entirely any standing definitions of art.

The two projects have their detractors, but after "Black Folk Art in America" and *Flash of the Spirit,* conceptions of African American folk art were indelibly revised. The 1980s saw few other theoretical developments in the emerging field, but dozens of previously unrecognized artists soon came to light, notably artists whose media (such as the yard shows and other site-specific creations prevalent in Thompson's study), styles, or thematic concerns had previously kept them unseen, despite their often ambitious and confrontational qualities. Academic studies of African American life began to spread slowly into interpretations of highbrow art forms, especially in Henry Louis Gates Jr.'s *The Signifying Monkey: A Theory of African-American Literary Criticism,* which posited the African American vernacular tradition of "signifying"—playing with coded communications to produce indirect or misleading utterances understood differently by different receivers—as a central trope of black literature. The idea of signifying, with its pro-

pensity for challenge through parody and misdirection, helped complete Livingston and Thompson's picture by demonstrating the ways in which cultural ideals could thrive while still remaining camouflaged, sometimes within forms that are seemingly crude, ugly, or random.

Meanwhile, vertiginously rising prices (and reputations) in the "mainstream" art world during the 1980s pushed many academic artists, and emerging groups of collectors and dealers, to prospect for alternative, unsullied voices in the supposed nether reaches of Western civilization, especially the black American South. By the end of the 1980s, two critical frameworks—the creative outsider and the folk community—outshone all others in the interpretation of African American Art. From these two perspectives a fundamental debate developed about the roles of and relationships between the individual and the community in the creation of art. Interestingly, ethnic enclaves and subcultures were usually considered final islands of folk culture, amid the forces of homogenization and modernization that were believed to have swamped rural European-American folk communities throughout the twentieth century. The combined energy of the two camps propelled rapid increases in visibility and demand for African American vernacular folk art throughout the 1990s, resulting in one-person museum shows for Edmondson, Pippin, Nellie Mae Rowe (1900–1982), Sam Doyle (1906–1985), Thornton Dial Sr. (1928–), Sister Gertrude Morgan (1900–1980), Elijah Pierce (1892–1984), William Hawkins (1895–1990), and others, while also creating a storm of stereotypes, from the nostalgic to the degenerate, that beset the art and its makers.

Can any art stand for conceptions of community *and* for truculently nonconformist, individual visions? Can any concept carry two otherwise incongruent notions about the other? In the case of African American—made artworks, the answer to both questions is yes, owing to the concept of "cultural pathology." First articulated by prominent black academics in the 1930s and 1940s, cultural pathology posits that African American progress (defined as assimilation into mainstream American society) has been impeded by structural deformities in African American culture brought on by slavery and the effects of race prejudice. African American folk culture, according to such cultural pathology, was born in the experience of bondage and therefore developed as a deformed version of the larger American culture. The distortions ultimately led, according to the theory, to all sorts of social ills and deviancies, including high levels of school dropouts, soaring crime rates, and the fraying

of the family unit. The concept of cultural pathology underlies much social policy of the second half of the twentieth century in America, including many landmark court decisions of the civil rights era, because of the belief that government should remove barriers to such assimilation. Social progress, within this context, pushed the have-nots further into the pathology of a permanent underclass. Therefore, the neo-conservative argument that highly motivated individuals will transcend such challenges also presupposes, in the case of race, the cultural pathologies of self-destructiveness and self-defeatism.

Social policy and aesthetic theory mix dangerously. Thus there have been wildly diverging interpretations of all African American vernacular cultural forms. The non-institutional nature of African American vernacular art extends beyond the creators' general lack of formal art schooling and their personal displacement from debates among critics, curators, and collectors. Vernacular art's radically non-institutional (perhaps anti-institutional) quality has always been closely tied to the very factors that gave rise to theories of cultural pathology: historical oppression, denial of basic rights, and unequal access to education, housing, and economic opportunity. Addressing such conditions from within their own culture, vernacular artists often feel a special burden to persist without institutional validation, vocational support, fellowship with other artists, or even legal protections from the destruction or theft of their works. Much vernacular art, then, stands against cultural pathology and its applications by the political left as well as the right.

Many African American vernacular artists operate within two deeply felt cultural contexts of responsibility: to act as documenters, and as visionaries. These artistic roles or ambitions coexist vividly for artists whose lives straddle the two epochs of Jim Crow, or the post–Civil War period after 1865, and the post–civil rights decades of the late twentieth century. On one hand, this is an art of witnessing and recounting, driven by the need to describe honestly the world as it has been overlooked, ignored, or mistreated, as well as misrepresented, by the powerful. Memory and memorial resound through nearly every artist's sensibility. Even when description simply elevates the everyday and the mundane, lifting commonplace experiences into the realm of the timeless, the implications may be radical, as in Purvis Young's (1943–) paintings of playground athletes with arms raised in gestures that recall those of mourners, rioters, and worshippers. At the same time, African American vernacular artists dare nearly always to re-imagine reality, to

wear the robes of a dreamer, and to transform. For this mission there is abundant precedent within black culture, from the religious sermon and divine calling to cultural heroes such as Abraham Lincoln and Martin Luther King Jr., and from song to sport.

Callings that might appear incompatible are often, instead, inseparable for the vernacular artist. Ronald Lockett (1965–1998), born in Alabama the same year that the Selma, Alabama, protest marches took place, depicted in his works the concurrent exterminations of animal species and peoples of color through naturalistic depictions of drought-encumbered deer and bison. Lockett's close observation and naturalism (an approach already at odds with many stereotypes about "primitive" artists) was executed in collages of scavenged, oxidized tin whose luminous colors were both ravaged and ravishing, an apt metaphor for his insistence on both commemoration and rebirth. Lockett's delicate mix of journalistic and visionary impulses led to holographic or mirage-like effects that feel as postmodern in form as they are traditional in theme.

Lockett's analogies between black people and endangered ecosystems were also a way of representing himself. For black Americans who lived through segregation, making art is an inherently political event, a rebuttal to invisibility. Autobiographical ambitions tie together virtually every artist working from the 1960s onward (and many from before then). Because indirection and misdirection have been primary tools of "signifying" communications among African Americans, their self-proclamation through art is varied and full of nuance. Statements of individual identity only occasionally reveal themselves as declarative personal narratives or in other overtly self-descriptive content, such as storytelling. Autobiographical features frequently reside instead in the medium. For tombstone makers like William Edmondson and Eldren M. Bailey (1903–1987), who created their artworks with the same materials and implements with which they made their grave markers, or like Leroy Person (1907–1985), whose woodcarvings were made after decades of work in a sawmill, the medium puts their professional skills into a new context, namely, the service of art. For woodcarvers like Elijah Pierce and Ulysses Davis (1914–1990), woodcarving became an extension of their barbering professions, as well as the hairstyling professionals' community-building positions within African American neighborhoods. For Jesse Aaron (1887–1979), a garden nursery worker, woodcarving enacted his religious faith and fulfilled the terms of an artistic mission initiated by a divine directive to "carve wood."

Aaron carved; but other artists, especially those who work with found roots, refrain from all but the slightest alterations to their wooden materials. Whether or not root sculptors believe divinities or energies repose in wood (as some scholars have suggested), spiritual metaphors abound in the acts of recycling and reclamation. Ralph Griffin's (1925–1992) roots were, to him, literal roots, something that preceded the founding of the United States and therefore called up forces from Africa and the Bible. Bessie Harvey (1928–1994) made roots, which overflow with phallic and aphrodisiac implications in folk medicine traditions, into feminist inversions: her large, black roots were transfigured into stylish women, and became symbols of female power.

Artists' materials and media also document social histories, such as movements to urban areas and industrialized occupations. Charlie Lucas (1951–) traces artmaking ancestors to the nineteenth century through skills learned from his father, who was an auto mechanic. Lucas's welded found-metal sculptures encapsulate the traditions of his forebears, who made woodcarvings, baskets, ceramics, quilts, and who worked in metal as blacksmiths.

Other artists have inscribed autobiography in style. Mississippian Mary Tillman Smith (1904–1995) endured a hearing impairment and an early life of sharecropping to wrest a fiercely independent life for herself. Her painted figures, sometimes self-portraits, convey their power through robust brushwork and dramatic figure-ground interactions.

If his work was considered outside its cultural context, Purvis Young might well be labeled an expressionist or abstract expressionist. His conviction that African American people have survived and triumphed over persecution through their vitality led him to a painterly style ruled by motion. Ripples of human respiration, beating hearts, nervous energies, and rhythmic rituals course through both his individual brushstrokes and his overall compositions. Young's almost romantic attitude belies his themes of the desperation and fragility of the life force.

The foremost practitioner of vernacular autobiographical art may be Alabamian Lonnie Holley (1950–), who seeks to represent thought itself in all its grandeur, accident, and messiness. Holley's assemblages of gathered materials, meant to evoke neighbors, friends, and relatives, as well as distant places visited only through the news media or imagination, form structures devoid of conventional order. Often, they are almost unbearably genuine, such as *Protecting Myself the Best I Can,* a collection of weapons (a baseball bat, a steel pipe, a golf club standing in a tall, ceramic jar) that Holley rescued from the abandoned home of an elderly, bedridden neighbor who had wielded this odd collection to fend off intruders who tried to get into her home. In restating this grouping of objects as an artwork, Holley questions an entire spectrum of artistic definitions as well as their assumed boundaries. This work is utilitarian, as it was used inside the woman's house; and it is artful, through its transformation into a source of contemplation. Yet its transformation also places it in the realms of religious observance (a pre-modern role for art) and modern/postmodern conceptual art, because there are no expressly aesthetic qualities to the piece—any such pretenses would be more sadistic than commemorative.

This work by Holley therefore fits into the category of history paintings such as Gustave Courbet's *A Burial at Ornans,* painted in 1849–1850, and Pablo Picasso's *Guernica,* painted in 1937, as an attempt to lift to mythic status the fate of every person. Holley's myths, however, harbor deep mistrust of mythologies. Like constellations, his artworks are essentially chance configurations of materials reconceived or intentionally misread as meaningful or portentous. Art becomes an experiment in history, ancestry, race, and gender, in which all pretenses of scale, material, and workmanship are eliminated in search of more authentic access to the truths of history as "made" by the forgotten.

For African Americans at every social station, a legacy of the civil rights movement, echoed by postmodernism in general, has been a newfound freedom not just to proclaim but to question all proclamations, including one's own. By viewing his cultural patrimony as a kind of potential wreckage or blight, Holley immerses his art in the deepest held stereotypes underpinning the premises of communal pathology. Holley leaves no stone unturned (or, more literally, no garbage at his curb).

Why do these artists do it? Why does anyone pierce the veil behind which many African Americans have shrouded their thoughts, the veil the dominating white culture once threw over black America, and make art, without promise of reward? In a negative way, this question has dominated most of the descriptive terminologies, which have tended to focus on the difficulty of achieving aesthetically significant forms from positions of extreme marginalization—circumstances that, from the vantage of the powerful, supposedly need to be overcome in order to create art. Vernacular art dives into these "margins," to rebalance relationships between expression and communication. The word *vernacular* denotes language: the

actual language used among a people or within a region. The vernacular is entirely cultural. While they denote everyday systems of communication, the languages developed by oppressed or colonized peoples (the term *vernacular* derives from the Latin word for house-born slaves) are complex because of—not in spite of—their unofficial status. Among the ways of grouping artists working from any perceived margins, the concept of shared cultural identity is both observable in practice, and responsive to ideas and interpretations that emanate from within the culture, rather than from outside observers. Most important, conceiving art as "vernacular" does not preclude other ways of seeing; in fact, it may sharpen them. The process of analysis becomes, through the vernacular, a dialogue among many actors and cultures, rather than a conclusion imposed by any one power.

Four developments beginning in the mid-1990s have brought two previously segregated practices—the art's production and its reception—into much closer intellectual proximity. The first development is the intensified documentation of artists, while they are still alive, to preserve crucial biographical and interpretive information, and to introduce the artists' stated intentions into the art's historical analysis.

The second development, proposed by folklorist Gerald Davis in an essay about Elijah Pierce, is the idea of expressive "equivalences." To understand the specifically "black" textures and layers of any artist's work, Davis argued, one must look at influences and correlations further afield than merely other visual art. Davis's "equivalences" were first used to explain the propensity of African American vernacular artists to create in many media, in which music and artmaking, and barbering and woodcarving, are among the common pairings. His formulation grounds African American folk art, or vernacular art, in an almost endlessly rich terrain of culture, enabling the study of art to bridge otherwise disparate fields, bringing verbal "signifying" into the interpretation of vernacular art, for example. These equivalences add a much-needed cultural context to constructions of even the most seemingly self-made, or "self-taught," creator. Moreover, these equivalencies also provide evidence for common perceptions and representational strategies that nourish the intrinsically individual task of creating visual art.

The third development, advanced by the historian of religion Theophus Smith in his essay, *Working the Spirits: The Will-to-Transformation in African American Vernacular Art,* applies principles from folk medicine to artmaking. Moving beyond simple "equivalences," Smith takes the traditional healing principle of homeopathy (the use of trace amounts of toxins to compel the body to cure itself) as a point of departure for explaining African American art that employs degraded or cast-off materials, tackles disturbing subject matter, depicts human suffering, and invokes convulsive or even ugly forms. A common purpose in such artworks, Smith argues, is to affect a comprehension and mending of ills in the social body, including endemic racism, class distinctions, and sexism. Like Davis, Smith returns conceptual control of the art to its makers, and repositions African American creativity within national and global cultural discussions in which the artists are speakers, not subjects.

The fourth development is interest in deeply embedded and continuing cultural practices such as the yard show and patchwork quilts. Ubiquitous throughout black America, particularly in the South, these traditions lie somewhere in the personal histories of nearly every African American folk artist. On such a level, quilts, for example, make a glorious "equivalence" with painting, providing an expressive language that is both self-sufficient for quiltmakers, as well as fruitful source material for vernacular painters.

Broadened notions of vernacular artmaking increasingly embrace undertakings as diverse as the flamboyant topiary sculptures of South Carolina's Pearl Fryar (1939–); the sprawling outdoor memorial to civil rights constructed by Alabama's Joe Minter (1943–); and the ephemeral debris graves erected for pets and wild animals by Alabama's Dinah Young (1934–). These and other artists have directed their creative energy away from the narrowness of art-as-object and toward significations of place, history, ecology, and ethics. Their twenty-first-century vernacular art finds prescient ways to make itself vital in the lives of its makers without reverting to the oversimplified, practical, and functional status associated with craft, or the unselfconscious compulsion associated with the outsider artist.

If many individual artists have been compelled by a precipitating event (visions, conversion experiences, debilitating injuries, or retirement, for example), it may be because some events, such as the civil rights movement in America, have compelled the redrawing of the maps of creativity in general, have become precipitating events for cultures to be looked at as a whole, and are responsible for an overall upswing in vernacular artmaking. Individuals who find themselves in increasingly ambiguous states of marginalization—partly assimilated into various mainstreams, yet conditioned by a lifetime of subaltern status—often turn to artmaking as a means of

speech. The clear sense of an audience for their work, and the sharpened formal consciousness of many folk artists support the argument that much, though not all, vernacular visual art constitutes a special arena of cultural practice, wherein issues of personal and collective identity are reinforced, tested, and ultimately created anew.

The diversity of African American experiences ensures there cannot be a single exemplary or archetypal African American artwork or style, "vernacular" or otherwise. Concepts change, like the artists themselves, because of increased social and economic mobility, educational opportunities, democratization of access to information, and the recognition that race and ethnicity are neither immutable nor pure. Critics looking to group together artists such as Bill Traylor and Lonnie Holley are not likely to find answers in labels or forms, for the linkages between African American folk artists ultimately resist such reductions. Their constructions of the self draw strength from larger purposes, whether secular or sacred. By any name, the unique hybrids of African American folk art, or vernacular art, constitute an attitude toward creation, born of and offering unique insights into the ceaseless transitions of all civilizations.

See also **Jesse Aaron; American Folk Art Museum; Steve Ashby; Canes; Ulysses Davis; Thornton Dial Sr.; Sam Doyle; William Edmondson; Environments, Folk; Gravestone Carving; James Hampton; William Hawkins; Bessie Harvey; Lonnie Holley; Joe Light; Ronald Lockett; Charlie Lucas; Sister Gertrude Morgan; Outsider Art; Painting, Folk; Leroy Person; Elijah Pierce; Horace Pippin; Quilts; Quilts, African American; Royal Robertson; Nellie Mae Rowe; Mary Tillman Smith; James "Son" Thomas; Bill Traylor; Yard Show.**

BIBLIOGRAPHY

Arnett, Paul, and William Arnett, eds. *Souls Grown Deep: African American Vernacular Art of the South,* vols. 1 and 2. Atlanta, Ga., 2000.

Davis, Gerald L. *Elijah Pierce: Woodcarver.* Columbus, Ohio, 1992.

Livingston, Jane, and John Beardsley. *Black Folk Art in America, 1930–1980.* Washington, D.C., 1982.

Metcalf, Eugene W. "Black Art, Folk Art, and Social Control." *Winterthur Portfolio,* vol. 18, no. 4 (1983): 271–289.

Thompson, Robert Farris. *Flash of the Spirit: African and Afro-American Art and Philosophy.* New York, 1981.

Vlach, John Michael. *Afro-American Tradition in Decorative Arts.* Cleveland, Ohio, 1978.

Wardlaw, Alvia. *Black Art—Ancestral Legacy: The African Impulse in African-American Art.* Dallas, Tex., 1989.

Yelen, Alice Rae. *Passionate Visions of the American South: Self-Taught Artists from 1940 to the Present.* New Orleans, La., 1993.

PAUL ARNETT

AIKEN, GAYLEEN BEVERLY (1934–) has created hundreds of drawings, paintings, and handmade books, using crayon, pen, pencil, and oil paint on paper, and on canvas board. Her fondness for comics is reflected in her artistic expression, and she returns to themes of nostalgia, family life, music, and industry.

Aiken has created a world that combines fantasy, memory, reality, and music through visual narratives that are generously sprinkled with text. The subject of an award-winning film, *Gayleen,* by Jay Craven, and in 1987 the recipient of a fellowship by the Vermont Council on the Arts, she is also a leading member of Grassroots Art and Community Effort (GRACE), a not-for-profit workshop program in Vermont. GRACE supports artists, many working at community centers, in nursing homes, and psychiatric facilities throughout the state.

Barre, Vermont, has been Aiken's home her entire life. From the age of two, Aiken has made art. As a child she drew on the woodwork of her parent's home. In Aiken's book, *Moonlight and Music,* the artist introduces the reader to her curious, integrated world. The illustration titled *The Funny Happy Raimbilli Cousins, Music, Hobbies, Me the Artist* features twenty-four smiling imaginary cousins, the Raimbillis, who have kept Aiken company since grade school, as well as a granite factory located just outside of town, and a nickelodeon that she keeps in her home. The world Aiken creates in her work is always sunny and filled with pleasant dreams, fireworks, and music. She keeps in her home life-size cardboard cutouts of the eternally youthful Raimbilli cousins featured in her drawings. The Vermont art dealer Pat Parsons arranged a one-person exhibition for Aiken in April 1987.

See also **Grassroots Art and Community Effort (GRACE).**

BIBLIOGRAPHY

Aiken, Gayleen, and Rachel Klein. *Moonlight and Music.* New York, 1997.

Gordon, Ellin, Barbara R. Luck, and Tom Patterson. *Flying Free.* Williamsburg, Va., 1997.

Rexer, Lyle. "Gayleen Aiken." *Raw Vision,* vol. 9, no. 41 (winter 2002): 30–37

LEE KOGAN

A.L. JEWELL & CO. was a weathervane manufacturer in Waltham, Massachusetts, owned by Alvin L. Jewell from 1852 to 1867. At a Springfield, Massachusetts, fair in 1860, Jewell weathervanes were considered the best in the show, and he is reported to have sold

twenty-three gilded weathervanes. A trade poster of A.L. Jewell & Co.'s, proclaiming "Prices Reduced for 1867," lists various designs of "copper weather vanes," including horses, oxen, bulls, cows, rams, pigs, deer, birds (rooster, peacock, eagle), vessels (ship, brig, schooner, steamer), church vanes, and miscellaneous designs (flag, cannon, pen, scroll, arrow, plow, "Goddess of Liberty," butterfly, locomotive, with or without tender, and codfish). The poster also noted that the company could produce "all kinds of vanes made to order." The catalog prices for these weathervanes ranged from four dollars for a small arrow to one hundred dollars for a large eagle.

The weathervane specialist Myra Kaye, consulting the text *Waltham Industries,* learned that in addition to vanes, the Jewell company manufactured iron hat trees, umbrella stands, dentist's spittoons, shelf brackets, and lightening rods. Jewell was a pioneer in the mass-production of cooper weathervanes, and one of the first manufacturers to market weathervanes through printed catalogs. He met an untimely death on June 26, 1867, when he and an assistant fell from a scaffold while erecting a building sign. The fall was fatal to both. The firm was acquired through auction by Leonard W. Cushing (d. 1907) and Stillman White (dates unknown), a purchase that has made attributions of Jewell weathervanes difficult, because Cushing and White continued to manufacture Jewell designs after his death. Some of Jewell's creations have been identified, however, most notably a magnificent *Centaur* weathervane, a gift from the collector Ralph Esmerian (1940–) to the American Folk Art Museum. It was recovered from a Hollis, New Hampshire, barn, built in 1854, and is celebrated for its gilded surface and geometric patterning.

See also **American Folk Art Museum; Ralph Esmerian; Cushing & White; Weathervanes.**

BIBLIOGRAPHY

D'Ambrosio, Paul S. "Sculpture in the Sky," *Heritage, The Magazine of the New York Historical Association,* vol. 2, no. 2 (winter 1995): 4–11.

Kaye, Myra. *Yankee Weathervanes.* New York, 1975.

Miller, Steve. *The Art of the Weathervane.* Exton, Pa., 1984.

Sanderson, Edmund L. *Waltham Industries.* Waltham, Mass., 1957.

WILLIAM F. BROOKS JR.

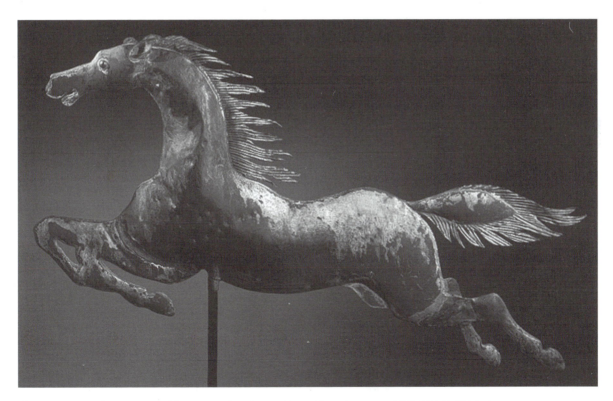

Flying Horse Weathervane. Probably A.L. Jewell & Co.; Waltham, Massachusetts, c. 1865; 37½ × 18¼ inches. Photo courtesy Allan Katz Americana, Woodbridge, Connecticut.

ALLIS, MARY (1899–1987), a dealer in American folk art and antique furniture, helped assemble several major private and public collections, including those at the Abby Aldrich Rockefeller Folk Art Museum; the New York State Historical Association at Cooperstown; the Shelburne Museum; Old Sturbridge Village; and the Winterthur Museum. She also assisted in the founding of the American Museum in Great Britain and served as a trustee of the American Folk Art Museum. Through her work as a dealer, she helped shape the field as well as the institutions of American folk art.

Born in Cleveland to a family of modest means, Allis moved to New York in 1929 to pursue a career in interior design. In the mid-1940s she established an antiques shop in the center of Southport, Connecticut. She also restored the Ogden House, an eighteenth-century Southport house, filling it with eighteenth- and early nineteenth-century American furniture and folk paintings. She was a mentor to many influential collectors, including Stewart Gregory (1913–1976).

It was Allis's acquisition, in 1958, of the folk art collection assembled by William J. Gunn (1879–1952) and his wife, Marion Raymond Gunn (1881–1957), of Newtonville, Massachusetts, that brought her to national prominence. Consisting of 630 paintings, the Gunn collection was especially rich in folk portraiture. Stephen Clark purchased about 150 paintings for the New York State Historical Association at Cooperstown, New York. Other institutions and private collectors purchased the remainder.

See also **Abby Aldrich Rockefeller Folk Art Museum; American Folk Art Museum; New York State Historical Association; The Shelburne Museum; Stewart Gregory; Winterthur Museum.**

BIBLIOGRAPHY

D'Ambrosio, Paul S., and Charlotte M. Emans. *Folk Art's Many Faces: Portraits in the New York State Historical Association.* Cooperstown, N.Y., 1987.

Smith, Scudder. "Mary Allis 1899–1987." *The Clarion,* vol. 12 (fall 1987): 77.

GERARD C. WERTKIN

ALMON, LEROY, SR. (1938–1997) was a carver born in Tallapoosa, Georgia. He moved with his family to Cincinnati, Ohio, when he was seven. He attended Kentucky State University in the late 1950s, and in 1961 served in the United States Army. He had a number of other sales jobs before the Coca-Cola Company hired him to work in that capacity in Columbus, Ohio. While living there, in the late 1970s, he began making painted bas-relief carvings under the influence of Elijah Pierce (1892–1984), an African American vernacular artist and former itinerant preacher widely known for his religiously inspired woodcarvings.

Pierce made his living operating a barbershop that doubled as a gallery for displaying his painted bas-reliefs. Deeply affected by Pierce's artworks and the spiritual teachings many of them embodied, Almon apprenticed himself to the aging artist and, after he lost his job with Coca-Cola, worked alongside him for three years, serving as the "curator" of Pierce's barbershop gallery. Their relationship stands as a rare example among contemporary African American folk artists, few of whom have been known to take apprentices. Almon initially provided Pierce with minor assistance, but eventually they collaborated on works as equal partners.

In 1982, two years before Pierce's death, Almon moved back to his birthplace and childhood hometown in northwest Georgia. In Tallapoosa he found employment as a radio dispatcher for the police department and began preaching as a non-denominational, Christian evangelist. He also continued to make his own painted bas-reliefs, which, over time, became increasingly distinctive and less derivative of Pierce's work.

Almon actively promoted himself as a folk artist, and he succeeded to the extent that he was able to retire from the police department in 1994. By that time he had moved back into and restored his childhood home, whose basement he transformed into a workshop and gallery for displaying his art. Most of his work falls into two basic thematic categories: the African American experience, and the teachings of Christianity, with special emphasis on messages of personal resourcefulness and spiritual redemption.

As he came into his own artistically, Almon reflected on his career and that of his mentor's, remarking, "The only difference in my work and the works of Pierce is that he created according to his time and experiences and I created according to my time and experiences."

See also **African American Folk Art (Vernacular Art); Elijah Pierce.**

BIBLIOGRAPHY

Arnett, Paul, and William Arnett, eds. *Souls Grown Deep: African-American Vernacular Art of the South,* vol. 1. Atlanta, Ga., 2000.

Connell, E. Jane, and Nannett V. Maciejunes. *Elijah Pierce: Woodcarver.* Columbus, Ohio, 1992.

Pass, Laura E. *Flying Free: Twentieth-Century Self-Taught Art from the Collection of Ellin and Baron Gordon.* Williamsburg, Va., 1998.

TOM PATTERSON

ALMSHOUSE PAINTERS refers to the work of three immigrant Pennsylvania German folk painters, Charles C. Hofmann (1821–1882), John Rasmussen (1828–1895), and Louis Mader (1842–c. 1899). These artisans, each incapacitated in later life by alcoholism and poverty, produced a series of iconographic folk landscapes depicting the Berks County Almshouse near Reading, Pennsylvania, where they all spent time as institutionalized residents.

Publicly funded almshouses had become a necessary and desirable element toward maintaining proper social and economic order within many urban and rural communities in America by the end of the eighteenth century. Reassuring symbols of social progress and human charity, almshouses, like other public institutions, factions, and churches, became proud sources of joint social accomplishment, and as a result were often a popular subject of the landscape painter. The surviving paintings of Hofmann, Rasmussen, and Mader provide the most numerous and consistent historical record for one of these important social institutions. Their crisp, sanitized views record the almshouse within which they sought refuge from personal weakness, frailty, and turmoil. By depicting pristine brick buildings, fenced green yards, and clean regimented order, the artists perhaps imagined to create for themselves the secure, tranquil, and happy existence that had consistently eluded them. In reality, however, many of these almshouses were overcrowded places of despair, insanity, abuse, and loneliness.

Charles C. Hofmann immigrated to America in 1860 and produced his first painting of the Berks County Almshouse in 1865. It was not until October 26, 1872, at age fifty-two, that he committed himself to that institution as an intemperate pauper, unable to support himself financially. He spent the remaining twelve years of his life in and out of the institution. While resident, he painted numerous commissioned views of the almshouse, its ordered grounds, and numerous support buildings for members of the staff, and may have used the income from these paintings to finance his periodic releases, until the next period of intemperance necessitated his return. Hofmann is also known to have produced views of the Montgomery and Schuylkill County Almshouses in Pennsylvania during his travels, as well as several local landscape views, such as of Wernersville, a thriving local village. His last works are dated 1881, the year before he died of dropsy in the Berks County facility.

Charles Rasmussen, born in Germany in 1828, arrived in America though the port of New York in 1865. He is listed as a painter and "fresco painter" in the Reading, Pennsylvania, business directories during the years 1867 to 1879. Widowed and suffering from chronic drinking problems and rheumatism, the painter's growing vagrancy led to Rasmussen's first committal to the Berks County Almshouse on June 5, 1879. He arrived roughly three years before his fellow inmate, painter Charles Hofmann, died. Possibly inspired by the attention Hofmann had received for his painted landscapes and views of the institution, or perhaps as a result of a friendship between the two painters, Rasmussen produced almshouse views and other landscapes similar in composition to the older Hofmann's during the period of their joint residency. Rasmussen is known to have painted a wider range of subject matter than Hofmann did, including portraits, still lifes, various landscapes, baptismal certificates, and, beginning in 1880, at least six views of the almshouse. In all of these, Rasmussen closely followed Hofmann's earlier 1878 composition of the institution, which hung in one of the administrative buildings of the complex. While both painters shared some common subject matter and seemed to prefer using thin, zinc-plated tin metal sheeting, available to them through the institution's wagon and machine shops, their techniques differed markedly. Rasmussen's somewhat more painterly approach utilized gradual tonal gradations, subtle shading, richer color tonalities, and a higher degree of detail. This is probably the result of his former role as a professional painter, particularly his more adept handling of the techniques of shading and depicting light, which would have been required by the expedient medium of fresco. By contrast, Hofmann tended to paint in broad areas of color with little shading or attention to the effects of natural light, and to repeat stylized figures using few details, which can be attributed to his status as a professional painter prior to his intemperance and vagrancy.

Louis Mader was born in Germany in 1842, immigrated to the United States, and settled in Pennsylvania in 1867. Little is known of his activities until 1892, when he was first committed to the Berks County Almshouse. Over the next three years, he painted at least eight views of the almshouse complex. Mader would have most likely had access to several of the earlier views produced by Hofmann and Rasmussen, several of which were displayed in the almshouse. While his compositions show marked similarities to the works of both earlier painters, he lacked their ability to record precise detail, and his paintings tend to utilize less vibrant colors. Mader is also known to have produced a series of mural paintings for a house in Parksburg, Pennsylvania, which constitute his only known variant subject from

the almshouse paintings. Mader left the almshouse for the last time on August 22, 1899. The date of his death remains uncertain.

See also **Painting, American Folk; Painting, Landscape.**

BIBLIOGRAPHY

Armstrong, Thomas. *Pennsylvania Almshouse Painters.* Williamsburg, Va., 1968.
Zellman, Michael David. *300 Years of American Art.* Secaucus, N.J., 1987.

JACK L. LINDSEY

ALSDORFF, CHRISTIAN (d. 1838) was a fraktur artist and schoolteacher. No record of his birth or of his descendants has been found. While his origins remain a mystery, he worked as a schoolmaster for many years, and the authors of one of Lancaster County's histories mentioned Alsdorff's work as a teacher long after his death. The earliest record of Alsdorff and his work appears in a fraktur he made for a student while he was a schoolmaster in Earl Township, Lancaster County, Pennsylvania, in December 1791. He continued to make frakturs in Lancaster, Montgomery, and Dauphin Counties in Pennsylvania, and later in his life in Mifflin County. He apparently knew and was strongly influenced by the work of fraktur artists Johann Adam Eyer (1755–1837) and his brother, Johann Friedrich Eyer (1770–1827); in turn Alsdorff influenced the work of Christian Strenge (1757–1825).

Alsdorff worked chiefly among the Mennonites. His production includes small music-notation books, religious texts, *vorschriften* (writing examples), bookplates, and presentation frakturs, all closely related to elementary education among Mennonites. An example of his work is a poem based on the story of Susanna from the Hebrew apocrypha that was in every German Bible.

The capital letter *A* he drew for Anna Stauffer, with its group of angels dancing and turning, along with a bookplate in an *ausbund,* the hymnal Amish and Mennonites in Lancaster County shared until 1804, both reveal that he knew the work done at the Ephrata Cloister in Pennsylvania, where the hymnals were decorated with crosshatched designs. Although Alsdorff's work was not exclusively made for Mennonites, and he surely was not one himself, his name is closely associated with their culture, rightly so.

See also **Johann Adam Eyer; Fraktur; German American Folk Art; Pennsylvania German Folk Art; Religious Folk Art; Christian Strenge.**

BIBLIOGRAPHY

Johnson, David R. "Christian Alsdorff, the Earl Township Artist." *Der Reggeboge,* vol. 20, no. 2 (1986): 45–59.

FREDERICK S. WEISER

ALTEN, FRED K. (1871–1945) was a carver of small animal sculptures and a few figural pieces in wood, which he produced over a twenty-year period in the isolation of his garage in Wyandotte, Michigan. His motivation to create was never revealed. Alten's carvings were left behind when he moved from Wyandotte back to his home in Lancaster, Ohio, and were not discovered until thirty years later at an estate sale in 1975.

Alten's father, an immigrant from Germany, settled with his family in Lancaster. They were devout members of the Missouri Synod of the Lutheran Church. The artist worked with his brothers John and August in the Alten Foundry and Machine Works, a business founded by another brother, Henry. He married Mary Ann Weidner about 1890, and they moved to Wyandotte, Michigan, in 1912, where Fred began a series of jobs as a mover, a machinery oiler, an employee of the Ford Motor Company, a carpenter, and a janitor.

Alten's animal figures range from prehistoric dinosaurs to circus lions and tigers to familiar barnyard creatures and household pets. He lined up groups of animals and placed them side-by-side in wooden cages that he constructed with thin metal bars. At times his animals were presented in combat. *Johnson's Household Book of Nature,* a natural history encyclopedia published in 1880 and based on the nineteenth-century writings of such naturalists as John James Audubon, and which Alten probably used as a reference, was found among his animal carvings after he left Michigan.

The animal figures were carved with common tools, such as pocketknives, in one piece, or with

Dinosaur; Fred Alten; c. 1915–1925. Carved and painted wood; 9⅜ × 24⅝ × 3½ inches. © Collection American Folk Art Museum, New York. Gift of Mr. and Mrs. Joseph A. Dumas, 1977.2.1.
Photo courtesy Helga Photo Studio.

interlocking parts, and assembled in a manner similar to the foundry patterns that Alten had worked with in his family's business. Occasionally, he used metal to balance a wooden animal, or to embellish a dinosaur's scaly skin. The animals were painted or given a waxy-looking surface, and textured with a pointed object to achieve a hair-like finish. Alten produced a few metal castings of his animal figures, which were turned into doorstops and trivets during the period when he worked in the foundry. Alten produced more than 150 animal figures in his lifetime.

See also **Doorstops; Sculpture, Folk.**

BIBLIOGRAPHY

Milwaukee Museum of Art. *Common Ground/Uncommon Vision: The Michael and Julie Hall Collection of American Folk Art.* Milwaukee, Wisc., 1993.

Hall, Julie. *The Sculpture of Fred Alten.* Ann Arbor, Mich., 1980.

LEE KOGAN

ALVAREZ, DAVID (1953–) discovered his talent as an animal woodcarver under the tutelage of Felipe Archuleta, the acknowledged master of the form. He then developed a unique style that has placed him among the finest of New Mexico's celebrated creators of folk art animals. Alvarez was raised in West Oakland, California, but moved to Santa Fe, New Mexico, at the suggestion of a friend, in the mid-1970s. In 1976 the same friend introduced Alvarez to Archuleta, who was then enjoying newfound success as the father of an original woodcarving style. Archuleta's roughly carved and painted representations of domestic and wild animals had thrust him into the limelight in international folk art circles, and the demand for his work had skyrocketed. Unable to keep up with his orders, Archuleta took on a number of apprentices, including Alvarez.

Alvarez had no prior artistic experience, but immediately upon entering Archuleta's Tesuque, New Mexico, workshop he assumed important artistic duties. His first assignment was to paint a large, fantailed turkey that Archuleta had carved by hand. With no instruction from Archuleta, Alvarez looked to the master's examples: large, often life-size, cottonwood images of tigers, bears, lions, zebras, giraffes, and other exotic animals, as well as fish, snakes, dogs, and everyday house pets. These were commonly depicted by Archuleta in menacing poses, wearing colorful coats of latex house paint, with toothpicks for teeth, nails for claws, and marble eyes. Despite intense criticism by Archuleta, Alvarez patiently endured the pressures of learning,

contributing carved or painted details to Archuleta's works.

As Alvarez's techniques improved, and he began carving his own creations, his unique style and expression began to emerge. The result is an eclectic animal menagerie—including armadillos, raccoons, sows, and piglets—characterized by soft, endearing, and humorous representations, as opposed to Archuleta's more aggressive pets. Even in Alvarez's popular "killer pig" creations, in which the animal's rigid posture and bared teeth and tongue create an illusion of aggression, the animal's charm shines through. Alvarez refined his distinctive talents and artistic touches through hundreds of signature works, though he rarely innovated or departed drastically from what he learned from Archuleta.

Alvarez's years with Archuleta established him as an accomplished animal carver, creating a demand for his work from private collectors, tourist shops, galleries, and museums. Indeed, for many animal collectors, Alvarez's works became the preferred carving style. By the mid-1980s, Alvarez had left Archuleta's workshop to establish his own in Santa Fe. He continues to carve and sell his works in local folk art shops and to private collectors.

See also **Felipe Archuleta; Sculpture, Folk.**

BIBLIOGRAPHY

Mather, C., and D. Mather. *Lions and Tigers and Bears, Oh My! New Mexican Folk Carvings from the Collection of Christine and Davis Mather.* Corpus Christi, Tex., 1986.

Museum of American Folk Art. *Ape to Zebra, A Menagerie of New Mexican Woodcarvings: The Animal Carnival Collection of the Museum of American Folk Art.* New York, 1985.

CARMELLA PADILLA

AMERICAN FOLK ART MUSEUM, known earlier in its history as the Museum of Early American Folk Arts (1961–1966) and the Museum of American Folk Art (1966–2001), was established in New York City in 1961. One of very few urban museums in the United States devoted to folk art, the American Folk Art Museum has supported a broadly based program of exhibitions since it was founded. During its first decade, the institution staked out a national and even international purview for its programming. Since then it has presented more than 220 exhibitions, many of which also have been seen in other museums through an active traveling exhibition program.

At the time of its founding, the American Folk Art Museum was without a collection of its own, unlike the Abby Aldrich Rockefeller Folk Art Center or the Shelburne Museum, which were established around

distinguished collections. The first object to enter the museum's collection was the now famous *Flag Gate* (c. 1876), the gift in 1962 of Herbert W. Hemphill Jr. (1929–1998), one of the institution's founding trustees and an influential pioneer in the field. Since then the museum's holdings have grown to encompass more than 4,000 objects in various media, including the highly important collection formed by Ralph Esmerian (1940–), president of the museum's board from 1977 to 1999, and chairman since then. Among the major works of art in the museum's collection is Ammi Phillips's (1788–1865) great portrait, *Girl in Red Dress with Her Cat and Dog* (c. 1830).

The museum publishes *Folk Art* (formerly *The Clarion*), a quarterly magazine; issues exhibition catalogs; and offers graduate courses in folk art studies in association with New York University and as part of the Folk Art Institute, an accredited educational division of the museum. In 1998, the museum established The Contemporary Center, a division devoted to the collection, exhibition, and study of the paintings, sculpture, and installations of twentieth- and twenty-first-century, self-taught artists. In 2001, The Contemporary Center announced the acquisition, by purchase and gift, of twenty-four works of art by Chicago artist Henry Darger (1892–1973), as well as an archive of Darger's manuscript books, tracings, drawings, and source materials.

After many years without adequate space, the museum inaugurated its own building in late 2001. Designed by architects Tod Williams and Billie Tsien, the 30,000-square-foot structure, at 45 West 53rd Street in New York City, includes a library, auditorium, classrooms, and exhibition galleries, among other facilities.

See also **Robert Bishop; Mary Childs Black; Henry Darger; Adele Earnest; Ralph Esmerian; Herbert W. Hemphill Jr.; Jean Lipman.**

BIBLIOGRAPHY

Earnest, Adele. *Folk Art in America: A Personal View.* Exton, Pa., 1984.

Hartigan, Lynda Roscoe. *Made with Passion: The Hemphill Folk Art Collection in the National Museum of American Folk Art.* Washington, D.C., 1990.

Hoffman, Alice J. "The History of the Museum of American Folk Art: An Illustrated Timeline." *The Clarion,* vol. 14 (winter 1988–1989): 36–63.

Wertkin, Gerard C. "The Museum at Forty: Four Decades of Achievement." *Folk Art,* vol. 26 (summer 2001): 43–51.

GERARD C. WERTKIN

AMERICAN FOLKLIFE CENTER, THE was established by the American Folklife Preservation Act in 1976 as part of the Library of Congress. The United States Congress mandated a center that would "preserve and present American folklife" through both active programs and the preservation and dissemination of archival collections. To fulfill the archival aspect of its mission, the Archive of Folk Song, originally created in 1928 within the library's Music Division, was transferred to the center in 1978. In the first generation of the center's life, its legislation required periodic extension, or reauthorization, but in 1998 the United States Congress made the center permanent within the Library of Congress.

The archive, now named the Archive of Folk Culture, comprises about 2 million items, making it the largest such ethnographic archive in the United States as well as one of the largest in the world. The archive's American and international holdings are strong in folk music, reflecting its origins within the library's music division, but the collections have included oral history and verbal traditions from the early twentieth century onward. The original archive was strong in sound recordings and manuscripts garnered in field expeditions throughout the United States and beyond. The archive's earliest recordings (and the earliest ethnographic recordings anywhere) are wax-cylinder recordings of Passamaquoddy Indian songs and stories collected by Harvard ethnologist Jesse Walter Fewkes in 1890. The collections also include the field recordings of John and Alan Lomax, as well as other New Deal documentarians, who made the archive their focus in the 1930s. From the 1970s, the collections expanded through a series of team field projects sponsored by the American Folklife Center in various parts of the United States. The newer materials include a wide variety of folklore and folklife documents as well as a broad range of documentary media: still photographs, motion-picture film and videotape, and digital technologies in addition to manuscripts and sound recordings. Currently, the center has an active program for the acquisition of internationally significant collections.

In the 1940s, the Folk Archive was a pioneer in the publication of documentary recordings for public purchase. These folk music albums provided a model that was imitated by the private sector in the second half of the century. In a similar vein, in the 1980s and 1990s the center began publishing collections in new technological formats—first experimentally, then as part of the broader efforts of the Library of Congress to share its collections online, known first as American Memory and then as the National Digital Library. Many multi-format center collections are now accessible in their entirety online.

The center's public programs have included a folk music concert series at the Library of Congress; a variety of conferences, symposia, and workshops; a number of exhibitions both at the library and traveling to other institutions; and a wide variety of publications in various media. In recent years, the center has sponsored several programs with a national dimension and scope, including the Local Legacies Project, the congressionally initiated Veterans History Project, and the Save Our Sounds Project to develop standards for audio preservation.

See also **Musical Instruments.**

<div align="right">*ALAN JABBOUR*</div>

AMERICAN MUSEUM OF QUILTS AND TEXTILES: *SEE* SAN JOSE MUSEUM OF QUILTS AND TEXTILES.

AMERICAN VISIONARY ART MUSEUM, THE (AVAM), overlooking the Inner Harbor of Baltimore, Maryland, is devoted to what it has described as "art produced by self–taught individuals usually without formal training, whose works arise from an innate personal vision that revels foremost in the creative act itself independent of the influence of mainstream art." The institution's founder and director, Rebecca Alban Hoffberger, conceived of the museum in the mid-1980s, while working in a hospital job-training program for people with chronic mental illnesses; she managed to raise $7.4 million to get the museum built and operative within ten years.

Opened in November 1995, the elliptical, three-story building that houses AVAM was designed by Rebecca Swanston and Alex Castro. It represents a substantial retrofit and addition to a 1913 building formerly occupied by a paint manufacturing company. Totaling 36,000 square feet, the focus of the main building is a broad, spiraling, travertine staircase that connects basement offices and storage areas to two floors of exhibition space, more offices, and a restaurant on the upper story with views of the harbor. In addition to its unusual design and scenic location, the museum's exterior is distinguished by a three–story broken–glass mosaic, a wildflower garden, and an outdoor sculpture plaza entered around a towering, three–ton whirligig by artist Vollis Simpson. Also located on AVAM's grounds is a former whiskey warehouse that has been adapted to serve as a "tall sculpture barn." An adjacent warehouse building is being transformed into a space for classrooms, a meeting area, and an additional large exhibition space.

The museum's ground floor has a gift shop, changing exhibition space, and an enclosed gallery displaying selections from the museum's permanent collection of more than 4,000 pieces. Collection highlights include a large, figural-abstract assemblage of painted-wood cutouts by the late James Harold Jennings; Wayne Kusy's model of the cruise ship *Lusitania,* constructed of 193,000 matchsticks and five gallons of glue; and William Kurelek's painting, *Where Am I? Who Am I? Why Am I?* Most of the museum's available space is used for its yearlong "mega–exhibitions," which have been AVAM's programming staples. The inaugural show, "The Tree of Life," included nearly four hundred sculptures and other works created from a wide variety of wood and tree products and expressing a reverence for the earth.

See also **James Harold Jennings; Outsider Art; Vollis Simpson; Visionary Art; Whirligigs.**

BIBLIOGRAPHY

Maizels, John. "AVAM: John Maizels introduces the American Visionary Art Museum and talks to Anita Roddick, one of the Museum's principal supporters and benefactors." *Raw Vision,* no. 14 (spring 1996): 46–49.

Shackleford, Tamara H. "Visionary Art A Reality." *Folk Art Messenger,* vol. 8, no. 4 (summer 1995): 13.

<div align="right">*TOM PATTERSON*</div>

AMES, ASA (1824–1851) is credited with at least eleven figural carvings that were created between 1847 and 1851. Based upon inscriptions that appear on many of the works, they appear to be specific portraits, primarily of children. Three-dimensional carving is an uncommon medium for this genre; typically, nineteenth-century portraiture was painted, and woodcarving was the domain of trade–figure and ship carving. Although we do not know the nature of Ames's training, one family remembered him as a seaman, suggesting perhaps that he may have learned to carve in a traditional ship-carving shop. The artist is highly regarded for his skill and his sensitive portrayals of young children, although he carved some adult figures as well. His work is characterized by the careful depiction of details of costume and drapery; linear treatment of hair with repetitions of incised lines; deep-set eyes with lashes painted as a series of dots; and fully modeled ears.

Ames first came to public notice in the seminal exhibition "American Folk Sculpture: The Work of Eighteenth and Nineteenth Century Craftsmen," presented in 1931 at the Newark Museum, New Jersey. At the time it was exhibited, *Bust of a Girl* was thought to be one of three portraits of sisters, and the artist

was incorrectly identified as Alexander Ames. It was not until 1977 that Jack T. Ericson located Asa Ames in the federal census of 1850 for Evans, Erie County, New York, where he listed his occupation as "sculpturing," and was living in the household of Dr. Harvey Marvin. In 1847 the artist may have been living with another physician, Dr. Armstrong, when he carved the full-length figure of Amanda Clayanna Armstrong. That same year, he carved the three portraits thought to be of sisters, though they are more likely portraits of Millard F. Dewey and his sisters, Adelaide and Maria.

Ames's most ambitious work is a memorial to three-year-old Sarah Reliance Ayer and her one year old sister, Ann Augusta, who both died during an epidemic in 1849. The memorial features a young girl seated with one arm around the lamb of Christ and a salver, or small tray, in her other, outstretched hand. The carving was completed in 1850, the year that Ames was living with Dr. Marvin in Evans. Marvin was a physician who was interested in alternative therapies such as the water cure, magnetism, and phrenology. Given this association, it is likely that the young artist carved the *Phrenological Head* about this time, and was perhaps seeking a cure for "lung fever," or tuberculosis, a disease that was terminal in the age before antibiotics. Ames was unsuccessful, and died in 1851 at the age of twenty-seven years, seven months, and seven days, as inscribed on his gravestone in the Evans Center Cemetery.

See also **Nautical Folk Art; Ship Figureheads; Shop Figures; Trade Signs.**

BIBLIOGRAPHY

Ericson, Jack T. "Asa Ames, Sculptor." *The Magazine Antiques*, vol. 122, no. 3 (September 1982): 522–529.

Hollander, Stacy C. "Asa Ames and the Art of Phrenology." *The Clarion*, vol. 14, no. 3 (summer 1989): 28–35.

STACY C. HOLLANDER

AMES, EZRA (1768–1836) was a portrait and ornamental painter working in the area of Albany, New York, primarily during the period from 1800 to 1820. Through his surviving account books, it has been determined that his work included miniature portraits and Masonic ritual paintings as well as the painting, lettering, and gilding of carriages, fire buckets, clock faces, fences, mirror frames, drums, sun blinds, ear trumpets, and pieces of furniture. Whether formally trained or not, at some point early on Ames began painting in an American academic manner. He is also thought to have carved figures in wood. Folk art

historian Robert Bishop concluded that Ezra Ames was probably the most successful portrait painter working in upstate New York in the first third of the nineteenth century. Because he painted many of the prominent politicians of the New York State capital, he was nicknamed the "official New York State portrait painter." Ames also is credited with influencing the folk painter Ammi Phillips (1788–1865).

Born in Framingham, Massachusetts, in 1768, Ames grew up in what is now Wayland, Massachusetts. Records indicate that by 1790 he was painting in Worcester, Massachusetts, but joined family members in Albany, New York, by 1793. In 1796 Albany became the state capital of New York, and it was there that Ames sold artists' material and did decorative painting as well as other craftwork before flourishing as a portrait painter. He was an active freemason, rose to the position of Grand High Priest of the Grand Chapter of New York State, and benefited from the connection by receiving Masonic regalia commissions. He is also known to have completed several landscape paintings.

In 1852 Ames was elected an honorary member of the American Academy of Fine Arts in New York City but was more active in Albany, where he served as chairman of the Fine Arts Committee of the Society for the Promotion of Useful Arts (1805), and as a director and president of the Mechanics and Farmers' Bank of Albany. Following his death in Albany, his family auctioned fifty of his artworks. He left an estate of $66,000, a considerable sum at the time.

Ames is well known for a portrait he painted about 1812 of United States vice president and New York State governor George Clinton, which was purchased by the Pennsylvania Academy of Fine Arts in 1812, after it won acclaim at the second exhibition of the Society of Artists of the Untied States, in Philadelphia. This portrait no longer exists, but another full-length likeness of George Clinton by Ames, dated about 1813, hangs in the New York State Capitol. Ames also painted the official half-length portrait of Clinton's nephew, Dewitt Clinton, another governor of New York.

See also **Robert Bishop; Fraternal Societies; Freemasonry; Miniatures; Painting, Landscape; Ammi Phillips.**

BIBLIOGRAPHY

Bishop, Robert Charles. *Folk Painters of America*. New York, 1979.

Bolton, Theodore, and Irwin F. Cortelyou. *Ezra Ames of Albany: Portrait Painter, Craftsman, Royal Arch Mason, Banker, 1768–1836*. New York, 1955.

Moore, William D. "American Masonic Ritual Painting." *Folk Art*, vol. 24, no.4 (winter 1999–2000): 58–65.

Schorsch, Anita. *Mourning Becomes America: Mourning Art in the New Nation*. Clinton, N.J., 1976.

Scottish Rite Masonic Museum of Our National Heritage. *Bespangled, Painted and Embroidered: Decorated Masonic Aprons in America 1790–1850*. Lexington, Mass., 1980.

WILLIAM F. BROOKS JR.

AMISH QUILTS AND FOLK ART reflect the simple and austere values of the community that produces them. The Amish, followers of Jacob Amman (1655–1730), a conservative Mennonite bishop who broke from the church because he believed it too lax in discipline in regard to church doctrines, came to Pennsylvania in 1727 from Germany and Switzerland at the invitation of William Penn. They settled first in Lancaster County and later spread to other parts of Pennsylvania, Ohio, Iowa, Indiana, and elsewhere.

Key to Amish beliefs are the ideals of humility, restraint, and simplicity, and to preserve their lifestyle and conservative beliefs they have kept themselves separate from the world and their "English" (non-Amish) neighbors. They place little value on art, and decoration for its own sake is shunned; rather, they believe that beauty is found in function, and fulfillment through commitment to family, friends, and community. The culture is not, however, devoid of artistic expression. Cabinetmakers such as Henry Lapp developed distinctive yet simple styles in keeping with Amish beliefs, and self-taught artists such as Barbara Ebersol used designs similar to those seen in the *fraktur* of other Pennsylvania German groups, to create colorful birth and family records and book plates. Wall decoration was proscribed, but home-crafted, embroidered, or painted family records and memorial samplers could be displayed as testimony to the value of family. The embroidering of show towels is another area in which decorative touches were allowed and proliferated.

The greatest creative expression in Amish folk art is seen in their quilts. The stark geometric designs and dramatic juxtapositions of deep, rich colors, the use of natural fibers (especially wool), and the meticulous stitching have made Amish quilts symbols of quilting excellence. Although highly decorative to a non-Amish eye, Amish quilts are fully in keeping with the values of their makers. The quilts are intrinsically functional and not made as works of art; elaborate embellishment and naturalistic images are prohibited, as are printed fabrics, but this does not exclude careful design and color selection as well as scrupulous attention to detail.

The Amish did not bring a quilting tradition with them from Europe, but learned from their English neighbors, probably in the mid- to late-nineteenth century, as there are no Amish quilts known before about 1860. The most traditional Amish quilts, those from Pennsylvania, are based on a center medallion style and are minimally pieced, while the quilts of the Midwest Amish show a greater range of pattern and color and more piecing, perhaps because those groups have not been as isolated from their neighboring English communities. In keeping with religious ideals that view pride as a sin, pre-1940s Amish quilts were rarely signed, but makers today will occasionally sign or initial their quilts, a practice again more common among the Midwestern groups.

Since the 1950s, Amish quilters have begun to use synthetic and printed fabrics, a color palette that includes pastels, a broader range of designs, and less intricate quilting patterns. Some of these changes are in reaction to market demand, as the women have found quilting a useful way to supplement their incomes. It remains to be seen whether the design tradition that made Amish quilts so distinctive will be maintained, or whether it will be taken over by mainstream aesthetics.

See also **Decoration; Family Records and Registers; Fraktur; Furniture, Painted and Decorated; Mennonites; Pictures, Needlework; Quilts; Religious Folk Art; Samplers, Needlework.**

BIBLIOGRAPHY

Garvan, Beatrice B. *A Craftsman's Handbook: Henry Lapp*. Philadelphia, 1975.

Hader, Phyllis. *Sunshine and Shadow: The Amish and Their Quilts*. Pittstown, N.J., 1984.

Hostetler, John. *Amish Society*. Baltimore, 1993.

Hughes, Robert, and Julie Silber. *Amish: The Art of the Quilt*. New York, 1993.

McCauley, Daniel, and Kathryn McCauley. *Decorative Arts of the Amish of Lancaster County*. Intercourse, Pa., 1988.

Peck, Amelia. *American Quilts and Coverlets in the Metropolitan Museum of Art*. New York, 1990.

Pottinger, David, and Kathleen McLary. *Amish Style*. Bloomington and Indianapolis, Ind., 1993.

Shaw, Robert. *Quilts: A Living Tradition*. New York, 1995.

Warren, Elizabeth V., and Sharon L. Eisenstat. *Glorious American Quilts: The Quilt Collection of the Museum of American Folk Art*. New York, 1996.

JACQUELINE M. ATKINS

ANCIENT ORDER OF UNITED WORKMEN: *SEE* FRATERNAL SOCIETIES.

ANDERSON, STEPHEN W. (1953–) primarily paints portraits of movie actresses, both famous and forgotten. From his library of some 1,800 videocassettes of vintage movies, he freezes frames of an actress and

takes photographs of images on the television screen. He uses these as models for sketching proposed portraits.

Born and raised in Rockford, Illinois, Anderson is graduate of West High School. Except for one year at the University of Chicago and four years in the United States Navy, he has always lived with his family in Rockford, and has never married. In addition to movie actresses, Anderson has painted portraits of some historical, imaginary, and mythological women, some men and floral pictures, completing about one thousand works ranging in size from seven by five to 36 by 28 inches.

Anderson is an accomplished, self-taught portraitist who has perfected and adapted his technique for more than twenty years. Because he failed to find commercial success as a writer, he turned to painting in 1982. At first he used pastel and tempera that he would mix in bottle caps and re-liquefy with his own saliva. He applied the paint on lampshade cloth with a plastic stylus in a pointillistic style, building up dots of color. He now paints using gouache and Prismacolor on museum board to achieve a sharper and more vivid image, and he likes to create a sepia effect using burnt sienna.

Anderson's portraits are precise and intense, with a mysterious remoteness. While the movie stars are identifiable, they have the stylized and generic quality of Hollywood publicity stills. The women are invariably voluptuous and romantic yet prim and detached, as though they are looking into another world. Anderson, interested in costume design, meticulously crafts the stylish and colorful gowns in his portraits. Moreover, he has designed and sewn his own clothes.

The portraits with detailed backgrounds are particularly impressive. His recent painting *A Sinister Couple* features the actors Vincent Price and Barbara Steele, a haunted castle, and the ominous touch of a lone black raven in the background—a scene that is not taken from any particular movie. Another recent painting, *Feminine Icons of the Silent Screen,* presents portraits of the actresses Pola Negri, Gloria Swanson, Mary Pickford, Lillian Gish, Theda Bara, and Clara Bow.

With these bright and luminous subjects, Anderson creates his own genre of the Hollywood actress as temptress and icon, which he presents with a skill unusual for a self taught artist. He deftly illustrates the American fascination with the movies, and the romantic urge to identify with idealized stars.

See also **Painting, American Folk.**

BIBLIOGRAPHY

Rosenak, Chuck, and Jan Rosenak. *Museum of American Folk Art Encyclopedia of Twentieth-Century American Folk Art and Artists.* New York, 1990.

JOHN HOOD

ANDREWS, EDWARD DEMING (1894–1964), and **FAITH** (1897–1990), a husband and wife team of collector–dealers and scholars, did more to foster appreciation for the Shaker contribution to American culture than anyone else in the twentieth century. Over the course of four decades, their publications and exhibitions introduced virtually every aspect of Shaker history and material culture to an increasingly receptive public. Despite the fact that some members of the Shaker Society took issue with the Andrewses approach to the subject or questioned their motives as collectors, their place as pioneers in the field of Shaker studies remains secure.

The Andrewses came to their interest in the Shakers indirectly. In the fall of 1923, while driving through the countryside of northwestern Massachusetts, they happened upon Hancock Shaker Village, just west of Pittsfield. They drove into the village, knocked at a door, and were allowed to purchase two loaves of home-baked bread. This was to be the first of many visits to Hancock and other Shaker communities as their collection and commitment to the subject developed, and as they came to know the Shakers themselves. Of the two of them, Edward Andrews did most of the writing. He had undertaken graduate studies in American history at Columbia University, and in 1930 received his Ph.D. from Yale. Even though most of their publications bear his name alone, however, theirs was a true partnership. Andrews's first essay on Shaker craftsmanship appeared in *The Magazine Antiques* in 1928. *The Community Industries of the Shakers,* his first book-length study, was published in 1932, while he was temporary curator of history at the New York State Museum in Albany.

In 1932, they met Juliana Force, the director of the Whitney Museum of American Art. She arranged for a monthly subsidy to support their research, which led directly to the presentation at the Whitney in 1935 of their "Shaker Handicrafts," the first comprehensive exhibition devoted to the subject, as well as to the publication in 1937 of the trailblazing *Shaker Furniture: The Craftsmanship of an American Communal Sect,* published by Yale University Press. Other books followed, on Shaker music and dance (1940); history (1953); and after Edward Andrews's death, on drawings (1969), among others. Although more recent research does not always support the Andrewses con-

clusions, their scholarship is sound, and their publications remain important as resources. Much of the collection assembled by Edward and Faith Andrews is now at Hancock Shaker Village, which since 1961 has been operated as a museum and historic site. Their Shaker library is at the Winterthur Museum in Delaware.

See also **Juliana Force; Shaker Drawings; Shaker Furniture; Shakers; Winterthur Museum.**

BIBLIOGRAPHY

Andrews, Edward Deming, and Faith Andrews. *Fruits of the Shaker Tree of Life: Memoirs of Fifty Years of Collecting and Research.* Stockbridge, Mass., 1975.

Shaker: Furniture and Objects from the Faith and Edward Deming Andrews Collections Commemorating the Bicentenary of the American Shakers. Washington, D.C., 1973.

GERARD C. WERTKIN

ARAGÓN, JOSÉ (working dates c. 1820–c. 1835) was a northern New Mexican *santero*, a painter, and probably a sculptor of Catholic religious images. His origins are unknown; no documentary evidence supports his family's traditional belief that he emigrated from Spain to New Mexico, about 1820. By 1821 he had begun painting *retablos* (devotional panels of saints) and other religious figures, in Hispanic villages of northern New Mexico, and he continued to do so until about 1835. José Aragón was one of the few nineteenth-century *santeros* to sign and date his paintings. In some cases he also gave the name of the place where they were painted, most often the village of Chamisal. He may have lived in Chamisal or may have been an itinerant *santero,* temporarily working in different villages to fill the need for depictions of *santos* among the residents. In some of his inscriptions he states that the piece was painted in his *escultería* (sculpture workshop), which suggests that he was also a sculptor. While there is no further documentary evidence of his work as a sculptor, it is likely that *bultos* (polychrome wooden sculptures) were carved and painted by him or under his direction, and several surviving pieces are attributed to him on stylistic grounds. At least two *bultos* have figures of angels painted on them in his style.

José Aragón often worked directly from engravings of Mexican or European origin, in some cases even copying the lengthy prayers that appeared on the prints. The subjects depicted by Aragón do not necessarily suggest a direct influence from Europe, because most of them are saints popular in Mexico and New Mexico: Nuestra Señora de Guadalupe, Nuestra Señora de Refugio, Nuestra Señora de San Juan de los Lagos, Cristo Crucificado, La Santísima Trinidad, San José, San Isidro, Santa Bárbara, and others. These prints, which may have been provided to him by priests or other literate settlers, were done in the naturalistic academic styles of the period (late Baroque and Neoclassic), and his paintings tend to be more naturalistic than those of most other New Mexican *santeros* of the period, but it is a simplified naturalism that emphasizes the saintly qualities of the personage depicted.

José Aragón had several followers, who were probably apprentices in his workshop. The most important of them is the Arroyo Hondo Painter, so named for the large altar screen of twelve panels that he painted in the church of Nuestra Señora de los Dolores de Arroyo Hondo, near Taos, New Mexico.

See also **José Rafael Aragón; Bultos; Religious Folk Art; Retablos; Santeros; Sculpture, Folk.**

BIBLIOGRAPHY

Boyd, E. *Popular Arts of Spanish New Mexico.* Santa Fe, N. Mex., 1974.

Wroth, William. *Christian Images in Hispanic New Mexico: The Taylor Museum Collection of Santos.* Colorado Springs, Colo., 1982.

WILLIAM WROTH

ARAGÓN, JOSÉ RAFAEL (c. 1796–1862) was one of the most prolific and popular of the *santeros* (carvers and painters of figures of saints) of northern New Mexico in the first half of the nineteenth century. Aragón's place and date of birth are not known, but by 1815 he was living in Santa Fe, where he was associated with some of the leading families of New Mexico as well as with other artisans, including woodworkers and a sculptor, Anastacio Casados, who may have been his teacher. There is no known family connection between José Rafael and the *santero* José Aragón, although they share characteristics in their painting styles. José Rafael Aragón was a property owner and a literate man who occasionally signed his work. After the death of his first wife in 1832, he remarried and moved to the village of Pueblo Quemado (now Córdova), where he made his living as a *santero* and a farmer until his death in 1862.

After his move, Aragón became the leading *santero* of the region. Nearly every church north of Santa Fe had (and some still have) an altar screen painted by him. Among them are major works at Santa Cruz de la Cañada, Chimayó, Pojoaque, Córdova, El Valle, Picurís Pueblo, Talpa, and Llano Quemado. He also

painted numerous smaller *retablos* for individuals, and as a sculptor made *bultos* (figures in polychrome cottonwood). As a young man in Santa Fe, Aragón was exposed to Baroque and Neoclassic work imported from Mexico, and his painting style is a compelling synthesis of spiritual and humanistic tendencies, in which the innocence and saintliness of his subjects are dominant. His sculptural style incorporates a restrained Baroque expressiveness with fundamentally static frontal stances.

The paintings of Aragón developed from small, carefully painted pieces in the 1820s to bolder imagery in the 1830s, as his style became progressively looser and more self-assured. Each period of his work is documented by signed and/or dated pieces. The sculptural work assigned to him is documented by archival evidence, as well as by the presence of painted faces and decorations in his style on the surface of some *bultos*. It is likely that Aragón had a small workshop with apprentices and other artists working with him. A number of *retablos* appear to have been painted by an apprentice. They are rendered more childlike than is his style, and they have been dated from the 1850s and 1860s by tree-ring dating and other physical evidence. The most likely apprentice was his son Miguel Aragón, who was still remembered as a *santero* in Córdova in the 1930s. Another *santero* who certainly worked with José Rafael Aragón was the Santo Niño *santero*.

See also **José Aragón; Bultos; Religious Folk Art; Retablos; Santeros; Santo Niño Santero; Sculpture, Folk.**

BIBLIOGRAPHY

Boyd, E. *Popular Arts of Spanish New Mexico*. Santa Fe, N. Mex.: 1974.

Wroth, William. *Christian Images in Hispanic New Mexico: The Taylor Museum Collection of Santos*. Colorado Springs, Colo., 1982.

The Chapel of Our Lady of Talpa. Colorado Springs, Colo., 1979.

WILLIAM WROTH

ARCHITECTURE, VERNACULAR is an imprecise term that has come to mean the most numerically common, and thus representative, buildings of a particular community, place, or region. For much of the twentieth century, vernacular architecture was understood to be the humble buildings erected by provincial, uneducated "folk," as distinguished from the architect-designed, high-style buildings of America's elite, educated, and cosmopolitan classes. Early scholars of vernacular architecture thus focused primarily upon traditional, rural, domestic, and agricultural structures. Based upon an anti-modernist critique of industrial America, pioneering studies often sought to find surviving constructions of a previous age, and documented the earliest structures in a region, as well as rare, enduring examples of obsolete and vanishing forms. Seminal works by folklorists, antiquarians, and architectural historians, for example, addressed Dutch barns in New York State; seventeenth-century brick-end dwellings in Rhode Island; double-pen houses of the lowland South; and two-story, four-room "I-houses" found in Indiana, Illinois, and other states.

Many of these invaluable scholarly contributions essentially established typologies, as well as a vocabulary of connoisseurship for previously unstudied and undervalued buildings. This initial literature generated an obsession with the intricacies of antiquated construction techniques, and a fanaticism for understanding variations in floor plans and room uses. Based upon these works, for example, it can be asserted that if a house exhibits *pièce-sur-pièce* construction, in which horizontal timbers are stacked vertically and held in place by grooved vertical corner posts, the structure was probably built by individuals of French-Canadian origin. Similarly, the "dogtrot" house of the Tennessee Valley can be defined as a single-story dwelling characterized by two rooms with doors opening onto an open center passage, allowing for cross-ventilation. The "shotgun" house, to provide a final example, is a domestic architectural form that made its way to the southern United States from western Africa via Haiti. It is one room in width and from one to three or more rooms deep, with a frontward-facing gable.

In the middle decades of the twentieth century, the forces of nationalism, patriotism, and romanticism that led the first collectors to acquire examples of American folk art similarly produced an interest in preserving and gathering vernacular architecture. A number of wealthy individuals purchased buildings and moved them to campuses to create open-air museums. In 1926 industrialist Henry Ford began to construct a complex near his business office outside Detroit. Ford's conglomerated American village, which included vernacular domestic, agricultural, industrial, and commercial structures, opened to the public in 1933. A similar impulse led philanthropist Stephen Clark to work in the 1940s with the New York State Historical Association to install regional vernacular structures at The Farmers' Museum in Cooperstown, New York, and heiress Electra Havemeyer Webb to move a lighthouse, Shaker shed, covered bridge, church, jail, and other historic structures to

her property south of Burlington, Vermont. Other notable collections of preserved vernacular structures relocated from their original sites include Old Sturbridge Village in Sturbridge, Massachusetts; Old Bethpage Village, on New York's Long Island; Old World Wisconsin in Eagle, Wisconsin; and the Genesee Country Village & Museum outside of Rochester, New York.

Inspired by these museum villages and by Colonial Williamsburg's precedent-setting endeavors in large-scale community restoration, other individuals and institutions have preserved vernacular architectural resources in their original locations. Henry Flynt, a granite magnate from central Massachusetts, for example, was the motivating force behind preserving, appreciating, and restoring a number of eighteenth- and nineteenth century houses in Deerfield, Massachusetts. Old Salem, in Winston–Salem, North Carolina, comprises the preserved and restored historic architecture of a Moravian town. Three important compounds created and currently stewarded by America's most successful communal religious sect are Hancock Shaker Village, in Hancock, Massachusetts; Canterbury Shaker Village, in Canterbury, New Hampshire; and Shakertown at Pleasant Hill, in Harrodsburg, Kentucky. Strawbery Banke, in Portsmouth, New Hampshire, preserves and interprets the urban vernacular spaces and structures built and used between the 1600s and the 1950s by residents of a neighborhood in this regional port.

Other institutions have used the best available scholarship to reproduce the vanished vernacular architecture of a previous era, to serve as a setting for the interpretation of social history. Most notably, Plimoth Plantation, in Plymouth, Massachusetts, presents the public with a constantly evolving simulation of the separatist Pilgrims' village of 1627. Similarly, Virginia's Colonial Williamsburg created a slave quarter at Carter's Grove as a strategy for making the realities of chattel slavery more visceral for visitors.

Since the 1970s, scholars have expanded the definition of vernacular architecture to include urban and contemporary forms. Inspired by the advances in social, gender, and economic history, researchers have also broadened their perspective to include the study of complexes of buildings and landscapes. For example, the field of vernacular architecture now encourages examination of not only the barn and the house but also the structure of the dooryard and gardens, the plan of the fields, and the physical interrelationship of the farm with its surrounding community. Similarly, scholars who make vernacular architecture their focus have analyzed mill towns and mining camps; public libraries and roadside food joints; Methodist camp meetings and postwar suburban subdivisions; and Anglican Church architecture of eighteenth century Virginia as well as that of twentieth century Masonic temples. In 2002 the Los Angeles Cultural Heritage Commission nominated an early trailer park to the city's list of historic and cultural monuments. Proponents deemed this complex irreplaceable as an example of the vernacular landscape created by twentieth-century America's fascination with automobile travel.

Leading scholars of the man-made American environment argue that vernacular architecture is ordinary architecture. This definition, which emphasizes the pervasiveness of built forms within the American landscape, serves to defang the classist, elitist, and ethnocentric conception that vernacular architecture is created by economically, culturally, or chronologically isolated groups, while legitimate architecture is produced by trained and licensed practitioners. Current scholarship tends not to be concerned with whether buildings were designed by individuals with formal academic training, but rather focuses upon the ways in which architecture both embodies and shapes human patterns of behavior. Instead of celebrating individual achievements of artistic expression, as do traditional architectural historians trained in the field of art history, scholars of vernacular architecture investigate the ways in which status, power, wealth, gender, ethnicity, religion, and other factors have shaped buildings and landscapes.

The term "vernacular architecture" has also been used to refer to folk art environments, such as Howard Finster's (1915–2001) *Paradise Garden* outside Summerville, Georgia; Mathius Wernerus's (1873–1931) inspiring concrete, metal, and glass grotto in Dickeyville, Wisconsin; or Simon Rodia's (c. 1875–1966) sublime *Watts Towers*. Debate simmers, sometimes becoming heated, over whether this is an appropriate use of the term. Aficionados of idiosyncratic architectural assemblages argue that these structures qualify, as their builders use common construction methods, are inspired by traditional forms, and are formally unschooled in architecture. Their adversaries contend that, although these often are exquisite artistic statements, they are not communally sanctioned, nor are they representative of a larger class of structures. In this view, these buildings and environments, which also could be labeled "intuitive" or "outsider" architecture, embody a single individual's personal vision rather than the cultural processes of an identifiable group of people.

The ordinary American-built environment is complicated; the manner in which Americans conceive and construct it has been influenced by ethnicity, environment, economics, technology, religion, and other factors. Because of the complexity of the undertaking, scholars explicating vernacular architecture have employed a variety of disciplinary perspectives, including folklore, cultural geography, gender studies, history, art history, and anthropology. The scholarly literature regarding vernacular architecture tends to be centered in academic and professional journals, including *Winterthur Portfolio; The Journal of the Society of Architectural Historians; Cultural Resource Management;* and the *Annals of the Association of American Geographers,* rather than in self-contained books. Founded in 1979, the Vernacular Architecture Forum is a lively organization of more than eight hundred members that sponsors annual meetings with insightful presentations and dynamic, scholarly tours of buildings, landscapes, and compounds. It also sponsors a quarterly newsletter, maintains an encyclopedic on-line bibliography of the topic, publishes the Perspectives in Vernacular Architecture publication series, and subsidizes scholarly consultation regarding the preservation and interpretation of architectural resources.

Advances in the study of vernacular architecture since the 1970s have led a number of individuals to observe that the term "vernacular architecture" is an artificial construct, derived from nineteenth-century Romanticism, which has outlived its usefulness. These radicals assert that *all* architecture, architect-designed or traditional, fulfills human functions, is shaped by cultural forces, and should be studied and explicated using the same criteria.

See also **Environments, Folk; Howard Finster; Freemasonry; German American Folk Art; New York State Historical Association; Simon Rodia; Shakers; Electra Havemeyer Webb; Mathius Wernerus.**

BIBLIOGRAPHY

Carter, Thomas, ed. *Images of an American Land: Vernacular Architecture in the Western United States.* Albuquerque, N. Mex., 1997.

Glassie, Henry. *Patterns in the Material Folk Culture of the Eastern United States.* Philadelphia, 1968.

Groth, Paul. "Making New Connections in Vernacular Architecture." *Journal of the Society of Architectural Historians,* vol. 58 (September 1999): 444–451.

Liebs, Chester H. *Main Street to Miracle Mile: American Roadside Architecture.* Boston, 1985.

Stone, Lisa, and Jim Zanzi. *Sacred Spaces and Other Places: A Guide to Grottos and Sculptural Environments in the Upper Midwest.* Chicago, 1993.

Upton, Dell, ed. *America's Architectural Roots: Ethnic Groups that Built America.* Washington, D.C., 1986.

Upton, Dell, and John Michael Vlach, eds. *Common Places: Readings in American Vernacular Architecture.* Athens, Ga., 1986.

WILLIAM D. MOORE

ARCHULETA, FELIPE BENITO (1910–1990) produced innovative carvings that reflect his strong personality as well as the *santo* (or holy figure) woodcarving tradition. He is credited with creating a secular art form as a carver of animal figures and gave new direction to more than a dozen younger carvers. Less well-known are his drawings.

Born in Santa Cruz, New Mexico, the eldest of six children, Archuleta worked from his early childhood to help support his family. He was employed as a migrant worker picking potatoes, *chiles,* and fruit; he did farm chores for less than a dollar a day; and in 1935 he joined the Civilian Conservation Corps as a laborer, later becoming an office orderly. He later worked for the Works Progress Administration as a stonemason, and as a hotel cook. At age thirty-five, he joined the United Brotherhood of Carpenters and Joiners of America, and worked as a carpenter for twenty-four years.

In 1964, Archuleta was virtually unemployed, and he prayed for guidance. In an interview with collector and dealer Davis Mather, Archuleta recalled, "I asked God for some kind of miracle, some kind of a thing to do, to give me something to make my life with. I started carving and they just come out of my mind after that."

Archuleta's early works were small; his subjects were *carretas,* wagons with oxen and driver, sheep, and snakes. During the 1970s he began to make larger pieces, some life-size. The favorable response his work received encouraged him to expand his menagerie of subjects to include figures of coyotes, pigs, and birds, as well as exotic animals, such as gorillas, lions, tigers, and rhinoceroses. Children's books, magazines such as *National Geographic,* and other sources were used as reference material, but Archuleta always individualized each animal figure. The artist created hundreds of works using local cottonwood; his basic tools were a chain saw, ax, chisel, rasp, knife, and sandpaper. He would begin each work using a chain saw, to rough out the general shape, and next he used a pocketknife to create the fine details. He carved larger animals in more than one piece, using a glue and sawdust mixture to fill in crevices, build up forms, and create texture. He added realistic details,

such as eyes and teeth, with baling wire, telephone cable, glass marbles, and sisal. He sanded his figures before finally painting them.

To meet the demand for his carvings, which were popular with dealers and collectors, he worked with his son Leroy, and his grandson Ron Rodriguez, as well as Alonzo Jimenez, and David Alvarez. All became independent carvers and established reputations of their own. In 1979, Felipe Archuleta, master carver and guiding spirit of the younger New Mexican animal carvers, was given the governor of New Mexico's Award of Excellence and Achievement in the Arts.

See also **David Alvarez; Leroy Ramon Archuleta; Religious Folk Art; Sculpture, Folk.**

BIBLIOGRAPHY

Mather, C., and D. Mather. *Lions and Tigers and Bears, Ob My! New Mexican Folk Carvings from the Collection of Christine and Davis Mather.* Corpus Christi, Tex., 1986.

Mather, Davis. "Felipe Archuleta, Folk Artist." *The Clarion* (summer 1977): 18–20.

Museum of American Folk Art. *Ape to Zebra: A Menagerie of New Mexican Woodcarvings: The Animal Carving Collection of the Museum of American Folk Art.* New York, 1986.

Rosenak, Chuck, and Jan Rosenak. *Museum of American Folk Art Encyclopedia of American Folk Art and Artists.* New York, 1990.

LEE KOGAN

ARCHULETA, LEROY RAMON (1949–2002) was a New Mexican woodcarver who followed the secular art form that his celebrated father, Felipe Benito Archuleta, initiated in Tesuque. Working with his father in his workshop for many years, he used local materials, mainly cottonwood, to carve such animal forms as coyotes, dogs, rabbits, and snakes, which were familiar in his environment. For more exotic species, such as bears, jaguars, kangaroos, lions, macaws, and yaks, he referred to sources like the *National Geographic Book of Mammals.*

After selecting his wood, Archuleta used a chain saw to rough out his forms, then refined them with an ax, knife, chisels, rasps, and sandpaper. A mixture of sawdust and glue was used to build up his forms and to fill crevices before painting. Latex exterior house paint was applied for finishing. Glass marbles, broom bristles, bottle caps, baling twine, telephone cable, and leather provided realistic embellishment for eyes, whiskers, skin, harnesses, and saddles. Plastic lawn edging was used for animal claws. Similar to his father's style in form, technique, and materials, Archuleta's animals are distinguished by smoother finishes and more benign attitudes.

After high school, Archuleta worked in Colorado in a variety of jobs, including factory work, tree cutting, and as a laborer loading trucks. He returned to Tesuque in 1973 and worked full-time, at first assisting his father, then carving his own animal figures. He represents the second of three generations of New Mexican woodcarvers, and was, along with his father, a mentor to Ron Rodriguez, his nephew, with whom he shared workspace for more than twenty years. Archuleta never married, but was beloved by family and friends.

In 1994 he shared with his father the Award of Distinction from the Folk Art Society of America. An exhibition of his work, "Leroy's Zoo," traveled to a number of museums in 1999, and a children's book of the same title, with text by Warren and Sylvia Lowe, was published in 1997.

See also **Felipe Benito Archuleta; Sculpture, Folk.**

BIBLIOGRAPHY

Lowe, Warren, and Sylvia Lowe. *Leroy's Zoo.* Montgomery, Ala., 1997.

Mather, C., and D. Mather. *Lions and Tigers and Bears, Ob My! New Mexican Folk Carvings from the Collection of Christine and Davis Mather.* Corpus Christi, Tex., 1987.

Museum of American Folk Art. *Ape to Zebra, A Menagerie of New Mexican Woodcarvings: The Animal Carnival Collection of the Museum of American Folk Art.* New York, 1986.

LEE KOGAN

ARMSTRONG, ZEBEDEE ("Z.B.") (1911–1993) received a vision when he was in his sixties telling him that "the end of the world is coming" and to stop "wasting your time." This awesome message compelled Armstrong to start constructing three-dimensional calendars to predict the date and time of this apocalypse. He created hundreds of these calendars by the time he died, all of which employed a very distinct visual vocabulary and palette. Using primarily red and black felt-tip markers, the artist would first delineate his surface with a grid design, a technique he called "taping." Then he would affix a numerical calendar system onto the grid using a variety of surfaces, such as cardboard boxes, paper ephemera, wooden understructures, mailboxes, containers, and other found three-dimensional objects. Some sculptures have moving parts, such as the hands on a clock or the points of a star, which can rotate to various days and months on the constructed calendar; this movement aided the artist in calculating the exact date of the final judgment. These embellished objects crowded the interior of the artist's home, creating a

distinct, visually exciting environmental and sculptural display.

Armstrong was born in, and never left, Thompson, Georgia. He was a cotton field worker most of his life; he started working in a box factory as a foreman sometime in the 1970s. Upon retiring from factory work in 1982, the artist devoted more time to his calendar creations. Having grown up in a rural farming community, Armstrong had a lifetime of practical experience in making things, whether it was chairs, benches, and cupboards, or his artistic calendar constructions.

See also **Environments, Folk; Visionary Art.**

BIBLIOGRAPHY

Manley, Roger. *The End Is Near: Visions of the Apocalypse, Millennium and Utopia.* Baltimore, 1997.

McWillie, Judith. *Even the Deep Things of God: A Quality of Mind in Afro-Atlantic Traditional Art.* Pittsburgh, Pa., 1990.

Sellen, Betty-Carol. *Self Taught, Outsider, and Folk Art: A Guide to American Artists, Locations and Resources.* Jefferson, N.C., 2000.

Yellen, Alice Rae. *Passionate Visions of the American South: Self-Taught Artists from 1940 to the Present.* New Orleans, La., 1993.

BROOKE DAVIS ANDERSON

ARNING, EDDIE (1898–1993) struggled back from the brink of mental and emotional instability with the help of art. He was born to German immigrants who settled in Austin County, Texas, where his father worked as a farmer. Signs of his illness appeared in Arning's mid-twenties. Cycles of depression and withdrawal followed by violent outbursts occurred with increasing frequency, and in 1928 he was committed to the Austin State Hospital. He was released a year later but recommitted in 1934, this time for thirty years.

A turning point in Arning's life came in 1964. That year he was moved to a nursing home, but perhaps more importantly, his artistic creativity drew the attention of a perceptive hospital aide. Helen Mayfield noticed that, instead of merely filling in the printed shapes in the coloring books she offered him, Arning added freehand lines and chose unusual color schemes. Encouraged by Mayfield, Arning soon graduated to blank sheets of paper, initially drawing on recollections of his boyhood for most of his subjects: animals, plants, farm implements, windmills, and automobiles. Eventually he added people to his iconography, and he switched from wax crayons to oil pastels. As his confidence increased, he developed the habit of deriving inspiration from the printed photographs and graphic artworks that appeared in magazines and newspapers.

Yet Arning never slavishly copied pictures. Instead, he transformed them into bold and unique statements reflective of his inner vision. Generally, he retained—but vastly simplified—key elements, preferring abstract shapes and graphic lines. Consequently, he reduced everyday objects into compelling, abstract

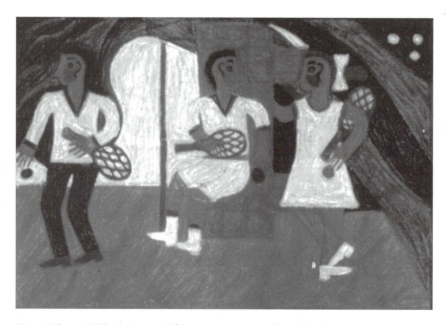

Tennis Players; Eddie Arning; c. 1965; crayon on paper; 16 × 22 inches. Photo courtesy Fleisher/Ollman Gallery, Philadelphia.

images that communicate a world from a fresh and unexpected viewpoint. A sharp eye for color aided his efforts; whether explosive or subtle, his color combinations are unpredictable and visually arresting. His *Tennis Players* (c. 1965) is one such composition that Arning structured using flattened schematic shapes to depict three dark-skinned people (two men and a woman) dressed to play tennis. The players's faces are articulated using bold striated marks similar to those found on African masks, and the background is blocked in using unmodulated areas of intense greens, blues, and whites.

In 1973, Arning left the nursing home to live with a widowed sister, a change that seemingly disrupted his creative drive. Drawing at this point became "hard work," and he no longer savored the pleasure and pride it had once brought. His productive period had been fruitful, though, resulting in several hundred drawings. Dedicated friends ensured the preservation of his work and, ultimately, their discovery by the larger art world. Without Mayfield and her husband, Martin; Robert and Betty Cogswell; and Alex and Ivria Sackton and their children, Arning's talent might have lain dormant or been appreciated by only a few.

See also **Outsider Art.**

BIBLIOGRAPHY

Luck, Barbara R., and Alexander Sackton. *Eddie Arning: Selected Drawings, 1964–1973.* Williamsburg, Va., 1985.
Maresca, Frank, and Roger Ricco. *American Self-Taught Artists: Paintings and Drawings by Outsider Artists,* New York, 1993.
Rumford, Beatrix T., ed. *American Folk Paintings: Paintings and Drawings Other Than Portraits from the Abby Aldrich Rockefeller Folk Art Center.* Boston, 1988.

BARBARA R. LUCK

ARNOLD, JOHN JAMES TRUMBULL (1812–c. 1865) painted likenesses in a distinctive, linear style long after the popularization of the daguerreotype and other photographic processes made it unfashionable and impractical to do so. In addition, he is a rare example of a portrait painter who was also a documented instructor of penmanship.

Arnold was born in Reading Township, Adams County, Pennsylvania, one of eight children of Dr. John B. Arnold and Rachel Weakley Arnold. He was active as a painter of full-size and miniature portraits and as a penmanship teacher by 1841. About thirty-five portraits have been attributed to him, painted mainly in oil on canvas, although his body of work includes a self-portrait in watercolor and ink on paper, advertising his penmanship skill, in the collection of the Abby Aldrich Rockefeller Folk Art Museum.

These works were largely executed in York County, Pennsylvania, although Arnold is also thought to have worked in Washington, D.C., and northern Virginia. Arnold consistently painted his sitters' faces in soft shades of grayish brown, posing his adult subjects in half-length compositions while portraying children full-length. His penchant for delineating facial features and hands in a precise, linear fashion may derive from his skill in penmanship. He is thought to have died after the end of the American Civil War, as a result of excessive alcohol consumption.

See also **Abby Aldrich Rockefeller Folk Art Museum; Miniatures; Painting, American Folk.**

BIBLIOGRAPHY

D'Ambrosio, Paul S., and Charlotte Emans. *Folk Art's Many Faces: Portraits in the New York State Historical Association.* Cooperstown, N.Y., 1987.
Rumford, Beatrix T., ed. *American Folk Portraits: Paintings and Drawings from the Abby Aldrich Rockefeller Folk Art Center.* Boston, 1981.

PAUL S. D'AMBROSIO

ARROYO HONDO CARVER (active c. 1830–c. 1850) was an important sculptor of religious folk images in northern New Mexico. His name derives from the large number of his works found in the village of Arroyo Hondo, north of Taos. His *bultos* (polychrome wood figures of important saints and holy persons) were made for the local church and for lay brotherhood meeting houses (*moradas*) in Arroyo Hondo, the nearby towns of Questa, Arroyo Seco, and Valdez, and for a private family chapel in Arroyo Hondo. The identity of this artist is not known, but he was probably an Arroyo Hondo resident who ceased working in the 1850s, and whose name had been forgotten by the time field research was done in the 1940s. His work can be dated to the first half of the nineteenth century through his use of hand-adzed wood, which was not used until after 1850, for bases and niches of statues rather than milled lumber, and his use of locally made water-based tempera paints rather than the commercial oils and enamels favored by later artists.

The carver's brightly painted pieces are characterized by static frontal poses, the bodies often relieved from heaviness by simple grooved lines running their length to indicate flowing robes. The faces are symmetrical and sharply carved, with distinctive clamshell ears and pointed chins and noses. They have an expressionless quality, placing them beyond the realm of human sentimentality and evoking the spirituality of medieval Christian sculpture. Most of the sculpture done at this time in New Mexico, such as

the work of José Rafael Aragón and the Santo Niño Santero, is characterized by a simplified naturalism, reflecting the academic art of the day. In contrast, the work of the Arroyo Hondo Carver is the first to move away from this aesthetic to achieve a more abstract and transcendent spirituality. The abstracted work of this artist provides a transition to that of the late nineteenth century, but unlike some of the later sculptors, whose work is often awkward and rigid, the Arroyo Hondo Carver's pieces are graceful and appealing. It is likely that Juan Miguel Herrera, a later sculptor from Arroyo Hondo, learned to carve with the Arroyo Hondo Carver.

See also **José Rafael Aragón; Bultos; Juan Miguel Herrera; Religious Folk Art; Retablos; Santeros; Santo Niño Santero; Sculpture, Folk.**

BIBLIOGRAPHY

Shalkop, Robert L. *Arroyo Hondo: The Folk Art of a New Mexican Village.* Colorado Springs, Colo., 1969.

Wroth, William. *Christian Images in Hispanic New Mexico: The Taylor Museum Collection of Santos.* Colorado Springs, Colo., 1982.

WILLIAM WROTH

ASHBY, STEVE (1904–1980) was born in Delaplane, in Fauquier County, Virginia. Except for a brief stint as a waiter at a hotel in nearby Marshall, he spent most of his life working on the farm where his father and several earlier generations of his family had been slaves. When he was in his late twenties, he married Eliza King, an older woman who worked as a cook at a girl's boarding school, and they set up housekeeping in a previously abandoned one-room schoolhouse. They had no children, but adopted and raised a son.

Ashby had occasionally made small carvings since his childhood, but after his wife's death in 1960, and his subsequent retirement, he began to make the slapdash, figural sculptures that he called "fixing-ups," which came to populate his house and yard. Pieced together largely from scraps of timber and lumber that he modified with a saw and augmented with paint, old clothing, cut-out images from magazines, and various found objects, these representations of people and animals are lively, expressionistic, humorous, and in many cases erotically charged. In addition to making individual figures and groupings of them, Ashby also made kinetic, wind-activated "whirligigs," some of which depict sexual couplings.

See also **African American Folk Art (Vernacular Art); Whirligigs.**

BIBLIOGRAPHY

Arnett, Paul, and William Arnett, eds. *Souls Grown Deep: African-American Vernacular Art of the South,* vol. 1. Atlanta, Ga., 2000.

Klein, Mason. "Steve Ashby," in *Self-Taught Artists of the Twentieth Century: An American Anthology.* edited by Elsa Longhauser, et al. New York: Museum of American Folk Art, 1998.

Livingston, Jane, and John Beardsley. *Black Folk Art in America, 1930–1980.* Jackson, Miss. and Washington, D.C., 1982.

TOM PATTERSON

ASIAN AMERICAN FOLK ART may be described as the traditional material culture of people of Asian ancestry living in the United States. There is essentially no concerted field of study nor academic history for addressing this broad subject area. The designation "Asian American" is formulated by geographic determinants that circumscribe a group of otherwise distinct people whose ancestry, as defined by the United States 2000 Census, relates to "the original peoples of the Far East, Southeast Asia, or the Indian subcontinent." This point of departure for defining Asian American folk art suggests an unwieldy, disparately constituted category encompassing a complex array of, in many cases, unrelated traditional forms, created for use in community contexts by immigrants, refugees, and their descendants. These forms might include, for example, Japanese flower arrangements, Hmong reverse appliqués, Tibetan sand paintings, Chinese kites, Javanese puppets, Thai vegetable carvings, Cambodian carved temple decoration, Indian henna tattoos, Lao silk weavings, Filipino lanterns, Korean carved seals, Mien scroll paintings, and Khmu baskets, as well as the vernacular architecture of American Chinatowns.

Asian arts and crafts have long been the object of American collecting fads; they have inspired art and design movements (for instance, Art Nouveau and the Aesthetic Movement), and have informed the work of American artists and architects. By the end of the nineteenth century, American audiences had grown accustomed to regarding Asian culture with wonder, and in terms of an exotic, mysterious, and undifferentiated "Orient." Chinese, Japanese, Indian, and Filipino people were routinely displayed and presented in museums, circuses, theater stages, and world fairs. Trade agreements between America and Asian countries gave rise to the popular collecting of Chinese and Japanese objects, such as furniture, fans, silk textiles, and pottery, all of which were acquired as rarities or luxuries and signaled the possessors' wealth and social station.

In contrast to this curiosity in Asian things, international politics and anti-immigrant sentiment incited an overwhelmingly negative public regard of Asian

people living in the United States. From the mid-1800s to the early 1900s, hundreds of pieces of legislation were enacted limiting or excluding persons of Asian ancestry from citizenship, intermarriage, land ownership, employment, and other legal rights that would have facilitated the permanent settlement and development of Asian American communities. The 1882 Chinese Exclusion Act initiated a series of restrictions that culminated in the 1924 Immigration Act, which completely halted the emigration of people from countries within a "barred zone," a triangular area encompassing most of the Asian continent. Immigrants from Asia did not begin to shed their legal status, and thus popular perception, as "aliens ineligible for citizenship" until the 1940s.

It was not until the 1950s that American-born people of Asian ancestry outnumbered immigrants; this situation changed with the passage of the 1965 Immigration and Nationality Act, which eliminated the quota system that previously restricted Asian immigration. By 2000, the fastest-growing segments of the United States population were Asian American.

This history underlines the complexity and diversity of Asian American communities. It also reflects historically how Asian Americans have been marginalized politically, socially, economically, and culturally. The consideration of Asian immigrants as a foreign group, incapable of assimilating, probably accounts for the historic lack of attention focused on the folk arts of these communities by earlier generations of American scholars of material culture as well as folklorists, who have otherwise generated a robust body of scholarship pertaining to European immigrant groups, and to other racial minorities such as Native Americans, Mexican Americans, and African Americans. Scholars and curators may well have overlooked the cultural products of Asian Americans because they did not consider these forms integral or related to their narrow definitions of an American identity and related folk art traditions. Perhaps, too, they imagined the material culture of Asians solely as foreign curiosities, souvenirs, or antiquities.

While early Asian immigrants were subject to residential and social segregation, the experiences of both past and present generations of Asian Americans have been substantively related to those of other Americans; their lives have not been discretely bound, nor have their activities and interactions been exclusively circumscribed along racial and ethnic lines. The post-1965 changes in American demography have shifted the ways in which people of Asian ancestry are considered, with respect to American history and American life. Thus, in the latter half of

the twentieth century, scholars of folklore, anthropology, and history have reconsidered the scope of what constitutes American folklore and folk art, proposing new frameworks for exploring how ethnic identity and immigration experiences are reflected in traditional life and forms of cultural production. In the field of folklore, Barbara Kirshenblatt-Gimblett, Robert Georges, and Stephen Stern, among others, suggested new conceptual categories with which to interpret the experiences of immigrants and their descendants, delineating among, for example, the "folklore of the immigrant experience," the "folklore heritage of immigrants," and the "folklore of ethnicity." All of these approaches account for differences in generational experiences. Most meaningfully, they also address "ethnicity" as one of many aspects of a person's identity, and, therefore, only one possible means by which communities and cultural production should be defined. Moreover, these scholars have directed attention to the dynamic way that traditional behaviors serve to mark cultural differences, and how multiple cultural resources inform the ways in which they change over time.

These frameworks may be adapted to a study of Asian American folk art and can be broken down into four categories: folk arts sustained and adapted by immigrants and refugees; folk arts adapted and maintained by American-born generations; folk arts specifically generated by conditions or experiences in the United States; and Asian folk arts in mainstream American culture. For the purposes of this broad discussion, the illustrations presented focus primarily on the folk arts of Japanese Americans, a population present in the United States since the late nineteenth century, and on Laotian-Hmong Americans, a tribal people from the mountainous area of Laos, who fought the Communist Pathet Lao and North Vietnamese, with money, supplies, and military leadership controlled by the Central Intelligence Agency, from 1955 until the end of the Vietnam War, in 1975. The Hmong resettled in the United States beginning in the mid-1970s.

As with all immigrants, those from Asian countries bring to the United States the traditions of their countries of origin. These include rites of passage, culinary ways, healing practices, music, dance, and seasonal celebrations. Generally speaking, all of these customs have related material forms that may be considered folk art.

An example of a form used by an early Asian immigrant group is the *senninbari,* a "one-thousand-stitches" scarf that served as a talisman and was sewn to protect the American-born sons of Japanese immigrants during their World War II tours of combat with the United States Army. These scarves feature the image

of a tiger—or another appropriately brave and fierce animal—situated amid a constellation of one thousand stitches, each one applied by a different female (with the exception of those born in the Year of the Tiger, who were permitted to sew more than one).

A more recent example is illustrated by the adaptation of a form of Chinese paper folding among a refugee population. In 1993 a ship attempting to smuggle approximately three hundred Chinese passengers into the United States, the *Golden Venture*, ran aground near New York City. The passengers were detained until 1997, and spent the interim petitioning for the right to remain in the country. During this time, using available materials such as newspapers, magazines, and toilet paper, they prolifically created elaborate figures of folded paper and papier-mâché. This process reportedly began with a particular individual who knew a form of Chinese paper folding (called *zhizha* or *huzhi*) that he then taught to the other detainees. Over time, more and more detainees began to create pieces. Some based their forms on traditional Chinese motifs; others explored new forms inspired by their situation in the United States. Common subject matter included pineapples, birds, plants, Chinese towers, and miniature landscape tableaux. The pieces that most captured the American public's attention were the eagles, referred to as Freedom Birds and interpreted as symbols of the refugees' dreams of liberty. Initially, these creations were presented to the pro bono lawyers working on the political asylum cases. They were later exhibited and sold to American supporters. Five of the refugees were eventually granted permanent United States residency based on their "extraordinary artistic ability" manifest in the works fabricated while confined. In 1996 a traveling exhibition, "Fly to Freedom: The Art of the Golden Venture Refugees," was organized by the Museum of the Chinese in the Americas, in New York City.

Textiles created and used in Hmong refugee communities in the United States provide another dynamic example of the ways in which immigrants adapt their folk arts. The Hmong continue to maintain cultural contexts that require the use of their traditional needlework, *paj ntaub*. In Laos, Hmong women typically learn to sew reverse appliqué and embroidery as a primary skill, sometimes even before farming, childcare, or cooking. In the United States, Hmong New Year is an important occasion for wearing traditional clothing. Tens of thousands of Hmong Americans gather in major centers such as Fresno, California, or Minneapolis, Minnesota, to socialize, court, eat, and perform the rituals that ensure a prosperous New Year. Mothers compete to provide clothing for their children that will bring status, compliments, and ultimately attract prospective in-laws. With

greater access to variety in fabrics and sewing accessories such as beads, sequins, glue, rickrack, and other Western craft supplies, Hmong American embroiderers are limited only by their imagination, and have developed a number of new styles. The sequined and beaded "rooster hat," for example, is an adaptation of a traditional Hmong baby hat. In the 1980s it was favored by girls in place of the traditional purple turbans that are wrapped by hand for each wearing. Hmong American women have also ingeniously adapted their sewing skills to create pillows, purses, jackets, wall hangings, place mats, aprons, and other goods-for-sale designed to appeal to American textile lovers. For these purposes, the artists use a palette designed to coordinate with mainstream American home-decor tastes. Thus, in place of the bright, saturated, contrasting colors preferred by the Hmong, like fluorescent greens and pinks or oranges and blue, textiles sold to a non-Hmong market utilize pastels and earth tones.

Some American-born descendants of Asian immigrants continue to produce and engage in the folk arts brought to the United States by earlier generations of their families. A contemporary example is the ongoing use among Japanese Americans of origami (paper folding) in celebrations and in gift exchanges. Even for the weddings of fourth-generation Japanese Americans, family and friends will collectively fold 1,001 paper cranes to display at the reception and to serve as auspicious symbols of fidelity, happiness, longevity, and health. Garlands of 1,001 cranes have also been created to present to people confronting challenges. In the aftermath of the September 11, 2001, terrorist attacks, Japanese American organizations around the country presented these folded cranes both to those directly touched by the attacks in New York, Washington, D.C., and Pennsylvania, and to American Muslim and Arab communities that were suffering under a climate of hostility and discrimination similar to that which had affected Japanese Americans after the 1941 attack on Pearl Harbor.

An example that demonstrates an adaptive process at a fairly young stage—given the more recent settlement of this population in the United States—is the fabrication and use of traditional clothing and textiles by American-born Hmong girls. With a different set of expectations and life circumstances than their mothers, these girls and young women place priority on their academic achievement and professional development, rather than becoming expert *paj ntaub* artists. Many, however, have learned traditional *paj ntaub,* and while fewer can sew the painstaking reverse-appliqué designs that their mothers can, they have embraced simpler cross-stitch techniques that

they use to produce their own New Year's finery. While styles in Laos were determined by specific region and clan, American-born Hmong girls may own many different regional outfits, from which they mix and match headdresses, skirts, and aprons according to their personal tastes and moods. Despite their culturally different approach to dress and adornment, many American-born Hmong women continue to value the use of traditional clothing in community celebrations, such as the New Year, as a means of expressing their sense of "Hmong-ness" as well as their individual conceptions of beauty and style. Several museums have staged Hmong textile exhibitions. In 1985 the John Michael Kohler Arts Center in Sheboygan, Wisconsin, organized "Hmong Art: Tradition and Change," which toured the United States. This exhibition served to define Hmong and Hmong American art for the general public, and provided a model for many ensuing exhibitions.

While Asian folk arts may change dramatically over subsequent American-born generations, they often retain certain elements that continue to refer to an identifiable and distinct Asian source. In contrast, there are also forms that, regardless of their creation by either immigrant or American-born generations, are not transferred or adapted directly from an Asian source, but rather are forged from specific experiences or conditions in the United States.

During World War II, for example, arts and crafts activities proliferated among Americans of Japanese ancestry as well as among Japanese immigrants who had been forcibly removed from their West Coast homes and incarcerated in camps located in six states. The carving and painting of wooden bird pins for adornment and exchange was an especially popular pastime developed to cope with the boredom and demoralization of confinement. Reportedly best developed as a craft at the Poston and Gila River camps in Arizona, the pins were carved from wood resourcefully salvaged from produce or egg crates, with legs shaped from scraps of excess window-screen wire, and the figures were then realistically painted according to examples found in various nature publications. The factors that probably lent this craft its particular popularity were the availability of basic materials, a process that accommodated individual variation and artistry within a set pattern, and the exchangeability of the finished product. It has also been suggested that, in a manner similar to the Freedom Birds created by the *Golden Venture* refugees, the bird motif resonated with inmates as a symbol of their desire to fly beyond the confines of the camps. Several museums, including the Japanese American National Museum in

Los Angeles, have examples of these pins, as well as other camp arts and crafts, in their permanent collections, and have featured them in exhibitions.

While the bird pins were promulgated by a specific event or experience, other forms have emerged out of more generalized American experiences and reflect the influence of multiple cultural repertoires. For example, in communities such as Orange County, California, which has substantial concentrations of Asian-American populations of Chinese, Japanese, Koreans, Filipinos, Vietnamese, and South Asians, a new type of car customization emerged in the 1990s. Through processes analogous to those that produced older American forms of custom cars like low riders and hot rods, subcompact cars imported from Asia, such as Hondas and Acuras, are "souped up" and transformed into lighter, faster, and more visually dramatic vehicles for cruising and racing. Common modifications include paint jobs that favor bright, unconventional automobile colors and combinations; lowering the car's suspension to minimize the space between the tire and fender; and accessorizing the cars with fancy wheel rims, thin tires, a shiny exhaust system, body skirts, and rear wings. These modifications are generally made by crews, who develop distinct, collective identities and recognizable styles. While there are many non-Asian participants, the form is noticeably prolific among Asian American youth. This association is reflected in popular coinages such as "rice-rocket," as well as the nickname "The University of Civics and Integras" for the University of California, Irvine, which has an Asian American enrollment that exceeds 50 percent.

It was not until the late 1960s that the concept of a pan-Asian identity was deliberately articulated and the term "Asian American" was both assumed by and ascribed to people of Asian ancestry in the United States. Developed in the context of the ethnic-consciousness, civil rights, and antiwar movements of the 1960s and 1970s, this pan-ethnic identity was formulated upon the perception of a shared history of racial discrimination in the United States, and it catalyzed a nationwide movement for social change. Artists' collectives and public arts projects were established to promote the idea of a synthetic, pan-Asian American culture, through community-based and accessible media such as public murals, printmaking, and the performing arts.

The proliferation of *taiko* drum ensembles in the United States emerged within the context of this so-called Asian American movement. While adapted from traditional Japanese drumming (the word "*taiko*" means "big drum" or "fat drum" in Japanese),

taiko in the United States developed in the late 1960s and early 1970s as a dramatic vehicle through which to assert a strong, powerful, collective pan-Asian American identity. Innovations in American drum building, which diverged from traditional Japanese methods, were crucial to the spread and viability of the form, making it affordable for grassroots ensembles. Specifically, the leaders of two pioneering California groups, San Francisco Taiko Dojo and Kinnara Taiko, developed methods that made it possible for groups to build their own drums from reconfigured old wine barrels, using car jacks to stretch the skins across the drum bodies. These techniques continue to be disseminated informally among ensembles throughout the country, with members of groups who have successfully built their own drums traveling to assist those attempting the process for the first time.

Since the late 1800s, Japanese vernacular forms have continued to inspire and influence American design, art, and architecture, especially well recognized in the works of artist Isamu Noguchi (1904–1988), furniture designer George Nakashima (1905–1990), and architect Frank Lloyd Wright (1867–1959), all of whom were born in the United States. Additionally, Asian folk art forms and motifs have been widely disseminated through mainstream American popular culture through films, video games, comic books, and contemporary houseware, such as rice-paper lanterns, bamboo baskets, lacquer ware, and textiles.

A number of Asian folk art forms have been directly absorbed into a generalized American popular culture. For example, the practice of Asian paperfolding techniques (such as origami) extends beyond Asian American community contexts. Henna tattoos, the *mehendi* tradition from India, and certain Asian and Pacific Island styles of tattooing (Japanese, Oceanic, and Chinese) are commonly applied as nonceremonial body adornment.

The folk arts prevalent in the state of Hawaii demonstrate how, through generations of cross-cultural interaction and creolization, the specific ethnic associations of certain forms may be absorbed into broader, generic ones. With a population comprised of native Pacific Islanders, immigrants and the descendants of immigrants from Asia, Puerto Rico, and Europe, as well as people whose heritage is constituted from various combinations of all of these derivations, a regional Hawaiian "local" identity often takes precedence over specific ethnic or cultural ones. Leis, for example, garlands made from flowers or other natural materials, have their origins in Polynesian cultures, but they have also become a traditional part of the celebratory life of all local residents. Similarly, as a consequence of the long history and demographic dominance of Asian American populations in the state, many regional folk arts not specifically identified as Asian have been nonetheless informed by traditional Asian techniques, styles, and materials. For instance, while the traditional art of Hawaiian fishnet knotting is derived from and identified with the culture of native Hawaiians, throw nets are also referred to locally by a Japanese name, *tsuji,* suggesting that techniques brought to the islands by immigrants have been incorporated into the regional form.

This broad survey of a range of traditional material culture demonstrates the difficulty of defining Asian American folk art exclusively by any one criterion, such as the ethnicity or race of the maker, the ethnic origin of the form, or its community context. The four categories delineated above are offered hypothetically, and there are many ways in which they overlap. Clearly, there is a multiplicity of forms and categories that could be identified under the broad rubric of "Asian American folk art." Ultimately, there are no unifying characteristics, formal, stylistic, or otherwise, that connect all of the possible examples and people for whom this term might apply. Additionally, many people of Asian ancestry continue to identify with more specific sources of cultural affiliation, such as nationality, region, religion, generation, and language, among others. Definitions and categories, therefore, should be considered open-ended and flexible, lest they cease to be useful tools for understanding forms that are by nature dynamic, and will continue to change as a consequence of internal migration, new immigration, intermarriage, personal creativity and innovation, and the diverse and fluid nature of public and popular culture.

While the material folk arts of Asian Americans have not been the subject of widespread scholarly and curatorial attention, the fieldwork and presentations of public folklorists and historians, especially since the 1980s, have played a central role in presenting and recognizing Asian American folk artists. Resulting exhibitions, festivals, performances, and awards have contributed to a public record that helps inform what can be considered Asian American folk art. The National Endowment for the Arts (NEA) Folk and Traditional Arts Program has led the national effort in developing and supporting programs that increase public awareness of individual folk artists. Since its initiation of the National Heritage Fellowships, the program has honored a handful of traditional artists of Asian heritage who work with material culture, including Em Bun (1916–), a Cambodian silk weaver from Harrisburg, Pennsylvania; Yong Fang

Nhu (1911–), a Hmong weaver and embroiderer from Detroit; Losang Samten (1953–), a Tibetan sand mandala painter from Philadelphia; John Naka (1914–), a bonsai sculptor from Los Angeles; Mone (1952–) and Vanxay (dates unknown) Saenphimmachak, Lao weavers, needleworkers and loom-makers from St. Louis; and Bounxou Chanthraphone (1947–), a Lao weaver from Brooklyn Park, Minnesota.

Most public sector folklore work has focused on Old World immigrant expressions, not on the categories that emerge from the American experience. Among the public history institutions that have played leading roles in preserving all aspects of the experiences of the older Asian American communities, including their traditional arts, are the Wing Luke Asian Museum in Seattle; the National Japanese American Historical Society in San Francisco; the Museum of the Chinese in the Americas in New York; and the Japanese American National Museum in Los Angeles.

Interdisciplinary studies, academic and public sector collaborations, as well as the continuing vitality and transformations of community life in the United States, provide exciting opportunities for shaping a new discourse that recognizes the complexities and heterogeneity of the historic and contemporary experiences, and material traditions, of Asian Americans.

See also **African American Folk Art (Vernacular Art); Architecture, Vernacular; Baskets; Circus Arts; Hmong Arts; Musical Instruments; Native American Folk Art; NEA American Heritage Awards; Paper Cutting; Pictures, Needlework; Pottery, Folk; Quilts; Quilts, African American; Samplers, Needlework; Tattoo; Toys, Folk.**

BIBLIOGRAPHY

Cubbs, Joanne, ed. *Hmong Art: Tradition and Change.* Sheboygan, Wisc., 1986.

Dorson, Richard M., ed. *The Handbook of American Folklore.* Bloomington, Ind., 1983.

Eaton, Allen H. *Beauty Behind Barbed Wire: The Arts of the Japanese in Our War Relocation Camps.* New York, 1952.

Georges, Robert A. "Research Perspectives in Ethnic Folklore Studies." *Folklore and Mythology Studies,* vol. 7 (spring 1983): 1–23.

Gesensway, Deborah, and Mindy Roseman. *Beyond Words: Images from America's Concentration Camps.* Ithaca, N.Y., and London, 1987.

Higa, Karin. *The View from Within: Japanese American Art from the Internment Camps, 1942–1945.* Seattle, Wash., 1992.

Siporin, Steve. *American Folk Masters: The National Heritage Fellows.* New York, 1992.

Stern, Stephen, and John Allan Cicala, eds. *Creative Ethnicity: Symbols and Strategies of Contemporary Ethnic Life.* Logan, Utah, 1991.

Tchen, John Kuo Wei. *New York Before Chinatown: Orientalism and the Shaping of American Culture, 1776–1882.* Baltimore and London, 1999.

Westerman, William. *Fly to Freedom: The Art of the Golden Venture Refugees.* New York, 1996.

SOJIN KIM AND AMY KITCHENER

AULISIO, JOSEPH P. (1910–1974) painted about fifty pictures, many of which are portraits, in oil paint on canvas board and Masonite. Aulisio's wife, Mary Heffernon Aulisio, bought him a paint-by-number set for Christmas in 1952, but he did not begin to paint until arthritis of the knee limited his physical activity. Painting seemed a viable way to spend free time; it gave him pleasure and afforded diversion from work he did not enjoy. Aulisio studied forestry management at Pennsylvania State College, but when he discovered that he did not enjoy this work, he relied on his training as a tailor's apprentice, received during his high school years, to open his own shop in 1929.

Among Aulisio's portraits, the one of his employee Frank Peters attests to the continuing power of portraiture as a vernacular art form in the twentieth century. Aulisio captures the nuances of Peters' personality with sensitivity, grace, and honesty in this waist-length portrait of an elderly, white-haired man with dark-rimmed glasses and a yellow measuring tape dangling gently from his neck. By depicting Peters' deeply furrowed brow and wrinkled cheeks and hands, suggesting years of hard work, Aulisio seems to pay homage to the worker. Among others, Aulisio also painted a portrait of American folk painter Grandma Moses (1860–1961) seated at her kitchen table near a ruffled curtained window.

In the 1960s, Aulisio won first prize in the Lackawanna County Art Show, which was sponsored by the Everhart Museum in Scranton, Pennsylvania. A few portraits of family and friends, landscapes, and hunting and fishing scenes of the Susquehanna River area near Falls, Pennsylvania, hang at Lease Cleaners in Old Forge, Pennsylvania, where Aulisio lived.

See also **Anna Mary Robertson "Grandma" Moses; Painting, American Folk.**

BIBLIOGRAPHY

Hemphill, Herbert W. Jr., and Julia Weissman. *Twentieth-Century American Folk Art and Artists.* New York, 1974.

Hollander, Stacy C., and Brooke Davis Anderson. *American Anthem: Masterpieces from the American Folk Art Museum.* New York, 2002.

Johnson, Jay, and William C. Ketchum. *American Folk Art of the Twentieth Century.* New York, 1983.

Rosenak, Chuck, and Jan Rosenak. *Museum of American Folk Art Encyclopedia of American Folk Art and Artists.* New York, 1990.

LEE KOGAN

BADAMI, ANDREA (1913–2002) is best known for his humorous paintings, full of irony and produced in an exaggerated Pop Art style, which possess a fusion of American and Italian sensibilities. Pop art was an art movement of the 1960s and 1970s that incorporated elements of modern popular culture and the mass media. Badami was self-taught and painted his entire life, but was most active as an artist between 1960 and 1990.

Badami's life was as colorful as his work. He was born on October 27, 1913, in Omaha, Nebraska. When he was five, his parents took him back to their native home in Corleone, Sicily. In 1929 he returned to Omaha to live with an uncle, but two years later he returned to Corleone and was married. Conscripted into Mussolini's army in 1940, he was captured by the British in North Africa, and spent the rest of World War II in prisoner of war camps in India and Britain. When he returned to Sicily in 1946, he contacted the American consulate in Palermo to reassert his American citizenship, and soon after, returned to the United States. He brought his family to America in 1948, and worked in the repair shop for the Union Pacific Railroad, in Omaha, Nebraska.

Badami spent all of his spare time painting, determined to become a better artist. Lacking proficiency in English, art became a way in which he could relate his past experiences and express his personal view of the world. Tom Bartek, associated with the Joselyn Museum and Creighton University in Omaha, recognized Badami's talent and appreciated the humor and pop images in his work, and exhibited some of the artist's paintings in the 1960s.

In 1978, after thirty years of service, Badami retired from the Union Pacific Railroad. Several years later he moved to Tucson, Arizona, where he continued to make paintings, until his death.

Mother Nursing Child (1974), for example, is a forthrightly sensuous nude, the mother nursing a robust baby and holding a bar of soap. By all accounts the artist never used live models, which is surprising because his figures are so realistic. The saints and Madonnas in the artist's paintings are a reflection of his Italian and religious upbringing, yet the overall impact of a Badami painting is always American because of their references to popular culture.

Badami's *Adam and Eve in the Sight of God* (c. 1969) is a play on the traditional Garden of Eden scene, with the snake and a figure of God rendered in the style of William Blake. The partially clothed Eve is voluptuous, while the nude Adam warms himself by a campfire. The trees in the background are painted using small dots in a Pointillist manner.

See also **Painting, American Folk; Religious Folk Art.**

BIBLIOGRAPHY

Hemphill, Herbert W. Jr., and Julia Weissman. *Twentieth-Century American Folk Art and Artists.* New York, 1974.

Maresca, Frank, and Roger Ricco. *American Self-Taught: Drawings and Paintings by Outsider Artists.* New York, 1993.

Rosenak, Chuck. "Rediscovering Andrea Badami." *The Clarion,* vol. 12 (spring/summer 1987): 50–53.

John Hood

BADGER, JOSEPH (1708–1765) was a portrait painter, housepainter, glazier, and painter of signs and heraldic devices in Charlestown, Massachusetts, where he was born to a tailor. He married Katherine Felch in 1731 and settled in Boston about 1733. The farthest Badger appears to have ventured from Boston was to Dedham, Massachusetts, where he painted a house. Badger, apparently self-taught, began painting portraits during the 1740s, although he never gave up his other trades. Approximately 150 of Badger's

portraits survive; none are signed, but they are attributed to him.

Badger's background as a tradesman, and the fact that many of his sitters were at least his age or older, probably made it inevitable that he would be less interested in advancing the art of portrait painting than in continuing conservative practice. In 1746 the retirement of Boston's leading portrait painter, John Smibert, created an opening for an ambitious, younger artist. Possessing a distinctive talent and fairly well patronized, Badger was one of the painters who filled the void between Smibert's departure and John Singleton Copley's (1738–1815) creative maturation, about the time of Badger's death.

Using subdued colors, heavily shadowed faces enlivened by rosy cheeks, and his apparent delight in painting the deep folds of costume fabrics, Badger created affable likenesses of sitters who, it has been noted, often appear as ill at ease in posing for Badger as the artist may have been in painting them. Backgrounds are frequently dark and ill defined, and Badger's practice of outlining unconvincingly foreshortened hands and arms with deep shadows gives his work a linear quality, which tends to flatten the images. Unlike his adults, Badger customarily painted children standing at full length, wearing colorful costumes before landscape backgrounds, and holding props such as toys or pets.

The distance a painting must stray from academic standards to be considered folk art is unclear. There were some artists capable of painting more refined works who deliberately simplified their style, to increase the speed at which they could finish a portrait and to make their work more affordable. Badger was aware of the prevailing portrait styles, and he may have applied painting techniques derived from decorative painting work to his portraits to increase efficiency. The results may be conservative and appear innocent to modern eyes, but the mariners, merchants, and physicians who patronized Badger sought his acknowledged ability to create fashionable expressions of their place in Boston society.

See also **Painting, American Folk; John Smibert.**

BIBLIOGRAPHY

Miles, Ellen G. *American Paintings of the Eighteenth Century.* Washington, D.C., 1995.

Saunders, Richard H., and Ellen G. Miles. *American Colonial Portraits, 1700–1776.* Washington, D.C., 1987.

RICHARD MILLER

BALDWIN, FRANK W. (1879–1964) was identified by many residents of Pittsburg, New Hampshire, as the creator of *The Crucifixion,* a large oil painting executed in the rich colors of stained glass, completed in the last year of his life. The unsigned painting was purchased by David Wiggins of Sanbornton, whose interest eventually solved the mystery surrounding its creation. An article about the painting in the *New Hampshire Sunday News* (October 10, 1976) triggered a number of letters that conclusively identified the painter as Baldwin.

Wiggins met with several people who knew Baldwin, and learned that for most of his life Baldwin ran a general store in the center of town. He also had interests in real estate and lumbering. A longtime resident of Pittsburg, Baldwin was also involved in town affairs, serving as town clerk, and ran unsuccessfully for the House of Representatives. He invested in a dance hall/restaurant called the Blue Bird in Lemington, Vermont. When that business failed, Baldwin paid his debts and turned to religion.

Baldwin became dedicated to painting in his final years. Mrs. Arthur Johnson, who worked for Baldwin, recalled a second unframed painting that Baldwin painted, but its whereabouts are unknown.

See also **Painting, American Folk; Religious Folk Art.**

BIBLIOGRAPHY

Dewhurst, Kurt C., et al. *Religious Folk Art in America.* New York, 1983.

LEE KOGAN

BALIS, CALVIN (1817–?), artist of more than thirty known likenesses, worked as a portrait painter in central New York state during the mid-nineteenth century. A native of Oneida County, Balis spent his documented professional life as an artist in this region. He was probably the son of Calvin and Sally Cogswell Balis of Whitestown, New York, a community just outside of Utica. The artist's practice of signing his work using the word "junior" after his name supports this supposition. According to the 1850 census for Whitestown, Balis is listed as a portrait painter, married to a woman named Mary, with four children.

Inscribed 1834, the portrait of Smith Dewey is among the artist's earliest known compositions, dating from when Balis was just seventeen. By January and February of 1845, he was working in Hamilton, New York, where he placed a newspaper advertisement in the *Democratic Reflector* soliciting patrons for portrait commissions. In this notice the artist pro-

claimed that he had been in the profession for ten years. The likeness of Mrs. M. Knapp, dating from 1856, is the artist's last documented canvas. His output also included landscape, historical, and genre subjects, as indicated by paintings titled *Philocles in the Islands of Samoa, The Morning Walk,* and *The Old Oaken Bucket,* though their locations are unknown.

Balis had significant ambitions for capturing the appearance of his middle-class clientele and their children in complex, dynamic compositions. Several of his large-scale group portraits record multiple family members on one canvas, such as the *Nellis Children of Sherburne, New York; Eliot and Julia; Adelbert Monroe;* consider also *Harriet Howes; George and Emma Eastman;* or the *Cadwell Family,* in which six figures are portrayed on one canvas measuring six feet across. In these scenes, men read newspapers and women hold babies, as individuals gather for portraits that depict families in parlors decorated with fashionable furnishings of the period. Children often stand or sit in outdoor scenes complemented by attenuated trees, rock formations, and distinctive clouds overhead. They frequently hold flowers and grapes while others wrap arms around siblings in gestures of comfort and companionship. Family pets, most notably dogs, sit obediently at their feet or are held lovingly in their arms. Other distinctive features include dark, penetrating eyes, flat ears showing little spatial recession, and tightly pursed lips.

See also **Painting, American Folk; Painting, Landscape.**

BIBLIOGRAPHY

D'Ambrosio, Paul, and Charlotte M. Emans. *Folk Art's Many Faces: Portraits in the New York State Historical Association.* Cooperstown, N.Y., 1987.

Jones, Agnes Halsey. *Rediscovered Painters of Upstate New York.* Utica, N.Y., 1958.

Sutherland, Cynthia. "The Elusive C. Balis." *The Clarion* (fall 1984): 54–61.

CHARLOTTE EMANS MOORE

BALKEN, EDWARD DUFF (1874–1960) was a pioneer collector of American folk art, primarily portraits. His first acquisitions, from the early 1920s, were installed in his country home in the Berkshire region of Massachusetts, where he resided for six months each year. His folk art collection grew to sixty-five paintings and drawings. Balken decorated his eighteenth-century prototype country home with "ladder-back and Windsor sidechairs, hooked rugs, pewter, stoneware pottery, early blown glass, needlework samplers, Shaker bandboxes and tilt-back chairs, and wrought-iron lighting devices." In 1958 Balken gave his folk painting collection to the Art Museum of Princeton University. His seminal role as a forerunner and connoisseur of American folk art was not fully appreciated until the year 2000, when Princeton mounted an exhibition of the works he had given to the university; it was accompanied by a comprehensive, scholarly catalog by Charlotte Emans Moore. Colleen Heslip did a great deal of research on the collection.

Balken, born in 1874 to an affluent family from Pittsburgh, graduated from Princeton University in 1897. He worked until 1906 in Pittsburgh, as a secretary to the tobacco firm of Weyman and Brother. In October 1902 he married Lois Livingston Bailey, daughter of a wealthy pioneer iron manufacturer, industrialist, railroad magnate, and banker. They had two children, Bailey Balken and Wilhelmina Duff Balken. Following Lois Balken's unexpected death from acute appendicitis in 1919, Balken raised the children as a single parent.

Balken devoted his adult life to the study and collecting of art. His knowledge was such that he was hired in 1916 to found the department of prints, in the department of fine arts of Pittsburgh's Carnegie Institute. While there, he served as a mentor to John Walker, later director of the National Gallery of Art in Washington, D.C. Balken was named acting assistant director of the department of fine arts in 1922, and upon his retirement in 1935 he continued as the department's honorary curator and trustee. His time and talent were devoted to both fine art and folk art. He also supported twentieth-century self-taught artists, purchasing works by John S. Kane (1860–1934) and Pop Hart (1868–1933).

As a folk art advocate, he befriended American antique dealers as well as folk art collectors Stuart Holladay and Herrel George Thomas, whose collection of American provincial paintings Balken arranged to have exhibited at the Carnegie Institute in 1941. New York dealer Edith Gregor Halpert (1900–1970) consulted with Balken. He specialized in nineteenth-century works of folk art depicting Berkshire residents and other subjects of artists, many unidentified, who painted and lived in western Massachusetts. Included in the collection Balken donated to Princeton were portraits by Zedekiah Belknap (1781–1858), Erastus Salisbury Field (1805–1900), Sarah Perkins (1771–1823), Ammi Phillips (1788–1865), and Asahel Lynde Powers (1813–1843), and two landscapes by Sarah E. Harvey (1834–1924).

See also **Zedekiah Belknap; Chairs; Erastus Salisbury Field; Edith Gregor Halpert; Hooked Rugs; John S. Kane; Painting, American Folk; Sarah Perkins; Ammi Phillips; Pottery, Folk; Asahel Lynde Powers; Samplers, Needlework; Shakers.**

BIBLIOGRAPHY

Moore, Charlotte Emans. *A Window into Collecting American Folk Art: The Edward Duff Balken Collection at Princeton*. Princeton, N.J., 1999.

WILLIAM F. BROOKS JR.

BANKS, MECHANICAL were introduced in the 1860s when American toy manufacturers decided to give children "more bang for their buck." The concept of thrift embodied in the penny bank, or moneybox, as the English call it, is as old as the capitalist system, with written references dating back to the sixteenth century. The mechanical banks induced saving by offering children some activity in return for pleasure deferred, rather than being mere coin repositories.

Made primarily of cast iron, mechanical banks were spring-loaded so that pressure on a lever would result in some interesting movement to accompany the coin deposit. For example, in the *Trick Dog* bank (one of the most popular, manufactured from 1888 to the 1930s), a coin was placed in the dog's mouth, then the lever was depressed, causing the dog to spring through a hoop held by a clown and to drop the money into a barrel–shaped depository.

Mechanical banks proved extremely popular, not only with children but also with adult collectors. Between 1870 and 1910, more than three hundred different types were patented. Most were produced by major manufacturers of cast-iron toys, such as the J. & E. Stevens Company of Cromwell, Connecticut, which is believed to have produced the first example; the Hubley Manufacturing Company of Lancaster, Pennsylvania; and the W.H. Shepard Hardware Company of Buffalo, New York.

Makers vied to create popular characters and unusual mechanisms, and to appeal to every preference and prejudice. Patriotic and political figures appeared, not always in a favorable light. While Uncle Sam's depositing a coin in his satchel might be interpreted as a sign of universal thrift, quite a different message came from the *Tammany* bank of 1875, which featured a corpulent politician, representing New York City's Boss Tweed, slyly pocketing the public's coin.

Disfavored minorities were lampooned without mercy. The *Chinese Reclining* bank hinted at an alleged Asian propensity for opium dens and gambling. *Paddy and His Pig* featured a gape–mouthed Irishman, while for a penny deposit one might witness, in the *Dentist* bank, a white dentist ripping a tooth from the mouth of a struggling black patient. Interestingly enough, reproductions of the latter bank, with a white patient, can be found in today's dental offices.

In addition, numerous figures from popular culture reappeared in the form of mechanical banks. Punch continued his spousal abuse in the *Punch and Judy* bank, while William Tell fired his gun and cleanly deposited a coin in the slot just above his son's head. Clowns and acrobats, familiar to all from numerous traveling carnivals and circuses, performed for pay, and now even obscure figures such as Chief Big Moon, the front man for a popular patent medicine, were employed to whet the public's imagination.

Considering the complexity of some of these banks, as well as the fact that they were usually hand-assembled and individually painted, it is amazing how inexpensive they were. The previously mentioned *Trick Dog* bank was offered in an 1894 Montgomery Ward & Co. catalog for 84 cents. Today, in good condition, this bank could bring three to seven hundred dollars. A less common example, *Teddy and the Bear,* based on Teddy Roosevelt's legendary refusal to kill a bear cub, could be ordered from Sears, Roebuck & Co. for 89 cents in 1912.

Mechanical banks were produced by the tens of thousands, but not all were equally popular. Current rarity, which affects value, reflects several factors. Certain banks never caught on with the intended audience and were quickly discontinued. The mechanisms in other banks would not function adequately or quickly broke down. Manufacturers went out of business. The result is a field in which some models may exist in the thousands, while of others less than a dozen are known. The popularity of mechanical banks has led to reproductions, which can usually be spotted because of their rough surface and/or inappropriate paint jobs.

See also **Political Folk Art; Toys, Folk.**

BIBLIOGRAPHY

Hertz, Louis H. *The Toy Collector*. New York, 1969.

Ketchum, William C. *Toys and Games*. New York and Washington, D.C., 1981.

King, Constance E. *The Encyclopedia of Toys*. New York, 1978.

WILLIAM C. KETCHUM

BARBER POLES: *SEE* TRADE SIGNS.

BARBER, JOEL (1877–1952), an authority on wild-fowl decoys, is referred to as the "father of decoy collecting" and is credited with giving more to the emerging awareness of decoys than any other American. Born in Brewerton, New York, he grew up in Syracuse and graduated with a degree in architecture from Cornell University in Ithaca. Subsequently, he received a Beaux Arts Scholarship, which took him to Paris and Rome for further study. For much of his professional life, he lived and practiced architecture in New York City before moving to Wilton, Connecticut. He began collecting decoys as early as 1918 and helped to organize the first known decoy show, held in Bellport on Long Island, New York, in 1923, and sponsored by the local Anti-Duskers' Society. ("Dusking" is the discredited practice of shooting birds as they come to feed after dark.)

In addition, Barber is the author of *Wild Fowl Decoys,* first published in 1934. The book provides a comprehensive description of the origins and use of wildfowl decoys, and is the basis for subsequent research on the subject. Barber called waterfowl decoys "floating sculpture," and recognized them as the only waterborne forms of carving originally made for utilitarian rather than decorative purposes. In the opening chapter of *Decoys,* he outlines his inspiration:

The origin and development of decoys has remained a persistent obscurity. No separate treatise on the subject has ever appeared, likewise no pictorial records of early examples. With these facts before me, I have collected old decoys and painted portraits of typical examples. . . . No one has ever bothered about them as I have, perhaps no one ever thought about it. But it is my wish that the decoy ducks of American duck shooting have a pedigree of their own. For this reason I have become a collector and historian.

Barber is also the author of *Long Shore,* published in 1939, a compendium of short stories and verse describing places he visited and fished during his love affair with the outdoors, especially Monhegan Island, Maine. Barber gradually built a comprehensive collection of wildfowl decoys. In 1952 Electra Havemeyer Webb purchased four hundred historic decoys from Barber's collection for Vermont's Shelburne Museum. Her acquisition included as well dozens of decoys that Barber carved himself, and upwards of three hundred watercolors and drawings of historic decoys by Barber, many of which were used as illustrations in *Wild Fowl Decoys.* At the time of Barber's death, in 1952, he left unfinished a planned book, *Decoys of North America.*

See also **Decoys, Wildfowl; Shelburne Museum; Electra Havemeyer Webb.**

BIBLIOGRAPHY

Barber, Joe. *Wild Fowl Decoys.* New York, 1954.
———. *Long Shore.* New York, 1995.
Ernest, Adele. *Folk Art in America: A Personal View.* Exton, Pa., 1984.
———. *The Art of the Decoy.* New York, 1965.
Joyce, Henry, and Sloane Stephens. *American Folk Art at the Shelburne Museum.* Shelburne, Vt., 2001.
Liu, Allan J., ed. *American Sporting Collector's Handbook.* New York, 1976.
Mackey, William F. Jr. *American Bird Decoys.* New York, 1965.

WILLIAM F. BROOKS JR.

BARD, JAMES (1815–1897) and **JOHN** (1815–1856) were twin brothers born into the family of a laborer living in lower Manhattan who, by the middle of the nineteenth century, had established the ship portrait as a mainstay of American marine painting. Though it had European roots, the American ship portrait had, by that time, assumed its own style and character.

The brothers drew their first ship portrait as a joint effort, when they were twelve years old. Their first works were executed in watercolor; in fact, virtually all of the pictures identified as the work of J. & J. Bard are somewhat naive drawings in watercolor. John seems to have faded from the partnership about 1850; he died in poverty a few years later. James, however, had developed both skill and a clientele, and his trade flourished over the next forty years. He also extended his reach beyond the watercolor medium, and many of his most significant paintings were done in oil or gouache.

The form of the ship portrait is dictated in large measure by the demands of those who commission them. Ship owners tend to demand pictorial accuracy above all else. Those who go to sea know that imprecision can be fatal; a single piece of rigging out of place can spell the difference between survival and death. There is no pleasure to be found in looking at a painting that memorializes such errors. James Bard had learned this lesson well.

Bard's work centered on the steamboats that plied the Hudson River and Long Island Sound. While New York harbor was the maritime center of the country, bustling with ships of all nations, an entirely different fleet served its inland transportation needs. These steamboats were the technological marvels of their day, competing for pride of place in speed and luxury. Through family connections and longstanding associations, James Bard painted most of the river and

sound steamboats that were built in or served New York throughout the nineteenth century. Other painters served the markets for oceangoing ships and yachtsmen, but the riverboats were Bard's territory.

When a client demanded a ship's accuracy, it seems reasonable to suppose that the artist might have looked to the naval architect's construction drawings as his source. That supposition was applied to Bard's painting for many years, but close examination of surviving drawings now makes it clear that the artist relied on his own careful measurements of the vessels themselves before drawing their forms and details. For a price of twenty to twenty-five dollars a painting, Bard spent at least a week measuring and drawing; he then reviewed his meticulous drawing with the owner, and, after recording his corrections, executed the final painting. The results must have been good, as most of his work was commissioned by return clients. With crisp detailing, bold broadside views, and billowing flags emblazoned with the ships' names, these paintings pleased their owners and set a standard for their age.

See also **Maritime Folk Art; Painting, American Folk.**

BIBLIOGRAPHY

Peluso, Anthony J. Jr. *J. & J. Bard, Picture Painters.* New York, 1977.
The Bard Brothers: Painting America Under Steam and Sail. New York, 1997.
Sands, John O. "The River Bards." *FMR Magazine,* no. 5 (October 1984): 49–64.

<div align="right">JOHN O. SANDS</div>

BARELA, PATROCIÑIO (c. 1900–1964), who is considered by artists and scholars as a pivotal figure in twentieth-century Hispanic New Mexican art, was the first Mexican-American artist to exhibit at the Museum of Modern Art, in 1936. Born in Bisbee, Arizona, to parents of Mexican descent, Barela moved to Taos, New Mexico, at age four. With little formal education (Barela remained illiterate throughout his life), he left home at age eleven to work as a migrant laborer. Returning to Taos in the early 1930s, he married and settled in the nearby village of Cañon.

About 1931, according to local legend, a priest asked Barela to repair a broken wooden *santo* (figure of a saint). Barela felt an immediate affinity with wood and began carving religious images. His works were not typical of the New Mexican *santeros,* or makers of religious images, whose work replicated centuries-old polychrome prototypes. Barela's unpainted sculptures, carved mostly from cedar, juniper, or pine, depicted traditional biblical and secular themes in an original manner that encompassed primitive, expressionist, and surrealist styles. As a matter of practicality, he created his carvings from single pieces of wood so that their appendages would not break off.

Barela's subject matter, however, was not limited to religion. He delved deeply into the gamut of human feeling and experience, from a newborn child in a mother's tender embrace to a crippled old man hobbling toward death. He confronted personal hardships, including his longtime struggle with alcoholism, in stark, honest, often startling images that addressed the complex web of his family dynamics. Many works are fixed in positions of entanglement or embrace, emphasizing the struggles of the human condition. Though usually fewer than eighteen inches tall, his stylized, distorted forms have a nevertheless monumental physical and emotional impact.

In 1935 Barela's work caught the eye of Holger Cahill, the director of the Federal Art Project (FAP) of the Works Progress Administration, who gave him a job. In 1936 Barela's work was included in an FAP show at the Museum of Modern Art, and his sophisticated, contemporary style was acclaimed by art critics nationwide. The press referred to Barela as a native Henry Moore, comparing his sculptures to the primitive art of Africa, Oceania, and Easter Island. *Time* magazine deemed Barela "the discovery of the year."

Barela worked with the FAP until 1944, while his work was shown and added to permanent collections nationwide. Even Henry Moore was said to have collected his work. Barela, however, remained in Cañon, selling his sculptures for small amounts of cash. He continued to nurture his modern vision with hundreds of sculptures, breaking further and further away from the *santero* tradition that inspired his career.

Sadly, many at home viewed Barela as little more than an illiterate alcoholic throughout his life. That changed after the artist's death in a studio fire, as a new generation of Hispanic New Mexican artists adopted Barela as an artistic role model. In the twenty-first century, Barela's works are valuable collector's items, and his singular style inspires traditional and contemporary artists alike.

See also **Religious Folk Art; Santeros; Sculpture, Folk.**

BIBLIOGRAPHY

Crews, Mildred, et al. *Patronciño Barela: Taos Wood Carver.* Taos, N. Mex., 1962.

Gonzales, Edward, and David L. Witt. *Spirit Ascendant: The Art and Life of Patrociño Barela*. Santa Fe, N. Mex., 1996.

Nunn, Tey Marianna. *Sin Nombre: Hispana and Hispano Artists of the New Deal Era*. Albuquerque, N. Mex., 2001.

CARMELLA PADILLA

BARKER, LINVEL (1929–), who worked between 1988 and 1997, is recognized as an important carver of animal forms. Using basswood, Barker created his work with a combination of the meticulous attention to detail of a machinist and an original sense of form, both unified by his unique artistic vision. He worked for thirty years in a northern Indiana steel mill as a maintenance technician. When he retired in the late 1980s, he moved to Isonville, Kentucky, where he preached at a local church. He was encouraged to carve by artist, neighbor, and friend Minnie Adkins (1934–), and his work was immediately recognized as exceptional. Barker's cats, cows, dogs, giraffes, pigs, roosters, squirrels, and other animals are highly refined, both in their elegant forms and in the soft treatment of their surfaces. His figures of pigs, for instance, with their large rolls of fat, have legs that taper downward to small, delicate feet. The absence of carved eyes further underscores the ambiguity of these graceful forms. Barker's work is essentially unpainted, but the painted-on eyes of some pieces were added at the suggestion of an art dealer. The artist abruptly stopped carving when his wife died, in 1997. He was confined to a nursing home in 1999.

See also **Minnie Adkins; Sculpture, Folk.**

BIBLIOGRAPHY

Moses, Kathy. *Outsider Art of the South*. Atglen, Pa., 1999.

Yelen, Alice Rae. *Passionate Visions of the American South: Self-Taught Artists from 1940 to the Present*. New Orleans, La., 1993.

ADRIAN SWAIN

BARNES, LUCIUS (1819–1836) is known primarily for his small watercolor portraits on paper. He painted at least seven portraits of his grandmother, Martha Atkins Barnes (c. 1738–1834), of Middletown, Connecticut, an extraordinary woman who raised ten children and was a devout Baptist. Each of the portraits depicts her in profile, wearing oval eyeglasses, a black dress with long sleeves, a shawl, a white cap with black bow, and either walking with a cane or sitting in a chair, often with a pipe in her mouth, and, occasionally, reading a bible. She usually is posed on what appears to be a mound or platform.

Why so many similar portraits were painted is not known, although it has been suggested that they may have been painted to illustrate copies of her biography, *Memoir of Mrs. Martha Barnes,* written by John Cookson, the pastor of the First Baptist Church of Middletown, and published in 1834. One of the seven portraits was found inserted as the frontispiece in a copy of the biography. It is also possible that the artist made some of the portraits as gifts for family members.

Barnes, the seventh child of Elizur and Clarissa Barnes, was born in Middletown on August 1, 1819. At the age of four he injured his spinal cord, and was restricted to a wheelchair for the rest of his life. According to his obituary, the only way he could move about was on his hands and toes. Despite his handicap, Barnes was able to paint not only the portraits of his grandmother but also one other signed watercolor, which depicts three children and a dog adrift on an ice floe. This painting shares the stylistic characteristics, including the mound or platform, found in the portraits.

Other members of the Barnes family also painted portraits of Martha Barnes; one is attributed to a nephew, the other to a great grandson. A third portrait, with features identical to those seen in the portraits painted by Lucius Barnes, was discovered in 1997; it was painted by her granddaughter, Clarissa Barnes, Lucius Barnes's older sister. Because she was seven years older than her brother, she may have supplied the stimulus for his painting activity.

See also **Painting, American Folk.**

BIBLIOGRAPHY

D'Ambrosio, Paul S., and Charlotte M. Emans. *Folk Art's Many Faces: Portraits in the New York State Historical Association*. Cooperstown, N.Y., 1987.

Rumford, Beatrix T., ed. *American Folk Portraits: Paintings and Drawings from the Abby Aldrich Rockefeller Folk Art Center*. New York, 1981.

ARTHUR AND SYBIL KERN

BARR, ALFRED H., JR. (1902–1981) was one of the first American art scholars drawn to modernism. Born in Detroit, he moved to Baltimore with his family at age nine, when his father became the pastor at Baltimore's First Presbyterian Church. In the early 1920s he earned a bachelor's degree in art history and a master's degree in art and archaeology at Princeton University, and he later earned a Ph.D. in art history at Harvard University. Barr curated his first exhibition, a controversial show of European modernist works, at Harvard's Fogg Museum in 1925.

When he was drafted by a group of New York art patrons to serve as founding director of the Museum of Modern Art (MoMA), Barr brought with him a vision of modernism that encompassed all manner of

visual culture, including the work of nonacademic artists. MoMA opened in November 1929 as a three-gallery exhibition space in an office building near the permanent home in which it would open ten years later, at 11 West 53rd Street in New York City.

Barr's interest in the field was reflected in the folk art acquisitions he arranged for MoMA's collection, as well as in several exhibitions he organized at the museum. In 1937 he presented a landmark showing of limestone sculptures by William Edmondson (1874–1951), who thereby gained the distinction of being the first African American artist to exhibit at MoMA. In late 1942, Barr exhibited the imaginatively decorated shoeshine stand of Sicilian immigrant Joe Milone (c. 1887) in MoMA's lobby, and in the summer of 1943 he mounted a show by self-taught painter Morris Hirschfield (1872–1946).

The museum's conservative trustees deemed these shows unworthy of a serious art museum and considered Barr an ineffective administrator; both factors played a role in his ouster from the museum's directorship in October 1943. Initially demoted to an advisory directorship, he was named director of collections in 1947, and served in that influential capacity until his retirement in 1968. There were no further exhibitions of folk art or vernacular art at the museum during the last twenty-five years of Barr's tenure there, nor have there been since.

Tragically, Barr was stricken with Alzheimer's disease during the last few years of his life, and his memories of his own unprecedented influential career evidently died before he did.

See also African American Art (Vernacular Art); William Edmonson; Morris Hirschfield.

BIBLIOGRAPHY

Barr, Alfred. *What Is Modern Painting?* New York, 1943.

———. *Painting and Sculpture in the Museum of Modern Art.* New York, 1977.

Kantor, Sybil Gordon. *Alfred H. Barr Jr. and the Intellectual Origins of the Museum of Modern Art.* Cambridge, Mass., and London, 2002.

Marquis, Alice Goldfarb. *Alfred H. Barr Jr.: Missionary for the Modern.* Chicago and New York, 1989.

Newhall, Beaumont. "Alfred H. Barr Jr.: He Set the Pace and Shaped the Style." *Artnews,* vol. 78, no. 8 (October 1979): 134–137.

TOM PATTERSON

BARTLETT, MORTON (1909–1992), who carved, clothed, and photographed figures of children from wood and other materials, commented on his pastime in the twenty-fifth anniversary yearbook of the Harvard class of 1932: "Its purpose is that of all proper hobbies—to let out the urges which do not find expression in other channels." Although a relative published an article about Bartlett's "hobby" in *Yankee* magazine in 1965, few people who knew the artist were aware of his dolls or his photographs of them during his lifetime. His artmaking was a very private activity.

Born in Chicago and orphaned when he was eight years old, Bartlett was adopted by Mr. and Mrs. Warren Goddard Bartlett of Cohasset, Massachusetts. He attended Phillips Exeter Academy, then Harvard for two years. Bartlett worked at a series of jobs beginning in 1930 (freelance advertising photographer, gas station manager, traveling furniture salesman, manufacturer of gift objects), but eventually started his own business as a print broker. He also served in the U.S. Army during World War II. He never married and received no formal training in art.

Bartlett fashioned his figures with an extraordinary precision, researching their anatomy and clothing in books and popular magazines, even consulting growth charts to achieve accuracy of detail. He spent as many as fifty hours completing the heads of the figures, as even the teeth were fashioned individually. Bartlett knitted sweaters, complete with tiny buttons and buttonholes, tailored pleated skirts, and styled the hair of his figures. He measured and recorded the ratio of the lengths of his figures' limbs to their torsos and kept monthly tables of their imagined growth, using standardized children's growth charts as a guide. He also consulted *Gray's Anatomy* and costume books.

There was a deeper focus to Bartlett's labors, however, than the surface prettiness and perfection of the figures, for it's the posed photographs he took of his "family" that seem to have been the goal of the artist. Bartlett made intimate, photographic portraits of "his children," reading, sleeping, laughing, and weeping, and they were private components of the alternate world he created for himself. When he died in 1992, the figures, their clothing, his charts and other records, and the photographs, of which there was no record in his will, were discovered carefully wrapped in newspaper, stored in wooden boxes, and locked away in a cupboard.

Bartlett completed fifteen sculpted figures (twelve of girls and three of boys) in his lifetime, over a thirty-year period from, 1935 to 1965, representing children of eight to fourteen years of age, and constructed to about half of actual life size. The three male "children" may have been autobiographical figures. One hundred evocative photographs as well as his archival materials are part of the entire body of

Bartlett's work purchased in November 1993, when Marion Harris and husband Jerry Rosenfeld saw the cache of the artist's work offered for sale at an antiques show.

The remarkable craftsmanship and attention to detail in these personal, sculpted figures and photographs that Bartlett focused on for years provided him with an alternate universe. The artist's drive to create and his obsession with precision, as realized in the carving, painting, clothing, and embellishment of his figures, has not been surpassed. The exacting details of his unique, sometimes provocative, prepubescent and pubescent figures possess an edgy, surrealistic quality.

See also **Dolls; Outsider Art; Sculpture, Folk.**

BIBLIOGRAPHY

Harris, Marion. *Family Found: The Lifetime Obsession of Morton Bartlett.* New York, 2002.

Hollander, Stacy C., and Brooke Davis Anderson, co-curators. *American Anthem: Masterworks from the American Folk Art Museum.* New York, 2002

Kogan, Lee. "The Secret Children of Morton Bartlett." *Raw Vision,* no. 16 (fall 1996): 46–49.

LEE KOGAN

BARTOLL, WILLIAM THOMPSON (1817–1859), a native of Marblehead, Massachusetts, painted mainly portraits and landscape scenes in the vicinity of his place of birth. The son of John and Rebecca Thompson Bartoll, the artist was baptized in the town's First Church on June 22, 1817. He married local resident Sally Lindsey Selman on April 21, 1835, and continued to reside in Marblehead, where the couple had seven children. Bartoll died of "lung fever" on February 15, 1859, at the age of forty-one.

Local tradition indicates that Bartoll began his career in his father's trade as a housepainter. His earliest known portrait is of David Quill and dates from 1829. Quartermaster on the frigate *Constitution,* Bartoll's subject is depicted in a bust-length composition, devoid of decorative details except for the gold pin, initialed with the letter *Q,* that he wears on his cravat.

Working from the 1830s to the mid-1850s, Bartoll executed portraits depicting men involved in Marblehead's maritime economy and their families. As he developed into a skilled portrait artist, Bartoll generally painted subjects in interior scenes, seated at tables and often holding books to communicate their status as literate members of New England's burgeoning middle class. In later years, he is believed to have occasionally based his compositions on photographs.

In addition to portraiture, Bartoll also painted landscapes, murals, and genre subjects. Suggesting ambitions beyond local renown, from 1841 to 1855 he exhibited numerous pictures at the Boston Athenaeum, including several landscapes as well as a genre scene titled *The Miser,* the location of which is now unknown. In 1852 the Marblehead Bank paid him fifty-four dollars to decorate the paneled great hall of its facility with faux oak graining, indicating that Bartoll continued to paint, using a variety of methods, over his lifetime in order to maintain his professional livelihood.

See also **Maritime Folk Art; Painting, American Folk; Painting; Landscape.**

BIBLIOGRAPHY

Chamberlain, Narcissa G. "William T. Bartoll, Marblehead Painter." *The Magazine Antiques,* vol. 122 (November 1982): 1089–1095.

Perkins, Robert F. Jr., and William J. Gavin III. *The Boston Athenaeum Art Exhibition Index, 1827–1874.* Boston, 1980.

CHARLOTTE EMANS MOORE

BASCOM, RUTH HENSHAW (1772–1848) became in midlife a pastelist of life-size bust profiles on paper. Her artistic productivity was facilitated by a way of life that strongly emphasized community as well as family involvement, and was further nurtured by a penchant for travel in New England.

Born in rural Leicester, Massachusetts, Bascom was the eldest of ten children. Combining a fondness for children with an ardent advocacy of education, she taught summer school between 1791 and 1801 in Leicester and adjacent towns. The daily diary Bascom began in 1789 at age sixteen and faithfully kept for fifty-seven years, through 1846, attests to her broad scholarly interests and accomplishments. It is held in the collection of the American Antiquarian Society in Worcester, Massachusetts

In 1804, Bascom married Dr. Asa Miles. She returned to Leicester when Miles died, about a year later, and used her designing and needlework skills to establish a millinery business. In 1806 she married Ezekiel Lysander Bascom, minister of the Congregational Church in Gerry (later Phillipston), Massachusetts. By 1820 the Bascoms had moved to Ashby, Massachusetts, where her painting career developed and flourished. Bascom and her husband enjoyed a ministerial exchange in Maine from 1837 to 1838, followed by an appointment in Fitzwilliam, New Hampshire, where Rev. Bascom died in 1841. Ruth Bascom returned to Ashby and continued to paint and travel.

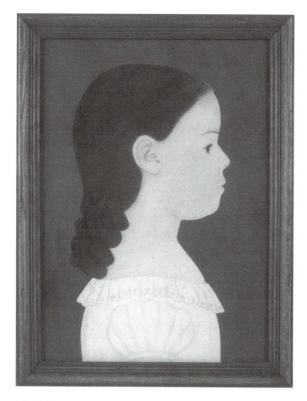

Elizabeth Cummings Low; Ruth Henshaw Bascom; 1829. Watercolor, pastel, and pencil on cutout paper, mounted over slate blue paper; 16 × 11⅜ inches. The Bertram K. Little and Nina Fletcher Little Collection auction at Sotheby's 6612, October 21 and 22, 1994.
Photo courtesy Sotheby's, New York.

Bascom's profile portraits, known as "shadows" or "likenesses," were produced by darkening a room and tracing the sitter's shadow by candle or lamplight as it was cast upon a wall or other flat surface, to which drawing paper had been affixed. Facial features were then delineated in pencil. Her stylistic development moved through three overlapping stages. In the first, between 1801 and the mid-1820s, Bascom indicated features with a few hollow cuts placed against a dark ground. In the second stage, beginning in 1828, Bascom separately cut clothing parts, such as jackets, jacket collars, dress bodices, boys' shirt collars, and bonnet bows, then colored and assembled them as a collage, with the sitter's head to neck region on solid colored paper. Her portrait of *Elizabeth Cummings Low* (1829) is one such collage composition pasted onto a slate blue ground; the crisp photographic lines are evocative of the shadow-tracing process. Some of the portraits also had metallic foil decoupage pasted on as buttons, necklace beads, earrings, or spectacle frames. Occa-

sional, but rarer, touches of realism included genuine-silk neck ribbons that Bascom would affix to the surface. A third type of composition appeared in the mid-1830s, in which Bascom began to draw the likenesses and their backgrounds on one sheet of paper, often employing dark green trees to highlight the sitter's face, or sketching the background with blue or brown pastel, sometimes with upper-corner convex arcs or ruffled curtains, and alternatively with spandrel corners to suggest an oval inner frame. References to more than 1,400 profiles are found in the artist's diary. Her extant profiles number approximately 215.

See also **Painting, American Folk.**

BIBLIOGRAPHY

Avigad, Lois S. "Ruth Henshaw Bascom: A Youthful Viewpoint." *The Clarion,* vol. 12 (fall 1987): 35–41.
Benes, Peter, ed. *Itinerancy in New England and New York.* Boston, 1986.

LOIS S. AVIGAD

BASKETS AND BASKETRY, or basket making, has been described as the ultimate folk craft, allowing for maximum personal expression with a minimal amount of machinery and material. A skilled craftsperson, utilizing natural materials and practical skills, may create an object that is both useful and a work of art.

The Native American inhabitants of North America were making baskets at least 9,000 years ago, and European colonists were equally familiar with the craft. Contact between the cultures led to an amalgamation of techniques and design; but for the most part, what were referred to as "Indian baskets" remained distinctly different.

European-influenced baskets are practical, durable, and made primarily from three materials: wooden splints, willow, and rye straw. Splints, which are long, thin strips of wood, were produced by soaking an ash or oak log in water until it began to separate along the annular rings, then splitting out the wooden strands. Today, machines do this work. The strands, or splints, were woven or plaited together at right angles in a crosshatch pattern. Handles, when desired, were carved from a piece of the same wood, and either woven into the basket sides or attached to loops on the rim to create swing handle baskets.

Baskets made in this way might seem delicate, but they were actually both light and tough; they were used for a remarkable variety of purposes in the home, on the farm, and even at sea. Every home had

a variety of oblong, handled market baskets as well as egg baskets with bottoms that curved up at the center to distribute the weight and to avoid crushing the goods when carrying eggs or soft fruit. For the woman of the house there would be a round sewing basket with several smaller baskets for pincushions or tools woven into the sides. Baskets with tops that slid up and down on the handles were used to carry cakes and pies, or as storage for the feathers that were used in stuffing pillows and mattresses. Stout, rectangular laundry baskets along with tall, ovoid covered ones served to store soiled clothing.

Food processing required specialized forms. Large, flat baskets with low sides were filled with sliced fruit, which were suspended to dry above the stove or at a window; round cheese baskets with an open, hexagonal weave were filled with curds to allow the whey to drain off prior to working up the cheese. In the days when many families raised sheep, the wool-rinsing basket, an oblong form with four wooden legs, was used in drying washed or dyed wool.

Farmers used a variety of stout, handled baskets, both round and oblong, to carry produce from the fields as well as to market. For fruit- and berry-picking, they had unusual receptacles curved to fit about the waist, with loops for a supporting belt so that both hands were left free. Bottle-shaped vessels with narrow necks were used for sowing seeds; the small aperture was designed to prevent spillage of the precious seeds. Once grain was harvested, a large, triangular winnowing fan was used to separate grain from chaff.

For the fisherman, there was the splint creel to store his catch, the backpack basket to carry his equipment, and the tubular eel trap into which a fish might pass, but from which it could not return. Clam and oyster dredgers used vast numbers of handled baskets with openwork bottoms designed to allow water to drain out.

Miscellaneous splint baskets included cribs or cradles in both baby and doll sizes; narrow-necked pigeon baskets, which held the birds before their release at the once-popular pigeon shoots; shallow, curved baskets with a central handle, which might be used for gathering flowers or storing kindling for a fire; and wall baskets with flat backs and one or more pockets, which could store everything from toothbrushes and keys to the day's mail.

Baskets made from willow osiers (the tall shoots that spring from the stump of a willow tree) have been used for generations, and remain popular today for flowers and fruit. Referred to as wickerwork, these vessels were more limited in form than their splint cousins were. Most often seen are the round and open table or sewing baskets (sometimes with a decorative, openwork rim), and various round, oblong, and handled market baskets. Less common are the field or gathering baskets with domed tops attached by woven loops. These were employed in harvesting fruit and vegetables.

Owing to its great durability, willow was employed to make baskets that might be expected to see hard usage. These included baby cribs or bassinets, both with and without legs; animal carriers and doghouses; children's carriages and chairs; even sleigh bodies and the gondolas for hot air balloons. Interestingly enough, some of these objects, such as the gondolas, are still made of the same material.

Settlers of Germanic heritage brought to Pennsylvania, Texas, and other states a tradition of rye-straw basketry. Rather than being woven, these baskets are made by binding together bunches of rye straw, which are then assembled by coiling them in a spiral, with each layer being sewn to the previous ones. Among the relatively limited forms made were shallow, round or oblong baskets in which bread dough was placed to rise before baking, and large, covered, ovoid storage containers for dried fruit and other foodstuffs. Perhaps the most interesting of rye-straw products was the bee "skep" or hive, a cone-shaped home for a bee colony, which was needed not only for the honey it provided but also for purposes of pollination. Since most were discarded after use, early bee skeps are rare.

Several social or ethnic groups made baskets that have attracted public attention. Among these are the Shakers, a religious and communal group that flourished during most of the nineteenth century and well into the twentieth century. Shaker basketry is mostly splint basketry, distinguished from that of other artisans primarily through its quality of workmanship. The sect's baskets were woven over wooden molds to ensure uniformity and generally have double-wrapped or cross-bound rims, which is less common among non-community makers. Also, the Shakers employed the hexagonal weave in many types of sewing, notions, and workbaskets while outsiders confined it almost exclusively to cheese baskets. Nevertheless, most experts agree that it is usually difficult to identify a Shaker-made basket.

Another type is the Nantucket basket. Originating in the 1850s as the pastime-product of sailors on the lightships stationed off Nantucket Island, and still made up to the present time by island craftsmen, these vessels are of a distinct construction. They have round or oval wooden bottoms upon which is woven

a body of hickory or oak ribs and rattan (tropical palm) weavers. Handles are attached to the body with brass "ears," and the pieces are often signed by famous manufacturers, such as Charles B. Ray (1798–1884) or Captain James Wyler (1816–1899).

Nantucket baskets were frequently made in nests of six or eight in graduated sizes, and a complete, signed set can bring a staggering sum. Modern versions continue to be made, and in the late 1940s a local schoolteacher, José Formoso Rayes, added a top to the conventional form, creating the Nantucket basket-purse. Usually decorated with a carved ivory ornament (later made of plastic), these purses are made by several island craftsmen, while inferior copies are produced in Asia.

A distinct kind of basketry is produced by the black Gullah artisans of the South Carolina coast and barrier islands. Based on African forms and made in the coil manner from a combination of sweet-smelling sea grass and long-leaf pine needles sewn together with split palmetto fronds, these pieces are sold by their makers along coastal roads. Production consists of a variety of baskets, with and without handles, as well as mats, purses, and fruit or flower containers.

Nearly all Native American tribal groupings produced basketry, and their products reflect a great diversity in style and materials. In the Northeast and upper Midwest the predominant materials used are splint and sweet grass. Algonquin and Iroquois craftsmen from Maine to New York as well as tribes such as Wisconsin's Winnebagos and Michigan's Chippewas produced (and in some cases, still produce) fine splint baskets similar in design to those made by the first white settlers.

The Native American products differ, however, in decoration. While vessels made by whites were rarely decorated beyond an overall coat of red, green, blue, or brown paint (usually added by not the maker but an owner), the Native American baskets were embellished in several ways. Bands of twisted splint called curlicue covered the exteriors of some containers, while others were decorated with paint. At its simplest this might consist of dotted patterns, but more sought after by collectors are those baskets with the so-called potato stamp decoration. Pieces of wood, corncob, or potato were cut into decorative designs, such as stars, circles, and half moons, then dipped in natural dyes and applied to the broad bands of splint. Some existing baskets are lined with newspapers from the 1830s and 1840s, indicating the early date of this decoration.

Sweet-grass baskets, the other Eastern specialty, are primarily decorative. The Penobscot tribe of Maine and New Brunswick weave an amazing variety of containers from sweet grass, a pleasant smelling but tough swamp plant, usually combining it with colorfully dyed splint. Covered containers, open bowls, handkerchief cases, pencil holders, pincushions, wall baskets, comb cases, and almost anything else that might appeal to a tourist are made. The craft, established in the late nineteenth century, continues to thrive.

The Native American basket-making craft was, and often continues to be, practiced in the South and Midwest, but for great examples collectors look to the Southwest and West Coast. The Pima and the Papago of southern Arizona, the Apache and the Hopi, to name just a few tribes, have produced extraordinary work, despite living in arid areas where basket-making material is in scant supply. For the most part, these basket makers plait or coil the long, tough fibers of the yucca leaf around split, pealed willow or sumac twigs, adding color by interweaving the shiny, black husk of the devil's claw seed pod.

The forms made are few and simple: round, flat trays; tall, ovoid ollas or jars; and a variety of bowls. But if the forms seem plain, the construction and decoration do not. So tightly woven are the vessels that some can hold water; and the decorative designs, usually in black or red against a tan background, may consist of complex geometric patterns or abstract pictorial forms representing figures in the tribal cosmology.

The numerous California tribes have produced equally fine basketry. Indeed, some experts feel that the baskets produced by the Pomo of northern California rival anything produced anywhere in the world, and the Washoe basket maker Dat So La Lee, also known as Louisa Keyser (1850–1925), is regarded as a master of the craft in the blending of form and decoration in vessels, some three feet in diameter. Of course, the state's numerous craftsmen were greatly assisted by the mild climate, resulting in a wide choice of materials. California baskets may incorporate tree bark or roots, wild grapevines, sedge, bull rush, or other natural materials. Decorative designs, such as the rattlesnake-skin pattern favored by the Tulare, tend toward the abstract and geometric. The Pomo signature piece is the "treasure basket," traditionally made by a mother as a gift to her daughter, and decorated with trade beads, abalone shell, and woodpecker feathers.

Farther up the coast, the Tlingit of Alaska and the Salish of British Columbia employ cedar bark and spruce-tree roots in twining delicate baskets and hats of remarkable flexibility. Lids may have boxlike com-

partments holding seeds that rattle when the piece is shaken, and the decoration deviates from the abstract geometric in its portrayal of graphic encounters between hunters and bears or whales.

There are many other remarkable Native American baskets and basket makers; yet what is most remarkable is that this cultural heritage has survived and often thrived despite the inroads of non-native culture and, in some cases, the active opposition of Anglo religious and cultural figures.

See also **German American Folk Art; Maritime Folk Art; Native American Folk Art; Religious Folk Art; Shakers.**

BIBLIOGRAPHY

Chase, Judith Wragg. *Afro-American Art and Craft.* New York, 1971.
Ketchum, William C. *American Basketry and Woodenware.* New York, 1974.
———. *Native American Art.* New York, 1997.
Teleki, Gloria Roth. *The Baskets of Rural America.* New York, 1975.
———. *Collecting Traditional American Basketry.* New York, 1979.
Whiteford, Andrew Hunter. *North American Indian Arts.* New York, 2003.

WILLIAM C. KETCHUM

BATES, SARAH (1792–1881) led a long and creative life as a member of the Shaker Society at New Lebanon, New York. The daughter of Elder Issachar Bates, one of early Shakerism's most important leaders, she was born in Hartford, New York, and entered the Shaker community at Watervliet, New York, in 1808 following her father's conversion to the Shaker faith. Three years later she moved to New Lebanon, the seat of the central authority of the church (more formally known as the United Society of Believers), where she resided for the rest of her life. As a Shaker sister, Bates was trained as a schoolteacher and "tailoress," and was closely associated in both pursuits with another gifted member of the community, Polly Ann (Jane) Reed (1818–1881). Bates and Reed were members of the First Order of the Church, one of several "families" in New Lebanon.

In the mid-nineteenth century, the Shaker communities entered a period of intense religious revival (1837–c. 1859) that is known to Shaker history as the "Era of Manifestations" or "Era of Mother's Work." A characteristic of this period was its openness to visionary phenomena (trances, spirit communications, and prophecy) and to the reception of spiritual "gifts" in the form of messages, songs, and drawings. Daniel W. Patterson's attribution to Sarah Bates of seventeen drawings, which share similar iconography, compo-

sition, and stylistic details, is convincing but circumstantial, based primarily on his analysis of the membership of the First Order of the Church. The calligraphy and drawing are as precise and elegant as Polly Reed's; indeed, it is clear that the two artists influenced each other's work.

Patterson has suggested that a number of telltale signs may be associated with Bates' drawings: the head of the hovering dove that often appears in her work has a distinctive bulblike shape; one of the wings of the dove in flight is thrust out "like the arm of a swimmer"; and the surfaces of tree trunks and tables are covered with crosshatching. Several of Bates' most complex drawings are in the form of "sacred sheets" (large gatherings of symbolic language) with direct appropriations from the visual culture of the world outside the Shaker communities, including Masonic iconography, gravestone design, and needlework samplers.

See also **Gravestone Carving; Polly Ann Reed; Religious Folk Art; Samplers, Needlework; Shaker Drawings; Shakers; Visionary Art.**

BIBLIOGRAPHY

Morin, France, ed. *Heavenly Visions: Shaker Gift Drawings and Gift Songs.* New York, 2001.
Patterson, Daniel W. *Gift Drawing and Gift Song: A Study of Two Forms of Shaker Inspiration.* Sabbathday Lake, Maine, 1983.
Promey, Sally M. *Spiritual Spectacles: Vision and Image in Mid-Nineteenth-Century Shakerism.* Bloomington, Ind., 1993.

GERARD C. WERTKIN

BEAR AND PEARS ARTIST, THE (active c. 1825–1850) is the unknown painter of a number of stylistically related wall murals in northern New England, dating to the second quarter of the nineteenth century. The artist's name is derived from a painted fireboard in the collection of the New York State Historical Association in Cooperstown, New York. This oil-on-panel work, *Bear and Pears,* is a decorative landscape, painted with broad brushwork and sponging, depicting a house and carriage shed surrounded by trees as well as a variety of stenciled animals, including one shaped like a bear that appears to be climbing a tree. Large reddish-orange pear-shaped forms ornament some of the trees. The unknown painter of this fireboard also decorated the walls and floors of several homes in the same manner, including a farmhouse in Lisbon, New Hampshire, a house in Thornton, New Hampshire (the painted walls from which are in the American Folk Art Museum in New York), and a house in Norridgewock, Maine.

See also **American Folk Art Museum; New York State Historical Association; Painting, American Folk.**

BIBLIOGRAPHY

Hollander, Stacy C., et al. *American Anthem: Masterworks from the American Folk Art Museum*. New York, 2001.

Lipman, Jean, and Alice Winchester. *The Flowering of American Folk Art, 1776–876*. New York, 1974.

PAUL S. D'AMBROSIO

BEARDSLEY LIMNER: *SEE* SARAH PERKINS.

BED RUGS: *SEE* COVERLETS; QUILTS; SHELBURNE MUSEUM.

BELKNAP, ZEDEKIAH (1781–1858) was one of the most prolific and aesthetically successful rural portrait painters working in nineteenth-century northern New England. Born in Ward (now Auburn), Massachusetts, Belknap moved to Weathersfield, Vermont, with his family at age thirteen. He pursued divinity studies at Dartmouth College in Hanover, New Hampshire, graduating in 1807. His preaching career, and his

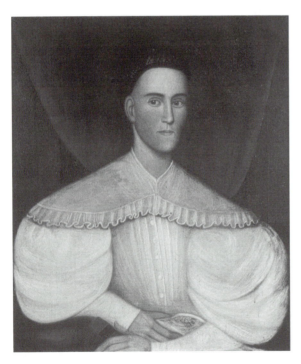

Miss Hannah F. Stedman; Zedekiah Belknap; 1836. Oil on canvas. 28 × 24 inches. The Bertram K. Little and Nina Fletcher Little Collection auction at Sotheby's 6612, October 21 and 22, 1994.

Photo courtesy Sotheby's, New York.

marriage in 1812, were short-lived. For most of his life Belknap traveled throughout Vermont, New Hampshire, and Massachusetts in search of portrait commissions. His nearly 200 extant portraits reveal a distinctive style, characterized by striking compositions (in which he contrasted light-colored faces and costumes against dark backgrounds), heavily outlined facial features, and—a signature trait—rounded roses. Belknap's portrait of *Miss Hannah F. Stedman* of 1836 evinces the artist's preference for static, elegant yet severe countenances and a high-contrast palette, in this case, the sitter's white pleated blouse set against rich red drapery.

The high number of easily attributed works allows scholars to trace the career of a successful itinerant portrait painter working at the historical height of the trade. Belknap's last known portrait dates to 1848. He entered the Chester Poor Farm in the town of Weathersfield in 1857, and died there in 1858.

See also **Painting, American Folk.**

BIBLIOGRAPHY

D'Ambrosio, Paul S., and Charlotte Emans, *Folk Art's Many Faces: Portraits in the New York State Historical Association*. Cooperstown, N.Y., 1987.

Mankin, Elizabeth R. "Zedekiah Belknap." *The Magazine Antiques*, vol. 110 (November 1976): 1055–1066.

Rumford, Beatrix T., ed. *American Folk Portraits: Paintings and Drawings from the Abby Aldrich Rockefeller Folk Art Center*. Boston, 1981.

PAUL S. D'AMBROSIO

BELL, JOHN B. (1800–1880) is recognized as one of America's outstanding nineteenth century potters. Born in Hagerstown, Maryland, the eldest son of potter Peter Bell, he also worked in Winchester, Virginia; Chambersburg and Waynesboro, Pennsylvania; and Baltimore, Maryland. He worked in Waynesboro from 1833 until his demise. His apprenticeship, under his father's instruction in Hagerstown, instilled in him the concepts of eighteenth-century German utilitarian pottery production. In Chambersburg (c. 1827–1833), his association with potter Jacob Heart (1791–1865) provided Bell with an understanding of English ceramic-molding techniques. This combination of German and English ceramic production techniques provided the foundation for the Shenandoah Valley pottery tradition. John, his father, Peter, and his brothers, Samuel and Solomon, were the potters primarily responsible for the dissemination of these pottery styles throughout the Shenandoah Valley region.

John Bell was a proven student of pottery techniques throughout his production period, and his

broad production repertoire included the earliest documented use in America of tin glaze and of the mocha dendritic style of glaze decoration (first used in England prior to 1785), which ornamented ware with moss-like, branching designs. His late production, in about 1850, of salt-glazed stoneware was preceded by a period of producing pottery with a cobalt and lead-oxide glaze, which resembled local stoneware products. His use of manganese dioxide as a coloring agent often resembles the coatings of Baltimore's Bennett Brothers, of some Bennington ware, and of other Rockingham-style glazes, exhibiting a deep brown, mottled, and/or running coloration contrasted with a cream to yellow ground. While in Baltimore, he was possibly associated with Charles Coxen, a Staffordshire and American ceramic modeler, as some of Bell's stamped products were the result of Coxen-fabricated molds. Many slip-decorated artifacts made in Bell's shop are extant today.

John Bell's earthenware products often exhibit the preciseness of European porcelain ware. Many of the extant artifacts from his shop, however, exhibit a folk art quality. His thrown hollowware most often exhibits thin walls with decorative moldings and rims, and many are architecturally consistent with sixteenth- and seventeenth century European forms. The hand modeled animal products of his shop show a distinctive playfulness common to the nineteenth century. His hand modeled lion doorstops, in both earthenware and stoneware forms, are hauntingly folksy in appearance, and are copies of early nineteenth-century chalkware figures. His salt-glazed utilitarian products are either rectilinear or curvilinear in form, and decorated with cobalt floral art painting.

John Bell is known to have employed only lead-oxide superglaze (consistent with that of his contemporaries) for his earthenware finish. He also employed white slip *engobe*, a liquid clay applied before a ceramic piece has been fired and usually before it has dried, as both a decorative addition and as a masking ploy to cover the redness of the earthenware clay. Bell used almost exclusively the metallic oxides of manganese dioxide (brown), copper oxide (green), and various cobalt oxides (blue), to produce decorative colors on his wares. Many of his products were decorated with commercial paints, and Bell used various stamps and signatures to authenticate and advertise his products.

See also **Solomon Bell; German American Folk Art; Museum of Early Southern Arts; Pottery, Folk.**

BIBLIOGRAPHY
Comstock, H.E. *The Pottery of the Shenandoah Valley Region.* Chapel Hill, N.C., and London, 1994.
Rice, A.H., and John Baer Stoudt. *The Shenandoah Pottery.* Strasburg, Va., 1929.

H.E. COMSTOCK

BELL, SOLOMON (1817–1882) was a potter who, along with other members of his family, was responsible for disseminating Shenandoah Valley pottery traditions. Born in Hagerstown, Maryland, the third potter-son of Peter Bell, he moved to Winchester, Virginia, in 1824 with his father, who taught him to make pottery. Solomon's ware was produced while in Winchester (c. 1839–1845), at the Peter Bell pottery shop, under the incised marks "P Bell" as well as "Solomon Bell," except during 1840, when he worked with his brother, John Bell, in Waynesboro, Pennsylvania. Never married, in 1845 Solomon moved to Strasburg, Virginia, where he joined his brother, Samuel Bell (1811–1891).

The glazed metallic oxides used in earthenware production in the Solomon Bell shop were manganese dioxide (brown), copper oxide (green), cobalt oxides (blue), and lead-oxide superglazes. Solomon's ware was rarely decorated in the Rockingham-glaze style (with its deep brown, mottled, and/or running coloration contrasted with a cream to yellow ground) as was the pottery produced by his brother, John. He used slip *engobe,* liquid clay applied to a piece pottery before it has been fired and usually before it has dried, as a mask and a decorative accent to the local red earthenware. In addition, his use of manganese, copper, and engobe under a lead-oxide superglaze gave his pottery a polychrome effect with an Old World flavor. This particular style of glaze provided a prototype for the Eberly potters of Strasburg, Virginia (1875–1908), who produced it so abundantly that it is now recognized as the "Strasburg Glaze." Some of Bell's products were also decorated with commercial paints.

Solomon Bell learned his molding technique in Waynesboro, Pennsylvania, at his brother John's shop. He duplicated so many of his brother's molds that more than a few of the products produced by each brother are similar. Solomon produced primarily utilitarian, molded ware, in both Winchester and Strasburg, Virginia. His ceramic folk art style of manipulating, altering, and decorating his molded ware, so evident in his animal forms of dogs, cats, lions, and bears, has been compared to that of Anthony W. Baecher's, among the Shenandoah Valley's outstanding nineteenth century ceramic folk artists. Bell's hand formed animals, particularly his singular lion

doorstop, are considered some of the best examples of ceramic folk art in the United States. Solomon Bell also produced handmade ware with molded additions, and his salt–glazed stoneware was often elaborately decorated with abstract cobalt floral painting.

See also **John B. Bell; German American Folk Art; Museum of Early Southern Arts; Pottery, Folk.**

BIBLIOGRAPHY

Comstock, H.E. *The Pottery of the Shenandoah Valley Region*. Chapel Hill, N.C., and London, 1994.
Rice, A.H., and John Baer Stoudt. *The Shenandoah Pottery*. Strasburg, Va., 1929.

H.E. COMSTOCK

BELLAMY, JOHN HALEY (1836–1914) was a woodcarver best known for his ship carvings. Born in Kittery Point, Maine, the son of a carpenter and boat builder, in his youth Bellamy studied art in Boston and New York City before apprenticing to a Boston ship carver. He worked in Boston and Charlestown, Massachusetts, and Portsmouth, New Hampshire, but spent most of his professional career in Kittery Point, working in a second-floor studio in his father and brother's boat shop. Bellamy's work marks the continuation of the ship carver's art from its heyday in the late eighteenth and early nineteenth centuries to the period just preceding the end of the sailing-ship era.

The staples of the ship carver's art were billet-head figures; sternboards; figureheads that often depicted mythological or allegorical figures; and other ornamental work. Bellamy is known to have carved at least one eagle billet-head figure, but his only known figurehead is also his most ambitious carving: a nearly two-ton eagle figurehead for the U.S.S. *Lancaster,* carved in 1880, the same year that his occupation in the United States federal census was listed as "carpenter."

Bellamy may be best remembered for carving numerous patriotic eagle wall plaques, intended as house decorations, as well as larger examples used for architectural ornaments. Possibly inspired by the national pride generated during Philadelphia's Centennial Exhibition in 1876, these plaques vary greatly in size. Those intended for domestic use, as well as some made as gifts, follow the same general format: a pair of stylized, spread wings are carved in relief from a single pine board, with the eagle's head and neck carved in three dimensions from a block of wood, then attached to the wings with screws. Bellamy's eagles have distinctively patterned feathers, ingeniously foreshortened heads and necks, and fierce expressions with large curved beaks. Often polychromed, some eagle plaques include shields, flags, or flowing banners, carved separately, on which sentiments such as "Happy New Year," "Long Live Dewey," or "Carpe Diem" are carved and painted. Based on the number of surviving examples, Bellamy's patriotic eagle plaques were popular decorative accessories in Kittery-area homes. Bellamy's eagles were so popular, in fact, that other unidentified carvers began to mimic his style. These derivative pieces have made identification of Bellamy's work sometimes difficult.

The advent of steam-powered iron ships in the 1850s significantly reduced demand for the ship carv-

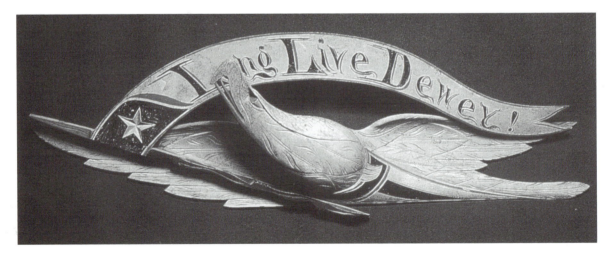

American Eagle Wall Plaque; John Haley Bellamy; Date unknown. 8½ × 25 inches. Carved and painted pine. The Bertram K. Little and Nina Fletcher Little Collection auction at Sotheby's 6612, October 21 and 22, 1994.
Photo courtesy Sotheby's, New York.

er's art. Bellamy's Portsmouth business card, advertising house and ship, furniture, sign and frame carving, and garden figures, demonstrates that as the importance of ship carving diminished over time, carvers nevertheless sought new ways to market their skills and sustain a livelihood.

See also **Maritime Folk Art.**

BIBLIOGRAPHY

Hollander, Stacy C., et al. *American Radiance: The Ralph Esmerian Gift to the American Folk Art Museum.* New York, 2000.
Smith, Yvonne Brault. *John Haley Bellamy, Carver of Eagles.* Portsmouth, N.H., 1982.

RICHARD MILLER

BENAVIDES, HECTOR ALONZO (1952–) makes drawings that resemble patterned, woven textiles. Their networks of interwoven lines are organized into patterns that appear to pulsate on paper. For a person who struggles daily with obsessive-compulsive disorder (OCD), the drawings give the artist a measure of control and focus over his thoughts and feelings.

Born in Laredo, Texas, Benavides was the youngest of three children in a family with a one-hundred-year history as ranchers. After graduating from high school, he went to Tyler, Texas, to study optometry. He completed his training, but his father's death in 1970 drew Benavides back to Laredo, where he took a job as an optician and moved in with his mother. Diagnosed with OCD, Benavides also developed another physical malady, and he required braces and crutches to walk.

During the 1980s Benavides' family encouraged him to enroll in an art class. While he loved to draw, he was unwilling or unable to adapt to the program, probably because he had already developed a personal artistic vocabulary.

Benavides drew with confidence as early as 1963; portraits of people and animal drawings were his first subjects. In time his work became more and more abstract, and the patterned elements increasingly organic. He turned his paper as he worked, obliterating any set position for viewing and unifying his drawings from all vantage points. Precisely lettered, multiple signatures appear on various edges of his work. His palette was colorful in his early drawings, evolved to black with some added color, and then all black; then it became red, white, and blue; and then back to black with color. Bruce and Julie Webb, dealers who discovered, befriended, and represent Benavides at their gallery, point out that the artist's palette is a reflection of his mood.

Some of Benavides' designs are composed of tiny dots, squares, triangles, circles, and lines drawn with an ultra-fine ballpoint pen. The artist, a Catholic, told the Webbs that the triangles represent the Father, Son, and Holy Spirit of the Holy Trinity. The squares make the triangles "stand out," and he likens the "squares to the cage he lives in with his obsessive-compulsive disorder and the circles as his escape out of his disorder." Benavides has also told the Webbs, "Through my art, I have turned a negative into a positive." He has completed some five to six hundred drawings.

See also **Painting, American Folk.**

BIBLIOGRAPHY

Adele, Lynne. *Spirited Journeys: Self-Taught Texas Artists of the Twentieth Century.* Austin, Tex., 1997.
Webb, Bruce. "Hector Alonzo Benavides: Bruce Webb Views the Creative Energy of Hector Alonzo Benavides." *Raw Vision,* no. 27 (fall 1999): 46–48.

LEE KOGAN

BENEVOLENT AND PROTECTIVE ORDER OF THE ELKS: *SEE* FRATERNAL SOCIETIES.

BENSON, MOZELL (1934–) was taught to quilt by her mother but did not become interested in sewing until later in life. Raised on a farm in Alabama with nine brothers and sisters, her quilting reflects the thrift and industry of her rural Southern life. She creates about twenty quilts a year, piecing them during the spring, summer, and fall, and in the winter quilting the quilt tops and linings together. Although she sometimes gives them away, she makes quilts mostly for her family's use.

Benson allows a quilt top design to evolve while she is piecing, rarely using patterns. She selects, cuts, and sews her scraps to make something new and original. Her wide strips, wider than typical African American quilt strips, and her bright colors show off her quilt top designs. Her multicolored patterns often look like modern art and her quilts often come across as paintings in cloth. Her quilts are the visual equivalent of jazz or blues, because she often takes a basic pattern idea and then creates variations on it, just as a musician will do with a jazz piece. Many people give her scraps of cloth because they admire her quilts.

Benson's quilts also reflect the African aesthetic of multiple patterning, and the African traditions of small, square, red protective charms, called *mojos* in African American culture. Benson comments: "Black families inherited this tradition. We forget where it came from because nobody continues to teach us. I

think we hold to that even though we're not aware of it."

In 1985 the United States State Department sent an exhibition of African American quilts to Africa, and Benson traveled with it, speaking about and demonstrating her quiltmaking skills in Nigeria, Senegal, and South Africa. In June 2001, Mozell Benson was awarded a National Endowment for the Arts National Heritage Fellowship.

See also **African American Folk Art (Vernacular Art); Quilts; Quilts, African American; Vodou.**

BIBLIOGRAPHY

Benberry, Cuesta. *Always There: The African American Presence in American Quilts.* Louisville, Ky., 1992.

Leon, Eli. *Models in the Mind: African Prototypes in American Patchwork.* Winston-Salem, N.C., 1992.

Mazloomi, Carol. *Spirits of the Cloth: Contemporary African American Quilt.* New York, 1998.

Wahlman, Maude. *Signs and Symbols: African Images in African American Quilts.* Atlanta, Ga., 2001.

MAUDE WAHLMAN

BENTZ, SAMUEL (1792–1850) made fraktur records that show minimal graphic accomplishment, but with bold lines. He was born in Cocalico Township, Lancaster County, Pennsylvania, and was the son of Reverend Peter Bentz and Anna Maria Caffroth Bentz. Bentz's mother raised him alone after her husband committed suicide. He became a schoolmaster in the area of Ephrata, and because his father had some theological training, Bentz could write at least the *tetragrammaton,* the four letter Hebrew name for God as revealed to Moses, usually written YHVH and commonly found on the title pages of Bibles—a striking feature in otherwise pietistic fraktur drawings. Bentz was also a member of the German Reformed church.

In 1813, shortly before he died, Bentz's father with some relatives and friends established a school on part of the family land, where Bentz taught for most of his life, living in the schoolhouse. He produced fraktur, mostly birth records, no doubt to supplement his income. Because some pieces refer to Mount Pleasant, Bentz was known as the "Mount Pleasant Artist," until a signed bookplate was discovered. When he died, a box with eighteen frakturs survived.

Bentz's work is frequently decorated with architectural elements, almost Greek Revival in style in their precise design. Occasionally, a human face is included and, more often, a clock face, with a thinly veiled religious message that implied of the importance of a work ethic and the value of time.

See also **Fraktur; German American Folk Art; Pennsylvania German Folk Art; Religious Folk Art.**

BIBLIOGRAPHY

Weiser, Frederick S. "Samuel Bentz, the 'Mount Pleasant Artist.'" *Der Reggeboge,* vol. 20, no. 2 (1988): 33–42.

FREDERICK S. WEISER

BESHARO, PETER "CHARLIE" ATTIE (1898–1960) produced more than seventy oil paintings on canvas, paper, and board that reflected his interest in outer space, alien invasions, and interactions and conflicts with aliens, together with ethnic and religious overtones. Besharo, whose ethnic background was Syrian-Lebanese, lived in Lebanon before immigrating to Leechburg, Pennsylvania, in 1912, where he worked briefly for a haberdasher and then as a peddler of dry goods to mining camps. For most of his life, he was self-employed as a sign and housepainter.

Besharo's interest in making paintings was an extension of his obsession with space. The owners of Tony's Lunch in Leechburg, where Besharo appeared daily for a meal, as well as his cousin remember that the artist often carried a roll of butcher paper, on which he calculated the distances to planets and the moon in addition to when the Earth was going to run "out of oxygen." He painted rocket ships fueled by atomic power, alien invaders, aggressors, victims, heroes, saints, and sinners. In his paintings Besharo traversed historical time and geographical space, combining biblical conflict and early weapons such as bows and arrows with deadly, futuristic-looking rays of light. Single images, such as rocket ships or spacemen, were subjects of this work, as were more complex compositions that were often divided into smaller units, such as in his painting *All Seeing Eye.*

Besharo used deep colors, and his palette was saturated with earth tones—brown, yellow, rust, and green—as well as black and white, punctuated with red and blue. He repeated images, such as the all-seeing Besharo eye as well as crosses, candles, scales, and chains, which seem to have symbolic significance. It is not always easy to understand Besharo's narratives, though he often provided neatly painted English and, occasionally, Arabic text references and dates, which generally reveal little about the accompanying images. As a result, the meanings of many of his works remain enigmatic.

Besharo was much affected by the World Wars, the development of nuclear power, the Cold War, and his own experiences as an Arab living as a member of a minority group in his adopted country. Popular cul-

ture, as reflected in comics, pulp magazines, and illustrated books, may also have influenced his conceptual ideas and visual forms. Besharo transformed all that he saw into a personal vocabulary of form.

Besharo's painted fantasy adventures in space and interplanetary interaction appeal to a universal interest in transcending mundane, everyday life and replacing it with exciting and surprising journeys. Rooted in his Arab heritage, the conflicts of his early life in Lebanon, and his integration into local American community life, in particular his involvement in church and fraternal organizations, Besharo takes a broad historical view—albeit with a liberal mixture of fact and fiction—and foresees eventual cosmic peace.

See also **Painting, American Folk.**

BIBLIOGRAPHY

Kogan, Lee. "New Museum Encyclopedia Myths." *The Clarion,* vol. 15, no. 5 (winter 1990/1991): 53–56.

———. "Peter Charlie Besharo," in *Self-Taught Artists of the Twentieth Century: An American Anthology,* edited by Elsa Longhauser, et al. New York: Museum of American Folk Art, 1998.

LEE KOGAN

BIRTH RECORDS: *SEE* FAMILY RECORDS.

BISHOP, ROBERT (1938–1991), director of New York's American Folk Art Museum from 1977 to 1991, was the author or co-author of more than twenty-five books on the American folk and decorative arts. An innovator and tastemaker, Bishop was the moving spirit behind the founding, in 1981, of New York University's Graduate Program in Folk Art Studies, for which he taught for almost two decades. As an educator, author, and museum director, he exerted a far-reaching influence on the development of the field of American folk art.

Bishop was born in Readfield, Maine, where he first developed an appreciation for antiques, but moved to New York in the early 1950s to pursue a career in dance and theater. He performed as a dancer in Broadway musicals and with the Metropolitan Opera Company, and from 1958 to 1960 attended classes at the School of American Ballet. To help support himself he sold antiques. By 1961, however, this spare time pursuit had become his principal vocational focus, and he left the theater to concentrate on his interest in American antiques.

In the late 1960s Bishop served as picture editor for the three-volume *American Heritage History of American Antiques* by Marshall B. Davidson, published in 1968. This led to assignments in book design and publishing. He designed the influential *Twentieth-Century American Folk Art and Artists* (1974) by Herbert W. Hemphill Jr. and Julia Weissman, and was appointed museum editor of the Henry Ford Museum, Greenfield Village, in Dearborn, Michigan. He also served that institution as a curator of American decorative arts. In 1975, Bishop earned a Ph.D. in American Studies from the University of Michigan; the university published his dissertation, *The Borden Limner and His Contemporaries,* the following year.

Within months of returning to New York to assume the directorship of the American Folk Art Museum (then the Museum of American Folk Art) in 1977, Bishop had set a new course for the institution. *The Clarion,* which had been an irregularly published members' newsletter, became a full-fledged quarterly magazine (later known as *Folk Art*) as well as a clearinghouse for information about the field. Through his initiative, the museum's collection was expanded, its membership dramatically increased, and its exhibitions presented to audiences throughout the United States. Widely acknowledged as a visionary leader, Bishop is credited with animating the institution's programming, developing important new earned-revenue programs, and transforming the American Folk Art Museum from a small walk-up gallery, known principally to enthusiasts, to a museum with a national reputation for innovation.

Bishop's books cover virtually every aspect of the field of American folk art. Among them are *American Painted and Decorated Furniture* (1972), with Dean Fales; *America's Quilts and Coverlets* (1972), with Carleton Safford; *American Folk Sculpture* (1974); *Folk Painters of America* (1979), with Patricia Coblentz; and *A Gallery of American Weathervanes and Whirligigs* (1981), with Patricia Coblentz.

See also **American Folk Art Museum; Earl Cunningham; Herbert W. Hemphill Jr.**

BIBLIOGRAPHY

Nelson, Cyril I. "Bob Bishop: A Life in American Folk Art." *Folk Art,* vol. 18 (spring 1993): 35–39.

Wertkin, Gerard C. "Dr. Robert Bishop (1938–1991): A Personal Memoir," *The Clarion,* vol. 16 (winter 1991–92): 35–40.

GERARD C. WERTKIN

BLACK AMERICAN FOLK ART: *SEE* AFRICAN AMERICAN FOLK ART.

BLACK, CALVIN (1903–1972) and **RUBY** (1915–1980) built a celebrated folk art environment in the Mojave Desert near Yermo, California. Calvin was born in Tennessee, and was only thirteen when he took re-

sponsibility for the care of his mother and siblings. He taught himself to read and write and worked in the circus and carnival, where he learned puppetry and ventriloquism. Ruby was raised on a Georgia farm. They were married in 1933, and at the height of the Great Depression the couple moved from Tennessee to northern California to pan for gold. They lived in Los Angeles before buying land outside of Yermo, south of Death Valley, in 1953. There, the Blacks opened a combination rock shop, souvenir shop, and refreshment stand to attract the few tourists who passed through the area.

While Ruby managed the shop, Calvin began to build an attraction he called *Possum Trot,* a Southern phrase describing the shortest distance between two points. Prompted by the need to augment the income their shop provided, *Possum Trot* was also an outlet for the couple's creative energies. The environment would eventually become a collection of wind powered merry-go-rounds, whirligigs, a wooden train, carved figures, signs, stagecoaches, and paintings, all made of found materials and stretching for a hundred yards along the road that passed in front of their home and shop.

Possum Trot is best remembered for the more than eighty "dolls" carved by Calvin. With smooth faces, rectangular heads, wide mouths, and articulated limbs, the stylized figures were dressed by Ruby in costumes she made from discarded clothing. Most were female, and many were based on friends or celebrities. The dolls danced and sang for visitors who paid the requested donation to view the "Fantasy Doll Show." Calvin mounted speakers on the back of several dolls, which allowed him to play tapes of prerecorded dialogue and songs he composed. He created a distinctive falsetto voice for each character, recalling his work as a ventriloquist.

The Blacks were childless, and Ruby remembered that Calvin often referred to the dolls as their children. On driving trips East to visit family, the Blacks would bring with them several dolls. Having devoted much of their adult life to creating their unique environment in the desert, it is understandable why Ruby refused to agree with Calvin that the dolls should be destroyed after his death. After Ruby's own death, *Possum Trot* was abandoned, and the Blacks' "children" were dispersed.

See also **Dolls; Environments, Folk; Whirligigs.**

BIBLIOGRAPHY

Milwaukee Art Museum. *Common Ground/Uncommon Vision: The Michael and Julie Hall Collection of American Folk Art.* Milwaukee, Wisc., 1993.

Hartigan, Lynda Roscoe. *Made with Passion: The Hemphill Folk Art Collection in the National Museum of American Art.* Washington, D.C., 1990.

RICHARD MILLER

BLACK, MARY CHILDS (1923–1992) was closely identified with the development of the field of American folk art, as an art historian, museum curator and director, and writer. She asserted that her interest in the subject came to her almost by inheritance. As a child in Pittsfield, Massachusetts, where she was born, she was impressed by two pairs of portraits of her ancestors, Hosea and Sarah Phillips Merrill, and Phillips and Frances Stanton Merrill. These portraits, which hung in the home of her grandparents, were by Erastus Salisbury Field (1805–1900). Black spent much of her professional life in a successful effort to identify, document, and exhibit the work of early folk painters. Field, among other artists, remained one of her enduring scholarly interests.

The holder of a master's degree in art history from George Washington University, Black was employed early in her career as a research assistant at the Colonial Williamsburg Foundation in Virginia. In 1958 she became curator of the Abby Aldrich Rockefeller Folk Art Collection at Williamsburg, and in 1961 was appointed director. Black not only helped to build the collection at Williamsburg but also undertook several notable projects there, including one devoted to the paintings of Edward Hicks (1780–1849), in 1960, and another to Erastus Salisbury Field in 1963. In 1964 she left Virginia for New York to become director of the Museum of Early American Folk Arts (later the American Folk Art Museum), which had opened its doors to the public the preceding year.

Several artists will always be associated with Mary Black because of the significance of her pioneering research. In 1965 she published her conclusions about the watercolor portraits of Jacob Maentel (c. 1763–1863) in *Art in America* as "A Folk Art Whodunit." Later, in collaboration with the collectors Lawrence and Barbara Holdridge, she demonstrated that Ammi Phillips (1788–1865) was the painter of a large group of portraits previously thought to be the work of as many as four different artists. She presented a comprehensive exhibition of Phillips' portraits at the Museum of American Folk Art in 1969. Black is also recognized for her meticulous scholarship on New York's earliest artists, including Pieter Vanderlyn (c. 1687–1778). Black also identified the "Aetatis Suae" Limner as Nehemiah Partridge, and the Wendell Limner as John Heaton.

In 1970 Black was appointed curator of Painting, Sculpture, and Decorative Arts at the New-York Historical Society, a post she held until 1982. Following her retirement, she continued to work in the field, as consulting curator to the Museum of American Folk Art. In 1984 she served as guest curator of a comprehensive traveling exhibition of the paintings of Erastus Salisbury Field organized by the Museum of Fine Arts, Springfield, Massachusetts, and wrote the authoritative catalog that accompanied it. Black was the author of many important published works, including the trailblazing *American Folk Painting* (1967), which she wrote with Jean Lipman.

See also **Abby Aldrich Rockefeller; Abby Aldrich Rockefeller Folk Art Museum; American Folk Art Museum; Erastus Salisbury Field; Jacob Maentel; Ammi Phillips; Pieter Vanderlyn.**

BIBLIOGRAPHY

Black, Mary. *Erastus Salisbury Field: 1805–1900.* Springfield, Mass., 1984.
Wertkin, Gerard C. "Mary Childs Black: In Memoriam." *The Clarion,* vol. 17 (summer 1992): 62–63.

GERARD C. WERTKIN

BLACK, MINNIE (1899–1996) became nationally recognized as "The Gourd Lady" for her whimsical, imaginative gourd sculptures. She was also regionally known for the Minnie Black Gourd Band, an ensemble of senior citizens that played musical instruments she made from gourds. She began making sculpture about 1960, when she grew her first crop of gourds. She later became so well-known that she made guest appearances on national television on *The Tonight Show* and the *David Letterman Show.*

Black had made sculptures from the gourds she grew until the year before her death, at age ninety-seven, and growing and cultivating the gourds actually became an integral part of her creative process. The various shapes of different gourds inspired certain forms in her creative imagination, but she also manipulated the growth of some of them. She tied one variety so that it would curl in a certain way as it continued to grow. She dug a hole in the ground beneath a long gourd hanging on the vine so that it could grow longer and remain straight. Harvested and dried, the gourds provided an eclectic selection of shapes that could be used as they were or cut out into a desired shape. Often, she joined the parts of several different gourds together to portray a wide variety of subjects, including various animals, dinosaurs, monsters, and self-portraits.

The parts of her earliest work were joined together and the cracks filled in with a modeling paste concocted from a special recipe, which she kept as her own closely guarded secret. It is thought that the recipe included flour, because many of those pieces have, over the years, attracted insects. Holes bored by the insects have appeared on the surface of many early Black sculptures. She seems to have overcome this problem with a commercial modeling medium that served as both filler and glue. Black displayed her artworks for public viewing in a store building adjacent to her home near East Bernstadt, Kentucky, which she called the "Gourd Museum." Black broke new ground with her use of gourds as an artistic medium. The bold, imaginative, and whimsical forms she created remain a testimony to her extraordinary creative drive.

See also **Musical Instruments; Sculpture, Folk.**

BIBLIOGRAPHY

Patterson, Tom. *Pictured in My Mind.* Birmingham, Ala., 1995.
Yelen, Alice Rae. *Passionate Visions of the American South.* New Orleans, La., 1993.

ADRIAN SWAIN

BLACKBURN, JOSEPH (Jonathan) (c. 1700–1778) was an eighteenth-century colonial portrait painter who introduced the rococo style of portraiture to America from Europe. He is believed to have been born in England, but details of his early life are unknown. His earliest portraits were painted in Bermuda (from 1752 to 1783), where he painted at least twenty-five likenesses of members of the Pigott, Jones, Harvey, Tucker, Gilbert, and Butterfield families. Based on the artist's skill in depicting the details of then-fashionable decorative fabrics, scholars have speculated that he may have been a drapery painter while living in England. Some of Blackburn's Bermuda portraits survive in the collections of the sitters' descendents, and likenesses of at least two members of Thomas Gilbert's family are in the collection of the Bermuda National Gallery.

Blackburn left Bermuda for New England in 1753, and spent a decade in Boston, where he became that city's leading portrait painter. A letter of introduction from a grateful Newport, Rhode Island, client to a possible Boston customer lauds "the bearor Mr. Blackburne to your favor & friendship, he is late from the Island of Bermuda a Limner by profession & is allow'd to excel in that science." During his stay in Boston, Blackburn painted several dozen portraits of members of the city's most distinguished families, including the Bowdoins, Olivers, Pitts, and Winslows.

Based on the evidence, the artist's extant portraits are of Andrew Oliver Jr. (1755), Susan Apthorp (1757), Lt. Gen. Jeffrey Amherst (1758), Gov. Benning Wentworth, and Lt. Gov. John Wentworth (both 1760). Moveover, Blackburn was mentor to John Singleton Copley (1738–1815), undoubtedly the most artistically accomplished and financially successful American colonial portraitist. Scholars credit Blackburn for his "important and lasting influence upon Copley's artistic development," and suggest that evidence of such an influence was reflected in Copley's shimmering textiles, rococo poses (loose hair, stylized features), compositions (oval bust-length format), and themes (pastoral). Copley, like Blackburn, collected imported contemporary mezzotints. As Blackburn's patronage faded, however, Copley's fame grew. Blackburn returned to England in 1763, and a handful of portraits from the last years of his life in Europe (1763 to 1778) have been identified. Blackburn is also known to have journeyed to Dublin, in 1767, where he signed and dated the *Portrait of a Young Girl Holding a Dublin Lottery Ticket.*

See also **Painting, American Folk.**

BIBLIOGRAPHY

Ackroyd, Elizabeth. "Joseph Blackburn, Limner in Portsmouth." *Historical New Hampshire,* vol. 30 (winter 1975): 231–243.

Foote, Henry Wilder, and John Hill Morgan. "An Extension of Lawrence Park's Descriptive List of the Works of Joseph Blackburn." *Proceedings of the American Antiquarian Society,* vol. 46 (April 1936): 15–81.

Miles, Ellen, and Richard H. Saunders. *American Colonial Portraits, 1770–1776.* Washington, D.C., 1987.

Oliver, Andrew. "The Elusive Mr. Blackburn." *Colonial Society of Massachusetts,* vol. 59 (1982): 379–392.

Park, Lawrence. "Joseph Blackburn: Portrait Painter." *Proceedings of the American Antiquarian Society,* vol. 322 (October 1922): 270–329.

Stevens, William B. Jr. "Joseph Blackburn and His Newport Sitters, 1754–1756." *Newport History,* vol. 40 (summer 1967): 95–107.

WILLIAM F. BROOKS JR.

BLACKMON, PROPHET WILLIAM J. (1921–) has produced art ranging from simple hand-painted signs to his environment, *Revival Center and Shoe Repair Shop,* a combination mission and business enterprise, located in Milwaukee. During his more than eighteen-year painting career, Blackmon, a self-styled preacher, has completed and sold close to six hundred works to support his ministry and help his community. His works convey religious and social messages through biblical parables and figures, in graphic settings alongside texts that add clarity and unity to the works. His visual sermons revolve around contemporary moral and social issues: crime, addiction, AIDS, and family life, which Blackmon considers essential to combat helplessness and powerlessness. In *The Best Teacher Is Jesus Say No To Drugs,* produced in 1993, Blackmon's anti-drug advice to junior and senior high school students is conveyed visually and with text, and points to both the temptation and the refusal to succumb to drugs.

Blackmon's parents, Dan and Gussie Blackmon, were part of the great African American migration northward, and settled in Albion, Michigan. Blackmon was one of twelve children, and left high school to help support his family. He worked for a brief period with the New York Central Railroad, and then at the Malleable Iron Works in Albion. During World War II, he joined the United States Army and served in the South Pacific. In the war's aftermath, he worked with a carnival in Kalamazoo, Michigan, operated a shoeshine stand in Chicago, and joined the Christian Hope Missionary Baptist Church. He left the church to become an itinerant preacher, and in 1974 opened a non-denominational, storefront revival center in Milwaukee.

Characteristic of his multi-figured painted narratives are bold patterns, strong color, text, and a flattened perspective. His compositions are asymmetrically balanced, and often built of segmented units that are rhythmically activated by figures with curving limbs. David K. Smith writes that Blackmon works on salvaged–wood boards that he cleans and repairs, sometimes attaching leather pieces, to smooth edges, and often applying a pale red undercoat. After painting a black frame, he sketches his composition in pencil, and then begins to paint with latex paint. With small brushes, he retraces the pencil outline with black paint, then fills in the shapes. Titles added in white paint and his signature fill all of the borders.

A retrospective of his paintings and signs, "Blackmon Signs of Inspiration: The Paintings of Prophet William J. Blackmon," was organized in 1999 for the Patrick and Beatrice Haggerty Museum of Art, Marquette University, Milwaukee.

See also **Painting, American Folk; Environments, Folk; Religious Folk Art.**

BIBLIOGRAPHY

Balsey, Diane. "Prophet Blackmon: Painter of Predictions." *Folk Art Messenger,* vol. 3, no. 4 (summer 1990): 1, 3.

The Bottlecap (special issue on Prophet Blackmon), vol. 2, no. 1 (summer 1999).

Hayes, Jeffrey R. "From the Home to the Projects: Affirming Community in the Art of Prophet William J. Blackmon." *Envision,* vol. 8, no. 1 (January 2003): 8–15.

Rosenak, Chuck, and Jan Rosenak. *Museum of American Folk Art Encyclopedia of Twentieth-Century Folk Art and Artists.* New York, 1990.

LEE KOGAN

BLAGDON, EMERY (1907–1986) produced approximately six hundred intricate wire and wood sculptures—some freestanding, others made to hang on a wall either chandelier-like or flatter—and eighty small paintings on wood. He never thought of himself as an artist, but rather felt that his works were part of a giant healing machine meant to cure arthritis, rheumatism, and other ailments, and that each piece had different properties. His works were created and installed in a shed next to his house, and these sculptures and paintings were the focus of his life for decades.

Local residents in his community agreed with Blagdon's claims that his assembled objects had special properties released through electromagnetic fields, and they visited his work shed for its curative properties. Blagdon believed so strongly in the curative properties of his works that he stacked his small paintings, designed with mandala-like circles, stripes, and curved and intersecting linear forms, some with echoing bands of earth colors, one on top of the other, placing the painted sides down, to create more effective magnetic fields for healing.

Born in central Nebraska, Blagdon received an elementary education, worked at farming, and then left Nebraska to explore the world. An inheritance in 1954 of 160 acres of farmland and a house brought Blagdon back to Nebraska. He took up farming again but did not like the work, so he decided to sell part of his property. The money allowed him to begin work on his "machines." Bent and twisted copper or steel wire were basic elements in his work. He set the wire in a myriad of rhythmically patterned shapes, embellished with beads, ribbon, aluminum strips, plastic, and tinfoil. Blagdon's wire constructions appeared magical as they reflected the light coming through holes in his work shed's walls. This dense assemblage of clustered works also twinkled and glowed from the illumination of tiny Christmas lights that he installed above, and from the painted light bulbs that he set out in coffee cans on the ground as well as on the planked path to his shed. Although he had no previous artistic experience, Blagdon worked consistently on his art for thirty years.

Dan Dryden, a local pharmacist, discovered Blagdon's artistic talent on a visit to his shed in 1975. Following the artist's death, in 1986, Dryden and some friends purchased Blagdon's life's work at auction, and became its curators. The artist's work has been shown in Europe and the United States.

See also **Environments, Folk; Sculpture, Folk.**

BIBLIOGRAPHY

Gergen, Kenneth J. "Emery Blagdon." in *Self-Taught Artists of the Twentieth Century: An American Anthology.* edited by Elsa Longhauser, et al. New York: Museum of American Folk Art, 1998.

LEE KOGAN

BLAYNEY, WILLIAM ALVIN (1917–1986) originally worked as an automobile mechanic, but eventually became a Pentecostal preacher with a roadside ministry in Oklahoma. He used his complex, message-laden paintings to illustrate his interpretations of biblical prophecy. The imagery of the Book of Revelation has been a fruitful source of inspiration for American folk artists since the early nineteenth century, but Blayney's apocalyptic compositions stand out for the sense of drama and urgency that he brings to them.

Beginning in the mid-1950s, Blayney was drawn deeply into evangelical Christianity, through an intense study of the Bible as well as the ministry of Kathryn Kuhlman (1907–1976), perhaps the most widely known radio preacher of the day. Blayney attended her meetings in Pittsburgh, Kuhlman's headquarters from 1948 to 1965. By 1957, Blayney had begun to paint, taking his subjects almost exclusively from biblical narrative, especially the Book of Revelation. His first composition, *Moses Holding the Tablets,* depicts the lawgiver descending from Mount Sinai. The artist used oil paints on canvas or Masonite, occasionally creating a relief effect by mixing sand into the paint. His compositions generally include written inscriptions, and he often quoted or paraphrased biblical texts.

In 1966, Blayney moved from Pittsburgh to Thomas, Oklahoma, where he became associated actively with Pentecostalism. As some of his most ambitious works reveal, he accepted the ideas of dispensationalism, an interpretive approach to the Bible that divides human history into successive ages or dispensations. It relates specific historic events to biblical prophecies: the course of ancient empires, the waging of great wars, and the occurrence of exceptional natural phenomena. Dispensationalism also emphasizes the imminence of the Second Coming of Christ and the dawning of the millennium. Blayney addressed these themes in many of his compositions. Ironically, the artist, who preached an end-time message, was obsessively concerned with protecting the rights to his paintings. Several of his major works are replete with repeated trademark and copyright notices and other reservations of rights.

Although the most impressive of Blayney's paintings are crowded with strong, colorful images and lengthy texts, they are exceedingly well composed,

emphasizing the theatrical quality of the Book of Revelation's visionary themes. Blayney effectively captured the catastrophic flow of the biblical narrative in such works as *The Double-sided Christ* and *Reign of the Gentile Kingdoms/The Sealed Book of the Revelation of Jesus Christ,* and *Church and State/Spiritual Powers of the Nation,* two of his most successful works, and fitting complements to his doomsday preaching. In using his paintings to help his audience understand his interpretation of the complicated endtime chronology of the Book of Revelation and other apocalyptic texts, Blayney joined a tradition with deep roots in American religious history.

See also **Religious Folk Art.**

BIBLIOGRAPHY
Curry, Marshall. "William A. Blayney," in *Self-Taught Artists of the Twentieth Century: An American Anthology,* edited by Elsa Longhauser, et al. New York: Museum of American Folk Art, 1998.
Owsley, David T. "William A. Blayney/Self-Taught Pittsburgh Painter." *Carnegie Magazine,* vol. 54 (March 1980): 4–9.

GERARD C. WERTKIN

BLINN, HENRY CLAY (1824–1905), one of the most influential Shaker leaders of his generation, was skilled in many pursuits. Born in Providence, Rhode Island, where he was apprenticed to a jeweler, he entered the community at Canterbury, New Hampshire, in 1838. In addition to presiding as an elder for most of the second half of the nineteenth century, he served at various times as a printer and typesetter; publisher and editor of *The Manifesto,* the Shaker Society's monthly journal; author; schoolteacher; chronicler of community history; beekeeper; dentist; tailor; maker and repairer of tinware; cabinetmaker; and mapmaker. Although only three maps of Shaker villages may be attributed to him (one each for Canterbury; Watervliet, New York; and New Lebanon, New York) they are among the most important examples of the genre.

Robert P. Emlen has demonstrated that the making of illustrated maps was a characteristic feature of Shaker life in the nineteenth century. Intended as detailed records of the built and natural environments, these village views or plans often include other valuable information about the communities, as Shaker mapmakers typically shared their methods with one another. David Austin Buckingham (1803–1885) of Watervliet, creator of a meticulous view of his own community, may have influenced Blinn's approach to cartography. In the hands of skillful draftsmen like Blinn, Buckingham, or Joshua Bussell (1816–1900) of Alfred, Maine, the maps transcended their purpose as utilitarian documents and became works of art. This is especially true when the mapmaker introduces watercolor, to animate the depictions of buildings, trees, and flowering plants, as Blinn does in two of his three drawings. According to Emlen, Blinn's 1848 map of Canterbury, which is almost seven feet in length, is the largest and most elaborate of all Shaker village views. With captions in a variety of ornamental lettering, as well as stylized representations of orchards, gardens, and other dramatic and colorful flourishes, the map presents a complete picture of a large community at the height of its development.

Of Blinn's efforts as a cabinetmaker several pieces survive, including a handsome sewing desk, dating about 1870, of butternut and contrasting woods, porcelain knobs, and an inscription documenting Blinn as the maker. He is also credited with making a dining table, a slant-front desk, a large secretary, and a number of other pieces. Blinn's cabinetry belongs to the later period in Shaker furniture production, when an interest in ornamentation resulted in a loss of the spare simplicity characterizing the earlier work.

See also **Joshua Bussell; Cora Helena Sarle; Shaker Furniture; Shakers.**

BIBLIOGRAPHY
Emlen, Robert P. *Shaker Village Views: Illustrated Maps and Landscape Drawings by Shaker Artists of the Nineteenth Century.* Hanover, N.H., 1987.
In Memoriam, Elder Henry C. Blinn, 1824–1905. Concord, N.H., 1905
Rieman, Timothy D., and Jean M. Burks. *The Complete Book of Shaker Furniture.* New York, 1993.

GERARD C. WERTKIN

BLIZZARD, GEORGIA (1919–2002) was a sculptor of clay who came from an American family with roots in three diverse cultures: Apache, Irish, and Appalachian. When Blizzard was a child, she was taught traditional Native American firing techniques by her father. She made clay toys with one of her sisters, Lucy May, and "fired" them in the sun. As young women, the two sisters made fake Native American relics, such as pots and pipes, and sold them as authentic items. Returning to ceramic making as an adult, Blizzard created a wide array of non-utilitarian sculptural vessels. Using both a coal kiln for colorful surfaces and an electric kiln to prevent breakage, the artist continued to retrieve her clay from the creek behind her home. Her vessels were typically nonfunctional, even if created in the form of a vase or a pitcher; in Blizzard's hand a pitcher became a crouching woman or a reclining man. A respect for nature and God as well as a "can-do" approach to living consumed Blizzard's life and art.

Born in Statesville, Virginia, Blizzard attended public school through the eighth grade, married at the age of twenty-one, and was widowed fourteen years later. The artist worked in a factory and textile plant before turning to ceramics full-time. Her daughter, Mary, opened a shop, providing an opportunity for the artist to share her clay sculpture with the public. Throughout her life, Blizzard witnessed her experimental approach to clay become a vital source of economic support, which created a sense of purpose for the artist.

See also **Native American Folk Art; Pottery, Folk; Sculpture, Folk.**

BIBLIOGRAPHY

Hill-Burwell, Debra. "Georgia Blizzard: Virginia's Visionary Vessel Marker." *Voices,* vol. 4 (1995).
Williams, Jonathan. *Georgia Blizzard: Cleansing Vessels.* Winston-Salem, N.C., 1996.

BROOKE DAVIS ANDERSON

BLUNT, JOHN S. (1798–1835) was a nineteenth-century painter with patrons in New England, many living near Portsmouth, New Hampshire, and Boston, where he lived. He painted portraits including some miniatures, but he also extended his subjects to land-scapes, seascapes, ship portraits, and genre scenes. In newspaper notices, Blunt advertised that he could paint oil portraits on canvas, work on glass, paint signs, do ornamental enameling, gilding, and bronzing, and make military standards. He was proficient not only in oils but also in watercolor and with crayons or pastels. Through his ads, which appeared between 1819 and 1828 in the *New Hampshire Patriot* and the *New Hampshire Gazette,* he solicited commissions for portraits, advertised an exhibition of his paintings, and sought young lady "scholars" for his drawing and painting school. His detailed ledger indicates that he was frequently hired by Masonic groups, for whom he made aprons, sashes, and military standards.

Characteristic of Blunt's portraits is naturalism in facial features, flesh tones, and hair. A portrait of a youngster, *Frances A. Motley,* shows the sweet, expressive face of a child, with saturated color in the child's clothing, and an emphasis on details such as stylized pleats, folds, puffed sleeves in the clothing, and a coral necklace. The portrait includes such items as a sewing basket with spools of thread, scissors, and cloth; and a table on which is a tasseled blue reticule, a vase of flowers, and a card bearing the name

Portraits of Mrs. and Mr. Wood; John S. Blunt; c. 1798–1835. Oil on mattress ticking. 33½ × 28¼ inches. The Bertram K. Little and Nina Fletcher Little Collection auction at Sotheby's 6612, October 21 and 22, 1994.
Photo courtesy Sotheby's, New York.

"*Frances A. Motley,*" the same identifying device Blunt had used in a portrait of a gentleman painted about 1830. Women are fashionably dressed and elegantly coifed in elaborate period hairdos, some wearing gauzy lace caps or tortoiseshell combs, and are wearing brooches, necklaces, earrings, and rings. Blunt sometimes placed his figures near open windows against the backdrop of a stylized landscape of celery-colored trees. In the pendant portraits of Mr. and Mrs. Wood, Blunt's meticulous rendering of the couple's stoic, somewhat severe countenances and crisp detailing of Mrs. Blunt's lace-embellished cap, for instance, contrast with the summary sketch of the outdoor vista.

The attribution by museum director Robert Bishop (1938–1991) of a number of unsigned portraits to John S. Blunt, previously identified as the "Borden Limner," link these portraits to a group of signed landscapes, marine paintings, and genre works.

Blunt may have descended from an Englishman who settled in Andover, Massachusetts, in 1634. In the 1821 Portsmouth directory, Blunt was listed as an "Ornamental and Portrait Painter married to Edith P. Colby." His painting of *Lake Winnipiseogee* was exhibited at the Boston Atheneum in 1829. In 1831, Blunt moved to Boston, where he purchased a house, on Castle Street, and opened a studio, on Cornhill Street. Blunt died aboard the vessel *Ohio,* while traveling from New Orleans to Boston.

See also **Robert Bishop; Fraternal Organizations; Freemasonry; Maritime Folk Art; Miniatures; Painting, Landscape; Trade Signs.**

BIBLIOGRAPHY

Bishop, Robert. *The Borden Limner and His Contemporaries.* Ann Arbor, Mich., 1976.

———. "John Blunt: The Man, the Artist, and His Times." *The Clarion* (spring 1980): 20–39.

Lee Kogan

BOARD SIGNS: *SEE* TRADE SIGNS.

BOGUN, MACEPTAW (1917–), whose first name is actually Miecieslaw, was first inspired to paint in 1967, when he saw an art exhibition, sponsored by the New York City Transit Authority, in Brooklyn. Unimpressed by the abstract paintings he saw, he thought he "could do better." A religious man, he asked for guidance from God and the angels. The impulse to paint led him to buy brushes, oil paint, linseed oil, charcoal, and canvas, and he started to paint in his free time. Employed by the transit author-

ity, Bogun had his work shown in one of the authority's exhibitions in the early 1970s, and was subsequently discovered by collector Herbert W. Hemphill Jr. (1929–1998). Hemphill asked to borrow two of Bogun's paintings, *Sail On, Old Ironsides* (1970) and *Chaplain* (1972), for an exhibition of twentieth-century folk artists at the Museum of American Folk Art in New York.

Bogun painted more than a dozen landscapes and portraits, using photographs, prints, and his imagination. He worked only when the spirit moved him, and stopped painting, in 1986, because his "walls were full." In a signed self-portrait from 1972, he depicted himself in a frontal pose, close to the picture plane. The dark-haired, dark-eyed figure with a mustache wears a black clerical robe, softened with a colorful tie and a wide embroidered satin stole. Seated against an altar adorned with a white lace cloth, candles, and flowers, his kindly expression and clasped hands inspire confidence. Bogun was a spiritualist, and in 1951 was ordained a minister at the Temple of Light Church in New York City. He reads the Bible and meditates every night, and wants his paintings to be looked at as spiritual art.

See also **American Folk Art Museum; Herbert W. Hemphill Jr.; Painting, Landscape; Religious Folk Art; Visionary Art.**

BIBLIOGRAPHY

Hemphill, Herbert W. Jr., and Julia Weissman. *Twentieth-Century American Folk Art and Artists.* New York, 1974.

Lee Kogan

BOLDEN, HAWKINS (1914–) has had a lifelong facility for making things by hand from scavenged materials. He and a twin brother were born in the Bailey's Bottom section of Memphis. When Bolden was seven, he was struck in the head with a bat while playing baseball. This accident was probably responsible for the seizures he began to suffer soon afterward, as well as for the blindness with which he was suddenly stricken about one year later. He has never regained his eyesight.

When he was about sixteen years old, Bolden's family moved into a small house in Memphis, which he has continued to occupy. In his early fifties, despite his blindness, he began to use his skills to make mask-like faces by puncturing and altering cast–off metal or plastic, and also created other, often anthropomorphic, assemblage pieces. Gathering broken furniture, carpet scraps, discarded kitchenware, old clothing, and other throwaways that he comes across

while making the rounds of his neighborhood, Bolden has used these objects to construct the scarecrows, guardian figures, abstract assemblages, and wind–activated, noisemaking devices that he originally made to display in his yard, alongside the border of a vegetable garden. Bolden's reliance on found materials to produce his art is something he shares with other artists working in low-income communities throughout the world.

See also **African American Folk Art (Vernacular Art); Environments, Folk; Sculpture, Folk; Whirligigs; Yard Show.**

BIBLIOGRAPHY

Arnett, Paul, and William Paul Arnett, eds. *Souls Grown Deep: African-American Vernacular Art of the South,* vol. 2. Atlanta, Ga., 2001.

McWillie, Judith, et al. *Another Face of the Diamond: Pathways Through the Black Atlantic South.* New York, 1989.

Patterson, Tom. *Ashe: Improvisation and Recycling in African-American Visionary Art.* Winston-Salem, N.C., 1993.

Sims, Lowery S., et al. *Next Generation: Southern Black Aesthetic.* Winston-Salem, N.C., 1990.

TOM PATTERSON

BOND, MILTON WALLACE (1918–) is a prolific Connecticut artist who uses the medium of reverse painting on glass to produce pictures of sailing and steamships, historical battle scenes, and city views, featuring New York's Empire State and Chrysler Buildings, Rockefeller Center, and the George Washington and Brooklyn Bridges.

When Bond retired from his job as a tool grinder at the Remington Arms Co. in Bridgeport, Connecticut, in 1968, his sister taught him the technique of reverse painting on glass. Bond's paintings vary in size, from one-inch square to thirty by forty inches. He paints on clear glass with a number of different types of paint as well as India ink. He prepares a detailed drawing, places it under the glass, and traces it. Then he paints on the reverse side of the glass, first the details, then the background. Occasionally, he fixes tinfoil or metallic paper to the back of the painting, which adds a glow to the unpainted areas. Bond has completed more than 1,500 paintings.

Sources for Bond's compositions come from old prints and photographs. His interest in the sea relates to his heritage. In the 1500s the artist's ancestor, Sir William Bond, owned a shipyard and built a flagship for the English king Henry VIII. Prior to his job as a tool grinder, Bond worked with his father as a commercial fisherman, operating a forty-foot oyster boat called the *Dorothy G.* His father's death in 1950 ended Bond's career at sea.

Bond was awarded a silver medal in 1983, a bronze medal in 1984, and a gold medal in 1992 at the Swiss International Folk Art Exhibition in Morges, Switzerland, for artistic excellence. He was celebrated by the city of Bridgeport and given a one-man exhibition in 1996.

See also **Reverse-Glass Painting.**

BIBLIOGRAPHY

Johnson, Jay, and William Ketchum. *American Folk Art of the Twentieth Century.* New York, 1983.

Rosenak, Chuck, and Jan Rosenak. *Museum of American Folk Art Encyclopedia of Twentieth-Century American Folk Art and Artists.* New York, 1990.

LEE KOGAN

BORDER LIMNER: *SEE* AMMI PHILLIPS.

BORKOWSKI, MARY (1916–) uses thread to make pictorial narratives that she calls thread paintings. She says they "are expressions of awful truths and deep emotional experiences of self, of others, and God's creations." Many of these works relate to current events, as well as incidents in her life. Her superb craftsmanship belies the dark subject matter of some of her work. Objects and figures are often presented in undefined, spatial settings, lending both emphasis and ambiguity to the subjects. Borkowski is also a master quilter and paints as well, using acrylics on Masonite and canvas.

Borkowski was born in Sulfur Lick Springs, near Chillicothe, Ohio, and graduated from Stiver High School in Dayton. She learned to sew and quilt from her mother and grandmother, and distinguished herself for many years at the Ohio State Fair, beginning with a grand-prize-winning quilt, *Poinsettia* (1952). Over the years she won additional prizes at the fair, and sold some of her original quilt patterns to *McCall's* and *Needlecraft* magazines, and her designs also appeared in the *Quilter's Newsletter.*

Borkowski's thread technique is precise, and she uses silk thread on a silk, velvet, felt, or cotton ground. She does not view her thread paintings as embroideries, as she makes no attempt to use thread as decoration, embellishment, or ornament. She uses satin stitch to build her pictorial narratives, and each picture takes several months to complete.

Crash (1968) is an autobiographical work in which Borkowski, in a small auto, passes the bank that rejected her loan to buy property. An unfriendly sign, indicating that the bank is closed, hangs on a shade on the front door; a disembodied arm pulls down the shade. In a semi-autobiographical work, *The Slap*

(1974), male and female nude figures cavort in a house interior, with a man in dark, horn-rimmed glasses lustfully winking from behind a door. In *The Unhappy Hooker* (1975), a svelte blonde, nude but for red panties, sees herself in a mirror as a hideous Medusa, toothless, with dark circles under her eyes. Despite these works that display the dark side of human behavior and experience, there are lighter moments in Borkowski's work as well. In *The President's Decision* (1981), she illustrates American president Ronald Reagan's decision to give up smoking, substituting jellybeans in place of cigarettes. *Moonlight Romance* (1994) features her dog and a neighbor's tenderly gazing at each other in front of a fence against a moonlit sky. Borkowski has had several one-person exhibitions at the Dayton Art Center (1968) and at Sinclair College, also in Dayton (1999). In 2003 she was nominated for an Ohio Folk Art Heritage Award.

See also **Painting, American Folk; Pictures, Needlework; Quilts; Samplers, Needlework.**

BIBLIOGRAPHY

Akron Art Institute. *Six Naives: Ashby, Borkowski, Fassanella, Nathaniel, Palladino, Tolson.* Akron, Ohio, 1974.

Borkowski, Mary. *Pets in My Life.* Dayton, Ohio, 2002.

Cole, Kevin, and Barbara Cole. *Self-Taught and Made in Ohio.* Columbus, Ohio, 1999.

Hemphill, Herbert Jr., and Julia Weissman. *Twentieth-Century American Folk Art and Artists.* New York, 1974.

Johnson, Jay, and William C. Ketchum Jr. *American Folk Art of the Twentieth Century.* New York, 1983.

Rosenak, Chuck, and Jan Rosenak. *Museum of American Folk Art Encyclopedia of American Folk Art and Artists.* New York, 1990.

LEE KOGAN

BOTTLE CAP ART, a by-product of the age of disposable products, is an expressive medium for craftsmen, hobbyists, and self-taught as well as trained artists. The colorful surfaces of bottle caps make them appealing objects to collect and save because of their attractiveness. The "crown" cap, made of tin with crimped edges, is both readily available and adaptable as a material for making art.

The bottle cap lined with cork was invented in 1891 and patented in 1892, and first used by the American Brewing Company in Baltimore. Beer and soda companies used crown caps extensively until the mid- to late 1960s, when aluminum pull-tabs and metal or plastic screw tops began to replace them.

Objects made from or decorated with bottle caps, such as baskets, chairs or thrones, clothing, mirrors, toys, and vases, can be both utilitarian and decorative. Bottle caps also can be used as rhythmic, percussive vehicles for making sounds, for handmade musical instruments. Two methods of application are common in bottle cap art. Most often, the cap is kept in its crimp-edged form, but it can be hammered flat as well. Nailing caps to a surface transforms the surface into a display of colorful patterns. Punching a hole in the center of the caps and stringing them on a wire to form a "necklace," to use by itself or to wrap around surfaces, gives dimension to the form. Some artists use a combination of the two techniques.

The most ubiquitous bottle cap forms were figures approximately twelve inches high, with strung bottle cap arms and legs, which were identified beginning in the 1940s but were most popular from the late 1950s through the 1970s. The figures often held ashtrays or candy dishes in their arms, with another balanced on their head. The source for these figures is not known, but they may have originated in a hobby magazine as a simple and popular craft, or they may have been marketed as craft kits. Some have been found with "Junior Achievement" stickers pasted on them. According to collectors Bill Swislow (1956–) and Michael Hall, bottle cap forms can often be regionally identified. Serving figures, for example, with a prominent mouth and teeth along with white shirts and bow ties under a jacket, measuring up to twenty inches in height, were probably made in Wisconsin.

Bottle cap baskets and vases resonate with traditional folk art forms. About 1950 Bertha Engele, a seamstress from southern Illinois, used the stringing technique to fashion very large baskets and vases. Ron Rodriquez (1968–), grandson of the artist Felipe Benito Archuleta (1910–1990), used the same technique to render his figures of snakes, while also adding wood, plastic, and paint.

Gregory Warmack (1948–) who calls himself Mr. Imagination, was inspired to use bottle caps as signature elements to make his spiritually charged thrones and staffs, as well as unique clothing (vests, hats, ties) after seeing the anonymous serving figures mentioned previously. In 1971, Clarence and Grace Woolsey (d. 1992), Iowa farm workers, displayed four hundred objects they created, along with many bottle cap figures, arranged in a sculptural environment they called *Caparena,* in Lincoln, Iowa.

An ambitious use of bottle caps was displayed at the North Miami Bottlecap Inn in Florida. During the 1930s the owner of this restaurant and bar, Joe Wiser, varnished and then nailed hundreds of thousands of bottle caps to furniture and other surfaces around his property. Trained artist Richard Ladd (1958–) from Brooklyn uses bottle caps to embellish furniture and home furnishings.

An exhibition, "Crimped and Cutting Edge in Bottle Cap Sculpture," was staged in Chicago at Intuit, the Center for Intuitive and Outsider Folk Art, in 1994. Bottle cap art continues to be practiced around the world, not only by American artists but also in Canada, Mexico, and Kenya.

See also **Intuit: the Center for Intuitive and Outsider Art Folk Art; Musical Instruments; Sculpture, Folk; Toys, Folk; Gregory Warmack.**

BIBLIOGRAPHY

Czerny, Charlene, and Suzanne Sherif. *Recycled, Re-Seen: Folk Art from the Global Scrap Heap.* New York, 1996.

Hartigan, Linda. *Made with Passion: The Hemphill Folk Art Collection in the National Museum of American Art.* Washington, D.C., 1990

Museum of American Folk Art. *Ape to Zebra: A Menagerie of New Mexican Woodcarvings: The Animal Carving Collection of the Museum of American Folk Art.* New York, 1986.

Swislow, William. "Unsealing the Art of Bottle Cap Sculpture." *Intuit,* vol. 3, no. 1 (summer 1994): 10–13.

LEE KOGAN

BOWMAN, WILLIAM H. (1824–1906), a wildfowl decoy carver and permanent resident of Maine, is known nonetheless as the most recognized of all Long Island decoy carvers. Bowman's biographical details are few, but among those established are his annual summer visits to the beaches in the area of Lawrence, Long Island, New York, where he fashioned decoys and gunned shorebirds. Oral histories and Maine documentation suggest that he worked in a sawmill in Bangor, Maine, and/or was a cabinetmaker there. He has been characterized as a "friendly, lazy hermit" who enjoyed "lifting the cup" and carving, a "true artist making decoys, rather than just a decoy maker that has an artistic bent."

Based on his extant wildfowl decoys, he flourished in the period from 1890 to 1900, before restrictions were imposed on shorebird hunting. His shorebirds include ruddy turnstones, black-breasted plovers, long-billed curlews, nestled lesser yellowlegs, Hudsonian curlews, and Dowitchers. Superior body shaping and plumage painting are Bowman's more appreciated decoy characteristics. Very few of his shorebird decoys show vibrant colors; rather, he daubed blacks and whites over white-to-tan bodies to indicate plumage patterns. To obtain a more realistic appearance, he used imported German glass for the eyes in his decoys. Another salient Bowman signature is Dowitcher wings, extended from the body, and separate both from each other and from the tail.

Bowman's duck and goose decoys are carved with rounded chests, arched backs, low-set tails, and flattened bottoms. The necks of his ducks are inletted or inserted, which is typical of Maine decoys. Bowman's carvings also often incorporated both Maine and Long Island characteristics. For example, most Maine decoys lacked carving and painting details, while his Long Island shorebirds were oversized with more complex relief carving. Decoy historian Robert Shaw notes that Bowman "captured his subject's faces and bodies more precisely than any other shorebird carver."

See also **Decoys, Wildfowl.**

BIBLIOGRAPHY

Mackey, William J. Jr. "Bill Bowman's Decoys." *Decoy Collectors Guide,* vol. 4 (1966–1967): 18–22.

Bishop, Robert Charles. *American Folk Art: Expressions of a New Spirit.* New York, 1983.

Brill, Mama K. *Wood Sculpture of New York State.* New York, 1975.

Colio, Quintana. *American Decoys: Ducks, Eiders, Scoters, Geese, Brant, Swans . . . and Other Unusual Decoys from 1865–1928.* Ephrata, Pa., 1972.

Headley, Somers G., and John M. Levinson. *Shorebirds: The Birds, the Hunters, the Decoys.* Centreville, Md., 1991.

Kangas, Gene, and Linda Kangas. *Decoys: A North American Survey.* Spanish Fork, Utah, 1983.

Kehoe, William David S. *Decoys at the Shelburne Museum.* Shelburne, Vt., 1961.

WILLIAM F. BROOKS JR.

BOXES, small containers with hinged, sliding, or detachable lids, are one of the most visible records of America's decorative folk art traditions and craftsmanship. Designed to protect and store personal property and household objects, boxes are cultural artifacts, many of their original uses now obsolete. Admired and collected for their exterior decoration, diminutive size, unique shape, complex interiors, or fine state of preservation, boxes vary widely in size, shape, material, finish, and design.

Handcrafted or later factory-made boxes were constructed of oak, maple, poplar, pine, and tiger maple, and less frequently of exotic woods, horn, whale ivory, or whale skeletal bone (scrimshaw), tortoiseshell, birch bark, cardboard, papier mâché, silver, and copper. The surface decoration of boxes presents both a rich vocabulary of traditional cabinetmaking skills (carving, incising, hand painting, and inlays of exotic woods, tortoiseshell, brass, and mother-of-pearl) and decorative craft techniques using leather, moose hair, embroidery yarns, shells, pine needles,

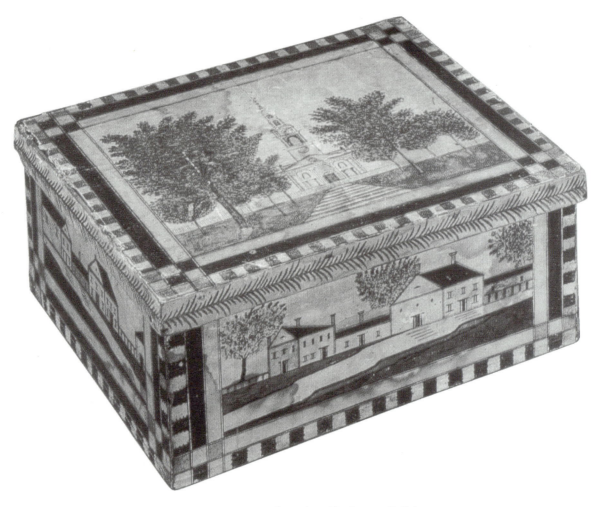

Toilet Box; Attributed to Daniel Eva; c. 1850. Paper covered pine box. The Bertram K. Little and Nina Fletcher Little Collection auction at Sotheby's 6526, January 29, 1994. Photo courtesy Sotheby's, New York.

watercolors, wallpaper, trompe l'oeil devices, imaginative graining, and stenciling as embellishment.

As small furnishings, boxes follow America's prevailing furniture and decorative arts styles. The earliest documented pieces of seventeenth-century New England furniture, for example, are small oak boxes decorated with low-relief carved flowers and simple geometric patterns. Other early boxes include domed-top document boxes with locks for valuables, and portable desk boxes with slanted writing surfaces and departmentalized interiors for writing implements. Paint-decorated boxes of the same period include saltboxes, customarily hung near the fireplace to keep the contents dry, and long, rectangular, wooden candle boxes with sliding lids for storing tallow candles, to prevent discoloration and cracking.

Eighteenth-century painted and decorated boxes from Pennsylvania display a variety of different conventionalized motifs derived from combinations of designs drawn from the folk art traditions of emigrants from the Rhine Valley as well as the Palatinate in Germany, Alsace-Lorraine in France, and the German-speaking cantons of Switzerland. In both form and decoration, these boxes often mimic the regional characteristics of painted and decorated blanket chests, case furniture, and fraktur. The *Schmuckkästchen* (small, decorative gift boxes made to hold textile accessories) from Lancaster County, for example, are inscribed with a compass in the shape of pinwheels, floral and vine motifs, and outlined in white on blue, green, or red backgrounds, echoing the decoration on Lancaster blanket chests. Other

paint-decorated Pennsylvania German boxes include those of "turned," or barrel, construction with inset lids, designed for storing tobacco and spices, and boxes of bentwood construction, with the sides and edge of the lid overlapped and feathered, glued, and stapled, for storing ribbons.

Unique to the Federal era (1790–1825) are satinwood or bird's-eye maple trinket boxes, which were decorated in watercolors by young women attending the female seminaries and academies along the American East Coast. These boxes display the decorative vocabulary of the period: polychrome or monochrome romantic landscapes with castellated ruins, arched bridges, sunlit seascapes, and thatched cottages, as well as delicate bouquets, single roses, clusters of shells, scrolling vines, trophies of music, and cornucopia overflowing with fruits and nuts.

Beginning in the 1790s, Shaker communities fashioned lidded oval and round boxes, often in graduated sets, drawing on another period aesthetic—that of simplicity, form, harmony, and order. Using thin strips of maple that were soaked in hot water and steamed, these boxes were shaped around a wooden mold and secured with characteristic swallowtail joints. Most were stained in the rich colors of Shaker interiors and furniture: red, yellow, blue-green, and green. In contrast to the single-color decoration of Shaker boxes are a host of lavish paint-decorated boxes, produced between 1810 and 1840. These boxes display creative and exuberant faux graining and marbleizing, stenciling, and bronze-powder stenciling—scaled down versions of what embellished the flat surfaces of cupboards, blanket chests, and dressers of the same period.

Originally designed as small boxes for men's shirt collars and hats, bandboxes gained popularity in the 1820s as lightweight luggage for stagecoach rides, and trips aboard steamboats, canal boats, and trains. They were constructed of pasteboard or thinly sliced wood and covered on the outside with imported block-printed wallpapers. Those produced by Hannah Davis (1787–1863) were also lined on the interior with newspapers and identified with her Jaffrey, New Hampshire, factory label.

A paper-covered pine toilet box, attributed to Daniel Eva and probably crafted around 1850, features bold checkered trim framing delicately rendered landscape scenes. Toilet boxes were commonly used by gentlemen travelers for carrying toiletries.

While many of the ornamental painters and decorators of boxes remain anonymous, several artisans have been identified. These include Rufus Porter (1792–1884), whose ornamentation is characterized by two-dimensional landscapes and trees in red and ochres on a cream background; Jacob Weber (1802–?), a Lancaster, Pennsylvania, painter whose distinctive boxes feature a single two- or three-bay house flanked by a pair of manicured trees set on a lawn painted in thin washes of greens and brown on backgrounds of blue-green, light blue, light green, or yellow; and George Robert Lawton (1813–1885), a Providence County, Rhode Island, ornamenter whose simply constructed rectangular boxes with conforming leather-hinged tops depict an all-over pattern of incised and painted hearts, checkerboards, or other geometric motifs, in brilliant and contrasting reds, browns, and blues on white backgrounds.

See also **Decoration; Fraktur; Furniture, Painted and Decorated; Maritime Folk Art; Pennsylvania German Folk Art; Rufus Porter; Shakers.**

BIBLIOGRAPHY

Garvan, Beatrice B. *The Pennsylvania German Collection*. Philadelphia, 1982.

Hollander, Stacy C. *American Radiance: The Ralph Esmerian Gift to the American Folk Art Museum*. New York, 2000.

Little, Nina Fletcher. *Neat and Tidy: Boxes and Their Contents Used in Early American Households*. New York, 1980.

Ross, Pat. *To Have and To Hold: Decorative American Boxes*. New York, 1991.

Schaffner, Cynthia, and Susan Klein. *Folk Hearts: A Celebration of the Heart Motif in American Folk Art*. New York, 1984.

The Henry Francis du Pont Winterthur Museum. *A Place for Everything: Chests and Boxes in Early Colonial America*. Winterthur, Del., 1986.

Cynthia Van Allen Schaffner

BOYD, E. (1903–1974) was the foremost scholar of Hispanic folk art in New Mexico in the mid-twentieth century. Born in Philadelphia as Elizabeth Boyd White, she adopted the professional name of E. Boyd to disguise her sex because of the lack of respect given to female scholars at the time. Boyd attended the Pennsylvania Academy of Fine Arts for four years, and spent two years studying art in Europe before moving to Santa Fe, in 1929, where she became a member of a group of modernists, the Rio Grande Painters. In 1936 she began work under the Works Progress Administration's (WPA) Federal Art Project as a researcher and watercolorist for the *Portfolio of Spanish Colonial Design* (1937), a precursor of the national *Index of American Design,* an ambitious WPA project to record American folk arts and crafts. Through this experience she realized how little was known about Hispanic arts of New Mexico, and she dedicated the rest of her life to their study. In the late 1940s she became registrar at the Los Angeles County

Museum, and in 1951 was appointed curator of the Spanish Colonial collection at the Museum of New Mexico, a position she held for the rest of her life.

Boyd's research followed the pioneering but unsystematic efforts of writer Mary Austin and artist Frank Applegate, who in 1926 had founded the Spanish Colonial Arts Society in Santa Fe; both were avid collectors and promoters of Hispanic folk arts. While Boyd was interested in all the Hispanic arts, her most important contributions were in the study of New Mexican *santos* (carved and painted figures of saints). In the 1940s Boyd and a few other scholars, such as Mitchell Wilder and William S. Stallings, did the first serious research and writing on the subject of *santos*, identifying many of the eighteenth- and nineteenth-century artists as well as dating their work. Much of Boyd's work was based on field research; she made numerous trips to isolated Hispanic villages and interviewed descendants of the artists and others knowledgeable about the folk art traditions. She also was a self-taught conservator and was responsible for the preservation of several important altar screens in village churches. Her major work, *Popular Arts of Spanish New Mexico,* was published posthumously in 1974, and it remains a valuable source today. Scholars are greatly indebted to E. Boyd for establishing the basic outline of the field of Hispanic New Mexican folk arts, and for providing much valuable field data that otherwise would have been lost.

See also **Bultos; Retablos; Santeros.**

BIBLIOGRAPHY

Boyd, E. *Popular Arts of Spanish New Mexico.* Santa Fe, N. Mex., 1974.

Weigle, Marta, ed. *Hispanic Arts and Ethnohistory in the Southwest: New Papers Inspired by the Work of E. Boyd.* Santa Fe, N. Mex., 1983.

WILLIAM WROTH

BRADLEY, JOHN (active 1831–1847) was one of a handful of folk portrait painters known to have earned a livelihood during the second quarter of the nineteenth century in New York City. The belief that the folk portrait aesthetic appealed only to those who lived in rural, isolated areas is refuted by Bradley's apparent success as a painter in New York City, Staten Island, and possibly New Jersey.

One of Bradley's portraits is inscribed "*I. Bradley. / From Great Britton.*" Although unconfirmed, Bradley may have been the person of that name who arrived in New York from Ireland in 1826. He was listed in New York City directories as a "portrait painter," living at 56 Hammersley Street in 1836, 128 Spring Street from 1837 to 1843, and at 134 Spring Street from 1844 to 1847. In 1832 Bradley made the first of several painting trips to Staten Island. The following year, three weeks before he completed one of five portraits of members of a Staten Island family, a "John Bradley," residing at a home for retired seamen, was declared "deranged." The artist may have used visits to his namesake to secure commissions on Staten Island.

Bradley's earliest known works were probably painted in Britain. Portraits of a boy feeding rabbits and an unidentified woman, dated 1831, as well as a portrait of a cellist painted the following year, use full-length poses on canvases that are smaller than those he used in the United States, and include more accoutrements than his American works. In the United States Bradley painted adults half-length and often posed seated in painted chairs, a swag of red drapery ornamented with gold tassels clipping an upper corner of the canvas. Sitters hold newspapers, books, and, in two male portraits, lighted cigars.

Children's portraits are arguably Bradley's most appealing works. He painted them standing on colorful carpets or sitting on sofas, with toys held by or scattered at the feet of young children. Bradley's style displays hard-edged drawing, a rich palette of reds, greens, blues, and yellows, and carefully observed details. Faces, bare arms, and shoulders are outlined in white, separating the figures from their brown backgrounds, but also flattening the figures. Bradley painted a pair of husband and wife portraits in oil and distemper, a mixture of dry pigment and water with glue or oil added as a binder. Distemper was used for wall painting and poster painting, indicating that Bradley may have done decorative and commercial painting in addition to portraits.

See also **Painting, American Folk.**

BIBLIOGRAPHY

Chotner, Deborah, et al. *American Naive Paintings.* Washington, D.C., 1992.

Rumford, Beatrix T., ed. *American Folk Portraits: Paintings and Drawings from the Abby Aldrich Rockefeller Folk Art Center.* Boston, 1981.

RICHARD MILLER

BRANCHARD, EMILE (1881–1938) painted dramatic landscapes with trees as centerpieces. According to his wife, Bonnie, Branchard "loved to paint trees, snow, and sky, but humans did not interest him; he did not find them beautiful." The trees that Branchard painted were indeed beautiful, their undulating trunks often mimicking the shapes of dancers. In *The Struggle,* two interlocking, leafless trees engage in an

almost intimate interaction. In *Winter Night,* a forest of dark tree trunks is set against a white, snowy foreground and still darker sky. The earth and sky do not compete with Branchard's mysterious trees. Some of his unpopulated paintings give off a sense of loneliness. In *Farm in Winter,* trees and a house are surrounded by a vast field of snow and solid pastel sky. Sidney Janis, in writing about the artist, suggested that the "bleak and stark scene is America to the core, the America of Whittier's *Snow-Bound.*"

Branchard was born on MacDougal Street in Greenwich Village, New York, in 1881. His mother established Mme. Branchard's rooming house for artists, known as the House of Genius, near Washington Square. Educated by French nuns, Branchard worked as a truck driver, stevedore, and for the Home Defense Force during World War I. He developed tuberculosis while patrolling the New York waterfront, which ended his formal employment. During his extended period of required convalescence, he took up painting. He had no art training, but his stepfather had studied painting throughout his childhood, and Branchard had watched him paint. Branchard began painting using paints and brushes left behind by one of his mother's lodgers.

Painting only from memory, and favoring oil on canvas or board, Branchard first exhibited with the Society of Independent Artists in New York (1919). The gallery owner, Stephen Bourgeois, "discovered" Branchard at that exhibition, and showed the artist's paintings from 1919 to 1932.

See also **Painting, American Folk.**

BIBLIOGRAPHY

Cahill, Holger, et al. *Masters of Popular Painting: Modern Primitives of Europe and America.* New York, 1938.

Janis, Sidney. *They Taught Themselves: American Primitive Painters of the Twentieth Century.* New York, 1942.

Rosenak, Chuck, and Jan Rosenak. *Museum of American Folk Art Encyclopedia of American Folk Art and Artists.* New York, 1990.

LEE KOGAN

BRECHALL, MARTIN (c. 1757–1831) was a fraktur artist who made many baptismal certificates from his home on the Berks-Lehigh county line between Allentown and Reading, Pennsylvania, from the 1790s to the 1810s. Born in Europe, Brechall was a schoolmaster in Weisenberg Township, Pennsylvania. The baptismal certificates he drew were for children who lived in about a dozen townships near the area where he resided, with the exception of a few made in Penn Township, Northumberland County, which has since become part of Center County, suggesting that he had a teaching job for a term or two there as well.

An extremely typical artist, Brechall produced baptismal forms listing the names of the child and its parents, the place and date of birth, the date of baptism and the names of the sponsors, and the officiating clergyman. He had some certificates of his own design printed to expedite the work, and frequently signed them, becoming one of the first fraktur artists to be identified by name. His colors were restricted to red and black, for the most part, and his designs to hearts and rectangles. Occasionally, he added an angel's head or an eagle, and sometimes a crown with the alphabet in it. He also designed a house blessing, a child's prayer, and presentation frakturs for the little children in his schoolroom. Like most Pennsylvania German schoolmasters, he lived a quiet and withdrawn life, and would probably have been forgotten but for the records of baptism he produced and signed. Because he lived in an area inhabited almost entirely by Lutherans and Reformed Protestants, he prepared certificates for children of both faiths. His work is known in Berks, Lehigh, Northampton, and Schuylkill counties in Pennsylvania, as well as in the central part of the state.

Brechall served in the American Revolutionary War. On July 3, 1818, in a pension application, Brechall stated that he enlisted in "April 1777 in the Congress Regiment" for three years. He then re-enlisted until 1783, and fought at Short Hills, Brandywine, Monmouth, and other places, and was present at the capture of the British general Cornwallis.

See also **Fraktur; German American Folk Art; Pennsylvania German Folk Art; Religious Folk Art.**

FREDERICK S. WEISER

BREWSTER, JOHN, JR. (1766–1854) had a long and successful portrait-painting career despite being deaf from birth. Brewster was born in Hampton, Connecticut, to Dr. John and Mary Durkee Brewster, who encouraged him at a young age to cope with his disability through learning to read and write. He displayed a talent for painting, which was fostered by studying with an established portrait painter, the Reverend Joseph Steward. Brewster began painting likenesses of family members and friends in the 1790s, and by 1796 had moved to Buxton, Maine, to live with his brother Royal Brewster between periods of itinerancy. He traveled widely in Connecticut, Maine, Massachusetts, and eastern New York State in search of

portrait commissions. In 1817, Brewster enrolled in the Connecticut Asylum for the Education and Instruction of Deaf and Dumb Persons in Hartford, where he learned new methods of non-verbal communication. He returned to Maine in 1820 and resumed his career as a portraitist.

Brewster's more than one hundred extant portraits show his ability to produce delicate and sensitive likenesses, full-size or miniature, in oil on canvas or ivory. His practice of priming his canvases with gray paint gives his portraits a particularly soft, serene appearance. As his career progressed, Brewster painted his sitters' facial features using more three-dimensional modeling, and moved from full-length to half-length or bust-length portrait formats. After 1805 he often signed and dated his works in pencil on the stretcher. Brewster died in Buxton, Maine, in 1854, having lived a long, successful, and independent professional life.

See also **Miniatures; Museum of Fine Arts, Boston; Painting, American Folk.**

BIBLIOGRAPHY

D'Ambrosio, Paul S., and Charlotte Emans, *Folk Art's Many Faces: Portraits in the New York State Historical Association.* Cooperstown, N.Y., 1987.

Little, Nina Fletcher. "John Brewster, Jr., 1766–1854: Deaf-Mute Portrait Painter of Connecticut and Maine." *Connecticut Historical Society Bulletin,* no. 25 (October 1960): 97–129.

Rumford, Beatrix T., ed. *American Folk Portraits: Paintings and Drawings from the Abby Aldrich Rockefeller Folk Art Center.* Boston, 1981.

PAUL S. D'AMBROSIO

BRITO, FRANK, SR. (1922–) did not intend to become a *santero* (a maker of religious images), yet his thirty-five-year devotion to the art form has established him as one of the most respected *santeros* in New Mexico. Brito was born in Albuquerque, but his family moved north to Santa Fe. During the Great Depression, Brito quit the fifth grade to sell newspapers and work other jobs. Traditional carvings and paintings of saints were a familiar part of Brito's Hispanic upbringing, and at age thirteen he began experimenting with using a pocketknife to copy the faces of popular saints in wood.

Years later, in 1965, when an illness temporarily sidelined Brito from his work as a plumber, he turned to carving to help pass the time. It was at this point that he attempted to create full-bodied renditions of saints. In addition to a pocketknife, he used hand chisels to shape original images from aspen and pine. Brito based his works on traditional colonial-era pro-

totypes, but shunned the conventional uses of color and detail in favor of his own color combinations and designs. As Brito became more personally connected to his work, his saints' facial features began to reflect the faces of his friends and neighbors. He also portrayed saints, such as Saint Patrick, who were not ordinarily depicted.

In 1967 Brito decided to sell his creations at Santa Fe's Spanish Market, an annual exhibition of artworks modeled after Spanish colonial styles. There, Brito became well-known for his unique style of *bultos* (three-dimensional religious sculptures), creating demand for his work among private collectors, galleries, and museums. Brito originally used native woods, homemade gesso, and paints from natural pigments as his primary materials. By 1985, however, he had determined that modern materials were more efficient, and switched to using commercial watercolor and acrylic paints, and even non-native woods that proved softer to carve.

Brito also expanded upon his repertoire of saints to include carved and painted animals (roosters, cats, rabbits, and coyotes) which were then in great demand among area folk art collectors, although saints remained his main focus. In 1987, during a visit from Pope John Paul II to Salinas, California, a Brito *bulto* of San Ysidro, the patron saint of agriculture and one of Brito's favorite subjects, was presented to the pontiff as a gift. In 1996 Brito's artistic longevity was acknowledged at the Spanish Market, where he received the Master's Award for Lifetime Achievement.

See also **Bultos; Religious Folk Art; Santeros; Sculpture, Folk.**

BIBLIOGRAPHY

Rosenak, Chuck, and Jan Rosenak. *The Saint Makers: Contemporary Santeras and Santeros.* Flagstaff, Ariz., 1998.

CARMELLA PADILLA

BROADBENT, DR. SAMUEL (1759–1828), itinerant doctor, possible part-time dentist, and portrait artist, lived and worked in Connecticut during the early nineteenth century. Born in England on March 29, 1759, Broadbent was in Wethersfield, Connecticut, by 1798, and possibly Sag Harbor, on Long Island, New York, earlier, from newspaper advertisements that record him soliciting business as a doctor who practiced surgery and midwifery. Official Connecticut state medical records, however, fail to confirm his involvement in the medical profession. In 1808, when he was forty-nine years old, he married the widow Abigail Griswold in Hartford. The couple had two

children. On April 2, 1828, at the age of sixty-nine, Broadbent died, owing to the effects of dropsy and "high living."

The extent of Dr. Broadbent's professional involvement as an artist has not been well documented. No newspaper advertisements have been found to suggest that he had a career other than medicine. A small watercolor portrait depicting architect Samuel Blin is signed by the artist and dated 1808 twice. It remains the only known surviving image to link Broadbent with the portrait-making business. In 1819 one Romanta Woodruff made an entry in his diary noting that Dr. Broadbent had been to see him and had taken his likeness for a portrait. This notation is the single piece of evidence confirming that Dr. Samuel Broadbent, the physician, and the artist of Blin's portrait, are the same individual. Based on this documentation, approximately thirty likenesses have been attributed to Broadbent's hand; the details of his career as an artist, however, remain shrouded in mystery.

Dating from 1819, the portraits depicting Mr. and Mrs. Romanta Woodruff are typical of the artist's known compositions. Subjects are rendered half-length, with hands placed visibly at their sides. While heads and bodies are executed in three-quarter view, a distinctive feature of his appears to be Broadbent's placement of the sitters' pupils at the far side of the eye, as if the individuals are peeking back at the viewer without moving their heads. Their pursed lips, finely executed lacework garments, and distinctively executed hairstyles, with Mrs. Woodruff's tendriled curls appearing as prominently featured effects in her likeness, are all hallmarks of this artist's portrait style.

See also **Painting, American Folk.**

BIBLIOGRAPHY

Abby Aldrich Rockefeller Folk Art Center. *American Folk Portraits: Paintings and Drawings from the Abby Aldrich Rockefeller Folk Art Center.* Williamsburg, Va., 1981.

Warren, William Lamson. "Doctor Samuel Broadbent (1759–1828), Itinerant Limner." *The Connecticut Historical Society Bulletin,* vol. 38 (October 1973): 97–128.

CHARLOTTE EMANS MOORE

BROADSIDES: *SEE* TRADE SIGNS.

BROOKS, THOMAS V. (1828–1895), a leading carver of ships and shop figures, operated studios in New York City and Chicago. Known as the "father" or the "old daddy" of the carving business, Brooks was born in New York City, where he was apprenticed to John L. Crowell (1805–1873). He opened his own shop on South Street in 1848, enjoyed a brief partnership with

fellow carver Thomas Millard (1803–1870), and later moved to Chicago, about 1880 to 1881, while still operating his New York City studio. In 1889 his son James Brooks (1869–1937) joined him in Chicago as a partner, and took over the New York studio in 1890. When Thomas Brooks died the two shops were sold, but son James continued to operate from his Brooklyn home, under the name of Standard Show Figure Company, until 1905. Thomas Brooks' employee Isaac Lewin (dates unknown), who changed his name to Lewis, purchased the Chicago shop.

Art historian Ralph Sessions, after examining *Products of Industry Schedules of the Federal Census,* determined that in 1850 the Brooks shop of four employees, with its carved figures valued at $4,500, adjoined other leading carving studios on South Street in New York City. By 1860 the business had moved to 117 Canal Street, which one contemporary referred to as "down in West Broadway somewhere," and had an inventory of one hundred figures valued at $4,000, and a staff of six. Renowned carver Samuel Anderson Robb (1851–1928) is thought to have apprenticed with Brooks about 1864. At that time Brooks identified himself as a "carver and gilder," and had a second shop at 256 South Street. Ralph Sessions concluded that "many elements of the New York show-figure style were established in Brooks' shop in the 1850s and 1860s."

Later schedules and directories reflect a subsequent partnership with Thomas J. White (1825–1902), as "Brooks & White—Carvers," producing "Figure Heads" and "Cigar Figures." An 1872 New York City directory advertisement listed Brooks as a "Show Figure and Ornamental Carver" with "from 75 to 100 figures always on hand." Frederick Fried, an authority on shop figures, gave the National Museum of American History at the Smithsonian Institution a photograph of a cigar store Indian that he attributed to Brooks, but there appear to be no extant carvings that can be attributed to the woodworker.

See also **Frederick Fried; Maritime Folk Art; Samuel Anderson Robb; Ships' Figureheads; Shop Figures.**

BIBLIOGRAPHY

Fried, Frederick. *Artists in Wood: American Carvers of Cigar-Store Indians, Show Figures, and Circus Wagons.* New York, 1970.

WILLIAM F. BROOKS JR.

BROWN, JAMES (active 1806–1808) produced seven signed works, along with seven other portraits linked stylistically to his name, each painted in an expres-

sive, realistic style. Little is known about Brown's life, however, and until the publication of Elizabeth V. Warren's article "The Mystery of J. Brown" in *Folk Art* magazine in 1998, not even Brown's first name had been uncovered. A portrait of Maxcy Fisher of Franklin, Massachusetts, signed "James Brown" on the reverse in the same bold, block script as other signatures found on works by Brown, helped solve the mystery. As an additional clue, "Brimfield," also written on the back of this portrait, is a town located near Franklin and Medway, Massachusetts, where four of Brown's other portrait subjects lived. What is known about where Brown worked has been discovered largely through studying the lives of his sitters. It appears that he worked in towns in northwestern Massachusetts as well as in Plymouth, in the eastern part of the state. Brown's portraits, all painted in oil on canvas, vary in size and complexity. Some are bust and three-quarter length portraits, but the portrait of Laura Hall is a full-figure depiction, measuring more than six feet in height. Some of his other portraits are oval in shape, and all are painted using a warm palette. He paid great attention to lace details and hair—painting, for instance, the wispy ringlets of his female sitters. Brown lightened the area behind the heads of his subjects, thus highlighting and illuminating the sitters' features. Anatomically, there are few deficiencies in his portraits, but scholars of Brown's work have observed that his sitters do not appear to be comfortably seated in their chairs.

Barbara and Lawrence Holdrige, experts on Ammi Phillips, have suggested that Phillips, the younger of the two artists, may have studied painting with Brown, as both artists painted in locations in New York State, Vermont, and Massachusetts, and there are striking similarities in the format of and in the attention to detail in some of their paintings.

See also **Painting, American Folk; Ammi Phillips.**

BIBLIOGRAPHY

D'Ambrosio, Paul S., and Charlotte Emans. *Folk Art's Many Faces.* New York, 1987.

Heslip, Colleen Cowles. *Between the Rivers: Itinerant Painters from the Connecticut to the Hudson.* Williamstown, Mass., 1990.

Museum of American Folk Art. *Revisiting Ammi Phillips: Fifty Years of American Portraiture.* New York, 1994.

Rumford, Beatrix. *American Folk Portraits: Paintings and Drawings from the Abby Aldrich Rockefeller Folk Art Center.* New York, 1981.

Warren, Elizabeth V. "The Mystery of J. Brown." *Folk Art,* vol. 23, no. 3 (fall 1998): 55–62.

LEE KOGAN

BROWN, WILLIAM HENRY (1808–1883) was a silhouette artist who cut both head and full-length portraits, as well as large groups and subject pieces. As a writer, he authored *Portrait Gallery of Distinguished American Citizens,* first published in 1845, which features full-length silhouette portraits of twenty-seven men, with brief biographical sketches written by Brown. He is especially well-known for two unique silhouettes, the first a six-foot-long rendering of the locomotive *De Witt Clinton.* Brown had been a passenger on its first trip, from Albany to Schenectady, New York, in 1831. The commemorative cutting included images of the engineer as well as prominent politicians of the day. The second silhouette, measuring 25 feet in length, pictured the St. Louis Fire Company and served as a decoration for its engine house. Another commanding silhouette was of the entire South Carolina legislature of December 1846. Other cuttings of note were of the ships *Constitution* and *Philadelphia,* and of the entire Washington Light Brigade.

Brown was born and died in Charleston, South Carolina, and during his maturity was an inveterate traveler throughout the southern United States, Pennsylvania, New York, and the New England states. The artist cut his silhouettes with scissors out of matte black paper, occasionally outlining parts of the body in pencil or embellishing them with gold or silver. He often made "pasties," renderings made from pictures cut from trade magazines and glued onto painted landscapes. One of his more ambitious pasties, titled *Holding the Whole Week's Picking,* consisted of four panels measuring five feet in length. On the panels against a painted watercolor background he placed silhouettes depicting African Americans hauling cotton.

Brown's surviving notes, advertisements, and published sources provide details of his travels and his artistic habits. Sittings for Brown's standard semi- or full-bodied portraits lasted about a minute; the cutting of the silhouette portrait required another ten minutes; they usually measured six inches in height. Brown charged one dollar for a full-length silhouette portrait. He sometimes printed his signatures, but more often they were in longhand. In addition to the watercolor backgrounds he painted for his silhouettes, Brown also used lithographed interior or exterior views, usually suggesting the profession, location, or interest of the sitter as a background.

Scholar Anna Wells Rutledge has determined that in 1859 Brown "quitted his profession of artist and worked as an engineer." Records indicate that by 1874 he resided in Pennsylvania and was employed

by the Huntington and Broad Top Railroad. He died in Charleston, South Carolina, of "physical debility."

See also **Papercutting.**

BIBLIOGRAPHY

Bishop, Robert Charles. *Folk Painters of America.* New York, 1979.

Brown, William Henry. *Portrait Gallery of Distinguished American Citizens.* Hartford, Conn., 1845.

Rutledge, Anna Wells. "William Henry Brown of Charleston." *The Magazine Antiques,* no. 60 (December 1951): 532–533.

WILLIAM F. BROOKS JR.

BUDINGTON, JONATHAN (c. 1779–1823) was a Connecticut portrait painter whose work has been included in many important exhibitions of early American folk art. The son of Walter and Ruth Couch Budington of Fairfield, Connecticut, he married Sarah Peck on June 13, 1820. Budington died in New Haven on January 18, 1823. Of his subjects whose identities are known, all resided in Fairfield County.

Budington painted his large portraits in oil on canvas, and five are signed "J. Budington" in red paint in the left lower corner. The heads and bodies of his sitters are posed in a three-quarter view, with adults depicted seated while children, with one exception, are shown standing. The subjects are often placed next to an open doorway or window, frequently with background drapery. As a rule his portraits include details that suggest the social status and interests of the subject.

These stylistic details, plus the frequent inclusion of red, upholstered, round-backed side chairs; the outlining of fingers, hands, and forearms with dark brown paint; heavy shadowing along the nose and under the chin; and large ears, suggest that Budington was strongly influenced by Ralph Earl, who was active in Connecticut between 1774 and 1801. Although they probably never met, Budington had undoubtedly seen Earl's portraits hanging in Connecticut homes. The connection between the two is best illustrated by the marked similarity of portraits that each did of three of the same subjects: John Nichols, his wife Mary, and Nichols and his son. Particularly significant is Earl's 1795 portrait of Mrs. Nichols, showing her seated with her infant daughter on her lap. Budington's portrait of Mrs. Nichols, painted seven years later, is essentially identical except for the fact that the child, no longer an infant, is replaced by the spectacles that Mrs. Nichols holds.

Although the number of his known paintings is small, their quality alone establishes Budington as an important member of the group of early nineteenth century Connecticut portrait painters.

See also **Ralph Earl; Painting, American Folk.**

BIBLIOGRAPHY

Kern, Arthur, and Sybil Kern. "Jonathan Budington: Face Maker." *Folk Art,* vol. 22 (fall 1997): 41–49.

Kornhauser, Elizabeth Mankin. *Ralph Earl: Artist-Entrepreneur.* Boston, 1988.

ARTHUR AND SYBIL KERN

BULTOS are three-dimensional polychrome wood sculptures, usually of a religious iconic nature, from New Mexico. The Spanish term *bulto* derives from the Latin *vultus,* the primary meaning of which is "countenance, expression of the face," or "face" itself, and it is extended to mean "painted face, portrait, or likeness." The use of *bulto* to refer to a sculpted image is common in Mexican and New Mexican inventories of the colonial period, with frequent references to *santos de bulto* in both private estates and churches. The maker of *bultos* in New Mexico was called an *escultor* (sculptor), a term also used more loosely to mean "artist."

In New Mexico, *bultos* were usually carved from cottonwood, occasionally from pine and aspen. Cottonwood and especially its root was the preferred wood because of its dense grain. It was much less likely than pine to shrink and split, yet was easy to carve. Usually the body of the *bulto* was carved from one piece, while the head, arms, and legs (if present) were carved from separate pieces, which were then pegged and glued into the body. Like the *retablo,* or altar screen, the carved figure was coated with a gesso ground and then painted with water-based or oil paints.

In New Mexico in the eighteenth century and the first half of the nineteenth century, water-based paints prepared from plant and mineral sources were usually used to paint *bultos.* Red was prepared from cinnabar, iron oxide, and imported cochineal, among other sources. Yellow was usually made from local dye plants, such as the rabbit bush (*chamisa*). Blue was usually prepared from imported indigo or a local mineral. Brown was derived from local iron oxides, and black from carbon. In the early 1800s wool weaving was a major New Mexican industry, and cochineal, indigo, and yellow plant dyes were all available to the *santeros* from local weavers, who used them for dyeing yarns. The paint technology of the early 1800s combined traditional European methods with those used by Pueblo and other Native Americans of the Southwest, who painted wall surfaces and wooden ceremonial objects as well as painted and dyed cotton and animal hides. After a *bulto* was

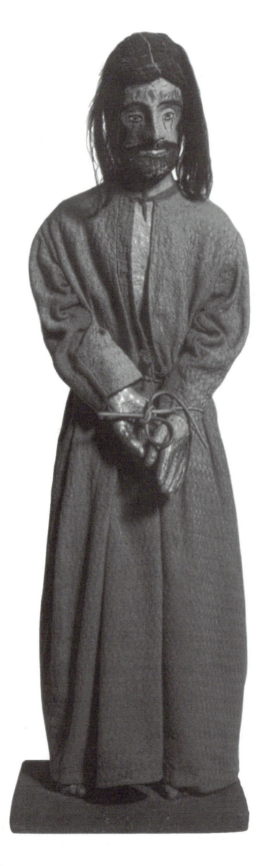

painted, it was usually coated with a protective varnish of pine resin. This varnish darkens with age, so the original brilliant colors used by the artist would often be hidden.

The attribution and dating of polychrome sculpture in New Mexico is difficult for several reasons. First, because of the delicate nature of three-dimensional surfaces and the frequent handling of *bultos* on ceremonial occasions, many of the pieces have been repaired and repainted over the years, often several times, thus obscuring the characteristics and techniques of the original artist. Second, *bultos* are unlikely to have dates or inscriptions written on them. *Retablos* often do, and their identification and dating are further aided by the presence of documented altar screens in churches. Finally, the valuable aid of tree-ring dating is seldom applicable to *bultos* because cottonwood, of which almost all of them are made, does not have an identifiable pattern of annual growth rings as does pine, the wood of choice for *retablos*. Therefore, attributions of New Mexican *bultos* must frequently remain tentative.

Most of the sculpture in New Mexican churches in the seventeenth and early eighteenth centuries were provincial pieces imported from Mexico. By the second half of the eighteenth century, however, a few local sculptors were making images that were dependent in style and technique upon Mexican Baroque prototypes. Pieces from this period, some of which were probably made in southern New Mexico, are painted with water-based paints, sometimes in oils. They include typical academic techniques, such as the modeling of heads, faces, and hands in plaster rather than being carved in wood; the use of cloth dipped in plaster and shaped as part of the costume; and the occasional use of gold leaf. The important inventories by Father Francisco Atenacio Domínguez in 1776 identify two local sculptors of images in the churches: the explorer and cartographer Bernardo Miera y Pacheco, who came to New Mexico in 1754, and the Franciscan friar Andrés García, who served in New Mexican mission churches from 1749 to 1779. A few pieces that were identified by Domínguez as the work of Miera y Pacheco and García may be in situ still, but they have been repainted, making it difficult to confirm the attribution or to extend the oeuvre of these artists to include other pieces. The sculpted figures of the stone-carved 1761 Castrense altar screen in Santa Fe bear resemblance to some of the work attributed to Miera y Pacheco. It may have been an inspiration for

Bultos Christ figure; Artist unknown; New Mexico; c. 1849–1860. Paint over gesso on carved pinon wood. © Esto.

him, as it clearly was for some later artists, or it is possible that he carved these figures himself.

The sculpture that emerged in New Mexico in the first half of the nineteenth century moved further away from the provincial Baroque work of the earlier artists. *Santeros* such as José Aragón, José Rafael Aragón, and the Santo Niño Santero all made *bultos* in a simplified naturalistic style in which a restrained Baroque expressiveness melds with the impassive and static qualities reminiscent of medieval sculpture. Figures tend to be symmetrical in their frontal stance, costumes are often carved and painted in simple geometric patterns, and the faces, although derived from naturalism, are universalized by their mask-like quality. These features, enhanced by the clear, bright tempera colors of the painted surfaces, give the figures a quality of innocence quite appropriate for the important spiritual roles they played in the lives of Catholic believers in nineteenth-century New Mexico.

Bultos served several purposes for parishioners. Some figures were used in processions and reenactments during annual ceremonies such as Holy Week. Other figures, such as the patron saint of a community, were placed on the altar of the church and were carried in procession through the streets in the festival of the saint's day. Still others, usually smaller pieces, were devotional images belonging to individuals and placed on family altars. Such figures provided a focus for prayers and petitions for both spiritual and worldly needs.

After the American occupation of what would become New Mexico (1846–1850), commercial plaster statues became available from the Eastern United States while fewer figures were made by local *santeros*. In more isolated areas, however, some wooden *bultos* were still made, especially for the lay brotherhoods that carried out the ceremonies of the suffering and crucifixion of Christ during Holy Week. These ceremonies required articulated figures in which the legs and arms were jointed and moveable, in order to perform the different stages of Christ's Passion, his sorrowful last meeting with Mary, and his crucifixion and burial. These reenactments were not possible with the commercially made plaster statues.

After 1850 the use of local water-based paints began to die out, eventually to be replaced with more readily available commercial oil paints. Sculptors working after 1850 included Juan Ramón Velázquez, José Benito Ortega, and Juan Miguel Herrera. Their work follows the move even further away from naturalism that was begun by the Arroyo Hondo Carver, achieving a higher level of abstraction that was compared by some observers to the sculpture of ancient and primitive art. The Mexican immigrant sculptor and painter José de Gracia Gonzales was an exception to this tendency. Gonzales, with some training in Mexico, made *bultos* in a provincial, Neoclassic style, with rather sweet naturalistic faces modeled in plaster. Yet another exception was the Abiquiú Santero who flourished in the late 1800s, and who may have been Mexican as well. His work, mostly figures of Christ in his suffering, has a decidedly Mexican Baroque flavor in its powerful expressiveness.

By the early twentieth century few *bultos* were being made in New Mexico, and the tradition effectively died out. Then, with the recognition of Hispanic arts by outsiders, beginning in the 1920s, the making of *bultos* was revived. Revival pieces at this time, however, were made for outside collectors rather than for community use, and, in deference to modernist aesthetic tastes of the day, they were left unpainted. The leading makers of these unpainted figures in the 1920s and 1930s were José Dolores Lopez, Celso Gallegos, and Patrocinio Barela. One *santero,* Juan Sanchez, made careful copies of nineteenth-century painted *bultos* for the WPA's (Works Progress Administration) Federal Art Project in the late 1930s. A revival that began in the 1970s and continues into the twenty-first century has been based much more within the culture. Many makers of both polychrome and unpainted *bultos* have emerged, some of them working in traditional styles and techniques and making pieces for use in the Hispanic community as well as for sale to outsiders. Among the many excellent *santeros* working since the 1970s are Charles Carrillo, Gloria López Córdova, Nicolás Herrera, Felix López, Ramón López, Eulogio and Zoraida Ortega, Luis Tapia, and Horacio Valdez.

See also **José Aragón; José Rafael Aragón; Arroyo Hondo Carver; Patrocinio Barela; Bultos; Juan Miguel Herrera; Nicolás Herrera; José Dolores Lopez; Retablos; Santeros; Santo Niño Santero; Sculpture, Folk; Luis Tapia; Truchas Master; Horacio Valdez.**

BIBLIOGRAPHY

Boyd, E. *Popular Arts of Spanish New Mexico.* Santa Fe, N. Mex., 1974.

Wroth, William. *Christian Images in Hispanic New Mexico: The Taylor Museum Collection of Santos.* Colorado Springs, Colo., 1982.

———. *Images of Penance, Images of Mercy: Southwestern Santos in the Late Nineteenth Century.* Norman, Okla., and London, 1991.

WILLIAM WROTH

BUNDY, HORACE (1814–1883), itinerant portrait artist, landscape painter, and preacher, worked principally in Vermont, New Hampshire, and Massachusetts, during the mid-nineteenth century. Born on July 22, 1814, in Hardwick, Vermont, Bundy began his career as a carriage maker in Lowell, Massachusetts, in 1836. The following year the artist executed his first recorded portraits of residents of Nashua, New Hampshire. Over the next twenty years, between 1837 and 1859, the man once described in a testimonial of his work as a "backwoods Vermont artist" painted approximately one hundred known portraits. His most recognized canvases today include a painting titled *Vermont Lawyer* (1841) as well as a monumental, full-length group portrait depicting eight members of the Parsons family.

Bundy's enthusiasm for the portrait business may have been inspired in part by his desire to generate the income that would enable him to pursue his passion for the ministry. In 1842 he joined the Adventist faith, becoming a "Millerite," and subsequently traveled as both a revival-meeting preacher and as an artist. In addition to selling portraits, in the 1850s Bundy also made and sold painted copies of well-known landscape and genre scenes by acclaimed artists, such as William Sidney Mount (1807–1868) and Jasper Cropsey (1823–1900).

Although no information has been found to indicate why the artist stopped painting in 1859, Bundy may have become more involved in his ministerial work. In 1863 he accepted an appointment as pastor of the Second Advent Church in Lakeport, New Hampshire, although he continued to be listed as an artist in the state's city directories into the 1880s. His obituary of 1883, however, which describes him as a widely known portrait and landscape painter, indicates that even in his later years he was still recognized for his artistic talent.

Advances in photography, including the announcement of the invention of the daguerreotype in 1839, clearly influenced Bundy's portrait work. In the likeness titled *Girl with Dalmatian,* the artist portrayed his young subject and her furry companion in a large, oval spandrel reminiscent of an oversize daguerreotype case. The language the artist used in his advertisements also reflected his awareness of the new technology's encroaching competition. According to art historian Lauren B. Hewes, Bundy's claim in the 1850s that he painted likenesses based on daguerreotypes was meant to assuage the customer's fear of the tiresome sittings required of portraits in oil. Further, lifelike coloring, animated facial expression, and the use of a large-scale format were perceived to be hallmarks of Bundy's line of business that could not be attained easily through contemporary photography methods.

See also **Painting, American Folk; Painting, Landscape; Photography, Vernacular.**

BIBLIOGRAPHY

Hewes, Lauren B. *Painting and Portrait Making in the American Northeast, Annual Proceedings of the Dublin Seminar for New England Folklife*. Boston, 1994

———. "Horace Bundy, Itinerant Portraitist." *The Magazine Antiques* (October 1994).

Shepard, Hortense O. "Pilgrim's Progress: Horace Bundy and His Paintings." *The Magazine Antiques* (October 1964): 445–449.

CHARLOTTE EMANS MOORE

BURNSIDE, RICHARD (1944–) is a self-taught artist who resides in Pendleton, South Carolina, where he often paints allegorical stories, such as the temptation of Adam and Eve. Born in Baltimore, Maryland, Burnside moved to Anderson County, South Carolina, with his family when he was five. He attended Sterling High School, worked at the S&H Green Stamp store in Greenville, South Carolina, and received his high school equivalency diploma (GED) while serving in the United States Army between 1974 and 1978. Following his discharge in 1978, he worked as a cook in Charlotte, North Carolina, until 1982, then relocated to Pendleton, South Carolina, in 1983.

Recollections differ as to whether Burnside began painting in 1976 or 1980. His initial works were made on found objects, such as paper bags, plywood, gourds, and pieces of furniture. He favors painting animal subjects (lions, tigers, snakes, wolves, turtles) but continually returns to round, flat faces of human figures, often adding long white hair. He commonly surrounds the faces with symbols that he calls the "Roman alphabet" or "Roman writing"—letters of an ancient language that appear to him in visions.

The artist's paintings are sometimes embellished with bits of pinecones and twigs. Kelly Wirth, a collector, refers to Burnside's as a "palette [that] changes from paint can to paint can" and describes his use of "oil-based enamels and epoxies." Some critics liken his paintings to Navajo sand paintings.

See also **African American Folk Art (Vernacular Art); Outsider Art; Painting, American Folk; Religious Folk Art.**

BIBLIOGRAPHY

Gordon, Ellin, Barbara Luck, and Tom Patterson. *Flying Free: Twentieth Century Self-Taught Art from the Collection of Ellin and Baron Gordon*. Williamsburg, Va., 1997.

Rosenak, Chuck, and Jan Rosenak. *Museum of American Folk Art Encyclopedia of Twentieth Century American Folk Art and Artists*. New York, 1990.

WILLIAM F. BROOKS JR.

BUSKS: *SEE* SCRIMSHAW.

BUSSELL, JOSHUA (1816–1900) served as an elder and trustee of the Shaker community at Alfred, York County, Maine, but he will be remembered as well as a gifted mapmaker and landscape artist. Bussell entered the Shaker community with his family in 1829. Respected for his faithfulness, he remained a resident of Alfred's Second family for the rest of his long life. He also composed hymns, one of which, the rousing "Jubilee," remains in the oral tradition of the Maine Shakers to this day.

During the 1830s and 1840s, the Shaker central leadership at New Lebanon, New York, encouraged the drafting of illustrated maps or site plans of each Shaker village, to record the location of dwellings, shops, barns, pastures, orchards, and other features of the natural and built environments. Initially, talented Shaker draftsmen responded by creating documentary records with meticulous attention to detail but little artistic expression. Bussell, whose first drawing is dated 1845, was a cobbler by trade. He carried the mapmaking tradition later into the nineteenth century than any other Shaker artist did. By the 1880s his early diagrammatic renderings had evolved into fully developed watercolor paintings. In addition to the Alfred community in which he resided, Bussell's subjects included Maine's other Shaker village at New Gloucester, its subsidiary Poland Hill family, and the Shaker community at Canterbury, New Hampshire. Robert P. Emlen, the author of a definitive study of Shaker village views, attributes seventeen drawings to Bussell.

See also **Henry Blinn; Painting, Landscape; Shakers.**

BIBLIOGRAPHY

Emlen, Robert P. *Shaker Village Views: Illustrated Maps and Landscape Drawings by Shaker Artists of the Nineteenth Century*. Hanover, N.H., 1987.

Patterson, Daniel W. *The Shaker Spiritual*. Princeton, N.J., 1979.

GERARD C. WERTKIN

BUTLER, ANN (1813–1887) was the foremost decorative painter in the successful tin shop established about 1824 by her father, Aaron Butler (1790–1860), in Greenville, Greene County, New York. Butler's father came to Greene County from Connecticut in 1799, and by 1811 he married Sarah Cornell. Ann was the oldest of their eleven children, nine of whom survived and attended Greenville Academy, founded in 1816. Ann Butler may have learned flower painting and other artistic skills at this academy, as ornamental arts were often deemed an essential aspect of a young woman's education in the early decades of the nineteenth century. She was conversant with all phases of production of her father's tinware business at a young age, and accompanied him on trips to as far away as New York City. According to family history, Ann was in charge of the decorating, or "flowering," of tinware produced by the shop by the time she was fourteen or fifteen. She later taught her sisters Minerva, Marilla, and Harriet to decorate tinware as well, and their work follows her own closely in design and technique. Ann Butler's involvement in the family business effectively ended when she married Eli Scutt, a union arranged by her father. Thereafter she moved to nearby Livingstonville, where she raised her own family of three children, and is buried in the Scutt family plot.

It has been possible to identify specific motifs and styles as the work of Ann Butler, based on several pieces signed with her full name or with a heart-shaped device enclosing her initials that have survived to the present day. Dense decoration of roses, rosebuds, tulips with turned-back petals, diamond-patterned baskets, and delicate filler elements are brightly painted against dark surfaces. Flowers are painted in reds, sometimes with the addition of blue, with lean overlays of white to give definition. Fine ink work appears around the outlines or tendrils, and as crosshatching in flower openings. Fancy pieces, such as an English tea caddy and a Battersea-type shaped trinket box, were among seven pieces that were part of the Butler family legacy until the 1930s. These were probably made for relatives and friends. Unlike the tinware produced for the general trade, which was typically painted Japan black, these are decorated with white bands on the lids or upper portions. The bands have either straight edges or are scalloped in a swag design. On dome-top trunks, the white band follows the curve of the lid on each short end.

Butler's short professional life highlights one of the few artistic occupations sanctioned for young women at the time. Painting on tin, clock faces, and other

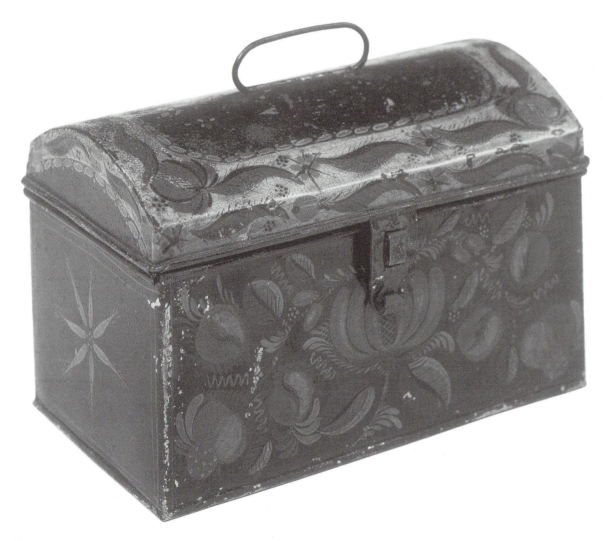

Trunk; Ann Butler; Greenville, Greene County, New York; c. 1830. Paint on asphaltum over tinplate. 4⅛ × 6¾ × 3¾ inches. © Collection American Folk Art Museum, New York. Gift of the Historical Society of Early American Decoration.
Photo courtesy Esther Oldham and Anne Oldham Borntraeger, 53.2.2.

household decorative arts provided an opportunity for the practical application of skills that girls had learned in school. Butler's bold signature, inscribed on several pieces, is evidence that she clearly took pride in her work. Her impact on the aesthetics of tinware produced by the Butler shop helped to determine the popularity of its wares. Ann Butler's experience, however, typifies that of many young women who were expected to cease such activities after marriage and the establishment of their own homes.

See also **Decoration; Tinware.**

BIBLIOGRAPHY

Brazer, Esther Stevens. *Antique Decoration: Twenty-seven Articles Reprinted from The Magazine Antiques.* Uxbridge, Mass.
Coffin, Margaret. "The Fabulous Butlers of Brandy Hill." *The Decorator,* vol. 18, no. 2 (spring 1964): 5–11.
Martin, Gina, and Lois Tucker. *American Painted Tinware: A Guide to Its Identification,* vol. 1. North Berwick, Maine, 2000.
Wright, Walter Herron. "The Butlers of Brandy Hill." *The Decorator,* vol. 7, no. 1 (1952): 9–10.

STACY C. HOLLANDER

BUTLER, CHARLES (1902–1978) began to carve wooden sculptures while in his sixties, using his own

homemade tools. He was born in Montgomery, Alabama, and moved as an adult to Clearwater, Florida. Butler worked in the hotel business as a porter, handyman, and shoe shiner. The artist Working the wood at times very sparingly and at other times highly decoratively, and often using a crosshatched, incised pattern, Butler depicted historical, biblical, political, and genre images. Occasionally the artist would work on a flat surface and depict his images in wood relief. At other times he would create freestanding figures that he positioned in front of a narrow, stage-like wooden backdrop. The artist would often finish his sculpture by applying a layer of shoe polish. Wall calendars and other sources from popular mass media provided Butler with pictorial ideas from which to begin creating his sculptures, and he completed nearly one hundred works during his lifetime.

See also **Sculpture, Folk.**

BIBLIOGRAPHY

Sellen, Betty-Carol. *Self Taught, Outsider, and Folk Art: A Guide to American Artists, Locations and Resources.* Jefferson, N.C., 2000.
Laffal, Florence, ed. "Sketches." *Folk Art Finder,* vol. 8, no. 3 (1987): 12.

BROOKE DAVIS ANDERSON

BUTLER, DAVID (1898–1997) filled his yard and the windows of his home in Patterson, Saint Mary Parish, Louisiana, with colorful, whimsical sculptural works cut from discarded tin roofing. Born in Good Hope, Louisiana, on October 2, 1898, he was raised in a religious family as the first of eight children, and helped considerably with the care of his seven siblings. His father was a carpenter while his mother was known for her missionary work on behalf of her community church. Butler worked with his hands, taking jobs as a grass cutter, sugarcane harvester, farmer, and buggy driver.

Butler turned to his art full-time after he was partially disabled in a sawmill accident, which is variously reported as having occurred either in the 1940s or 1960s. He told his friend and advocate, curator and director William A. Fagaly of the New Orleans Museum of Art, that before his accident he had "whittled wooden boats and animals," and had often made pictures of "people picking cotton or fishing, shrimp boats, sugarcane fields," and other scenes around Saint Mary Parish.

Butler's outdoor sculptures were painted with brightly colored house paint. The yard of his home, which was filled with these cutouts, many wind-driven, was visited frequently by neighboring children. Many of his themes were religious; he constructed a Nativity scene every Christmas. He favored renderings of fantasy animals: flying elephants, fire-spitting dragons, and sea monsters, but he also imaginatively sculpted the more traditional roosters, chickens, lizards, fish, dogs, and alligators. His assemblages ranged from the very simple to the more complex, with one as tall as eight feet. On occasion his intricate cutouts were decorated with small plastic animals, toys, and flags.

Butler died in his sleep at the Saint Mary Guest Home in Moran City, Louisiana, on May 16, 1997, just short of his ninety-ninth birthday. He enjoyed acclaim and recognition in his lifetime; his work was the subject of a one-man exhibition at the New Orleans Museum of Art in 1976, organized by William A. Fagaly.

See also **African American Folk Art (Vernacular Art); Sculpture, Folk.**

BIBLIOGRAPHY

Beardsley, John, and Jane Livingston. *Black Folk Art in America: 1930–1980.* Jackson, Miss., 1982.
Fagaly, William A. *David Butler.* New Orleans, La., 1976.
Kogan, Lee. "David Butler 1898–1997," *Folk Art,* vol. 22, no. 3 (fall 1997): 36.
Rosenak, Chuck, and Jan Rosenak. *Museum of American Folk Art Encyclopedia of Twentieth Century American Folk Art and Artists.* New York, 1990.

WILLIAM F. BROOKS JR.

BUTTER MOLDS AND PRINTS, simple but attractive, are among the earliest examples of American folk art. European examples from Scandinavia and Holland date to the seventeenth century, and immigrants brought the custom of decorating, or marking, butter to this country.

Shaped from wood (usually pine, poplar, or birch), molds and prints are of several types. Most are prints that consist of a round disk, one to four inches in diameter, with a design carved on one or (rarely) both sides. For convenience, a handle was sometimes added to the disk, either a knoblike form set at a right angle to the disk or a horizontal paddle that extended from the disk, like the handle of a spoon. By pressing this disk down onto the top of a slab of butter, it could be decorated.

In the bell-and-plunger mold, the disk was enclosed within a bell-shaped receptacle. The plunger was elevated and the bell then filled with butter, which was ejected from the mold by pushing down

on the plunger. This produced a uniformly sized unit of butter decorated on the top with the disk design. Square, hexagonal, or rectangular variations of this device were made. Farmers who sold butter at market favored the rectangular form that could hold one pound.

The earliest butter prints and molds were hand-cut and the designs were chip-carved in a V-shaped pattern, often as the piece turned on a lathe. By the mid-nineteenth century, however, most were factory-made. The first design patent in this field was issued in 1866, and by 1883 L.H. Mace & Co. of New York City was selling mass-produced butter prints and molds for as little as ninety cents a dozen. The designs on these were not carved but stamped on under great pressure.

Several hundred different butter print and mold designs are known, and they fall into several distinct categories. Food forms, understandably popular among agriculturists, include the sheaf of wheat, corn, pineapple (the symbol of hospitality), cherries, and grapes. From the farm came impressions of cows, horses, sheep, chickens, and ducks, while wildlife was represented by deer, beaver, fish, various birds, and the ephemeral butterfly.

Women, who handled most dairy chores, favored flowers, such as the rose, tulip, sunflower, daisy, and Scotch thistle. Also seen are ferns, clover, pine needles, and holly leaves as well as berries, acorns, and oak leaves. No doubt some of these designs were intended not only to beautify a butter pat or pound but also to identify its maker. There are a substantial number of prints and molds with carved names or initials, and it is likely that these served as a form of advertising.

See also **Cake Prints; Woodenware.**

BIBLIOGRAPHY

Gould, Mary Earle. *Early American Woodenware*. Rutland, Vt., 1962.

Ketchum, William C. *American Basketry and Woodenware*. New York, 1974.

Trice, James E. *Butter Molds*. Paducah, Ky., 1980.

WILLIAM C. KETCHUM

BYRON, ARCHIE (1928–) is one of the few vernacular artists ever elected to political office. He has also developed a medium—sawdust mixed with glue—that he uses in bas-reliefs and freestanding sculptures to convey his thoughts about gender, ethnic, and personal identity. Byron has lived in Atlanta since his birth. His father was a music instructor. Raised primarily by his maternal grandmother (part Native American, part English, and also named Archie) in the Buttermilk Bottom neighborhood, Byron was a childhood playmate of Martin Luther King Jr.'s, and attended Catholic school. After serving in World War II and attending a vocational school for brick masonry and architectural drawing, Byron tried to join the Atlanta police force but failed to meet its minimum height requirement, so he became a mason instead. In 1961, however, he founded a detective agency.

By the mid-1970s Byron owned several businesses, including a bait shop, gun-repair service, firing range, and security guard training school. In 1975, while working as a security guard, he was intrigued by a tree root that he found at a construction site. Soon afterward, he was making root-based sculptures for his home. A few years later, he noticed piles of sawdust lying on the floor of the gun-repair workshop, and another idea possessed him. Sensing "a beauty there that shouldn't be wasted," he mixed sawdust with household glue to create a paste that he modeled into painted relief sculptures and three-dimensional wall hangings on wood supports. These were made at first for home use. Many of the earliest works, such as his eerie still life, *Black Roses,* and his street scenes of ghetto life, were inspired by home-decor paintings refracted through his interest in black consciousness.

In 1981, unhappy with government services in his impoverished neighborhood, Byron ran for city council, won, and served for eight years. During his council terms his art moved away from overt political commentary and toward metaphysical issues. He began emphasizing biological commonalties of men and women (as in his four *Anatomy* works, which display a hydra-like male/female human radiating arms, legs, ears, and eyes) as well as the guiding roles of family and heredity. The more inward-looking reliefs, dating from the mid-1980s, feature human forms less obviously African American and more generalized in appearance, as Byron searched for common denominators among both the sexes and the races. His works finally became less obviously painted, allowing the natural tawny colors of the claylike sawdust compote to show proudly, and he achieved his original social goals by alternative means.

See also **African American Folk Art (Vernacular Art).**

BIBLIOGRAPHY

Arnett, Paul, and William Arnett. *Souls Grown Deep: African American Vernacular Art of the South,* vol. 1. Atlanta, Ga., 2000.

PAUL ARNETT

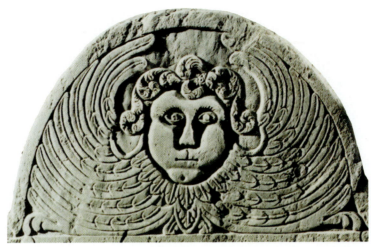

Photo © V.F. Luti. Reproduced with the permission of Steve Meredith.

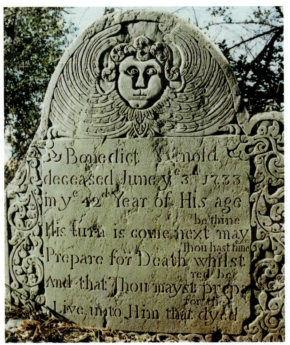

Photo © V.F. Luti. Reproduced with the permission of Steve Meredith.

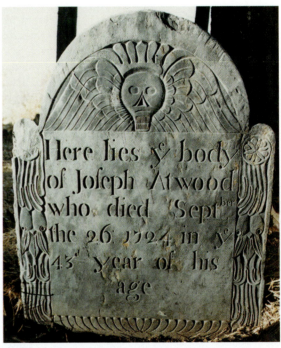

Photo © V.F. Luti.

Gravestone carving is arguably the oldest form of American folk art sculpture. John Stevens (1646–1736), of Newport, Rhode Island, began a local gravestone carving tradition that was carried on by his four sons and grandson. A bricklayer and mason by trade, Stevens carved the curvilinear, florid patterns seen in the 1733 Benedict Arnold headstone, Jamestown, Rhode Island (*top and above left*). Arnold's (1691–1733) older first cousin, Benedict (1683–1719) was the grandfather of Benedict Arnold, the American army officer who was court-martialed and found guilty of treason in 1780. The arched headstone echoes the headboard of a bed, symbolizing a subject at rest, or deceased. The winged effigy with prominent, deeply recessed eyes and nose was typical of eighteenth century gravestone iconography in the northeast (detail, *top left*). His son Philip Stevens (1706–1736) carved the headstone for Joseph Atwood in Blake Cemetery, Taunton, Massachusetts in 1724, (*above right*). Stern Puritan values influenced gravestone iconography throughout the eighteenth century; skulls, crossbones, coffins, and hourglasses were common themes. On the other hand, the organic decorative borders reflect a growing interest in resurrection and the dichotomy of life and death.

PLATE 1

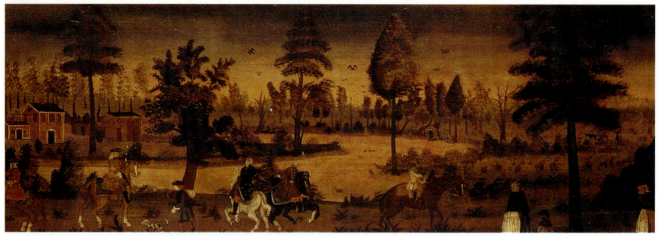

The Bertram K. Little and Nina Fletcher Little Collection auction at Sotheby's 6612; October 22, 1994, #71.
Photo courtesy Sotheby's, New York.

Winthrop Chandler (1747–1790) of Woodstock, Connecticut, executed this *Overmantel Panel (View of the River with Trees and Figures, above)* for Ebeneezer Waters's house, Sutton, Massachusetts. Overmantels were painted wood panels used to decoratively conceal the fireplace chimney when not in use. Chandler developed his own style of overmantel painting that melded actual scenes from the New England landscape with imaginative and romantic European pastoral prototypes, copied from books and prints. This overmantel painted in oil on pine panel, measures 22¾ × 60 inches.

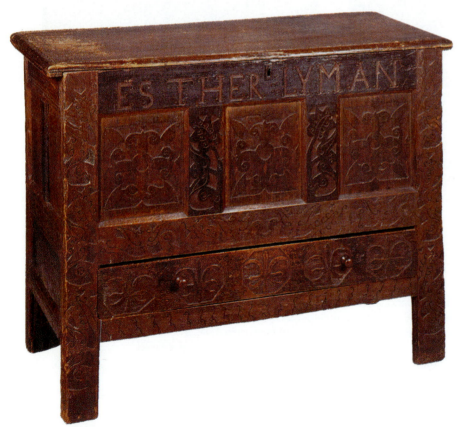

Hadley chests were made between about 1675 to 1740 by Puritan craftsmen in the Connecticut River Valley of Western Massachusetts. Usually oak or pine, they were often painted, and bore the carved name or initials of the owner, typically young women approaching marriageable age. Hadley chests were elaborately carved with relief patterns, often organic motifs such as tulips, hearts, trailing vines, and "S" curves. This Hadley Chest (Lift-Top Blanket Chest with "Esther Lyman" inscribed on front face; Northampton, Massachusetts, c. 1712–1722) is by an unknown maker. It measures 24 × 45 × 18¾ inches.

The Bertram K. Little and Nina Fletcher Little Collection auction at Sotheby's 6526;
January 29, 1994, #71.
Photo courtesy Sotheby's, New York.

PLATE 2

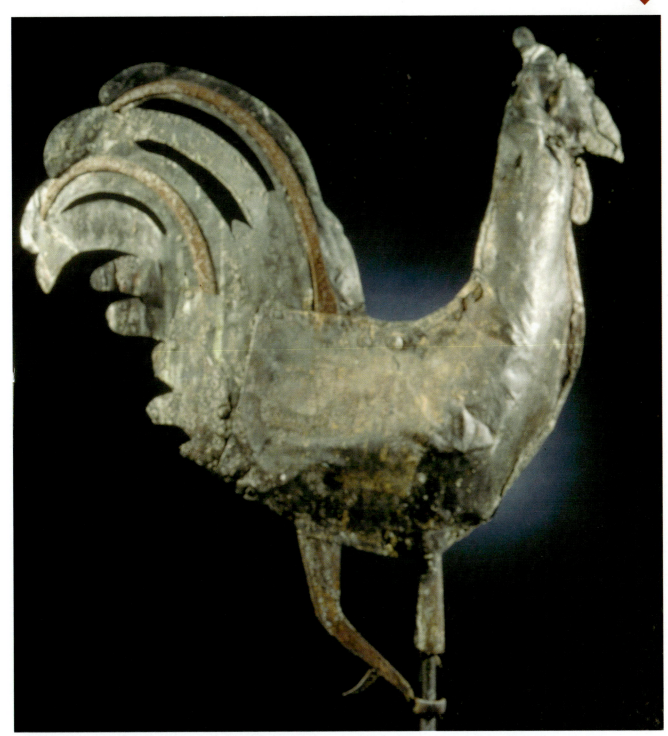

Private Collection.

Weathervanes, with their long European history as utilitarian objects, offered early American craftspeople opportunities for creative expression. American designs often reflected the objects and surroundings of the artist. Animals, such as the one represented in the iron *Rooster Weathervane* produced in New Hampshire in the early 1700s, were significant in American life on the farm and on the frontiers as they were a symbol of wealth and prosperity. This handsome fowl, 36 inches in height, might have aided a farmer in predicting a change in the weather, or may have reminded devout New Englanders of St. Peter's denial of Jesus.

PLATE 3

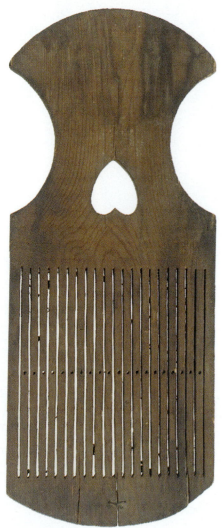

Photo © Esto.

Much of American folk art made prior to industrialization comprised ordinary objects and tools for everyday use in the home. Woodenware such as the *Carved Pine Tape Loom* used to make neckties and belts (carver unknown, Connecticut, c. 1780–1800, *left*) boasts a decorative cut-out heart. Other woodenware items such as washboards, turned bowls, pipe boxes, candlesticks, platters, salt containers, and mugs were carved by hand until the mid-nineteenth century when mechanization became widespread.

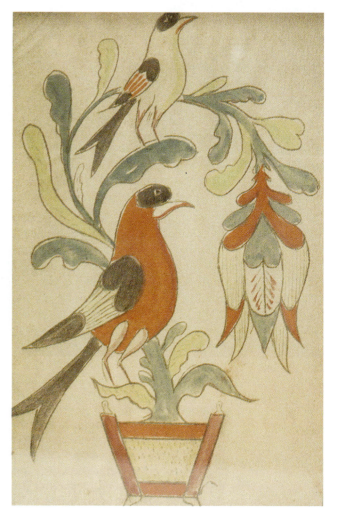

Photo © Esto.

Fraktur—a term originally denoting a specific German Gothic black letter—is a general term to describe the folk art drawings made by the Pennsylvania Germans from the 1740s to the present. Fraktur included baptismal documents, marriage and death certificates, and frontispieces or book plates that might be embellished with painted flowers, fauna, birds, hearts, and other fanciful forms such as this *Book Plate with Distelfinks and Flowers* (maker unknown, Pennsylvania, c. 1790–1810, watercolor on paper, *right*). Because fraktur was a relatively common practice and not associated with artistry in the conventional sense, most extant pieces remain anonymous.

PLATE 4

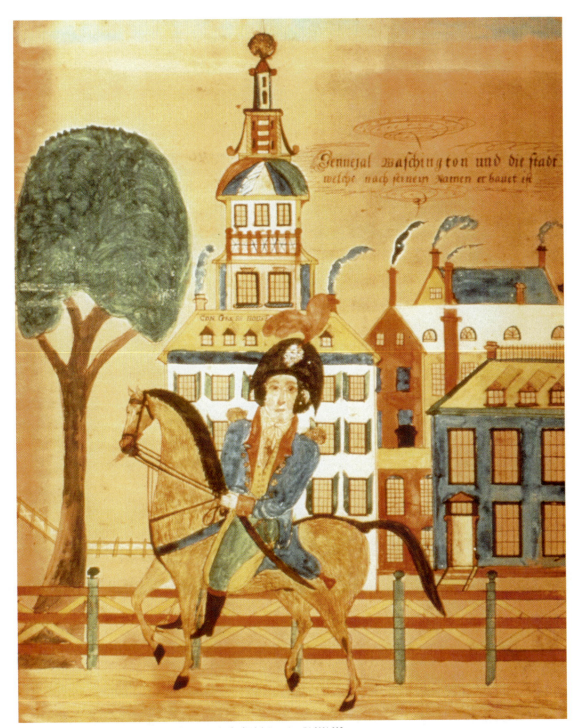

Collection American Folk Art Museum, New York. Promised gift of Ralph Esmerian, P1.2001.235.

Independence Hall, built in Philadelphia from 1732 to 1741 as the State House for the colony of Pennsylvania, served as the forum for George Washington's appointment as general of the Continental Army (1775), the signing of the Declaration of Independence (1776) and the Articles of Confederation (1778), and the adoption of the United States Constitution (1787). This southeastern Pennsylvania German fraktur piece (*above*), from about 1810 by an unidentified maker, depicts General Washington astride his horse with meticulously detailed architectural facades of the city in the background. Painted with watercolor, gouache, ink, and metallic paint on paper, the work measures $9\frac{5}{8} \times 8$ inches.

PLATE 5

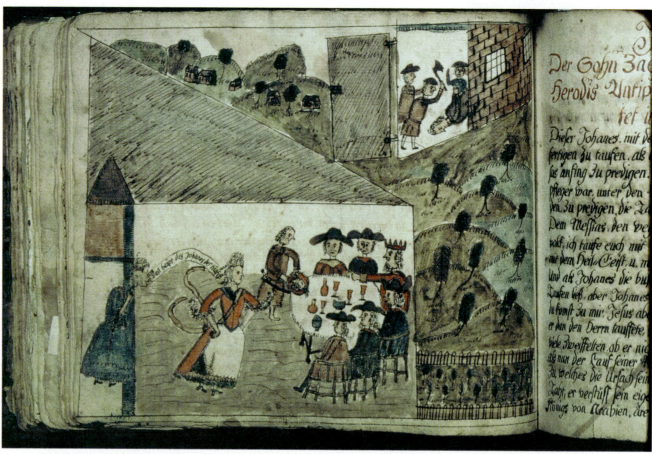

Private Collection.

The *Scene from the Picture-Bible of Ludwig Denig (The Beheading of John the Baptist)* by Lancaster, Pennsylvanian Ludwig Denig (1755–1830) is an example of German American fraktur (*above*). Denig, a member of the Reformed Church, conveyed the importance of piety, repentance, and the need for Christian beliefs to be reflected in daily living. Denig's illustrated manuscript, which he produced in 1784, contained primarily New Testament images of the Passion of Jesus Christ and the martyrdom of the apostles. Although a portrayal of Biblical times, Denig uses contemporary eighteenth-century dress for the characters. Drawn with ink and watercolor, this fraktur measures 6⅝ × 8⅛ inches.

PLATE 6

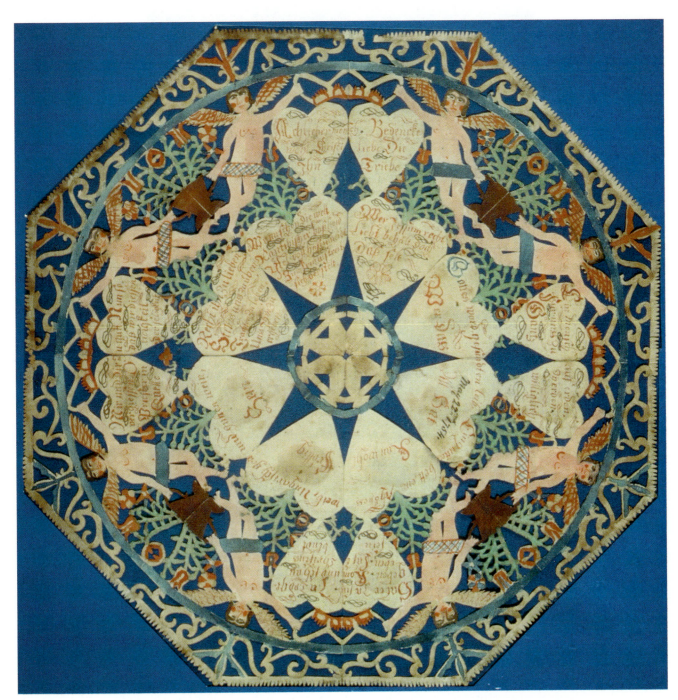

Photo © Esto.

German and Swiss immigrants brought the practice of *Scherenschnitte* (cut-paper design produced by folding paper) to the United States in the seventeenth and eighteenth centuries. In Pennsylvania, especially in Lancaster County, paper cutters cut shapes of hearts, cupids, tulips, and other flowers, birds, and abstract, lacy borders, sometimes with the addition of text. This valentine (maker unknown, c. 1800) has been enhanced with calligraphic inscriptions and watercolor (*above*).

PLATE 7

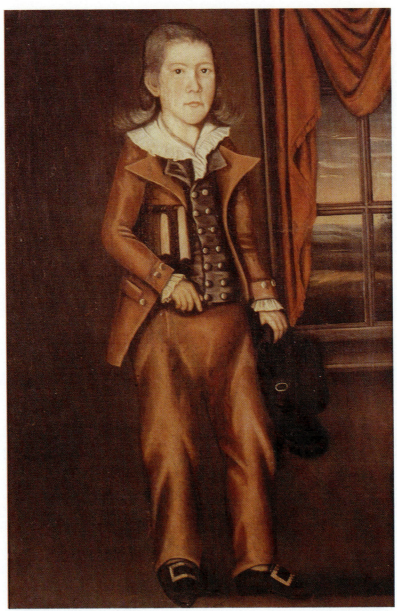

The Bertram K. Little and Nina Fletcher Little Collection auction at Sotheby's 6526, January 29, 1994, #300.
Photo courtesy Sotheby's, New York.

By the end of the Colonial Period, many of Connecticut's leading citizens had accumulated enough wealth to wish to be immortalized in portraits and to decorate their homes with painted scenes. Despite the Puritan tradition of frugality, modesty, and strictures against self-aggrandizement, Connecticut produced a thriving school of primarily itinerant and self-taught painters (limners) who specialized in portraiture. Sarah Perkins (1771–1831), of Plainfield, Connecticut, has been identified by Helen Kellogg as the anonymous and talented Beardsley Limner, who was active in the area between 1785 and 1805 and painted settlers in Connecticut and Massachusetts along the Boston Post Road. Although few details are known about Perkins's life, art historians have recently confirmed that she authored up to seventeen oil and pastel portraits, including this oil on canvas, *Portrait of Joseph Wheeler* (c. 1790, probably made in Massachusetts). Although the composition is typical, borrowing from the English convention of placing the full-length sitter in front of a window with a distant view, Perkins's unusually painterly stroke and dramatic use of *chiaroscuro,* or the arrangement of light and dark areas, are noteworthy. It measures 45 × 29¾ inches.

PLATE 8

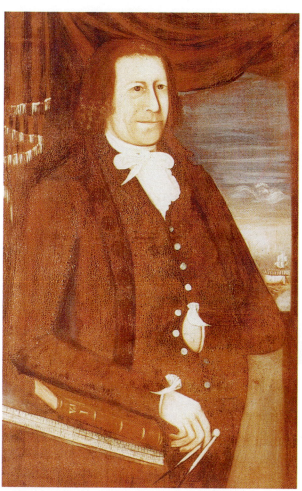

The Bertram K. Little and Nina Fletcher Little Collection auction at Sotheby's 6612, October 22, 1994, #905.
Photo courtesy Sotheby's, New York.

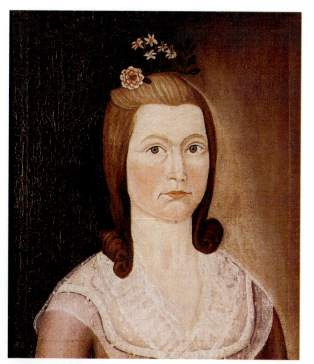

The Bertram K. Little and Nina Fletcher Little Collection auction at Sotheby's 6612, October 22, 1994, #896.
Photo courtesy Sotheby's, New York.

Naïve portraits painted during the eighteenth century shared similar qualities including flat surfaces and hard edges, largely the result of an inadequate understanding of technical perspective but also from the fact that their stylistic models were sometimes prints rather than paintings. The distortions that derived from inadequate artistic training were compensated for by the use of lively patterns and well-balanced harmonious designs. Rufus Hathaway (1770–1822), of Freeport, Massachusetts, painted the prominent families of Duxbury and Taunton, Massachusetts, including the shipping magnate *Ezra Weston* (*King Caesar*). This portrait (*left*), painted around 1793, is an oil on canvas measuring 37⅜× 24⅜ inches. Joseph Steward (1753–1822) of Hartford, Connecticut, gave up a career in the ministry to become a traveling portrait painter. Steward's style apparently changed a great deal over his lifetime, reinforcing the belief that he would adapt his style to suit his patrons (*right: Portrait of Betsey Coit*). This oil on canvas, painted around 1793, measures 18½ × 15¾ inches.

PLATE 9

Liberty Needlework (*right*) produced by Lucina Hudson (1787–?) in South Hadley, Massachusetts, in 1808, used many of the symbols that became popular in American folk art after the American Revolutionary War. Liberty pictured as an allegorical figure, the flag, and the eagle—executed here in watercolor, silk, and metallic thread, and spangles on silk—were icons that helped establish a new national identity. The work measures 18 × 16 inches.

American Folk Art Museum, New York. Museum purchase with funds from the Jean Lipman Fellows, 1996, 1996.9.1.

Soldiers, both admired and feared in American history, are a popular source of imagery in American folk art. This wooden *Hessian Soldier Whirligig* (*left*), probably made in Pennsylvania in the 1830s, measures 15¼ × 14 inches. Hessian soldiers were German mercenaries who fought with the British in the American Revolutionary War. In *The Legend of Sleepy Hollow*, written by Washington Irving (1789–1859), the author describes a whirligig such as this one, a "Little wooden warrior who, armed with sword in each hand was most valiantly fighting the wind on the pinnacle of the barn."

Private Collection.

PLATE 10

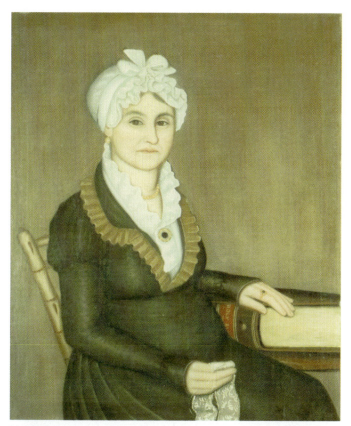

Private Collection.

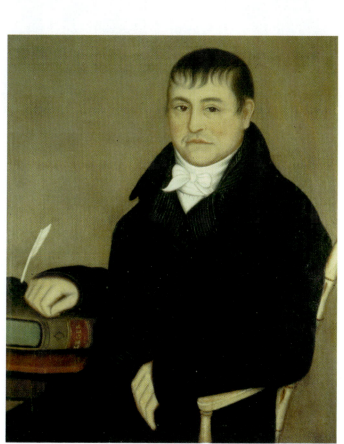

Private Collection.

Ammi Phillips (1788–1865) was one of the most prolific of the many itinerant portrait painters who traveled to American towns and rural areas looking for prosperous clients. He painted these pendant portraits of *Rebecca Rouse Eddy (1799–1846)* and *Jonathan Eddy (1774–1846)* of Hoosick Falls, Rennsselaer County, New York, between 1817 and 1820 in oil on canvas. Each is approximately 36 × 30 inches. Phillips's oeuvre manifested a number of stylistic changes over the course of fifty years, although works from the 1820s tended to evince a strong sense of realism, high contrast, plain backgrounds, and awkwardly articulated figures. In 1830, when Phillips was to be married to his second wife, the record listed his occupation as "portrait painter." Unlike many untrained portraitists who had to resort to other means to supplement their income, Phillips seems to have pursued a single vocation, and approximately 500 works have been attributed to him.

PLATE 11

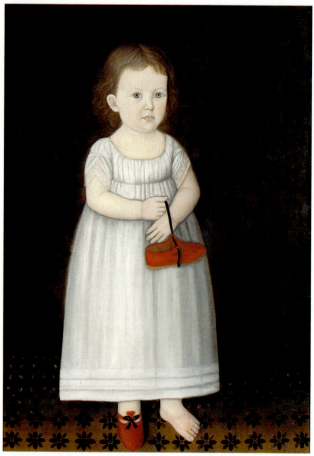

Fenimore Art Museum, Cooperstown, New York. © New York State Historical Association, Cooperstown, New York, N-231.61.
Photo courtesy John Bigelow Taylor, New York.

Pictures of domesticity were highly sought by middle- and upper-middle-class patrons in the nineteenth century. John Brewster Jr.'s (1766–1854) *One Shoe Off* (1807), measuring 35 × 25 inches, is one such painting that reflects the changing attitudes and beliefs about children during this era (*left*). Up until the mid-1700s infancy was a period of life to be survived; and babies—once thought to have little ability to respond to their environment— were rarely pictured as animated. Brewster's sensitive and meticulous oil on canvas exudes a sense of the little girl's charm, innocence, and mischief.

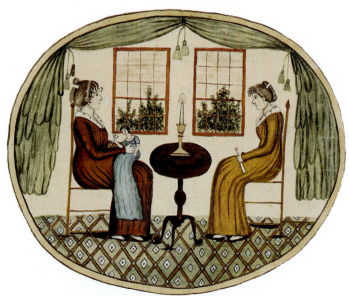

Fenimore Art Museum, Cooperstown, New York. © New York State Historical Association, Cooperstown, New York, N-77.61.
Photo courtesy John Bigelow Taylor, New York.

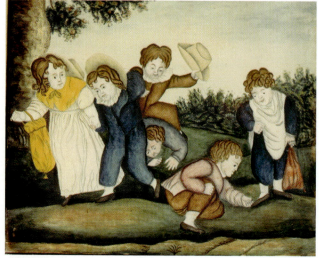

Private Collection.

Eunice Pinney (1770–1849), of Simsbury, Connecticut, specialized in domestic scenes. In *Two Women* (c. 1815, 9½ × 11¾ inches, *above*), the detailed period costumes signify the importance of everyday life. A prolific watercolor painter, Pinney was one of a small number of women artists who worked as professionals in the early years of the new American republic while at the same time fulfilling the domestic needs of her family. Pinney was drawn to subjects such as of *Children Playing* (c. 1830, 12 × 15 inches, *left*), as she raised five of her own children, products of two marriages.

PLATE 12

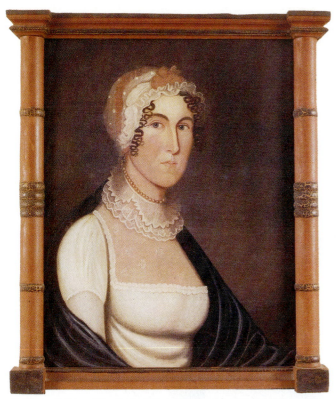

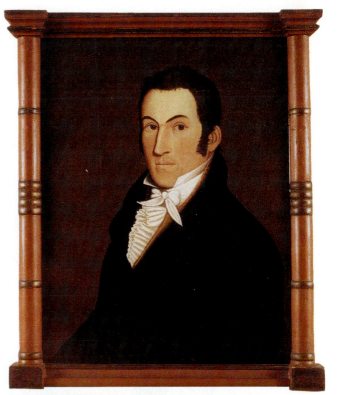

The Bertram K. Little and Nina Fletcher Little Collection auction at Sotheby's 6526.
January 29, 1994, #354.
Photo courtesy Sotheby's, New York.

The Bertram K. Little and Nina Fletcher Little Collection auction at Sotheby's
6526. January 29, 1994, #355.
Photo courtesy Sotheby's, New York.

In the nascent years of the American Republic, prosperous citizens were motivated to
have their likenesses recorded for posterity. The rise of a new merchant class, the
migrations westward, and a growing interest in decorative objects for the home
created an audience for portraiture. Family portraits signaled a growing awareness of
individuality and cultural status. Rather than travel to a large city to commission a
well-known portraitist, a would-be sitter could hire one of the many itinerant painters
(limners) who traveled up and down the eastern seaboard in search of work. Limners
(from the Latin *luminare*, meaning "to illuminate") were welcomed into homes, and
often treated to free lodging. Although itinerant painters lacked the academic skills
that characterized European portraiture, they compensated by inventing highly
personal styles. Zedekiah Belknap (1781–1858) is one such portraitist who authored
these two pendant pictures of unidentified sitters (c. 1815, probably New Hampshire,
oil on panel). The portraits, each measuring 24 × 18½ inches, indicate Belknap's
preference for flat, simple shapes with a minimum of modeling, heavy black outlines,
and crisp details.

PLATE 13

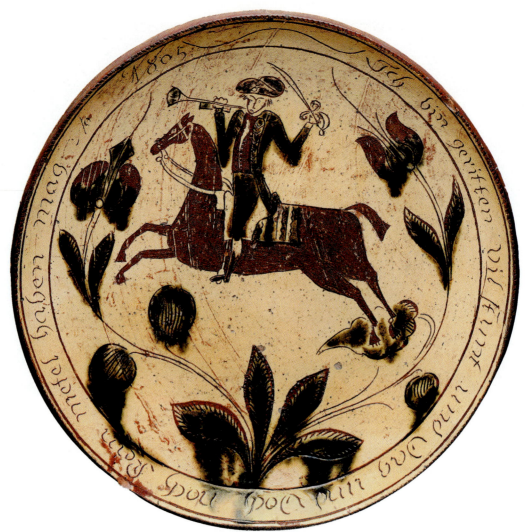

Collection American Folk Art Museum, New York, P1.2001.132.

Sgraffito-decorated pottery, often with textual and painted inscriptions, was common among the German and Swiss pottery traditions. This glazed, red earthenware plate— *Horse and Rider*—was made by John Neis of Upper Salford Township, Montgomery County, Pennsylvania, c. 1805. Plates with horse-and-rider motifs, many of which incorporated folk proverbs, might depict a particular military hero (such as George Washington) or a generic figural type. Civic celebrations and local militia exercises of the day may have provided inspiration for this rousing portrayal. Neis' schematic, linear, and yet fully described figure and floral motifs have the fluid, confident character of metal engravings and utilize similar curved and hatched lines to delineate outline and shading. This plate measures 1¾ × 12¼ inches.

Fireboards—painted panels designed to cover fireplace openings when not in use— were some of the most popular folk art objects in the late eighteenth and early nineteenth centuries. Conventional iconography for fireboards included organic patterns and floral still life, mimicking the practice of placing an urn of flowers directly inside a fireplace (as in this example with an eagle-embellished urn [*opposite page top*], artist unknown, Connecticut, early nineteenth century). This particular fireboard, oil on pine panel, measures 35 × 45½ inches. Other examples, such as the *Bear and Pears* fireboard (by an anonymous artist referred to as the "Bear and Pears Artist," c. 1825–1850, oil on wood panel, *opposite page bottom*) exemplified primitive brushwork, sponging, and stenciling techniques. It measures 33 × 45 inches.

PLATE 14

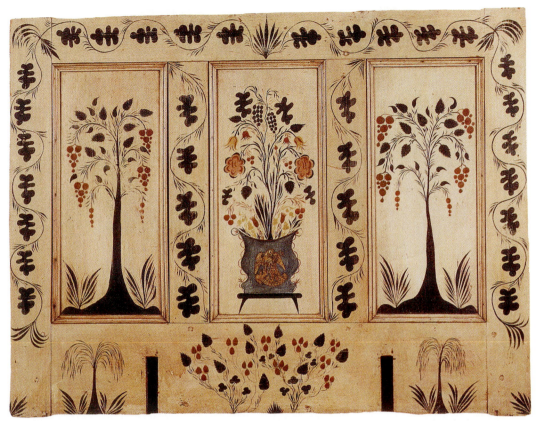

The Bertram K. Little and Nina Fletcher Little Collection auction at Sotheby's 6612. October 22, 1994, #782.
Photo courtesy Sotheby's, New York.

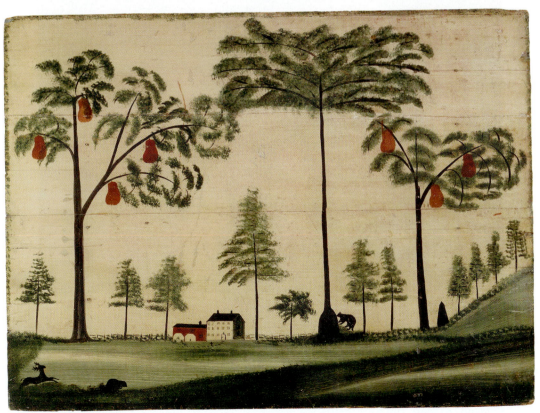

Fenimore Art Museum, Cooperstown, New York. © New York State Historical Association, Cooperstown, New York, N-44.61.
Photo courtesy Richard Walker.

PLATE 15

The Bertram K. Little and Nina Fletcher Little Collection auction at Sotheby's 6526. January 29, 1994, #442.
Photo courtesy Sotheby's, New York.

The portrait of a toddler—*Mary H. Huntington*—by an unidentified artist and displayed in its own decorated carrying case (*top*), typified the desire for keepsake family pictures. This simple, delicately rendered profile portrait, from Brockton, Plymouth County, Massachusetts, was designed to fit in the palm of one's hand, much like the daguerreotypes that would largely replace these works by the 1840s. This one is painted in watercolor and gouache on paper, in an embossed wallpaper-covered pasteboard box with silk lining and cotton padding, and measures 3 × 2½ × 2¾ inches.

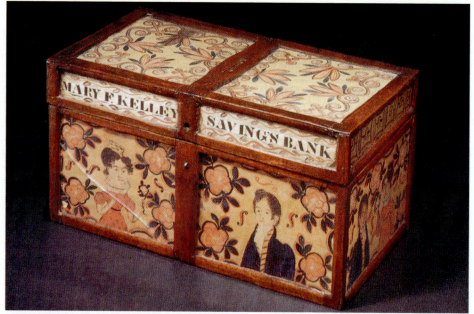

The Bertram K. Little and Nina Fletcher Little Collection auction at Sotheby's 6526. January 29, 1994, #74.
Photo courtesy Sotheby's, New York.

Miniature portraits and decorative boxes for money, jewelry, and other keepsakes were found in many prosperous homes. A variety of ornamentation including carving, papier mâché, silver or pearl inlay, and polychrome techniques was used to embellish boxes such as the "*Mary F. Kelley Saving's Bank*" (artist unknown, c. 1825, New England, *bottom*). The bank, crafted of watercolor on paper, printed wallpaper, glass, and wood, measures 5⅜ × 10¼ × 5⅝ inches.

PLATE 16

CADY, EMMA JANE (1854–1933) of East Chatham, New York, created a small but exceptional group of theorem paintings at the end of the nineteenth century. By the time Cady was practicing this art, in the 1890s, the fashion for theorem paintings had long since passed; nevertheless, the works that have been attributed to her are considered some of the finest examples of the technique.

Theorem paintings (watercolors composed through the use of hollow-cut stencils) were most commonly still-life arrangements of flowers or fruit, such as Cady's two nearly identical depictions of overflowing glass compotes. The artist's oeuvre, however, also includes two versions of doves sitting on a branch. The four watercolors were executed on paper, rather than the velvet ground favored earlier in the century; one additional painting is her only known oil on canvas. Cady's mastery of the theorem technique is evident in her skillful use of both transparent and opaque watercolors, enhancing the illusion of glass and other materials. Her watercolors also show the influence of chromolithography in the stippled effect that Cady achieved by "pouncing," or spreading a fine powder or pounce over her stencils with a textured cloth rather than a stiff brush. The application of mica flecks to the compote intensifies the juxtaposition of the delicate transparent glass with the satisfying solidity of the fruit.

When Cady's work was discovered in the 1930s, by J. Stuart Halladay and Herrell George Thomas, two early folk art collectors, it was thought to have been painted by another Emma Jane Cady of New Lebanon, New York, and dated about 1820, when theorem painting was at the height of its popularity. It was not until 1978 that Ruth Piwonka and Roderic H. Blackburn, researching the art of Columbia County, New York, for a forthcoming publication and exhibition, serendipitously learned of a painting inscribed "*Mr. and Mrs. Eben N. Cady / Canaan / Columbia Co / N.Y. / April 9, 1890 / E.J. Cady / East Chatham / N.Y.*"

This discovery enabled a good deal of information about Cady to be unearthed from family records and photographs, and public records. Her family migrated from Connecticut to Columbia County in the mid-eighteenth century. Her father, Norman J. Cady, was a farmer, and she was the oldest of three children. Piwonka and Blackburn were able to locate surviving family members and neighbors, who remembered Cady as a beautiful, strong-willed, and active woman, though none remembered that she painted. One surviving letter written by Cady mentions needlework she completed as a young girl, but it does not note her later watercolors; her occupation in census records is listed as "housework."

Cady never married, and after her parents died she moved first to the home of a nephew, then about 1920 to Grass Lake, Michigan, where she lived with her sister and her family until her death.

See also **Painting, Still-life; Painting, Theorem; Pictures, Needlework; Samplers, Needlework.**

BIBLIOGRAPHY

Piwonka, Ruth, and Roderic H. Blackburn. "New Discoveries About Emma J. Cady." *The Magazine Antiques,* vol. 113, no. 2 (February 1978): 418–421.

———. "Emma Cady's Theorem Painting." *The Courier* (January 21, 1988): A–8.

Rumford, Beatrix T., ed. *American Folk Paintings: Paintings and Drawings Other Than Portraits from the Abby Aldrich Rockefeller Folk Art Center.* Boston, 1988.

STACY C. HOLLANDER

CAHILL, HOLGER (1887–1960) was an art critic, curator, and arts administrator whose landmark exhibitions brought American folk art to the attention of the art world and whose seminal writings defined folk art as the unconventional expressions of makers with little formal training in art. He asserted that American folk art, often an overflow from the work of craftsmen, expressed the spirit of a people. Cahill viewed

folk art in aesthetic terms and his first two exhibitions, "American Primitives: An Exhibit of the Paintings of Nineteenth Century Folk Artists" (1930) and "American Folk Sculpture: The Works of Eighteenth and Nineteenth Century Craftsmen" (1931), divided folk production into the traditional categories of painting and sculpture. In these first catalogs, Cahill emphasized formal elements and noted the affinities between folk art and modernist works: simplification of form, lack of shading, unmixed color, and emotional directness. In his writings, including the important catalog essay that accompanied the first comprehensive exhibition of American folk art, "The Art of the Common Man in America, 1750–1900," organized for the Museum of Modern Art, Cahill supported the idea that folk art had flourished before the age of industrialization but insisted that folk art was a living art created in cities as well as in rural areas.

The facts of Cahill's early life are disputed; it is also unclear when he changed his name from Sveinn Kristjan Bjarnarson, but by 1907 he was signing letters as Holger Cahill. According to published sources, Cahill was born in Skogarstrond, Iceland, and shortly thereafter immigrated first to Canada and then to North Dakota with his parents, Bjorn Jonsson and Vigdis Bjarndottir. Correspondence between Cahill's wife and sister state that Cahill was born in St. Paul, Minnesota, after his parents had immigrated. In 1904, Cahill's father abandoned the family. Cahill, separated from his mother and sister, was sent to work on a nearby farm. Two years later, he ran away and wandered from job to job before finding a home at an orphanage in Winnipeg, where he attended school. After leaving the orphanage, Cahill worked at various jobs and attended night school. His experiences working as a coal passer on a freighter that took him to Hong Kong and Shanghai provided background for later writings.

In 1914, Cahill moved to New York, where he worked as a short order cook and attended night classes at New York University, the New School for Social Research, and Columbia University. He became a newspaper reporter and freelance writer, using the name Edgar Holger Cahill. In 1920, he met the painter John Sloan and began to write publicity for Sloan's Society of Independent Artists. An exhibition review brought Cahill to the attention of the Swedish-American News Exchange, which in 1921 sent him to Sweden, Norway, and Germany to study peasant arts. With the expertise gained through his travels and friendships with artists, Cahill joined the staff of the Newark Museum, where he served under the innovative director John Cotton Dana. With his friend, Edith Gregor Halpert, an early folk art

collector and dealer, Cahill visited the artists' colony in Ogunquit, Maine, where he saw the folk art collected by American modernist painters. Cahill and Halpert became advisers to such important collectors of folk art as Abby Aldrich Rockefeller.

After the successes of "American Primitives" and "American Folk Sculpture," Cahill moved in 1932 to the Museum of Modern Art, where he served as director of exhibitions and acting director and organized "The Art of the Common Man." The works shown in this exhibition were drawn almost entirely from Mrs. Rockefeller's collection. Another exhibition, "American Sources of Modern Art," explored the relationships between pre-Columbian art on artists and modern artists including Gaugin, Fauvists, Cubists, and Latin American muralists.

Between 1935 and the beginning of World War II, Cahill was director of the Works Progress Administration's Federal Arts Project, which surveyed regional arts, established community art centers, and produced *The Index of American Design*. Employing thousands of artists who produced watercolors of decorative arts including fraktur, painted chests, and southwestern *santos*, the *Index* documented regional contributions to American folk art. In 1938, Cahill organized "American Art Today" for the New York World's Fair and "Masters of Popular painting," which presented the work of twentieth century self-taught painters. During that year, he also married Dorothy Canning Miller, a curator and former colleague at the Museum of Modern Art, who had organized the exhibition of William Edmondson's work in 1937.

In 1943, when the Federal Arts Project was discontinued, Cahill returned to New York, where he devoted himself to writing. In 1950, he participated in the famous *Antiques* symposium, "What Is American Folk Art?" True to his belief that folk art continually reinvents itself, Cahill argued that definitions of American folk art must broaden to include new forms of expression created by living artists.

See also **Edith Gregor Halpert; Abby Aldrich Rockefeller.**

BIBLIOGRAPHY

Cahill, Holger. *American Folk Art: The Art of the Common Man in America, 1750–1900.* New York, 1932.
———. *American Folk Sculpture: The Work of Eighteenth and Nineteenth Century Craftsmen.* Newark, N.J., 1931.
———. *American Primitives: An Exhibit of Paintings of Nineteenth Century Folk Artists.* Newark, N.J., 1931.
Perspectives on American Folk Art, eds. Ian M. G. Quimby and Scott T. Swank. New York, 1980.

Vlach, John Michael, "Holger Cahill as Folklorist," *Journal of American Folklore*, vol. 98: (April–June, 1985): 148–162.

CHERYL RIVERS

CAKE PRINTS, carved wooden prints sometimes referred to as *springerle* boards, were used to impress designs onto the surface of gingerbread or marzipan, usually decorating Christmas or New Year's cakes, and are considered a form of folk art that the colonists in America brought with them from Europe. Also referred to as "molds" (which they are not, as nothing is inserted into them), prints were originally hand-carved from hard woods such as cherry, walnut, or apple, and ranged in size from a few inches square to great oblong examples three feet high. The larger carvings were used primarily by professional bakers, while housewives favored smaller ones, often with multiple images, so that the cake could, after baking, be cut into several cookie-like sections for serving.

Existent European cake prints indicate that, prior to the eighteenth century, designs were primarily religious in nature. Once secular images became acceptable, however, a veritable flowering in the art of print carving ensued. Images of fashionably dressed gentlemen and ladies, remarkable animals, and a profusion of fruit and flowers appeared upon the holiday table.

The earliest known American cake prints date to the 1820s, but the majority of existing examples are from the 1840–1880 period. Many of these are masterfully carved and feature national patriots, Lady Liberty, the American eagle, and even an early fire engine rather than the nobility and Santa Claus figures found on European examples. Many of these images were copied directly from contemporary prints or engravings, a common characteristic of American folk art, from scrimshaw to watercolor paintings.

Several of the men who carved these prints have been identified. Best known is John Conger, a New York City baker and carver active from 1827 until 1835. Quite a few of his signed pieces are extant. Conger's business was acquired by James Y. Watkins, whose successors continued making molds into the twentieth century. William Farrow, who worked in Manhattan from 1815 to 1835, made and signed a remarkable print depicting the Marquis de Lafayette; another carver, William Hart, advertised in Philadelphia as late as 1876. By then, however, machine-made wooden and cast pewter molds were already replacing the carver's art.

See also **Butter Molds and Prints; Woodenware.**

BIBLIOGRAPHY

Gould, Mary Earle. *Early American Woodenware*. Rutland, Vt., 1962.

Ketchum, William C. *American Basketry and Woodenware*. New York, 1974.

Weaver, William Woys. "The New Year's Cake Print: A Distinctly American Art Form." *The Clarion*, vol. 14 (fall 1989): 58–63.

WILLIAM C. KETCHUM

CALLIGRAPHY AND CALLIGRAPHIC DRAWING, the practice of fine and ornamental handwriting, flourished in the United States in the nineteenth and early twentieth centuries. Practitioners of calligraphy (from the Greek word that means "beautiful writing") typically learned the art from copybooks or penmanship manuals or from attending classes taught by an accomplished instructor. During the heyday of American calligraphy, itinerant writing masters brought the traditions and methods of plain and decorative handwriting to towns and villages throughout the country. It was considered a sign of social and professional attainment to have mastered the practice.

In calligraphic drawing, the cursive flourishes and strokes ordinarily used to write letters are also employed to create images. The subjects of these drawings are often dramatic in content (leaping horses, roaring lions, prancing deer, graceful swans, or any of a stock of heroic or patriotic depictions) allowing the penman a bravura performance as the image emerges from a swirl of elegant pen strokes. Occasionally, watercolor is added to calligraphic drawings, especially in more fully developed works: portraits, for example, of Washington or Napoléon on horseback. Apart from their visual appeal, these drawings provided an accomplished calligrapher with an attractive way to demonstrate his or her prowess with the pen. Professional penmanship instructors also used calligraphic drawings to advertise their services. In addition to model alphabets, writing samples, and exercises, copybooks often contained examples of calligraphic drawings with instructions for their replication.

Although Platt Rogers Spencer (1800–1864) was the best known and most influential American penmanship instructor of the nineteenth century, he was heir to a long and distinguished succession of writing masters dating back to the colonial period. Abiah Holbrook (1718–1769), for example, taught handwriting to a generation of boys at Boston's South Writing School. The manuscript volume in his elegant hand, "The Writing Master's Amusement," now in the collection of the Houghton Library at Harvard University, gathers the various British writing styles together in a series of sam-

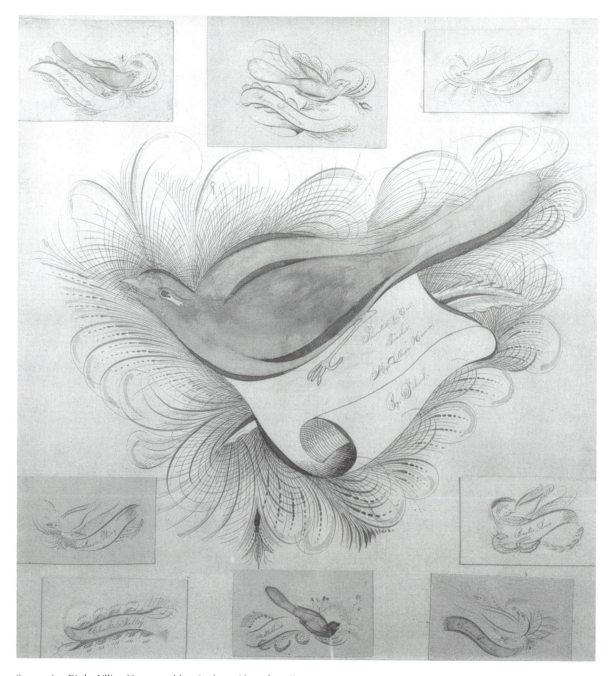

Spencerian Birds; Lillian Hamm and her Students (dates for Lillian Hamm unknown); United States; c. 1850–1900. Watercolor on paper. 19½ × 18¼ inches. © Collection American Folk Art Museum, New York, 1883.29.4.

ple alphabets, embellished borders, and brief texts. Among other features of the compilation are Holbrook's calligraphic drawings, with each letter of the alphabet transformed into a fanciful figure using "knot-work" designs and other forms of ornamentation.

The first American manual of handwriting is generally considered to be *The Art of Writing, Reduced to a Plain and Easy System* (Boston, 1791), by John Jenkins (c. 1755–1823), although several copybooks had been published previously. Christoph Saur

(1693–1758), for example, published sample Gothic "round hand" and "running hand" writing styles, in his German-language almanac *Der Hoch-Deutsch Americanische Calendar,* as early as 1754, for use by the Pennsylvania German community. Pennsylvania German schoolmasters continued this practice with the *vorschriften* ("writing samplers") that they created for their pupils in the last quarter of the eighteenth century and the first quarter of the nineteenth century. Often richly decorated with elements drawn from a traditional body of floral and other designs, these watercolors typically contain one or more sample alphabets.

The calligraphic system taught by Jenkins emphasized simplicity and legibility, employing a handful of interchangeable strokes for all letters. Among the important American teachers who followed Jenkins was Benjamin Franklin Foster (1803–1859), whose copybooks were distributed internationally. It was the Spencerian System, however, that had the greatest impact on handwriting in America. Because of the ornate, embellished, and shaded quality of its uppercase letters, the Spencerian System was also conducive to the creation of calligraphic drawings, a practice that was especially widespread in the United States between 1850 and 1925.

Platt Rogers Spencer was born in East Fishkill, New York, the youngest of twelve children, but moved to Ashtabula County, Ohio, with his widowed mother when he was ten. From early in his childhood he demonstrated an interest in penmanship, and by the age of fifteen he was teaching writing classes in Ashtabula and Kingsville, Ohio. Spencer's style, which evolved over the years he taught it, was also called the Semi-Angular System, and lent itself to rapid, legible handwriting and embellishment. As with other writing methods, the Spencerian System taught posture, hand and arm positions and movements, and the manner in which the pen was to be held, and also relied on repeated exercises and drills. As the late William E. Henning recounts in his study of American penmanship, the widely admired Spencer studied law, occasionally worked as a clerk and bookkeeper, and even served as a county official, but he nevertheless continued to teach penmanship for the remainder of his life. James Garfield (who later became president of the United States) was one of Spencer's students, in Jefferson, Ohio. Eventually, Spencer acquired a farm in Geneva, Ohio, and in 1854 established the Log Cabin Seminary there, where he and members of his family taught students from many states. He also operated Spencerian writing academies, often in partnership with his students or other instructors, in various parts of the country. As the Spencerian style developed, it became simpler, with less shading and fewer ornate embellishments.

Spencer published his handwriting method in copybook format in 1855, but it was only after his death that Spencer's sons published a comprehensive study of his method. Other important penmanship instructors with systems of their own followed Spencer: George A. Gaskell (1844–1885), who had studied with Spencer at the Log Cabin Seminary; William E. Dennis (1858–1924), author of *Studies in Pen Art* (1914); and Austin Norman Palmer (1860–1927), who developed the influential Palmer Method, among others. Spencer's dominance in the field was so far reaching, however, that it became customary to refer to the traditions of fine handwriting in the second half of the nineteenth century and the first quarter of the twentieth century as "Spencerian," no matter the method actually employed.

A lively literature devoted to penmanship developed in the nineteenth century, including specialized journals, and writing schools flourished throughout the country. There was an idealistic and democratizing character to the teaching and practice of handwriting in America; a mastery of calligraphy, which was possible for anyone willing to apply himself to learning one of its methods, was seen as way to advance in society and business. The practice became part of American vernacular culture.

By the mid-twentieth century, the respective meanings of "calligraphy" and "penmanship," or "handwriting," had begun to change. Increasingly, "calligraphy" was used to describe the specialized writing associated with certificates, diplomas, invitations, and other formal documents, while the other terms were employed to refer to ordinary writing. By then, the practice of fine and ornamental handwriting—and, indeed, the teaching of penmanship itself—had largely come to an end, supplanted, for the most part, first by typewriters and then by computers.

See also **Decoration; Fraktur; German American Folk Art.**

BIBLIOGRAPHY

Filby, P.W., *Calligraphy and Handwriting in America, 1710–1962.* Caledonia, N.Y., 1963.

Henning, William E. *An Elegant Hand: The Golden Age of American Penmanship and Calligraphy.* New Castle, Del., 2002.

Johnson, Bruce. *Calligraphy: "Why Not Learn to Write."* New York, 1975.

GERARD C. WERTKIN

CANES, or walking sticks, as they are sometimes called, have been acknowledged to be an important form of American folk art. Particularly in the second half of the nineteenth century in America, canes became fashionable as an accessory to a gentleman's attire, resulting in the manufacture of a large number of formal decorative walking sticks, such as those with gold-plated handles. During this same period some makers of simple, utilitarian wooden canes added hand carving and decoration, and it is from these examples that we find most American folk art canes. Although scrimshaw and glass canes are also considered in the category of folk art, almost all of the folk art canes in the past were made of wood, with the carver often using little more than a jackknife.

Hand-carved canes were made in all fifty states, and makers, almost all of whom were men, were of virtually every nationality and ethnic background, including African Americans and Native Americans. Most nineteenth-century cane makers were anonymous, but some important American carvers, all of whom carved more than one cane, have been identified. These include Michael Cribbins (1837–1917), Alanson Porter Dean (1812–1888), and "Schtockschnitzler" Simmons (active 1870–1910).

The personal or individual nature of canes is an important characteristic in the tradition of and includes their function as well as their ability to symbolically communicate information about the user. The canes' themes are almost endless, and include politics, occupation, religion, patriotism, fraternal loyalty, animals, people, sports, drinking, and erotica. Snakes as a subject were particularly common. Another important characteristic of folk art canes is their historical or cultural aspect, which was often drawn freely and adapted from the popular culture of the day. The artistic quality of folk art canes is largely dependent on the maker's ability to utilize the stick form while simultaneously creating a sculpture.

The heyday of American hand-carved canes was from around 1840 until World War I. Folk art canes are being made even today, with the tradition not lost but rather adapted to fit the times. Themes of contemporary canes include newer subjects, such as Dolly Parton, Elvis Presley, and space ships. Contemporary folk art canes, though, are often made primarily to be a work of art, not a utilitarian object. Contemporary folk art cane carvers include Denzil Goodpaster (1908–1995), Tim Lewis (1952–), and Hugh "Daddy Boy" Williams (1919–1988).

See also **Denzil Goodpaster; Sculpture, Folk.**

BIBLIOGRAPHY

Dike, Catherine. *Canes of the United States*. Michigan, 1994.

Meyer, George H., and Kay White Meyer. *American Folk Art Canes, Personal Sculpture*. Bloomfield Hills, Mich., Seattle, Wash., and London, 1992.

Stein, Kurt. *Canes and Walking Sticks*. York, Pa., 1974.

GEORGE H. MEYER

CAROUSEL ART, the ornately carved wooden figures used for carnival rides known as carousels or merry-go-rounds, evolved from simple machines first employed in seventeenth-century France to practice lancing a dangling ring with a sword while riding a horse. This lancing game was one of the events staged at tournaments in which talented riders on horseback competed in various games. The ornamentation on these first carousels was minimal because the emphasis was on practicing the game of catching the brass ring and not on the enjoyment derived from the ride itself.

By the early 1800s carousels began to appear at country fairs and other local public events, both in Europe and America. Most of these simple machines, powered by a single horse, carried small, primitively carved figures of horses or just a few benches created from scraps of wood. Although these prototypical carousels began to display innovation and imagination in the design and construction of the animals, the carvings lacked sophistication. Despite the simplicity of the figures, however, carousels continued to grow in popularity.

In the 1870s the steam engine replaced the horse as a power source. The carousel evolved into a whirling machine that carried a wide variety of carved animals. The design to create the movement of the carousel figures was patented; movement was achieved by suspending each of them from a center pole attached to a bent rod, that when rotated, made the animals move up and down as the platform spun. As the carved figures gained more detail the entire machine became part of the attraction. Carvings were added to decorate the cornice at the top of the machine while painted scenes hid the motor and gears that ran the carousel.

The introduction of the trolley as a form of mass transit contributed to the popularity and demand for more carousels. The towns, cities, and private corporations that owned the trolley systems sought to increase ridership on weekends by placing recreational parks at the end of their trolley lines. The addition of a fancy carousel helped to draw customers to these parks.

As the popularity of carousels continued to increase, companies dedicated to manufacturing them began to start up. In 1867 Gustav Dentzel (1846–1909) was the

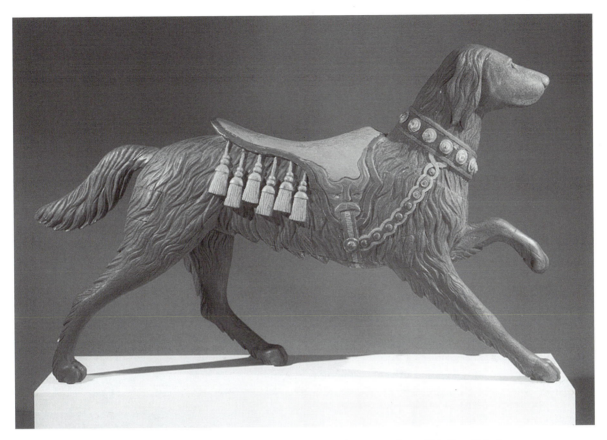

Carousel Dog Figure; Produced by the Herschell-Spillman Co.; Tonawanda, New York; c. 1905. 58 × 35 inches.
Photo courtesy Allan Katz Americana, Woodbridge, Connecticut.

first of several enterprising cabinetmakers to turn their attention to producing carousels. The opening of Dentzel's Philadelphia shop was followed several years later by the start of Charles Looff's (1852–1919) carousel company in the Coney Island section of Brooklyn. The first carousel figures carved at these companies were rudimentary in style because they were intended as simple horse-like seats on a ride.

Between 1870 and 1905 other entrepreneurs began to see the potential for profits in carousels. New businesses were opened by carvers while others were started by savvy businessmen. One of those businessmen was William Mangels, who in 1886 opened his Carousal Works near Coney Island, New York. Many of his best craftsmen would go on to open their own manufacturing operations there. Solomon Stein and Harry Goldstein left the employ of Mangels in 1902 to start the Artistic Carrousell Manufacturers; Marcus Charles Illions opened Illions & Sons in 1904; and Charles Carmel opened his own shop near Prospect Park in Brooklyn several years later.

Based on Dentzel's success, Philadelphia became a burgeoning area for carousel makers. In 1901 amusement-park-ride manufacturers Henry Auchy and Chester Albright bought the E. Joy Morris Carousel Company and formed the Philadelphia Toboggan Company. Former Dentzel carver Daniel Müller opened D.C. Müller & Bro. in 1904, and was soon producing magnificent, highly detailed work. In 1900 in North Tonawanda, New York Allan Herschell and the Spillman family opened a factory where they specialized in eighteen separate "menageries" including horses and dogs that embellished large-scale carousels ranging from Ocean City, Maryland to Golden Gate Park, San Francisco, California. Today the Herschell-Spillman Carousel Factory is on the National Resgister of Historic Places and serves as a carousel museum. Herschell-Spillman carousels are now featured at such places as the Henry Ford Museum in Dearborn, Michigan and at the Strong Museum in Rochester, New York.

As competition increased, carousels grew in size and intricacy. The carved animals became more ornate and

85

the designs were carefully thought out, with matching color schemes on the rounding boards, animals, and trim. Each company began to hire talented craftsmen, mostly newly arrived European immigrants, to outdo the competition. Carved steeds with wide, snorting nostrils or lions with extraordinarily intricate trappings began to replace the simpler animals.

Once the carving was complete, the figures were moved to the paint shop, where other skilled craftsmen used casein- (or milk-) based paints to decorate the bodies and trappings of the figures. In some cases silver and gold leaf was added to bring out detail, and fine, precision striping was used on the trappings. To complete the overall effect of fantasy, the cornices of the carousels were filled with carved and painted filigree, accentuated with detailed scenes from exotic countries, and illuminated with hundreds of electric lights.

Each carousel maker developed a distinctive style. Illions' horses, with wild manes decorated with gold leaf, could be found throughout Coney Island, where no fewer than eleven of his machines operated at one time. Dentzel's figures were known for exacting realism, and a menagerie of creatures and huge jester heads were placed on the cornices of his machines. Charles W. Parker of Parker Amusement Co. in Leavenworth, Kansas, had his carvers create horses that appeared to be racing the wind with their outstretched legs and straining necks.

Over a forty-year period, nearly 2,000 carousels were produced by various shops. By 1916, however, the lights in the carousel shops began to dim. After the World War I, demand for wooden carousels increased again, but the public also began to seek out more thrilling rides, such as the exciting roller coasters that were appearing in amusement parks around the country. Several manufacturers understood this change and retooled their businesses to produce other types of rides, while others turned to repair work on existing carousels and received only the occasional commission for a new machine. By 1930, the business of creating brand-new hand-carved carousels was over. The shops that remained in business had turned to making carousels out of aluminum, a much more durable material, or had simply moved on to other things.

See also **Salvatore Cherny; Gustav Dentzel; Marcus Charles Illions; Charles Looff; Daniel Müller; Charles W. Parker; Sculpture, Folk.**

BIBLIOGRAPHY

Dinger, Charlotte. *Art of the Carousel.* Green Village, N.J., 1983.
Fraley, Tobin. *The Carousel Animal.* San Francisco, 1983.
————. *The Great American Carousel.* San Francisco, 1994.
Fried, Frederick. *A Pictorial History of the Carousel.* Vestal, N.Y., 1964.
Mangels, William F. *Outdoor Amusement Industry.* New York, 1952.
McCullough, Edo. *Good Old Coney Island.* New York, 1957.
Stevens, Marianne. *Painted Ponies.* New York, 1986.
Summit, Roland. *Carousels of Coney Island.* Rolling Hills, Calif., 1970.
Weedon, Geoff. *Fairground Art.* New York, 1981.

TOBIN FRALEY

CARPENTER, MILES BURKHOLDER (1889–1985) became widely known during the last dozen years of his life for the figural wood sculptures that he carved, painted, and displayed by the roadside stand where he sold ice and fresh produce in Waverly, Virginia. His family moved to that part of the country from their Pennsylvania farm, and his father opened a sawmill. Laboring in the mill during his childhood and adolescence, Carpenter became accustomed to working

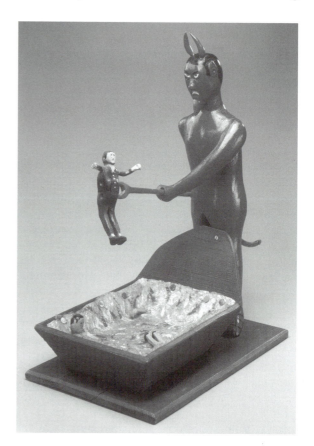

The Devil and the Damned; Miles Burkholder Carpenter; c. 1972. Painted wood and cellophane. 19 inches high. © Collection American Folk Art Museum, New York, 1990.1.10.
Photo courtesy Gavin Ashworth.

with wood. When he was in his early twenties, he opened his own sawmill nearby. With his business in a slump during World War II, Carpenter took to carving small animals and other figurines from scrap wood, but he did not develop his creative woodworking abilities until an injury prompted him to close his lumber business, in 1955.

By the 1960s Carpenter had resumed carving as a means of drawing attention to his roadside enterprise, which he continued to operate, and he considered the results of his efforts as promotional trade signs. After his wife's death in 1966, in part as therapy to help him overcome his grief, he undertook more ambitious woodcarving projects, which included life-size sculptures of animals and people as well as "root monsters," which he made from evocatively gnarled and twisted tree roots. Carpenter displayed these works in the back of his pickup truck while it was parked alongside his place of business, and while he drove around Waverly.

Among these life-size figures was a Native American family ensemble that included a man, a young boy, and a woman, which Carpenter dressed in his late wife's clothes. Another such figure was the fur-haired, red-lipped woman he named Lena Wood, which regularly occupied the passenger seat of his 1951 Chevrolet. In the whimsical carved and painted sculptural piece *The Devil and the Damned*, a nineteen-inch tall horned red devil figure drops figures into a pit of fire.

Students from Virginia Commonwealth University in Richmond discovered Carpenter's art in 1972, and soon he began to receive visits from the few individuals who were then buying or selling contemporary folk art in this country. By the time of his death, Carpenter was widely recognized as one of this country's most important contemporary self-taught sculptors.

See also **Sculpture, Folk.**

BIBLIOGRAPHY

Carpenter, Miles B. *Cutting the Mustard*. Tappahannock, Va., 1982.
Gregson, Chris, and Marilyn A. Zeitlin. *Miles Carpenter: The Woodcarver from Waverly*. Richmond, Va., 1985.
Hartigan, Linda Roscoe. *Made with Passion: The Hemphill Folk Art Collection in the National Museum of American Art*. Washington, D.C., and London, 1990.
Oppenhimer, Ann. "Miles Carpenter, The Woodcarver from Virginia." *Raw Vision*, no. 5 (winter 1991/1992): 38–41.

TOM PATTERSON

CARTLEDGE, NED (1916–2001) was a prolific, self-taught artist from Atlanta, best known for his satiric and provocative painted wood-relief carvings, infused with liberal political and social commentary. For more than forty years this dignified, mild-mannered, highly principled man expressed his disdain for racism, political corruption, mendacity, hypocrisy, and injustice with incisive wit, and challenged the social conscience of his audience through his carvings. His concerns extended beyond America's borders to the global issues of hunger and nuclear holocaust.

Carving began as a hobby for Cartledge when he was a boy growing up in the Georgia communities of Canon and Austell. He attended public schools in Atlanta, completed one year of law school, then worked for many years for a cotton merchandising firm, later as a cotton broker, and finally as a hardware salesman. Cartledge served in the 89th Chemical Mortar Battalion during World War II and witnessed the horror of a liberated concentration camp at Woebbelin, Germany. His wartime experiences reinforced his social conscience, but it was not until the mid-1960s and his development of opposition to the war in Vietnam that Cartledge began to focus on political themes. In *Uncle Samson* (1966), his first political piece, Uncle Sam is metaphorically represented as destroying the United States.

Most of Cartledge's carvings are bas-relief and painted in acrylics or oils. He carved in various types of wood, depending on their availability, but preferred pine, poplar, and basswood. He also created some sculptural works as well as paintings. The American flag, Uncle Sam, doves, and bulls are recurrent motifs in Cartledge's work, and he often used text or descriptive titles to enhance his visual commentary. In *One of Our Leading Economic Indicators* (1982), in which Cartledge portrays a homeless man wrapped in *The Wall Street Journal* while lying on the sidewalk facing an empty brick wall, he points out the social inequities among people. In one of his most controversial carvings, *Garden of Eden* (1979), Cartledge shows a naked couple expelled by a black female God who is wearing a Star of David necklace. Paradise is framed by a white picket fence, and a television set with a Coca-Cola logo on the screen is centrally positioned. Eight one-man exhibitions of Cartledge's work were organized: in 1979, 1985, 1987, 1988, 1989, 1991–1992, 1993, and 1994.

See also **Sculpture, Folk.**

BIBLIOGRAPHY

Cartledge, Ned, and Robert F. Westervelt. *Ned Cartledge*. Atlanta, Ga., 1986.
Muller Joan. *Under the Cloak of Justice: The Work of Ned Cartledge*. Richmond, Va., 1994.
———. "Ned Cartledge: Under the Cloak of Justice." *Folk Art Messenger*, vol. 7, no. 1 (fall 1993): 10–11.

LEE KOGAN

CARVING: *SEE* CONSUELO GONZALEZ AMEZCUA; JOHN HALEY BELLAMY; RAYMOND COINS; JIM COLCLOUGH; CUSHING & WHITE; WILLIAM EDMONDSON; FREDERICK FIELD; GRAVESTONE CARVING; JEWISH FOLK ART; HENRY LEACH; SAMUEL MCINTIRE; CARL MCKENZIE; LEWIS MILLER; JOHN STEVENS; OLD STONE CARVER; WILLIAM RUSH; WOODENWARE.

CASTLE, JAMES (1899–1977) produced drawings, constructions, and handmade books that are representations of the world he inhabited in rural Garden Valley, near Boise, Idaho, throughout his life. Born deaf and mute, Castle's prodigious art output was both a personal statement and a way of communicating with others. Executing his works with charcoal and saliva while using sharpened sticks as brushes, Castle also employed a variety of other materials, such as scraps of butcher paper and wrapping paper, postal forms, and cardboard to draw on. He used string, thread, and yarn for tying his constructions and binding his books. Even after his work was "discovered" in the 1950s, Castle resisted the use of traditional art supplies, preferring instead recycled materials. The artist treated all his subjects with eloquence and grace, sometimes using colored tissue paper, which he ground to a pulp and mixed with saliva or water, to provide color to the images in his work, such as doorways, houses, and barns, as well as everyday objects, like beds, dressers, doorknobs, shelves of dishes, chairs, and articles of clothing. Various interiors are presented as seen through doorways, and this perspective lends intimacy to Castle's subjects. His people-free interiors and details are subdued and tranquil. But Castle also invented a series of geometric, blocky people for some of his artwork, companions clearly derived from his active imagination.

Castle never learned sign language nor to read and write. At home, a rudimentary hand-signing system was devised for communication. At age twelve, his parents sent him and his deaf sister to a school for the hearing-impaired in Gooding, Idaho, where he remained for less than a year. He was unmotivated, and was discharged as "non-educable." Castle's interest in art, however, was consistent throughout his life. He further developed his own art over the years, and his drawings indicate that he eventually understood perspective, vanishing points, horizon lines, and the effects of shading. Early works, according to scholar Tom Truskey, were stashed away in the family icehouse that served as his studio. Small thematic bound books were filled through the years with references to numbers, letters, postage stamps, dates, advertising logos, and other printed material. Castle also pro-

Man at a Stove; James Castle; Date unknown. Mixed media including graphite and saliva on paper. © Collection American Folk Art Museum, New York.
Photo courtesy Dr. Kurt Gitter and Alice Yelen, New Orleans, Louisiana.

duced such highly prized constructions as a carefully rendered shirt with folded back collar and buttons, and a stitched and colored abstraction on cardboard.

Castle's nephew Ron Beach, a graphic designer, brought his work to the attention of art professors and gallery owners in Portland, Oregon. In the 1950s, exhibitions in art galleries in the Northwest established a reputation for the artist, but friction developed between his family and gallery owners, collectors, and museum professionals. The public reception of Castle's work at the Outsider Art Fair of 1997 in New York, however, firmly established him as a major twentieth-century artist.

See also **Outsider Art.**

BIBLIOGRAPHY

Butler, Cornelia. *A Silent Voice: Drawings and Constructions of James Castle.* Philadelphia, 1998.
Cory, Jeff. "Images in a Silent World: The Art of James Castle." *The Outsider,* vol. 1, no. 2 (1996).
Gamblin, Noriko. *James Castle, 1900–1977.* Boise, Idaho, 1999.
Tobler, Jay. *James Castle: House Drawings.* New York, 2000.
Trusky, Tom. "Found and Profound: The Art of James Castle," *Folk Art,* vol. 24, no. 4 (winter 1999/2000): 39–47.
———. "James Castle and the Burden of Art." *Raw Vision,* no. 23, (summer 1998): 38–44.
Yau, John. *James Castle: The Common Place.* New York, 2000.

LEE KOGAN

CERAMICS: *SEE* POTTERY, FOLK.

CHAIRS are seating furniture for one person, composed of a horizontal surface, or seat, resting on legs, with a vertical element, or back, rising from the rear edge. Designated as side chairs or armchairs, chairs

are further characterized with names associated with their style, the shape of the back, function, maker, or original owner, for instance, the Chippendale side chair, the shield-back chair, the rocking chair, the Hitchcock chair, and the Brewster chair. As American folk art, chairs are part of the country or vernacular furniture tradition, that is, furniture generally produced by rural cabinetmakers or chair manufactories, characterized by a conservative interpretation of high-style counterparts, creative surface decoration, and idiosyncratic methods of construction.

The earliest American-made chairs can be traced to seventeenth-century English models, dating from 1640 to 1690. The most common forms of seating furniture of this period are oak forms or joint stools composed of plank seats supported by turned legs, with no back. Rectilinear and sturdy joined and turned great chairs were rare, usually reserved for senior members of the family or important guests. Other early chairs include spindle-back, slat-back, and Turkeywork chairs. Mannerist or William and Mary–style (1690–1730) country chairs are lighter, more vertical, with carved crest rails and turned stiles supported by spiral or columnar legs, often ending in Spanish feet. Seats and backs are sometimes made of cane, rush, or leather, and country furniture forms are commonly painted or stained, to mask the use of several woods and to imitate the more expensive walnut and maple urban styles.

Most surviving country furniture dates from the Baroque or Queen Anne (1725–1750) period, with chairs characterized by their cabriole legs, yoke-shaped top rails, solid vase-shaped back splats, horseshoe-shaped seats, and painted or stained surface treatments. The rococo or Chippendale style (1750–1780) was also adopted by country cabinetmakers, as seen in the distinctive furniture produced by the Dunlap family (active 1760s–1860s) of cabinetmakers of New Hampshire. A surviving blue-green painted side chair, with a yoke-shaped cresting rail with exaggerated ends, vase-shaped splat with pierced scroll, heart and diamond, straight-molded front legs, and a rectangular seat bearing its original needlework upholstery evinces knowledge of Chippendale styling, for example. Attributed to Major John Dunlap (1746–1792), the progenitor of the Dunlap family of furniture makers, this side chair exemplifies the creative adaptation of high-style furniture to conform to local conservative tastes. Cabinetmakers in other isolated communities retained elements of eighteenth-century chair forms well into the nineteenth century, including chairs produced by the Dominy family in East Hampton, New York, as well as chair

makers along the Hudson River Valley and the Connecticut River Valley.

The most durable, comfortable, and economical of American vernacular seating forms are Windsor chairs, first produced in Philadelphia as early as 1720. American chair makers adopted the British Windsor form into a vast array of distinctive variations throughout the nineteenth century. Characterized by stick legs and spindles driven into plank seats, Windsors were constructed using a number of types of wood, and painted to unify and protect the surface. While early Windsors were painted green, later chairs were painted in shades of yellow, from a pale to a rich golden color; painted black; and stained and faux grained in red, to simulate the mahogany versions found in countless nineteenth-century portraits of sitters posed in Windsor chairs. Modified and adopted by both urban and rural manufactories, Windsor chair variations are characterized by their own vocabulary of turned elements and regional characteristics.

During the opening decade of the nineteenth century, delicately fashioned and elegantly painted English-style chairs became popular in America. The period name, "Fancy chairs," referred to their decoratively painted surfaces. Fancy chairs were painted in fancy colors (poppy, green, yellow, cream, white, and black) and were decorated in a specific vocabulary of neoclassical motifs: musical trophies, clusters of shells, scrolling vines, and foliated vines, urns, cornucopia, and eagles, and were painted to simulate bamboo. While the most innovative of fancy chairs were produced by the Boston chair maker Samuel Gragg (1772–1855), the leading fancy-chair maker was the Baltimore firm of John (active 1799–1840) and Hugh (active 1803–1831) Finlay. Characterized by a distinctive vocabulary of hand-painted decorative motifs (landscapes, saw-tooth banding, bows and arrows, winged thunderbolts, anthemia, eagles within wreaths with copper-colored gilt highlights) the Finlay Brothers' fancy furniture was emulated by chair makers in Philadelphia and New York, and adopted by furniture manufactories throughout New England, Pennsylvania, and later in Ohio and St. Louis.

Responding to the popularity of high-style, Federal era fancy chairs, Windsor chair makers produced spindle-back chairs with wide top rails or overhanging tablet tops, U-shaped seats, and vertical, tapered legs. They painted these surfaces in a rich array of ornamentation drawn for the American fancy-chair vocabulary: freehand-painted bouquets of flowers, shells, cornucopia, bowknots, landscapes, and eagles, on grounds of bright yellow, white, vermilion, green, blue, or grained in imitation of rosewood and

mahogany. The Empire or Grecian style (1815–1840), with its profusion of brass mounts on richly grained rosewood and mahogany veneers, inspired chairs grained in imitation of rosewood and overlaid with stencil-drawn motifs, as well as gold and metallic powders. Lambert Hitchcock (1795–1852), founder of the Hitchcock Chair Company in 1829, produced the best known of the bronze-stenciled chairs, combining elements of the fancy chairs and Windsor chairs at less than half the cost.

Within the rural furniture tradition are chairs hand-fashioned by waves of immigrants re-creating furniture forms and decoration drawn from the vernacular traditions of Germany, Scandinavia, Spain, and France. First-generation settlers of the Old Northwest Territory, Utah, and California used basic woodworking skills to fashion temporary seating furniture from native woods. The beliefs that shaped the lives of the Shaker communities in Maine, New Hampshire, New York, Kentucky, and elsewhere had an important impact on the design, function, and finish of the simple ladder-back chairs, with caned or woven worsted-wool taped seats produced in these utopian communities. Amateur carvers produced chairs for dolls and dollhouses, while countless chairs were altered by the addition of handcrafted rockers, layers of new paint, repaired legs, and stylized upholstered cushions. These idiosyncratic chairs resonate with their historic past, and in rare examples convey an overall dynamic sculptural expression that transcends their original use. Throughout the nineteenth century decorative painters were commissioned to ornament chairs, by depicting local landscapes, symbolic motifs of fraternal organizations, or emblems of colleges and professional organizations. These uniquely decorated chairs reinforce craft traditions, the art of the amateur, and the innate ability to produce something of lasting value.

See also **Decoration; Furniture, Painted and Decorated; Miniatures; Painting, American Folk; Painting, Landscape; Shakers; Shaker Furniture.**

BIBLIOGRAPHY

Baron, Donna Keith. "Furniture Makers and Retailers in Worcester County, Massachusetts, Working to 1850," *The Magazine Antiques*, vol. 143, no. 5 (May 1993): 784–794.

Evans, Nancy Goyne. *American Windsor Chairs*. New York, 1996.

Fales, Dean A. *American Painted Furniture, 1660–1880*. New York, 1972.

Kane, Patricia E. *Three Hundred Years of American Seating Furniture*. Boston, 1976.

Lea, Zilla Rider, ed. *The Ornamented Chair: Its Development in America, 1700–1890*. Rutland, Vt., 1960.

Schaffner, Cynthia V.A., and Susan Klein. *American Painted Furniture, 1790–1880*. New York, 1997.

Weidman, Gregory R. "The Painted Furniture of John and Hugh Finlay." *The Magazine Antiques*, vol. 143, no. 5 (May 1993): 744–755.

———. *Furniture in Maryland, 1740–1940: The Collection of the Maryland Historical Society*. Baltimore, 1984.

CYNTHIA VAN ALLEN SCHAFFNER

CHALKWARE were figurines, often called the poor man's Staffordshire, which first appeared in Europe in the early 1700s and that were, by 1768, being advertised in New York and Boston newspapers. Cast in molds, they were made of gypsum, a mineral that was ground to a powder, baked to remove all moisture, and then mixed with water to create castable slurry. Produced in multiples, the figurines were distinguished by their oil-painted decoration. Each piece differed in coloration, reflecting the tastes of the artist-decorator.

Inspiration for these highly individualistic pieces came from the earthenware mantelpiece decorations made in England during the eighteenth and early nineteenth centuries. Featuring animals, flowers, and, particularly, historical or romantic figures, and produced primarily in the Staffordshire region, these ceramics were as popular in the United States as they were in England. Such pottery was sufficiently expensive, however, to justify a cheaper substitute. By the mid-nineteenth century, itinerant vendors, often Italian by origin, were traveling American country roads while bearing upon their back a variety of chalkware copies of the Staffordshire forms. As these copies cost a fraction of what one might pay for a similar example in earthenware, they found a ready market.

The great variety of nineteenth-century chalkware forms fall into several broad categories. Animals, particularly dogs (the English spaniel was especially popular), as well as cats, deer, rabbits, squirrels, and birds, such as doves or chickens, were common forms. Human figures were seen less often. Heroic figures, ranging from an equestrian George Washington to a noble fireman, were balanced by figures of such popular entertainers as the singer Jenny Lind. Among the inanimate subjects could be found fruit compotes, baskets of flowers, churches, and watch stands, or "hutches," in the shape of castles or bearing religious themes.

All these items, however, had a common characteristic—they were hollow. While the chalkware tradition continued into the twentieth century, the figures themselves changed. About 1890, larger shops began making solid cast figurines that were sold to carnivals and circuses to be offered as prizes at games of chance. Incorporating traditional forms while adding twentieth-century icons, such as Betty Boop and

Popeye, this latter-day chalkware offers a different slant on an old tradition.

See also **Pottery, Folk.**

BIBLIOGRAPHY

Feldman, Suzanne, and Rowenna Pounds. "The Chalk Menagerie." *The Clarion* (spring 1982): 30–35.
Robacker, Earl F. *Pennsylvania Dutch Stuff*. Philadelphia, 1944.
Stoudt, John Joseph. *Pennsylvania German Folk Art*. Allentown, Pa., 1966.

WILLIAM C. KETCHUM

CHAMBERS, THOMAS (1807–c. 1865) produced some of the most lively and decorative folk renditions of Hudson River School landscape painting in nineteenth-century America. Chambers was born in London but immigrated to New Orleans, where he filed a Declaration of Intention to become a citizen in 1832. He is listed as a painter in that city in 1834, then specifically as a landscape and marine painter in New York City from 1834 to 1840. Chambers lived in Boston from 1843 to 1851, then in Albany, New York, from 1851 to 1857, with a possible sojourn in Boston from 1860 to 1861.

Chambers' body of work, numbering sixty-five oil-on-canvas paintings, includes a large number of stylized landscapes derived from published prints. One of Chambers' favorite sources was the work of Englishman William Henry Bartlett, whose engraved landscapes were published in Nathaniel Parker Willis's *American Scenery* in 1840. Other subjects painted by Chambers include marine paintings depicting different types of sailing vessels in various harbors. In rendering scenery based on academic art sources, Chambers enlivened well-known images with bold color and a lively sense of visual rhythm. His *View of Cold Spring and Mount Taurus from Fort Putnam* (c. 1850) is one such landscape that exploits quintessen-

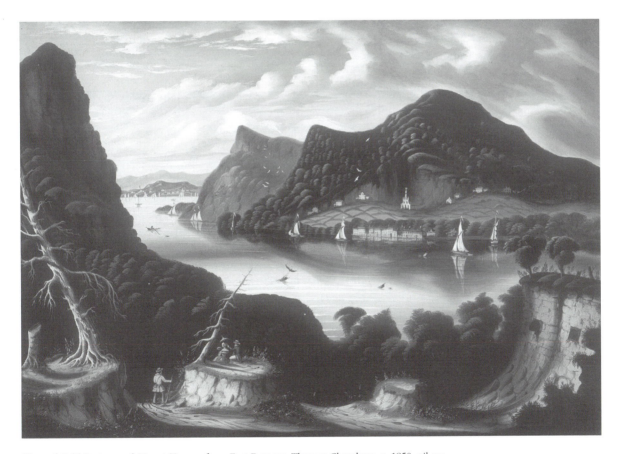

View of Cold Spring and Mount Taurus from Fort Putnam; Thomas Chambers; c. 1850. oil on canvas. framed size: 58 × 42⅝ inches; N-11.99. Collection Fenimore Art Museum, Cooperstown, New York. © New York State Historical Association, Cooperstown, New York. Photo courtesy John Bigelow Taylor, New York City.

tial compositional devices from Hudson River Landscape artists such as Asher B. Durand in combination with quirky and often exuberantly expressive embellishments such as birds, contemporary houses and figures.

See also **Maritime Folk Art; Painting, American Folk.**

BIBLIOGRAPHY

Chotner, Deborah, et al. *American Naive Paintings.* Washington, D.C., 1992.

Rumford, Beatrix T., ed. *American Folk Paintings: Paintings and Drawings Other Than Portraits from the Abby Aldrich Rockefeller Folk Art Center.* Boston, 1988.

PAUL S. D'AMBROSIO

CHANDLER, JOSEPH GOODHUE (1813–1884) had a successful portrait-painting career in both rural and urban New England. He is also one of the few folk painters of his era who collaborated artistically with his spouse. Chandler was born in South Hadley, Massachusetts, and was trained as a cabinetmaker before traveling to Albany, New York, to study painting under William Collins. His earliest known portraits date from about 1837, just prior to his taking over the family farm after his father's death in 1838, and his marriage in 1840 to the artist Lucretia Ann White. From 1840 to 1852 Chandler traveled around northwestern Massachusetts as an itinerant portrait painter working in oil on canvas. He is also known to have painted still-lifes, street scenes, and landscapes. In 1852 Chandler and his wife set up a studio in Boston, where they frequently collaborated on portraits, with Lucretia supplying the finishing touches. Chandler's body of work reveals two distinct styles: flat and linear on the one hand, and naturalistic on the other. His full-length portraits of children are his most engaging. In 1860 Chandler and his wife moved to Hubbardston, Massachusetts, where they purchased a farm. Chandler died there in 1884.

See also **Painting, American Folk; Painting, Landscape; Painting, Still-life.**

BIBLIOGRAPHY

Chotner, Deborah, et al. *American Naive Paintings.* Washington, D.C., 1992.

D'Ambrosio, Paul S., and Charlotte Emans. *Folk Art's Many Faces: Portraits in the New York State Historical Association.* Cooperstown, N.Y., 1987.

Keefe, John W. "Joseph Goodhue Chandler (1813–1884), Itinerant Painter of the Connecticut River Valley." *The Magazine Antiques,* vol. 102 (November 1972): 848–854.

PAUL S. D'AMBROSIO

CHANDLER, WINTHROP (1747–1790) was a portrait painter who was born on his family's farm on Chandler Hill, near the border of Woodstock and Thompson, Connecticut. After his parents died, he chose his brother-in-law as his guardian. Chandler's whereabouts from 1762 until 1769 are unknown. A nineteenth-century historian wrote that Chandler studied portrait painting in Boston. While this has not been corroborated, Chandler probably received some professional training before he reappeared in Woodstock in 1770, possessing the skills to paint his earliest known portraits.

Besides portraiture and landscape painting, Chandler also practiced house painting, ornamental painting, carving, and gilding. His self-portrait from 1770–1775 is a confidently drawn, bust-length likeness, with strong lighting adding depth to the well-modeled face, while the entire image is surrounded by a painted spandrel. The self-assured likeness of this young artist showed his ability to paint in an academic manner, and may indicate Boston influence as well.

Chandler's extended family, friends, and acquaintances in Connecticut and Massachusetts comprised his clientele. The artist's earliest known works, portraits of Rev. Ebenezer Devotion and Martha Devotion of Scotland, Connecticut, dating from 1770, introduced elements that would become hallmarks of his style. Large canvases often allowed Chandler to depict his sitters full-length. His predilection for showing subjects seated in rooms, with piercing gazes, and with considerable attention devoted to backgrounds, elaborately patterned costumes, and impressive draperies are also evident. The Devotions, along with the other ministers, judges, physicians, and landowners that Chandler painted, were prominent people whose rococo chairs, tilt-top tables, and libraries manifested their prosperity and refinement, while their likenesses exude their confidence and pride in their place in rural society.

One landscape easel painting by Chandler is known, in addition to eight landscape overmantel paintings. Several of the latter depict imaginary views, while others were based, to some extent, on prints. His bright colors and stylized houses and trees display the sure hand of an experienced ornamental painter.

Chandler married, and purchased additional land on Chandler Hill in 1772. His family would grow to include seven children, but by 1775 financial difficulties arose that would plague him for the remainder of his life. He moved to Worcester, Massachusetts, in 1785, where he painted houses. After the death of his wife in 1789, Winthrop Chandler returned to Wood-

stock, where he died at age forty-three, leaving behind an artistic legacy that would await rediscovery and acknowledgment as the work of a provincial master.

See also **Fireboards and Overmantels; Painting, American Folk; Painting, Landscape.**

BIBLIOGRAPHY

Chotner, Deborah, et al. *American Naive Paintings.* Washington, D.C., 1992.
Lipman, Jean, and Tom Armstrong, eds. *American Folk Painters of Three Centuries.* New York, 1980.

RICHARD MILLER

CHARLESTOWN CARVER: *SEE* OLD STONE CARVER.

CHERNY, SALVATORE (Cernigliaro) (1879–1974) used his furniture-carving skills and talents to become a carousel maker. He learned the crafts of furniture carving and cabinetmaking from master craftsmen in Palermo, Italy, where he was born. His interests lay beyond the shores of Italy, however, and at the age of twenty-three, despite suffering from acute seasickness, he ventured across the Atlantic to America.

He found a job at the E. Joy Morris Carousel Company in Philadelphia, where he was able to transfer his knowledge and talents in furniture carving to carousel making. Unfortunately, Cherny joined the company only a few months before it was sold, so he soon lost his job. Several months passed before he entered the gate of Gustav Dentzel's (1846–1909) prosperous carousel company. Using the only English words he knew, Cherny asked Dentzel for a job as a carver in his factory. Interpreting Dentzel's gruff response to mean no, Cherny walked away disappointed, only to find out a week later that he had actually been offered a job. While working for Dentzel, Cherny contributed flamboyant Baroque relief carvings to many of the outside rows of carousel figures. His carvings of flowing ribbons, Ruben-esque cherubs, and dancing clowns are readily identifiable.

Cherny kept busy carving carousel figures for the next sixty-five years. When business was slow at the Dentzel company, Cherny could be found working for two other carousel companies, the Philadelphia Toboggan Company or Daniel Müller (1872–1951). During World War I, when carousel production was limited, he was occupied with the precision carving of hundreds of airplane propellers. After 1930, he moved to California and used his talents to train others in art and woodcarving.

See also **Carousel Art; Gustav Dentzel; Daniel Müller; Sculpture, Folk.**

BIBLIOGRAPHY

Dinger, Charlotte. *Art of the Carousel.* Green Village, N.J., 1983.
Fraley, Tobin. *The Carousel Animal.* San Francisco, 1983.
———. *The Great American Carousel.* San Francisco, 1994.
Fried, Frederick. *A Pictorial History of the Carousel.* Vestal, N.Y., 1964.
Mangels, William F. *Outdoor Amusement Industry.* New York, 1952.
McCullough, Edo. *Good Old Coney Island.* New York, 1957.
Stevens, Marianne. *Painted Ponies.* New York, 1986.
Summit, Roland. *Carousels of Coney Island.* Rolling Hills, Calif., 1970.
Weedon, Geoff. *Fairground Art.* New York, 1981.

TOBIN FRALEY

CHRISTENSEN, CARL CHRISTIAN ANTON (1831–1912) recorded the story of the founding of the Mormon faith and the Mormon trek west to Utah's Salt Lake Valley in a series of large paintings that he began in 1869, twelve years after he participated in the great migration himself. Born in Copenhagen, Christensen joined the Church of Jesus Christ of Latter-day Saints, as the Mormon faith is formally known, while he still resided in Denmark. He pushed a two-wheeled cart 1,300 miles from Iowa to the Salt Lake Valley in 1857 as a member of one of the pioneering Mormon "handcart companies." He was a missionary, journalist, and historian as well as an artist.

Christensen's most ambitious work was his Mormon panorama, a series of 22 tempera paintings on canvas that he completed in 1890. Measuring as many as 8-by-10 feet each, these paintings were sewn together, then rolled onto a large wooden rod. The artist used the panorama to illustrate his public lectures about Mormon Church history, beginning with the revelation in 1827 of the golden tablets of the Book of Mormon to Joseph Smith, and culminating in the arrival in 1847 of the Mormons under Brigham Young in the Salt Lake Valley. As Christensen spoke to his audiences, his panorama would be unrolled and displayed by lamplight.

While still in Denmark, Christensen received some training at Copenhagen's Royal Academy of Art, but his work has less in common with the formal traditions of academic art than with the direct, stylized aesthetic and narrative spirit of folk painting. His well-composed paintings take full advantage of the dramatic qualities of the Mormon story. Each image provides a detailed and colorful visual account of an important incident in the history of the church: the murder of Smith in Carthage, Illinois, in 1844; the burning of the temple in Nauvoo, Illinois, in 1848; and

the miraculous deliverance of the Saints as they moved westward to Utah.

In addition to his panorama, Christensen painted individual studies of events in Mormon history, generally using oil paint on canvas. He is also responsible for the "creation" murals in the temple in Manti, Utah. An honored member of his church, Christensen died in Ephraim, Utah.

See also **Painting, American Folk; Religious Folk Art.**

BIBLIOGRAPHY

Bishop, Robert. *Folk Painters of America.* New York, 1979.

Oman, Richard G., and Robert O. Davis. *Images of Faith: Art of the Latter-Day Saints.* Salt Lake City, Utah, 1995.

Wheelwright, Loren F., ed. *Mormon Arts.* Provo, Utah, 1972.

GERARD C. WERTKIN

CHRISTENSON, LARS (1839–1910) was one of the most distinguished of the Norwegian-American woodcarvers of the upper Midwest. His work drew on the traditions of Norwegian folk art while demonstrating significant American influence and individuality. Christenson was born in Sogndal in the fjord country of western Norway, and emigrated to the United States in 1864, just as the great wave of mass immigration of Norwegians to America was beginning to build. First settling in Iowa, he moved in 1866 to Swift County, Minnesota, at that time a remote and rural area in the western part of the state. This region, where Christenson lived for the rest of his life, remained undeveloped until the railroad arrived in 1870 and the small community of Benson was established. Norwegians were among the first white settlers in Benson.

As in the case of other immigrant Norwegian woodcarvers, Christenson, a farmer and butcher, did not carve as a means of livelihood, although he made furniture for members of his family. Vesterheim Norwegian American Museum, in Decorah, Iowa, owns two handsome cupboards by Christenson, the only examples of his furniture known to be extant. One of them, a bow-front corner cupboard in pine and elm from about 1890, draws upon the traditional acanthus-based designs of Norwegian folk art but in a freer, more individualistic style.

Christenson's masterwork is undoubtedly the great altarpiece that he carved between 1897 and 1904 for his church in Benson. Now installed in a chapel-like setting at Vesterheim, the impressive reredos, is animated by the use of woods of contrasting hues, including natural maple, oak, pine, and walnut, among

others. The central panel of the altarpiece contains a highly stylized and moving representation of the crucified Christ at Calvary; other panels depict the Last Supper, the Risen Christ, and other biblical themes, with ornately carved texts in Norwegian as well as vines with fruit and floral motifs. Commenting on Christenson's freedom from strict Norwegian precedent, Marion Nelson—who wrote extensively about the artist and his altar—observed that the most notable features of his work are "the grandeur and originality of his decorative and symbolic schemes and the quaint but expressive doll-like qualities of his figures." Christenson "possesses a creativity of such dimensions," Nelson wrote, "that tradition, though present, seems insignificant."

See also **Religious Folk Art; Scandinavian American Folk Art; Sculpture, Folk.**

BIBLIOGRAPHY

Henning, Darrell D., Marion J. Nelson, and Roger L. Welsch. *Norwegian-American Woodcarving of the Upper Midwest.* Decorah, Iowa, 1978.

Nelson, Marion J. "A Pioneer Artist and His Masterpiece." *Norwegian American Studies,* vol. 22 (1965): 3–17.

GERARD C. WERTKIN

CHRISTMAS DECORATIONS, Christmas tree ornaments, and other decorations associated with this holiday are by far the most popular category of holiday folk art. Ranging from delicate blown-glass ornaments to candy containers, table favors, costumes, toys, and various lighting devices, they offer an insight into changing social mores.

Though celebrated among Christians to mark the birth of Christ, the religious holiday has pagan origins in the Mithraic observances of the "sun's birth" at the winter solstice and the Roman festival of Saturnalia. Moreover, the secular aspects of the day have long been dominant, from the medieval Christmastide revels with their bawdy "Lord of Misrule" to today's commercial extravaganza embraced by millions of non-Christians (the holiday is celebrated with particular enthusiasm in Japan).

The shift from religious to secular is evidenced in the history of St. Nicholas, or Santa Claus. The historic figure, a fourth-century nobleman who gave everything he had to the poor, has been transformed into a fat, jolly elf whose figure dominates the ornament market. Hand-carved or molded of papier-mâché and individually painted, Santa Claus candy containers and table decorations were first made in Germany during the mid-nineteenth century. By the 1920s

American and Japanese manufacturers had entered the field.

The earlier and more desirable figures are clad in long blue, green, or purple robes, and appear shockingly undernourished, with thin, aesthetic faces. Nor do they bear presents, carrying instead a Christmas tree and a bunch of holly or shepherd's crook. It was not until the late 1800s that the contemporary overstuffed fellow, bearing a bag of gifts and clad in red jacket and pants, appeared.

Tree ornaments of blown glass or other materials are the most popular Christmas folk art. The earliest glass bulbs, called "Kuglen," were made in Germany about 1820. These large (up to 8 inches in diameter) silver, blue, red, or green balls may still be found, but by 1860, German glassmakers had introduced a new form that was light as a feather and paper-thin. These delicate decorations gave free range to the glassblower's creativity, and myriad types were produced. There were, of course, plain, round balls along with lots of Santa Claus figures, but there were also thousands of unusual and surprising figures.

Every imaginable animal appeared in glass, as did popular figures, from Admiral George Dewey to Charlie Chaplin. Fruits and vegetables, flowers, and even insects were also popular types. Ornaments in the form of houses were rather mundane, but vehicles were highly elaborate. Pre-1900 ornaments in the shape of carriages and balloons were later replaced by a variety of airplanes, zeppelins, ships, and even World War I tanks. Musical instruments (including horns that could be blown), clocks, lamps, purses, pistols, and even exercise "dumbbells" also graced the family tree.

Not all ornaments were made of blown glass, however. Die-cut cardboard decorations called "Dresden" after their place of manufacture were made in Germany from about 1880 to 1910. Usually painted silver or gold, and generally in the form of animals, vehicles, or musical instruments, these fragile pieces are hard to find. Much the same is true for the wax angels with spun-glass wings that graced the top of so many late-nineteenth-century trees. Their vulnerability to high temperatures has assured that few survive.

Other materials have fared better over the years. Brightly colored fruits and vegetables and figures made from rolled-cotton batting can be found in some number. These figures, ranging from Santa to a man riding an elephant, usually have glued-on, printed paper faces. Plainer examples were sold in 1912 for thirty to seventy-five cents a dozen. Carved and painted wooden ornaments are still made, while examples cut from satin cloth and stuffed with cotton are less common. A few ornaments were manufactured in metal, chiefly lead or tin.

See also **Holidays.**

BIBLIOGRAPHY

Brenner, Robert. *Christmas Past.* Atglen, Pa., 1996.

Ketchum, William C. *Holiday Ornaments and Antiques.* New York, 1990.

Schiffer, Margaret. *Holiday Toys and Decorations.* West Chester, Pa., 1985.

WILLIAM C. KETCHUM

CHURCH, HENRY, JR. (1836–1908) was an Ohio blacksmith, musician, woodsman, self-taught painter, and sculptor. Born in Chagrin Falls, Ohio, a new settlement on the Western Reserve, the artist acquired as a boy attitudes that were to inform his adult work. Judged too sickly to attend school, he roamed the woods, developing a sense of autonomy, a love of nature, and respect for Native American traditions. Apprenticed at thirteen in his father's blacksmith shop, the young man learned his trade well, but the work did not satisfy his intellectual or artistic yearnings. Among the ideas he explored was spiritualism and its belief that the spirits of the dead are accessible to the living.

Through painting and sculpture Church gave his philosophical notions material form. On a massive block of sandstone jutting into a river, he carved a Native American woman surrounded by symbols of the American state and Iroquois artifacts. Beneath her is a skeleton. He called the work *Rape of the Indians by the White Man* (1885), and preached to the spirits of the Indians from a pulpit on the riverbank. Living in harmony with nature and at peace with one's neighbors are other themes that recur in Church's work. Intended as a monument for the village square but rejected by the town fathers, *The Lion and Fatling Together* (1888) is a large sandstone sculpture, based on the verse in Isaiah 11:6. Another sculpture, *A Friend in Need Is a Friend Indeed* (1885), shows a sheepdog fearlessly attacking a wild animal that threatens his master. In Church's hands Benjamin Franklin's cynical aphorism becomes a statement about loyalty. Animals are also featured in many of Church's paintings. Best known is *The Monkey Picture* (c. 1885–1890), a spoof of a still-life painting in which two monkeys escape their cage and run amok on a staid Victorian dining table as a policeman, bent on corralling them, appears in the doorway.

Church taught himself to paint by reading manuals, copying works of established artists, and experimenting with a variety of media. He showed considerable

resourcefulness, if little success, in attempting to generate income as an artist, and he continued to do so until his death. Church achieved only local renown during his lifetime.

See also **Painting, American Folk; Sculpture, Folk; Visionary Art.**

BIBLIOGRAPHY

Babinsky, Jane E., and Miriam C. Stem. *The Life and Work of Henry Church, Jr.* Chagrin Falls, Ohio, 1984.

Lipman, Jean, and Tom Armstrong, eds. *American Folk Painters of Three Centuries.* New York, 1980.

Robinson, William C., and David Steinberg. *Transformations in Cleveland Art, 1796–1946.* Cleveland, Ohio, 1996.

Studer, Carol Millsom, and Victor Studer. "Henry Church Jr.," in *Self-Taught Artists of the Twentieth Century: An American Anthology,* edited by Elsa Longhauser, et al. New York: Museum of American Folk Art, 1998.

CAROL MILLSOM

CIGAR STORE INDIANS: *SEE* SHOP FIGURES.

CIRCUS ART, folk art related to American circuses, falls into three categories: the parade wagons that were the pride of the circus between 1860 and 1920; the sideshow banner lines that were designed to catch the eye with their often lurid depictions of the anomalies and wonders to be seen inside the sideshow tent; and the exquisitely detailed miniature circuses built by talented fans.

American circuses began adding specially constructed, ornately carved, and often gilded wagons to their street parades after seeing the specimens that Seth B. Howes brought to America from England after 1857. These wagons were said to look like gilded wooden wedding cakes. Howes' American competitors attempted to equal or better these vehicles, touching off a rivalry that would last until 1921, when the automobile made circus street parades impractical.

Most of these wagons, save the bandwagons, served no practical purpose other than ornamentation. Despite that fact, circuses took great pride and spared no expense in the wagons, which they had built for them by such companies as the Bode Wagon Works of Cincinnati; Sullivan & Eagles of Peru, Indiana; Moeller Bros. of Baraboo, Wisconsin (the principal builders for the Ringling brothers); the Sebastian Wagon Works of New York; and the Beggs Wagon Co. of Kansas City, Missouri.

Many outstanding examples of their art can be found today in the collection of the Circus World Museum, which holds the largest collection of restored circus vehicles in the world. Among them are the Twin Lions, a telescoping tableau wagon that originated in England (more than a century old, it stands higher than seventeen feet, is fourteen feet long, and weighs 7,400 pounds); the Lion and Mirror Bandwagon, built for Ringling Bros. in 1890; the France Bandwagon; the Pawnee Bill Wild West Show's Bandwagon, depicting Columbus landing in the New World on one side and the rescue of Pocahontas by John Smith on the other; the Ringling Bell Wagon; the Swan Bandwagon; the Asia Tableau Wagon; the Gladiator Telescoping Tableau Wagon; the Five Graces Bandwagon; and John Zweifel's Two Hemisphere Bandwagon, this last one being the only privately owned wagon known to exist today (it is also the largest of the surviving bandwagons, measuring more than twenty-eight feet in length).

Another art unique to the circus is the sideshow banner line. These displays could be extensive; one turn-of-the-century display ran 216 feet, made up of eighteen double-decker banners. Because these banners—painted on whitewashed canvas with an oil-based paint—were lashed to poles, subjected to the weather, and repeatedly folded and stored for transportation, few of those produced during the first half of the twentieth century survive.

The earliest suppliers were companies such as Tucker Bros. in New York City and J. Bruce in Williamsburg, Brooklyn. By the 1890s Hafner Bros. of Philadelphia was advertising itself as the largest supplier of sideshow banners in America. In the first decades of the twentieth century, the Neuman Tent Co. of Chicago and Charles Driver and Co., also of Chicago, featured the work of Fred Johnson, distinguished by its detail and depth of field. They offered new and recycled banners to the trade. Those still working in this form include Johnny Meah, Fred Johnson's grandson Randy, and John Hartley.

The circus has inspired artists of all kinds to capture the magic of this fabulous world of sawdust and canvas. Some have taken to building their own circuses in miniature, in scales varying from the standard, approximately ⅛ inch to a foot, to the much larger, of one inch to a foot. They are authentic and exacting in detail, built from photographs, painstakingly acquired firsthand measurements, and blueprints of the original equipment.

The work of these model builders falls into several categories: the carving and painting of figures, both human and animal, and the building and painting of the wagons and equipment. The carved figures are often augmented by those purchased from specialty manufacturers, usually found in Europe. The model builders also purchase carved figures that they have had specially made for their collections to match the scale of their wagons.

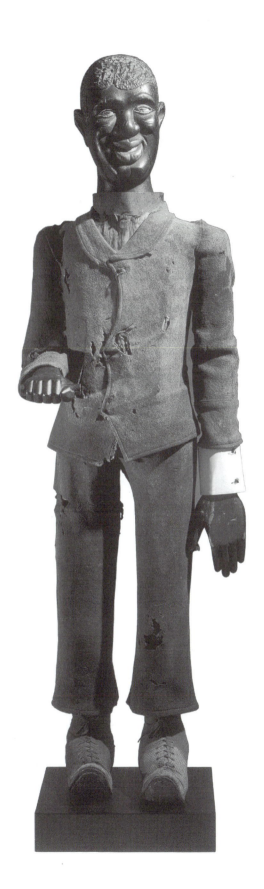

Circus or carousel figure carved by the Herschell-Spillman Company of North Tonawanda, New York; 1905. Carved and polychromed painted wood, metal, and wool felt. 49 inches high.
Photo courtesy Allan Katz, Americana, Woodbridge, Connecticut.

Outstanding model builders of the past include Robert Clarke and William Donahue, both from Connecticut, who worked in a scale of one inch to a foot, and Harold Dunn of Florida. Howard Tibbals of Oneida, Tennessee, has worked on his model since the late 1950s, and it has grown into the largest circus model in America. Built to a scale of ¾ inch to a foot, the model, when completely assembled, requires about 3,500 square feet of table space to accommodate its tents, rail yard, animals, and 140 wagons. So authentic is his circus model that it can be broken down and stored in the wagons, just like its full-scale inspiration, the Ringling Bros. and Barnum & Bailey Circus of the 1920s and 1930s.

The finest model in the smallest scale is the work of Joseph Casper of New York City. One of the carvers most sought after by the model builders was the itinerant Charley Dech.

See also **Miniatures; Sculpture, Folk.**

BIBLIOGRAPHY

Clement, Herbert, and Dominique Jando. *The Great Circus Parade.* Milwaukee, Wisc., 1989.
Fox, Charles Philip, and Tom Parkinson. *The Circus in America.* Waukesha, Wisc., 1969.
Johnson, Randy, Jim Secreto, and Teddy Varndell. *Freaks, Geeks, and Strange Girls.* Honolulu, Hawaii, 1996.
Weedon, Geoff, and Richard Ward. *Fairground Art.* New York, 1985.

ERNEST ALBRECHT

COBB FAMILY, a family of Chesapeake Bay decoy carvers, had its roots in Eastham, on Cape Cod, Massachusetts. Nathan F. Cobb Sr. (1797–1890), who was also called Old Man Nathan, Big Nathan, and The Boss, while married to his first wife, Nancy Doane, had three sons: Nathan Jr. (1825–1905), Warren D. (1833–1903), and Albert F. (1836–1890). Nathan Sr. sailed with his family to the town of Oyster, in Northampton County, Virginia, an area known as the Eastern Shore, in about 1836. Nathan Sr. opened the Yankee General Store and began a salvage business for which, in 1839, he purchased Sand Shore Island, eight miles off the shore of Oyster. He changed the name to Cobb's Island, and his salvage business flour-

ished there as sailing ships ran aground on the waters of the treacherous Cape of Virginia.

Nathan Sr.'s sons and grandsons assisted him in the prosperous salvage business, but they also supplemented their incomes by fishing and hunting for "the market." Waterfowl and fish were sold to passing freighters. The island and its environs was a gathering place for all varieties of waterfowl, such as shorebirds including geese and brant, a type of small, wild goose, which lingered there all through the fall and winter. The Cobb family began to take in paying guests and soon built a hotel, followed by a chapel and domestic servants' quarters, a ballroom, a bowling alley, and a billiard room, on the island. Sportsmen came to the island in the winter to hunt geese and ducks, returned in the spring with their families to hunt shorebirds, and vacationed there in the summer. The Cobb family enterprise flourished, especially after the American Civil War.

Researchers believe that the Cobb men began carving decoys in the 1870s. Both hollow and solid decoys survive, the latter most probably made from ships' spars, used to hold up rigging, salvaged by the family. Decoy historian Henry A. Fleckenstein Jr. has examined many decoys attributed to the Cobb family, though he readily admits, "little is known for sure or can be documented concerning the decoys." Markings on the decoys' bottoms have been the basis of identification by scholars of Cobb family decoys. Identifying marks on the bottom of many Cobb decoys are in the form of carved *N*'s (for Nathan Jr.), carved *E*'s (for Nathan Jr.'s son Elkanah (1852–?), and carved *A*'s (for brother Albert), with or without serifs. Fleckenstein discovered that "only the hollow birds had the good, original *N*'s and *E*'s with serifs," that "none of the solid birds did," and that a few of the solid birds "had plain, small *N*'s without serifs." In addition, for further identification, Fleckenstein noted that the Cobb shorebirds he handled were solid and had initials. Decoy historian William F. Mackey Jr. applauds the "detail work on each decoy, painstakingly performed and calculated to produce the most naturalistic result." He has praised the superb wood selection, as well as the "individual character and pose" of the Cobb or Cobb's Island decoys, which, in general, were made in the New England carving tradition.

See also **Decoys, Waterfowl; Sculpture, Folk.**

BIBLIOGRAPHY

Engers, Joe, ed. *The Great Book of Wildfowl Decoys.* New York, 2001.

Fleckenstein, Henry A. Jr. *Southern Decoys of Virginia and the Carolinas.* Exton, Pa., 1983.

Mackey, William F. Jr. *American Bird Decoys.* New York, 1965.

WILLIAM F. BROOKS JR.

COE, CLARK W. (1847–1919) was well-known to residents of the small town of Killingworth, Connecticut, where he produced his *Killingworth Images.* In 1915 local people regularly visited the folk environment on the cow lot located across the road from 134 Green Hill Road, and enjoyed the ingenious creativity of Coe, a farmer and basket maker skilled in carving ax handles, which he sold in New Haven. Coe's work is significant as being one of the earliest documented folk environments.

About 1900 he built an environment consisting of approximately twenty-two animated, life-size figures with painted faces and simulated hair. They were propelled by waterpower set in motion by a home-made waterwheel at the side of a stream that emptied into the Hammonasset River. The figures, many of them dressed in recycled clothing that became tattered from exposure to the elements, were constructed from bits of wood, barrel staves, basket slats, and the limbs and trunks of trees. Among the forms were a flirting man being beaten by his wife, a mother spanking a small child, a woman tugging at a recalcitrant pig, two wrestlers in combat, and a seated musician sawing away on his string instrument. A Ferris wheel in the center was filled with twenty-two dolls riding in the swinging chairs. Many visitors recalled hearing the moving parts clanking and squeaking day and night through all seasons. Accounts differ as to Coe's motivation for creating his wooden people and animals. Some say he did it to relieve himself of insomnia; others said he created the environment to entertain his two grandchildren; and still others believe it was just a hobby.

When Coe died, he left his personal property to his daughter Minnie Morse, but there was no mention of the wooden figures. The environment eventually went to a Mr. Parmelee, who intended to keep it active. He replaced the torn clothing of the performers and in 1921 installed a contribution box for visitor donations. Mr. Parmelee moved about 1926, and a "No Trespassing" sign was put up on the property, signaling the end for the environment. Some figures were stolen, some fell apart, and the remaining six or seven were stored in the basement of the new owner's house.

In 1964 most of the Killlingworth figures that still existed were exhibited at the Stony Point Folk Art Gallery in Stony Point, New York, and at the Willard

Gallery in New York City. Three of the figures are now part of the permanent collections of the American Folk Art Museum, the Smithsonian American Art Museum, and the Killingworth Historical Society.

See also **Environments, Folk.**

BIBLIOGRAPHY

Smith, Bertram R.A. *Three Town Tales.* Guilford, Conn., 1975.
Stevens, Alfred. "The Images," *Yankee Magazine,* vol. 79 (July 1969): 104–106.

LEE KOGAN

COHOON, HANNAH (1788–1864) was a gifted Shaker artist, but only five drawings from her hand are known to survive. Among these is *The Tree of Life,* which has become emblematic of the Shaker experience in America as the result of its widespread appropriation and popular use during the course of the last fifty years. Unlike many drawings produced by Shaker artists, Cohoon's work is bold and emphatic, dramatically composed, and colored with thick, opaque paint. Her drawings are dated from 1845 through 1856, during the revival period in Shaker history known as the Era of Manifestations or the Era of Mother's Work, when visionary experiences, or "gifts," were features of everyday life in the religious communities. The artist believed that she saw the subjects of her drawings—allegorical trees and a basket of apples—in visions before she carefully planned and executed her work.

Cohoon was born in Williamstown, Massachusetts, and in 1817 entered the Shaker Society at Hancock, near the New York border in northwestern Massachusetts. Her two young children accompanied her. Cohoon's drawings reflect the visual culture of the environment in which she lived before she became a Shaker. Among the apparent influences on her work were popular prints, quilt motifs, and needlework samplers, none of which would have had a place within the spare, communal aesthetic of Shakerism. Cohoon rendered these images in an abstract, stylized manner that invests them with an otherworldly sensibility. Equally important as influences on her work were the written and oral traditions of the church, the recorded testimonies of the Shaker founder, Mother Ann Lee (c. 1736–1784), and other early Shaker leaders, and the experience of the revival period itself. Gift drawings share equivalent symbolic imagery with the gift songs and gift messages that were "received by inspiration" during the Era of Mother's Work.

In 1980 the four drawings by Cohoon that were then known were chosen for inclusion in "American Folk Painters of Three Centuries," an influential exhibition at the Whitney Museum of America Art in New York. Researcher Ruth Wolfe's essay in the accompanying catalog records what little is known about the artist. In 1823, six years after moving to Hancock, Cohoon signed the Church Covenant, signaling her decision to make her home among the Believers for the remainder of her years. Deeply imbued with the faith of the Shakers, she composed wordless "laboring songs," to accompany the Shaker dance or march in worship. Cohoon died at Hancock at the age of seventy-five.

See also **Quilts; Samplers, Needlework; Shaker Drawings; Shakers; Visionary Art.**

BIBLIOGRAPHY

Lipman, Jean, and Tom Armstrong, eds. *American Folk Painters of Three Centuries.* New York, 1980.
Patterson, Daniel W. *Gift Drawing and Gift Song: A Study of Two Forms of Shaker Inspiration.* Sabbathday Lake, Maine, 1983.
Promey, Sally M. *Spiritual Spectacles: Vision and Image in Mid-Nineteenth-Century Shakerism.* Bloomington, Ind., 1993.

GERARD C. WERTKIN

COINS, RAYMOND (1904–1998), a prominent folk carver of the twentieth century, worked most actively in the 1970s and 1980s. He is known for his bas-relief sculptures made from soft, river stone as well as his carvings in the round in stone and wood of animals and human figures. He lived on a small farm near Pilot Mountain, North Carolina, with his wife of more than sixty years, Ruby King. When asked how old he was, Coins would give his age but would always add that Ruby was one year older.

Coins's family, Scottish-American tenant farmers in Stuart, Virginia for generations, moved to North Carolina when he was seven. He attended school until the fifth grade. He worked all his life raising field crops and tobacco, and as a tobacco warehouseman. In 1968 he began making imitation Native American tomahawks and arrowheads from local stone, and sold them inexpensively. His ability and imagination led him to create larger and more complex sculptures in stone and wood.

Much of Coins's work was inspired by his religious beliefs as well as his visionary experiences in the Rock House Primitive Baptist Church, which he joined in 1917 and where he later became a deacon. Additionally, his dreams, which he could remember for many years, were another source of inspiration. He re-created them in bas-relief carvings using local gray or blue river stone. These carvings are often about thirty inches high, quite heavy in weight, and

each refers to a specific dream or vision that Coins had experienced. In one of these "dream" carvings, Coins painted the top half to represent a storm, with accompanying high winds. Below the storm are two figures carved in relief, both self-portraits; one is cutting wheat with a scythe while the other, with arms outstretched, marvels at the power of God.

Coins's carved human figures have a primitive simplicity. The eyes and mouths of the figures are rounded and bulging, and they are bald, as was the artist, from an early age. He produced figures of angels, "baby dolls," Adam and Eve, and crucifixions, and also carved many animal figures (frogs, bears, dogs, sheep, buffalo, and deer) in wood and stone in a solid and powerful minimalist style.

Coins generally used cedar for his woodcarving, and followed the natural configuration of the wood when he carved. Some works are almost life-size, including his self-portrait as well as a portrait he made of his wife. The artist carved continually with his ax, chisel, and sander, often working on several pieces at the same time. He said that time did not count when he was carving.

Coins thought of himself as a little boy who never "growed up" and was "amazed" by what he created. He died on June 4, 1998, in Winston-Salem, North Carolina. His carvings, made from a religious and visionary stimulus, have established him as a folk artist of major importance.

See also **Religious Folk Art; Sculpture, Folk; Visionary Art.**

BIBLIOGRAPHY

Trechsel, Gail Andrews, ed. *Pictured in My Mind*. Birmingham, Ala., 1995.

University of Southern Louisiana. *Baking in the Sun: Visionary Images from the South*. Lafayette, La., 1987.

Yelen, Alice Rae. *Passionate Visions of the American South: Self-Taught Artists from 1940 to the Present*. New Orleans, La., 1993.

JOHN HOOD

COLCLOUGH, JIM (Suh) (1900–1986) was a carver who learned to use woodworking tools in his father's blacksmith shop. He did not begin to actively carve until 1961, when his wife, Marian, died. His witty, sometimes irreverent carvings often carried messages meant to satirize human foibles. He also intended to surprise the viewer by devising a system using a crank to activate some of his carvings. Over the course of more than twenty years, Colclough completed several hundred sculptures. His subjects were drawn from his early memories of people and happenings, carnival life, folk tales, classical mythology, current events, and religion.

Colclough was inspired to carve a portrait of Harry Truman when he learned that he was distantly related to the U.S. head of state. A full-figured rendition of the thirty-third president is outfitted in the uniform of an artillery captain in World War I, a rank Truman held. Truman thumbs his nose at the viewer and the world when a crank in the statue's base is turned. Colclough finished the carving with linseed oil and took special care to lace Truman's high boots with copper wire.

Born in Fort Smith, Arkansas, Colclough moved with his family to Sallisaw, Oklahoma. He operated a garage and was a car dealer for many years, but when his agency failed during the Great Depression, Colclough began to work for carnivals in many capacities, including building and "operating kiddy rides, mug joints, and side shows." Following his retirement from carnival life after more than ten years in the business, he settled near Hearst Castle in California. When the adobe house he built was condemned to make room for a freeway, he moved with his wife to Westport, a logging center in northern California.

After his wife's death Colclough began to carve, using the redwood logs that washed up on the beaches near his home. Most of his carvings were finished with linseed oil, but a few were painted. A polychromed wedding portrait of the Duke and Duchess of Windsor, inspired by a photograph, is a Colclough masterpiece. The elegantly groomed couple appears solemn and impassive at the event, that captured the world's attention in 1937. The artist's special interest in the subject came from his belief that he was related to Wallis Simpson, the Duchess of Windsor.

The collector David Davies discovered Colclough's work in a gallery in Fort Bragg, California, in the 1960s. The Mendocino Art Center in Mendocino, California, organized a one-man exhibition of Colclough's carvings in 1986.

See also **Whirligigs.**

BIBLIOGRAPHY

Hartigan, Lynda Roscoe. *Made with Passion: The Hemphill Folk Art Collection in the National Museum of American Art*. Washington, D.C., 1990.

Horwitz, Elinor Lander. *Contemporary American Folk Art*. Philadelphia, and New York, 1975.

Kaufman, Barbara, and Didi Barrett. *A Time to Reap: Late-Blooming Folk Artists*. South Orange, N.J., 1986.

Larsen-Martin, Susan, and Lauri Martin. *Pioneers in Paradise: Folk and Outsider Artists of the West Coast*. Long Beach, Calif., 1984.

Oakland Museum Art Department. *Cat and Ball on a Waterfall: 200 Years of California Folk Painting and Sculpture*. Oakland, Calif., 1986.

Rosenak, Chuck, and Jan Rosenak. *Museum of American Folk Art Encyclopedia of Folk Art and Artists.* New York, 1990.

LEE KOGAN

COLLINS, POLLY (1808–1884) was still a child when she entered Hancock Shaker Village in northwestern Massachusetts with her family in 1820, but she remained a faithful member of the religious community until the end of her life. She was an active participant in the spiritual manifestations that were associated with the revival period in Shaker history (c. 1837–1859), and created at least sixteen watercolor "gift drawings," bearing dates from 1841 to 1859. Collins was born east of Albany, in Cambridge, New York, a small town near the Vermont border.

The revival period, which is referred to in the Shaker chronicles as the Era of Mother's Work or the Era of Manifestations, was characterized by a greater receptivity by the members of the community to visionary experiences (trances, prophetic utterances, spirit communications) than at other times, although these phenomena have been present during much of the history of the United Society of Believers, as the community is more formally called. Collins was a "medium," or "instrument," during the Era of Manifestations, receiving and recording many visions and "gifts."

Collins's gift drawings generally are not as bold and direct in composition or color as those of another Hancock Shaker, Hannah Cohoon (1788–1864), but they often incorporate similar arboreal motifs. Cohoon's drawings are characterized by strong central images, as are some of Collins's compositions. For several of her drawings, however, Collins constructed a distinctive grid of squares or rectangles, each of which contains stylized figures of trees, flowering plants, and, occasionally, arbors or other objects. The overall composition of these works and their individual elements suggest the design of album quilts, although decorative bedcovers had no place in the spare Shaker aesthetic. Needlework samplers also appear to have had an influence on Collins's drawings. The Believers sought to live separately from the ways of the world, but they nevertheless were influenced by the visual culture of their place and time.

Perhaps the most distinctive of Collins's drawings is *An Emblem of the Heavenly Sphere* (1854), a complex work in which the artist employs carefully ruled horizontal and vertical lines to form a grid. The outer squares of the grid contain lyrically drawn allegorical figures, including flowering fruit trees with names like "Flower of Eden," "The Celestial Plum," "Repen-tance," and "Forgiveness." In the center of the work, the artist has placed a celestial choir composed of Mother Ann Lee (c. 1736–1784), the Shaker founder; other early leaders of the church; Jesus; the apostles and other figures from sacred history; and Christopher Columbus.

Following the Era of Manifestations, Collins lived an uneventful life at Hancock, serving for a period of years as caretaker to the young girls of the village's West family.

See also **Hannah Cohoon; Quilts; Samplers, Needlework; Shaker Drawings; Shakers; Visionary Art.**

BIBLIOGRAPHY

Morin, France, ed. *Heavenly Visions: Shaker Gift Drawings and Gift Songs.* New York, 2001.
Patterson, Daniel W. *Gift Drawing and Gift Song: A Study of Two Forms of Shaker Inspiration.* Sabbathday Lake, Maine, 1983.
Promey, Sally M. *Spiritual Spectacles: Vision and Image in Mid-Nineteenth-Century Shakerism.* Bloomington, Ind., 1993.

GERARD C. WERTKIN

CONCATENATED ORDER OF HOO HOO: *SEE* FRATERNAL SOCIETIES.

CORNÈ, MICHELE FELICE (c. 1752–1845) was a Neapolitan painter and teacher who immigrated to Salem, Massachusetts in 1800. Italian coastal cities were ports of call for American merchant and naval vessels beginning in the late eighteenth century, and numerous portraits of American vessels were commissioned by their masters or owners and were painted by Italian artists. Cornè may have received firsthand knowledge of America in this way, prompting him to immigrate. It is believed that he sailed for America aboard the *Mount Vernon,* owned by the prominent Derby family of Salem. Cornè later established a professional relationship with the Derbys, painting a view of the *Mount Vernon,* commanded by Elias Hasket Derby, outrunning the French fleet, and a topographical view of the home of Derby's brother, Ezekiel Hersey Derby. The painting includes a vignette showing Cornè making a drawing of the house while seated next to a figure probably representing the architect and carver Samuel McIntire, who made architectural ornaments for the house.

An artist of considerable as well as diverse skills, Cornè painted portraits in oils and watercolor, landscapes, historical scenes, ornamental paintings, and made drawings of genre scenes, in addition to marine paintings. Like many other artists in America at the

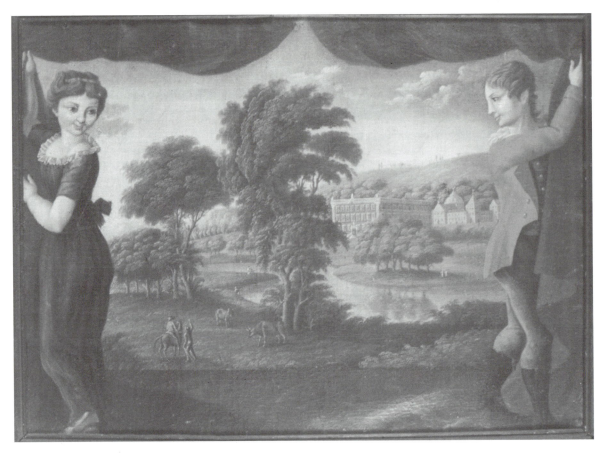

Painted Fireboard depicting a Distant View of Chatsworth; Derbyshire, England; Michele Felice
Corné; Date unknown. Oil on canvas mounted on a pine panel. 34¼ × 47 inches. The Bertram K.
Little and Nina Fletcher Little Collection auction at Sotheby's 6526, January 29, 1994.
Photo courtesy Sotheby's, New York.

time, Corné could not sustain a livelihood from portraiture alone, so he appealed to a broader clientele by painting signs, fireboards, overmantel paintings, and decorative murals on the walls of rooms (a less expensive substitute for imported scenic wallpaper). One such painted fireboard representing a distant view of Chatsworth, Derbyshire, England is framed by a young man in red and a young girl in blue who are depicted drawing a curtain back as if to reveal the pastoral scene in *trompe l'oeil* fashion.

Although his portraits depict Americans, Corné brought with him a European aesthetic that he continued to practice in America, rather than adapt his style to the plainer American taste. He favored vivid colors, and often used strong reds and blues in contrast. His portraits and landscapes share fluid contours and close attention to detail in costume and foliage. Children's likenesses are stylized, with broad heads tapering down to small chins, large eyes, and full cheeks. Some of Corné's landscapes were topographical views, while others were imaginary or were based upon European prints.

Corné moved to Boston around 1807, where he contributed the illustrations for Abel Bowen's *The Naval Monument* (1816), an account of America's naval engagements during the Revolutionary War. In 1822 he relocated to Newport, Rhode Island, where he lived for the remainder of his life. Remembered as an entertaining raconteur, Corné also championed the tomato, which he is credited with having introduced to Newport.

See also **Maritime Folk Art; Painting, American Folk; Painting, Landscape.**

BIBLIOGRAPHY

Little, Nina Fletcher. *Little By Little: Six Decades of Collecting American Decorative Arts.* New York, 1984.

Rumford, Beatrix T., ed. *American Folk Portraits: Paintings and Drawings from the Abby Aldrich Rockefeller Folk Art Center.* Boston, 1981.

RICHARD MILLER

CORNETT, CHESTER (1912–1981) established a reputation as a highly inventive chairmaker in the 1950s and 1960s. Working within the craft traditions of southeastern Kentucky, he created pegged and slat-backed armchairs, "settin' chairs," rockers, and folding chairs from a variety of local woods, and he wove chair seats from hickory and other barks. Although he learned the techniques of chairmaking from his grandfather, Cal Foutch, and other family members, Cornett was an innovator. Some of his more idiosyncratic constructions combine chair elements with bookcase and other furniture forms, or add to the number of legs or rockers customarily used in a chair. Several of Cornett's chairs have carved decorations or are made of wood of contrasting colors to augment their visual impact.

Cornett was born in Letcher County, Kentucky, a mountainous region bordering Virginia, and he spent his childhood there as well as in neighboring Harlan County. As an adult, he lived and worked in Dwarf, a hamlet in nearby Perry County, where he created his chairs. According to Michael Owen Jones, who visited Cornett frequently, a sign on his property in Dwarf advertised "hand Mad Furniture/maker of the Cornett chaires/we make iney thin/ar hit Cant be mad." The family lived in crushing poverty, experiencing serious illness and sorrow.

Cornett occasionally turned his creativity to other efforts. An impressive eight-foot-high crucifix by the artist, with a carved figure of Jesus, is now in the collection of the American Folk Art Museum. According to a story that has been published in several exhibition catalogs, Cornett dreamed sometime in 1968 that eastern Kentucky was going to be engulfed in a great flood, which he associated with the Second Coming of Christ. Building a twenty-foot ark that he hoped would carry him and his family to safety, he affixed the figure of the crucified Christ to the bow of the vessel. Although the flood did not occur as expected, a subsequent storm carried the ark away. The sculpture was saved, though, and Cornett reworked it several times until it took its present form. In another version of the story, Cornett created the crucifix during a time of intense sorrow occasioned by marital discord and loneliness. He moved from Kentucky to Indiana, and it was there that he carved the figure, linking his own sufferings to those of Christ on the cross.

See also **Chairs; Furniture, Painted and Decorated; Religious Folk Art.**

BIBLIOGRAPHY

Jones, Michael Owen. *Craftsman of the Cumberlands: Tradition and Creativity.* Lexington, Ky., 1989.

GERARD C. WERTKIN

COTÉ, ADELARD (1889–1974) was a Maine woodcarver whose small painted figures reflect the rural life of his French-Canadian community in the vicinity of Biddeford, Maine. Born in Saint-Sophie, Quebec, Coté left school after only four years to help on his father's farm. A love of animals led Coté to become a blacksmith. As a young man, he immigrated to Maine in search of better paying work. He worked as a blacksmith for the Pepperell Manufacturing Company, where he shod draft horses, and worked for a time in a light bulb factory before establishing his own blacksmith shop. When the demand for blacksmiths decreased with the increasing availability of cars, Coté took up farming. A frugal and hard working man, Coté first learned woodworking to construct furniture for his home. He could boast that he had made every piece of furniture in his parlor except the piano. During the 1940s Coté began to carve for his own pleasure. His affectionate carvings of horses, oxen, cows, and people taking their rest in small rocking chairs won prizes at the Fryeburg Fair in Maine, as did Coté's full-size rocking chairs.

See also **Chairs; Sculpture, Folk.**

BIBLIOGRAPHY

Beaupré, Normand. *L'Enclume et le Couteau: The Life and Work of Adelard Coté, Folk Artist.* Manchester, N.H., 1982.

CHERYL RIVERS

COVERLETS take their name from the French *couvre-lit,* or bedcover, and they served both a utilitarian and a decorative function on the beds of early American homes. Coverlets have also been called "coverlids" or "counterpanes," although these terms are now rarely used. A number of different types of bedcovers may be subsumed under the term "coverlet," including bed rugs (sometimes spelled "ruggs"), embroidered and crewelwork bedspreads, candlewicking, stenciled spreads, and handwoven bedcovers. Quilts also fit within this category, but they hold their own unique place in American folk art, and so are considered in a category of their own.

The bed rug, embroidered and needle-sewn with heavy yarn, is among the earliest type of American bedcover; it is found primarily in New England, as its

warmth is ideal for a cold climate. A seventeenth-century mention of a "yearne courlead" probably refers to a bed rug, but the earliest one extant is dated 1722; others date from the late eighteenth or early nineteenth century. Bed rugs are usually executed in warm colors and bold designs, often in variations of the Tree of Life.

The designs in crewel coverlets and bedhangings were created with a fine wool yarn embroidered on a base of linen homespun. Floral designs were especially popular during the eighteenth century, and show the influence of Jacobean embroidery as well as that of imported Indian fabrics. In the late eighteenth to early nineteenth century, a taste developed for elaborate embroidered floral designs on a black wool background; such coverlets were much treasured, for the dyes required to color them were expensive. Crewel embroidery was also used to embellish hand-woven woolen blankets, although this work was usually more idiosyncratic.

During the first half of the nineteenth century, a fashion developed for stenciling, and stenciled bed-spreads were made as a result of this fad. Most were made of one layer of hemmed cotton, without backing or lining. Flower, bird, and fruit designs, similar to those used for theorem paintings, appear on these spreads, and the same stencils may have been used for both paintings and spreads.

Coverlets did not escape the fad for whitework that lasted from about 1790 to 1830, and candlewick spreads, with their elaborate floral or stylized designs picked out with coarse cotton thread or roving, were popular. This same material was used to create patterns in loom-woven candlewick coverlets. All-white woven coverlets that mimicked the much-coveted Marseilles quilts were also produced during this period.

Handwoven coverlets, made both in the home and by professional weavers, flourished from the late eighteenth through the mid-nineteenth century and were outstanding examples of the hand weaver's art. A blue-and-white floatwork (overshot) coverlet from 1773 is the earliest example that can be firmly dated, although estate inventories, diaries, and advertisements indicate that they were being woven much earlier. These coverlets, made of wool or a combination of wool and cotton or linen, are found in a variety of color combinations, but the predominant blue-and-white combination helps to define the genre.

Coverlets fall into two distinct design categories: geometric and figured, or "fancy," designs, which include stylized flora and fauna as well as a variety of other motifs. In both categories, the design is pre-planned and follows the constraints of the loom; because of the narrow width of many early looms, two or more woven panels were often stitched together to make up the necessary width for a bed. The complex multiple-harness looms used by professionals could weave both geometric and figured coverlets, while simpler home looms were restricted to the geometric.

The striking geometric designs characteristic of home-woven coverlets are produced by floatwork, or overshot, a weave technique that uses a supplementary weft that "floats" over a plain weave foundation in a specific progression, thus creating the pattern. Floatwork coverlets, which were made at home as well as by professionals, are the most common type of coverlet found in America. Summer and winter weave, a floatwork variation, also produces geometric designs, and forms a textile with one light side and one dark side (hence the term "summer and winter"); it was usually woven by professional weavers. Double cloth, another weave structure produced by professionals, could be woven in geometric or figured designs.

Specialized equipment and trained weavers were needed to make the elaborate curvilinear designs that characterize figured, or fancy, coverlets. These were produced with a mechanical attachment for the loom, which contained a series of pattern cards punched with holes through which warp threads were guided, then raised and lowered as the design demanded. The device, called a "figured head" or "jacquard head," after its French inventor, Joseph-Marie Jacquard, was introduced in America in the mid-1820s. Figured coverlets made prior to the introduction of the figured head required the use of a cumbersome, labor-intensive drawloom or barrel loom; the earliest one known was made in 1817 in New York State. James Alexander, a New York weaver in the early 1820s, is thought to have used a drawloom for his elegant figured and "flowert" coverlets.

The figured head dramatically altered coverlet production. Coverlets could be produced quicker, and an individual weaver working without an assistant could turn out an astounding array of designs simply by purchasing or making additional cards. In addition to floral motifs, weavers could now depict animals, birds, buildings, methods of transportation, religious symbols, patriotic images, even letters and numbers. Coverlets could be personalized with the names of the weaver, the client, and where and when the coverlet was made; verses or other inscriptions could also be added.

Eighteenth- and nineteenth-century professional weavers were, for the most part, men who had learned their skills in Europe; Elizabeth Perkins Wildes Bourne in Maine and Sarah LaTourette in Indiana were among the few exceptions. Typically, weavers collected orders for coverlets, then wove them in their home workshop, sometimes with yarn that clients supplied. The popular concept of the itinerant weaver who traveled with his loom is mostly folklore, as is the idea that every household had a loom and every woman was a weaver.

The advent of the power loom and other advances in textile technology in the nineteenth century took a toll on handwoven coverlets, as did changing popular tastes as well as the rapid move to factory production that was a result of the American Civil War. There was a brief revival in handwoven coverlets at the time of the American Centennial, but by the end of the century they were viewed as hopelessly old-fashioned, objects of curiosity rather than necessity or desire. It was not until nearly the mid-twentieth century that handwoven coverlets began to be recognized as valuable representatives of a bygone material culture.

See also **Quilts; Painting, Theorem; Pictures, Needlework; Samplers, Needlework.**

BIBLIOGRAPHY

Anderson, C. *Weaving a Legacy: Coverlets in the Stuck Collection.* New York, 1995.

Androsko, Rita J. *Proceedings.* Washington, D.C., 1976.

Bishop, Robert, and Jacqueline M. Atkins. *Folk Art in American Life.* New York, 1995.

Davidson, Mildred, and Christa C. Mayer-Thurman. *Coverlets: A Handbook on the Collection of Woven Coverlets in the Art Institute of Chicago.* Chicago, 1973.

Goody, Rabbit. "Will the Real James Alexander Please Stand Up?" *The Clarion,* vol. 17 (spring 1992): 52–58.

Heisey, John W. *A Checklist of American Coverlet Weavers.* Williamsburg, Va., 1978.

Peck, Amelia. *America's Quilts and Coverlets.* New York, 1990.

Safford, Carleton L., and Robert Bishop. *America's Quilts and Coverlets.* New York, 1972.

Ulrich, Laurel Thatcher. *The Age of Homespun: Objects and Stories in the Creation of an American Myth.* New York, 2001.

Weissman, Judith Reiter, and Wendy Lavitt. *Labors of Love: America's Textiles and Needlework, 1650–1930.* New York, 1987.

Jacqueline M. Atkins

COYLE, CARLOS CORTEZ (1871–1962) was a self-taught painter who was prolific but little known during his own lifetime. His paintings are mysterious and ambitious in size, with many exceeding six feet in height. His most adventurous paintings present unrelated images that combine to form a complex narrative storyline that operates on several different levels.

Born in Dreyfus, Kentucky, Coyle's extensive and articulate diary writing confirms a formal education, which he received at the nearby Berea Foundation School. Although his diary chronicles his feelings, describes a personal sense of loss, and explores issues and topics such as tyranny, motherhood, alcohol, science, and astronomy, most details of his adult life remain a mystery. He married three times and had three children. He left Kentucky and moved to the San Francisco Bay Area, where between 1929 and 1942 he completed 169 paintings, many of them large in size.

Coyle's technique, especially when representing the human figure, was well developed. His skillful control of oil paints enabled him to depict a wide range of subject matter, including landscapes, scenes from his childhood in rural Kentucky, and allegorical compositions, at times featuring female nudes. His treatment was alternately realistic and surrealistic, often with several images graphically layered. In one of his paintings, *And Departing, Leave Footprints in the Sand,* for instance, he portrays an Egyptian landscape, with sphinx and pyramids, along with Stonehenge superimposed on one side of the canvas and the Washington Monument on the other. Two giant pairs of bare legs, which fade out below the knee, stride to left and right against the desert backdrop. Many of his paintings similarly include such multiple images. Though Coyle's writings touch on a sense of overwhelming sadness in life, his paintings transcend the personal to focus on broader issues.

Berea College in Kentucky received four crates containing Coyle's paintings, drawings, his diary, and notes in 1942. Legend has it that these arrived, unannounced, on the doorstep of the college president, who is said to have opened one crate, declared his shock, and ordered it resealed. In a letter, received soon after the crates arrived, Coyle stated: "I am resolved to give my art to the land of my birth where I played and spent most of my youth." The paintings remained in storage until Berea College professor Thomas Fern discovered the crates, in 1960. Fern recognized their significance, located the artist, and formally thanked him. Coyle, who by then was living in Leesburg, Florida, died in 1962 at age ninety.

See also **Outsider Art; Painting, American Folk; Painting, Landscape.**

BIBLIOGRAPHY

Marcus, Brad. Unpublished paper on Carlos Cortez Coyle, "A Higher Need of Expression." Special Collections, Hutchins Library, Be-

rea College, Berea, Kentucky, and Kentucky Folk Art Center, Morehead, Ky., 1993.

<div align="right"><i>ADRIAN SWAIN</i></div>

CRAFFT, R.B. (active 1836–1866) painted likenesses in an increasingly accomplished style over a thirty-year period in the American Midwest and South. His earliest known painting is a signed and dated portrait of a merchant, done in 1836. By 1839 Crafft was plying his trade in Clinton, Indiana, and by 1844 he was advertising his portrait business in Fort Wayne. Aside from executing likenesses of Anglo-American subjects, Crafft also painted portraits of an Indian chief, Francis La Fontaine, and his family. Much of Crafft's later career, after the mid-1840s, is less well documented. He is believed to have painted in Kentucky, particularly Louisville, Madison, and Jefferson Counties, between 1845 and 1853. Crafft was working in Lexington, Mississippi, in 1854, and toward the end of his career, in 1865, painted at least one portrait in Danville, Kentucky. His last known work, dated 1866, marked the end of an artistic career documented by only twelve signed portraits.

Crafft's style changed considerably over the course of the three decades in which he painted. This evolution, toward a more academic style, indicates that Crafft either acquired some artistic training, formal or informal, or that he was observant of more accomplished works and emulated what he saw. His early portrait of the aforementioned merchant displays a forthright folk portrait style. The sitter's features, costume, and props are flat and angular, with forms modeled in heavy, dark lines. The skewed perspective of the sitter's books adds to the strong sense of visual pattern. As he developed as a portraitist, Crafft gradually eliminated the props and accessories and showed his sitters against solid backgrounds. His modeling of figures changed from flat to round, with more realistic volume. Crafft's 1865 portrait from Danville, Kentucky, is executed in a clearly academic style.

See also **Painting, American Folk.**

BIBLIOGRAPHY

Rumford, Beatrix T., ed. *American Folk Portraits: Paintings and Drawings from the Abby Aldrich Rockefeller Folk Art Center.* Boston, 1981.

Whitley, Edna Talbot. *Kentucky Ante-Bellum Portraiture.* Lexington, Ky., 1956.

<div align="right"><i>PAUL S. D'AMBROSIO</i></div>

CRAFT AND FOLK ART MUSEUM (CAFAM) was founded in 1973 by Edith R. Wyle, a Los Angeles community leader and artist who served as its director until 1985, as an outgrowth of The Egg and the Eye Gallery she established in 1965, which adjoined a popular omelette restaurant. The combination gallery/restaurant became well-known for exhibitions of innovative international contemporary craft and folk art.

In October 1976 the biennial "International Festival of Masks" was organized by the museum and co-sponsored by the city and county of Los Angeles. More than 170 exhibitions have been presented since 1975, covering an amazing array of subjects, including "Indian Folk and Tribal Art" (1975), "Los Angeles Collects Folk Art" (1977), "Traditional Toys of Japan" (1979), "Wind and Weathervanes" (1976), "Four Leaders in Glass" (1980), "Masks in Motion" (1984), and "Transitions: New Fiber Works" (2003).

The museum de-accessioned its small collection in 1997, and donated the Edith R. Wyle Research Library to the Los Angeles County Museum of Art. Strengths of these holdings include important information on the history of folk art and contemporary craft collecting; masks and mask making; bead and textile history and collecting; vernacular architecture; museology in general; folk art and textiles from Mexico, Japan, India, and the United States; American folk art making and collecting, including self-taught as well as traditional art; and documentation of the history of the post–World War II studio-craft movement in the United States.

Reopened in 1998, in its original home, as a non-collecting institution under the administration of the City of Los Angeles Cultural Affairs Department, CAFAM is located on Museum Row on Wilshire Boulevard. A Weingart Foundation grant has made possible an education studio that allows adults and children to learn about various cultural and family traditions, and to develop craft skills. Education outreach programs are offered for elementary to high school students. Changing exhibitions are scheduled to feature the work of local artists. The museum is well-known for its gift shop, which sells only handcrafted objects of domestic and international origin. Since his appointment in 2003, CAFAM executive director Peter Tokofsky has increased the museum's focus on the cultural diversity and emerging traditions of the Los Angeles communities.

See also **Architecture, Vernacular; Asian American Folk Art; Native American Folk Art; Toys, Folk; Weathervanes.**

BIBLIOGRAPHY
Craft and Folk Art Museum. *Los Angeles Collects Folk Art*. Los Angeles, 1977.
Chow, Cha-Yong. *Guardians of Happiness: A Shamanistic Approach to Korean Folk Art*. Seoul, 1982.

DEBORAH LYTTLE ASH

CRAIG, BURLON (1914–2002) was the modern master of the 200-year-old Catawba Valley stoneware tradition in the western Piedmont area of North Carolina. Raised in a region filled with pottery shops, he apprenticed at age fourteen and quickly learned the skills to produce the alkaline-glazed jars, jugs, churns, milk crocks, and pitchers needed by local residents. He made pottery all his life, and in his later years was renowned for his huge grinning face jugs.

Craig began his career in the late 1920s, working first for his neighbor, Jim Lynn, and then as a journeyman at shops all across the Catawba Valley area in western Lincoln and Catawba Counties. His wares sold for a mere ten cents a gallon and were critical to farm families, who mostly used them to store foods and other goods. Pots were valued for their utility, and artistic embellishments were largely considered a waste of time.

When World War II broke out, Craig enlisted in the Navy and served on gun crews on merchant ships in the Pacific. He returned home in 1946 and purchased a pottery shop and kiln, but he realized that demand for the utilitarian forms had fallen off sharply, and most potters had moved on to factory work. Consequently Craig worked in a solitary environment for decades, fully assuming he would be the last in a long line of potters.

Beginning in the late 1970s, however, a new clientele comprised of collectors, dealers, academics, and museum curators appeared, who valued Craig's work for its historical and aesthetic significance. Regional and national interest surged creating a new market in which Craig was widely acclaimed for his traditional skills. To appeal to new audiences, he began to enlarge his repertory by reviving old forms (ring jugs, monkey jugs) and creating new ones (canister sets, lamp bases). Recognizing that pots were now valued and collected primarily for their artistic (that is, nonfunctional) qualities, he also increased his use of traditional decorative techniques and began applying faces to most of his works. One of Craig's whimsical face jugs, now in the collection of the American Folk Art Museum, has ears for handles, bulbous eyes, and exhibits an exuberant grotesquerie typical of the southern American tradition.

This increase in interest soon attracted younger men eager to learn the authentic forms, glazes, and

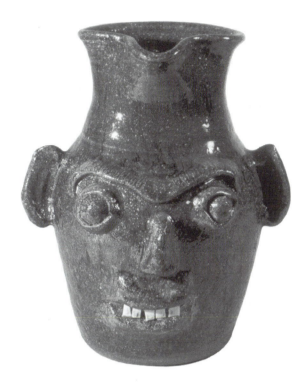

Grotesque Face Jug; Burlon Craig; Vale, North Carolina; c. 1978. Stoneware. 11 × 9½ × 9⅜ inches. © Collection American Folk Art Museum, New York. Gift of Roddy Moore, 1979.2.1.

technology that Craig alone possessed. Through his informal but highly effective teaching, Craig trained new potters and ensured the perpetuation of the Catawba Valley tradition. He also received numerous awards for his achievements, including the prestigious National Heritage Fellowship (1984) and the North Carolina Folk Heritage Award (1991).

See also **Jugs, Face; Pottery, Folk.**

BIBLIOGRAPHY
Huffman, Barry. *Catawba Clay: Contemporary Southern Face Jug Makers*. Hickory, N.C., 1997.
Zug, Charles G. III. *Burlon Craig: An Open Window into the Past*. Raleigh, N.C., 1994.
———. *Turners and Burners: The Folk Potters of North Carolina*. Chapel Hill, N.C., 1986.

CHARLES G. ZUG III

CRANE, JAMES AUGUSTUS (1877–1974) was a painter who had a lifelong interest in the sea and the ship disasters that grew out of his work as a fisherman in Bath, Maine, as well as his life near Ellsworth, Maine. Beginning about 1962, when he was eighty-five years old, Crane painted a small number of ship

portraits, including several versions of the *Titanic,* and New England landscapes and seascapes. Like other self-taught artists, Crane often showed multiple perspectives of an object simultaneously. In one of his paintings of the *Titanic,* Crane depicts the side and top views of the ship. There is also no single light source in the work. For materials, Crane used oil and house paint on plywood, oilcloth, bed sheets, and he occasionally used paper collages.

Born in Winter Harbor, Maine, Crane enjoyed a long life. When he was fourteen, his father, a fisherman, was lost at sea during a storm. The traumatic event led Crane to abandon any idea of becoming a fisherman, and he pursued work as a mechanic. The circumstances of his father's death may have influenced the subject matter of his paintings, although he claimed that he painted to raise money to complete and test a plane he was building, his lifelong dream.

In 1909 Crane had a vision of an angel that "showed him an airship with oscillating wings, demonstrated it for him, and departed." When Crane was hired to supervise a salvage yard in 1962, he found many of the materials he needed to build his airship, based on the vision. He completed the *Eagle Airship* and placed it in his front yard with his paintings.

See also **Environments, Folk; Maritime Folk Art; Painting, American Folk; Sculpture, Folk.**

BIBLIOGRAPHY

Bishop, Robert. *Folk Painters of America.* New York, 1979.
Hemphill, Herbert W. Jr., and Julia Weissman. *Twentieth-Century American Folk Art and Artists.* New York, 1974.
Johnson, Jay, and William C. Ketchum. *American Folk Art of the Twentieth Century.* New York, 1983.
Kogan, Lee. "New Museum Encyclopedia Shatters Myths." *The Clarion* (winter 1990): 55–56.

LEE KOGAN

CRAZY QUILTS: *SEE* QUILTS.

CREATIVE GROWTH ART CENTER, THE (CGAC), founded in 1973, is a non-profit, tax-exempt art studio and gallery designed to provide physically, mentally, emotionally, and developmentally disabled adults with opportunities, supplies, space, and encouragement to make and exhibit visual art. Housed in a 12,000-square-foot former auto-dealership building in downtown Oakland, California, the center serves an area with one of the largest populations of disabled individuals in the United States. It provides visual-art programs and education as well as training in independent living for more than 125 people every year. One of its broader goals is to promote connections among artists with disabilities, the larger arts community, and the general public.

The center is staffed with seven full-time teachers who also maintain independent artistic careers. They oversee a studio-art "immersion" program that offers more than 17,000 classes annually. The center's education program includes classes and workshops in ceramics, cooking, fiber arts, movement, painting, photography, printmaking, sculpture, and woodworking. Clients with jobs, attending school, or with other daytime responsibilities may take part in the center's afternoon program, which provides specialized art instruction and assistance along with personal and social development. Although its programming is designed primarily for adults, the CGAC also offers summer scholarships that provide younger disabled artists with formal training, a network of peer artists, and access to working artists with and without disabilities. All of these programs are open to disabled individuals who are interested in taking advantage of them, without regard to their previously demonstrated levels of artistic talent.

An anchor organization located in an urban neighborhood that is seeking to revitalize itself through art-related development, the facility incorporates a gallery that regularly exhibits and sells works produced by its clients. Having attracted an international audience, the gallery has in recent years brought in about $200,000 annually. Half of the proceeds from any work sold through the gallery is returned to the artist who created the piece, while the other half is used to cover the center's expenses. Artists are paid on a quarterly basis for any of their works sold through the gallery, and for many CGAC clients, this is the only income they earn.

The work produced by several CGAC clients—unotably Dwight Mackintosh, Judith Scott, and, most recently, Donald Mitchell—has received widespread attention among enthusiasts of folk art and self-taught art (or "outsider" art). In the years since its inception, the center has inspired the creation of more than thirty similar facilities in the United States.

See also **Dwight Mackintosh; Outsider Art; Judith Scott.**

BIBLIOGRAPHY

Rivers, Cheryl. "Donald Mitchell: Cheryl Rivers Discusses the Working Process of One of Creative Growth's Most Outstanding Artists." *Raw Vision,* no. 38 (spring 2003): 46–52.
Smith, Barbara Lee. "Judith Scott: Finding a Voice." *Fiberarts* (summer 2001): 36–39.

TOM PATTERSON

CROATIAN AMERICAN FOLK ART: *SEE* EASTERN EUROPEAN AMERICAN FOLK ART.

CROLIUS FAMILY POTTERS was a pottery business established in Manhattan about 1728 by William Crolius the elder, and finally shut down in 1849 by his great-great-grandson, Clarkson Crolius Jr. This family's kiln was one of America's first, as well as New York City's longest lasting. Originally from Germany's Rhineland and thoroughly familiar with stoneware production, the Crolius clan produced a wide variety of durable, salt-glazed products. Their 1809 price list (the earliest known example of this advertising form) was an illustrated catalog of pots, jugs, jars, pitchers, mugs, oyster pots, spout pots (batter jugs), chamber pots, kegs or water coolers, churns, and inkwells.

The Crolius shops (the business was moved several times) were located in the vicinity of Centre, Reade, and Chambers Streets, in lower Manhattan. Now occupied by courthouses, government buildings and offices, in the eighteenth century this was an area of open land, adjacent to a small pond known as the Collect. Over time, the shops passed to William's son, John; then to his son, John Crolius Jr.; and on to his son, Clarkson; then to the final owner, Clarkson Crolius Jr.

Little Crolius pottery that is identifiable has been found from the earlier years of the business, but when Clarkson Crolius Sr. took over in 1800, he began to impress his name on his wares, a reflection of the fact that they were now being sold all along the eastern seaboard and as far away as the West Indies. Variations of the mark, "C.CROLIUS / MANUFACTURER / MANHATTAN WELLS / NEW YORK" (the "Manhattan Wells" refers to the pottery's location adjacent to the municipal water supply), are found on dozens of surviving pieces. Clarkson Crolius Jr., who took over the shop in 1838, continued this tradition of marking the pieces, with "C.CROLIUS / MANUFACTURER / NEW YORK."

Early Crolius ware was often decorated with simple abstract floral designs incised into the clay and filled with cobalt blue before firing. Presentation pieces or special orders might be more elaborate. A pitcher owned by the New-York Historical Society is embellished with flowers and leaves and has a cover topped by a molded squirrel. Large quantities of blue-decorated stoneware shards, which may have been associated with one of the Crolius sites, were excavated at the African Burial Groundsite in lower Manhattan in the 1990s. Unfortunately, they were destroyed in the terrorist attack on the World Trade Center on September 11, 2001, as they were housed at the time in the twin towers' storage area.

See also **Potter, Folk; Remmey Family Potters; Stoneware.**

BIBLIOGRAPHY

Clement, Arthur W. *Our Pioneer Potters*. New York, 1947.
Guilland, Harold F. *American Folk Pottery*. Philadelphia, 1971.
Ketchum, William C. Jr. *American Stoneware*. New York, 1991.
———. *Potters and Potteries of New York State, 1650–1900*. Syracuse, N.Y., 1987.

WILLIAM C. KETCHUM

CROSS-LEGGED ANGEL ARTIST is a fraktur artist not known by name despite a recognizable body of work in which usually appears an angel with crossed legs. Similar angels are to be found in Baroque church decoration in Europe during the period of Pennsylvania German immigration to the United States, in the eighteenth century and earlier. The artist had poor handwriting with which he filled in the certificates he drew, although a few exist that were printed then completed in his hand. His work was primarily done in northeastern Lancaster and adjoining Berks County, and he may well have taught at a parochial school in the area. There is an impish appeal to the figures he created; two of the best examples picture a man in one and a woman in the other. He also drew birds that were frequently posed looking over their shoulders.

See also **Fraktur; German American Folk Art; Pennsylvania German Folk Art.**

FREDERICK S. WEISER

CROWELL, A. ELMER (1862–1952) of East Harwich, on Cape Cod, Massachusetts, was a prolific and talented early twentieth century carver of wildfowl decoys, including shorebirds, ducks, brant (or wild geese), and geese. He died at 90 following an illustrious career that lasted until rheumatism forced him to retire in 1944. An artist of superb carving and painting ability, Crowell excelled in subtle feathering and coloration. He most often used split swamp cedar for the solid bodies, and pine for decoys' heads. Crowell's talents were recognized at auction in January 2003, at Christie's in New York City, when his pintail drake decoy, with an elegant, turned head and crossed-wing carving, sold for $801,500. The price set a world record for American waterfowl decoys.

Dealer and author Adele Earnest (1901–1993) described Crowell as a man who was "round, ruddy-

faced, with twinkling blue eyes, who loved to sit with his hands folded across his plump stomach, telling tales of the time when he was young, skinny, and a crack shot." He began duck hunting and decoy carving at age ten. His boyhood decoys were crude and unimaginative, from a period when wildfowl game was plentiful and sophisticated carving and painting techniques were unnecessary. An article in the *Cape Cod Compass* in 1951 reported that Crowell managed the Wenham Lake hunting camp of Dr. John C. Phillips, who was Crowell's first decoy customer. Crowell's studio is described as a "humble little wooden shed," where he used white cedar exclusively for his carvings. The cedar was cut in winter when the sap is dry, and then cured under cover for three to four years before use. Crowell told a journalist he applied two prime coats of paint in thin colors to all his birds, and that the markings were applied four to five times. Historian William F. Mackey Jr. notes that Crowell also used pine for his solid body carvings of one piece construction, and faults him for a selection and drying process that failed often, at times producing decoys plagued by cracks and checks.

Crowell's painting techniques, once fully developed, suggest soft, deep feathers. His shorebird decoys are highly prized, and some connoisseurs believe them to be his best wildfowl carvings. Adele Ernest identifies Crowell as a devoted ornithologist, and she opined that his shorebirds were as distinguished and as lovingly and naturally interpreted as Audubon prints. The primary characteristics of Crowell's shorebird decoys are the separation of wingtips from the tail and a dark brushwork through the eyes.

See also **Decoys, Wildfowl; Adele Earnest.**

BIBLIOGRAPHY

Earnest, Adele. *Folk Art in America: A Personal View.* Exton, Pa., 1984.
———. *The Art of the Decoy.* New York, 1965.
Engers, Joe, ed. *The Great Book of Wildfowl Decoys.* New York, 2001.
Mackey, William F. Jr. *American Bird Decoys.* New York, 1965.

WILLIAM F. BROOKS JR.

CUNNINGHAM, EARL (1893–1977) seldom sold his paintings, and his artwork received little significant attention during his lifetime. His posthumous career was launched in 1986 by Robert Bishop (1938–1991), the late director of New York's American Folk Art Museum, with an eleven-city museum tour. The collectors Marilyn and Michael Mennello, who acquired much of the artist's estate, proved pivotal in furthering his reputation, and in 1998 they donated a substantial portion of their holdings to establish the Mennello Museum of American Folk Art in Orlando, Florida. Cunningham's almost invariable subject is the American coastline, the interplay of snug harbors, open seas, and sailing vessels, recalling a lifetime spent largely on or near the water. Despite the artist's often-serene subject matter, a sense of subliminal unease is imparted by a palette that favors contrasting complementary hues.

Born to a relatively poor farming family in Edgecomb, Maine, Cunningham was forced by economic necessity to become an itinerant peddler at the age of thirteen. Eventually he turned to sailing, traveling the East Coast on the large cargo schooners that were a principal means of interstate trade in the era before World War I. Even after his marriage to Iva Moses in 1915, Cunningham preferred to roam, first on a houseboat and later in a camper truck. During the 1920s, the couple earned their living scavenging relics and coral in Florida and bringing them north to Maine to sell. Periodically Cunningham would settle down, attempting at one point to farm in Maine and, during World War II, raising chickens for the United States Army. These stabs at stability, however, seem to have been doomed by the artist's irascible temperament. He quarreled with his family in Maine, and eventually separated from his wife.

By 1949, when Cunningham established an antiques and secondhand shop called the Over-Fork Gallery in St. Augustine, Florida, he had grown distinctly paranoid. Dubbed the "Crusty Dragon of St. George Street," he became convinced that the local preservation committee was out to burn down his shop, or even murder him. His often erratic behavior notwithstanding, however, Cunningham managed to sustain his business and, during his years in St. Augustine, devoted more and more time to painting. In the last twenty-eight years of his life, he created approximately 450 paintings based on memory, history, and fantasy, including some of his favorite images of early-twentieth-century sailing schooners, scenes of New England villages and harbor towns, and provocative portrayals of Seminole Indian life enhanced with Viking ships.

His artistic career late in life was made possible in part through the generosity of his landlady, Teresa Paffe, who subsidized his rent and dreamed of one day marrying him. Cunningham nonetheless became increasingly embittered; he died by his own hand at the age of eighty-four.

See also **American Folk Art Museum; Robert Bishop; Mennello; Painting, Memory.**

BIBLIOGRAPHY

Bishop, Robert. *Folk Painters of America.* New York, 1979.

Hobbs, Robert. *Earl Cunningham: Painting an American Eden.* New York, 1994.

Johnson, Jay, and William C. Ketchum Jr. *American Folk Art of the Twentieth Century.* New York, 1983.

FRANK HOLT AND JANE KALLIR

CUSHING & WHITE (later L.W. Cushing & Co., and L.W. Cushing & Sons) was a weathervane manufacturer located in Waltham, Massachusetts, between 1867 and 1933. In 1867 civil engineer Leonard W. Cushing (d. 1907) and mechanic Stillman White (dates unknown) acquired the Waltham weathervane company of A.L. Jewell & Co., following the accidental death of its owner, Alvin L. Jewell (d. 1867). White and Cushing had met while employed by a Waltham watch company, but the partnership was short-lived, and Cushing bought out White in 1872, and was joined by his sons Harry (dates unknown) and Charles Cushing (dates unknown). A twenty-page "Catalogue No. 9," published by L.W. Cushing & Sons in 1883, includes designs for the angel Gabriel, a grasshopper, an English setter dog, numerous roosters, a foxhound, and a fox. The catalog guaranteed that the vanes were "gilded with twenty-three karat gold leaf . . . will not corrode or discolor, but remain

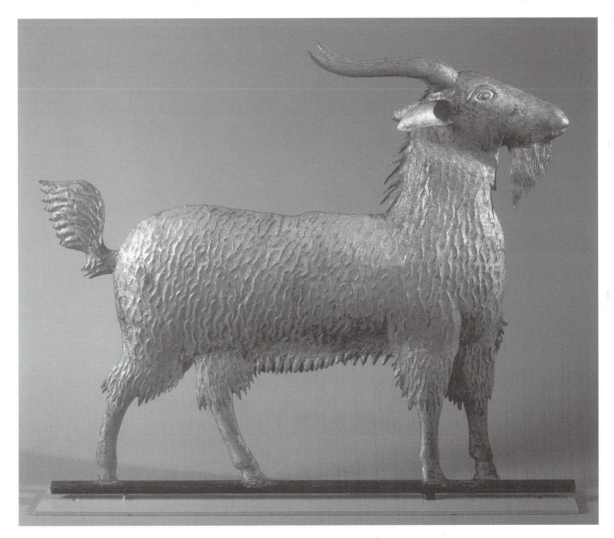

Goat Weathervane; Produced by L.W. Cushing & Sons; Waltham, Massachusetts; c. 1875.
Gilded copper. 29½ inches long.
Photo courtesy Allan Katz, Americana, Woodbridge, Connecticut.

bright and clean for many years." Accompanying a vane were a "wrought-iron spire with steel spindle; cardinal points, gilt letters, and two copper balls." Weathervane specialist Steve Miller reports that a small oval tab with the company name "*Cushing & White*" was often soldered to the crossbar of the vanes. In addition to the catalogs and sales agents, a retail outlet in New York City promoted the Cushing vanes in 1870.

Leonard Cushing maintained a daily journal, now in the collection of the Waltham Massachusetts Historical Society, that provides a detailed account of his personal and professional activities in 1867, 1868, and 1869. The journal identifies two woodcarvers, Henry (Harry) Leach (1809–1885) and E. Warren Hastings (dates unknown) of Boston, whom Cushing engaged to carve the wooden models used for his vanes. Cushing also discusses in his journal frequent business trips by train between Waltham and Boston; his involvement in gilding and painting his vanes; his designing of tools used in the trade; his completion of directional cardinal points that accompany the weathervanes; and payments to Mrs. Jewell for the original purchase of the firm, to his partner, Mr. White and to woodcarver Leach. He reports picking up the wooden models in Boston and transporting them home by train to Waltham. His *Goddess of Liberty* was an especially popular weathervane, and in May 1868 Cushing records painting an image of the *Goddess* in the store window of H.C. Sawyer, attracting a thousand onlookers.

See also **A.L. Jewell & Co.; Henry Leach; Weathervanes.**

BIBLIOGRAPHY

D'Ambrosio, Paul S. "Sculpture in the Sky." *Heritage: The Magazine of the New York Historical Association,* vol. 2, no. 2 (winter 1995): 4–11.

Kaye, Myra. *Yankee Weathervanes.* New York, 1975.

Miller, Steve. *The Art of the Weathervane.* Exton, Pa., 1984.

Sanderson, Edmund L. *Waltham Industries.* Waltham, Mass., 1957.

WILLIAM F. BROOKS JR.

CZECH AMERICAN FOLK ART: *SEE* EASTERN EUROPEAN AMERICAN FOLK ART.

DALEE, JUSTUS (1791–?) was a painter of distinctive miniature portraits and family records. He was born in Cambridge, New York; he married Mary Fowler in 1816. Dalee worked in Cambridge, West Troy, Rochester, and Buffalo, New York, and in Massachusetts. One of his portraits depicts a resident of Berea, Ohio, but whether Dalee lived or worked in that state has not been determined. The earliest evidence of his interest in art lies in a sketchbook in which he referred to himself as "Professor of Penmanship." It also contains watercolor, pencil, and ink drawings, dated 1826 and 1827. Dalee's earliest known commission is a family record from 1834; the latest, a portrait from 1845. No portrait from before 1835 has been found to date. Dalee was listed in the 1847 *Commercial Advertiser Directory* for the city of Buffalo as a "portrait painter," and as a "grocer" the following year, indicating that he had probably ceased painting.

Dalee's half-length miniatures, drawn in pencil, ink, and watercolor on paper, typically show sitters posed in profile, facing left; early works, however, show bodies facing forward with the head turned to the left. Fashionable coiffures and costumes are executed with precision, while ears, as well as the transition from neck to shoulders in early women's portraits, were difficult for Dalee to execute convincingly. Painted oval spandrels cause the portraits to resemble miniatures on ivory, which may have been intentional.

The colorful family records that Dalee made when he resided in Cambridge and West Troy are similar in design and among the most attractive of the genre. Using commercial preprinted family registers, Dalee augmented the forms with ink and watercolor images, and inked inscriptions that are ample evidence of his penmanship skills. The records feature paired fluted columns at the sides wrapped with festoons and supporting an arch, and above them is printed and inked, "*IN GOD WE HOPE.*" Above the left columns is a man painted full-length, and an anchor, symbolizing hope, while below, a red cradle; above the right columns stands a woman dressed in mourning attire beneath a willow branch, and below that, a black coffin. Dalee typically painted a pair of conjoined red hearts below the center of the arch.

Ironically, daguerreotypes (early small-scale photographs produced on a silver or copper-coated plate, often displayed in a unique gold-plated or velvet frame), which became widely circulated by the 1850s and probably ended Dalee's career as a portrait painter, resembled Dalee's portraits in size, and included decorative, oval mats. Daguerreotypists offered novelty and a low price, which Americans have always embraced, and against which Dalee could probably no longer compete.

See also **Family Records or Registers; Miniatures; Mourning Art.**

BIBLIOGRAPHY

Rumford, Beatrix T., ed. *American Folk Paintings: Paintings and Drawings Other Than Portraits from the Abby Aldrich Rockefeller Folk Art Center*. Boston, 1988.

D'Ambrosio, Paul S., and Charlotte M. Emans. *Folk Art's Many Faces: Portraits in the New York State Historical Association*. Cooperstown, N.Y., 1987.

RICHARD MILLER

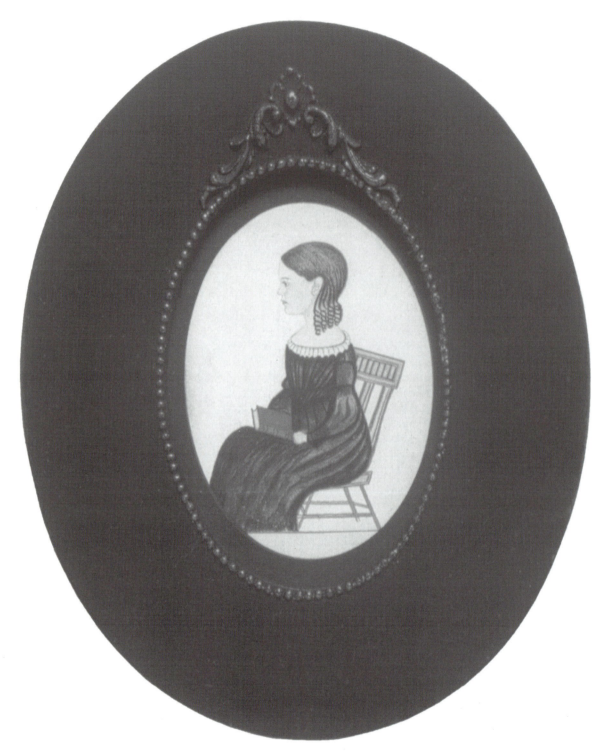

Blonde Haired Little Girl; Justus Dalee; c. 1833–1841. Watercolor, pen, and ink on paper. 4 × 3 inches (oval). The Bertram K. Little and Nina Fletcher Little Collection auction at Sotheby's 6525, January 29, 1994.
Photo courtesy Sotheby's, New York.

DARGER, HENRY (1892–1973) was a recluse who created and inhabited a vast imaginary world through his writing and painting. Darger's work was discovered in 1972 by his Chicago neighbor and landlord, photographer Nathan Lerner, and was made public upon the artist's death. What Lerner found was a room full of unpublished manuscripts and bound piles of paintings. The magnitude of Darger's writing is mind-boggling; his texts include a six-part weather journal kept daily for nearly ten years (from 1958 to 1967); several miscellaneous diaries; an autobiography, *History of My Life,* comprising more than 5,000 pages; *Further Adventures in Chicago: Crazy House,* numbering more than 10,000 pages; and the sequel to his masterful, illustrated epic, the 15,000 page *Story of the Vivian Girls in What Is Known as the Realms of the Unreal, or The Glando-Angelinnian War Strom, Caused by the Child Slave Rebellion.* Darger created an astonishing body of artwork to accompany this manuscript; these fantastic, mural-size watercolors, executed in lyrically seductive hues, are celebrated widely today.

In the Realms of the Unreal was begun when Darger was nineteen years old. Written first in longhand and later typed, it is a fictional story of war and peace, good against evil, and is somewhat loosely based on the events of the American Civil War. The story follows the heroic efforts of a band of young women, the Vivian Girls, to free enslaved children held captive by an army of adults, the Glandelineans. Throughout the tale, one confronts much death and destruction, but in the end the forces of good triumph. The artist poignantly captures the powerlessness of enslavement by depicting the children naked. The nakedness of the children also exposes their mixed gender, which is a compelling aspect of Darger's imagery, open to many interpretations.

Henry Darger taught himself drawing and painting techniques in the privacy of his home. He produced several hundred paintings, almost all in watercolor and many of which incorporating collage. As the artist became a competent painter and a confident colorist, his paintings grew in scale; his later, more sophisticated compositions are often more than ten feet in length. In order to realize his aesthetic vision, the artist created inventive techniques involving collage and appropriation from popular media. He devised a clever system of enlarging images culled from coloring books and comic strips to achieve his desired scale; he traced parts of these images using carbon paper. Popular culture was transformed in his compositions. Using collage and painting, he placed his subjects at times in lush fantastical gardens, other times against the backdrop of a menacing storm, or he used a bloody war background painted with dime-store watercolor sets. Darger's brilliance as an artist rests partially in his ability to create his drawings as much more than tracings from borrowed images, an effect achieved through his complex processes and a confident hand.

See also **Outsider Art.**

BIBLIOGRAPHY

Bonesteel, Michael. *Henry Darger 1892–1973.* New York, 2000.

MacGregor, John. *Henry Darger: In the Realms of the Unreal.* New York, 2002.

Prokopoff, Stephen. *Henry Darger: The Unreality of Being.* Iowa City, Iowa, 1996.

BROOKE DAVIS ANDERSON

DARLING, SANFORD (1894–1973) was a self–taught artist whose *House of a Thousand Paintings,* in Santa Barbara, California, was decorated inside and out with scenes of his travels around the world. Using semigloss enamel, Darling often painted on plywood and compressed cardboard that he affixed to the walls of his house. Other vignettes, painted directly on the bungalow, reached from the risers of the front steps to the eaves under the roof. Darling even painted on his window screens, on the screened front door, and embellished his refrigerator, kitchen cabinets, and easy chairs. While Darling included some views of familiar American landmarks, he was particularly drawn to exotic vistas of Chinese and Japanese temples, snow–covered peaks, volcanoes, and uninhabited beaches. Palm trees, present in many of Darling's landscapes, seem to offer escape from mundane cares.

Darling's art environment, with its evocation of picaresque adventures, was the culmination of a varied life. Darling had worked as a Hollywood stuntman, commercial fisherman, and chiropractor before becoming a technician for the General Petroleum Company, a position that he held for twenty-five years. Soon after Darling retired, in 1959, his wife died. Bored with fishing and golf, Darling spent six months traveling in Europe and Asia. He enjoyed this first tour so much that he set off on a second trip, around the world, visiting almost all the places that he later depicted in his paintings.

Darling welcomed visitors, and enjoyed recounting his adventures to the many guests who arrived after *Time* magazine published an account of Darling's eccentric creation. After Darling's death, in 1973, the house was sold, and the paintings were dispersed.

See also **Environments, Folk; Painting, American Folk; Painting, Landscape.**

BIBLIOGRAPHY

Cat and a Ball on a Waterfall: Two Hundred Years of California Folk Painting and Sculpture. [exhibition catalogue] Oakland, Calif., 1986.

Larson-Martin, Susan, and Lauri Robert Martin. *Pioneers in Paradise: Folk and Outsider Artists of the West Coast.* Long Beach, Calif., 1984.

Rosen, Seymour. *In Celebration of Ourselves.* San Francisco, 1979.

CHERYL RIVERS

DAVE THE POTTER worked from about 1834 to 1863 at Lewis Miles's pottery, just south of the Edgefield-Aiken county line in South Carolina. One of the lesser-known aspects of the Southern stoneware industry was its reliance upon African American labor, from both slaves and those that were free. This was particularly true in the Edgefield District of South Carolina, northwest of Aiken, where throughout the 1830s and 1840s black craftsmen were sold along with the shops in which they worked. Little is known about most of these potters, but Dave has become legendary because he combined his skill as a turner with some literary talent.

Dave established his legacy by signing and dating his stoneware vessels, occasionally adding a bit of poetic doggerel, such as "Great and Noble Jar / Hold sheep, goat or bear." Such inscriptions are rare on Southern pottery, particularly on those pieces made by slaves, because after 1837 it was against state law to teach slaves to read and write. Dave's earliest known signature pot, however, is dated 1834. There is also some evidence that Dave's education may have been a by-product of his employment by a local newspaper, the *Edgefield Hive*. Still, his primary occupation for nearly thirty years was that of a turner at the Miles shop.

Southern shops serving rural agricultural areas tended to produce outsize jugs, jars, and pots that were designed for bulk storage of molasses, cracked corn, and other staples. The larger sizes, up to twenty gallons in capacity, are notoriously hard to throw on the wheel. The potter must be quick, facile, and strong enough to build the pieces without their slumping into a mass of dirt, either on the way to the kiln or during firing. Dave's pots, covered with a rich alkaline glaze, are uniformly well shaped; they have generally been made with from one to four substantial lug handles to facilitate use—precisely what the trade demanded.

That Dave's skills were appreciated by his employer seems evident from the fact that he was al-lowed to sign and date his work, and one suspects that the poesy may well have been an added selling point with some customers.

See also **African American Folk Art (Vernacular Art); Lanier Meaders; Pottery, Folk; Stoneware.**

BIBLIOGRAPHY

Horne, Catherine Wilson. *Crossroads of Clay: The Southern Alkaline Glazed Stoneware Tradition.* Columbia, S.C., 1990.

Ketchum, William C. Jr. *American Stoneware.* New York, 1991.

WILLIAM C. KETCHUM

DAVIDSON, DAVID (1812–?), who called himself an Artist in Penmanship, excelled in "micrography," an ancient Jewish art form in which texts written in tiny characters are used to create portraits or other figures, architectural devices, and abstract geometric and organic shapes. In micrographic drawings, the texts themselves are so minute that they cannot be seen, except on close examination, only the images that they form are immediately apparent to the eye. Davidson was born in Russian-controlled Poland, where the traditions of micrography continued to be known and actively practiced, left there in 1848 for England, and finally settled in the United States in 1851.

A number of clues have been uncovered about Davidson's life and career. Researcher S. Ruth Lubka has demonstrated that he sought and briefly secured employment as a *hazzan* in synagogues in New York and Baltimore, but he was not successful in this calling. In nineteenth-century America, the *hazzan* not only was expected to lead the congregation in prayer but to deliver sermons as well, and Davidson apparently lacked sufficient facility in English to be effective as a public speaker. His failure led to a deep personal crisis and a determination to devote his efforts to micrography, although he had had no instruction in the practice. Exhibiting two works based on biblical texts, one in Hebrew and the other in English, in New York's Crystal Palace from 1853 to 1854, he was praised as an artist by commentators in the Jewish press of the day.

Lubka's research has revealed that Davidson published a small, eighteen-page pamphlet in 1855 as a key to a massive "pictorial specimen of penmanship" that he created over a two year period. According to the pamphlet the large, micrographic drawing depicted a visionary temple in black, red, and blue inks. Measuring six-and-a-half by five feet, it contained the entire text of thirty-six books of the Old Testament on one side of a sheet of paper. The work, which is no longer extant, was publicly shown at the Stuyvesant

Institute in New York in 1855. *The Asmonean,* a Jewish periodical, urged its readers to see "the most astonishing specimen of artistic skill and patience ever exhibited." Blind in one eye, Davidson was intensely, perhaps obsessively, devoted to his art form.

Among the handful of works by Davidson that survives is a *mizrach,* his earliest effort and only known work in a non-micrographic format. A *mizrach* (the word in Hebrew means "east") is an ornamented sign or marker placed on the eastern wall of a synagogue or home to indicate the traditional direction of Jewish worship. Davidson's *mizrach* is composed of cut paper and employs brilliant watercolors and Hebrew calligraphy in gold. Also extant is a pair of micrographic portraits of a Mr. and Mrs. H. Brody on embossed and perforated lacelike paper, one of which contains the English text of the Book of Ruth and the other the books of Haggai and Zechariah; a frontal elevation of the New York Public Library; and a geometric rendering of the Declaration of Independence, in which the artist, in a true tour de force, fashioned the tiny characters of the text not by writing the letters themselves but by filling in the negative space around them.

See also **Calligraphy and Calligraphic Drawings; Fraktur; Jewish Folk Art; Papercutting; Religious Folk Art.**

BIBLIOGRAPHY

Kleeblatt, Norman L., and Gerard C. Wertkin. *The Jewish Heritage in American Folk Art.* New York, 1984.

GERARD C. WERTKIN

DAVIS, JANE ANTHONY (1821–1855), until 1981 known only as J.A. Davis, produced more than two hundred portraits during her short life. In 1923 three of the artist's unsigned portraits were attributed to James Ellsworth and later to Alexander Emmons; in 1970 three others were attributed to Joseph H. Davis and to Eben Davis. In 1973 Gail and Norbert Savage found the name "J.A. Davis" on four portraits. In 1981, Sybil and Arthur Kern identified the artist, previously assumed to be a man, as Jane Anthony Davis, the daughter of Giles and Sara Robinson Greene Anthony, born September 2, 1821, in Warwick, Rhode Island. Two later reports by the Kerns supported this identification.

For a short time in 1838 Jane attended the Warren (Rhode Island) Ladies Seminary, where she may have studied drawing and painting. On February 1, 1841, she married Edward Nelson Davis of Norwich, Connecticut. The newlyweds initially lived in Norwich,

where, on January 10, 1842, Davis delivered her first child. Late in 1844 they moved to Providence, Rhode Island, and on April 26, 1847, Davis gave birth to her second child. Her last portrait, of Louella Hodges, was painted in August 1854. Eight months later Jane Anthony Davis died of tuberculosis, at the age of thirty-three, and was buried in Providence's Swan Point Cemetery.

Most of the watercolor and pencil portraits by Davis are bust-length, in three-quarter view. The subjects often wear black clothing, and usually show a ragged part in the hair, bluish coloring of the eyelids, a wide, colored horizontal band below the bustline, and negative space between arms and body. Occasionally, flowers are held or are shown growing next to the subject. Many of the portraits are dated and signed "J.A. Davis," and on some the subject's name is inscribed.

Almost all of Davis's subjects were residents of the Norwich or Providence-Warwick areas; they may have been fellow students or teachers, or they may have been related to or associated with her family. Two of the periods of her inactivity as an artist correspond to those when she was busy caring for her newborn children.

See also **Painting, American Folk.**

BIBLIOGRAPHY

Kern, Arthur, and Sybil Kern. "J.A. Davis: Identity Reviewed." *The Clarion,* vol. 16 (summer 1991): 41–47.
———. "Surprising Identity of J.A. Davis." *The Clarion* (winter 1981–82): 44–47.
———. "Was J.A. Davis Jane Anthony Davis? New Supporting Evidence." *Folk Art,* vol. 24 (summer 1999): 26–31.

ARTHUR AND SYBIL KERN

DAVIS, JOSEPH H. (active 1832–1837) was a portrait painter who worked in southwestern Maine and southeastern New Hampshire during the second quarter of the nineteenth century. A prolific artist, Davis executed more than 150 known portraits in watercolor on paper over a period of five years. Information pertaining to his identity has been gleaned primarily from elaborate calligraphic inscriptions that he included along the bottom borders of his portraits, recording sitters' names and ages at the time their likenesses were painted. By linking genealogical information regarding these clients with their place of origin, Davis's perambulations can be traced. Only a few of these works bear the artist's signature; the signature on the portrait of Bartholomew Van Dame confirms that the artist was a left-handed painter.

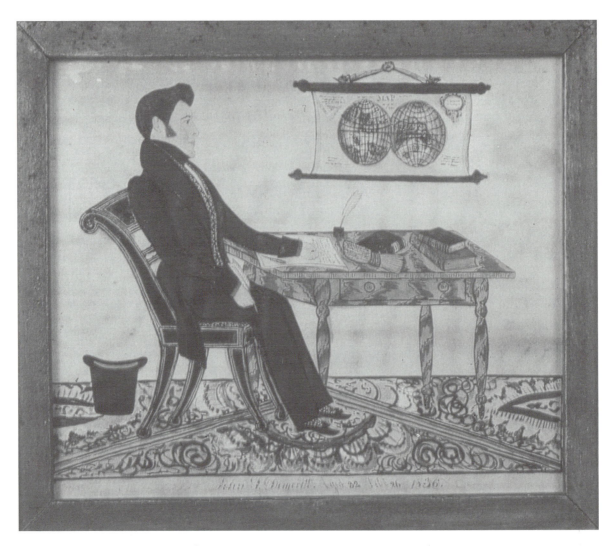

John F. Demeritt; Joseph H. Davis; 1836. Watercolor, pen, and ink on paper. 9¾ × 11¾
inches. The Bertram K. Little and Nina Fletcher Little Collection auction at Sotheby's 6612,
October 21 and 22, 1994.
Photo courtesy Sotheby's, New York.

Davis used a variety of formulaic compositions to represent his subjects in watercolor. Husbands and wives as well as siblings are often posed together, either on the same sheet of paper or facing each other on separate pages, seated or standing, their faces in profile with bodies turned slightly, to almost three-quarter view. Portrayed in parlor settings, men, women, and children are surrounded by attributes of their middle-class status. They hold books, read newspapers, or write letters with quill pens, and they sometimes play music, among other activities. Davis depicted interiors decorated with painted tables and chairs, complemented by pictorial landscape views festooned with swags of garlands, fruit and flower arrangements, and ornate carpets. In one such portrait of *John F. Demeritt* the sitter is depicted at his writing desk, perhaps in a study, dress in a fine black suit with red trim, tails, and decorative shoes and stockings. A map on the wall as well as period furniture would seem to indicate Mr. Demeritt's relative wealth and cultural status.

Davis often included family pets, posed as if they too knew their likenesses were being recorded for posterity. Davis also drew sitters posed outdoors,

where children, in particular, are engaged in leisure activities, such as picking flowers, or are holding articles associated with horseback riding, kite flying, or bird hunting, among other interests.

Several individuals have attempted to identify the person known as Joseph H. Davis, a search complicated by the artist's relatively common name. Most recently, researchers Arthur and Sybil Kern have posited an association between Davis's portrait subjects and the Freewill Baptist Church in New Hampshire and Maine. They have also proposed that the artist may be the same Joseph H. Davis who was born on August 10, 1811, to Joseph and Phebe Small Davis of Limington, Maine.

See also **Ralph Esmerian; Fraternal Societies; Freemasonry; Painting, American Folk.**

BIBLIOGRAPHY

Kern, Arthur, and Sybil. "Joseph H. Davis: Identity Established." *The Clarion*, vol. 14, no. 3 (summer 1989): 48–50.

Savage, Gail, Norbert H. Savage, and Ester Sparks. *Three New England Watercolor Painters.* Chicago, 1974.

Spinney, Frank O. "Joseph H. Davis, New Hampshire Artist of the 1830s." *The Magazine Antiques*, vol. 44 (October 1943): 177–180.

CHARLOTTE EMANS MOORE

DAVIS, ULYSSES (1913–1990) was a woodcarver who taught himself the craft of carving wood when he was about ten years old. He was born and raised in Fitzgerald, Georgia, where he attended school until the tenth grade, when he dropped out to help support his family. His earliest known works are bas-reliefs of rural scenes he made shortly after he began to carve. Davis married in 1933, and the first of his nine children was born the following year. In 1942 the family moved to Savannah, where Davis found employment as a railroad office worker.

In 1960 Davis went into business as a barber, using the small building he constructed behind his house. For the rest of his life he earned his living by cutting hair, an essentially sculptural skill that he had also learned as a child. His Ulysses Barber Shop doubled as a gallery for displaying his growing body of wood sculpture, and by the early 1980s he had filled it with more than two hundred pieces, neatly displayed on shelves and countertops around the inner periphery of the one-room building.

Davis's repertoire of in-the-round sculpture included portraits of key individuals from biblical lore and United States history, relatively realistic depictions of real animals, and his more fanciful portraits of African chieftains and fictional, dragon-like beasts. Among his more widely known works are his portrait busts of forty United States presidents, several wearing miniature eyeglasses that he handcrafted. He stained many of his carvings, to heighten and add gloss to the natural colors of the different types of wood he used. He often embellished his pieces with glitter, sequins, rhinestones, and bits of costume jewelry, and on relatively rare occasions he also painted them.

Acknowledging the extent to which he could become absorbed in the painstaking detail work that his art required, Davis once said that before he began a new piece, "I have in mind what I want it to look like, but after a while you've just got to stop your mind and just finish it, because your mind will keep going, and you'll keep carving till you don't have nothing left." Despite persistent pleas from art collectors and dealers, Davis refused to sell his works throughout his lifetime, making very few exceptions. In explaining his reluctance to part with his sculptures, he referred to them collectively as "a treasure," and said, "They're part of me." A portion of his works have now been retained and catalogued at the Beach Institute, Savannah, Georgia.

See also **African American Folk Art (Vernacular Art); Sculpture, Folk.**

BIBLIOGRAPHY

Arnett, Paul, and William Arnett. *Souls Grown Deep: African American Vernacular Art of the South,* vol. 1. Atlanta, Ga., 2000.

Patterson, Tom. "A Strange and Beautiful World," *Brown's Guide to Georgia,* vol. 9, no. 12 (December 1981): 53–54.

Perry, Regenia A. *Elijah Pierce, Woodcarver.* Columbus, Ohio, 1992.

TOM PATTERSON

DAVIS, VESTIE (1904–1978) painted scenes of New York City, including its landmark buildings, parks, beaches, streets, and people. While often filled with minute detail, the patterned, rhythmic order in Davis's pictures seems to suspend time, allowing and encouraging the viewer to take in the details of the vignette. Painted in a flat, compositional style with a shallow picture plane, generalized lighting and pure color, Davis's New York is a bright, merry place. In an interview, he said, "You've got to make a song of a painting, you've got to give it a sweet melody." In *Cyclone*, a four-car train filled with people, on a dense track network, is momentarily frozen in midair over an elevated peak, about to experience a dramatic descent. At ground level, passengers wait for the next ride, and in the foreground, people are watching, buying tickets, promenading, or purchasing frozen custard, hamburgers, and frankfurters from concession operators.

His *Coney Island Boardwalk with Parachute Jump* (1972) is one such structured horizontal composition that includes sunbathers in the left portion of the

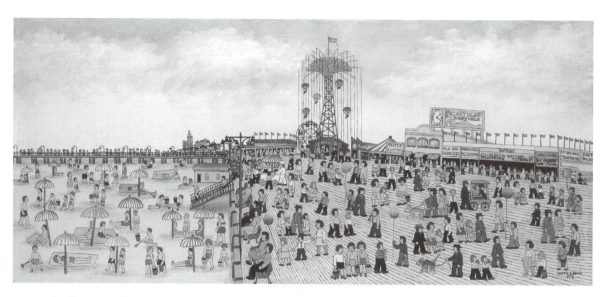

Coney Island Boardwalk with Parachute Jump; Vestie Davis; 1972. Oil on canvas. 17 × 37 inches. © Collection American Folk Art Museum, New York. Gift of Mr. and Mrs. Ivan Karp, 1984.10.1.

composition and boardwalk strollers on the right. Towering over this scene of minutiae is the parachute jump ride of the title, a gold embellished structure topped with an American flag. Tiny figures appear to float to the earth in their brightly colored parachutes.

Davis was born in Maryland in 1904. He joined the navy for seven years, and in 1928 he went to live in New York. He worked many jobs, among them train conductor, circus barker and ticket taker, undertaker, church organist, and subway newsstand operator. From childhood Davis showed an aptitude for art, but like so many other self-taught artists he postponed painting until later in life. About 1947, he recalled that while walking on 57th Street in New York, as a middle-aged adult, he saw paintings of barnyard scenes in a gallery window, and mused, "I can paint like that."

In 1950, Davis participated in the Washington Square Outdoor Art Exhibit, and his work hung on a fence on Washington Square South. Morris Weisenthal, a New York City gallery owner, saw the paintings and decided to represent Davis among his stable of artists.

Davis worked predominantly in oil on canvas, but he also created drawings that, on several occasions, he traded with his friend Sterling Strauser for Strauser's own paintings. In letters he wrote to Strauser, Davis described his drawing and painting methods. Before making a sketch, he studied each location he chose to paint, and took a series of photographs to help compose what was often a panoramic scene. Using the photographs for reference, he spent hours

drawing on canvas. Once satisfied with the general outlines, he filled in details, such as windows, the bricks of buildings, and people. Habitually working from left to right, Davis outlined the drawing in india ink before applying color. He did not mind repeating subjects.

One Coney Island painting of Davis's was used as the cover for the September 6, 1958, issue of *The New Yorker. Newsweek* published a feature article about Davis on June 6, 1960. His obituary ran in *The New York Times* on November 15, 1978.

See also **Painting, American Folk; Sterling Strauser.**

BIBLIOGRAPHY

Hemphill, Herbert W. Jr., and Julia Weissman. *Twentieth-Century American Folk Art and Artists.* New York, 1974.

Miller, Gloria Bley. "Vestie Davis Brooklyn Painter in His Own Words." *Folk Art Summer,* vol. 28, no. 2 (summer 2003): 40–51.

Lee Kogan

DAWSON, WILLIAM (1901–1990) was one of the few self-taught artists to achieve national recognition in his lifetime: first in 1982 with the seminal exhibition, "Black Folk Art in America: 1930–1980," at the Corcoran Gallery of Art in Washington D.C., and then in 1990 with a major retrospective, "The Artworks of William Dawson," in which 250 works were shown at

the Chicago Public Library Cultural Center. The artist carved in wood and painted pictures.

Born on a large farm that his grandfather owned in Madison, Alabama, Dawson moved with his family to Chicago in 1923. He worked for the E.E. Aron Company, a wholesale produce distributor in Chicago's South Water Market. He was one of the first African-American men to become a member of the Teamsters' Union, and began his career with the Aron company as a laborer, working his way into a management position over the years.

After his retirement in the 1960s, Dawson enrolled in an art class at the local YMCA, but found it too regimented. He progressed from painting small pictures of houses and birds to carving figures of humans and animals executed in wood that he found in his neighborhood. His style was characterized by strong outlined features, penetrating eyes, and prominent teeth. The artist painted his carvings with acrylic paint and then sprayed them with shellac. Some of his figures bore a strong resemblance to people he knew, and he produced many self-portraits. Personalities from popular culture, such as Sammy Davis Jr., and political figures were subjects of his woodcarvings, as were a gun-toting man in a stylish hat, an elegantly gowned woman, and a pair of hippies. His figures of people often had articulated arms nailed to the body, hands, and feet that were small in proportion to the head. Memories of farm life inspired many carvings and paintings of horses and dogs.

Susann Craig, a teacher at Columbia College who saw his work in a display case at the Lincoln Park branch of the public library, was impressed with Dawson's singular expression. She arranged his first one-person exhibition at the college in 1976. Dawson completed about five hundred carvings and approximately 150 paintings in his lifetime.

See also **African American Folk Art (Vernacular Art); Painting, American Folk; Sculpture, Folk.**

BIBLIOGRAPHY

Chicago Public Library Cultural Center. *The Artworks of William Dawson: 1980–1990.* Jackson, Miss., 1982.

Horwich, Elinor L. *Contemporary American Folk Artists.* Philadelphia, 1975.

Livingston, Jane, and John Beardsley. *Black Folk Art in America: 1930–1980.* Jackson and Oxford, Miss., 1982.

LEE KOGAN

DEATH CARTS are wooden-wheeled carts surmounted by a gaunt skeletal figure personifying death. They have been used since at least the early nineteenth century by Catholic lay brotherhoods in New Mexico during Holy Week as well as on other ceremonial occasions. The skeletal figure of Death is hand carved from cottonwood and painted white. It typically has a fearsome aspect and holds a bow and arrow or scythe-like implement in its hands.

Figures of Death and other death imagery have a long history in Catholic practice, dating from at least the medieval period. The personification of death in both Europe and the New World has two related meanings. First, it serves as a reminder of the evanescence of human life and as an inspiration to the faithful not to attach themselves to worldly things, but rather to prepare for the inevitability of death by living a pious life. This aspect is seen in the attention paid to allegorical representations such as the medieval Dance of Death, and triumphal images, on funeral monuments, for example, in which Death is often portrayed riding in a sumptuous, open carriage. The second aspect of this imagery in Catholic tradition is the triumph of Jesus Christ over death. His divine nature, which is eternal and all-powerful, triumphs over death. This victory is made clear through the symbolism of His resurrection. In Spain and colonial Mexico, a figure of Death in its cart was drawn in processions during the Holy Week ceremony of the Descent from the Cross and Burial of Christ. Above the figure was a cross with inscriptions reading "Death, where is thy victory?" and "Death, I will be thy death." These two aspects of death imagery come together in the life of Catholic believers because if they take the first aspect seriously and live a pious life, they will in a sense also triumph over death by attaining salvation, or eternal life.

The Catholic emphasis on preparing for the posthumous state makes death less fearful. It is simply a transition between two states and thus a factor to be lived with in everyday life. After the conquest of Mexico, this view concurred nicely with that of the Nahuas and other indigenous groups, who saw human existence as a whole, comprising both life and death, two different aspects of the one existence. Just as "day" comprises both day and night, so "life" comprises both life and death. The European and indigenous Mexican traditions come together in religious and funeral ceremonies, popular art and song, and the annual Day of the Dead celebrations in which people bring food as offerings for their ancestors.

The use of death carts in New Mexico probably derives from the popular Mexican ceremony of the Descent and Burial of Christ. By the late 1800s at least, however, the emphasis was no longer on the triumph of Christ over death but rather on the aspect of death as a reminder. The reminder was made graphically

real by the Holy Week penitential practice of dragging a heavy death cart loaded with rocks over rough ground up the hill of the Calvario. In another ceremony, perhaps reflecting the aspect of Christ's triumph over death, newly elected brotherhood officers would ride with the figure of Death in the cart drawn by two brothers in a procession to the Calvario, singing hymns about Jesus as they went. In New Mexico, death (*la muerte*) is personified as an aged woman, often dressed in a black shawl and known familiarly as Doña Sebastiana. Because Death figures often carry a bow and arrow, this name probably derives from San Sebastiano (St. Sebastian), an early Roman martyr who was pierced by arrows.

At least one maker of death carts is known: Nasario Lopez of Córdova (the father of folk artist José Dolores Lopez) made them for brotherhood meeting houses, from about 1840 to 1870. Death figures were not available from commercial sources and were only made locally. Thus their making survived to the end of the *santero* tradition in New Mexico, some pieces dating from about 1910 to 1920. Since the 1920s, when an aesthetic appreciation of New Mexican folk art began to develop, death carts have evoked high interest from art historians and connoisseurs of folk art. On seeing a figure by Nasario Lopez in the 1930s, Daniel Catton Rich, director of the Chicago Art Institute, called it one of the really significant examples of folk art in America. The importance of death carts as objects of art is not only because of their aesthetic qualities; they have a visceral meaning that is not limited to their cultural context but is universal, for it must remind everyone who views them of his or her mortality.

See also **Bultos; Religious Folk Art; Santeros.**

BIBLIOGRAPHY

Boyd, E. *Popular Arts of Spanish New Mexico*. Santa Fe, N. Mex., 1974.
Steele, Thomas J. "The Death Cart: Its Place Among the Santos of New Mexico." *The Colorado Magazine*, vol. 55 (1978): 1–14.
Wroth, William. *Images of Penance, Images of Mercy: Southwestern Santos in the Late Nineteenth Century*. Norman, Ind., and London, 1991.

WILLIAM WROTH

DECORATED FURNITURE: *SEE* FURNITURE, PAINTED AND DECORATED.

DECORATION is an embellishment or adornment, an adjunct that is not essential to, although it may affect, the structure or beauty of an object. The decoration of American folk art draws from many cultures, and is conditioned both by the material to which it is applied and by the aesthetic preferences of the ornamentor. Decoration may have symbolic significance, or a magical or spiritual function; sometimes it is socially demonstrative or intended for a particular class, gender, race, or ethnic group. The distinctions between the symbolic and the decorative, the abstract and the naturalistic, are often hazy. Taste preferences in decoration change over time and vary among different communities, so that what is seen as stylish in one era or in certain communities can be regarded as vulgar and garish in others. The elaborate symbolic and social code of American folk art is often absorbed without clearly understanding it, and it is easily misinterpreted today.

The basic forms of linear ornament (upright stripes, horizontal bands, zigzags, chevrons, diamonds, and checkerboard patterns) appear in nearly every medium of American folk art. Conforming to the medium in which they appear, geometric shapes vary depending upon whether they are painted on paper, stitched onto samplers, pierced into tin, carved on furniture, incised into whales' teeth, woven into coverlets, cut out of paper, or painted into redware, with lines transformed into wavy and spiraling ornament to conform to the shapes of bottles, plates, jars, and jugs. Figurative motifs (fish, animals, humans, plants, and flowers) in American folk art can be reduced to their basic elements, stylized into two-dimensional patterns, or carefully delineated and shaded as accurate representations. Architectural motifs combine the geometric and figurative elements, decorating the flat surfaces of fireboards, wagons, walls, and doors with landscapes, seascapes, city views, biblical scenes, scenes of daily life, and moments of historic importance.

Decoration as surface treatment on American folk art closely follows the progression of tastes from the seventeenth century to the present. Seventeenth-century surface embellishment of furniture, samplers, and textiles is divided into numerous small, visually separate units of decoration, with a vocabulary of stylized plant forms such as sunflowers or tulips emanating from vessels, or contrasting rows of rosettes alternating with lozenges. The mannerist vocabulary of the last quarter of the seventeenth century features sweeping S curves, central motifs of a tree of life with outwardly curving branches displaying luxuriant blossoms, tulip and leaf motifs, pinwheels, and undulating veins, as exhibited in the crewel bedhangings, painted furniture, gravestones, silver, and costumes of the period. *Chinoiserie* patterns drawn from Asian lacquer and pottery in imitation of japanning, a

style of decoration in which the ground color was most often black and the decorations usually gold, influenced both the motifs and arrangement of figures on American japanned furniture, needlework, tiles, and pottery during the opening decades of the eighteenth century. The iconography of Pennsylvania German folk art draws on the folk art motifs of emigrants from Switzerland, Alsace, and southwest Germany, illustrated particularly in the hand-drawn fraktur, or certificates of birth, family records or registers, house blessings, bookplates, religious broadsides, drawings, and writing sample traditions. Decorative elements such as stars, hearts, paired birds, stylized tulips, peacocks, double-headed eagles, lilies, unicorns, trees of life, and perching birds were often incorporated into German text found in the communities around Philadelphia.

The years following the American Revolutionary War marked the beginning of the great flowering of American folk art along with a new decorative vocabulary. Adopted from the classical vocabulary of ancient Greece and Rome and filtered through British and French decorative arts, American furniture and folk arts display classical ornament thought suitable and appropriate as symbols for the new republic, including the spread eagle, the figure of Columbia, scrolling acanthus leaves, bellflowers, anthemion, paired griffins, palmettes, and dolphins, all organized within egg-and-dart and Greek-key borders. These motifs acted as an elaborate symbolic code for liberty, justice, and freedom, which was absorbed without its origins being clearly understood. Within the Neoclassical context, decorative artists used symbols sympathetic to the times: the cornucopia for Plenty, acorns for Welcome, the olive branch for Peace, the pineapple as a symbol of Hospitality, and the heart as a token of Love, Friendship, and Fidelity.

The iconography of African American quilts, with its emphasis on vertical strips, bright colors, large designs, asymmetry, improvisation, multiple-patterning, and symbolic forms, was derived from ancient traditions with roots in African culture and textiles. It may have been adopted for its religious significance and protective charms, and as visual iconography inherent to its own time.

The revival styles of the last three quarters of the nineteenth century found expression in the decoration of American folk art. The Gothic revival adapted the architectural elements of medieval architecture to furniture and decorative arts in the years before the American Civil War, as evidenced in the use of the cinquefoil, a symmetrical five-lobed formalized leaf form; the crocket, carved flowers or foliage placed on the outer edges of a vertical element; and the quatrefoil, a four-lobed leaf form used in Gothic tracery. In the last half of the nineteenth century, the revival of the rococo, with its asymmetrical use of florid S curves, C scrolls, and naturalistic motifs derived from rocks, shells, and plants, dominated the needlework, furniture decoration, watercolors, and handcrafted accessories that filled homes throughout the Victorian era.

Despite attempts to create a new style of ornament, notably by Owen Jones in the 1860s, none succeeded until the organic forms of art nouveau in the 1880s, followed by the geometric simplicity of art deco in the 1920s. In the years between, the arts and crafts movement in America, promoting craftsmanship and a reform of industrial design, prompted an attack on the profusion of meaningless ornament and demanded functionalism in furnishings and architecture, along with simplicity without decoration and ornamentation in American folk art. This led to a reversal in the traditional significance of decoration, and its reduction or total elimination was thought to be culturally superior.

See also **African American Folk Art (Vernacular Art); Calligraphy and Calligraphic Drawings; Coverlets; Family Records or Registers; Fraktur; Furniture, Painted and Decorated; German American Folk Art; Gravestone Carving; Pennsylvania German Folk Art; Pictures, Needlework; Pottery, Folk; Quilts; Quilts, African American; Redware; Samplers, Needlework; Tinware, Painted.**

BIBLIOGRAPHY

Brackman, Barbara. *Encyclopedia of Pieced Quilt Patterns*. Paducah, Ky., 1993.

Schaffner, Cynthia V.A., and Susan Klein. *Folk Hearts: A Celebration of the Heart Motif in American Folk Art*. New York, 1984.

Trilling, James. *The Language of Ornament*. London, 2001.

Wahlman, Maude Southwell. *Signs and Symbols: African Images in African-American Quilts*. New York, 2001.

Zea, Philip. "Diversity and Regionalism in Rural New England Furniture." *American Furniture* (1995): 69–110.

CYNTHIA VAN ALLEN SCHAFFNER

DECOYS, FISH are handcrafted effigies used by ice fishermen to lure game fish within range of the fisherman's wrought-iron spears. It is believed that the woodland Indians passed on the fish decoy tradition to the European settlers of North America. Early French families who settled around lakes St. Clair, Huron, and Superior in North America were the first Europeans to fashion the carved, wooden fish sculp-

tures. The decoys are used for ice fishing in freshwater. In the United States fish decoys were prevalent during the winter on the frozen freshwater lakes of Michigan, Minnesota, Wisconsin, New York, and Vermont. Spearfishing has been banned in all states except Minnesota, where it is still legal to spear northern pike, and the crafting of fish decoys has dwindled proportionately.

Fish decoys come in various shapes and sizes, with certain consistent characteristics. They have no hooks, for it is the fisherman's spear, not the hook, that will catch the fish. To force the decoy to sink, weights are attached to it, usually made of molten lead and inserted into the decoy's underbelly. Most fish decoys are wooden, and painted with alluring colors to which fins made from tin or cooper are attached for further realism, as well as to stabilize the decoy underwater. The fins also allow the decoy to glide through the water when "jigged" with a jigging stick, which is connected to the decoy with fishing line, and, when used properly, prompts the decoy to glide in the water as if it were a real fish. An average fish decoy measures from six to twelve inches long, but size varies according to the type of fish being lured. Bits of glass are sometimes used for eyes.

Very few fish decoys from the last half of the nineteenth century survive or can be documented. Harry Seymour of Chautauqua, New York, is one of the few nineteenth-century carvers whose decoys survive. His decoys had leather tails, and he often drilled a hole from the decoy's top through the bottom weight, to accommodate the fishing line. Most collectible fish decoys were made by carvers of the Great Depression era. While fish decoy carvers primarily sought to produce a decoy that would attract the catch, many carvers also labored to leave their individual artistic imprint on the decoy. Well-known Depression-era decoy carvers include Hans Janner, Theodore Van Den Bossce, and Gordon Pecore Fox of Mt. Clemens, Michigan, as well as Isaac Goulette of New Baltimore, Michigan. Most fish decoys were carved by fishermen for their own use, but a few individuals became professional fish decoy carvers, especially in Michigan and Minnesota. Manufacturers also produced commercial fish decoys that sought to achieve the artistry of the individual carver.

See also **Decoys, Wildfowl; Sculpture, Folk.**

BIBLIOGRAPHY

Bishop, Robert. *American Folk Sculpture*. New York, 1974.
Peterson, Donald J. *Folk Art Fish Decoys: With Values*. Exton, Pa., 1996.

———. *Fish Decoy Makers, Past and Present*. Exton, Pa., 2000.
Lie, Allan J., ed. *The American Sporting Collector's Handbook*. New York, 1976.

WILLIAM F. BROOKS JR.

DECOYS, WILDFOWL are carved wooden effigies used by hunters to attract wildfowl within range of their weapons. They are the major folk art indigenous to America, and probably the only utilitarian, floating sculpture ever produced. Historically, live waterfowl were tethered by hunters within the passing view of migrating flocks to lure the wild birds. The wildfowl decoy was introduced to the United States by Native Americans of the southwest and predates the arrival of Europeans by 1,000 years. In 1924 decoys of woven bulrushes were discovered in Nevada's Lovelock Cave by archaeologists who dated them to about the year 1000. Decoys are also known as "stools," or "stool ducks." An assemblage of decoys is called a "rig."

There are two types of wildfowl decoys: floaters and stickups. Floating decoys are the most common and replicate ducks common to the United States such as mallards, black ducks, bluebills, redheads, canvasbacks, widgeons, pintails, golden eyes, mergansers, geese, brants (wild geese), scoters, and eiders. Stickups are images of shorebirds—the wading birds that live on the edges of salt marshes and ponds—often seen scampering along ocean beaches at the water's edge. Prevalent shorebird species represented by stickups are sicklebill curlews, willets, Hudsonian curlews, yellowlegs, black-breasted plovers, golden plovers, dowitchers, and ruddy turnstones. The heads and bodies of floaters are usually carved separately. The bodies are often made of two joined pieces of wood, and are weighted for balance. Most stickups are made of a single piece of wood with a bill added, and are mounted on sticks or poles to simulate the longer legs of the shorebirds. Both floaters and stickups are painted to replicate the plumage patterns of the species.

Wildfowl decoys are as diverse as the regions, bird migratory patterns, hunting practices, techniques, and abilities of the decoy carver and painter. Some are solid, while others are hollow. They are both oversized and undersized, flat bottomed and round bottomed. Weights, usually lead, are attached to decoy bottoms to lower the center of gravity and for balancing, and are placed toward the back, in the center, and toward the front. Most decoys are painted, both to make them conspicuous and identifiable. Usually two paint coats were used. The purpose of the first coat is to seal the wood against weathering and water

logging; the second coat is to decorate the decoy with the plumage of the species. Feathering is most often accomplished with scratches from a nail or comb, as well as brushing from a feather or a rag. On occasion, only wood preservatives such as creosote, are used to replicate feathering.

The development and popularity of wildfowl decoys in the United States coincided with the seemingly inexhaustible supply of wildfowl, the increased and diverse food needs of a growing population, the technological improvements to weaponry, and the development of a nationwide railroad system that allowed better distribution of food. In the United States, the height of the hunting phase and the concomitant proliferation of wildfowl decoys occurred between the American Civil War and World War I. To meet the demand for wildfowl, professional "market hunters" slaughtered thousands of birds yearly. The day's female fashions also intervened; hundreds of shorebirds were killed daily to provide feathers for hats, fans, and frocks. Feather hunters sought herons, egrets, bitterns, crane, swans, and gulls for their plumage. Frank Chapman, a New York City columnist, noted the feathers of forty different species of birds affixed to the bonnets of the well-appointed lady strollers in Central Park in the 1890s. Robber barons, made rich by the industrial revolution, formed hunting clubs, vacationed at hunting resorts, and hired guides who were often the decoy carvers. Demand for wildlife decoys prompted the manufacture of decoys. Concern for the decreasing wildfowl population led New York State in 1895 to ban spring shooting, and other states soon followed by the shortening of hunting seasons. The concern strengthened in 1918 with a federal ban on the interstate transport of wildfowl, and culminated in 1928 with a complete prohibition of shorebird shooting. By the mid-twentieth century, decorative bird carving had surpassed utilitarian decoy carving in artistic concentration and popularity.

Most preeminent wildfowl decoy carvers were located in those states that fall under the migration flyways of the Atlantic, the Mississippi, the Great Plains, and the Pacific. Decoys of the Atlantic flyway were fashioned by artists from Maine to North Carolina. In northern New England, turbulent waters require outsized, heavy, solid decoys. Lothrop T. Holmes (1824–1899) and A. Elmer Crowell (1862–1952) were accomplished Massachusetts carvers. In the region of Connecticut's Long Island Sound and the mouth of the Housatonic River, wildfowl carvers fabricated smaller, lighter decoys, often hollow or made of cork, usually with full breasts and withdrawn

heads to navigate the slushy ice. Best known in Connecticut is the "Stratford" school of carvers, Charles E. "Shang" Wheeler (1872–1949), Albert Laing (1811–1886), and Ben Holmes (1843–1912). On Long Island, roots and tree knots were collected from fallen trees and beach debris and shaped into decoy heads. In New Jersey small, round-bottom decoys were utilized. Duck hunting and decoy carving were popular along the Delaware River, the Susquehanna River, and throughout the Chesapeake Bay, especially its eastern shore. Nathan Cobb (1825–1905) of Cobb's Island, Virginia; Ira Hudson (1876–1949) of Chincoteague, Virginia; and brothers Steve (1895–1976) and Lemuel "Lem" Ward (1896–1984) of Crisfield, Maryland, are several of the many reputable carvers. The Ward brothers were self-proclaimed "counterfeiters in wood." In coastal Carolina, especially the Back Bay of Currituck Sound, North Carolina, there is an abundance of Ruddy Duck and Whistling Swan decoys. John Williams (1857–1937) specialized in carving swans and Lee Dudley (1861–?) is known for his ruddy ducks.

The Mississippi River flyway passes over the midwest United States. Wildfowl were once in such abundance that decoys were initially rarely used; market shooting was prevalent from Michigan to Iowa. Midwestern hunters and bird carvers patterned their decoys after those of their Atlantic flyway brethren. The Mississippi and Illinois River areas produced competent carvers. Decoy historians credit decoy displays at the 1876 Philadelphia Exposition as influencing Midwestern carvers. Among the more prominent are Robert A. Elliston (1849–1915) of Bureau, Illinois, who is known as the "grand-daddy" of Mississippi flyway decoy carvers. Other recognized carvers are Charles H. Perdew (1874–1963) of Henry, Illinois; Charles Walker (1875–1954) of Princeton, Illinois; and G. Bert Graves (1887–1956) of Peoria, Illinois.

During the second half of the nineteenth century, Detroit, Michigan, became the center for machine-made decoy. The factories producing the most illustrious decoys were the Dodge Decoy Factory started by Jasper N. Dodge and Mason's Decoy Factory owned by Herbert William Mason (mid-1880s–1905). Dodge advertised his "cheap decoy ducks at $5 and $7 a dozen, made to order" with *Satisfaction Guaranteed.* Mason advertised that it was the "largest exclusive manufacturer of decoys in the world." Folk art historian Adele Earnest (1901–1993) noted that decoy companies offered employment to skilled craftsmen and fine woodworkers in need of jobs who created individual, well-designed, and practical decoy molds. The town of Weedsport in Cayuga

County, New York, was home to decoy manufacturer H.A. Stevens, founded and operated by Harvey A. Stevens (d. 1894) and his brothers, George and Fred.

The best museum-quality wildfowl decoys, both "floaters" and "stick-up," are an artist's interpretation of a creature's individuality, often sensuous and sometimes comic, captured through pose, paint, and pattern. Ironically, the most celebrated wildfowl decoy carvers sculpted images of lifelike beauty and character for purposes of attracting for the kill one-of-a-kind living creatures of unsurpassed beauty. Today, most carvers produce lifelike wildfowl for show, the "mantle" fowl used for decorative and illustrative purposes. The day of the market gunner, the professional, full-time, utilitarian decoy carver, and the decoy factory has passed. As attempts have been made to preserve habitats for wildfowl, the popularity of collecting and conserving those historic, weathered decoys of species that once graced those habitats, has also grown.

See also **Cobb Family; A. Elmer Crowell; Decoys, Fish; Adele Earnest; Lothrop T. Holmes; Ira Hudson; Mason Decoy Factory; Sculpture, Folk; Steve Ward, and Lemuel Ward; Charles E. Wheeler.**

BIBLIOGRAPHY

Barber, Joel. *Wild Fowl Decoys.* New York, 1954.
———. *Long Shore.* New York, 1995.
Delph, Shirley, and John Delph. *New England Decoys.* Exton, Pa., 1981.
Earnest, Adele. *Folk Art in America: A Personal View.* Exton, Pa., 1984.
———. *The Art of the Decoy.* New York, 1965.
Engers, Joe, ed. *The Great Book of Wildfowl Decoys.* New York, 2001.
Liu, Allan J., ed. *The American Sporting Collector's Handbook.* New York, 1976.
Mackey, William F. Jr. *American Bird Decoys.* New York, 1965.
Shaw, Robert. *American Waterfowl Decoys: The Distinguished Collection of Dr. James. M. McCleery.* New York, 2000.
Starr, George Ross Jr. M.D. *Decoys of the Atlantic Flyway.* Tulsa, Okla., 1974.

WILLIAM F. BROOKS, JR.

DEISERT, GEORGE PETER (1732–c. 1810), a fraktur artist, was born in Niederhochstadt, Palatinate, Germany. After his arrival in Pennsylvania in 1764, the next reference to him is found in the records of the Christ Reformed Church near Littlestown, where he probably served as a schoolmaster. He married Wilhelmina Hund, and they had several children; his son, John (1778–c. 1815), succeeded his father as a teacher at the congregation's school. In 1776 the Dei-

serts served as baptismal sponsors in the Middletown Valley of Frederick County, Maryland.

Deisert's work chiefly consists of meticulously lettered baptismal records with carefully crosshatched backgrounds. There seems to have been no direct influence on his work, but he was a contemporary of printers who worked in nearby Hanover, who issued a series of baptismal certificates from the 1790s to the 1840s. One of Deisert's students was surely Johannes Bard (1797–1861), a fraktur artist who copied baptismal certificates printed in Hanover, and whose drawings of presidents and other prominent people rank him as an important folk artist. Deisert made New Year's greetings for girls who were neighbors, and with great effort penned at least two sheets with hymns in German, one with each verse positioned within its own heart. What he lacked in iconographic imagination is compensated for by the exactitude of his work, and what is not presented in color is balanced by the overall neat and clean effect of his work. Deisert died without an estate, near Littlestown, Adams County, Pennsylvania.

See also **Fraktur.**

BIBLIOGRAPHY

Weiser, Frederick S. *The Gift Is Small, the Love Is Great.* York, Pa., 1994.

FREDERICK S. WEISER

DELLSCHAU, CHARLES AUGUST ALBERT (1830–1923) was an artist obsessed with the early years of flight. From age seventy, when he retired from work as a butcher, and as a clerk in his stepdaughter's saddlery in Houston, Texas, he wrote and illustrated *Reminiscences of Years Past of Time and a Way of Life Written and Illustrated in Idle Hours.* Following *Reminiscences,* Dellschau created thousands of watercolor, gouache, pen-and-ink drawings, and newspaper collages, which he called "press blooms," included in twelve large, hand-bound books. His art and accompanying text fused fantasy and reality.

Born in Brandenburg, Prussia, the son of a master butcher, Dellschau immigrated to Texas in 1849, following Prussia's social and economic revolution of 1848. He traveled to California between 1850 and 1860, and returned to Richmond, in Fort Bend County, Texas, around 1860, when he also became a United States citizen.

Created in private and forgotten after his death at age ninety-three, Dellschau's writings and drawings barely escaped the trash heap when an order from the fire department was issued in the 1960s to clear the

Dellschau house of all litter. Fred Washington, an antiques dealer, found the notebooks at the curb and took them to his OK Trading Center, where they were discovered by an art student, Mary Jane Victor. She in turn brought them to the attention of the art patron Dominique de Menil, who purchased four of the books.

The drawings, many of balloon-driven flying machines, and newspaper collages were numbered sequentially. The date the drawing was made, the date Dellschau claimed the aero designs were proposed, and the name of the inventor were noted. The contraptions, fueled by a pink gas called *soupe,* were depicted in flight as well as on the ground, some with retractable landing gear, flaps, wheels, crew members, passengers, and others, with dining and sleeping quarters or safety features, such as a "Falleasy" device or a No Smoking sign.

The designs were attributed to members of the Sonora Aero Club, organized in the 1850s. Names of members, dates, meeting places, and the activities of the secret club are referred to in detail in Dellschau's work. No evidence has been found, however, of the existence of the society, which was thought to meet regularly in Sonora, California, or of NYMZA, the financial backers of the club, from "back east."

See also **Outsider Art.**

BIBLIOGRAPHY

Baker-White, Tracy. "Flight or Fancy: The Secret Life of Charles A.A. Dellschau." *Folk Art,* vol. 25 (fall 2000): 47–54.

Redniss, Lauren. "Charles Dellschau." *Raw Vision,* no. 30 (spring 2000): 42–49.

———. *Charles A. A. Dellschau 1830–1923: Aeronautical Notebooks.* New York, 1997.

LEE KOGAN

DEMUTH, WILLIAM (c. 1835–?), founder and owner of William Demuth & Co., employed leading show figure (also known as shop or trade figure) woodcarvers Samuel Anderson Robb (1851–1928) and Thomas White (1825–1902), sold their hand-carved wooden shop figures, and mass-produced figures based on their carvings for national distribution. German born, William Demuth immigrated to the United States in 1851 at the age of sixteen. By 1860 he was employed by William Hen (dates unknown), another German immigrant, who founded and operated New York City's premier tobacco and novelty distributor of meerschaum clay pipes, Turkish water pipes, walking canes, and show figures. Hen excelled at marketing, and was the first to offer New York-carved shop figures throughout the nation.

Demuth opened a competing business in New York in 1863, and in 1868 went into partnership with another German immigrant, Moritz J. Seelig (dates unknown), a Brooklyn foundry operator. Together, they cast figures in zinc and soon offered a wide range of metal shop figures through catalog sales. Demuth improved on Hen's marketing by expanding catalog sales nationally.

The 1870 *New York Products of Industry Schedule of the Federal Census,* reviewed by American folk art historian Ralph Sessions, lists one of Demuth's two employees as Robb and indicates production of 120 show figures valued at four thousand dollars. In 1871 Demuth produced the first American-made glass Christmas ornaments. An 1875 Demuth Company illustrated catalog of thirty figures explains that his metal show figures, made of zinc, durable, and long-lasting, have replaced the equally light wooden ones, which were short-lived and subject to "cracking from exposure to climactic changes."

Demuth exhibited his metal show figures at the Philadelphia Centennial Exposition of 1876, as well as at the Chicago World Columbian Exposition of 1893, celebrating the four hundredth anniversary of the discovery of America by Christopher Columbus. In Chicago, according to articles from the 1893 and 1894 issues of the periodical *Tobacco,* reviewed by Ralph Sessions, Wm. Demuth & Co. exhibited several cases of carved pipes, as well as zinc show figures that included three Indians, a Gambrinus (a mythical Flemish king said to have invented beer), and a "Moorish girl." Wooden figures of four Nubian boys were also on exhibit. By hiring woodcarvers, Demuth encouraged the development of their craft, based manufactured models on their carvings, and introduced to a wider audience the beauty of shop figures. His role was not unlike that of the weathervane companies operating in the same period.

See also **Canes; Christmas Decorations; Cushing & White; Samuel Anderson Robb; Shop Figures; Weathervanes.**

BIBLIOGRAPHY

Fried, Frederick. *Artists in Wood: American Carvers of Cigar-Store Indians, Show Figures, and Circus Wagons.* New York, 1970.

WILLIAM F. BROOKS JR.

DENIG, LUDWIG (1755–1830) would have been lost to history but for an untitled book of spiritual texts and sermons in German that he produced in 1784.

Richly illustrated in watercolor by its creator, the 200-page manuscript volume contains images related principally to the New Testament accounts of the Passion of Jesus Christ and the martyrdom of the apostles. Denig also included symbolic floral and other allegorical images in the leather-bound work, as well as the music for twenty hymns. Each page measures six and one-half by eight and one-half inches. In 1975 Esther Ipp Schwartz (1904–1988), a well-known collector, acquired the book and encouraged its study by Don Yoder, a distinguished folklorist and specialist in Pennsylvania German culture and American religious history. Yoder arranged for an annotated facsimile edition of the work to be published in 1990, with a biography of Denig and a translation into English of his texts, as *The Picture Bible of Ludwig Denig: A Pennsylvania German Emblem Book*.

Denig was born in Lancaster, Pennsylvania. He became a member of the Pennsylvania German community and its Reformed Church. He attended the church's congregational school, served in the American Revolutionary War, and earned a living as a master shoemaker. Yoder demonstrates how Denig's book, with its dense moralistic texts and dramatic illustrations of sacrifice and martyrdom, reflects the artist's acceptance of the pietistic values then current among some Pennsylvania German Protestants. Pietism stressed the experience of inner conversion and repentance, the practice of personal study of the Bible, and the need for Christian beliefs to be reflected in daily living.

Denig was familiar with Christian devotional prints and illustrated Bibles, the sources of many of his drawings. He created his manuscript volume during the early flowering of the fraktur tradition in southeastern Pennsylvania. In contrast to most frakturs, Denig's drawings are dominated by figural imagery and direct renderings from the biblical narrative, yet the influence of the fraktur tradition on his work cannot be disregarded. Denig's figures are occasionally rendered awkwardly, but if anything the lack of refinement brings greater intensity and visual strength to the drawings. In 1787 Denig moved to Chambersburg, Pennsylvania, and established himself there as an apothecary. It was in Chambersburg that he died. Denig's remarkable book contains a register of his family in which births, marriages, and deaths are recorded. The last entry, that of his own death, was added to the volume by one of his children.

See also **Fraktur; German American Folk Art; Pennsylvania German Folk Art.**

BIBLIOGRAPHY

Bishop, Robert. *Folk Painters of America*. New York, 1979.

Yoder, Don. *The Picture Bible of Ludwig Denig: A Pennsylvania German Emblem Book*. New York, 1990.

GERARD C. WERTKIN

DENISON LIMNER (active c. 1790) created works that are boldly distinctive in style and well-documented as to geographical origin, yet their maker's identity is less certain. There are nine known works by this hand that share very similar dimensions (about thirty-five by twenty-seven inches) and are in nearly identical in width, with black frames and sculpted gilt edges. These portraits, all depicting sitters from Stonington, Connecticut—six surnamed Denison, hence the appellation of "Denison Limner"—share strong contours; intense palettes; elongation of the sitters' hands; straight, tight-lipped mouths; dark lining over the eyes; and geometric forms, particularly the oval exaggeration of eye-shape and the sitters' egg-shaped heads.

As early as 1956, one historian attributed the Denison portraits to Joseph Steward (1753–1822), an artist, clergyman, and entrepreneur who lived in Connecticut, and painted sitters in several New England locations. Steward's documented works, most from about 1793, share many characteristics with the Denison portraits, yet they are much more naturalistic than this probably slightly earlier group. A link between the two may be the portraits of John and Lucy Ayer Avery (1788–1789). Although both are very Denison-like appearance, they are noted in John Avery's account book as being by Steward. If the Denison Limner and Joseph Steward are not one and the same, the visual evidence suggests there was some close working relationship between them.

See also **Painting, American Folk; Joseph Steward.**

BIBLIOGRAPHY

Chotner, Deborah. *American Naïve Paintings*. Washington, D.C., 1992.

Harlow, Thompson R. "The Life and Trials of Joseph Steward." *Connecticut Historical Society Bulletin*, vol. 46, no. 4 (October 1981): 97–164.

———. "The Versatile Joseph Steward: Portrait Painter and Museum Proprietor." *Antiques*, vol. 121, no. 1 (January 1982): 303–311.

Little, Nina. "Little-Known Connecticut Artists, 1790-1810." *Connecticut Historical Society Bulletin*, vol. 22, no. 4 (October 1957): 101.

DEBORAH CHOTNER

DENTZEL, GUSTAV (1846–1909), a young cabinetmaker, was among the throngs of immigrants who

arrived on the shores of America in the mid-nineteenth century. Dentzel had learned his woodworking skills in his father's shop in Kreuznach, Germany, where the family business had not only created fine furniture but had also built an operating carousel in the 1830s.

Not long after settling in the Germantown area of Philadelphia, Dentzel decided to try his hand at the carousel business, opening G.A. Dentzel, Steam & Horsepower Caroussell Builder in 1867. His goal was to build and operate a carousel, and use it to make a living. Unfortunately, in order to generate enough revenue to stay in business, Dentzel had to move his new carousel from place to place, setting up wherever he could.

By 1870, the Dentzel family had begun to grow and traveling with small children became difficult, so Dentzel started to produce more carousels, some for his own use as well as others he sold outright. At the time Dentzel went into production, many carousels already dotted the countryside. Yet these carousels were all produced by craftsmen or entrepreneurs who were looking to create a single ride. No one had ever gone into the business of manufacturing carousels in number until Dentzel opened his shop.

Over the course of the next thirty-five years, Dentzel's carousel business continued to grow, but as demand for his carousels increased, he became more of a businessman and less of a craftsman. Sons William and Edward and nephew Harry soon became integral members of the carving crew and business staff.

The style of the carvings produced at Dentzel's company evolved under the creative influence of such master carvers as Charles Leopold, Daniel Müller (1872–1951), and Salvatore Cherny (Cernigliaro) (1879–1974). The carvings became much more intricate, and a wide variety of animals were added to the Dentzel stable of carousel figures. By 1905, Dentzel's company was producing the most realistic as well as the most fanciful of designs to ever grace a carousel.

Gustav died in 1909, leaving the business to his oldest son, William. After the estate was settled, William reopened the business as the William H. Dentzel Co., even though the style of the carvings varied little. The carousel business began to fade with the advent of World War I. In 1928 William died, and the business closed its doors for good.

See also **Carousel Art; Salvatore Cherny; Daniel Müller; Sculpture, Folk.**

BIBLIOGRAPHY

Dinger, Charlotte. *Art of the Carousel*. Green Village, N.J., 1983.
Fraley, Tobin. *The Carousel Animal*. San Francisco, 1983.
————. *The Great American Carousel*. San Francisco, 1994.
Fried, Frederick. *A Pictorial History of the Carousel*. Vestal, N.Y., 1964.
Mangels, William F. *Outdoor Amusement Industry*. New York, 1952.
McCullough, Edo. *Good Old Coney Island*. New York, 1957.
Stevens, Marianne. *Painted Ponies*. New York, 1986.
Summit, Roland. *Carousels of Coney Island*. Rolling Hills, Calif., 1970.
Weedon, Geoff. *Fairground Art*. New York, 1981.

TOBIN FRALEY

DERING, WILLIAM (d. c. 1751) was a Tidewater, Virginia, portrait painter whose career roughly spanned the period between the departure of portraitist Charles Bridges (1670–1747) from Williamsburg about 1743 to 1744, and the first sojourn in Virginia in 1751 made by the Philadelphia painter John Hesselius (c. 1728–1778). Biographical information about Dering is virtually non-existent, but what is known about his activities has been gleaned from newspaper advertisements, court records, ledgers, and journal entries.

Dering was in Philadelphia in 1735 when he opened a school in which he taught dancing, reading, writing, embroidery, and French. He arrived in Gloucester County, Virginia, by 1737, then moved to nearby Williamsburg, where he lived from 1742 to 1749. In Williamsburg, Dering acquired a house located on the Palace Green, advertised himself as a "Dancing-Master," and organized balls and assemblies in Williamsburg as well as at the plantation houses of the Carter and Byrd families, at which he sometimes also provided the music. Plagued by debts and other legal problems, Dering left Williamsburg for Charleston, South Carolina, but it is not known whether he painted there.

Dering owned two hundred prints and a "paint box" in 1745, which he probably acquired from Bridges. Dering certainly knew of the older painter's work, which may have encouraged him to add portrait painting to his repertoire and to establish himself as Bridges' successor. Dering's portraits show his debt to Bridges as well as to English mezzotints, in his use of half-length figures in elegant poses, sometimes framed in oval spandrels, and an emphasis on the play of light on fabrics. Dering could also depart from these models and be unexpectedly innovative, as is seen in his portrait of George Booth. Less than a dozen works signed by or attributed to Dering are known, suggesting that his output was small and that painting for the artist was a sideline.

Dering does not fit the accepted definitions of folk artist. He emulated the prevailing academic style and was patronized by some of the wealthiest and most

prominent members of Virginia's planter elite. Despite his limited grasp of London models and his modest skills, the scarcity of artists in the colony capable of painting an acceptable likeness certainly contributed to his success there. Portraiture was but one of Dering's creative interests, each of which provides insights into attitudes about personal refinement within his patrons' social class. His legacy as a painter may be to act as a link in the history of colonial portraiture in the South, rather than as an artist who influenced the succeeding generation of painters.

See also **Painting, American Folk.**

BIBLIOGRAPHY

Craven, Wayne. *Colonial American Portraiture.* Cambridge, England, 1986.
Hood, Graham. *Charles Bridges and William Dering, Two Virginia Painters, 1735–1750.* Williamsburg and Charlottesville, Va., 1978.

RICHARD MILLER

DESCHILLIE, MAMIE (1920–) is a Navajo artist known for her mud toys and cardboard cutouts. She was born on the Navajo Nation Reservation in northwestern New Mexico, and lives near Farmington, New Mexico, close to her family. She speaks only a few words of English and has had little formal education.

An accomplished weaver of traditional Navajo rugs, Deschillie learned these skills while she was young. The mud toys that she makes are small figures made of clay and then dried in the sun. Made as playthings for children, they are part of a Navajo tradition that can be traced to the nineteenth century. Deschillie forms her clay primarily into animal forms: cows, sheep, buffalo, and a horse and rider. She decorates them with bits of fur, cloth, and jewelry, and highlights their features with touches of paint. They are only a few inches in size and are very fragile.

In the 1980s Deschillie began making cardboard cutouts that she decorates with bits of found objects and jewelry. Her smallest cutout is of a ten-inch, striped horse with a woman rider in a colorful flowing skirt, wearing a turquoise necklace and earrings. She also makes larger pieces, such as a three-foot-high white buffalo with white cotton fur and a necklace and earrings of turquoise, accompanied by a one-foot-high baby white buffalo. Deschillie is most noted for these imaginative and whimsical cutouts decorated with cloth and jewelry. And while her weaving and mud toys are in the Navajo tradition, Deschillie's

cutouts represent a departure from what had been done in her Native American community.

See also **Native American Folk Art.**

BIBLIOGRAPHY

McGreevy, Susan Brown. "I Never Saw a Purple Cow." *American Indian Art Magazine* (autumn 1997): 48–57.
Rosenak, Chuck, and Jan Rosenak. *The People Speak: Navajo Folk Art.* Flagstaff, Ariz., 1994.

JOHN HOOD

DEY, JOHN WILLIAM ("Uncle Jack") (1912–1978) painted approximately 650 seriocomic scenes of the rural landscape, combining memories from his childhood in Virginia with those from his time spent hunting and logging in Maine, and with fantasy. He often painted snow scenes and woodland animals, including moose, bears, rabbits, and birds. Trademark crows, a threatening presence in his detailed landscapes, punctuate bright blue skies. The narrative works, some with a humorous twist, others with a dark edge, occasionally refer to popular culture. In one painting the actor Charlie Chaplin, for instance, dressed in his familiar black coat and baggy pants, stands in the middle of a snowy, rural landscape and is, according to the painting's title, *Inspecting Country Real Estate.*

Dey combed flea markets and secondhand shops for old frames in which he placed his compositions. Using model-airplane enamel on corrugated cardboard with wooden or Masonite supports, the surfaces of Dey's paintings sparkle. Dey used templates to trace his figures and was exacting in their execution, often shining a light on them and using a magnifying glass "to see if anything is wrong." He frequently attached to the back of a painting an envelope with his notes commenting about the work.

While growing up in Phoebus, Virginia, Dey's parents separated when he was eleven. His mother worked at a variety of jobs to support her family, and Dey helped as well, serving a newspaper route and working at his school as a janitorial assistant. He dropped out of school at age eighteen, and two years later left Virginia for Maine, where he worked as a trapper and lumberjack. He returned to Virginia, moving to Richmond in 1934, married, and in 1942 joined the Richmond police force. Affectionately known as Uncle Jack by the neighborhood children, he repaired their toys and bicycles. He retired from the police department at age forty-three.

As early as 1935, Dey had produced some decorated objects, but he did not begin to paint on a

regular basis until his retirement. Art absorbed Dey, and he expressed his obsession with painting in a letter to collector Jeff Camp: "I spent over three weeks on these works. . . . These days are not eight-hour days, but instead twelve, fourteen, or eighteen."

See also **Painting, American Folk; Painting, Landscape.**

BIBLIOGRAPHY

Hemphill, Herbert W. Jr., and Julia Weissman. *Twentieth-Century American Folk Art and Artists.* New York, 1975.

Horwitz, Ruth. *Contemporary American Folk Artists.* Philadelphia, 1975.

Johnson, Jay, and William C. Ketchum. *American Folk Art of the Twentieth Century.* New York, 1983.

Kaufman, Barbara Wahl, and Didi Barrett. *A Time to Reap: Late-Blooming Folk Artists.* Seton Hall, N.J., 1985.

Rosenak, Chuck, and Jan Rosenak. *Museum of American Folk Art Encyclopedia of Twentieth-Century American Folk Art and Artists.* New York, 1990.

Trechsel, Gail Andrews. *Pictured in My Mind: Contemporary American Self-Taught Art from the Collection of Dr. Kurt Gitter and Alice Rae Yelen.* Jackson, Miss., 1995.

Wright, R. Lewis, et al. "John William ('Uncle Jack') Dey." *The Clarion* (spring 1992): 36.

LEE KOGAN

DIAL, ARTHUR (1930–) uses the materials he knows from factory work to create assemblage paintings, often satirical in tone, of regional folklore and biblical events. He was born in the hamlet of Emelle in rural Sumter County, Alabama. As his mother was unable to care for him and his older half brother, Thornton, they were raised by an aunt. When Dial was about the age of ten, the two boys were sent to Bessemer, an industrialized satellite of Birmingham, to live with their great aunt. Dial attended the Sloss Camp School until third grade, then went to work in a sawmill.

After stints at the water department and as a road mender, Dial and his half brother each found employment at the Pullman Standard boxcar factory in Bessemer. Two years later Dial began working at United States Pipe, whose nickname, "Pipe Shop," was given to the adjacent Bessemer neighborhood where Arthur and Thornton both lived. Arthur Dial worked at United States Pipe for thirty-seven years before retiring in the mid-1990s.

Dial began making art as a child: "When I was a little thing I did a lot of drawing, mostly cowboys and stuff. I made wagons and scooters and all kinds of toys. Most folks made their own toys back then. I made pictures of Jesus Christ, and I remember the one that I was most proud of was Eve and Adam. After I got to working at the Pipe Shop, I started making other stuff, little peoples, animals, and crucifixions

and stuff like that out of scrap pipe and steel and leftover supplies around the shop."

Inspired in part by Thornton, Arthur Dial's strength as a visual storyteller lies in his ability to depict precise moments of dramatic tension, as in his Eve and Adam series in which Eve reaches for the fruit of the Tree of Knowledge, calling maximum attention to her temptation. In other works, such as his picture of Governor George Wallace blockading the entrance to the University of Alabama in Montgomery, in which the central figure is flanked by two "separate-but-equal" flowering shrubs, Dial recalls actual local histories while linking them iconographically and morally with his theological works. "Art is a good way to keep your head working," Dial says. "I lie up in bed at night mapping out what I'm going to do and how I'm going to do it. My art is a record of what went by."

See also **African American Folk Art (Vernacular Art); Painting, American Folk.**

BIBLIOGRAPHY

Arnett, Paul, and William Arnett. *Souls Grown Deep: African American Vernacular Art of the South,* vol. 1. Atlanta, Ga., 2000.

Rosenak, Chuck, and Jan Rosenak. *Museum of American Folk Art Encyclopedia of Twentieth-Century American Folk Art and Artists.* New York, 1991.

PAUL ARNETT

DIAL, RICHARD (1955–) is an accomplished metal-worker and furniture maker who periodically creates austere yet whimsical sculptural chairs. The second son of renowned artist Thornton Dial Sr. (1928–), he worked as a machinist at the Pullman Standard Company in Bessemer, Alabama, where his father was employed, before leaving to pursue his dream of owning his own business. In 1984, along with his father and brother, Dan, he founded Dial Metal Patterns, a small business making metal patio furniture, which from beginnings in a tin shed in his father's backyard developed into a cottage industry through the 1980s and 1990s.

Richard Dial christened his original line of functional furniture "Shade Tree Comfort," and adapted the theme of comfort to his sculptures. They bear names like *The Comfort of Moses and the Ten Commandments, The Comfort of Prayer, The Comfort of the First Born, The Man Who Tried to Comfort Everybody,* and *The Comfort and Service My Daddy Brings to Our Household.* In each work, the physical support the chair provides plays against the psychological comfort (or discomfort) of the piece's subject. Fabricated with the same basic steel armatures as Dial's patio furniture, the sculptures are life-size and anthro-

pomorphic, with stylized features and a few scene-setting details, such as wire shoelaces to indicate feet, or runic incisions in wood panels to imply the stone tablets of the Decalogue, or Ten Commandments. The range of emotional tones in the works' components is often astonishingly complex: the parallel steel bands of the bodies are ascetic and regular; the faces, round and open; the themes, quietly challenging; the painted surfaces, frenzied and dripped. The result is art as self-effacing as it is exalted. Human figures become both servants (literal seats) and royalty, much like living thrones, with an autobiographical power that transforms any sitter into a Richard Dial, whose investiture is his ancestors, his convictions, his family, and his trade skills.

Dial's metalworking ties him to the history of his region and of black people's lives there. The mining and industrial corridor of north central Alabama was originally developed at the turn of the twentieth century to offer a low-cost alternative to Northern-made steel; in greater Birmingham, workers were not members of the unions, generally, and often made up of convict labor. In fact, it was the harsh, dangerous conditions in local factories that pushed the Dials to start their own small business. Dial's art explores the comforts and bonds that members of the black working class forged within a civic environment that denied them economic and political rights.

See also **African American Folk Art (Vernacular Art); Chairs; Thornton Dial Sr.; Sculpture, Folk.**

BIBLIOGRAPHY

Arnett, Paul, and William Arnett. *Souls Grown Deep: African American Vernacular Art of the South*, vol. 2. Atlanta, Ga., 2001.
Rosenak, Chuck, and Jan Rosenak. *Museum of American Folk Art Encyclopedia of Twentieth-Century American Folk Art and Artists.* New York, 1990.

PAUL ARNETT

DIAL, THORNTON, JR. (1953–) is an Alabama artist who has broken free of his family's famous name to develop an art that is both fiercely independent yet respectful of his aesthetic lineage. The firstborn child of artist Thornton Dial Sr. (1928–), "Little Buck," as he is known to friends, attended school through the eleventh grade, after which he dropped out, moved to nearby Birmingham, and began eight years of work in the construction business. Upon returning to his hometown of Bessemer, he found a job with his father's employer, the Pullman Standard Company. He stayed with the company until it closed, in the late 1980s, and then became a partner with his brothers in the family's steel patio-furniture business.

Like his father, Dial Jr. creates freestanding sculpture and three-dimensional paintings in mixed media. His style has been further influenced by furniture making (many of his sculptures slyly double as tables, benches, or chairs); by the holiday lawn displays that are especially abundant in Bessemer neighborhoods; by the heavy industry of the Birmingham region; and by his background. As with other artists in the family, he often uses animals and religious themes, with a satiric twist, as a vehicle for social commentary.

Dial's ironic sensibility is among the most caustic in all of American folk art. His painting, *Tornadoes Don't Discriminate with Nobody* (a red, white, and blue twister tearing up homes both grand and puny) comments not only on nature's impassiveness toward human pretense, but also on the stratification in American society that seems vulnerable only to occasional acts of God. In a similar vein, his *King of Africa in America* paintings depict a lion (Dial's symbol for black men) inside a paltry thicket of corrugated tin trees—a shrunken kingdom/jungle. The frogs basking on lily pads in *The President and His Staff Trying to Decide What to Do About Children on Drugs* are depicted in gay, almost psychedelic colors, lending this withering indictment of disconnected politicians a dry wit worthy of classic black folktales or newspaper editorial cartoons.

Dial's series of crucifixes (some of which are life-size) are generally fabricated of steel, with blood red painted wounds. He re-imagines Jesus as an entirely fresh Messiah: a poker-faced muscleman who, in pieces such as *I'll Be Back,* stares down at his tormentors like a Hollywood tough guy—perhaps the only Christ likely to command respect among Dial's peers on the factory floor.

See also **African American Folk Art (Vernacular Art); Chairs; Thornton Dial Sr., Painting, American Folk; Religious Folk Art; Sculpture, Folk.**

BIBLIOGRAPHY

Arnett, William, and Paul Arnett. *Souls Grown Deep: African American Vernacular Art of the South*, vol. 2. Atlanta, Ga., 2001.
Rosenak, Chuck, and Jan Rosenak. *Museum of American Folk Art Encyclopedia of Twentieth-Century American Folk Art and Artists.* New York, 1990.

PAUL ARNETT

DIAL, THORNTON, SR. (1928–) is a renowned self-taught, African American artist who works in many media. He was born to an unwed teenage mother in rural Sumter County, Alabama, and he never knew his father. Dial and his younger half brother, Arthur, were raised first by their mother and older female relatives,

and then, when Thornton was twelve, the brothers were sent to live with their great aunt in industrialized Bessemer, Alabama, a satellite of Birmingham. Thornton dropped out of school after the third grade to help support the family, and worked as a carpenter, road mender, brickmaker, housepainter, and as a commercial fisherman. In 1950, he married Clara May Murrow, and they had five children, several of whom are artists. For thirty years, he worked at the Pullman Standard boxcar factory as a "welder's helper"—as African Americans could work as welders in this factory—and finally as an instructor. In the early 1980s, Dial quit his job, and, with two of his sons, he started a business making metal patio furniture by hand in the small shed behind his home. In 1988, he stopped making furniture to pursue his art full time.

Despite "making things" all his life—and hiding them from all but his immediate family and friends—Dial first witnessed his creations labeled as "art" in 1987, the year he began allowing them to be exhibited. He works with found objects, produces assemblage sculpture, makes easel paintings, and works with pastels and watercolors. His themes range from uplifting, universal concerns to incisive social commentary. Two related but distinct visual styles have emerged in his mature work: intimate, lyrical, and often whimsical depictions of humans and animals; and edgier, occasionally disconcerting images of suffering, injustice, and oppression. Dial's large-format pieces often blend the two. Many early works are allegories and parables, with characters and situations conjured from African American folklore, cartoons, and comics, as well as popular culture, local histories, personal experiences, and current events. Besides humans, the metaphorical players in Dial's works include tigers, birds, roosters, dogs, snakes, squirrels, fish, and other animals, as well as flowers, trees, water, and other elements of the natural world. The tiger, Dial's best-known subject, has been described as an autobiographical symbol as well as a generalized icon of the historical struggles for social justice endured by African Americans.

The majority of works from 1994 are painting-sculpture hybrids that feature few symbols or themes that can be categorized—line, color, mass, and texture are instead laid on as undecided, paradox-filled struggles, with recognizable images jostling among abstractions and found materials. The later works employ happenstance, contingency, unpredictable transformations, and a recycling of forms as a palimpsest for the seeking of larger truths.

See also **African American Folk Art (Vernacular Art).**

BIBLIOGRAPHY

Arnett, William, and Paul Arnett. *Souls Grown Deep: African American Vernacular Art of the South,* vol. 2. Atlanta, Ga., 2001.

Baraka, Amiri, Thomas McEvilley, et al. *Thornton Dial: Image of the Tiger.* New York, 1993.

Longhauser, Elsa, Harald Szeemann, et al. *Self-Taught Artists of the Twentieth Century: An American Anthology.* New York, 1998.

PAUL ARNETT

DINSMOOR, SAMUEL PERRY (1843–1932) created the early-twentieth-century *Cabin Home and Garden of Eden* in Lucas, Kansas, one of America's oldest-surviving and best-preserved visionary environments. Dinsmoor, a Civil War veteran and later a farmer, retired to Lucas in 1905 and, over the next two years, built a three-story, eleven-room house out of local limestone cut to look like logs. Within a few years of completing the *Cabin Home,* Dinsmoor was hard at work on the enterprise for which he soon became more renowned: the *Garden of Eden*—a half-acre landscape containing about 150 figures and thirty trees, all made by hand from concrete.

On the west side of the house, the figures illustrate Old Testament stories; included are Adam and Eve, Cain and Abel, the Devil, and an angel, all watched over by the eye of God, its pupil illuminated by an electric light. Dinsmoor's views of politics and human nature, colored by his populist leanings, are represented in the sculptures on the north side of the garden. Featured here are multi-figure groups, including the Crucifixion of Labor (a martyred working man surrounded by persecutors from the professional class, including a banker, a doctor, a lawyer, and a preacher) and the Goddess of Liberty, who wields a spear upon which is impaled a many-armed monster that resembles a scorpion or an octopus (Dinsmoor's emblem for corporate trusts).

Dinsmoor modeled both trees and figures in place with wet cement, even though some of the trees approach heights of forty feet and some of the figures are well above ground. He apparently used a scaffold and worked alone, except for a helper who occasionally mixed cement. Sculptures were reinforced with steel and chicken wire, and carefully finished so that moisture could not penetrate the surface and cause them to deteriorate. The garden must have been well along by 1913, when it was described by the *Kansas City Star* as "a mecca for tourists"; by 1918 the major sculptural groups on the west and north sides were finished, along with a forty-foot-high, stone-log mausoleum built by Dinsmoor to serve as his own tomb.

Before his death, Dinsmoor had left instructions that he should be embalmed and placed in a coffin under glass in this mausoleum; anyone who paid a dollar was to be permitted to enter and view his body. Although the price of admission has gone up over the years, he is still there, visible under the glass. In all, Dinsmoor's *Cabin Home* and *Garden of Eden* might just qualify for the accolade that he bestowed upon them in a booklet he provided for his visitors: "The most unique home, for living or dead, on earth. Call and see it."

See also **Environments, Folk; Religious Folk Art; Visionary Art.**

BIBLIOGRAPHY

Beardsley, John. *Gardens of Revelation.* New York, 1995.
Friedman, Martin, et al. *Naives and Visionaries.* New York, 1974.

<div align="right">*JOHN BEARDSLEY*</div>

DOBBERSTEIN, FATHER PAUL (1872–1954), pastor of the Catholic Church of Saints Peter and Paul in West Bend, Iowa, devoted much of his life to the creation of one of America's most astonishing and popular devotional shrines. Known as the *Grotto of the Redemption,* the shrine includes seven large caves and numerous stone canopies set within a walled park that is dominated by two artificial hills, one more than forty feet high. Constructed principally of petrified wood and boulders embedded with fossils, as well as stalactites, calcite, quartz crystals, jasper, malachite, turquoise, and other geological wonders, Father Dobberstein's shrine is an unusually ambitious variation on a phenomenon virtually ubiquitous in the Catholic world: the replica of the sacred cave. These replicas are in turn part of a larger practice of re-creating the important shrines of the Holy Land, in both the Old and New Worlds, to provide a vivid religious experience for those unable to make the pilgrimage to the Middle East.

What sets Father Dobberstein's work apart from these other replicas, however, is the way he embellished the form, marrying the cave of Christian mysteries with both the Renaissance grotto of natural history specimens and the theatrical aspects of Baroque church architecture. Father Dobberstein's articles of faith were taken literally from church teachings, but his choice of materials, gathered on rock-hunting expeditions to the Black Hills of South Dakota or the deserts of the Southwest, and his combinations of forms, including Roman arches, triple-apsed interiors, and highly ornamented columns and domes, reveal an extraordinary degree of imaginative prowess.

Born in 1872 in Rosenfeld, Germany, Dobberstein immigrated to the United States in 1892, and studied for the priesthood at the Saint Francis Seminary in Milwaukee. In May 1897, a month before his scheduled ordination, he fell gravely ill with pneumonia. In prayers to the Virgin Mary, he vowed that if he recovered he would build a shrine in her honor. He was well enough to be ordained that June; in 1898 he was appointed to his position in West Bend. With the help of his parishioners, he began to amass materials for his shrine; by 1912 he began work on the first artificial cavern, known as the *Grotto of the Trinity,* the interior of which is encrusted with calcite and stalactites and contains a marble statue of Mary and the infant Jesus. Dobberstein continued working on the *Grotto* until his death in 1954, enlarging the focus of his project to encompass representations of the Fall of Adam and Eve, of Moses and the Ten Commandments, and of the redemption of humanity through the life and death of Christ.

See also **Environments, Folk; Religious Folk Art.**

BIBLIOGRAPHY

Beardsley, John. *Gardens of Revelation: Environments by Visionary Artists.* New York, 1995.
Stone, Lisa, and Jim Zanzi. *Sacred Spaces and Other Places: A Guide to Grottos and Sculptural Environments in the Upper Midwest.* Chicago, 1993.

<div align="right">*JOHN BEARDSLEY*</div>

DODGE, CHARLES J. (1806–1886) was an accomplished ships' figurehead and shop figure carver who operated a carving shop in New York City. Many of his talents were learned from his father, Jeremiah Dodge (1781–1860), the son of a shipwright. Jeremiah enjoyed a brief carving partnership with Simeon Skillin III (1766–1830), in the period from 1804 to 1806; became the partner of Cornelius Sharp (dates unknown), between 1815 and 1821; and finally during the period of 1833 to 1839 partnered with son Charles (1806–1886), who eventually took over the business. Historian Ralph Sessions notes that the best work from the shop showed accomplished woodcarving, matched with the academic standards used in marble carving, and that the figures were distinctive and individualized, with well-modeled faces and boldly swirling hair. A painted woodcarving of the god *Hercules* from the USS *Ohio,* of about 1820, is identified as carved by Jeremiah Dodge and Cornelius Sharp. Charles Dodge later became the partner of respected carver Jacob Anderson (1810–1855), from 1843 to

1847. The 1850 *Products of Industry Schedule of the Federal Census,* reviewed by Sessions, lists the Dodge shop as having four employees and carvings worth $3,250. The city directories of that period locate the shop at 253 South Street, adjacent to the East River, in New York City.

A well-known carving by either Charles Dodge or his father is of the head of *President Andrew Jackson,* dated about 1835, commissioned to replace a head taken from the full-bodied ships' figurehead of Jackson on the USS *Constitution.* Charles Dodge is identified as the carver of a portrait bust of his father, about 1835, which remained in the family until it was given to the New-York Historical Society in 1952. In 1883 a *Harper's Weekly* journalist wrote about an "Old Jim Crow, a famous figure cut forty years ago [1843] by 'Charley' Dodge—now dead and gone." The journalist found the figure, being used as a shop figure in a hotel, after it had been repaired by a Canal Street carving workshop, thought to be that of Samuel Anderson Robb (1851–1928). By 1860 Dodge, listed as a deputy tax commissioner in that year's directory, is thought to have abandoned carving. Later records from 1870 list him as a New York City alderman, assessor, tax commissioner, and as a colonel in the tenth regiment of the New York State militia.

See also **Ships' Figureheads; Shop Figures.**

BIBLIOGRAPHY

Brewington, M.V. *Shipcarvers of North America.* New York, 1972.
Fried, Frederick. *Artists in Wood: American Carvers of Cigar-Store Indians, Show Figures, and Circus Wagons.* New York, 1970.
Norton, Peter. *Ships' Figureheads.* New York, 1976.
Pinckney, Pauline A. *American Figureheads and Their Carvers.* Port Washington, N.Y., 1969.

WILLIAM F. BROOKS JR.

DOLLS made in North America, from the earliest primitive examples found at the sites of prehistoric Arctic villages to those made in contemporary times, all share a handcrafted folk art tradition. Many of these dolls were made out of necessity from whatever scraps were at hand, and were substitutes for costly, store-bought toys. Parents and children in colonial America fashioned dolls from utilitarian objects, such as clothespins, cornhusks, dried apples, and rags. These homemade dolls were often conceived in isolation and hardship, and reflected triumphs of the spirit of imagination. They mirrored the ingenuity and pluck required of pioneer families on the American frontier.

Throughout United States history, by far the most popular handmade doll was the cloth or rag doll.

Most of these dolls were made of linen or unbleached cotton and stuffed with bran, sawdust, or straw. A typical early rag doll's face was flat; its features were embroidered or painted on with fruit and vegetable dyes, and its hair was made with yarn, thread, animal fur, or even human hair. As with pioneer children's clothing, cloth dolls were often mended and repaired with varying degrees of skill. Cloth dolls made for Amish children form a special sub-group, mirroring the customs of the Amish people. In the Amish community, printed fabrics were banned as too worldly; thus Amish dolls are always dressed in plain clothing and remain faceless, so as not to be considered graven images.

When fathers made dolls for their children, they were usually carved dolls fashioned from leftover pieces of wood or worn-out household utensils, such as potato mashers, spoons, and bedposts. The finest wooden dolls appear more sculptural than doll-like and reflect hours of skillful whittling. Wooden dolls enjoy a high survival rate as a result of their sturdy construction. In the early twentieth century, cottage industries formed around helping rural families in Appalachia produce wooden dolls, which were sold through catalogs and in stores across the country.

Paper dolls in the figures of soldiers and horses—created with cut-out paper and embellished with watercolors, inks, and colored pens and pencils made in Boston, Massachusetts (c. 1840–1850) by an unknown artist—are vivid examples of this folk art tradition.

In most pioneer settlements, life revolved around corn. Discarded corncobs were transformed into dolls. Mothers who made dolls for their children followed patterns in ladies' magazines for dolls with corn-silk hair and cornhusk clothing, including elaborate hats and parasols. Despite the popularity of these corn dolls, very few examples have survived. The earliest corn doll was found in an undisturbed seventeenth-century dwelling in Cutchogue, Long Island in 1940. Corn dolls have always been a form of folk art in southern mountain regions, flourishing in cottage industries and craft guilds. Cornhusk dolls have also been a staple of many Native American tribes. Native American dolls can be found both unadorned and painted with bright colors or decorated with beadwork.

Unlike corn dolls, which have dual origins in the European and Native American cultures, nut and apple dolls were largely indigenous to American soil. Most nut-head dolls were small, averaging three to ten inches in height, with the character and personality determined by the type of nut used. They fit into

Horse and Soldier Paper Dolls; Artist unknown; Boston, Massachusetts; c. 1840–1850.
Watercolor, pen, and ink on cut paper. Soldiers: 4 × 2 inches. Horses: 4 × 4½ inches.
© Collection American Folk Art Museum, New York, 1981.8.1.
Photo courtesy Helga Photo Studio.

the rich craft heritage of the southern United States highlands. In the Deep South, nut-head dolls often portrayed African Americans in stereotypical roles. Native Americans made the first apple-head dolls. As pioneers came into contact with various tribes, they began to copy their dolls. Traders persuaded Native Americans to dress their apple-head dolls in bright costumes with elaborate ornamentation, for sale to tourists. Their apple faces were either carved or pinched in, to create the features before they shrank as they dried.

American folk historians are particularly interested in African American dolls, made from various materials, as they were created in slavery and reflected the troubles of the people they portrayed. It is mostly through oral histories, often told by the children of plantation owners, that we learn of dolls made in the antebellum South. After the American Civil War, dolls made by African-American women often displayed the considerable skills of seamstresses as well as newly won social gains, as they portrayed African American ministers, teachers, and fashionable ladies dressed in their Sunday best. A number of dolls reflect racial stereotyping, promoting the image of the carefree "darky" and faithful servant. Dolls were also made from household objects such as whiskbrooms, feather dusters, doorstops, toaster covers, rubber nipples, and mops. Their upper bodies were made of stuffed cloth that covered bottles filled with sand, buckshot, or newspapers. Cottage industries developed in which the dolls were sold as tourist items. Even when they were made in bulk, there was still plenty of diversity in the costumes and painted or sewn-on features. While these dolls offended many

people, and fell into disfavor with the rise of the civil rights movement, they are now avidly collected and studied as important artifacts of American history. African American collectors are among the largest groups of collectors of these dolls.

See also **African American Folk Art (Vernacular Art); Morton Bartlett; Native American Folk Art; Nellie Mae Rowe.**

BIBLIOGRAPHY

Coleman, Dorothy S., Elizabeth A. Coleman, and Evelyn J. Coleman. *The Collector's Encyclopedia of Dolls.* New York, 1968.
Lavitt, Wendy. *American Folk Dolls.* New York, 1982.
McQuiston, Don, and Debra McQuiston. *Dolls and Toys of Native America.* San Francisco, 1995.

WENDY LAVITT

DOORSTOPS are a form of folk art that appeared as a response to the need for household ventilation. Keeping a door ajar allowed air to flow through stuffy, often smoky homes. A rock or lump of iron would serve this purpose, but at least as early as the eighteenth century, English artisans were designing painted wood or cast-iron or brass "door porters," as they were then called. Collectible American examples date to a much later period, roughly 1920 to 1940. Early English examples tended to feature mythological forms such as the Sphinx or winged Griffins, but American doorstop subjects were more bucolic, ranging from a variety of animals through innumerable floral patterns to comic book characters and political figures.

While wood, brass, and marble stops are sometimes seen, the great majority is made of cast iron. A

carved wooden or molded plaster form was used to impress a design in wet sand, which was then filled with molten iron. When cool, the iron was smoothed and painted. Some doorstops, such as those resembling flower baskets, were cast in a single section, with a flat back and a slablike foot to fit beneath the door; others, such as dog forms, were made in two sections, which were then bolted together to create a freestanding, three-dimensional sculpture.

There are hundreds of different doorstop designs, tributes to the American desire to turn a utilitarian object into a piece of art. These forms fall into several broad categories. Among the most popular are figural forms, such as a rare example, depicting a fleeing slave in broken chains. Considerably more common are literary figures, such as Huck Finn and Little Red

Little Red Riding Hood doorstop; Hubley Manufacturing Co.; c. 1820–1930. Maker unknown. Polychrome painted cast iron. © Esto.

Riding Hood; patriotic images, like Uncle Sam and George Washington; various ethnic types (some clearly racist); popular comics heroes, including Popeye and Donald Duck; and figures that capture the spirit of an era, such as the flapper or Charleston dancer of the 1920s.

Animals comprise another broad classification. There are numerous dogs and cats, representing the more popular breeds; lots of birds, such as ducks, parrots, pelicans, and owls; menagerie animals like the elephant, lion, and giraffe; and a barnyard full of domestic stock animals, such as horses, cows, sheep, turkeys, and chickens; and even unlikely subjects, such as lobsters and frogs.

Flowers, mostly represented in baskets bulging with recognizable daisies, lilies, peonies, roses, and sunflowers, make up one of the most collectible categories. There are also numerous miscellaneous types. Houses (usually of the vine-covered-cottage type), lighthouses, windmills, ships, carriages, and covered wagons are seen most often. There is even an outhouse doorstop!

Except for reproductions, all these forms have fallen out of use. First, manufacturers ceased production in 1942, when iron was diverted for wartime use; then came air-conditioning. Today, doorstops are, for the most part, purely ornamental but still highly collectible.

See also **Metalwork; Political Folk Art.**

BIBLIOGRAPHY

Bertoia, Jeanne. *Doorstops*. Paducah, Ky., 1985.
Hamburger, Marilyn G., and Beverly S. Lloyd. *Collecting Figural Doorstops*. New York, 1978.

William C. Ketchum

DOWLER, CHARLES PARKER (1841–1931), a Rhode Island sculptor, woodcarver, and decorative carver, lived and worked in Providence. A 1980 report by the Rhode Island Historical Preservation and Heritage Commission identifies Dowler as a gunsmith who arrived in Providence in 1863 from Birmingham, England, to produce arms for the American Civil War. An entry in *Industries and Wealth of the Principal Points in Rhode Island,* dated 1892, lists Dowler as a sculptor with twenty-seven years of practical experience, and with studios on the third floor at 45 Eddy Street in Providence. The entry characterized him as "the olde [*sic*] established sculptor in Rhode Island," whose "operations consist largely in carvings, modeling and chiseling in plaster; executing any kind of design for interior and exterior decorations; also mod-

els for monumental workers or stone workers to copy from." An extant visiting card reads: "Charles Dowler, Carver and Modeler. Ornamental Designer. All kinds of carving for furniture and house in the latest style of the Art. Modelling [sic] of centers, and all kinds of Stucco work. No. 49 Peck Street, Providence."

Dowler is also known for the decorative carvings he produced for Providence's "Narragansett Hotel, inside and outside." His acclaimed wood and plaster carvings were also prevalent in his residential architectural, decorative, and construction commissions, produced for both himself as well as several owners of Providence's most notable mansions. In 1867 he designed and built in Providence his first home, at 83 Camden Street, and, in 1872, his next home, at 581 Smith Street, which was highlighted by "richly detailed exterior articulation, including fish-scale shingling on the roof, incised Eastlake detailing on the dormers, an oculus window in the mansard, imaginative Corinthian colonettes on the porch." A home designed and built by Dowler for Charles Kelly in 1875 sported a gable roof, two-bay facade, hooded entrance, and a "diamond-pattern jig saw cornice," with "bold hoods over the side and attic windows." By the end of the nineteenth century he advertised himself as a "designer of interior and exterior decorations, models for monumental works, and patterns for jewelry." Upon Dowler's retirement at the age of seventy-eight, in 1919, he took up painting.

In the folk art field, Dowler is recognized as a woodcarver of shop figures, particularly "Dudes" or "Sporting Dudes," also referred to as "Race Track Touts," takers or fixers of gambling bets. Only one confirmed carving of a tout by Dowler, owned by a Connecticut collector in 1937, is known. It was the basis for a 1937 rendering in the *Index of American Design,* the federal art project begun in 1935 by the Works Progress Administration that published this visual archive of 1,900 pieces of American folk art. Boldly painted, the tout's features and costume are meticulously carved. It portrays a young, mustachioed gent sporting a top hat, wearing a high-collared shirt and girded in tight pants and jacket, with his right hand jauntily inserted in his right pocket and his left hand raised as if holding a lighted cigarette or cigar, with other smokes apparent in his left breast pocket. Incorrect Dowler shop-figure attributions have resulted from a misleading caption attached to a photograph of a racetrack tout, purporting to be a Dowler, in Frederick Fried's (1908–1994) book, *Artists in Wood* (1970). Ongoing scholarship is under way to verify Dowler's extant shop-figure carvings.

See also **Architecture, Vernacular; Decoration; Frederick Fried; Sculpture, Folk; Shop Figures; Trade Signs.**

BIBLIOGRAPHY

A.F. Parsons Pub. Co. *Industries and Wealth of the Principal Points in Rhode Island.* New York, 1892

Fried, Frederick. *Artists in Wood: American Carvers of Cigar-Store Indians, Show Figures, and Circus Wagons.* New York, 1970.

Woodward, William McKenzie. "Smith Hill, Providence: Statewide Historical Preservation Report." *Rhode Island Historical Preservation and Heritage Commission.* Providence, R.I., 1980.

WILLIAM F. BROOKS JR.

DOYLE, THOMAS ("Sam") (1906–1985) dedicated the last fifteen years of his life to celebrating the cultural heritage and stories of his local Gullah community, in painted portraits on roofing tin. Members of the Gullah community are of African descent and live along the coasts of South Caroline, Georgia, northern Florida, and the neighboring Sea Islands. Doyle lived his entire life on St. Helena Island, South Carolina, where his artistic talents were first recognized at a young age while attending the island's Penn School, founded in 1862 to educate freed slaves. Leaving school after the ninth grade to work at a local store, Doyle later married, became a father, and began to paint when he was in his twenties. His wife and children moved to New York City without him in the mid-1950s, and by the 1960s, Doyle was making animal sculptures from roots and branches.

Doyle produced most of his paintings and sculptures—thought to total between five hundred and seven hundred works—after retiring from the Parris Island Marine Corps Recruit Training Depot laundry room, about 1970. Preferring to work outside, Doyle used cast-off materials from his immediate surroundings, most notably roofing tin and enamel house paint, to create portraits characterized by bold juxtapositions of bright colors, expressive gestures, and a frequent use of text to convey the identity of each subject.

Doyle displayed his portraits in the yard outside his house, in what he referred to as his "Nationwide Outdoor Art Gallery." Doyle used his yard show as a vehicle for grassroots education, encouraging memory, cultural pride, and humor. His portraits depict a rich and diverse cast of characters. Stories he heard as a boy about firsthand experiences of slavery inspired depictions of island ancestors. Individuals from the generations following the American Civil War who became the first to claim their freedom as professionals within their community were painted by Doyle as part of a "First Blacks" series. Portraits of his contemporaries reveal Doyle's interest in distinctive behavior

and eccentric personalities. African American leaders and various heroes from popular culture (especially those associated with local history) as well as biblical stories, tales of local root doctors, and the "haints," or spirits, of low-country lore were also included in Doyle's pantheon.

As an accomplished storyteller, artist, and teacher, Sam Doyle celebrated the African American identity and legacy through the life stories and experiences of his Gullah community. Doyle died three years after participating in "Black Folk Art in America: 1930–1980," the first of many group and solo exhibitions that have included his work.

See also **African American Folk Art (Vernacular Art); Religious Folk Art; Yard Show.**

BIBLIOGRAPHY

Arnett, Paul, and William Arnett, eds. *Souls Grown Deep: African American Vernacular Art of the South*. Atlanta, Ga., 2000.

Livingston, Jane, and John Beardsley. *Black Folk Art in America: 1930–1980*. Jackson, Miss., 1982.

Perry, Regenia. "Sam Doyle: St. Helena Island's Native Son." *Raw Vision*, vol. 23 (summer 1998): 28–35.

Spriggs, Lynne E. *Let It Shine: Self-Taught Art from the T. Marshall Hahn Collection*. Atlanta, Ga., 2001.

———. *Local Heroes: Paintings and Sculpture by Sam Doyle*. Atlanta, Ga., 2000.

LYNNE E. SPRIGGS

DOYLE, WILLIAM MASSEY STROUD (1769–1828), a painter of pastel and oil portraits, silhouettes, and watercolor miniatures, as well as a museum proprietor, plied his profession principally in Boston during the early nineteenth century. Possibly the son of a British officer stationed in Boston before the American Revolution, Doyle was born there in 1769. He was married twice, first to Mary Clifton, on August 20, 1792, and subsequently to Polly Polfrey, on November 27, 1797. His daughter, Margaret Byron Doyle (later Mrs. John Chorley), also worked as an artist, at least during the second and third decades of the nineteenth century.

Presumably working initially as a wallpaper stainer and manufacturer, by 1803 Doyle was recorded in Boston directories as being associated with the Columbian Museum on Milk Street (later on Tremont Street). Founded by showman and artist Daniel Bowen in 1795, this institution offered a variety of attractions, from wax figures and marble statues to natural and artificial curiosities. It was under Bowen's tutelage that Doyle probably first learned to cut silhouettes and paint portraits. In addition to executing full-size likenesses in oil and pastel, Doyle, with the aid of a physiognotrace used to create likenesses, was charging in 1804 from twenty-five cents to two dollars for profiles. A year later he had added miniatures, which could be purchased for between twelve and twenty dollars, to his repertoire. In 1825 the contents of the Columbian Museum were sold to artist Ethan Allen Greenwood (1779–1856), proprietor of the New England Museum. Doyle continued to be associated with this institution until at least 1827.

Doyle executed likenesses in a variety of mediums, but he is recognized today primarily for his full-size pastel portraits, depicting either adults, in bust or half-length, or children, in full-length compositions. Signed by the artist, *Child of the May Family* (1806) is his earliest known pastel. Seated in a Windsor-style chair, this beautiful blond-haired subject is portrayed playing with a toy horse. As was characteristic of Doyle's known portraits of children, he recorded his sitter's appearance against a neutral background devoid of extraneous details except for the ornately patterned, ingrained carpeting, which defines the composition as an indoor scene. Doyle's last known likeness, dated May 3, 1828, is a self-portrait done approximately two weeks before his death from consumption.

See also **Ethan Allen Greenwood; Miniatures; Painting, American Folk; Papercutting.**

BIBLIOGRAPHY

Jackson, E. Nevile. *Silhouettes: A History and Dictionary of Artists*. New York, 1981.

Kern, Arthur, and Sybil Kern. "The Pastel Portraits of William M.S. Doyle." *The Clarion*, vol. 13 (fall 1988): 41–47.

CHARLOTTE EMANS MOORE

DRAWINGS: *SEE* LEDGER DRAWINGS.

DROWNE, SHEM (1683–1774) was a Boston maker of weathervanes and a self-described tinsmith. He was heralded for his *Grasshopper* trade sign weathervane, made of gilded cooper with a glass eye and installed atop Faneuil Hall in Boston on May 25, 1742. Faneuil Hall, located on the waterfront's Dock Square, was a new central market serving the busy colonial port where sailing ships docked, and where sailors and merchants gathered. The trade sign weathervane measures four feet by four inches in length, and was inspired by a larger grasshopper adorning the Royal Exchange in London. In the mid-eighteenth century, the grasshopper was associated with mercantile exchanges. Drowne is the title character of writer Nathaniel Hawthorne's (1804–1864) short story

"Drowne's Wooden Image," first published in 1844. Hawthorne celebrated Drowne as a woodcarver rather than as a tinsmith.

Hawthorne also highlighted an earlier weathervane that was made about 1716 by Shem Drowne; the *Indian* is constructed of copper with glass eyes, measures five feet, five inches in height, was made for the Province House in Boston, and is now in the collection of the Massachusetts Historic Society.

Equally renowned is Drowne's *Swallow-tailed Banner* weathervane, made of copper, measuring six feet in length, and located atop Boston's Christ Church on Copp's Hill. Christ Church is better known as the Old North Church memorialized by Henry Wadsworth Longfellow (1807–1882) in his 1860 poem "The Midnight Ride of Paul Revere," with its belfry tower "as it rose above the graves on the hill, lonely and spectral and somber and still." A third surviving weathervane is the *Weathercock,* made of gilded copper with glass eyes, measuring 5½ feet long and weighing 172 pounds, and located on top of the spire of the First Church, Congregational, Cambridge, Massachusetts (although Drowne originally made the *Weathercock* for the New Brick Church on Hanover Street in Boston, where it was dedicated on May 10, 1721).

Shem Drowne's son, Thomas Shem (1715–1796), joined his father, and in June 1768 Thomas repaired the Faneuil Hall grasshopper. During his father's lifetime, he is credited with the 1767 *Weathercock,* constructed of gilded copper, measuring four feet, four inches long, and made for the First Parish Waltham, Massachusetts, but now on the spire of that city's First Congregational Church, as well as the 1771 *Weathercock,* constructed of copper with glass eyes, measuring four feet, four inches in length, and made for the East Meetinghouse in Salem, Massachusetts. Myra Kaye, whose *Yankee Weathervanes* is a seminal work on Shem Drowne, concluded that Thomas, while trained by his father, was more artistically accomplished.

See also **Trade Signs.**

BIBLIOGRAPHY

Babcock, Mary Kent Davey. *Christ Church, Salem Street, Boston.* Boston, 1947.

Babcock, Mrs. S.G. (Mary K.D.). "Weather–Vane on Christ Church, Boston." *Old–Time New England,* vol. 32, no. 2 (October 1941): 63–65.

Baker, Daniel W. "The Grasshopper in Boston." *The New England Historical and Genealogical Register,* vol. 49 (January 1891): 24–28.

Brown, Abram English. *Faneuil Hall and Faneuil Hall Market* or *Peter Faneuil and His Gift.* Boston, 1900.

Kaye, Myra. *Yankee Weathervanes.* New York, 1975.

Thwing, Leroy L. "Deacon Shem Drowne—Maker of Weathervanes." *Early American Industries Association Chronicle,* vol. 2, no. 1 (September 1937): 1–2, 7.

WILLIAM F. BROOKS JR.

DU PONT, HENRY FRANCIS (1880–1969) created the Winterthur Museum, the largest collection of American decorative art, in his family home in Winterthur, Delaware. Concentrating on the period of 1640 to 1840, he acquired architectural details as well as entire rooms of paneling from old homes along the eastern seaboard, reinstalled them in one hundred rooms in his home, and furnished the rooms with American antiques of the appropriate period. The Winterthur Gardens around the museum are a noted horticultural achievement.

Henry du Pont was the last great-grandson of E.I. du Pont de Nemours, founder of the DuPont Chemical Company. He graduated from Harvard University in 1903, was elected a director of DuPont in 1915, and soon after that became a director of General Motors. Du Pont married Ruth Wales at Hyde Park, New York, in 1916; they had two daughters, Pauline and Ruth Ellen. Du Pont resided at Winterthur, which he inherited in 1926 from his father, for at least part of every year until 1951.

Two factors helped stimulate du Pont's interest in American decorative art. In 1923, he visited the home of Electra Havemeyer Webb (1888–1960)—a collector of Americana, folk art, and antiques as well as the founder of the Shelburne Museum in Shelburne, Vermont—and became interested in collecting American antiques. Then there was the opening of the American wing of the Metropolitan Museum of Art in New York City in 1924, which created a sensation and also influenced du Pont's collecting.

From 1926, when he inherited Winterthur, until his death in 1969, du Pont engaged in almost continual renovation and enlargement of Winterthur and its gardens with great energy, meticulous care, and large resources. He preferred room settings for his collections rather than gallery displays. The Pennsylvania German pieces du Pont collected in the 1920s and that he purchased on automobile tours, chauffeured by his driver, resulted in the creation of the Pennsylvania Folk Art and the Fraktur Rooms, for instance. The Pennsylvania German Bedroom, with its version of Edward Hicks's *Peaceable Kingdom,* and Schimmel Hall, containing a number of eagles by the itinerant carver, Wilhelm Schimmel, also reflect this particular interest. The woodwork in the Shaker Dwelling Room and the Shaker Storeroom came from large stone

dwellings dating from the 1840s that du Pont had found in Enfield, New Hampshire, and he filled the rooms with furniture he had found in other Shaker villages. A two-story hall—moved virtually intact from the Ezra Carroll house in East Springfield, New York—dating from about 1820 and painted in 1831 by William Price, the itinerant artist, is one of Winterthur's folk art gems. In the end, du Pont brought together the most comprehensive collection of American decorative art of the highest quality.

Winterthur, which had been deeded to a foundation, was opened to the public in 1951 after 112 years of occupancy by the du Pont family. Du Pont, who moved into a home nearby, had said that he was now only a visitor to the museum but still the head gardener.

Henry du Pont received many awards and honors for his achievements. He was named to special committees formed to redecorate and furnish the White House by Mrs. John F. Kennedy and President Lyndon B. Johnson. He received the highest awards given to non-professional horticulturists from the National Association of Gardeners and the Garden Club of America. The National Society of Interior Decorators gave him their first Thomas Jefferson Award. He was on the board of the New York Botanical Gardens, the Whitney Museum of American Art, and the Cooper-Hewitt Museum, among others.

See also **Architecture, Vernacular; Decoration; Fraktur; German American Folk Art; Edward Hicks; Pennsylvania German Folk Art; Wilhelm Schimmel; Shakers; Shelburne Museum; Electra Havemeyer Webb; Winterthur Museum.**

BIBLIOGRAPHY

Cantor, Jay E. *Winterthur.* New York, 1997.
Sweeney, John A.H. *Winterthur Illustrated.* New York, 1963.

JOHN HOOD

DURAND, JOHN (active 1765–1782) was one of the preeminent colonial painters of wealthy New York, Virginia, and Connecticut families during the second half of the eighteenth century. Although little biographical information is available about the artist, his activity can be traced from 1765, when he is first documented as working in Virginia, to 1782, when his name last appears on a tax list for Dinwiddie County in Virginia.

Durand was working in New York City in 1766, when he painted portraits of the six children of merchant James Beekman. The portraits strongly suggest that Durand was already a proficient artist by the time

he earned this commission, although the nature of his training is not clear. In his account book, Beekman refers to the artist as "Monsieur Duran." This and similar references in later sources have led to speculation that the artist was either of French ancestry or perhaps was American-born to French Huguenot parents. Durand tended toward a linear and decorative approach to painting, with heavy outlining and flat areas of color. The soft rococo colors, as well as the profusion of flowers and other embellishments, may suggest some training as a decorative painter, a notion supported by Durand's advertisement in the (Williamsburg) *Virginia Gazette,* on June 21, 1770, that states his willingness to "paint, gild, and varnish wheel carriages; and put coats of arms, or ciphers, upon them, in a neater and more lasting manner than was ever done in this country."

Durand's most ambitious canvas, and the only known group portrait in his oeuvre, was completed in 1768. Depicting the four children of Garret Rapalje, a New York City importer, the figures are arranged in a naturalistic composition, one in front of the other, with the oldest son in the foreground. Each of the four figures exemplifies a pose or convention that Durand had already relied upon in his individual portrayals of the six Beekmans: hand on hip or hand in vest for each of the boys, a flower held to the bosom of the girl, and a self-conscious disposition of fingers, often with one or two lifted and separated from the rest. That same year Durand also advertised in *The New-York Gazette* or the *Weekly Post-Boy* that he had "from infancy endeavored to qualify himself in the Art of historical Painting." As no paintings of historical subjects by Durand are known, however, he appears to have been unsuccessful in this aspiration.

Between 1768 and 1770, Durand worked primarily in Connecticut and New York, with at least one commission in Virginia, in 1769. These early portraits show little modeling but a freshness and naturalism that the artist rarely achieved in most of the Virginia portraits, which Durand's nephew, Robert Sully, characterized as "dry and hard." A new attempt at modeling appears in the portraits of the early 1770s, when he was probably traveling through New York on his way back to Connecticut and may have become acquainted with the work of John Singleton Copley (1738–1815).

In 1772, a signed and dated portrait of Benjamin Douglas places Durand back in Connecticut. His movements are not known thereafter until he reappears in Virginia in 1775 with the portraits of *Mr. and Mrs. Gary Briggs* of Dinwiddie County. These continue to show the influence of Copley, in that the

figures emerge dramatically from a dark background. After 1775 Durand may have remained in Virginia; his last known painting marks a return to the "hard and dry style," and is dated 1781.

See also **Painting, American Folk.**

BIBLIOGRAPHY

Chotner, Deborah et al. *American Naïve Paintings: The Collections of the National Gallery of Art Systematic Catalogue.* Washington, D.C., 1992.

Kelly, Franklin W. "The Portraits of John Durand." *The Magazine Antiques,* vol. 122, no. 5 (November 1982): 1080–1087.

Weekley, Carolyn J. "Artists Working in the South, 1720–1820." *The Magazine Antiques,* vol. 110, no. 5 (November 1976): 1046–1087.

Stacy C. Hollander

DUTCH SCRIPTURE HISTORY PAINTINGS are a small group of paintings based on engravings in Dutch Bibles that have survived from early-eighteenth-century New York. They were painted by local limners or artists for descendants of early Dutch settlers, who displayed them in their homes as emblems of their Protestant faith and their identifying with the biblical Israelites.

Less than four dozen scripture history paintings are known to exist from this era of unusual peace and prosperity in New York, between 1713 and 1745, and it was here that this genre of painting was primarily produced, existing hardly at all in other colonies, where religion was equally important. The reasons for this can be found in Dutch history.

The Netherlands Dutch were and still are a people small in population and territory, though not in energy and creativity. For centuries they persevered against larger nations and alien faiths, especially the Catholic Spanish who dominated the Low Countries in the sixteenth and early seventeenth centuries. Remembering the oppression of liberty and faith they had suffered under the Spanish, the Dutch found solace in their Bible, identifying with the persecuted Old Testament Israelites. The importance to them of the Bible and its stories are found in the biblical images the Dutch displayed in their homes, on fireplace tiles, and in framed prints, paintings, and biblical engravings.

Family Bibles supplied the same images for the Dutch in New York, and for similar reasons. In the New World, the Dutch were again under subjugation, this time from the British. In their home, they worshiped with scripture paintings on the walls. As did the Israelites, the Dutch saw themselves as "a remnant in the wilderness," in danger of losing their cultural identity just as they had lost their political independence. In their faith they found justification for their worldly prosperity as well as for their relations with other Europeans, Native Americans, and slaves. In this sense their scripture paintings say more about their ideas of self and their social and political history than their faith does.

The New Testament was equally appealing to the Dutch in America, but for different reasons. Here they found the basis for a personal faith in a loving God that coincided with the goals of the Great Awakening, a colonial revivalist movement of the 1730s and 1740s, when these paintings were especially popular. A schism in the Protestant churches in Europe soon manifested itself in the Great Awakening in America. Pietism, which stressed personal devotion over formal religious orthodoxy and that salvation was achieved through faith and good works, not like the Calvinist belief in pre-destination, caused many Dutch families and some congregations to become deeply affected by this moralistic view of their faith. This may account for the popularity of scripture history paintings during this period.

Nearly all of the four dozen scripture history paintings now known to exist are closely adapted from Bible engravings depicting themes important to the Dutch, such as the finding of Moses (saving the Israelites' savior); Isaac blessing Jacob (fulfilling the Lord's prophecy, even if by deceit); and Christ on the road to Emmaus (the miracle of Christ's first appearance after his Resurrection). The degree of favor these paintings elicited among the Dutch may be judged by the comment of Dr. Alexander Hamilton in 1744: "The Dutch here [at Albany] . . . affect pictures much, particularly scripture history, with which they adorn their rooms."

Determining the identity of the limners who produced these paintings has been complicated by the fact that only one picture, *The Naming of John the Baptist,* is signed by a limner and dated 1713, Gerardus Duyckinck I (1695–1746). It is also the only signed work among more than five hundred known paintings, mostly portraits, produced before 1750 in New York and New Jersey. Despite this fact, attributions to some of the two dozen limners of this period have been made possible through the efforts of several scholars; efforts built upon not only a careful examination of limner techniques but especially the consistency in the application of color, the modeling of the human form, and details of the features, which scripture paintings share with portraits by the same limners. Most scripture history paintings have been attributed to Gerardus Duyckinck I, working in New York City and Albany between 1713 and 1746, and

John Heaton (active 1730–1745), who was painting in and around Albany.

The style of scripture paintings was especially influenced by its derivation from woodcut engravings in Dutch Bibles, which emphasize simplified lines. The limners were also constrained in their creative expression by the subject matter, which required fidelity to the original image and story line. They were free, however, to indulge in their taste for expression through their use of color. None of the limners of this period, except for John Watson (1685–1768), were apprenticed in the high standards of European guild training; their scripture, portrait, genre, and decorative paintings all show the influence of either modest apprenticeship training and/or modest talent, often associated today with folk or vernacular art. Their scripture paintings appear stylized, sometimes crude, and often lack proper perspective, yet many are appealing for their combination of rich colors and the visual motion of individual features as well as overall composition.

In 1980 these paintings were the subject of an exhibition and catalog, "A Remnant in the Wilderness: New York Dutch Scripture History Paintings of the Early Eighteenth Century," sponsored by the Bard College Center and the Albany Institute, in which all the known paintings were featured. Since the exhibition, only four other scripture paintings have been discovered.

See also **Gerardus Duyckinck I; John Heaton; Painting, American Folk; Religious Folk Art; John Watson.**

BIBLIOGRAPHY

Black, Mary C. "Contributions Toward a History of Early Eighteenth-Century New York Portraiture: Identification of the Aetatis Suae and Wendell Limners." *American Art Journal,* vol. 12 (1980): 4–31.

———. *Dutch Arts and Cultural in Colonial America.* Albany, N.Y., 1987.

Blackburn, Roderic H., and Ruth Piwonka. *Remembrance of Patria: Dutch Arts and Culture in Colonial America, 1609–1776.* Albany, N.Y., 1988.

Piwonka, Ruth, and Roderic H. Blackburn. *A Remnant in the Wilderness: New York Dutch Scripture History Painting of the Early Eighteenth Century.* Albany, N.Y., 1980.

Wheeler, Robert. "Hudson River Religious Paintings." *The Magazine Antiques* (April 1953): 346–350.

RODERIC H. BLACKBURN

DUYCKINCK, GERARDUS, I (1695–1746) is the best known of several limners (and stained-glass glaziers) in this New York City family, which included his grandfather Evert (1621–c. 1703), his father, Gerrit (1660–c. 1710), his cousin Evert III (1677–c. 1725), and his son Gerardus Jr. (1723–1797). As with the Vanderlyn family of limners, talent and experience passed through several generations.

Duyckinck was probably trained by his father and then by his older cousin Evert. In 1713 he signed and dated a scripture history painting, *The Naming of John the Baptist,* the only signed example to be found among early New York paintings. This painting, produced when he was eighteen years of age, may represent his "masterwork" and the proof of his apprenticeship training. When this signed painting was discovered in 1978, by art dealer Richard H. Love, further "detective work" led art experts to identify other paintings by the same artist. Art historian James Flexner first identified the group of portraits (which he ascribed to the "De Peyster" limner) that Waldron Phoenix Belknap Jr. subsequently connected to Gerardus Duyckinck I. Mary C. Black (1923–1992) later confirmed the attribution of the works to Duyckinck. More than twenty other scripture history paintings as well as more than forty portraits have since been attributed to the artist. The painter's close relations to certain sitters also helped experts discover that Duyckinck was indeed the painter of many early portraits.

Gerardus Duyckinck's early works, such as the signed scripture history painting and portraits of his parents, show the influence of his cousin Evert's style, with their softly modeled and elongated faces and their simply drafted bodies and clothing. By the 1720s, Duyckinck's portraits and scripture paintings displayed more polished features and modeling as well as a richer palette of colors. His portraits were usually inspired by mezzotint prints based on English court portraits, which he, as an art supply dealer, had readily available to show prospective patrons. This mature style continued for the last twenty years of his life. His son Gerardus II succeeded him as an art supply dealer and limner, and although no paintings by him have been identified, a recently discovered bill does substantiate that he, like his father, painted portraits.

See also **Mary Childs Black; Dutch Scripture History Paintings; Religious Folk Art; Pierter Vanderlyn.**

BIBLIOGRAPHY

The Albany Institute of History and Art. *Remembrance of Patria: Dutch Arts and Culture in Colonial America, 1609–1776.* Albany, N.Y., 1988.

Belknap, Waldron Phoenix. *American Colonial Painting: Materials for a History.* Cambridge, Mass., 1959.

Black, Mary C. *Rivers, Bowery, Mill, and Beaver.* New York, 1974.

Blackburn, Roderic H., and Nancy Kelley, eds. *Dutch Arts and Culture in Colonial America.* Albany, N.Y., 1987.

Flexner, James Thomas. *First Flowers of Our Wilderness: American Painting, the Colonial Period.* New York, 1969.

Piwonka, Ruth. *A Portrait of Livingston Manor, 1686–1850.* New York, 1986.

Piwonka, Ruth, and Roderic H. Blackburn. *A Remnant in the Wilderness: New York Dutch Scripture History Painting of the Early Eighteenth Century.* Albany, N.Y., 1980.

Quimby, Ian M.G., ed. *American Painting to 1776, A Reappraisal.* Charlottesville, Va., 1971.

Wheeler, Robert, and Janet R. MacFarlane. *Hudson Valley Painters.* Albany, N.Y., 1959.

RODERIC H. BLACKBURN

EARL, RALPH (1751–1801) painted many of the most enduring images of American people and places during the last quarter of the eighteenth century. He has become known as the initiator of the "Connecticut school" of portrait painting, and his style has come to be associated with New England portraiture. Raised in Worcester County, Massachusetts, in 1774, he turned his back on his agrarian roots and established himself as a fledgling artist in New Haven, Connecticut. He painted portraits of a number of leading Revolutionary War patriots in New Haven, including his early masterwork, *Roger Sherman* (1775–1776). Earl also collaborated with his New Haven colleague, the engraver Amos Doolittle, to produce sketches for four engravings of the 1775 battles of Lexington and Concord, which would become among the first historical prints to be made in America. Despite his seemingly patriotic endeavors, Earl declared himself a Loyalist, and in 1778, with the assistance of a young British officer, Capt. John Money, he fled to England.

During his eight-year stay in England, Earl divided his time between Norwich, in the province of East Anglia, and London. His early years were spent painting portraits for the Norwich country gentlefolk in a provincial style. By 1783, Earl was part of the entourage of American artists in the London studio of Benjamin West, where he absorbed the lessons of the British portraiture tradition. Many of Earl's highly accomplished London and Windsor portraits were shown at Royal Academy exhibitions.

In 1785 Earl returned to America and quickly established a residence in New York City. His ambitious start came to a sudden halt, however, when he was confined to a New York debtors' prison, where he remained from September 1786 until January 1788. Earl engaged the support of the Society for the Relief of Distressed Debtors, composed of the most illustrious of New York families, who allowed Earl to paint their portraits while he was still in prison. By painting such elegant works as *Mrs. Alexander Hamilton* (1787) as well as a series of portraits of heroes of the American Revolution, he earned enough money to obtain his release.

Earl's release from debtors' prison marked a turning point in his career. With the help of his court-appointed guardian, Dr. Mason Fitch Cogswell, who convinced the artist to follow him to Connecticut, Earl regained stability. He modified his artistic ambitions to ply his trade as an itinerant artist in the agriculture-based society of Connecticut. He found his greatest success in this region, where, with Cogswell's impressive connections, he painted for ten years.

Earl furthered the formation of a national imagery by portraying a segment of American society that had never before received the attention of a trained and highly gifted artist. More than any other artist of his time, Earl was qualified to create an appropriate style to satisfy the aesthetic sensibilities of his Connecticut subjects. Earl deliberately rejected British aristocratic imagery, cleverly tempering his academic style to suit his subjects' modest pretensions. He began to paint realistic portrayals of his subjects' likenesses and surroundings, including their attire, locally made furnishings, newly built houses, regional landscape features that celebrated land ownership, and emblems of the new nation. In addition, he adopted a more simplified technique, using broad brushstrokes and favoring primary colors—a portrait style popular with citizens of the new republic.

Earl was also one of the few American artists in the 1790s to receive commissions for landscape paintings, an art form that was still scarce in his native country. In 1798 he moved north to Vermont and Massachusetts in search of new commissions. The next year, Earl became the first American artist to travel to Niagara Falls, where he sketched the "stupendous cataract." After this arduous journey, Earl

returned to Northampton, Massachusetts, where he produced a panorama of the falls that measured approximately fifteen by thirty feet. With great fanfare, the panorama was first placed on public view in Northampton, and subsequently in New Haven, Connecticut, as well as in Philadelphia, before finally traveling on to London.

At the end of his life, Earl returned to his native town of Leicester, Massachusetts, where he painted a final panoramic landscape of the region, titled *Looking East from Denny Hill* (1800). In 1801 Earl traveled to Bolton, Connecticut, where he died at the home of Dr. Samuel Cooley. The cause of death was listed as "intemperance." The artist's problems with alcoholism, the rigors of his life of continual travel, and his separation from his family all contributed to his early death at the age of fifty.

See also **Painting, American Folk.**

BIBLIOGRAPHY

Kornhauser, Elizabeth Mankin. "'By Your Inimitable Hand': Elijah Boardman's Patronage of Ralph Earl." *The American Art Journal*, vol. 23 (1991): 4–20.

———. "Ralph Earl As an Itinerant Artist: Pattern of Patronage," in *Itinerancy in New England and New York: Annual Proceedings of the Dublin Seminar for New England Folk Life*. Boston, 1986.

Kornhauser, Elizabeth Mankin, et al. *Ralph Earl: The Face of the Young Republic*. New Haven, Conn., 1991.

Sawitsky, William, and Susan Sawitsky. "Two Letters from Ralph Earl, with Notes on His English Period." *Worcester Art Museum Annual*, vol. 8 (1960): 8–41.

ELIZABETH MANKIN KORNHAUSER

EARNEST, ADELE (1901–1993), an authority on wildfowl decoys and other forms of folk sculpture, was the catalyst for the founding of the American Folk Art Museum (then the Museum of Early American Folk Arts) in 1961. Born in Waltham, Massachusetts, she was a graduate of Wellesley College. After a stint as stage manager for Eva LaGalliene's Fourteenth Street Repertory theater in New York, she moved to Stony Point in nearby Rockland County and in 1948, with her business partner Cordelia Hamilton, established the Stony Point Folk Art Gallery. The gallery became well known for its collection of folk sculpture, especially decoys. In 1965 she published *The Art of the Decoy: American Bird Carving,* one of the first authoritative studies of this important tradition in folk sculpture.

As a founding trustee of the American Folk Art Museum, Earnest spearheaded many of its early programs and contributed to its permanent collection.

For much of its history, the museum was associated symbolically with the Archangel Gabriel weathervane (c. 1840), donated by Earnest in 1963. Among her other important contributions to the museum's collection were a pair of wildfowl decoys (c. 1860), two mergansers from the hand of master carver Lothrop "Lott" T. Holmes (1824–1899) of Kingston, Massachusetts.

Earnest published her *Folk Art in America: A Personal View* in 1984. A personal memoir as well as a history of the field and of the American Folk Art Museum, it traces her interest in folk art to Pennsylvania German country, where she resided as a young bride in the late 1920s. Earnest became associated with many notable scholars and collectors of American folk art, and maintained a wide-ranging correspondence on issues affecting the field. Her papers are in the library of the American Folk Art Museum.

See also **American Folk Art Museum; Joel Barber; Decoys, Wildfowl; Herbert W. Hemphill Jr.; Lothrop T. Holmes; Sculpture, Folk; Weathervanes.**

BIBLIOGRAPHY

Earnest, Adele. *Folk Art in America: A Personal View.* Exton, Pa., 1984.

GERARD C. WERTKIN

EASTER EGGS, DECORATED: *SEE* EASTERN EUROPEAN AMERICAN FOLK ART; HOLIDAYS.

EASTERN EUROPEAN AMERICAN FOLK ART, in its various national expressions, has served as a potent means for asserting cultural distinctiveness and group identity in the countries of its origin and in the United States, where immigrants introduced it beginning in the second half of the nineteenth century. The map of Europe was markedly different during the early period of this immigration, with many Eastern European peoples living in one of two multinational states: the Russian Empire or the Austro-Hungarian Empire. Through folk art, which was considered an authentic expression of the national spirit, Poles, Ukrainians, Lithuanians, and others were able to promote and preserve a continuing sense of group cohesion, despite changing political boundaries and a lack of national independence. Religion always has played a major role in the folk art of Eastern Europeans and their descendants, many expressions being related to the liturgical calendar or the celebration of life-cycle events in the Eastern Orthodox or Roman Catholic faiths, or, to a lesser extent, in Protestant denomina-

tions. Significant Jewish communities existed in Eastern Europe until World War II.

Although individual emigrants from Eastern Europe arrived in North America as early as the seventeenth century (Poles settled in Jamestown, Virginia, in 1608), the production of folk art did not become a widespread practice among Americans of Eastern European heritage until much later, when larger-scale emigration led to the establishment of ethnically based communities and community organizations (churches, parochial schools, political and self-help associations, labor unions, clubs, performing arts groups) throughout much of the United States. These organizations often encouraged the maintenance of inherited cultural forms, including the folk arts. Some Eastern European communities like the Polish Americans, for example, have grown in the early twenty-first century to at least 6 million Americans of Polish descent. Other communities are considerably smaller but still have had an impact on American life.

Early in the twentieth century, a series of pioneering exhibitions organized in the United States highlighted the traditional arts of immigrant communities from various parts of the world, including Eastern Europe. Allen H. Eaton of the Russell Sage Foundation chronicled these programs in an influential book, *Immigrant Gifts to American Life,* published in 1932. One of the most important of the exhibitions was "The Arts and Crafts of the Homelands," organized in Buffalo in 1919 by the University of the State of New York, the American Federation of Arts, and the Albright Art Gallery. Perhaps for the first time in a museum setting in America, an exhibition featured the painted and decorated furniture of Czech and Slovak communities; musical instruments from Serbia and Croatia; Polish toys and woodcarvings; Hungarian embroidery; and other traditional arts.

Among the many folk art traditions of Eastern Europeans in the United States, decorated Easter eggs play an especially prominent role. The practice of decorating eggs ultimately derives from ancient cults in which the egg symbolized fertility, renewal, life, and birth. Among Hungarians, for example, decorated eggs, or *hímes tojas,* were placed in the hands of the deceased before burial, to represent eternal life. With the advent of Christianity, this tradition became associated throughout Eastern Europe with Easter and the Resurrection of Christ. Hungarian Americans decorate Easter eggs utilizing the wax resist ("batik"), painted, or "scratch" techniques. In the scratch technique, a dyed egg is carefully scored by a sharp instrument, such as a quill. Although many commercially made dyes are now available, traditional decorators in the various Eastern European communities often use a coloring process in which eggs are immersed in the liquid of cooked red-onion skins, which yields varying hues, from tan to red-brown.

In Ukraine, where the practice of decorating Easter eggs, or *pysanky,* has been known at least since the tenth century, there are hundreds of variations in the symbolic and decorative designs, many regional in nature. Ukrainian immigrants and their descendants continue to employ these motifs on *pysanky* produced in North America. Solar symbols, the *bezkonechnyk* (a never-ending curving line, or meander), patterns drawn from nature, geometric shapes, and Christian and pre-Christian iconography are all used. The batik method of decorating eggs is the most popular technique among Ukrainians and Ukrainian Americans. Designs are drawn on an egg using melted wax and a special stylus, called a *kystka.* After the egg is dipped in dye, the wax is melted to reveal the imagery.

Decorated eggs are woven into the religious folkways associated with Easter in various communities. Among Lithuanian Americans, the decoration of Easter eggs, or *margučiai,* generally takes place on Easter Saturday. The eggs, which are distinctive because of their characteristically fine and repetitive patterns, are taken to the church, blessed, and brought back to the home, where they are among the foods characteristically eaten on Easter Sunday. Other communities of Eastern Europeans in North America—Russians, Romanians, Latvians, Czechs, and Slovaks among them—have also retained distinctive practices relating to the decoration of Easter eggs. Indeed, the traditions of dyeing and decorating eggs may be found in other parts of the world as well, but it is in Eastern Europe, and among the descendants of Eastern Europeans, that this folk art is most fully developed.

Among Americans of Polish heritage, the making of *wycinanki,* or traditional paper cuts, continues to be practiced. The origin of this folk art is lost in obscurity, but it reached its full flowering among Polish peasant women in the last third of the nineteenth century, especially in the regions of Kurpie and Lowicz. *Wycinanki* were originally cut from a single sheet of folded paper, but later in the history of the form cut-paper elements in contrasting colors were applied with glue. Sheep shears, despite their bulkiness, were traditionally used to cut *wycinanki.* The patterns are most often decorative rather than representational, and include stylized depictions of flowers and other organic shapes, but full-fledged domestic or village scenes, often with figures dressed

in colorful folk costumes, also have a place in the tradition. Among the most characteristic forms is the *gwaizdy,* or "star" pattern. *Wycinanki* also serve as Christmas and Easter decorations.

Much of Eastern Europe is deeply forested. Hence, it is not surprising that woodcarving and the creation of woodenwares of various kinds were widely practiced in the countryside. As an adornment of objects both sacred and secular in nature, decorative woodcarving may be found on altars and iconostases, as well as furniture, chests, boxes, and other implements of daily life, and carts and sleighs. Folk carvings also adorn the doorways, eaves, and windows of rural buildings in parts of Eastern Europe. Among Americans of Hungarian descent, traditional chip-carved forms, like the linen beater (*sulykoló*) and the mud scraper (*sárkaparok*), continue to be created by gifted folk artists as an assertion of ethnic identity, although these objects no longer serve their original function. In the countryside of old Hungary, the *sárkaparok* played a role in courtship. When a suitor carved the object for a young woman, her acceptance of this token signified her interest in pursuing a relationship with him.

The carving of religious figures continues to be a living tradition in the Lithuanian community in the United States. In Lithuania, the *dievdirbis,* or carver of images, was highly respected. His images, or *dievukai,* frequently housed in wayside niches or chapels in rural areas, erved a central role in the popular devotional practices of Lithuanian Roman Catholics. Among the characteristic Lithuanian religious images carved in America is the *Rūpìntojélis,* the Sorrowful or Wayside Christ. According to legend, *Rūpintojélis* is the image of the Resurrected Christ, resting alone by the wayside and weeping over the state of mankind. The image continues to be venerated, receiving special devotion during Lent.

Straw is another material that Americans of Eastern European descent use in the production of inherited folk art forms. Especially notable are the wheat weavings, house blessings, and harvest crosses of Americans of Slovak heritage; the decorative palms for Palm Sunday created by Slovenian Americans; and the three-tiered *puzuris,* or mobiles, traditional Latvian home decorations, woven in symmetrical geometric shapes, that are characteristic of Latvian folk art. Many of these are assumed to be pre-Christian in origin.

Among Eastern European folk traditions in woven and embroidered textiles that remain fully integrated into daily life among immigrants and their descendants in the United States, the Ukrainian "ritual cloth" is highly significant. Ritual cloths, or *rushnyky,* play a prominent and varied role for Ukrainians as well as Ukrainian Americans. The celebration of a marriage, for example, requires several ritual cloths: one is given to the groom and worn as a sash; another is used in the blessing of the wedding bread; still another is knelt on by the bride and groom before the priest; and one is held by the couple during the ceremony. A newborn infant may be wrapped in a *rushnyk;* after death, a ritual cloth may cover the deceased. In Ukrainian-American homes, it is customary to display icons with *rushnyky* draped around them. Among the customary decorative motifs on Ukrainian ritual cloths, whether embroidered or woven, are pre-Christian symbols, including the ancient fertility goddess Berehynia, solar signs, and the tree of life. Distinctive patterns, which are highly stylized, may be associated with specific regions in Ukraine.

The weaving of sashes, or *juostos,* an important part of the traditional way of life of Lithuanian countrywomen, continues to be practiced by Lithuanian Americans today. In view of the narrow nature of the sash, it is remarkable how many different weaving patterns are associated with it. The weaver's choice of colors tends to distinguish the region of origin. In Lithuania, *juostos* were given as tokens of love, had several roles in weddings, and were used to lower a coffin into the grave.

Folk costume and objects of personal adornment are important elements in the folk traditions of Eastern Europe, each region having its own distinctive dress. These costumes continue to be produced in the United States, especially in connection with performances of dances and songs, events on the church calendar, community festivals, and parades celebrating national holidays. The wearing of traditional dress helps sustain a sense of distinctive ethnic identity and group cohesiveness. This may be true for specific items of costume as well. Mittens knitted in a traditional repertoire of regional patterns, for example, play a prominent role in the folklife of Latvians and Latvian Americans.

The vitality of Eastern European folk arts in the United States varies from community to community. The mobility of American life, intermarriage, higher education, and the impact of mass communication have tended to erode traditional folkways in ethnic communities. In some cases, the continuity of a visual or decorative arts tradition rests in the work of a mere handful of artists; in others, a renewal of interest in exploring personal and communal roots results in a revival of old forms; in still others—egg decorating, for example—the traditions remain robust.

See also **Boxes; Decoration; Furniture, Painted and Decorated; Holidays; Jewish Folk Art; Musical Instruments; Papercutting; Religious Folk Art; Toys, Folk; Woodenware.**

BIBLIOGRAPHY

Eaton, Allen H. *Immigrant Gifts to American Life.* New York, 1932.
Hasalová, Věra, and Jaroslav Vajdiš. *Folk Art of Czechoslovakia.* New York, 1974.
Newall, Venetia. *An Egg at Easter: A Folklore Study.* Bloomington, Ind., 1971.
Wolynetz, Lubow. *Ukrainian Folk Art.* New York, 1984.

GERARD C. WERTKIN

EASTMAN, EMILY (1804–?) has achieved a modest level of recognition for a small but appealing group of highly stylized watercolors depicting fashionably garbed and coiffed young women. The drawings appear to have been based largely upon European fashion prints, which were available as separate plates or through publications such as Ackerman's *Repository of Arts, Literature, Commerce, Manufactures, Fashions, and Politics,* printed in London from 1809 through 1829. These illustrations heavily influenced American taste in clothes, and also provided handsome copy prints for amateur arts and artists.

Although little is known about Eastman's life, she appears to have painted at least through the 1820s or 1830s, based upon the clothing and hairstyles she portrayed. The watercolors show evidence of light pencil under-drawing, and all the elements are subsequently outlined with ink. Each drawing focuses primarily on a young lady, in the guise of a "fashion plate." Heads tilt alluringly on strong, graceful necks, and slim fingers sometimes flutter into compositions, which are generally bust-length. Faces are distinguished by strong Neoclassical features that are sharply delineated in ink with precise and sinuous lines that usually form a continuous curve from the brows to the nose. The suggestion of shade and shadow is skillfully handled with watercolor washes. Fine ink work, transparent washes, and touches of gouache suggest filmy laces, netting, tightly rolled curls, ringlets, and eyelashes. Occasionally, additional decorative elements, such as birds or flowers, are also included.

Eastman's work has been collected by such early folk art luminaries as William Edgar and Bernice Chrysler Garbisch, Maxim and Martha Codman Karolik, and more recently by Ralph Esmerian. Through these collectors, examples have entered the collections of the National Gallery of Art (Washington, D.C.), Museum of Fine Arts (Boston), and the American Folk Art Museum (New York). The scant biographical information that is known about the artist is gleaned from the works themselves. Each of the two watercolors in the National Gallery bears an inscription in brown ink that gives the artist's name and the location "Louden." Additional information is contained in a brief pencil inscription on *Lady's Coiffure with Flowers and Jewels,* in the Karolik collection: "This picture painted by / Mrs Dr Daniel Baker soon after / she (married April 4, 1824."; below is written "for Julia Cooke / Nov. 28, 1878."

See also **Ralph Esmerian; Edgar William and Bernice Chrysler Garbisch; Maxim Karolik; Painting, American Folk.**

BIBLIOGRAPHY

Lipman, Jean. *American Primitive Painting.* New York, 1972.
Museum of Fine Arts. *M. & M. Karolik Collection of American Water Colors and Drawings, 1800–1875,* vol. 2. Boston, 1962.

STACY C. HOLLANDER

EASTON BIBLE ARTIST: *SEE* JOHANNES ERNESTUS SPANGENBERG.

EATON, ALLEN HENDERSHOTT (1878–1962) was a promoter of immigrant art, Southern and Northeastern rural art, and Japanese American folk art, primarily under the auspices of the Russell Sage Foundation, described by Eaton scholar Sharon Lee Smith as "a charitable organization dedicated to sociological study and amelioration with a broad philosophical and organizational connection to the settlement house movement." He was born and lived as a child in Union Oregon, located in the Grande Ronde Valley of northeast Oregon. A 1902 graduate of the University of Oregon in Eugene, he opened a book and art store there, on Willamette Street. According to his friend Ellis Lawrence, dean of the School of Architecture at the University of Oregon, Eaton and his wife were enthusiastic about crafts.

Allen Eaton quickly adopted a distinctive approach to folk art promotion and exhibition that matured during his career: to encourage a better understanding of and to stimulate social and civic cooperation between diverse immigrant, geographic, and racial groups; to show folk artists engaged in their crafts, to demonstrate both their aesthetic sense and their cultural and social context; and to define folk artists as members of cultural communities and to value their points of view. His career spanned the coasts of America; included election to public office; academic and curatorial art assignments; authorship of three

primary folk art texts; and a brief, life-changing pacifist controversy.

Eaton was elected to the Oregon State Legislature on the Republican ticket in 1906, and served until 1918. He was a strong advocate of higher education, and was instrumental in the establishment of Oregon University's School of Architecture and the appointment of its first dean. He was also a part-time instructor at the school, teaching art appreciation and directing exhibitions. He created the Oregonian Art Room, made of native materials and displaying native folk art and craft, for the Panama-Pacific International Exposition, held in San Francisco in 1915. At the exhibition he met and began a long educational association with Lydia Avery Coonley Ward, who invited him to be the director of her Summer School of Arts and Life at "Hillside," in Wyoming, New York (near Buffalo).

In September 1917, after the United States had become involved in World War I, Eaton attended a meeting of the People's Council of America for Democracy and Terms of Peace, a peace group that received wide support from the working population, including many New York labor unions. Eaton's attendance created an uproar in Oregon, and he resigned from the university in October 1917; not long after that he withdrew from elected politics after being defeated in the May 1918 primary. He moved to New York City, and through his friendship with Robert W. DeForest, a social reformer, board member of the Russell Sage Foundation, and president of the Metropolitan Museum of Art, Eaton was appointed field secretary of the American Federation of Arts, and was later hired by the Russell Sage Foundation. For the remainder of his career, Eaton promoted the folk arts through exhibitions and his writings.

See also **Asian American Folk Art.**

BIBLIOGRAPHY

Eaton, Allen H. *Handicrafts of New England.* New York, 1949.
———. *Handicrafts of the Southern Highlands.* New York, 1937.
———. *Immigrant Gifts to American Life: Some Experiments in Appreciation of the Contributions of Our Foreign-Born Citizens to American Culture.* New York, 1932.

WILLIAM F. BROOKS JR.

EATON, MOSES, SR. (1753–1833) and **MOSES EATON JR.** (1796–1886) were a father and son who practiced wall stenciling throughout New Hampshire and Maine. The Eatons were among the earliest and most influential of the itinerant decorative painters who have been identified. They established a con-

vention of all-over patterning within bordered panels, which is now recognized as the "Eaton style."

Eaton Sr. was descended from early settlers of Dedham, Massachusetts, and served in the American Revolutionary War. In 1793, at the age of forty, he moved with his family from Needham, Massachusetts, to Hancock, New Hampshire, where his son, Moses Jr., was born. Moses was probably trained by his father at an early age, and was reportedly proficient in the art of wall stenciling by the time he was eighteen.

Stenciled wall decoration was most popular from about 1815 through the 1840s, predating the widespread affordability of wallpaper and coinciding nearly exactly with the years that Eaton Jr. was active. It is now believed that Eaton formed a brief partnership during the 1820s with his contemporary, Rufus Porter (1792–1884), working primarily in southern New Hampshire and Maine. After his father's death in 1833, Eaton Jr. may have traveled to the West from his home base in Dublin, New Hampshire, which possibly accounts for the presence in Tennessee and Indiana of interiors unmistakably decorated in the Eaton style, although it is not known if Eaton or a copyist actually painted these homes.

Of father and son, Eaton Jr. seems to have been the more prolific, and is the better-documented artist. His home in Dublin survived in the family for several generations, as did his stencil kit along with a grain-painted box containing ten panels with painted and stamped designs. The kit includes eight brushes, seventy-eight stencils cut from heavy oiled paper, and several small, wooden stamps. Traces of paint on these materials indicate the colors favored by Eaton: green, yellow, and red; in Maine he seems to have occasionally added pink and mulberry. The stencils form forty complete designs, included weeping willows, pineapples, flower sprays, leaves, as well as various borders with swags and tassels, bells, and other motifs. No registration marks appear on the stencils, implying that Eaton relied on his eye alone for proper placement. Based on these contents, it has been possible to identify a large number of home decoration as Eaton's work, and a great many more show at least his influence. In addition to wall stenciling, the sample box suggests that Eaton was also able to provide imaginative and realistic grain-painted treatments for areas of wood paneling and perhaps furniture.

The pervasiveness of the Eaton style is demonstrated in a study of stenciled interiors that was conducted by Margaret Fabian from 1981 to 1988. At least half of the stenciled walls documented in New Hamp-

shire were the work of the Eatons or else directly influenced by them.

See also **Furniture, Painted and Decorated; Rufus Porter.**

BIBLIOGRAPHY

Allen, Edward B. *Early American Wall Paintings, 1710–1850.* New York, 1968.

Brown, Ann Eckert. *American Wall Stenciling, 1790–1840.* Lebanon, N.H., 2003.

Little, Nina Fletcher. *American Decorative Wall Painting, 1770–1850.* New York, 1989.

McGrath, Robert L. *Early Vermont Wall Paintings, 1780–1850.* Hanover, N.H., 1972.

Tarbox, Sandra. "Fanciful Graining: Tools of the Trade." *Folk Art,* vol. 6, no. 4 (fall 1981): 34–37.

Waring, Janet. *Early American Stencils on Walls and Furniture.* New York, 1968.

STACY C. HOLLANDER

EDMONDSON, WILLIAM (1874–1951) was an African American stone carver who is regarded as among America's most important artists. He was one of five children of Jane Brown and Orange Edmondson, who had been slaves on the adjacent Compton and Edmondson plantations in Davidson County, Tennessee. By 1890, after her husband's death, Jane Edmondson moved her family from the Edmondson plantation to Nashville, where William lived for the rest of his life. He worked as a field hand and as a laborer at Nashville's sewer works until about 1900, when he was hired by the railroad. He lost that job after suffering a leg injury in 1907, and then worked as a janitor at Nashville's Woman's Hospital until about 1930.

By 1931 Edmondson had started a stone-carving business, offering gravestones and yard ornaments to members of the local African American community. He had prospered enough to purchase two lots on Nashville's Fourteenth Avenue, where his home, studio, a display area, and an orchard were located. Edmondson was a religious man, and his faith served as inspiration and source material for his stone carvings. He said that stone carving was, for him, a God-given calling, that the Lord had given him a vision of a gravestone, then told him to cut gravestones and stone figures. The angels, crucifixes, figures of a preacher, figures of Eve, Noah's ark, a pulpit, and the gravestones he carved may have been intended to serve a higher calling; while figures of a lawyer, a teacher, birdbaths, a boxer that Edmondson identified as Jack Johnson, figures of Eleanor Roosevelt, various seated and standing figures, images of courting couples, and numerous animals verify that Edmondson

remained firmly rooted in the secular world and the African American community.

One of Edmondson's gravestones features a bas-relief carving of a recumbent lamb. The motif, symbolizing Christ and innocence, was commonly placed atop a child's gravestone throughout the latter half of the nineteenth century, and it is likely that he had seen such gravestones in Nashville's Mount Ararat Cemetery. Other gravestones that he cut include flat slabs of stone whose shapes bear a curious resemblance to the outline of a human torso, sometimes with a face carved at the top. If Edmondson had indeed intended these gravestones to represent human forms, then he could have meant them to symbolize the soul of the departed literally rising from the grave.

Using a five-pound hammer and railroad spikes that he modified into chisels to use for rough and finished carving, Edmondson carved from limestone that he acquired primarily from a nearby quarry. The softness of the stone enabled him to rough out the form, removing large amounts of material to create voids and spaces; his surface treatments range from coarse to smooth. Edmondson's forms contain the minimum amount of information required to identify the subject. This refinement was dictated, to a great extent, by his medium. Nonetheless, it sets his work apart from that of other self-taught artists, and helps to explain part of the appeal that Edmondson's art held for those interested in modern art, as comparisons were inevitably made between Edmondson's work and modern sculpture, which led to Edmondson's work receiving unprecedented attention.

Between 1934 and 1937, fashion photographer Louise Dahl-Wolfe made several visits to Nashville and photographed Edmondson and his sculpture. She showed her photographs to Alfred H. Barr Jr., director of the Museum of Modern Art, and in 1937 a one-person exhibition of Edmondson's work was organized at the museum, featuring a dozen examples. The show provided the first widespread exposure for Edmondson and his art, and it was also the first solo exhibition by an African American artist to be organized by the museum. This exhibition was followed the next year by Edmondson's inclusion in a broad survey of American art in Paris.

See also **African American Folk Art (Vernacular Art); Alfred H. Barr Jr.; Gravestone Carving.**

BIBLIOGRAPHY

Thompson, Robert Farris. *The Art of William Edmondson.* Nashville, Tenn., 1999.

Livingston, Jane, and John Beardsley. *Black Folk Art in America, 1930–1980*. Washington, D.C., 1982.

RICHARD MILLER

EDSON, ALMIRA (1803–1886) was a little-known painter of a group of New England family registers that were unusual in that they combined the typical features of the family record with those of the mourning picture. Her unsigned watercolor-and-ink Woodard family register, of about 1837, was initially brought to public attention by Lipman and Winchester's *The Flowering of American Folk Art 1776–1876* (1974).

About seven years later, a family register for David and Anna Niles from about 1838 appeared at auction. The similarity of the Niles and Woodard records is so striking that they can be attributed to the same hand. Each contains a central large drape in the form of an arch. Features commonly found in the family register—flowers, birds, hearts, columns, and mother with infant—surround the arch, while willows, tombstones, and mourners, characteristic of the mourning picture, are found in the space between the lower arms of the arch.

The Niles and Woodard families were both from Halifax, Vermont. A register for Dennis and Lois Stebbins, similar to the Niles and Woodard registers, was painted about 1835. The Stebbins family lived in Colrain, Massachusetts, just across the state line from Halifax. A register produced about 1836 was made for Oliver and Olive Wilkinson, who lived in Townsend, Vermont, about twenty miles from Halifax. A register from about 1834 for James and Jane Clark, also of Halifax, is very much like the others, with one very important difference: it is inscribed "Executed by Almira Edson, Halifax, Vt."

Edson was born in Halifax on January 20, 1803, to Jesse and Rebecca Edson. After Edson's father's death in 1805, her mother married Captain Edward Adams of Colrain, Massachusetts. At the age of seven years, Almira moved with her family to Colrain. In 1841 the unmarried Edson joined a religious community in Putney, Vermont, founded by the dictatorial John Humphrey Noyes. Almira fell in love with John R. Lyvere, a member of the community, and they asked permission from Noyes to marry. This was not granted, and during Noyes' absence the couple crossed the border into Hinsdale, New Hampshire, and were married on September 18, 1842. Upon his return, Noyes banished the couple, and they moved to Vernon, Connecticut.

Edson's last register, basically the same as the others, was painted about 1847 in Ellington, only a few miles from Vernon, for William C. and Emily Porter Russell. Edson died in Vernon on December 14, 1886.

See also **Family Records or Registers; Mourning Art.**

BIBLIOGRAPHY

Kern, Arthur, and Sybil Kern. "Almira Edson, Painter of Family Registers." *The Magazine Antiques,* vol. 122 (September 1982): 558–561.

ARTHUR AND SYBIL KERN

EHRE VATER ARTIST is the name given to the unknown artist who made a group of colorful fraktur or calligraphic pictorial documents, late in the eighteenth and early nineteenth centuries, in almost every one of the counties of Pennsylvania, Virginia, North Carolina, and Ontario, Canada, where German immigrants settled. In spite of this widespread representation (and maybe because of it) the artist's name has not been discovered. The name of the artist applied to this body of work comes from the German meaning "honor father and mother," which the artist frequently placed at the head of his pieces.

Not much can be said about this artist other than that he was comfortably at home among the Moravians living in Salem, North Carolina, and that his patrons also included Germans from the religious groups that baptized infants, including Roman Catholics. He used in his work the Moravian hymnody that was sung and played during the period in which he produced fraktur. His cursive penmanship is skillful, and he used special paper on which scenes were engraved, the only fraktur artist to do so. His designs are bold, often geometric, and the colors are brilliant, with green and red dominating his pallet. He used architectural pilasters to form parts of his borders; large, geometric balls, at times with a verse penned in a circle around them; and snakes intertwining with words. One of these snakes works its way through the text of the hymn *Jesu Meine Freude (Jesus My Joy),* and it appears to proclaim the ultimate victor over harm and danger.

See also **Fraktur; German American Folk Art; Museum of Early Southern Decorative Arts; Religious Folk Art.**

BIBLIOGRAPHY

Bivins, John Jr. "Fraktur in the South: An Itinerant Artist." *Journal of Early Southern American Decorative Arts,* vol. 1, no. 2 (1975): 1–23.

FREDERICK S. WEISER

EICHHOLTZ, JACOB (1776–1842) was a portrait painter of German ancestry from Lancaster, Pennsylvania. He showed an interest in drawing from the age of seven, and was given rudimentary drawing lessons from a sign painter. His father arranged for him to serve an apprenticeship as a copper and tinsmith. He practiced these trades to support his family, while also painting portraits, until the age of thirty-five, when he began to paint full-time. More than nine hundred works have been attributed to Eichholtz.

Best known for his portraits, Eichholtz also painted a sign for the William Pitt Tavern, and painted the Lancaster Union Hose Company's carriage. The artist moved to Philadelphia about 1821, and later moved back to Lancaster. He also worked in Baltimore and Pittsburgh. Eichholtz painted portraits of his relatives and friends, as well as of wealthy patrons such as Nicholas Biddle, president of the United States Bank. Contemporary writer William Dunlap wrote that Eichholtz's portraits, "hard likenesses at thirty dollars a head," were more sought after than those painted by Rembrant Peale or Thomas Sully. However, he is generally regarded as a second- or third-tier painter of academic portrait.

Though he painted details, his portraits were not excessively decorative in their style, and reflected academic traditions that Eichholtz observed in the works of European-trained painters, such as the modeling of facial features; the standardized half-turned poses of his sitters, with their sloping shoulders and slightly tilted heads; and details such as a finger placed to mark the page of a book; columns used as room furnishings; or a glimpse of a landscape in the background.

See also **Painting, American Folk; Trade Signs.**

BIBLIOGRAPHY

Beal, Rebecca J. *Jacob Eichholtz*. Philadelphia, 1969.
Dunlap, William. *History of the Rise and Progress of the Arts of Design in the United States*. Boston, 1965.
Groce, George C., and David H. Wallace. *The New-York Historical Society's History of Artists in America, 1564–1860*. New Haven, Conn., 1957.
Harris, Alex. *A Biographical History of Lancaster County*. Lancaster, Pa., 1872.
Pennsylvania Academy of the Fine Arts. *Jacob Eichholtz 1776–1842, Pennsylvania Painter: A Retrospective Exhibition*. Philadelphia, 1969.

LEE KOGAN

ELLIS, A. (active c. 1830), a provincial folk portrait painter with an unusually flat, decorative style, has thus far eluded biographical documentation. Ellis's fifteen known or attributed works, nearly all executed in oil on wood panel, were either found in or depict subjects from the Readfield-Waterville area of central Maine. At least two watercolors on paper, miniature portraits, are also thought to be by Ellis, and the two signed portraits of a gentleman and lady are in the collection of the New York State Historical Association. Ellis consistently depicts sitters with highly stylized faces, little or no shading or contour, and lively patterned costumes. The degree of stylization in Ellis's work suggests that the artist may have painted furniture.

See also **Furniture, Painted and Decorated; Miniatures; Painting, American Folk.**

BIBLIOGRAPHY

D'Ambrosio, Paul S., and Charlotte Emans. *Folk Art's Many Faces: Portraits in the New York State Historical Association*. Cooperstown, N.Y., 1987.
McDonald, Sheila. "Who Was A. Ellis? And Why Did He or She Paint All Those Pictures?" *Maine Antique Digest*, vol. 11 (April 1981): 26-A, 27-A.

PAUL S. D'AMBROSIO

ELLSWORTH, JAMES SANFORD (1803–1875) was a prolific painter who was born and died in Hartford, Connecticut. He painted miniature watercolor portraits and several oil on canvas likenesses in Massachusetts, Connecticut, Rhode Island, New Hampshire, and Vermont, and claimed to have traveled to New York State, Pennsylvania, and as far west as Ohio. More than three hundred works by Ellsworth have been identified.

Ellsworth married Mary Ann Driggs in 1830 and the couple had one child. His wife alleged that Ellsworth deserted her three years after their marriage, which ended in divorce in 1839. Itinerant painting often required extended periods of travel in search of commissions, and this probably made it difficult for some artists to establish or maintain relationships.

Ellsworth's earliest watercolor portraits show sitters in frontal or three-quarter poses. Two portraits from 1835 depict a boy and a girl painted full-length and standing in a landscape, while a portrait of a gentleman displays Ellsworth's ability to create a semiacademic, polished likeness. By about 1840 he introduced a stylized format that he varied throughout the remainder of his career. Often signed, these watercolors, on thin woven paper, incorporate half-length profile poses, with subjects often holding books, flowers, or other props. A gray, cloudlike aureole surrounds the head and separates the face from the lighter background, while another encloses the bottom of the figure. One variant places subjects in

rococo-revival upholstered armchairs, and swags and columns are sometimes included in the background. Several later portraits were made on larger sheets of pink paper, with an oval spandrel framing the sitter. Ellsworth consistently painted finely detailed, carefully modeled, and delicately colored faces that revealed the individuality and character of the sitter.

During the 1850s Ellsworth painted some of his portraits on decorative, embossed paper, and he framed some of them in the commercially available stamped brass mats used for daguerreotypes. His use of these mats shows the inroads that photography was making into Ellsworth's portrait business, and his efforts to make his work appear up-to-date.

Six signed oil portraits by Ellsworth are known. Aesthetically less interesting than his watercolor miniatures, the oils are for the most part indistinguishable from the scores of portraits painted by artists of nominal ability who worked during the 1840s.

See also **Miniatures; Painting, American Folk; Painting, Landscape.**

BIBLIOGRAPHY

Mitchell, Lucy B. *The Paintings of James Sanford Ellsworth: Itinerant Folk Artist, 1802–1873.* Williamsburg, Va., 1974.

Lipman, Jean, and Tom Armstrong, eds. *American Folk Painters of Three Centuries.* New York, 1980.

RICHARD MILLER

ENGELLHARD, GEORGE HEINRICH (or Hennerich Engelhard) (dates unknown) was a fraktur artist and a communicant at the Lutheran Church in New Holland, Lancaster County, Pennsylvania, in 1805. He made several frakturs for families living along the Schwaben Creek in Northumberland County, Pennsylvania, including one for Johannes Braun in 1818. Engellhard married in the Tulpehocken region of the same state in 1818, and relocated near Bethel in Berks County, where he became the schoolmaster for the Salem Church. He and his wife had six children.

For many years the artist was identified as the "*Haus-Segen* Artist," before a signed example of his work was published in 1973. One of the types of fraktur he made was a house blessing, usually based on a text of biblical character. He also produced bookplates, baptismal certificates, and presentation drawings, as well as a curious drawing of a girl without a mouth. Probably the most remarkable piece by Engellhard to be found portrays a boy singing. The unusual text accompanying it, written in Italian and German, reads, "I sing in a beautiful way to the Lord."

See also **Fraktur; German American Folk Art; Pennsylvania German Folk Art.**

BIBLIOGRAPHY

Hollander, Stacy C. *American Radiance.* New York, 2001.

FREDERICK S. WEISER

ENVIRONMENTS, FOLK is a broad term used to describe a wide variety of handmade, idiosyncratic spaces, typically fabricated with found materials by visionary artists. These environments are often made in the artist's own backyard or surroundings, even engulfing the home. They generally have an obsessive character, and are the result of many years of work. In form they are various and extraordinary, ranging from soaring spires to garishly painted temple compounds, from mock castles to miniature cities, and from sculpture gardens populated with biblical and historical figures to artificial caverns encrusted with geodes and stalactites. Among the most familiar of such environments are Samuel Perry Dinsmoor's (1843–1932) *Garden of Eden* in Lucas, Kansas; Simon Rodia's (c. 1875–1965) *Watts Towers* in Los Angeles; Joseph Zoetl's (1878–1961) *Ave Maria Grotto* in Cullman, Alabama; Edward Leedskalnin's (1887–1951) *Coral Castle* in Miami; Howard Finster's (1915–2001) *Paradise Garden* and Eddie Owens Martin's (1908–1986) *Land of Pasaquan,* both in Georgia; and Jeff McKissack's (1902–1980) *Orange Show* in Houston, Texas. As different from one another as these environments are, they share several characteristics: they are made by people with no training in art and often little formal education of any kind; they manifest an aesthetic of salvage and accumulation; they often embody deeply held religious, ethical, or political convictions.

Most of these environments are made of the coarsest materials: cement and common rocks at the *Garden of Eden,* the *Ave Maria Grotto,* and the *Coral Castle*; broken glass, tiles, and other kinds of brightly colored and decorative junk that can be found along the roadside or at local dumps are used at the *Watts Towers,* the *Paradise Garden,* and the *Orange Show.* These poor materials, however, are put to rich uses. They are often arrayed in the most dazzling abundance and confusion: every space and every surface is typically treated with the same cluttered emphasis, so there is no rest from encrustation and elaboration; nor do many of these environments show any clarity in plan. There are few conventional organizing devices—no axes or cross-axes, bilateral or radial symmetry. Visual and spatial features are presented instead in an apparently random or haphazard way.

Part architecture, part sculpture, part landscape, visionary environments defy the usual categories of artistic practice, as these creations display too great an indifference to the niceties of composition and technique to have earned admiration as fine art. They owe their uniqueness to their rhetorical ambitions: they are often made to express highly personal visions. The *Land of Pasaquan,* for example, presents its maker's unorthodox religious views, while the *Orange Show* is dedicated to the health-giving properties of the orange, as well as to the principles of healthy living more generally. Some environments are made for love: Leedskalnin built the *Coral Castle* to win back a woman who jilted him on the eve of their wedding. Others express notions of patriotism or brotherhood, though these artists often dissent from both political and social norms. Dinsmoor's *Garden of Eden,* for instance, conveys his populist political convictions; it contains a sculptural group, *The Crucifixion of Labor,* in which the working man is martyred by the banker, the doctor, the lawyer, and the preacher.

Because of their deeply personal character, these environments are often presented as *sui generis,* or one of a kind. In the catalog for the Walker Art Center's 1974 "Naives and Visionaries," a groundbreaking exhibition in the United States, they are described as "a wholly intuitive expression, as unbounded by stylistic convention as by local building codes." While visionary environments are certainly very individualistic creations, they nevertheless reveal numerous links to their social contexts; they also suggest connections—some deliberate, some apparently unconscious—to historical antecedents. The *Ave Maria Grotto,* for example, can be linked to various pilgrimage sites in Europe, such as the grotto at Lourdes, while Rodia's *Watts Towers* may have been inspired by the elaborate towers and ships constructed in observance of the feast day of an Italian saint.

In large measure, visionary environments in America owe their existence to popular versions of patriotism on the one hand, and to the cultural geography of religion on the other. They convey a particular kind of patriotism, one that allies itself more with the individual than with the corporation or the state; that embraces a notion of what America could be rather than what it is; and that celebrates folk heroes as much as national leaders. Visionary environments have also been powerfully shaped by popular versions of American Christianity, especially in its more evangelical forms. In more or less visible ways, the environments can be seen in the context of a great saga in which countervailing faiths spread across the continent and battled for converts, especially on the frontiers of the American South and West. Some environments are the direct expression of a missionary spirit, such as the numerous grottoes built by the priests who followed the flood of Catholic immigrants into the upper Midwest around the turn of the century, including Father Paul Dobberstein's (1872–1954) *Grotto of the Redemption* in West Bend, Iowa, and Mathias Wernerus's (1873–1931) *Grotto of the Blessed Virgin* in Dickeyville, Wisconsin. Their shrines were a vivid way of attracting and holding their parishioners. Other environments are linked directly or indirectly to Protestant evangelism, with its emphasis on vivid expressions of personal revelation. Finster was an itinerant Baptist minister before settling down to build his *Paradise Garden,* which he saw as an extension of his preaching, while Martin created his own creed at the *Land of Pasaquan,* much in the spirit of other self-anointed, charismatic leaders who established independent religions.

While visionary environments have been shaped by popular versions of patriotism and religion, their interpretation in the literature of art generally follows a different line, dominated by Surrealism and Jean Dubuffet's (1901–1985) notions of *art brut* (raw art) especially. Eager to confirm their notions of an unmediated or "automatic" creativity free of conscious moral or aesthetic constraints, the Surrealists championed the art of the mentally ill; they were also among the first to recognize the achievements of self-taught environment builders. The Surrealist poet and essayist André Breton (1896–1966) for example, was an early champion of the *Palais Idéal,* a fabulous construction near Lyon, France, built in the late nineteenth century by a postman named Ferdinand Cheval (1836–?). After World War II, Jean Dubuffet emerged as the most vigorous supporter of artists outside the mainstream of culture. He developed his own designation for the work he admired, *art brut,* which proved to be a remarkably elastic notion, embracing anything that Dubuffet felt displayed originality in defying cultural norms, including the work not only of children and the insane but of visionaries, mediums, and various other untutored as well as popular artists. He championed anything that was raw and authentically inventive instead of cooked according to the conventional recipes. Two of the first books to deal extensively with visionary environments, Roger Cardinal's *Outsider Art* (1972) and Michel Thvoz's *Art Brut* (1975), were deeply informed by the ideas of Dubuffet.

In the United States, environments were also appreciated within the context of the evolving junk

aesthetic. Inspired by artists like Jean Dubuffet and Kurt Schwitters (1887–1948), sculptors began to incorporate found objects into their work, relying on the imaginative juxtapositions of ordinary objects to create striking visual effects. This aesthetic was celebrated in a landmark exhibition in 1961 at the Museum of Modern Art called "The Art of Assemblage"; photographs of Rodia's *Watts Towers* were included in the catalog.

The notions of Surrealism, *art brut,* and assemblage have all helped to create a context in which the environments of visionary artists have been recognized and celebrated; all three have their virtues as well as their limitations. Surrealism opened eyes to the uncanny and to the marvelous in a variety of quarters, but it also contributed to a tendency to confuse psychosis with non-clinical forms of creative obsession, leading to the common but mistaken assumption that idiosyncratic creators, including environment builders, must be mentally ill. Moreover, with the notion of "pure psychic automatism" Surrealism fostered an illusion that it was possible to be entirely innocent of received culture, a notion that Dubuffet began to challenge and that is in full retreat in much of the current literature on folk and visionary environments. The ideas of assemblage art, in their emphasis on technique and found materials, may have fostered the appreciation of the aesthetic dimensions of these environments at the expense of more complex and thorough interpretations, based either on their rhetorical intent or on their social and cultural contexts.

Preservation has proved to be an especially vexing problem for environments. Because of the generally solitary character of their creators as well as the punishing effects of weather, few environments outlive their makers. Local historical societies have sometimes stepped in to help, as in the case of the Marion County (Georgia) Historical Society's efforts on behalf of the *Land of Pasaquan,* but most preservation work is carried out by organizations with a particular commitment to folk and visionary art, such as SPACES in Los Angeles; the Kansas Grassroots Art Association; the Orange Show Foundation in Houston, Texas; and the Kohler Foundation in Wisconsin.

See also **Howard Finster; Folk Art Society of America; John Michael Kohler Art Center; Edward Leedskalnin; Jeff McKissack; Outsider Art; Simon Rodia; Visionary Art; Mattias Wernerus; Joseph Zoetl.**

BIBLIOGRAPHY

Beardsley, John. *Gardens of Revelation: Environments by Visionary Artists.* New York, 1995.

Friedman, Martin, et al. *Naives and Visionaries.* New York, 1974.

Manley, Roger. *Self-Made Worlds: Visionary Folk Art Environments.* New York, 1997.

JOHN BEARDSLEY

EPHRATA CLOISTER, PENNSYLVANIA: *SEE* GERMAN AMERICAN FOLK ART.

ESMERIAN, RALPH (1940–) has played a vital role in the history of the American Folk Art Museum, both as a collector and as an officer of the board of trustees, serving since 1973 as treasurer, president, and chairman. A longtime advocate for expanded museum quarters, Esmerian's support was pivotal in the acquisition in 1979 of two properties that would become the future site for the American Folk Art Museum, at 45 West 53rd Street. In 2001, Ralph Esmerian began transferring to the museum more than four hundred works of art promised from his prestigious collection in celebration of the opening of the museum's new building, designed by the firm of Tod Williams Billie Tsien Architects. These comprised the inaugural exhibition "American Radiance: The Ralph Esmerian Gift to the American Folk Art Museum."

Over the years, the Esmerian collection has come to be regarded as a benchmark for quality through masterworks such as *The Peaceable Kingdom* by Quaker artist Edward Hicks (1780–1849) and *Girl in Red Dress with Cat and Dog* by Ammi Phillips (1788–1865). Many of the artworks were included in the influential exhibition "Flowering of American Folk Art, 1776–1876," which was presented in 1974 by the Whitney Museum of American Art in New York, and have since been widely exhibited.

Esmerian is a fourth-generation dealer in colored gemstones, a business started by his great-grandfather in Constantinople (now Istanbul). He was born in Paris to a French-Armenian father and American mother, and the family moved to New York when he was an infant. Following his graduation from Princeton University in 1962 with a degree in French literature, Esmerian taught for two years at Athens College in Greece. As he traveled through Greece during those years, he was drawn to pottery as an art form and became increasingly aware of its evocative power in recalling ancient history and culture.

As a foreigner living in Greece, Esmerian acquired a new perspective on America and was intrigued by the seeds of civilization that had grown into the society he knew. Soon after he returned to the United States, in 1964, he purchased a small piece of redware that he learned was a Pennsylvania German child's plate with simple slip decoration. From that modest

beginning and over a period of more than thirty years, Esmerian has assembled an impressive collection of American folk art, rivaling in quality and scope the seminal collections that were formed earlier in the century.

Pottery became a springboard for a deeper investigation into Germanic material culture in America, notably through decorative arts from culturally specific regions, such as the Mahantango or Schwaben Creek Valley in Pennsylvania, and a significant group of painted furniture by the Virginia artist Jacob Strickler (1770–1842). Among the collection's many strengths are its works on paper. Watercolor portraits by German immigrant artist Jacob Maentel (1778–?) were among Esmerian's earliest purchases in this medium, and added an immediacy and context to the pottery and other Pennsylvania German decorative arts. These opened the door to an interest in the richly colored, handwritten, and decorated documents known as fraktur. Esmerian has assembled superb examples by individual artists as well as rare works from particular Pennsylvania German groups or sects, including decorated hymnals from the Ephrata Cloister.

In 1979, Esmerian launched a comparable collection of New England material with the addition of watercolor portraits by Joseph H. Davis (active 1832–1837), followed by numbers of watercolors by Samuel Addison Shute (1803–1836) and Ruth Whittier Shute (1803–1882), a husband and wife team who worked together to portray numerous men, women, and children, many of whom were workers in the local textile mills in New Hampshire and Massachusetts. The New England collection now includes boxes, furniture, paintings, portraits, and textiles. In 1980, Esmerian introduced the first sculpture into his collection: a weathervane in the form of the Statue of Liberty. Several rare, carved wooden weathervane patterns by Henry Leach (1809–1885) augment the weathervanes, and the collection also boasts such icons as *Dapper Dan,* included in the *Index of American Design,* and a life-size *Tin Man* made in New York by David Goldsmith (1901–1980).

Today the Esmerian collection is defined not by a single theme but by its aesthetic consistency and personal focus. It encompasses painted furniture, decorative arts, portraits, landscape painting, books, scrimshaw, Shaker gift drawings, textiles, schoolgirl watercolors, and myriad other forms. In his collecting, Ralph Esmerian has been both a connoisseur and a humanist. He is concerned with rarity and quality but has also sought answers to questions about the essence of American identity, as revealed through the touch of the human hand in American folk art.

See also **American Folk Art Museum; Boxes; Joseph H. Davis; Fraktur; Furniture, Painted and Decorated; Edward Hicks; Henry Leach; Jacob Maentel; Painting, American Folk; Painting, Landscape; Pennsylvania German Folk Art; Ammi Phillips; Redware; Religious Folk Art; Sculpture, Folk; Scrimshaw; Shaker Drawings; Ruth Whittier Shute; Samuel Addison Shute; Jacob Strickler; Weathervanes.**

BIBLIOGRAPHY

Ellis, Estelle, Caroline Seebohm, and Christopher Simon Sykes. *At Home with Art: How Art Lovers Live with and Care for Their Treasures.* New York, 1999.

Hollander, Stacy C. *American Radiance: The Ralph Esmerian Gift to the American Folk Art Museum.* New York, 2001.

Schaffner, Cynthia Van Allen, and Susan Klein. "Living with Antiques: Pennsylvania-German Folk Art in a City Apartment." *The Magazine Antiques,* vol. 72, no. 3 (September 1982): 510–515.

STACY C. HOLLANDER

ESTEVES, ANTONIO (1910–1983) is one of many twentieth century self-taught artists who began to paint in their mature years, following retirement, the death of a spouse, illness, or an accident. He began painting to relieve persistent pain and a burning sensation in his hands, chest, and neck after a boiler explosion, about 1970, that severely injured those parts of his body. Esteves sketched his first picture, the outline of a rose, on a tablecloth. Satisfied with the result, Esteves added color to the drawing using house paint. As superintendent of a Brooklyn apartment building, located across the street from the Brooklyn Museum of Art, he often painted apartments, so leftover paint was generally available. From 1973 until his death, he completed more than 150 pictures, as well as two plaster sculptures.

Esteves painted primarily on discarded furniture, wooden boards, and Masonite. He prepared his surface with a coat of white paint, and then applied a coat of varnish after painting his picture. Esteves's subjects ranged from still-lifes to portraits and landscapes; he was especially drawn to religious subject matter. His masterpiece, *The Crucifixion* (1978), was painted on an old circular tabletop. In this expressionistic interpretation, three centrally crucified figures are represented on an earth-toned ground, surrounded by onlookers. A swirling, dark sky is punctuated by an ominous orange-rimmed, blackened orb that activates the entire scene. Over each of

the crucified figures, a pitchfork-shaped lightning flash pierces the sky in a downward thrust.

Born in Rio de Janeiro, Brazil, Esteves was still a child when he moved to the United States with his family. His mother died when he was young and his father worked as a ship's carpenter and on a Cuban sugar plantation. According to his family, from the time Esteves was twelve until he married, he had spent years living "under stoops." He attended school through the sixth grade, then held a variety of jobs. He married in about 1930, and had five children. With the insurance settlement that Esteves received from his boiler explosion accident, he purchased a building and invested in the Eastern Pet Company, a firm that imported exotic animals.

Artistic recognition came to Esteves through the Brooklyn Museum of Art. In 1976 Esteves was represented in an annual community outdoor art show sponsored by the museum. He sold three paintings at the show and won a prize for painting. The museum offered to display Esteves's award-winning painting, and it was there that Stephen Gemberling, a New York City gallery owner, saw the work, and subsequently offered to become his agent.

See also **Painting, American Folk; Painting, Landscape; Painting, Still-life; Religious Folk Art.**

BIBLIOGRAPHY

Hemphill, Herbert W. Jr., and Julia Weissman. *Twentieth-Century American Folk Art and Artists*. New York, 1974.

Johnson, Jay, and William C. Ketchum. *American Folk Art of the Twentieth Century*. New York, 1983.

Rosenak, Chuck, and Jan Rosenak. *Museum of American Folk Art Encyclopedia of Twentieth-Century American Folk Art and Artists*. New York, 1990.

LEE KOGAN

EVANS, J. (active 1827–1834) painted individual and group watercolor portraits, as well as several miniatures, one of which was completed in 1827 and remains the artist's earliest known work. Extant examples number about thirty and were painted in the Portsmouth, New Hampshire, and Boston and Roxbury, Massachusetts, areas. An elusive figure, the artist's first name and gender remain unknown. Evans worked without making a preliminary pencil drawing, an uncommon practice that indicates the artist's confidence in handling the watercolor medium. Full-length figures are posed with heads turned in profile and bodies are shown in three-quarter view. This profile format suggests that Evans was not comfortable with drawing faces from another perspective, though faces are nevertheless exquisitely rendered

and delicately colored, as are costumes and props. The artist's idiosyncrasies include the awkward proportions of arms, hands, and feet, protruding upper lips, and figures that appear to be hovering over floors rather than standing on them. Despite these faults, the artist's stylistic consistency indicates there was no compelling reason for Evans to alter a style that had proved acceptable to clients.

A distinguishing feature of Evans' portraits is their size. Working on watercolor sheets measuring as many as fourteen by eighteen inches allowed Evans to create ambitious, multiple-figure compositions. One, showing a husband standing at the foot of a staircase, his young son holding a hoop toy and his wife seated in a fancy chair with her feet resting on a cushion and an infant standing on her lap, is Evans' most ambitious work. Families are grouped in interior settings, while individuals are portrayed either inside or outside, usually standing on grassy knolls or in gardenlike settings.

Evans' preference for the profile format, patterned floor covers, and men holding beaver hats, as well as the inclusion of a cat in one portrait, gives his work more than a passing resemblance to the early work of Joseph H. Davis (active 1832–1837). Davis started painting after Evans did, in the same area. Thus there is a strong likelihood that Davis knew of and appropriated elements from Evans' watercolors.

The proliferation of itinerant watercolor painters before 1850 may be explained by the relative ease with which the requisite skill could be obtained, as well as the use of materials easily procured and transported. The prices charged for watercolors were less than for oils, but experienced watercolorists worked quickly, increasing their productivity. J. Evans is representative of a group of artists who traveled within a fairly circumscribed area, painting efficient and attractive likenesses for a mostly rural clientele.

See also **Joseph H. Davis; Miniatures; Painting, American Folk.**

BIBLIOGRAPHY

D'Ambrosio, Paul S., and Charlotte M. Emans. *Folk Art's Many Faces: Portraits in the New York State Historical Association*. Cooperstown, N.Y., 1987.

Savage, Gail, et al. *Three New England Watercolor Painters*. Chicago, 1974.

RICHARD MILLER

EVANS, MARY: *SEE* QUILTS.

EVANS, MINNIE (1892–1987) made drawings of lush, exotic forests filled with colorful flora and fauna;

mythical beasts; masklike faces with elaborate head-dresses and neckpieces; and angels. She was born in Long Creek, Pender County, North Carolina; her subjects were products of her religious faith and of her fertile imagination. Her pictures, in graphite, oil, tempera, wax crayon, and ink, were conceived and recorded from her dreams. She was a member of the African Methodist Episcopal Church and the Pilgrim's Rest Baptist Church, and had a lifelong interest in world mythologies. She worked as a domestic for wealthy families who were collectors of art, and later became the gatekeeper for Airlie Gardens, near Wilmington, North Carolina, from 1948–1974.

Evans was raised by her grandmother, Mary Crooms Jones; one of her ancestors was brought as a slave to Charleston, South Carolina, from Trinidad. Evans left school when she was in the sixth grade. When her family moved to Wilmington, North Carolina, she went to work as an oyster and clam peddler. She married Julius Caesar Evans at age sixteen, and they had three sons.

Evans's first drawing was created on Good Friday in 1935, and the second was done on the following day, according to the artist, who recounted that "funny things" filled a page following her preparation of a grocery list. The doodling that Evans called funny things continued the day after, and she was then told through a dream to "draw or die." Five years passed before Evans drew again; but when she did, drawing became a major preoccupation, and she worked at it several hours a day. Beginning in 1940, she completed 144 small drawings, mostly abstract works in pencil and wax crayons, to add color. She signed these works "*Minnie Evans*" or "*M.E.,*" and carried some or all of them around with her wherever she went, which suggests that they had special meaning for her.

In the later 1940s and 1950s Evans worked in both an abstract as well as a more natural, realistic style. Her abstract drawings and organic floral and leaf designs were often punctuated with heads and multiple eyes. In the 1960s Evans further refined her motifs and symbols, filling her works with stars, angels, rainbows, butterflies, and mythological creatures, as well as mask-like faces and a profusion of eyes. Breast-shaped figures fill the exotic gardens she drew. In 1966 Evans began to utilize collage and mixed media, reusing earlier material, and used oil and other paint media in her new, larger compositions.

Scholars and authors, such as John Mason, Mitchell Kahan, Sharon Patton, Robert Farris Thompson, Maude Wahlman, and Sharon Koota, have pointed out that Evans's drawings resonate with African art, resembling Yoruba ideographs, the Kongo cosmogram (a graphic charting of that religious belief system), and *veve,* or Haitian "ground painting." Symmetry and asymmetry, strong use of floral and vegetal imagery, arabesques, and flattened perspective all form an important part of her distinctive style. Her palette moved from black and white to deeply saturated bright colors, and then to muted pastels in her later works.

Evans achieved artistic recognition during her lifetime. She was encouraged by Wilmington lawyer George Rountree Jr., and in 1961 the Little Gallery of Wilmington, North Carolina, mounted the first solo exhibition of her work. In 1962 photographer Nina Howell Starr learned about Evans, arranged several exhibitions of her work, and was influential in promoting a one-person exhibition of Evans's drawings at the Whitney Museum of American Art in 1975. Evans subsequently had more than nineteen one-person exhibitions, nationally and internationally.

See also **African American Folk Art (Vernacular Art); Visionary Art.**

BIBLIOGRAPHY

Kahan, Mitchell. *Heavenly Visions/The Art of Minnie Evans.* 1986.
Koota, Sharon. "Cosmograms and Cryptic Writings: 'Africanisms' in the Art of Minnie Evans." *Folk Art*, vol. 16, no. 2 (summer 1991): 48–52.
Lovell, Charles Muir. *Minnie Evans, Artist.* Greenville, N.C., 1993.
Starr, Nina Howell. "The Lost World of Minnie Evans." *The Bennington Review*, vol. 111, no. 2 (summer 1969): 40–58.
———. "Minnie Evans and Me." *Folk Art*, vol. 19, no. 4 (winter 1994/95): 50–57.

LEE KOGAN

EYER, JOHANN ADAM (1755–1837) produced hundreds of pieces of fraktur for about fifty years, while serving as a schoolmaster in Mennonite and Lutheran schools in Pennsylvania. He initially copied Mennonite or Schwenkfelder schoolmaster artists who made *vorschriften* (writing examples) for their pupils, but quickly began to develop new forms of the art. His school roll book from 1779 to 1787 still exists, making it possible to link surviving fraktur pieces to the school terms of their owners. A *vorschrift* generally contains a religious text elaborately lettered, outlined in normal cursive script, and concluded with the alphabet and a selection of numerals on a full sheet of early Pennsylvania paper, measuring eight by thirteen inches. Eyer's fastidious hand had an influence on other Pennsylvania schoolmasters for many years. By folding the paper once he made a *vorschrift* booklet,

with four pages of text and an elaborate cover. By cutting a large sheet of it in half lengthwise, he made the pages for a book of musical notes (Eyer was an accomplished musician and taught musical notation to his students).

Johann Eyer was born in Bedminster Township, Bucks County, Pennsylvania, and taught in Chester and Lancaster Counties, but by about 1786 he and his entire family moved to Upper Mount Bethel Township, Northampton County, where he taught in the Lutheran school. In 1801 they moved again farther north to Hamilton Township, Monroe County, where Eyer was a teacher and a clerk at Christ Hamilton Lutheran Church.

Eyer never married. As the oldest son he presided over his parental estate, turning it into a valuable one for its day. One brother, Johann Frederick (1770–1827), was a schoolmaster-organist and fraktur artist in Chester, Berks, and Snyder Counties. Another, Ludwig, was Eyer's agent in developing the town of Bloomsburg in Columbia County, in 1802. Eyer's

good friend, Andreas Kolb, was a Mennonite schoolmaster and fraktur artist in Montgomery County, Pennsylvania, and the two exchanged work.

In his later years, Eyer made bookplates for hymnals, baptismal records, and many small presentation frakturs. His drawing of a soldier's wedding along with some of his birds and eagles make him one of the most important practitioners of the art. In his early years, he made some of the finest fraktur that exists, in the form of carefully lettered and illustrated poems. Eyer died in 1837 in Hamilton Township, Monroe County, Pennsylvania.

See also **Fraktur; German American Folk Art; Pennsylvania German Folk Art; Religious Folk Art; Schwenkfelders.**

BIBLIOGRAPHY

Weiser, Frederick S. *Something for Everyone, Something for You.* Breinigsville, Pa., 1980.

FREDERICK S. WEISER

FACE JUGS: *SEE* JUGS, FACE.

FAMILY RECORDS OR REGISTERS were an important means of visually keeping a record of the family's genealogy, to be passed from generation to generation. The family unit was of major importance in early America, and its genealogical makeup was clearly delineated in these registers. In their earliest form they are no more than just an inscription in ink, made in the family bible or on a piece of paper, of the names of family members and the dates of their births, marriages, and deaths. In the latter part of the eighteenth century, decorative features were added to the basic genealogical data, and these newer records began to appear in watercolor and ink on paper, on printed forms, and in needlework. The importance to the family of these registers is evident from several paintings, including the 1837 family portrait by Caroline Hill in which a register is pictured prominently hanging on the parlor wall.

The watercolor and ink renderings were most frequently done by schoolchildren, teachers, and clergy, and by professional painters. Although some are the birth or death records of a single individual, they generally relate to the entire family. Their decorative features, along with the genealogical data, make them far more exciting than just static listings of names. Portraits of family members, landscape backgrounds, depictions of homes and home furnishings, and symbols of various types make these prime examples of folk art as well as genealogical records. Frequently seen symbols include hearts, birds, flowers, vines, trees, coffins, Masonic emblems, and angels. All of these emblems are presented in a variety of ways, though most commonly as circles or chains, perhaps symbolizing family unity; hearts and angels, symbolizing love; and as the tree design, with the names of the parents usually at the roots, and the names of the children in hanging, fruitlike circles on the branches above.

Printed family records or registers appear in three forms: as engravings, lithographs, or broadsides. The engravings were made by a small number of professionals, including Richard Brunton, Jervis Cutler, and Benjamin Blythe. They incorporate peripheral symbolic forms, such as birds, as well as the figures of Hope, Faith, Charity, and Peace, with a central area in which the data concerning the family members could be written in the appropriate spaces. Lithographed records were produced by such firms as Currier and Ives, and Kellogg and Kellogg. As a rule there were four columns, marked "Family," "Born," "Married," and "Died," under which the names of the family members could be written by the purchaser. Above each of the columns was a scene relating to that particular category. The broadside version, made with letterpress type, in most cases was just a printed record, usually on paper but occasionally on fabric, of the names, births, marriages, and deaths in the family. In some cases the names were accompanied by the common decorative elements, and in a small series, by silhouettes of husband and wife. Needlework family registers, usually produced by schoolgirls with the help of their teachers, took the same basic forms as those on paper did. Basic sewing was part of the household duties of most girls, but finer sewing was taught at school. The samplers, family registers, and other types of needlework were evidence of a girl's refinement and education.

Records of birth and death, like family records, were also painted, embroidered, and, occasionally, printed works, and they are a combination of genealogical data and decorative representations. In contrast to the family registers, which deal with most, if not all, family members, these records primarily present genealogical data for only one person. New England birth records are far less common than family

records. However, the Pennsylvania German birth and baptismal certificates, known as fraktur, are the most common type of record produced by those of German heritage. Little is known of most fraktur makers, but ministers and schoolteachers most often produced the records.

The most common record of death in early America was the mourning picture. Inspired by the death of George Washington, they were created most frequently by girls and women, and less frequently by teachers and professional artists, to commemorate the death of a family member.

See also **Justus Dalee; Decoration; Fraktur; Fraternal Societies; Freemasonry; German American Folk Art; Warren Nixon; Pennsylvania German Folk Art; Pictures, Needlework; Samplers, Needlework.**

BIBLIOGRAPHY

Simons, D. Brenton, and Peter Benes, eds. *The Art of Family: Genealogical Artifacts in New England.* Boston, 2002.

ARTHUR AND SYBIL KERN

FARMER, JOSEPHUS (1894–1989) was born the son of a former slave near Trenton, Tennessee, in the rural community of Gibson Courts, where he lived until his family moved to Humboldt, Tennessee. At the age of twenty he left his agrarian, small-town milieu and moved to St. Louis, where he found work in a meatpacking plant.

According to his own account, Farmer had a series of intensely spiritual experiences when he was in his late twenties, commencing with his sensation that God was calling him to join the church. When he was baptized shortly thereafter, he manifested the phenomenon of "glossolalia," or the making of indecipherable vocal sounds, more commonly known as speaking in tongues. Ordained in the Pentecostal Church, he soon began preaching the Gospel on the streets of St. Louis. All of these episodes in his dramatic religious conversion took place in 1922, the same year that he met and married Evelyn Griffin, with whom he had a son.

In the mid-1920s, Farmer became a roving evangelist and brought his family along as he moved from place to place, living for brief periods of time in six different states in the Midwest and on the West Coast. On weekends he preached outdoors in a tent or in storefront churches, and on weekdays he performed various manual labor jobs, including construction work that he did for the federal government during the 1930s and 1940s. For a while he served as the regular pastor at churches in Murphysboro and Harrisburg, Illinois, and in 1931 he founded El Bethel Apostolic Church in South Kinloch, Missouri. In 1947 he moved his family to Milwaukee, where he found work as a hotel porter, opened a storefront church, and settled in for the next forty years.

Like most woodcarvers, Farmer learned his craft as a child, and early on he practiced the African American tradition of carving monkeys and other animal figures from the hard, red pits of peaches. After he retired, in 1960, he reclaimed his childhood pastime and began carving bas-reliefs with religious and patriotic themes, inspired by imagery he found in popular publications. Among his favorite subjects in his early work were President John F. Kennedy and First Lady Jacqueline Kennedy, who then occupied the White House. Although he occasionally made sculpture in-the-round and later built sculptural tableaux or dioramas, Farmer initially and through the 1970s worked most often in low wood relief, painting his works when he finished carving them, and sometimes including passages of painted text as well.

Farmer eventually made a number of works, often based on images in the *American Heritage Illustrated History of the United States,* one of his favorite source books. Recurring themes in these historical pieces are the enslavement and subsequent emancipation of blacks in the United States. To some extent, his works dealing with those subjects were probably informed by family stories about his father's experiences as a slave. When treating historical themes, he retained the religious focus of a preacher, often including in these works numerical references to passages from the Bible that he saw as prophecies of the historical events he depicted.

To create his early reliefs, Farmer employed only a utility knife, even when working with a hard wood such as mahogany. He later switched to pine and other softer woods and began to use more sophisticated tools, some of them electrically powered. His tableaux, most of which date from his last ten years, are made in part of carved and painted wood, but unlike the relief pieces, they were assembled from wood components, as well as cloth, plastic, wire, wood putty, and other materials, affixed to each other with glue and nails, and are typically mounted on plywood bases. The only other artworks he is known to have produced are a number of representational, text-augmented banners that he painted on window shades and used to illustrate his sermons. He also produced several sculptures, carved in-the-round, and including variations on the Crucifixion of Christ and the Statue of Liberty.

In 1987, shortly after the death of his wife, Farmer left Milwaukee for Joliet, Illinois, to live near his son. There he moved into an apartment building for senior citizens, where he continued to carve and create his tableaux until the last few months of his life. He spent those final months in a nursing home, where he died after suffering a heart attack.

See also **African American Folk Art (Vernacular Art); Religious Folk Art; Sculpture, Folk; Visionary Art.**

BIBLIOGRAPHY

Colonial Williamsburg Foundation. *Flying Free: Twentieth-Century Self-Taught Art from the Collection of Ellin and Baron Gordon.* Williamsburg, Va., 1997.

Columbus Museum of Art. *Elijah Pierce, Woodcarver.* Columbus, Ohio, 1992.

Yelen, Alice Rae. *Passionate Visions of the American South: Self-Taught Artists from 1940 to the Present.* New Orleans, La., 1993.

TOM PATTERSON

FASANELLA, RALPH (1914–1997) was a self-taught painter whose body of work is one of the most compelling artistic critiques of post–World War II America. His paintings—bold, colorful, and loaded with detail yet unified in composition—speak powerfully of a distinct working-class identity and culture, and of the dignity of labor. They capture the past and express hope for the future.

Fasanella had an artistic vision inspired by a working life. A child of Italian immigrants, he was born in Manhattan's Greenwich Village and spent his youth delivering ice with his father while enduring the harsh regimen of a Catholic reform school. During the Great Depression, Fasanella worked in garment factories and as a truck driver. From his mother—a literate, sensitive, and progressive woman—Fasanella acquired a social conscience. Through her influence he became active in antifascist and trade union causes. Fasanella's political beliefs were radicalized by the Depression. His antifascist zeal led him to volunteer for duty in the International Brigades fighting fascism in Spain, where he served from 1937 to 1938. Upon his return to New York City, Fasanella became an organizer for various unions, particularly the United Electrical, Radio, and Machine Workers of America, with whom he achieved some major organizing successes.

In 1945, disillusioned by the labor movement and plagued by a painful sensation in his fingers, Fasanella started to draw; the result was an immediate outpouring of creative energy. Fasanella left organizing and began to paint full-time. He painted obsessively, capturing the vibrant moods of the city and the tumult of American politics. For a brief time he received some critical notice for his work, and had shows of his work in galleries as well as union halls. Soon after he began to paint, Fasanella mastered a style that allowed him to communicate visually with workers. He captured a profusion of familiar details, boldly showed interiors and exteriors simultaneously, and combined past and future. Fasanella's art became the visual equivalent of street talk: direct, opinionated, improvisational, and passionate. The way Fasanella painted, with bright colors and bold, sweeping compositions, appeals to viewers ordinarily unaccustomed to looking at art. In his work, they see their own lives. Fasanella's method of populating his paintings with likenesses of family and friends gives the work real familiarity and affection, and captures a universality of experience.

In 1950 Fasanella married Eva Lazorek, a schoolteacher, who supported the couple through more than two decades of artistic obscurity and blacklisting by the FBI. In the 1950s Fasanella retreated from political content in his works out of fear of reprisals. With the emergence of the New Left in the 1960s, however, his works became large, sharply focused political essays using images from the popular media. In 1972 Fasanella was featured in *New York Magazine* and in an illustrated book, *Fasanella's City.* His large-scale, intricate paintings of urban life and American politics were then introduced to art critics and the public.

In the late 1970s Fasanella spent two years in Lawrence, Massachusetts, researching the 1912 Bread and Roses strike. The result was a series of eighteen paintings depicting the life of the mill town's diverse immigrant population as well as the events of the strike. The Lawrence series represents one of the largest and most significant bodies of historical painting by any American self-taught artist. In the 1980s and 1990s Fasanella mostly painted scenes that refined familiar subjects, such as urban neighborhoods, baseball, and labor strikes. He also worked with Ron Carver, a labor organizer, to place his works on public view through the Public Domain Project, which was initiated in 1987 to purchase works from private collections and donate them to institutions or municipalities. In 2001 Fasanella was the subject of a comprehensive book and retrospective exhibition, "Ralph Fasanella's America," at the New York State Historical Association.

Fasanella died on December 16, 1997. His epitaph reads simply: "Remember who you are. Remember where you came from. Change the world."

See also **Frederick Fried; Memory Painting; Painting, American Folk.**

BIBLIOGRAPHY

Carroll, Peter. "Ralph Fasanella Limns the Story of the Workingman." *Smithsonian,* vol. 24 (August 1993): 58–69.

D'Ambrosio, Paul S. *Ralph Fasanella's America.* Cooperstown, N.Y., 2001.

———. "Ralph Fasanella: The Making of a Working-Class Artist." *Folk Art,* vol. 20 (summer 1995): 26–33.

Watson, Patrick. *Fasanella's City.* New York, 1972.

PAUL S. D'AMBROSIO

FEKE, ROBERT (c. 1707–c. 1751) of Oyster Bay on Long Island, New York, was the son of a Baptist preacher. Details of Feke's early life as well as what training he may have received are vague. He married a tailor's daughter in Newport, Rhode Island, which became the center of Feke's painting activity until about 1745, when he settled in Boston. He painted portraits in Philadelphia in 1746 and 1748, attended a wedding in Newport in 1751, and then disappeared.

The highlight of Feke's early career was a commission he received in 1741 from Isaac Royall Jr. (1719–1781), who lived near Boston. The commission would have gone to that city's leading painter, John Smibert (1688–1751), had he not been ill at the time. Feke's large canvas shows his debt to Smibert. Depicting five members of the Royall family, seated and standing, the portrait is evidence of Feke's artistic ambition and Isaac Royall's estimation of his place in colonial society. The figures in the Royall portrait are somewhat stiff and linear, but Feke would develop rapidly and impressively. Indeed, his portraits from the late 1740s of Boston and Philadelphia merchant aristocrats, including members of the Bowdoin and Willing families, show Feke's mastery at creating elegant poses, dramatic lighting effects, and depicting rich costume fabrics.

See also **Painting, American Folk; John Smibert.**

BIBLIOGRAPHY

Craven, Wayne. *Colonial American Portraiture.* Cambridge, England, 1986.

Saunders, Richard H., and Ellen G. Miles. *American Colonial Portraits, 1700–1776.* Washington, D.C., 1987.

RICHARD MILLER

FELLINI, WILLIAM (died c. 1971) painted still-lifes, landscapes, and figures in landscapes, but for about twenty-five years he earned his living as a New York City housepainter and decorator. Though his works are colorful and robust, he never sold a painting during his lifetime. His training as a painter and decorator contributed to his skill in representing marble-ized tabletops in his paintings, such as *Still-life: Vase of Flowers* (1936) and *Lily in Boot* (1951). The artist has depicted in each painting a plant growing out of a laced work shoe filled with soil and set on a marble table.

Fellini worked in oil on canvas and his output was limited. Little is known of the artist's life except what has been gleaned from a few letters, as well as a brief essay written by Nancy Bayne Turner, whose mother hired Fellini over the years as a painter, decorator, and handyman. Turner wrote that Fellini was so poor he was unable to buy new canvas, and often bought used canvases for about twenty-five cents and painted on the reverse side. Fellini was teased about his "art" by his coworkers at the Third Avenue paint contractor and decorator that employed him, but he took it all good-humoredly, replying, "Wait, someday those 'big shots' will be surprised!"

See also **Painting, American Folk; Painting, Still-life.**

BIBLIOGRAPHY

Hemphill, Herbert W. Jr., and Julia Weissman. *Twentieth-Century American Folk Art and Artists.* New York, 1974.

Johnson, Jay, and William C. Ketchum. *American Folk Art of the Twentieth Century.* New York, 1983.

LEE KOGAN

FENIMORE HOUSE: *SEE* NEW YORK STATE HISTORICAL ASSOCIATION.

FESTIVALS: *SEE* HOLIDAYS.

FIELD, ERASTUS SALISBURY (1805–1900) was a farmer and painter whose portraits of relatives and their acquaintances, executed from 1826 to 1841, are among the most sympathetic likenesses from the period, while his history paintings of about 1844 to 1885 are visionary and often unprecedented in subject matter. Field studied with Samuel F.B. Morse (1791–1872) in New York City in 1824–1825 before setting off on a series of portrait painting trips throughout western Massachusetts and nearby communities in Connecticut, New York, and Rhode Island. His first documented work, of his eighty-year-old grandmother, Elizabeth Billings Ashley, was painted about 1825 in Leverett, Massachusetts, Field's birthplace. Broad brush strokes give volume to the woman's head and face while smoothing out the texture of her skin. The alert, dark eyes, looking straight ahead, are emphasized. The three-dimensional appear-

ance of the figure is countered by two-dimensional schematic patterns of a white collar and cap. A dappled gray background, light-filled near Mrs. Ashley's head, darkens toward the edges of the canvas. The only bright color is the red upholstery of a chair back, partially seen from behind the sitter's shoulder. These characteristics, learned partly from Morse, and partly from the country tradition Field already knew, are conspicuous in other early portraits by Field.

By about 1841, after working for a long line of patrons, Field moved to New York City, where he stayed for seven years and painted his earliest history subjects. He returned to Massachusetts to work as a daguerreotypist and painted portraits from photographs that he took. By 1866 he retired to Plumtrees, a small community near Leverett, where he produced a series of biblical and historical paintings based on prints and his own naive visions, such as *The Garden of Eden,* painted about 1865. During the Civil War, Field began what would be a masterpiece of the nineteenth century, a twenty-two-foot canvas called *The Historical Monument of the American Republic* (completed 1888), which shows ten towers carved with relief sculptures illustrating the history of the United States. Field was unable to arrange a suitable public showing of this ambitious painting. During his lifetime, it remained in his barn, where he used it to illustrate history lessons for local school children. Today it is displayed in the Museum of Fine Arts in Springfield, Massachusetts.

See also **Painting, American Folk; Religious Folk Art.**

BIBLIOGRAPHY

Black, Mary. *Erastmus Salisbury Field: 1805–1900.* Springfield, Mass., 1984.

Carson, Jenny, and Paul Staiti. *Selections from the American Collection of the Museum of Fine Arts and the George Walter Vincent Smith Art Museum.* Springfield, Mass., 1999.

RICHARD C. MÜHLBERGER

FIELD, HAMILTON EASTER (1873–1922) founded the Ogunquit School of Painting and Sculpture, at Perkins Cove in Ogunquit, Maine, in 1911, where he encouraged his students to study the roots of America through its folk arts and colonial painting. Field was celebrated as a proponent of American Modernism. His students included Lloyd Goodrich (1897–1987), Yasuo Kuniyoshi (c. 1889–1953),

Robert Laurent (1890–1970), and Niles Spencer (1893–1952). He was also closely associated with Bernard Karfiol (1886–1952) and William Zorach (1889–1966), and influenced Marsden Hartley (1877–1943). These artists were struck by the modern look of the American weathervanes, decoys, folk paintings, hooked rugs, and pottery that decorated their cabins in Ogunquito. Some of them became folk art collectors, and others incorporated aspects of American folk art into their art. For example, Kuniyoshi utilized a distinct folk art style with simplified modeling and unusual perspectives.

Field was the son of two prominent Quakers, Aaron Field (1829–1897) and Lydia Seaman Haviland (1838–1918); the family lived in Brooklyn. Field attended the Brooklyn Friends' School, matriculated at the Brooklyn Polytechnic Institute, and studied at the Columbia School of Mines. After a short enrollment at Harvard University, he spent fifteen years traveling in Europe, studying and collecting art. About 1912 or 1913, he opened Ardsley Studio in his Brooklyn residence to exhibit the work of American Modernists, and, in 1916, he opened the Ardsley School of Modern Art. Field was both the art critic and later the art editor for the *Brooklyn Daily Eagle,* from 1919 to 1922; served briefly as both contributor and editor of the periodical *Arts and Decoration,* from 1919 to 1920; and, in 1920, he started his own magazine, *The Arts,* serving as editor and publisher, until his death at forty-nine years of age. Field's interest in American folk art influenced a generation of New York Modernists, and contributed to its acceptance as a form of artistic expression in the first quarter of the twentieth century.

See also **Holger Cahill; Decoys, Wildfowl; Edith Gregor Halpert; Hooked Rugs; Painting, American Folk; Pottery, Folk; Weathervanes.**

BIBLIOGRAPHY

Bolger, Doreen. "Hamilton Easter Field and His Contribution to American Modernism." *The American Art Journal,* vol. 20, no. 2 (1988): 79–107.

Quimby, Ian M.G., and Scott T. Swank, eds. *Perspectives in American Folk Art.* New York, 1980.

Vlach, John Michael, and Simon J. Bronner, eds. *Folk Art and Art Worlds.* Ann Arbor, Mich., 1986.

WILLIAM F. BROOKS JR.

FIGUREHEADS: *SEE* SHIPS' FIGUREHEADS.

FINCH, ARUBA (RUBY) BROWNELL DEVOL

(1804–1866) fits modern society's conceptions of a folk artist more neatly than many nineteenth-century amateurs so labeled. The painter was born, raised, and buried in the same small community; not even marriage took her more than ten miles from her childhood home. Although aware of period styles and conventions, she developed personal solutions to artistic problems and showed little reliance on academic sources. These facts and the number of works executed for friends and neighbors suggest that Finch enjoyed a longstanding closely-knit support system, one that not only met her social needs but also encouraged her interest in artistic endeavors.

The artist was born in Westport, Massachusetts on November 20, 1804, the second of seven children of Benjamin Devol Jr. and Elizabeth Rounds. Nothing is known of her schooling. An 1831 family register, done for neighbor Silas Kirby, establishes that Finch was engaged in artwork prior to her marriage. On November 8, 1832, she married William T. Finch of nearby New Bedford.

Half- and full-length portraits (two of the former being memorials) as well as two serial illustrations of the story of the Prodigal Son constitute the remainder of Finch's known body of work in watercolor. Evidence of her creativity and willingness to experiment can be found in the original verses that she added to some likenesses. Differences between her two depictions of the Prodigal Son reflect her efforts to improve the clarity and cohesiveness of the overall composition and its correlation between text and imagery. Despite the naïveté of their execution, her profile portraits are distinguished by individualistic details, such as Abner Davis's patterned stockings, dotted waistcoat, and even small hairs on the back of his hand. Finally, although pictorial motifs sometimes recur in Finch's works, she avoided slavish repetition. For instance, spread eagles appear on three of her pieces, yet each is distinctly posed. Decorative qualities were important to Finch. Even her plainest portraits, such as her full-length likenesses of Abner and Betsy Allen Davis, incorporate the unusual compositional device of plinths, which are set beneath the figures and artfully twined with vines.

Ruby and William T. Finch had one daughter, Judith, who married Otis Pierce, a mason. When Finch died of a tumor on July 7, 1866, in New Bedford, she had been a widow for an undetermined length of time and appears to have been living with her elderly widowed mother.

See also **Painting, American Folk.**

BIBLIOGRAPHY

Rumford, Beatrix T., ed. *American Folk Portraits: Paintings and Drawings from the Abby Aldrich Rockefeller Folk Art Center.* Boston, 1981.

———. *American Folk Paintings: Paintings and Drawings Other Than Portraits from the Abby Aldrich Rockefeller Folk Art Center.* Boston, 1988.

Walters, Donald R. "Out of Anonymity: Ruby Devol Finch (1804–1866)." *Maine Antique Digest* (June 1978): 1C–4C.

BARBARA R. LUCK

FINSTER, REVEREND HOWARD

(1915–2001) was born on a small farm in northeast Alabama, and as an adult lived in adjoining northwest Georgia. He left school after finishing the sixth grade, and at age sixteen began a long career as a traveling Baptist preacher. In the late 1940s, he created an environment of miniature buildings and religious monuments, as well as the beginnings of a collection he called *Inventions of Mankind,* in the yard of his house in Trion, Georgia. In 1961, when he moved with his family to nearby Pennville, he brought some of those things with him, and they formed the nucleus of an art environment he initially called *Plant Farm Museum.* He commenced work on the latter project almost immediately, in response to a vision in which he claimed that a fifteen-foot-tall man admonished him to "get on the altar."

After retiring from formal church ministry, in 1965, Finster supported his family by repairing bicycles and lawn mowers, and devoted any spare time to his ambitious backyard project. He had spent fifteen years developing his *Paradise Garden,* as it became known, by the time it began to attract widespread attention. Then, in 1976, another vision, in the form of a tiny human face that spoke to him from a paint-smudge on his fingertip, prompted him to start painting "sacred art."

Finster consistently tended to fill any available space in his paintings, surrounding the highly varied imagery with handwritten Bible quotes, opinionated messages, and startling accounts of visions in which he claimed to travel to "other worlds beyond the light of the sun." These early "sermons in paint," as he called them, were fairly small works in enamel on plywood, sheet metal, or Masonite. Later, he began to make sculpture and to experiment with other materials, including mirror glass, Plexiglas beads, and wire. Invariably urgent in tone and intensely overwrought, his works deal with themes of history, biography, autobiography, divine power, worldly calamity, sin, salvation, steadfast faith, heavenly reward, and extraterrestrial life. By the time he died of heart failure, he

had created more than 47,000 dated and numbered pieces, including many on a fairly ambitious scale.

Now in severe decline, with many of its best components removed to public and private collections, *Paradise Garden* is owned by the artist's youngest daughter, who operates a gift shop adjoining the site, open to the public for an admission fee.

See also **Environments, Folk; Visionary Art.**

BIBLIOGRAPHY

Finster, Howard, as told to Tom Patterson. *Howard Finster: Stranger from Another World: Man of Visions Now on This Earth.* New York, 1989.

Peacock, Robert, and Annibel Jenkins. *Paradise Garden: A Trip Through Howard Finster's Visionary World.* San Francisco, 1996.

Turner, J.F. *Howard Finster, Man of Visions: The Life and Work of a Self-Taught Artist.* New York, 1989.

TOM PATTERSON

FIREBOARDS AND OVERMANTELS were two major decorative forms that developed around one of the most important features of early American homes: the fireplace. Embellishing these forms was generally the purview of ornamental, or fancy, painters, who advertised their abilities to "execute Ornamental Work, such as Fire-Boards, Fire Screens, and Pictures, painted in landscape, naval victories, & c. for ornamenting Rooms," as did Henry E. Spencer (dates unkown) in North Carolina in 1828. As a result, few names of the artists who were engaged to do this type of ornamentation have emerged, although Winthrop Chandler (1747–1790), Michele Felice Cornè (1751–1845), Jonathan W. Edes (1751–?), Charles Codman (1800–1842), and Rufus Porter (1792–1884) are among those known to have painted overmantels. Other artists, such as the as yet unidentified Bear and Pears Artist, decorated fireboards and also painted scenic murals on walls.

During the eighteenth century, overmantels were called "chimney paintings" or "chimney pieces." The term "chimney board" was applied to decorative panels that were made to conceal fireplaces during the summer months, when they were not in use. Some ornamental painters learned to decorate overmantels and fireboards from European instruction books that gave detailed descriptions of appropriate subject matter as well as correct proportions. Images based on prints and engravings were common. These included hunting parties, pastoral scenes, prospects, and town views; "deception painting," or *trompe l'oeil,* was also popular.

"Fireboards," as chimney boards came to be known by the early nineteenth century, were meant to fill the entire fireplace opening, but usually had additional hardware for stability, such as a wide base molding and a "turnknob" to catch the sides, or two slots on the bottom that were mounted on andirons. The simplest fireboards were constructed of wooden boards battened together at the back, while others were painted directly onto the front boards. More elaborate fireboards might have had canvas stretched over the wooden boards and tacked around the edges; others were more like paintings: stretched canvas that was decorated in oils, wallpaper, or paper cutout appliqués. The most conventional imagery was of an urn of flowers, imitating the practice of placing an actual vase of flowers in the open hearth. One of the earliest references was penned in 1723 by a Mr. Custis of Williamsburg, Virginia, who wrote, "It is to put in ye summer before my chimneys to hide ye fire place. Let them bee some good flowers in potts of various kinds. . . ."

Overmantels were typically painted directly onto the wood paneling or plaster that covered the chimney, or occasionally on canvas. The first landscape paintings in America occur on these interior architectural embellishments, and at times depicted the very homes in which they were installed. The *Van Bergen Overmantel,* attributed to John Heaton (active 1730–1745) and painted about 1733, is perhaps the earliest document of Dutch life in New York State, and represents the farm belonging to the Van Bergen family of Leeds, Albany (now Greene) County. The overmantels painted by Winthrop Chandler toward the end of the eighteenth century, by contrast, combine actual elements from the New England landscape with fanciful notions of romantic European scenes drawn from print sources and his own imagination. The overmantel *Situation of America,* a promised gift to The American Folk Art Museum from Ralph Ermerian, is dated 1848, indicating that these forms continued to be made and used through the middle of the nineteenth century. By the 1830s, however, the demand for fireboards and overmantels began to wane as supplies of firewood dwindled, resulting in higher costs, and cooking stoves that burned less wood began to replace open hearths in homes throughout the country.

See also **Winthrop Chandler; Michele Felice Cornè; Decoration; Furniture, Painted and Decorated; John Heaton; Painting, American Folk; Painting, Landscape; Rufus Porter.**

BIBLIOGRAPHY

Allen, Edward B. *Early American Wall Paintings, 1710–1850.* Cambridge, Mass., 1926; Watkins Glen, N.Y., 1969.

Little, Nina Fletcher. *Country Arts in Early American Homes.* New York, 1975.

———. *American Decorative Wall Painting, 1700–1850.* New York, 1989.

Schaffner, Cynthia V.A., and Susan Klein. *American Painted Furniture.* New York, 1997.

STACY C. HOLLANDER

FISH DECOYS: *SEE* DECOYS, FISH.

FISHER, JONATHAN (1768–1847) was a painter and Congregational minister from New Braintree, Massachusetts. He was admitted to Harvard in 1788. In 1796 Fisher was named the first permanent pastor of the Congregational Church at Blue Hill, Maine, where he lived for the rest of his life. Fisher's many intellectual interests besides theology included natural history, poetry, and literature. He was fluent in several languages, including that of the Penobscot people, and his social concerns embraced promoting Native American rights and supporting the purchase of slaves from their owners to return them to Africa. Fisher also had practical skills that he used to supplement his minister's salary. Besides farming, he made medicines, furniture, straw hats, bone buttons, and combs. He also painted sleighs and surveyed local roads with instruments that he made himself.

A self-taught artist, Fisher began painting oils on canvas and panels about 1798, and completed approximately twenty-five works. Besides portraits, he painted still-lifes, religious and allegorical scenes, and at least one topographical view of Blue Hill. An 1804 still-life is noteworthy for having a painted scrap of paper with a dog-eared corner attached to a board background with a straight pin, an early example of *trompe l'oeil* painting in America.

The panoramic view of Blue Hill that Fisher painted in 1824 shows a rocky pasture with two women and a man, who is about to strike a snake with a stick in the foreground. Extending to the horizon is the neat village of clapboard houses situated along the main road leading to Fisher's church. Blue Hill's prosperity and rural affluence was achieved through fishing and agriculture: the former is indicated by a sailing ship entering the harbor; the latter was made possible by clearing the virgin forest that remains in scattered patches in Fisher's view of the town.

Fisher's 1838 self-portrait depicts him as bald, with a deeply lined face, seated in his library and pointing to a verse in the Bible. The painting shows that Fisher could use his art as an extension of his ministry: looking directly at the viewer with an intent expression, Fisher seems to admonish us to adhere to biblical canon.

Fisher continued painting until the year he died, but his major late work was the book *Scripture Animals, or Natural History of the Living Creatures Named in the Bible, Especially for Youth,* published in 1834. Fisher not only wrote the text but also taught himself to cut and print the book's more than 140 woodblock illustrations.

See also **Painting, American Folk; Painting, Still-life; Religious Folk Art.**

BIBLIOGRAPHY

Chase, Mary Ellen. *Jonathan Fisher, Maine Parson, 1768–1847.* Blue Hill, Maine, 1978.

Lipman, Jean, and Tom Armstrong, eds. *American Folk Painters of Three Centuries.* New York, 1980.

RICHARD MILLER

FLAGS are a colorful, highly collectible category of American folk art. A ubiquitous element of folk art, the American flag, more familiarly known as the Stars and Stripes, is possibly the most famous American icon throughout the world.

The American flag began its history with this resolution, hastily adopted by the Continental Congress on 14 June 1777: "RESOLVED: that the flag of the United States be made of thirteen stripes, alternate red and white; that the union be thirteen stars, white in a blue field representing a new constellation." Much about the flag was left undefined, including the size and number of points on each star, their arrangement on the blue field, the proportion and relative position of the elements, and the width and direction of the red and white stripes. Some historians believe that Congress felt comfortable with the resolution's vague wording because the elements of the flag were already familiar, visible in regimental banners, in the Sons of Liberty's "stripes of rebellion," and in the Grand Union Flag known throughout the colonies. Francis Hopkinson of New Jersey, who chaired the Continental Navy's Middle Board and is credited with designing the flag, appears to have drawn heavily on the symbolism behind these earlier banners. Originally viewed solely as a military emblem, the first American flag was intended to identify the American naval fleet and military property. Charles Willson Peale's (1741–1827) painting of General George Washington (1782) used the flag as a device for conveying Washington's military standing.

Over time, the broad wording of the flag resolution invited citizens as well as commercial flag-makers to

design the flag as they pleased. They arranged stars of varying sizes—five pointed and otherwise—into concentric circles, staggered rows, giant star patterns, geometric shapes, and in random order. Congress increased the likelihood of variations in 1794 when it decreed that each new state entering the Union be recognized with a new star and a new stripe, beginning with Kentucky and Vermont. By 1818, Congress had second thoughts about this decision when five more states joined the Union and more territories clamored for statehood. It voted to return to thirteen horizontal stripes, representing the original colonies, and to just add a star for each new state. The fifteen-star, fifteen-stripe flag that flew over Fort McHenry during the War of 1812 which inspired Francis Scott Key to write *The Star-Spangled Banner* is the only version of the American flag that does not have thirteen stripes.

The frequent addition of new stars (twenty-eight between 1818 and 1912) meant that the American flag was not a static symbol. During the nineteenth century, new states were being admitted with such frequency that practical flag-makers left gaps on the canton so new stars could be stitched into place.

The average citizen continued to view the nation's flag as primarily a military standard until the American Civil War fostered a flag cult among those who sought to preserve the Union. The flag became a rallying symbol, when Confederate Secretary of War L.P. Walker predicted, after the fall of Fort Sumter in April 1861, that the Confederate flag would fly "over the dome of the old Capitol at Washington before the first of May." Outraged Unionists defiantly raised the "Star-Spangled Banner" throughout every town and village. The groundswell of patriotic fervor opened a new phase of patriotic folk art as citizens incorporated the flag motif into everyday objects to show their loyalty and national pride. Salt-glazed stoneware with crossed flags, flag pattern quilts, and handmade regimental flags were common objects.

The cult of the flag gained even greater momentum with the celebration of America's Centennial in 1876. During this same period, the flag also emerged as a prominent symbol in many Native American crafts. Navajo flag weavings and Iroquois whimsies were primarily created for the tourist trade, but the flag also found its way into ceremonial vests, moccasins, belts, and pouches made from porcupine quills and beads. By the late 1890s, the flag decorated everything from pincushions and pillowcases to political campaign ribbons, weather vanes, and scrimshaw. It was also exploited for commercial gain, appearing on everything from pickled pork cans to laundry detergent boxes.

Patriotic groups lobbied for restraint, and between 1912 and 1934, Congress approved a code of flag etiquette and a series of detailed design standards. Today the official American flag adheres to strict design standards and is uniform in appearance and presentation.

However, more than a century without official guidelines had established a tradition of free interpretation. Well into the twentieth century, artists incorporated the flag into their design. For example, the flag features prominently in the naïve metal sculptures of R.A. Miller (1912–) the folk paintings of William Doriani, and the Pop Art paintings of Jasper Johns (1930–).

As the nation's most recognizable symbol, the American flag continues to hold tremendous emotional, patriotic power. For many, it embodies everything America stands for—a fact that people have seized upon when looking to give visual expression to their patriotism and protests. Major American events, whether celebratory or elegiac, have always generated new flag interpretations that eventually enter the lexicon of American folk art. Although contemporary works are often viewed within the context of current affairs, in time, we distinguish between propaganda and promotion, and works that exhibit the essential qualities of art.

See also **Circus Folk Art; Fraternal Societies; Maritime Folk Art; Native American Folk Art; Political Folk Art; Pottery, Folk; Quilts; Scrimshaw; Weathervanes.**

BIBLIOGRAPHY

Hinrichs, Kit, and Delphine Hirasuna. *Long May She Wave: A Graphic History of the American Flag*. Berkeley, Calif., 2001.

KIT HINRICHS AND DELPHINE HIRASUNA

FLAT TULIP ARTIST: *SEE* DANIEL OTTO.

FLETCHER, AARON DEAN (1817–1902), a portrait and landscape painter, worked principally in Vermont and New York during the nineteenth century. Little is known about him, but stories to define his life and artistic career have been constructed, working largely from the canvases he left behind. Described as "a trifle queer" and having pockets filled with gold, Fletcher is remembered for wearing a long black cape and high silk hat. At an early age, he learned to play the violin and taught himself to paint using homemade canvases and pigments. The youngest of David

and Sally Lovell Fletcher's ten children, the artist was born in Springfield, Vermont. Never marrying or settling down, Fletcher chose a transient lifestyle that allowed him to travel for portrait commissions, his only apparent means of employment. Some experts speculate that he painted portraits in exchange for room and board.

According to existing inscriptions on his paintings, from 1835 to 1840 Fletcher executed likenesses of subjects who lived in Springfield, Vermont, and nearby Rockingham and Saxtons River. These early works are characterized by the sitters' features appearing heavily contoured, at times outlined in black. Expressions are solemn, lips are tight, and eyes are intense. Frequently using a distinctive, flat olive-brown background color, he also painted subjects on neutral grounds, and employed various props, such as books, flowers, and family pets, to enliven compositions. By 1840 the artist had moved to Keeseville, New York, where his brothers lived, allowing him to make portraits of individuals who lived in the surrounding Essex and Clinton counties. Existing canvases depicting three New Hampshire residents suggest that Fletcher may have traveled across state borders for work. Having always wanted to see the West, in the mid-1850s he made a journey to La Porte, Indiana, leaving behind a handful of portraits. His later canvases reveal the influences of photography as well as high Victorian portrait conventions.

Although Fletcher's last known likeness, depicting Mary Broadwell, dates from 1862, he continued to list himself as an artist in official documents of a later period. Several known landscape paintings from this period also convey a breadth of artistic skill beyond portraiture. In 1880 he was recorded as a portrait painter in the federal census for Chesterfield Township, New York, and by 1886–1887, he is listed as a painter in the city directory for Plattsburgh. The artist died homeless in Keeseville, New York, at the age of eighty-five on December 27, 1902, leaving what few assets he had to the local Home for the Friendless.

See also **Painting, American Folk; Painting, Landscape.**

BIBLIOGRAPHY

Baker, Mary Eva. *Folklore of Springfield*. Springfield, Vt., 1922.

Burdick, Virginia, and Katherine Lochridge. *Portraits and Painters of the Early Champlain Valley*. Plattsburgh, N.Y., 1975.

Burdick, Virginia, and Nancy C. Muller. "Aaron Dean Fletcher, Portrait Painter." *The Magazine Antiques*, vol. 115 (January 1979): 184–193.

CHARLOTTE EMANS MOORE

FOLK ART SOCIETY OF AMERICA is a non-profit organization that advocates the discovery, documentation, preservation, and exhibition of contemporary folk art, folk artists, and folk art environments. In April 1987, under the leadership of William and Ann Oppenhimer, a group of fifteen people met in Richmond, Virginia, for the purpose of starting a local organization for folk art enthusiasts. The group quickly evolved from a local to a state and then to a national entity, to become the Folk Art Society of America.

Since 1989, its advisory board has presented 34 Awards of Distinction to folk artists, scholars, and other major contributors to the field. Beginning in 1999, one or more works of art purchased through the Society's Herbert Hemphill Memorial Fund have been donated by the society annually to a museum to honor a living artist, as well as the museum to which the work is given.

In 1991 the National Advisory Board (now with thirty-one members) was elected to represent various regions of the United States, and the society gained more of a national presence. The society's annual national conference, held in a different city each year, features a symposium, tours of public and private art collections, a benefit auction, and presents the opportunity to discover emerging talent in the field.

Project Save Art and Folk Environments (SAFE) was established in 1995 to promote and support the preservation of existing folk environments in danger of being destroyed. Through the efforts of the society, local supporters, and a grant from the U.S. Department of Housing and Urban Development (HUD), the murals from Anderson Johnson's (1915–1998) *Faith Mission* were saved and restored. Recently, Project SAFE has been limited to awarding plaques to folk art environments, designating them as historical sites worthy of preservation. Following the near destruction of Tessa "Grandma" Prisbrey's (1896–1988) *Bottle Village* during the Simi Valley earthquake of 1994 in California, the city of Los Angeles decided not to raze the structure after seeing the Folk Art Society's plaque.

The society maintains a growing research library that houses artists' biographies and personal papers, as well as books, exhibition catalogs, videotapes, photographs, and slides, providing an important repository for scholarship and information relative to the entire field of self-taught art. A color magazine, *Folk Art Messenger,* is published three times a year.

See also **African American Folk Art (Vernacular Art); Environments, Folk; Herbert W. Hemphill Jr.; Anderson Johnson; Tessa Prisbey.**

BIBLIOGRAPHY

Bowman, Russell. *Driven to Create: The Anthony Petullo Collection of Self-Taught Art.* Milwaukee, Wisc., 1993.

Guis, L.R. *Outsider Art: Creating Outside the Lines.* New York, 2001.

DEBORAH LYTTLE ASH

FOLK ENVIRONMENTS: *SEE* ENVIRONMENTS, FOLK.

FOLK MARQUETRY: *SEE* MARQUETRY, FOLK.

FOLK TOYS: *SEE* TOYS, FOLK.

FORCE, JULIANA RIESER (1876–1948), the first director of the Whitney Museum of American Art, was one of the earliest collectors of many varieties of American folk art, objects, and crafts. Her endorsement of the field led to the first public exhibition of folk art in the United States. Her advocacy of the folk idiom, in turn, was grounded in her wider professional aim of gaining recognition for American art.

Born in Doylestown, Pennsylvania to German immigrants, Juliana Rieser was always attached to Pennsylvania and its arts and crafts. About 1907 she met the sculptor and art patron, Gertrude Vanderbilt Whitney, and became the manager of Whitney's art enterprises in New York City. In 1912 Juliana Rieser married Willard Burdette Force, a dentist; two years later, the Forces bought a farm in Holicong, Pennsylvania, close to Doylestown. Juliana Force became a collector of folk art when she set up housekeeping in the country. Drawn to objects representing rural life in Bucks County, she began collecting Pennsylvania German cabinetry, and went on to acquire still-lifes, portraits, theorem paintings on velvet, vernacular sculpture, hand-carved toys, chalkware, quilts, and hooked rugs.

Although Force entered the field as an offshoot of her decorating, folk art also appealed to her as a manifestation of a vital American culture that she and her employer were working so tirelessly to validate. Force equated folk art with other examples of once ignored or disenfranchised expressions of artists flourishing outside official or academic channels. These independent artists, living and dead, were exactly the ones that Whitney and Force championed through exhibitions and purchases.

The initial public manifestation of Force's intent to elevate the aesthetic standing of folk art and establish a kinship with contemporary art was presented at the Whitney Studio Club, a precursor of the Whitney Museum, from February 9–24, 1924. "Early American Art," the first public showing of folk art in America,

was organized by Force's friend, the painter Henry Schnakenberg (1892–1970). In February 1927, the club exhibited the collection of the New England dealer Isabel Carleton Wilde.

In late 1929 Gertrude Whitney (1875–1942) and Juliana Force decided to establish a museum wholly devoted to American art, and the Whitney Museum of American Art opened on November 18, 1931. Force donated most of her nineteenth-century folk paintings and works on paper to the museum, which showed them in March 1932, in "Provincial Paintings of the Nineteenth Century." Of the fifty-three paintings and eleven watercolors and pastels on view, at least fifty-five works were Force's gifts. These works, along with nearly all of the rest of the Whitney's nineteenth-century holdings, were sold by the museum after Force's death.

See also **African American Folk Art (Vernacular Art); Chalkware; Juliana Force; Hooked Rugs; Painting, Theorem; Pennsylvania German Folk Art; Quilts; Quilts, African American; Sculpture, Folk; Still-life Painting; Toys, Folk.**

BIBLIOGRAPHY

Berman, Avis. *Rebels on Eighth Street: Juliana Force and the Whitney Museum of American Art.* New York, 1990.

———. "Juliana Force and Folk Art." *The Magazine Antiques,* vol. 136, no. 3 (September 1989): 542–553.

AVIS BERMAN

FRAKTUR is a twentieth-century term used to describe the folk art drawings made by the Pennsylvania Germans from the 1740s to the present. The word properly describes a typeface and related penmanship, but first came into American usage as a verb meaning "fancily written," and later as a noun to describe a body of work that recalled the tradition of illuminated manuscripts from medieval cloisters. That link cannot be satisfactorily established, but there are clear connections to European peasant practices in the eighteenth century and earlier. In some Swiss cantons, schoolmasters made fancy documents at the end of the school term, and from these *vorschriften* (writing examples) developed. At about the same time in Alsace, the German area of the Palatinate region in the eighteenth century, and in other parts of Switzerland, baptismal sponsors or godparents gave gifts intended for children wrapped in a greeting called a *goettelbriefe,* which usually named the child and wished him or her well. In Pennsylvania and

other areas of German settlement in the United States, items similar to these are what are generally defined as fraktur.

Birth and baptismal records, or *geburts und tauf-scheine,* or simply *taufscheine,* were records of the birth and baptism of Pennsylvania German children from the eighteenth century onward, naming the parents, the place of baptism, the clergyman who presided, the sponsors or godparents, and sometimes the sign of the zodiac for the day of the baptism, as German settlers in Pennsylvania used a lunar zodiac that changed signs nearly every day. The borders of the document were decorated with hymn verses about the meaning of baptism, as well as decorations of all sorts, from birds and flowers to images of the baptismal sponsors. Secular objects filled in the empty spaces. As early as 1784, Pennsylvania printers were making large quantities of these decorated certificates. The scriveners who filled in the texts at first were parochial schoolmasters supplementing their incomes, but by the latter half of the nineteenth century, vagrants wandering the countryside provided this service. Many of these documents survive, despite the widespread tradition of burying them with their owners. Some were attached to pension applications and others were just stored away; few were framed or otherwise displayed. In time, baptismal data ceased to be kept as diligently, but records of birth were still being produced as fraktur documents.

The *taufscheine* had a natural market among the majority of Lutheran and Reformed church members who baptized infants; the Mennonites, Amish, and Brethren, who did not do so, rarely adopted them. Instead, the schoolmasters among these people, as well as the Schwenkfelders (members of a German Protestant sect with so few members that they copied by hand their devotional literature, and who did not baptize their children), made a souvenir of a child's school years by writing a pious text (generally a hymn or a scripture) in several kinds of penmanship, and concluding it with the alphabet and numerals (known as a *vorschrift,* or a writing example). While the text might stop abruptly in mid-sentence in some examples, a few pieces were more carefully planned, and contained a complete hymn or passage of scripture without the added alphabet. Both versions were given, in all likelihood, to good students as encouragement, as indeed a few of them state. Some schoolmasters made a booklet of several leaves, sewn together to allow room for more examples of fine writing, with a fancy title page naming the owner. These were known as *vorschrift* booklets.

Because hardly any hymnals contained actual musical notation, "manuscript" hymnals were produced. The celibate members of the Ephrata Cloister in Lancaster County and at the Snow Hill Cloister in Franklin County, both in Pennsylvania, produced musical notation books for their entire membership, but in time schoolmasters made much smaller versions for their pupils' use. Each had a decorated title and ownership page.

Books were not common household possessions, and this fact made them highly treasured. Some artists personalized these prized possessions for their owners, often also indicating who had presented the book. As family Bibles became popular, fraktur artists entered the names and birth dates of each child born into the respective family's copy. In fact, among the Amish there are some people who still "mark" a book with elaborate penmanship, though with none of the flowers and birds associated with fraktur.

Christopher Dock, an eighteenth-century Pennsylvania German schoolmaster, wrote a manual for teachers who counseled love for their students. For those little ones who learned their ABCs well, he suggested the mother fry them an egg, and then he would give them a drawing of a flower or a bird. From this suggestion came the many small drawings, or presentation pieces, that were produced with simple designs and bright colors, most measuring about four by six inches. As time went on, they became more elaborate and often bore a simple text about giving one's heart to Jesus. Children would then save them as a souvenir of their schooling.

Eighteenth-century marriage and death records were as uncommon as birth records were plentiful. Some printers, however, made simple and somewhat romantic marriage certificates for the clergy to distribute, and other handmade fraktur certificates also exist. One eighteenth-century printer in central Pennsylvania devised a form to record information about the deceased, which would have been a boon to genealogists had this custom become a widespread practice. Still other kinds of frakturs include love letters, political frakturs, and wall pockets for holding letters or other papers.

Fraktur was definitely a part of the elementary education of Pennsylvania German children, who in the eighteenth century were raised as miniature adults, and the adult themes expressed in most examples of fraktur were, therefore, appropriate. Schoolmasters presented them, however, in ways that appealed to children, with fanciful images and bright colors. In this way the schoolmaster gained the child's favor—and increased his chances for a renewed con-

tract the next year. Enough pieces of fraktur exist with prices attached to support the fact that this was one of several ways in which schoolmasters increased their meager incomes. A *taufschein* would have cost about thirteen cents in the eighteenth century. Incomplete examples left in a fraktur artist's estate enjoyed a ready sale.

Fraktur also seems to have been the arena for discussion of the reality of death, among other important themes. Some of the small presentation pieces incorporate coffins, graves, and have texts advising constant readiness for what is to come at the end of life. The bright colors of these frakturs often mask a somber tone. Although some frakturs were buried with their owners, and many more lost to vermin, fire, or disintegration over time, there are still many surviving frakturs in existence. Moreover, the high prices frakturs command attests to their appeal.

A high percentage of fraktur incorporates copies of images from other visual sources, including everything from British coats of arms to the American eagle. Printers used small "cuts" (woodcuts or metal cuts) to add design elements to printed fraktur. The printer Henrich Otto (1733–c. 1800), who worked in Lancaster, Lebanon, and Northumberland Counties in Pennsylvania, added birds to many of his frakturs. At the same time, a standard motif of a heart with flowers springing out of it (and hearts containing a sentence or two concerning themes of the heart) was intended to represent the seat of human emotions. Crowns were popular because of a much-loved Bible verse, "Be faithful unto death and I will give you the crown of life." Religious symbols, such as the cross, however, rarely occur, probably so there would be no confusion with Roman Catholic art. In general, there is no hidden, secretive mysticism in the drawings that required any explanation. The pietistic Protestant teachings, so popular during the eighteenth century, that placed less emphasis on doctrinal precision and more on the disposition of the believer's will in religious matters had a profound influence on fraktur, more clearly in the texts than in the images.

While hundreds of people drew or lettered printed fraktur forms, a few stand out as masters of their art, and influenced their fellow artists more than is generally realized. Johann Henrich Otto fathered four fraktur-producing sons, and through his printed birds, copied by many artists, he had a significant impact on the genre. Otto along with Daniel Schumacher (1728–c. 1787) were likely the first to produce *taufscheine,* which eventually became important as records of birth. Schumacher in turn had many followers in Lehigh County, where he lived. Printers in

Ephrata, Reading, and Hanover, Pennsylvania, issued *taufscheine* with texts in three hearts that became almost standard among those who drew fraktur. The Mennonite artists of Montgomery County were copied by John Adam Eyer (1751–1837) and his many followers, including Andreas Kolb (1749–1811). Each of these men was highly productive. Without American precedent or many successors, the still unidentified Sussel-Washington Artist (active 1770s–1780s) made striking drawings of colonial figures that are eagerly sought by collectors. From Ontario to South Carolina, fraktur enjoyed immense popularity among German-speaking settlers who enshrined their piety, as well as love of color and symmetry, alongside whimsy in its design.

See also **Christian Alsdorff; Samuel Bentz; Martin Brechall; Cross-Legged Angel Artist; George Deisert; Ehre Vater Artist; George Heinrich Engellhard; John Adam Eyer; German American Folk Art; Johann Conrad Gilbert; Samuel Gottschall; Johann Jacob Friedrich Krebs; Christian Mertel; Museum of Early Southern Decorative Arts; Museum of Fine Arts, Boston; Daniel Otto; Johann Henrich Otto; Papercutting; Pennsylvania German Folk Art; Daniel Peterman; Francis Charles Portzline; Religious Folk Art; Daniel Schumacher; Schwenkfelders; Johannes Ernestus Spangenberg; Christian Strenge; Sussel-Washington Artist.**

BIBLIOGRAPHY

Amsler, Cory, ed. *Bucks County Fraktur.* Kutztown, Pa., 2001.

Bird, Michael S. *Gott sei Ehre: Religious Dimensions in Pennsylvania German Fraktur.* Lancaster, Pa., 2003.

Hess, Clarke. *Mennonite Arts.* Atglen, Pa., 2002.

Hollander, Stacy C., et al. *American Radiance: The Ralph Esmerian Gift to the American Folk Art Museum.* New York, 2001.

Moyer, Dennis. *Fraktur Writings and Folk Art Drawings of the Schwenkfelder Library Collection.* Kutztown, Pa., 1992.

Shelly, Donald A. *The Fraktur Writings or Illuminated Manuscripts of the Pennsylvania Germans.* Allentown, Pa., 1961.

Swank, Scott T., ed. *Arts of the Pennsylvania Germans.* New York, 1983.

Weiser, Frederick S. *The Gift Is Small, the Love Is Great.* York, Pa., 1994.

Weiser, Frederick S., and Howell J. Heaney. *The Pennsylvania German Fraktur of the Free Library of Philadelphia,* 2 vols. Breinigsville, Pa., 1976.

FREDERICK S. WEISER

FRATERNAL SOCIETIES, typified by the Freemasons, the Odd Fellows, the Elks, and the Knights of Columbus, have used ceremonial initiations to bind Americans together in brotherhood since the first half of the eighteenth century. Members of these groups

have placed fraternal symbols on objects from ceremonial chairs to razor blades, calligraphic certificates to ornate ceremonial staves, and from ice cream molds to casket handles. Although the line of demarcation is often indistinct, fraternal material culture may be broadly divided into two categories: objects made for institutional use, and personal items used by members to celebrate their participation. Ceremonial altars, ritual regalia, emblematic paintings, lodge room ornaments, parade banners, and officers' jewels fall within the former grouping. Marquetry sideboards and mirror frames, decorated snuff boxes and walking sticks, and symbolic watch fobs and coverlets characterize the latter class.

Fraternal objects are created in a wide range of contexts. Some items are lovingly created by enthusiasts to express devotion to organizational ideals and unity. In other cases, professional artists and artisans, including milliners, painters, and furniture turners, have been awarded specific commissions. Starting in the 1850s, and more commonly after the American Civil War, specialized regalia houses provided large quantities of manufactured goods to fraternal groups across the country. Many of these businesses maintained distinct catalogs for a variety of organizations, with the goods distinguished only through interchangeable motifs and symbols. Among the most prominent of these were M.C. Lilley & Company, of Columbus, Ohio, the Henderson-Ames Company of Kalamazoo, Michigan, and the Ward-Stilson Company of Anderson, Indiana. Although regalia firms produced fraternal goods in large quantities, they also regularly created unique goods, such as parade banners and embroidered lodge-room furnishings, to consumers' specifications. Distinguishing between goods created locally and those manufactured by regalia houses can be difficult.

Fraternal materials are often included in collections of American folk art. Edgar William (1899–1979) and Bernice Chrysler Garbisch (1907–1979), for example, donated to the Museum of Fine Arts, Boston, a painting by Charles Sidney Raleigh (1830–1925) featuring an emblematic vision of a Native American and an Anglo American shaking hands, and inscribed "Sargis Lodge." Herbert W. Hemphill Jr. (1929–1998) and Michael (1941–) and Julie Friedman Hall (1943–) have also exhibited a taste for fraternal materials. Some enthusiasts are attracted to the bold graphic compositions often employed by fraternalists, and find arrangements of ritual iconography reminiscent of twentieth century Surrealism. Others find fraternal material culture an irresistible entry into an arcane world of apparently endless systems of rituals and symbols. Most collectors of fraternal objects, however, are also motivated by nostalgia for a seemingly simpler America in which individuals gathered in lodges to share fellowship and brotherhood.

Fraternal groups, which historically have segregated members along race, class, and gender lines, organize themselves around fictive kin relationships. Members of these groups characteristically share secret knowledge concerning arcane systems of symbols, refer to one another as "brothers" or "sisters," and take a special interest in one another's welfare. Fraternalism is defined by the initiation ceremonies that candidates undergo to become members. In these rituals, initiates characteristically assume metaphoric new identities and are exposed to words and images that symbolize the ideology of the group. Many lodges have multiple tiers of membership with discrete ceremonies performed to mark an individual's progress through the levels. Entered Apprentice, Fellow Craft, and Master Mason, for example, are the three basic degrees of Freemasonry, just as the Initiatory, Armorial, and the Chivalric are the first three ranks of the Knights of Pythias. The performance of these rituals serves both to inculcate new members into the organization's lessons and to reinforce beliefs in the established membership. The identities assumed by members through participation in fraternal initiation ceremonies are meant to guide their behavior according to the dictates of the organization. By joining the Order of the Little Red Schoolhouse, founded in 1895, for example, a man vowed to support the patriotic and egalitarian principles embodied by public education. By participating in the Royal Order of Jesters, a minor organization within the Masonic community whose motto is Mirth Is King, fraternalists learn how not to take life too seriously.

Although organizations attempted to keep private their ceremonies and the symbolic meanings of their emblems, they simultaneously wished to project a vital and prosperous public identity. Institutional emblems, such as the square and compass of the Freemasons, the three links of the Odd Fellows, and the tent of the Rechabites, were proudly emblazoned on buildings, painted on parade banners, and sported on lapel pins and watch fobs. Organizations also used initials, such as B.P.O.E for Benevolent and Protective Order of Elks, M.W.A. for the Modern Woodmen of America, and I.O.R.M. for the Improved Order of Red Men, to simultaneously reveal their presence to the initiated while intriguing or mystifying outsiders.

Freemasonry, which established lodges in many American cities along the Atlantic seaboard by 1750, was the earliest fraternal society and set the pattern

for other voluntary organizations. The Odd Fellows, which like the Freemasons had roots in England, was established in the United States by the first quarter of the nineteenth century. The Improved Order of Red Men, which has claimed it evolved out of the patriotic Sons of Liberty of the American Revolution, was among the earliest fraternal organizations founded in America.

The popularity of fraternal societies exploded in the second half of the nineteenth century, leading to the creation of the Knights of Pythias in 1864, the Benevolent and Protective Order of Elks in 1866, the Ancient Order of United Workmen in 1868, the Knights of Columbus in 1882, and the Concatenated Order of Hoo Hoo in 1892, among many others. In 1897 an estimated 6 million Americans belonged to more than three hundred distinct fraternal groups that accepted more than 200,000 new members each year. Rapid industrialization, immigration, and urbanization in America during these years of growth led many Americans to experience social dislocation and alienation. Consequently, many individuals made fraternalism integral to their personal identity, often joining multiple organizations to gain the advantages that membership conferred. Within the growing national economy, belonging to a fraternal organization also tied a joiner to a broad, geographically dispersed interpersonal network. Fraternalism additionally provided American men with instruction in the concepts of masculinity during a period in which men and women functioned largely in separate realms, and male authority was being de-emphasized in mainstream churches. Because of these omnipresent secret societies in American culture during this period, the final years of the nineteenth century in this country have been characterized as the "Golden Age of Fraternalism."

The fraternal model was so pervasive in American society during these years that it was adopted by a wide range of organizations promoting disparate—and often conflicting—agendas. For example, the Grand Army of the Republic initiated Union Army veterans into local camps to promote patriotism and to organize political support for government benefits. The Patrons of Husbandry, better known as the Grange, was founded as a mutual support network for agricultural communities, and still functions in this capacity. The Sons of Temperance used the organizational schema to fight the evils of alcohol, while the Royal Fellows of Bagdad (*sic*) lobbied against Prohibition. The Royal Arcanum, the Independent Order of Foresters, and many other mutual-benefit societies essentially provided insurance coverage to their members. Various Ku Klux Klan groups, active in

both the nineteenth and twentieth centuries, utilized fraternalism to promote reactionary politics and race hatred.

Although many groups restricted membership to Protestant male Caucasians, fraternal organizations were also founded by and for women as well as religious, ethnic, and racial minorities. Women usually joined groups such as the Order of the Eastern Star and the Pythian Sisters, which were female auxiliaries to Freemasonry and the Knights of Pythias, respectively. African Americans, who because of the pervasive racism of American society were systematically denied membership in Caucasian organizations, participated in parallel fraternities such as the Grand United Order of Odd Fellows, Prince Hall Freemasonry, and the Improved Benevolent and Protective Order of Elks, which often had organizational antecedents in Europe where the color barrier was not as pervasive. Other groups, such as the Knights of Tabor, are unique to African American communities. Immigrants to the United States often used fraternal organizations as a resource for maintaining ethnic identity, founding groups including the Sons of Italy, the Ancient Order of Hibernians, the Polish Falcons of America, and the Maids of Athena, among others.

Many fraternal organizations, including the Knights of Pythias, the Knights of Columbus, and the Red Men, have continued to function into the twenty first century. The Golden Age of Fraternalism, however, came to an end at about the time of the Great Depression. The economic climate meant that many could no longer afford the expense of membership, but more important, American society had changed. Companionate marriage undercut the ideology of separate gender spheres through which fraternalism had blossomed at approximately the same time that radio broadcasting eroded the isolation of local communities. After World War II, some of the vitality of fraternal brotherhoods was refocused into service clubs such as the Rotary and the Kiwanis, but much of the energy that had previously been expended in performing rituals and managing organizations simply dissipated into other leisure activities.

See also **Coverlets; Edgar William and Bernice Chrysler Garbisch; Fraternal Societies; Freemasonry; Michael and Julie Friedman Hall; Herbert Waide Hemphill Jr.; Marquetry; Museum of Fine Arts, Boston; Powder Horns.**

BIBLIOGRAPHY

Axelrod, Alan. *The International Encyclopedia of Secret Societies and Fraternal Orders.* New York, 1997.

Carnes, Mark C. *Secret Ritual and Manhood in Victorian America.* New Haven, Conn., 1989.

Clawson, Mary Ann. *Constructing Brotherhood: Class, Gender, and Fraternalism.* Princeton, N.J., 1989.

Franco, Barbara. *Fraternally Yours: A Decade of Collecting.* Lexington, Mass., 1986.

Stevens, Albert C. *Cyclopedia of Fraternities.* New York, 1899.

WILLIAM D. MOORE

FREAKE LIMNER: *SEE* FREAKE-GIBBS-MASON LIMNER.

FREAKE-GIBBS-MASON LIMNER (active 1670–1674) is known by approximately ten closely related portraits in oil on canvas that were painted of merchants, public officials, ministers, and children in Puritan Boston between 1670 and 1674. The works of this artist have been regarded by many scholars as seminal in the history of American folk portraiture, at least since 1935, when noted proponents of folk art Holger Cahill (national director of the Federal Art Project) and Alfred H. Barr (director of the Museum of Modern Art) declared the Freake portraits "among the finest of American primitives" as well as among the roots of nineteenth-century folk painting.

Although no biographical information is known with certainty about the Freake-Gibbs-Mason Limner, the artist's ten surviving works are linked by their common style, color, and composition. Each of the portraits is painted in a richly patterned, linear style that emphasizes the decorative lace, Turkeywork upholstery, and other textiles that belonged to the sitters and are included in the paintings. The costumes and possessions depicted in the Freake-Gibbs-Mason Limner's portraits identify the social position of the sitters. Seventeenth-century probate records confirm that the clothes, jewelry, and furniture depicted were actually owned by the subjects with whom they appear. Such details not only helped to individualize the sitter but also conveyed information about occupation, social rank, or gender. For example, portraits of John Freake, Edward Rawson, Robert Gibbs, and John Mason each depict a man or a boy holding gloves, a sign of gentility.

An even light usually flattens the figure and de–emphasizes any modeling of the features. The draftsmanship is precise yet simplified and slightly stylized. Most of the known works represent a single standing figure facing forward, though the noted likeness of Elizabeth Freake and her daughter Mary is a double portrait—originally a single portrait—with the child on her mother's lap added in 1674, and the three Mason children appear together in the only surviving group portrait by this artist. In addition to black, brown, and white, this artist used bright, appealing colors, such as green, red, and yellow.

In short, the flat, linear style, strong frontal compositions, and use of attributes are among the defining strengths of paintings by the Freake-Gibbs-Mason Limner. These are also some of the characteristics that suggest these portraits are the basis of the American folk portraiture in the nineteenth century that flourished in the hands of artists such as Ammi Phillips (1788–1865), Joseph Whiting Stock (1815–1855), and Erastus Salisbury Field (1805–1900).

While the Freake-Gibbs-Mason Limner has long held a place of honor in the history of folk art, this artist is also thought to represent an expression of the English courtly style in Boston. The Boston portraits are consistent with the writings and miniatures of the Elizabethan artist Nicholas Hilliard (1547–1619). According to Hilliard, linear style and flatness were to be admired, while depth and three-dimensionality were to be avoided. Indeed, Hilliard equated the linear style with truth and virtue, qualities that may have helped to make such portraits acceptable within the restrictive Puritan culture. The use of attributes to convey social position also has its roots in English academic painting, albeit as a holdover from the earlier medieval style. Thus, the work of the Freake-Gibbs-Mason Limner is also claimed as the foundation of American academic painting.

The term "limner," long associated with this artist and many others, was used in the seventeenth century to refer specifically to miniaturists; the broader definition of "a painter of likenesses" was added later. As such, the term is useful in linking this artist to a tradition of American folk portraiture, but misleading in the context within which the Freake-Gibbs-Mason Limner worked.

See also **Erastus Salisbury Field; Painting, American Folk; Ammi Phillips; Joseph Whiting Stock.**

BIBLIOGRAPHY

Cahill, Holger, and Alfred H. Barr Jr. *Art in America: A Complete Survey.* New York, 1935.

Craven, Wayne. *Colonial American Portraiture: The Economic, Religious, Social, Cultural, Philosophical, Scientific, and Aesthetic Foundations.* Cambridge, England, and New York, 1986.

Dresser, Louisa. *Seventeenth-Century Painting in New England.* Worcester, Mass., 1935.

Fairbanks, Jonathan L., et al. *New England Begins: The Seventeenth Century,* 3 vols. Boston, 1982.

Strickler, Susan E. "Recent Findings on the Freake Portraits." *Worcester Journal,* vol. 5 (1981/1982): 32–47.

DAVID BRIGHAM

FREEMASONRY, a ritual-based fraternal brotherhood with roots in seventeenth century Great Britain, has been active in America since the fourth decade of the eighteenth century. Elements of its symbolism, which center on the building of Solomon's Temple in ancient Israel, are pervasive in American art and material culture. The sheer numbers of Americans involved in Masonic organizations over the centuries has resulted in its symbolism becoming part of the national visual vocabulary. Masonic symbols appear, among other places, woven into coverlets and sewn into quilts, incised into powder horns and inlaid into furniture. John Haley Bellamy (1836–1914), who is best known for his carved eagles, created designs for Masonic frames and shelves. Joseph H. Davis (active 1832–1837), the "left-hand" portraitist from antebellum New England, included Masonic attributes in his images of bourgeois men. Masonic symbolism even informed Shaker gift drawings.

Freemasonry is the country's oldest, largest, and most influential fraternal organization. Millions of American men, including such disparate figures as George Washington, Benjamin Franklin, Andrew Jackson, John Philip Sousa, Harry Houdini, Henry Ford, and J. Edgar Hoover, have been initiated into Masonic lodges. Significant numbers have also participated in Freemasonry's related organizations, including the Knights Templar, the Scottish Rite, the Ancient Arabic Order of Nobles of the Mystic Shrine, the Tall Cedars of Lebanon, and the Mystic Order of Veiled Prophets of the Enchanted Realm, among others. Because Freemasonry has gathered both harsh critics and ardent advocates throughout its institutional history, contradictory accounts of the organization abound. When conducting research on Masonic matters, individuals must carefully evaluate all sources.

Masonic rituals posit that the contemporary fraternity is derived from the labor force that erected King Solomon's Temple, the structure built on Mount Moriah in Jerusalem to house the Ark of the Covenant and serve as the central place of worship for the ancient Israelites. Referring to this origin myth, Freemasonry instructs initiates in a system of ethics and morals based upon architectural allegories and metaphors centered on Solomon's temple. When a man becomes a Freemason, he undergoes a ritual drama of three levels or degrees. The murder of Hiram Abiff, the legendary architect of the temple, forms the central narrative of this ceremony. By witnessing this drama, initiates are exposed to supposedly ancient wisdom encapsulated in architectural symbolism. The process of becoming a Freemason has traditionally been represented by rough and perfect ashlars, or building stones. A rough ashlar, drawn straight from the quarry with irregularities intact, signifies a man before he is schooled in Masonry. A perfect ashlar, in contrast, with square corners and planar sides, represents a man educated by the fraternity to fit into society. Solomon's temple serves as a metaphor for a community made up of enlightened citizens. Stonemasons' tools, such as the square, compass, plumb, and level, are used to convey ideas concerning virtue, moderation, and correct behavior. Artists including Ezra Ames (1768–1836), John Ritto Penniman (1782–1841), and John Gadsby Chapman (1808–1889) created paintings used for teaching the lessons of this ritual. Jeremy Cross (1783–1860), an American Masonic ritualist, did much to standardize Masonic ritual usage in the United States by publishing his *Masonic Chart and Hieroglyphic Monitor,* in 1819, with illustrations by Connecticut engraver Amos Doolittle (1754–1832).

Freemasonry historically evolved from medieval stonemasons' guilds. During the seventeenth century (having been influenced by Rosicrucianism, which posited the existence of a secret religious society of individuals initiated into ancient wisdom, and by Neoplatonism, which held that human actions in the material world influence outcomes in the spiritual realm, as well as by other ideas current in Europe during the Renaissance) wealthy and educated men joined these craftsmen's organizations. In the second decade of the eighteenth century, gentlemen gained control of a number of guilds, and transformed them. Rather than being fellowships that bound skilled workmen together, these Masons' lodges became fraternities dedicated to instructing men in morality and ethics. To use the fraternity's own terminology, these lodges were composed of "speculative" Freemasons rather than "operative" masons who worked in stone. To coordinate their activities, four lodges located in London united in 1717 to form the first Grand Lodge. In this context, Freemasonry became a conduit for instructing elite gentlemen in genteel sociability and the concepts of the Enlightenment, including humanism, self-rule, and rationality. This group of gentlemen early on gained the patronage of members of the British royal family.

From England, Freemasonry spread quickly. In the 1730s, Masonic lodges existed in Madrid, Paris, Hamburg, and The Hague. During these years, Continental Freemasonry functioned within the aristocracy and, rather than connecting itself metaphorically with artisanal building guilds, claimed descent instead from educated architects and medieval chivalric orders like the Knights Templar. Freemasonry's growth, with its

concomitant spread of Enlightenment thought, drew the attention of the Catholic hierarchy. In 1731, fearing that the fraternity undermined the status quo, the Pope issued a ban on participation in Masonic activities.

Masonry also traveled west across the Atlantic, and by the 1730s lodges were functioning in Boston; New York; Philadelphia; Charleston, South Carolina; Savannah; and the Cape Fear region of North Carolina. At its genesis, American Freemasonry was an elite institution that gathered the most important men in the colonies while simultaneously linking them to powerful individuals in the British Empire.

During the middle decades of the eighteenth century, alternative Masonic organizations developed in the British Isles that challenged the authority and legitimacy of the Grand Lodge formed in 1717. Grand Lodges developed in York, England, and in Scotland and Ireland. Laurence Dermott (1720–1791), an Irish-born merchant with an artisanal background, led a competing Grand Lodge that announced its presence in London in 1751. This upstart group claimed that the earlier Grand Lodge had strayed from ancient precedents by introducing detrimental innovations into Masonic practices. Thus dubbing the earlier Grand Lodge as "Modern," this later organization designated itself as "Ancient." Dermott's Ancient Grand Lodge, composed of men of less elevated social origin, grew from ten lodges in 1753 to more than fourteen times that many twenty years later. During this period, British military regiments came to have Ancient lodges associated with them.

American men like the silversmith Paul Revere (1735–1818) and the printer Isaiah Thomas (1749–1831), who had risen to local prominence but were not elite gentlemen, founded Ancient Masonic Lodges in the colonies in the 1750s and 1760s. Unlike earlier American Freemasonry that had developed only in coastal cities, Ancient lodges were formed inland. On the eve of the American Revolution, "Modern" elite Freemasonry uneasily coexisted in the colonies with its artisanal "Ancient" counterpart. Modern lodges tended to have Loyalist affinities, while Ancient lodges contained men with more democratic and republican ideals.

Following the war, lodges identified as Modern either ceased to exist or merged with the Ancient system of lodges. Although lodges continued to identify themselves as both Free and Accepted Masons (F. & A.M.), and as Ancient Free and Accepted Masons (A.F. & A.M.), after the 1790s the distinction basically became meaningless. During the first years of America's new republic, Freemasonry became a de

facto deistic civic religion. On September 18, 1793, George Washington participated in a Masonic ceremony and wore a Masonic apron to dedicate the Capitol of the United States.

In the 1770s, a Masonic lodge associated with a British regiment stationed in Boston initiated a free black man named Prince Hall (1735–1807), along with fourteen other African Americans. Hall received a lodge charter from London in the 1780s, and founded African Lodge No. 459, comprised of Boston's most prominent black men. The Caucasian American Grand Lodges that formed in each of the states following United States independence refused to recognize the legitimacy of the black Freemasons. Hall nevertheless came to claim the title of Grand Master, and chartered lodges composed of African Americans in Providence and Philadelphia. From this genesis, an African American Masonic movement developed, prospering throughout the nineteenth and twentieth centuries while being either ignored or persecuted by the white Masonic establishment. In 2001, Prince Hall Masonry and the Grand Lodge of New York finally established mutual recognition.

Throughout the end of the eighteenth to the beginning of the nineteenth century, rituals composed of esoteric ideas associated with Freemasonry were carried to America from Europe. Eventually, these *hautes grades,* or "higher degrees," many of which reflected the Continental heritage of associating Freemasonry with aristocratic chivalric orders, were organized into two systems, designated as the York Rite and the Scottish Rite. The York Rite included the Royal Arch degrees, whose central drama unfolded around rebuilding Solomon's temple, and the Knights Templar degrees, which gave individuals a metaphoric identity as crusading knights who once defended Jerusalem. The Scottish Rite, which systematized a series of chivalric rituals that descended from France via the Caribbean, was institutionalized in Charleston, South Carolina, in 1801.

During the 1820s, an anti-Masonic movement, driven by Jacksonian egalitarianism and Christian perfectionism, nearly drove the Masonic fraternity out of existence. By the 1850s, however, the fraternity rebounded, reaching unparalleled influence and membership following the American Civil War as part of a larger blossoming of interest in fraternal societies. Freemasonry became an important institution through which middle-class American men defined masculinity. Robert Morris (1818–1888), one of the leaders of the mid-nineteenth century resurgence, also founded the Order of the Eastern Star, an organization for female relatives of Freemasons. During

the final decades of the nineteenth and the first decades of the twentieth century, a wide variety of auxiliary organizations were founded for Freemasons and their relatives. The most successful, the Ancient Arabic Order of the Nobles of the Mystic Shrine, claimed a Middle Eastern origin and wrapped itself in Egyptian and Islamic motifs.

See also **Ezra Ames; John Haley Bellamy; Coverlets; Joseph H. Davis; Fraternal Societies; Marquetry; John Ritto Penniman; Powder Horns; Quilts; Shaker Drawings; Shakers.**

BIBLIOGRAPHY

Bullock, Steven C. *Revolutionary Brotherhood: Freemasonry and the Transformation of the American Social Order, 1730–1840.* Chapel Hill, N.C., 1996.

Duncan, Malcolm C. *Duncan's Masonic Ritual and Monitor.* New York, n.d.

Hamilton, John D. *Material Culture of the American Freemasons.* Lexington, Mass., 1994.

Moore, William D. "American Masonic Ritual Paintings." *Folk Art,* vol. 24 (winter 1999/2000): 58–65.

Museum of Our National Heritage. *Masonic Symbols in American Decorative Arts.* Lexington, Mass., 1976.

WILLIAM D. MOORE

FRIED, FREDERICK (1908–1994) conducted groundbreaking research on American carousels, the woodcarvers of carousel animals, cigar store figures, amusement parks (especially Coney Island), arcadia ephemera (canvas and wooden advertising signs, photographs, games, and ornamentation), and tattoos. He also discovered the work of the important American folk painter, Ralph Fasanella, in 1972. He was a consultant to the Shelburne Museum, the South Street Seaport Museum, and the American Folk Art Museum, as well as a frequent writer and lecturer. Besides books on carousel art, shop figures, circus art, and American folk art in general, he also wrote *New York Civic Sculpture: A Pictorial Guide* (1976), with photographs by Edmund V. Gillon Jr., and *Built to Amuse: Views from America's Past (Postage Postcard Series)* (1990). Frederick Fried also served as the historian for the Musical Box Society International, and was a founder of the National Carousel Association.

Fried was a native of Brooklyn, but as an adult lived in Manhattan and summered in Lincoln, Vermont, where in 1993 an arsonist set fire to his barn; a portion of Fried's folk art collection was destroyed. Fried obtained a college education in fine arts in the 1930s, served in the United States military in World War II, and enjoyed a career as an art

director at several fashion agencies. By 1961 he devoted all his time to collecting, research, and consulting. He and his wife Mary (1913–) were active in landmark conservation. They donated their folk art archives to the Smithsonian Institution. The files are summarized as "subject files [that] relate to carousels and carousel animals, but there are also voluminous files on other folk art topics, including show figures, architectural ornamentation, signs, weathervanes, ship carvings, circus art, coin-operated machines."

Fried is known for his primary research on New York City shop figure carver Samuel Anderson Robb (1851–1928), resulting from his discussions with the carver's daughter, Elizabeth, before her death in 1967. Fried also interviewed Thomas H. McKay, son of successful clipper shipbuilder Donald McKay (dates unknown), and learned of the young McKay's interview with shop figure carver Thomas V. Brooks (1828–1895), who maintained shops first in New York City and later in Chicago and under whom Robb had apprenticed. His primary research and interviews lead to the publication of *Artists in Wood,* Fried's greatest contribution to folk art scholarship.

See also **American Folk Art Museum; Thomas V. Brooks; Carousel Art; Circus Art; Ralph Fasanella; Maritime Folk Art; Samuel Anderson Robb; Shelburne Museum; Ship Figureheads; Shop Figures; Tattoo; Toys, Folk; Weathervanes.**

BIBLIOGRAPHY

Fried, Frederick. *A Pictorial History of the Carousel.* New York, 1964.

———. *Artists in Wood: American Carvers of Cigar-Store Indians, Show Figures, and Circus Wagons.* New York, 1970.

———. *America's Forgotten Folk Arts.* New York, 1978.

WILLIAM F. BROOKS JR.

FROST, JOHN ORNE JOHNSON (1852–1928) had a deep love of the sea and a pride in his hometown of Marblehead, Massachusetts, that inspired more than one hundred paintings based on maritime themes and local history. Many of Frost's painted scenes are aerial views enhanced by accompanying text. *Marblehead Fleet Returned from the Grand Banks* shows minutely detailed houses, fences, animals, flowers in doorways, as well as factories, shipyards, and street names, and includes captions. A lookout sights the fleet and alerts the townspeople, who assemble from every direction to welcome the fishermen upon their return from sea.

At age sixteen, Frost went to sea as a fisherman. Despite the hazardous weather conditions out on the Grand Banks in the North Atlantic, he signed up again the following year. The challenge of these journeys quelled his wanderlust, and he settled down to work in Marblehead the next year. In 1870, after Frost met and married Ann Lillibridge, he took a job with his uncle as a carpenter's apprentice. A year later, he went to work in a restaurant owned by his father-in-law. He remained in the restaurant business most of his working life.

Following an illness in 1895, Frost worked with his wife in her successful flower business. When his wife's own health deteriorated in 1919, he began to paint. He constructed a small building behind his house where he exhibited his paintings and carved models of Marblehead buildings, ships, and fish. Frost said that he was drawn to painting because he wanted to be prepared to answer questions from visitors to Marblehead who might ask about "the town and the way the fishing business was carried on . . . That started me to try." Frost worked with oil paint on academy board, chipboard, and Masonite, and applied color with no attempt at shading or modeling. He also worked entirely from memory.

When local citizens derided paintings of his displayed in a shop window, Frost said, according to Arthur Hentzelman of the Boston Public Library, "If they make people laugh, they were doing some good." Upon his death, Mrs. Albert Carpenter, a collector, acquired many of Frost's paintings. About thirty additional panels were discovered in 1954 by Mr. and Mrs. Frederick Mason, who had purchased Frost's home. They were found nailed to the walls with the images facing in.

See also **Maritime Folk Art; Painting, American Folk; Painting, Memory.**

BIBLIOGRAPHY

Lipman, Jean, and Tom Armstrong, eds. *American Folk Painters of Three Centuries.* New York, 1980.

Little, Nina Fletcher. "J.O.J. Frost: Painter Historian of Marblehead." *Art in America,* vol. 43, no. 3 (October 1955): 26–33.

Reynolds, Robert L. "History in House Paint." *American Heritage,* vol. 13, no. 4 (June 1962): 10–19.

Rumford, Beatrix T., ed. *American Folk Painting from the Abby Aldrich Rockefeller Folk Art Center.* Williamsburg, Va., 1988.

LEE KOGAN

FRYMIRE, JACOB (born between 1765 and 1774–1821) was a portrait painter who worked in oil on canvas in the Middle Atlantic states of Pennsylvania, Maryland, New Jersey, and Virginia, as well as Kentucky from the early 1790s until his death. His work was rediscovered in the later half of twentieth century, and is regarded as representative of the itinerant limners or portrait painters active in the American South.

Little is known of the artistic training of this painter. His life can be traced through the signed and dated portraits he created, as well as land and estate records in Franklin and Cumberland Counties in Pennsylvania. His family had ties to Lancaster County, Pennsylvania, and it is speculated that he worked from there and east to New Jersey during his early painting career. His father moved to Franklin County, Pennsylvania, and by the mid-1790s the artist had followed, and was also traveling to the adjoining states of Maryland and Virginia seeking commissions. In successive visits in 1799, 1800, and 1801, he visited Winchester and Alexandria, Virginia, painting portraits of local innkeepers and merchants, including members of the Lauck and McKnight families. The Shenandoah Valley and nearby counties of Virginia was a region to which he returned over the next few years. In 1803 he worked in Warrenton, Virginia, and two years later he was back in Winchester. Like many of his contemporaries in the region, Frymire's movements followed the westward population shift, and in 1806 he was working in Woodford County, Kentucky, depicting families with ties to the valley regions he had earlier frequented, suggesting a system of recommendations conveyed by the artist as he moved from place to place.

Frymire owned property in Shippensburg, Pennsylvania, where he resided with his wife, Sarah, and his growing family. His later years appear to have been spent farming land inherited after his father's death in 1816. He was taxed not only as a farmer but also a limner, in both Franklin and Cumberland Counties, between 1807 and 1820. His will, written two months before his death in July of 1822, is a document of kindness and sensitivity, providing care for his wife and nine children as well as a tenth child, who was born after the artist's death.

See also **Painting, American Folk.**

BIBLIOGRAPHY

Simmons, Linda C. *Jacob Frymire: An American Limner.* Washington, D.C., 1975.

———. "Early Nineteenth-Century Non-Academic Painting in Maryland, Virginia, Kentucky, and the Carolinas." *The Southern Quarterly,* vol. 24, no. 1 (1985): 32–55.

———. "Eighteenth- and Nineteenth-Century Artists Active in the Northern Shenandoah Valley." *Winchester-Frederick County (Virginia) Historical Society Journal,* vol. 4, (1989): 48–110.

LINDA CROCKER SIMMONS

FUREY, JOSEPH ENDICOTT (1906–1990) created a dazzling painted and decorated mixed-media environment in his rented New York City apartment, located in the Park Slope neighborhood of Brooklyn. The polychromed walls and ceilings of all the rooms were enhanced with collage elements: paint-dotted clam and mussel shells; painted cardboard cutouts of hearts, crosses, and diamonds; bits of mirror; two large, scenic murals; as well as other materials, such as lima beans and plaster-of-paris birds. More than 70,000 decorative pieces were applied to the surfaces and organized into small, balanced, self-contained units, with a surprisingly coherent and harmonious total effect. Furey also constructed a few small and idiosyncratic pieces of furniture.

The environment was discovered in 1988, shortly after Furey moved out of the space he had occupied for half a century, to live with his son in Goshen, New York. Maintenance men, sent to work on the vacated apartment, contacted the owners, who subsequently were put in touch with the American Folk Art Museum.

Born in Camden, New Jersey, Furey also spent time in Newfoundland, Canada. He worked as a seaman, had some success in his career as a prizefighter, and spent years as a structural steelworker, with jobs on the George Washington and Golden Gate Bridges. Furey never considered himself an artist until museum professionals identified him as such.

In the 1970s Furey began, with his wife's approval, to tile the bathroom along with some kitchen cabinets, to which he applied small, multicolored tiles. His creative efforts, however, intensified in 1981, after his wife, Lillian Barker, died. He had said that he was very lonely and "was looking for something to do to get over the grief." Furey claimed that many of his design ideas came to him during the night. Otherwise generally impatient, he spent thousands of hours planning his designs, gathering his materials, and executing the work. Some early training in blueprint reading was useful in planning his designs and calculating the number of pieces required for filling in his designs.

Recognized as a work of art by both the Brooklyn Museum of Art and the American Folk Art Museum, the urban environment was razed when the subsequent occupants of the apartment, Addison Thompson and Lesa Westerman, moved out. During the time they occupied the apartment, the couple was committed to maintaining the aesthetic integrity of Furey's creation.

See also **Environments, Folk; Furniture, Painted and Decorated.**

BIBLIOGRAPHY

Kogan, Lee. "Living in a Brooklyn Apartment." *The Clarion*, vol. 15, no. 2 (summer 1990): 51–55.

———. "Joseph Endicott Furey (1906–1990)." *The Clarion*, vol. 16, no. 2 (summer 1991): 14.

LEE KOGAN

FURNITURE, PAINTED AND DECORATED, falls within the purview of American folk art when the surface treatments applied to vernacular furniture supersede the functional elements. Indeed, some of the best painterly effects of American folk artists appear not on canvas, but on pieces of furniture. The fluidity of paint, its variety of colors, and a host of application techniques combine to create the possibility of incalculable surface treatments for chairs, tables, chests, desks, beds, and other furniture forms. Furniture could be painted a single color or more, or in combination with carving. Paint could be manipulated to imitate woods or marbles, or it could emulate or improve upon nature. As both artistic expression and material culture, painted furniture follows the prevailing styles codified in the history of American furniture as well as the decorative arts.

The earliest known American painted furniture from the colonial period (1630–1730) dates to the last quarter of the seventeenth century, with decoration found on surviving panel-and-frame oak chests bearing traces of red and black paint within the strapwork carving or ebonized finishes on applied spindles, as well as other decorative components. By the end of the seventeenth century, furniture making underwent numerous changes: the cabinetmaker replaced the joiner; panel-and-frame construction gave way to mortise-and-tenon construction; and carved and applied spindle and boss decoration was often superceded by painted polychrome decoration.

Two regional schools of cabinetmaking exemplify this new aesthetic. The first was centered around Hadley, Massachusetts, situated on the banks of the Connecticut River in western Massachusetts; the second was located in the Guilford/Saybrook region of coastal Connecticut, east of New Haven. Both schools drew from an expanded palette of blues, greens, reds, varying shades of yellow, black, and white, but differ in their motifs, composition, and the spirit of the decoration. The best known of the Hadley chests is the "SW" chest, in the collection of the Pocumtuck Valley Memorial Association, with its carefully laid out, hand-painted, compass-delineated, geometric

patterns within borders on the drawer fronts. Delicately stylized trailing vines and leaves decorate the intervening drawer frames. The two front stiles frame the interior with hand-painted inverted heart shapes, simple diamonds, open circles, stylized leaves, and concentric circles. The carefully organized palette of red, black, gray, and brown motifs on a white ground pops with an abstraction that anticipates contemporary art. In its overall appearance, this chest brings to mind the carving of its predecessors, yet at the same time looks forward by using paint as the single exhilarating embellishment.

In contrast to the geometric patterning on Hadley chests, surviving chests from the Guilford/Saybrook area display delicate hand-painted decorative devices, including roses, thistles, fleur-de-lis, and urns of flowers with trailing vines emanating from a central motif and flowing outward to the edge of the drawers. A single tulip or bird occupies nearly the full length of the chest's side panels. The decorative palette of these chests includes ochre, red, yellow, green, and white paints on a black ground. The patterning on the Guilford/Saybrook chests is related to needlework in the Mannerist style seen in English embroidery, which was adopted during the first quarter of the eighteenth century in American textiles, on engraved silver.

Another imported English aesthetic is that of japanned furniture, with its chinoiserie motifs inspired by oriental lacquer. Cabinetmakers, working primarily in Boston and New York, produced high-style versions of japanned furniture between 1715 and 1740, featuring raised figures, animals, birds, and pagodas decorated in gold powders and gold leaf on ebonized black grounds. This captivating aesthetic was interpreted by rural cabinetmakers in eastern Massachusetts on the front surfaces of so-called Harvard chests. These chests display lively painted motifs in a balanced formula placed horizontally across four drawers. In one example from the Shelburne Museum in Vermont, each drawer has a semicircular pattern in the center, perhaps representing the rising sun, and is flanked by different motifs united by undulating vines that flow to the edges of the drawers. A pair of Georgian-style red brick buildings, once thought to be copies of buildings on the campus of Harvard University, provides the visual emphasis for the chest, with its dramatically appealing palette of red, white, and brown on a black ground.

The Dutch cabinetmakers who helped to colonize parts of New York, New Jersey, and New York's western Long Island in the seventeenth century fashioned *kasten,* or large storage cupboards, several of which were embellished with freehand painting *en grisaille,* or in monochromatic tones of blue-gray in a manifestation of Dutch Baroque-style carving. With trophy-like panoplies of fruit hanging within *trompe l'oeil* arched recesses on the doors, and clusters of fruit hanging from bowknots on the side panels, the sophisticated decoration assured these cupboards' longevity. The fertile Hudson River Valley also attracted immigrants of Germanic descent, and six board blanket chests produced in Schoharie County, New York, by Johannes Kniskern (1746–?) are notable for their distinctive, geometrically arranged grid patterns, selectively filled with contrasting colors of paint. There are four surviving chests attributed to Kniskern: one made for his brother, Jacob, and two smaller chests for his daughters, Elisabet and Margreda.

Throughout the seventeen and eighteenth centuries, New England country furniture was embellished not only with highly imaginative polychrome patterning but was also plainly painted in a single color, and finished with layers of varnish to protect and prolong the painted surface. Documentation increasingly suggests that furniture, like interior architectural paneling of the period, was painted in bright, intense colors made from pigmented paints with period names such as lead white, red lead, Spanish brown, Indian and Venetian red, ivory, and lampblack, umber, Prussian blue, vermillion, and verdigrises. Furniture produced around Bedford, New Hampshire, by a family of cabinetmakers whose central figure is Major John Dunlap (1746–1792) was fashioned from local woods (maple, pine, birch, and sometimes cherry). The Dunlap cabinetmakers' interpretation of Chippendale styling included deeply carved shells; S-shaped scrolls for the skirts of case pieces; interlaced basket-weave cornices; and eye-catching ornamentation that carried the viewer from top to bottom of characteristically elongated chairs and case furniture. Active during the last quarter of the eighteenth century, John Dunlap's account books record recipes for Spanish brown and mahogany, colors probably used for graining furniture in imitation of more expensive woods, as well as ingredients for green and orange stains, examples of which survive on chairs and high chests of drawers attributed to this idiosyncratic group of cabinetmakers.

The end of the American Revolutionary War heralded a change in both the design and manufacture of American furniture. The light palette, delicate forms, and straight or elliptical lines of high-style Federal-era (1790–1825) furniture, with its painted or carved swags, paterae, urns, ferns, bellflowers, honeysuckle

vines, beribboned sheaves of wheat, paired dolphins, and armorial devices, was interpreted by vernacular furniture makers by the opening decade of the nineteenth century. Specialization within many rural cabinetmaking shops was now widely practiced, as cabinetmakers employed ornamental painters to finish furniture in increasingly varied patterns, and shop owners strove to meet the demands of a growing public anxious to furnish their homes in the newest fashions.

The surviving trade card of W. Buttre's Fancy Furniture factory in New York City illustrates typical specialization within cabinetmaking shops. On this card the work of six specialists is illustrated. Under the direction of the shop manager, one artisan turns the chair members on a lathe, another assembles the chair, and a third canes the seat. Once the chair is completed, it is transported to the finishing room, away from the sawdust, where an apprentice grinds and prepares the paint. A fifth artisan applies the ground coat; the chair is then sent to the workbench of an ornamental painter to apply the finely painted decorative details. The chair is then varnished and left to dry.

Specialization, increased access to paint pigments, an expanding population, and a prevailing fashion for color and decoration resulted in the first four decades of the nineteenth century being recognized as the heyday of American painted furniture. Evidence of early-nineteenth-century interior settings is graphically conveyed in the watercolor portraits of three American folk artists: Joseph H. Davis (active 1832–1837), Deborah Goldsmith (1808–1836), and Jacob Maentel (1778–?). These portraits reveal vibrant, highly decorated painted rooms filled with richly grain-painted furniture or fancy Windsor chairs. Floors are covered in multicolored figured carpets; walls are stenciled or wallpapered, on which are hung pillar looking glasses, maps, banjo clocks, and picturesque landscapes. This rich diversity of color and pattern reflects interpretations of urban styles; draws from the ethnic and folk traditions of craftsmen and clients; and portrays a uniquely rural American self-consciousness in having one's furnishings reflect fashionable tastes, but at good price. Further documentation records that American homes (from Portland, Maine, to the hills of Tennessee, and from the shores of the Delaware River to the pioneer settlements of the Northwest Territory) were filled with painted furniture. New infusions of immigrants brought to America the rich folk art traditions of Germany, Switzerland, Scandinavia, and Mexico, and it is these rich traditions of decorative painted furniture that constitutes the vast majority of nineteenth-century painted furniture.

Immigrants of Germanic heritage settled in self-contained pockets of communities throughout Pennsylvania, New York, Maryland, and Virginia, and each group produced a distinctive decorative vocabulary and style of painted furniture. Some of the most exuberant and unique paint-decorated furniture was produced in the Pennsylvania German settlements of the Mahantango or Schwaben Creek Valley area in the counties of Northumberland and Schuykill, Pennsylvania. Two groups of furniture from this region have been identified: the first group consists of fifteen surviving blanket chests, often inscribed with the owner's names and commemorative dates, ranging from 1798 to 1828; the second group constitutes more than fifty examples of case furniture, including chests of drawers, slant-front designs, cupboards, and hanging cupboards, made between 1827 and 1841. A distinctive vocabulary of hand-painted motifs characterizes this furniture, including carefully rendered leaping stags, female figures, prancing deer, compass-drawn devices, undulating flowering vines, paired birds, and stylized central tulips emanating from urns. Arranged horizontally along the front of the furniture, often with a central motif flanked by paired images, the side panels feature single, paired motifs. The decorative border devices that frame the figurative motifs, echoing the bands of inlay on busy facades of high-style neoclassical furniture, include hand-painted quarter fans in the drawer corners, two-color stringing, and rosettes produced by a stamp or stencil in alternating colors, framing the stiles of case furniture. While the decorative painters of Mahantango or Schwaben Creek Valley furniture are largely unknown, several furniture forms from the latter group are attributed to Johannes Mayer (1794–1883), whose home still stands in Upper Mahanoy Township.

Another furniture maker of note is Johannes Spitler (1774–1837), who worked in the Shenandoah area of Virginia, where more than twenty known pieces have been ascribed to his hand. Though it is not known whether Spitler constructed his own furniture, his carefully rendered painted designs range from geometric forms (checkerboard, diamond, grid patterns, and simple compass work) to stylized motifs (such as hearts, flowers, and birds), hand-painted in mirror image in a limited palette of pigmented colors, including black, white lead, red lead, and Prussian blue. Spitler's patterns and motifs have incised outlines, probably indicating a method of copying or tracing a pattern, which are then filled in with cursory brush-

strokes of heavily pigmented paint. Many of Spitler's pieces are signed and inscribed in a unique and abbreviated manner, allowing researchers to trace Spitler furniture from Virginia to Ohio, where he eventually settled.

Numerous other regional Pennsylvania German schools and examples of decorative furniture painting survive. Many pieces can be identified and codified by maker and owner as blanket chests. A traditional form associated with customs of marriage and dowry, these chests survive in large numbers, and often contain initials and commemorative dates. Among the most well known of the Pennsylvania German regional schools of decorative painted chests are examples from Berks County, Pennsylvania, characterized by a central panel decorated with a unicorn flanked by panels containing mounted horses. Surviving blanket chests from the Mennonite community of Soap Hollow Valley include those decorated by Peter K. Thomas, with the characteristic use of stenciled patterns in shades of gold on bright orange grounds. More than thirty chests from Wythe County, Virginia, have come to light; each displays variations of stylized tulips and dahlia-like flowers, emanating from an urn within two and three arched reserves on the front of the chests, with brown or dark red grounds. The lids of several of the Wythe County chests are enhanced with two reserves containing a star, or two large white circles. From the Germans who settled in Schoharie County, New York, another decorative style of chests prevailed, on both blanket chests and two-drawer chests, from the 1830s to the 1850s. The decoration of these chests featured an urn filled with floral bouquets, with distinctive red and white cabbage roses. This central motif is framed by scrolling vines and a simple flower in the corners. The palette of these chests is yellow, green, white, red, and orange, on grounds of blue-green or faux-grained woods.

Landscapes as embellishment for fancy furniture was another decorative device unique to the first quarter of the nineteenth century. In 1803 Thomas Sheraton, in his *Cabinet Dictionary*, defined landscapes in painting as "the view or prospect of any country extended as far as the eye can see." Prior to the 1840s, with the emergence of the Hudson River School of landscape painting, landscapes were considered a decorative art. Though some ornamental painters of high-style Baltimore furniture painted Baltimoreans' homes on the back of chairs directly from the subject, most landscapes on furniture were copied or traced onto the furniture using European prints, mezzotints, maps, and drawings. A Windsor armchair

with a view of Ithaca Falls on its broad top rail, for example, was probably created using a contemporary print of this scenic area of New York State. Landscapes on chairs reflect the nineteenth-century association with land as the major form of wealth, a social convention with its roots in sixteenth-century European traditions.

Though found in fewer numbers, another unique hand-painted Federal furniture form is the worktable and sewing table decorated with watercolors by young women attending the seminaries and academies that flourished along the East Coast of America during the first two decades of the nineteenth century. Watercolor painting was a part of the school curriculum, designed to educate women of accomplishment, not women who would need a skill for later employment. Choosing etchings, engravings, or illustrations from drawing books, young women made preliminary drawings on separate templates, one for each surface of the table. The patterns were then traced onto the tabletops and outlined in india ink using a quill pen. Once the ink dried, watercolors were applied, one color at a time to prevent the colors from running together. The motifs chosen for these tables were from the classical vocabulary and often featured imaginary landscapes, allegorical scenes, or historic sites on the top. The sides were embellished with baskets of flowers, cornucopia spilling forth fruit, baskets of shells, and paired birds. Once the watercolors were complete, the tables were returned to the cabinetmaker's shop, where they received coats of varnish to secure and protect the hand painting. Once finished, the tables were typically placed in the parlor and used to store needlework and sewing materials.

Two types of wood graining were executed during the nineteenth century: imaginative graining, in which the ornamenter captured the character of the veins, grains, and figures of woods, often in colors never found in nature; and faux graining that so accurately imitated real wood as to trick the eye. In the nineteenth century imaginative graining was achieved using two-toned painting, vinegar painting, mottling, sponging, strippling, scumbling (applying a thin coat of opaque or semi-opaque paint to soften the colors), and feather painting. The ornamenter's tools for producing these effects included badger-hair brushes, natural sponges, washed leather, goose quills, sticks, feathers, putty, chamois, buckskin, and candles (for smoke-graining). A remarkably well-preserved sample box that belonged to Moses Eaton Jr. (1796–1886) demonstrates the variety and richness

of imaginative graining on nine panels, each with a different grained finish.

Several schools of imaginative painted furniture have been identified. The Vermont town of Shaftsbury is regarded as the center of a distinctive school of imaginative grain-painted furniture, with examples dating from first two decades of the nineteenth century. The progenitor of this group of furniture is thought to have been Thomas Matteson or Matison (active 1803–1825) based on five chests inscribed with his name. Current research, however, has discovered that neither Matteson nor any member of the Matteson family owned painters' tools, and a number of ornamental painters as far away as New York grained in a similar style. The painted six-board blanket chests of this school impart a controlled, masterful rendition of high-style figured veneers, using a palette of yellow, green, red, and black paint framed by painted borders that simulate cross-banding of string veneers, all in imitation of their Federal high-style figured wood counterparts being manufactured locally in nearby Portsmouth, New Hampshire, and by Michael Allison in New York City.

Another group of imaginative grain-painted furniture includes two-drawer blanket chests characterized by the similarity of their construction, with turned and detachable legs, carefully organized graining using glazes over color grounds, some in wide stripes, and a masterful manipulation of materials and graining tools to produce totally original grained surfaces, all exuberant and imaginative manifestations of the veneered and inlaid high-style Federal furniture. Taking full advantage of the fluidity of paint, some ornamental painters created free-flowing designs using broad strokes, unintentionally creating wood graining as an artistic abstraction, a result that often attracts the contemporary eye.

As opposed to imaginative graining, faux graining is so close to nature as to trick the eye. The imitator of natural and exotic woods, wrote one ornamental painter, should select the best examples from nature for study and observation, and then travel "the long road of patient study, close observation, and practice, practice, practice." Nathaniel Whittock's *Decorative Painters' and Glaziers' Guide* (London, 1828) contains complete recipes and directions for creating exacting wood grains, with the added bonus for the reader of including more than a dozen hand-colored lithographs showing samples of superbly grained woods. Whittock writes that the artistry of graining comes from the movements of the hand—they should be quick, light, spirited, and practiced. The most common tools for faux graining were sets of metal combs

with teeth of graduated width, and graining brushes. "Veining rollers," leather-coated cylinders with incised lines duplicating the knots and grains of wood when rolled onto long flat surfaces, have been discovered in graining toolboxes, and are thought to have been used on coffins rather than furniture.

Faux graining is often used in combination with other decorative techniques, such as stencils, bronze-powder stenciling, and striping in imitation of brass inlay. Several tall case clocks produced by Rufus Cole (1804–1874) and his father, Abraham, in New York's Mohawk Valley, for example, exhibit painted and grained grounds that simulate crotch mahogany and rosewood, and are overlaid with bronze-powder stencil designs on dark reserves in imitation of high-style Empire furniture. Much of the Empire furniture produced in Maine also displays faux-grained rosewood with red over black or black over red patterning executed in a quick, cursory manner, and then highlighted with striping in chrome yellow and a distinctive Maine green in imitation of the brass inlays on high-style furniture.

The golden age of grain painting prevailed on the East Coast of America during the first three decades of the nineteenth century, and was reborn and reinterpreted during the last half of that same century in the West, where faux-grained furniture was not produced in imitation of fine furniture, but was regarded as high-style decoration. This is exemplified by an octagonal desk made by William Bell, with graining attributed to Brigham Young (1801–1877), the Mormon leader of the Church of Jesus Christ of Latter-day Saints, who lead his followers to the Utah Territory in 1846. Young was himself a cabinetmaker, and masterfully rendered the green and black faux marble on the rotating desk used in his office and in the church tithing office. Faux graining appears as the ground for much of the furniture produced in the western plains states settled during the last quarter of the nineteenth century, including a sizeable cupboard painted and grained with a large cross-section of an exotic tree that spans the entire front of the chest's two front doors. This Texas frontier piece is superbly executed, with stripling, sponging, and veining across the skirt and drawer fronts and along the bold cornice at the top of the wardrobe.

During the 1870s and 1880s, Mennonites from Poland, Russia, and Prussia settled in central Kansas, the Dakotas, and Nebraska, where the cabinetmakers among them fashioned large, sturdy furniture constructed of native ash or pine. With the commercial production of readymade paints following the American Civil War, Mennonite furniture ornamenters

could more easily continue the faux-grained traditions brought with them from Eastern Europe. The distinctive Mennonite furniture of the northern plains states exhibits faux grains to simulate light-colored woods, and is overlaid with delicate floral patterns similar to those found on traditional embroidered textiles and in illustrations from the pages of Mennonite hymnals and songbooks. While the art of graining furniture all but disappeared by the opening decades of the twentieth century, William E. Wall, a third-generation wood grainer, authored two important books on graining, *Practical Graining* (1905) and *Graining, Ancient and Modern* (1905), prompting a resurgence, not of painted furniture, but of highly finished interior architectural paneling in imitation of exotic woods, marbles, and stone facades.

As one nineteenth century ornamental painter wrote, imitating the colors, grains, and figures of fancy hardwoods required the same facility, talent, and perceptive powers of a fine artist portraying a human face. Graining required several layers of paint and varnish: first a priming coat, followed by sequential layers of ground color. Imaginative graining received a glaze over the ground color that was manipulated using different tools to produce the desired effect. Faux graining required a ground color, a second graining color, and often a third or fourth color for detailing. The artistry of faux graining is found in the subtle understanding of the natural graining of wood; the extra care taken to finish each stroke; the imaginative graining artistry seen in the vigorous sweep of the lines in the glaze; and in the controlled manipulation of the medium to create an abstraction of the original.

The bronze powder-stenciled side chairs produced by the chair manufactory of Lambert Hitchcock (1795–1825) in Hitchcocksville, Litchfield County, Connecticut, survive as examples of the rural adaptations of high-style Empire furniture decorated with bronze mounts on glistening rosewood veneers. Using interchangeable chair parts and stencils, or thin sheets of metal or prepared paper in which designs are cut to facilitate the application of images, as well as newly introduced ground–metal powders (made from bronze, brass, zinc, aluminum, silver, or gold), and different colored varnishes, the Hitchcock factory finished chairs with such speed and consistency that it was able to sell chairs for only $1.50, less than half the cost of other fancy chairs. The best of the Hitchcock chairs were special commissions, for which up to twenty stencils were used to create elaborate designs characterized by abundant arrangements of fruits and flowers, classical urns, stylized acanthus

leaves, and circular mounts, with each element shaded with the stencil brush to give it a roundness and depth.

In the 1850s suites of painted furniture, called cottage furniture, became fashionable, prompted by features in *Godey's Lady's Book* and the recommendation of mid-century tastemaker A.J. Downing in the book *The Architecture of Country Houses*. Suites of inexpensive, machine-made cottage furniture produced in Renaissance Revival style were recommended by Downing as being "remarkable for its combination of lightness and strength, and its essential cottage-like character." The highly finished surfaces of cottage furniture were painted with enamel grounds of gray, lilac, and gray-blue; the better sets were enlivened with freehand-painted reserves filled with lush bouquets of flowers, landscapes, Japannisque motifs, or were faux grained with striping and borders imitating the carving of high-style Renaissance Revival furniture. Cottage-furniture manufactories sprang up in all the major cabinetmaking centers; the best surviving examples were produced by the Heywood Brothers of Gardner, Massachusetts, and the Hart, Ware Co. of Philadelphia. These factories hired skilled ornamenters, including Thomas Hill, who trained as a coach painter and later became a distinguished American landscape painter known for his paintings of the White Mountains and the American West. The decoration of cottage furniture was also an amateur art, as exemplified by a set of cottage furniture decorated by writer Harriet Beecher Stowe for her bedroom, now on view at the Stowe House in Hartford, Connecticut.

Plain painted furniture also prevailed throughout the nineteenth century, used most effectively in the furniture of northern New Mexico produced in the late nineteenth century in the aftermath of the Mexican War. Anglo-American and Hispanic cabinetmakers fashioned flat, rectilinear furniture forms with applied decoration of Ponderosa pine, and then painted the surfaces with water-based paints in strong desert colors of brightly contrasting reds, greens, turquoise blues, and yellows.

See also **Boxes; Chairs; Joseph H. Davis; Decoration; Moses Eaton Jr.; German American Folk Art; Deborah Goldsmith; Hadley Chests; Jacob Maentel; Thomas Matteson; Painting, Landscape; Religious Folk Art; Shelburne Museum; Johannes Spitler.**

BIBLIOGRAPHY

Barker, Marilyn Conover. *The Legacy of Mormon Furniture*. Salt Lake City, Utah, 1995.

Churchill, Edwin A. *Simple Forms and Vivid Colors: Maine Painted Furniture, 1800–1850*. Augusta, Maine, 1997.

Connell, E. Jane. "Ohio Furniture, 1788–1888." *The Magazine Antiques,* vol. 125, no. 3 (February 1984): 462–468.

Cullity, Brian. *Plain and Fancy: New England Painted Furniture.* Sandwich, Mass., 1987.

DeJulio, Mary Antoine. *German Folk Arts of New York State.* Albany, N.Y., 1985.

Evans, Nancy Goyne. *American Windsor Chairs.* New York, 1996.

Fabian, Monroe H. *The Pennsylvania German Decorated Chest.* New York, 1978.

Fales, Dean A. Jr. *American Painted Furniture, 1660–1880.* New York, 1972.

Garvan, Beatrice B. *The Pennsylvania German Collection.* Philadelphia, 1975.

Garvan, Beatrice B., and Charles F. Hummel. *The Pennsylvania Germans: A Celebration of Their Arts, 1683–1850.* Philadelphia, 1982.

Hageman, Jane Sikes. *Ohio Furniture Makers.* vols. 1 and 2. 1984.

Hollander, Stacy C., et al. *American Anthem: Masterworks form the American Folk Art Museum.* New York, 2001.

———. *American Radiance: The Ralph Esmerian Gift to the American Folk Art Museum.* New York, 2001.

Janzen, Reinhild Kauenhoven, and John M. Janzen. *Mennonite Furniture: A Migrant Tradition, 1776–1910.* Intercourse, Pa., 1991.

Julio, Mary Antoine. "New York-German Painted Chests." *The Magazine Antiques,* vol. 127, no. 5 (May 1985).

Kenny, John Tarrant. *The Hitchcock Chair: The Story of a Connecticut Yankee.* New York, 1971.

Moore, J. Roderick. "Painted Chests from Wythe County, Virginia." *The Magazine Antiques,* vol. 126, no. 3 (September 1982): 516–521.

Muller, Charles R. *Made in Ohio: Furniture, 1788–1888.* Columbus, Ohio, 1984.

Reed, Henry M. *Decorated Furniture of the Mahantango Valley.* Lewisburg, Pa., 1987.

Schaffner, Cynthia V.A., and Susan Klein. *American Painted Furniture, 1790–1880.* New York, 1997.

———. "Two-Toned Finishes: American Grain-painted Furniture." *Folk Art,* vol. 23, no. 1 (spring 1998): 36–43.

Stanny, Carrie M. *Manufactured by Hand: The Soap Hollow School.* Loretto, Pa., 1993.

Taylor, Loon, and Dessa Bokides. *New Mexican Furniture, 1600–1940: The Origins, Survival, and Revival of Furniture Making in the Hispanic Southwest.* Santa Fe, N. Mex., 1987.

Taylor, Lonn, and David B. Warrren. *Texas Furniture: The Cabinetmakers and Their Work, 1840–1880.* Austin, Tex., 1975.

Weiser, Frederick S., and Mary Hammond Sullivan. "Decorated Furniture of the Schwaben Creek Valley." *Ebbes fer Alle-Ebber—Ebbes fer Dich: Something for Everyone—Something for You,* vol. 14 (1980).

Zogry, Kenneth Joel. *The Best the Country Affords: Vermont Furniture, 1765–1850.* Bennington, Vt., 1995.

CYNTHIA VAN ALLEN SCHAFFNER

GAMEBOARDS, the origins of which date to Neolithic times, were homemade forms of amusement in the hands of American and Canadian folk artists. Before the advent of the phonograph, radio, or television, people played board games such as checkers (draughts), Parcheesi, or backgammon, as well as more unusual games such as Chinese checkers, Agon, or Mill, to while away the time in social settings. Some gameboards were made for unique games whose rules were probably known only by their anonymous creators. While a few were made of materials such as slate or reverse-painted glass, the majority of gameboards were painted on wood. The varieties of gameboards—ranging from primitive examples made by untrained amateurs to carefully painted boards exhibiting the most sophisticated of graphic designs, usually turned out by carriage or sign painters—are prime examples of folk art and are highly sought after by collectors.

One category of gameboards was designed for use at country fairs or carnivals. Made for games of chance (the wheel of fortune, ring toss, or penny pitch) they are larger and were produced using grain and carriage-painting techniques. Gold leaf and oil- or milk-based paints were used for the design elements, which include American flags and eagles, birds, flowers, hearts, horseshoes, houses, human or animal figures, mermaids, numbers, pinwheels, ships, stars, and the sun or moon. Occasionally, incised or chisel-carved designs, decoupage, wood marquetry, brass inlay, or stenciling was also employed.

Some gameboards were designed to fold into boxes and to store the playing pieces. Unfortunately,

most handmade gameboards are usually found without their playing pieces. Two-sided gameboards, with a different game or some other decoration on the reverse side, were often designed. Homemade game tables, inlaid or painted in imitation of the game tables made by professional furniture makers in England, New York, or Philadelphia, are also to be found. Some later gameboards include homemade copies of popular lithographed games, such as Monopoly or Chutes and Ladders. The production of machine-produced games by companies such as Parker Brothers, beginning in the 1880s, sadly curtailed the long tradition of homemade games in North America.

As folk art, gameboards are expressions of individual artistic endeavors, but they also reflect the importance of social interaction, whether a game of checkers at the general store or a game of chance at the county fair. The best examples have become icons of folk art imagery. Displayed on the wall, they often stir irresistible comparisons to modern art, with their patinated, painted surfaces and bold graphic impact.

See also **Decoration; Flags; Reverse-Glass Painting; Trade Signs.**

BIBLIOGRAPHY

Chambers, Tim. *The Art of the Game*. New York, 2001.
Field, Richard. *Canadian Gameboards of the Nineteenth and Twentieth Centuries*. Nova Scotia, Canada, 1981.
Wendel, Bruce, and Doranna Wendel. *Gameboards of North America*. New York, 1986.

BRUCE AND DORANNA WENDEL

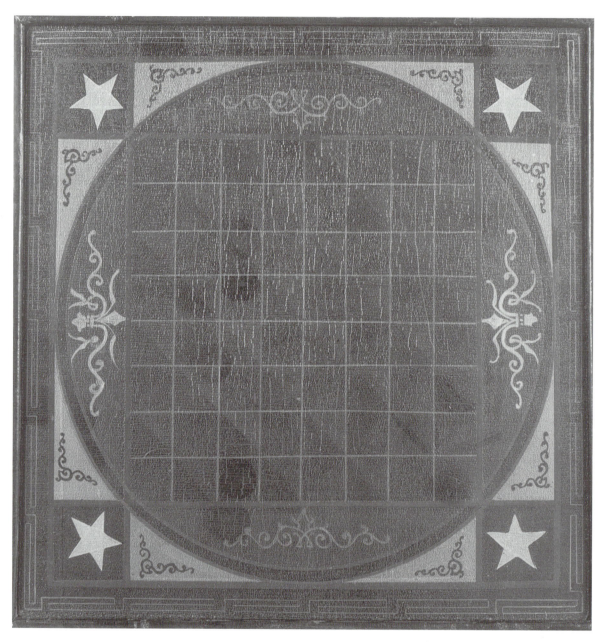

Checkered gameboard. Unknown maker [probably a coach painter]; New England; c. 1875
17½ × 17½ inches.
Photo courtesy Allan Katz, Americana, Woodbridge, Connecticut.

GANSEVOORT LIMNER: *SEE* PIETER VANDERLYN.

GARBISCH, EDGAR WILLIAM (1899–1979) and **BERNICE CHRYSLER** (1907–1979) were ardent collectors of American folk paintings, the majority of which were bequeathed to the National Gallery of Art, Washington, D.C. In addition, they made gifts to the Metropolitan Museum of Art in New York City, to form the core of its American folk art collection, and gifts to the Philadelphia Museum of Art, the Corning Glass Museum and other museums. Bernice Chrysler Garbisch, born in Olwein, Iowa, studied in Paris and New York. She was the second daughter of Walter P. Chrysler, founder of the Chrysler Motor Company. She married Edgar William Garbisch in 1930. A native of LaPorte, Indiana, Edgar Garbisch attended Washington and Jefferson College in Pennsylvania in 1918 and entered West Point in 1921, where he played football. He was named to the all-American team as a center in 1922, 1923, and 1924, and elected to the National Football Hall of Fame in 1954. He rose to the rank of colonel (the title by which he preferred to be addressed), served in World War II with the Corps of Engineers, and became district engineer for the New York district in 1944. The Garbisches resided at the Carlyle Hotel in New York City, as well as in homes in Palm Beach, Florida, and Cambridge, Maryland. They had two children, Edgar William Garbisch Jr. and Gwynne Chrysler Garbish.

The Garbisches' New York apartment consisted entirely of eighteenth-century, mostly French furniture, and paintings by French impressionists and post-impressionists. It was in Cambridge, Maryland, that they exhibited their folk art canvases, favoring the term "naive" paintings. Their Maryland home, "Pokety," built by Walther Chrysler as a hunting lodge in the late 1920s, served as their summer home in the early 1940s, but was later enlarged and remodeled as a year-round residence. In adapting to Pokety's setting and history, the Garbisches decided to purchase a few examples of American folk painting to brighten and enrich its walls. This casual decision led to the acquisition of nearly 2,500 works of eighteenth and nineteenth century American naive art, the largest private collection of its time. In 1946 (their first year of collecting), they purchased paintings by William Matthew Prior (1806–1873) and Edward Hicks (1740–1849). Over the years, six additional paintings by Hicks were added to the collection. In 1949 alone, the Gar-

bisches purchased 480 pictures. She favored needlework pictures and portraits; he favored scenes of daily life and illustrations of games and sports. Most of their collection dated from 1785–1840. It grew to include iconic works by the greatest names in American folk painting, such as Rufus Hathaway (1770–1822), Joshua Johnson (active 1796–1824), and Ammi Phillips (1788–1865).

From 1976 to 1977, the Garbisches auctioned six hundred works of fraktur, needlework, portrait miniatures, silhouettes, and theorem paintings. Before their deaths in December 1979, within an hour of each other, most of their remaining collection had been offered as gifts or promised to museums. Pokety and the remaining Garbisch decorative arts and furniture collections were auctioned in 1980.

See also **Fraktur; Rufus Hathaway; Edward Hicks; Joshua Johnson; Miniatures; Painting, American Folk; Painting, Theorem; Papercutting; Ammi Phillips; Pictures, Needlework; William Matthew Prior.**

BIBLIOGRAPHY

American Federation of Arts. *101 Masterpieces of American Primitive Painting from the Collection of Edgar William and Bernice Chrysler Garbisch.* New York, 1962.
Bishop, Robert. "Letter from the Director." *The Clarion,* vol. 10 (fall 1985): 17.
Black, Mary. "Collectors: Edgar and Bernice Chrysler Garbisch." *Art in America,* vol. 57 (May 1969): 48–49.
Lipman, Jean, ed. "American Primitive Painting: Collection of Bernice Chrysler Garbisch and Edgar William Garbisch." *Art in America,* vol. 42 (May 1954): 94–166.

WILLIAM F. BROOKS JR.

GARRETT, CARLTON ELONZO (1900–1992), an ingenious woodcarver of human and animal figures, created at least eight dioramas, most of which were motorized. He also whittled smaller vignettes, hundreds of individual carvings, and a number of toys. Garret had an innate talent as a carver and an understanding of mechanics.

Born in Gwinnett County, Georgia, Garrett was raised on a farm in Forsyth County, and moved with his family to Flowery Branch, near Gainesville, Georgia, in 1924, where he married Bertie Catherine Clark, in 1927, and remained for the rest of his life. He worked for almost forty years as a craftsman at the Chattahoochee Furniture and Mooney Furniture factories, and, for many years, simultaneously managed

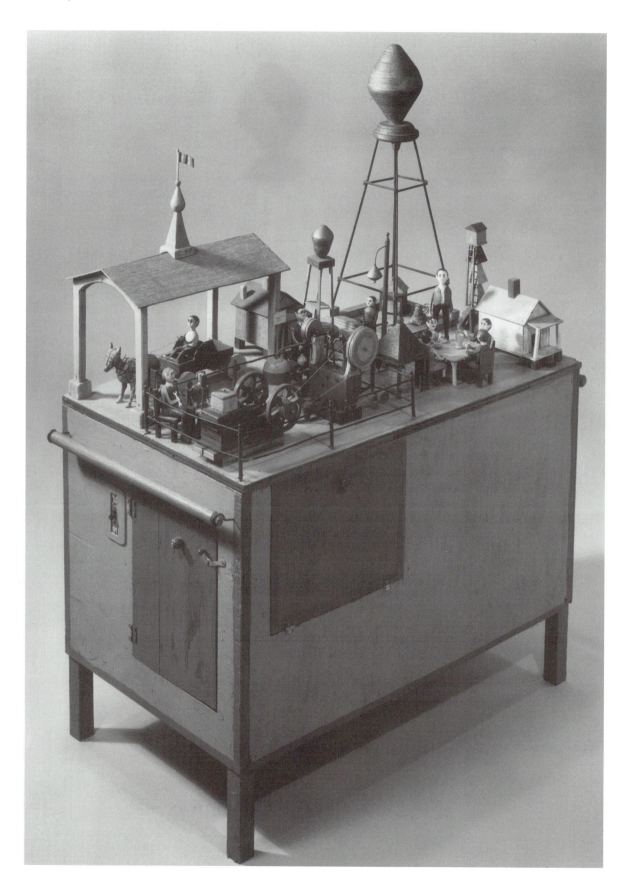

the local water works. He was ordained a minister at the Flowery Branch Baptist Church in 1931.

Growing up near a water mill, Garrett was fascinated by mechanical processes and the way power was harnessed to do work. He whittled from an early age, "carving toy-truck wagons, bicycles, flutter mills, [and] waterwheels." He made his first large work, *Hospital,* following abdominal surgery in 1962, the year that he retired.

Mt Opel is a major work, comprising a country church service with thirty-seven figures arranged as a congregation in two rows of pews facing a preacher. The flip of a switch triggers a phonograph to start the sound and action of the work. To the tune of "When the Saints Go Marching In," the preacher moves his hands up and down, a man moves a collection plate through the aisles, a woman appears to be playing the piano while another fans herself, and someone pulls the rope attached to a bell. Other figures shake hands and a child is spanked—all movements that Garrett rigged electrically. Garrett called his complex piece a "wonder box," because when the viewer looks at it, "you wonder if it will work." Other significant works by Garrett include *The Waterworks, Car Parade, The Old Mill, The Machine, John Henry, Crucifixion, Merry Go Round,* and *Courtroom.*

Garrett used only a pocketknife, drill press, band saw, and a homemade electric metal hacksaw to make the hand-carved wooden gears, pulleys, cams, and shafts, which he held together with strong cord and powered with a motor, used to create the motion in many of his complex works. The various types of cottonwood, oak, plywood, and other materials that he sanded, painted, and assembled in his workshop, which he called The Playhouse, were purchased at the local hardware store. "The Folk Art Sculpture of Carlton Garrett" was a one-person exhibition of Garrett's work at The High Museum of Art, held in 1981.

See also **Sculpture, Folk; Toys, Folk.**

BIBLIOGRAPHY

Gaynor John, and Michael Stowers. "Folk Art That Comes to Life." *Popular Mechanics,* vol. 159, no. 5 (May 1983): 105, 206–208.

LEE KOGAN

GATTO, VICTOR JOSEPH (1893–1965) painted in an energetic style, using precise brushwork to complete an estimated 350 paintings on board and canvas, pencil sketches, and watercolors. Drawing on his imagination and memories, he depicted subjects as varied as exotic jungle and underwater scenes, circus spectacles, flowers, biblical allegories, current events, and outer space landscapes. An oil on canvas from about 1943, *Dragon,* depicts one such toothy, winged figure on a riverbank perilously near a knight dressed in full armor. Gatto uses expressive, repetitive outlines of white, black and yellow to articulate the forms and masses. Across the river stands a castle on the horizon, and Gatto has taken pains to render a tiny face in each castle window as well as describe the figures watching the scene from the far riverbank.

Gatto resolutely refused to use printed sources or other artists' work as models. The artist's interest in exact detail is manifest in his painting of a circus performing in Madison Square Garden. Working sixteen hours a day for six months, he attempted to paint thousands of people in the stands, reflecting the 18,500 spectators he was informed had attended a particular circus performance.

Although patient and painstaking as an artist, Gatto was personally temperamental and volatile. His antisocial behavior led to a dishonorable discharge from the United States Navy during World War I, as well as subsequent criminal activity for which he served time in prison.

An Italian American, Gatto was born in New York City's Greenwich Village. His drawing talent was recognized early, and he was awarded an art prize at the Catholic school he attended. When Gatto was eight, Theodore Roosevelt paid the class a visit and remarked, according to the artist, that Gatto "was the best drawer in the school."

Gatto went to work at an early age and held a variety of jobs, including as a dishwasher, carpenter's assistant, and as an extra in a movie. He was a professional prizefighter from 1913 to 1920, and a plumber's assistant and steamfitter until 1940, when a hernia forced him to look for less strenuous work. Observing the work of and talking to artists at the Greenwich Village Outdoor Art exhibition in 1938, he believed he could paint as well as they could. Owing to increasing

Shadow Brook Waterworks; Carleton Elonzo Garrett; c. 1980. Mixed media, wood, paint, metal, twine; 63 × 44½ × 26½ inches; base on raised 8-inch legs. Collection American Folk Art Museum, New York. Gift of Judith Alexander.

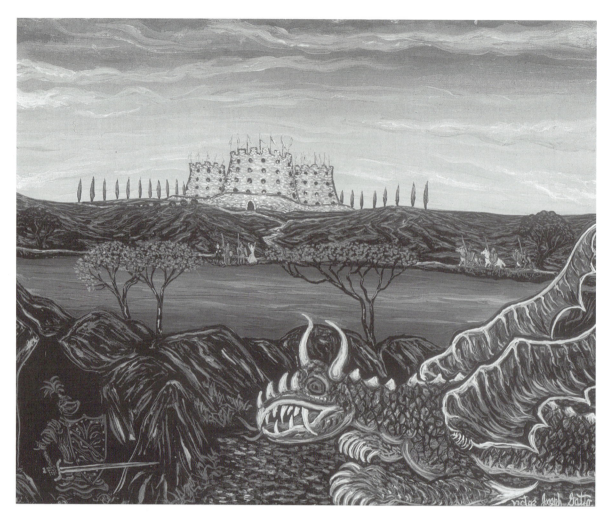

Dragon; Victor Joseph Gatto; c. 1943. Oil on canvas 16 × 19¾ inches.
Collection American Folk Art Museum, New York. Gift of Ken and Asa Mille, 1985.6.2.
Photo courtesy John Parnell.

health problems, including failing eyesight, Gatto stopped painting in 1960; he died in Miami, Florida.

Represented by the Charles Barzansky Gallery in New York, Gatto's work was reviewed in newspapers in 1944 and 1956, and magazine features about him appeared in *Esquire, Colliers, Town and Country,* and *Life.*

See also **Painting, American Folk; Sterling Strauser.**

BIBLIOGRAPHY

Epstein, Gene. "The Art and Times of Victor Joseph Gatto." *The Clarion,* vol. 13 (spring 1988): 56–63.

———. "The Art of Becoming Gatto." *Raw Vision,* no. 6 (summer 1992): 20–23.

Trechsel, Gail Andrews. *Pictured in My Mind: Contemporary American Self-Taught Art from the Collection of Dr. Kurt Gitter and Alice Rae Yelen.* Birmingham, Ala., 1996.

LEE KOGAN

GERMAN AMERICAN FOLK ART, one of the richest visual arts traditions in the United States, has its historic roots in the German-speaking regions of Europe, and its first expressions in the Germanic communities of southeastern Pennsylvania. Responding to the invitation of William Penn (1644–1718), who founded Pennsylvania as a "holy experiment" where freedom of conscience could flourish, a group of Mennonites and Quakers from Krefeld established Germantown,

Pennsylvania, in 1683 under the leadership of Francis Daniel Pastorius (1651–c. 1720). It was North America's first permanent German settlement. Weaving and textile processing thrived in Germantown. William Rittenhouse (1644–1708), a Mennonite minister, built America's first paper mill there in 1690.

Immigration from Prussia, Alsace, the Rhenish Palatinate, Württemberg, Bavaria, Switzerland, Austria, and other German-speaking regions continued in successive waves through the twentieth century. In addition to southeastern Pennsylvania, early centers of Germanic settlement in North America were located in the Hudson, Schoharie, and Mohawk Valleys of New York, where German-speaking immigrants had established communities by the 1710s and 1720s; New Bern, North Carolina, founded by Swiss and Germans in 1710; Frederick, Washington, and Carroll Counties, Maryland, and the Shenandoah Valley of Virginia, where Pennsylvania Germans settled in the 1730s; South Carolina and Georgia, where 12,000 Swiss Germans put down roots between 1734 and 1744; and Broad Bay—later Waldoboro—Maine, where 150 families from the Rhineland landed between 1740 and 1753. Amish settlers began arriving in Pennsylvania as early as 1727, there being a second, larger wave of Amish immigration in the nineteenth century.

Between 1683 and 1820, approximately 75,000 German-speaking immigrants came to Pennsylvania. In the communities that they established throughout the southeastern part of the state, a fully integrated agrarian lifestyle prevailed, a distinctive German dialect, *Pennsylvaanisch Deitsch*, was spoken, Germanic cultural forms were maintained, and the folk arts flourished. Painted and decorated furniture, woodcarving, ceramics, manuscript illumination, and textiles all reached remarkable levels of creativity. Although expressions of Germanic folk culture may be found in virtually all areas of German settlement in the United States, it was in eighteenth- and nineteenth-century Pennsylvania that the folk arts reached their full flowering.

A mainstay of Pennsylvania German culture was the German-language parochial school. In 1834, however, the Pennsylvania legislature passed an act providing for free public education that ultimately resulted in a shift from German-language instruction and a progressive loss of cultural distinctiveness. Nevertheless the Pennsylvania German dialect continued to be spoken into the twenty-first century in Pennsylvania and elsewhere in the United States, especially among the members of conservative religious groups like the Old Order Amish and Mennonites, and there

is an active effort to preserve Pennsylvania German culture by such organizations as the Pennsylvania German Society in Kutztown.

During the hundred-and-fifty-year period beginning in 1820, 6.9 million Germans came to the United States—the largest of all immigrant groups—and they settled in many part of the country. In addition to Pennsylvania, the states that received large numbers of German-speaking immigrants included New York, New Jersey, Ohio, Indiana, Michigan, Illinois, Missouri, Wisconsin, Minnesota, Iowa, Nebraska, Texas, and California. Most American families of German heritage have long been fully assimilated into American culture. However German American festivals, traditional cuisine, holiday celebrations, and crafts have helped sustain a sense of group identity even among persons whose families arrived in the United States many generations ago. Oktoberfest, for example, is one of the most widely observed celebrations. Having its origins in 1810 in a royal Bavarian wedding, this autumn harvest festival has become part of American popular culture. Hundreds of thousands of Americans throughout the country participate in Oktoberfest events each year.

Fortunately abundant records exist to provide insights into the way of life of the early German-speaking communities in the United States. Lewis Miller (1796–1882), who was born in York, Pennsylvania, to German-immigrant parents, was a carpenter by trade, but is remembered for his carefully annotated watercolor sketchbooks that chronicle life in York from 1810 to 1865. Although an adventurous life took Miller to Europe and elsewhere, his illustrated accounts of York provide an unparalleled opportunity to trace day-to-day events in the town, especially those related to the institutions of Pennsylvania German life and culture. In his narrative drawings and their accompanying texts, Miller depicts in great detail York's old German Lutheran and Reformed churches, its German-language parochial and singing schools, its taverns and shops, and its trades and recreations.

Pennsylvania German farmers, merchants, and a physician were among the subjects of the portrait painter Jacob Maentel (1778–?), himself an immigrant from Hesse-Cassel, who often portrayed residents of Dauphin, Lebanon, Lancaster, and York Counties, occasionally in the colorful, well-appointed interiors of their homes. These watercolor portraits provide insight into the aspirations of prosperous members of the Pennsylvania German community, the quality of their household furniture and decorations, and the manner of their dress. Maentel arrived in the United

States about 1805–1807, and lived in Pennsylvania until the mid-1830s, when he moved to New Harmony, Indiana, a community established by the Harmonists, German sectarians from Württemberg under the leadership of George Rapp (1757–1847). Another group of watercolor portraits by an unidentified artist known as the Reading Artist provides additional insight into the lives and times of mid-nineteenth-century Pennsylvania Germans in Berks and Lebanon Counties.

Although most of the pioneering Germanic immigrants and their descendants were members of the Lutheran or German Reformed churches, a distinctive minority were adherents of smaller faith communities. Among these, the German Seventh-Day Baptist community at Ephrata Cloister in Lancaster County, Pennsylvania, is especially noteworthy. Founded in 1732 under the charismatic leadership of Georg Conrad Beissel (1691–1768), a master baker from Eberbach in the Rhenish Palatinate, it functioned as a Protestant monastery, with two "solitary" or celibate orders, one for men and the other for women. Married "householders" lived outside the Cloister but shared its faith and aspects of its life. The imposing medieval-style wooden buildings at Ephrata, which date to the 1740s, are unlike any in North America, and helped support the austere self-discipline and ascetic devotional practices of approximately two hundred members. The wooden structures are notable for their steep roofs, small casement windows, shed-roof dormers, and narrow central chimneys; there is also a handsome stone almonry, where poor wayfarers were welcomed. Remarkably productive and largely self-sufficient, the Cloister produced its own food, furniture, and clothing, operated several mills, including a paper mill, and maintained one of North America's most important German-language printing presses.

Beissel, who had arrived in America in 1720, established a singing school at the Cloister, which developed a distinctive style of vocal music, and a scriptorium, or writing room, where the sisters of the community practiced manuscript illumination and drawing in ink and watercolor. Eighteenth- and nineteenth-century visitors to Ephrata Cloister often commented admiringly on the handsome *Frakturschriften* or ornamented fraktur writings and calligraphic wall charts that were produced there in the 1740s and 1750s. Among other impressive works, the sisters illuminated a series of hymnbooks, most often with elegant symmetrical floral and other organic motifs, and created at least two versions of *The Christian ABC Book* (1750), which includes several decorated alphabets and meticulous full-page drawings based in large part on the biblical narrative. The artwork of the Ephrata scriptorium constitutes the earliest flowering of Pennsylvania German folk art. Sources for some of the ornamental motifs in Ephrata watercolors may be found in European textile pattern books, which circulated widely in the seventeenth and eighteenth centuries.

Following the death of Beissel in 1768, Ephrata Cloister entered a period of sustained decline. However, during the American Revolutionary War, the community mustered enough strength to provide care to wounded American soldiers; before the end of the eighteenth century it also established a daughter congregation, Snow Hill Nunnery, in Franklin County, Pennsylvania. Although Ephrata's last celibate member died in 1813, the Cloister's traditions in the arts were maintained well into the nineteenth century at Snow Hill. Examples of illuminated tunebooks from that community are dated as late as the 1850s. A small German Seventh-Day Baptist congregation continued to worship at Snow Hill into the twenty-first century, although its last celibate member died in 1895.

If German manuscript illumination in America had its beginnings in the 1740s at Ephrata Cloister, it was during the seventy-year period beginning in 1770 that the art form flourished throughout the German-speaking communities of southeastern Pennsylvania and to a lesser extent elsewhere, especially Maryland and Virginia. The tradition was largely unknown outside the Pennsylvania German culture region until 1897, when preservationist Henry Chapman Mercer (1856–1930) discovered examples of fraktur among Mennonites in central Bucks County and published his pioneering study of the art form, *The Survival of the Mediaeval Art of Illuminative Writing among Pennsylvania Germans*.

Johann Henrich Otto (1733–c. 1800), who arrived in Pennsylvania from Germany in 1753, was among the first to create decorated *Taufscheine* (birth and baptismal certificates), the most common form of fraktur in America. A schoolmaster like most fraktur artists, Otto had substantial influence on the format and design vocabulary of these illuminated texts. Despite the religious nature of the *Taufschein*, Otto's work is bold, colorful, and earthy; indeed, many examples of fraktur combine spiritual and secular elements. Other common forms of fraktur include *Vorschriften* (writing exercises or samplers), bookplates, house blessings, religious texts, and small gifts or keepsakes. The Sussel-Washington artist, Georg

Friedrich Speyer (active c. 1774–1801), Johannes Ernst Spangenberg (d. 1814), Hans Jacob Brubacher (c. 1726–1892), Daniel Schumacher (c. 1729–1787), Friedrich Krebs (1749–1815), Andreas Kolb (1749–1811), Johann Adam Eyer (1755–1837), Martin Brechall (c. 1757–1831), Christian Strenge (1757–1828), Christian Alsdorff (c. 1760–1838), David Kulp (1777–1834), Durs Rudy Jr. (1789–1850), Henry Young (1792–1861), and Samuel Gottschal (1808–1898) are among the most significant fraktur artists.

Many important fraktur artists, including Brubacher, Kolb, Eyer, Kulp, and Gottschal, were Mennonites, members of a Christian denomination that shares an Anabaptist heritage with the Amish, Hutterian Brethren, and other faith communities. Rejecting infant baptism and refusing to bear arms, they take their name from Menno Simons (c. 1496–1561), a Dutch reformer. Mennonites were among the first German-speaking immigrants in Pennsylvania and they shared in the larger Pennsylvania German culture, including traditions in folk art. Researchers consider Christian Dock (1698–1771), a Mennonite schoolmaster in Montgomery County, to be the first teacher to create *Vorschiften* in Pennsylvania. The 1719 Hans Herr House in West Lampeter Township, Lancaster County, the oldest extant Mennonite meetinghouse in the Western Hemisphere, was built by Christian Herr (1680–1749), a Mennonite minister; it also served as a residence for several generations of the Herr family. Of stone construction, it is related to South German architectural prototypes in the Palatinate, where the Herr family and other Lancaster Mennonites lived before immigrating to Pennsylvania.

Some Mennonites were among the Pennsylvania Germans who moved south and west in search of more land and better farming conditions. Jacob Strickler (1770–1842), whom researchers believe to have been a Mennonite preacher, created a distinctive group of frakturs between 1787 and 1815 in Shenandoah (now Page) County, Virginia. Mennonite Anna Weber (1814–1888) was born in Lancaster County, Pennsylvania, and moved to Waterloo County, Ontario, in 1825. She is remembered for a series of colorful and whimsical drawings in the fraktur tradition that she created beginning in 1855.

Some Mennonite quilts, especially those created by members of "Old Order" or conservative groups within the denomination, share the distinctive palette and design vocabulary of Amish quilts, but many others draw from general American quilting traditions and are more difficult to identify as Mennonite without a specific family history or provenance. Some especially fine Mennonite quilts were created in the late nineteenth and early twentieth centuries in Holmes, Wayne, and Fulton Counties, Ohio; Elkhart County, Indiana, and McPherson County, Kansas.

Members of another small but influential German-speaking faith community to settle in colonial Pennsylvania were the Schwenkfelders, followers of a Silesian nobleman, Caspar Schwenckfeld von Ossig (1489–1561). Persecuted in Europe for their religious beliefs, most Schwenkfelders came to America in 1734, where they established individual family farms in Montgomery County, Pennsylvania. The art of manuscript illumination was widely practiced in the community; among the prominent Schwenkfelder artists were Susanna Heebner (1750–1818) and David Kriebel (1787–1848). In 1885, the General Conference of the Schwenkfelder Church began the formation of an historical collection, including examples of fraktur. Now housed in the Schwenkfelder Library and Heritage Center in Pennsburg, Pennsylvania, it is one of the first collections of Pennsylvania German material culture ever to be assembled; it includes fraktur and other works of art relating to the Schwenkfelder, Mennonite, and other communities.

About the same time that the Schwenkfelders were establishing themselves in Montgomery County, Pennsylvania, another German-speaking faith community, the Unitas Fratrum or Moravian Church was beginning to settle in North America. Tracing their spiritual roots to Bohemia and Moravia and to Jan Huss (c. 1369–1415), an early reformer and martyr, the persecuted Moravians found refuge in 1722 on the lands of Count Nikolaus Ludwig von Zinzendorf (1700–1760) in Saxony, where they established a settlement called Herrnhut. It was from Herrnhut that they migrated to North America, seeking asylum and converts. After an unsuccessful attempt to sustain a colony in Savannah, Georgia, that they founded in 1735, the Moravians organized communities in 1740 in Bethlehem, Nazareth, and Lititz, Pennsylvania, and in Bethabara (1753), Bethania (1759), and Salem (1766), North Carolina. The earliest structures in these communities show strong Germanic architectural influences; the folk and decorative arts had an important place in Moravian life.

Pottery was a well-developed craft and art form among the Moravians, especially in the North Carolina communities, which were located in a region rich in natural clay and mineral deposits. The first Moravian potter in Bethabara, Gottfried Aust (1722–1788) served apprenticeships in Herrnhut and Bethlehem, before settling in North Carolina in 1755. Not surpris-

ingly, decorated Moravian wares produced in North Carolina draw deeply upon the ornamental traditions of central and eastern Europe in which Aust was trained. Among Aust's apprentices was Rudolph Christ (1750–1833), whose slip-decorated wares are especially exuberant and colorful. Christ is also known for creating figural, press-molded flasks or bottles in the whimsical forms of fish, squirrels, bears, and other animals, often using tin-enameled glazes.

Early Moravians prided themselves on their commitment to education, including the education of women. Although instruction in fancy needlework was initially viewed as subordinate to other pursuits of a more utilitarian character, pupils in nineteenth-century Moravian girls' academies learned the required skills and excelled in the practice, as demonstrated by extant mourning pictures and floral embroideries. Unlike the show towels, decorated hand towels, and needlework samplers of other Germanic groups in America, however, the silk embroideries produced in Moravian schools in Salem, Lititz, and elsewhere, did not acknowledge Germanic precedent, but rather demonstrated a rather complete assimilation of American forms and techniques.

Among the distinctive family or congregational traditions maintained into the twenty-first century by Moravians throughout the United States is the creation of the Christmas *putz* (from the German, *putzen,* "to decorate"). Similar to a nativity scene, a *putz* features a three-dimensional representation in miniature of the manger in Bethlehem in which Jesus was born, and often includes depictions of other parts of the biblical Christmas narrative, as well: the Annunciation, the Adoration of the Magi, the Flight into Egypt. Of varying sizes and complexity, a *putz* may be placed on a table or fill an entire room. Whole families during the course of a year are often involved in collecting the materials to be used in the construction of a *putz*. Another widespread Moravian Christmas tradition is the display of illuminated twenty-six-pointed Advent stars, a custom that was instituted in 1850 by a Moravian teacher in Germany.

In their search for freedom of conscience and worship—as well as for the promise of inexpensive land and economic self-sufficiency—several other German-language Christian sectarian groups found their way to America. They were distinguished by a communal way of life, a pietistic faith, and charismatic leadership. Seeking autonomy and separation from the world outside their communities, they often encouraged the development of the arts and crafts. The celibate Harmonists established three successive set-tlements: Harmony, Pennsylvania (1805–1814); New Harmony, Indiana (1814–1825); and Economy, Pennsylvania (1824–1905), which ceased to function on the death of the last member. Many Harmonist buildings remain extant and are now open to the public as museums, including the impressive Feast Hall—a blending of Germanic and Georgian elements—in the third of the communities, now known as Old Economy Village. A gifted Harmonist mapmaker, Wallrath Weingartner (1795–1873) created detailed illustrated plans of the built and natural environments of these villages that are remiscent of the Shaker village views.

The followers of Joseph Bimeler (1778–1853), German Separatists from Württemberg, established the community of Zoar, Tuscarawas County, Ohio, in 1817. Principally agricultural in its economy, Zoar was also a center of furniture production, maintained flour, woolen, and sawmills, and undertook a variety of industrial pursuits. Some Zoar furniture is true to Germanic precedent, including plank chairs or stools, while many of the major pieces associated with "Number One House," Bimeler's Georgian-style residence (1835) demonstrate the influence of the Empire style. There was a little-known visual arts tradition at Zoar. Zoar drawings—created in ink and water-color—include subjects of a spiritual, mystical, or biblical nature that are occasionally reminiscent of the Pennsylvania German fraktur tradition. Some of these drawings are thought to be the work of Thomas Maier, a member of the community. Zoar ceased to function as a communal society in 1898.

Among the most successful of the German communal groups was the Community of True Inspiration, known today as the Amana Society. Originally settling on lands of the Seneca Indian reservation near Buffalo and known as the Ebenezer Society, the community moved to Iowa in 1855, establishing itself in six contiguous villages. In addition to farming its vast properties, the community engaged in cabinetmaking, maintained woolen and flour mills, engaged in textile production, and was largely self-sufficient. Willow basketry, carpet weaving, tinsmithing, and woodworking are associated with the villages, as well as a distinctive tradition of whole-cloth quiltmaking. Of a single color, Amana quilts are sewn in elaborate floral and geometric designs. Although the communal phase of Amana history came to an end in 1932 when the society incorporated, the faith of the Inspirationists continued to be practiced at Amana into the twenty-first century.

Among the most characteristic folk art expressions in early North American Germanic communities were

various forms of painted furniture produced in the eighteenth and nineteenth centuries, especially the *Kischt* or storage chest and the *Schrank* or wardrobe. Although the source of these colorful furniture forms is in the richly carved German and Swiss chests of the late Middle Ages, their more immediate antecedents are the polychrome chests produced in the German-speaking regions of Europe in the eighteenth century. Examples created in the Pennsylvania German culture region—dower chests, chests of drawers, cupboards or dressers, and candlestands—are decorated with a traditional body of ornamental motifs, including floral, geometric, and figural designs: flowering plants, hearts, birds, unicorns, and riders on horseback. Paint-decorated chests, desks, and other furniture forms produced in the 1830s and 1840s by a group of craftsmen in the geographically isolated communities of southeast Pennsylvania's Mahantango Valley in Northumberland and Schuylkill Counties are especially colorful and exuberant.

A distinctive body of eighteenth-century Germanic furniture was produced in New York's Schoharie County. Perhaps the most important surviving group of early decorated Germanic chests in New York was created for members of his family by Johannes Kniskern (1746–?), one of which, a dower chest, is dated 1778. Kniskern employed applied framed moldings and corner pilasters on this chest, showing a reliance on early Germanic cabinetmaking traditions from the late Renaissance.

Another significant group of early Germanic decorated furniture that may be attributed to a single maker is the work of Johannes Spitler (1774–1837) of Shenandoah (now Page) County, Virginia. Descended from a group of German and Swiss settlers who came to the region from Pennsylvania in 1733, Spitler was a neighbor of Jacob Strickler (1770–1842), who created a body of distinctive fraktur. More than twenty pieces from about 1800 have been identified as Spitler's—principally chests, but including two tall case clocks. Researcher Donald R. Walters has shown that Spitler and Strickler utilized a shared design vocabulary in some of their work. Spitler's painted decoration—geometric and organic in nature—is highly stylized and individualistic.

Potters were active in southeastern Pennsylvania, especially in Bucks and Montgomery Counties—where clay was readily available—from early in the history of German settlement in the state. In addition to many kinds of utilitarian wares, Pennsylvania German potters produced slip- and sgraffito-decorated, red-glazed earthenware in a rich variety of forms.

Among important Pennsylvania German potters were George Hubener (1757–1828), David Spinner (1758–1811), Conrad Mumbouer (1761–1845), John Leidy I (1764–1846), John Leidy II (1780–1838), John Neis (1785–1867), John Monday (1809–1872), and Conrad Kolb Ranninger (1809–1869). Lester Breininger Jr. carried this tradition into the twentieth century.

Figural sculpture in glazed, red earthenware, generally depicting whimsical animals, is associated with the potteries of John Bell of Waynesboro, Franklin County, Pennsylvania (1800–1880), and his brothers, Samuel and Solomon Bell (active 1834–1882) of Strasburg, Shenandoah County, Virginia. Another important potter, Anthony Wise Baecher (1824–1889), created figural sculpture and a variety of other wares in potteries in Mechanicstown, Frederick County, Maryland, and Winchester, Frederick County, Virginia. In the pottery-producing region of Catawba County, North Carolina, potters of German heritage produced a distinctive alkaline-glazed stoneware.

In virtually all German American communities, woodcarving and the making of woodenware has been a characteristic pursuit. Joseph Long Lehn (1798–1892) of Lancaster County, Pennsylvania, was a farmer, cooper, woodworker, and painter. His wooden sugar buckets, small cabinets, and other paint-decorated objects are colorful and exceedingly well made. Wilhelm Schimmel (1817–1890) of Cumberland County, Pennsylvania, is remembered especially for his carved and painted figures of eagles. "Schtockschnitzler" ("cane carver") Simmons (active 1885–1910), generally thought to be a German immigrant who roamed the back roads of Berks County, Pennsylvania, traded his fancifully carved canes for food and lodging. Immigrant German woodcarvers included such influential artisan sculptors as John Philip Yaeger (1823–1899) of Baltimore and Julius Theodore Melchers (1829–1909) of Detroit.

Wherever German-speaking immigrants settled in large numbers in the United States there is tangible evidence of their cultural heritage. Beginning in 1832, for example, immigrants from the German states began settling the lower Missouri valley. In sections of Gasconade, Franklin, St. Clair, and Warren Counties, Missouri, Germans became the dominant ethnic group. Throughout the region, there are extant examples of vernacular architecture that reflect Germanic building traditions—half-timbered or *fachwerk* structures in which the framework and masonry filling are exposed, or stone buildings. German American furniture produced in the region between 1840 and 1870 tends to be a provincial adaptation of Biedermeier-

style cabinetry. Belleville, county seat of St. Clair County in southwestern Illinois, also reflects an architectural heritage of a Germanic character.

Several German immigrants were responsible for the creation of important Roman Catholic shrines or grottoes, which have their origin in the popular European devotional practice of building replicas of sacred sites. Related to the pilgrimage tradition, the oldest European grottoes date to the fifteenth century. Paul Mathias Dobberstein (1872–1954) came to the United States in 1892 to study for the priesthood at Milwaukee's St. Francis Seminary and was assigned in 1898 to the parish church of SS. Peter and Paul in West Bend, Iowa, which was then a frontier settlement. Dobberstein was born in Rosenfeld, a small community in southwest Germany, and was familiar with grottoes in that region. He began the Grotto of the Redemption in 1912. After his death in 1957, work on the Grotto was taken up by Father Louis Grieving. Another German-immigrant priest and graduate of St. Francis Seminary, Mathias Wernerus (1873–1931), was influenced by Dobberstein's work; he built the Dickeyville Grotto in Dickeyville, Wisconsin. Another noteworthy shrine is the Ave Maria Grotto, the work of Brother Joseph Zoetl (1878–1961) on the grounds of St. Bernard's Abbey, a Benedictine monastery and college in Cullman, Alabama.

See also **Christian Allsdorf; Amish Quilts and Folk Art; Architecture, Vernacular; Baskets and Basketry; John Bell; Solomon Bell; Martin Brechal; Calligraphy and Calligraphic Drawing; Christmas Decoration; Decoration; Paul Mathius Dobberstein; Johann Adam Eyer; Fraktur; Furniture, Painted and Decorated; Samuel Gottshal; Holidays; Johann Jakob Friederick Krebbs; Jacob Maentel; Julius Theodore Melchers; Henry Chapman Mercer; Lewis Miller; Johannes Neis; Johann Friedrich Otto; Painting, American Folk; Pennsylvania German Folk Art; Pictures, Needlework; Pottery, Folk; Quilts; Reading Artists; Religious Folk Art; Durs Rudy Jr.; Samplers, Needlework; Wilhelm Schimmel; Daniel Schumacher; Schwenkfelders; Shrines; Johannes Ernestus Spangenberg; David Spinner; Johannes Spitler; Christian Strende; Jacob Strickler; Sussel-Washington Artist; Mathias Wernerus; Joseph Zoetl.**

BIBLIOGRAPHY

Amsler, Cory M. *Bucks County Fraktur.* Kutztown, Pa., 2001.

Benson, Cynda L. *Early American Illuminated Manuscripts from the Ephrata Cloister.* Northampton, Mass., 1995.

Bivins, John Jr. *The Moravian Potters in North Carolina.* Chapel Hill, N.C., 1972.

Bivins, John Jr., and Welshimer, Paula. *Moravian Decorative Arts in North Carolina: An Introduction to the Old Salem Collection.* Winston-Salem, N.C., 1981.

Fabian, Monroe H. *The Pennsylvania-German Decorated Chest.* New York, 1978.

Herr, Patricia T. *"The Ornamental Branches": Needlework and Arts from the Lititz Moravian Girls' School between 1800 and 1865.* Lancaster, Pa., 1996.

Hess, Clarke. *Mennonite Arts.* Atglen, Pa., 2002.

Hollander, Stacy C. *American Radiance: The Ralph Esmerian Gift to the American Folk Art Museum.* New York, 2001.

Madden, Betty I. *Art, Crafts, and Architecture in Early Illinois.* Urbana, Ill., 1974.

Moyer, Dennis K. *Fraktur Writings and Folk Art Drawings of the Schwenkfelder Library Collection.* Kutztown, Pa., 1998.

Murtagh, William J. *Moravian Architecture and Town Planning: Bethlehem, Pennsylvania and Other Eighteenth-Century American Settlements.* Chapel Hill, N.C., 1967.

Pellman, Rachel, and Kenneth. *A Treasury of Mennonite Quilts.* Intercourse, Pa., 1992.

Ohrn, Steven. *Passing Time and Tradition: Contemporary Iowa Folk Artists.* Des Moines, Iowa, 1984.

———. *Remaining Faithful: Remaining Faithful: Amana Folk Art in Transition.* Des Moines, Iowa, 1988.

Reed, Henry M. *Decorated Furniture of the Mahantongo Valley.* Lewisburg, Pa., 1987.

Schlee, Ernst. *German Folk Art.* Tokyo, Japan, 1980.

Swank, Scott T. *Arts of the Pennsylvania Germans.* New York, 1983.

van Ravenswaay, Charles. *The Arts and Architecture of German Settlements in Missouri.* Columbia, Mo., 1977.

Wiltshire, William E. III. *Folk Pottery of the Shenandoah Valley.* New York, 1975.

Zug, Charles G., III. *Turners and Burners: The Folk Potters of North Carolina.* Chapel Hill, N.C., 1986.

GERARD C. WERTKIN

GIBSON, SYBIL (1908–1995) is known for her tempera paintings on grocery bags and newspaper, which she produced by the thousands. Her depictions of flowers and children were colorful in a soft and sentimental way, but when she painted a woman's face looking directly at the viewer, she created an ominous and mysterious effect. Gibson's appealing yet haunting subjects make her an individualistic and compelling artist.

Born to affluent parents on February 18, 1908 in Dora, Alabama, Gibson led a chaotic life. When she was twenty-one, she married Hugh Gibson, and in 1932 they had a daughter, Theresa. When they divorced in 1935, she left her daughter in the care of her own parents, and attended a number of Alabama colleges. She received a degree from Jacksonville State Teachers College in Alabama and eventually taught grade school, first in Alabama and then in Florida, where she moved in 1945 or 1946. She re-

married in 1950 or 1951, but her second husband, David De Yarmon, moved to Ohio without her.

Gibson's life as an artist began spontaneously in 1963, when she saw some striking gift-wrapping paper that inspired her to paint feverishly with tempera poster paint on damp grocery bags. This wet-on-wet technique produced a soft, delicate quality that is characteristic of her work and contributed to a fluid, painterly style, which is unusual for a Southern folk artist. She also painted with oils, house paint, and watercolors on anything she could find in the trash. Her poverty and the volume of her output dictated the use of grocery bags, in particular, as a surface. Gibson said that good art paper turned her off, while something out of the trash pile inspired her. Still-lifes, landscapes, flowers, birds, cats, children, and groups of figures as well as haunted, female faces were all subjects of her paintings. She said she did not plan or sketch her work first, but let the paint tell her what to do. Gibson said she was painting her childhood memories; she did not believe that art could be taught, but that it must come from within.

In 1971 the Miami Museum of Modern Art organized a one-woman show of Gibson's work, but the artist never saw the exhibition because she had disappeared two years earlier. She was found living in Birmingham, Alabama, in a seedy hotel. Over the next twenty years, she lived with her cousin in Florida and then at a facility for the elderly in Jasper, Alabama, which she was forced to leave because of her disruptive behavior. Gibson stopped painting because of her deteriorating eyesight.

In 1991 Gibson's daughter took charge of her mother's life, moving her to the Dunedin Care Center in Florida, and arranging for a cataract operation. The artist was soon back at work, covering her bed and floor with stacks of new paintings. Gibson died there. While thousands of her paintings were discarded, many survived, and they are now collected and exhibited extensively.

See also **Painting, American Folk; Painting, Landscape; Painting, Still-life.**

BIBLIOGRAPHY

John Hood. "More Than a Pretty Face: The Art of Sybil Gibson." *Folk Art*, vol. 23, no. 4 (winter 1998–1999): 47–51.
Kemp, Kathy, and Keith Boyer. *Revelations: Alabama's Visionary Folk Artists.* Birmingham, Ala., 1994.
Yelen, Alice Rae. *Passionate Visions of the American South: Self-Taught Artists from 1940 to the Present.* New Orleans, La., 1993.

JOHN HOOD

GIFT DRAWINGS: *SEE* SHAKER DRAWINGS.

GIBBS LIMNER: *SEE* FREAKE-GIBBS-MASON LIMNER.

GILBERT, JOHANN CONRAD (1734–1812) was a fraktur artist and Lutheran schoolmaster who worked at several churches in Berks and Schuylkill Counties in Pennsylvania. He copied the work of Daniel Schumacher (c. 1728–1787), a Lutheran clergyman who decorated church records and made baptismal and confirmation certificates; he also borrowed from the work of the anonymous Sussel-Washington artist, who in turn depicted the animals and birds from the fraktur artist Henrich Otto (c. 1770–c. 1820).

Gilbert's production consists of many baptismal records; presentation frakturs showing schoolmasters holding slates; images of the Easter rabbit (the earliest American drawing of this mythical creature); and religious texts. His work is distinguished by neat lines, deep colors, and the exotic attire of the angels he portrays. Firmly rooted in Pennsylvania German elementary education as practiced by the church, Gilbert's designs sought to delight children in their baptism, in the teachings of their church, in respect for school, and in household order. At the same time his work appealed to childhood whimsy; one drawing, of bright-red horses facing each other with a pious text, would immediately engage nearly any child. Gilbert did initial one piece, but his bold penmanship led to the artist's identification long before the initialed piece was discovered.

Gilbert married and had a large family. To one grandson he left his family Bible with "writings therein," undoubtedly some family frakturs. These seem to have been lost—a real tragedy, as baptismal records for his own children were especially carefully made.

See also **Fraktur; German American Folk Art; Henrich Otto; Pennsylvania German Folk Art; Religious Folk Art; Daniel Schumacher; Sussel-Washington Artist.**

BIBLIOGRAPHY

Weiser, Frederick S. "His Deeds Followed Him: The Fraktur of John Conrad Gilbert." *Der Reggeboge*, vol. 16, no. 2 (1982): 33–45.

FREDERICK S. WEISER

GIRARD, ALEXANDER (1907–1983) was an important textile designer of the mid-twentieth century and, with his wife, Susan, one of the greatest collectors of international folk art of his time. Born in New York, he grew up in Florence, Italy, attended school in

England, and trained as an architect in London and Rome. He worked for a short time in Europe before moving to the United States.

In 1932 Alexander Girard opened his first United States architecture and design office, in New York City. He moved to Detroit in 1937, where he created some of his most important interiors, among them the headquarters of the Ford Motor Company. He received significant recognition and achieved success as a designer in New York in the 1950s as director of the textile division of the design firm Herman Miller; as a designer at the Museum of Modern Art; and as the designer of two restaurants, L'Etoile and La Fonda del Sol.

Girard, who collected miniatures as a child, and his wife began to collect folk art seriously in 1953, when they purchased a house and he opened an office in Santa Fe, New Mexico. While living in New Mexico, the focus of their collection became Latino folk art. They eventually amassed more than 100,000 items from around the world, but the collection's main focus remained on Latino art from Mexico and Latin America. The Girards lived with part of their collection, but because of its size much of it was kept in storage until 1978, when they donated 106,000 works to the Museum of International Folk Art in Santa Fe.

The Girards' gift quintupled the size of the museum. Their donation included textiles, from European samplers to sub-Saharan African clothing; religious and devotional art from eighteen countries; puppets from Asia and Europe; and European toy theaters. Girard was particularly enthusiastic about the art of the Native American and the Hispano-Latino cultures of the southwestern United States, and his collection includes Cochiti storyteller figures, Navajo pictorial weavings, and carvings by northern New Mexicans. A selection of 10,000 items from the collection was put on permanent view in the installation, designed by Alexander Girard, "Multiple Visions: A Common Bond," when the Girard Wing of the museum opened in 1982.

See also **Miniatures; Native American Folk Art; Religious Folk Art.**

BIBLIOGRAPHY

Glassie, Henry. *The Spirit of American Folk Art: The Girard Collection at the Museum of International Folk Art.* New York and Santa Fe, N. Mex., 1989.
Museum of International Folk Art. *Folk Art from the Global Village: The Girard Collection at the Museum of International Folk Art.* Santa Fe, N. Mex., 1995.

ANNIE CARLANO

GODIE, JAMOT EMILY (Lee) (1908–1994), one of Chicago's best-known twentieth-century self-taught artists, is remembered for her intense, idealized portraits of glamorous, wide-eyed women and handsome men. One of her favorite subjects was a profile of a woman with a prominent jaw with her hair pulled into a topknot. A favorite male subject was *Prince Charming, or Prince of the City,* based on a postcard reproduction of a Pablo Picasso portrait of the ballet master Leonid Massin. She also created multiple versions of a waiter with black sideburns and a mustache.

Born in Chicago, Godie later married and had three children. Following the death of two of her children and the failure of her marriage, she chose to live without a permanent residence. A street artist for nearly two decades, Godie was a familiar figure in the center of Chicago. She was often found perched on the steps of the school of the Art Institute of Chicago, where she declared herself a French Impressionist, and sold her work to museum-shop employees, students, and passersby.

Godie completed several thousand drawings and paintings, and sometimes embellished them with one or more photographs of herself dressed in dramatic clothing, wearing hats, and with various facial expressions, all taken in photo booths. She worked in a variety of media, including tempera, ballpoint pen, crayon, watercolor, pencil, and combinations of these. She worked mostly on canvas, but also on matte board, bristol board, and poster board. Occasionally, she included pictures from magazines and newspapers in her work. She carted her work around and stored it, along with her art supplies and material possessions, in rented lockers at bus terminals, department stores, and parking garages.

After more than forty years, Bonnie Blank, Godie's only surviving child, traced her birth mother's whereabouts through a copy of her own birth certificate, and, in 1988, mother and daughter were reunited. Though she resisted, Godie eventually agreed to move to a nursing facility. On August 28, 1991, Chicago's Mayor Daley proclaimed September 6 to October 8 "Lee Godie Exhibition Month," and urged citizens to "pay homage to this gifted artist." In 1993 Godie, physically and mentally infirm, attended a twenty-year retrospective of her work at the Chicago Cultural Center.

See also **Outsider Art; Painting, American Folk.**

BIBLIOGRAPHY

Bonesteel, Michael. "Lee Godie: Michael Bonesteel Reflects on the Life and Work of the Queen Mother of Chicago Outsider Artists." *Raw Vision*, vol. 27 (summer 1999): 40–45.

Moss, Jessica. "Transformations of the Self." *The Outsider*, vol. 7, no. 1 (fall 2002): 12–13, 25.

LEE KOGAN

GOLDING, WILLIAM O. (1874–1943) was a significant African American self-taught artist of the early twentieth century, known primarily for his lively drawings of sailing vessels. His work condensed a half-century of seagoing experience into more than sixty small but lively drawings in pencil and crayon. During the 1930s, Golding was suffering from chronic bronchitis, and was registered as a patient at the United States Marine Hospital in Savannah, Georgia. In 1932 he began to draw from memory, encouraged by Margaret Stiles, a local artist and the hospital's recreation director. Information gleaned from his letters to Stiles suggests that Golding had led a hard but colorful life. Golding began his career at sea as a cabin boy at the age of eight, and later claimed to have made numerous voyages to far-flung corners of the world for more than forty-nine years.

Golding's work recalls both maritime painting and the phenomenon of memory painting in self-taught art. His images are primarily detailed, if fanciful, descriptions of ships he had seen or served on, and views of exotic ports. The works are imaginatively composed to include activities and landmarks of specific places: sailing ships chasing whales in the Arctic, South Sea ports featuring erupting volcanoes, and Chinese architecture. Golding apparently saw all or many of the sights he recorded, and pointedly mentions in one of his letters that he could not draw Bali or Hawaii because he had never seen them.

Golding developed a style all his own that is easily recognized. His earliest works feature some of his trademarks, including an ever-present sun resembling a compass rose (a navigational symbol found on nautical maps) bursting forth from behind clouds, buoys, flocks of birds, lighthouses, and nameplates. Golding depicted historically famous watercraft such as the *Constitution,* which he may have seen in Savannah in 1931, as well as, in rare instances, ships that predated him. Golding additionally portrayed a variety of ports of call in his work, including locations in China, the Philippines, Java, Newfoundland, Trinidad, Cape Horn, the Rock of Gibraltar, and Plymouth, England.

Golding's last drawings are dated 1939. He died in 1943, at the Marine Hospital in Savannah. Although his output was relatively small, Golding's work began to achieve popular notice with a 1970 article in *Art in America,* and was included in the seminal exhibition, "Missing Pieces: Georgia Folk Art 1776–1976," in 1977.

See also **African American Folk Art (Vernacular Art); Maritime Folk Art; Painting, Memory.**

BIBLIOGRAPHY

King, Pamela, and Harry H. DeLorme. *Looking Back: Art in Savannah, 1900–1950.* Savannah, Ga., 1996.

Wadsworth, Anna. *Missing Pieces: Georgia Folk Art, 1776–1976.* Atlanta, Ga., 1976.

HARRY H. DELORME

GOLDSMITH, DEBORAH (1808–1835), an early-nineteenth-century painter, created sympathetic portraits of family and friends in the community and surrounding areas of New York State where she lived. Economic necessity was thought to motivate the young woman, though there is no evidence to corroborate this. One scholar suggests that Goldsmith became an itinerant painter to support her parents. Although there are no advertisements in newspapers from the communities in which her patrons resided, proof that she traveled and painted portraits for residents of Brookfield, North Brookfield, Hamilton, Lebanon, Cooperstown, Hartwick, Toddsville, and Hubbardsville is documented in her own records between 1826 and 1832. Goldsmith stopped seeking professional commissions in 1832, the year she married George Addison Throop, a patron and a member of a family for whom she painted. Their marriage followed a correspondence with Throop in which Goldsmith voiced her concerns about their different religious affiliations (she was a devout Baptist, he was a Universalist), the fact that she was two years older than he, and that her teeth were partially artificial.

The legacy of this young woman consists of watercolors on paper and ivory, as well as portraits in oil. Her friendship albums were filled with poetry, interspersed with decorative motifs of birds, flowers, musical instruments, landscapes, illustrated copies of prints, and a mourning picture. The artist left correspondence, her worktable, and a tin paint box, with watercolor powders wrapped in newspapers and oils stored in tins.

Goldsmith's masterpieces are two group portraits, one of the *Lyman Day Family* (1823), and the other of the *Talcott Family* (1832). These group portraits, important documents of social history, are replete with

interior painted details, furnishings, carpet, wallpaper, and accessories. In the Day portrait, husband and wife are presented in a spare but well-appointed and decorated room, seated side by side, and looking directly at the viewer. The marriage seems a harmonious partnership, with Mr. Day's right arm extended over Mrs. Day's chair rail. Mrs. Day's role as wife and mother is clearly delineated: seated next to her husband, she is responsible for the baby she holds on her lap. Mr. Day's role as provider is understood by the subtle emphasis placed on his worldly interests, such as by the placement of a newspaper on his lap.

Goldsmith's parents, Richard and Ruth Miner Goldsmith, settled in Brookfield, New York, having moved from Guilford, Connecticut, between 1805 and 1808. Although Brookfield was small, Goldsmith benefited from her proximity to nearby Hamilton, with its vital religious revivals and strong educational opportunities.

Her early death followed weeks of sickness. Goldsmith left two children, whose descendants preserved her memory over the generations.

See also **Painting, American Folk.**

BIBLIOGRAPHY

Dewhurst, C. Kurt, et al. *Artists in Aprons: Folk Art by American Women.* New York, 1979.

Jones, Agnes Halsey. *Rediscovered Painters of Upstate New York, 1700–1875.* Utica, N.Y., 1958.

Lipman, Jean, and Alice Winchester, eds. *Primitive Painters in America.* New York, 1950.

———. "Deborah Goldsmith, Itinerant Portrait Painter." *The Magazine Antiques,* vol. 44 (November 1943): 227–230.

Shaffer, Sandra C. *Deborah Goldsmith, 1808–1835: A Naïve Artist in Upstate New York.* St. Louis, Mo., 1968.

LEE KOGAN

GONZALES, JOSÉ DE GRACIA (1835–1901) was an itinerant Mexican-born painter and sculptor, and one of the most important artists working in late-nineteenth-century New Mexico. Gonzales left his native Chihuahua, Mexico, in 1860, and moved to northern New Mexico to pursue his self-described vocation as a painter. The American occupation of the New Mexico territory in 1846 had resulted in an influx of trade, including commercial religious images, initiating a slow decline in works by area *santeros* (makers of religious images). Upon his arrival, Gonzales immediately set to work as both creator and restorer of several important church altar screens, religious paintings, and sculptures in various northern New Mexico villages.

Gonzales was a trained artist who worked in a provincial Neoclassic style, a simplified interpretation of the academic painting style that prevailed in mid-nineteenth-century Mexico. His works in oil had a distinctive Mexican flair, with detailed depictions of saints in rich colors bordered by popular floral and other Mexican motifs. Between 1864 and 1869, approximately, Gonzales was commissioned to restore the early-nineteenth-century wooden altar screens in the church of Las Trampas. He repainted the same images as they had originally been portrayed, with the exception of one altar screen dedicated to St. Francis of Assisi. Gonzales also created three altar screens in churches near the village of Peñasco, and one in the parish church at Arroyo Seco. These altar screens stand as premier examples of Gonzales's masterful painting and restoration skills.

As a sculptor, Gonzales brought new life to the tradition of making *santos* as well. In keeping with the *santo*-making tradition in New Mexico, Gonzales created polychrome *bultos* (three-dimensional religious sculptures), although even in this medium his detailed painting skills are emphasized. A unique polychrome sculpture made between 1860 and 1875 combines the artist's sculpting and painting styles, with a carved image of the Crucifixion flanked by two painted wooden panels depicting Our Lady of Sorrows and St. John the Evangelist. The image reveals the artist's resourcefulness; stenciling on the back of the cross indicates that it was made using a packing box from St. Louis, Missouri, which would have been shipped to the area via the Santa Fe Trail.

Gonzales moved to Trinidad, Colorado, in the 1870s. There he continued to paint and sculpt, making his own molds and casting them in plaster, another popular Mexican technique. He lived in Trinidad until his death, presumably supporting himself as an artist.

See also **Bultos; Painting, American Folk; Religious Folk Art; Santos; Sculpture, Folk.**

BIBLIOGRAPHY

Frank, Larry. *A Land So Remote.* Santa Fe, N. Mex., 2001.

Padilla, Carmella, and Donna Pierce. *Conexiones: Connections in Spanish Colonial Art.* Santa Fe, N. Mex., 2002.

Wroth, William. *Images of Penance, Images of Mercy: Southwestern Santos in the Late Nineteenth Century.* Norman, Okla., 1991.

CARMELLA PADILLA

GONZÁLEZ AMÉZCUA, CONSUELO (Chelo) (1903–1975) created imaginary worlds through her

visionary pen-and-ink drawings, stone carvings, and poetry. She began to carve in 1956, but was forced by respiratory problems in 1964 to give it up, and she turned to drawing. Her drawings, which she referred to as Texas Filigree Art, synthesized her love of Mexico and America, especially the state of Texas. She sang, danced, and was proficient at playing the guitar, piano, castanets, and tambourine.

A strong belief that her inspiration was divine led the artist to depict biblical subjects with exotic backdrops, such as Egypt, Persia, and Judea. Mythological and classical themes also prompted her to feature in her works fantastic architectural forms, including castles, turrets, elaborate walls and columns, as well as flowers, gardens, birds, hands, winged muses, mythical figures, and animated women. Some of her themes were philosophical, as in *Road of Life* (undated) or *Symbol of Truth* (1967), while others were autobiographical. Poetry was occasionally integrated into her drawings; at times it appears on the reverse side of the paper or cardboard on which she drew.

Born in Piedras Negras, Coahuila, Mexico, across the Rio Grande from Eagle Pass, Texas, González Amézcua left her birthplace, along with her schoolteacher parents, Jesus González Galvan and Julia Amézcua de González, when she was ten, settling further northwest in Del Rio, Val Verde County, Texas. She attended school for six years but never received formal art training. She credited her sister Zare for her musical inspiration, and her parents for the stories that nurtured the "dream visions" she executed.

González Amézcua began to draw at an early age. The San Carlo Academy in New Mexico offered her an art scholarship, but family responsibilities following the death of her father prevented her from accepting it. She nevertheless continued making art, and developed a personal style using readily available materials. She favored black ballpoint pens and white cardboard for her meticulous work. Occasionally, she added red, green, and blue to her drawings. During the last five years of her life, she expanded her color palette, using crayons and felt-tip pens along with the ballpoints. González Amézcua did no research prior to drawing, but planned her drawings in advance before execution. She carefully outlined major forms, then filled in intricate details. In 1968 a solo exhibition of her work was organized at the Marion Koogler McNay Art Museum in San Antonio.

See also **Sculpture, Folk; Visionary Art.**

BIBLIOGRAPHY

Borum, Jenifer. "The Visionary Drawings of Chelo Gonzalez Amezcua." *Folk Art*, vol. 24 (fall 1999): 53–61.

Lee, Amy Freeman. *Filigree Drawings by Consuelo Gonzalez Amezcua.* San Antonio, Tex., 1968.

LEE KOGAN

GOODELL, IRA CHAFEE (1800–c. 1875), a portrait painter, worked in western New England, the Upper Hudson Valley of New York State, and New York City during the mid-nineteenth century. A native of Belchertown, near Amherst and Northampton, Massachusetts, he was born on July 3, 1800, the son of Moses and Susannah Pettengill Goodell. Little is known about Goodell as an artist, although he must have begun to paint as a young man in Belchertown, as many of his earliest subjects, dating from the early 1820s, lived in this area.

Goodell's figures are rendered bust-length, without hands. Women, in particular, are portrayed wearing elaborate lace bonnets and collars as well as ornate shawls that all appear as abstracted forms lying flat on their bodies, or as outlined shapes contrasting against a neutral background.

By the late 1820s Goodell was working in New York State, where he married Delia Cronin of Hudson on May 31, 1832. The couple continued to reside in the region while Goodell traveled the countryside painting portraits, principally of the residents of Columbia, Albany, and Washington Counties. Most of his sitters were part of the burgeoning middle classes then populating the region, from merchants, shopkeepers, and farmers to wool-growers, attorneys, and physicians. His likenesses from this time are painted on tulipwood panels, a departure from his earlier use of canvas in Massachusetts.

Perhaps to gain exposure to an urban center for the fine arts, Goodell had moved with his wife and family to New York City by 1835, where he lived until 1871. This period of Goodell's career remains largely undocumented. City directories list him as a portrait painter, limner, or artist living in the Greenwich Village district until 1861. He also spent some time in Vestal, New York, near Binghamton, in 1840; in New Brunswick, New Jersey, in 1859 and 1860; and in Nyack, New York, in 1861. Ultimately, the artist returned to Belchertown, Massachusetts, where he died by about 1875.

Goodell's most impressive likeness depicts his six-year-old son, Angelo Newton Franklin. Something of a prodigy, the child is portrayed giving a public demonstration of phonographic writing, or the Pitman

Method of shorthand, at the Apollo Rooms in New York, where he is captured in the process of transcribing from memory the Declaration of Independence. Dating from 1849, the year the Pitman Method was introduced to New York, the portrait is the only documented painting attributed to Goodell's residency in the city.

See also **Painting, American Folk.**

BIBLIOGRAPHY

Rumford, Beatrix T., ed. *American Folk Portraits: Paintings and Drawings from the Abby Aldrich Rockefeller Folk Art Center.* Williamsburg, Va., 1981.

Piwonka, Ruth. *Painted by Ira C. Goodell: A Catalogue and Checklist of Portraits Done in Columbia County and Elsewhere by Ira C. Goodell (1800–c. 1875).* Kinderhook, N.Y., 1979.

CHARLOTTE EMANS MOORE

GOODPASTER, DENZIL (1908–1995) was the best-known carver and painter of canes in Kentucky in the late twentieth century. As a farmer, he learned how to work with metal and wood, and how to fix things. Over the years he crafted various items from wood, some functional, others decorative. Around 1970, when he retired, he noticed canes made by other men at the Morgan County Sorghum Festival in West Liberty, Kentucky. Boasting that he could make better sticks, he soon began to produce them in a distinct, colorful style. His work became easily identifiable, and was later copied by other regional canemakers. His brightly painted, humorous sticks featured female figures, snakes, alligators, and other animals. His human figures—which included cheerleaders, bathing beauties, nudes, and portraits of Dolly Parton—all had the same face. He also carved small sculptures of animals, and made flexible, articulated alligators, with wooden sections held together using leather.

Goodpaster's work exerted an important influence on American folk canes, as the risqué subject matter he frequently portrayed as well as the flamboyant colors he used established a standard for stickmaking that other regional artists continue to aspire to today.

See also **Canes; Sculpture, Folk.**

BIBLIOGRAPHY

Meyer, George H. *American Folk Art Canes.* Bloomfield Hills, Minn., 1992.

Milwaukee Museum of Art. *Common Ground, Uncommon Vision.* Milwaukee, Wisc., 1993.

ADRIAN SWAIN

GORDON, THEODORE (1924–) executed portraits in pen, magic marker, and colored pencils on paper that are made up of dense, patterned networks of lines, which the artist contends are exercises in "self-observation and self-transformation." His drawings "assemble themselves on paper" without preplanning. His faces are staring, complex, and sometimes dour. Gordon's patterned grids of stripes, cross-hatching, and circular swirls are self-contained, and he leaves narrow, unembellished space around the major figure or head, setting off the main subject from its background.

Born in Louisville, Kentucky, in 1924, Gordon lived with his grandparents. Following the death of his father when he was fourteen, Gordon moved with his grandparents to New York City. He graduated from Eastern District High School in Brooklyn, was drafted into the United States Army in 1944, and following his discharge took some college courses. Restless in the classroom, he took a series of jobs, as a messenger, clerk, and bricklayer, before moving to California, in 1953, where he met his wife; they settled in San Francisco. Gordon obtained a B.A. degree with a concentration in social welfare from San Francisco State College.

In 1939, after his father died, Gordon attempted caricature sketches to honor his father's memory. His father had also produced some caricatures and cartoons, and Gordon says that he, like his father, "doodled" in "response to some of his anxiety feelings." Gordon began to draw again in the early 1950s, this time virtually automatically. He worked on any paper that was at hand, such as envelopes, receipts, and the paper used as dividers to separate X-ray film in the hospitals in which he worked. He used all of his spare time from his jobs working in veterans' hospitals to draw human faces and heads, restless plants, birds, cats, and abstract compositions. After retiring, in 1985, he continued to draw daily and continues to do so.

In 1990 Gordon had a solo exhibition at the Collection de l'art brut in Lausanne, Switzerland. In 1998 he received the Award of Distinction from the Folk Art Society of America in San Diego, California.

See also **Outsider Art.**

BIBLIOGRAPHY

Cardinal, Roger. "A Very Ordinary Man: The Obsessive Drawings of Ted Gordon." *Intuit,* vol. 7, no. 1 (fall 2002): 8–11, 18, 29.

Larsen-Martin, Susan. *Pioneers in Paradise: Folk and Outsider Artists of the West Coast.* Long Beach, Calif., 1984.

MacGregor, John. *Theodore Gordon.* Lausanne, Switzerland, 1990.

LEE KOGAN

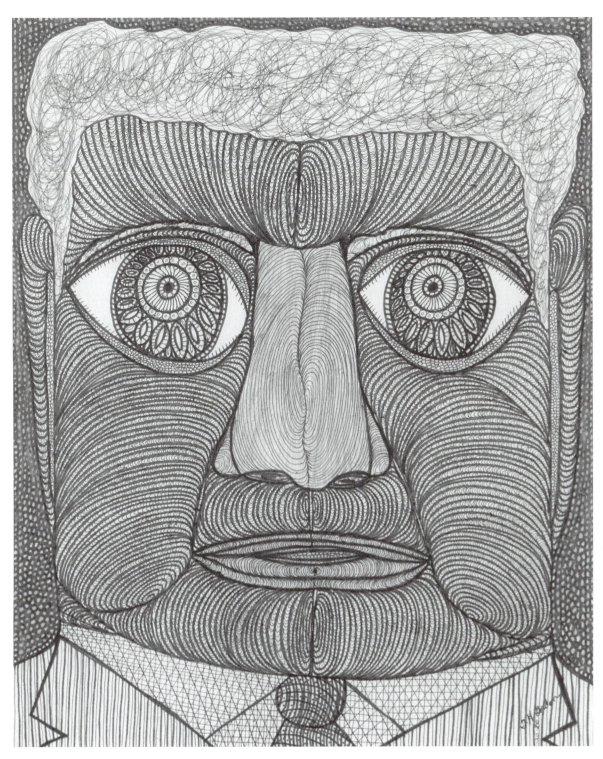

Head of a Man; Theodore H. Gordon; 1980. Magic marker, pencil, ballpoint pen on paper;
17 × 14 inches. Collection American Folk Art Museum, New York, 1982.13.1.
Photo courtesy Ken Hicks.

GOTTSCHALL, SAMUEL (1800–1898) was a member of a family of schoolmasters that made fraktur and owned land in the Franconia Mennonite settlement of Montgomery County, Pennsylvania. His father, Jacob, was a Mennonite preacher and bishop who had taught school for a while, leaving behind books of musical notation that he produced with his students. Among Jacob's eleven children, four apparently taught school in Pennsylvania. Two of the four, Martin (1797–1870) and Samuel, seem to have made fraktur in the schools they taught, that were located on their property. Because the brothers rarely signed their work and both used heavy applications of gum arabic, telling their work apart is no easy task; but the richly saturated colors and strong imagery have made it highly desirable to collectors. Neither brother married, and they worked together as successful millers after their teaching days were over. Samuel was also a weaver, and his weaver's record book and his weather diary have survived. It is on the basis of these records that it has been possible to identify Samuel Gottschall's work.

See also **Fraktur; German American Folk Art; Pennsylvania German Folk Art; Religious Folk Art.**

BIBLIOGRAPHY

Hollander, Stacy C., et al. *American Radiance: The Ralph Esmerian Gift to the American Folk Art Museum.* New York, 2001.

<div align="right">*Frederick S. Weiser*</div>

GRASS ROOTS ART AND COMMUNITY EFFORT (GRACE) was started in 1975 as a daytime applied arts program for the elderly in northeast Vermont. The program was founded by artist Don Sunseri (1939–2001) at the St. Johnsbury Convalescent Center, in St. Johnsbury, Vermont, because he felt that the residents of the convalescent home would find a course in art to be a source of learning. He secured funding for a two-year program and provided artists' materials along with a supportive environment in which the residents could make art. Sunseri abandoned traditional art teaching when he realized that residents preferred to explore independently.

GRACE's mission has expanded considerably since 1975. Mental health agencies, for example, use GRACE services for their clients. The intergenerational community workshops at GRACE's facility are among the five hundred workshops it runs annually. GRACE additionally maintains a permanent collection of art made within the program since the organization was founded, with works available for exhibition and sale, as well as for school and community exhibition. It also holds an archive documenting its efforts, and has served as a model for other programs, both nationally and internationally. GRACE has been recognized as a community arts organization by the Vermont Arts Council, the National Endowment for the Arts, the New England Foundation for the Arts, and the Vermont Community Foundation.

See also **Gayleen Aiken.**

BIBLIOGRAPHY

GRACE. *States of Grace: Vermont's Grass Roots Art and Community Effort since 1975.* Hardwick, Vt., 1998.

<div align="right">*Lee Kogan*</div>

GRAVE DECORATION: *SEE* WILLIAM EDMONDSON; GRAVESTONE CARVING; OLD STONE CARVER; JOHN STEVENS.

GRAVESTONE CARVING, used to identify and ornament graves, is America's earliest form of sculpture. Among early American artifacts, these carvings are unique, in that each is dated and most are found in their original settings, surrounded by similar carvings of the same period. The oldest stones are scattered through North America's early settlements, with the largest and oldest groups standing in the oldest cities, frequently adjacent to a church or a meetinghouse, or on a town common. Many have disappeared, the victims of theft, vandalism, power mowers, and natural deterioration, but thousands are still standing, in good condition. Because the procedure for removing a gravestone from a burying ground is complex, few have been placed in museum settings.

America's colonial gravestone carvers were usually local tradesmen who practiced other vocations as well. With hammer and chisel, they developed their skill through trial and error and with devotion and ingenuity. They produced many carvings of remarkable artistic strength. They signed their work when the carving was unusual or if the marker was to be placed on a grave located far from the carver's home base. More than three hundred pre-1800 gravestone carvers have been identified, primarily through searches of probate records and comparisons of their carving styles. Among those carvers now identified are John Hartshorne (1650–c. 1737), a survivor of King Philip's War, who worked and influenced carvers in Massachusetts and eastern Connecticut; Joseph Lamson (1658–1722), a creative Boston-area carver, whose sons worked in his shop; John Stevens (1646–1736), who began a family stone-carving tradition in New-

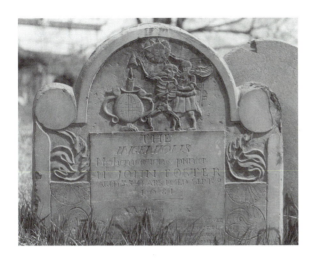

Headstone for John Foster depicting a skeletal figure with winged Father Time holding an hourglass, and a large sun dial overhead and sea creatures left and right. Carver unknown; Dorchester, Massachusetts, c. 1681.
Photo courtesy the American Antiquarian Society, Massachusetts.

orative carving than those made for less prominent citizens and children.

The iconography and decorative carving on America's early gravestones underwent alterations over time, reflecting changes in philosophical attitudes toward life and death. The imagery on the earliest markers derived from the strong and stern religious beliefs of the Puritans. Mortality and preparedness for death were dominant themes, symbolized on the stones by various bones, coffins, hourglasses, scythes, whole skeletons, and skulls. By the middle of the eighteenth century, winged faces (many of them crowned), hearts, birds, the tree of life, and other motifs, including portraits of the deceased, indicated an increased interest in the Resurrection and everlasting life. After 1800, gravestone carvings began to show an enthusiasm for classical antiquity. A larger, simpler stone, decorated by an elegant carving of an urn and weeping willow, became the standard. The inscriptions as well as the iconography reflected this change. "In Memory of. . ." replaced the more regal-sounding "Here Lies the Body of. . . ."

This outline of the development of American gravestone carving is of course somewhat simplified. Because the carvers worked independently and in isolation, innovation in both concept and design came about naturally. Thus, gravestone sizes, shapes, iconography, and inscriptions, which developed throughout the settlement of this large country, can be surprisingly different and do not necessarily follow the model described above. Rural yards in areas of Virginia, North Carolina, Georgia, and Texas are examples of the many locations in which themes originated and evolved in their own unique patterns of development.

By the middle of the nineteenth century, large, rural "garden cemeteries" were replacing the small, crowded, burying grounds. Improved transportation made it possible to import soft, white marble, while three-dimensional tombstones with carving on a grand scale became popular. Monument makers began to communicate with one another, to advertise as well as to transport their work over long distances. Monument making became a lucrative business. In this milieu, the local, untrained, innovative, part-time carver disappeared. Gravestone carving as a folk art, for the most part, died.

port, Rhode Island, in 1705; and John Zuricher (active 1749–1778), one of the first carvers identified in New York City.

Early gravestones were produced in two parts: a headstone and a footstone, to be placed at the head and foot of a grave. The shape of the stones suggests the headboard and footboard of a bed, as well as the arches and portals through which the Puritans, who came from Europe and settled on the American East Coast in the seventeenth century, believed the soul must pass to enter eternity. Typically, a colonial headstone's rounded tympanum, at the top of the stone, is flanked on either side by rounded shoulders, a tripartite shape that was dominant until the middle of the eighteenth century, when variations began to appear.

Early gravestones were set in random, family groupings. Today, to facilitate mowing, the stones have often been reset in rows, and in this process footstones have sometimes been discarded. The stone used for most colonial gravestones was usually slate, sandstone, or schist, depending on the kind of stone available from nearby quarries or from those that could be reached by boat. Although there is no standard above-ground height or width for these markers, there is a consistent relationship between the size of a gravestone and the importance of the deceased. Markers for deacons and other important citizens tend to be larger in size and more elaborate in their dec-

See also **Decoration; William Edmondson; Old Stone Carver; Religious Folk Art; Sculpture, Folk; John Stevens.**

BIBLIOGRAPHY

Chase, Theodore, and Laurel K. Gabel. *Gravestone Chronicles: Some Eighteenth-Century New England Carvers and Their Work.* Boston, 1990.

Farber, Daniel, and Jessie Lie Farber. *Early American Gravestones.* Worcester, Mass., 1997.

Forbes, Harriette Merrifield. *Gravestones of Early New England and the Men Who Made Them, 1653–1800.* Brooklyn, N.Y., 1989.

Ludwig, Allan I. *Graven Images: New England Stonecarving and Its Symbols, 1650–1815.* Middletown, Conn., 1966.

Neal, Avon, and Ann Parker. *Early American Stone Sculpture Found in the Burying Grounds of New England.* Hamden, Conn., 1987.

JESSIE LIE FARBER

GRECO, JOHN (1893–1986) conceived this nation's Lilliputian version of the Middle East, *HolyLand U.S.A.* Standing atop Pine Hill in Waterbury, Connecticut, *HolyLand* is an instructional and educational visual aid about the Bible and the life of Jesus Christ. Greco is enshrined in his charmingly monumental, epic recreation of Bethlehem and Jerusalem. Constructed in 1956 as a tourist site, *HolyLand* in its heyday, in the late 1960s, had more than 40,000 visitors annually; since the artist's death in 1986, however, his folk art environment has been threatened by vandalism, budget cuts, and religious doctrine.

Greco, the son of an immigrant Italian cobbler, was born in Waterbury. He entered the seminary as a young man and studied law at Yale University, later founding a law practice in Waterbury. In 1956 he bought seventeen acres of dry, eroded land on Pine Hill for $7,000. Though lacking architectural or engineering expertise, he devised an ingenious design of roads, foundations, and terraced hills. Greco carted thousands of tons of concrete up the hills and planted bushes and trees. Aided by volunteers who called themselves the Bucket Brigade, the artist transformed the hill in four years. Then he started to build a miniature version of Jerusalem along with the multitude of shrines lining the many paths of *HolyLand.*

Didacticism was the motivating force for the artist; John Greco's aim was to spread the word of God. He willingly employed an unconventional method, simultaneously using *HolyLand* as a visual aid and theme park, to realize his vision. Hundreds of dioramas, grottoes, habitats, shrines, temples, and tombs litter the labyrinth of paths winding around the hill. An exacting artist, Greco traveled to Israel and photographed sites pertinent to Christ's life. Maps and photographs were studied so that *HolyLand U.S.A.* might be an accurate reproduction of the Holy Land in the Middle East. At the base of *HolyLand* is a postcard panorama of Jerusalem, with hundreds of buildings constructed in miniature scale. The style of windows, flat roofs, and soft hues of little Jerusalem accurately evoke *HolyLand's* namesake.

Time, harsh weather, careless vandalism, and strict Church doctrine have all contributed to the decline of *HolyLand U.S.A.* While folk art enthusiasts applauded *HolyLand* for its alluring aesthetic qualities and its testimony to the human spirit, the Catholic community viewed it as an outmoded expression of religious piety. The densely ornamented environment did not reflect the Church's plans to streamline its symbols. In response, in 1988 a group of concerned citizens formed the "Committee to Save HolyLand."

Efforts are still underway to preserve this folk art environment, now viewed by fewer than 1,000 visitors each year.

See also **Environments, Folk.**

BIBLIOGRAPHY

Ludwig, Allan I. "HolyLand U.S.A.: A Consideration of Naïve and Visionary Art." *The Clarion* (summer 1979): 28–39.

Prince, Daniel C. "Folk Art Environments: Environments in Crisis." *The Clarion,* vol. 13, no. 1 (winter 1988): 44–51.

BROOKE DAVIS ANDERSON

GREEN, HENRY: *SEE* SHAKER FURNITURE.

GREENLEAF, BENJAMIN (1769–1821), a portrait painter, worked in New England during the early nineteenth century. Born in Hull, Massachusetts, the artist was the son of Mary and John Greenleaf. He married Abigail Greenleaf Rhoades (Rhodes) of Dorchester, Massachusetts, on November 20, 1799. Greenleaf's career as an artist is defined primarily by his portraits, which give an indication of where he secured commissions, the nature of his clientele, and the stylistic features of his work. Paper labels attached to backing boards, as well as a handful of diary references, offer additional insight into his career.

According to biographers Arthur and Sybil Kern, Greenleaf worked within a small circle of contacts; several of his sitters were acquainted or interrelated through marriage. Predominantly made up of members of New England's middle classes, the artist's known subjects were doctors, military officers, clergymen, and their families. Dating from 1803, the portrait of *Jacob Goold,* a Weymouth, Massachusetts resident, as well as Greenleaf's great uncle, is the artist's earliest known composition, and is executed in oil on canvas mounted on board, a technique common to his initial experiments with portraiture. Over a career spanning at least fifteen years, from 1803 to 1818, Greenleaf principally used reverse painting on glass

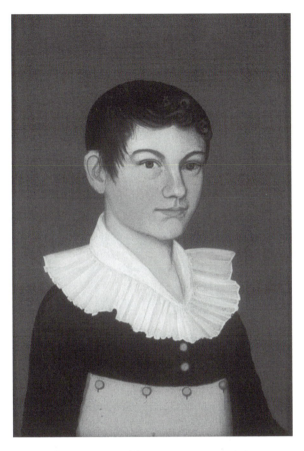

Portrait of Henry B. McCobb; c. 1818. Reverse painting on glass 15 × 11 inches. The Bertram K. Little and Nina Fletcher Little Collection auction at Sotheby's 6526, January 29, 1994. Photo courtesy Sotheby's New York.

(a folk art tradition also common in eighteenth century Germany and America in which the artist paints "in reverse" or on the back of a piece of glass) to capture his clients' appearances. Because the image is viewed from the front side of the glass, the artist must paint highlights and details first, followed by larger areas of color and background forms. As in the likeness of *Mrs. Lydia Waterman,* dating from 1810, the artist first noted fine details, then applied broad strokes of color to contour facial features and costumes. Typically, he recorded sitters in profile, as in Mrs. Waterman's portrait, but occasionally he painted them in three-quarter view as well. Greenleaf's portrait of the young Henry B. McCobb is another reverse painting on glass.

In addition to working in Weymouth, extant portraits indicate that Greenleaf traveled extensively in New England, making trips to Boston and the surrounding vicinity; Hanover and Hopkinton, New

Hampshire; and parts of eastern Maine, including Phippsburg, Paris, and Portland. He may have secured lodging as partial payment for his portraits, as Bath resident Dr. Samuel Adams recorded in his diary for 1816 that Greenleaf's board was paid up, and Adams' portrait was finished. Although little is known about these business transactions, a year later Dummer Sewall, another Bath resident, paid Greenleaf nine dollars to make his portrait in oil on glass. Not many years later, in 1821, Benjamin Greenleaf died of apoplexy in Weymouth.

See also **Painting, American Folk; Reverse-Glass Painting.**

BIBLIOGRAPHY

D'Ambrosio, Paul, and Charlotte M. Emans. *Folk Art's Many Faces: Portraits in the New York State Historical Association.* Cooperstown, N.Y., 1987.

Kern, Arthur and Sybil Kern. "Benjamin Greenleaf: Nineteenth-Century Portrait Painter." *The Clarion,* (spring/summer 1985): 40–47.

———. "Who Was Benjamin Greenleaf?" *Antiques World,* vol. 3 (September 1981): 38–47.

CHARLOTTE EMANS MOORE

GREENWOOD, ETHAN ALLEN (1779–1856), a portrait artist and museum proprietor, as well as a schoolteacher, lawyer, and manufacturing clerk, made silhouettes, miniatures, and painted portraits in New England and New York State during the early nineteenth century. Existing memorandum books, dating from 1801 to 1810, present a vivid account of the artist's life and career. Additional extracts generated by a descendant, based on the artist's destroyed original volumes, provide further insight into Greenwood's world during the years between 1798 and 1825. A third source, also provided through the descendant, is a checklist of Greenwood's portraits. According to this list, the artist executed more than eight hundred likenesses during the twenty-four-year period between 1801 and 1825.

Born in Hubbardston, Massachusetts, the artist was the son of Moses and Betsey Dunlap Greenwood. He attended Dartmouth College, graduating in 1806. In addition to later practicing law, Greenwood began painting portraits as early as 1801. His earliest compositions depict family members, as well as likenesses copied from famous pictures of American patriots, including George Washington, Thomas Jefferson, and Benjamin Franklin.

By 1813 Greenwood had given up his lifestyle as an itinerant portraitist and settled in Boston, where he opened a studio. He received art criticism from Gil-

bert Stuart (1755–1828), and interacted with fellow artists John Ritto Penniman (1782–1841), John Vanderlyn (1775–1852), and John Wesley Jarvis (1780–1840), among others. He also secured instruction in art from Edward Savage (1761–1817), ultimately purchasing Savage's museum in 1818, and incorporating it as the New England Museum and Gallery of the Fine Arts. In time Greenwood, the entrepreneur, supplemented this attraction with other collections he purchased, including William M.S. Doyle's (1769–1828) Columbian Museum; the Boston Museum, founded in 1804 by Philip Woods; John Mix's collection in New Haven, Connecticut; and the artifacts belonging to the Linnaean Society at Harvard. By 1825 his success in securing curiosities led Greenwood to open additional facilities in Providence, Rhode Island, and Portland, Maine.

After his father's death in 1827, Greenwood returned to Hubbardston; two years later, on February 1, 1829, he married Caroline Carter Warren. Although he maintained ownership of the New England Museum, Greenwood retreated from the institution's daily activities to his residence in central Massachusetts, and instead served in local politics, became a justice of the peace, farmed, and purchased property. During the 1830s, sculptor Thomas Ball (1819–1911) relieved Greenwood of his museum duties. By 1839 Greenwood had sold the museum to Moses Kimball, thus concluding the artist's participation in the worlds of art, culture, and popular amusement.

See also **William M.S. Doyle; Painting, American Folk; Papercutting; John Ritto Penniman.**

BIBLIOGRAPHY

"A List of Portraits Painted by Ethan Allen Greenwood." *Proceedings of the American Antiquarian Society,* vol. 56, part 1 (April 1946): 129–153.

Barnhill, Georgia Brady. "Extracts from the Journals of Ethan A. Greenwood: Portrait Painter and Museum Proprietor." *Proceedings of the American Antiquarian Society,* vol. 103, part 1 (April 1993): 9–101.

Benes, Peter. *Itinerancy in New England and New York: Annual Proceedings of the Dublin Seminar for New England Folklife.* Boston, 1986.

CHARLOTTE EMANS MOORE

GREENWOOD, JOHN (1727–1792), portrait artist, engraver, art dealer, and auctioneer, was born in Boston, but spent most of his life and career in Europe. From a prosperous family of shipwrights and traders, Greenwood was forced to seek alternative employment at fifteen when his father died prematurely, and worked as an apprentice in a shop pro-

ducing heraldic decoration, japanning, house and ship painting, and engraving. He initially experimented with executing portraits of his friends, with his first known likenesses dating from 1747. As a portrait painter in the Boston area, Greenwood came to maturity after artist John Smibert's (1688–1751) residency in the city and before John Singleton Copley's (1738–1815) rise to prominence. Robert Feke (c. 1707–c. 1751) and Joseph Badger (1708–1765) were his contemporary competitors in the local portraiture market. From about 1747 to 1752, Greenwood secured commissions from prominent merchants, clergymen, sea captains, and educators in Boston and Salem, Massachusetts, Portsmouth, New Hampshire, and the surrounding area.

Among his most ambitious and monumental compositions, the group portrait of the Greenwood-Lee family records the appearance of six members of Greenwood's family, including a self-portrait of the artist standing proudly at the right, holding paintbrushes and a palette in his hand. As was common with artists of his generation, Greenwood frequently relied upon engravings as sources for his sitters' poses and props. Subjects have large, long eyes and straight mouths. Drapery folds on clothing are boldly contoured to achieve the effect of light cast on expensive fabrics.

In 1752, at the age of twenty-five, Greenwood left Boston for Suriname, South America, where allegedly he spent the next five years painting portraits. A scene titled *Sea Captains Carousing in Suriname* dates from this period. In 1758 the artist moved to the Netherlands, where he furthered the skills he had acquired in printmaking, in part from Peter Pelham, by studying Dutch engraving techniques. By 1762 Greenwood was in London, where he was elected a fellow in the Incorporated Society of Artists of Great Britain. Over the years, he became a highly successful art dealer and auctioneer, trafficking in old master paintings. In 1770 he wrote Copley that he had introduced more than 1,500 paintings into London's art market. Two years before his own death in 1792, Greenwood was the dealer responsible for selling the pictures and prints that were left in William Hogarth's studio after the artist died.

See also **Joseph Badger; Robert Feke; Painting, American Folk; John Smibert.**

BIBLIOGRAPHY

Boston Museum of Fine Arts. *American Paintings in the Museum of Fine Arts, Boston.* Boston, 1999.

Burroughs, Alan. *John Greenwood in America, 1745–52.* Andover, Mass., 1943.

CHARLOTTE EMANS MOORE

GREGORY, STEWART (1913–1976), an influential collector of American folk art, was descended from a Wilton, Connecticut, family whose presence in the Fairfield County town stretched back many generations. It was in Wilton that Gregory converted an eighteenth-century barn into a home and showplace for his collection. He also served as chairman of the board of the Wilton Historical Society. Gregory was a dedicated cellist; it was his purchase in 1944 of a seventeenth-century Guarneri cello, in fact, that sparked his interest in collecting antiques. The holder of degrees from Princeton University (1936) and Harvard Law School (1939), Gregory retired at the age of fifty from a successful career in the pharmaceutical industry.

In building his collection of American folk art, Gregory often sought the advice of Mary Allis (1899–1987), the well-known Southport, Connecticut, dealer, from whom he purchased many major works. His collection eventually grew to include portraits by John Brewster Jr. (1766–1854), Erastus Salisbury Field (1805–1900), and Ammi Phillips (1788–1865), as well as decoys, weathervanes, hooked rugs, tinware, watercolors, and other objects, all of which were drawn primarily from the folk art traditions of New England and other parts of the Northeast. He also collected American Civil War memorabilia. In 1972 the American Folk Art Museum exhibited Gregory's collection in "An Eye on America: Folk Art from the Stewart E. Gregory Collection." He served that institution as a vice president and trustee beginning in 1964.

If anything, Gregory's collection had even more of an impact on the field of American folk art after his death. Its sale at public auction in 1979 is often considered a watershed in the field because of the widespread public interest that it engendered and the high prices that it realized. Indeed, many of the finest works acquired by Gregory are now in the collections of important American museums.

See also **Mary Allis; American Folk Art Museum; John Brewster Jr.; Decoys, Wildfowl; Erastus Salisbury Field; Hooked Rugs; Ammi Phillips; Tinware, Painted; Weathervanes.**

BIBLIOGRAPHY

An Eye on America: Folk Art from the Stewart E. Gregory Collection. New York, 1972.

Lipman, Jean. "Living with Antiques: Stewart Gregory's Connecticut Barn." *The Magazine Antiques* (January 1971).

Sotheby, Parke Bernet. *Important American Folk Art and Furniture: The Distinguished Collection of the Late Stewart E. Gregory.* New York, 1979.

GERARD C. WERTKIN

GRIMES, KEN (1947–) produces black and white paintings that convey his interest in paranormal alien communication, extraterrestrial intelligence, UFO phenomena, and the world of coincidences. He is a visionary artist whose worldview extends far beyond this planet and solar system into other systems and galaxies. The radio telescope's potential to explore space continues to fascinate Grimes, who is an avid reader of books on the subject. His technique is unusual in that instead of painting white images and text over a black ground, he draws outlined forms and text and then paints black around the penciled outlines, leaving the white areas unpainted. He adds texts to his paintings in the form of messages that are embellished with symbols representing crop circles, flying saucers, and alien figures.

Born in New York City in 1947, Grimes moved with his family to Westchester, Florida, then back to New York, and, finally, when Grimes was six years old the family settled in Cheshire, Connecticut. He graduated from Cheshire High School, and continued his studies at Nasson College in Springvale, Maine. Although he is not certain of what triggered his interest in art, Grimes began to paint in 1984, during a period when he was a volunteer in a program for the chronically ill under the auspices of Yale Medical School in New Haven, Connecticutt. His first artistic efforts were landscapes and pictures of buildings rendered in color. He took a summer studio art class at

Throw the Switch; Ken Grimes; 1993. Acrylic on canvas; 48 × 56 inches.
Photo courtesy Ricco Maresca Gallery, New York.

213

the Rhode Island School of Design in Providence where he executed his first still-lifes using traditional forms and color. Grimes was fascinated by the writings and ideas of academic and science writer Carl Sagan and Robert K.G. Temple book's *Sirius Mystery: New Scientific Evidence for Alien Contact 5,000 Years Ago*; the black and white photographs of the latter may have influenced Grimes to choose a monochrome graphic palette for his paintings.

Grimes has completed about 350 paintings. He uses acrylics to paint on canvas, Masonite, or paper, and paints one to three hours every day. A one-person exhibition of Grimes' paintings was held in Waterloo, Canada, in 1995.

See also **Visionary Art.**

BIBLIOGRAPHY

"Grimes, Ken: Live from Outer Space." *Faces*, vol. 1, no. 2: 1–3.
Longhauser, Elsa, and Harald Szeemann. *Self-Taught Artists of the Twentieth Century: An American Anthology.* San Francisco, 1998.
Maresca, Frank, and Roger Ricco. *American Self-Taught: Paintings and Drawings by Outsider Artists.* New York, 1993.

LEE KOGAN

GUILD, JAMES (1797–1844), one of the most fascinating figures in the history of early American folk art, until recently had been known almost entirely because of his remarkable diary. He was born in Halifax, Vermont, on July 9, 1797, to Nathaniel and Mehitable Guild. His mother, a widow early in life, was probably unable to care for her four children, and James was placed as an indentured servant with a family in Tunbridge, Vermont. Given his freedom on July 9, 1818, his twenty-first birthday, he began his diary about three months later.

With no desire to continue life as a farmer, he used what money he had to buy goods and started traveling through Vermont as a peddler. He found this unrewarding, however, and turned to work as a tinker, then became part owner of a traveling bison show. In Albany, New York, where he played the "tamborin" in a band, he learned how to cut profile likenesses and started calling himself a "profile cutter." After spending a day with a local painter, he told a woman that if she would wash his shirt he would paint her portrait. He describes the result as looking more like a strangled cat than it did his subject. Nevertheless, he continued his travels, on foot and by horse, wagon, stagecoach, and ship, through New York, New England, Pennsylvania, Ohio, Maryland, Virginia, and North and South Carolina, painting small watercolor portraits and at times teaching penman-

ship. He writes of interesting and humorous experiences, and of the low esteem in which itinerant painters were held. Frequently, he placed advertisements in local newspapers. Initially charging just one dollar for a portrait, later he earned thirteen thousand dollars in only seven months.

In 1824 he went to England to continue painting, returning some time before September 22, 1831, for on that date he married Maria Phelps in Hartland, Vermont. Where he lived and what he did during the next thirteen years is not clear, but he died on June 11, 1844, at the age of forty-seven, and was buried in the Summer Hill Cemetery of Springfield, Vermont.

Today, only nine miniatures and two of his calligraphic exercises are known, but judging from his diary as well as records regarding his estate, these must represent only a very small portion of his total production. Guild's watercolor and pencil-on-paper portraits are small, generally of bust length and in profile, with six signed and dated.

See also **Miniatures; Painting, American Folk.**

BIBLIOGRAPHY

Kern, Arthur, and Sybil Kern. "James Guild: Quintessential Itinerant Portrait Painter." *The Clarion*, vol. 17 (summer 1992): 48–57.
Peach, Arthur Wallace, ed. "James Guild, from Tunbridge, Vermont, to London, England—The Journal of James Guild, Peddler, Tinker, Schoolmaster, Portrait Painter from 1818 to 1824." *Proceedings of the Vermont Historical Society*, vol. 5 (September 1937): 249–314.

ARTHUR AND SYBIL KERN

GUILFORD LIMNER is the appellation given to a painter of watercolor portraits who worked in Guilford County, North Carolina, and Clark County, Kentucky, during the 1820s. None of the work is signed, but two references to the artist are known. One, written by the granddaughter of a North Carolina sitter, states that "a traveling French artist" had painted her grandmother's portrait. The other, from an inscription on one of the two known Kentucky portraits, notes that it was painted by "Dupue." These remarks may appear to support one another, but more information is required to conclude that "Dupue" was indeed the Guilford Limner.

In the nearly forty known examples, sitters' names frequently appear below their likenesses or in the backgrounds, and dated works range from 1820 to 1827. The North Carolina subjects were successful merchants, plantation owners, and their families, most of whom were related, knew one another, and lived within a five-mile radius of Greensboro. Adults are seated indoors, facing forward or in three-quarter

poses. Some male subjects sit cross-legged, while others are seated at tables, writing letters or attending to business accounts. Women often hold handkerchiefs, books, or knitting implements. Children usually stand indoors, or are posed outdoors in landscape or garden settings. Carefully rendered faces are distinguished by large eyes with oversize irises. Hands did not intimidate the artist, for they appear in all the known portraits. Plants are prominent, including flowering vines that flank or arch over some sitters, as well as trees, rosebushes, cut flowers, and, in one instance, ears of corn.

Room furnishings are an integral part of many portraits, making the works valuable records of early-nineteenth-century North Carolina domestic tastes. Adults and youths are seated in painted and gilded fancy chairs, and one elderly subject sits in a turned armchair. Patterned carpets or floor cloths, candle stands, and drop-leaf tables are standard props. Wainscoting and chair rails brightened by faux marble decoration painted in vivid, contrasting hues also appear frequently.

The most vexing question about the Guilford Limner, besides the artist's identity, regards the source or inspiration for these compositions. Portraits by the Canadian watercolor artist, Thomas Macdonald (c. 1784–1862), come to mind, but it is unlikely that their paths crossed. No body of work of comparable size, originality, or technical proficiency from this period painted in America is known. One explanation, which the two references to the artist may support, is that the Guilford Limner was foreign-born and introduced a new style of portraiture to America.

See also **Painting, American Folk; Watercolors.**

BIBLIOGRAPHY

Carroll, Karen Cobb. *Windows to the Past: Primitive Watercolors from Guilford County, North Carolina, in the 1820s.* Greensboro, N.C., 1983.

Little, Nine Fletcher. *Little by Little: Six Decades of Collecting American Decorative Arts.* New York, 1984.

RICHARD MILLER

GULICK, HENRY THOMAS (1872–1964) of Monmouth County, New Jersey, fits a stereotype of the traditional American memory painter. In 1947, after fifty-five years of service on his hundred-acre farm, toil that gave him no spare time, Gulick retired. Of Dutch lineage, his roots are also deeply American: no members of his family arrived in America after the American Revolutionary War. The Puritan ethic of hard work and busy hands was a strong influence on Gulick, and he could not cope with leisure time. When his son gave him an artist's paint box, the seventy-five-year-old Gulick took on the challenge and began to paint on odd pieces of cardboard, using his paints frugally and tentatively. "It is better," he said, "than rocking and rocking and blowing away." Within two years the Newark Museum acquired one of his paintings for its permanent collection.

The subjects Gulick chose were those he knew and loved best: his own historic farmhouse, the fields and farms around him, and the houses of his friends and neighbors. Gulick instinctively set things in the past, as they had looked to him in his youth. He preferred to paint onsite, but by no means did he feel obliged to record things literally; he tailored a scene to suit himself, snipping, cutting, and revamping to his taste.

Gulick was devoted to his home, his family, his country, and his God. His minister said that even though he was the most aged of the church elders, he was wise but young at heart, always willing "to take a risk." One of the rare departures from Gulick's usual bucolic themes is the stark and uninhabited interior of his own church. Health permitting, he painted daily until the time of his death, leaving a legacy of more than 160 paintings. Although Gulick said that he hated to be called a primitive painter "because it makes me feel like a savage," he would have been pleased that he was acknowledged by respected American art historian William H. Gerdts as "the state's leading self-taught primitive painter." Gulick said that people are like tops, and some are wound up for a longer spin. His "spin" lasted for ninety-two years. One-man exhibitions of Gulick's work were held at Seton Hall University (1964) and the Montclair Art Museum (1974).

See also **Painting, American Folk; Painting, Memory.**

BIBLIOGRAPHY

Cohen, David Steven. *The Folklore and Folklife of New Jersey.* New Brunswick, N.J., 1983.

Rosenak, Chuck, and Jan Rosenak. *Museum of American Folk Art Encyclopedia of Twentieth-Century American Folk Art and Artists.* New York, 1990.

BARBARA CATE

HADLEY CHESTS comprise one of the largest and most significant groups of American joined furniture, both for their distinctive methods of joinery and decoration, and for the light they shed on patterns of patronage in seventeenth-century western Massachusetts. They were made for and owned primarily by young women whose initials are often carved or painted on the front surface, and who retained ownership even after marriage. The similarity in style and carving among the 250 or so related cupboards, chests with drawers, chests of drawers, boxes, and tables was the direct result of their production by a community of craftsmen joined by ties of training and of intermarriage, and by the force of a single powerful patron whose aesthetic predilections determined the taste of a region as well as the financial success of its craftsmen. William Pynchon (1590–1662) was a wealthy trader who founded Springfield, Massachusetts, in 1636. By the end of the century, at least one-third of the population of Springfield and hundreds of people in the wider area were financially connected to Pynchon and his son, John (1626–1703). The carved motif favored by the Pynchons, the Mannerist-inspired tulip and leaf, was employed by those joiners whose livelihoods were dependent upon William and John, and which is now specifically identified with so-called Hadley chests and other forms.

Hadley chests, made primarily between 1680 and 1740, were of mortise and tenon construction, with stiles and rails framing inset panels with elaborate low-relief carving based on the repetition of a single template. The earliest examples are related to furniture from Connecticut, suggesting a generational path of joiners who traveled up the Connecticut River training younger craftsmen. The chests can be divided into sixteen centers of production in several towns in Hampshire County, Massachusetts, with some variations in the development of design and in levels of skill. Local red or white oak was used for the visible members before 1715, and hard yellow or southern pine for bottoms of the carcass and drawers, backs, and lids. More sophisticated examples from Springfield were sometimes made with walnut and cherry on the decorative panels, and later chests included turned legs, applied balusters, and carved members. The *Hannah Barnard Cupboard* exemplifies the transition from carving to paint that was occurring about 1715, and may also document the earliest use of Prussian blue in the colonies.

The modern interest in Hadley chests had its seeds in the Arts and Crafts movement (1876–1916), and reached its full bloom during the Colonial Revival period (c. 1880–c. 1940). Memorial Hall, in Deerfield, Massachusetts, was one of the first museums to showcase this type of early American furniture, and acquired its first chest, initialed "*WA,*" in 1877, three years before it opened to the public. By then, antiquarian Henry Wood Erving (1851–1941) of West Hartford, Connecticut, had already informally coined the appellation "Hadley chest," first used in print in 1901 by Luke Vincent Lockwood in *Colonial Furniture in America.* By the early decades of the twentieth century, Hadley chests had become emblematic of Pilgrim-century furniture, the earliest style of furniture in America, and their association with young women of long ago imparted a romantic mystique that they have maintained to the present day.

See also **Furniture, Painted and Decorated.**

BIBLIOGRAPHY

Luther, Clair Franklin. *The Hadley Chest.* Hartford, Conn., 1935.

Trent, Robert F. *New England Begins: The Seventeenth Century,* vol. 3. Boston, 1982.

Zea, Philip, and Suzanne L. Flynt. *Hadley Chests.* Deerfield, Mass., 1992.

STACY C. HOLLANDER

HAIDT, JOHN VALENTINE (1700–1780), portrait painter, painter of biblical scenes, preacher, and evangelist for the Moravian Church, was born in Danzig, Germany, and died in Bethlehem, Pennsylvania. Although trained in drawing at the Royal Academy of Arts in Berlin, Germany, he began his artistic career working for his father (who was jeweler and sculptor by appointment to German Emperor Frederick I) as a goldsmith. Haidt traveled widely in Europe, living and painting in Dresden, London, Paris, Venice, and Rome, but his affiliation with the Moravian Church of London in 1740 was the pivotal event in his life's journey.

After beginning his missionary work in Europe, Haidt was sent in 1754 by Count Nicholas Zinzendorf, the founder of the New Moravian Church in Germany, to Bethlehem, Pennsylvania. He was charged with carrying the Gospel to the Native Americans, and his missionary work took him to New England and Maryland. He continued his painting, supplying religious canvases to the Moravian churches, and portraying members of their congregations. The church gave him a studio in Bethlehem in 1756, which he occupied until 1774.

Haidt is recognized for his portraits of Moravians who lived in Bethlehem, Lititz, and Nazareth, Pennsylvania, as well as for his subjects of Moravian theology. Haidt neither dated nor signed his paintings. His portraits are valued for documenting the personalities of the Moravian church's earlier days. Scholars have concluded that Haidt's paintings influenced the early work of Benjamin West (1738–1820), acclaimed as the best-known American artist of his generation, who painted in Philadelphia and Lancaster, Pennsylvania, in 1775 and 1776.

Haidt's portraits of Moravian church leaders and congregants have similar compositions. They usually measure 25 by 20 inches, and portray the head and upper torso of the sitters. Historically, the paintings hung unframed on the walls of the Moravian churches, in accord with their precepts of strict simplicity. The titles of his biblical paintings convey the subjects: *Crucifixion, Christ Before Pilate, Rest on the Flight into Egypt, Christ Before Herod, Lamentation Over the Body of Christ, Christ Scourged,* and *Thomas Doubting.* Perhaps the most significant painting in the history of the Moravian Church is Haidt's *First Fruits.* Painted about 1760, it contains twenty-five life-size figures, including a Native American in a feathered headdress. The figures depict either potential converts awaiting the Gospel, or the already converted.

See also **Painting, American Folk; Religious Folk Art.**

BIBLIOGRAPHY

Baker, Virgil. *American Painting, History, and Interpretation.* New York, 1950.

Engel, Charlene S. *Paintings by John Valentine Haidt.* Bethlehem, Pa., 1982.

Art Institute of Chicago. *From Colony to Nation: An Exhibition of American Painting, Silver, and Architecture, from 1650 to the War of 1812.* Chicago, Ill., 1949.

Howland, Garth A. "John Valentine Haidt: A Little Known Eighteenth-Century Painter." *Pennsylvania History,* vol. 8 (October 1941): 303–313.

Morman, John F. "The Painting Preacher: John Valentine Haidt." *Pennsylvania History,* vol. 20 (April 1953): 180–186.

Nelson, Vernon. *John Valentine Haidt.* Williamsburg, Va., 1966.

Saunders, Richard H., and Ellen G. Miles. *American Colonial Portraits, 1700–1776.* Washington, D.C., 1987.

WILLIAM F. BROOKS JR.

HALL, DILMUS (1900–1987) was an artist, born in Oconee County, Georgia, into a large farming family headed by a blacksmith father. When his regimen of farm work permitted, he attended a rural schoolhouse and occasionally made small figural sculptures. Around 1913 he moved with his family to Athens, Georgia, where he repeated the eighth grade. During World War II he went to Europe and served as a stretcher-bearer with the United States Army Medical Corps. After the war, Hall worked in Athens at various service and manual-labor jobs until he retired in 1961. He and his wife of many years, Zaydie, had no children, and she died in 1973.

During the 1950s Hall embellished his small concrete-block house in West Athens with painted concrete decorations and wall-mounted relief sculptures, while filling most of the small front yard with figural sculptures in the same medium, including a central cautionary tableau he called *The Devil and the Drunk Man.*

Hall made a number of strikingly reductive, sculptural variations on the theme of the Crucifixion, and the facade of his house was ornamented with his anthropomorphic sculptural reliefs of the sun and moon. Hall also made many small mixed-media drawings about religious as well as secular themes.

See also **Religious Folk Art; Sculpture, Folk.**

BIBLIOGRAPHY

Patterson, Tom. "D. Hall." *Brown's Guide to Georgia,* vol. 9, no. 12 (December 1981): 57–58.

Arnett, Paul, and William Arnett, eds. *Souls Grown Deep: African-American Vernacular Art of the South*, vol. 1. Atlanta, Ga., 2000.

TOM PATTERSON

HALL, MICHAEL (1941–), and **JULIE** (1943–) assembled one of the late twentieth century's most important and influential collections of American folk art, and played key roles in the emergence of the contemporary folk art field. A sculptor, art scholar, teacher, and curator, Michael Hall was born in Upland, California. He conducted anthropological fieldwork at Mexico City College in 1960, then majored in art and studied folklore while at the University of North Carolina at Chapel Hill.

Julie Friedman grew up in Nashville, the daughter of a stockbroker father and a mother who wrote children's books and collected traditional African and contemporary American art. In the early 1960s she majored in art history at the University of Colorado, and it was there that she met her husband when she enrolled in the pottery class he was teaching. They married in 1965 and moved into a farmhouse outside Lexington, Kentucky, where Michael had been hired to teach in the art department at the University of Kentucky.

The couple initially collected early American pottery, but the focus of their collecting began to shift dramatically in 1968, when, after being introduced to the figural wood sculptures of Edgar Tolson (1904–1984), they went to Campton, Kentucky, and sought out Tolson, whom they befriended and whose art they began to collect.

That summer the Halls visited the American Folk Art Museum in New York City, where they were inspired by a group exhibition co-curated by Herbert W. Hemphill Jr. (1929–1998). Because Hemphill was present in the museum gallery the day the Halls visited, they met him, accepted his invitation to see his personal collection of American folk art, and, by day's end, had experienced what Michael later characterized as a conversion to this rough-and-ready, common peoples' art.

Within a year of meeting Tolson, the Halls became instrumental in the directing of his career as a nationally acclaimed folk artist. Michael wrote essays about and arranged exhibitions of Tolson's work, with the aim of presenting the self-taught woodcarver as "another contemporary artist." He also took on the role of middleman in transacting sales of Tolson's art with private collectors and museum curators around the country.

The Halls' work with Tolson was part of a larger effort they coordinated with Hemphill in directing attention to self-taught artists of the American South and Midwest, in the form of books and articles they wrote, and touring exhibitions they organized. Works from the Hemphill and Hall collections began traveling to museums across the country in 1970, and continued touring into the late 1980s. Through their collections they challenged the prevailing notion that folk art was a pre-twentieth-century phenomenon largely confined to the northeastern United States.

In 1970, Michael Hall became chairman of the sculpture department at Cranbrook Academy near Detroit; he also continued to be closely involved in Tolson's career as his agent, until the artist's death in 1984. In the early 1970s, Hall began to represent several other contemporary folk artists as well.

In 1990 the Halls sold about 270 works from their collection to the Milwaukee Art Museum. In 1993 the museum showcased these works in the exhibition "Common Ground/Uncommon Vision."

See also **Herbert W. Hemphill Jr.; Edgar Tolson.**

BIBLIOGRAPHY

Ardery, Julia S. *The Temptation: Edgar Tolson and the Genesis of Twentieth-Century Folk Art*. Chapel Hill, N.C., 1998.

Hall, Michael. *Stereoscopic Perspective: Reflections on American Fine and Folk Art*, Ann Arbor, Mich., 1988.

Hall, Michael, and Eugene W. Metcalf Jr., eds. *The Artist Outsider: Creativity and the Boundaries of Culture*. Washington, D.C., 1994.

Milwaukee Art Museum. *Common Ground/Uncommon Vision: The Michael and Julie Hall Collection of American Folk Art*. Milwaukee, Wisc., 1993.

Hartigan, Linda Roscoe. *Made with Passion: The Hemphill Folk Art Collection in the National Museum of American Art*. Washington, D.C., and London, 1990.

TOM PATTERSON

HALLOWEEN: *SEE* HOLIDAYS.

HALPERT, EDITH GREGOR (1900–1970), the founding director of the Downtown Gallery and its extension, the American Folk Art Gallery, was the first dealer to remove folk art from the category of antiques and historical artifacts. In the Downtown Gallery, the most ambitious commercial firm in New York City to sell folk art, not only did Halpert assign it a fine art context but also customarily cited folk artists as ancestors of the living painters and sculptors she promoted. By linking the folk tradition with leading American modernists, she facilitated the accep-

tance of contemporary art. Halpert also shaped several major public and private collections of folk art.

Born in Russia as Edith Gregoryevna Fivoosiovitch, Halpert and her family immigrated to the United States in 1906. She studied art until marrying the painter Samuel Halpert, in 1918. Through her husband, Edith Halpert met many artists who lacked gallery representation, and on November 6, 1926, she opened Our Gallery—renamed the Downtown Gallery in 1927. The gallery specialized in such progressive artists as Stuart Davis (1894–1964), Yasuo Kuniyoshi (1889–1953), Charles Sheeler (1883–1965), Max Weber (1864–1920), and William (1887–1966) and Marguerite Zorach (1887–1968).

Edith Halpert did not discover folk art herself—she saw it first in the collection of Viola and Elie Nadelman (1882–1946) in Riverdale, New York, and in Ogunquit, Maine, in 1925 and 1926. Nor did she sell folk art until 1929, when it became a potential moneymaker because enough groundwork had been laid, though the market for the young talent in her stable remained a financial unknown. Halpert's crucial insight was to devise a frame of reference that would encompass both Modernism and folk art. She recognized that folk art shared certain formal qualities with Modernism; it could be advertised as the root of an authentically American spirit as well as a key to understanding contemporary work.

Edith Halpert would not have been able to advance this agenda without Abby Aldrich Rockefeller (1874–1948), who became a client in February 1928. Rockefeller bought only contemporary art from the Downtown Gallery at first, but between 1929 and 1931 she purchased at least two hundred pieces of folk art, and Halpert was able to expand her business by adding the American Folk Gallery in October 1931. Of the 175 objects in "American Folk Art: The Art of the Common Man in America, 1750–1900," the Museum of Modern Art's landmark folk art exhibition of 1932, 174 were purchased from Halpert by Rockefeller. Other important collectors whom Halpert influenced include Edgar (1899–1979) and Bernice Chrysler Garbisch (1907–1979), Maxim Karolik (1893–1963), and Electra Havemeyer Webb (1888–1960).

See also **Edgar and Bernice Garbisch; Maxim Karolik; Elie Nadelman; Abby Aldrich Rockefeller; Electra Havemeyer Webb.**

BIBLIOGRAPHY

Gaines, Catherine Stover, and Lisa Lynch. *A Finding Aid to the Records of the Downtown Gallery.* Washington, D.C., 2000.

AVIS BERMAN

HAMBLETT, THEORA (1895–1977) was inspired to paint by her dreams. She also painted cherished memories of her own and of people close to her—the old O'Tuckolofa School, children's games, "trees along the highways," making lye soap and sorghum, and carrying cotton to the gin.

Hamblett was born on a 200-acre farm near Paris, Mississippi, that had been owned by her father since before the American Civil War, and she understood farm chores and responsibilities from an early age. She graduated from Lafayette County Agricultural High School, near Oxford, Mississippi, and attended Mississippi Normal College before teaching primary grades in small rural schools on and off for fifteen years. Teaching was not satisfying to her, though; and a business she tried, raising chickens, was financially unsuccessful. She moved to Oxford, where she bought a house and converted it into rental apartments. A lingering yearning led her to fill the rooms with paintings.

Hamblett began to paint in 1950, enrolling in a nearby university; but her time there was short because the course focused on abstract art, which did not interest her. Instead, she followed her own inclinations. The first vision that she painted, *Angel's Request*, showed an angel visiting as the artist was ironing. Because people tended to interpret her "vision" paintings differently from what she intended, Hamblett wrote two small books, *Theora Hamblett Paintings* (1975) and *Dreams and Visions* (1975), in which she interpreted these works herself. The artist claimed that once she committed herself to paint, specific images ceased to obsess her.

In composing a picture, Hamblett would first paint trees and then tackle the rest of the forms. Her pared-down minimalist style was abstract yet representational. Patterned trees vibrate with tiny leaves, made all the more kinetic by being placed near fields of solid color. Her mother had bought her a set of crayons when she was eight, but by the time she reached adulthood she preferred to paint with oils on canvas or Masonite, using a subtle palette. The artist followed a rigorous schedule: she painted on "Monday, Tuesday, Wednesday mornings, Thursday all day, and sometimes Friday," but not on weekends.

Hamblett's paintings—some 600 in all—were willed, along with her home, to the University of Mississippi in Oxford. Her painting *Golden Gate*, renamed *The Vision*, was donated to the Museum of Modern Art in New York City. She had one-person exhibitions at the University of Mississippi Art Center (Oxford, 1955), Brooks Memorial Art Gallery (Memphis, Tennessee, 1956), University of Nebraska (Omaha, 1969), and Mount Hood Community College (Gresham, Oregon, 1969).

See also **Painting, American Folk; Painting, Memory; Visionary Art.**

BIBLIOGRAPHY

Bihalji-Merin, Oto. *Encyclopedia of Naïve Painting.* Scranton, Pa., 1984.

Ferris, William. *Local Color: A Sense of Place in Folk Art.* New York, 1962.

Four Women Artists. Center for Southern Folklore, Memphis, Tenn., 1977. (16-mm color film, 25 minutes.)

Hamblett, Theora, with Ed Meek and William S. Hayne. *Theora Hamblett Paintings.* Jackson, Miss., 1975.

Rosenak, Chuck, and Jan Rosenak. *Museum of American Folk Art Encyclopedia of American Folk Art and Artists.* New York, 1991.

LEE KOGAN

HAMBLIN, STURTEVANT J. (active 1837–1856) was one of the namesakes of the Prior-Hamblin School, a small group of Boston-based artists who were related by marriage and who painted in a markedly similar style. The two families were united when William Matthew Prior (1806–1873) of Bath, Maine, married Rosamond Hamblin of Portland, Maine, in 1828. Prior, who was already practicing as a portrait and ornamental painter, joined a family with a long tradition in the artisan trades, primarily as glaziers and painters. Of the four Hamblin brothers however, Sturtevant seems to have been the only one listed in public records as a portrait painter, while his brothers were successful real estate developers whose row of four Greek Revival houses built in Portland in 1835 now enjoys landmark status.

It is not known whether Sturtevant Hamblin painted portraits before his association with Prior. The beginning of Hamblin's artistic activity is usually cited as 1837, when he took up residence with his sister and brother-in-law in Portland. His earliest documented paintings, however, date from 1841, when the Priors and Hamblins were living together in brother Nathaniel's house at 12 Chambers Street in Boston. At this time, Hamblin portrayed several members of the Jewett family in a bold, confident style that was heavily influenced by Prior, yet he already exhibited trademark characteristics that differentiate the work of the two artists. The following year, the families moved to Marion Street where they continued to share a residence until 1844. By 1846, the Priors and Hamblins were living separately. Following the lead of his brother-in-law, however, Sturtevant Hamblin continued to pursue a career as a painter until 1856, when he entered the "gent's furnishing" business in partnership with his brother, Joseph. The federal census of 1860 lists Hamblin as a 42-year-old male in the "furnishing goods" business with real estate holdings of $12,000. The other members of the household included forty-three-year-old Harriet B. (possibly his wife), Elizabeth P., age twenty, Effie, age four, and a sixteen-year-old domestic, Mary Toburn.

In 1948, when Nina Fletcher Little (1903–1993) first published her research on the artists of the Prior-Hamblin school, she had identified only four signed extant works by Sturtevant J. Hamblin, all depicting the members of the Jewett family. By 1976, Little had increased this number by two to include *Portrait of Ellen*, then in her own collection, and *Woman and Child by a Window*, dated 1848. In the intervening years a small number of signed and dated portraits have surfaced, including *A Rosy-Cheeked Girl* (c. 1840) and *Dr. and Mrs. Smith of Dover, New Hampshire* (1848). Based upon these documented examples, specific characteristics have been identified that distinguish Hamblin's portraiture from that of Prior's. These include prominent "rabbit" ears; hands with heavy, dark outlining that taper to a point at the index finger; a smudge of paint that defines the chin; and a trailing line at the corners of the mouth. Details of lace, curtains, ropes, and edges of leaves are often painted wet-on-wet in thick white strokes applied on a wet ground, and a heavy, white impasto delineates the areas under brows and along the length of noses. Background views often exhibit a rosy, sunset hue, and trees starkly limned against the sky, with shadow on one side and highlighted in white on the other. Children are most frequently portrayed in a frontal pose looking straight ahead and holding a prop, such as a basket, flower, fruit, or pet, while adults are depicted in three-quarter poses. When painted on small academy board, the subjects are usually portrayed to just below the waist; oils on canvas are sometimes full-length, and may have more than one

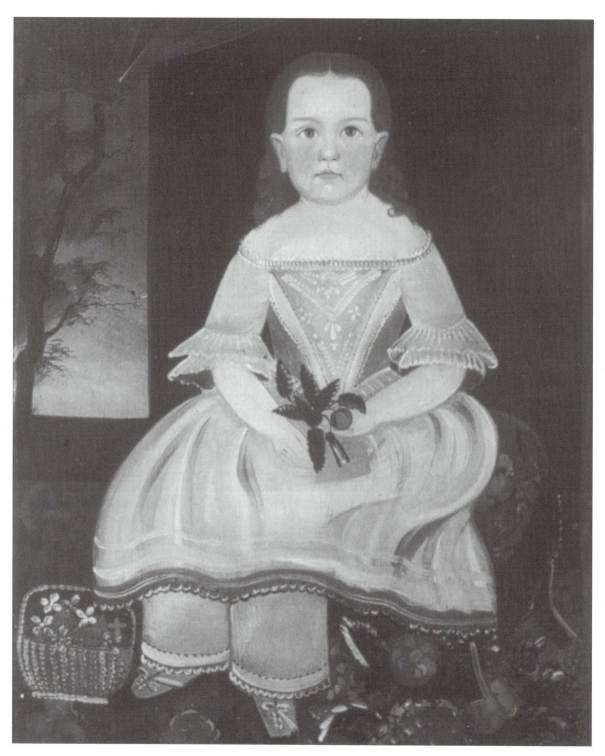

A Rosy-Cheeked Girl. Sturtevant J. Hamblin; c. 1840. Oil on canvas 27½ × 22¼ inches.
The Bertram K. Little and Nina Fletcher Little Collection auction at Sotheby's 6526, January 29, 1994.
Photo courtesy Sotheby's, New York.

figure in the composition. While Hamblin is not known to have painted fancy pictures, as did William Matthew Prior, he did complete at least one portrait of a historical figure, based upon an esoteric eighteenth-century mezzotint engraving. *General Israel Putnam* is signed on the front "S.J. Hamblin Artist." In this landscape with trees, lines of soldiers, grass, and sky, Hamblin introduces a technique more usually associated with the work of decorative painters: the texture of the bark is achieved with the use of a combing tool.

In Boston, Prior and Hamblin had established themselves as the primary practitioners of a schematic style of portraiture that could be completed quickly and at little cost to the client. Although no advertisements placed by Hamblin have come to light, Prior's ads clearly indicate his willingness to paint in either an academic or "flat" style, based upon a price structure that ranged from about $2.92 to $25 a portrait. The scope of style in Hamblin's body of work illustrates that he too probably followed this approach, although he never reached the same level of academic proficiency as Prior did.

See also **Nina Fletcher Little; William Matthew Prior.**

BIBLIOGRAPHY

Chotner, Deborah, et al. *American Naïve Paintings: The Collections of the National Gallery of Art Systematic Catalogue.* Washington, D.C., 1992.

D'Ambrosio, Paul S., and Charlotte Emans Moore. *Folk Art's Many Faces: Portraits in the New York State Historical Association.* Cooperstown, N.Y., 1987.

Little, Nina Fletcher. "William M. Prior, Traveling Artist and His In-Laws, the Painting Hamblins." *The Magazine Antiques,* vol. 53, no. 1 (January 1948): 44–48.

——. "William Matthew Prior and Some of His Contemporaries." *Maine Antiques Digest,* vol. 4, no. 3 (April 1976): 19A–21A.

Rumford, Beatrix T., ed. *American Folk Portraits: Paintings and Drawings from the Abby Aldrich Rockefeller Folk Art Center.* Boston, 1981.

STACY C. HOLLANDER

HAMERMAN, ESTHER (1886–1977) painted memories and vignettes from several periods of her life: in Poland and Austria; under British internship in Trinidad, in the West Indies, during World War II; and in New York City and San Francisco.

The artist was born Esther Wachsmann in Wieliczka, Poland, near Krakow, in or around 1884. She and her husband, Baruch Hamerman, moved to Vienna, where they successfully operated a business, importing straw for hats, and raised four daughters. During this period, Esther Hamerman stitched wall hangings and needlework tapestries. The family fled Vienna on the brink of the war in 1938. They lived in Port of Spain before immigrating to New York. Helen Breger, the Hamermans' youngest daughter, remembered that just before her mother's sixtieth birthday, she and her husband, both artists, encouraged Esther to pursue art after seeing some small drawings she had made. Hamerman began to paint seriously in New York, and she continued painting when she moved to join Breger in San Francisco. Hamerman lived in San Francisco for twelve years before moving back to New York in 1963.

Hamerman painted somewhat naturalistically, although she also abstracted forms and flattened the perspective of her compositions. Her palette was jewel-like and beautifully nuanced. She devised a personal style by painting in oils on canvas or canvas board and then outlining the forms in India ink. Occasionally, Hamerman used photographs or printed images for reference, but she then transformed the subject in a personal way. She completed some seventy-five works that include paintings, drawings, and watercolors; nearly fifty remain in the possession of her family.

One of her strongest works, *Passover* (c. 1957), glows with the warmth of a ritual family meal, the seder. The setting appears to be based on an early memory: the muted golden tones of the European-style carved furniture and woodwork contrast with the white tablecloth and ritual garment worn by the leader of the *seder*. The family members sit around a table bearing all the appropriate ceremonial objects as they recount the Passover story.

The critic Alfred Frankenstein called Hamerman "the Grandma Moses of the West Coast"; he added, though, that "with all due respect to Grandma Moses, she paints more beautifully." Hamerman received recognition and several honors during her lifetime, such as an award from a jury at the Whitney Museum of American Art in New York. There were one-person exhibitions of her paintings in the later 1950s and early 1960s at the De Young Museum (San Francisco, California) and the Oakland (California) Museum of Art.

See also **Painting, Memory.**

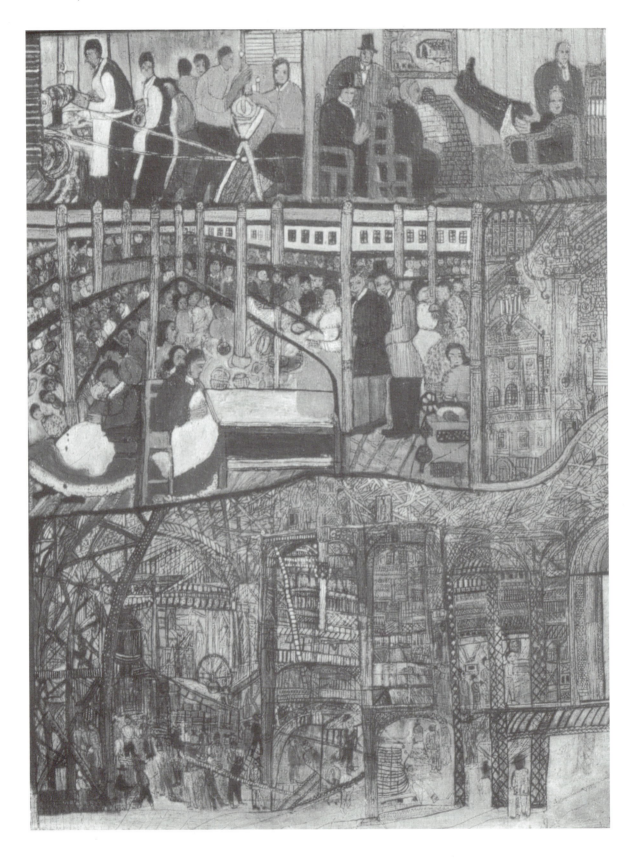

BIBLIOGRAPHY

Kaufman, Barbara Wahl, and Didi Barrett. *A Time to Reap: Late Blooming Folk Artists.* South Orange, N.J., 1986.

Oakland (California) Museum, *Cat and Ball on a Waterfall: 200 Years of California Folk Painting and Sculpture.* Oakland, Calif., 1986.

Rosenak, Chuck, and Jan Rosenak. *Museum of American Folk Art Encyclopedia of Twentieth-Century American Folk Art and Artists.* New York, 1990.

LEE KOGAN

HAMPTON, JAMES (1909–1964) was among the many African Americans who headed north during the Great Migration when he moved from rural Elloree, South Carolina, to Washington, D.C., in 1928. After serving overseas in a segregated United States Army unit between 1942 and 1945, Hampton returned to Washington, where he worked as a janitor for the General Services Administration until his death.

A mild-mannered bachelor with little formal education, Hampton also had a strong desire, as a fundamentalist Baptist, to counsel others about personal salvation in preparation for the Second Coming of Christ. He began recording visions from God in 1931, and by 1950 he had dedicated himself to building *The Throne of the Third Heaven of the Nations Millennium General Assembly* in a rented garage not far from his modest boardinghouse. Hampton described his project as a monument to Jesus in Washington, the city of monuments, and hoped to develop a storefront ministry, a goal he did not live to realize. Nonetheless, in 1976 art critic Robert Hughes of *Time* magazine wrote that *The Throne* "may well be the finest work of visionary religious art produced by an American."

Hampton built 180 objects from furniture, cardboard, paper, light bulbs, and metallic foils scavenged from secondhand stores, the street, and government buildings in which he worked. He arranged the objects on and in front of a platform in the garage to suggest a stage or an altar. The shimmering, symmetrical arrangement has a central core comprised of a throne chair, pulpit, and altar table. Pairs of matching objects—themselves reminiscent of church furniture—flank this core.

Describing himself as "Director, Special Projects, for the State of Eternity," Hampton drew inspiration from the Book of Revelation, which concentrates on the Second Coming of Christ. His sense of prophetic mission also yielded an undecipherable script that he recorded on his constructions and in a small volume, *The Book of the 7 Dispensation of St. James.* Efforts to save Hampton's work after his death culminated in its donation to the Smithsonian American Art Museum in Washington, D.C., in 1970. The museum has prominently displayed *The Throne of the Third Heaven* and has also lent it to other exhibitions.

See also **African American Folk Art (Vernacular Art); Environments, Folk; Religious Folk Art; Visionary Art.**

BIBLIOGRAPHY

Arnett, William, and Paul Arnett. *Souls Grown Deep: African American Vernacular Art,* vol. 2. Atlanta, Ga., 2001.

Hartigan, Lynda Roscoe. "Going Urban: American Folk Art and the Great Migration." *American Art* (summer 2000): 26–51.

———. *James Hampton: The Throne of the Third Heaven of the Nations Millennium General Assembly.* Montgomery, Ala., 1977.

LYNDA ROSCOE HARTIGAN

HARLEY, STEPHEN W. (Steve) (1863–1947) was a painter who revered nature. He was born to William and Mary Ann Lee Harley of Fremont, Ohio. The family moved to Scottville, Michigan, in Harley's boyhood, and it was there that the artist's lifelong love of the outdoors began. Although he inherited a dairy farm as a young man, Harley took no interest in its operation, preferring to roam in the woods while a caretaker tended his cows. His interest in wildlife inspired him to study taxidermy, and he preserved carcasses for both pleasure and income.

In the 1880s or 1890s, Harley took a correspondence course in drawing and drafting and began to paint. By the early 1920s, financial problems, alcoholism, and involvement with the caretaker's wife prompted Harley to leave Michigan for the Pacific Northwest, where he visited Washington, Oregon, northern California, and Alaska. The area's magnificent scenery inspired Harley to take several photographs, but, according to tradition, he was disappointed with the results, and tried oil painting as an alternative means of recording his impressions.

When Harley returned to Scottville in the early 1930s, he brought with him the three landscapes on which his fame rests today: *Upper Reaches of the Wind River* (painted near Carson, Washington), *Wallowa Lake,* and *South End of Hood River Valley* (both of the latter painted in Oregon). All of these paintings incorporate vistas of great depth, yet all are so meticulously detailed that, in some cases, one can count the leaves on the trees. Rich, saturated colors also

The Factory; Esther Hamerman; c. 1954. Oil on canvas. 30 × 46 inches. Courtesy the Collection Helen Breger, Berkeley, California.

distinguish these scenes. Cultivated fields dominate the foreground of *South End of Hood River Valley,* while the other two are unmitigated celebrations of wilderness. Harley kept these three landscapes with him through the beleaguered last years of his life.

The family farm was lost in a mortgage foreclosure, and Harley had only a small dwelling for shelter; for income, he drew twenty dollars a month from the state's Bureau of Old Age Assistance. (Later, that sum was reduced to eighteen dollars a month.) He had ceased painting upon his return from the Northwest, possibly because of crippling arthritis. In the end, coronary heart disease and arteriosclerosis put an end to the life of the man who, on the back of one of his paintings, had described himself as "The Invincible." Harley never married, died childless, and no one attended the funeral that saw him laid to rest in an unmarked grave.

See also **Painting, American Folk; Painting, Landscape.**

BIBLIOGRAPHY

Bishop, Robert. *Folk Painters of America.* New York, 1979.

Dewhurst, Kurt C., and Marsha MacDowell. *Rainbows in the Sky: The Folk Art of Michigan in the Twentieth Century.* East Lansing, Mich., 1978.

Hemphill, Herbert W. Jr., and Julia Weissman. *Twentieth-Century American Folk Art and Artists.* New York, 1974.

Lipman, Jean, and Tom Armstrong, eds. *American Folk Painters of Three Centuries.* New York, 1980.

Lowry, Robert. "Steve Harley and the Lost Frontier." *Flair,* vol. 1, no. 5 (June 1950): 12–17.

Rumford, Beatrix T., ed. *American Folk Paintings: Paintings and Drawings Other Than Portraits from the Abby Aldrich Rockefeller Folk Art Center.* Boston, 1988.

BARBARA R. LUCK

HARMONISTS: *SEE* GERMAN AMERICAN FOLK ART.

HARVEY, BESSIE (1928–1994) was a self-taught artist who made mixed media root sculptures that synthesized Afro-Atlantic vernacular tradition with intense personal vision. A native of Dallas, Georgia, Harvey was the seventh of thirteen children. At the age of fourteen, she married Charles Harvey and settled in Buena Vista, Georgia. When she was in her early twenties, Harvey separated from her husband and relocated to Knoxville, Tennessee, and by age thirty-five she was raising eleven children as a single mother. Harvey cited her accidental discovery in 1972 of a small medallion while gardening as a portent of her subsequent creative activity, and she began making sculpture in response to her grief after the death of her mother in 1974. Her first works were "dolls"

fashioned from roots that she culled from her local environs and in which she saw faces and intuitively sensed the presence of spirits. Harvey understood her unique vision and her ability to "bring it out" in wood and mixed media to be divine gifts.

Harvey's early works are relatively simple and unadorned figural compositions in painted wood, typically titled with the name of the spirits the artist believed to reside in the roots. These names often referred to spirits of African kings and warriors or biblical subjects. In time her works grew more complex as she experimented with a variety of media. Her larger works from the mid-1980s and after—Baroque, mixed-media, multi-figural *opera magna* built from gnarled, large-scale roots and tree stumps—represent the artist's mature style. A corollary to the artist's visionary output is her series, begun in the 1980s and titled *Africans in America,* of didactic dioramas created to teach African American children about their heritage. Harvey ultimately intended her artwork to be a tool for divine healing, a purpose consistent with the centuries-old Afro-Atlantic vernacular tradition of root medicine within which it may be viewed: "Anybody that looks upon the work, I believe you are truly blessed, because it is an instrument of love." Harvey's root sculptures have been accepted within multiple contexts, including contemporary folk art, outsider art, and the mainstream art world.

See also **African American Folk Art (Vernacular Art); Outsider Art; Sculpture, Folk.**

BIBLIOGRAPHY

Borum, Jenifer P. "Spirit from Head." *Raw Vision,* no. 37 (winter 2002): 42–49.

Cavin Morris, Shari. "Bessie Harvey: The Spirit in the Wood." *The Clarion* (spring/summer 1987): 44–49.

Wicks, Stephen C. *Revelations in Wood: The Art of Bessie Harvey.* Knoxville, Tenn., 1997.

JENIFER P. BORUM

HASKINS, ORRIN N.: *SEE* SHAKER FURNITURE.

HATHAWAY, RUFUS (1770–1822) painted landscapes, overmantels, and an important group of early New England portraits, including several of the most prominent citizens of Duxbury, Massachusetts. Hathaway was born in Freeport, Massachusetts, and was painting in the vicinity of Taunton, Massachusetts, by 1790, when he was only twenty years of age. His first portrait, *Lady with Pets,* probably of Molly Wales Fobes, is also his best known and most eccentric. This decorative painting features the impressive Mrs. Fobes wearing a powdered wig

that sprouts two large feathers, and surrounded by butterflies, birds, and her black cat Canter. The artist's initials along with the year 1790 appear in the lower right corner. The earliest portrait to bear his full signature is *Reverend Caleb Turner,* dated 1791, with a pendant portrait of Mrs. Turner, who was related to Mrs. Fobes. These early efforts establish a pattern of patronage among relatives and neighbors, as well as many of the conventions that characterize Hathaway's work, including his emphasis on costume and accessories such as flowers, jewels, and fans; arms stiffly posed in angular positions; three-quarter-length figures filling the canvases; and incisive delineation of faces, with heavy outlining and shading from the brow to the nose. A number of the paintings are framed in heavy bolection molding that Hathaway is thought to have made himself.

In 1793 Hathaway went to Duxbury, where he painted ten portraits for the powerful family of shipping magnate Ezra "King Caesar" Weston. Shortly thereafter, he painted *Joshua Winsor,* another wealthy and influential Duxbury patriarch, as well as members of his family. He also painted *Joshua Winsor's House & c.,* which shows Winsor himself in the foreground holding the key to his extensive residential and business properties. It is conjectured that while painting Winsor's two pretty daughters, the young artist fell in love with 17 year old Judith, and married her in December 1795. The Hathaways settled in Duxbury, and possibly at the behest of his father-in-law, Hathaway began studying to be a physician. Although his primary occupation after marriage was in medicine, Hathaway continued painting until about 1808. Twenty-five works are known today, including portraits, miniatures, landscapes, and overmantels. Dr. Hathaway also made at least one woodcarving, a large spread-winged eagle that was placed at the top of a temporary arch erected to inaugurate a new bridge over the Bluefish River. Hathaway was highly respected as a physician, and practiced medicine until the end of his life; in 1822 he was made an honorary fellow of the Massachusetts Medical Society. It is as a physician that Hathaway is remembered on his headstone, in an epitaph that he himself may have composed.

See also **Miniatures; Painting, Landscape.**

BIBLIOGRAPHY

Lipman, Jean, and Tom Armstrong, eds. *American Folk Painters of Three Centuries.* New York, 1980.

Little, Nina Fletcher. "Doctor Rufus Hathaway, Physician and Painter of Duxbury, Massachusetts, 1770–1822." *Art in America,* vol. 41, no. 3 (summer 1953): 95–139.

———. *Paintings by New England Provincial Artists, 1775–1800.* Boston, 1976.

Valentine, Lanci. *Dr. Rufus Hathaway: Artist and Physician, 1770–1822.* Duxbury, Mass., 1987.

Valentine, Lanci, and Nina Fletcher Little. "Rufus Hathaway, Artist and Physician." *The Magazine Antiques,* vol. 131, no. 3 (March 1987): 628–641.

STACY C. HOLLANDER

HAUS-SEGAN ARTIST: *SEE* GEORGE HEINRICH ENGELLHARD.

HAWKINS, WILLIAM (1895–1990) painted powerful portrayals of the urban scene, and bold paintings of animals; historical subjects; and buildings, including some of the landmark architecture in Columbus, Ohio, such as the Neil House and the Willard Hotel; images from popular culture; and Bible scenes, including his many versions of the Nativity and Leonardo da Vinci's *Last Supper.* His bold religious narratives demonstrate a contemporary approach to ancient themes that enhances their relevance in modern times.

Hawkins' paintings display a technical virtuosity. He used materials at hand, including large pieces of Masonite, cardboard, discarded paper, and enamel house paint, which he applied with sticks and brushes and mixed occasionally with glitter or sawdust to create texture. He integrated collage into his work, using pictures and articles torn from magazines, newspapers, and books as well as postcards and other printed matter, which he kept in a suitcase and referred to as "research." His painterly brushstrokes, loose and full of movement and emotion, sustain his broad and dramatic visual gestures. Coupled with his use of bright colors and a sharply contrasting palette, Hawkins' techniques help to maintain a strong element of excitement and surprise in his work, one of his stated goals.

Demonstrating artistic interest and ability at an early age, Hawkins began to paint when he was ten years old. He loved to draw horses, using photographs as references. Hawkins and Vertia, his brother, were raised by their maternal grandmother, Mary Mason Runyon Scudder, on her farm in Union City, Kentucky, where the two brothers became expert at riding horses and where they hunted and fished.

Hawkins was sent to Columbus, Ohio, by his family when he was nineteen. With little education or money, Hawkins faced the additional burden of coping with racial prejudice for the first time in his life. Drawing on his enormous self-confidence and personal strength, he developed survival skills that helped him throughout his life. He worked as a truck

driver and continued to do so until he was eighty-five, subsidizing his income by selling the salvaged materials he found on the streets of Columbus, an activity that also contributed to his artistic pursuits.

Hawkins' work was discovered in 1981 by Lee Garrett, a trained artist as well as Hawkins' neighbor. Impressed with their vitality, Garrett entered a Hawkins painting into an art competition at the Ohio State Fair; Hawkins was awarded first prize. Garrett encouraged Hawkins to use materials of better quality and sent slides of his work to Roger Ricco, a New York City gallery owner. Ricco represented the artist until Hawkins' death in 1990. Through the gallery, Hawkins sold many paintings, and his reputation grew. An exhibition of William Hawkins' paintings was organized at the Museum of American Folk Art (now the American Folk Art Museum) in Manhattan in 1997. His work has been a part of many important group exhibitions and is included in the permanent collections of museums throughout the United States.

See also **African American Folk Art (Vernacular Art); American Folk Art Museum; Painting, American Folk.**

BIBLIOGRAPHY

Arnett, William, and Paul Arnett, eds. *Souls Grown Deep: Vernacular Art of the South.* Atlanta, Ga., 1998.

Hartigan, Lynda Roscoe. *Made with Passion: The Hemphill Folk Art Collection in the National Museum of American Art.* Washington, D.C., 1990.

Hollander, Stacy C., and Brooke Davis Anderson, eds. *American Anthem: Masterpieces from the American Folk Art Museum.* New York, 2002.

Longhauser, Elsa, and Harald Szeemann. *Self-Taught Artists of the Twentieth Century: An American Anthology.* San Francisco, 1998.

Maresca, Frank, and Roger Ricco. *William Hawkins: Paintings.* New York, 1997.

Rosenak, Chuck, and Jan Rosenak. *Museum of American Folk Art Encyclopedia of Twentieth-Century American Folk Art and Artists.* New York, 1991.

Yelen, Alice Rae. *Passionate Visions of the American South: Self-Taught Artists from the 1940s to the Present.* New Orleans, La., 1993.

LEE KOGAN

HEART AND HAND ARTIST (active 1850–1855), an unidentified but prolific creator of ornamented family records and other documents, in Maine, New Hampshire, and Vermont, frequently decorated his work with hearts and extended hands. In contrast to the well-known heart-*in*-hand symbol of the Independent Order of Odd Fellows, the two motifs are not combined into a single element in the work of the Heart and Hand Artist. Intended by the artist to sug-

gest the sentiments of love and friendship in marriage, the motifs do not dominate his compositions, in which all decorative elements are generally rendered diminutively for placement within a grid.

It has been proposed that Samuel Lawhead (dates unknown) is the Heart and Hand Artist; his name appears on a business card by the artist in the collection of the late Nina Fletcher Little (1903–1993), as well as on a family record for the Hodgdon family in New Hampshire, but no information has been developed about Lawhead. Hence, his identification as the Heart and Hand Artist awaits confirmation. The use of the heart emblem in nineteenth century family records of the northeastern United States (most extravagantly in the work of William Murray [1756–1828]) is widespread and conventional.

The Heart and Hand Artist uses a columnar format for his family records, generally with carefully ruled vertical and horizontal lines that form a grid for the entry of the names of family members and important dates. The artist's hand is sure and elegant, if restrained. Although he employs a minimum of ornamentation, his exacting application of watercolors to the drapery that often frames the top of his compositions, as well as to his bold uppercase letters and numbers, strikes a decorative note. In addition to the heart and hand (or quite often, simply a heart or series of hearts) that accompanies the listing of marriages and the birth of children, the artist employs stylized images of monuments and weeping willow trees to introduce the register of deaths of family members. He also uses representations of pine trees and a stock of organic and geometric decorative devices to animate his work. The Heart and Hand Artist worked at a time when engraved forms were supplanting hand-drawn family records. He occasionally used these forms himself, painting them with watercolor while entering vital statistics in his robust and distinctive hand.

See also **Family Records or Registers; Fraktur; Fraternal Societies; Nina Fletcher Little; William Murray.**

BIBLIOGRAPHY

Isaacson, Philip M. *Vital Statistics: American Folk Drawings and Watercolors from a Private Collection.* Brunswick, Maine, 1986.

Schaffner, Cynthia V.A., and Susan Klein. *Folk Hearts: A Celebration of the Heart Motif in American Folk Art.* New York, 1984.

Simons, D. Brenton, and Peter Benes. *The Art of Family: Genealogical Artifacts in New England.* Boston, 2002.

GERARD C. WERTKIN

HEATON, JOHN (active 1730–1745), who was probably British by origin, became the most active limner or painter in the Dutch town of Albany, New York, from 1730s to 1740s. He arrived there by 1730, the year he married Maria Van Hooghkerke, the daughter of a local Dutch family. It was not until the art historian Mary C. Black (1923–1992) discovered an entry for the year 1737 in the daybook of Abraham Wendell of Albany ("John Heaton I sent 7 fram[e]s & Ells Speckled Linne[n] to Cover the Same for the Pictures I ordered") that the limner's name was established. Until then, a group of Albany portraits were attributed to the unidentified "Wendell limner."

Little more is known about Heaton other than what can be gleaned from the paintings that survive. These include at least twenty portraits, eleven scripture history paintings, a genre scene, and one of the most remarkable early American folk art paintings—a landscape view of Marten Van Bergen's farm near what is now called Leeds, in Greene County, New York, a few miles south of Albany. The painting includes images of his family, servants, slaves, and members of a neighboring Native American tribe. That farm landscape relates to the portrait of Abraham Wendell, in which the artist painted Wendell's proudest possession, a water-driven gristmill at Albany, in the same style as Van Bergen's farm.

Heaton's other portraits of prosperous merchants and farmers and their wives and children are similar to the subjects painted by Pieter Vanderlyn (c. 1682/1687–1778), who worked at the same time in Albany and Kingston, New York. Both upriver limners were faithful to the costumes and background details of their subjects' lives, although they were painted in a vernacular style. These two limners satisfied their conservative provincial patrons who preferred accuracy to flattery and retained their Dutch culture, in contrast to the wealthy Anglo-Dutch sitters who patronized New York City limners whose portrait compositions and clothing were painted to mimic English courtly portraits.

See also **Mary Childs Black; Painting, American Folk; Painting, Landscape; Pieter Vanderlyn.**

BIBLIOGRAPHY

Belknap, Waldron Phoenix. *American Colonial Painting: Materials for a History.* Cambridge, Mass., 1959.

Black, Mary C. "Contributions Toward a History of Early-Eighteenth-Century New York Portraiture: Identification of the Aetatis Suae and Wendell Limners." *American Art Journal,* vol. 12 (1980): 4–31.

———. *Rivers, Bowery, Mill, and Beaver.* New York, 1974.

Blackburn, Roderic H., and Nancy Kelley, eds. *Dutch Arts and Culture in Colonial America.* Albany, N.Y., 1987.

Blackburn, Roderic H., and Ruth Piwonka. *Remembrance of Patria: Dutch Arts and Culture in Colonial America, 1609–1776.* Albany, N.Y., 1988.

MacFarland, Janet R. "The Wendell Family Portraits." *The Art Quarterly,* vol. 25, no. 4 (winter 1962): 385–392.

Piwonka, Ruth, and Roderic H. Blackburn. *A Remnant in the Wilderness: New York Dutch Scripture History Painting of the Early Eighteenth Century.* Albany, N.Y., 1980.

Quimby, Ian M.G., ed. *American Painting to 1776: A Reappraisal.* Charlottesville, Va., 1971.

RODERIC H. BLACKBURN

HEMPHILL, HERBERT W., JR. (1929–1998) altered the course of the folk art field when he began championing the work of twentieth-century folk artists in 1968. Born in Atlantic City, New Jersey, Hemphill acquired an early appreciation of America's popular culture in this resort town where his father was a prominent businessman. His love of Southern culture owed much to his mother's prestigious ancestry in Georgia, while her love of shopping and collecting was an equally important formative influence, as Hemphill began collecting Americana even as a child.

After briefly studying theater, poetry, and painting in Paris and at Bard College in Annandale-on-Hudson, New York, Hemphill moved to New York City in 1949 with hopes of developing a career as an artist. His forte, however, quickly proved to be collecting—first African sculpture, then modern European and American art, and, ultimately, folk art. Inspired by pioneering collectors such as Abby Aldrich Rockefeller (1874–1948) and Jean Lipman (1909–1998), Hemphill focused on early American weathervanes, portraits, watercolors, and furniture during the early 1950s. In 1956 he purchased a pair of nontraditional cigar store Indians from Sotheby's auction of Rudolph Haffenreffer's collection of American trade signs. This acquisition was the first public indication of the unusual and under-appreciated works that he would become known for championing, so much so that his detractors and admirers alike often identified such art as "Hemphill things."

Hemphill was one of six private collectors and dealers who founded the Museum of Early American Folk Art (now the American Folk Art Museum) in New York in 1961. A year later he co-organized the museum's inaugural exhibition, at the Time and Life Exhibit Center under the auspices of *Life* magazine, and he also donated the first object to enter the museum's collection: *Flag Gate,* by an unidentified artist, c. 1876.

In 1964 Hemphill became the museum's first full-time curator. Over the next decade he developed an

exhibition program of innovative topics and memorable installations, among which "Twentieth-Century Folk Art" (1970), "Macramé" (1971), "Tattoo" (1971), and "Occult" (1973) are widely considered the epitome of his curatorial career.

Hemphill's perception of folk art's possibilities changed dramatically in 1968, when artists and folk art collectors Michael (1941–) and Julie Hall (1943–) introduced him to the Kentucky woodcarver Edgar Tolson (1904–1984). Spurred by what he frequently described as an epiphany, Hemphill began canvassing the country in search of living folk artists. Although he remained interested in nineteenth-century folk art, his collection became decidedly contemporary, national, and ethnically diverse as he acquired paintings, sculptures, drawings, and other objects made by folk artists active in almost all of the fifty states. His exhibition, "Twentieth-Century Folk Art" (1970), and book, *Twentieth-Century Folk Art and Artists,* co-authored with Julia Weissman in 1974, inspired several generations of collectors, dealers, curators, and critics to follow and expand upon his pioneering example.

Hemphill's lasting impact as a collector, curator, and author has been felt in so many ways that *Connoisseur* magazine honored him as "Mr. American Folk Art" in 1982. Between 1973 and 1990, twenty-five American museums featured selections from his collection of some three thousand works, and in 1976 the American Bicentennial Commission circulated his collection in Japan. He was an active trustee emeritus and member of the Collections Committee at the American Folk Art Museum, and he regularly donated works to museums nationwide. Although trained as a painter, Hemphill showed a decided preference for sculpture, which culminated in the historic exhibition "Folk Sculpture USA," a two-hundred-year survey that he organized for the Brooklyn Museum in 1976. He also served as a consultant to a wide variety of exhibitions, most notably another Bicentennial project, "Missing Pieces: Georgia Folk Art (1770–1976)." In 1989 he became a founding member of the national advisory board of the Folk Art Society of America, and continued to serve in that capacity until his death. The society granted Hemphill its first annual Award of Distinction in 1990; the award described him as "the man who preserves the lone and forgotten," a phrase that appears in his iconic portrait painted by a friend, Georgia folk artist Howard Finster.

Between 1986 and 1998 the Smithsonian American Art Museum acquired more than six hundred nineteenth- and twentieth-century works from Hemphill's collection, to assert folk art's significance in the nation's visual history. The Smithsonian Institution awarded Hemphill its James Smithson Society Founder medal in 1987 for his gift to the nation, and in 1990 the Smithsonian American Art Museum celebrated this major acquisition with the exhibition and publication, *Made with Passion: The Hemphill Folk Art Collection.*

See also **American Folk Art Museum; Furniture, Painted and Decorated; Hall, Michael and Julie; Jean Lipman; Abby Aldrich Rockefeller; Sculpture, Folk; Smithsonian American Art Museum; Tattoo; Edgar Tolson; Trade Signs; Weathervanes.**

BIBLIOGRAPHY

Dudar, Helen. "Mr. American Folk Art." *Connoisseur,* vol. 210 (June 1982): 70–78.

Hartigan, Lynda Roscoe. "The Hemphill Folk Art Collection." *Antiques,* vol. 138 (October 1990): 798–807.

———. *Made with Passion: The Hemphill Folk Art Collection.* Washington, D.C., 1990.

Hemphill, Herbert W. Jr., and Julia Weissman. *Twentieth-Century Folk Art and Artists.* New York, 1974.

Milwaukee Art Museum, with contributions by Russell Bowman, Michael Hall, and Donald Kuspit. *American Folk Art: The Herbert Waide Hemphill Jr. Collection.* Milwaukee, Wisc., 1981.

LYNDA ROSCOE HARTIGAN

HERRERA, JUAN MIGUEL (1835–1905) was a well-known late-nineteenth-century sculptor of religious images and a native of the village of Arroyo Hondo, New Mexico, north of Taos. Herrera specialized in large, processional figures (*bultos*) for use by local churches and lay brotherhoods (*moradas*). These figures, which included Christ Crucified, Christ in the Holy Sepulchre, and the Virgin Mary as Our Lady of Solitude, were used in community Holy Week processions to reenact the suffering of Christ, his last meeting with Mary, and his crucifixion and descent from the cross.

Like many Hispanic villagers of his day, Herrera pursued several occupations to make a living. He was a farmer and musician as well as a carver of *bultos*. In the 1860 Taos County census he lists his occupation as "fiddler" and later listed it as "farmer." Herrera was probably an apprentice to the Arroyo Hondo Carver (active c. 1830–c. 1850), whose earlier work was popular in the region. In addition to living in the same community, Herrera's work bears some stylistic similarities to the Arroyo Hondo Carver's. Herrera's range of subjects, at least based upon surviving pieces, was more limited, however, and his colors were limited by dependence upon commercial oil paints. Like those

of his presumed mentor, his *bultos* also tend to be quite abstract and severe, yet they are powerful in their straightforward presentation. In their frontal stance and expressionless gaze they are also quite in keeping with the work of other *bultos* sculptors of the late nineteenth century, such as Juan Ramón Velázquez and José Benito Ortega (1858–1941). In making *bultos* Herrera was assisted by his brother, Candelario Herrera, and his son, Juan de Dios Herrera, who was perhaps the last of the traditional *santeros,* or makers of figures of saints. During an interview in 1949, Juan de Dios Herrera stated that he had helped his father make *bultos,* and that he had made a few himself, including one as late as 1908.

See also **Arroyo Hondo Carver; Bultos; José Benito Ortega; Religious Folk Art; Retablos; Santeros.**

BIBLIOGRAPHY

Shalkop, Robert L. *Arroyo Hondo: The Folk Art of a New Mexican Village.* Colorado Springs, Colo., 1969.

Wroth, William. *Images of Penance, Images of Mercy: Southwestern Santos in the Late Nineteenth Century.* Norman, Okla., and London, 1991.

WILLIAM WROTH

HERRERA, NICHOLAS (1964–), commonly known as the El Rito Santero (a maker of religious images from the village of El Rito), has been branded an outsider artist because his wildly unconventional polychrome woodcarvings of saints and other subjects turn traditional New Mexico *santero* themes on their heads. Though the artist frequently expresses religious subjects in the traditional *bulto* (three-dimensional religious sculpture) and *retablo* (religious painting on wood) forms, his works are rough, unselfconscious reflections of the artist's difficult personal experiences, strong opinions on social issues, and quirky outlook on ordinary life. His irregularly carved and painted images have been criticized as crude, but Herrera's purposeful imperfections reveal the artist's desire for his works to look truly handmade.

Herrera was born in a lush river valley, where, as a child, he collected river rocks and wood and turned them into whimsical artworks, only to take them back to the river and watch them float away. A rebellious teen, Herrera fought, drank, and made trouble throughout high school before dropping out in eleventh grade. The only place where Herrera did not feel like a misfit was in the village *morada,* the meetinghouse of the *Penitente* brotherhood, a lay religious order that Herrera joined at age fifteen. The structure

was filled with polychrome paintings and carvings of saints, including one created by his late great-uncle, who had worked as the village *santero* before Herrera was born. Herrera's early interest in art was revived, and he used time away from his construction and maintenance job at Los Alamos National Laboratory to begin replicating the *morada* artworks. Yet even his strong spirituality was overshadowed by alcohol and drugs.

In 1990 Herrera's drinking resulted in a car accident, and a subsequent near-death experience, that changed his life dramatically. Having survived the accident, Herrera quit drinking and left his job to practice art full time. Yet even as he created intensely spiritual images of saints, using cottonwood, homemade paints and gesso, and other traditional materials, Herrera's offbeat personality emerged in original interpretations of religious themes. Herrera's small *retablos* might portray a low-rider car as a long-suffering saint, for example, while his large *bultos* might depict death as a skeleton armed with an automatic weapon, or a life-size Christ dripping in blood. In both forms, Herrera's hand-adzed technique is revealed in uneven surfaces and odd facial expressions.

Herrera is perhaps best known for satirical commentaries on his profound life and death experiences, as well as those of others. In *Los Alamos Death Truck,* Herrera uses the traditional *carreta de la muerte* (death cart) image to comment upon his former employment at the Los Alamos National Laboratory. The piece portrays three garish work-a-day skeletons driving a flatbed truck filled with barrels of radioactive waste. Though such images have generated their share of controversy for the artist, Herrera's twists on tradition remain respectful to the historical origins of *santero* art. Nonetheless, Herrera proves that even the most sacred of images are not sacred in the hands of an outrageously original artist.

See also **Bultos; Death Carts; Outsider Art; Retablos; Santeros.**

BIBLIOGRAPHY

Cirillo, Dexter. *Across Frontiers: Hispanic Crafts of New Mexico.* San Francisco, 1998.

Rosenak, Chuck, and Jan Rosenak. *The Saint Makers: Contemporary Santeras and Santeros.* Flagstaff, Ariz., 1998.

CARMELLA PADILLA

HICKS, EDWARD (1780–1849) was the creator of perhaps the most widely recognized and best loved of all American folk paintings. His instantly identifiable *Peaceable Kingdoms,* sixty-two versions of

which are known, are appealing in their apparent, yet deceptive, innocence and in the extraordinary exuberance of their jam-packed compositions. As art historians Eleanor Mather and Caroline Weekley have observed, the images, which evolved in form considerably over the course of the thirty years in which they were Hicks's most important visual theme, are rich with meaning close to the heart of this devout Quaker.

Born April 4, 1780, in Attleborough (now Langhorne), Pennsylvania, Hicks was raised by the David Twining family following the death of his mother. It was through the kindness and industriousness of this Quaker family that he first absorbed the religious beliefs that would powerfully influence his life and work. Apprenticed to coach-makers William and Henry Tomlinson at the age of thirteen, Hicks subsequently used his training to paint not only coaches but also signs, furniture, and other decorated objects. He married Sarah Worstall in 1803, and the couple had five children. While ornamental painting was Hicks's means of making a living, his true calling was the Quaker ministry, and he was far better known in his lifetime for this role than for his achievements as an artist.

Beginning in 1811 he spoke locally as a minister, and in 1819 he set out from his home in Newtown, Pennsylvania, on the first of several preaching trips. Owing to a split within the American Society of Friends in 1827, Hicks became a follower of the Hicksite movement led by his cousin, Elias Hicks. This schism in Quakerism deeply affected the artist. His depictions of animals, based loosely on Isaiah 11:6, "When the wolf shall dwell with the lamb and the leopard shall lie down with the kid," lend the creatures of the *Peaceable Kingdoms* alert and often troubled facial expressions. Their agitation and unease are reflective not only of man's daily struggle to overcome his natural appetites to achieve a higher level of spirituality, but also of the artist's angst over the philosophical tumult taking place in Quaker theology at the time.

Hicks turned to easel paintings later in life, producing most of these works after 1820. While ornamental painting continued to be his primary source of income, his portrait works appear to have been created for the pleasure and contemplation of family and close friends in Bucks County, where he lived throughout his life. He was evidently skilled enough to have provided some instruction to his cousin, Thomas Hicks (1823–1890), who became a portrait artist, and to the young Martin Johnson Heade (1819–1904). Self-taught and never particularly skillful in the depiction of the human figure, Hicks nevertheless had a talent for adopting elements from print sources, reusing them to create compositions with both deep emotional resonance and clever design.

In subjects such as *Penn's Treaty with the Indians* (thirteen versions) or *The Grave of William Penn* (six versions), he begins with printed sources (The Boydell-Hall engraving after Benjamin West in the first instance, and Paul Gauci's lithograph after Hendrik Frans de Cort in the second), but transforms them through his bold, idiosyncratic vision. His several farm scenes, in contrast, document places he knew well. In works such as the supremely beautiful *Cornell Farm,* painted toward the end of his life, he achieves an orderly composition and light-infused atmosphere that reflect the belief in a serene heaven-on-earth provided by a beneficent being. Hicks himself had tried his hand at agriculture about 1815, believing it a higher calling than that of being an artist, but was ultimately a failure as a farmer.

In addition to the subjects noted above, Hicks made images of Niagara Falls, Washington crossing the Delaware, the signing of the Declaration of Independence, and painted a remarkable *Noah's Ark*. His work is distinctive in its creation of lively patterns, in the sinuous contours of the creatures depicted, and in the harmonious palette of greens, golds, and browns. Often the works are inscribed with large, careful lettering that reflect the artist's training as a sign painter. Landscapes from the latter part of Hicks's career demonstrate an increased ease of his handling of paint, a more highly developed sense of spatial progression, and a softer, more lyrical atmosphere.

At first known only locally, Hicks's work was rediscovered in the 1930s when it was included in important early exhibitions at the Newark Museum (1930–1931) and the Museum of Modern Art (1935 and 1938), and has been widely exhibited ever since.

See also **Furniture, Painted and Decorated; Painting, American Folk; Painting, Landscape; Religious Folk Art; Trade Signs.**

BIBLIOGRAPHY

Ford, Alice. *Edward Hicks: Painter of the Peaceable Kingdom.* Philadelphia, 1952.

———. *Edward Hicks, His Life and Art.* New York, 1985.

Hicks, Edward. *Memoirs of the Life and Religious Labors of E. Hicks.* Philadelphia, 1851.

Mather, Eleanor Price, and Dorothy Canning Miller. *Edward Hicks: His Peaceable Kingdoms and Other Paintings.* East Brunswick, N.J., 1983.

Weekley, Carolyn. *The Kingdoms of Edward Hicks.* New York, 1999.

DEBORAH CHOTNER

HIDLEY, JOSEPH HENRY (1830–1872) is best known for his five highly detailed bird's-eye views of Poestenkill, New York, documenting that village's appearance over a period of about twenty years. Hidley was born near Wynantskill, New York, to George and Hannah Hidley, and was the only one of their four children to survive to adulthood. After the death of his father in about 1834, family tradition holds that Hidley was raised by his maternal grandparents, Christian and Patience Simmons, of Sand Lake. Hidley moved to Poestenkill in 1850, the same year that his mother moved to Monroe County, New York. He married Caroline Matilda Danforth in 1853. Their house, at the center of the village, appears in several of Hidley's views of Poestenkill. The couple had five daughters and a son.

Hidley began painting in 1850, and from that time until his death he painted the graining of interior woodwork, floral scenes for architectural panels, and religious and allegorical subjects based on prints, genre scenes, and townscapes of Poestenkill and surrounding villages. He was also a house and sign painter as well as a taxidermist, and his daughter Emmeline claimed that he made shadowboxes with dried flower arrangements. Hidley's painting style is exacting and precise, full of specific details regarding the appearance and daily life of the villages he painted. Although the obvious skill with which Hidley painted strongly suggests that he received some form of artistic instruction, no documentation of any such training has come to light. Working in oil on canvas or wood panel, he was also capable of rendering the surrounding landscape with realistic color and mood in a variety of seasons. Hidley painted fine portraits of family members as well.

See also **Painting, Landscape; Religious Folk Art.**

BIBLIOGRAPHY

Rumford, Beatrix T., ed. *American Folk Paintings: Paintings and Drawings Other Than Portraits from the Abby Aldrich Rockefeller Folk Art Center.* Boston, 1988.

PAUL S. D'AMBROSIO

HIGH MUSEUM OF ART, THE, founded in 1905 as the Atlanta Art Association, has significant holdings of nineteenth- and twentieth-century American art, and is noted for critically acclaimed collections of decorative arts and contemporary folk art. Since 1994, the High Museum distinguished itself as the only major American fine arts museum with a curator and department devoted to folk art. Today it is recognized as one of the most significant repositories of contemporary American self-taught art, with an actively growing collection of more than six hundred works in various media, the majority of which highlight the rich vernacular traditions of the American South.

The museum acquired its first early American folk painting in 1956, and hosted exhibitions of early American folk art from the Smithsonian (1959), Abby Aldrich Rockefeller (1960, 1974), and the Edgar and Bernice Chrystler Garbisch collections (1962). In 1975 the High Museum purchased its first work by a contemporary folk artist, Georgia memory painter Mattie Lou O'Kelley (1908–1997), and presented its first exhibition of contemporary works by another local artist, Carlton Elonzo Garrett (1900–1992), in 1981. The museum purchased thirty drawings by Bill Traylor (1854–1949) the following year. The museum's contemporary collection of self-taught art grew significantly from 1996 to 1997 as a result of T. Marshall Hahn's decision to donate a substantial portion of his private collection.

The High Museum is the primary public repository for major sculptural and painted works by Georgia artist Howard Finster (1915–2001), celebrated for his well-known *Paradise Garden* outdoor environment, as well as works by Alabama artist Bill Traylor and Atlanta artist Nellie Mae Rowe (1900–1982). Other focus collections include masterworks by Felipe Benito Archuleta, Ned Cartledge, Ulysses Davis, Thornton Dial, Sam Doyle, Carlton Garrett, Dilmus Hall, William Hawkins, Lonnie Holley, Ronald Lockett, José Dolores López, John Perates, Elijah Pierce, Martin Ramirez, and Charlie Willeto. The High Museum's folk art collection is further complemented by exceptional examples of Southern painted furniture, memory jugs, and Edgefield pottery, and African American quilts, canes, and Gullah baskets.

Installations featuring self-taught art are regularly on view in the museum's main facility, part of its award-winning building designed by Richard Meier, which opened in 1983. Folk art exhibitions and programming are also featured at the museum's satellite facility located in downtown Atlanta at the Georgia-Pacific Center, which has served as the High Museum of Art's Folk Art and Photography Galleries since 1993.

See also **African American Folk Art (Vernacular Art); Felipe Benito Archuleta; Baskets; Canes; Ned Cartledge; Ulysses Davis; Thornton Dial; Sam Doyle; Reverend Howard Finster; Furniture, Painted and Decorated; Edgar and Bernice Chrystler Garbisch; Carlton Elonzo Garrett; Dilmus Hall; William L. Hawkins; Lonnie Holley;**

Jugs, Memory; Ronald Lockett; José Dolores López; Mattie Lou O'Kelley; John Perates; Elijah Pierce; Pottery, Folk; Quilts; Martín Ramírez; Abby Aldrich Rockefeller; Nellie Mae Rowe; Smithsonian Museum of American Art; Bill Traylor; Charlie Willeto.

BIBLIOGRAPHY

Highlights from the Collection: Selected Paintings, Sculpture, Photographs and Decorative Art. Atlanta, Ga., 1994.

Rice, Bradley R., ed. *Atlanta History: A Journal of Georgia and the South*. Atlanta, Ga., 1994.

LYNNE E. SPRIGGS

HIRSHFIELD, MORRIS (1872–1946) produced rhythmically patterned paintings of women, animals, and biblical subjects that have earned him a place among the best of the self-taught artists of the twentieth century. Characteristic of his style were bold forms, bright colors, and fabric-like textures painted in a flattened style. His stylized figures have tiny hands and feet, and often appear frontally and in profile simultaneously.

Hirshfield was one of the first self-taught artists of the twentieth century to gain recognition. His paintings were included in the exhibition "Contemporary Unknown American Painters" in 1939, organized for the Museum of Modern Art (MoMA) by the collector Sydney Janis (1896–1989). Janis also organized a one-person exhibition of Hirshfield's work at MoMA in 1943. The Hirshfield exhibition brought a torrent of negative criticism from the press. Emily Genauer of *World Telegram* wrote that Hirshfield was "an apparently gentle soul with deeply felt artistic aspirations, but with little gift for expressing them." The publicity inflamed MoMA trustee Stephen Clark, and contributed to the dismissal of Alfred H. Barr Jr., MoMA's director, who supported the exhibition. Since then, Hirshfield paintings have been included in virtually every important exhibition and publication featuring twentieth century selftaught artists, and several of his paintings are now part of the permanent collection of the Museum of Modern Art. How different from Genauer's was the assessment of critic Carter Ratcliffe, who wrote in 1998 that Hirshfield ". . . transformed a set of pictorial clichés . . . into an image that looks fresh nearly six decades after it was painted The ordinary became extraordinary."

Demonstrating artistic talent as a boy, Hirshfield carved a "grogger," or noisemaker, for his synagogue's Purim celebration when he was twelve, and an approximately 6 foot high, gilded wooden prayer stand, which featured rampant lions and other figures in bold relief, two years later. Hirshfield began painting as a hobby following his retirement in 1937. He painted for hours every day, taking finished works to a curator at the Brooklyn Museum to be evaluated.

Born in Lithuania to a German mother and a Russian-Polish father, Hirshfield immigrated to America with his family at the age of eighteen. He worked in the garment trade, starting his own company with his brother. They began as cloak and suit manufacturers, calling the company Hirshfield Brothers, and then following the artist's marriage they started the EZ Walk Manufacturing Company, which became New York City's largest manufacturer of bedroom slippers.

Hirshfield applied the techniques he knew from garment and slipper manufacturing to his art. Just as he had grown accustomed to preparing patterns for clothing to be assembled after cutting, he prepared full-scale drawings for his paintings, sketching outlines of the major forms before he began to paint. Hirshfield's affinity for textiles, as noted by Carter Ratcliffe, is evident in the prominence of draperies in his paintings, which also include ornate and striped upholstery, embroidered and printed clothing, and rugs.

Hirshfield always thought of himself as an artist and consciously aspired for recognition as one. In the self-portrait *The Artist and His Model*, painted only months before his death, a mustachioed artist, palette in one hand and brushes in the other, portrays his fantasy: an artist painting a nude model.

The female figure, often idealized, dominates Hirshfield's subjects. The artist painted nudes as well as stylishly clothed women, often surrounded by patterned draperies in stage-like contexts; curved drapery pleats accentuate the natural female contours in paintings such as *Nude with Cupids*. Hirshfield also painted a number of animals (tigers, lions, zebras, elephants, cats, dogs, and birds) that appear in lush landscapes filled with ferns and flowering shrubs. In Hirshfield's paintings, the strong use of pattern-on-pattern with tiny stippled areas rhythmically activate his stylized forms, and add a shimmering glow that accentuates the brighter illumination in areas without patterning. Patriotism and references to Jewish ritual and ceremony are themes also found in Hirshfield's paintings.

See also **Alfred H. Barr Jr.; Sidney Janis; Jewish Folk Art; Abraham Levin; Painting, American Folk.**

BIBLIOGRAPHY

Bihalji-Merin, Oto, and Nebojša-Bato Tomašević. *World Encyclopedia of Naive Art.* Secaucus, N.J., 1984.

Hemphill, Herbert W. Jr., and Julia Weissman. *Twentieth-Century American Folk Art and Artists.* New York, 1974.

Janis, Sidney. *They Taught Themselves: American Primitive Painters of the Twentieth Century.* New York, 1942.

Lipman, Jean, and Tom Armstrong, eds. *American Folk Painters of Three Centuries.* New York, 1980.

Longhauser, Elsa, et al. *Self-Taught Artists of the Twentieth Century: An American Anthology.* San Francisco, 1998.

Saroyan, William. *Morris Hirshfield.* Parma, Italy, 1975.

LEE KOGAN

HISPANIC AMERICAN FOLK ART: *SEE* BULTOS; NICHOLAS HERRERA; PRISON ART; RETABLOS; SANTEROS; SCULPTURE, FOLK.

HMONG ARTS, best exemplified by the traditional textile art *paj ntaub* (pronounced *pa ndao*), with a history that spans millennia, are practiced by Hmong women exiled from the highlands of Laos, and are sold to supplement their families' incomes. Ancient Chinese chronicles tell legends about the Hmong, an independent people known for their resistance to Chinese assimilation policies. Many Hmong fled China in the 1800s, seeking autonomy in the highlands of Vietnam and Laos. They settled in the highest elevations, practiced swidden agriculture, and lived in small mountaintop communities.

Traditions of personal adornment and gift exchange characterize *paj ntaub's* role in Hmong culture. In the multicultural highlands of Southeast Asia, *paj ntaub*-decorated clothing distinguishes the Hmong from neighboring ethnic peoples. Translated literally as "flower cloth," *paj ntaub* is used to decorate the festive and daily dress of both sexes. Regional subgroups named themselves according to traditions of dress; for example, the Green Hmong use batik techniques to decorate their skirts and dye them with indigo, whereas White Hmong leave their pleated skirts undyed.

Paj ntaub helps to mediate relationships within Hmong communities. Mothers give daughters wedding gifts of *paj ntaub*-decorated sashes and aprons. In return, married daughters provide their parents with funeral clothes, and the designs sewn onto funeral pillows are meant to restore the dead to their ancestors. The exchange of *paj ntaub* enacts the continuity of family, of community, and of what it means to be Hmong.

Hmong subgroups practice different needlework techniques. All utilize embroidery, particularly cross, chain, and satin stitches. Most Hmong groups also practice different techniques of appliqué, in which layers of cloth strips form and accent design. Green Hmong women work in batik, and White Hmong women practice reverse appliqué, in which the background fabric and an appliqué layer together form the total design. *Paj ntaub* artists manipulate complex geometric structures to form intricate designs on a two-dimensional fabric plane. Women who invent new designs or creatively adapt old ones gain reputations as skilled *paj ntaub* makers. *Paj ntaub* is an exacting art that demands a high level of sewing skill and geometric analysis. Esteemed makers execute up to eighty stitches an inch.

War and displacement added a new value to *paj ntaub*, as it became a moneymaker. Decades of peace in the Laotian highlands gave way to warfare in the 1950s. Most Laotian Hmong defended the Lao monarchy against the Vietnamese-backed Pathet Lao. When the military struggles escalated with American involvement in the 1960s and 1970s, the strategic position of the Hmong proved invaluable. Covert CIA officers trained and armed Hmong soldiers and pilots. The North Vietnamese-backed Pathet Lao gained full control of the government in 1975. In the face of harsh persecution, more than 100,000 Hmong fled the country to find sanctuary in Thailand's refugee camps. Most of the exiled Hmong have since resettled in Western countries, with the majority now residing in the United States.

Hmong women in refugee camps turned to their traditional skills as needleworkers to develop products that they could sell to camp visitors, brokers from tourist shops, and ethnic-art dealers. Women adapted traditional designs to forms that would appeal to outsiders, from wall hangings to baby bibs. The traditional techniques of *paj ntaub* all served as tools to render age-old designs into modern accessories.

The refugee camps proved to be fertile ground for the flowering of *paj ntaub*. Not only did makers excel at innovative adaptations of tradition, but they also invented a new form of *paj ntaub* that they called story cloths. Radically departing from traditions of geometric design principles, story cloths used representational art, often punctuated by English captions, to tell about Hmong life, and to communicate Hmong history and daily life to outsiders. The story cloths told tales about growing rice, hunting tigers, celebrating weddings, and healing spiritual maladies. They detailed the horrors of the war and the desperate flight to Thailand. Refugee camp life also provided an environment

for the deepening of traditional *paj ntaub* artistry. Selling to the increasingly affluent market of resettled Hmong, *paj ntaub* artists took their handiwork to new heights of geometric precision and technological perfection as they made outfits for young women to wear at annual New Year celebrations.

Many Hmong women continue to sew *paj ntaub* in the United States. Its commercial popularity peaked in the late 1980s, yet numerous artists continue to sew for their families, for other Hmong, and for customers encountered at craft fairs, art shows, and even farmers' markets. Several Hmong artists have been featured in various folk art exhibitions across the country. In 1988, Yang Fang Nhu was the first Hmong woman to be granted an American Heritage Award from the National Endowment for the Arts.

The difficulty of realizing a profit from the sale of this labor-intensive art form discourages many American Hmong from making the attempt, particularly when better-paying jobs are available. Most young women choose to focus on careers and family rather than learn the tedious needlework skills. Yet *paj ntaub* artistry remains an important part of American Hmong festive and ceremonial life. Currently, American Hmong have become primarily consumers rather than producers of flower cloth. The creative trends in *paj ntaub* have shifted to Hmong communities in China, who supply the world's Hmong diaspora with fashionable New Year finery. The legacy of superior skill and sophisticated design that characterizes Hmong *paj ntaub* remains a cultural asset acknowledged by American Hmong. The aesthetic principles underlying this art form may well resurface through new art forms or even through a form of revitalization.

See also **Asian American Folk Art; NEA American Heritage Awards.**

BIBLIOGRAPHY

Cubbs, Joanne, ed. *Hmong Art: Tradition and Change.* Sheboygan, Wisc., 1986.

Dewhurst, Kurt C., and Marsha MacDowell. *Michigan Hmong Arts.* East Lansing, Mich., 1983.

Peterson, Sally. "Translating Experience and the Reading of a Story Cloth." *Journal of American Folklore* 101 (1988): 6–22.

SALLY PETERSON

HOFMANN, CHARLES C.: *SEE* ALMSHOUSE PAINTERS.

HOLIDAYS in the United States have generated a vast array of objects and collectibles, from blown-glass Christmas ornaments to hand-carved Halloween noisemakers, which form an integral part of the American folk art tradition, while the public enthusiasm (or lack thereof) for a given observance reflects profound changes in our society. Christmas and Halloween, two of the most popular holidays, have spawned myriad folk art objects; New Year's and Thanksgiving Day items, however, are disproportionately few relative to the importance of the dates.

The vast array of Christmas items specifically is dealt with in another entry, Christmas decorations, in this encyclopedia. Halloween items exist in numerous forms, often handmade from wood, metal, plaster of Paris, or pulped paper. Lanterns, candy containers, party favors, and simple musical instruments were all made in Germany, Japan, and the United States between 1900 and 1950. Most were designed to be used at the two great Halloween events: the party as well as the traditional "trick or treat" evening. Yet the forms of devils, witches, black cats, skeletons, and sinister pumpkin heads hark back to the origin of the holiday in the pagan rituals of Samhain, or the Day of the Dead.

Thanksgiving, too, is much older than its legendary advent in the Massachusetts Colony, being founded on the ancient European Ingathering festival, a day of feasting and rejoicing at the conclusion of the fall harvest season. Because the meal is the heart of this event, the relatively few examples of folk art relate to the table. Papier-mâché or plaster of Paris candy containers and party favors in the shape of turkeys, Pilgrims, and Native Americans adorned the groaning board, while visitors wore period costumes. Like early Halloween costumes, this clothing is now difficult to find.

Despite its great importance as a social event, New Year celebrations have produced few examples of folk art. Most readily acquired are the painted tin and wood noisemakers, rattles, horns, and clackers used to usher in the nascent year. Party favors usually take the form of champagne bottles, though one may occasionally encounter napkins and tablecloths made at the turn of the last century and carefully embroidered with New Year's greetings.

Easter, a joyous day more or less combining and coinciding with Christian and Jewish commemorations as well as ancient pagan spring rites, has become primarily a children's holiday, and has spawned a variety of interesting objects. Though fragile, the paint-decorated Easter egg is a true piece of folk art. The tradition of blowing out the contents of an egg and then covering its surface with geometric or pictorial patterns came to this country from central Europe, and continues to be practiced here.

Candy is, of course, central to nearly every child's Easter experience; German-made papier-mâché and plaster of Paris candy containers from the 1920s and 1930s are much sought after. Typically they take the form of the ubiquitous Easter rabbit or an egg, but there are some interesting variations, including the cartoon characters Baby Snookums, Foxy Grandpa, and the Campbell Soup Kid, whose cherubic countenance enticed thousands of children to gobble down their otherwise unappetizing tomato soup.

Valentine's Day, based on the Roman fertility festival of Lupercalia, is known for an amazing variety of greeting cards designed to express love and affection. Made primarily in Germany, England, and the United States from the 1850s into the 1930s, these lithographed cardboard missives could be remarkably complex, and some included pop-up features, mirrored glass, exotic feathers, and even precious metals. Hand-assembled and often one of a kind, they are now highly desirable.

With the exception of the Fourth of July, patriotic holidays, once extremely important, are largely ignored, or, like the Washington-Lincoln birthday event, combined for the convenience of vacationers. It was once common to observe presidential birthdays with celebratory dinners and an exchange of memorial postcards. Candy containers and party favors in the form of Washington or Lincoln figures, or the famous log cabin, ax, and cherry tree stump would adorn the festive board.

There are also firecracker-shaped Fourth of July favors, but the most interesting folk art from this holiday—the fireworks—are traditionally displayed in the celebration. Collectors have begun to accumulate the charming paper labels that have adorned firecracker packages.

Less universal holidays also produced interesting folk art objects. From the Jewish Festival of Lights, Hanukkah, comes the painted wooden top, or dreidel; from Columbus Day, postcards and party favors; from May Day celebrations, painted cardboard and flower baskets; and from St. Patrick's Day, candy containers and party favors focusing on the leprechaun, his pipe, and the shamrock.

See also **Asian American Folk Art; Christmas Decorations; Eastern European American Folk Art; Fraktur; German American Folk Art; Jewish Folk Art; Native American Folk Art; Papercutting; Pennsylvania German Folk Art; Religious Folk Art; Santería.**

BIBLIOGRAPHY
Ketchum, William C. *Holiday Ornaments and Antiques.* New York, 1990.
Schiffer, Margaret. *Holidays: Toys and Decorations.* West Chester, Pa., 1985.

WILLIAM C. KETCHUM

HOLLEY, LONNIE (1950–) is a polymath creator of artworks in many media, including found-object assemblages, carvings in wood and sandstone, and paintings. The seventh of twenty-seven children, his younger years, spent in a succession of foster homes and reformatories, were crushingly sad. As a teenager, he often flirted with crime, and ended up in Florida as a short-order cook at Disney World. In 1979, after relocating to his native Birmingham, Alabama, he became distraught over the death of his sister's two daughters in a fire, and made his first artwork: small, carved, ceremonial tombstones. He moved into a house on land (unofficially a garbage dump) first cleared by his grandfather two generations earlier. Holley was soon making grave markers for area children as well as pets, from which evolved more elaborate carvings made of a sandstone-like slag, which is a by-product of castings from local foundries.

Holley also began creating commemorative, accumulative sculptures from other types of debris and cast-off consumer goods, which for conceptual reasons he situated in his yard amid the same piles of fallow scrap that had given birth to the artworks. He dubbed his hillside display Holleywood, and devoted it to laying bare each of the world's problems along with the illusions that mask them. This "yard show" grew rapidly in the 1980s to include more than two acres and thousands of artworks in many media, addressing themes of personal history, family, and community, as well as a host of metaphysical concerns. Many of the works linked the most local of neighborhood ills, such as the dissolution of families and interpersonal abuses, to broader societal and global issues, such as ecological trauma and the expendability of human life.

During its heyday in the early 1990s, Holley's yard, filled with artworks up to twenty feet tall and incorporating environmental features, including his own home, the surrounding forest, and the old garbage dump, was at the time one of the most ambitious projects in American art. His property, however, lay in the path of Birmingham airport's planned expansion. The collision between Holley and local authorities became increasingly vituperative during the mid-

1990s, when his art and site were also repeatedly vandalized. He finally settled out of court with the planners in 1997, and relocated to nearby Harpersville. Holley was forced to dismantle the original yard, and as a result much of his work was lost. He continues to produce paintings and sculpture, as well as site-specific works on the Harpersville property.

See also **African American Folk Art (Vernacular Art); Environments, Folk; Painting, American Folk; Sculpture, Folk; Yard Show.**

BIBLIOGRAPHY

Arnett, William, and Paul Arnett, eds. *Souls Grown Deep: African American Vernacular Art of the South*, vol. 2. Atlanta, Ga., 2001.

Longhauser, Elsa, and Harald Szeemann. *Self-Taught Artists of the Twentieth Century: An American Anthology*. New York, 1998.

Spriggs, Lynne, Joanne Cubbs, Lynda Roscoe Hartigan, and Susan Mitchell Crawley. *Let It Shine: Self-Taught Art from the T. Marshall Hahn Collection*. Atlanta, Ga., 2001.

PAUL ARNETT

HOLMES, LOTHROP T. (1824–1899), a carver of wildfowl decoys, has been celebrated as the "most sophisticated carver of [the] nineteenth century" by decoy specialist Adele Earnest (1901–1993), and as demonstrating "superb examples of the finest in decoy craftsmanship" by William F. Mackey Jr., a pioneer scholar in the field. Holmes resided in Kingston, Massachusetts, a village in Plymouth Harbor, and is best known for his red-breasted merganser decoys. Earnest extols the "sensitive modeling and brushwork of these birds [which] resembles the exquisite rendering of waterfowl on Chinese scrolls and china." Mergansers, also known as Sheldrakes, have notoriously rank and unpalatable meat and were not hunted as food, but rather for their feathers and beauty.

Biographical material at the Kingston, Massachusetts, public library identifies the carver's parents as Martin Holmes and Mary Turner Johnson Holmes, and his wife as Elizabeth Howland Washburn. Holmes worked as a molten-iron pourer at a Kingston foundry, as well as a "molder" at factories in neighboring Rhode Island. He was superintendent of the Evergreen Cemetery, which abutted his property. He played the banjo and was a carpenter, and was known locally for his decoys. Holmes died at the Westboro Insane Hospital in Worcester County, Massachusetts; the cause of death was senile dementia. His estate included guns, fishing tackle, and carpentry tools. A shooting box and carpentry tools were purchased at his 1899 estate sale by a Kingston neighbor. A ruddy turnstone carved by Holmes was sold for

$470,000 at auction in 2000, and a pair of mergansers for $394,500 at auction in 2003.

See also **Adele Earnest; Decoys, Wildfowl; Sculpture, Folk.**

BIBLIOGRAPHY

Earnest, Adele. *Folk Art in America: A Personal View*. Exton, Pa., 1984.

———. *The Art of the Decoy*. New York, 1965.

Mackey, William F. Jr. *American Bird Decoys*. New York, 1965.

WILLIAM F. BROOKS JR.

HONEYWELL, MARTHA ANN (1787–after 1847), a native of Lempster, New Hampshire, was known for her profile silhouettes, needlework, penmanship, and paper cutouts. While her silhouettes are not remarkable in themselves, all her artwork is remarkable because of her physical limitations. Honeywell was born without hands or forearms, and one foot had only three toes; she created art using her mouth and toes. A description of her working process cited by Alice Carrick was drawn from an eyewitness account by a diarist, William Bentley, on January 27, 1809. Bentley wrote that he had seen evidence of Miss Honeywell's talents. During a single "performance," she threaded a needle and embroidered using her toes and mouth, made fancy paper cutouts by balancing a pair of scissors with her mouth and arm stump, and wrote a letter with her toes.

As noted above, Honeywell executed and sold silhouettes. Another of her specialties was a cutout with a handwritten version of "The Lord's Prayer" on a dime-size central panel. She also made and sold flowers and landscapes. Honeywell signed her silhouettes "Cut by M Honeywell with the mouth" or "Cut without hands by M.A. Honeywell"; one of her profiles bears the signature "Cut with the lips." She also signed her other cut paper works.

Many of Honeywell's public appearances in the United States are documented in newspaper advertisements and broadsides. She would perform three times a day, with each performance lasting two hours; tickets cost fifty cents. She appeared in Salem, Massachusetts, in 1806 and 1809; in Charleston, South Carolina, in 1808 and again in 1834–1835; and in Louisville, Kentucky, in 1839. In the *Columbian Centinel* of June 21, 1806, her performance was described in order to attract interest among Bostonians. A broadside some years later mentioned her well-received European presentations and advertised a

profile likeness cut in a few seconds for twenty-five cents—half price for children.

There are examples of Honeywell's profiles in the collections of the Abby Aldrich Rockefeller Folk Art Center in Williamsburg, Virginia; and in the Essex Institute in Salem, Massachusetts.

BIBLIOGRAPHY

Blumenthal, M. L. "Martha Ann Honeywell Cut-Outs." *The Magazine Antiques* (May 1931): 379

Carrick, Alice Van Leer. *Shades of Our Ancestors.* Boston, 1938.

Groce, George C., and David H. Wallace. *The New-York Historical Society's Dictionary of Artists in America 1564–1860.* New Haven, Conn., and London, 1957.

Rifken, Blume J. *Silhouettes in America, 1790–1840: A Collectors' Guide.* Burlington, Vt., 1987.

Rumford, Beatrix, ed. *American Folk Portraits, Paintings, and Drawings from the Abby Aldrich Rockefeller Folk Art Center.* Boston, 1981.

LEE KOGAN

HOOKED RUGS and mats may well be one of the very few indigenous North American folk arts. Though somewhat similar to fabrics made at earlier periods in other parts of the world, these floor coverings first appeared in New England and eastern Canada during the 1840s (the earliest written reference is an 1838 Maine Charitable Mechanics' Association award for "best hooked rug"). Their ensuing popularity reflected the fact that they provided sturdy and attractive floor coverings that were much needed in colder climates and that could be made with relative ease from inexpensive materials.

In fact, rug hooking is readily learned. Worked on the lap or on a frame, the rug is created by pulling short lengths of yarn or twisted strips of wool or cotton cloth through a coarse backing (usually burlap) on which a pattern has been drawn or printed. The only tool required is a hooklike piece of metal (even a bent nail will do). Varying the fabric color from one section of the design to another creates the image. The loops formed in hooking the material through the backing are drawn tight on the underside of the rug. They may also be drawn tight at the top, or they may be cut off to create a shirred effect.

The earliest rugs were hooked on a coarse linen or canvas backing, and the designs followed were laid out in freehand, sometimes through the repetitive employment of a geometric shape such as a teacup or a brick. The tight weave of the backing material required holes for the fabric to be punched throughout, a time-consuming task. Loosely woven burlap sacking became widely available in the 1850s, and soon after the Civil War manufacturers began to produce

lengths of this fabric on which rug designs were already imprinted. Edward Sands Frost (active 1868–1900) of Biddeford, Maine, is regarded as the first of these merchant innovators, though the existence of earlier dated rug patterns indicates that he had competitors in the field. Also, the availability of commercial dyes obviated the need for people to make their own coloring agents from natural materials such as berries and bark.

Hooked-rug designs fall into three broad categories: florals, geometrics, and pictorials, with the latter the most popular among contemporary collectors. Floral patterns appear to have been the earliest, with room-size rugs being based on early European floor coverings, such as Aubusson and Savonnaire carpets. In the 1920s these were supplanted by designs taken from Navajo rugs and Near Eastern textiles. Early-twentieth-century collectors held these patterns in high regard, but today they are less favored.

Geometric designs lent themselves to unassisted creation at home, but were also often copied from quilt patterns appearing in such women's magazines as *Godey's Lady's Book.* Familiar quilt forms such as the Log Cabin, Broken Dishes, and the Maltese Cross appeared throughout the late nineteenth and early twentieth centuries, and underwent a collector renaissance in the 1960s, when many regarded them as related to popular Op Art. It was also at this time that smaller rugs and mats were removed from the floor, framed, and hung on the wall in homes and galleries.

Most popular today are pictorial rugs, which are found in a wide range of designs. The earliest and often most charming were created freehand, and are animated by the same spirit of design seen in folk paintings. Indeed, they are in a sense folk paintings in fabric, with all the idiosyncrasy of a landscape by Anne Mary Robertson Moses who was know as "Grandma Moses." Animals tower over their owners, houses are lost in gigantic gardens amid colors never seen in nature, and a range of cultural icons, from George Washington to Mickey Mouse, play across the textile stage. Small wonder that today pictorial rugs can bring prices ranging in the thousands of dollars.

Not all of these rugs are singular creations. In fact, one of the most sought-after pictorials is a recumbent lion produced from a commercial pattern created by Edward Frost. Even the "standard" patterns are seldom truly standard. Though manufacturers printed suggested colors on the fabric, rug makers seldom felt constrained to follow these hints. Thus the same design of a dog may be found in numerous color combinations.

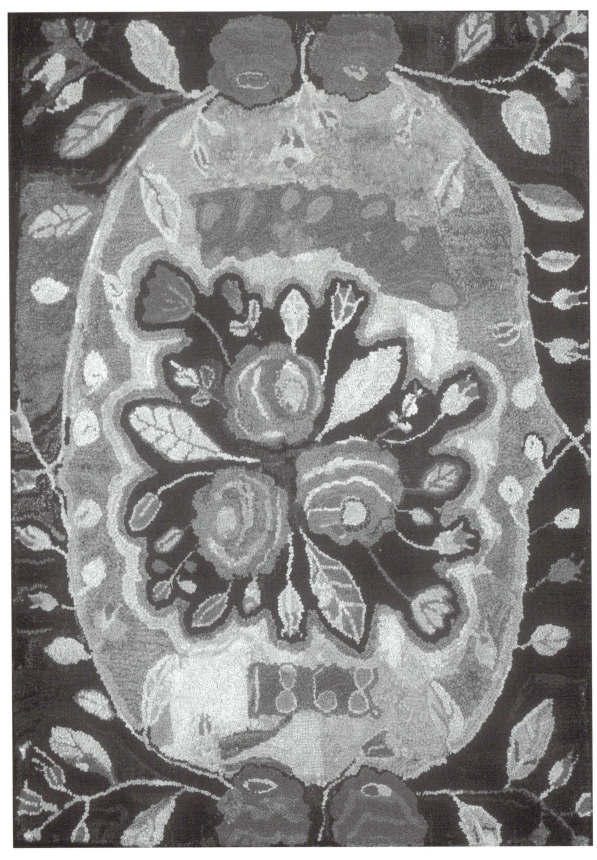

Hooked Rug, Spray of Flowers; Artist unidentified; initialed "M.E.H.N." Probably New England;
1868. Wool on burlap 46 × 32½ inches. Collection American Folk Art Museum, New York.
Gift of Joel and Kate Kopp, 1979.27.1.

There are also important contemporary hooked-rug makers, men and women who have adapted earlier methods to create images that are in essence textile art, and that may rival the best work being done on canvas or paper.

See also **Anna Mary Robertson "Grandma" Moses; Rugs.**

BIBLIOGRAPHY

Ketchum, William C. *Hooked Rugs: A Historical and Collector's Guide.* New York, 1976.

Kopp, Joel, and Kate Kopp. *American Hooked and Sewn Rugs: Folk Art Underfoot.* New York, 1975.

McGown, Pearl K. *The Lore and Lure of Hooked Rugs.* Acton, Mass., 1966.

WILLIAM C. KETCHUM

HOPKINS, MILTON WILLIAM (1789–1844) exemplifies the westward migration of New England portrait painters to western New York State in the wake of the opening of the Erie Canal in 1825, and to the newly settled frontier in Ohio. His stylistic similarities and geographical proximity to the younger portrait painter, Noah North (1809–1880), suggest a mentor-student relationship. Indeed, a portrait of a man, signed and labeled by Hopkins, in the collection of the New York State Historical Association led to the reevaluation of both Hopkins' and North's respective bodies of work.

Hopkins was born in Harwinton, Litchfield County, Connecticut, and moved in 1802 with his family to Pompey Hill, New York. He was married twice, to Abigail Pollard (who died prior to 1817) and Almina Adkins, both from Guilford, Connecticut. Hopkins spent his early painting career traveling around Connecticut in search of portrait commissions, from about 1810 to 1820. His work was probably influenced by Connecticut painters Joseph Steward (1753–1822), Reuben Moulthrop (1763–1814), and Ammi Phillips (1788–1865). In the 1820s Hopkins worked in the Watertown, New York, area, and then in canal towns as far west as Buffalo.

In the late 1830s and early 1840s Hopkins (and North) worked in Genesee and Orleans Counties in western New York, and in Ohio City (Cleveland), Columbus, and Cincinnati, Ohio. Hopkins, a progressive Presbyterian, was active in the temperance, abolition, and anti-Masonic movements, and many of his portrait commissions came from likeminded people. In addition to his oil-on-canvas portraits, Hopkins also offered ornamental painting as well as instruction in art. His frequent practice of showing half-length, seated subjects with one arm draped over a stenciled Hitchcock-type chair hints at his ornamental work. Hopkins' style is also characterized by well-modeled facial features and a muted brown background. Hopkins died of pneumonia in Williamsburg, Ohio, in 1844, his career having provided a link from the Connecticut portrait painters of the eighteenth century to the folk art of the American frontier.

See also **Reuben Moulthrop; Noah North; Painting, American Folk; Ammi Phillips; Joseph Steward.**

BIBLIOGRAPHY

D'Ambrosio, Paul S., and Charlotte Emans. *Folk Art's Many Faces: Portraits in the New York State Historical Association.* Cooperstown, N.Y., 1987.

Oak, Jacquelyn, et al. *Face to Face: M.W. Hopkins and Noah North.* Washington, D.C., 1988.

PAUL S. D'AMBROSIO

HOWARD, JESSE (1885–1983) was born into a large family and grew up on an eighty-acre farm in Shamrock, Missouri. Educated through the sixth grade, he left home at age fourteen to lead a transient life, hopping freight trains around the country and working odd jobs. In 1905 he moved back to Missouri, where he lived and worked on the family farm until he married, in 1916, fathering five children over the next several years. In the early 1940s he bought a house and twenty acres in Fulton, Missouri. He began decorating his property with model airplanes that he made from wood, along with mock tombstones and other constructions. He also began using the premises as a forum to air his religious, political, and philosophical convictions, in the form of prominently posted signs covered to the edges with neatly aligned, hand-lettered texts in black or fiery red letters. This uniquely personal manifestation of textual logorrhea predated conceptual art's heavy reliance on the written word by twenty years.

Some among this polemical yard show's audience of neighbors and random passersby were evidently displeased with Howard's viewpoints, as well as his audacity in placing them outside in full public view. From the late 1940s until the 1970s, *Hell's 20 Acres,* or *Sorehead Hill* (as he alternately called his place) was frequently vandalized, and he was harassed repeatedly for his unconventional means of exercising his freedoms of thought and speech. During a petition campaign in 1952, some of his neighbors attempted unsuccessfully to have the outspoken artist committed to a mental institution. Such attacks angered Howard and lowered his opinion of his fellow human beings, but he was not intimidated, and continued to

publicly express himself without regard to the social consequences.

Eventually, by the 1970s, his handmade signs began to attract more favorable attention, and the inclusion of several of them in "Naives and Visionaries," a 1974 exhibition at the Walker Art Center in Minneapolis, stirred up considerable interest in Howard from art collectors, curators, and scholars. Most of his signs carry religious messages and many of them rant against the federal government, as well as the vandals who repeatedly damaged and destroyed his work. A quintessentially American figure, whose life was literally an open book, Howard aptly described himself in at least one of his works as "*The Man with Signs and Wonders.*"

See also **Environments, Folk; Outsider Art; Religious Folk Art; Yard Show.**

BIBLIOGRAPHY

Foster, John. "Jesse Howard: Missouri's Man of Signs and Wonders." *Envision: The St. Louis Newsletter for Folk, Visionary, and Outsider Art,* vol. 3, no. 2 (July 1998): 1–5.

Marshall, Howard, ed. *Missouri Artist Jesse Howard with a Contemplation on Idiosyncratic Art.* Columbia, Mo., 1983.

Self-Taught Artists of the Twentieth Century: An American Anthology. [exhibit catalogue, published by Chronicle Books] New York, 1998.

TOM PATTERSON

HOWES, SAMUEL P. (1806–1881) lived and worked in Lowell, Massachusetts, from 1835 until his death, painting portraits of residents and visitors in the new industrial city. Howes was born in Plympton, Massachusetts, and may have pursued divinity studies before turning to painting. He worked as a painter in Boston from 1829 to 1835, after he had traveled to Lowell with the intention of staying only a few days. Instead, Howes set up a studio and remained in the town permanently, working in oil on canvas as well as painting miniatures on ivory. His first marriage ended in divorce, and he later married a mill worker, Catherine Bennett, in 1844. In the 1840s Howes added daguerreotype likenesses to his portrait business, and advertised his photographic skills more aggressively than he did his portrait painting. His studio on Merrimack Street, where he also sold pianofortes, was a fixture in the Lowell business community for more than forty years.

In the 1850s and 1860s Howes increasingly turned to historical and patriotic subjects, completing a monumental *Historical Panorama of the American Republic* as well as likenesses of Abraham Lincoln, Ulysses S. Grant, and William T. Sherman. Howes advertised performances of the narrated panorama extensively in the local paper, and included pianoforte music in the presentation.

Howes' style is consistent and easily recognizable. His sitters are often portrayed in half-length, seated poses with stiff, upright postures, triangular sloping shoulders with long, attenuated arms, and a draped hand. Facial features exhibit an awkward turn of the nose, with the far nostril drooping downwards, as well as an upward arch to the eyelids along with vertically elongated irises. The artist continued to paint portraits until at least 1879, at times basing his compositions on photographs. Howes died of peritonitis in Lowell in 1881.

See also **Miniatures; Painting, American Folk; Photography, Vernacular.**

BIBLIOGRAPHY

D'Ambrosio, Paul S. *Samuel P. Howes: Portrait Painter.* Lowell, Mass., 1986.

D'Ambrosio, Paul S., and Charlotte Emans. *Folk Art's Many Faces: Portraits in the New York State Historical Association.* Cooperstown, N.Y., 1987.

PAUL S. D'AMBROSIO

HUDSON, IRA (1876–1949) of Chincoteague, Virginia, was a full-time boat builder and wildfowl decoy carver who carved decoys of all species in many different styles. His early customers were the market hunters who kept the wild-game markets in New York and Philadelphia well stocked with ducks, geese, rails, and other wildfowl delicacies. Hudson also handcrafted gunning skiffs, locally called bateau, as well as sailboats and yachts. His clientele were often local "sports" or wealthy sportsmen, who came to Chincoteague Island for its incredible hunting and fishing. Ira and his wife, Eva, had twelve children. As adults, his sons Norman and Delbert were also recognized decoy carvers.

By 1900, Hudson was an established carver and his output was prolific for the next forty years. His decoys ranged from the very plain to the more ornate. As examples of Hudson's stylistic varieties, decoy historian Henry A. Fleckinger Jr. cited Ira Hudson black duck decoys in nine distinct models. Hudson used both feather and scratch painting, and his decoy bodies were both rounded and flat-bottomed. The weighting materials he used ranged from lead pad to bolts and hinges. His earlier carvings are primarily made of white pine taken from the spars of wrecked ships found on the island. Later, he used the cypress

wood of telephone poles discarded by workmen as they extended telephone and power lines along the Delmarva Peninsula in Virginia. He also carved pine, cottonwood, and balsa. He commonly used iron or copper upholstery tacks for eyes. A unique characteristic of many Hudson decoys is his "banjo" tail. While thousands of his duck decoys are extant, fewer of the Hudson shorebirds survive. He usually carved shorebirds posed in alert positions, with long, thin necks and fragile bills, easily breakable and quick to be discarded. Ira Hudson took up decorative carving later in his career, but is best known as an accomplished commercial decoy carver.

See also **Decoys, Wildfowl; Adele Earnest; Sculpture, Folk.**

BIBLIOGRAPHY

Earnest, Adele. *The Art of the Decoy.* New York, 1965.

Fleckenstein, Henry A. Jr. *Southern Decoys of Virginia and the Carolinas.* Exton, Pa., 1983.

Mackey, William F. Jr. *American Bird Decoys.* New York, 1965.

WILLIAM F. BROOKS JR.

HUGE, JURGAN FREDERICK (1809–1878), born in Hamburg, Germany, was a painter of Long Island Sound steam and sailing craft for about forty years. He left his native land at an early age and spent the rest of his life adapting to, and adopting, his new homeland. As he shed his European name (Jurgen Friedrich Huge), he also rejected the artistic conventions of the Old World and developed a distinctly American style.

In nineteenth-century America, steam propulsion was the icon of a new era. The United States, a country that still looked seaward for its commerce, was fixated on new, fast, and luxurious steamboats; Huge found his niche in the depiction of the coastal craft that plied Long Island Sound. By 1830 he had married and settled in Bridgeport, Connecticut, where he established himself as a grocer. Beginning with a rash of remarkable drawings in 1838, Huge produced watercolor paintings of both steam and sailing craft over the next forty years. These homages to the new technology were interspersed with a smaller number of town views, probably courtesy depictions of the homes of his prosperous neighbors and customers.

With flags boldly flying and smoke billowing from their stacks, Huge's steamboats plow through the waters at flank speed. And no mere pond water is this, either. His waves are staccato repetitions that almost appear as a corrugated surface, reflecting light and shadow. The boats themselves are drawn in

broadside profile, creating a recognizable silhouette while avoiding the problems of a perspective view. Huge left no detail to the imagination. He delineated his vessels in rich detail, was meticulous in his depiction of both hull and rigging, and peopled them with the full panoply of appropriately garbed sailors and passengers. It is apparent that these pictures were, as the inscription often states, "drawn and painted." In their basic approach, they owe allegiance to the work of the naval architect, but the rich embellishment is strictly attributable to the artistic impulse.

Fewer than fifty watercolors by Huge are known to have survived, but they are an astounding body of work. Among the earliest is his watercolor *Bunkerhill,* executed in 1838. This boldly stylized steamboat, labeled in a somewhat Germanic font, is a true landmark in the genre of American marine painting. It stands as remarkable testimony to the Americanization of this émigré "grocer and artist."

See also **Maritime Folk Art; Painting, American Folk.**

BIBLIOGRAPHY

Hall, Elton W. *American Maritime Prints.* New Bedford, Mass., 1985.

Lipman, Jean. *Rediscovery: Jurgan Frederick Huge.* New York, 1973.

JOHN O. SANDS

HUNGARIAN AMERICAN FOLK ART: *SEE* EASTERN EUROPEAN AMERICAN FOLK ART.

HUNTER, CLEMENTINE (1886–1988) drew upon her experiences living and working as a field hand at the Hidden Hill plantation near Cloutierville, Louisiana, and working as a cook at the Melrose Plantation in Natchitoches Parish, Louisiana, to produce thousands of paintings that recorded daily plantation life. A mecca for artists, Melrose was an ideal place to stoke Hunter's desire to "mark a picture."

Born Clementine Reuben in 1886 at the Hidden Hill plantation, this African American artist witnessed in her lifetime the gradual dissolution of the plantation system. The oldest of seven children, she gave birth to seven children, as did her mother, Antoinette Adams. After Hunter's husband, Charles Dupre, died in 1914, she married Emmanuel Hunter, a woodchopper at Melrose, in 1924. Hunter picked cotton and pecans to help provide for her family, and she took in washing and ironing from Melrose when Emmanuel was diagnosed with cancer in the 1940s. A creative person, she sewed clothing, made dolls, wove bas-

kets, and created functional pieced-cotton quilts for her family in the spare time she could find.

Hunter began painting using the discarded paint tubes of the artist Alberta Kinsey, a guest of Cammie Henry's, the owner of Melrose. Encouraged by the landscape artist and historian François Mignon, Hunter began to paint people working on the plantation; she also planted cotton; harvested gourds, pecans, and sugarcane; made syrup; and washed clothes. She portrayed women doing kitchen chores, paring apples, and caring for children. She painted people in lighter moments: dancing, playing cards, and socializing Saturday nights at the local honkytonk. Religion was an important part of Hunter's life as well as that of the community, so she painted people going to church and participating in baptisms, weddings, and funerals. Crucifixions and Nativity scenes were also among the subjects she painted. The artist loved flowers, particularly zinnias, and often painted them displayed in large pots. To encourage her to experiment, her friend, teacher and writer James Register, commissioned Hunter to create a number of abstract works. Register realized, however, that Hunter preferred to follow her own muse and make representational works.

Using oil paint and gouache, Hunter painted in a flat style, close to the picture plane, or the imaginary window that separates the viewer from the image, using pure, bright colors. Linear layering (the placing of shapes above or on top of other shapes) was substituted for shading and naturalistic perspective. Hunter painted mostly on cardboard, occasionally on canvas, and on other materials as diverse as window shades, lampshades, spittoons, and bottles.

This prolific painter produced several thousand paintings, most about twenty by thirty inches in size, but among her masterpieces were also room-size murals. Melrose's *Africa House Mural,* painted by Hunter, documents the diverse activities of plantation life. Among the mural's vignettes is a self-portrait of the artist, seated in a chair and painting in front of an easel. Hunter also created several hand-sewn, appliquéd, and pictorial quilts with scenes of life at Melrose. The different signature initials she used during her life aid in dating many of her works.

Hunter was motivated enough to make art until the last few months of her life, when she became too ill to continue working. She said, "God gave me the power. Sometimes I try to quit paintin'. I can't. I can't." She also acknowledged that "paintin' is a lot harder than picking cotton. Cotton's right there for you to pull off the stalk, but to paint you got to sweat yo' mind." She thought of her art as "a gift from the Lord." Hunter's achievement went beyond simply providing pleasure for viewers. Her portrayals of Southern plantation life, recorded over more than half a century, are important documents, as important as letters or diaries, from a significant era in American history.

Hunter received a measure of artistic recognition during her lifetime. She was awarded an honorary doctorate from Northwestern University in 1986, and her work is represented in the permanent collections of many American museums and has been seen in exhibitions throughout the United States.

See also **African American Folk Art (Vernacular Art); Painting, American Folk; Quilts; Religious Folk Art.**

BIBLIOGRAPHY

Gilley, Shelby R. *Painting by Heart: The Life and Art of Clementine Hunter.* Baton Rouge, La., 2000.

Kogan, Lee. "Unconventional Eloquence: The Art of Clementine Hunter." *African American Folklife in Louisiana,* vol. 17 (1993): 17–23.

Sellen, Betty-Carol, and Cynthia Johanson. *Twentieth-Century American Folk, Self Taught, and Outsider Art.* New York, 1993.

Wilson, James L. *Clementine Hunter.* Gretna, La., 1988.

LEE KOGAN

HUSSEY, BILLY RAY (1955–) has spent most of his life in his birthplace, the small town of Robbins, in Moore County, North Carolina, a longtime center of traditional pottery production. Raised largely by his maternal grandparents, he was exposed at a young age to the potter's craft through his great-uncle M.L. Owens, who operated a pottery business founded by Hussey's great-grandfather, J.H. Owens. Between the ages of six and eighteen, Hussey lived across the road from the Owens Pottery and in close proximity to the famous Jugtown Pottery operation. From the time he was ten he performed a variety of chores for both businesses, and closely observed the processes by which their utilitarian earthenware pieces were formed, glazed, and fired.

Hussey's first creative efforts were horror movie-inspired "face jugs," which he made in the late 1970s for the Owens Pottery, and these were soon followed by a variety of animal figurines that he sculpted. In 1982, after several years of employment as a carpenter and as a furniture-factory worker, he was hired to make utilitarian pieces on a full-time basis for Owens Pottery, and shortly thereafter he began doing part-time carpentry and repair work at nearby Jugtown Pottery.

The 1980s were years of increasing experimentation for Hussey. He began developing a richly varied repertoire of figural forms that set him sharply apart from his fellow Moore County potters, and trying his hand at several different glazing techniques. In 1986 he finished building his first wood-fueled "groundhog" kiln, from which his first successfully fired load of fifty lead-glazed pieces was purchased in its entirety by the Smithsonian Institution's folklife office. Two years later he left the Owens and Jugtown Potteries to begin operating his own shop, and by the early 1990s he had built a second groundhog kiln reserved for firing salt-glazed pieces.

Unlike his more traditional counterparts among Southern potters, Hussey has extensively studied the international history of the ceramic arts, and his works are generally far more sophisticated than those of his many potter neighbors are. In a major departure from local tradition, some of his sculptural pieces deal with personal, religious, and social themes. In addition to his creative activities, Hussey has served since the late 1980s as president of the Southern Folk Pottery Collectors' Society, which auctions older pieces to collectors and serves as a clearinghouse for information on potters and their wares.

See also **Jugs, Face; Pottery, Folk.**

BIBLIOGRAPHY

Billy Ray Hussey: North Carolina Visionary Potter. Charlotte, N.C., 1997.

Gordon, Ellin, Barbara R. Luck, and Tom Patterson. *Flying Free: Twentieth-Century Self-Taught Art from the Collection of Ellin and Baron Gordon.* Williamsburg, Va., 1998.

TOM PATTERSON

HUTSON, CHARLES WOODWARD (1840–1936) had a multifaceted career as a soldier, lawyer, professor, author, and writer before beginning, upon retirement, a new thirty-year career, at age sixty-five, making art. As a Southern gentleman of gentry and an erudite scholar, his art, while without formal art training, was sophisticated, and reflected his love of nature and knowledge of literature, poetry, mythology, and history.

Born of patrician heritage in McPhersonville, South Carolina, Hutson enjoyed literature at an early age, reading Homer, Virgil, William Shakespeare, and Sir Walter Scott. After he fought for his beloved South in the American Civil War, he followed his father's footsteps and studied law, but was admitted to the state bar only to find that practicing law was an unprofitable venture in the war-torn and destitute South. Following his studies of German, French, Italian, and Spanish, he began a lifetime career teaching Greek, metaphysics, moral philosophy, history, and modern languages at a variety of private schools, colleges, and universities throughout the South.

Hutson moved his family to New Orleans at the conclusion of his teaching career and began making, at the urging of one of his children, pastel drawings, *en plein air,* of the southern Louisiana landscape, the Mississippi Gulf Coast, and, occasionally, reminiscences of the countryside of states where he had resided and taught. He had an uncanny facility to abstract nature without compromising the reality of its elements and atmosphere. Later, he worked in the mediums of watercolor and oil, painting almost every day until his death in New Orleans on May 27, 1936. Begun in 1923, the oils incorporated Hutson's vast knowledge of obscure subjects with mythological and literary references, often mischievously testing his viewer's understanding of the baffling imagery.

Hutson's artistic career attracted the attention of the art world, the press, and the public. His artwork was first shown publicly in 1917, at the Society of Independent Artists in New York, and again in 1925. His first one-person museum exhibition was held in 1931 at the Isaac Delgado Museum of Art in New Orleans, where 47 oils were presented. Two other posthumous, solo exhibitions of Hutson's work at the Delgado Museum were staged in 1948 and 1965; the latter was a full retrospective.

See also **Painting, American Folk; Painting, Landscape.**

BIBLIOGRAPHY

Fagaly, William A. "The Gifted Amateur: The Art and Life of Charles Woodward Hutson." *Folk Art,* vol. 22, no. 3 (fall 1997): 50–57.

Janis, Sidney. *They Taught Themselves.* New York, 1942.

Toledano, Ben C., and Roulhac Toledano. *Charles W. Hutson, 1840–1936.* New Orleans, La., 1965.

WILLIAM A. FAGALY

HYDE DE NEUVILLE, BARONESS ANNE-MARGUERITE (c. 1749–1849), a Frenchwoman, created some 200 pencil and watercolor sketches of American life. Straightforward, balanced, and aesthetically pleasing, they depict a growing, optimistic new nation; provide early realistic portrayals of Native Americans; and augment the memoirs of her husband, Baron Jean-Guillaume Hyde de Neuville.

The couple first lived in America in 1807–1813, after the baron was implicated in a royalist plot and exiled by Napoleon I; at this time they toured upstate

New York. During their second stay, 1816–1822, the baron was the French ambassador; they bought a farm in New Brunswick, New Jersey, but lived in Baltimore and then Washington, D.C. The baroness (who, according to the writer, Jadviga M. da Costa Nunez, may have had some instruction in drawing) sketched places where she visited or lived. She made elegant drawings of official buildings in Washington, such as *The White House with State, War, and Treasury Buildings* (1820); in *F Street, Washington, D.C.* (1821) she shows domestic architecture, trees, picket fences, and people at work and leisure.

Her work is at the New York Historical Society; Abby Aldrich Rockefeller Folk Art Museum (Williamsburg, Virginia); Hagley Museum (Wilmington, Delaware); and Museum of Fine Arts, Karolik Collection (Boston, Massachusetts). An exhibition, "Baroness Hyde de Neuville: Sketches of America, 1807–1822," was cosponsored by the New York Historical Society and Jane Voorhees Zimmerli Art Museum (1984–1985).

BIBLIOGRAPHY

Fenton, William. "The Hyde de Neuville Portraits of New York Savages in 1807–1808." *New-York Historical Quarterly,* vol. 38, (April 1954): 130.

Nunez, Jadviga M. da Costa, and Ferris Olin. *Baroness Hyde de Neuville: Sketches of America, 1807–1822.* New Brunswick, N.J., 1984.

LEE KOGAN

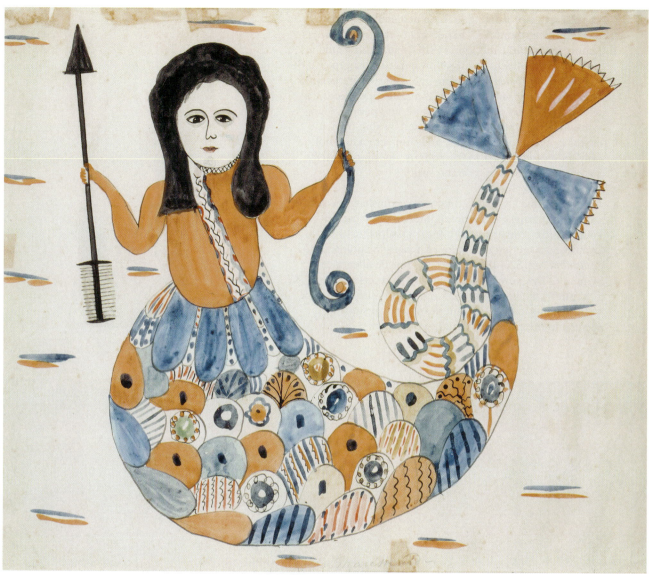

Fenimore Art Museum, Cooperstown, New York. © New York State Historical Association, Cooperstown, New York, N85.61.
Photo courtesy Richard Walker.

One of the most obscure nineteenth-century folk painters was Mary Ann Willson (active 1810–1825) to whom historians have credited a handful of remarkable paintings such as *Marimaid* (c. 1815, *above*). A portfolio of twenty of Willson's watercolors was discovered only in 1943. Little is known of Willson other than that she worked in Greene County, New York, in the first quarter of the nineteenth century. Her paintings are the earliest folk watercolors found to date, with the exception of isolated examples and a contemporary group by Eunice Pinney of Connecticut. Lionel de Lisser wrote an account of Willson's work in 1894, stating that the paintings "*are unique in the extreme, showing great originality in conception, drawing and color . . . The paper used was the wrappings of candles and tea boxes, or something of that sort. The pigments were of home manufacture,*" hand-ground from berries, flowers, and brick-dust. *Marimaid*, ink and watercolor on paper, measures 12¾ × 15½ inches.

PLATE 17

Maritime folk art reflected America's naval might, its independence from Britain, and emergent industrialization. Popular types of painting in the nineteenth century included "ship portraits," a specialty of the twin brothers James (1815–1897) and John (1815–1856) Bard. Paintings such as *North America* (c. 1840, watercolor on paper, 23⅝ × 33⅝ inches, *below*) reflect an age when steamboats began replacing sailing vessels as a faster and more efficient means of transporting goods and people. Ship portraits were typically commissioned by ship owners, captains, agents and builders, and commemorated not only the vessels, but also the patrons, attesting to their success in business and on the seas.

Other maritime art included intricate scrimshaw pieces, carved by whalers and seamen. Incised drawings on sperm whale teeth, skeletal bone, or walrus tusks composed a unique repertoire of images including *Columbia* (c. 1820–1840, *right*), the female allegorical symbol of the New World. Both ship portraits and scrimshaw, while different in origins and purposes, came to be seen as markers of American nationalism and identity in the nineteenth century.

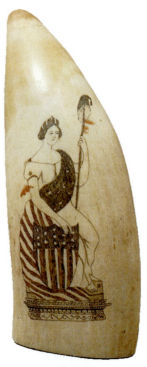

Photo courtesy Andy Clausen.

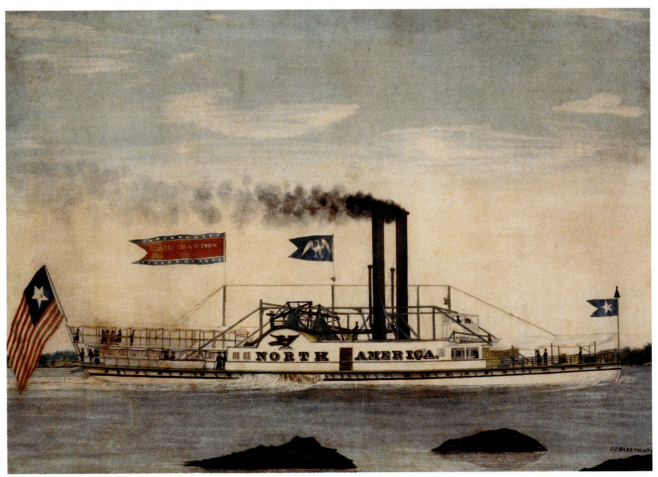

PLATE 18

The desire to document life and legacy in eighteenth- and nineteenth-century America engendered a proliferation of folk art forms such as silhouettes. Silhouettes were an inexpensive and easy way to create a subject's likeness. An ancient art traced to the Stone Age, silhouettes were often executed by casting the sitter's shadow upon a wall (using candlelight) and then tracing the image. Silhouettes were prototypes of photography; they were often framed and hung as keepsakes (*Silhouette of a Man*, cut paper with ink elaboration, New England, c. 1830–1860, *left*).

Photo © Esto.

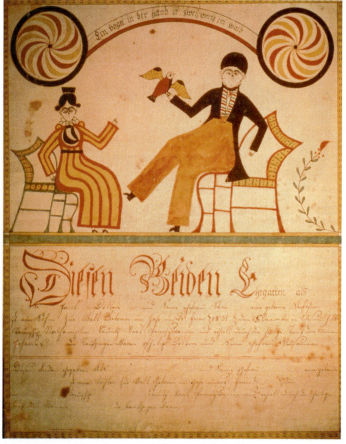

Although fraktur pieces such as marriage licenses, and birth and baptismal certificates were based on the influence of European traditions in the Pennsylvania German (Dutch) communities, practitioners adapted these conventions to create a particularly American vernacular art form, drawing on regional narratives and experiences from their own lives. This *Taufscheine for Johannes Dottere* (baptismal certificate) by the "Bird-in-the-Hand" artist of Northampton County, Pennsylvania, (c. 1831), includes inscriptions embellished with watercolors (*right*). It measures 15$\frac{1}{16}$ × 12 inches.

Collection American Folk Art Museum, New York. Promised gift of Ralph Esmerian, P1.2001.212.

PLATE 19

Folk pottery in the nineteenth century was one of the most widespread of folk art forms. Although pottery was required to be durable and useful, artisans clearly valued aspects of decoration and design. The *Rockingham Whiskey Flask* (c. 1820–1840, *right*), made of yellowware with brown sponging in East Liverpool, Ohio, features an American eagle design. Rockingham pottery was used to make a variety of molded and figurative pieces from Baltimore to Cincinnati. The *Pitcher with Embossed Hunting Scene* (c. 1825–1835, American Pottery Co., Jersey City, New Jersey, *bottom left*) is also yellowware. The unknown maker has crafted its handle in the form of a hunting dog in keeping with the image embossed on the lower register. The yellowware *Cow Creamer* (c. 1840–1850, *bottom right*) was made with a commercial mold by the United States Pottery in Bennington, Vermont.

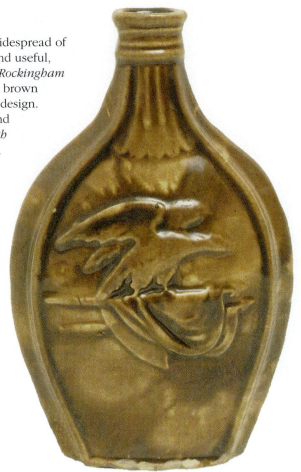

Photo © Esto.

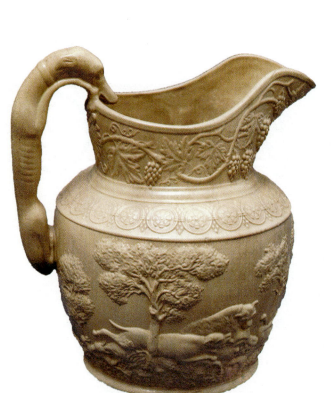

Photo © Esto.

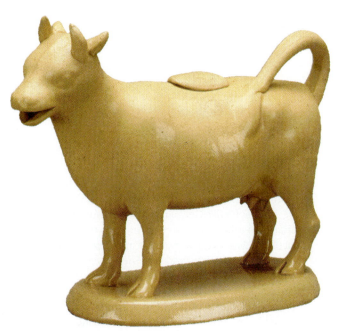

Photo courtesy Schecter Lee © Esto.

PLATE 20

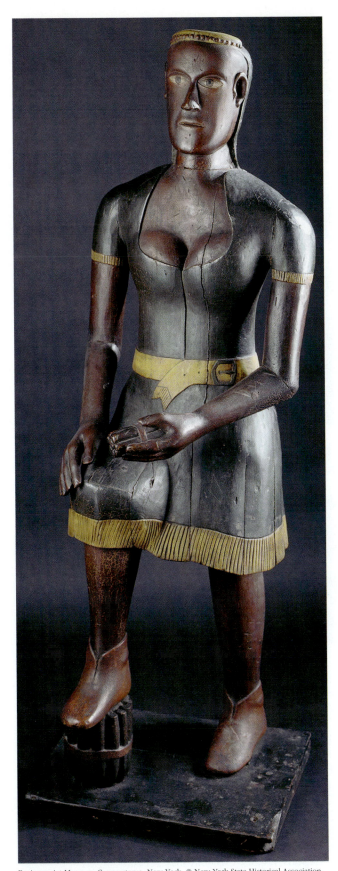

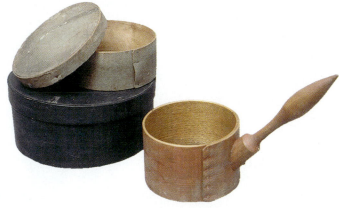

Photo © Esto.

These woodenware cheese boxes and dipper with handle, of pine and birch, were created by unidentified makers (c. 1830–1860).

African Americans made lasting contributions to carving and folk pottery traditions in the second half of the nineteenth century such as the *Cigar Store Figure*. The piece depicts a Native American woman carved in African style (c. 1850, carved and painted wood, $46\frac{1}{2} \times 16\frac{1}{2} \times 12\frac{1}{4}$ inches, *left*). This shop figure, created by an African American artist from Freehold, New Jersey, known only as "Job," reflects the preponderance of commercial and market influences on folk art of the time. While the "Indian" figure clearly possesses "African" features in its face and body shape, historians do not know enough about the figure or its maker to ascertain whether it is a self-conscious depiction of race.

PLATE 21

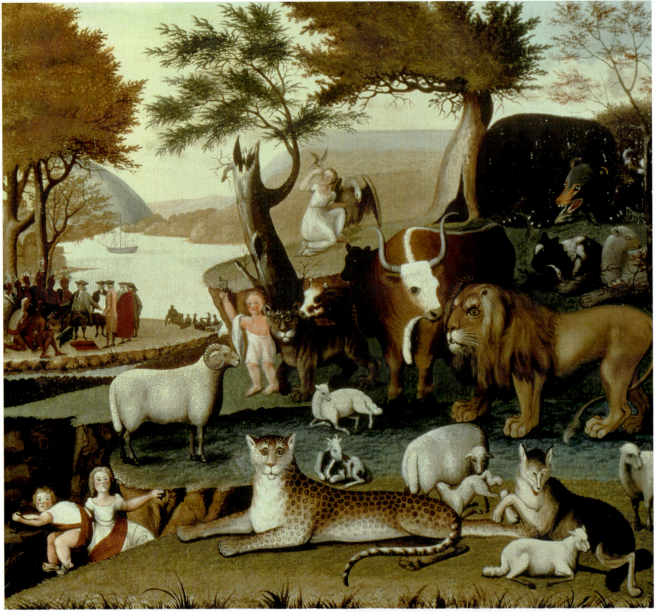

Collection American Folk Art Museum, New York, P1.2001.59.

Edward Hicks (1780–1849), a Quaker from Newtown, Bucks County, Pennsylvania, ran a successful ornamental painting business specializing in carriages, coaches, furniture, and other utilitarian wares. Around 1816 Hicks began to paint a series of works based on the Old Testament lesson of Isaiah (116:9)—the peaceable kingdom. Historians assume that this verse, which prophesies that all earthly creatures will live in peace and harmony according to God's will, may have placated the few of Hicks's Quaker critics who believed that "fancy" painting was immodest and in conflict with the Society of Friends' doctrine of simplicity. Experts have identified sixty-three versions of *The Peaceable Kingdom*; this one (c. 1846–1848, oil on canvas, 26 × 29⅜ inches, *above*) was executed shortly before his death. Unlike earlier versions, here the animals are more widely dispersed rather than gathered, and facial expressions lack the energy and dynamism of earlier canvasses. Experts suggest this shift may reflect Hicks's awareness of conflicts within the Quaker Society that threatened its unity in the third and fourth decade of the century.

PLATE 22

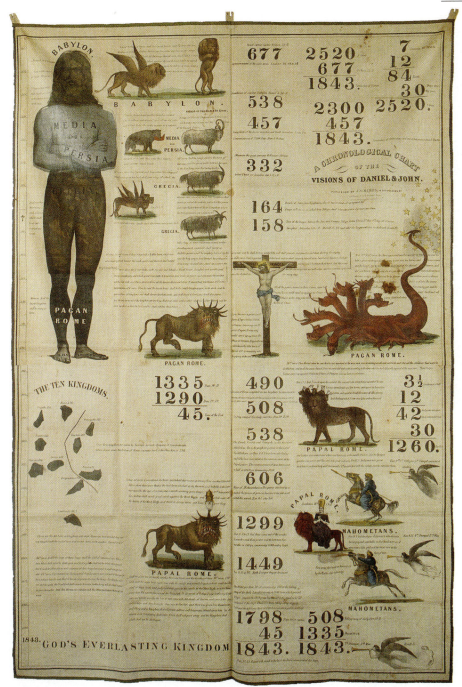

Private Collection.

In the 1830s William Miller (1782–1849), a farmer-turned preacher from upstate New York, founded a religious movement whose followers were called Millerites (later Adventists, based on the belief in the imminent advent of Christ). Miller's study of the prophecies in the books of Daniel and Revelation indicated to him that the long-awaited millennium—"God's everlasting kingdom"—would occur in 1842 or 1843. Two of Miller's followers, Charles Fitch and Apollos Hale, prepared *A Chronological Chart of the Visions of Daniel & John* in 1842, published by Joshua V. Himes and printed by the Boston lithographer B.W. Thayer and Co. The intricately detailed chart helped disseminate Millerite ideas. Pictured is a range of curious and fearsome creatures, including the Four Horsemen of the Apocalypse, winged trumpeters, and a statuesque, bearded figure symbolic of the four ancient empires. The chart, made with watercolor and ink on linen, measures 56 × 39 inches.

PLATE 23

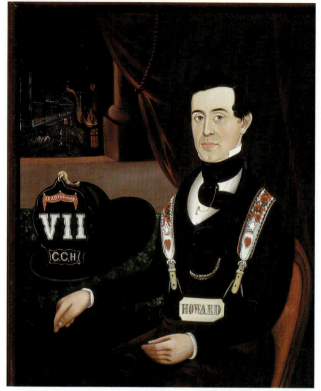

Sturtevant Hamblin's (active 1837–1856) attributed portrait of *Charles C. Henry* (c. 1851, oil on canvas, 36 × 29 inches) (*left*) dramatically relays information about the sitter, a member of Company VII, whose initials are proudly emblazoned upon his fireman's hat. The vista through the window reveals that same company fighting a dramatic nighttime blaze. Hamblin, an accomplished portraitist of Boston, Massachusetts, used velvety brushwork and a high contrast palette to precisely record the visage and personality of Mr. Henry.

Fenimore Art Museum, Cooperstown, New York. © New York State Historical Association, Cooperstown, New York, N-263.61.
Photo courtesy John Bigelow Taylor, New York City.

The painting of Joseph H. Hidley (1830–1872) is equally illustrative of a specific time and place, in this case, the town of Poestenkill, New York (1862), where the artist lived for twenty-two years (*bottom*). A taxidermist and house and sign painter, it would appear from the perspective that Hidley received some instruction, although this remains undocumented. The oil on wood panel, measuring 25½ × 37½ inches, depicts the main dirt road that extends through the town to the horizon line, indicated by less detailed, wispy brushstrokes. Hidley includes specific references to Poestenkill life including the Poestenkill Union Academy in the upper left portion of the composition.

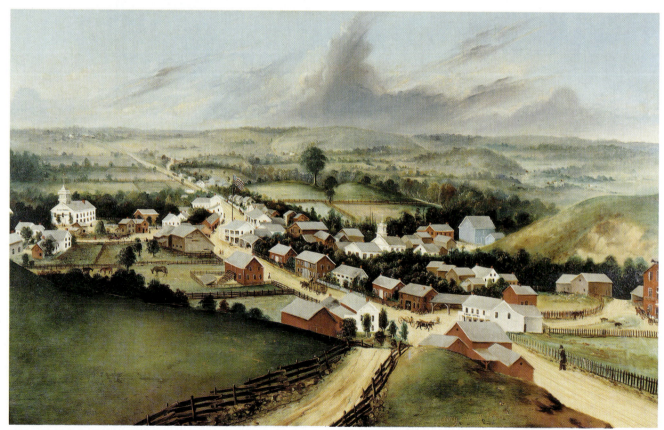

Fenimore Art Museum, Cooperstown, New York. © New York State Historical Association, Cooperstown, New York, N-382.55.
Photo courtesy Richard Walker.

PLATE 24

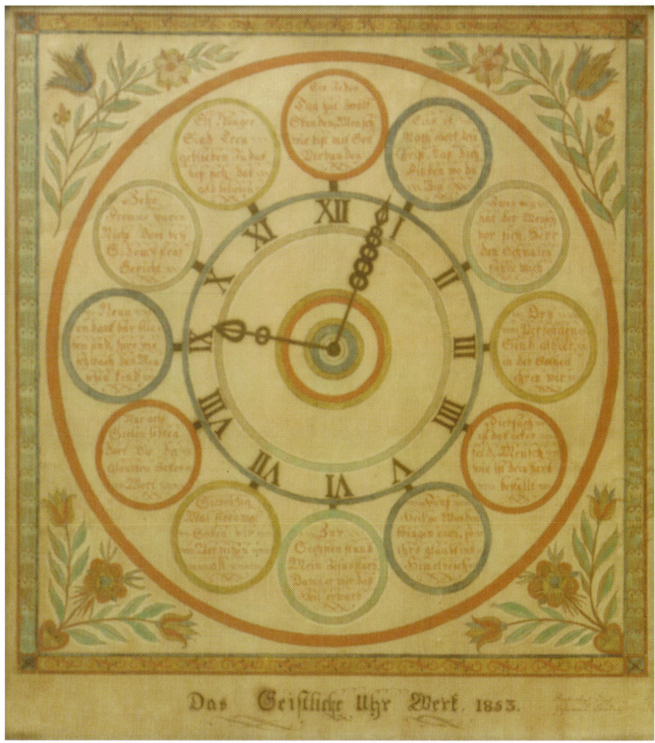

Private Collection.

In the rich Pennsylvania German tradition of illuminated and decorated texts known as fraktur, the depiction of clocks is rare. When a clock does appear, as in this work by Johannes Landes of Pennsylvania (1853), it is often accompanied by moralistic verses intended to emphasize the fleeting nature of time, especially in contrast to the coming millennial day: "Each day has twelve hours: Man are you bound up with God?" Embellished with floral and abstract patterns, this fraktur is made with watercolor and pen and ink on paper. It measures 12¾ × 13¾ inches.

PLATE 25

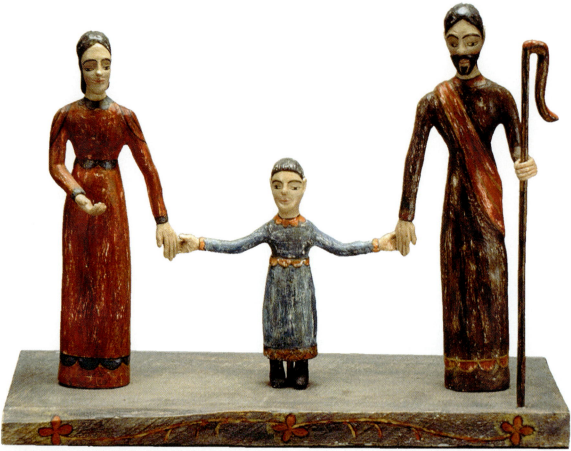

Photo © Esto.

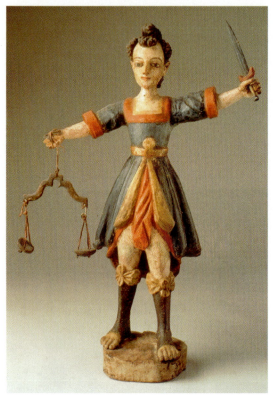

Collection of Larry and Alyce Frank.

Spaniards seeking to Christianize the "New World" and explore its riches founded the colony of New Mexico in 1598, announcing dominion over the land and the people who they called "Pueblos." Hispanic American folk art derives its traditions and forms within this background of Spanish domination and cultural influence. Religious *bultos* (sculptures) and *retablos* (painted images or altarpieces) have characterized much of Hispanic folk art since the seventeenth century. The trio of bultos figures (c. 1840–1860, paint over gesso on carved piñon wood, *top*) symbolizes the sanctity of family.

José Rafael Aragón (c. 1796–1862) was one of the most prolific and popular of the *santeros* (carvers and painters of figures of saints) of northern New Mexico in the first half of the nineteenth century. His carved and painted St. Michael bultos (c. 1830, 24 × 18 inches) was made in New Mexico (*left*).

PLATE 26

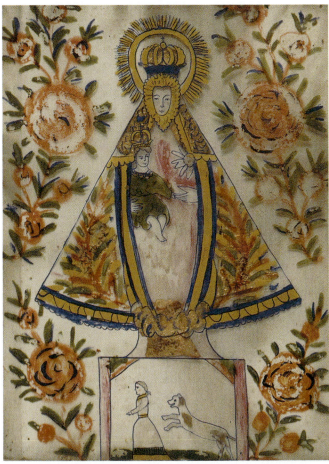

Photo © Esto.

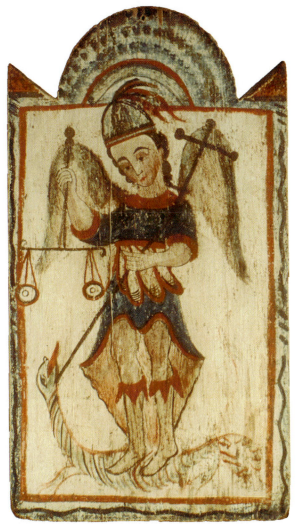

Collection of Larry and Alyce Fink.

New Mexican *retablos* (devotional Catholic panel paintings), often used within altarpieces and shrines, were painted on wood panels often cut from ponderosa pine logs and painstakingly shaped with adzes and chisels. The surface was treated with a gesso to fill in any imperfections and provide a satiny surface. The *Virgin Mary and Child retablo* (c. 1840–1860, oil, gesso, on cottonwood panel, *above left*) is one such example crafted by an anonymous artist.

The shaped *St. Michael retablo* (*above right*) is avibrant depiction of the warrior angel. St. Michael, the archangel who defeated and banished Satan (symbolized by a snake or serpent). He is depicted vanquishing the demon, brandishing a sword, and holding the scales of justice. This example, by José Rafael Aragón (c. 1796–1862), was made about 1830 of painted pine. It measures 14⅜ × 8¼ inches.

PLATE 27

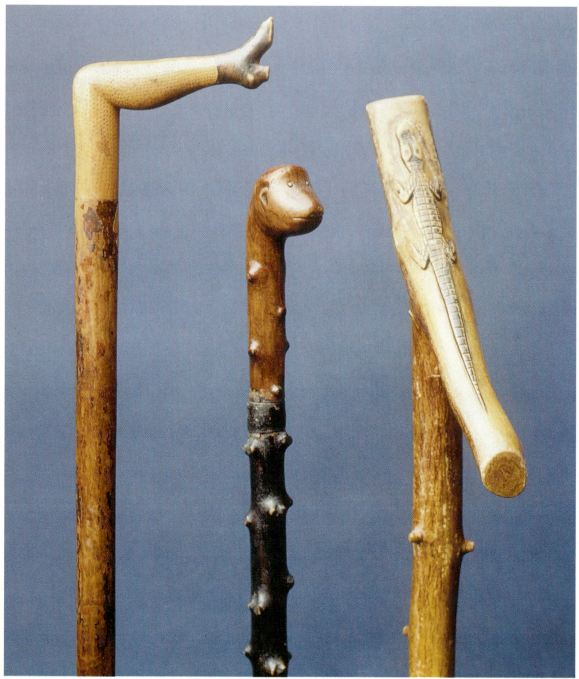

Photo courtesy Schector Lee © Esto.

Carved canes, or walking sticks—widely crafted in the late nineteenth century—were used up through World War I. Canes were largely made by male artisans (mostly anonymous) and began as utilitarian objects but quickly grew to be prized for their unique artistic embellishments and designs. Although precious materials such as gold and ivory might be used, the less wealthy buyer could obtain carved, wooden canes treated to mimic the surface and texture of ivory. The *Lady's leg cane* (c. 1830–1850, *left*), carved by an unknown artist in pine with stippled decoration in Maine, is one such example. The *Monkey head cane*, artist unknown, carved in pine in New York, c. 1860–1880, features a textured and painted shaft (*center*). A more recently carved pine cane (*right*) depicts an alligator incised in low relief on the handle (artist unknown, St. Petersburg, Florida, 1927).

PLATE **28**

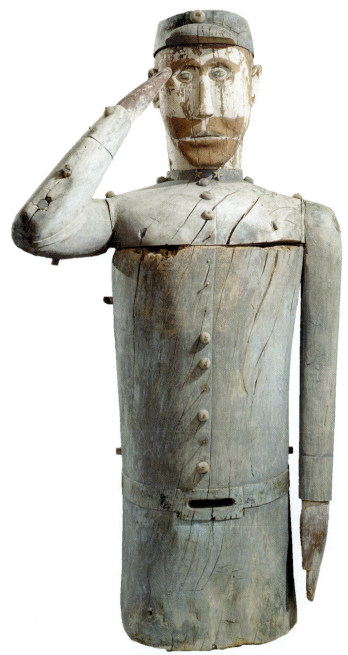

One of the valuable functions of folk art is to document historical and cultural ideas, beliefs, and traditions. The proliferation of objects that reflected the country's early independence as well as the strife and patriotism of the American Civil War is remarkable. The carved *Civil War Confederate Soldier Beehive* (*left*, 45½ × 25 × 20 inches) was made about 1900 in DeKalb County, Georgia. Originally painted gray, and later repainted blue, it was carved of wood by an unidentified artist. The bees entered and exited through the soldier's belt buckle.

Photo courtesy Allan Katz, Americana, Woodbridge, Connecticut.

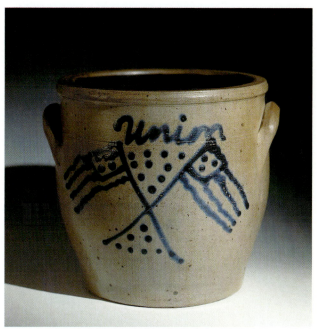

This *One-Gallon Cobalt Blue, slip decorated Wide-Mouth Jar* (*right*) is an example of wheelthrown stoneware, decorated by painting on the fired surface with a cobalt blue slip (a fine mixture of clay and water used along with pigments for surface embellishment). Made around 1865 by an unknown potter, the jar commemorated the Union army.

Photo courtesy Allan Katz, Americana, Woodbridge, Connecticut.

PLATE 29

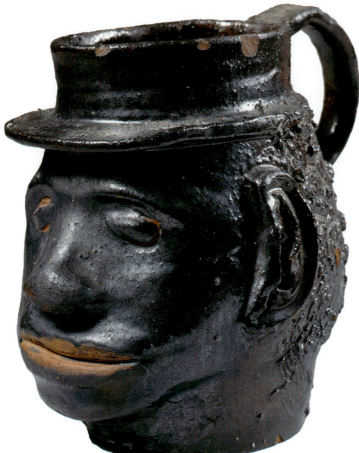

The abolition of slavery unfortunately brought with it the Jim Crow laws (c. 1880–1960). Made largely by white carvers, objects such as the *American Civil War "portrait pitcher" of an African American Solider* (redware, Pennsylvania, c. 1870, *left*) represent an all-too typical racial stereotype that emerged alongside of the vaudeville and minstrel entertainments performed by blacks and whites alike. African Americans were subjected to a range of racist and dehumanizing caricatures in novels, advertisements, on sheet music, and in theaters. A pitcher such as this one (its maker unknown) shows exaggerated African features including the large, red-painted lips typical of blackface makeup. It measures 8 × 7 × 9 inches.

Photo courtesy Allan Katz, Americana, Woodbridge, Connecticut.

The origins of the anthropomorphic face jug, a folk tradition among African American potters in the South, remain unclear, although some of the earliest examples date to South Carolina in the 1840s. (*Face Jug*, by Morris Dollings, Ohio, c. 1880, clay with Albany slip, 11 × 9 inches [*right*]). Some historians have linked these jugs to African ritual artifacts, others to imported European figurative vessels. Generally made of stone and redware with applied glazes, the genre quickly spread throughout the Carolinas, Georgia, and Alabama, resulting in the production of thousands of distinct face jugs. Many appear to have been made by slaves and passed down through families. Whatever their purpose aside from holding liquids, these jugs exude a unique and expressionistic artistry.

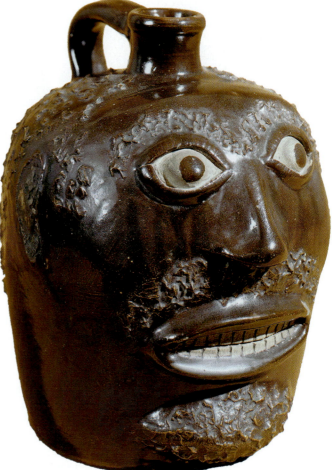

Photo courtesy Allan Katz, Americana, Woodbridge, Connecticut.

PLATE 30

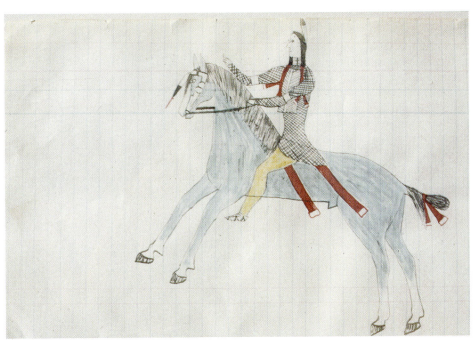

Photo © Esto.

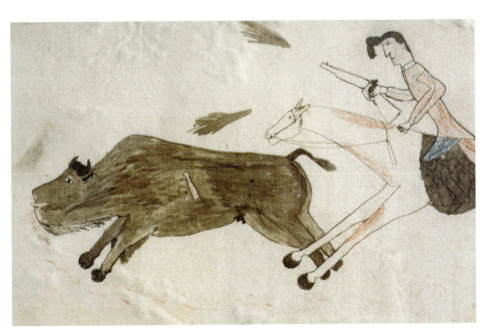

Photo © Esto.

Ledger drawings—made by American Indians (Cheyenne, Kiowa, Sioux, and others) on the Great Plains during the latter half of the nineteenth century—were primarily used as pictorial narrative devices by male artisans. Using materials that arrived with the invasion by white America (ledger paper, ink, crayons), these drawings document images of war, conflict, and scenes of everyday life. Drawings such as the Sioux warrior on a blue horse (Rain Eagle, c. 1870–1890, ink and crayon, *top*), and *Cheyenne Indian after Wild Buffalo* ("Old White Woman" of the South Cheyenne, c. 1870–1890, ink and crayon, *bottom*) provide an artistic record of the profound changes that occurred within nineteenth-century indigenous Native American life. Although the majority of ledger drawing artists remain unknown, analysis has revealed particular signature styles and bodies of work.

PLATE 31

The proliferation of trade signs, signboards, and other related commercial emblems in the latter nineteenth century reflect America's urban and economic development and its importance within material vernacular culture. Folk artisans contributed to the birth of advertising, constructing trade signs for almost every conceivable profession, from dentists—such as this *W. Dodge* sign (*right*) by an unknown maker (c. 1870, carved wood with polychrome paint, gilding, smalt, and iron hardware, 28 × 27 × 4½ inches)—to butchers, brothels, and itinerant preachers.

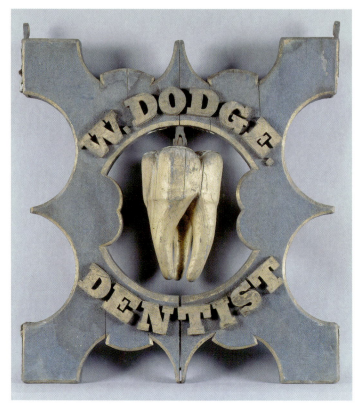

Photo courtesy Allan Katz, Americana, Woodbridge, Connecticut.

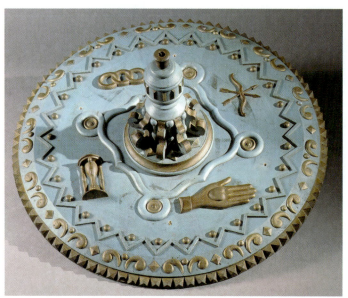

Photo courtesy Allan Katz, Americana, Woodbridge, Connecticut.

Often dubbed the golden age of fraternalism, the latter nineteenth century witnessed an explosion in the numbers of fraternal societies nationwide, including the Odd Fellows, begun in seventeenth-century England as an altruistic group organized to "improve and elevate the character of man." In America the Odd Fellows were established in Baltimore, Maryland, in 1819. This *Chandelier Mount and Ceiling Medallion* (constructed by unknown members, for one of their Baltimore lodges, c. 1870) is constructed of carved, applied, and painted wood, with a diameter of 39 inches. Designed to emulate ornate ceiling plasterwork, the mount includes a variety of cryptic symbols including the Fellows emblem—the three links of Friendship, Love, and Truth.

PLATE 32

ILLIONS, MARCUS CHARLES (1865–1942) was a Jewish woodcarver who learned his craft as a carver of carousel, carnival, and circus art (for which he is best known); trade signs; decoration of façades for public and private buildings at an early age, while working as an apprentice in Vilna, Lithuania. After a few years he journeyed to England, where he continued his apprenticeship under the tutelage of C.W. Spooner. Spooner's most important client was a man named Frederick Savage, the preeminent carousel maker in England. Savage's carousels, or "gallopers," as they were known, were world famous, and Spooner's shop employed a great many craftsmen to keep up with the demand for a variety of hand-carved fairground art.

About 1880, Illions continued his westward journey aboard a ship bound for America. Savage had promised delivery of a carousel and several circus wagons to an amusement entrepreneur in time for the opening of an exhibit and a carnival. Spooner's production was behind schedule, so the young carver, still an apprentice and therefore expendable, was given strict orders to finish the carving onboard by the time the ship reached New York. For the next two and half months, Illions worked in the hold of the sailing ship as it made its way across the Atlantic, finishing the job before docking in New York harbor.

In the United States, Illions eventually found work with William Mangels. Mangels' Carousel Works, located in Coney Island, New York, produced a wide variety of carnival rides and carved amusement-park facades. Illions was a highly skilled and prolific carver, and Mangels used this talent to his full advantage, giving Illions his most complex carving work.

Eventually Illions grew weary of watching Mangels reap the profits from his work, so in 1909 he opened his own shop. Illions' reputation as an excellent carver had already been established at the Mangels shop, so orders for his own carousels were soon keeping Illions' shop very busy.

Over the next twenty years, Illions created some of the wildest and most animated carousel horses ever produced. Flying manes covered in gold leaf, exotic armored steeds, and fiery expressions became Illions' trademarks. The untamed look of his horses fit in so well with the image advertised by the amusement parks of Coney Island that no less than eleven Illions carousels were operating in the Coney Island area at one time. As the shop grew, Illions' sons entered the family business, and the name of the company changed to M.C. Illions & Sons. Despite the company's growth, Illions still reserved the carving of all the heads of the outside row of horses for himself.

Illions' drive to create and his desire to succeed were extraordinary. His carving skills were legendary in Coney Island. His prolific output was part of the reason that he stayed so involved with the carving process. Although Illions would be commissioned for other carving projects, his reputation was built around carousels.

In the 1920s the demand for carousels faded. Illions, took the decreasing demand for his work personally. Along with other carousel carvers, he did what he could to stay busy by repairing existing carousels, but the era of the great carving shops had ended.

See also **Carousel Art; Circus Art; Jewish Folk Art; William Mangels.**

BIBLIOGRAPHY

Dinger, Charlotte. *Art of the Carousel.* Green Village, N.J., 1983.
Fraley, Tobin. *The Carousel Animal.* San Francisco, 1983.
———. *The Great American Carousel.* San Francisco, 1994.
Fried, Frederick. *A Pictorial History of the Carousel.* Vestal, N.Y., 1964.
Mangels, William F. *Outdoor Amusement Industry.* New York, 1952.
McCullough, Edo. *Good Old Coney Island.* New York, 1957.
Stevens, Marianne. *Painted Ponies.* New York, 1986.

Summit, Roland. *Carousels of Coney Island.* Rolling Hills, Calif., 1970.

Weedon, Geoff. *Fairground Art.* New York, 1981.

TOBIN FRALEY

INDEPENDENT ORDER OF ODD FELLOWS was the second-largest and most influential fraternal organization in America during the nineteenth century. Odd Fellows symbols have been painted, carved, and inlaid into many classes of American material culture, including paintings, furniture, textiles, and buildings. Sometimes referred to as the "Three-link Brotherhood" because of its emblem of three links of chain (representing the tenets of friendship, love, and truth), the Odd Fellows use symbolism reminiscent of Masonic iconography, and both groups share images, including the all-seeing eye, the moon and stars, the sword, the Bible, the Ark of the Covenant, the hourglass, and the beehive. Other emblems, however, like the heart in the hand, the three links, the bundle of rods, and the cornucopia, are identified primarily with the Odd Fellows. The rituals of the Odd Fellows draw upon biblical characters including Jonathan, David, and the Good Samaritan. Both the Odd Fellows and the Masons traditionally have worn ceremonial aprons, as well as met in lodge rooms furnished in a ritually prescribed manner.

American orders of Odd Fellows have always been drawn from slightly lower socioeconomic strata than have Freemasons; however, the two groups are similar in origin, in ritual practices, and in social function. Like the Freemasons, the Odd Fellows have roots in eighteenth-century London, where the organization developed in taverns as a "friendly society" for artisans. During the movement's infancy, a number of schismatic English Odd Fellows organizations competed for authority and members. Eventually the Manchester Unity of the Independent Order of Odd Fellows, formed in 1813 in this northern mill city, became dominant.

The American Independent Order of Odd Fellows derives from the Manchester Unity. In 1819, Thomas Wildey (1782–1861), who is celebrated as the "Father of American Odd Fellowship," gathered expatriate English Odd Fellows in Baltimore, formed Washington Lodge No. 1, and gained recognition from the Manchester Unity. Odd Fellows Lodges subsequently were formed in Boston in 1820, and in Philadelphia in 1821. In the 1820s the brotherhood established a Grand Lodge of Odd Fellows of the United States, to coordinate all activities within the nation. By 1829 this body contained thirty-one local lodges under the supervision of state Grand Lodges in Maryland, Massachusetts, New York, Pennsylvania, and the District of Columbia. Although the anti-Masonic movement of the 1820s spurred many Americans to question the motives and practices of fraternalism, Odd Fellowship spread throughout the nation during the 1830s and 1840s. In 1843 the Grand Lodge I.O.O.F. of the United States severed relationships with the Manchester Unity of Odd Fellows because of issues related to inter-visitation of members and the revision of rituals.

Peter Ogden (d. 1852), an African American sailor, became an Odd Fellow in a lodge in Liverpool, England. Refused recognition by American Odd Fellows, and unable to obtain a charter for a lodge composed of Americans of African heritage, Ogden secured one from the English Grand United Order of Odd Fellows. From this genesis, the alternative Grand United Order of Odd Fellows spread throughout American communities of color, while still maintaining ties to the chartering English organization, which, in the 1890s, boasted that its brotherhood had transcended the "evils" of American racism.

In the middle decades of the nineteenth century, the Odd Fellows developed rituals and organizations to supplement those that originated in England. The most developed are the Patriarchs Militant and the Daughters of Rebekah. The Patriarchs Militant, which originated after the Civil War as a paramilitary group, wore uniforms and practiced close-order drills to demonstrate martial discipline. The Daughters of Rebekah was founded in 1851 for female relatives of Odd Fellows. The beehive, crescent moon and stars, and dove are its primary emblems. In 1856 the Households of Ruth was established as a female auxiliary to the African American G.U.O.O.F. The Imperial Order of Muscovites, which met in groups called "Kremlins," was established in Cincinnati in 1894 to provide Odd Fellows with a group that preached fun rather than righteousness.

American Odd Fellows have traditionally prided themselves on their systems of mutual support. Membership provided individuals with relief during distress, burial benefits, and support for widows and children. About the beginning of the twentieth century, the fraternity developed a system of "homes" throughout the nation to support those who required assistance. As is characteristic of many fraternal organizations, the Odd Fellows' membership boomed during the "Golden Age of Fraternalism" at the end of the nineteenth century, but declined throughout much of the twentieth century.

See also **Fraternal Societies; Freemasonry; Religious Folk Art.**

BIBLIOGRAPHY

Beharrell, Thomas G. *The Brotherhood: Being a Presentation of the Principles of Odd Fellowship*. Indianapolis, Ind., 1875.

Ross, Theodore. *Odd Fellowship: Its History and Manual*. New York, 1888.

WILLIAM D. MOORE

INDIAN AMERICAN FOLK ART: *SEE* ASIAN AMERICAN FOLK ART.

INDIAN CLUBS, which resemble bowling pins in shape, were used in a popular form of physical exercise in the United States from the 1860s through the mid-twentieth century. Indian clubs played a role in American intercollegiate athletics and recreation as late as the 1930s, but they are no longer to be found lined up along the walls of gymnasiums. As their use declined, however, they began to be collected for their graceful forms, decorative turnings, and handsome painted decoration.

The origin of Indian clubs may be traced to an ancient form of war club, or *gada,* used in India. In the nineteenth century, the British army adapted the clubs for use in exercises designed to enhance physical strength as well as for sport. Produced (generally in pairs) in various sizes and weights, and either individually handcrafted or factory made, Indian clubs became widely used in England by the mid-nineteenth century. In 1862 Sim D. Kehoe, an American entrepreneur and fitness enthusiast who had observed the practice of calisthenics with clubs during an 1861 visit to England, introduced Indian clubs to the American market. Kehoe not only manufactured Indian clubs but also published *The Indian Club Exercise* in 1866, to promote the practice of Indian club swinging.

By the end of the nineteenth century, more than a dozen American manufacturers of sporting equipment, including A.G. Spalding & Bros., were manufacturing Indian clubs, but individual makers continued to produce them as well. Many are not painted or decorated, but some bear floral motifs, geometric patterns, stars, or representations of the American flag. They differ in bulk and in the intricacy of their carved or turned elements, but the clubs are remarkably pleasing in design, and in recent years have entered collections of folk art.

See also **Sculpture, Folk.**

BIBLIOGRAPHY

Hoffman, Alice J. *Indian Clubs*. New York, 1996.

GERARD C. WERTKIN

INTERNATIONAL QUILT STUDY CENTER, THE, established in 1997 at the University of Nebraska-Lincoln (UNL), encourages the interdisciplinary study of all aspects of quiltmaking, from the quiltmakers and the materials they used to their finished products, and fosters preservation of this tradition through the collection, conservation, and exhibition of quilts and associated textiles. The center supports the examination of quilts and quiltmaking from historical, social, technical, and cultural perspectives. The International Quilt Study Center (IQSC) was made possible through the generosity of Robert and Ardis James, who donated their renowned collection of more than 950 antique and contemporary art quilts to the university, along with a pledge of financial support to create a center that encourages scholarship and nurtures the appreciation of quilts as art and cultural history. The university built a state-of-the-art storage facility and established the IQSC, which has close ties to the university's academic departments.

In addition to the James collection, which contains a remarkable range of quilts, dating from the late 1700s to the present, the IQSC collection includes the Robert and Helen Cargo collection, given to the IQSC in 2000 and encompassing 156 quilts made by African American women from Alabama; and the Sara Miller collection of ninety Amish crib quilts, which was also acquired in 2000 by the IQSC, with the support of Robert and Ardis James. The IQSC's quilt collection is now one of the largest in the world, with more than 1,200 quilts. Exhibits showcasing both traditional and contemporary quilts from the IQSC can be found at various locations on the UNL campus throughout the year, as well as in traveling exhibitions. The UNL Department of Textiles, Clothing, and Design and the IQSC jointly sponsor a master's degree program in textile history and quilt studies, the only program of its kind in the world. Summer workshops and seminars also offer students and interested individuals opportunities to study with some of the world's foremost authorities on the American quilt, and to pursue related topics in textile history.

See also **Amish Quilt and Folk Arts; Quilts.**

JACQUELINE M. ATKINS

INTUIT: THE CENTER FOR INTUITIVE AND OUTSIDER ART was founded in early 1991 as a nonprofit organization to recognize the creative work of individuals who demonstrate little influence from the mainstream art world, but who seem motivated by their unique personal visions. Today, Intuit's six hundred members, nationwide and abroad, support this

249

cause. Through its exhibitions and educational programs, Intuit bolsters the nationally prominent role that Chicago artists and collectors have played in generating interest in Outsider Art.

Since its founding, Intuit has presented more than fifty exhibitions, as well as scores of lectures, panel discussions, documentary film screenings, study tours, and performances. Highlights have included two exhibits presented in collaboration with Chicago's Department of Cultural Affairs at the Chicago Cultural Center, in 1996 and 1998; an exhibition of the work of artist James Castle (1899–1977), in 1996; a solo exhibition of the work of Judith Scott (1943–), in 2000; and an exhibition contrasting the work of self-taught photographers Jamot Emily "Lee" Godie (1908–1994), Morton Bartlett (1909–1992), and Eugene Von Bruenchenhein (1910–1983) with work by Cindy Sherman, Harry Callahan, and Hans Bellmer in 2002. Intuit has also sponsored numerous discussions with scholars in the field, as well as study tours to art environments in Kansas, Wisconsin, New York, New Mexico, and Illinois.

In 1995 Intuit converted the former studio of Chicago artist and Intuit founding member Roger Brown into the group's first permanent home. It quickly outgrew this small, Lincoln Park storefront, and in 1998 the organization purchased the former Randolph Street Gallery space on Milwaukee Avenue in Chicago's West Town neighborhood to serve as headquarters for the organization's expanding activities. In 2001 Intuit marked its tenth anniversary with a retrospective exhibition and an accompanying catalog. In 2002 Intuit became a collecting organization, and is engaged in the process of formulating policies, procedures, and collecting parameters that will reflect the organization's mission, while addressing the wealth of material that could contribute to a core collection. Initial gifts to the collection include works by Henry Darger (1892–1973), Minnie Evans (1892–1987), Howard Finster (1915–2001), Theodore Harold "Ted" Gordon (1924–), Johann Hauser, Dwight Mackintosh (1906–1999), Justin McCarthy (1892–1977), Sister Gertrude Morgan, Oswald Tschirtner, Perley "P.M." Wentworth (active in the 1950s), and Joseph Yoakum (1890–1972).

See also **Minnie Adkins; Morton Bartlett; James Castle; Henry Darger; Howard Finster; Jamot Emily Godie; Theodore Gordon; Justin McCarthy; Sister Gertrude Morgan; Outsider Art; Painting, American Folk; Judith Scott; Eugene Von Bruenchenhein; Perley Wentworth; Joseph Yoakum.**

JEFF COREY

JACOBSEN, ANTONIO (1850–1921) broke the bank in the field of the American ship portrait, painting portraits of virtually every consequential oceangoing vessel that entered the Port of New York between 1875 and 1919. By the time of his death, the photograph had replaced the oil painting, and never again would an artist make a comfortable living strictly as a ship portraitist. But Jacobsen certainly had, having produced as many as 6,000 ship portraits—paintings sometimes completed in little more than a day, at a cost to the artist of five dollars each.

The son of a Danish violinmaker, Jacobsen left his native country at the age of 22, taking with him some musical training and a bit less artistic training. Upon his arrival in New York in 1873, he traded on both skills. He seems to have played the cello and the viola as well as the violin, perhaps in a professional setting. More important, he was hired to paint decorative schemes on the doors of the Marvin Safe Company's products; when a shipping line asked for a portrait of their ship rather than the standard garlands of flowers, his career was launched. Jacobsen seems to have sprung full-grown into his profession, for there are few halting examples of early work—he loved ships and he knew how to paint them.

Once commissioned to paint a vessel, Jacobsen set out to draw the ship at dockside. He carried a small pocket notebook, and his drawings frequently extended over a number of pages. In contrast to the highly detailed and exacting draftsmanship of his protégé James Bard, Jacobsen's drawings were sketches at best. He did capture all the salient details of the ship, however, and was able to convert these rough images into perfect semblances of the original. Though Jacobsen took his measurements at dockside, he always depicted the ship at sea, with the rough lines of the sketch converted into the fully faired sheer of a powerful ocean liner. He worked in oil on canvas, and carefully maintained his collection of sketchbooks over the years. Often he was called upon to replicate an earlier work for another client, and it is not uncommon to find that up to a dozen paintings were created of any given ship. What with all the builders, owners, captains, and mates, there was no shortage of potential clients.

Jacobsen's mastery of the details of naval construction meant that his paintings showed little variation in the depiction of the ship over the years. His work does fall into distinct periods, however, thanks to other details. The water in his earliest works, for example, is that of a boldly rolling open ocean. By the turn of the twentieth century, however, his seas had become choppier and less painterly. The waves he painted in his last years, especially in those paintings he executed on artists' board, could seem nearly perfunctory as he rushed to complete a painting. They almost give credibility to the notion that one or more of his children helped him with this aspect of the paintings. By the end of his career, the competition of the camera had become irresistible, and he had turned his hand to historical paintings to keep bread on the table. These retrospective paintings of clipper ships were undoubtedly good sellers, but they are among Jacobsen's least satisfactory works.

When Antonio Jacobsen set out to paint an oceangoing vessel at sea during the first twenty years of his career, he was without equal. When he painted a broadside of a steam tugboat (captain at the wheel in striped shirt and suspenders) he was without peer. Jacobsen left behind a remarkable artistic record of a time when America still looked to the sea as a frontier full of opportunity, when being the "pride of the seas" was to be prideful indeed.

See also **James and John Bard; Maritime Folk Art; Painting, American Folk.**

BIBLIOGRAPHY

Sniffen, Harold S. *Antonio Jacobsen's Painted Ships on Painted Oceans.* Newport News, Va., 1994.

————. *Antonio Jacobsen—The Checklist: Paintings and Sketches by Antonio N.G. Jacobsen, 1850–1921.* New York, 1984.

JOHN O. SANDS

JAKOBSEN, KATHY (1952–) has painted her memories of growing up in Dearborn Township, Michigan, but some of her strongest works are views of New York, where she moved in 1978. She wrote and illustrated the book *My New York,* which included landmarks such as the Plaza Hotel, events such as the Sixth Avenue flea market, and cutaway views of building construction and underground pipes. Jakobsen is also interested in broader American subjects; she illustrated the book, *This Land Is Your Land,* honoring Woody Guthrie's song.

Jakobsen, the daughter of an artist, was interested in art as a child but began to paint seriously in the mid-1970s, doing fraktur. She was discovered by Robert Bishop, a former director of the Museum of American Folk Art, who was then associated with the Henry Ford Museum in Greenfield Village, Dearborn. He encouraged her to come to New York, where he arranged for gallery representation.

Jakobsen works in oils on canvas, having first photographed the scenes she plans to paint. Her bright colors reflect her cheerful view of American life: "I paint the way I would like it to be." Of her 600 or more paintings, many were commissioned and many have been sold in print editions. Jakobsen had a 25-year retrospective at the Housatonic Museum of Art (Bridgeport, Connecticut, 1991). Her paintings are in the American Folk Art Museum (New York) and American Museum (Bath, England).

See also **Robert Bishop; Fraktur; Painting, American Folk.**

BIBLIOGRAPHY

Ketchum, William C. Jr. *American Folk Art of the Twentieth Century.* New York, 1983.

Kogan, Lee. "Review of *My New York.*" *Folk Art,* vol. 18, no. 3 (fall 1993): 76.

Rosenak, Chuck, and Jan Rosenak. *Museum of American Folk Art Encyclopedia of Twentieth-Century American Folk Art and Artists.* New York, 1990.

LEE KOGAN

JANIS, SIDNEY (1896–1989) was an influential collector, dealer, and writer, whose seminal *They Taught Themselves: American Primitive Painters of the Twentieth Century,* published in 1942, was the first book to describe and analyze the works of twentieth-century American self-taught artists. In his book, Janis described the works of self-taught artists in terms that continue to guide scholars. He noted also, however, that these artists create their art without reference to art traditions, producing work that is idiosyncratic in theme and artistic technique. He also noted that the works of twentieth-century self-taught artists bear the stamp of their times through their resonance with modernist aesthetics. Janis used the term "self-taught," rejecting "folk," "primitive," and "naive" because of their associations with the work of peasants or with persons lacking in intelligence or sophistication. He believed that as a purely descriptive term, "self-taught" was broad enough to encompass many artistic styles. Although a number of the thirty individuals discussed in *They Taught Themselves* have faded from view, Janis nevertheless identified many significant artists at the time, including Henry Church Jr. (1836–1908), Morris Hirshfield (1872–1946), John Kane (1860–1934), Laurence Lebduska (1894–1966), Anna Mary Robertson "Grandma" Moses (1860–1961), Joseph Pickett (1848–1918), Horace Pippin (1888–1946), and Patrick J. Sullivan (1894–1967).

Janis, like many early folk art critics and collectors, did not come to his appreciation of art through formal education. Born in Buffalo, New York, in 1896, Janis attended Buffalo Technical High School, but dropped out during his senior year to become a professional dancer. He worked at a local dance hall before touring as a vaudevillian and teaching new dance steps in nightclubs. After a World War I stint in the United States Navy, he joined his brother's shoe business in Buffalo. During these years, from 1919 to 1924, Janis developed an interest in art, traveling often to New York, where he visited galleries. In 1925 Janis and his wife, Harriet, moved to New York, where they established a shirt manufacturing business. In 1926 Janis bought his first work of art, an etching by James McNeil Whistler (1834–1903), which he traded the following year for the first of his modern art purchases, a small painting by Henri Matisse (1869–1854). Soon his collection included works by Pablo Picasso (1881–1973), Paul Klee (1879–1940), Salvador Dalí (1904–1986), Giorgio de Chirico (1888–1978), and Piet Mondrian (1872–1944). His purchase in 1934 of Henri Rousseau's (1844–1900) masterful painting, *The Dream,* drew his interest to artists who created excellent work despite their lack of academic training.

In recognition of his connoisseurship, Janis was invited in 1934 to join the Advisory Committee of the Museum of Modern Art (MoMA). In 1939 he sold his shirt company to devote himself to writing and lecturing. During the late 1930s Janis became aware of the work of a number of self-taught artists. Alfred H. Barr Jr., director of MoMA, had included works by Lebduska and Pippin alongside European artists in his

1938 exhibition "Masters of Popular Painting," and Janis had discovered the works of other artists in galleries as well as such venues as the Washington Square Outdoor Art Mart. In 1939 Janis organized for MoMA the exhibition "Contemporary Unknown American Painters." While modest, this exhibition nevertheless made history by introducing both Hirshfield and Moses to a wider public.

With his parallel interests in European and American modernists, including self-taught artists, Janis had become an influential member of the art world. He was a member of the committee that brought Picasso's *Guernica* (1937) to MoMA, and in 1942 he published *They Taught Themselves*. Janis also became an advocate of the European artists who had taken up residence in New York during World War II, including Mondrian, Fernand Léger (1881–1955), and Max Ernst (1891–1976); he acquired works by these artists for his growing collection. He took an interest as well in the younger generation of artists who came to be known as "abstract expressionists," and in 1944 published *Abstract and Surrealist Art in America. Picasso: The Recent Years, 1939–1946* followed in 1946. In 1948 he took the next step in his career, opening the Sidney Janis Gallery, where, in addition to Hirshfield, whose work he continued to champion, Janis exhibited prominent European and American artists. Janis was open to every new movement; he represented numerous abstract expressionists and pop artists, and even took a chance on graffiti artists.

In 1967 Janis and his wife donated 103 works from their collection to MoMA. In 1986 Janis turned his gallery over to his sons, Conrad and Carroll, but continued to play a supervisory role until his death in 1989. Conflicts between Janis's sons precipitated the closing of the gallery in 1999.

See also **Henry Church Jr.; Morris Hirshfield; John Kane; Laurence Lebduska; Anna Mary Robertson "Grandma" Moses; Joseph Pickett; Horace Pippin; Patrick J. Sullivan.**

BIBLIOGRAPHY

Goldstein, Malcolm. *Landscape with Figures: A History of Art Dealing in the United States.* New York, 2000.

Janis, Sidney. *They Taught Themselves: American Primitives of the Twentieth Century.* New York, 1942 (reprinted 1999).

Robson, A. Deirdre. *Prestige, Profit, and Pleasure: The Market for Modern Art in New York in the 1940s and 1950s.* New York, 1995.

CHERYL RIVERS

JAPANESE AMERICAN FOLK ART: *SEE* ASIAN AMERICAN FOLK ART.

JENNINGS, JAMES HAROLD (1931–1999) was an artist who made colorful, idiosyncratic constructions in wood, plywood, and metal from the 1970s to 1990s in Pinnacle, North Carolina, where he was born. He lived and created his art in an environment comprised of a group of abandoned school buses, without running water, electricity, a telephone, or television. Surrounding his buses were the whirligigs, Ferris wheels, standing Indian figures, and other complex constructions that the artist created. This colorful scene attracted many visitors, who bought Jennings' works as fast as he was able to produce them while working seven days a week from dawn to dusk. Although he was reclusive, Jennings liked the attention his work brought.

Jennings' complex of buses was located across the road from his family home, where he had lived with his schoolteacher mother until she died in 1974. He attended school until the fifth grade, after which his mother instructed him at home. He worked in the local tobacco fields, as a projectionist at a drive-in movie theater, and collected bottles and cans along the highway to cash in for a little money. He never married, claiming that he had to pay too much in taxes to be able to afford it. When his mother died and left him a small inheritance, he started making art.

Jennings obsessively made thousands of pieces of art using many materials; all are full of movement and color. The themes of his art reflect his religious philosophy, which rejected organized "hell-and-damnation" religion because, he said, it frightened him. He believed instead in the "sun, moon, and stars" and in metempsychosis, or the transmigration of the soul into another body, either human or animal. A wooden cutout of an angel is the subject of one of his works; above its head in wooden letters the artist spells out *metempsychosis,* which is also the title he gave to the piece. He created as well colorful decorative crowns (which were not actually to be worn on the head) of metal, wood, and plastic, and wooden signs depicting large-breasted Amazons dominating men, such as his "tufgh" women tableaux, labeled *Bully Gits Sat On* and *Kathy Tames a Bully.*

A prolific and accomplished abstract artist, Jennings felt that his art reflected his dreams, which he said he never forgot, as well as his interests in old movies and reading. He loved primary colors, and painted his wood constructions using outdoor paint. One large and complex work, *James Harold Jennings Arts,* incorporates a colorful tableau of Indians, totem poles, and animals. In his later works, the artist used a wider range of color and applied this color using small dot patterns. Jennings said that his art gave him

a feeling of self-respect. The artist died on April 20, 1999, his sixty-eighth birthday, of a self-inflicted gunshot wound.

See also **Religious Folk Art; Sculpture, Folk; Whirligigs.**

BIBLIOGRAPHY

Lampell, Ramona, Millard Lampell, and David Larkin. *O, Appalachia: Artists of the Southern Mountains.* New York, 1989.

Manley, Roger. *Signs and Wonders: Outside Art Inside North Carolina.* Raleigh, N.C., 1989.

Yelen, Alice Rae. *Passionate Visions of the American South: Self-Taught Artists from 1940 to the Present.* New Orleans, La., 1993.

JOHN HOOD

JENNYS, RICHARD (c. 1734–c. 1809) was a portrait painter whose earliest known work is a mezzotint portrait of a Boston pastor, painted about 1765. Educated at the Boston Latin School, where his classmates included a son of painter John Smibert (1688–1751), Jennys' mezzotint bears a similarity to Smibert's work, raising the likelihood that he received some training from the older artist, or, at least, had used Smibert's portraits as self-teaching aids. Jennys married Sarah Ireland in 1770; the union produced five children, including William (1774–1859), who trained as a painter with his father and accompanied him on painting trips.

Debt probably prompted Jennys' moving to Charleston, South Carolina, where he advertised "Portrait painting in all its branches." He made a trip to the West Indies and another to Boston, before moving to Savannah, Georgia, where he stayed from 1785 to 1791. Despite his long sojourn in the South, none of Jennys' portraits from the area have been identified.

About 1787 Richard and Sarah Jennys divorced, and in 1791 Jennys left Savannah for New Haven, Connecticut. There, besides his adding of "chaise and other painting" to his repertoire, Jennys advertised the opening of his school, where he offered to teach "Drawing and Painting Flowers, Birds, Landscapes, or Portraits." Clearly, Jennys found it difficult to sustain a livelihood from portraiture alone in New Haven, and like so many other artists, he turned to other branches of painting for income.

From 1794 to 1798, however, Jennys, along with son William, enjoyed modest success painting portraits in New Milford, Connecticut. His sitters were among New Milford's most prominent citizens, and the success Jennys achieved in New Milford indicates that the local gentry embraced his realistic style. The portraits follow the formula he used for his early mezzotint portrait: half-length likenesses in three-quarter poses, with dark backgrounds and surrounded by painted spandrels. Jennys was adept at creating well-modeled faces with blended facial tones, although arms and hands are unconvincingly rendered.

Despite his itinerancy, which often characterizes folk painters, it would be erroneous to classify Jennys as a folk painter. He was aware of academic models, and followed them more closely than painters of lesser ability. Jennys' competent, if prosaic, portraits fall within a gray area, which may explain why his work has not received greater attention.

Jennys worked in Newburyport, Massachusetts, and the surrounding area from 1804 to at least 1809. The place and the date of his death are unknown.

See also **William Jennys; Painting, Landscape; John Smibert.**

BIBLIOGRAPHY

Benes, Peter, ed. *Painting and Portrait Making in the American Northeast.* Boston, 1995.

Little, Nina Fletcher. *Paintings by New England Provincial Artists, 1775–1800.* Boston, 1976.

RICHARD MILLER

JENNYS, WILLIAM (1774–1859) painted stylish, neoclassical portraits that exhibit a level of sophistication not generally associated with folk art. He traveled widely, and the large number of surviving works indicate that his distinctive, if sometimes harsh, likenesses were popular from New England's coastal cities to its remote northern villages.

William Jennys was a son of painter Richard Jennys (c. 1734–c. 1809), and his artistic debt to his father is seen clearly in the strong similarity of his compositions to the elder Jennys'. Still, William introduced elements into his own portraits that distinguish his work. Sitters are illuminated by strong, single-source lighting placed high and casting deep shadows across sharply modeled faces with thinly applied, warm facial tones and a characteristic sheen. In many cases the paint has become transparent over time, revealing the gray ground below and making the faces look sallow and even more forbidding than Jennys' typically severe expressions. The flat spandrels extend beyond the edges of the picture plane in most portraits, while others are complete and painted to appear three-dimensional. The intricate and stylish costumes worn by Jennys' female sitters are very carefully rendered, often resulting in a profusion of painted folds and pleats competing with the subject's face for attention.

In 1793 Jennys placed an advertisement in a Norwich, Connecticut, newspaper, although he may have been working with his father in New Haven the year before. By about 1795 he and his father were working in the New Milford, Connecticut, area, where the two artists collaborated on several portraits. Jennys was listed in New York City directories for 1797 and 1798 as a "portraitist," and beginning about 1802, Jennys, sometimes accompanied by his father, completed commissions in the Connecticut River Valley towns of Massachusetts, before moving on to New Hampshire and Vermont. He also painted in Portsmouth, New Hampshire, and was working in Newburyport, Massachusetts, from 1804 until 1809, the year he lived in the Bahamas.

After returning to America, Jennys could no longer support himself and his family through painting, and the succession of occupations he engaged in suggest that he had difficulty making the transition to another livelihood. From 1810 to 1817, he worked as a comb maker and florist in New York City, before relocating to Littleton, New Hampshire, where he established himself as a dry goods merchant. Moving to Coventry, New Hampshire, in 1821, Jennys farmed and operated a tavern. He was back in New York City during the 1840s, where he died about a decade later.

See also **Richard Jennys; Painting, American Folk.**

BIBLIOGRAPHY

Benes, Peter, ed. *Painting and Portrait Making in the American Northeast*. Boston, 1995.

Rumford, Beatrix T., ed. *American Folk Portraits: Paintings and Drawings from the Abby Aldrich Rockefeller Folk Art Center*. Boston, 1981.

RICHARD MILLER

JEWISH FOLK ART, as a living tradition in the visual arts, was brought to the United States by mid-nineteenth century immigrants from Central and Eastern Europe. Although Jewish settlement in North America began in 1654, when twenty-three refugees from persecution in Brazil arrived in New Amsterdam, it was not until about 1850 that Jewish folk art would find vigorous expression in the United States. The earliest communities, which were composed principally of Sephardic Jews (Jews with a family heritage rooted in the Iberian Peninsula) were too small and distant from the centers of Jewish life and culture to maintain and transmit these vernacular practices. Having been uprooted from their ancestral homes in Spain and Portugal in the late fifteenth century, and having moved in succeeding generations to Holland, England, the West Indies, or Brazil before settling in North America, the early Sephardic settlers brought few artistic traditions with them.

There are examples of eighteenth-century and early-nineteenth-century American needlework samplers by Jewish women, but these relate more closely to Anglo-American rather than Judaic practices, even when the maker included Hebrew lettering in her work. A similar observation may be made about eighteenth century Jewish gravestones in America. If decorative elements are present at all, they generally mirror those of the contemporary grave markers of the majority population, their makers more often than not being Christian stone carvers. It is true that American *ketubbot* (Jewish marriage contracts) from the eighteenth century exist, but these tend to be almost entirely textual in nature, without the decorative embellishments that would come to typify the form later in American Jewish history. Documentary evidence demonstrates that America's earliest Jews participated in the domestic arts of their neighbors. Their faith was Jewish, but their cultural expression was American. With the arrival of large numbers of Ashkenazic Jews (Jews with ancestral roots in Central or Eastern Europe) in the mid-nineteenth century, Jewish folk art became part of the American Jewish experience.

Judaism is a religion of texts, from the words of the Bible to the legal and ethical tractates of the Talmud to the discourses of generations of rabbinic sages. As might be expected of a tradition that is tied closely to religious faith, much Jewish folk art is rooted in religious practice and ritual, and hence in text. Whatever the medium—paper, wood, or textile—a combination of text and ornamental elements almost invariably characterizes the work of art. This is not to imply that a rich body of symbolic and decorative motifs did not develop in Jewish folk art, but rather that the imagery tends to be closely related to the written word. Among the most commonly used ornamental figures, for example, are the four animals referred to in Avot, or the Ethics of the Fathers, a popular Jewish text: "Be as strong as a leopard, light as an eagle, swift as a deer and brave as a lion to do the will of our Father in heaven" (Ethics of the Fathers, 5:23).

Cultural historians often consider Judaism to be iconoclastic and ambivalent to the visual arts. Although it is incorrect to suggest that the Jewish faith has abjured the use of figural representation, rabbinic interpretation of the Second Commandment's prohibition against graven images has in various times and places limited the iconographic repertoire available to Jewish artists. Over time, these limitations challenged artists to discover an acceptable iconography in Scrip-

ture, Jewish lore, and popular wisdom, the result of which was the development of a distinctive body of visual materials that appear in many Jewish folk art expressions. While folk art in general tends toward abstraction and two-dimensionality, Jewish folk artists use these conventions to transfer imagery from the real world, which might be considered contrary to more stringent religious scruples, to the acceptable realm of symbols.

The combination of text and imagery that typifies Jewish folk art may be demonstrated by the *mizrah* (from the Hebrew word for "east"), a decorated sign or marker on paper that is placed on the eastern wall of a dwelling or community building, to indicate the proper direction of prayer according to Jewish tradition. *Mizrahim* were among the first Jewish folk art forms to be produced in the United States, the earliest examples dating to about 1850. Drawing from Central and Eastern European precedents, the makers of American *mizrahim* often used intricately cut paper and ink, and occasionally watercolors, to create complex symbolic displays. The dominant element in these works invariably is the word *mizrah* in Hebrew characters, often with other textual materials. American examples occasionally include patriotic motifs. At least one *mizrah*, a well-known work (1850) by Moses H. Henry (dates unknown) of Cincinnati, is replete with a comprehensive gathering of Masonic symbols. Another American *mizrah* is by the micrographer, a writer of texts written in tiny characters to create portraits, representations of objects, architectural devices, abstract forms, or other figures, David Davidson (1812–?), who advertised himself as an "Artist in Penmanship." Made in Baltimore in 1851, it employs cut paper, brilliant watercolors, and Hebrew calligraphy in gold.

Similar in function to a *mizrah* as a sign or marker, but generally with more elaborate texts, is another category of Jewish works on paper called the *shiviti*, which is often used as a decoration in a synagogue to underscore the sacred nature of the place. The name is derived from the first of the Hebrew words in a verse from the Book of Psalms, which is the principal textual emphasis of this form: "*Shiviti Adonai le-negdi tamid*," or "I am ever mindful of the Lord's presence" (Psalms, 16:8). The *shiviti* is a common folk art expression in much of the Jewish world. A delicate paper-cut *shiviti* (1861) by Philip Cohen is one of the earliest known American examples. In addition to conventional Jewish design elements, Cohen included representations of two American flags in this intricate work.

Western and Central European Ashkenazim brought another Jewish folk art form to the United States in the mid-nineteenth century: the Torah binder, or *wimpel*. To create a Torah binder, the cloth (generally linen) that was used during a circumcision ceremony is cut into narrow strips that are then sewn end to end and embroidered or painted. With inscriptions that generally include the child's name, as well as a blessing in Hebrew from the circumcision service that he grow up with the study of Torah, perform good deeds, and marry, the binder often contains individualistic and exuberant decorations. Several nineteenth-century examples incorporate images of the American flag along with English texts. It was the practice to present the Torah binder to a synagogue at an appropriate occasion, such as the child's first visit. In some communities the *wimpel* was later used to wrap the scrolls of the Torah at the child's bar mitzvah, the ceremony marking his religious majority at the age of thirteen years.

Among other Jewish textile traditions finding expression in America beginning in the nineteenth century were the creation of embroidered cloths: challah covers, which are used to cover the festive Sabbath loaves; matzo covers, which are placed on unleavened bread during the Passover ritual meal; tablecloths for Sabbath and holiday dinners; and *tallit* bags for carrying the prayer shawls worn by men during synagogue services. Jewish women also have participated in various kinds of ornamental needlework, including quiltmaking that was not necessarily Judaic in content. In the late nineteenth and early twentieth centuries, several Jewish tailors used silks and satins from the lining of suit jackets and ties to create decorative bed coverings. One of these, an appliqué quilt (c. 1887) by Adolph Schermer (1846–1934) of New York, incorporates a Star of David and an American flag into its decorative motifs.

Micrography, a Jewish art form dating back to the ninth century, is yet another example of Jewish folk art's emphasis on the written word. Micrographic texts are so minute that the words themselves are not apparent except on very close examination. Only the images formed by the letters are immediately visible to the eye. In the mid-nineteenth century the aforementioned David Davidson brought this Jewish tradition in the visual arts to the United States from his home in Russian Poland. Using micrographic biblical texts in Hebrew or English, he created a wide variety of images, including portraits of prominent Americans and renderings of important buildings. The practice of micrography continues in traditional Jewish communities to this day.

The art of paper cutting was well established in Europe by the eighteenth century. Popular in Jewish communities in Europe, North Africa, and the Middle East, paper cuts were usually created by using a knife on a sheet of paper that was folded in half. The resulting symmetrical composition was then set off against a black or colored background. Most surviving American Jewish paper cuts date from the late nineteenth and early twentieth centuries, although several date from as early as the 1860s and 1870s. Often intricate in design and execution, paper cuts may be found in a variety of forms; for example, a pen-and-ink *mizrah* embellished with watercolor ornamentation might also include paper-cut elements as part of its overall design. Bernard Ring (1870–1927) of Rochester, New York, is especially celebrated for the excellence of his paper cuts. Between 1904 and 1917 he created a series of meticulous *yortsayt* (a Yiddish term meaning "year time," or the anniversary of the death of a close relative) records, *mizrahim,* and other illuminated documents that were admiringly displayed in synagogues. A *sofer stam* (a Hebrew word meaning "scribe"), Ring was trained in the practice of inscribing scrolls of the Torah and other sacred texts required for Jewish religious practice and ritual.

Many forms of Jewish folk art relate to events in the traditional cycle of life, such as the *ketubbah,* or marriage contract. Although examples with minimal decoration may be found in early America, by the mid-nineteenth century fully illuminated *ketubbot* were being produced in the United States. A well-known example from Utica, New York, made in 1863 by Zemeh Davidson (dates unknown), includes images of clasped hands, a crown, and two clock faces, all in ink and watercolor. The text of the *ketubbah,* which is traditionally written in Aramaic, contains the names of the bride and groom and outlines their mutual obligations, especially that of husband to wife. The first *ketubbot* date back to 440 BCE. Illuminated examples may be found virtually everywhere that Jews have settled.

In Jewish religious practice it is customary for special prayers to be recited on the anniversary (according to the Hebrew calendar) of the death of close relatives. That anniversary, or *yortsayt,* is often recorded in a document with appropriate decorative elements. The first American examples date to the late nineteenth century, and may include cut paper and watercolor, together with floral imagery and figures of lions, eagles, deer, and other animals, and columns and gates, trees, and candles. Akin to these memorial records, a tradition of family records also exists within Jewish folk art. In these illuminated records, marriages and births and sometimes deaths are inscribed. The family record (1888) of Joseph Zelig Glick (1852–1922) of Pittsburgh is perhaps the earliest known American example. Created by Glick with ink and cut and painted paper, this colorful family record is unusual in its asymmetry. It depicts intricately curved and branched tendrils growing from a single branch, which also sprouts a variety of flowers, leaves, and fruit. The artist may have intended to represent a bough from the tree of life, a major theme in Eastern European Jewish folk art. The tree of life also dominates the appealing family record that Isaac S. Wachman created in 1922 in Milwaukee, to celebrate the marriage of David and Ida Goodman and the birth of their son, Jacob.

Upon the arrival in the United States of large numbers of Eastern European Jews that commenced in the last two decades of the nineteenth century, communal organizations modeled on European patterns were established in American Jewish communities. In the *shtetlach* (Yiddish for "small towns" or "villages") of Eastern Europe, Jewish life was organized into *hevrot,* associations having specific religious, charitable, or trade functions. Each *hevrah* recorded its rules and regulations, the names of its founders and members, and the minutes of its meetings in a *pinkas,* or register. The members of the community treated the register with veneration. Because of their importance, the pages of early European *pinkasim* were often parchment and bound in fine leather with gold lettering, but most American *pinkasim* are standard large blank journal or account books purchased from commercial stationers. Professional scribes, or *sofrim,* often entered the proceedings of the *hevrah* in the register, sometimes employing the same style of lettering used in scrolls of the Torah. The title pages and section headings of a *pinkas* were frequently illuminated with fine ornamentation and drawings, fanciful folk figures of animals and zodiac signs, and decorated Hebrew letters. A key to the communal affairs of Eastern European Jewry in the United States, the *pinkas* frequently represents a striking example of folk art itself. It was in the nature of American life that other forms of community organization would quickly supplant many traditional *hevrot,* but *pinkasim* recording their activities survive. In one example from 1911–1912, which documents a group within Philadelphia's Congregation Atereth Israel, the artist, Benjamin J. Wexlar, surprisingly substituted a pair of northwest coast Indian totem poles as a decorative element in place of the more conventional columns.

Many Jewish immigrants from Eastern Europe came from heavily forested regions, and skills in woodcarving were well developed among them. Wooden synagogues could be found in villages throughout much of Ukraine, White Russia, Poland, and Lithuania, with intricately carved and painted interiors. As a result of the ravages of war and the Holocaust, almost none of them survive, but photographs and descriptions demonstrate the elaborate nature of their reader's platforms, Torah arks, and pulpits, with mazes of pillars, vines, candelabra, traditional animals, and other Judaic symbols in meticulous carved openwork. Jewish woodcarvers brought these skills and design repertoires with them to the United States and utilized them to create works of art in both sacred and secular settings. Among the objects traditionally employed in synagogue decoration are representations of a pair of rampant lions that flank carved tablets of the law. Placed above or on either side of the "ark"—a closet- or cupboard-like structure or niche in which the scrolls of the Torah are kept—carved lions are so common as to give rise to an astonishing variety of leonine depictions. Indeed, lions are among the most familiar motifs in all classes of Jewish folk art. Other conventions include using carved eagles as the topmost decoration of Torah arks. Cast in the role of guardian, they often are placed above a carved "Crown of Torah." An 1899 carved Torah ark from Congregation Adath Jeshurun in Sioux City, Iowa, the work of Abraham Schulkin, not only includes rampant lions and the tablets of the law but also an impressive figure of a large dove with outspread wings, intricate low-relief carving of dense foliage, and representations of a crown and a pair of hands, the fingers of which are opened in the traditional gesture of priestly blessing. Jewish folk artists also carved *groggers* (Yiddish for "noisemakers"), for use on the holiday of Purim; charity boxes; and other ritual objects.

Marcus Charles Illions (1865–1949), who was born in Vilna, Lithuania, in 1865, and came to the United States at the age of seventeen, was one of several Jewish woodcarvers who used skills acquired in Europe to carve carousel horses, ornamental facades for public buildings and private residences, and trade signs. Others include Charles Carmel (1865–1931), Solomon Stein (1882–1937), and Harry Goldstein (c. 1882–1945). Illions, who was associated with the development of the exuberant "Coney Island" style of carousel carving and generally recognized for that aspect of his work, is known to have also undertaken commissions for ornamental carving in synagogues, producing Torah arks and decorations.

By the end of the first half of the twentieth century, many traditional Jewish folk art practices were lost, the result of assimilation and acculturation. In some cases, the production of folk art did not survive the immigrant generation. After a period of neglect, however, a revival of many Jewish traditions in the visual arts is under way. The arts of paper cutting and manuscript illumination are again being practiced, and the arrival of a new generation of immigrants is providing renewed inspiration. The twentieth and now the twenty-first centuries have also witnessed creative expression by Jewish self-taught artists, who often bring to their painting and sculpture an interest in exploring Jewish themes. Among them are Meichel Pressman (1864–1953), Israel Litwak (1868–1952), Morris Hirshfield (1872–1946), Zelig Tepper (1877–1973), Harry Lieberman (1880–1983), Samuel Rothbort (1882–1971), Sophy Regensburg (1885–1974), and Malcah Zeldis (1931–).

See also **Charles Carmel; Carousel Art; David Davidson; Morris Hirshfield; Marcus Charles Illions; Harry Lieberman; Israel Litwak; Papercutting; Meichel Pressman; Religious Folk Art; Malcah Zeldis.**

BIBLIOGRAPHY

Kleeblatt, Norman L., and Gerard C. Wertkin. *The Jewish Heritage in American Folk Art*. New York, 1984.
Shadur, Joseph, and Yehudit Shadur. *Traditional Jewish Papercuts: An Inner World of Art and Symbol*. Hanover, N.H., 2002.
Ungerleider-Mayerson, Joy. *Jewish Folk Art: From Biblical Days to Modern Times*. New York, 1986.

GERARD C. WERTKIN

J. HARRIS & SONS (later A.J. HARRIS & CO., and HARRIS & CO.) was a Boston weathervane manufacturer that operated from 1868 to 1882. While it dealt principally in weathervanes, it also manufactured metal railings with finials and crestings, as well as decorative, metal garden items. The owners were Josephus Harris (dates unknown) and his son, Ansel J. Harris (dates unknown) of Brattleboro, Vermont, who were the highest bidders, at $7,975, for the Waltham Massachusetts weathervane manufacturer, A.L. Jewell & Co., at an auction in September 1867. When Harris was unable to offer adequate security, the Jewell company was purchased by Leonard Cushing (d. 1907) and Stillman White (dates unknown). Nevertheless, Harris & Sons soon became a weathervane manufacturer in Boston. It was the first company to design a durable iron mold, which was adopted extensively throughout the industry, making mass-production of weathervanes possible.

Myrna Kaye, a weathervane researcher, located company catalogs published in Boston about 1870, 1875, and 1879. In its 1879 catalog (with thirty-three pages devoted solely to weathervanes) a vane of *Massasoit,* the Native-American chief of the Wampanoags tribe known for befriending the Plymouth, Massachusetts, colonists, was featured. Made of cooper and gilded, it stood thirty inches high, and depicted a proud warrior with a bow and arrow, standing beside a sculpted log and greenery, to suggest the woodlands. Its design is in the tradition of the cigar store Indian shop figures. An identical woodland setting was used in a Harris company deer vane. Harris also produced an image of the famous Morgan horse, *Black Hawk,* which had won many trotting races in the 1840s. The vane, while commemorating this champion, was also often purchased by horse-farm owners, to serve as a trade sign. Harris also produced a popular weathervane of *Smuggler,* a horse that was a natural pacer and also won many trotting races. Additionally, setter dog vanes were manufactured, as was an image of a stork, a rare subject for a weathervane. The Harris firm invited custom work as well, advertising, "We also make Vanes of any desired pattern from Architects' plans or other drawings. Vanes carefully packed for exportations. Vanes for home trade are also packed with care, and shipped to all parts of the country."

See also **A.L. Jewell & Co.; Cushing and White; Shop Figures; Weathervanes.**

BIBLIOGRAPHY

Kaye, Myra. *Yankee Weathervanes.* New York, 1975.
D'Ambrosio, Paul S. "Sculpture in the Sky." *Heritage, The Magazine of the New York Historical Association,* vol. 2, no. 2 (winter 1995): 4–11.
Miller, Steve. *The Art of the Weathervane.* Atlgen, Pa., 1984.

WILLIAM F. BROOKS JR.

J. HOWARD (also known as J. Howard & Co., as well as J. & C. Howard) was a weathervane company operated from West Bridgewater, Massachusetts, in the mid-nineteenth century. The company was owned and operated by Charles Howard (1817–1907) and a J. Howard, who has been variously identified as Jonathan Howard (1806–1889), or his son, John Williams Howard (1836–1865). The vanes themselves were of an unusual construction. They were often made of combined zinc castings, hollowed copper, and corrugated-sheet copper. Many of the vanes carried the maker's mark, "*Made by J. Howard & Co. W. Bridgewater Mass.*"

A price list from the mid-nineteenth century, titled "Wholesale Price List of Vanes Manufactured by J. Howard & Co., West Bridgewater, Mass.," records numerous designs and their cost, together with the notation, "All Vanes manufactured by Howard & Co. are warranted Copper, and gilded with the best Sign Gold." In time, the gold gild disappeared from the zinc castings, and the vanes are often in need of re-gilding. The designs listed on the price list included large and small cows, oxen, a rooster, peacock, and deer; horses, numbered 1 to 3; church vanes, numbered 1 to 4; a horse and gig; a horse leaping through a hoop; a Lady Suffolk horse; a codfish; a greyhound; a plow; a locomotive; "fancy" vanes, numbered 1 to 6; a large dart; small darts, numbered 1 and 2; and an academy vane (probably a quill). Prices ranged from four to thirty dollars. Correspondence from July and September 1850 between the firm of Ruggles, Nourse, Mason & Co. and Charles Howard III reveals that J. Howard also produced hound weathervanes.

Myrna Kaye conducted extensive research in 1982, and her findings, appearing in an article published by *Maine Antique Digest* in August 1982, revealed that J. & C. Howard advertised in March 1854 in the weekly *Gazette* of North Bridgewater, offering "church and fancy vanes," and was additionally listed in several reporting publications until 1867. In a 1855 census Charles Howard III is listed as a "manufacturer of vanes," while Jonathan Howard is listed as a "farmer" in both the 1855 and 1865 census. Jonathan's son, John Williams Howard, is listed as a "vane maker" in the 1855 census, and as a "clerk" in the 1865 census.

See also **Weathervanes.**

BIBLIOGRAPHY

Christensen, Erwin O. *The Index of American Design.* New York, 1950.
Fitzgerald, Ken. *Weather Vanes and Whirligigs.* New York, 1967.
Klamkin, C. *Weathervanes: The History, Design, and Manufacture of an American Folk Art.* New York, 1973.
Kaye, Myrna. "The Many Directions of J. Howard, Weathervane Maker." *Maine Antique Digest,* vol. 10, no. 8 (August 1982): 10A.
Miller, Steve. *The Art of the Weathervane.* Exton, Pa., 1984.

WILLIAM F. BROOKS JR.

JOB (active c. 1850) was, according to tradition, a freed African American slave from Freehold, New Jersey, who created a highly distinctive painted woodcarving of a cigar store figure in the collection of the New York State Historical Association, Cooperstown, New York. In this carving of an Indian woman, formerly in the collection of Jean and Howard Lip-

man, the artist displays his awareness of conventional cigar store figures, through the pose, costume, and bunches of cigars. The masklike face and abstracted body are bold departures from convention, however, and may reflect the carver's African roots. Another distinctive feature of the figure regards the method of construction, namely the careful joining of thirteen separate pieces of wood to make the whole. Cigar store figures were generally carved out of a single log, with arms often added separately. The unusual construction of the figure also suggests knowledge of the lamination process used in furniture construction.

See also **African American Folk Art; New York Historical Society; Sculpture, Folk; Shop Figures.**

BIBLIOGRAPHY

Lipman, Jean. *American Folk Art in Wood, Metal, and Stone*. New York, 1972.

Lipman, Jean, and Alice Winchester. *The Flowering of American Folk Art, 1776–1876*. New York, 1974.

PAUL S. D'AMBROSIO

JOHN MICHAEL KOHLER ARTS CENTER (JMKAC), established in 1967 in Sheboygan, Wisconsin, has supported the objects and environments made by self-taught, vernacular artists, and folk artists since its inception. Today JMKAC is one of the largest and most diverse arts institutions in the midwestern United States, widely known for its support of innovative explorations from a broad range of artists—academically-trained, communally-trained, and untrained artists—with a particular concentration on art forms and artists that have received little critical attention or support.

JMKAC's permanent collection, comprised of several thousand works of art, concentrates on relatively large bodies of work by self-taught, vernacular, and folk artists, particularly those that were initially envisioned as part of a cohesive art environment but could not be preserved as such, including several hundred works by Eugene Von Bruenchenhein (1910–1983), the home and wardrobe of "The Original Rhinestone Cowboy" Loy Bowlin (1909–1995), the primary collection of works from Carl Peterson (1869–1970), and smaller collections of work from the environments of David Butler (1898–1997), Peter Jodacy (1884–1971), and Albert Zahn (1864–1953).

Other works in this collection include objects that have extenuating reasons for being cared for in an institutional setting, such as the oeuvre of Levi Fisher Amers (1843–1923) that includes over six hundred hand-carved animals set in shadow boxes that the artist had developed as a traveling tent-show-style environment. Nek Chand Saini's (1924) *Rock Garden of Chandigarh* in Chandigarh, India, is still extant but the artist, concerned with long-term preservation, aided JMKAC in selecting nearly 200 pieces to be included in the collection. Selections from Fred Smith's (1886–1988) *Wisconsin Concrete Park* and Nick Engelbert's (1881–1962) *Grandview* were placed in the collection for similar reasons. Mary Nohl (1914–2001) is another artist that selected hundreds of paintings, drawings, and sculptures that were no longer installed in her vernacular art environment for JMKAC's collection. A large collection of Hmong textiles, jewelry, and musical instruments are included in the collection to represent the largest local minority population and their ongoing traditional arts. And several hundred pieces made or collected by Adolph Vandertie (1911–?) chronicle the history of tramp and hobo carving styles and traditions of the region.

Though separate entities, JMKAC works with nearby plumbingware factory Kohler Co. to support the arts through an internationally attended artist's residency program and in preservation efforts. Since the establishment of the company's preservation foundation (Kohler Foundation, Inc.) in the 1970s, JMKAC has served as curator for the foundations projects. KFI, in conjunction with JMKAC, has orchestrated the conservation of, and subsequently offered as gifts, numerous art environments and bodies of work, in Wisconsin and other states, to local governments and not-for-profit organizations. KFI is internationally recognized as one of the leaders in folk and vernacular art and architecture preservation. Together the two institutions work toward the preservation, study, and exhibition of objects and environments by self-taught makers, thus drawing them into the context of contemporary American culture as a whole.

See also **African American Folk Art (Vernacular Art); Asian American Folk Art; David Butler; Environments, Folk; Hmong Arts; Fred Smith; Tramp Art; Eugene Von Bruenchenhein; Yard Show; Albert Zahn.**

BIBLIOGRAPHY

Dihoff, Charlotte, ed. *The Encyclopedia of the Midwest*. Bloomington, Ind., 2003.

Feldman, Michael. *Wisconsin Curiosities*. Guilford, Conn., 2000.

Sellen, Betty-Carol, and Cynthia J. Johanson. *Self Taught, Outsider, and Folk Art: A Guide to American Artists, Locations, and Resources*. Jefferson, N.C. and London, 2000.

LESLIE UMBERGER

JOHNSON, ANDERSON (1915–1998) was an African American preacher who created his own chapel, Faith

Mission, in Newport News, Virginia, and filled it with portrait paintings. He preached and sang in this environment, and transmitted the African American religious experience through his folk art.

Born August 1, 1915, in Lunenburg County, Virginia, he was eight years old when he had a vision of two angels holding a large, open, leather-bound book. He took this to mean that God was calling him to be a preacher, and at a young age he traveled all over the United States, playing his guitar and preaching in churches and on the street. While Johnson had little formal education, he was a devoted student of the Bible, and he hoped one day to have his own church.

In the 1970s he returned to Newport News to live with his mother. When she died in 1984, Johnson transformed the house into the Faith Mission, which was to become his own church. He constructed a stage on which he sat playing his guitar and drums, he set up pews for his parishioners, and he fashioned a pulpit for Sunday prayer meetings from painted wood, egg cartons, Styrofoam, rayon ribbons, house paint, nails, and plastic ice trays.

The most striking elements in the mission were the hundreds of portrait paintings on the walls and hanging by string from the ceiling, which he considered his congregation. These "parishioners" were dressed as if attending church: the men in suits and ties and the women in their Sunday best, often wearing hats. There were also large paintings of a black Jesus, and portraits of Washington, Lincoln, John and Jacqueline Kennedy, and Martin Luther King Jr. He painted with house paint and acrylic on found materials, such as cardboard, wallboard, wood paneling, countertops, canvas, and paper, creating several thousand portraits. In addition, he covered the exterior of the mission with quotations from the Bible, and painted a sign by the door that read, "Elder Anderson Johnson."

Johnson's music was another facet of his creativity. He played his guitar, electric piano, and drums on the stage, and sang gospel songs and the blues. Johnson sang and preached with a fervor rooted in his faith in God and his fundamentalist belief in Scripture.

When his house was condemned because of urban renewal, there was a public outcry to save the Faith, which resulted in a grant to save Johnson's creations. Although it was impossible to replicate the intensity as well as density of the art of the Faith Mission, those works that were saved bear eloquent witness to Johnson's creativity.

See also **African American Folk Art; Environments, Folk; Religious Folk Art.**

BIBLIOGRAPHY

Miller, Richard. "The Faces of Anderson Johnson." *Folk Art Messenger,* vol. 4 (winter 1991): 1–3.
Oppenheimer, Ann. "Anderson Johnson, 1915–1998." *Folk Art Messenger,* vol. 2 (summer 1998): 23.
Yelen, Alice Rae. *Passionate Visions of the American South: Self-Taught Artists from 1940 to the Present.* New Orleans, La., 1993.

John Hood

JOHNSON, JAMES E. (c. 1810–1858), portrait artist, lived and worked in New York State in the mid-nineteenth century. Nothing is known about his early life or how he initially developed an interest in painting likenesses. According to Ruth Piwonka and Roderic H. Blackburn, who researched and wrote the seminal work on Johnson published in 1975, the artist was born about 1810 in Sandy Hill, New York. He appears to have begun working as an artist in the 1830s, as at least eight portraits have been recorded from this decade, all depicting residents of Spencertown, New York.

His earliest known composition, dating from 1831, depicts a Mrs. Johnson, who may be the artist's mother. Census records indicate that by 1846 Johnson was living in Kinderhook, New York, in Columbia County. In 1852 he married local resident Sarah Ann Van Vleck, who was from a prominent agricultural family. Seventeen portraits of Kinderhook citizens have been documented, including one of the artist's wife that dates from a year after their marriage. In 1855 the couple still resided in Kinderhook, as the census records list Johnson as an artist. Three years later, in 1858, James E. Johnson died at the age of 48.

Although only a handful of Johnson's likenesses have been located, the double portrait depicting Sherman Griswold and his wife, Lydia Dean, dating from about 1837, may be the artist's most ambitious composition. Measuring seven by four feet, the couple stands full-length in the foreground, their family homestead, the "Hatfield Farm," stretching out behind them in the background. Three sheep gather at their feet, being fed from a basket that Mr. Griswold holds in his hand.

A contemporary of Ammi Phillips (1788–1865), who also made portraits of Columbia County residents, Johnson executed his later compositions without the lightness of color and artistic finesse that made many of his competitors so successful. Instead, existing portraits suggest that the artist portrayed most of his patrons using the somber tones of a dark, muted palette. Subjects are often presented in spandrel surrounds, a Victorian convention borrowed, in part, from photography. Women are dressed in dark cloth-

ing and wear white lace bonnets. Men are portrayed in bust-length format, wearing black suits, and sitting in chairs that are cast against neutral backgrounds devoid of decoration or context.

See also **Ammi Phillips; Painting, American Folk.**

BIBLIOGRAPHY

Piwonka, Ruth, and Roderic H. Blackburn. *James E. Johnson, Rural Artist: A Catalogue of an Exhibition of Portraits by James E. Johnson, 1810–1858, of Columbia County,* N.Y. Kinderhook, N.Y., 1975.

CHARLOTTE EMANS MOORE

JOHNSON, JOSHUA (1767–1820s) is noted as an exceptionally talented portrait painter, one of the first identified as an African American to whom a surviving significant body of work can be attributed. Indeed, he has been the subject of extensive study since his rediscovery in the 1940s by Dr. Jacob Hall Pleasants of Baltimore, Maryland. In contemporary records, Johnson's name has been found spelled with and without the *t;* recent scholars have deleted it.

Johnson was the son of George Johnson and a slave mother whose identity has not been determined. In 1764 he was apprenticed to learn the trade of a blacksmith. Eighteen years later, he was manumitted and gained his freedom. Subsequently married within five years, he started a family, and sixteen years later began a career as a portrait painter. The extent of his artistic training is not known, but hints of the difficulties he faced are evident in this advertisement that appeared in the *Baltimore Intelligencer* on December 19, 1798 (one of his three known newspaper advertisements): "PORTRAIT PAINTING. The subscriber, grateful for the liberal encouragement which an indulgent public have conferred on him in his first essays in PORTRAIT PAINTING, returns his sincere acknowledgements. He takes the liberty to observe, that by dint of industrious application, he has so far improved and matured his talents, that he can insure the most precise and natural likenesses. As a self-taught genius, deriving from nature and industry his knowledge of the Art, and having experienced many insuperable obstacles in the pursuit of his studies, it is highly gratifying to him to make assurances of his ability to execute all commands, with an effect, and in a style, which must give satisfaction." Johnson's training as an artist has never been documented, but visual comparisons relate his work to the members of the Peale family active in the Baltimore region, including Charles Willson Peale (1741–1827), James Peale (1749–1831), and Charles Peale Polk (1776–

1822). Johnson very likely knew of portrait paintings by Polk, as the two used similar compositional devices and props, and were interested in both the physical and psychological relationships between sitters. Thus, Polk, who has never been legally documented as Johnson's master, can rather claim an artistic relationship.

Johnson is thought to have usually painted portraits of families seated on a sofa and depicted together on one large canvas. He frequently painted portraits of children, many of which survive and include his signature elements, such as books, fruit, and red shoes.

See also **African American Folk Art (Vernacular Art); Painting, American Folk; Charles Peale Polk.**

BIBLIOGRAPHY

Saltman, Jack, et al., ed. *Encyclopedia of African American Culture and History.* New York, 1996.
Simmons, Linda Crocker. *Charles Peale Polk, 1776–1822: A Limner and His Likenesses.* Washington, D.C., 1981.
Torchia, Robert, and Jennifer Bryan. "The Mysterious Portraitist Joshua Johnson." *Archives of American Art Journal,* vol. 36, no. 2 (1996): 2–7.

LINDA CROCKER SIMMONS

JOHNSTON, HENRIETTA (1675–1729) was the first known pastelist and professional female artist to work in the American colonies. She was born Henrietta de Beaulieu, the daughter of Cézar and Susanne (du Pré) de Beaulieu, French Huguenots who fled to England in 1685 to avoid persecution. In 1694 she married William Dering and moved to Ireland. Although the sophistication of her pastel drawings suggests that she may have had some formal training, nothing is known of her education. Her work has been compared to that of the Irish born artists Edmund Ashfield (d. 1700) and Edward Luttrell, who worked from 1690 to 1720. She may have been taught by both men.

Johnston's earliest known works were drawn about 1704 in Ireland. In 1705 she married again, to Gideon Johnston, who was to become commissary for the Bishop of London, at St. Philip's Church in Charles Town, South Carolina, in 1708. Evidence suggests that, once in Charleston, the artist supplemented the family income by drawing portraits of many of Charleston's French Huguenot residents and members of St. Philip's Church. Frustrated by debt and misfortune in South Carolina, Gideon Johnston wrote the bishop in 1709: "Were it not for the Assistance my wife gives me by drawing of Pictures . . . I shou'd not have been able to live."

Johnston's work can be divided into three periods: the Irish period (c. 1704–1705), the period in Charleston prior to Gideon's death (1708–1715), and the period between Gideon's death in 1716 and Henrietta's own death in 1729, during which she worked in Charleston and briefly in New York. Johnston is not known to have worked in any medium other than pastels on paper, although at least one of her portraits was later copied in oil by Jeremiah Theus. Nearly forty works attributed to Johnston survive, many of these in original frames with backboards signed and dated by the artist. In addition, many of the artist's sitters have been identified, some through original backboard inscriptions, including the fourth Earl of Barrymore, whose portrait Johnston completed in Dublin in 1704.

The extant Irish works are all waist-length portraits and show the most attention to detail of all her portraits, with well-defined facial features, lively and expressive eyes, attention to clothing, and dramatic background shading. Several of the Charleston portraits also retain characteristics of the Irish works, but most are bust-length, and some show less attention to clothing and facial details. Her adult female sitters are posed facing slightly left or right and are draped in either white or gold, with white, slightly ruffled borders forming a V-shaped neckline. Their hair is generally swept up, with ringlets falling over one shoulder.

Johnston's portraits became almost ethereal in the period immediately after her husband's death. Her subjects' faces lack the lively expression seen in earlier works, clothing details are not as clearly defined, and colors are less saturated, suggesting that the artist was either running low on supplies or was trying to complete the portraits quickly.

In their final period, Johnston's portraits vary in the quality of detail; while some of the later works exhibit a return to skillfully executed facial and clothing details, at least one reflects the ethereal quality seen immediately after her husband's death. The New York works feature the only known portraits of small children, both of which are closer to three-quarter length and include the children's arms and hands. The only landscapes attributed to Johnston are those used as backgrounds in these two portraits of children.

See also **Painting, American Folk; Painting, Landscape.**

BIBLIOGRAPHY

Batson, Whaley. *Henrietta Johnston: "Who greatly helped . . . by drawing pictures,"* Winston-Salem, N.C., 1991.

Middleton, Margaret Simmons. *Henrietta Johnston of Charles Town, South Carolina: America's first Pastellist.* Columbia, S.C., 1966.

Severens, Martha. "Who was Henrietta Johnston?" *The Magazine Antiques,* vol. CXLVIII, no. 5 (November 1995): 704–709.

JOHANNA METZGAR BROWN

JOHNSTON, JOHN (c. 1753–1818), a Bostonian, was trained as an ornamental painter—he and his brother-in-law Daniel Rea had a decorating business—but was also a talented portraitist and miniaturist. The account books of Rea & Johnston (1768–1803) are significant historical documents not only for the business of the ornamental painter but for arts and crafts in New England generally.

Johnston was one of eleven children of the japanner and organist Thomas Johnston. John's brothers Thomas Jr., William, and Benjamin were engaged in crafts and related trades, and his sister Rachel married Daniel Rea; but John was the best-known because of his competence as a portraitist, according to Coburn. When John was a teenager, his father died. With little formal education, he was apprenticed to John Gore, a sign painter and house painter, until 1773. The American Revolutionary War interrupted Johnston's career; he served under General Henry Knox with Richard Gridley's artillery regiment (1775), became a lieutenant and then a captain, fought in the Battle of Long Island (New York), and was wounded and taken prisoner by the British before being honorably discharged. Years later, he was elected captain of an artillery company and was known as Major Johnston; on January 17, 1795, he advertised in the *Columbia Centinel:* "Miniature Painting, Is performed at the room over Major Johnston's Painting Room, Court Street, where good likenesses, neatly painted, may be had upon reasonable terms."

Johnston joined Rea, who had taken over the business of Thomas Johnston Sr. Rea & Johnston painted signs, ships, houses, venetian blinds, cradles, chairs, and garden gates. In 1786, there was an entry on Paul Revere's account: "Aug. 23. To painting the backs of masonick chairs. /6/." In 1778, during the War, the firm charged Deacon Shem, Drowne, tinsmith, maker of the icon grasshopper weathervane on top of Faneuil Hall, 12/00: "To Cleaning old drowns picture," with a follow-up, "By error of Mr. Drowns picture, being never paid, 12." They also did business with the painter Ralph Earl in 1778, when he was in Boston. A schoolmaster was charged $1.25 for one day's work by one painter. Rea & Johnson painted signs (sometimes amusing) for several Bostonian tradesmen: William Caldwell, coppersmith; Kettle and Leach, founders; John Sealaring, saddler; James Yancey, auc-

tioneer; Joseph Ruggles, sailmaker; William Shattuck, merchant; Isaac White, tallow chandler. The firm also gilded picture frames for the joiner and cabinetmaker Samuel Stratford.

See also **Shem Drowne; Ralph Earl; Miniatures; Painting, American Folk; Trade Signs.**

BIBLIOGRAPHY

Coburn, Frederick W. "The Johnstons of Boston." *Art in America*, vol. 21, no. 1 (December 1932): 27–36.
———. "The Johnstons of Boston, Part Two." *Art in America*, vol. 21, no. 4 (October 1933): 132–138.
Dunlap, William. *History of the Rise and Progress of the Arts of Design*, vol. 111. New York, 1834, 1965; Boston, 1918.
Groce, George C., and David H. Wallace. *The New York Historical Society's Dictionary of Artists in America 1564–1860*. New Haven, Conn., and London, 1957.

LEE KOGAN

JONES, FRANK (c. 1900–1969), using blue and red pencil to represent smoke and fire, drew meticulously rendered, multistory, cell-like "devil houses" inhabited by what he called "haints" ("haunts," or ghosts) or "haint-devils"—stylized humans, animals, and birds, in rooms bordered by "devils' horns," though occasionally a devil hovers outside. Jones's iconography reflects his vision, experiences, and African American aesthetic and cultural traditions. His art spanned the last five years of his life, when he was serving a sentence at the state penetentiary in Huntsville, Texas. Clocks appear in much of his work; they may refer to a large clock in the prison yard, to the strict schedules in the prison, or, symbolically, to the passage of life, particularly for prisoners "doing time."

Jones was born in Red River County, Texas, near Clarkville. Before he was six, both parents left him. His mother had told him that he was born with a caul and therefore had second sight. According to Jones, this folk belief was borne out: he had his first vision at age nine and saw spirits throughout his life.

Jones's works, on typing paper salvaged from the trash in the office where he worked, were at first stiff forms with few figures but became more complex and detailed as his confidence grew. They were often signed with his prisoner's number, 114591, and later his name. In his mature style, the haints appear benign, but Jones said they smile "to get you to come closer . . . to drag you down and make you do bad things" (quoted in an unpublished paper by Dee Steed).

In 1964, the Texas department of corrections held its first annual art show. Major David Mathison, an officer at the Huntsville unit, brought Jones's art to the

attention of education officials, who encouraged Jones to submit a drawing; it won first prize. Murray Smither of Atelier Chapman Kelley, a gallery in Dallas, was impressed by Jones's talent and promoted his art.

In February 1969, Jones was granted parole (after having been turned down repeatedly), but one day before his release he entered the prison hospital with advanced liver disease. He died two weeks later. He had received some material benefits from his art—a radio, wristwatch, a Christian funeral—and had also achieved acceptance, for the first time.

Jones won prizes in "Art on Paper," a national exhibition sponsored by the Witherspoon Art Gallery of the University of North Carolina (1965); and the Seventeenth Exhibition of Southwestern Prints and Drawings, organized by the Dallas Museum of Art (1968). His drawings are at the American Folk Art Museum (New York) and Smithsonian American Art Museum (Washington, D.C.).

See also **African American Folk Art (Vernacular Art); Prison Art.**

BIBLIOGRAPHY

Adele, Lynne. *Black History/Black Vision: The Visionary Image in Texas*. Austin, Tex., 1989.
———. *Spirited Journeys: Self-Taught Texas Artists of the Twentieth Century*. Austin, Tex., 1997.
Devil Houses: Frank Jones, Drawings. Philadelphia, Pa., 1992.
Perry, Regenia. *Free within Ourselves: The African-American Artists in the Collection of the National Museum of American Art*. Washington, D.C., 1992.
Rosenak, Chuck, and Jan Rosenak. *Museum of American Folk Art Encyclopedia of Twentieth-Century American Folk Art and Artists*. New York, 1990.

LEE KOGAN

JONES, LOUIS C. (1908–1990) guided the development of one of the most important folk art collections in the United States, at the New York State Historical Association in Cooperstown, New York. A graduate of Hamilton College, with a Ph.D. in English literature from Columbia University, Jones had a distinguished career at Albany State Teacher's College, where he taught English and American folklore. He came to the Historical Association as director in 1948, when the institution was entering a period of rapid growth following World War II. Working with benefactor Stephen Carlton Clark, Jones oversaw the addition of thirteen pieces from the Nadelman collection in 1948; more than 250 works from the Jean and Howard Lipman collection in 1950; and 175 paintings from the Mr. and Mrs. William J. Gunn collection in 1958. He created and fostered a variety of innovative educational programs that greatly advanced the fledgling

folk art field, including seminars on American culture as well as the Cooperstown Graduate Programs in History, Museum Studies, and American Folklore.

Jones was fascinated with folklore and ghostlore. His interest in the latter led him to publish *Spooks of the Valley* (1948) and *Things That Go Bump in the Night* (1959), which focuses on traditional folklore about ghosts and ghost hauntings in New York State. Jones also had a strong interest in historical murders, which was the inspiration for his book *Murder at Cherry Hill*. Along with his wife, Agnes Halsey Jones, a folk art scholar in her own right, Jones published *New-Found Folk Art of the Young Republic* (1960). Other important contributions include *The Triumph of American Folk Art* (1975), and the creation of a 30,000-slide archive of folk art images from across the United States, taken on a yearlong trip with his wife from 1972 to 1973. One of Jones's most important contributions was the course on American folk art that he and Mrs. Jones taught in the Cooperstown Graduate Program in the 1970s and 1980s, which inspired dozens of folklorists and folk art historians.

See also **Jean Lipman; Elie Nadelman; New York State Historical Association.**

BIBLIOGRAPHY

Jones, Louis C. *Three Eyes on the Past: Exploring New York Folklife.* Syracuse, N.Y., 1982.

Jones, Louis C., and Agnes Halsey. *New-Found Folk Art of the Young Republic.* Cooperstown, N.Y., 1960.

PAUL S. D'AMBROSIO

JONES, SHIELDS LANDON (1901–1997), recognized as one of America's most important folk carvers of the twentieth century, was born, raised, worked, and made art in the Appalachian Mountains of West Virginia. He is best known for his carvings of figures in wood and his stylized drawings. Jones was also an accomplished mountain fiddler. He attended school for eight years, and in 1923 he married Hazel Boyer; they had two sons and two daughters. He worked on the Chesapeake and Ohio Railroad from 1918 until retiring as a shop foreman in 1967. Upon retirement and his wife's death in 1969, Jones built a workshop and took up carving along with fiddle playing with country bands. In 1972 he married Madeline Miller.

Jones started carving small animals and winning ribbons at country fairs. In 1975 he began to make larger carvings, and heads. His figures, whether carved or drawn, male or female, are readily recognizable. He carved yellow poplar, maple, and walnut, and decorated his carvings with paint; they measure up to four feet in height. Jones's drawings, however, are seldom larger than twelve by eighteen inches, and those drawings made with pen, ink, and crayon feature solid, boxlike human figures with an open, friendly expression and large lips. The animals he draws are realistic, yet have a smiling, anthropomorphic character. The color and shading of his drawings is soft and subtle.

Jones carved and drew what he knew. Growing up on a small farm in Appalachia with twelve siblings, he hunted and trapped animals, was good at making things, and liked whittling. For his carvings Jones used a properly aged log, which he first shaped roughly with a chainsaw, and then he sculpted details with chisel and knife. His early carvings were unpainted, but he eventually started to use paint, stain, and pencil to enhance them. His mature style often featured three country musicians, playing violin, banjo, and guitar, some measuring more than three feet in height. He made other figures of standing men and women, as well as busts from the shoulders up. All are solid, stoic, and powerful images with thick lips and necks. The men often sport a red bow tie, with arms carved separately and articulated like toy soldiers. The women are generally solid and full-breasted.

A formal yet friendly man, Jones was proud of his work and the attention it received. Illness in his later years made his carvings and drawings less precise, but Jones nevertheless continued to make art, and to show visitors his workshop and his recent works.

See also **Sculpture, Folk.**

BIBLIOGRAPHY

Hartigan, Lynda Roscoe. *Made with Passion: The Hemphill Folk Art Collection.* Washington, D.C., and London, 1990.

Lampell, Ramona, et al. *O Appalachia: Artists of the Southern Mountains.* New York, 1989.

Rosenak, Chuck, and Jan Rosenak. *Museum of American Folk Art Encyclopedia of Twentieth-Century American Folk Art and Artists.* New York, 1990.

Yelen, Alice Rae. *Passionate Visions of the American South: Self-Taught Artists from 1940 to the Present.* New Orleans, La., 1993.

JOHN HOOD

JORDAN, SAMUEL (c. 1803–after 1831) is the painter of four known portraits and one memorial, all in oil on canvas and signed and dated 1831. Jordan's signature on the memorial, in the National Gallery of Art in Washington, D.C., identifies his residence as Boston and his age as 27. The only other documentation on Jordan is in the diary of Isaac Watts Merrill of Plaistow, New Hampshire, which cites the artist as

painting portraits at a local farm in early 1831. Jordan's known portraits are all half-length and show faces strongly modeled, in brown and gray, with cupid-bow mouths, foreshortened arms, and short, stubby fingers. Two of the known likenesses are double portraits of a husband and wife, in the collection of the New York State Historical Association, Cooperstown, New York.

See also **New York State Historical Association; Painting, American Folk.**

BIBLIOGRAPHY

Chotner, Deborah, et al. *American Naive Paintings.* Washington, D.C., 1992.

D'Ambrosio, Paul S., and Charlotte Emans. *Folk Art's Many Faces: Portraits in the New York State Historical Association.* Cooperstown, N.Y., 1987.

Rumford, Beatrix T., ed. *American Folk Portraits: Paintings and Drawings from the Abby Aldrich Rockefeller Folk Art Center.* Boston, Mass., 1981.

PAUL S. D'AMBROSIO

JUGS, FACE anthropomorphic stoneware or redware jugs and pitchers in the form of faces or heads, are widely made by contemporary Southern potters following an age-old custom. While some profess to see a wholly African origin in these pieces (especially the Mangbetu or Zaire tradition), their genesis is far more complex, relating to such diverse sources as thirteenth-century Saxon Aquamanile (pitchers), seventeenth-century German Bellarmine jugs, and the cheerful English Toby pitcher. Indeed, given their generally grotesque features, it is possible that these vessels may be traceable to the ancient warlords who drank from mugs fashioned from their enemies' skulls (the ultimate insult). Whatever their origin, American face jugs and pitchers began to be made in quantity in the mid-nineteenth century. One of the earliest marked and dated examples (1838) is by the Philadelphia potter Henry Remmey (dates unknown), while other face jugs and pitchers may be traced to the Crafts family (active c. 1838–1852) of Nashua, New Hampshire, the Stein Pottery (active in the mid-nineteenth century) at White Cottage, Ohio, and a Medford, Massachusetts firm.

Southern craftsmen have produced by far the greatest number of these anthropomorphic pieces, beginning about the time of the American Civil War, and it is among them that the tradition continues. The typical vessel is a jug, formed in the shape of a head complete with eyes, ears, and mouth, the latter often adorned with a set of jagged white teeth made of kaolin or even shards of discarded porcelain plates.

Glazes vary greatly, from a brown Albany slip and runny green alkaline shades to tan-brown "tobacco spit." There is, of course, a spout, or perhaps two or three, as well as one or two handles. As the potters strove for market share the pieces became more creative or bizarre.

Despite its nineteenth-century origins, the face jug phenomenon is clearly of the twentieth century. Most shops in North and South Carolina and Georgia, where the bulk of the figures were produced, did not begin to make them until the 1940s; widespread customer demand dates only from the 1970s. Though many make them still, a few potters stand out. Lanier Meaders (1917–1998) of Cleveland, Georgia, produced several thousand examples. Burlon Craig (1914–2002) of Vale, North Carolina, is a worthy rival, and earlier pieces from the Brown Pottery (active in the mid-nineteenth century) of Arlen, North Carolina, as well as those from South Carolina's Edgefield District (active c. 1820–1865) are much sought after.

See also **Burlon Craig; Lanier Meaders; Pottery, Folk; Remmey Family Potters.**

BIBLIOGRAPHY

Burrison, John A. *Brothers in Clay: The Story of Georgia Folk Pottery.* Athens, Ga., 1983.

Sweezy, Nancy. *Raised in Clay: The Southern Pottery Tradition.* Washington, D.C., 1984.

WILLIAM C. KETCHUM

JUGS, MEMORY is a general term used to describe any type of vessel or container that has first been covered with a layer of adhesive, such as putty, cement, or plaster. Then, while the adhesive is still damp, a variety of objects are embedded into the vessel's malleable surface, including beads, buttons, coins, glass, hardware, mirrors, pipes, scissors, seashells, tools, toys, and watches. The endless variety of adornment causes the surface to take on such importance that the form becomes secondary. Often intended as non-functional ware, the former mere vessel can become colorful and playful, or enigmatic and mysterious.

It is difficult to attribute memory jugs, as the provenance of most has been lost over time. In the world of art and folklore, some academics think memory jugs were made as memorials for deceased loved ones; other scholars suggest they were made as memorials that were then placed in burial sites, and that this was particular to the African American community. Still other researchers believe these objects were made as a kind of hobby craft—something to occupy

the hands on a rainy day, for example. Other terms applied to this type of object include forget-me-not jug, memory vessel, mourning jug, spirit jar, ugly jug, variety work, whatnot jar, and whimsy jar. All of these terms suggest that a memory jug may have as many of its roots in hobby craft traditions as it does in memorial making and the funerary arts; most of these terms embrace a common thread throughout this art form, that is, the idea of commemoration.

Lack of research and provenance of most memory jugs make it difficult to attribute makers to the vessels. Only a few extant memory jugs have a documented history and surviving provenance, thus fakes have entered the marketplace. It is possible, however, to date a memory jug roughly by determining its understructure, identifying the type of adhesive used (usually window putty, wood putty, or cement), and to inventory the myriad of miscellany crowding the surface.

See also **Pottery, Folk.**

BIBLIOGRAPHY

Anderson, Brooke. *Forget-me-not: The Art and Mystery of Memory Jugs.* Winston-Salem, N.C., 1996.

Thompson, Robert Ferris. *Flash of the Spirit: African and Afro-American Art and Philosophy.* New York, 1983.

Vlach, John Michael. *The Afro-American Tradition in Decorative Arts.* Cleveland, Ohio, 1978.

BROOKE DAVIS ANDERSON

J.W. FISKE, a weathervane manufacturer founded by Joseph Winn Fiske (c. 1832–?) in New York City in 1858, opened a second location in Massachusetts in 1858, and conducted manufacturing and retail business there until 1864. Only a factory remained in Massachusetts until 1900, when the company moved to Brooklyn. A retail outlet continued to do business in New York City between 1864 and 1956. Both factory and retail operations moved to Patterson, New Jersey, in 1956, where they remained until 1985. During World War II, many of the Fiske weathervane molds were donated as scrap metal for the war effort. In addition to copper weathervanes, over the years J.W. Fiske also manufactured architectural metals, tools, hardware, and general hardware.

A 47-page catalog, dated 1875, from J.W. Fiske has 39 pages devoted to weathervanes, and includes the patriotic designs in copper of an American flag; a liberty cap, a soft, conical cap originally found in ancient Greek art to suggest oriental dress, but later identified in American folk art with liberty; and the Goddess of Liberty. In addition, a brewer's vane, *Malt Shovel and Barrel,* is listed. Included in other catalogs are farm animal designs of an ox and a bull. The 1893 Fiske catalog featured two hundred copper weathervane designs, including a twenty-inch anvil mounted over a six-foot arrow for the price of $120. The catalog further mentioned that "any size made to order." An example of a commissioned Fiske weathervane is the bison, or buffalo, weathervane at Bucknell University in Lewisburg, Pennsylvania.

Deer vanes were also popular, and one Fiske catalog listed four deer vanes, one with an unusual design of a dog chasing a deer. An extraordinarily large bald eagle with a fourteen-inch wingspan was offered for $600. Weathervane historian Myra Kaye found three extant nineteenth-century catalogs for J.W. Fiske, with those for the years 1875, 1885, and 1893 all published in New York. The 1893 catalog additionally printed a cautionary note regarding poor-quality vanes manufactured by Fiske's competitors: "I would caution my customers and the public against being deceived by Vanes which are now being made, copied after my designs, some of which are made of sheet zinc, and covered with a thin solution of copper and zinc tubing. Unlike my Vanes, which are made of Sheet Copper, and mounted with brass tubing."

See also **Weathervanes.**

BIBLIOGRAPHY

D'Ambrosio, Paul S. "Sculpture in the Sky." *Heritage The Magazine of the New York Historical Association,* vol. 2, no. 2 (winter 1995): 4–11.

Fitzgerald, Ken. *Weather Vanes and Whirligigs.* New York, 1967.

Kaye, Myra. *Yankee Weathervanes.* New York, 1975.

Klamkin, C. *Weathervanes: The History, Design, and Manufacture of an American Folk Art.* New York, 1973.

Miller, Steve. *The Art of the Weathervane.* Exton, Pa., 1984.

WILLIAM F. BROOKS JR.

KANE, JOHN S. (1860–1934) was the first contemporary self-taught American artist to be recognized by the art establishment. He is best known for his large paintings of industrial Pittsburgh, most of which are today held in major American museums and institutions. Scenes of Scotland, recalling the artist's homeland, and depictions of children, elegiac allusions to his estranged family, also figure prominently in his work.

John Kane, the son of poor, working-class parents, immigrated to the United States from Scotland in 1879 with the hope of improving his economic circumstances. He roamed Pennsylvania, Alabama, Tennessee, and Kentucky in search of employment. Buffeted from one job to the next by economic vicissitudes, he helped build the Baltimore and Ohio Railroad, worked in a tubing factory, a coal mine, a steel mill, as a construction worker, and as a street paver. Kane's career of heavy physical labor terminated in 1891, after he lost a leg in a train accident. With his physical prowess diminished, he had a much more difficult time finding work, and when he did finally land a job, as a railroad watchman, he worked for substantially reduced wages.

In 1897 Kane married Maggie Halloran, and the following year their first child was born. Family obligations made it imperative for Kane to seek a higher paying job, so he went to work painting railroad cars for the Pressed Steel Car Company in McKees Rocks, Pennsylvania. There he developed his lifelong passion for art. At noon, while the other men were eating, Kane would slip back into the rail yards and cover the sides of the bare boxcars with pictures. Much to his relief, the foreman did not object, so long as the artist's creations were painted over after the lunch break. When the boxcar business slackened and Kane was laid off, he decided to put his new knowledge of painting to practical use. Like the limners who roamed America looking for portrait commissions, Kane went door to door offering to paint people's likenesses. Usually his customers would give him a photograph of the desired subject, which the artist had enlarged, and then he colored it with paint or pastel.

This phase in Kane's life came to an abrupt end in 1904, when his third child, a son, succumbed to typhoid fever. Kane took to drinking and temporarily lost all incentive to work. He left his family for long periods, finally losing track of them for several years. After wandering Pennsylvania, Ohio, and West Virginia for some time, he settled permanently in Pittsburgh. During periods of economic depression, he depended upon the support of charitable organizations such as the Salvation Army. In better times, Kane worked as a housepainter and carpenter. Despite his circumstances, he always tried to find a place for art in his life.

In order to teach himself more about painting and drawing, Kane haunted the only halls of knowledge that were open to him: Pittsburgh's public museums and libraries. From these sources, he developed a hazy awareness of the techniques and subjects of the "fine artist." In 1925 and again in 1926, Kane submitted copies of academic religious pictures to the Carnegie International Exhibition, then the most important American forum for international contemporary art. On both occasions, his submissions were rejected. On his third try, in 1927, however, Kane succeeded in winning over the Carnegie jury with one of his original compositions, a painting he called *Scene in the Scottish Highlands*.

The admission of a common housepainter and handyman to so prestigious an exhibition caused an immediate furor, both positive and negative. Many serious collectors and museums immediately took Kane into their hearts (and their collections). In addition to exhibiting repeatedly in the Carnegie International, Kane's work was shown at the then recently

established Whitney Museum of American Art and at the Museum of Modern Art, both in New York. While some journalists, most notably Marie McSwigan, who helped Kane pen his autobiography, championed the artist's work, others were surprisingly cruel. The Pittsburgh tabloids turned Kane's career into a procession of little scandals. His enduring poverty, and the irony of his so-called success, became the subject of numerous vulgar headlines. Even the artist's death, from tuberculosis in 1934, was transformed into a garish media event, with photographers recording the final agonies of the emaciated, semi-conscious man, while writers debated his financial health daily in print. Though Kane reaped little tangible benefit from the success of a painting career that came so late in his life, he left a powerful legacy, both in terms of his own artwork and of the pathway that he blazed for future self-taught artists.

See also **Edward Duff Balken; Outsider Art; Painting, American Folk; Horace Pippin.**

BIBLIOGRAPHY

Arkus, Leon Anthony. *John Kane, Painter*. Pittsburgh, Pa., 1971.
Cahill, Holger, et al. *Masters of Popular Painting: Modern Primitives of Europe and America*. New York, 1938.
Janis, Sidney. *They Taught Themselves*. New York, 1942.
Kallir, Jane. *John Kane: Modern America's First Folk Painter*. New York, 1984.
Kane, John, as told to Marie McSwigan. *Skyhooks: The Autobiography of John Kane*. Philadelphia, 1938.
Lipman, Jean, and Tom Armstrong, eds. *American Folk Painters of Three Centuries*. New York, 1980.
Stein, Judith E. "John Kane," in *Self-Taught Artists of the Twentieth Century: An American Anthology*, edited by Elsa Longhauser, et al. New York: Museum of American Folk Art, 1998.

JANE KALLIR

KAROLIK, MAXIM (1893–1963) and his wife, Martha Codman Karolik (1858–1948), were collectors of American furniture, paintings, and folk art. Residents of Boston, Massachusetts, and Newport, Rhode Island, they made substantial gifts of American folk art to the Museum of Fine Arts, Boston, and the Shelburne Museum in Vermont. Of Jewish heritage, Maxim Karolik was born in Russia. Trained as an operatic tenor at St. Petersburg Conservatory, he immigrated to America in 1922. He is said to have met Martha Codman, a Boston Brahmin, at a private dinner party at her Washington, D.C., home, where he entertained her guests as a singer. He was 35 years her junior, and their 1928 marriage was criticized by some members of her family. He adopted and soon surpassed her passion for collecting American furni-

ture, sculpture, and painting, as well as both academic and folk art.

Between 1938 and 1964, the Karoliks contributed more than two thousand objects to the Museum of Fine Arts, Boston. The first gifts, primarily hers, were of fine American furniture and decorative objects. The second major gift, in 1949, of American paintings, executed in the period from 1815 to 1865, included a substantial body of what Maxim Karolik referred to as primitive paintings. "The Primitives," he wrote, "are often fascinating in their technical artlessness, which is probably one cause of their appearing so genuine and so winning." He attempted to compare the products of the more academically trained artists to those of the primitives, and concluded that the comparison had no meaning. An immigrant who passionately adopted the ideals of his new country, Karolik became an important proponent of the aesthetic quality of folk painting. Included in the gift were paintings by John Brewster Jr. (1766–1854), Erastus Salisbury Field (1805–1900) and William Matthew Prior (1806–1873).

A third large gift, primarily his, was of a substantial body of 350 portraits, landscape paintings, sandpaper paintings, memorial art, velvet paintings, fraktur, calligraphy, and primitive sculpture, all by folk artists. Works on paper included that of Ruth Henshaw Bascom (1772–1848), Joseph H. Davis (active 1832–1837), Eunice Pinney (1770–1849), and Mary Ann Willson (active c. 1800–c. 1830), as well as more than seventy frakturs by Pennsylvania German artists. The carved sculptural figures were represented by birds and animals, weathervanes, a whirligig, a carousel rooster, and twenty-one wildfowl decoys. In addition there were Pennsylvanian Wilhelm Schimmel's (1817–1890) carvings of eagles, roosters, birds, a lion, and a soldier. The stated goal of the Karoliks, to provide "art for the nation," was achieved through these gifts.

Following the death of his wife, Maxim Karolik befriended fellow folk art collector Electra Havemeyer Webb (1888–1960), founder of Vermont's Shelburne Museum. She purchased from Karolik a substantial body of American paintings. Several sales, in fact, were completed in the late 1950s by Webb, and by others at the Shelburne in 1961, following her death. Paintings by Erastus Salisbury Field and Matthew Prior, as well as by a dozen unidentified folk artists, constituted only a minor portion of the purchases, which also included paintings by the major American academic artists Washington Allston, Albert Bierstadt (1830–1902), Martin Heade (1918–1904), and Fitz Hugh Lane (1084–1865). The Karolik paintings formed the core of the Shelburne Museum's American art gallery.

See also **Ruth Henshaw Bascom; John Brewster Jr.; Calligraphy and Calligraphic Drawings; Carousel Art; Joseph H. Davis; Decoys, Wildfowl; Erastus Salisbury Field; Fraktur; Museum of Fine Arts, Boston; Paintings, Landscape; Paintings, Sandpaper; Pennsylvania German Folk Art; Eunice Pinney; William Matthew Prior; Wilhelm Schimmel; Sculpture, Folk; Shelburne Museum; Weathervanes; Electra Havemeyer Webb; Whirligigs; Mary Ann Willson.**

BIBLIOGRAPHY

Cox, Janet. "Maxim Karolik's American Originals." *Harvard Magazine* (February 1976): 35–41.

Karolik, Maxim. "The American Way." *Atlantic Monthly,* vol. 170, no. 4 (October 1942): 101–105.

Troyen, Carol. "The Incomparable Max: Maxim Karolik and the Taste for American Art." *American Art,* vol. 7, no. 3 (summer 1993): 65–87.

Winchester, Alice. "Maxim Karolik and His Collections." *Art in America,* vol. 45, no. 3 (fall 1957): 34–44, 70.

WILLIAM F. BROOKS JR.

KASS, JACOB (1910–2000) painted scenes of urban New York, rural Vermont, and Florida on more than one hundred saws and other tools, following his retirement at age 63. He painted people at work as well as at leisure, and his art reflected a reverence and respect for nature. His subjects include subway and pushcart scenes, children playing baseball, planting and harvesting scenes, and people ice skating in the moonlight. The vision of America that Kass presented was an optimistic view.

A second-generation artisan truck and letter painter, for more than 40 years (from the 1940s to 1970s) Kass owned William Kass and Sons, a truck-painting business located in Brooklyn, New York. Kass's father, Wilhelm, immigrated to America from Germany, and started the business as a carriage and wagon paint shop in 1910.

When Kass retired from the business, he said, "I didn't want to pick up a paintbrush again." But his interest in painting was rekindled after he moved to Vershire, Vermont, where he began to buy old tools and furniture at flea markets, to fix them up for resale. He discovered that people responded particularly well to his painted milk cans, frying pans, saws, and other tools. This positive reinforcement stimulated his enthusiasm to paint.

The artist worked by first making a drawing of each tool, tracing it on paper. Then he prepared the surfaces meticulously, as if they were the truck surfaces he used to paint and decorate. The metal blades of his tools were sanded smooth to remove all traces of rust. An undercoat was painted, and then with acrylic paint he worked up the scene he had sketched in the traced drawing, adding or deleting details as he painted. Occasionally, Kass also added details on the final varnish coat that he applied over the finished surface of each piece.

Because of his skill as a master letter-painter, Kass understood how to manipulate color and shadows to make his images stand out. His understanding of color and design, from years of experience, were utilized in creating his painted tools. Just as Grandma Moses and William Hawkins kept a cache of drawings, printed materials, and photographs from newspapers, magazines, greeting cards, and other popular sources to use as references, Kass kept organized files full of pictures of trees, ships, animals, buildings, landscapes, seascapes, and subway stations.

In 1981 Kass received a grant from the National Endowment for the Arts. The Tampa Museum of Art (in 1994), the Mennello Museum of Folk Art (from 1999–2000), and the American Folk Art Museum (in 2002) have each staged one-person exhibitions of Kass's painted saws.

See also **Anna Mary Robertson "Grandma" Moses.**

BIBLIOGRAPHY

Mennello Museum of American Folk Art. *Saws, Sickles, Squares, and Tongs.* Orlando, Fla., 1999.

Kogan, Lee. "Jacob Kass/Painted Saws." *Folk Art,* vol. 27, no. 2 (summer 2002): 46–51.

———. *Jacob Kass/Painted Saws.* New York, 2002.

LEE KOGAN

KEMMELMEYER, FREDERICK (active 1788–1816) was an atypical naive artist in that he ambitiously tackled historical scenes rather than portraits. Among his subjects are *The First Landing of Columbus* (c. 1805), *The Battle of Cowpens, January 17, 1781* (1809), *General Weyne Obtains a Complete Victory over the Miami Indians, August 20, 1794* (c. 1800), and three versions of *General George Washington Reviewing the Western Army at Fort Cumberland* (all c. 1800). Some of these may have been based on print sources, as yet unidentified.

Nothing is known about Kemmelmeyer's early life or training. His career in the United States is traceable primarily through advertisements and city directories. The artist is almost certainly the same Frederick Kimmelmeiger who became a naturalized citizen in Annapolis, Maryland, on October 8, 1788, and who advertised his drawing school and his miniature- and sign-painting business that same year. Kemmelmeyer

appears to have taught in several Baltimore locations throughout the next decade. From 1803 he moved frequently—in June of that year to Alexandria, Virginia, where he offered painting, gilding, and drawing commissions; a few months later he moved across the river to the busy port of Georgetown, in Washington, D.C. By 1805 he was advertising in the Frederick and Hagerstown, Maryland, newspapers. From western Maryland he went north to Chambersburg, Pennsylvania, and provided services as an ornamental, landscape, and miniature painter.

During the last years of his career, Kemmelmeyer executed portraits in pastel, and at least two are inscribed and dated. *James McSherry Coale* (1811) depicts a little boy from Frederick County, Maryland, while *Catharina Weltzheimer* (1816) portrays a woman who was a tavern keeper in Shepherdstown, West Virginia. These late portraits in chalk display the palette of which Kemmelmeyer was so fond, regardless of the medium, tending heavily toward pinks and blues. He also executed paintings in oil, both on canvas and on paper. In all, fewer than twenty works by the artist are known. Those that are identified share an attention to detail, stiffly rendered figures, and crisp outlines. Kemmelmeyer seems to have particularly appreciated the curving contours of horses, and liked to emphasize the arch of a horse's neck especially.

See also **Miniatures; Painting, American Folk; Painting, Landscape; Trade Signs.**

BIBLIOGRAPHY

Adams, E. Bryding. "Frederick Kemmelmeyer, Maryland Itinerant Artist." *Antiques,* vol. 125, no. 1 (January 1984): 284–292.

Bivins, John, and Forsyth Alexander. *The Regional Arts of the Early South: A Sampling from the Museum of Early Southern Decorative Arts.* Winston-Salem, N.C., 1991.

DEBORAH CHOTNER

KENDALL INSTITUTE: *SEE* NEW BEDFORD WHALING MUSEUM.

KENDALL WHALING MUSEUM: *SEE* NEW BEDFORD WHALING MUSEUM.

KENNEDY, WILLIAM W. (1818–after 1870) is numbered among the few members of the so-called Prior-Hamblin School, a small group of artists who were related by marriage, and who worked in a similar style that ranged from "flat portraits without shade" to semi-academic portrayals with facial modeling. No direct association with William Matthew Prior (1806–1873), Sturtevant J. Hamblin (active 1837–1856), nor George G. Hartwell (1815–1901), the other artists comprising the Prior-Hamblin School, has yet been established. Advertisements, inscriptions, and city directories, however, place Kennedy in the same locale as Prior was, both in Boston, where Prior and his in-laws centered their activities after 1841, and in Baltimore, where Prior lived during the 1850s, just doors away from William W. Kennedy on East Monument Street.

In 1845 Kennedy was working and advertising in New Bedford and Nantucket, Massachusetts. In February of that same year he painted portraits for at least three members of New Bedford rope-maker Josiah Bliss's family. In July he was in Nantucket, where he advertised a "New Style of Portrait" in the *Inquirer and Mirror.* The 1845 portrait, *Captain David Worth,* suggests Kennedy was referring to a flat style of portraiture advocated by Prior that could be accomplished quickly and inexpensively. The wording of the ad is strikingly similar to language used earlier by Prior in his own advertisements, and Kennedy also states that he is "of Boston," lending further credence to some connection between the artists. From these seafaring coastal towns of Massachusetts, where he portrayed primarily sea captains and other members of the maritime trades, Kennedy traveled to Ledyard, Connecticut, in 1846, and Berwick, Maine, in 1847.

Sometime during the winter of 1849–1850, Kennedy moved to Baltimore, where his work acquired a somewhat more academic cast. A little more information about the artist is gleaned from the 1850 Maryland census, which lists Kennedy as a 32-year-old portrait painter who is a native of New Hampshire, and who is married with three children. Baltimore city directories situate him at various addresses between 1853 and 1871, including 229 Light Street from 1851 to 1854; 227 East Monument Street from 1856 to 1859; 82 West Baltimore Street in 1860 and 1864; 75 Chew Street from 1867 to 1868; and 257 West Fayette Street from 1870 to 1871.

At least fourteen signed examples of Kennedy's work have provided the basis for the attribution of additional portraits, as well as the identification of certain characteristics that distinguish his hand from the other artists of the Prior-Hamblin School. These include, most significantly, Kennedy's delineation of brows and blunt-tipped noses with a continuous, smooth, U-shaped outline; curved and extended fingers; and a dark line between the upper and lower lips with T-shaped creases at the corners.

See also **Sturtevant J. Hamblin; Painting, American Folk; William Matthew Prior.**

BIBLIOGRAPHY

D'Ambrosio, Paul S., and Charlotte Emans Moore. *Folk Art's Many Faces: Portraits in the New York State Historical Association.* Cooperstown, N.Y., 1987.

Little, Nina Fletcher. "William Matthew Prior and Some of His Contemporaries." *Maine Antiques Digest* (April 1976): 19A–21A.

Rumford, Beatrix T., ed. *American Folk Portraits: Paintings and Drawings from the Abby Aldrich Rockefeller Folk Art Center.* Boston, 1981.

STACY C. HOLLANDER

KENT LIMNER: *SEE* AMMI PHILLIPS.

KENTUCKY FOLK ART CENTER (KFAC) is a cultural and educational service of Morehead State University, and is operated by Kentucky Folk Art Center, Inc. It is a university-affiliated, non-profit corporation, in partnership with Morehead State University dedicated to the folk art of Kentucky. It was originally established in 1985 under the name "The Folk Art Collection," as part of the Department of Art at Morehead State University. It was formally established in 1994 when plans were already underway for the development of a new facility for the collection. In 1998, KFAC celebrated the opening of its new museum, after entirely remodeling the former Morehead Grocery Building, originally a grocery warehouse in downtown Morehead built around 1906. The mission of the center is to focus on works made by self-taught visual artists from Kentucky, and on expanding public appreciation of self-taught art in general. The center has two galleries, a museum store, a research library, and a continually expanding archive.

A long-term exhibition of works from the permanent collection is installed in the first floor gallery, but the area can also be converted to a series of smaller exhibit spaces. The center presents four or five new exhibitions each year, in the Minnie and Garland Adkins Gallery. The exhibition program includes self-taught art, self-made environments, folk art traditions, and art from found materials, and the exhibitions are selected and designed to expand understanding of creative expression by self-taught artists. The center also produces traveling exhibitions that tour regionally and nationally. Educational programs place strong emphasis on programs for schools and university students.

The permanent collection contains about 1,000 works by self-taught artists, mostly from Kentucky, but some by artists from other states. The collecting focus, however, is on Kentucky artists, and all acquisition resources are used to support this goal. Certain works by non-Kentucky artists that enhance the collection have been donated to the museum.

The center has established a model for cultural preservation, presentation, and interpretation. By limiting the focus of its activities to a single state, this approach has established goals that are realistic for a small institution.

See also **Environments, Folk; Outsider Art.**

ADRIAN SWAIN

KINNEY, CHARLES (1906–1991) was a prolific, self-taught artist, best known for his paintings. Though it was not until between 1970 and 1991 that he received widespread public attention through exhibitions of his work, Kinney had been involved in some form of creative activity since his childhood. Born in northeast Kentucky with a birth defect (*pectus excavatum*), he learned ways to innovate early on to compensate for a lack of upper-body strength. He worked as a farmer, cut hair, and baked pies for sale at home, and also made oak-splint baskets. He learned to play the fiddle in a local style and played music all his life with his younger brother, Noah, a guitarist. He was a passionate storyteller and eagerly shared his knowledge of the natural world, local lore, and folk legends.

As a young man, Kinney shaped animal forms from clay, dried them on his woodstove, and painted them. He sold many of these to the Kentucky state parks, but few survive. He also made clay busts of Moses, George Washington, and Abraham Lincoln. His paintings present unforgiving scenes of hell, local legends, the old way of life in Kentucky, landscapes, and events of local importance, all portrayed in bold, colorful brushstrokes of tempera, often applied over a preliminary pencil sketch. Many of the paintings have an outer border of black stove polish. Although Kinney attended school for about three years, the phonetic spellings of his writing on many of his paintings require some interpretation. Sometimes he wrote the title of a painting as "*Griller,*" meaning *Gorilla*; an inscription as "Corn redy shuk," for "the corn is ready to shuck" (when depicting a cornfield); or wrote both, as in "hen hok gat snak," for "the hen (chicken) hawk has got the snake," on a painting he titled "*Hean Hok Gat Radler,*" for *Hen Hawk Got a Rattler.*

With bold brushstrokes sparingly applied, Kinney produced stark images of a disappearing, self-reliant, agrarian world, depicting the practices, lore, and legends that had sustained it. In a larger sense, his paintings portray the vanishing cultural perspectives of a generation raised, according to longstanding tradition, in a way of life no longer viable in a world permanently transformed by the explosive events of a turbulent century. Kinney's paintings also portray and

273

document his appreciation for natural as well as supernatural forces, hinting at a body of knowledge gained only through intimate association with nature, now also virtually extinct. Through his art, craft, and music making, in the tradition of storytelling about which he was passionate, Kinney unapologetically attempted, right up until his death, to transmit and propagate the culture that was his birthright.

See also **Outsider Art; Painting, American Folk.**

BIBLIOGRAPHY

Swain, Adrian. *Pictured in My Mind.* Birmingham, Ala., 1995.
Yelen, Alice Rae. *Passionate Visions of the American South.* New Orleans, La., 1993.

ADRIAN SWAIN

KINNEY, NOAH OLIVER (1912–1991) made drawings in pencil for many years before he began making sculpture, in about 1970. His parents were subsistence farmers, and Noah lived on the family farm his entire life. His older brother, Charley, was a fiddler, and Noah played guitar. Both were regionally known for their music, which they played together.

Kinney's early works were small drawings in pencil and colored pencils to which he occasionally added oil paint. He drew animals and buildings, such as houses and churches, mostly to please friends. Few of his drawings have survived.

After recovering from a heart attack that forced his retirement from farming, Kinney began working in wood. He referred to his sculptures as "carvings," although his process of woodworking involved many production steps. As his sculpturing evolved over the course of twenty years, his work changed, and eventually encompassed several different types of sculpture. His earliest sculptures were wooden replicas of tools from his childhood on the farm, including various axes, a froe, a hay cradle, and other tools. His detailed models of early vehicles and machines from farm life, including a tractor, a tobacco warehouse truck, a steam-driven sawmill complete with lumber workers, and miniature full-figure portraits of several U.S. presidents, were his most complex works. While often asymmetrical with rough surfaces, Kinney's attention to detail nevertheless is evident in these complicated constructions.

Kinney also made life-size human figures, including a group of female Nashville musicians clothed in his wife's old dresses and sporting real string instruments, but sculptures of animals were what he produced most often. Whether making a snapping turtle or a tiger, he typically started by laminating two two-inch thick boards, from which he roughed out the outline of the various parts with a jigsaw. He would then soften those lines with a pocketknife, assemble the piece, paint it, and add any necessary wood shavings for a mane, whiskers, and other details.

Noah Kinney is important as a highly creative, rural folk artist. His own life was essentially traditional, yet his art transformed traditional techniques, to create contemporary, idiosyncratic sculpture.

See also **Charles Kinney.**

BIBLIOGRAPHY

Moses, Kathy. *Outsider Art of the South.* Atglen, Pa., 1999.
Yelen, Alice Rae. *Passionate Visions of the American South.* New Orleans, La., 1993.

ADRIAN SWAIN

KITCHEN, TELLA (1902–1988) was a memory painter whose works recount events from her life in rural Indiana and Ohio. Her brightly colored landscapes and town scenes, full of incident, depict both the joys and misfortunes shared by small communities. Kitchen was born in Londonderry, Ohio, and was brought up on a farm in nearby Independence, Indiana. After her marriage, Kitchen moved to Adelphi, Ohio, where her husband, Noland Kitchen, served as mayor. The Kitchens also operated a gas station, sold used cars, ran a greenhouse, and farmed. After Noland's death in 1963, Kitchen was elected mayor, the first woman to hold the post. Like many self-taught artists, Kitchen did not paint until later in life. After her husband died, Kitchen's son, Denny, bought her a paint set, but three years passed before Kitchen found a congenial subject from her own memories. Many of her oil paintings, some as small as two inches square, were made as gifts for family members. It was Denny Kitchen who brought his mother's work to the attention of Robert Bishop (1938–1991), who was then at the Henry Ford Museum in Dearborn, Michigan, and later became director of the American Folk Art Museum. Bishop in turn included Kitchen and her work in his book, *Folk Painters of America.*

See also **Robert Bishop; Painting, American Folk; Painting, Landscape; Painting, Memory.**

BIBLIOGRAPHY

Bishop, Robert. *Folk Painters of America.* New York, 1979.
Dewhurst, C. Kurt, et al. *Artists in Aprons: Folk Art by American Women.* New York, 1979.
Rosenak, Chuck, and Jan Rosenak. *Museum of American Folk Art Encyclopedia of Twentieth-Century American Folk Art and Artists.* New York, 1990.

CHERYL RIVERS

KLUMPP, GUSTAV (1902–1980) was a German-born artist who rejected traditional landscape and portrait paintings in favor of paintings that depicted, as he put it, "beautiful girls in the nude or seminude in fictitious surroundings, including some other paintings of dreamlike nature." He had seen paintings by Grandma Moses on television and reacted to them as follows: "They looked like very simple landscapes of what she saw in the country. For myself, I like to paint landscapes only in combination with fictions because in the past and present were painted millions and I still like imaginary landscapes." Klumpp was delighted by his own spirited painted fantasies, and he believed that he had accomplished his goal as an artist, which was "to inspire other senior citizens or the younger generation." His witty paintings are executed as rhythmically balanced compositions, and he uses very lively color harmonies in them.

Klumpp was born in Baiersbronn, in the Black Forest area of western Germany. He was the son of a photographer and general store manager. In 1932, he immigrated to the United States; there, his uncle, who was a janitor, offered Klumpp housing in a synagogue where he worked. Klumpp himself soon found employment in the printing trades, working as a compositor and as a linotype operator. He retired many years later, in 1964, and thereafter he lived on his social security benefits in the Red Hook housing project in Brooklyn, New York. In 1966, with the encouragement of the personnel at the senior center in this housing project, he began to paint. Klumpp derived great satisfaction from his ability to create works of art.

Over the next five-year to six-year period, he developed his own individual stylistic vocabulary—a vocabulary that is marked by compositional balance, flattened perspective, bright colors, a distinctive array of forms, and the liberties the artist took with scale. He gave his paintings such titles as *Burly, Reclining Nude, Dream of a Nudist Camp, The Art Gallery Saluting the Nude*, and *Virgin's Dream of Babies*.

Gustav Klumpp worked in oil and acrylic on canvas and completed about fifty paintings. Interestingly, he was reluctant to sell any of his paintings; and when he did bring himself to sell one, he would sometimes replace the sold painting with another work on the same subject.

In 1970, paintings by Klumpp were shown in an exhibition called "Art of the Elders of Brooklyn" at the Community Gallery of the Brooklyn Museum of Art. Henri Ghent, who was the director of this gallery, set off something of a controversy when he responded to a scathing review of Klumpp's work in the *New York Times*. The art critic John Canaday, who wrote the review, had actually been mildly enthusiastic about one of Klumpp's paintings—but Ghent felt that the painting that Canaday chose to praise was in fact the weakest in the show; furthermore, Ghent maintained that in general Canaday had no understanding of work by self-taught artists. Ghent, for his own part, praised *Burly*, a painting that offers an amusing look at the world of burlesque. This painting shows scantily clad bathing beauties on a stage, lined up on two sides of a tiered mid-ground form so as to create two sides of a compositional triangle. The third side of this triangle is made up of a fully clothed dancing couple in the center foreground. Curved draperies frame the top and sides of the painting, and these draperies are echoed by the rounded heads and rounded breasts of the women in the chorus line.

Mr. and Mrs. William Leffler of New York read both John Canaday's piece and the piece by Henri Ghent in the *New York Times*, were intrigued, and got in touch with the artist. Their ensuing correspondence and friendship with Gustav Klumpp has since been a valuable resource for scholars.

Klumpp's paintings have been included in a large number of group exhibitions and publications. The paintings are held in the permanent collection of the American Folk Art Museum in New York and the Museum of International Folk Art in Santa Fe, New Mexico. In addition, the archives of the American Folk Art Museum contain copies of the correspondence between Gustav Klumpp and Mr. and Mrs. William Leffler.

See also **Anna Mary Robertson "Grandma" Moses; Painting, American Folk.**

BIBLIOGRAPHY

Bihalji Merin, Oto. *World Encyclopedia of Naïve Art*. Scranton, Pa., 1984.

Bishop, Robert. *Folk Painters of America*. New York, 1979.

Hemphill, Herbert W. Jr., and Julia Weissman. *Twentieth-Century American Folk Art and Artists*. New York, 1974.

Johnson, Jay, and William C. Ketchum Jr. *American Folk Art of the Twentieth Century*. New York, 1983.

Kaufman, Barbara Wahl, and Didi Barrett. *A Time to Reap: Late Blooming Folk Artists*. South Orange, N.J., 1985.

Rosenak, Chuck, and Jan Rosenak. *Museum of American Folk Art Encyclopedia of Twentieth Century Folk Art and Artists*. New York, 1990.

LEE KOGAN

KNIGHTS OF COLUMBUS: *SEE* FRATERNAL SOCIETIES.

KNIGHTS OF PYTHIAS: *SEE* FRATERNAL SOCIETIES.

KOZLOWSKI, KAROL (1885–1969) was a painter of detailed, colorful scenes of both real and imagined locales. He lived with his family in an agricultural region south of Warsaw. Drafted into the Russian army in 1907, he was classified by army officials as a "peasant" and "servant worker," and stationed in Siberia on the Mongolian border. Discharged in 1910, Kozlowski and a brother came to America three years later, and settled in the Greenpoint section of Brooklyn. Greenpoint was a heavily industrialized area in the early decades of the twentieth century, and Kozlowski found work there as a laborer at a baking powder company. He was befriended by a coworker, Edward Gronet, who eventually urged him to move in with his family. The invitation appears to have been prompted primarily by Gronet's impression of Kozlowski as being naive and childlike, and his concern for Kozlowski's welfare. Kozlowski lived with the Gronet family for the remainder of his life.

In 1923 Kozlowski began working as a fire cleaner for the Astoria Light, Heat and Power Company in Queens, New York, a job he held until his retirement 27 years later. A member of a crew that cleaned a large furnace, in which coal was burned to produce gas, he worked eight-hour days, seven days a week, except Saturday, when he worked twelve hours. After work and on Sundays, Kozlowski would retreat to a small, unheated shed without electricity behind the Gronets' house, half of which was reserved for Kozlowski's use. There he raised exotic birds, built elaborate cages for them, and, beginning in the early 1920s, he started to paint. Painting in oil over detailed, preparatory pencil drawings on canvases often measuring more than four feet in length, his subjects included Manhattan; various landscapes and gardens; people enjoying the beach, countryside, or promenading on city streets; foreign cities; and vistas that appear to be imagined views, rather than being derived from printed sources. In Kozlowski's paintings, it is always summertime, birds fill the air and waters, trees are green, and the sun shines brightly on cities of sparkling buildings carefully aligned in row upon row.

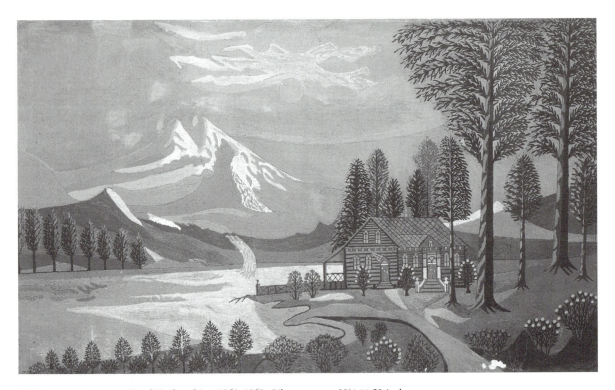

Cabin in the Mountains. Karol Kozlowski; c. 1962–1968. Oil on canvas; 29½ × 52 inches.
Collection American Folk Art Museum, New York, The Abril Lamarque Collection; gift of Lita M. Elvers, 1991.21.2.
Photo courtesy Gavin Ashworth.

Never married, Kozlowski lavished attention on his birds, which he considered his children. His birds, painting, and the affection of the Gronet family must have provided him relief from the hot, dirty, dangerous work that occupied his days. Kozlowski's orderly cities and landscapes, infused with insistent rhythms, patterns, and bright colors, were an alternate world created by the shy and retiring artist, one that offered predictability and reassurance.

See also **Painting, American Folk; Painting, Landscape.**

BIBLIOGRAPHY

Sarno, Martha Taylor. *Karol Kozlowski 1885–1960: Polish-American Folk Painter.* New York, 1985.

Rumford, Beatrix T., ed. *American Folk Paintings: Paintings and Drawings Other Than Portraits from the Abby Aldrich Rockefeller Folk Art Center.* Boston, 1988.

RICHARD MILLER

KRANS, OLOF (1838–1916) dedicated himself to the preservation of the history of the Swedish religious colony at Bishop Hill, Illinois, through his portraits of its people, his narrative paintings of its development and his landscape paintings of its built and natural environments. Born in Salja, a village in Westmanland, in eastern Sweden, Krans was brought to Bishop Hill by his parents in 1850, the same year that Erik Jansson, the leader of the colony, was murdered. Deprived of Jansson's strong leadership, the communal structure of Bishop Hill began to disintegrate. Krans resided there for eleven years, working in the community's blacksmith and paint shops. Following a brief period of service in the Civil War he moved first to Galesburg and then to Galva, Illinois.

From the beginning of his working life, Krans demonstrated an interest in creative expression, although there is no evidence that he received any formal training in art. He assisted a photographer for a period after his Civil War experience, but soon began to earn his living as a decorative and commercial painter. Attracting considerable local patronage, he received commissions to paint the interiors of churches in Bishop Hill, Galva, and other communities and became expert in the application of *faux* marble and wood grain finishes. He also hung wallpaper, and painted signs and other objects.

In 1894, Krans was asked to paint a stage curtain for a new community center in Bishop Hill. The resulting work, an impressive fifteen-and-a-half by ten-foot depiction on canvas of the village in 1855, less than ten years after it was founded, marked the beginning of a new phase in the artist's creative life.

In addition to auditorium interiors, stage curtains and scenery, Krans began to paint works that recalled the life and times of the Bishop Hill colonists. In 1896, inspired by the fiftieth anniversary of the founding of the community, he painted some of his most ambitious and successful works. Publicly exhibited for the first time in the ceremonies that marked this local milestone, the paintings depict the Swedish pioneers planting, sowing, and harvesting. These compositions, in which the artist emphasizes overall structure and design over detail, stress the sense of unity that motivated the participants in this communal venture. Indeed, Krans invests the figures in these works with little individuality or personality. Instead they blend together to form a harmonious, almost abstract, whole. In one work, for example, a single row of women planting corn stretches out almost to the horizon, their individual features barely visible as they work, united by a common purpose, in the vast expanse of the empty prairie.

Krans generally painted in oil on canvas, using a colorful palette in his genre and landscape paintings and a more restrained, almost monochromatic, palette in the majority of his portraits—his self-portraits and portraits of his mother, Beate Krans, being the principal exceptions. Using early photographs as sources, the artist painted dozens of character studies of members of the community, including the founder, Erik Jansson, and other leaders. Generally appearing stiff and serious in demeanor, his subjects more likely reflect the long exposures of photography than they do a common grimness of character. His self-portraits, including one as a Civil War soldier and another, palette in hand, as an artist, are among the most appealing of his works.

In addition to his studies of Bishop Hill, Krans created genre and landscape paintings of Galva and other places, biblical scenes, wildlife studies, and other subjects. Some of his work is rendered crudely, but at its best it is well composed, robust and engaging, a remarkable record of a pioneer community and its people. After living in Galva for thirty-five years, Krans spent the last thirteen years of his life in Altona, Illinois, where he died.

See also **Painting, American Folk; Painting, Landscape; Painting, Memory; Religious Folk Art; Scandinavian American Folk Art.**

BIBLIOGRAPHY

Isaksson, Olov. *Bishop Hill: A Utopia on the Prairie.* Stockholm, Sweden, 1969.

Lipman, Jean, and Tom Armstrong. *Folk Painters of Three Centuries*. New York, 1980.

Swank, George. *Painter Krans: OK of Bishop Hill Colony*. Galva, Ill., 1976.

GERARD C. WERTKIN

KREBS, JOHANN JACOB FRIEDRICH (c. 1749–1815), commonly known as Friedrich Krebs, produced more fraktur than did any other artist in the Pennsylvania German tradition. Born in Zierenberg, Hesse, Germany, Krebs was a Lutheran schoolmaster in and around Harrisburg, Pennsylvania, from about 1790 until his death. His orders for printed fraktur documents numbered in the thousands, but his overall output includes many handmade examples as well. He also produced *taufscheine* (baptismal certificates) in great quantities with minimal decoration, as well as some of the best examples of unique fraktur, such as his unusual drawings of Bible stories, illustrations of tales from the Brothers Grimm, and other pieces.

Krebs came to America from Germany as a member of the Hessian troops who fought for the British in North America during the American Revolution between 1776 and 1782. Although he is reported to have returned to Germany, it seems more likely that he remained in America. In 1787 he began to purchase and embellish printed records of baptism records, and ultimately turned this work into a profitable business, feeding the growing desire of Pennsylvania German Americans to keep family records. Eventually, he had his own forms printed, chiefly by printers in Reading, Pennsylvania.

Broadsides of Adam and Eve, portrayed as the primary example of the ideal marriage as well as the origin of sin, became popular in Pennsylvania German life. Krebs designed them as marriage records with birth dates for the bride and groom. Sometimes he applied embossed paper designs to his *taufscheine*, or he drew on half of the certificate and folded it while the ink was wet to duplicate the drawing on the other half.

Krebs also produced other drawings, such as portraits of the Prodigal Son, the Seven Swabians, two Turks, a giant clock face, mazes, and other subjects. He also made bandboxes, according to the inventory of his estate. When he died in Swatara Township, Dauphin County, Pennsylvania, he left hundreds of blank forms for the executors of his estate to sell, and others that he decorated, but the presence of another artist's hand in some of his work reveals that the market for fraktur documents was strong.

See also **Fraktur; German American Folk Art; Pennsylvania German Folk Art; Religious Folk Art.**

BIBLIOGRAPHY

Weiser, Frederick S. "*Ach wie ist die Welt so Toll!*" ("The mad, loveable world of Friedrich Krebs.") *Der Reggeboge*, vol. 22, no. 2 (1982): 49–88.

FREDERICK S. WEISER

L.W. CUSHING & SONS: *SEE* CUSHING & WHITE.

LAGUNA SANTERO, THE (working dates c. 1795–c. 1808) was the most important religious folk artist working in New Mexico at the beginning of the nineteenth century. During a limited period of time, the Laguna Santero and his workshop produced a considerable body of work in several media. Altar screens, panel paintings, hide paintings, gesso low reliefs, decorative shrine niches, and most likely sculpture were all produced by him or under his direction in his workshop. His most important and ambitious productions were a series of large altar screens undertaken in churches in Indian pueblos and Hispanic towns. In addition to that of the Laguna Pueblo church (c. 1800–1808), altar screens in the following churches are attributed to him: Santa Cruz de la Cañada (c. 1795); San Francisco and San Miguel in Santa Fe (c. 1796 and c. 1798); Nuestra Señora de Guadalupe in Pojoaque (c. 1796–1800); Nuestra Señora de la Asunción in Zia Pueblo (c. 1798); Santa Ana Pueblo (c. 1798); and San Esteban in Acoma Pueblo (c. 1802–1808).

The Laguna Santero was probably a Mexican artist engaged by priests or well-to-do patrons to carry out a series of commissions in New Mexican churches. His work is clearly based upon Mexican provincial sources. The saints and their attributes are accurately depicted, and his compositions derive directly from colonial paintings and engravings. He was also responsible for building the altar screens, most of which have hand-carved, twisted Solomonic columns (curvilinear Baroque design said to derive from the Temple of Solomon) delineating the sections, a characteristic of seventeenth- and early eighteenth century Mexican altars. The complex decorative painting of the columns replicates in a simpler fashion the elaborately carved and gilded Baroque altars of Mexico.

Although drawing from Mexican sources, the figurative work of this artist highly simplifies the Baroque naturalistic conventions of the day. Costumes are stylized and weightless, the faces of the saints have an ascetic quality quite removed from the prevailing sentimentalism of the Baroque style, and the backgrounds are emblematic, with little concern for perspective. The Laguna Santero can be viewed as the first New Mexican folk artist, a transitional figure between the provincial Baroque work of the eighteenth century and the pure folk art styles that emerged in the nineteenth century.

It appears that after completing the Laguna altar screen in 1808, he ceased painting in New Mexico. No later works have been identified. The production of smaller pieces by members of his workshop did not continue long after this date. One possible exception is the work of the artist Molleno (active c. 1815–c. 1845), who was probably an apprentice in the Laguna Santero's workshop.

See also **Bultos; Molleno; Painting, American Folk; Religious Folk Art; Retablos; Santeros; Sculpture, Folk.**

BIBLIOGRAPHY

Boyd, E. *Popular Arts of Spanish New Mexico.* Santa Fe, N. Mex., 1974.
Wroth, William. *Christian Images in Hispanic New Mexico: The Taylor Museum Collection of Santos.* Colorado Springs, Colo., 1982.

WILLIAM WROTH

LANDSCAPE PAINTING: *SEE* PAINTING, LANDSCAPE.

LATVIAN AMERICAN FOLK ART: *SEE* EASTERN EUROPEAN AMERICAN FOLK ART.

LEACH, HENRY (Harry) (1809–1885) was a self-taught ornamental woodcarver with a shop in Boston and later in Woburn, Massachusetts. Born in New Milford, Pennsylvania, he served in the Pennsylvania militia, rising to the rank of lieutenant colonel before traveling east to Boston, about 1847, where he operated a series of retail outlets on the waterfront, selling maps, books, clothing, and pens. From 1849 to 1872, he lived in Boston's Southend, where he operated an ornamental carving shop between 1865 and 1872. Leach and his family then relocated to the Boston suburb of Woburn, where he practiced his craft until 1884. Leach was hired by Leonard W. Cushing (d. 1907) to carve weathervane wood patterns. Based on Cushing's journal and surviving Leach *cartes de visite*, he carved the Morgan horse *Black Hawk*, now part of the Smithsonian Institution's collection in Washington, D.C.; a *Goddess of Liberty*, now at Vermont's Shelburne Museum; a larger *Liberty*, today in the Mystic Connecticut Seaport Museum collection; as well as a setter dog, an eagle, a rooster, and a peacock. His other commissions ranged from allegorical and mythological figures to furniture and carved likenesses of prized farm animals, household pets, deer, elk, and African exotics. Leach returned to Pennsylvania, and died in Montrose.

See also **Cushing & White; Weathervanes.**

BIBLIOGRAPHY

Christensen, Edwin O. *The Index of American Design.* New York and Washington, D.C., 1950.

Hornung, Clarence P. *Treasury of American Design: A Pictorial Survey of Popular Folk Arts Based Upon Watercolor Renderings in the Index of American Design, at the National Gallery of Art.* New York, 1972.

Joyce, Henry, and Sloane Stephens. *American Folk Art at the Shelburne Museum.* Shelburne, Vt., 2001.

Lipman, Jean. *American Folk Art in Wood, Metal, and Stone.* Meriden, Conn., 1948.

Kaye, Myra. *Yankee Weathervanes.* New York, 1975.

WILLIAM F. BROOKS JR.

LEBDUSKA, LAWRENCE (1894-1966) was among the first contemporary self-taught painters to be recognized within the New York mainstream art world. He is best known for his paintings of horses, yet in his long and varied career the artist addressed a broad range of subjects, including landscapes, portraits, nudes, and still lifes. Lebduska's earliest paintings tend to be muted in tonality, while his later works evince a brighter palette, often incorporating vivid pinks and blues.

Lebduska was born in Baltimore, Maryland, where his father was employed as a representative of the

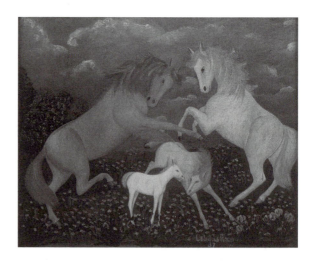

Prancing Horses. Lawrence Lebduska; 1937. Oil on canvas; 16 × 20 inches. Collection American Folk Art Museum, New York. Museum of American Folk Art purchase, 1984.19.1.

stained glass firm of Flieder and Schneider in Leipzig, Germany. In 1899 Lebduska's father returned to Leipzig, where Lebduska thus completed his education. Subsequently, he studied the craft of making stained glass at a school run by his father's company. While Lebduska had no formal training in art, his experiences with stained glass inspired him to try painting. An early canvas, *Bit of Bohemia,* garnered a prize at an international exposition, and Lebduska proceeded to study decorating under the tutelage of Joseph Svoboda in Chrudim, Bohemia. His studies focused on the technical aspects of mixing colors and varnishes.

Lebduska returned to the United States in 1912, living first in Baltimore and then moving to New York a year later, where he worked for the noted interior designer Elsie de Wolfe, creating stained glass decorations and murals for private homes. Lebduska also submitted his paintings to exhibition juries around New York. In 1936 The Contemporary Gallery gave him his first one-person exhibition, which was favorably reviewed by Howard Devree of *The New York Time* and launched Lebduska's reputation within the New York avant-garde. It is said that the exhibition inspired Abby Aldrich Rockefeller to begin her folk art collection, today housed in Williamsburg, Virginia. Other patrons included Eleanor Roosevelt, W. Averell Harriman, and members of the Du Pont family of Delaware. Lebduska participated in the Works Progress Administration's Federal Art Project in New York, and was given exhibitions by the Babcock, Valentine, and Kleeman galleries in New York.

In the early 1940s, as interest in self-taught art was waning, Lebduska gradually succumbed to alcoholism. He lived for many years in desperate poverty, until June 1960, when he was rescued by the art dealer Eva Lee. With Lee's encouragement, Lebduska stopped drinking and returned to painting. He had exhibitions at the Krasner Gallery in 1960 and the Tutti Gallery in 1962. Unfortunately, this period of sobriety did not last, and Lebduska's health began to deteriorate rapidly; he died at the age of 72.

See also **Sidney Janis; Painting, Folk; Abby Aldrich Rockefeller Folk Art Center.**

BIBLIOGRAPHY

Bishop, Robert. *Folk Painters of America.* New York, 1979.
Cahill, Holger et al. *Masters of Popular Painting: Modern Primitives of Europe and America.* New York, 1938.
Hemphill, Herbert Wade Jr., and Julia Weissman. *Twentieth-Century American Folk Art and Artists.* New York, 1974.
Janis, Sidney. *They Taught Themselves.* New York, 1942.
Johnson, Jay, and William C. Ketchum Jr. *American Folk Art of the Twentieth Century.* New York, 1983.

JANE KALLIR

LEDGER DRAWINGS are works of art on paper drawn by Plains Indians (Lakota, Cheyenne, Kiowa, and others), principally during the second half of the nineteenth century. Male artists, who had previously drawn their autobiographical exploits and visions on hide robes, began increasingly to work in a smaller scale after 1860, in discarded ledger or account books, as well as on other types of paper, both lined and unlined.

While some drawings reflect a relatively untrained approach, incorporating abstract stick figures in pictographic style with little use of detail, others show not only the use of materials newly introduced to Native Americans, such as paper, ink, crayons, and watercolors, but also a slightly Europeanized style of drawing. Most were made on the Great Plains, both for indigenous use, as mnemonic devices in recounting episodes of personal valor, and for sale to military officers, traders, and other early collectors, who were eager for native depictions of life on the Plains. A notable exception to the Great Plains provenance were drawings produced by Kiowa and Cheyenne warriors while in military prison at Fort Marion in St. Augustine, Florida, from 1875 to 1878. These were executed in small sketchbooks and were for sale exclusively to tourists and other visitors to the prison.

In addition to recording personal and tribal history, ledger drawings provide an artistic record of the profound changes that occurred in indigenous life in the second half of the nineteenth century. Scenes of warfare with enemy tribes are the single largest subject category: Lakota against Crow, for example, or Kiowa against Pawnee. Battles against United States troops, genre scenes of courtship, camp life, and hunting, as well as ceremonies and personal visions, are depicted. Some works portray traditional Plains Indian life with ethnographic precision. With their limited use of perspective, foreshortening, and overlap, they share with many other folk drawings a sense of immediacy and freshness much valued by collectors. Scenes are sometimes drawn over two pages, with the spine of the book serving as the bottom of a page. Seldom is background indicated. English captions, when extant, are usually additions by the nineteenth-century collectors, though some literate artists, especially among the Lakota after 1880, added their own captions.

Some drawings are anonymous; others are the work of well-known and well-studied artists, such as Wohaw (Kiowa), Silver Horn (Kiowa), Black Hawk (Lakota), and Howling Wolf (Cheyenne). Individual artists' hands are readily recognizable, even when names are not yet known. Men principally drew pictures of their own deeds, but there is also some evidence of finer draftsmen being commissioned to draw the exploits of their cohort. Men sometimes shared drawing books—multiple artists' hands are evident in a number of books. The last ledger drawings were done in the 1930s by elderly Lakota warriors, such as White Bull, who recorded the scenes of his youth for collectors.

See also **Native American Folk Art.**

BIBLIOGRAPHY

Berlo, Janet C. *Plains Indian Drawings, 1865–1935: Pages from a Visual History.* New York, 1996.
———. *Spirit Beings and Sun Dancers: Black Hawk's Vision of a Lakota World.* New York, 2000.
Donnelly, Robert. *Transforming Images: The Art of Silver Horn and His Successors.* Chicago, 2000.

JANET CATHERINE BERLO

LEEDSKALNIN, EDWARD (1887–1951) built Coral Castle (originally called Rock Gate Park) single-handedly in Florida City, Florida, between 1920 and 1940, from blocks of local coral. Born in Latvia, he was a stonemason by trade. He made his way to Canada in 1912, and by 1920, he had traveled to California, where he worked in lumber camps. Work in the camps gave Leedskalnin the physical strength, skills, and knowledge that he later used in cutting and moving blocks of coral weighing many tons. What makes his work remarkable is the fact that he was a

mere five feet tall and weighed only one hundred pounds.

From 1918 to 1920, Leedskalnin traveled to Florida City, and settled on one acre of land. For unknown reasons, he chose to build a castle on his land and dedicated it to "Sweet Sixteen," thought to be a girlfriend from his adolescence in Latvia. Southern Florida is generally composed of fossilize coral covered with a few inches of topsoil. Using only hand tools, Leedskalnin cut, carved, and moved huge blocks of coral alone to construct his castle.

He remained in Florida City until 1936. In 1937, he bought three acres of land in Homestead, Florida, and moved the castle, block by block, to Homestead, a distance of about ten miles. He mounted the chassis of an old truck on two rails and added wheels with rubber tires to construct a make shift trailer. With the help of a friend who owned a tractor, he moved the castle from Florida City to Homestead. Despite the difficulty of this work, no one ever reported seeing Leedskalnin loading or unloading the truck.

In 1940, after the carvings were in place, he finished erecting the walls. Each section of wall is eight feet tall, four feet wide, three feet thick, and weighs approximately 13,000 pounds. It took him a year to build a coral tower, containing two hundred forty three tons of coral. The blocks of coral that make up the walls weigh from four to nine tons each. The roof is composed of 30 blocks of coral, each weighing approximately one ton. Leedskalnin also carved and built from coral a telescope, a sun-dial clock that is both a clock and a calendar, and a gate weighing nine tons that can be moved very easily, using only one finger to push it.

Leedskalnin lived in his castle from 1923 to 1951 He made a living by charging visitors ten cents each. Today Coral Castle is open to visitors. Under the supervision of the Dade County Office of Historical Preservation, the castle is administered by the Barr family, whose antecedents purchased it in 1954 from Harold Leedskalnin, who had inherited it from his cousin Edward in 1951.

See also **Architecture, Vernacular; Outsider Art.**

BIBLIOGRAPHY

Irwin, Orval M. *Mr. Can't Is Dead: The Story of the Coral Castle.* Homestead, Fla., 1996.

RAMON RAMIREZ

LEVIN, ABRAHAM (1880–1957) suffered the rags-to-riches, riches-to-rags fate of many self-taught artists in the 1940s. Swept up in the "naive" boom of that period, he was heralded with numerous gallery exhibitions and rave reviews. His renown faded, however, as quickly as it had arrived, and Levin was not rediscovered until the 1990s, as the result of a growing interest in self-taught artists. His paintings have a moody, bluish palette, as well as a distorted style reminiscent of the Spanish painter El Greco (1541–1614) or the German expressionists who worked in the first decades of the twentieth century, while his evocation of Eastern European village life, based on childhood memories, has been compared to the work of Marc Chagall (1887–1985). Levin's subjects also included portraits and still-life paintings.

Levin, like his better-known compatriot Morris Hirshfield (1872–1946), immigrated to the United States from Lithuania and found employment in the garment industry. Bored and eventually disgusted with his mind-numbing job sewing "knee pants," he started making pencil sketches; at the age of 57, he turned to painting. Encouraged by his teacher at a Works Progress Administration art class in the Bronx, New York, community where he lived, he brought his work to the Uptown Gallery in Manhattan, where he was given his first show in 1941. Several exhibitions at the Galerie St. Etienne followed in quick succession.

Initially, Levin was hailed as a great "find." *The New York Times* called his first exhibition "a thrilling experience." Critics responded strongly to the elements of his intuitive style that evoked the modern masters. The Amalgamated Clothing Workers Union sent their own critic to evaluate Levin's work, and then granted him a $25-a-week stipend that enabled him to paint full-time. Though Levin was delighted by this change of fortune, his windfall was not sufficient to permit his family to leave their three-room walkup apartment, nor to allow his wife, also a garment worker, to quit her job. And Levin's luck did not last. The dovetailing of folk art and modernism, which in the early 1940s still seemed cogent, began to lose support as the decade progressed. In the end, Levin was forced to beg the union for his old garment-industry job back. Levin's painting career never revived. He died at the age of 77.

See also **Morris Hirshfield; Painting, American Folk; Painting, Memory.**

BIBLIOGRAPHY

Braggiotti, Mary. "Abraham Levin: From Pants to Paints." *New York Post Daily Magazine* (March 5, 1943): 3.

Johnson, Jay, and William C. Ketchum Jr. *American Folk Art of the Twentieth Century.* New York, 1983.

JANE KALLIR

LIEBERMAN, HARRY (1880–1983) began painting at the age of 76, creating about 1,500 vibrant and dynamic narrative paintings of Jewish life, religion, lore, and literature. He explicated these with texts that he wrote in Yiddish and attached to the backs of his paintings. Lieberman was born Naftuli Hertzke Liebhaber to a Hasidic Jewish family in a small Polish *shtetl*, or Jewish village, called Gniewoszów. In 1906 he came to the United States, one of thousands of Eastern European Jews fleeing the hardships of pogroms and forced conscriptions. In New York City he led a largely secular life, working first in the textile trades and then owning and operating a candy store on Manhattan's Lower East Side with his wife, Sophie. In 1950 the Liebermans retired to their home in Great Neck, New York. After six quiet years of retirement, he and his wife visited Israel, where Lieberman had a revelatory experience. Early one morning, he went to King David's tomb, and randomly opened the Book of Psalms to Psalm 130: "From the depths I called you Oh Lord." Lieberman was inspired by these words to return to an Orthodox way of life, and coincidentally, this was also the year he began to paint.

Lieberman had been spending time at the Golden Age Club of the Senior Citizen Center in Great Neck. One day his chess partner did not show up, so he attended a painting class instead. This sparked an emotional rebirth for the 76-year-old Lieberman. He began to pour his life into autobiographical oil paintings that recalled his memories of Poland. *My Father's Store* is rich in its details of goods filling shelves and crates. Haunting such early works is the specter of the Holocaust that destroyed the way of life Lieberman was remembering in paint; later works deal more explicitly with this theme. *Yizkor* depicts a crematorium, while *My Father Holding a Cigarette (He Was 87 When Hitler Killed Him)* is a tiny painting that reveals the distortions of memory, with his father's small figure dwarfed by an enormous cigarette. As time went on, Lieberman was increasingly drawn to his own rich Jewish heritage, in lyrical works such as *The Blessing of the New Moon*; in the conflicts of assimilation evident in *The Hasid and the Dreamer*; and in ironic tales from Yiddish literature. In addition to brilliantly colored acrylic paintings, which Lieberman started to create after about 1976, he made ceramic sculptures as well as drawings in ballpoint pen and pencil.

Lieberman achieved great recognition during the 27 years he painted. To look the part, he grew his hair into a long white ponytail and sported a dark beret. Hailed as the "Jewish Grandma Moses" and the "Chagall of folk art," Lieberman was the subject of an award-winning film, *102 Mature: The Art of Harry Lieberman* (Light-Saraf Films), and his work has been included in numerous museum exhibitions, including "Harry Lieberman: A Journey of Remembrance," organized by the American Folk Art Museum in 1991. In 1979 Leiberman testified before the Joint Committee on Aging to stress the contribution that seniors could continue to make to their communities. He died at the age of 103.

See also **Jewish Folk Art; Painting, American Folk; Painting, Memory.**

BIBLIOGRAPHY

Hollander, Stacy C. *Harry Lieberman: A Journey of Remembrance.* New York, 1991.

Mann, Peggy. "Age: 101—Motto: Go Do!" *Reader's Digest* (August 1978).

STACY C. HOLLANDER

LIGHT, JOE LOUIS (1934–) is a self-taught painter whose colorful, cartoon-influenced style belies an allegorical vision of divine moral order developed through his private religious quest. Joe Louis Light's life mixes misfortune with the touchingly improbable. Named for a signal African American hero, he was alienated at a young age from his parents, Hiawatha and Virgie (Virgin) Mary. He spent parts of his youth in trouble with the law, and he spent much of the 1960s in a prison cell, where he was inspired by a preacher—along with a mysterious voice and a bird on his windowsill—to convert to the principles of the Old Testament. Renouncing the Baptist Christianity of his youth, he developed a personal faith conditioned by the racial prejudice he experienced in the pre-civil rights era South, as well as suspicion toward Christianity's effects on colonized peoples.

Upon his release in 1966, Light journeyed throughout the United States, finally settling on Looney Street in Memphis, Tennessee, and starting a family of ten that he supported by selling bric-a-brac at flea markets. He spread his new beliefs through drawings made on sidewalks and viaducts. In the mid-1970s he created a six-foot-tall fish from an enormous piece of driftwood that he found on the banks of the Mississippi River. He painted his home inside and out with personal symbols (flowers, ships, a river) and text messages about divine remedies for social ills. His house was filled with painted objects, including televisions, fans, mirrors, toys, lamps, dinner trays, and artificial plants. He also used these materials in assemblage paintings he calls "attachments."

Light's aesthetic has been influenced primarily by what he saw in the flea markets, everything from

comics and toys to product packaging and kitsch landscapes. His paintings tell about divine truth through every visual language that their maker has managed to imbibe. The works combine graffiti-like spray-paint abstractions, cartoon heroes, barren Western landscapes, floral motifs, an identification with Native Americans, and a host of autobiographical symbols, especially a hobo as well as a "Birdman" that he depicts as a human head topped with a bird. Sometimes executed on wood panels or on the walls of his home, the paintings are often glossed with religious citations and glyphs. Every artwork is motivated by his desire to explain his beliefs to the community, and by his need to enlighten populations that he considers misguided and confused. The paintings also contain a more indirect, inward-looking focus on the obstacles, especially sexual temptation, that he perceives as lying between himself and the attainment of moral purity, uniting his odyssey with that of his audience.

See also **African American Folk Art (Vernacular Art); Painting, American Folk.**

BIBLIOGRAPHY

Arnett, William, and Paul Arnett, eds. *Souls Grown Deep: African American Vernacular Art of the South,* vol. 2. Atlanta, Ga., 2001.

Spriggs, Lynne, Joanne Cubbs, Lynda Roscoe Hartigan, and Susan Mitchell Crawley. *Let It Shine: Self-Taught Art from the T. Marshall Hahn Collection.* Atlanta, Ga., 2001.

PAUL ARNETT

LIPMAN, JEAN (1909–1998) began collecting American folk art in 1936 to furnish a country home in Connecticut, but her interest in the subject almost immediately turned into a scholarly pursuit. Her first book, *American Primitive Painting,* was published in 1942, to be followed in 1948 by another trailblazing work, *American Folk Art in Wood, Metal, and Stone.* A pioneer in fostering the study of American folk art, Lipman remained a passionate advocate of the subject for sixty years.

Born in Manhattan as Jean Herzberg, Lipman received an M.A. in art history from New York University, her thesis devoted to a group of Florentine profile portraits. Her husband, Howard Lipman (1905–1992), an investment banker and sculptor, shared her interests. In 1938 Lipman became associate editor, and in 1940, editor, of *Art in America,* a position she held until 1971. Although the publication embraced the entire field of American art, Lipman regularly opened its pages to new scholarship on American folk art.

The Lipmans sold their collection of American folk art to Stephen Clark of the New York State Historical Association at Cooperstown, New York, in 1950, but Lipman nevertheless remained committed to the subject. She continued to research and write in the field, publishing studies on folk painting with Alice Winchester (1907–1996), editor of *The Magazine Antiques* (1950); and with Mary C. Black (1923–1992), director of the American Folk Art Museum (1966); and she also wrote monographs about the artists Rufus Porter (1792–1884), in 1968, and Jurgan Frederick Huge (1809–1878), in 1973. Moreover, the Lipmans also began building a second collection of American folk art, which they sold to the American Folk Art Museum in 1981.

In addition, the Lipmans shared an interest in modern American sculpture; they collected works by Alexander Calder (1898–1976), Don Judd, Louise Nevelson (1899–1988), and David Smith (1906–1965), among others, which they later gave to the Whitney Museum of American Art. Lipman published nearly as extensively on this subject as she did in the field of American folk art. Her 1975 book, *Provocative Parallels: Naïve Early Americans/International Sophisticates,* demonstrated the remarkable visual parallels between her fields of interest.

In 1974 Lipman organized a widely influential exhibition at the Whitney Museum and was co-author with Alice Winchester of the accompanying book, *The Flowering of American Folk Art.* In 1980 she and the museum's director, Thomas N. Armstrong, co-edited *American Folk Painters of Three Centuries,* to document an important exhibition by that name. Two other significant exhibitions and publications followed—*Young America: A Folk Art History,* in 1986, and *Five Star Folk Art,* in 1990.

In addition to her other pursuits, Lipman was a visual artist. Her paintings and collages, many inspired by works of American folk art, were exhibited in several museum and gallery shows beginning in 1981. Maintaining an active and richly creative schedule until the end of her long life, Lipman died at her home in Carefree, Arizona.

See also **American Folk Art Museum; Mary Childs Black; Fenimore House; Jurgan Frederick Huge; New York State Historical Association; Rufus Porter; Alice Winchester.**

BIBLIOGRAPHY

Lipman, Jean, and Tom Armstrong, eds. *American Folk Painters of Three Centuries.* New York, 1980.

Zeitlin, Marilyn A., and Carol G. Bombeck. *The Eye of the Collector: Works from the Lipman Collection of American Art.* Tempe, Ariz., 1999.

<div align="right">GERARD C. WERTKIN</div>

LITHUANIAN AMERICAN FOLK ART: *SEE* EASTERN EUROPEAN AMERICAN FOLK ART.

LITTLE, NINA FLETCHER (1903–1993) was the most important figure in the history of early American folk art. Renowned as a collector, researcher, lecturer, and writer, she was a model for those who shared her interests. She was born in Brookline, Massachusetts, on January 25, 1903, attended the Park School and Miss May's School in Brookline, and married Bertram K. Little in 1925. Shortly thereafter she started collecting English Staffordshire pottery. Over the years her interests expanded to include, among other things, early New England furniture, decorative arts, and folk art. Although she lacked professional training and began her investigations before there were many helpful sources available, Little was a pioneer in the field of folk art research. Her writings and lectures stimulated interest in previously neglected areas, such as itinerant artists, overmantel panels, fireboards, wall and floor decorations, schoolgirl needlework, and theorem paintings.

Little's passion as a collector is evident from the huge collection that was divided between her two homes, the "Pumpkin" house in Brookline and her summer home at Cogswell Grant in Essex, Massachusetts. Objects covered all available space, including the inside surfaces of closets and closet doors, while the attic was a storage area for paintings and sculptures that museums and collectors would have been delighted to hang in places of honor. Her collection was not only large but of the highest quality. Little was a scholar, not just a collector. Each of the objects was the subject of extensive research, the result of which was the uncovering of previously unknown facts concerning them as well as the artists responsible for their production. Little wrote articles on important early American folk painters such as Rufus Hathaway, Sturtevant J. Hamblin, Asahel Lynde Powers, John Brewster Jr., and the Beardsley Limner. Her report on Winthrop Chandler was so significant that the entire April 1947 issue of *Art in America* was devoted to it.

More than one hundred of her articles were published in *The Magazine Antiques, Art in America, Old-Time New England, American Art Journal,* and *Country Life.* She also wrote numerous museum catalogs for exhibitions on early American folk artists. In addition to reports on specific folk painters, there were many others on subjects such as blue Staffordshire pottery with nineteenth-century American scenes; European redware; early ceramic flower containers; the dating of New England houses; New England provincial portraits; coach, sign, and fancy painting; painted floors; and bedhangings. Her books include *American Decorative Wall Painting, 1700–1850; Country Arts in Early American Homes; Neat and Tidy: Boxes and Their Contents Used in Early American Households;* and the autobiographical *Little by Little: Six Decades of Collecting American Decorative Arts.*

In 1964 Nina Little and her husband, Bert, were honored with the Louis du Pont Crowninshield Award from the National Trust for Historical Preservation, and in 1984 the Littles received the Henry Francis du Pont Award for their work in the study, preservation, and interpretation of American art.

Little was a role model for those who followed her in the researching of early American folk artists. She served as an inspiration, and was always happy to give advice and guidance to those who endeavored to uncover the stories of the many little-known, early American folk painters.

Little's decision to have half of her collection sold at auction reflects her desire to share with other collectors the joy of living with her treasures. Her summer home, Cogswell Grant, was willed to the Society for the Preservation of New England Antiquities.

Little was also a trustee and Honorary Fellow for Research in the American decorative arts department of the Museum of Fine Arts, Boston. She cataloged their 1976 exhibition of paintings by New England provincial artists, and was the principal consultant for the establishment and cataloging of the collection at the Abby Aldrich Rockefeller Folk Art Center. She was a trustee of the New York State Historical Association, Cooperstown, New York; Old Sturbridge Village, Sturbridge, Massachusetts; the Essex Institute, Salem, Massachusetts; and the Essex (Massachusetts) Historical Society.

See also **John Brewster Jr.; Winthrop Chandler Jr.; Sturtevant J. Hamblin; Rufus Hathaway; Asahel Lynde Powers.**

BIBLIOGRAPHY

Garrett, Wendell. "Nina Fletcher and Bertram K. Little." *The Magazine Antiques,* vol. 144, no. 4 (October 1993): 505–512.

Lucky, Laura C. "Exploring Early Painting." *The Magazine Antiques,* vol. 144, no. 4 (October 1993): 513–519.

<div align="right">ARTHUR AND SYBIL KERN</div>

LITWAK, ISRAEL (1868–1960) was one of the most successful self-taught artists of the New York scene in the 1940s and 1950s. He painted almost exclusively landscapes, many based on views of New York and New England copied from postcards and photographs. His bright, almost fauvist palette and expressive stylization, however, make these subjects entirely his own.

Litwak's earliest works, done in pencil and crayon on wood panel, sometimes have incised contours that may have derived from his work with marquetry. Later, possibly at the suggestion of his dealer, J.B. Neumann, Litwak switched to paint and canvas. This led to difficulties with his landlady, who objected to the smell of turpentine. To appease her, he sketched his compositions in the winter and then colored them in the summer, when the windows could be left open to air the apartment.

Litwak was born in Odessa, Russia. He was apprenticed to a cabinetmaker at the age of eleven, and served in the Russian army from 1889 to 1894. In 1903 he immigrated to the United States with his wife and two children, settling in the East Flatbush section of Brooklyn. After being forced to retire from cabinetmaking at the age of 68, Litwak decided to try his hand at drawing and painting. Although he had never painted before, he had always enjoyed visiting museums, and admired the work of the old masters. Litwak brought some of his work to the Brooklyn Museum and showed it to the curator in the department of paintings and drawings. Immediately recognizing his talent, the museum's director gave him a one-man show in 1939. It was an auspicious beginning for a self-taught artist, and Litwak lived to enjoy an impressive career, with steady gallery representation lasting into the 1950s. In 1946 *Time Magazine* published a significant—though not entirely favorable—illustrated article on Litwak. Nevertheless, like many such artists who came to prominence during this period, Litwak subsequently faded from view, and only began to experience an incipient revival in the 1990s, many years after his death at the age of 92.

See also **Marquetry; Outsider Art; Painting, American Folk.**

BIBLIOGRAPHY

Hemphill, Herbert Wade Jr., and Julia Weissman. *Twentieth-Century American Folk Art and Artists*. New York, 1974.
Janis, Sidney. *They Taught Themselves*. New York, 1942.

JANE KALLIR

LOCKETT, RONALD (1965–1998) was a self-taught painter whose life and art straddled two eras: the rural, prewar worldview of the elders who raised him, and the industrialized, steel-dependent way of life in his Bessemer, Alabama, neighborhood, known as Pipe Shop. Lockett's family was torn apart when he was young; his parents divorced, his father remarried and took up residence nearby, and his mother suffered nervous collapses. Lockett's four siblings gradually left his mother's home, but he lived with her his entire life. He remembered wanting to be an artist since childhood. After finishing high school, he stayed in Pipe Shop—jobless, making drawings, and spending many of his days at the home of his neighbor and relative, artist Thornton Dial Sr. (1928–) watching the older man work on metal patio furniture and the painted sculptural "stuff" that would later bring Dial renown. Lockett never formally took up any occupation; in 1987 his art was "discovered" shortly after Dial began to receive outside attention.

Lockett was influenced by mentor Dial philosophically but not stylistically. Lockett's paintings were always naturalistic, although, like Dial, he sought to express himself through a variety of found materials and mixed media, including wood and tin siding salvaged from the barns and outbuildings throughout Pipe Shop. Lockett invented a personal, postmodern folklore that expressed correspondence among his hopelessness as a young black urban male, the travails of endangered species and ecosystems, and historical tragedies (the Holocaust, the decimation of native peoples, Ku Klux Klan terror, and Hiroshima were favorite themes). In the early 1990s he nearly abandoned painting, and began creating collage-like assemblages of snipped, oxidized tin that he formed into unpainted, illusionist depictions of beleaguered creatures, especially deer, bison, and wolves. Shortly after that transition in his art, Lockett tested positive for HIV, and his work plunged further into the deep ironies of his fate.

The 1995 bombing in Oklahoma City catalyzed Lockett's most thoroughly realized series of works: abstract accumulations of tin nailed to plywood that resemble cityscapes, gutted buildings, gateways, prison cells, and patchwork quilts. During his last two years Lockett returned to painting, combining his "Oklahoma" tin-collage process with sickly sweet coatings of bilious yellows, rose reds, milk whites, and blacks in quilt-like works that commemorate his recently deceased great-grandmother, Sarah Dial Lockett (who raised Thornton Dial), and Princess Diana, while foretelling his own death. Lockett died of AIDS-related pneumonia in August 1998.

See also **Thornton Dial Sr.; Painting, American Folk.**

BIBLIOGRAPHY

Arnett, William, and Paul Arnett, eds. *Souls Grown Deep: African American Vernacular Art of the South,* vol. 2. Atlanta, Ga., 2001.
Spriggs, Lynne, Joanne Cubbs, Lynda Roscoe Hartigan, and Susan Mitchell Crawley. *Let It Shine: Self-Taught Art from the T. Marshall Hahn Collection.* Atlanta, Ga., 2001.

PAUL ARNETT

LOOFF, CHARLES I.D. (1852–1919) was a carousel carver who, like his competitor, Gustav Dentzel (1846–1909), immigrated to the United States from Germany and was also an accomplished woodworker by the time he arrived in Brooklyn in 1870. Looff then went to work for one of the many furniture makers in the New York area. In 1876, perhaps inspired by Dentzel's success, Looff created his first carousel. Using scraps of wood from the furniture maker for

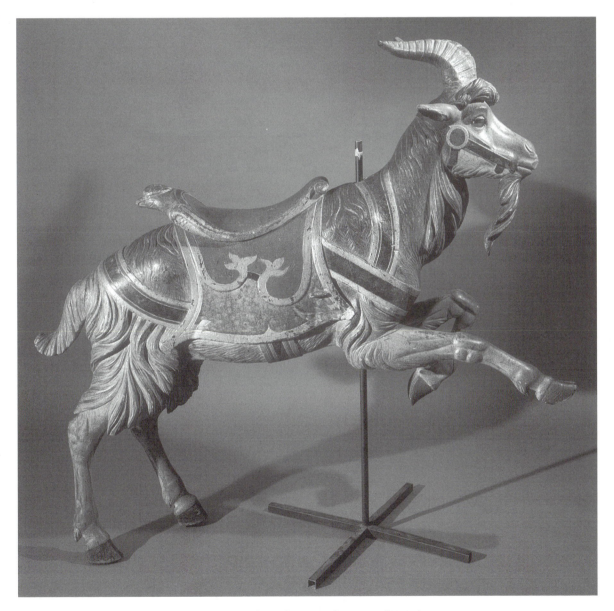

Carousel Goat. Charles I.D. Looff; Painted and carved wood; New York, c. 1890; 60½ inches high.
Photo courtesy Allan Katz, Americana, Woodbridge, Connecticut.

287

whom he worked, he fashioned a simple yet functional machine that became an instant success. Within a few years, Charles Feltman, inventor of the "red hot" (or "hot dog") carousel, approached Looff to create another carousel. In 1880 that second machine opened in Coney Island amusement park in Brooklyn.

The ensuing expansion of the Coney Island amusement businesses allowed Looff the opportunity to begin producing carousels full-time. Looff developed a style of carving in keeping with the adventurous nature of the new amusement parks as social spaces by creating animated, sculptural carousel horses and using glass jewels to enhance the figures. This style of carousel carving is now referred to as the Coney Island style.

In 1905 the Looff factory relocated to Riverside, Rhode Island, where the local amusement ground, Crescent Park, featured one of his carousels that had been placed there in 1895. Looff used this carousel as a sales model to show potential clients, filling it with a variety of carving styles as well as some of his grandest creations, including chariots sporting huge, ferocious dragons. At this time, Looff hired a young, Slovenian carver, John Zalar (dates unknown), who continued to work for Looff for twelve years and had a profound influence on the style of the carvings produced at Looff's factory.

Looff had a sharp business sense and realized the potential for carousels and amusement parks on the West Coast, moving his factory again in 1909, this time to Long Beach, California. His goal was to continue manufacturing carousels and other rides, while opening and operating his own amusement parks. Over the next ten years, with the help of his family, especially his eldest son Arthur, Looff built amusement centers throughout the West Coast. In 1919, Charles Looff passed away at the age of 67, leaving a legacy of grand carousels and millions of happy riders.

See also **Carousel Art; Gustav Dentzel.**

BIBLIOGRAPHY

Dinger, Charlotte. *Art of the Carousel*. Green Village, N.J., 1983.
Fraley, Tobin. *The Carousel Animal*. San Francisco, 1983.
———. *The Great American Carousel*. San Francisco, 1994.
Fried, Frederick. *A Pictorial History of the Carousel*. Vestal, N.Y., 1964.
Mangels, William F. *Outdoor Amusement Industry*. New York, 1952.
McCullough, Edo. *Good Old Coney Island*. New York, 1957.
Stevens, Marianne. *Painted Ponies*. New York, 1986.
Summit, Roland. *Carousels of Coney Island*. Rolling Hills, Calif., 1970.
Weedon, Geoff. *Fairground Art*. New York, 1981.

TOBIN FRALEY

LÓPEZ, GEORGE T. (1900–1993) carried the "Cordova Style" of woodcarving developed by his father, José Dolores López, to new heights by becoming the namesake village's first artist to make woodcarving a primary source of income. During the 1920s and 1930s, López watched and learned as his father established a viable local enterprise in Cordova, New Mexico, with a new, unpainted style of woodcarving that was a profound departure from conventional colonial-era polychrome carving styles. Soon after the elder López's death in 1937, George López set out to achieve a level of production and public recognition that his father had never realized.

Like many villagers who supplemented their farming income with migrant-laborer work, López helped support his family beginning at age fifteen by working in sheep camps, on farms, and on road crews throughout the region. Back home in 1925, he was inspired by his father's burgeoning career, particularly the supplementary income it provided, and began to carve. López carefully began to hone his craft alongside his father, using his father's works as prototypes for his own.

In countenance and pose, López's early works were thus strikingly similar to his father's; except for slight changes in scale and other minute differences, it is hard to distinguish between the works of father and son. He carved many of the same subjects, including secular animals and birds, religious *santos* (figures of saints), and skeletal images of death. He also copied some of the more unconventional items his father made, such as screen doors and lazy Susans. Likewise, his choice of woods, including aspen, juniper, cedar, willow, cottonwood, and pine, echoed his father's preferences. And while López's works initially lacked his father's refinement and finesse, his personal style was emerging. The younger Lopez's works, which ranged from a few inches tall to life-size, were generally more elaborately carved than his father's, as well as more block-like and massive.

In the early 1940s, shortly after his father's death, López was forced to take a construction job in nearby Los Alamos, then the budding birthplace of the atomic bomb. His carving took a backseat to his job, and his artistic production became rare and sporadic. The artist compensated by simplifying his style, leaving his images smooth and plain by limiting the amount of filigree surface carving to simple border designs. But in 1952, López quit his Los Alamos job in an effort to make carving his principal occupation. He now worked full-time to refine his artistic technique, in hopes of reaching his father's level of precision and complexity. He succeeded: his production level in-

creased significantly, and with it came a newly refined repertoire of *santos* and other narrative themes. López made one particularly complex tree of life from 395 separate pieces.

The extra time on his hands also allowed López to develop his entrepreneurial skills. Though his four siblings also worked as woodcarvers, none had yet to undertake it as a serious vocation. With help from his wife, Silvianita, López became the first Cordova carver to set up a shop in his own house, only a short distance from the highly traveled road that brought tourists into the village. His house not only had ample display space for the hundreds of carvings he produced, López's availability to talk with patrons in person proved to be a strong selling point as well. By 1960, López was renowned as Cordova's leading woodcarver, popular with customers throughout the Southwest and beyond. While his siblings and others in the village also began to market their carvings from home-based, tourist-friendly shops, López was still widely acknowledged by his fellow villagers as the most successful carver of his time, as well as the best.

In López's later years, his production declined and his works became less ambitious, both in the range of subjects and degree of design. Nonetheless, in 1978, he was invited to participate in the Smithsonian Institution's annual Festival of American Folk Life. Four years later, he was awarded the prestigious National Heritage Fellowship. By the time López died at the age of ninety-three, generations of Cordova natives proudly listed woodcarving as their primary profession. Owing in large part to López's efforts, the Cordova carving style that his father pioneered remains firmly entrenched as an essential part of the village economy.

See also **José Dolores López; Religious Folk Art; Santos; Sculpture, Folk.**

BIBLIOGRAPHY

Briggs, Charles L. *The Wood Carvers of Cordova, New Mexico: Social Dimensions of an Artistic "Revival."* Albuquerque, N. Mex., 1989.

Pierce, Donna, and Marta Weigle, eds. *Spanish New Mexico: The Spanish Colonial Arts Society Collection.* Santa Fe, N. Mex., 1996.

CARMELLA PADILLA

LÓPEZ, JOSÉ DOLORES (1868–1937) is the acknowledged father of the "Cordova Style" of woodcarving, an unpainted interpretation of Spanish colonial-New Mexican polychrome woodcarvings that the artist developed in the early 1920s. A farmer, sheepherder, carpenter, and devout Catholic, López lived in Cordova, New Mexico, the same village in which the acclaimed nineteenth-century *santero* (maker of religious images) José Rafael Aragón (c. 1796–1862) had practiced his art. López's father, Nasario, was a woodcarver who may have worked with Aragón.

López turned seriously to woodcarving in 1917, as a distraction from his worries about his son's overseas service during World War I. He first made pine furniture, such as chairs, chests, *roperos* (cabinets), and *relojeras* (clock shelves), finished with bright commercial house paints and motifs reflecting popular Mexican imports. Occasionally, he created polychrome *santos* (saints) for use in the village church. But in the early 1920s, after meeting artist and writer Frank Applegate and other area art aficionados, López's style changed dramatically.

Applegate and writer Mary Austin were Santa Fe newcomers who cofounded the Spanish Colonial Arts Society in 1925 to provide artistic and economic outlets for area Hispanics producing colonial-era art forms. They encouraged López to sell his furniture in Santa Fe, but his crude, polychrome technique proved too gaudy for the mostly Anglo patrons. The patrons' rejection prompted López to follow the demands of the marketplace, and he developed a new, unpainted woodworking style.

Earlier in the century, López had become a skilled filigree jeweler. Using simple hand tools, he now integrated this art into furniture making and other woodwork, using incised, filigree-like designs, chip carving, and hand-etched bird, tree, and leaf motifs to emphasize details he had failed to achieve with paint. The result was an ornate, innovative style that gave a completely contemporary look to López's diverse and functional repertoire, which included bookshelves, lazy Susans, record racks, even screen doors. These detailed appointments were in complete contrast with the more traditionally painted furniture that had been used in homes and churches throughout the region since its settlement in 1598. His Santa Fe patrons praised López's originality, purchasing his works and crediting him with revolutionizing a centuries-old art form.

López's onetime hobby quickly became a key supplement to his farming income. During the second half of the 1920s, López continued to innovate, moving away from furniture to three-dimensional unpainted figures. He also occasionally made crosses and other woodcarvings inlaid with straw, following another colonial-era technique. Mostly, however, López carved tiny, whimsical sculptures of birds, cats, mice, pigs, squirrels, and other animals. These images were influenced by Swiss and German toys that

Lopez's son had brought back from the war. Again, López embellished his creations with chip carving to accentuate facial and bodily features. He placed his birds and other figurines in playful, lifelike poses on tree branches bursting with finely detailed leaves.

In 1929 López followed Applegate's suggestion to try his hand at making unpainted *bultos* (three-dimensional carvings of saints). López drew inspiration from the nineteenth-century *santos* by José Rafael Aragón that adorned the Cordova church. But while Aragón had used paint to detail iconography and facial expressions, López used chip-carved filigree motifs to bring his *santos* to life. He relied strongly on facial expressions, body gestures, and crisp, chip-carved detail to evoke the drama of the lives of saints such as St. Peter, St. Michael the Archangel, St. Anthony, and Our Lady of Light. His use of contrasting native woods like aspen, cedar, and pine further enhanced the details of the simple, spiritual subjects, some of which stood up to three feet tall. Other religious themes included Adam and Eve, the tree of life, the flight into Egypt, and the Nativity, as well as a number of death carts and other regional depictions of Death riding in a wooden cart.

López carved hundreds of unpainted *santos* during the last eight years of his life. Moreover, some were made from literally hundreds of separate handcarved pieces. These carvings were the most complex and ambitious of his career as well as those for which he is best known. In 1933 and 1934, he made at least two saints for the Public Works of Art Project (PWAP) of the Works Progress Administration (WPA), which were seen by President Franklin D. Roosevelt and Eleanor Roosevelt in a 1934 exhibit at the Corcoran Gallery of Art in Washington, D.C.

By the time of his death, López had appeared in numerous publications and exhibitions as the renowned creator of a thoroughly modern carving style, and he had passed down his techniques to his five children. The Cordova Style is firmly established as an artistic tradition among López's extended families in Cordova, and in art markets nationwide. Not only had López developed a new approach to traditional woodcarving, he also created a vital cottage industry, which continues to thrive.

See also **José Rafael Aragón; Bultos; Furniture, Painted and Decorated; Santos; Sculpture, Folk.**

BIBLIOGRAPHY

Briggs, Charles L. *The Wood Carvers of Cordova, New Mexico: Social Dimensions of an Artistic "Revival."* Albuquerque, N. Mex., 1989.

Nunn, Tey Marianna. *Sin Nombre: Hispana and Hispano Artists of the New Deal Era.* Albuquerque, N. Mex., 2001.
Pierce, Donna, and Marta Weigle, eds. *Spanish New Mexico: The Spanish Colonial Arts Society Collection.* Santa Fe, N. Mex., 1996.

CARMELLA PADILLA

LOTHROP, GEORGE EDWIN (1867–1939) created animated paintings that reflect his fascination with theater. With dramatic flair, he painted circus entertainers; a tightrope walker; a beauty pageant; a staged bacchanalian revel; Edith Roberts, a glamorous movie star of the 1920s; and (twice) the Russian ballerina Anna Matveyevna Pavlova. Against an exotic landscape, Pavlova is depicted onstage in feathered pants, head tilted back, arms gracefully extended, her red hair streaming behind her. A figure hovers above her; other forms appear near her feet. Lothrop's pointillist technique suggests movement and gives vibrancy to the work.

Lothrop was born in Dighton, Massachusetts. By age sixteen, he had learned piano polishing and carving from his father, who worked at that trade. During World War I, he was a machinist in the Charlestown Navy Yard; he then returned to piano carving and later worked as a doorman or watchman. In high school he was interested in drama; afterward he self-published fifteen original plays. He also wrote two books of poetry and claimed to have written forty songs. A handwritten advertisement, one of two pasted on the back panel of a painting, shows Lothrop as the "Poet King" in a costume suggesting the sea god Neptune, surrounded by bathing-beauty cutouts. His literary and musical aspirations may have been realized through his paintings, which resemble stage sets filled with flamboyant nude women. Lothrop, by then destitute, was found dead of a heart attack on a street in Boston.

Lothrop's work was included in an exhibition at the Society of Independent Artists (New York) in 1917–1920 but was rejected for the 112th annual exhibition at the Pennsylvania Academy of Fine Arts in 1917. Lothrop's paintings were discovered by Peter Hunt, an art dealer in Provincetown, Massachusetts, who bought them in a thrift shop. Years earlier, Lothrop had put the paintings in storage, where they languished after his death before being turned over to a charity.

Lothrop, whose output is believed to be small, worked primarily in oil on canvas. Occasionally, he would glue costume jewelry to the back of a painting. He signed his works "Geo. E. Lothrop" with "Boston" on the next line, often signing the reverse side as well and inscribing "Boston" or "Boston, Mass." Applying

his skill as a piano carver, he hand-carved several frames. In 1971, Parke-Bernet Galleries in New York auctioned twenty-one Lothrop paintings. Most of his paintings are in private hands, but *Buttercup* is at the American Folk Art Museum.

See also **Outsider Art; Painting, American Folk.**

BIBLIOGRAPHY

Janis, Sydney. *They Taught Themselves: American Primitive Painters of the 20th Century.* New York, 1942.

<div align="right">

LEE KOGAN

</div>

LUCAS, CHARLIE (1951–) is a sculptor and painter who descends from several generations of craftspeople (blacksmiths, quiltmakers, woodcarvers, basketmakers, and ceramicists) who have inspired his artistic techniques, a family heritage that his wife, Annie, and several of his children have continued. Born and raised in Pink Lily, Alabama, Lucas was inspired as a child by his blacksmith grandfather to make toys and whirligigs, but became discouraged after his third-grade teacher ridiculed his desire to become an artist. Lucas dropped out of school, ran away from home a few years later, and worked in construction and as a truck driver.

In the 1980s, after a back injury left him unable to perform jobs involving heavy physical labor, Lucas began again to pursue his creative aspirations. With skills learned from his grandfather and father, an auto mechanic, Lucas began welding sculptures from scrapped automobile parts and other pieces of cast-off metal. By the late 1980s his property along both sides of a country road bore elaborate artistic witness—sometimes in sculptures ten to fifteen feet high—to his life story.

Nearly all the artist's work is autobiographical, with a twist: he fuses his story with issues significant in the wider world, including current events and societal ills. Lucas has also described his artmaking as having originated as an attempt to communicate his inner feelings to family members, many of whom live nearby, as well as to a more generalized audience. Although some of his pieces are anecdotal or humorous, most are personal narratives fusing individual experience with timeless insights into human nature, effectively transforming his life into a series of visual fables. Sometimes he represents himself in these allegorical tales as animals, such as horses, dogs, or dinosaurs.

One of his earliest sculptures, *Three-Way Bicycle,* depicts an abstracted human figure perched atop an unsteady, three-wheeled bicycle, a symbol for three distinct life choices or directions the artist felt lay before him while he recuperated from his debilitating injury. A subsequent work, *Power Man,* depicts a utility worker with fist raised in a gesture of triumph. The piece is constructed of lengths of discarded telephone pole wires that the artist reused as a symbol of personal rejuvenation. Although Lucas's completed sculptures are usually unpainted, laying bare the rust and wear of reused materials, he also makes mixed-media pictures with themes similar to his sculptures, as well as "drawings," sometimes on a large scale, with welding torches and soldering irons applied to auto bodies, appliance panels, and ironing boards.

See also **African American Folk Art (Vernacular Art); Painting, American Folk; Quilts; Sculpture, Folk.**

BIBLIOGRAPHY

Arnett, William, and Paul Arnett. *Souls Grown Deep: African American Vernacular Art of the South,* vol. 2. Atlanta, Ga., 2001.

Yelen, Alice Rae. *Passionate Visions of the American South: Self-Taught Artists from 1940 to the Present.* New Orleans, La., 1993.

<div align="right">

PAUL ARNETT

</div>

LUDWICZAK, TED (1927–) became a stone carver after his retirement and created an environment around his home on the Hudson River, north of New York City, made up of hundreds of faces he carved in stone.

His life has been an adventurous odyssey. As an accidental stowaway, he left his native Poland in 1949 on a cargo ship sailing to India through the Mediterranean. On the return voyage he left the ship in Italy and became a German-speaking guide in Rome with a souvenir business on the side. His aunts, who had lived in New York City for some time, encouraged him to join them there. When he applied for a visa his language skills so impressed the staff that he was offered a job with the U.S. Army. He worked for five years in Frankfurt, German, and was made an honorary master sergeant, with his own car and driver. He became an expert on wine and lived the good life; but his aunts were adamant that he come to New York, we he did finally in 1956. In America Ludwiczak learned to grind contact lenses and eventually started his own business. He retired in 1986.

He started carving in 1988 when he was building a red sandstone retaining wall on his property that abuts the Hudson River. He carved a face on one of the stones and cemented it into his wall. He said it looked lonely, so he added more. Eventually he added hundreds of heads from the water level of the

river, up the hillside to his house, and in front of the house facing the road. The environment created by Ludwiczak's sculptures is powerful and startling to see for the first time. It is a mysterious and striking scene, often compared to the impact made by the figures on Easter Island in the Pacific.

Ludwiczak's favorite carving tool is the metal blade from an old lawn mower, although he uses other tools as well. Following his first carvings in red sandstone that he found on the river bank, he subsequently used granite, white limestone, curbstones, and even marble. The carved heads range in size from a few inches to three or four feet in height, and may weigh hundreds of pounds. Ludwiczak transported some of the stones in the winter using a sled with the help of his son.

The faces he sculpts have a wide range of expression. Some are thin and tall and others are jowled. Some have an enigmatic smile and others express strong emotion or portray a man singing. They are primarilymale faces and often reminiscent of Greek or Cycladic figures. Ludwiczak finds the face inherent in each stone and brings out the character as he sees it. He does not repeat himself because the nature of and form of the stone determines the face. His affinity is to the stone.

While he is basically interested in the front of the human face with its many variations, Ludwiczak's work is more than bas-relief carving. His heads are worked in the round as he sees the face develop. As he follows the shape of the stone he says it talks to him. Some stones have more than one face. On occasion he groups them together or stacks them one on top of another.

Most of his stone carvings remain on his property, but he does sell some. His sculptures reflect Ludwiczak's personality. He ascribes his success in many enterprises and his ability to adjust to life in different cultures to his good education, travel, and his innate optimism. And to this must be added his energy, talent, and creativity.

See also **Environments, Folk; Outsider Art; Sculpture, Folk.**

BIBLIOGRAPHY

Anton, Aarne. *American Primitive Gallery.* New York, 2003.

Hutton, Maridean. "Dialogues with Stone: William Edmondson, Ernest "Popeye" Reed, and Ted Ludwiczak." *Folk Art*, vol. 21, no. 1 (spring 1996): 46–54.

Studer, Carol Millson and Victor Studer. "Ted Ludwiczak"s Easter Island on the Hudson." *Folk Art Messenger*, vol. 10, no. 2 (winter 1997): 4–6.

JOHN HOOD

MACKINTOSH, DWIGHT (1906–1999) was an artist who made spontaneous, fluid, and highly inventive drawings. He lived with his family in Hayward, California, until he was sixteen, and did not begin drawing until late in life. Although he participated in an art program at Stockton State Hospital in Stockton, California, where he was a resident in the 1970s, it was not until he began making art at the Creative Growth Art Center, a visual-arts program for disabled adults in Oakland, California, in 1978 that his drawing became a major thrust in his life. His images rise out of a swirl of complex, deftly drawn lines. Mackintosh generally used felt-tipped pens, pencil, or chalk to create his drawings, with color (tempera, watercolor, or colored pencil) applied only sparingly. Early in his association with Creative Growth, his imagery often incorporated groups of human, generally male, figures. Later, he included representations of school buses and other forms of transportation, as well as buildings, animals, and other subjects, in his compositions, which are characteristically accompanied by text written in a rhythmic, indecipherable cursive script. Mackintosh, who not only suffered from mental retardation but may have also suffered from other psychological impairments, the result in part of fifty-six years of institutionalization, has received widespread recognition for his artwork.

See also **Creative Growth Art Center; Outsider Art.**

BIBLIOGRAPHY

MacGregor, John. *Dwight Mackintosh: The Boy Who Time Forgot.* Oakland, Calif., 1990.

<div align="right">*Lee Kogan*</div>

MADER, LOUIS: *SEE* ALMSHOUSE PAINTERS.

MAENTEL, JACOB (1778–?) was a German immigrant who painted more than two hundred portraits throughout German communities in southeastern Pennsylvania and Indiana. Rendered in watercolor and gouache over graphite underdrawings, these portraits capture minute details of the landscape of German life in America. Attempts to elucidate the facts of Maentel's own life have been less successful, although certain landmark events are known. Johann Adam Bernhard Jacob Maentel was born in Germany to Frederich Ludwig Maentel and Elizabeth Krügerin. Tradition maintains that Maëntel served under Napoléon Bonaparte, and immigrated to Baltimore sometime between his father's death in 1805 and the appearance of a Jacob Maentel "Portrait painter" in the Baltimore Directory of 1807. About 1821, Maentel married Catherine Weaver of Baltimore. Based on portrait subjects in Dauphin, Lebanon, and York Counties, he may have already been living in Pennsylvania by 1810. A "Jacob Mantell" of Lancaster served in the Pennsylvania militia from September 1, 1814, to March 1, 1815, and was naturalized in York County a short time later.

In 1816 Lewis Miller (1796–1862) sketched two gentlemen in York County, both named Jacob Maentel, leading to some confusion about the identity of the artist. It appears that he was living in Schaefferstown, Lebanon County, in 1830, where his name appears in the parish register of the St. Luke's Evangelical Lutheran Church, along with many of his subjects (Zimmerman, Bucher, Haak) suggesting that they were personally known to the artist. In Schaefferstown, his name also appears in the Zimmerman ledger books for purchases of paint and confectionery supplies. By 1838 Maentel was listed in the Indiana tax rolls for New Harmony Township, where he continued to portray members of the tight-knit German community.

Based on dated works, Maentel was active from 1807 to 1846, with only four signed examples. The watercolors fall into several stylistic modes, but all are

defined by fine and distinct ink strokes delineating brows and lashes, while heavy washes in watercolor and gouache are used to indicate landscape and drapery. The earliest works include full-length figures in the foreground standing in profile against sparse backgrounds with active cloud formations. A tree often appears on one side of these early works, and blades of grass often spring from the ground. The empty backgrounds yield to architectural structures, fences, and other narrative elements as the artist matures. From about 1816 to 1820, Maentel developed a format of pendant portraits of frontal figures set into colorful interiors. Portraits *John Bickel* and *Caterina Bickel* are notable early examples of this format, and illuminate interior details of period furnishings and decorative arts. Portraits *Dr. Christian Bucher* and *Mary Valentine Bucher* represent a rare deviation from this formula, with Dr. Bucher shown in his professional environment and Mrs. Bucher in her domestic one. By the mid-1820s, however, symmetrical companion portraits such as *Peter Zimmerman* and *Maria Rex Zimmerman* had become Maëntel's typical forms of presentation, and he continued to reuse these established conventions in Indiana. Jacob Maentel is buried in Maple Hill Cemetery in New Harmony, where his headstone bears only the initials "*J.M.*"

See also **German American Folk Art; Lewis Miller; Painting, American Folk.**

BIBLIOGRAPHY

Black, Mary C. *Simplicity, a Grace: Jacob Maentel in Indiana.* Evansville, Ind., 1989.

———. "A Folk Art Whodunit." *Art in America*, vol. 53, no. 3 (June 1965): 96–105.

Fleming, Mary Lou Robson. "Folk Artist Jacob Maentel of Pennsylvania and Indiana." *Pennsylvania Folklife*, vol. 37, no. 3 (spring 1988): 98–111.

Lipman, Jean, and Tom Armstrong, eds. *American Folk Painters of Three Centuries.* New York, 1980.

Redler, Valerie. "Jacob Maentel: Portraits of a Proud Past." *The Clarion* (fall 1983): 48–55.

STACY C. HOLLANDER

MALDONADO, ALEXANDER A. (1901–1989) began to paint during retirement at the suggestion of his sister. Painting absorbed him for years as he worked on his visionary landscapes, utopian cities, and planetary vistas. Maldonado's iconography blended fantasy, autobiography, and religious imagery drawn from his Mexican heritage. Racial and social prejudice was a recurring theme in his paintings (perhaps a natural subject for a Mexican American who spoke halting English). He also expressed sympathy for human rights and antipathy toward big business in his paintings.

Wax Museum with Painted Frame (1964) comprises a theatrical setting including tableaux from Shakespeare's *Romeo and Juliet* and *Julius Caesar*, English history, and Mexican history, each set in discrete areas on a stage. Spectators, with their backs to the viewer, are represented on the lower edge of the painted frame.

In this and other compositions Maldonado employs an intense palette of luminous color, often depicting night scenes. In *Out of Space Planet* (1973), a crater and a mountainous moonscape glow with yellow highlights and reflections against a black sky that is sharply punctuated by constellations, comets, and planets. A strong sense of pattern evinced through repetitive lines and geometric forms is evident in *Laguna Azul* (1969), a waterfront landscape with fantastical architectural structures loosely ranging from Art Deco to Expressionist.

Maldonado was born in Mazatlán, Sinaloa, Mexico. In 1911, following the outbreak of revolution in Mexico, he settled in San Francisco with his family. After his father died, Maldonado sold newspapers and attended to a milkman's horse to supplement the family income. During World War I he worked as a riveter in the San Francisco shipyards. From 1917 to 1922 he was a featherweight boxer under the name Frankie Baker; he claimed that during those years he had shaken hands with Jim Corbett and had been chauffeured to fights by San Francisco's mayor, "Sunny" Jim Roiphe. After retiring from the ring, Maldonado worked for Western Can for almost forty years.

He first drew with pencil and crayon, gradually incorporating watercolor before moving on to oil on canvas. His canvases are often symmetrical, with bold outlining, text captions, and embellished patterned frames ("to look nice"). In his basement studio, the floor, wooden beams, and tools were all colorfully decorated.

Maldonado was discovered by gallery director Bonnie Grossman, after he donated a painting to a public television station, KQED, for auction in 1973. This painting received KQED's Annual Auction Art Award, and the next year Maldonado donated another; as a result, he was included in the station's documentary on local artists, which Grossman helped prepare. According to Grossman, there are biographical parallels between Maldonado and Achilles Rizzoli. In 1988, the San Francisco Craft and Folk Art Museum featured Maldonado in a solo exhibition. His paintings are included in the collections of the American Folk Art Museum and Smithsonian American Art Museum.

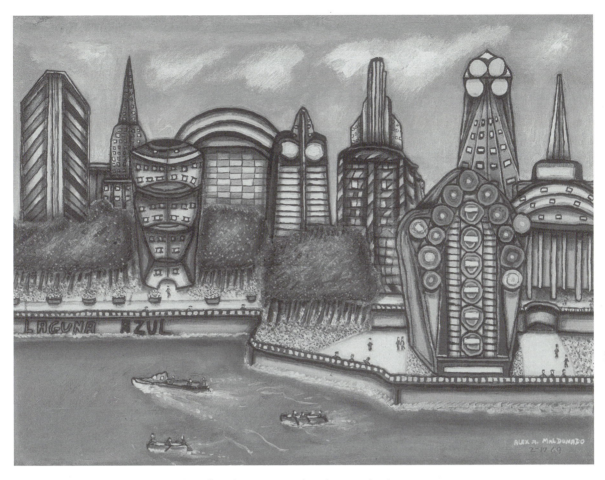

Laguna Azul; Alexander A. Maldonado; 1969. Oil on canvas on board; 18 × 24 inches. Collection American Folk Art Museum, New York. Gift of the artist, courtesy of the Ames Gallery, Berkeley, California, 1987.6.1.
Photo courtesy John Parnell.

See also **Painting, American Folk; Religious Folk Art.**

BIBLIOGRAPHY

"Alexander A. Maldonado, Naïve Painter, Dies." *Antiques and the Arts Weekly,* vol. 14 (April 1989): 45.

Beato, Greg. "Alex Maldonado: California Painter of the Space Age." *Folk Art Messenger,* vol. 1, no. 4 (summer 1988): 1, 3.

Grossman, Bonnie. "Alexander Maldonado (19-1-1989)." *Clarion* (spring 1989).

Kaufman, Barbara Wahl, and Didi Barrett. *A Time to Reap: Late Blooming Folk Artists.* South Orange, N.J., 1986.

Martin, Robert, and Lauri Larsen-Martin. *Pioneers in Paradise: Folk and Outsider Artists of the West Coast.* Long Beach, Calif., 1984.

"Parallel Lives—Different Minds." *Antiques and the Arts Weekly,* 8 (November 2002): 25.

Rosenak, Chuck, and Jan Rosenak. *Museum of American Folk Art Encyclopedia of Twentieth-Century American Folk Art and Artists.* New York, 1991.

LEE KOGAN

MANYGOATS, BETTY (1945–) is a Navajo potter who learned to make pottery from her paternal grandmother. Among the Navajos, pottery making most frequently is passed down from mother to daughter, or in the case of Manygoats, from grandmother to granddaughter. Since the early nineteenth century, most Navajo pottery has consisted of unpainted cooking vessels along with ceremonial bowls, pipes, and other ritual objects. Although she has created a variety of typical Navajo forms, such as bowls and jars, Manygoats is best known for her large, Pueblo-style double-spouted wedding vases.

Manygoats makes her pottery according to time-honored techniques. Both utilitarian and ceremonial pots are handmade in the same traditional Navajo way: after the clay is cleaned and mixed, the vessel is built from coils that are added until the pot has

reached the desired size and shape. During the next step, the coils are smoothed out with a river stone or piece of gourd. A decorative fillet is added below the rim. When the pot is finished, it is dried in the sun until it is ready for the outdoor firing process. After firing, while the pot is still warm, it is coated inside and out with *piñon* pitch, a distinctive Navajo technique.

Manygoats' work is distinguished by the innovative creation of low relief, appliquéd figures such as *hogans* (Navajo dwellings), sheep, cactus plants, yuccas, horses, people, and, most especially, horned toads. On occasion, Manygoats further embellishes the appliquéd features using household paint, to enhance her ornamental detail. Her appliquéd forms always reflect objects that are a familiar part of everyday Navajo life. From time to time, she also makes freestanding animal figures, usually of horses, cows, and sheep. Although most of her work is unsigned, she occasionally adds her initials, "BM" or "BBM" (Betty Barlow Manygoats), on the bottom of the pot, either incised in the clay or written on with a felt-tipped pen.

Manygoats lives in the Shonto-Cow Springs (Arizona) region of the Navajo Nation, an area that is home to several other Navajo potters. Her imaginative pottery has won numerous awards, at both the Museum of Northern Arizona in Flagstaff and the Intertribal Ceremonial in Gallup, New Mexico. Like most traditional Navajo potters, she never submits her own work at these or other shows; her pottery is submitted most often by traders and gallery owners. Manygoats is fostering another generation of innovative Navajo potters by teaching the art to some of her daughters.

See also **Native American Folk Art; Pottery, Folk.**

BIBLIOGRAPHY

Hartman, Russel P. *Navajo Pottery, Traditions, and Innovations.* Flagstaff, Ariz., 1987.

Rosenak, Chuck, and Jan Rosenak. *The People Speak: Navajo Folk Art.* Flagstaff, Ariz., 1994.

Susan Brown McGreevy

MARITIME FOLK ART accumulated over the centuries because of the chronic isolation and confinement of sailors on board ships, often for long periods under arduous and hazardous conditions. This resulted in a galaxy of diversions to fill time, satisfy creative impulses, and fill the social and cultural voids engendered by separation from home and hearth. Removed from family, friends, church, and the conventional social relationships that might normally impart stability, self-identity, and camaraderie ashore, seamen developed their own distinctive cultural microcosm and expended their creative energies with the limited materials on hand. The peculiar conventions of the seafaring trades, and a characteristic (and rather complex) occupational pride, imparted an idiosyncratic nautical character to sailors' artistic endeavors—a flavor that carried over to life ashore and is accordingly reflected in many of the artistic productions and analogous pursuits of non-sailors in seaports and shoreside communities.

The genre perhaps most uniquely identified with deepwater mariners is scrimshaw, the whalers' art of making decorative and practical objects out of sperm whale teeth, skeletal bone, walrus tusks, and baleen. Scrimshaw was only one of many diversions to alleviate boredom at sea, but it typifies both the genesis of sailor diversions in occupational circumstances, and the characteristically practical aspect of nautical arts. Long voyages, infrequent landfalls, and chronic over-manning in the whale fishery, and the fact that hazardous hunting and butchering operations could be accomplished effectively only in daylight (so that, unlike sailors in other trades, whale men had most evenings off) created an overabundance of leisure time. Many captains were grateful for any harmless amusements, that kept idle crews out of trouble and occupied. Even aboard merchant ships there were musical soirees and occasional theatricals put on by the crew, that also entailed scriptwriting, casting, rehearsing, making costumes and props, and handwriting programs.

But all of this was more prevalent and more frequent on whaling ships, where the production of journals, poetry, art, music, and handcrafts achieved levels far exceeding any other trade. Many shipboard journals produced by whalemen (and, to a lesser degree, those of mariners in the navy and merchant trades) are rich in pencil, ink, and watercolor drawings, as well as whale-stamps and ship-stamps carved by the sailors themselves, original poetry, song lyrics, musical and theatrical programs, and narrative evidence of scrimshaw, woodworking, and other vernacular shipboard arts.

The pastime most deeply rooted in the practical skills of sailoring was rope fancywork. Mariners mastered reeving (fastening by passing the rope through a hole, ring, or pulley), serving, splicing, and knot-tying as elementary prerequisites for even the lowest grades of advancement. Fishermen had to tie and repair nets and longlines, especially on sailing vessels, and lives and livelihood depended on the ability to work rope and to employ just the right knot for

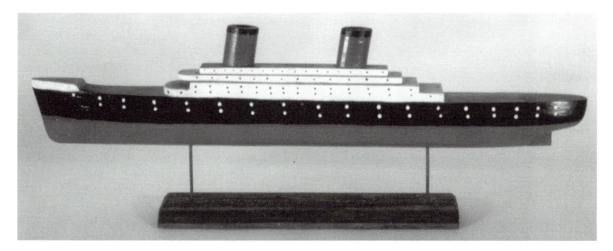

Ship Model of a 20th Century Trans-Atlantic Steamer. Artist unknown; c. 1950. Carved and painted wood; © Esto.

each specialized purpose. The tools required were few and always at hand: an ordinary sailor knife, and a conical *fid*, made of wood or bone, for reeving and splicing, and for making grommets for sails (a marlinspike is the same tool made of steel, intended for working steel cable). Covered with Stockholm tar, ropework became a waterproof preservative.

Skill with rope and twine led to decorative expressions. Ordinary objects like tool handles, box handles, lanyards, belts, and fobs could be decorated and their utility, strength, and longevity improved by the addition of fancy ropework: handles with better grips, needle cases protected from sun and surf, and garments more handsomely festooned. A popular fanfare was the knot-board: specimens of sailors' knots mounted on a wooden backboard for display and pedagogical purposes.

Skill with needle and thread was also an essential sailor skill, not only to manage sails and cordage, but to make and repair clothing. Inevitably, artistic manifestations emerged. Embroidered shirts and trousers were fashionable in the Royal Navy by the eighteenth century; as were embroidered ditty bags and duffels. These were adopted in varying degrees by Americans, especially nineteenth-century navy tars, by whose hand a few ornately decorated hats, shirts, and satchels survive. Woolwork pictures, primarily ship portraits and nautical scenes, composed of wool yarn sewn on cloth were a common pursuit of British and colonial seamen but were evidently rare on American ships. Judging from surviving examples, Yankee sailors inclined more towards embroidery with fine thread on velvet and sumptuous cloth backings, frequently with ornate silver and gold highlights, pro-

ducing commemorative tapestries, kerchiefs, and pillows, often elaborately inscribed. This genre enjoyed its heyday in the 1890s and during the Spanish-American War in 1898.

Ship models, especially "rigged" models of sailing vessels in all their splendor of spars and sails, are popularly associated with sailors, and certainly some mariners ashore capitalized on their intimate familiarity with the architecture and technology of watercraft to produce replicas. This impulse is best realized in warship models fabricated from steak bones and miscellaneous flotsam by French naval prisoners-of-war incarcerated in England during the Napoleonic Wars in the 1790s to 1815. American model makers were evidently more partial to wood than bone. Not many rigged models, however, were likely made at sea: even for the few sailors who may have possessed the skill and stamina to complete so elaborate an undertaking on the bounding main, there simply was not sufficient time or space. Leisure time was short-lived and intermittent everywhere but the whaling trade, and even officers were squeezed into miniscule quarters; meanwhile, the hazards of pitching and rolling suggest that a delicate rigged model could not have survived easily in any forecastle.

A more modest but highly significant form of model emerged from shipbuilding. The so-called half-hull model is a scaled rendition of the hull only (actually, only one side of the hull, of which the other half is a mirror image), without rigging or fixtures. Half-hulls built by shipyard artisans served as plans—the actual basis for constructing a ship with lines and sheer (a ship's position at anchor at which it is maintained to keep clear of the anchor) scaled up from the

model maker's prototype. These vernacular productions survive in fairly large numbers and frequently embody aesthetic virtues far surpassing mere industrial interest.

Seashells were available to mariners through myriad means and were commonly incorporated into shipboard handcrafts, notably as mother-of-pearl inlay on scrimshaw but, also in other sailor arts. Least common are mosaics, a form of sailor's valentine, where the arrangement of multicolored shells forms a geometric, figural, or floral motif, or where some other kind of picture or image is framed by a wreath of shells. More prevalent was the engraving of pictures, mottoes, or inscriptions on nautilus and cowrie shells (however, these were often purchased or commissioned from professional artisans ashore and, like most sailors' valentines, are not sailors' work at all). Cowrie shells carved in low relief were produced as souvenirs for sailors and for vacationers at seaside resorts from the 1870s onward, and these were evidently emulated by sailors at sea and ashore. Sumptuous relief-carved floral garlands on red and black abalone shell by cabinetmaker and former whaleman and artist Charles Durgin of Laconia, New Hampshire, and Stockton, California, are an evidently unique departure. The best known engraver of seashells was Englishman C.H. Wood (active c. 1840–1865), whose finest works are nautilus shells portraying the British steamships *Great Britain* and *Great Western,* with lengthy inscriptions, produced in multiple copies in various sizes, each claiming to be exact duplicates of ones he presented to Queen Victoria and Prince Albert in 1845, though there is no evidence that anyone in the royal family ever actually accepted or acknowledged such a gift or commission. Wood's significance is principally that he sold his wares in New York, and possibly Sydney and Melbourne; the workmanship is so compelling that he may have influenced a generation of anonymous American and Australian amateurs. James Dugan reports in *The Great Iron Ship* (1953) that on the occasion of the *Great Eastern's* maiden voyage to New York in 1860, with the ship opened to public view at quayside, an artist named Wood manned a booth [on board] where he sold seashells engraved with the ship's picture.

Engraved powder horns—typically cow horns fitted with wooden plugs and a shoulder strap, for use with muzzle-loaded firearms—were a mainstream grassroots phenomenon, also significant in Native American usage. A far older genre than scrimshaw, its nautical significance has been overstated. Nevertheless, some powder horns have nautical themes, some claim nautical provenance, and a handful were en-

graved by mariners. Carson A. Ritchie notes in *Bone and Horn Carving* (1975) a powder horn of American origin dated 1819 and inscribed "Here's death to the living / Long life to the killer / Kisses to sailors' wives / And greasy luck to whalers" a form of the motto that later appeared on the famous "Susan's Teeth" scrimshaw by Frederick Myrick of Nantucket (1828–1829). Two powder horns are associated with whale ships named *Atlas,* one with the *Atlas* of Newport, Rhode Island, engraved about 1823–1825 by Captain Abraham Gardner, the other attributed to Gideon Baker aboard the *Atlas* of Norwich, Connecticut, dated 1834. A horn credited to whaling and merchant captain James Smith aboard the New London, Connecticut, whaleship *Columbia,* is dated 1836; another was profusely engraved by a whale man known as the Pagoda Artisan or the Albatross Artisan, about 1840. A flask for carrying round shot carved from a sperm whale tooth with engraved decorations possibly by an African American hand, about 1840, may be unique. However, powder horns and shot flasks are primarily the province of the frontier, woodlands, and farmlands. There was not much call for them at sea: personal firearms had little place on merchant ships, and the navy generally issued regulation equipment.

The perennial container for a sailor's worldly goods was the wooden sea chest, that could be purchased or handmade, and was intended to be stowed in the crowded forecastle. These too became objects of painted personalization, a practice popular in Holland and Germany and extremely common in Scandinavia, where numerous examples are preserved in maritime museums. American specimens are comparatively scarce, but the architecture and iconography are consistent internationally: decorations appear mostly on the inside of the box (where they are less subject to the hazards and vicissitudes of wear), and the primarily take the form of ship portraits, patriotic symbols, flags, anchors, and nautical scenes, often naming the sailor and his ship.

A unique genre closely identified with deepwater mariners is the tattoo. An age-old practice among tribal peoples throughout the world, tattooing gradually came into nautical fashion in the late eighteenth century, after the Cook and other Pacific expeditions first encountered traditionally tattooed Polynesians and Eskimos. Increasing contacts with tattooed native peoples led sailors to adopt tattoos of their own, and by the twentieth century, tattoos had become a coveted badge of the deepwater mariner.

Finally, the ubiquitous presence of bits of wood (as opposed to cabinetmakers' lumber) on shipboard and in virtually every port, enabled whittling and a wide

variety of woodcarving pursuits. Since the Viking era, the highest forms of nautical woodcarving had been figureheads and decorative ship carvings produced by professional artisans ashore, many of them self-trained and working on commission for shipbuilders and owners. Much of the work is anonymous, but some practitioners were renowned in rarefied ship-building circles; others, like Philadelphia sculptor William Rush (1756–1833), are celebrated for a wide variety of related and unrelated artistic accomplishments. Their work inspired countless sailors and other amateurs to try their hands at figural and patriotic sculptures in various sizes. More commonly, wood was employed as a convenient medium for tool handles, toys, chests, boxes, furniture, practical household objects, corset busts, and virtually anything that could alternatively have been made as scrimshaw.

See also **African American Folk Art (Vernacular Art); Boxes; Toys, Folk; Pictures, Needlework; Powder Horns; William Rush; Sailors' Valentines; Scrimshaw; Ships' Figureheads; Tattoo.**

BIBLIOGRAPHY

Brewington, M.V. *Shipcarvers of North America.* New York, 1972.
Dresslar, Jim. *The Engraved Powder Horn.* Bargersville, Ind., 1996.
duMont, John S. *American Engraved Powder Horns.* Canaan, N.H., 1978.
Frere-Cook, Gervis. *Decorative Arts of the Mariner.* Boston, 1966.
Grancsay, Stephen V. *American Engraved Powder Horns.* New York, 1946.
Guthman, William H. *Drums A–Beating, Trumpets Sounding: Artistically Carved Powder Horns in the Provincial Manner, 1746–1781.* Hartford: Conn., 1993.
———. "Powder Horns of the French and Indian War 1755–1763." *The Magazine Antiques,* vol. 114, no. 2 (1978): 312–331.
Hamilton, Georgia. *Silent Pilots: Figureheads in Mystic Seaport Museum.* Mystic, Conn., 1984.
Henderson, J. Welles, and Rodney P. Carlisle, *Marine Art and Antiques: Jack Tar: A Sailor's Life, 1750–1910.* Woodbridge, Conn., and Suffolk, England, 1999.
Martin, Kenneth R. *Whalemen's Paintings and Drawings.* Sharon, Mass. and London, 1983.
Pinckney, Pauline A. *American Figureheads and Their Carvers.* New York, 1940.

STUART M. FRANK

MARLING, JACOB (c. 1773–1833) was a portrait, miniature, and landscape painter, an art teacher, and a museum director. He worked along the Atlantic seaboard and, principally, in Raleigh, North Carolina, during the early nineteenth century. A mysterious individual whose identity is known primarily through newspaper references and business correspondences relating to land transactions and portrait commissions, he studied for seven years under the artist James Cox (1751–1834) and may have spent some of these years with him in Albany, New York. Marling was in New York City in 1793 and in Fredericksburg, Richmond, and Petersburg, Virginia from 1795 to 1809, and later in Philadelphia, where he is believed to have painted portraits and instructed students in art. He settled permanently around 1813 in Raleigh, North Carolina, in search of work from the area's prospering republican citizenry.

Initially, Marling served as director of the North Carolina Museum. Comprising a reading room with newspapers and literary works, this fashionable institution, located on Fayetteville Street in Raleigh, also exhibited natural and artificial curiosities, maps, and rare coins, in addition to paintings by artists (including Marling). Although he advertised his services as a portrait and miniature painter innewspapers of the period, no signed examples of his work have been located. The artist is believed to have executed several likenesses of members of the state's legislature and other local politicians, including images of John Gray Blount, William A. Blount, and Joseph John Daniel. A pleasing landscape scene of North Carolina's first state house is attributed to him.

Jacob Marling's wife Louisa, also an artist, worked at the Raleigh Academy, beginning in the spring of 1815 where she taught drawing and painting. Occasionally, her husband assisted her in teaching. A drawing of a bowl of cherries, signed "Marling," has been attributed inconclusively to Jacob Marling, although it could be his wife's work.

Jacob Marling's most ambitious known composition is entitled *The Crowning of Flora.* According to a contemporary newspaper account, Marling's picture of 1816 presents a group of young schoolgirls from the Raleigh Academy gathered outdoors to celebrate the first day of May by crowning one of their own as "queen." Various identifiable individuals are portrayed in this composition, including that year's May Queen, the school's principal, the music teacher, Mrs. Marling, and possibly the artist.

See also **Miniatures; Painting, American Folk; Painting, Landscape.**

BIBLIOGRAPHY

North Carolina Museum of Art, Raleigh. *Jacob Marling: Retrospective Exhibition.* Raleigh, N.C., 1964.
Deutsch, Davida. "The Crowning of Flora: Mr. Marling and Ladies Identified." *The Luminary, Museum of Early Decorative Arts, Winston-Salem, North Carolina* (summer 1988): 3–4.

CHARLOTTE EMANS MOORE

MARQUETRY, FOLK, used to decorate wooden objects with patterns and pictures composed of wood veneers that are carefully cut and glued onto the surface of the wood, has been known since ancient times. It became an important form of folk art in America in the 1860s, during the "Gilded Age," when luxury furniture, popularized at international expositions, used marquetry for enrichment and was imitated on a more modest scale by cabinetmakers, carpenters, and recent immigrants from Germany who were skilled in woodworking. The range of marquetry designs is great, from uniform geometric borders using two or more contrasting woods, to elaborate scenes that incorporate many colors and shapes, sometimes creating the illusion of paintings. The pigmentation, graining, and natural markings of the wood are as much a part of the beauty of marquetry as is the arrangement of the pieces themselves. Both elements enhance the form of the core furniture it decorates, which is sometimes a ready-made item, but often a product of the carpentry skills of the marquetry maker. Marquetry is found on boxes more than on any other objects, but it has also enriched almost every other domestic item made of wood: beds, chairs, clocks, tables, and even violin cases. Related wood techniques include parquetry (geometric shapes cut with straight edges) and intarsia (wood pieces laid into an indentation in a solid wood base cut to receive them).

Ancient Egyptian tomb paintings show marquetry furniture being made and examples of Egyptian marquetry still exist. During the late Middle Ages, marquetry embellished the choir stalls of churches and monasteries. In 1588, marquetry workshops were established by the Medici, the ruling family in Florence, Italy, that were to become the model for marquetry production for the furnishing of Versailles and other palaces of Louis XIV in France. Marquetry quickly became a conspicuous symbol of the king's love for luxury and marquetry makers, most of them German, flocked to France to offer their services, which were accepted and richly rewarded.

The French Revolution ended large-scale patronage for marquetry making. With the Industrial Revolution, factories began to supplant workshops throughout Europe. It is not known how many woodworkers found themselves unemployed and forced to immigrate, but many Germans arriving in the United States in the late 1840s quickly sought work in the furniture industry centered in New York City. In 1855, 61 percent of New York City's furniture trade was made up of German workers. The nation looked to New York for fine cabinetmaking. The city also became the center for marquetry ornamentation of furniture, the inspiration for the period of America's greatest production of folk marquetry.

Luxury furniture with marquetry embellishments became known to rural Americans in exhibits at local fairs. Average American woodworkers were ready to adapt the wood patterns and designs. The hand-held fretsaw, with its fine-toothed blade of clock-spring steel, and the jigsaw, were familiar tools to carpenters who learned to use them to cut veneers from hunks of wood and to shape them for marquetry designs. Many of the steam-powered lumber mills of America could cut fifteen to twenty slabs of veneer to the inch of timber, and large cities like Boston were importing great quantities of wood for their cabinetmakers from the Caribbean islands, Africa, and other places. The easy availability of veneers in a large assortment of colors and textures was important in the eventual development of marquetry.

Mass-produced veneers were cheap and popular by 1830, yet some marquetry makers applied handmade methods to their work, particularly in the sawing of veneers. Because marquetry patterns were frequently repeated for borders, spaced accents, and for highlighting the corners of a square or rectangular piece, a sixteenth-century technique called "piece by piece," "separate packs," or *tarsia a toppo* regained popularity with marqueters of the nineteenth century and produced quantities of small patterns of flat geometrical shapes. The desired woods were cut into sticks of geometrical shapes and then bundled together. The stack of shaped sticks was glued together under pressure, and then sawed across the grain into veneers, each identical in the desired pattern.

The history of woodworking in America began before nineteenth-century immigrants arrived with their specialized skills. Among the very first settlers were trained woodworkers who brought their tools with them on the *Mayflower* and subsequent passenger ships. They helped build houses and were responsible for most of their furnishings. They also trained the first native generation of wood workers and very likely inspired the ubiquitous jacks-of-all-trades. Though some young men served apprenticeships with master carpenters as early as the seventeenth century (and in Boston were required by law to complete a seven-year apprenticeship before they could work), carpentry was more customarily passed on from father to son. From the start, there were both types of woodworkers: the formally but practically trained men who eventually gravitated to the growing cities, and the rural carpenter who could do a host of tasks with equal skill.

Frederick Stedman Hazen (1829–1908), a sixth-generation descendent of *Mayflower* immigrants, was a direct descendent of America's first woodworkers. Born at Feeding Hills, Massachusetts, his family moved to Southwick, Massachusetts, where, as a very young man, he started the town's first weekly newspaper. Upon its failure, he moved to Springfield, Massachusetts, and began to work in the car shops of the Boston and Albany Railroad. He gave the fine finish to the wood of passenger cars and later worked in the shop that constructed the woodwork of locomotives.

Woodworking was Hazen's profession and cabinetmaking was his passionate hobby, occupying much of his spare time. The Springfield City Directory of 1858 notes that Hazen kept a wood shop in his house, and it was there that he produced the marquetry that brought him local fame. Between 1850 and 1870, he built some minor pieces of marquetry, and four ambitious works, including a secretary that is considered the masterpiece of American folk marquetry. An early large piece was a buffet, of which no description exists. A tool chest, completed in 1857, was constructed of 200 different kinds of wood and other materials cut into 14,265 pieces and arranged to picture the tools used in its construction. A newspaper article of August 9, 1866, reported that Hazen owned a library table that he made with 250 different kinds of wood cut into 12,433 pieces. The article went on to say that Hazen declined to show it at the Paris exposition, "and after giving it a few more extra touches, will probably exhibit it at some of the state fairs." The present locations of these pieces are lost; of Hazen's output, only the secretary is known.

From 1862 to 1869, Hazen painstakingly constructed his secretary. It contains wood from 200 different kinds of trees, as well as an assortment of symbolic woods, relics of American military and social history, many of them sent to Hazen by people who learned of his marquetry projects through at least twelve articles in the *Springfield Daily Republican* between 1857 and 1879. A total of 21,378 pieces of wood are intricately patterned in geometrical designs or figural representations to form his cabinet. A list written in alphabetical order in Hazen's own hand enumerates myriad species of trees used in making the secretary, including those collected from far-flung places. He also listed materials with historic associations that he used in the secretary's ornamentation, such as a piece of rail that Abraham Lincoln split. Hazen left diagrams that show the locations of these souvenirs, along with all of his working drawings, cardboard patterns, and chips of unused wood. The

many newspaper articles that document his marquetry projects were also saved.

The secretary consists of three parts. The base has a two-door cabinet and slide-out desk. Two drawers and a two-door bookcase make up the body of the secretary. A cornice rests on top of the bookcase, with a small cut-out eagle with flags and shields hovering above it. The carcass of the secretary is made chiefly of mahogany and every visible surface is richly patterned with an overlay of marquetry.

The designs in the upper and lower cabinet doors are the most imposing of Hazen's inventions. The upper panels are dominated by exploding six-pointed stars, reminiscent of a design on a crazy quilt. Below, overlapping circles fill one door while the other shows a square with a diagonal basket-weave grid of bars presented three-dimensionally. Floating at random around it, as though moving in space, are more three-dimensional bars. Hazen included an illusionistic pile of books inside one of the cabinets, but all of his other designs are flat, two-dimensional profiles.

Hazen's tendency toward intricacy fascinated Springfield residents and others who saw the secretary when it was exhibited in Hazen's parlor in 1869. *The Springfield Daily Republican* of September 29, 1869, heralded it as, "A Triumph of Ingenuity." The same newspaper reported that Hazen followed the progress of the Civil War, binding newspaper articles into a book to "treasure . . . in the secretary." Thus it is not only a masterpiece of folk furniture but also a reliquary, a memorial to the Civil War, and a celebration of its conclusion.

Peter Glass (1824–1901), the son of a farmer, trained in the making of marquetry in Germany before he came to America in 1844. He settled in Leominster, Massachusetts, where he married, and began entering his marquetry furniture at exhibitions, winning prizes for it. Glass was granted American citizenship in 1852. In 1856, he opened a woodworking company in New York City but the next year he moved to an eighty acre farm in Wisconsin. The census of 1860 listed him as a farmer. From 1858, when he won a three dollar prize for the "best mosaic center table" at the Wisconsin state fair, to 1865, there is no other known example of his woodwork.

Still operating his farm after the death of his wife and three of his children in 1861, he completed two marquetry pieces, a center table and a workbox, that he arranged to send to President Abraham Lincoln. However, the president was assassinated before he received the gifts. In memory of him, the pieces were shown in Chicago in the early weeks of April 1865. *The Chicago Tribune* referred to Glass as "a Wiscon-

sin backwoods man," and reported that his table contained 20,000 pieces of colored wood to create "truthful medallion portraits of Lincoln, Johnson, Grant, and Butler." The present location of these pieces is unknown, but the Smithsonian Institution in Washington, D.C., owns a similar table by Glass with four circular portraits of American military generals arranged between flamboyant bouquets of flowers.

Glass produced marquetry inlays for a Boston pianoforte factory, perhaps supplying the marquetry inlays by mail, for he was still operating his Wisconsin farm. One of his center tables was shown in the Boston store before it was sent to Paris, where it was exhibited at the Universal Exposition of 1867 and received an honorable mention. The same table was shown in fairs in Wisconsin, Massachusetts, and New York the next year, winning prizes at all three venues, and finally was exhibited at the Philadelphia Centennial Exposition of 1876. Although he was only in his early forties when he made this table and received so much recognition from it, he seemed to have abandoned marquetry making until the 1890s, an interim of about thirty years. Nine workboxes and eight work stands survive from this later period.

Uriah H. Eberhart (1866–1937), a farmer and barber in Savannah, Ohio, crafted a very large and elaborate secretary of wood marquetry and inlay that celebrates American patriotism and Eberhart's own gifts as a woodworker. He had constructed a bedroom set out of veneers before he saw an inlaid table from Guatemala at the 1893 Chicago World's Fair that inspired him to fabricate an important marquetry piece that would contain a larger variety of woods than any other piece of furniture. He cut and assembled 135,341 pieces of 550 kinds of wood from every state in the Union and from thirty-one foreign countries. Most of the foreign samples were requested by Eberhart from missionaries. "This is a product of spare time . . . working between shaves," Eberhart wrote in one of the many documents about this project that he saved. His barbershop was located in his house and his wood shop was on the second floor of his barn, behind the house. He used hand planes, saws, mallets, and a foot-powered bracket saw to build the piece.

The walnut case is about eight feet tall by four and a half feet wide and four feet deep. The desk consists of two pedestals with an arched kneehole. A roll top cabinet and a tall bookcase rest on a support that bridges the pedestals. A pediment rises above two cornice spandrels that depict portrait busts of the maker and his wife. Under the pediment, inlaid between the portraits, is this quotation from the nineteenth century English Baptist preacher Charles Haddon Spurgeon, "Find your niche and fill it, if it be ever so little, if it is only to be hewer of wood or drawer of water, do something in the great battle for God and Truth."

The marquetry surfaces of the secretary extend without the interference of drawer pulls or other breaks for all of the cabinets use spring-loaded hidden catches. The upper case is inlaid with the names of each state; thirty countries; and fraternal, religious, and national symbols. One section of the secretary shows samples of every variety of wood used in the piece with inlaid letters spelling out the names of the places the woods came from. The most conspicuous designs, centered on the front, show the White House, George Washington, and an American eagle carrying a shield. The battleships *Maine* and *Kearsage* occupy places of honor on the sides of the secretary. On the back of the secretary, Eberhart carefully inscribed that he began his work on November 17, 1896, and completed it July 31, 1900. Throughout his life, he sought opportunities to show the secretary and wrote his own publicity when he did.

Anthyme Leveque (1880–1951) immigrated as a child with his family from Quebec, Canada, to the Black Hills of South Dakota where they settled in or near Lead, a fast-growing gold mining town. At fourteen years of age, he began what was to become a fifty-three year career with the Homestake Mining Company. His father taught him carpentry, a skill that helped him to advance from laborer, to millwright, and then carpenter at Homestake. Marquetry occupied most of his free time. By 1934, he had produced a bridge table and chairs that was illustrated and described in a leaflet as having occupied him six hours every day after work, six days a week, for four years. He cut the 257,703 individual pieces used in the project thicker than usual, at four veneers to an inch.

The cabriole legs of the table and chairs are treated with simple inlaid diamond shapes. Astounding features of the furniture are the marquetry seats and the table top. They are covered on top and underneath with extraordinary designs that incorporate traditional marquetry subjects like tumbling blocks, stripes, crisscrossing bands, and other geometric and abstract motifs with boldly placed pictorial subjects like a harp, a lyre, the Liberty Bell, a crescent moon, the rising sun, golden stairs, and the date 1930.

Although the lives of Glass, Hazen, Eberhart, and Leveque are well documented, most marquetry makers are known only by their work. Signatures, initials, and dates are commonly missing from the pieces they

made, and vital connections to places and history have been severed. Consequently, the careers of most American marqueters must be inferred from the few known details associated with particular pieces of marquetry. Farmers and sailors are two categories of men whose work was famously cyclic, giving them time to work woods into veneers and marquetry objects if that activity appealed to them. Prisoners constitute a third category of individuals who had time on their hands. Documented pieces by farmers and sailors are in limited supply, while a number of boxes, pieces of furniture, and other objects are specifically attached to convicts who labored in wood in prisons.

Marquetry boxes and furniture items in a rural style that blends the sophisticated with the naive often are ascribed to farmers or farmer-carpenters. Sometimes these carried written notations of the number of wood pieces that went into them. From the start of a project, wood chips were counted and sometimes the kinds of woods were listed. Unfortunately, names were not also attached to these products. Local fairs provided opportunities to exhibit woodwork and the best work was sought for America's world's fairs.

Many boxes and pieces of furniture suggest maritime associations in their decorative motifs or the integration of whale ivory into their marquetry overlays, even though these are not sure signs that a piece was made by a sailor or even by a port city cabinetmaker. One of the most noteworthy examples of American folk marquetry said to be associated with the sea is an impressive round table with the globe as a major theme of its shape and inlays. A globe is the largest feature of the pedestal, a triumph of cabinetmaking skill. The top of the table, with a central inlay of large whale ivory letters that spell out the motto "In God We Trust," and the initials "D.E.E.", is rimmed with circular patterns. The outermost band of the tabletop is divided into panels, each displaying a Roman numeral from I to XXVIII. In the skirt below the tabletop are fifteen drawers with rounded fronts that conform to the overall shape of the table. Each is numbered with Arabic numerals, the fifteenth, marked "LOCKS," in ivory letters. The bold globular shape and low center of gravity of the table's supporting pedestal, its probable use for storing keys, and its rich scrimshaw ornamentation all suggest the centerpiece of a captain's stateroom, but documentation to prove this does not exist.

An esoteric category of folk marquetry is prisoners' work. As a result of the prison reform movement that started in Philadelphia in 1787, Auburn Prison in upstate New York developed a model manufacturing program that was imitated by thirty new prisons built after 1830. Convicts worked in the prison's shops at various industries, including furniture-making. Their products earned considerable income for the prison. After hours, in their cells, inmates were allowed to do marquetry "hobby work" using scrap wood. A vanity box carries the notation, "Auburn Prison, June 15, 1879." A miniature pump organ, fourteen inches high and ten inches wide, sparsely ornamented with marquetry, bears an inscription etched in ink into the bottom of the piece in an untidy cursive script: "This organ was built at Eastern Penitentiary by James Griner, presented to Mary J. Jones, August 26, 1902." From 1839 to 1929, the prison at Jefferson City, Missouri, was leased to outside business interests that ran various profit-making, convict-labor enterprises. Two almost identical sideboards of about 1890 are linked to the prison by independent but similar provenances. A variety of game boards have also been attributed to convicts, though none are documented.

"Male quilting," a phrase applied to the making of marquetry, is an apt expression on the most basic levels. Quilts and marquetry use bits and pieces of material, sometimes discarded from other undertakings and sometimes purchased or saved for a special project. From a formal perspective, both folk forms fill flat surfaces with repeated patterns, or use simplified pictures and symbols as designs. There is even a marquetry equivalent to the random crazy quilt design.

The making of quilts and marquetry is similar in that they both depend on a patient, additive progression from detail to detail, until plain cloth or naked wood is embellished with multiple designs that are also made of cloth or wood. Quiltmaking was a flourishing activity in America far longer than marquetry-making, supporting the argument that men knew quilts and when they became engaged in marquetry-making, they based many of their designs on them.

Two marquetry boxes, in particular, demonstrate a close link between the art of the scissors and needle, and that of the saw and glue pot. The interior of the first box, just under twelve inches wide, conspicuously displays needlework, suggesting the collaboration of a woodworker and a needle worker. The exterior of the box is inlaid with the palest colored woods to contrast with touches of ebony that enliven elongated medallions, symmetrically placed on the sides, the sloping cover, and the top. Inside, blue, cream, and gray velvet cover all the surfaces and the velvet of the interior of the lid is embroidered with sprays of green leaves and perky yellow blossoms, framed in silk roping. The jollity of the interior pre-

sents a surprising contrast to the staid ornamentation of the exterior. The box can be seen as a reliquary holding and preserving a fine example of the needlework of a member of the box maker's family.

A second box speaks to an even closer partnership between a needle worker and a cabinetmaker. As in the exterior of the first box, here light-colored woods again contrast with ebony, and there is also an elongated medallion in the center of the cover. Sprays of leaves and blossoms, cut from ebony with fine precision by a jigsaw, move horizontally around the box; and ten sprays of leaves and blossoms, cut from single pieces of wood, ornament the top. These nature motifs consist of three identical designs, cut in packs, and placed with symmetrical formality. Inside, embroidered into the deep red velvet lining, is a flamboyant, eight-pointed star in threads of white, soft yellow, light blue, and two shades of pink. To make the star look like a medal of honor, wide red and white ribbons were folded into a bow and attached to the top of the decoration. Under the vanity tray, covering the walls and bottom of the well, is a miniature quilt. Composed of forty small squares in a checkerboard pattern of red and pink, it is designed to fit the inside of the box without a square being folded or cut. Each pink square is embroidered with a white circle. The red squares are plain. White thread was used to create decorative stitches in a triangular shape that moves across the edges of all of the blocks, linking one to another. The box documents and celebrates the coming together of male and female quiltmaking.

The occasional "sewing bee" allowed women a social outlet while they worked on communal quilts, while marquetry, in contrast, appears to have been created in relative isolation from family and friends in basement or barn workshops, after hours, or during fallow periods in the woodworkers' ordinary occupations. These men made no money from marquetry, but created it to mark important occasions, sometimes to celebrate a national event, but most especially as gifts to family members and other loved ones.

See also **Boxes; Decoration; Fraternal Societies; Furniture, Painted and Decorated; Gameboards; Maritime Folk Art; Miniatures; Pictures, Needlework; Prison Art; Quilts; Quilts, African American; Samplers, Needlework; Scrimshaw.**

BIBLIOGRAPHY

Howe, Katherine S., et al. *Herter Brothers, Furniture and Interiors for a Gilded Age.* New York, 1994.

Lincoln, William Alexander. *The Art and Practice of Marquetry.* London, 1971.

Mühlberger, Richard. *American Folk Marquetry, Masterpieces in Wood.* New York, 1998.

Raymond, Pierre. *Marquetry.* Newtown, Conn., 1989.

RICHARD C. MÜHLBERGER

MARTIN, EDDIE OWENS (1908–1986) was a painter, sculptor, and builder whose crowning achievement was *Pasaquan,* the boldly painted, sculpturally elaborated, architectural environment that he created in Marion County, Georgia. The son of a sharecropper, Martin spent his early years in a nearby farming community, but fled his abusive father at fourteen and hitchhiked to New York City, where he lived by his wits from the 1920s to 1940s. During a serious illness in 1935, he had a near-death experience that concluded when a larger-than-life apparition offered to restore his health if he would promise to lead a more spiritually attuned life. A few months later, he had another visionary experience, accompanied by a voice that bestowed on him a new name, "Saint EOM," and a mysterious title, "Pasaquoyan," which he later interpreted as an arcane reference to the conjoining of past, present, and future times.

These experiences occurred during a period when Martin was beginning to draw and paint, and they immediately preceded his adopting a flamboyant persona. He stopped shaving and having his hair cut, and he began to design and make his own apparel, based on clothing traditionally worn in India, ancient Egypt, sub-Saharan Africa, parts of Asia, and the indigenous Americas. Educating himself on the cultural and spiritual traditions of such locales by reading and going to museums, he began to incorporate variations on non-Western designs and iconography into his own artwork.

For the last half of his life, Martin supported himself as a psychic reader, initially working in a tearoom on 42nd Street, then moving his business to Georgia after his mother's death in 1950. She left him her small farmhouse and four surrounding acres, and in 1957 he went there to live year-round. By 1960 he had begun building *Pasaquan,* which eventually consisted of five separate, roofed structures of varying sizes and designs, as well as a series of elaborately painted and sculpted walls, walkways, and staircases, all reflecting influences of the various non-Western artistic and architectural traditions that had for so long interested him.

Martin continued his creative activities until shortly before his tragic death. Weakened and depressed

after a series of health problems, he committed suicide with a gunshot to the right temple on April 16, 1986. Martin's deteriorating *Pasaquan* environment is currently in the custody of the Pasaquan Society, a non-profit subsidiary of the Marion County Historical Society, in Buena Vista, Georgia.

See also **Environments, Folk; Outsider Art; Painting, American Folk; Sculpture, Folk.**

BIBLIOGRAPHY

Joiner, Dorothy. "Pasaquan: Eddie Owens Martin (a.k.a. St. EOM) created one of the great visionary environments of the South." *Raw Vision*, no. 19 (summer 1997): 28–35.

Patterson, Tom. *St. EOM in the Land of Pasaquan: The Life and Times and Art of Eddie Owens Martin*. Winston-Salem, N.C., 1987.

———. "The Strange Life and Lonesome Death of an American Outsider Artist." *Bomb* (spring 1987): 64–67.

TOM PATTERSON

MARTINEZ, MARIA (c. 1887–1980) a member of the Tewa tribe living at San Ildefonso Pueblo in New Mexico, with her husband Julian, created prized and innovative black-on-black pottery that spurred a revival of Native American pottery-making during the first half of the twentieth century. Maria Martinez generously taught others to make this distinctive pottery, thus helping the residents of San Ildefonso to preserve their traditional way of life.

Born around 1887, when Native American pottery production was declining due to improved access to less expensive, mass-produced ceramics and enamel ware, Maria learned to make pots from her aunt, Nicolasa Montoya (1863–1904), who made traditional polychrome cooking vessels. By observing her aunt, the young girl learned how to make perfectly shaped pots without the use of a wheel. However, since pottery-making did not appear to offer an escape from the grinding poverty of the pueblo, Martinez left to attend St. Catherine's Indian School in Santa Fe. She considered becoming a teacher but returned to the pueblo, where she helped on her family's farm and resumed making traditional pottery.

In 1904, Maria married Julian Martinez, son of a San Ildefonso farmer and saddle maker. In addition to his work as a farm laborer, Julian assisted archaeologists excavating nearby ancient pueblos. Through Julian's connections, the young couple was invited to travel to the 1904 World's Fair in St. Louis, Missouri, where Maria exhibited her pottery. The couple demonstrated pottery techniques again at the 1914 Panama-California Exposition and at the 1934 Chicago World's Fair.

As travel to the west became easier, Anglo artists, writers, and tourists began to flock to New Mexico. These newcomers encouraged Native Americans to produce traditional arts, and Julian and Maria began to collaborate. Using the coil technique, Maria created pots with refined shapes and meticulously burnished them with stones to remove all tool marks. Julian decorated the pots with his adaptations of traditional motifs. Julian's discovery in 1907 of a shard of shiny, jet-black pottery led to the collaboration that brought them widespread recognition. The two experimented with various firing techniques before finally discovering in 1919 that by smothering the fire with ash or horse manure they could produce lustrous black pottery. Much to their surprise, Julian's painted designs, when used with this firing process, formed matte areas that contrasted with the glossy unpainted surfaces.

Abby Aldrich Rockefeller (1874–1948) was an early collector of Martinez's pottery, and her black-on-black pots have been included in many exhibitions and museum collections. Her descendants and other residents of San Ildefonso continue to create their own variations of Maria's black-on-black pottery.

See also **Native American Folk Art.**

BIBLIOGRAPHY

Chapman, Kenneth Milton. *The Pottery of San Ildefonso Pueblo.* Albuquerque, N. Mex., 1970.

Peterson, Susan, ed. *Maria Martinez: Five Generations of Potters.* Washington, D.C., 1978.

———. *The Living Tradition of Maria Martinez.* New York, 1977.

Spivey, Richard L. *Maria.* Flagstaff, Ariz., 1970.

CHERYL RIVERS

MARZÁN, GREGORIO (1906–1997) was employed as a doll- and toy maker for more than three decades, using the skills developed on the job for the creation (after his retirement in 1971) of a distinctive, often whimsical body of folk sculpture. Born in Vega Baja, a town in the fertile coastal flatlands west of San Juan, north central Puerto Rico, he worked as a field hand and carpenter from very early in his life, leaving school when he was only nine years old. The economic pressures of the Great Depression brought him to New York in 1937, prior to the mass migration of Puerto Ricans to the city after World War II. By the time of his arrival, small communities from the island had been formed in East Harlem and Brooklyn. The Works Progress Administration found employment for Marzán first as a sewer worker and shortly thereafter in a factory that manufactured toys.

Obviously possessed of an inventive spirit and unusual technical proficiency, Marzán transformed his retirement into a period of intensive creative endeavor. Working alone in his small East Harlem apartment, he fashioned miniature houses, fanciful figures of animals and birds, striking portrait heads and busts, wry interpretations of the Statue of Liberty (with beaded necklaces and working electric light bulbs) and models of the Empire State Building. He used plaster and found materials in his work, sometimes employing wire coat hangers to serve as the inner framework of sculptural objects that he built up with cloth and secured with plastic tapes. Indeed, it is the use of tapes in a broad range of contrasting colors, including silver, that gives his figures of animals their distinctive character. Some of Marzán's work may be influenced by the mask-making traditions of Puerto Rico, especially the *caretas de carton* associated with festival parades and processions on the island and in New York.

Although Marzán originally created in obscurity, he was fortunate that a community-based arts organization was located within a short walk from his East Harlem home. Among its other institutional objectives, El Museo del Barrio was dedicated to encouraging the arts in its immediate neighborhood. The museum began to acquire examples of Marzán's work, which in turn brought it to the attention of a wider audience. In 1987, a selection of the artist's animal sculptures was chosen for inclusion in "Hispanic Art in the United States: Thirty Contemporary Painters & Sculptors," a major traveling exhibition organized by the Museum of Fine Arts, Houston.

See also **Miniatures; Outsider Art; Sculpture, Folk; Toys, Folk.**

BIBLIOGRAPHY

Beardsley, John, and Jane Livingston. *Hispanic Art in the United States: Thirty Contemporary Painters & Sculptors.* New York, 1987.

GERARD C. WERTKIN

MASON DECOY FACTORY (1896–c. 1924) of Detroit, Michigan, manufactured decoys in a variety of styles, grades, and models. William James Mason (d. 1905) was the principal owner. An excellent hunter, he was a member of the Old Club on Harsen's Island in the St. Clair Flats delta area of Michigan. When living on Tuscola Street in Detroit, Mason carved decoys in a backyard shed. In 1882, he joined with partner George Avery (dates unknown) to found the W.J. Mason Company, a sporting goods store, which presumably stocked his decoys. They soon specialized in decoys. The official starting date attributed to the Mason Decoy Factory is 1896. In 1903, success led to the factory's relocation to 456–464 Brooklyn Avenue, Detroit, adjacent to the Nicholson Lumber Company. When Mason died in 1905, his son Herbert Mason (c. 1887–1956) took over the business.

Decoy historians have access to factory documentation through three extant catalogs. The Mason Decoy Factory advertised itself as the "largest exclusive manufacturer of decoys in the world." Stock orders were prevalent, but special orders were also taken. Decoys were offered for all kinds of hunted waterfowl: ducks, geese, shorebirds, swans, and crows. Made of cedar, they were available in four grades: Premier, Challenge, Detroit (standard) and Fourth (mistakes). The better "premier" grades sold for $25 a dozen. The premiers were usually hollow, while most others were solid. Historian Adele Ernest (1901–1993) notes that "the look of a Mason duck is unmistakable—the strong, rolling sweep of the body, the poised head, and the typical scoop and crosscuts where the bill joins the head." The factory also produced highly sought-after shore birds. Decoy historian Joel Barber (1877–1952) speculates that customers came from primarily southern, Midwestern, and western states.

The limited seasonal demand and the economic need to utilize the factory year round led Herbert Mason in 1919 to go into partnership with his friend, paint salesman Fred Rinshed (dates unknown). They combined the decoy business with paint manufacturing to incorporate the Rinshed-Mason Company in 1919. Neither one had experience in paint manufacturing; they hired a chemist and started production. Later Mason decoys are known to have retained their superior paint, its well-textured consistency applied in swirling designs. The paint manufacturing became so successful that the decoy operation was closed down in 1924. The discontinuation of decoys was prompted as well by the legal prohibitions against battery hunting and interstate transport of waterfowl.

See also **Decoys, Wildfowl; Sculpture, Folk.**

BIBLIOGRAPHY

Barber, Joel. *Wild Fowl Decoys.* New York, 1954.
Cheever, Bryon. *Mason Decoys.* Spanish Fork, Utah, 1974.
Delph, John, and Shirley Delph. *Factory Decoys of Mason, Stevens, Dodge and Peterson.* Exton, Pa., 1980.
Ernest, Adele. *Folk Art in America: A Personal View.* Exton, Pa., 1984.
———. *The Art of the Decoy,* New York, 1965.

Fleckenstein, Henry A. Jr. *American Factory Decoys*. Exton, Pa., 1981.

Goldberger, Russ J. and Alan G. Haid. *Mason Decoys: A Complete Pictorial Guide*. Burtonsville, Md., 1993.

Mackey, William F. Jr. *American Bird Decoys*. New York, 1965.

WILLIAM F. BROOKS JR.

MASON LIMNER: *SEE* FREAKE-GIBBS-MASON LIMNER.

MATERSON, RAY (1954–) embroiders miniature pictures using thread from unraveled socks. His subjects range from realistic portraits inspired by sports heroes to theatrical dramas and song lyrics, as well as autobiographical narratives that evoke nostalgic memories and expose the pain and suffering he endured from an abusive father. Hopes, dreams, and fears are graphically translated into small, intricate vignettes. He estimates that each work, most the size of the palm of a hand, takes sixty hours to complete, and that he sews 1,200 stitches to the inch.

Materson began sewing in 1988, after serving seven years of a fifteen-year prison sentence at the Connecticut Correctional Institution in Somers, Connecticut, for armed robbery. Art transformed the life of this former alcohol and drug abuser. Observing the rimmed mouth of a plastic container in his cell, Materson remembered his grandmother Hattie's embroidery hoop, and pictured her embroidering on the porch of their home in Parma Heights, Ohio. He fashioned a hoop, and cut another hoop from the container lid to hold in place a small piece of cloth from his bedsheet. A sewing needle borrowed from the prison, his unraveled sock thread spooled around a pen barrel, and pencils became Materson's primary tools.

Materson's first project was a sewn *M* that he stitched and then transferred to a cap he made, as an expression of pride for Michigan, his home state team. Materson then started to make logo and flag designs for fellow inmates, reflecting the interest of the recipient. The respect Materson received from fellow prisoners gave him the courage to contact Country Folk Art Shows, based in Michigan, to request an exhibit with them. The organizers were impressed; so was Melanie Hohman of Albany, New York, who saw the traveling exhibition and wrote to Materson. Hohman and Materson met, fell in love, and married while Materson was still serving time. Acting as Materson's agent, Hohman took his work to a curator at the Albany Institute of History and Art, where a show called "Peace" that included Materson's work was organized in 1991. Local television coverage, an Associated Press interview, and the sale of three pieces to the Museum of International Folk Art in Santa Fe, New Mexico, were the results.

Crediting artwork along with religious faith as a cure for his dysfunctional behavior, Materson created an anti-drug poster, a thread picture for the Special Olympics World Games, and a mural for the prison in which he had served time. The Aarne Anton of the American Primitive Gallery gave him a solo exhibition in 1994 that brought him more reviews and extensive media coverage. His memoir, *Sins and Needles: A Story of Spiritual Mending,* was published in 2002. Materson was granted a conditional parole in 1994.

See also **Miniatures; Prison Art.**

BIBLIOGRAPHY

Materson, Ray, and Melanie Materson. *Sins and Needles: A Story of Spiritual Mending*. Chapel Hill, N.C., 2002.

Nutt, Amy. "A Stitch in Time," *Sports Illustrated,* vol. 81, no. 16 (October 1994).

Reif, Rita. "From Scraps of Prison Cloth a Miniature World Grows." *The New York Times* (December 11, 1994): 43.

LEE KOGAN

MATTESON-GROUP CHESTS (1803–1825) are a group of paint-decorated, six-board blanket chests and two-drawer blanket chests. They were ascribed to Thomas Matteson, a member of the extensive Matteson family of South Shaftsbury, Vermont. These chests share a distinctive style of imaginative graining along with similar construction traits. Inspired by the highly figured mahogany, satinwood, flamed birch, tiger maple, and bird's-eye maple veneers of Federal-era high-style furniture, Matteson-group chests exhibit the skillful use of paint as an economical device for enlivening the visible surfaces of simply constructed white-pine chests. Masterfully grained in mustard, green, red, and brown grounds, and highlighted with precise renderings of decorative details, including hand-painted stringing and cross-banding around the edges of the drawer fronts; parallel diagonal stripes on the legs; suggestions of inlaid oval panels on the aprons; and faux cut-out inlays on the tops and sides, these chests rank among the finest examples of American nineteenth-century grain-painted furniture.

Although the decorative surface treatments vary in technique and pattern, the construction of all the known Matteson-group chests is identical. The back of each chest consists of two boards nailed to the side panels, with the upper board generally much wider than the lower one; trapezoidal pieces at the rear feet are sometimes notched into the backboard; lids of the

tills have beaded edges with a thin, grooved line parallel to the round edge; and the hinges are all butt types, fastening to the lid with screws and to the case with nails.

The first to document the similarities of these chests was Caroline Hebb in 1973, in an article in *The Magazine Antiques* that illustrates seven chests, including two with inscriptions on the backs. The first bears this inscription in black paint on the back of the two-drawer chest: "Thomas Matteson / S. Shaftsbury, Vermont / 1824," and the second, "Thomas G. Matison / South Shaftsbury / Vt / 1824." While Hebb discovered that there were six Thomas Mattesons living in South Shaftsbury during the opening decades of the nineteenth century, genealogical research did not list the occupation of any of them, and she was not able to confidently ascribe authorship. Hebb's research intrigued and puzzled furniture historians, however, and over the intervening thirty years, seventeen chests have been attributed to the Matteson group. The inscriptions include, "By J. Matteson / August I A.D. 1803," "Benonia Matteson to B. Burlingame Dr. [debit] / To Paint $2.70 / To Paint & Grain Chest $2.00 / $4.70," and "W.[?] P. Matteson / S. Shaftsbury."

Unfortunately, extensive genealogical research reveals that no member of the extended Matteson family was a cabinetmaker or an ornamental painter. It is thus presumed that the inscriptions denote ownership rather than authorship. While the ornamental painter and cabinetmaker remain unknown, it is assumed that many of these chests were made around Shaftsbury, and thus can be cautiously attributed as Matteson-group chests, or more broadly Shaftsbury-group chests, though not to Thomas Matteson.

See also **Decoration; Furniture, Painted and Decorated.**

BIBLIOGRAPHY

Hebb, Caroline. "A Distinctive Group of Early Vermont Painted Furniture." *The Magazine Antiques*, vol. 104, no. 3 (September 1973): 458–461.
Krashes, David. "New England Paint-Decorated Chests: Discoveries of Attributions." *Folk Art*, vol. 25, no. 2 (summer 2000): 38–45.
Zogry, Kenneth Joel. "Bennington Museum, 1765–1840." *The Magazine Antiques*, vol. 144, no. 2 (August 1993): 197–199.
———. "Urban Precedents for Vermont Furniture." *The Magazine Antiques*, vol. 147, no. 5 (May 1995): 769–770.
———. *The Best the Country Affords: Vermont Furniture 1765–1850*. Bennington, Vt., 1995.

CYNTHIA VAN ALLEN SCHAFFNER

MAYHEW, FREDERICK W. (1785–1854), worked primarily as a portrait artist on his native island of Martha's Vineyard, off the coast of Cape Cod, and in New Bedford, Massachusetts, during the early nineteenth century. Born in Chilmark, Massachusetts on July 6, 1785, the artist was the son of Abner Mayhew, a farmer. In 1811, he married Zelinda Tilton and the couple had one child. Two years earlier, at the age of twenty-four, Mayhew turned to making portraits as a means of supporting himself and later his family. At this time, he advertised in New Bedford newspapers that he painted profile likenesses, however, none have been located.

Over the next twenty-five years until 1834, Mayhew traveled the region executing principally profiles, oil portraits, and watercolor-on-paper miniatures while intermittently returning to Chilmark, his home base. The rapid expansion of the whaling industry in the region fueled the artist's ability to secure commissions for likenesses from the area's swelling middle class. Of the twenty-five portraits signed by Mayhew or attributed to his hand, the majority depict sea captains, their wives and families. Frequently, the artist portrayed male subjects with attributes of their seafaring trade, such as in the portrait of Captain Richard Luce of Tisbury. This composition includes a spyglass and a small boat in the distance, resting mysteriously on a bed of waves. Women are shown in complementary compositions, dressed in beautiful clothing ornamented with elaborate lace collars, as in the double portrait depicting Mrs. Sylvia Howland Almy and her daughter Sarah. They wear hats, hair combs, and jewelry such as necklaces and rings, and frequently hold infants in their arms.

Mayhew's security as a portraitist was affected, in part, by economic fluctuations in the local whaling industry, and by increased competition from other artists including William Swain (1803–1847), a native of Newburyport, William Allen Wall (1801–1885) of New Bedford, and Edward D. Marchant (1806–1887), who was born in nearby Edgartown, Massachusetts. As a result, Mayhew supplemented his income as a resident artist on Martha's Vineyard through fishing and farming. In 1834, he and his family moved to Olive Township in Ohio to be near his wife Zelinda's relatives who previously had migrated west from the island. Although evidence suggests Mayhew may have made some landscape paintings in this new location, he appears to have worked principally as a farmer as confirmed by federal census records for 1850. The artist died in Cambridge, Ohio, at the age of almost sixty-nine.

See also **Maritime Folk Art; Miniatures; Painting, American Folk; Painting, Landscape.**

BIBLIOGRAPHY

Hill, Joyce. "Cross Currents: Faces, Figureheads, and Scrimshaw Fancies." *The Clarion*, vol. 9 (spring/summer 1984): 25–32.

Stoddard, Doris. "Frederick Mayhew, Limner: Chilmark's Little Known Artist." *Dukes County Intelligencer*, vol. 28 (1986): 10–17.

Thomas, Andrew L. "Frederick Mayhew, 'Limner': Portraits of Early-Nineteenth-Century New Bedford and Martha's Vineyard." *Painting and Portrait Making in the American Northeast, Annual Proceedings of the Dublin Seminar for New England Folklife*, vol. 19 (1994): 98–106.

CHARLOTTE EMANS MOORE

McCARTHY, JUSTIN (1892–1977) was a prolific, complex, and enigmatic Pennsylvania artist who experimented with many different styles and subjects. He painted a wide variety of subjects over a fifty-year period. Movie stars, fashion models, sports figures, flowers, vegetables, and historic and biblical events all interested this prolific self-taught painter. Elements of fantasy that he found in everyday life appealed to McCarthy, and themes such as glamour, energy, and reverence, as well as satirical social commentary, all found a place in his work.

Owing to the deaths of his younger brother in 1907 and his father the following year, his failed attempt to earn a law degree, and the collapse of his family's finances, McCarthy suffered a nervous breakdown. He spent the years from 1915 to 1920 in the Rittersville State Homeopathic Hospital for the Insane in Allentown, Pennsylvania. There he began drawing and painting with pencil, pen, and watercolor in 1920, signing his drawings, especially those of glamorous women, with several pseudonyms, among them "Prince Dashing."

Upon his release from the hospital, McCarthy moved back into his family home in Weatherly, Pennsylvania. He expanded his use of art materials to crayon and oils in the 1950s and 1960s, and to acrylics

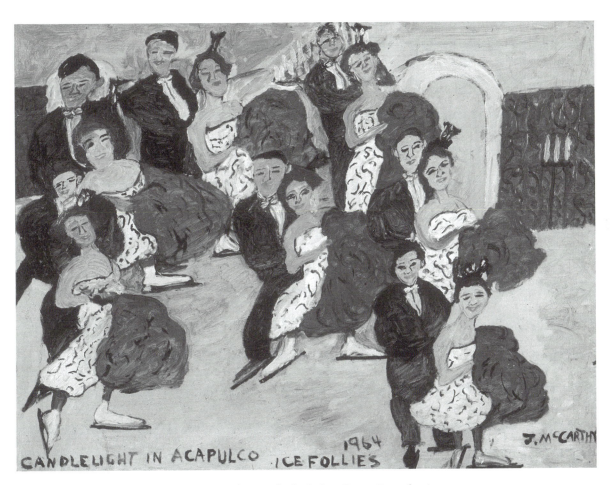

Candlelight in Acapulco Ice Follies; Justin McCarthy; Weatherly, Carbon County Pennsylvania; 1964. Oil on Masonite; 23½ × 31⅝ inches. Collection American Folk Art Museum, New York. Gift of Elias Getz, 1981.7.4.

in the 1970s, drawing and painting on old file folders, Masonite, composition board, cardboard, and canvas. His works varied from delicate paintings of beautiful women to those executed in a more painterly, expressionistic style, characterized by broad brushstrokes, sharp color contrasts, intentional distortion, and abstraction to achieve vibrant movement and emotional intensity. Photographs and prints culled from newspapers, magazines, and books served as visual sources in some of his works. An oil on Masonite of 1964, *Candlelight in Acapulco Ice Follies,* pulsates with a rhythmic energy achieved by the bold patterning of the dancing men and women's black, white and red costumes as well as the ambiguous figure-ground relationship. In a composition such as this one, McCarthy's loose and vibrant brushwork communicate the *joie de vivre* of his subject.

Additionally, McCarthy painted personalized versions of well-known paintings such as *Washington Crossing the Delaware* by Emanuel Loetze and *The Last Supper* by Leonardo da Vinci.

McCarthy, like the folk painter Jack Savitsky, was encouraged by Sterling Strauser, who collected his works and believed in his originality and artistic vision. In failing health, McCarthy eventually moved to Tucson, Arizona, where he died in 1977. His paintings were shown along with the polychrome, relief carvings of the Columbus, Ohio, barber, preacher, and artist, Elijah Pierce, at the Philadelphia Academy of Fine Arts in 1972. A solo exhibition of McCarthy's work was mounted at the Allentown Art Museum in Allentown, Pennsylvania, in 1985, and at the Noyes Museum of Art in Oceanville, New Jersey, in 1999.

See also **Painting, American Folk; Elijah Pierce; Jack Savitsky; Sterling Strauser.**

BIBLIOGRAPHY

Hollander, Stacy C., and Brooke Davis Anderson, co-curators. *American Anthem: Masterworks from the American Folk Art Museum.* New York, 2002.

Longhauser, Elsa, and Harald Szeemann. *Self-Taught Artists of the Twentieth Century: An American Anthology.* San Francisco, 1998.

Stebich, Ute. *Justin McCarthy.* Allentown, Pa., 1985.

LEE KOGAN

MCINTIRE, SAMUEL (1757–1811) was the foremost architect/builder and carver working in Salem, Massachusetts, from the early 1780s until his death. Trained as a carpenter by his father, McIntire began practicing the building trade while he was still in his teens. Despite his lack of formal training, McIntire's

houses, churches, and public structures helped transform colonial Salem into a city of neoclassical buildings. His early work was influenced by Boston's premier architect working in the style, Charles Bulfinch (1763–1844), although McIntire's designs were built of wood and retained conservative Georgian floor plans. Later, McIntire introduced oval rooms to his designs of brick houses, showing his familiarity with the writings of Bulfinch's disciple, Asher Benjamin (1773–1845).

Salem's building boom was made possible by the enormous wealth of its merchant ship owners, many of whom, including Elias Hasket Derby (1739–1799), were eager to express their material success with new houses. Derby engaged Bulfinch to design his house, but he hired McIntire to revise the plan and to construct it. McIntire's exceptional carving skills enabled him to carve the ornamental woodwork that he designed for the interior of Derby's house and others. Festoons, swags, bellflowers, cornucopias, grapevines, sheaves of wheat, baskets of fruit, and urns are among the decorative motifs associated with McIntire, and these designs also appear on some of the most costly furniture made in the Salem area during the early Federal period. McIntire is believed to have carved a suite of furniture ordered by Elizabeth Derby West (c. 1762–1814), on whose house he also worked. It is unlikely, however, that McIntire carved all of the Salem pieces that have been attributed to him over the years; with more than sixty cabinetmakers and six carvers working in Salem between 1790 and 1820, McIntire's designs were likely appropriated by other carvers whose clients wanted pieces that reflected the decorative standard already set by McIntire.

At least one figurehead and several drawings of ships' carvings by McIntire survive. Indeed, he carved ornaments for several ships between 1802 and 1806, though Elias Hasket Derby turned to the Skillin shop in Boston for most of his ships' carvings. McIntire's three-dimensional work includes eagles; an allegorical figure for the pediment of an important chest-on-chest owned by Elizabeth Derby West; and busts of Gov. John Winthrop (1588–1649), and the French writer and philosopher François Voltaire (1694–1778). McIntire's 1792 submission for the United States Capitol competition included nineteen allegorical figures, on the roof balustrade, and two pediment carvings, all of which he presumably intended to carve.

See also **Maritime Folk Art; Ships' Figureheads; John and Simeon Skillin.**

BIBLIOGRAPHY

Craven, Wayne. *Two Hundred Years of American Sculpture.* New York, 1976.

Kimball, Fiske. *Mr. Samuel McIntire, Carver: The Architect of Salem.* Magnolia, Mass., 1966.

<div align="right">

RICHARD MILLER

</div>

MCKENZIE, CARL (1905–1998), who practiced traditional whittling for many years, became one of the best-known self-taught Kentucky artists of the twentieth century. His importance lies in his vivid imagery and his range of subjects, which bridged traditional and contemporary concerns. Born and raised near Campton, Kentucky, McKenzie worked in the Kentucky coalfields, and later drove a lumber truck until retiring in 1970. For years, he carved traditional whimsies, most of which he gave away, but his subject matter broadened after 1970, when his carvings became sought-after and were included in exhibits of regional folk art. By the mid-1980s, McKenzie was known nationally for his carvings portraying biblical stories in complex assemblages, including the *Garden of Eden, Noah's Ark,* and the *Devil Family.* He also carved figures from legend and life; simple, cutout birds; and an extensive series of human figures with similar faces whose identity relates to their work: a nurse, a housecleaner, a hunter, a musician, and a topless waitress are part of this series of works. McKenzie used felt-tipped markers to decorate his early figures; on his later works he generously applied brightly colored gloss paints that often ran together.

See also **Religious Folk Art; Sculpture, Folk.**

BIBLIOGRAPHY

Hayes, Jeffrey R. *The Art of Carl McKenzie.* Milwaukee, Wisc., 1994.

Yelen, Alice Rae. *Passionate Visions of the American South: Self-Taught Artists from 1940 to the Present.* New Orleans, La., 1993.

<div align="right">

ADRIAN SWAIN

</div>

MCKILLOP, EDGAR ALEXANDER (1879–1950), carved an extraordinary collection of outsized animals and human figures during the late 1920s and early 1930s. To the delight of his neighbors, he exhibited his creations in his modest house in the mill village of Balfour, south of Asheville, North Carolina. Later he took them on the road in the back of a pickup truck and also displayed them in a tent on the main highway. His daughter, Lelia McKillop, recalled that people would stare at them and ask, "Are they alive?"

Woodcarving is a common pastime, but few men ever matched McKillop's vision and intensity. Working with several black walnut trees donated by a neighbor, he sawed and chiseled out a wide-ranging menagerie that included eagles, a rhinoceros, a gorilla, a kangaroo, an owl, a lion, a bear, a cougar, a frog, a turtle, a squirrel, and even a seven-headed, ten-horned dragon inspired by the biblical Book of Revelation. What distinguishes McKillop's carvings are their enormous size, careful finishing, and expressive qualities. Many stand two feet high; the rhinoceros is five feet long and contains a record player in its belly. As its red tongue slid back and forth, it would announce to all assembled, "E. A. McKillop, a born, carving man." Clearly, McKillop had a talent for self-dramatization and regarded his carvings as a unified collection.

McKillop also created at least five human figures ranging from two to four feet high, including a fiddler, a man holding an eagle aloft, and a man with a rifle standing beside an eagle, with a shield and "LIBERTY" carved into the base. These works emphasize the importance of music and patriotism to McKillop. The two remaining figures, however, are enigmatic. Two naked, demonic-looking men stand clutching the head of a thick, fanged rattlesnake that encircles their bodies. Whatever personal or religious significance these gaunt, grimacing men held for McKillop is now lost.

By all accounts, McKillop was a dreamy, eccentric man who thought nothing of devoting years to hewing out his walnut blocks. Variously a farmer, cooper, logger, mill mechanic, and blacksmith, he was a true jack-of-all-trades who could make nearly anything he wanted (including musical instruments, walking sticks, toys, decorative clock cases, furniture, kitchen implements, and plows). Sometime during the late 1930s he apparently tired of his collection, bartering it away for a small farm, where he quietly spent his remaining years.

See also **Canes; Musical Instruments; Toys, Folk; Sculpture, Folk.**

BIBLIOGRAPHY

Johnston, Pat H. "E. A. McKillop and His Fabulous Woodcarvings." *The Antiques Journal,* vol. 33, no. 11 (November 1978): 16–18, 48.

Parker, Cherry. "The Eerie Art of E. A. McKillop." *Tar Heel: The Magazine of North Carolina,* vol. 8, no. 6 (August 1980): 20–22.

Zug, Charles G., III. "E. A. McKillop: 'A Born Carving Man.'" *May We All Remember Well: A Journal of the History & Cultures of Western North Carolina,* vol. 1 (1997): 36–49.

<div align="right">

CHARLES G. ZUG III

</div>

MCKISSACK, JEFF (1902–1980) created *The Orange Show,* a folk art environment in Houston, Texas. The

site illustrates his theories of health and can be seen as a visual version of his book, *How You Can Live 100 Years . . . and Still Be Spry,* self-published in 1960. McKissack has become a symbol of the power of art in individual lives as a result of the work of a non-profit foundation that preserves and presents community-based art projects inspired by his work.

The youngest of six children, McKissack was born on January 28, 1902, in Fort Gaines, Georgia. After receiving a degree in commerce from Mercer College, he pursued graduate studies at Columbia University in New York while working at a Wall Street bank. During the Great Depression, McKissack trucked oranges from the Atlanta Farmer's Market throughout the South. He served briefly in the U.S. Army, and then built ships in Florida for the duration of World War II.

When his mother died in 1948, his family was concerned over McKissack's increasingly erratic behavior and committed him briefly to an institution. Making a fresh start in Houston, McKissack found work at the post office, where he carried special delivery mail. Years later, McKissack said he was inspired to create *The Orange Show* by the sight of discarded materials from older buildings in Houston being taken down to make way for new skyscrapers.

McKissack purchased some land in 1952, on which he built a concrete house with his own hands. Then he bought additional property. For 25 years he worked without formal plans, constructing a 6,000-square-foot, multi-level building site using concrete blocks, decorative tiles, found objects, and industrial castoffs. McKissack imagined vast crowds, and created performance arenas and a gift shop to amuse visitors. Narrative displays near the entrance explain McKissack's philosophy of longevity, which he believed could be achieved through personal responsibility, hard work, and proper nutrition. Intricate tile mosaics cover bright white walls, extolling the virtues of the orange, which he believed to be the perfect food. A wishing well, a boat in a pond, and a steam engine make up the mazelike ground floor, and observation decks made of colorful wrought iron allow a second-floor view of just as colorful awnings, flags, whirligigs, and windmills.

On opening day, May 9, 1979, artists and friends attended, but not the crowds McKissack expected. On January 20, 1980, McKissack died of a stroke—or, some say, of a broken heart. Houston's art community, led by Marilyn Oshman Lubetkin, formed a foundation to preserve *The Orange Show.* The site reopened on September 24, 1982, and the foundation's goal was to integrate it into the mainstream of Hous-

ton's cultural life. Through programs that document and educate the public about self-taught artists and that provide the opportunity for a hands-on experience of the creative process, The Orange Show Foundation reaches hundreds of thousands of people each year, finally fulfilling McKissack's vision.

See also **Environments, Folk.**

BIBLIOGRAPHY

Abernethy, Francis Edward, ed. *Folk Art in Texas.* Dallas, Tex., 1985.

Adele, Lynn. *Spirited Journey: Self-Taught Texas Artists of the Twentieth Century.* Austin, Tex., 1997.

Beardsley, John. *Gardens of Revelation: Environments by Visionary Artists.* New York, 1995.

Jacobs-Pollez, Rebecca. "Eat Oranges and Live: Jeff McKissack, The Orange Show, and The Orange Show Foundation." Houston, Tex., 2000.

Martin, William. "What's Red, White, and Blue . . . and Orange All Over?" *Texas Monthly* (October 1977): 120–123, 224–225.

McKissack, Jeff D. *How You Can Live 100 Years . . . and Still Be Spry,* Houston, Tex., 1960.

SUSANNE THEIS

MEADERS, LANIER (1917–1998) was one of the most gifted of Southern potters from the Mossy Creek community in Cleveland, Georgia. Established in 1893 by his grandfather, John Milton Meaders, and carried on by his father, Cheever, Lanier Meaders' pottery produced both practical ceramics for household use and artistic forms, particularly the grotesque "face jugs" so popular with contemporary collectors. Everything in Meaders' shop smacked of the nineteenth century: the small, wooden shop building usually occupied by a single worker, the old-fashioned potter's wheel, and the tubelike tunnel, or "hogback," kiln in which the ware was fired. Three generations of Meaders took their stoneware clay from the same local river bank for more than a century, and their traditional alkaline glaze (composed of clay, wood ash, feldspar, and whiting) was dripped over the vessels to produce a rich, brown finish with shades of black, yellow, and green.

Though Meaders loved the old country forms of pots, jars, and churns that had a real connection to rural farm life, as well as, particularly, the jugs used for the illicit moonshine trade during Prohibition that kept many a country potter in business, Meaders also recognized that the survival of his craft depended upon production of ceramics for a broader audience. He became one of the foremost makers of the extremely popular face jugs that are now a mainstay of the Southern pottery craft. Shaped as a face or as a complete head, with eyes and teeth of the white firing kaolin clay, these humorous (or foreboding) vessels

are individual works of art, and take several hours each to complete. Though many Southern folk potters created face jugs, those that bear the imprint of Lanier Meaders' are among the most highly prized, both for their artistic merit and for the continuing tradition they represent.

See also **Jugs, Face; Pottery, Folk; Stoneware.**

BIBLIOGRAPHY

Horne, Catherine Wilson, ed. *Crossroads of Clay: The Southern Alkaline-Glazed Stoneware Tradition.* Columbia, S.C., 1990.
Sweezy, Nancy. *Raised in Clay: The Southern Pottery Tradition.* Washington, D.C., 1984.

WILLIAM C. KETCHUM

MECHANICAL BANKS: *SEE* BANKS, MECHANICAL.

MELCHERS, JULIUS THEODORE (1829–1909) was the most accomplished and influential commercial carver working in the American Midwest during the second half of the nineteenth century. Born in Prussia, where he apprenticed to a master woodcarver, Melchers later studied in Paris before immigrating to Detroit in 1852. A teacher as well as a sculptor, Melchers' knowledge of European fine art traditions and his experience as an artist made him a leading figure in Detroit's fledgling artistic community.

With little demand in Detroit for fine art sculpture, and even fewer collectors, Melchers opened a commercial carving studio that completed commissions for clients in Detroit, elsewhere in the Midwest, and in Ontario, Canada. Despite completing church commissions and carving the interior decoration for the main office of the Hiram Walker & Sons distillery in Windsor, Ontario, it is for his tobacconist figures that Melchers is best remembered today.

Carved figures had been associated with tobacco shops since the seventeenth century, with the earliest American examples appearing during the 1700s. The market for tobacconist figures flourished after 1850 as the popularity of cigar smoking swept the nation. From New York, the center of tobacconist-figure carving, to the upper Midwest, carvers created figures to serve as sidewalk advertisements for tobacco shops. Most carvers learned their craft by serving an apprenticeship with a master. The carving techniques they used, as well as the aesthetic they followed, were time-honored and passed from generation to generation. As a result, the quality of the work produced by these commercial carvers, in the majority of cases, places them outside of the folk tradition.

Melchers, like other carvers, offered many different tobacconist figures, but the most popular was the Native American. Unlike other carvers of "cigar-store Indians," however, whose knowledge of their appearance and costume came secondhand, Melchers was an earnest student of Native American material culture. He amassed what was considered the finest collection of Native American artifacts in Michigan, having purchased the collection assembled by Gen. David S. Stanley (1828–1902), who had explored the Yellowstone area in 1873. Melchers used his collection as source material for his carvings. Using old ships' masts, whose seasoned, straight-grained wood eliminated the danger of cracking that mars many carvings by others, Melchers endowed his sculptures of Native Americans with a verisimilitude that few other carvers achieved. Authentically garbed and sensitively portrayed, Melchers' figures show the hand of an artist trained in the classical tradition who elevated his distinctive style of commercial carving to art.

See also **Native American Folk Art; Shop Figures.**

BIBLIOGRAPHY

Fried, Frederick. *Artists in Wood: American Carvers of Cigar-Store Indians, Show Figures, and Circus Wagons.* New York, 1970.
Pendergast, A.W., and W. Porter Ware. *Porter Ware: Cigar Store Figures in American Folk Art.* Chicago, 1953.

RICHARD MILLER

MEMORY JUGS: *SEE* JUGS, MEMORY.

MEMORY PAINTING: *SEE* PAINTING, MEMORY.

MENNELLO MUSEUM OF AMERICAN FOLK ART, THE is located in Orlando, Florida. Its origins can be traced back to 1969, when the collector Marilyn Mennello met the painter Earl Cunningham. She fell in love with his paintings, which he had displayed in the dusty windows of his curio shop, called The Over-Fork Gallery, in St. Augustine, Florida. Near the paintings was a sign that read, "these paintings are not for sale." It was the artist's intention to create 600 paintings that would then be housed in a museum. After deliberation, Cunningham sold one painting each to Marilyn and her friend, Jane Dart.

In 1984, Marilyn Mennello learned that Earl Cunningham had passed away in 1977, and the whereabouts of his paintings was unknown. She and her husband, the collector Michael Mennello, located the paintings and purchased sixty-two of them from a member of Cunningham's family. Over the years the Mennellos found and purchased nearly all of the known paintings attributed to Cunningham.

In the summer of 1998, the Mennellos approached Mayor Glenda Hood of the city of Orlando about the possibility of establishing a museum to house Cunningham's paintings. With a core collection of forty-four works, the museum was opened to the public on 22 November 1998.

Since that time, additional gifts to the museum have broadened the scope of the collection. Paintings, sculptures, and other works by contemporary American folk artists have been purchased by the city to complement the Cunningham paintings. The collection includes pieces by Reverend Howard Finster (1915–2001), Raymond Coins (1904–1998), Jesse Aaron (1887–1979), James Castle (1899–1977), Sister Gertrude Morgan (1900–1980), Earnest "Popeye" Reed (1919–1985), Sybil Gibson (1908–1995), and Georgia Blizzard (1919–2002).

The museum has hosted traveling exhibitions of sculpture by William Edmondson (1874–1951), drawings by Nellie Mae Rowe (1900–1982), and paintings by Ralph Fasanella (1914–1997). In 2001, the museum presented it's first "in-house" exhibit, titled "American Folk Art Masters," which showcased the paintings and sculptures by many of the major folk artists working in the United States over the course of the last two hundred years.

FRANK HOLT

See also **Jesse Aaron; Georgia Blizzard; James Castle; Raymond Coius; Earl Cunningham; William Edmondson; Ralph Fassanella; Howard Finster; Sybil Gibson; Sister Gertrude Morgan; Earnest Reed; Nellie Mae Rowe.**

MERCER, HENRY CHAPMAN (1856–1930), archaeologist, historian, architect, and Arts and Crafts-era tile manufacturer, founded the Mercer Museum in Doylestown, Pennsylvania, to house his seminal collection of tools and products of pre-industrial handcraft. Born in Doylestown, Pennsylvania, Mercer graduated from Harvard University in 1879. Following travels abroad, he returned to America and accepted a position at the University of Pennsylvania Museum in 1891, specializing in American and prehistoric archaeology. In 1897 Mercer began turning his attention to historical artifacts, eventually amassing an exhaustive and encyclopedic collection of early American material culture. That same year, he published a catalog of his inaugural exhibition, "The Tools of the Nation Maker," describing the use, origins, and associated folklore of the first 761 implements in his collection.

To house his collection, Mercer imagined and constructed an immense concrete castle, one of three self-designed, visionary structures that included his home, Fonthill, and the Moravian Pottery and Tile Works. At the time of its completion, in 1916, Mercer presented the new museum building to the Bucks County Historical Society, along with contents ranging from pottery and lighting devices to agricultural implements and hand tools. Mercer served as curator and Historical Society president until his death in 1930.

As a scholar, Mercer researched and wrote extensively. He published the first significant studies of Pennsylvania German fraktur (1897), stoves and stove plates (1914), building hardware (1923), and woodworking implements (1929). He aggressively documented the tools and processes of traditional crafts through active correspondence, observation, and interviews with folk informants, recording his findings in voluminous research notes and papers. An investigation into Pennsylvania German pottery traditions eventually inspired him to produce architectural tiles, employing native earthenware clays. In commissions that included the Pennsylvania State Capitol and the Isabella Stewart Gardner Museum, Mercer's "Moravian" tile designs reflected his interests in history, folklore, literature, and the natural sciences.

Mercer viewed his collection broadly. Combining elements of archaeology, folklife studies, and social history, he sought a more objective, democratic, and inspiring way of presenting the past. Mercer was especially concerned with artifacts associated with human labor, and viewed tools and evolving technologies as essential to understanding historical change. Though his purposes transcended aesthetic appreciation alone, Mercer's collecting and scholarship laid the groundwork for the "discovery" of folk art. His pioneering research into the arts of the Pennsylvania Germans, his appreciation for vernacular forms of material culture, and his efforts to document craft traditions greatly inspired later generations of folk art collectors and scholars.

See also **Fraktur; German American Folk Art.**

BIBLIOGRAPHY

Amsler, Cory M., ed. *Bucks County Fraktur.* Kutztown, Pa., 2001.

Bronner, Simon, ed. *Folklife Studies from the Gilded Age.* Ann Arbor, Mich., 1987.

Conn, Steven. *Museums and American Intellectual Life, 1876–1926.* Chicago, 1998.

Reed, Cleota. *Henry Chapman Mercer and the Moravian Pottery and Tile Works.* Philadelphia, 1987.

CORY M. AMSLER

MERTEL, CHRISTIAN (1739–1802) was a fraktur artist. Born in Herborn, Germany, he was the son of John Jacob and Elizabeth Mertel. He came to America aboard the *Crawford* in 1773, with fellow passenger John Conrad Trevitz (1750–1830), who became a schoolmaster and made fraktur in Snyder County, Pennsylvania. Mertel followed in his father's occupation as a blue dyer, a specialist in the indigo-dying of cloth, for a time. By 1793 Mertel had acquired a small tract of land located between Elizabethtown and what is now Hershey, in Conewago Township, Dauphin County, Pennsylvania, and it was while living there that he made fraktur for his neighbors. He was also a teacher, probably at a school operated by Hoffer's Brethren Meeting, but his output is primarily of *taufscheine* (baptismal certificates) for Lutheran and Reformed families. He was raised as well with Reformed church doctrine.

Mertel clearly copied elements from the fraktur produced by others, including the printed work of Johann Henrich Otto (1733–c. 1800), and the drawings of his neighbor, fraktur artist Johann Jacob Friedrich Krebs (c. 1749–1815), but Mertel also developed designs of his own that included images of castles, the Princess of Brunswick, fish, mermaids, lions, unicorns, and a wide variety of flowers. He made fanciful zodiacs, a source of endless fascination to the Pennsylvania Dutch, and he produced a charming song of springtime in which his appreciation for the world around him can be seen. Mertel's fraktur work was neither highly original nor completely boring. He sent his family and fraktur customers New Year's greetings that he designed annually and filled with good cheer. Mertel died in Conewago Township, Dauphin County, Pennsylvania, and upon his death, his household items included the usual accoutrements of country life, as well as an inkstand, a box of pictures, and a musical instrument.

See also **Fraktur; German American Folk Art; Johann Jacob Friedrich Krebs; Johann Henrich Otto; Pennsylvania German Folk Art; Religious Folk Art.**

BIBLIOGRAPHY

Weiser, Frederick S. "Christian Mertel, the 'C M Artist.'" *Der Reggeboge*, vol. 21, no. 2 (1987): 75–85.

Frederick S. Weiser

METALWORK is a technique found in folk art that encompasses a broad range of objects, chiefly formed of iron, tin, brass, and copper, and iron, in various combinations. The northeastern United States was

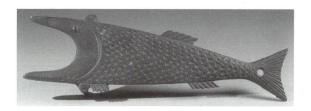

Fish bootjack. Maker unknown; Cast iron; American c. 1890. 17¼ × 5 inches. Photo courtesy Allan Katz Americana, Woodbridge, Connecticut.

(and still is) rich in iron ore deposits, and colonial settlers were quick to take advantage of this. An ironworks was established at Saugus, Massachusetts in the 1650s, and others quickly followed in Connecticut, New York and Pennsylvania. The ore was transformed into bars that could be reheated and worked (or wrought) by blacksmiths or was cast in molds.

Wrought iron may be readily appreciated as a form of folk expression. A set of snake form andirons, complete with incised eyes, or a boot scraper formed of twisted metal with ram's horn terminals, display individual creativity. The pride that blacksmiths and whitesmiths (the latter of whom finish and polish the work), who produced delicate items such as fat lamps and pipe tongs, took in their skills is evidenced by the common practice of signing the work. For example, a lamp or dough scraper is marked by Peter Derr from Reading, Pennsylvania, and dated about 1834 to 1848, and a set of cooking forks, spoons, and spatulas bears the imprint of the mid-nineteenth century Berks County craftsman, Johann Schmidt.

Although cast iron metalwork is often produced via a mold, producing a number of identical objects as opposed to a single original, folk art historians understand these objects within the context of functionalism as well as aesthetics. In fact, the original wooden molds used for casting are hand-carved to be unique and, when painted, the castings are a profuse source of creativity and expression of formal qualities. Surviving eighteenth century stoves and firebacks (placed at the rear of a fireplace to protect the brick) are richly decorated with embossed representations of biblical and historic scenes. Late nineteenth century andirons, cast in the form of African Americans, Hessian soldiers, George Washington, and other historical figures as well as ducks, dogs, and other animals, show a distinctly folk manner.

In the form of sheets or straps, iron could be shaped into unique weathervanes such as the one bearing the initials of William Penn and the date 1699,

which is in the collection of the Historical Society of Pennsylvania in Philadelphia. The same materials served to produce adjustable candle stands and a remarkable variety of elaborate door latches and hinges.

Tinplate (thinly rolled sheet iron coated with tin) was another important medium for folk expression. Craftsmen, especially in Pennsylvania, made tea and coffee pots decorated with "wriggle work," a technique that involved embossing a raised design, usually floral, on the vessel's surface. The design did not perforate the tin; however, throughout the northeast tinsmiths produced foot warmers decorated with punched-out decoration, usually hearts or diamonds. Colanders and cheese molds were also punch-decorated.

These items were usually not painted, but tinsmiths produced a wide variety of what was termed "Japanned ware" including coffee pots, storage canisters, deed boxes, lamps, trays, mugs, and other vessels, that were given a solid background of red or black varnish, and then decorated with polychrome floral designs, either by free-hand or using stencils. Referred to as "tole ware," this nineteenth century painted tin is today extremely collectible. It is also quite fragile, and collectors must be wary of repainted pieces.

Copper's malleability lent itself to creative design, and one of America's earliest surviving weathervane, a grasshopper atop Boston's Faneuil Hall, was made of this material in 1742 by the tin and copper smith, Shem Drowne (1683–1774). Another chief example of folk art, the bed warmer, uses copper as a medium. Filled with coals, this long-handled pan was used to warm beds in unheated rooms. Artisans regularly decorated the top of the bed warmer with chased or engraved designs of birds, flowers, and geometric patterns. One of the earliest such examples, dated 1779, was signed by Richard Collier (active c. 1770–1780) of Norwich, Connecticut.

Brass, a harder alloy of copper and tin, was also used to make decorated bed warmers, and similar engraving was utilized in elaborate brass sundials such as the 1763 example by Benjamin Harbeson (active c. 1760–1800) of Philadelphia. Finely cast brass andirons were made by many eighteenth- and nineteenth-century firms. Among the known marks is that of Paul Revere (1734–1818). Among the smaller objects are cast brass buttons decorated with patriotic slogans or the United States eagle.

See also **Boxes; Doorstops; Shem Drowne; Political Folk Art; Tinware, Painted; Weathervanes.**

BIBLIOGRAPHY

Coffin, Margaret. *American Country Tinware: 1700–1900.* New York, 1968.

Kauffman, Henry J. *American Copper and Brass.* New York, 1979.

———. *Early American Ironware: Cast and Wrought.* Rutland, Vt., 1966.

Sonn, Albert H. *Early American Wrought Iron.* New York, 1979.

WILLIAM C. KETCHUM

MILLER, LEWIS (1796–1862) was a watercolor artist, the son of German immigrants who settled in York, Pennsylvania, where Miller was born. A lifelong bachelor, he worked as a house carpenter for more than thirty years after apprenticing to one of his brothers. His father, a schoolmaster, probably instilled in his tenth son the love of learning and curiosity about the world that Miller expressed in his watercolor drawings, done between about 1813 and the year he died.

Miller's subjects included everyday life in York, historical events, sights in New York, New Jersey, Maryland, Virginia, and Europe, landscapes, botanical studies, and likenesses of friends and acquaintances. Coupled with his informative descriptions and engaging poetry, Miller's drawings comprise a lively and informative portrait of his life and times. He also carved an architectural pediment featuring relief-carved animals, human faces, and flowers, which he placed over the door of his house, as well as other works that await identification.

Miller's lively sense of composition matched his facility with the brush. A sheet of paper in his hands might contain a single subject, or multiple scenes interspersed with appealing vignettes and annotated commentary. His style is consistently spontaneous and unlabored, which is notable given that his earliest works may date to when he was sixteen. The wealth of detail in his drawings rewards careful scrutiny. Miller was also capable of creating more finished works: a half-length, watercolor self-portrait shares stylistic similarities with portraits by Jacob Maentel (1763–1863), for example, who worked in York County. Miller probably knew Maentel, and he made a drawing of him. Miller's self-portrait additionally suggests that Maentel exerted some influence on the younger artist.

Beginning in 1831, Miller made numerous trips to the Christiansburg, Virginia, home of his brother Joseph, a physician. Among his most significant documents of pre-American Civil War Virginia are several drawings depicting the life of slaves, including one showing a group of slaves being led from Staunton to eastern Tennessee, with written commentary expressing Miller's distress at the sight.

Miller assembled four travel diaries documenting his 1840–1841 European trip. Showing cities, public monuments, notable buildings, and landscapes, primarily in England, Scotland, Switzerland, and Germany, some of the drawings were made during the trip while others were probably drawn from memory upon his return.

By 1880, impoverished and in failing health, Miller increasingly relied on friends and relatives for support. Among Miller's last works are more than two hundred portraits of York citizens, drawn from memory, for a friend who gave him fifty dollars.

See also **Jacob Maentel; Painting, American Folk; Painting, Landscape.**

BIBLIOGRAPHY

Rumford, Beatrix T., ed. *American Folk Portraits: Paintings and Drawings from the Abby Aldrich Rockefeller Folk Art Center.* Boston, 1981.

Shelley, Donald A. *Lewis Miller: Sketches and Chronicles.* York, Pa., 1966.

RICHARD MILLER

MILLER, SAMUEL (c. 1807–1853) produced some of the most visually arresting images of children in the folk art genre. Very few facts about his life have been ascertained, although Miller's death certificate indicates that he was born to Robert and Ann Miller of Boston, and died on October 18, 1853 of heart disease. An inscription on Miller's portrait of *Emily Moulton* places the artist's studio or home at the corner of Pearl and Bartlett Streets in Charlestown, Massachusetts, in 1852. City directories also locate him on Bartlett Street during this period. Approximately seventeen portraits are attributed to Miller, all appearing to date from the 1840s and early 1850s and all oils on canvas. These include a group of five works in the collection of the New York State Historical Association in Cooperstown, New York. Fourteen of his likenesses, including *Picking Flowers*, an oil on canvas attributed to Miller and dated circa 1845, depict children. Miller's lively and decorative style includes flat, delineated figures often in frontal poses, the use of bold, local color, meticulously rendered costume details, and the frequent inclusion of pets, flowers, and trees. The young girl who is the subject of *Picking Flowers* seems to be of a type that Miller typically represented with full cheeks, a round face, and prominent ears. Although the size of the canvas is modest, the figure appears monumental, nearly filling the frame and skewing the already awkward sense of perspective indicated by a schematic rendering of a

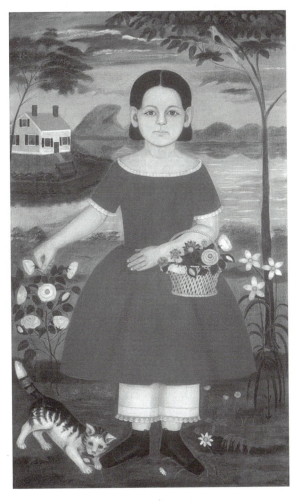

Picking Flowers; Attributed to Samuel Miller; c. 1845. Oil on canvas; 44½ × 27½ inches; N-255.61. Collection Fenimore Art Museum, Cooperstown, New York. © New York State Historical Association, Cooperstown, New York. Photo courtesy Richard Walker.

dirt path, a green expanse of grass, and a house on a riverbank in the distance.

See also **Painting, American Folk.**

BIBLIOGRAPHY

Chotner, Deborah, et al. *American Naïve Paintings.* Washington, D.C., 1992.

D'Ambrosio, Paul S., and Charlotte Emans, *Folk Art's Many Faces: Portraits in the New York State Historical Association.* Cooperstown, N.Y., 1987.

PAUL S. D'AMBROSIO

MILWAUKEE ART MUSEUM is dedicated to presenting folk art in juxtaposition to mainstream academic

art. The museum was formed from the merging of the Layton Art Gallery, established in 1888, and the Milwaukee Art Institute, founded early in the 1900s. In 1957 a unique, floating cruciform structure with cantilevered portions, now considered a classic in the development of modern architecture, was designed by Finnish architect Eero Saarinen, and opened to the public as the Milwaukee Art Center. In 1980 the name was changed to the Milwaukee Art Museum. Permanent holdings number close to 20,000 objects, from ancient times to the present, and include old masters paintings, nineteenth and twentieth century art, American decorative arts, German Expressionism, folk art, Haitian art, and post–1960s American art. Some important artists represented include Winslow Homer (1836–1910), Georgia O'Keefe (1887–1986), Pablo Picasso (1881–1973), and Claude Monet (1840–1926).

The museum's commitment to folk art began in 1951 with the acquisition of works by Wisconsin self-taught artist Anna Louise Miller (1906–?). The collection expanded over the next three decades to include works by Wilhelm Schimmel (1817–1890), Ammi Phillips (1788–1865), John S. Kane (1860–1934), Ralph Fasanella (1914–1997), Joseph Yokum (c. 1890–1972), Eddie Arning (1898–1993), and Felipe Benito Archuleta (1910–1990), among others, as well as important textiles and Shaker furniture. Two significant folk art exhibitions presented in the 1980s were "American Folk Art: The Herbert Waide Hemphill Jr. Collection" (1981), and "American Folk Art from the Milwaukee Art Museum" (1989).

In 1989 the Julie and Michael Hall Collection of American Folk Art, encompassing 270 works by self-taught artists, was added to the museum's permanent collection. Included are important examples of nineteenth-century traditional forms, such as portraits, still-life paintings, trade signs, wildfowl decoys, weathervanes, ceramics, canes, and whirligigs, as well as works of twentieth century artists William Edmondson (1874–1951), Martin Ramirez (1895–1963), Elijah Pierce (1892–1984), Edgar Tolson (1904–1984), Sister Gertrude Morgan (1900–1980), and Howard Finster (1915–2001).

Exhibitions that were presented in the 1990s include "Common Ground/Uncommon Vision: The Michael & Julie Hall & Michael Collection of American Folk Art" (1993); "Driven to Create: The Anthony Petullo Collection of Self-Taught and Outsider Art" (1994); and "Fine and Folk: The Ruth and Robert Vogele Gift" (2002).

The 1990s brought a dramatic increase in membership and a record number of additions to the collection, requiring the remodeling and renovation of existing galleries. A dynamic architectural statement and functional addition, designed by the Spanish-born architect Santiago Calatrava, the Quadracci Pavilion—where new galleries for Asian and African art were created and the collections of Haitian, folk art, and self-taught art were reinstalled—opened in 2001.

See also **Felipe Benito Archuleta; Eddie Arning; Canes; Decoys, Wildfowl; William Edmondson; Ralph Fasanella; Howard Finster; Michael and Julie Hall; Herbert W. Hemphill Jr.; John S. Kane; Sister Gertrude Morgan; Painting, American Folk; Painting, Still-life; Ammi Phillips; Elijah Pierce; Martin Ramirez; Wilhelm Schimmel; Shaker Furniture; Shakers; Edgar Tolson; Trade Signs; Weathervanes; Whirligigs.**

BIBLIOGRAPHY

Bowman, Russell, et al. *Common Ground/Uncommon Vision: The Michael & Julie Hall Collection of American Folk Art.* Milwaukee, Wisc., 1993.

Milwaukee Art Museum. *American Folk Art: The Herbert Waide Hemphill Jr. Collection.* Milwaukee, Wisc., 1981.

DEBORAH LYTTLE ASH

MINCHELL, PETER (Isenberg) (1889–1982) created watercolors on paper of exotic landscapes, architectural settings, fictional worlds in space, and the creation of the earth. Born Peter James Isenberg, he changed his name because he thought that a non-Germanic name would help him succeed in a new business venture. Self-taught, Minchell's art developed from drafting skills he acquired while working in the building trades. His earliest pictures were architectural drawings, produced in the 1960s. Many of his early works were also influenced by his life in a Catholic seminary in the early 1900s.

Minchell's older brother brought the young artist to Louisiana from Germany. Minchell attended Catholic school, completed seminary training, and was only weeks away from ordination into the priesthood when he realized that he had another calling, as an architect, builder, or engineer, his family's trade. He retired in the 1970s, and died in 1982 at the Palm Beach Care facility in Lake Worth, Florida.

As Minchell's skills grew, vegetation and plants reminiscent of his early years living near the bayou appeared in his works. Birds and reptiles are often placed in and around water and dense, lush trees and plants. Many of his drawings were inspired by dreams and strong elements of fantasy. He painted a series he called *Geological Phenomena,* which were pictures of natural disasters such as hurricanes, tidal waves, and

tornadoes. Another series, *Planet Perfection,* illustrates a utopian world, and still another group of works features jungle landscapes. Often in the margin below the drawings Minchell neatly lettered tiny text narratives with comments on the work. Initially, the artist gave his drawings away, but later he began to sell his work at art shows in local shopping centers. He may have painted between two hundred and five hundred watercolors.

See also **Painting, American Folk; Painting, Landscape.**

BIBLIOGRAPHY

Johnson, Jay, and William C. Ketchum. *American Folk Art of the Twentieth Century.* New York, 1983.

Wrenn, Anne. Telephone interview with Donald Isenberg, grandson of Peter Minchell. Museum of American Folk Art Archives, New York, 1991.

LEE KOGAN

MINGEI INTERNATIONAL MUSEUM was originally incorporated in 1974 as a nonprofit public foundation devoted to encouraging the understanding of the art of people from all cultures of the world. The late Japanese scholar Dr. Soetsu Yanagi (1889–1961), founder of the Mingei Association of Japan and Tokyo's first folk art museum, coined the term *mingei,* the combination of two Japanese words, *min,* for "art," and *gei,* for "people." While continuing postgraduate research and studying the art of pottery in Japan, Martha Longenecker (1920–) Professor Emeritus at San Diego State University, was inspired to carry the message of *mingei* to the United States, where she founded Mingei International, for which she has also served as director.

By 1976 Mingei International was operating as a "museum without walls," lending and borrowing objects for traveling exhibitions in cooperation with collectors, craftspeople, designers, governments, and museums throughout the world. The Mingei International Museum of World Folk Art opened in 1978, at the University Towne Center in San Diego, California, with the exhibition "Dolls and Folk Toys of the World." In 1996 the institution changed its name back to Mingei International, and moved to a permanent location in the central square of the Plaza de Panama in Balboa Park, where it has become an important addition to the San Diego art community.

An anonymous gift in 2000 made possible the acquisition of the Greaves Collection of Pre-Columbian Marine Animals, which includes more than 250 objects sculpted of clay, metal, stone, and wood, representing marine fauna, associated mythological themes,

and rare pre-Columbian textiles from South America, Central America, Mexico, and the United States. The generosity of foundations, art connoisseurs, anonymous gifts, and bequests have supported the rapid growth of the permanent collection, to 14,000 objects from one hundred countries, predominantly India, Japan, China, Indonesia, Mexico, and the Pre-Columbian cultures. Mingei International has organized 108 major exhibitions of traditional and contemporary folk art, crafts, and design during the past 25 years, and has produced 31 documentary publications and 16 videotapes.

See also **Asian American Folk Art; Dolls; Toys, Folk.**

BIBLIOGRAPHY

Longenecker, Martha. *A Transcultural Mosaic: Selections from the Permanent Collection of Mingei International Museum of World Folk Art.* San Diego, Calif., 1993.

———. *Kindred Spirits: The Eloquence of Function in American Shaker and Japanese Arts of Daily Life.* San Diego, Calif., 1995.

DEBORAH LYTTLE ASH

MINIATURES are those lilliputian versions of real-life objects, including paintings, furniture, and decorative accessories, that have long fascinated collectors. Some were made by apprentices nearing the end of their training periods, when they were required to produce, as a sign of competence in their chosen craft, a scale-model chair, vase, or silver ewer. Because such tiny pieces were more difficult to create than larger versions, success assured admission to the trade.

Miniatures were also produced in quantity for sale, especially to furnish the lavish "baby-houses" (dollhouses) that became popular among rich Europeans during the seventeenth century. Later, inspired by the industrial revolution, scale models of steam engines, ships, locomotives, and, finally, automobiles and airplanes appeared. Perhaps the most interesting of these, from a collector's point of view, are the American patent models. At one time required to be submitted with every United States patent application, the models were eventually de-accessioned by the United States Patent Office, and are now widely collected.

The word "miniature" also has a more specific meaning in the art world, however, and refers to the tiny watercolor-on-ivory portraits popular during the eighteenth and nineteenth centuries. These miniscule likenesses—oval, round, or oblong, and seldom measuring more than two inches square—are thought to have developed from medieval illuminated manuscripts, the production of which required extremely

fine brushwork, as well as the portrait "medals" of the Renaissance period, which were gold or bronze images of nobles and important personages.

By the seventeenth century, miniatures were being painted on vellum (a calfskin parchment), and then backed with cardboard, and in the early 1800s thin, ivory disks replaced the vellum. Often mounted in gold or silver frames and set with precious stones, these early miniatures were created by academic artists for the amusement of the wealthy. It was not long before more modest examples, however, became popular in America, as well as in Europe and England. The earliest known miniature produced in the American colonies was painted in 1740 by Mary Roberts (dates unknown). During the following century they became widely popular, and many painters of folk portraits added this technique to their roster of accomplishments.

The relatively obscure New England portrait painter James Guild (1797–1844) kept a diary of his work and travels in which he ascribed his initiation into the art of ivory painting as having been due to a customer producing a piece of the material, and asking Guild to paint his portrait on it. So satisfactory was the result to both customer and artist that by 1823 Guild was advertising himself as a miniaturist and charging as much as sixteen dollars for each work, a sizable sum at the time.

It is evident that many other provincial artists tried their hands at this craft, not only from the signed American examples but also from the fact that so many existent full-size folk portraits show the sitter wearing a miniature. In the form of lockets supported on a chain (often with a back chamber for a bit of the loved one's hair) or as breast pins, miniatures became a common item of female dress. Men at times also wore them, as pins or attached to watch chains, and they were especially popular with both sexes as mourning jewelry.

The skill and attention to detail apparent in the work of American miniaturists is reflected in the fact that when comparing a full-size work by a well-known folk artist, such as John Brewster Jr. (1766–1854), with his miniatures on ivory in the same pose, the same costume detail and the same background in both large and small are clearly evident. No compromise has been made with quality. Though he worked for decades and advertised himself as a miniaturist (an ad he placed in the *Newburyport* [Massachusetts] *Herald* of November 17, 1809, indicated that he charged ten dollars for a miniature, as opposed to fifteen dollars for a full-length portrait), only a single signed example of Brewster's smaller work is pres-

ently known. This is generally the case among miniature painters, and it is probably due primarily to the fragile nature of ivory; many of these works have been destroyed. Additionally, many artists did not sign their paintings, and, when they did, they often attached a bit of paper to the back of the ivory disk or inserted it in the locket, and these were easily lost.

Nevertheless, signed miniature examples by important American folk artists do exist. Among these artists, in addition to Brewster and Guild, are Henry H. Walton (1804–1865), John Bradley (active 1831–1847), and Ruth Whittier Shute (1803–1882). Walton is known for seven signed miniature portraits on ivory, while the prolific New York City artist John Bradley is credited with two. There is also a charming signed miniature by Ruth Whittier Shute, one of the very few itinerant female folk artists of the nineteenth century. Though she often collaborated with her husband, Samuel A. Shute (1803–1836), Ruth Shute was working alone when she notified the citizens of Clinton County, New York, in 1834, via the *Plattsburg Republican,* that she had "taken a room at John McKee's hotel," where she would paint miniatures for five to eight dollars each.

There is a substantial quantity of American-made miniature furniture, though little of it is signed. Many of these pieces, dating in style from the Queen Anne period to the Victorian era, were made as graduation pieces by apprentices to the cabinetmaking trade. Others, identifiable by inscription, were made as gifts; still others were salesmen's samples, intended to be displayed as evidence of the type and quality of work available from a given producer. The latter often bear a manufacturer's label or stenciled name.

Miniature furniture, or at least the highest-quality examples, may be distinguished from dollhouse furniture by the fact that they are made to scale. They are usually made of better-quality woods (mahogany, rosewood, and the like) and show superior craftsmanship, but they are rarely signed, unless intended as gift pieces. Among the latter are some wonderful grain-painted folk art chests and chests of drawers, as well as the more common late-Federal era or Empire chests of drawers in walnut, with Sandwich-glass pulls and whitewood inlay.

American potters turned out a large number of miniatures in redware, stoneware, and yellowware. Redware potters, especially in Pennsylvania, produced pitchers, jugs, pots, crocks, and kegs, ranging in size from one to three inches and glazed in various ways. Most common were examples of pottery with a clear lead or a black manganese glaze. Less often seen and much sought after by collectors are slip-glazed

pie plates, bowls, and platters, with designs in brown, white, or green slip.

At the end of the nineteenth century, as their craft was dying, redware potters began to make unglazed, novelty miniatures. Some of these, such as the tiny pots impressed with "*Boston Baked Beans,*" were made for firms that used them to advertise their products. Others were sold in department stores or made to order for events such as fairs and banquets, or to be offered to tourists. These often bear stencils such as "*Michigan State Fair 1895*" or "*Lake George 1892.*"

Stoneware factories were not quite so prolific, but many still produced miniaturized versions of their wares, usually in a brown, Albany-slip finish. Especially well known are the small jugs made by the Norton Pottery in Bennington, Vermont. Sold as novelty pieces, these three-inch-high jugs bore incised inscriptions such as "*Battle of Bennington,*" "*Centennial 1876,*" or "*Little Brown Jug.*" Similar examples were made at potteries in Kentucky and the Midwest. Far less common are salt-glazed, blue-decorated miniatures. When these appear on the market, they tend to command high prices.

Miniature pieces in yellowware are less common still. Delicate pitcher-and-bowl sets or mugs, banded in white or blue slip, were made at the United States Pottery in Bennington, Vermont, in Ohio, and by various English manufacturers. The most common item is a yellowware potty, produced as a novelty and sold at resorts and historic sites as a souvenir.

There are also miniatures in metal. Tin, easily worked and decorated, was a popular medium. Tinsmiths from New England to Pennsylvania turned out miniature vessels, including coffeepots, mugs, and deed boxes. These were usually painted ("tole" ware), and were probably intended as children's toys rather than novelties or salesmen's samples. In the late nineteenth century, firms such as Griswold and Wagner began to make miniature cast-iron cooking utensils that mimicked the larger versions used in the home; these are now highly collectible. Less often made in the United States were bronze or brass miniatures. Primarily comprised of furniture such as tilt-top tables or settees, these examples are usually of English origin.

See also **John Bradley; John Brewster Jr.; Furniture, Painted and Decorated; James Guild; Mourning Art; Pottery, Folk; Redware; Ruth Whittier Shute; Dr. Samuel Addison Shute; Stoneware; Tinware, Painted; Toys, Folk; Henry H. Walton.**

BIBLIOGRAPHY

Bishop, Robert, and Judith R. Weissman. *Folk Art: The Knopf Collectors' Guides to American Antiques.* New York, 1983.

Kern, Arthur, and Sybil Kern. "On Some Little Known Miniature Portraits by Well-Known American Folk Painters." *Folk Art,* vol. 20, no. 1 (spring 1995): 48–55.

Lipman, Jean, and Tom Armstrong, eds. *American Folk Painters of Three Centuries.* New York, 1980.

WILLIAM C. KETCHUM

MOHAMED, ETHEL WRIGHT (1906–1992) created thread paintings—embroidery done on linen or cotton with a crewel needle, cotton thread, and various stitches. Mohamed "painted" people, places, and events: *My Husband in 1914, Waiting for the Stork, The New Baby, The Cotton Pickers, Storm, Depression Days, Family Night at the Crescent Theater.*

Mohamed was born on a cotton farm near Eudora, Mississippi. At eighteen, she married Hassan Mohamed, a Lebanese dry goods peddler and merchant. The couple moved to Belzoni, where Hassan opened a general store; after he died in 1965, Ethel managed the store herself.

A single work by Ethel Mohamed might take a week to four months to complete. She began with an outline on paper, transferred it to cloth using carbon paper, and then improvised the details with thread. She would use a print background fabric to suggest growing plants, or a blue fabric for the sky. At first she used pictures from magazines as inspiration; later, she relied on her imagination. She was eager to show her pictures but reluctant to sell them, though she donated some to charities.

Mohamed completed about 125 pictures and numerous embroidered sheets and pillowcases. While sewing, she felt like "another person," in a world of her own. She stitched steadily from 1965 until six weeks before she died.

Her work is at the Smithsonian Institution and at the Ethel Wright Mohamed Stitchery Museum in Belzoni.

BIBLIOGRAPHY

Ferris, William. *Local Color: A Sense of Place in Folk Art.* New York, 1982.

Kogan, Lee. "Ethel Wright (Big Mama) Mohamed 1906–1992." *Folk Art* (fall 1992): 15.

Mohamed, Ethel Wright. *My Life in Pictures.* Jackson, Miss., 1976.

———. *The Share Cropper: A Collection of Recipes, Art, and Information from the "Heart" of the Mississippi Delta.* Inverness, Miss., 1987.

LEE KOGAN

MOLLENO (active c. 1815–c. 1845) was a northern New Mexican *santero,* or carver and painter of figures

of saints, who painted several altar screens in village churches, as well as hundreds of small devotional paintings of saints and holy persons. Nothing is known of Molleno's background or even his full name. In the 1930s collectors and artifact dealers in Santa Fe knew the name "Molleno," presumably from older Hispanic informants, and in 1948 E. Boyd discovered a small panel painting inscribed in Spanish, translated as "St. Francis painted in the year 1845, by the sculptor Molleno." Although this inscription calls Molleno a sculptor, no sculptural work has been found that can be attributed to him.

Several altar screens in Molleno's distinctive style give primary evidence of when and where he worked. A side-altar screen of the saint, San Francisco, in Ranchos de Taos was painted by Molleno, c. 1815–c. 1817, and the main altar screen may have been done by him as well, but it was replaced by oil paintings from Mexico before 1831. Near Ranchos de Taos, the altar screen in the small church of Nuestra Señora de San Juan de Rio Chiquito was painted by Molleno in the year 1828. At least two of the altar screens in El Santuario de Chimayó were also painted by Molleno, one from c. 1815–c. 1818 and the other after 1820.

Some earlier work in Molleno's style includes decorative devices and color schemes identical to those found in paintings by the Laguna Santero, and at least one of Molleno's altar screens employs twisted Solomonic columns typical of the Laguna Santero's work. It is likely that Molleno was an apprentice in the Laguna workshop, and began painting on his own after the Laguna Santero ceased working in New Mexico. In general, the style of the work of the two artists is actually quite different. While the folk paintings of the Laguna Santero represent a transition from the more naturalistic academic art of the day, the work of Molleno is highly spiritualized and emblematic, almost severe in its simplicity, abstraction, and degree of impersonality. His work became formulaic, particularly in his later paintings, which have a limited palette and frequently repeat the same decorative devices. Unlike some of the other artists of his day, however, Molleno did not copy academic engravings but produced a coherent body of work in his own distinctive style. Molleno does not appear to have had a workshop. Nevertheless, one important painter, the Quill-Pen Santero (active c. 1830–c. 1850), appears to have worked with Molleno for a while, as a few of this artist's *retablos,* or altar screens, have border decorations in Molleno's style.

See also **Bultos; Laguna Santero; Retablos; Santeros.**

BIBLIOGRAPHY

Boyd, E. *Popular Arts of Spanish New Mexico.* Santa Fe, N. Mex., 1974.

Wroth, William. *Christian Images in Hispanic New Mexico.* Colorado Springs, Colo., 1982.

WILLIAM WROTH

MONZA, LOUIS (1897–1984) was a self-taught artist whose paintings, drawings, sculptures, and linoleum block prints express belief in the common man, distrust of political leaders, and wonderment at the beauty of nature. Born in Turate, Italy, he was apprenticed at the age of seven to a woodcarver who made traditional religious figures and church furniture. In 1913, he immigrated alone to the United States. He worked on the railroads and traveled throughout the United States and to Mexico, where he lived between 1915 and 1917. The populism and artistic flowering of the Mexican revolutionary period made a lasting impact on Monza's thought and art. Service in the United States Army between 1917 and 1919 left Monza a confirmed pacifist.

In 1919, Monza returned to New York and worked as a housepainter until 1938, when he fell from a scaffold and suffered serious injury. While recuperating, Monza listened with apprehension to the news of the events of World War II on the radio and produced a series of paintings that earned him one-person shows at the Artists' Gallery in New York in 1941 and 1943. A monumental modernist work, *The Comic Tragedy,* portrays the futility of war and the plight of common people during wartime. Amid symbols of classical and imperial Rome, tin soldiers resembling clowns do the bidding of leaders unconcerned with the plight of working people. A severed head, displayed in a public square, predicts the fall of the Italian leader, Mussolini. Other early works on the theme of war include depictions of Pearl Harbor and the fall of Paris.

In 1946, Monza moved with his wife Heidi to Redondo Beach, California. Heidi Monza supported her husband, allowing him to pursue a full-time artistic career. In California, Monza began to use a brighter palette. While some of Monza's landscapes depict monstrous creatures, or an animistic terrain where hillsides take the contours of human faces, others depict paradisiacal harmony. In 1969, a high school art teacher introduced Monza to printmaking. Monza's prints, which allowed him to exploit the carving techniques he had learned as a child, include lyrical

renderings of nature, angry condemnations of industrialists and governments that despoil nature, and elusive dreamlike works. His phantasmagoric late drawings echo the themes of the prints. During this period, Monza also tried his hand at terracotta and bronze sculptures. Few self–taught artists rival Monza's virtuosity in terms of varieties of media or career length.

See also **Painting, American Folk; Painting, Landscape; Sculpture, Folk.**

BIBLIOGRAPHY

Fels, Catherine. *Graphic Work of Louis Monza.* Los Angeles, 1973.

Larson, Susan, "Louis Monza: Passionate Protest and Hard Love," *Folk Art*, vol. 21 (winter 1996–1997): 39–44.

Larson-Martin, Susan, and Lauri Robert Martin. *Pioneers in Paradise: Folk and Outsider Artists of the West Coast.* Long Beach, Calif., 1984.

Maresca, Frank, and Roger Ricco, *American Self-Taught: Paintings and Drawings by Outsider Artists.* New York, 1993.

Rosenak, Chick, and Jan Rosenak, *Museum of American Folk Art Encyclopedia of Twentieth-Century Folk Art and Artists.* New York, 1990.

CHERYL RIVERS

MORAVIANS: *SEE* RELIGIOUS FOLK ART; MUSEUM OF EARLY SOUTHERN DECORATIVE ARTS.

MORGAN, SISTER GERTRUDE (1900–1980) was a self-appointed missionary and self-taught African American artist who executed approximately six hundred and fifty known drawings and paintings during an eighteen-year period, from 1956 until 1974. Her animated and vibrant artwork concentrated on two types of iconography: self-portraits and autobiography, and biblical narratives that primarily focused on the prophecies of the New Testament's Book of Revelation. Morgan was a musician, poet, and writer as well, using all her talents to foster her determined objective of spreading the word of her gospel to anyone who would listen to her warnings of the consequences of not living an ethical Christian life.

Born in Lafayette, Alabama, the first half of Morgan's life was spent living and working as a domestic and nursemaid in Alabama and Georgia. Throughout her life, Morgan experienced self-described visions that shaped her beliefs and the direction of her life. In 1934 while living in Columbus, Georgia she claimed that God called her to go out into the world to spread the gospel. Subsequently in 1939, she went to New Orleans, where she helped set up an orphan's mission and day care center.

Morgan reported that in 1956 and 1957 she received a second revelation from God that she was to be the bride of Christ. Subsequently, she left the orphanage and began creating the first art she had made since her childhood. When she went out in the community to preach the Gospel, she used the crayon drawings she made as visual aids to reinforce her teachings. Attracting the attention of gallery owner, E. Lorenz Borenstein, she was invited to show her artwork in his gallery, and was encouraged to perform her original music and to continue to conduct her religious services. She went on to establish a small church that she called "the Everlasting Gospel Mission" in her home in the mid-1960s where she held services and preached.

Morgan's earliest unsigned works, dating from the late 1950s to the early 1960s, are small, simple crayon drawings of biblical subjects executed on cardboard. In the mid-1960s she abandoned crayon and began to produce works in acrylics and mixed media with multiple figures, minute details, and complex compositions painted with a muted palette. Her mature paintings of the late 1960s, including a series of renderings titled *New Jerusalem*, reveal a confidence and exuberance manifest in the loose brush strokes and painterly application of vibrant tempera and/or acrylic color she used to produce densely packed compositions. Here pictorial and textual elements come together in a graphic, gridlike representation of a fantastical world in which human subjects (both dark and light skinned) are surrounded with multitudes of red and black-haired angels. Morgan has penciled in her name, the title of the work, and the scriptural passage (Revelation 21) in the upper register of the composition. Executed with unmodulated areas of primary color and a naïve, flattened perspective, *New Jerusalem* retains the freshness and animation common to the art of children and the insane.

In the early 1970s, Morgan's work was thrust into the national spotlight when it was included in prominent national art exhibitions, including two at the American Folk Art Museum in New York. Borenstein produced a record of her music, *Let's Make a Record*, in 1971, and the poet Rod McKuen (with Wade Alexander) produced a book illustrated with Morgan's artwork entitled *God's Greatest Hits*.

As Morgan described receiving another command from God in 1974, she stopped painting and devoted her energies to writing poetry until her death. Upon her death, Morgan was interred in an unmarked grave in a potter's field in Metairie, Louisiana. Despite her poverty and the handicaps she faced in life, Morgan's powerful messages and images, coupled with her unwavering determination and zeal, have found a

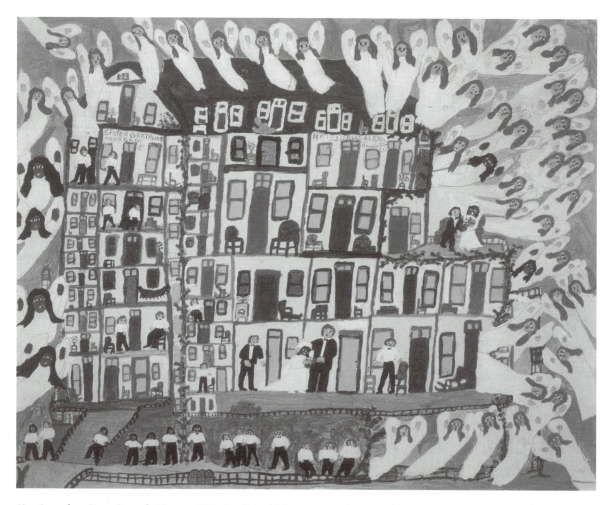

New Jerusalem; Sister Gertrude Morgan; 1972. Acrylic and ink on paper; 22 × 28 inches. Collection Dr. Kurt Gitter and Alice Yelen.

wide audience, and have helped solidified her reputation as one of America's foremost self-taught artists of the twentieth century.

See also **African American Folk Art (Vernacular Art); American Folk Art Museum; Painting, American Folk; Religious Folk Art; Visionary Art.**

BIBLIOGRAPHY

Alexander, Wade. *God's Greatest Hits.* Los Angeles, 1970.

Fagaly, William A. *Tools of Her Ministry: The Art of Sister Gertrude Morgan.* New York, 2003.

Hartigan, Lynda Roscoe. *Made with Passion: The Hemphill Folk Art Collection.* Washington, D.C., 1990.

Hemphill, Herbert W., and Julia Weissman. *Twentieth-Century American Folk Art and Artists.* New York, 1974.

Longhauser, Elsa, and Harald Szeemann. *Self-Taught Artists of the 20th Century: An American Anthology.* New York, 1998.

Rosenak, Chuck, and Jan Rosenak. *Museum of American Folk Art Encyclopedia of Twentieth Century American Folk Art.* New York, 1990.

WILLIAM A. FAGALY

MORMONS: *SEE* RELIGIOUS FOLK ART.

MOSES, ANNA MARY ROBERTSON "GRANDMA" (1860–1961) was the most popular and successful American self-taught artist of the twentieth century. Better known as "Grandma" Moses, this unassuming elderly farm woman from upstate New York captured the post-World War II imagination with her visions of an enduring rural paradise. Though her landscapes were often drawn from the artist's memories of a simpler, pre-industrial era, her work was less a retreat into the past than an attempt to link it to the present.

She offered a reassuring vision of continuity to a world that felt itself irrevocably changed by its recent confrontation with the Holocaust and the possibility of nuclear annihilation.

Anna Mary Robertson was born in Greenwich, New York, where her father farmed and operated a flax mill. In 1887, after working for fifteen years as a "hired girl" on neighboring farms, she married a "hired man," Thomas Salmon Moses. Lured by the economic opportunities of the Reconstruction-era South, the newlyweds moved to Staunton, Virginia. There they labored at first as tenant farmers, eventually earning enough to purchase their own place. In 1905 the couple returned to New York with their five children and bought a farm in Eagle Bridge, not far from Moses' birthplace. Thomas Moses died of a heart attack there in 1927.

Moses' earliest sustained encounter with art came in the early 1930s. At the urging of her daughter, Anna, Moses began embroidering what she called "worsted" pictures. When Moses complained that arthritis made it hard for her to hold a needle, her sister Celestia suggested that she paint instead. The artist gave many of her first paintings to family and friends, but she also entered a few in a competition at the Cambridge Country Fair, and sent others to a "women's exchange" competition, organized by the drugstore in the neighboring village of Hoosick Falls. Moses had little luck at either venue until 1938, when a New York City collector named Louis Caldor traveling through Hoosick Falls noticed the paintings in the drugstore window; he ended up buying the whole lot.

Vowing to help Moses find an audience for her art, Caldor began making the rounds of New York museums and galleries. In 1939 the collector Sidney Janis selected three Moses paintings for inclusion in a private viewing at the Museum of Modern Art in New York. Moses' first public exhibition took place about a year later, in October 1940, when Otto Kallir gave her a solo show at his recently opened Galerie St. Etienne, also in New York. What brought public attention to her work and gave impetus to her career as a painter, however, was a Thanksgiving Festival organized by Gimbels Department Store in New York, held shortly after the St. Etienne exhibition closed. A substantial group of paintings was reassembled at Gimbels, and Moses was invited to address the public. Her talk brought a burst of publicity, and she soon became something of a celebrity in upstate New York. It was during this period that a journalist, interviewing the artist's friends in Eagle Bridge, discovered that she was known locally as "Grandma Moses." The nickname appeared in print, and stuck.

Moses' ascendancy from local to national renown, and eventually to international fame, began in earnest after World War II. The Galerie St. Etienne launched a series of traveling exhibitions that would, by the mid-1960s, bring her work to more than thirty states as well as ten European nations. In 1946 Otto Kallir edited the first monograph on the artist, *Grandma Moses: American Primitive,* and oversaw the licensing of the first Grandma Moses greeting cards. Eventually, the public could also enjoy Grandma Moses posters, murals, china plates, drapery fabrics, and a number of other licensed products. In 1949 President Harry S. Truman recognized the artist's achievement with a special award.

The dawning age of mass communications helped spread Grandma Moses' renown. By live remote radio broadcasts, her voice was beamed from her home in Eagle Bridge to the larger world. In 1950 a documentary film about the artist was nominated for an Academy Award. Her autobiography, *My Life's History,* was published in 1952, and the following year she was featured on the cover of *Time* Magazine. In 1955 Moses was interviewed by the legendary television journalist Edward R. Murrow, while the actress Lillian Gish portrayed the artist in one of the first televised "docu-dramas."

As Moses aged, her career acquired only more luster. In 1960 *Life* magazine sent noted photographer Cornell Capa to do a cover story about the artist's one hundredth birthday. That birthday—declared "Grandma Moses Day" by New York's governor, Nelson Rockefeller—was celebrated much like a holiday in the nation's press. The fanfare was repeated the following year, when she turned 101. Grandma Moses passed away several months later.

See also **Sidney Janis; Painting, American Folk; Painting, Memory.**

BIBLIOGRAPHY

Janis, Sidney. *They Taught Themselves.* New York, 1942.

Kallir, Jane. *Grandma Moses: The Artist Behind the Myth.* New York, 1982.

———. "Grandma Moses," in *Self-Taught Artists of the Twentieth Century: An American Anthology.* New York: American Folk Art Museum, 1998.

———. *Grandma Moses in the Twenty-First Century.* Alexandria, Va., and New York, 2001.

Kallir, Otto. *Grandma Moses.* New York, 1973.

———. *Grandma Moses: American Primitive.* New York, 1946.

Ketchum, William. *Grandma Moses: An American Original.* New York, 1996.

Moses, Anna Mary Robertson. *My Life's History.* New York, 1952.

JANE KALLIR

MOULTHROP, REUBEN (1763–1814) was a Connecticut portrait painter and proprietor of a waxworks exhibition. He was born in East Haven, and lived in that vicinity for most of his life. Although little is known of his early years or training, he achieved recognition both for his portraits of eminent Connecticut citizens, such as Ezra Stiles (1727–1795), president of Yale University from 1778 to 1795, and for his successful waxworks of life-size figures staged in dramatic vignettes that traveled throughout Connecticut, New York City, and as far as the West Indies.

Moulthrop began painting in a plain style, which emphasized the personality of the sitter in a simple setting, in the wake of the American Revolutionary War, a period in which Connecticut emerged as the new center of American portraiture. Stylistic conventions appearing in his early portraits suggest that Moulthrop was familiar with the works of John Durand (active 1765–1782) and Abraham Delanoy (1742–1795), two artists who were active in Connecticut during the 1780s. Only a handful of paintings are signed by or can be firmly attributed to Reuben Moulthrop. These include the earliest documented portraits of *Job Perit* and *Sarah (Sally) Perit* (1790), *Ezra Stiles* (1794), *Thomas Robbins* (1801), and the portrait of Robbins' father, *Ammi Ruhamah Robbins* (1812). These commissions demonstrate how Moulthrop's work in wax influenced his approach to painted portraiture, displaying a thick plasticity in the handling of drapery and clothing, as well as a fascination with skin texture that Moulthrop evinced from his earliest portraits through his last works of 1812. Based upon these and additional documented works, a steady development of skill and format is traceable. A number of additional works that have been traditionally attributed to Moulthrop, however, show a second stylistic lineage that has led to some lack of clarity in establishing the artist's oeuvre. These include the portraits of *John and Mary Reynolds* (c. 1788), *Hannah Austin Street* (c. 1789), and *Amos Morris* (c. 1785–1789).

Reuben Moulthrop was the subject of a major exhibition at the Connecticut Historical Society in Hartford from November 1956 through February 1957. The Society was an appropriate venue, as one of its founders was Thomas Robbins, whose penetrating portrait shows the elegant simplicity of Moulthrop's mature and fully developed style. Family correspondence that Robbins left to the Society details some of the Moulthrop's activities during a five-year period in which Robbins attempted to commission portraits of his father and other family members. These commissions were interrupted first by Moulthrop's thriving waxworks business and then by a bout of "tipus fever," which left the artist too weak to work. Some interesting facts emerge from this period: it took Moulthrop seven weeks to paint seven portraits, including two of the elder Reverend Robbins, who complained to his son, "I had no idea it would take so long." The clients were expected to supply their own canvas or other material suitable for the portraits. In addition, the house was open to visitors while the portraits were being painted, leading Reverend Robbins to write, "Our pple [*sic*] came in plenty day after day as into a Museum—all agree that the likenesses are admirably drawn. . . ."

See also **John Durand; Painting, American Folk.**

BIBLIOGRAPHY

Black, Mary C., and Jean Lipman. *American Folk Painting.* New York, 1987.

Green, Samuel M. "Some Afterthoughts on the Reuben Moulthrop Exhibition." *Connecticut Historical Society Bulletin,* vol. 22, no. 2 (April 1957): 38–41.

Hollander, Stacy C. "Reuben Moulthrop: Artist in Painting and Waxworks." *Folk Art,* vol. 19, no. 3 (fall 1994): 36–41.

Little, Nina Fletcher. *Paintings by New England Provincial Artists, 1775–1800.* Boston, 1976.

Sawitzky, Susan. "New Light on the Early Work of Reuben Moulthrop." *Art in America,* vol. 44, no. 3 (fall 1956): 8–11, 52.

Sawitzky, William, and Susan Sawitzky. "Portraits by Reuben Moulthrop." *New-York Historical Quarterly,* vol. 39 (October 1955): 385–404.

Thomas, Ralph W. "Reuben Moulthrop, 1763–1814." *Connecticut Historical Society Bulletin,* vol. 21, no. 4 (October 1956): 97–111.

STACY C. HOLLANDER

MOUNT PLEASANT ARTIST: *SEE* SAMUEL BENTZ.

MOUNTZ, AARON (1873–1949) was a traditional Pennsylvania German woodcarver who was trained as a young child to carve by watching the itinerant Pennsylvania carver Wilhelm Schimmel (1817–1890). Mountz was born in Cumberland County, near the town of Carlisle, Pennsylvania, the oldest son of a fourth-generation farming family that owned land along the Conodoguinet Creek. Like many of the children in his community, Mountz became fascinated with the older Schimmel, watching him carve his imaginative figures of birds and animals, and was encouraged to learn to carve under Schimmel's tutelage. Much less prolific than his teacher, it is unclear whether Mountz continued to carve after he reached adulthood, or whether he continued to practice his skills after Schimmel's death in 1890. Unfortunately, few of his surviving works are signed or dated.

Inspired by the natural world he experienced day-to-day on his family's farm, Mountz seems to have

preferred carving birds and animal figures. Unlike Schimmel, he rarely further decorated his finished carvings with paint, leaving bare but smoothly refined the carved surface of the pine from which he fashioned his work. Certain characteristics of his carving style show a marked resemblance to those of his teacher's, particularly the use of crosshatched lines to decorate the surface of figures and to portray feathers or fur. In its careful, regular, and studied execution of carving, however, Mountz's work belies his effort to hone his skills by attempting to copy the more spontaneous, irregular, and rough surfaces indicative of Schimmel's style. While a number of earlier folk-carving traditions brought to America by immigrant German carvers include chiseled, cut-line, or crosshatched surface decoration, both carvers developed their own individual variations of these traditional decorative devices in their work.

Mountz spent much of his life in relative seclusion, rarely venturing beyond the boundaries of his family's farm, and he never married. A daydreamer to a fault, he proved incapable of earning a living wage or supporting himself, despite several well-intentioned efforts by his brother to provide Mountz employment in his business as a well-driller. Mountz later suffered from mental deterioration, and spent the last years of his life at the Cumberland County Almshouse. Interestingly, it was at this same institution that Wilhelm Schimmel, his creative mentor, had died 60 years earlier.

See also **Pennsylvania German Folk Art; Wilhelm Schimmel; Sculpture, Folk.**

BIBLIOGRAPHY

Flower, Milton E. *Three Cumberland County Wood Carvers: Schimmel, Mountz, Barrett.* Carlisle, Pa., 1986.

Garvan, Beatrice B. *The Pennsylvania German Collection.* Philadelphia, 1982.

JACK L. LINDSEY

MOURNING ART is a distinct category in folk art encompassing several aesthetic forms, including needlework, painting, and jewelry. Mourning needlework and paintings are visual representations of sorrow, loss, and remembrance—sometimes real, and sometimes imaginary—while jewelry was created and worn as a token of recognition of the death of a loved one or as a memorial to a famous person. Mourning ceramics have also been recognized, although the majority of these were made by established potteries as commemoratives for well-known individuals, and

therefore can be more accurately categorized and described as commercial ceramics rather than folk art.

Mourning arts objects became part of a national desire for remembrance in the early nineteenth century, an idea which, for a variety of reasons, captured the public imagination. The Romantic movement of the late eighteenth and nineteenth centuries, with its extravagances of sentimental thought and focus on separation and doomed and dramatic love, influenced the appeal of mourning art considerably. The Second Great Awakening—the religious revival of the early nineteenth century distinguished by an outpouring of evangelicalism, primarily in the Southern and Midwestern United States—also played a part in the era's affinity for and emphasis upon death, resurrection, and overt Christian symbolism. Moreover, George Washington's death in 1799 profoundly catalyzed the popularity of mourning art. America's collective loss of the cherished president proved to be an overwhelming event that stimulated the need and desire for memorial art as the nation went into an extended period of mourning. Washington's death was commemorated in many different ways and media, and it was considered patriotic to own and display such memorials in the home. Young women in finishing schools and academies created stitched and painted representations of the Virginian leader, and it was only a matter of time before this fashion was modified to commemorate family and friends as well as other recognized national heroes.

Middle- and upper-class women and girls created the majority of mourning art executed in needlework and paint with some pretensions to artistic skill. Needlework was initially the favored medium for memorial icons, but, as watercolors became widely available and more fashionable, paints eclipsed the stitched arts altogether. Many paintings, however, simulated the appearance of needlework with brushwork that mimicked its short, stitch-like strokes, and paper that was pinpricked to resemble fabric, indicating the importance of such pictorial conventions. Theorems, or stencils, were also used in creating mourning pictures, especially for flora and other background elements.

Among schoolgirls, mourning art was practiced as much for its beauty and classical themes as for its memorial aspects, with some girls choosing a mourning theme because they believed it to be, as one nineteenth-century young lady noted, "handsomer [sic] than landscapes." Mourning art was also a way, as Anita Schorsch has noted, "of showing that one had good taste and proper manners." The popularity of mourning iconography is additionally indicated by

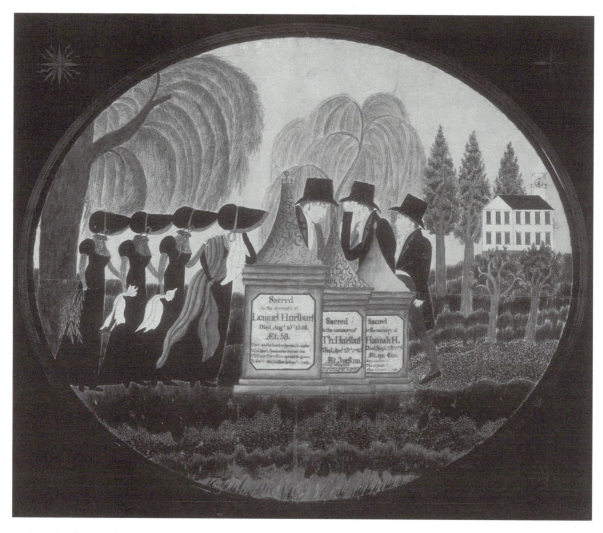

Hurlburt Family Mourning Piece. Probably Sara Hurlburt (1787–1866), c. 1808. Watercolor and ink on paper; 17 × 20 inches (oval). Collection American Folk Art Museum, New York. P1.2001.271.

those mourning pictures that appear to be premature; in other words, the tomb, a ubiquitous feature of these works, would often bear the name of the artist herself or of a still-living relative. The space for a name on a tomb might also be left blank, and names added later; however, mourning pictures were usually considered finished pieces of art, with or without names and accurate death dates. These needlework pictures and paintings also tended to emphasize the artist's romanticized vision of untimely death, communicating the emotion and despair that surviving family members might experience, as in the *Hurlburt Family Mourning Piece*, probably executed by Sara Hurlburt (c. 1808), in which a row of male and female

mourners—many of them drying tears—gather at a family gravesite.

While the significant aspect of mourning pictures would seem to be the idealization of death, in general, mourning and memorial artworks manifest a certain formulaic aspect. They were composed of an array of traditional, classical, and Christian symbols associated with death, all of which would have been well understood by educated nineteenth-century Americans. Conventions called for the inclusion of one or more mourning figures in classical postures of sorrow arrayed around a tomb, similar to the Hurlburt example. While the depiction of mourners at a tomb can be traced to early Greek and Roman burial

328

plaques, the American images are based on eighteenth-century French and English Neoclassical prototypes. The Swiss-born artist Angelica Kauffman (1750–1807) is credited with creating the archetypal mourning picture in the United States. Kauffman's work was widely collected in America and in England, where she lived and worked from 1766 to 1781. Her painting *Fame Decorating the Tomb of Shakespeare* incorporates the elements considered essential to the subsequent mourning art it influenced: a lush imaginary landscape, an impressive sarcophagus, and a Grecian maiden (here representing Fame) in Antique garments strewing flowers on the grave. The sense of melancholy communicated through the maiden's dramatic pose was a romantic reflection of the role women in nineteenth-century America played in relation to mourning as a social activity, and one that easily captured the schoolgirl imagination. Engravings based on Kauffman's painting were widely disseminated, and, on the death of Washington, they were adapted to commemorate his death by substituting the name of Washington for that of Shakespeare on the tomb. Prints based on Kauffman's painting served as the model for untold numbers of schoolgirl memorial needle pictures and watercolors, and other popular paintings were similarly copied, either in part or in their entirety. The more or less skilled hand of the individual artist, however, along with other added elements, served to make each work unique.

The female figures depicted in mourning pictures were usually young and graceful, and in early works of this type, figures are shown in classically influenced flowing white gowns or robes to symbolize hope, purity, and innocence. As the fashion for Neoclassical art and literature waned in the nineteenth century, artists began to represent figures wearing contemporary clothing, usually black for bereavement, and included images of men. A burial urn, often monumental in size, appeared as a necessary part of the mourning composition. Typically Etruscan in design it symbolized the resting place for the spirit of the departed, drawing upon historical and Antique prototypes for its emotional resonance. The urn or other gravemarker was often the focal point of the composition, and this element is considered by folk art historians to be one of the most identifiable features of American mourning art.

Every mourning picture would also have included one or more of the following elements in a verdant landscape replete with symbols that reinforced the idea of resurrection: a willow tree, representing regeneration and resurrection; evergreen trees, suggesting eternal life after death; oak and elm trees, for strength, dignity, and transitory life; ferns, for solitude and humility; a fallen tree or broken flower, to symbolize a good life cut short; a departing ship, for a completed journey; a church or cathedral, for faith and hope; a house or village as representative of the earthly home; and a garden, to suggest heaven, or the Garden of Eden. Additional elements such as angels, cherubs, garlands, flowers, and birds might also be included, and each would carry its own specific and recognizable symbolism. Overall, the pictures represented an idealized and perhaps sentimentalized view of eternity as well as a reflection of the romantic glorification of pastoral life.

Artists rarely signed mourning pieces, but frequently included inscriptions, such as the gravestone in the Hurlburt piece: "How can the heart suppress its sighs; when death dissolves the dearest ties. . . ." Names and dates on tombs or burial urns were not always reliable for dating an artwork, as pieces might be dedicated to people who had died long before the artist created the work. Other inscriptions were often based on austere religious texts or moral maxims.

Although some facets of mourning art, especially jewelry, continued well into the nineteenth century, the popularity of the mourning picture began to see a decline as early as the 1830s as a result of the rise of generalized same-sex education and the closing of the private female academies where mourning art had flourished. The end of the Romantic era and decreasing interest in religious revivalism also contributed to the decline in the memorial arts, but perhaps of greater importance still was the development of photography and advanced lithographic techniques in the 1830s, which meant that practical and economical substitutes for handwork could easily be found. Currier and Ives, for example, were among a group of printers who issued inexpensive mourning prints en masse; these were initially used as models but gradually replaced the one-of-a-kind pieces. By the time of the American Civil War (1861–1865), mourning needlework and paintings had all but disappeared.

Mourning jewelry, however, experienced a resurgence with the Civil War. While it had long been worn by the wealthy (hair work jewelry, for example, originated with a fifteenth-century fad for *memento mori*), it was not until the late eighteenth century that such jewelry became widespread among a broader public, helped considerably by the mechanized and standardized production of some jewelry as the result of the Industrial Revolution in the nineteenth century. Many eighteenth- and early nineteenth-century mourning pieces were delicately decorated minia-

tures on ivory; while professional artists frequently painted these, they were then often set into standardized brooches or lockets. The paintings might depict a portrait of the deceased or an attractive composition of conventional symbols such as a weeping figure, a willow tree, a tomb, and a departing ship or a setting sun.

Although hair work jewelry can be traced to an earlier century, it became highly fashionable in America after the mid-nineteenth century. Not all of it was made as a sign of mourning; the Civil War era witnessed a surge of interest in such jewelry, as many women wore a locket or brooch that held a lock of their loved one's hair while the men were at war. A vestige of the Romantic movement was also found in the sentimental expressions of friendship that continued to be popular at this time, in which female friends would exchange locks of hair, weave them into decorative designs, and then mount them in a decorative brooch, locket, bracelet, or earrings. Mourning pieces can sometimes be difficult to distinguish from this type of jewelry, although there are often obvious indications, such as memorial inscriptions (for example, "In Loving Memory of") or death dates. Mourning jewelry might also be rimmed with seed pearls, which typically represented tears, or with black enamel as a sign of bereavement.

Although the fashion for hair work had virtually ended by the end of the nineteenth century, mourning jewelry continued to be made and worn into the twentieth century. By this time, however, most examples of such jewelry were mass-produced in standard patterns and made from jet or other dark stones that connoted bereavement and grief, and the earlier iconic imagery became rare. By the end of World War I, the use of mourning jewelry and the attendant conventions associated with nineteenth-century mourning practices, had essentially disappeared.

See also **Gravestone Carving; Miniatures; Painting, American Folk; Painting, Landscape; Pictures, Needlework; Political Folk Art; Religious Folk Art.**

BIBLIOGRAPHY

Muto, Laverne. "A Feminist Art: The Memorial Picture." *Art Journal*, vol. 35, no. 4 (summer 1976): 352–358.

Pike, Martha V., and Janice Gray Armstrong, eds. *A Time to Grieve: Expressions of Grief in Nineteenth Century America.* Stony Brook, N.Y., 1980.

Ring, Betty. *Girlhood Embroidery: American and Pictorial Needlework, 1650–1850.* 2 vols. New York, 1993.

Rumford, Beatrix. "Memorial Watercolors." *Antiques* (October 1973): 688.

Schorsch, Anita. *Mourning Becomes America: Mourning Art in the New Nation.* Clinton, N.J., 1976.

Treschel, Gail Andrews. "Mourning Quilts in America." *Uncoverings 1989*, vol. 10 (1990): 143–144.

JACQUELINE M. ATKINS

MÜLLER, DANIEL (1872–1951) was a carousel carver, trained to carve by his father, Johann Müller, who made the long journey from Hamburg, Germany, to Brooklyn with his family in 1881. As a cabinetmaker and carver, Johann Müller soon found a job working for the Charles Looff Company, manufacturers of carousels. As was the tradition of the day, Johann's two sons, Daniel and his younger brother, Alfred, went to school in the mornings and studied their father's craft in the afternoons. As apprentices, they were slowly given small carving jobs, but as their confidence and abilities grew, so did the complexity of their work.

A few years after the Müllers' arrival in America, the family moved to Philadelphia, where Johann went to work for an old acquaintance from Germany, Gustav Dentzel. At Dentzel's shop, the Müller boys continued to train, but in 1887, when both of their parents died within a few months of each other, Dentzel assumed responsibility for the family.

Daniel Müller learned his craft very well, but his interests in art extended beyond carving carousel figures. He always carried a sketchbook, drawing people on the street, animals at the zoo, or even creatures from his imagination. This was a habit that would stay with him for most of his life. Müller signed up for classes at a local public art school, and later enrolled at the Pennsylvania Academy of Fine Arts, where he became an outstanding sculpture student. Müller's drive for self-improvement was constant, and despite the demands of his working life, he continued taking art classes at night for twenty years.

In 1904 Daniel and Alfred opened their own carousel shop, and were soon setting new standards of excellence in the creation of carousel figures. They produced carousels for a variety of clients while owning and operating several of their own machines. Over the next ten years, the most intricate and realistic carousel figures ever made were produced in the carving shop of D.C. Müller & Bro. Extraordinary attention was paid to details, especially in the creation of the outside row of carousel figures. The carvings from this period show a great deal of restrained elegance—never wild, but always intense.

Despite the quality of his work, Müller's shop never matched the success of the Charles Looff Co. or the Philadelphia Toboggan Co., and in 1917 the shop

was closed. Daniel Müller went back to work at the Dentzel company, where he stayed until it closed in 1928. He continued to receive occasional commissions until his death in 1952. The legacy of Daniel Müller, the sculptor, is embodied in the wooden figures that once were considered no more than seats on a ride.

See also **Carousel Art; Gustav Dentzel; Charles Looff.**

BIBLIOGRAPHY

Dinger, Charlotte. *Art of the Carousel.* Green Village, N.J., 1983.

Fraley, Tobin. *The Carousel Animal.* San Francisco, 1983.

———. *The Great American Carousel.* San Francisco, 1994.

Fried, Frederick. *A Pictorial History of the Carousel.* Vestal, N.Y., 1964.

Morgan, Brian. "Merry-Go-Roundup: The Daniel Müller Diaries." *National Carousel Association Newsletter,* vol. 26, no. 1 (spring 1999): 6–20.

Stevens, Marianne. *Painted Ponies.* Santa Fe, N. Mex., 1986.

Swenson, Marge. "Daniel Müller," *Carrousel Art Magazine,* vol. 4, no. 4 (1978).

Weedon, Geoff. *Fairground Art.* New York, 1981.

TOBIN FRALEY

MURRAY, JOHN BUNION (1908–1988) (or Murry, as it is sometimes spelled) was a visionary artist who spent his entire life in rural Glascock County, Georgia. Born into a poor African American family in an area rife with racial prejudice, he married a young neighbor, Cleo Kitchens, when he was in his early twenties. He built a small house for them and the eleven children they eventually had together, and he supported the family by working on nearby farms. His wife later left him, and he never remarried.

In 1978, soon after a dislocated hip forced his retirement, Murray experienced what he described as a vision, in which he was called to spiritually mediate between God and humankind in a world beset by evil forces. Although unable to read or write the English language, he subsequently began to compose calligraphic texts that he claimed were spiritually inspired–essentially a written equivalent of glossolalia, or speaking in tongues. He believed that this writing was the word of God and that it could be deciphered by spiritually pure individuals, but only if they read it through a clear glass container filled with clean water.

Murray inserted some pages of this "spirit script" in envelopes that he passed out to fellow members of his church congregation, until the pastor asked him to refrain from doing so. Others he nailed to the walls of his house, in keeping with an African American tradition that writing of any kind can be used to deflect and confuse evil spirits. At around the same time he began salvaging discarded objects that he found symbolically significant and painting them with expressionistically abstracted, columnar forms that have been characterized as guardian figures. As with the spirit scripts on his walls and the piles of rocks, bricks, and broken concrete slabs that he had previously constructed in his yard, he strategically placed these painted objects around his house for purposes of spiritual protection.

In the early painted objects and until collectors of his work later gave him access to a more varied palette, he employed a color scheme that, according to collector and scholar William Arnett's sources, is specifically coded, with yellow representing divine presence; blue connoting positive energy, and red signifying evil, while white and black respectively represented spiritual purity and impurity. All of his work deals with the interplay of these forces in the mortal world, from which he departed after succumbing to prostate cancer.

See also **African American Folk Art (Vernacular Art); Religious Folk Art; Sculpture, Folk; Visionary Art; Yard Show.**

BIBLIOGRAPHY

Arnett, Paul, and William Arnett, eds. *Souls Grown Deep: African-American Vernacular Art of the South,* vol. 1. Atlanta, Ga., 2000.

Birmingham Museum of Art. *Pictured in My Mind: Contemporary American Self-Taught Art from the Collection of Dr. Kurt Gitter and Alice Rae Yelen.* Birmingham, Ala., 1995.

INTAR Latin American Gallery. *Another Face of the Diamond: Pathways through the Black Atlantic South.* New York, 1989.

Padgelek, Mary G. *In the Hand of the Holy Spirit: The Visionary Art of J.B. Murray.* Macon, Ga., 2000.

TOM PATTERSON

MURRAY, WILLIAM (1756–1828) was one of the most important early painters of family records in the state of New York. Born in England on November 17, 1756, he enlisted at the age of eighteen in the British army and, according to an unconfirmed report, went to America in General John Burgoyne's army, but deserted in 1776 because of concern over England's treatment of its colony. By February 1, 1777, he was a private in the First Battalion of New York Forces.

Following his discharge from the army in 1783, Murray visited Montgomery County, New York, and his first known work, a birth record for John I.D. Nellis of Fort Plain, was painted in the latter part of that year. On February 12, 1783 he married Keziah Hilton in Montgomery County. His second known work, produced about this time, is a decorative drawing that may have been a gift for his new brother-in-

law. Shortly after their marriage, Murray and his wife moved to Schenectady, New York, where he painted at least two family records. He left there before 1789, then for years traveled through Albany, Ulster, Chautauqua, Chenango, Otsego, and Montgomery Counties in New York. Although his most active years were 1818 through 1822, on April 24, 1818 Murray applied for a pension as a Revolutionary War veteran. Two years later he requested an extension, claiming that he had been a teacher, but that failing eyesight effectively ended his career. There are no known paintings from the period between 1822, when he made a family record for Frederick Sexton, and his death on May 19, 1828.

Of the eighteen known watercolor and ink paintings, fourteen are signed "Drawn BY/WILLIAM MURRAY," or with some variation, with the date of execution usually inscribed after or below his name. A green leafy vine, with yellow-centered red flowers at regular intervals, generally forms a border. In many of the paintings there is a large central heart in which are placed the names of the parents, and with a large flower-like form growing from the top. On either side of the heart, and occasionally above, Murray has positioned circles, rectangles, or small hearts in which he had inscribed the names and the dates of birth of the children. Other symbols frequently used include clover leaves, snowflake-like shapes, black coffins, Masonic emblems, soldiers, and pineapples.

See also **Decoration; Family Records or Registers; Freemasonry; Painting, American Folk.**

BIBLIOGRAPHY

Kern, Arthur, and Sybil Kern, "Painters of Record: William Murray and His School." *The Clarion*, vol. 12, no. 1 (winter 1987): 28–35.

ARTHUR AND SYBIL KERN

MUSEUM OF AMERICAN FOLK ART: *SEE* AMERICAN FOLK ART MUSEUM; ROBERT BISHOP; EARL CUNNINGHAM.

MUSEUM OF THE AMERICAN QUILTER'S SOCIETY, dedicated to showcasing the work of contemporary quilters, was founded in Paducah, Kentucky, in 1990 by Bill and Meredith Schroeder, also of Paducah, as an outgrowth of their involvement in and activities with the American Quilter's Society (AQS). The Schroeders had founded the AQS as a division of their publishing company, Schroeder Publishing, after they became interested in contemporary quilting in 1983. AQS sponsored the first annual AQS Quilt Show and Contest in Paducah in 1985, and the first issue of

American Quilter, the AQS magazine, was published that same year. The top awards at the annual AQS show were established as purchase awards, and these, along with other quilts that the Schroeders had acquired, formed the basis of a strong contemporary collection. The idea of a museum dedicated to contemporary quilts and the people who made them grew as a result of the Schroeders' desire to share this collection with a larger audience. The Museum of the American Quilter's Society, established as a nonprofit corporation governed by its own board of directors, opened its doors in 1991 with an initial collection of nearly eighty-five quilts on loan from the museum's founders.

The mission of the museum is to "educate the local, national, and international public about the art, history, and heritage of quilt making, including the diversity of quilts and their makers." The museum carries out this mission through exhibitions of contemporary and antique quilts as well as related archival materials drawn from the collection and from other sources, and through workshops, lectures, conferences, and other events, and through a wide range of publications.

Since it was founded, the museum has continued to develop its activities and expand its collection, which currently includes more than two hundred quilts, the work of more than 162 quiltmakers. The works in the permanent collection were made from 1980 on, and, as a group, they serve as a document of quiltmaking from the 1980s to the present. Since 1993, the museum has also included art quilts, both in exhibitions and as part of its collection. The core of the collection includes quilts donated by the Schroeders, as well as the AQS Quilt Show and Contest purchase-award winners, which were donated through the American Quilter's Society. Donations from quiltmakers, other collectors, and purchased pieces make up the remainder of the museum's inspiring collection.

See also **Quilts.**

BIBLIOGRAPHY

American Quilter's Society. *MAQS Quilts: Founders Collection, Museum of American Quilter's Society,* Paducah, Ky., 2000.

JACQUELINE M. ATKINS

MUSEUM OF CRAFT AND FOLK ART, SAN FRANCISCO (MOCFA) is the only museum of its kind in northern California, and is the center for art in the San Francisco Bay area. Originally established as the San Francisco Craft and Folk Art Museum, it was founded by two bay area artists, Gertrud Parker (1930–), a fiber artist

and collector inspired to open a museum following a visit to the American Craft Museum in New York, where she found the permanent collection dominated by Bay area artists, and Margery Anneberg, a jewelry maker, gallery owner, and founder of the non-profit Center for Folk Art and Contemporary Craft. The two women merged their forces and collections in 1983 and opened a small museum in a private residence on Balboa Street near Golden Gate Park. In 1987 the museum relocated to Fort Mason Center, the thriving cultural complex in the marina district of San Francisco.

In 1988 the museum presented an innovative exhibition of quilts by east bay residents, "Improvisations in African American Quiltmaking," which focused on the relationship between the visual arts and the improvisational nature of jazz. This exciting exhibition traveled to thirty museums in twenty states across the nation, bringing the institution national recognition.

In 1991 the permanent collection was de-accessioned, with three quarters of the objects placed in other educational institutions. In 2000 the museum was renamed Museum of Craft and Folk Art. Operating now as a non-collecting museum, MOCFA continues to develop exhibitions emphasizing the accomplishments of diverse Californian populations. The museum works with established and emerging artists, both trained and self-taught, in a variety of materials and forms such as clay, clothing, fiber, glass, wood, metal, furniture and jewelry.

More than 200 exhibits of contemporary crafts, American folk art, and traditional cultural art have been presented since 1983. Four to six exhibitions are presented each year. An on-line registry is maintained which provides brief sketches of artists with their works categorized by medium. The library of 2,000 catalogued volumes offers specialized research in the history of craft and folk art. *A Report,* the museum's scholarly journal, is published quarterly and features in-depth coverage of current exhibits, biographies of local artists and collectors, and interviews with major artists.

See also **African American Folk Art (Vernacular Art); Quilts; Quilts, African American.**

BIBLIOGRAPHY

Austin, Carole. "Looking Back at a Museum." *A Report,* vol. 1, no. 3 (2000).
Kastner, Carolyn, ed. *Fusing Traditions: Transformations in Glass by Native American Artists.* San Francisco, 2002.

DEBORAH LYTTLE ASH

MUSEUM OF EARLY SOUTHERN DECORATIVE ARTS (MESDA) is one of the museums of Old Salem, Inc., the restored community established by German Moravians in the eighteenth century at what is now Winston-Salem, North Carolina. Founded in 1965 by Frank Horton (who, along with his mother Theo L. Taliaferro, assembled a comprehensive collection of Southern art that served as the core of the museum's collection), MESDA interprets the pre-1820 material culture and social history of the Carolinas, Georgia, Kentucky, Maryland, Tennessee, and Virginia. The collections include ceramics, furniture, metalwork, paintings, silver, textiles, and period room interiors. MESDA organizes exhibitions and annual seminars, and maintains the most comprehensive research archive on the arts of the early South, the basis of which is its unique inventory of Southern material culture and primary research materials. The museum's publications include a journal and a scholarly book devoted to specific Southern decorative arts topics.

MESDA's folk art collection includes the products of artisans who worked in urban centers, such as the Baltimore portraitist Joshua Johnson (1767–c. 1820s), but the majority of works originated in the backcountry, or the vast areas located west of the Southern coastal settlements. It was there that people of German, Swiss, Welsh, African American, and Scots-Irish origins settled and continued their traditional cultures. These cultures ultimately co-mingled, to an extent, resulting in distinctive interpretations of decorative arts that are an important feature of the backcountry's material culture. In addition to paintings, quilts, needlework, and decorated long rifles, MESDA has important holdings of German American fraktur from Maryland, Virginia, and North Carolina, including several examples produced in North Carolina by the unidentified painter known as the Ehre Vater Artist.

Painted and inlaid furniture ornamented with traditional folk motifs made in German communities in Maryland, Virginia's Shenandoah Valley, Wythe County in Tennessee, and North Carolina are represented in the MESDA collection. Of particular interest are eighteenth- and early-nineteenth-century pieces made by rural cabinetmakers who provided clients with fashionable, urban-inspired forms that, nonetheless, reflected local taste by incorporating traditional folk designs, such as hearts, pinwheels, and tulips.

The extensive utilitarian and decorative pottery collections at MESDA include examples made throughout the South, but among the most significant examples are the large lion doorstop by the Virginia potter, Solomon Bell (1817–1882), as well as vessels

from Salem, North Carolina, made by master potter Rudolph Christ (1750–1833).

See also **African American Folk Art (Vernacular Folk Art); John Bell; Solomon Bell; Decoration; Ehre Vater Artist; Fraktur; Furniture, Painted and Decorated; German American Folk Art; Joshua Johnson; Metalwork; Pictures, Needlework; Pottery, Folk; Quilts; Religious Folk Art; Samplers, Needlework.**

BIBLIOGRAPHY

Bivins, John, and Forsythe Alexander. *The Regional Arts of the Early South: A Sampling from the Collection of the Museum of Early Southern Decorative Arts.* Winston-Salem, N.C., 1991.

Hurst, Ronald L., and Jonathan Prown. *Southern Furniture 1680–1830: The Colonial Williamsburg Collection.* Williamsburg, Va., 1997.

RICHARD MILLER

MUSEUM OF FINE ARTS, BOSTON (MFA) acquired its first examples of American folk art in 1902, when American Civil War veteran Charles G. Loring gave the then 26-year-old museum two Pennsylvania German sgraffito dishes. This acquisition is notable not only for its early date, but also because this gift was made by a member of a prominent Boston family whose cultural background could not have been more dissimilar from that of the Pennsylvania Germans. Nevertheless, the gift shows the importance that one early patron placed on ensuring that the museum's collections would represent the broad range of American expression. As the MFA was enriched by subsequent gifts, its collection of German American folk art grew to include more than seventy examples of fraktur as well as a dozen sculptures by the German American artist Wilhelm Schimmel (1817–1890), the largest of such groupings in New England. Renowned for its holdings of worldwide art from all regions, cultures, and periods, the MFA's American collections show the same range and depth, with its collection of American folk art including approximately 25 oil paintings, 350 works on paper, and more than 60 examples of folk sculpture, in addition to pottery and textiles.

The M. and M. Karolik Collection of Eighteenth-Century American Arts, and the M. and M. Karolik Collection of American Paintings, 1815–1865, were given to the MFA in 1941 and 1949, respectively, by Maxim Karolik, a Russian immigrant to the United States, who embraced the art of his adopted homeland as expressions of its democratic ideals, and his wife, the Bostonian Martha Codman Karolik, who financed their collecting. These gifts included signif-

icant works by Erastus Salisbury Field (1805–1900), John Brewster Jr. (1766–1854), and William Matthew Prior (1806–1873), as well as wildfowl decoys and other sculptures. The Karoliks' gifts significantly increased the scope of the MFA's holdings, making it one of New England's most inclusive public folk art collections.

Between 1969 and 1980, the MFA's folk art collections were enhanced with gifts and a bequest from the large, encyclopedic collection of folk paintings and drawings assembled by Edgar and Bernice Chrysler Garbisch. In more recent years, folk art acquired by gift and purchase have continued to enhance the MFA's commitment to assembling a comprehensive and representative collection. The MFA's collection of American folk art encourages comparisons with the museum's major holdings of American academic art, thereby allowing the folk art and academic art collections to inform each other, and showing that no matter the social, economic, or cultural background of the artists, their aspirations and intentions were comparable.

See also **John Brewster Jr.; Decoys, Wildfowl; Erastus Salisbury Field; Fraktur; Edgar and Bernice Chrysler Garbisch; German American Folk Art; Maxim Karolik; Painting, American Folk; Pennsylvania German Folk Art; William Matthew Prior; Wilhelm Schimmel; Sculpture, Folk.**

BIBLIOGRAPHY

Museum of Fine Arts, Boston. *M. & M. Karolik Collection of American Water Colors and Drawings 1800–1875,* 2 vols. Boston, 1962.

Ward, Gerald W.R., et al. *American Folk.* Boston, 2001.

RICHARD MILLER

MUSEUM OF INTERNATIONAL FOLK ART is one of four units of the Museum of New Mexico. It is the world's first international folk art museum, and was founded by Florence Dibble Bartlett (1882–1954), a member of a prominent philanthropic Chicago family that made numerous contributions to the art world. Following her graduation from Smith College in 1904, Bartlett traveled the world for thirty years amassing a collection, particularly strong in material from Scandinavia and Central Europe, of more than 4,500 objects, including textiles, embroideries, metalwork, ceramics, and carvings, from fifty-five countries and regions of the world. This core collection of the Museum of International Folk Art was installed, in 1953, in a building set at the foothills of the Sangre de Cristo

Mountains and designed by architect John Gaw Meem (1894–1983), creator of the "Santa Fe style."

In 1978 the gift and exhibition of the Alexander and Susan Girard Collection, "Multiple Visions: A Common Bond," was permanently installed in a wing of the museum. The 106,000 works in this collection, from one hundred countries, include religious folk art, toys, puppets, textiles, costumes, masks, paintings, and beadwork. This collection additionally provides an in-depth understanding of many folk art traditions from around the world.

The Neutrogena Collection, installed in another wing of the museum in 1998, contains 2,500 objects, including textiles, ceramics, and carvings. Important examples include Egyptian Coptic textiles, Hispanic folk art carvings, ceramics of the Rio Grande pueblos, Japanese folk clothing, Pennsylvania Amish quilts, and Navajo weavings.

The museum's broader collection contains more than 125,000 objects from one hundred countries, and includes works from the Spanish colonial period of the seventeenth to the nineteenth centuries; contemporary southwestern Hispanic art from the twentieth century; and international textiles, costumes, and folk art objects from the nineteenth and twentieth centuries. The institution, moreover, is an invaluable resource for cultural understanding and artistic interpretation.

See also **Amish Quilts and Folk Art; Asian American Folk Art; Alexander Girard; Native American Folk Art; Pennsylvania German Folk Art; Pictures, Needlework; Religious Folk Art; Samplers, Needlework; Scandinavian American Folk Art; Toys, Folk.**

BIBLIOGRAPHY

Glassie, Henry. *The Spirit of Folk Art: The Girard Collection at the Museum of International Folk Art.* Albuquerque, N. Mex., 1993.
Smith, Laurel, and Ree Mobley, eds. *Folk Art Journey: Florence D. Bartlett and the Museum of International Folk Art.* Santa Fe, N. Mex., 2003.

DEBORAH LYTTLE ASH

MUSICAL INSTRUMENTS in the folk art lexicon are handmade, and are reflective of the creator's family, ethnic, or regional heritage. Instruments not only contain the visual and tactile appeal of sculpture but also possess the additional dimension of aural beauty common to the objects of the performing arts. Early European immigrants to the United States brought

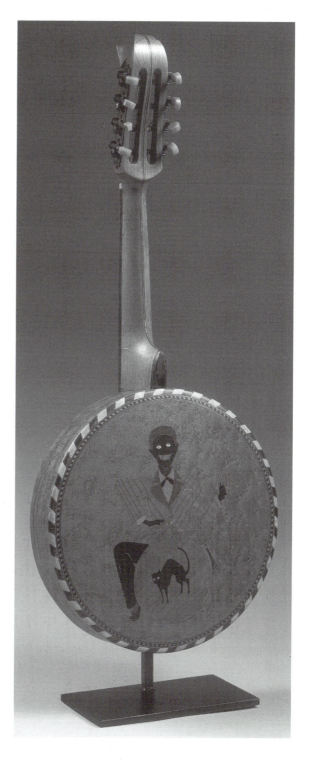

Inlaid banjo depicting a jazz musician playing the drums. Maker unknown; c. 1920. Various types of wood; 26 inches tall.
Photo courtesy Allan Katz Americana, Woodbridge, Connecticut.

instruments from their native lands that were soon replicated by local craftspeople who were free to add their own individual artistry to such forms. The German born piano manufacturer Henry Steinway commented that "American craftsmen have fostered the development of instruments such as the Appalachian dulcimer, banjo, electric guitar, and certain types of rotary-valve brasses and reed organs, thus giving the world something musically unique and enriching."

A popular folk musical instrument is the Appalachian dulcimer, a stringed instrument often made in the shape of an hourglass, usually produced of indigenous hardwoods, and strummed or plucked to accompany the human voice. It should not be confused, however, with its biblical counterpart, the hammered dulcimer, an ancient trapezoidal instrument of several strings. European in origin, the Appalachian dulcimer appeared in this mountain region of the United States (spreading from the southern tier of New York southward into Georgia) at the end of the eighteenth century. It has since evolved and been modified to suit the needs of its players, most often the instrument makers themselves.

The banjo, considered by some scholars in the field to be the only indigenous American folk instrument, originated from an African prototype. Africans, brought in bondage to the New World, were not allowed to play drums, so they started making "banjos" (also called *banzas, banjars, banias,* or *bangoes*) out of calabash gourds. After cutting off the top one-third of the gourd, they would cover the hole with groundhog hide, goatskin, or sometimes cat skin. These skins were usually secured with copper tacks or nails. The attached wooden neck was fretless, and usually supported three or four strings. Some of the earliest strings were made of horsehair, from the tail, twisted and waxed like a bowstring. Other strings were made of gut, twine, hemp fiber, or whatever else was locally available. As with the Appalachian dulcimer, self-taught musicians often designed and made the finest banjos, although the instruments evolved over time to incorporate various regional influences.

Also of African descent is an instrument known as "paired bones clapping," or simply "bones," which are crafted of brittle animal bones of uniform weight and shape. Poverty and isolation fostered the popularity of these simple, homemade instruments—spoon clappers, washboard scrapers, jug tubas, and musical saws—that were made of discarded utensils and brought to life by the musicians' hands. In addition, tinsmiths created metal coach horns and firefighters' trumpets. In sophisticated urban areas, silversmiths fashioned silver and gold whistle rattles for infants. Italian immigrants produced shimmering, ornate, exquisitely stringed mandolins, while the Shakers created a simple, boxy, austere fiddle, constructed of hemlock and maple. Wind and horn instrument makers were in great demand during the American Civil War (1861–1865), when band music blossomed.

Scholarship on folk musical instruments is a relatively recent invention, emerging in the postwar era. Musicologists have focused their work primarily on early folk composers and instrumentalists, often the makers of folk instruments, and this is an aspect that deserves greater attention.

See also **African American Folk Art (Vernacular Art).**

BIBLIOGRAPHY

Leary, James P. *In Tune with Tradition: Wisconsin Folk Musical Instruments.* Cedarburg, Wisc., 1990.

Libin, Laurence. *American Musical Instruments in the Metropolitan Museum of Art.* New York, 1985.

Ransom, Stanley Austin. *Folk Musical Instruments Made in the North Country.* New York, 1982.

WILLIAM F. BROOKS JR.

NADELMAN, ELIE (1882–1946), a Polish-born sculptor, was interested in classical forms and was also a pioneer collector of folk art. In 1926 he and his wife, Viola Flannery, established the first folk art museum in America: the Museum of Folk and Peasant Art (later the Museum of Folk Arts) at Alderbrook, their nineteenth-century villa in Riverdale, New York. Nadelman lent objects from its collection to (among others) the Newark Museum, which used folk objects in its watershed exhibitions of 1930 and 1931.

Nadelman had emigrated to America (New York City) in 1914; for the next twenty years, according to his son, they collected some 70,000 European and American objects. They seem to have been inspired by the Bavarian national museum of the nineteenth and twentieth centuries, by Viola Flannery's interest in antique textiles, and by the furnishings of a house they rented from the interior designer Henry Sleeper. Their museum collection spanned the thirteenth through nineteenth centuries and included paintings, fraktur, toys, dolls, quilts, samplers, rugs, dress, furniture, farm implements, boxes, weather-vanes, chalkware, wagons, and household objects.

Nadelman's own sculpture is representational but pared down and abstracted—a tendency consonant with folk idioms. His interest in theater, vaudeville, and the circus inspired him to create popular forms. *Tango* (c. 1918), *The Orchestra Conductor* (c. 1919), *Seated Woman* (c. 1917), *Woman at the Piano* (c. 1917), and *Host* (c. 1917) are all in wood; some are painted. Kirstein noted that Nadelman's techniques—carving in wood and then softening the effect by applying gesso to simulate flesh and clothing, and combining many pieces of wood joined with glue before carving—are similar to those of folk sculptors. Especially in his later years, Nadelman, like many vernacular artists, used everyday materials: plaster, papier-mâché, terracotta, and basic wood.

During World War II, Nadelman worked as an air warden and as a volunteer in occupational therapy at the Bronx Veterans' Hospital, where he provided materials for and expertise in sculpture and ceramics.

The Nadelmans lost their fortune when the stock market crashed in 1929, but their museum was helped by a grant from the Carnegie Corporation and by the formation of an advisory board that included the curator Holger Cahill. The museum, with the Index of American Design, sponsored by the Works Project Administration, a federal agency, employed artists to draw, paint, and photograph folk objects. Ultimately, though, the Nadelmans sold the bulk of their collection to the New-York Historical Society. Some individual objects went to private collectors and other institutions.

See also **Holger Cahill; Edith Gregor Halpert.**

BIBLIOGRAPHY

Kirstein, Lincoln. *The Sculpture of Nadelman.* New York: Museum of Modern Art, 1948.

"The Nadelman Folk Art Collection." *Antiques*, vol. 33 (March 1938): 152.

Oaklander, Christine I. "Elie and Viola Nadelman." *Folk Art*, vol. 17, no. 3 (fall 1992): 48–55.

LEE KOGAN

NATIONAL HERITAGE MUSEUM was founded in 1975 by Scottish Rite Freemasons in the Northern Masonic Jurisdiction as a museum and library of American history and popular culture. Originally known as the Museum of Our National Heritage, the institution changed its name in 2002. The National Heritage Museum is located in Lexington, Massachusetts, where it presents a wide range of changing exhibitions and educational programs relating to various aspects of the American experience, providing

insights into matters of everyday life as well as the larger issues marking American society.

Although the National Heritage Museum was organized under Masonic auspices, its programs are broadly based and diverse and not generally Masonic in orientation. However, the museum does hold an important collection of objects drawn from the visual traditions of Freemasonry in the folk and decorative arts, including paintings, textiles, ceramics, and furniture. The collection also includes objects relating to other fraternal organizations, and constitutes an especially well-preserved and documented resource for the study of American fraternalism.

An important feature of the museum is its Van Gorden-Williams Library, which holds over 60,000 volumes and other scholarly materials relating to American Freemasonry. This research facility, incorporating the library of the Supreme Council of Scottish Rite Freemasonry in the Northern Masonic Division, is the most comprehensive collection of its kind in the world.

Among the important exhibitions that the museum has organized relating to the history and decorative arts of American Masonry and other fraternal organizations are studies of Masonic symbolism (1976), Masonic aprons (1980), and the material culture of American fraternal organizations (1986), each with a catalog.

See also **Fraternal Societies; Freemasonry; Independent Order of Odd Fellows.**

BIBLIOGRAPHY

Franco, Barbara. *Masonic Symbols in American Decorative Arts*, Lexington, Mass., 1976.

———. *Fraternally Yours: A Decade of Collecting*, Lexington, Mass., 1986.

Hamilton, John D. *Material Culture of the American Freemasons*. Lexington, Mass., 1994.

GERARD C. WERTKIN

NATIVE AMERICAN FOLK ART emerged during the late nineteenth century as a genre that synthesized traditional American Indian art forms with influences from greater American society. By that time, many American Indian tribes had been displaced from their original territories and relocated on reservations. As a result, historic art styles were disrupted and a new creative vocabulary was born. Early American Indian folk art looked backward to artistic antecedents and forward to eclectic use of introduced ideas and materials. Even in the Southwest, where most Native

groups were not resettled, the influx of new materials, commercial goods, and tourists stimulated departures from previous artistic repertoires. As the twentieth century unfolded, Native American folk art became increasingly innovative, venturing even further from conventional aesthetic norms.

Although most Native American folk artists were self-taught, folk art traditions were passed along within families, with elders serving as mentors to younger generations. Prior to the twentieth century, the production of objects was an integral part of everyday life; hence most makers were unknown outside their tribal boundaries. With the development of a vital art market during the last half of the twentieth century, name recognition became increasingly important. The art market also supported the revival of old traditions and the invention of new ones. The responsive economic environment attracted artists of all ages, including many talented young artists. Thus, by the end of the twentieth century, the state of Native American folk art was lively and dynamic.

The magnitude of diversity found in twentieth-century Native American folk arts makes it virtually impossible to include every folk art genre in this short survey, so emphasis will be placed on the most important developments and interesting artists.

By the early 1900s, the availability of factory-made goods eliminated the need for utilitarian baskets. Although there were fewer and fewer Native American basket makers as the twentieth century unfolded, nevertheless, by about 1970, there was a remarkable basketry renaissance among some Southwest Indian tribes. The encouragement and support of collectors, dealers, traders, and galleries provided new incentives for basket makers to practice their art. During the last quarter of the twentieth century, Southwest Indian baskets continued to be made using the conventional techniques associated with each tribal group, however, innovations in design became an important development.

Among the Hopi people of northern Arizona, baskets have long played an integral role in the social matrix and ceremonial calendar of Hopi life. Kevin Navasie (1985–) is a Hopi-Tewa from First Mesa, Arizona, and one of the few male basket makers. He specializes in "sifter baskets," also known as yucca ring baskets, a plaited style that has its roots in prehistory. Navasie departs from the traditional undecorated form by using letters and pictorial images in his baskets, a major innovation since these containers had previously been used for utilitarian purposes only.

Abigail Kausgowva (1915–) is from Hot'vela, a Hopi village on Third Mesa in Arizona. Baskets made on Third Mesa are produced with a plaited wickerwork technique using either natural or aniline dyes. Like other Hopi basket makers, Kaursgowva's designs are most typically geometric, or depict *katsinam*, masked impersonators of spirit beings who come to help the Hopis. She also has created Anglo-influenced, non-Hopi designs, most particularly American flags.

In addition to traditional baskets, Bertha Wadsworth (1937–) from the Second Mesa village of Simopovi makes a unique basket of her own invention; a hollow, coiled figure of a *S'alakwmana katsina*, placed over a cottonwood base that has a pair of moccasins carved at the bottom. When the hollow form is placed over the base, the figure resembles the masked impersonator who participates in certain Hopi ceremonies.

Navajo women make coiled basketry trays of sumac splints sewn onto a sumac foundation. Ceremonial use of these baskets was established by sacred beings called Holy People. The most familiar design is the so-called "wedding basket" pattern that features a band of red and black with zig-zag edges. Mary Holiday Black of Douglas Mesa, Utah (1934–) has been a pivotal influence in the creation of innovative designs that define late-twentieth century Navajo basketry arts. Although she continued to make the occasional wedding basket throughout her career, her reputation has been based on her penchant for originality. An exciting design direction taken by Black and several of her daughters derived from traditional origin narratives. "Placing the Stars" and "Changing Bear Woman" were two of the most popular "story basket" themes. Black's eldest daughter, Sally Black (1963–) has made baskets with train and flag designs, and has added innovative details by clever use of overlay stitching. In the case of the story basket, "The Sun's Horses," she used real horsehair to embellish the horses' tails.

Papago (Tohono O'odham) basket weaver Annie Antone (1953–) learned to make baskets from her mother. The Tohono O'odham people live in the Sonoran Desert of southern Arizona. Antone is widely recognized for her original designs. Unlike most other basket makers, she often sketches her ideas on graph paper before she begins making her basket. Some of her designs are pictorial, featuring cactus, Gila monsters, and other aspects of her desert homeland. Others are based on pottery patterns developed by her prehistoric ancestors, the Hohokams. One particu-

larly idiosyncratic design that Antone calls her "face basket," features a realistic portrait of a man's head, a radical departure from traditional geometric patterns.

Among the Western Apaches of Arizona, twined burden baskets were used to collect and carry wild and domesticated foodstuffs. They also were an important part of the female coming-of-age ceremony. For the most part, the baskets had simple geometric decorations. It was not until the 1970s that several basket makers began to add in figurative designs that transformed plain twined baskets into delightful works of folk art. San Carlos Apache basket maker Evelyn Henry (1936–) became particularly well known for her engaging interpretation of the deer design.

Pottery is an ancient folk art tradition among the Pueblo peoples of New Mexico, whose ancestors were making fired clay vessels as early as c. 1000–1250. In spite of the fact that most pottery was utilitarian, elaborate painted designs transcended necessity. Ceremonial vessels also had sophisticated decorative details, especially those made by prehistoric peoples living in the Mimbres Valley of southern New Mexico. By the modern era of the late nineteenth and early twentieth centuries, the production of utilitarian pottery was no longer necessary due to the availability of manufactured merchandise, although ceremonial vessels continued to be made. During the early 1900s, encouragement and support by archaeologists and art patrons stimulated a resurgence of ceramic creativity among the Pueblos. Gathering and working with "Mother Clay" has always involved ceremonial observances, a practice that continued throughout the twentieth century.

Innovations began in the late nineteenth century, when a number of potters from Cochiti Pueblo, New Mexico, began to make satirical pottery figurines inspired by opera singers and circus performers. In the 1990s, this tradition was revived and elaborated by the Ortiz family of Cochiti Pueblo. The best known artist of the family is Virgil Ortiz (1969–), whose figurative ceramic sculptures are descended from those of his anonymous ancestors, although his approach is infinitely more sophisticated. Ortiz's mother, Seferina (1931–), fashions satirical Anglo "bathing beauties," while her daughters Joyce (1954–), Mary Jancie (1956–), and Inez (dates unknown), are equally innovative, creating a wide variety of amusing pottery figures including hippies, athletes, and strippers.

The most influential twentieth-century Cochiti potter was Helen Corsero (1915–1994), who invented the

"Storyteller Doll" in 1964. During the long winter nights, storytelling is the traditional way of educating Pueblo children about cultural values, tribal history, and ceremonial behavior. Cordero's storytellers portray her grandfather with many children crawling on his body. Cordero carefully fashioned each grandfather and child, and each was clothed in painted variations of imaginative and charming apparel. Cordero's influence on other potters was profound. By the end of the twentieth century, storyteller figures, of one kind or another, were made in most pueblos and by the Navajos as well.

The prehistoric Mimbres peoples of southern New Mexico made bowls decorated with bold geometric borders that surrounded central designs of stylized animal and human figures. Cochiti potter Diego Romero (1964–), uses themes and variations on the Mimbres style. His pottery consists of Mimbres-inspired bowl shapes and geometric borders, but there the similarity ends. Instead of imitating Mimbres figurative designs, the center of his bowls feature original images, such as Indians in pickup trucks, "cars and bars" scenes, factories, and comic strip characters adapted from American artist Roy Lichtenstein's paintings.

Traditional pottery made by Navajo women consisted of utilitarian ware and ceremonial objects. The vessels were hand coiled, fired outdoors, and coated inside and out with pitch from the piñon tree. However, by the last quarter of the twentieth century, a few imaginative Navajo potters began to move in new directions. Silas (1913–) and Bertha Claw (1926–) developed a pottery style that is uniquely theirs. Bertha makes the pots, favoring Pueblo-style wedding jars with many spouts, and her husband fabricates and paints cows, sheep, goats, and Navajo people that are subsequently appliquéd onto the vessel as relief designs. One particularly original and humorous theme features a scene from the Walt Disney movie *Pocahontas.*

There is another form of Navajo folk art that is made from clay. By the late 1970s, Mamie Deshillie (1920–) was fashioning charming "mud toys" of unfired, sun-dried clay. Her work is rooted in the tradition of toy making that she recalls from her childhood. She is especially known for riders astride all types of animals including giraffes, roosters, goats, and others. In one particularly whimsical image, Santa Claus is riding a purple cow. Her figures are adorned with found materials: bits of fur, hide, feathers, sequins, and beads. Deshillie also creates imaginative cardboard cutouts that feature animals such as ele-phants, buffalos, goats, sheep, rabbits, and others, also decorated with found objects. Many are wearing fanciful earrings made of beads and/or sequins. Some also include riders like her mud toys. Her cardboard cutouts are an original invention.

Personal adornment has been a universal value among Native Americans since prehistoric times. In particular, those inhabiting the Plains and Plateau regions made creative use of porcupine quills dyed in various colors that were embroidered on items of clothing such as moccasins, men's shirts, and women's dresses. During the sixteenth century, colorful glass beads imported from Europe became important and valued trade goods. Although quillwork continued to be practiced, for many women, beadwork provided a new and challenging outlet for their creativity. European influences resulted in a profusion of colorful floral patterns. By the nineteenth century, both quillwork and beadwork had achieved great artistic merit, a trend that persisted throughout the twentieth century.

During the nineteenth century, quillwork and beadwork designs could be identified by tribal styles. By the mid-twentieth century, the influence of Indian powwows and tribal art fairs resulted in a synthesis of pan-Native American themes. For example, one of the best known bead workers of the 1990s, Choctaw artist, Marcus Amerman (1959–) has created totally original designs on bracelets, pins, and other wearable art. His sophisticated skills transformed his beadwork into a unique painterly style that depicts landscapes, human portraits, and animals in action.

On the other hand, the celebrated Growing Thunder Fogarty family of beadworkers, stayed faithful to their Assiniboine-Sioux artistic roots, though at the same time, their work reflects a distinctively modern flair. Both Joyce (1950–) and her daughter, Juanita (1969–) create objects of dazzling beauty, including moccasins, shirts, and other items of beaded, buckskin clothing as well as dolls dressed in beaded apparel.

Terry Greeves, a Kiowa-Comanche beadwork artist, makes a variety of objects. Some are traditional, such as moccasins and bracelets, but others, such as beaded tennis shoes, are totally unconventional. She is particularly well known for buckskin parasols that feature a phalanx of Plains Indians on horseback, parading around the circumference. These motifs are reminiscent of ledger art.

Navajo beadworker Sheila Antonio (1961–) learned to work with beads while attending a Native American boarding school. Like other bead workers she

began by making barrettes, key chains, earrings, and other small items to be sold to tourists. However, she soon grew bored with the conventional repertoire and applied her skills to create innovative figurative beadwork depicting images of *hogans* or Navajo dwellings, women and children, horse-pulled wagons, domesticated animals, and other figures that illustrate everyday Navajo life.

When the Seminole and Miccosukee peoples fled to Florida during the early nineteenth century to avoid forced removal by the federal government, intermarriages between some tribal members and both white and black inhabitants of the area resulted in an expansion of artistic knowledge. New artistic influences in the form of European American patchwork quilt traditions as well as African American appliquè techniques further enhanced the folk art repertoire of the Native Americans. Initially, both tribes stitched patchwork by hand. With the introduction of sewing machines by South Florida traders around the turn of the twentieth century, patchwork patterns became more intricate and the tradition flourished as never before. Women's skirts and capes, and men's jackets and "big shirts" featured a dazzling display of colorful geometric patchwork designs formed of small cotton squares, rectangles, triangles, and rickrack.

After World War II, tourists began to visit the Everglades in Florida in increasing numbers. In response, both Seminoles and Miccosukees built "exhibition villages" featuring open-air sewing *chickees*, where visitors could watch women at their sewing machines while they created their patchwork magic. Patchwork garments soon became popular collectibles for non-Native Americans. By the end of the century, they were considered both wearable and non-wearable art. For example, Effie Osceloa (1919–), an outstanding Miccosukee artist, was commissioned to create a decorative patchwork panel for the Mashantucket Pequot Museum and Research Center in Mashantucket, Connecticut. Another celebrated patchwork maker, Annie Jim (1933–), was widely recognized for the complexity of her designs.

Native American quilts constitute another popular category of sewn articles. During the late nineteenth and early twentieth centuries, quilting techniques were taught to women of Plains Indian tribes by Presbyterian missionaries. Classes in quilting also were taught at Native American boarding schools. There was a hidden agenda related to the establishment of quilting classes, for it was hoped that the new craft would help "civilize" the Indians and discour-

age traditional beadwork, considered primitive and heathen.

Throughout the twentieth century, quilts were made to celebrate and commemorate special occasions including birthdays, graduations, naming ceremonies, marriages, and even sports achievements. Each quilt is unique; a reflection of tribal styles, family traditions, and individual choices regarding stitching, use of colors, and type of design. In the late twentieth century, star quilts became popular among all Plains tribes although the design had previously been associated exclusively with the Sioux (Lakota and Dakota). Star designs have particular appeal since the design derives from nineteenth-century buffalo hide paintings.

Since its earliest days, quilting has been a woman's art and females continued to dominate the art throughout the twentieth century. Several quilters gained national reputations including Lakota artist, Vera Big Talk (dates unknown), who presented a quilt to the mayors of New York City and Washington D.C. to commemorate the tragic events of September 11, 2001. Design details include a white buffalo, sacred peace pipes, American flags, and two teepees that represent the twin towers of the World Trade Center. Roy Azure, a Dakota Sioux (dates unknown) is one of a growing number of Native American male quilters and has become an entrepreneur in a company that makes quilts to order.

One of the earliest metals used to make Native American jewelry was German silver (also called nickel silver), an alloy of nickel, copper, and zinc. By the last decades of the nineteenth century, it was an important resource for Southern Plains metalsmiths. The tradition of German silver ornaments continued well into the twentieth century, reaching its apex during the 1970s with the work of Oklahoma Pawnee silversmith, Julius Caesar (c. 1910–1983). His work included rings, bracelets, and gorgets or circular or crescent-shaped ornaments worn around the neck. Of particular charm were his dangling earrings made from a series of linked German silver plates. The earrings were widely admired by other Southern Plains silversmiths who quickly adapted the style. Non-Indian women also were captivated by the earrings and demand for them drove continued fabrication. Caesar's son, Bruce (1952–), carries on his father's legacy, adding his own innovations. Of particular note are the elegant, open-work tiaras worn by the young women elected as Native American princesses from various tribes in Oklahoma.

Native American silverwork had its origins among the Navajos in the late nineteenth century. From the beginning, outside influences were integrated into the design repertoire, and included Mexican stamp work; oval ornaments, called *conchas*, adapted from Plains Indian hair drops; squash blossom shapes derived from Spanish trouser ornaments; and the *nazha*, a crescent-shaped pendant based on an ancient form from the Middle East. By the late nineteenth century, trading posts were supplying materials and tools to the silversmiths. Late nineteenth century Navajo silver was defined by jewelry crafted of elegant simplicity, a style that came to be known as "Classic."

By the end of the twentieth century there were many talented silversmiths reviving the Classic style; however, it also was a period of innovation. For example, Navajo silversmith, Clarence Lee (1952–) has full command of the Classic repertoire including concha belts and necklaces. However, he is best known as the originator of charming "story" jewelry, bracelets, pins, pendants, and earrings that depict activities of everyday Navajo life. There are women herding sheep, men chopping wood, Navajos on horseback, and other similar domestic scenes. This style became so popular among collectors, that other silversmiths soon began emulating it. However, Lee's originality and creativity are unique; his work stands out among that of his imitators.

Some time during the early eighteenth century, Navajos learned to weave from their Pueblo neighbors. The Spanish had brought sheep to the New World during the late-sixteenth century, thus providing wool, the raw material used for weaving. Until the late nineteenth century, Navajo women wove beautiful blankets, not only for Navajo use, but also for trade to both Native Americans and Anglo Americans. With the availability of factory-made blankets and cloth, traders encouraged weavers to produce rugs for eastern and Midwestern American markets.

Another important development of the late nineteenth and early twentieth centuries was the advent of pictorial textiles in which a few Navajo weavers began to record and interpret the world around them. Pictorial textiles can be viewed as cultural documents reflecting life through Navajo eyes. They also are an affirmation of Navajo imagination, humor, and artistic vision. Pictorials woven from 1900 to 1920 are notable for depictions of commercial products and trademarks seen in trading posts, as well as more familiar *hogans*, sheep, cows, and horses. By about 1930, airplanes and pick-up trucks made an appearance in the pictorial repertoire, and reservation scenes and livestock were the most popular subjects. Weavers of pictorial textiles tended to enjoy the artistic challenge of weaving them, a departure from the mainstream regional rug styles found at Two Grey Hills (Jackson Hole, Wyoming) and Teec Nos Pos (Arizona), for example. They taught their daughters to make them, who taught their daughters and so on. From about 1970 to the end of the century, pictorial weaving began to flourish as never before resulting in some remarkable new designs and techniques. The work of the Nez Family of Tuba City, Arizona, stands as a primary exemplar. Design ideas for Navajo textiles have always emerged from the weaver's imagination without the use of visual aids; however, in the early-1990s Bill Nez (1957–) began to sketch designs on cardboard for his sisters to place behind their looms. Working from these sketches, the weavers drew the design on the warp with a felt-tip marker. The resulting images are exceedingly sharp and realistic. Bill's mother, Louise Nez (1931–), is the matriarch of a family of weavers. During the 1980s, she invented the dinosaur pictorial, a unique idea that occurred to her while looking at a grandson's coloring book. Subsequently, the entire family has woven dinosaur scenes since the style has become extremely popular with collectors.

Ason Yellowhair (1930–) is best known for colorful textiles that she calls "bird pictorials." She wove her first one in 1957. Her unique work consists of several horizontal rows of plants with colorful birds perched on top. In a highly original adaptation, she uses the design from the Wrigley's Spearmint chewing gum wrapper as the source for her plant motifs. Most of her weavings are very large, a twelve-foot wide pictorial textile, for example, might remain on her loom for six to twelve months. Several of Yellowhair's nine daughters also weave bird pictorials, although each has developed an individual style.

The gift shop at Thunderbird Lodge at Canyon de Chelly, Arizona, a popular tourist destination on the Navajo Reservation, indirectly provided pictorial weaver, Cheryl John (1965–) with the inspiration for a fanciful pictorial. During one visit to the shop, she bought a postcard that featured a picture of an Indian powwow. The resulting textile depicts a number of powwow participants wearing Plains Indian regalia and a row of teepees in the background. During a subsequent visit to a museum in Santa Fe, John saw one of the Nez family's dinosaur scenes. She was so enchanted with it that she decided to weave a dinosaur powwow, a singularly imaginative idea, and typ-

ical of the kind of cross-fertilization that inspires many Native American folk artists.

Among native peoples of the Northwest Coast, there is a long tradition of carving human and animal figures of red and yellow cedar. Masks, totem poles, house screens, carved chests, and other art forms such as textiles and argillite sculptures, commemorate heraldic crests, celebrate family wealth, and illustrate mythical transformations between humans and animal spirits. Some masks also were carved to represent realistic portraits. Although the colonial period disrupted native life, it also stimulated an explosion of creativity with the introduction of new tools and wealth garnered from the fur trade. By the mid-twentieth century, however, there were fewer artists practicing who had been trained in the traditional apprenticeship system.

Bill Holm (1924–), an art historian and artist at the University of Washington, developed a seminal analysis of Northwest Coast artistic conventions in the 1960s. His scholarship was greatly respected by his colleagues and Northwest Coast carvers. His support and encouragement of many artists helped stimulate an extraordinary renaissance of Northwest Coast art.

Among the Navajos, reproduction of human images was prohibited by certain ceremonial sanctions. During the early twentieth century, proscriptions were gradually relaxed as a result of certain groundbreaking precedents. Consequently, there have been some remarkable examples of woodcarving. One of the earliest carvers, Clitso Dedman (c. 1879–1953), fashioned entire scenes of carved and painted masked impersonators called *yé'ii bicheii* dancers.

Charlie Willeto (1897–1964), a pioneering Navajo visionary artist, worked during a brief period from about 1960 until his death. His innovative work was radically different than any other Navajo art form previously produced. Working with scrap wood, Willeto used whatever tools were available included axes, hatchets, hammers, saws, and knives, and any paints that were at hand, but most commonly house paints. Willeto was a medicine man, and many of his later carvings exhibit potent ceremonial influences. Among his best-known works are his so-called *Spirit Figures*, carvings that have an eerie, otherworldly character.

Another noted folk artist, Johnson Antonio (1931–), did not begin to carve until 1982, when he was over fifty years old. Antonio's career began by accident when he found a dead cottonwood limb, took it home, and started to work with it. His figures are made using an axe and pocketknife, then painted

with water colors or acrylics. He focuses most of his work on depictions of everyday activities of Navajo people, dressed in typical Navajo clothing, with faces that are etched with character. His work has become a source of inspiration for many new carvers.

Native American folk art traditions at the turn of the twentieth-century recapitulated ancestral conventions while, at the same time, many artists began to experiment with new ideas and techniques influenced by Euroamerican society. These trends still persisted at the dawn of the twenty-first-century although eclectic adaptations had become increasingly important. Thus continued vitality and dynamic growth in future years is sure to follow.

See also **Baskets and Basketry; Decoration; Mamie Deschillie; Ledger Drawings; Betty Manygoats; Pottery, Folk; Quilts; Quilts, African American; Rugs; Sculpture, Folk; Toys, Folk; Charlie Willeto; Woodenware.**

BIBLIOGRAPHY

Berlo, Janet C. and Ruth B. Phillips. *Native North American Art.* Oxford and New York, 1998.

Coe, Ralph T. *Lost and Found Traditions: Native American Art, 1965–1985.* Seattle, Wash., 1986.

Downs, Dorothy. *Art of the Florida Seminole and Miccosukee Indians.* Gainesville, Fla., 1955.

Holm, Bill. *Northwest Coast Indian Art: An Analysis of Form.* Seattle, Wash., 1965.

McFadden, David Revere, and Ellen Napiura Taubman. *Changing Hands: Art without Reservation 1, Contemporary Native American Art from the Southwest.* London, 2002.

McGreevy, Susan Brown. *Indian Basketry Artists of the Southwest: Deep Roots, New Growth.* Santa Fe, N. Mex., 2001.

McGreevy, Susan Brown, and D.Y. Begay. *The Image Weavers: Contemporary Navajo Pictorial Textiles.* Santa Fe, N. Mex., 1994.

Rosenak, Chuck, and Jan Rosenak. *The People Speak: Navajo Folk Art.* Flagstaff, Ariz., 1994.

SUSAN BROWN MCGREEVY

NAUTICAL FOLK ART: *SEE* MARITIME FOLK ART; WILLIAM RUSH.

NEA AMERICAN HERITAGE AWARDS are honorific awards bestowed annually by the National Endowment for the Arts (NEA) upon master folk artists from throughout the United States. The program has honored quilters, singers, saddlemakers, storytellers, blacksmiths, potters, dancers, basket weavers, fiddlers, and practitioners of many other traditional arts from the various regional and ethnic cultures of the United States. Nearly every state and territory of the

United States has been represented by the award, and honorees range from Native Americans to some of the most recent immigrant groups.

Bess Lomax Hawes, director of the Folk and Traditional Arts Program at the NEA, developed the idea for the program, in response to a suggestion from Nancy Hanks, chairperson of the NEA from 1969 to 1977. After a period of debate and review, the NEA formally initiated the program in 1982. The Living National Treasures program of Japan was an inspiration for the National Heritage Fellowships, but the character of the program was shaped by American circumstances.

In 2002, the total number of awardees was 272; each year an additional ten to thirteen awards are given. Nominations are open to the public, and each year a panel of experts on folk and traditional arts meets to deliberate on the nominations. The artists who are selected attend a special awards ceremony in Washington, D.C. In some years the awards ceremony has been held at the White House, and in other years it has taken place on Capitol Hill. The awards generate a substantial amount of publicity, including home state publicity for the recipients.

The key concept behind the National Heritage Fellowships is providing cultural encouragement at the local level by honoring recipients at the national level. The hope is that by visibly honoring the recipients, most of whom are older practitioners who have devoted a lifetime to their art, the NEA will encourage younger people to pursue that art. Many of the awardees have been, and continue to be, not only master artists but also teachers, who devote their lives to passing along their art and knowledge to the next generation.

A special annual award, the Bess Lomax Hawes Award, was instituted in 2000 to honor artists, producers, and activists for contributions to the folk arts made primarily through teaching, organizational development, or advocacy. In 2002 the National Endowment for the Arts published a booklet, *National Heritage Fellowships, 1982–2002*, which provides a concise history and year-by-year overview of award recipients.

Allan Jabbour

NEEDLEWORK: *SEE* PICTURES, NEEDLEWORK; SAMPLERS, NEEDLEWORK.

NEEDLEWORK ARTS: *SEE* PICTURES, NEEDLEWORK; SAMPLERS, NEEDLEWORK.

NEIS JOHANNES (a.k.a. Neesz) (1785–1867), a Pennsylvania German potter, worked in the area of Rockhill and Salford Townships in Bucks and Montgomery Counties, Pennsylvania. There are conflicts regarding a uniform spelling of his name. Scholar John Ramsay cautions about Neis pottery, warning that "makers' marks were only rarely used, and the names found on some of the fine sgrafitto and slip ware pieces are often those of the decorators or recipients."

Scholars Jack L. Lindsey and Bernice B. Garvan have determined that John Neis, the son of Henry and Maria Elizabeth Neis of Salford Township, was probably apprenticed to his uncles, also potters, Abraham and Johannes Neis, or another of their apprentices, David Spinner (1758–1811). Johannes Neis decorated his earthenware with motifs associated with his Pennsylvania German community: equestrian designs with banded inscriptions based on folktales; and vines, flowers, or birds emerging from a container in symmetrically balanced compositions. Lindsey notes that most Neis sgrafitto floral designs "have the fluid, confident character of metal engraving and utilize similar curved, fine-scored parallel lines to delineate the petals of flowers, shading, or the turn of a leaf." Lindsey also notes that the balanced patterns used by Neis were found in the work of "scriveners, fraktur artists, needleworkers," and woodworkers.

Neis and his family of potters loved color and ornament and decorated their wares with traditional forms and motifs. They may have labored seasonally as farmers. From the local rich clay they produced both utilitarian and decorative ware. Their pottery was additionally enhanced by surface decoration of appliquéd impressed designs, incised sgrafitto patterns, or "trailed" slip decoration.

See also **Fraktur; Pictures, Needlework; Samplers, Needlework; Pennsylvania German Folk Art; Pottery, Folk; David Spinner.**

BIBLIOGRAPHY

Barber, Edwin Atlee. *Tulip Ware of the Pennsylvania German Potters: An Historical Sketch of the Art of Slip Decoration in the United States.* New York, 1970.

Clayton, Virginia Tuttle. *Drawing on America's Past: Folk Art Modernism and the Index of American Design.* Washington, D.C., 2002.

Garvan, Beatrice B. *The Pennsylvania German Collection.* Philadelphia, 1982.

Hollander, Stacy C. *American Radiance: The Ralph Esmerian Gift to the American Folk Art Museum.* New York, 2001.

Lichten, Frances. *Folk Art of Rural Pennsylvania.* New York, 1946.

Ramsey, John. *American Potters and Pottery.* Clinton, Mass., 1939.

William F. Brooks Jr.

NEW BEDFORD WHALING MUSEUM, which houses the world's preeminent collection of whaling art and history, was founded as the Old Dartmouth Historical Society at New Bedford, Massachusetts, in 1903. Its holdings, about 195,000 objects, represent a diverse array of cultures and peoples from ancient prehistory to the present, encompassing the seven seas and all seven continents: European, American, and non-Western paintings, drawings, and prints, as well as whaling gear, tools, ship models, navigation instruments, watercraft, maps, nautical charts, ships' plans, and whalers' occupational art. Its outstanding art collections include prints from the sixteenth to the twentieth centuries; Dutch and Flemish old master paintings; British and American paintings and drawings; Japanese scrolls; Pacific, Arctic, and Northwest Coast Indian ethnology; African American whaling history; and whalemen's scrimshaw. The museum's library, with its 50,000 titles from the sixteenth to the twenty-first centuries, holds a comprehensive array of books and treatises on whales, whaling, natural history, and voyages of exploration; about 300,000 manuscripts; approximately 50,000 photographs; and the libraries of the New Bedford Port Society, Joshua Slocum Society, and Herman Melville Society. The museum is also the repository for fine arts, decorative arts, furniture, art glass, and archival materials significant to the industries, trades, and social history of a region distinguished for Native-American entrepreneurial enterprise as well as a heritage of abolitionism, Portuguese and Cape Verdean immigration, textile and glass manufacture, and fishing.

Of particular interest are the museum's extensive holdings of American vernacular and occupational art. In addition to its definitive collections of scrimshaw and whaling photographs, dating from about 1850 to the present, many of the museum's 2,300 shipboard whaling journals contain drawings and watercolors by whalemen and whaling wives, including landscapes, portraits, caricatures, ship portraits, and recognition views; whaling and naval subjects; the flora and fauna of foreign seas and exotic landfalls; and interesting calligraphic specimens. The library's collection also includes original poetry, song lyrics, travel narratives, and didactic essays.

The museum's origins can be traced to 1847, when merchant Jonathan Bourne began managing his whaling empire from Merrill's Wharf—one of several consortia, each comprising an integrated galaxy of merchants and tradesmen engaged in outfitting, provisioning, equipping, and managing whaling vessels. Bourne's confidential clerk and executor, Benjamin Baker, was also a collector, of whaling relics, papers, and (remarkably) oral-history interviews, conducted decades before oral history and folklore field collecting became fashionable. His gleanings formed the core of the museum's collection; subsidies from Bourne's heirs fueled its progress. The New Bedford Whaling Museum long held the largest American whaling collection when, in 2001, the vast international art and history holdings of the Kendall Collection (founded in 1899) and former Kendall Whaling Museum (founded in 1955 at Sharon, Massachusetts) were gifted and assimilated, and the Kendall Institute was founded as the museum's library and research division.

See also **African American Folk Art (Vernacular Art); Calligraphy and Calligraphic Drawings; Maritime Folk Art; Painting, Landscape; Scrimshaw.**

BIBLIOGRAPHY

New Bedford and Old Dartmouth: A Portrait of a Region's Past. New Bedford, Mass., 1975.

Frank, Stuart M. *Biographical Dictionary of Scrimshaw Artists in the Kendall Whaling Museum.* Sharon, Mass., 1989.

Martin, Kenneth R. *Whalemen's Paintings and Drawings.* Sharon, Massachusetts; Newark, Del.; and London, 1983.

STUART M. FRANK

NEW ENGLAND QUILT MUSEUM, located in Lowell, Massachusetts, the heart of America's nineteenth-century textile industry, was founded in 1980 by the New England Quilter's Guild (NEQG). The museum had temporary homes in several locations until 1993, when an 1845 landmark savings bank building in downtown Lowell was purchased for its use. The museum's mission is to preserve, interpret, and celebrate American quilting, past and present, and it offers traveling exhibitions of contemporary, traditional, and antique quilts. Its own collection comprises some 150 quilts, representing all eras of quilt history. Through its holdings, exhibitions, programs, and technical assistance services, the museum serves as a resource for quilters, collectors, researchers, and a variety of quilt enthusiasts. Classes, lectures, and workshops supplement exhibits and serve to educate the general public in the art, history, making, and care of quilts. A reference library of books, periodicals, patterns, and slides is also available for research. The museum is a private, non-profit corporation supported by membership dues, admission fees, store sales, and private donations, as well as gifts and grants from public and private institutions, including the Lowell Cultural Council, the Massachusetts Cultural Council, The Stevens Foundation, and The

Theodore Edson Parker Foundation. The NEQG now functions as the museum's auxiliary, and sponsors a major quilt show every other year to benefit the museum.

See also **Quilts.**

BIBLIOGRAPHY

Gilbert, Jennifer. *New England Quilt Museum Quilts.* Concord, Calif., 1999.

<div align="right">JACQUELINE M. ATKINS</div>

NEW YORK STATE HISTORICAL ASSOCIATION was founded in Caldwell (Lake George), New York, in 1899. Stephen Carlton Clark offered the Association a home in the village of Cooperstown in 1939. Clark took an active interest in expanding the holdings and in 1944 turned over Fenimore House, one of his family's properties, to be used as a new headquarters and museum. In 1995 a new 18,000-square-foot wing was added to Fenimore House to hold the Eugene and Clare Thaw Collection, one of the nation's premier collections of American Indian art. The Fenimore Art Museum has superb holdings in American folk art, Native American art, academic portrait, genre, and landscape paintings, photographs, textiles, furniture, freeblown glass, and ceramics. The association mounts changing exhibitions and conducts statewide education programming as well as lectures and symposia. Since 1964 the association has collaborated with the State University of New York in co-sponsoring the Cooperstown Graduate Program in Museum Studies, a master's program that has produced scores of theses, exhibitions, catalogues, and books on the subject of American folk art.

The New York State Historical Association's folk art collection is regarded as one of the most comprehensive and significant in the United States. Three major purchases made by Clark form the collection's core. The first, a 1948 acquisition of thirteen pieces from the estate of modernist sculptor Elie Nadelman (1882–1946) provided major works of sculpture, textiles, and paintings. Two years later, with the addition of 164 pieces from the celebrated collection of Jean (1909–1998) and Howard Lipman (1905–1992), the Association's collection suddenly became one of the great assemblages of folk art in the country. Many examples had been published in Jean Lipman's pioneering books, *American Primitive Painting* (1942) and *American Folk Art in Wood, Metal, and Stone* (1948). The third and last major expansion occurred in 1958, when Clark purchased 175 paintings from the collection of Mr. and Mrs. William J. Gunn of Newton, Massachusetts.

Other additions of note include the 1979 bequest of over thirty sculptures from the collection of Effie Thixton Arthur. The association's twentieth-century folk art holdings have grown gradually, and now include works by Anna Mary Robertson "Grandma" Moses (1860–1961), Ralph Fasanella (1914–1997), Lavern Kelley (1897–1956), Malcah Zeldis (1931–), Queena Stovall (1887–1980), Minnie Evans (1892–1987), and William Hawkins (1895–1990).

See also **Minnie Adkins; Ralph Fasanella; Furniture, Painted and Decorated; William Hawkins; Anna Mary Robertson "Grandma" Moses; Native American Folk Art; Painting, American Folk; Painting, Landscape; Photography, Vernacular; Pottery, Folk; Queena Stovall; Malcah Zeldis.**

BIBLIOGRAPHY

Lord, Clifford L. *The Museum and Art Gallery of the New York State Historical Association.* Cooperstown, N.Y., 1942.

New York: New York State Historical Association. *Proceedings of the New York State Historical Association.* Albany and Cooperstown, N.Y., vols. 1–97 (1901–present).

<div align="right">PAUL S. D'AMBROSIO</div>

NIXON, WARREN (1793–1872), a painter from Framingham, Massachusetts, was active in calligraphy, paintings relating to parent and child, and family records. He is of particular interest because of his relationship to another Framingham folk artist, Joseph Stone (1774–1818).

Nixon's earliest known work is a page of calligraphy from an exercise book, consisting of seven horizontal lines of the alphabet, each written in a different style. It is inscribed "*Wrote* [sic] *April 25th 1808; by Warren Nixon agd 15 years, 1 1/2 month.*" During the following few years he created calligraphic bookplates for himself, his uncle, his brother, Otis, and his wife–to–be, Salome Rice. All but one of the plates includes his name, age, and date of execution.

Two watercolor and ink paintings dealing with the relationship between parent and son were painted in 1816. One, identified as "*PLATE IV,*" depicts a young man seated by the bedside of an older woman, and is signed and dated, "*Warren Nixon. Framingham 1816.*" An inscription speaks of the duty of the son to be there as his mother dies and, with his filial tenderness, to make her death easier. The second, picturing a weary young man with an elderly one, bears words that imply that the younger man is being led by the older one to a resting place. It is signed and dated,

and inscribed "*PLATE V.*" The numbering of the paintings suggests that they are part of a series of at least five.

Two family registers also can be attributed to Nixon. The first is inscribed, "*With a pen this was done for a father by a son at the age of twenty-two as you may plainly view. Warren Nixon 1815,*" and "*Long will this endure, if it be kept secure and will be handed down to generations to come, when you and I have done.*" The second is a watercolor-and-ink family register for Eliphalet Wheeler, based on another register engraved between 1810 and 1820 by Peter Maverick. Signed and dated, "*W. Nixon Pinx. Framingham 1820,*" it is Nixon's last known painting.

Genealogical links between the two Framingham painters, along with stylistic similarities in their paintings, make it likely that Stone was Nixon's teacher, who was nineteen years' his junior. Between 1820 and his death in Framingham in 1872, Nixon was employed as a teacher, land surveyor, selectman, and justice.

See also **Calligraphy and Calligraphic Drawings; Family Records or Registers; Joseph Stone.**

BIBLIOGRAPHY

Kern, Arthur, and Sybil Kern. "Joseph Stone and Warren Nixon of Framingham, Massachusetts." *The Magazine Antiques,* vol. 124, no. 3 (September 1983): 515–518.

ARTHUR AND SYBIL KERN

NORTH, NOAH (1809–1880), portrait artist, ornamental painter, daguerreotypist, and farmer, lived in western New York State and Ohio during the nineteenth century. The son of Noah and Olive Hungerford North, the artist was born on June 27, 1809, in Alexander, Genessee County, New York. Possibly exposed to the work of artist Ammi Phillips (1788–1865), whose brother was North's uncle by marriage, he may have received significant instruction in portraiture in the early 1830s from artist Milton William Hopkins (1789–1844). A man 20 years North's senior, Hopkins was in the area generating commissions and advertising his services as an art instructor. His work and North's bear such stylistic similarities that the two artists' compositions have often been confused. Art historian Jacquelyn Oak hypothesizes that the men must have been in professional partnership, or else interacted in a student–teacher relationship.

Only a handful of North's signed compositions have been located, and nearly all date from between 1833 and 1836. They principally depict residents of Genessee, Orleans, and Monroe Counties in New York. The portraits of Abijah W. Stoddard and his wife are among the artist's earliest documented portraits. Both signed, they are dated 1833, and according to their inscriptions each originally cost seven dollars and fifty cents. Produced only one year later, the portrait of Sarah Angelina Sweet Darrow shows a marked level of improvement in North's artistic skill, possibly reflecting, in part, Hopkins' tutelage. Anatomical features are developed more naturalistically, and greater depth of form is achieved on the two-dimensional surface of the canvas.

Probably encouraged by construction of the Ohio and Erie Canal in 1832, linking the Ohio River with Lake Erie, North migrated west, in 1836, to Ohio City, Ohio. According to the Cleveland and Ohio City directories, by 1837–1838 North was working as a portrait painter. Unconfirmed reports indicate that he also made sojourns to Cincinnati and Kentucky during this period. In June 1841 he had returned to New York State, where he married his neighbor, Ann C. Williams of Darien. During the 1840s he appears to have worked intermittently as an artist, supplementing his income with farming, as well as house, sign, carriage, and ornamental painting, paper hanging, and window glazing. He even tried his hand at making daguerreotypes. Having spent most of his life in a three-county area of western New York, North died in Attica, New York, on June 15, 1880, at the age of 70.

See also **Milton William Hopkins; Ammi Phillips.**

BIBLIOGRAPHY

Muller, Nancy C., and Jacquelyn Oak. "Noah North (1809–1880)." *The Magazine Antiques* (November 1977): 939–945.
Museum of Our National Heritage. *Face to Face: M.W. Hopkins and Noah North.* Lexington, Mass., 1988.

CHARLOTTE EMANS MOORE

NORWEGIAN AMERICAN FOLK ART: *SEE* SCANDINAVIAN AMERICAN FOLK ART.

NOYES MUSEUM OF ART, THE was founded in 1983 by the entrepreneurs Fred W. Noyes Jr. (1905–1987) and his wife Ethel (1911–1979) as a showcase for their collection of American fine and folk art. Their collection includes two hundred paintings by Fred W. Noyes Jr., an academically trained artist inspired by the natural landscape and wildlife of southern New Jersey; an outstanding group of four hundred carved wildfowl, shore bird and duck decoys; weathervanes; whirligigs; and furniture. The Noyes Museum is committed to the preservation, interpretation, and exhibition of the art and cultural heritage of southern New

Jersey. Located adjacent to the Edwin B. Forsythe National Wildlife Refuge overlooking Lilly Lake in Oceanville, New Jersey, it is the only art museum in the region.

The ever-growing collection of more than 1,300 objects includes many fine examples of traditional and contemporary forms of American folk art and craft. Some of the important works held in the collection are Dr. Andrew M. Blackman's (1904–1961) *American Bald Eagle*, Frank Van Fleet's (1922– c. 1950s) *Van Fleet Circus*, Leslie Christofferson's (1909–) *Purple Martin Palace*, Gideon Lippincott's (1820–1888) *Black Duck*, Albert Hoffman's (1915– 1992) *The Catch*, Marcia Sandmeyer Wilson's (1937–) whirligig *American Spirit*, Minnie Evans' (1892–1987) *Two Designs*, and Malcah Zeldis's (1931–) *Wedding*.

The museum endeavors to present eight to ten exhibitions per year highlighting the creativity of regional artists. Noteworthy exhibitions include "Preserving the Lone and Forgotten: The Herbert Waide Hemphill Jr. Collection of American Folk Art" (1988),

"Justin McCarthy, American Maverick Painter" (1999), and "New Jersey Quilts 1777–1950: Contributions to an American Tradition" (1993).

The museum serves as a community resource for those interested in expanding their understanding and appreciation of craft and folk art. A variety of activities are offered including childrens' workshops, poetry readings, concerts, and lectures. The "Young at Art Gallery" provides a special creative space to display the art projects of students from southern New Jersey area schools.

See also **Decoys, Wildfowl; Herbert W. Hemphill, Jr.; Metalwork; Justin McCarthy; Quilts; Weathervanes; Whirligigs.**

BIBLIOGRAPHY

Fabbri, Anne R. *Preserving the Lone and Forgotten.* Egg Harbor City, N.J., 1988.

White, Wendel A. *Small Town's Black Lives.* Oceanville, N.J., 2003.

DEBORAH LYTTLE ASH

O

ODD FELLOWS: *SEE* INDEPENDENT ORDER OF ODD FELLOWS.

O'KELLEY, MATTIE LOU (1908–1997) was a memory painter born into a farming family in rural Banks County, Georgia. She spent the first seven decades of her life there. When her father died in 1930, she stayed on to care for her mother long after her siblings left home to raise families of their own. After her mother died in 1955, she continued to support herself, as she had throughout her adult life, working as a housekeeper and in a school cafeteria.

In the 1960s, looking for a more agreeable means of earning an income, O'Kelley began to paint. Shortly thereafter, she began offering her paintings for sale at local art shows in Maysville (in Banks County). In 1975, seeking a wider audience for her art, she went to Atlanta and showed some of her paintings to Gudmund Vigtel, then director of The High Museum of Art. He arranged for her to sell her work through the museum gift shop, and introduced her to a dealer who began representing her work.

Robert Bishop saw her paintings on a visit to Atlanta in the late 1970s. When he became director of New York's American Folk Art Museum, he championed her work. Within a few years of her retirement in 1968 (from her last job, in a Maysville mop yarn plant), O'Kelley was earning a livable wage through sales of her paintings.

O'Kelley primarily painted scenes she recalled from her childhood, youth, and early adulthood on and around the farm where she grew up—images that place her work firmly in the memory painting genre. Painting at a time when small farms were noticeably struggling and declining in number, O'Kelley vividly expressed her nostalgic feelings for the rural, agrarian lifestyle she knew. Her landscapes are highly stylized, and make liberal use of pointillist brushstrokes, in which she uses small dots of paint that form shapes

and tones of color when viewed from a distance. The trees in her paintings are so uniformly shaped that they appear to have been created by a topiary artist. O'Kelley's paintings are idyllic panoramas that convey a sense of the family farm as a self-sufficient utopia, a place suffused with peace and contentment.

In 1977, O'Kelley left Banks County and, over the next three years, lived in New York City and Palm Beach, Florida, before settling in Decatur, Georgia, where she spent the rest of her life.

See also **American Folk Art Museum; Robert Bishop; High Museum of Art, The; Painting, American Folk; Painting, Memory.**

BIBLIOGRAPHY

O'Kelley, Mattie Lou. *From the Hills of Georgia: An Autobiography in Paintings.* New York, 1983.

———. *Mattie Lou O'Kelley: Folk Artist.* Boston, 1989.

Sellen, Betty Carol, and Cynthia Johanson. *Twentieth Century American Folk, Self Taught, and Outsider Art.* New York, 1993.

TOM PATTERSON

OLD STONECUTTER, THE (also known as the Charlestown Carver or the Stonecutter of Boston) is believed to be responsible for a remarkable group of Boston-area gravestones bearing dates between 1653 and the late 1680s. The paired headstones and footstones of fine-grained local slate that this anonymous craftsman carved display distinctive uppercase lettering, the frequent use of Latin phrases, and a variety of death-related iconography. No two stones are exactly alike. Several of this artist's more ambitious carvings are based on an allegorical scene found in Francis Quarles' *Emblem Book* (London, 1638). Most famous perhaps is the elaborate Joseph Tapping stone (1678, King's Chapel Burying Ground, Boston), which depicts the winged figure of Father Time with his hourglass and scythe hovering over the skeletal figure of Death, who holds a dart in his left hand while the

right hand reaches to extinguish the flame (or breath) on a candle of life. Another Boston-area carver, Joseph Lamson (c. 1658–1722) of Charlestown, Massachusetts, whose known work begins toward the end of the Old Stonecutter's period of productivity and whose own carving closely resembles that of the Old Stonecutter, makes it difficult to identify the last works of this master carver.

BIBLIOGRAPHY

Forbes, Harriette Merrifield. *Gravestones of Early New England and the Men Who Made Them, 1653–1800.* Boston, 1927.

LAUREL K. GABEL

ORTEGA, JOSÉ BENITO (1858–1941) was a prolific, itinerant *santero,* or carver and painter of *santos* (figures of saints), whose work represents the last flowering of the classical tradition of saint figure making in northern New Mexico. Traveling on foot from his home in La Cueva to the villages east of Santa Fe in Mora, San Miguel, and Colfax Counties, he created sculptural images (*bultos*) of popular Roman Catholic saints and other holy personages for use in the devotional practices of the Hispanic households of the region. He also carved images for use in *moradas,* the local chapters or meeting houses of the Catholic Brotherhood of Our Father Jesus Nazarene, more commonly known as *penitentes.* Providing mutual assistance and support for its members, the brotherhood became known for its public acts of penitence during Holy Week in imitation of the Passion of Christ.

In contrast to his household saints, which generally stand no higher than two feet, Ortega's *penitente* sculptures are imposing figures, standing as tall as five feet, and most often depict the Crucified Christ. William Wroth, the author of several authoritative studies of the *santos* of New Mexico, has observed that the artist's treatment of the features of his figures is "virtually the same for every piece he made. . . . The eyes protrude and stare, the nose is quite large and slightly turned up, the chin is clearly defined, often slightly pointed." Unlike earlier *santeros,* Ortega often used excessive amounts of gesso in the modeling of features, rather than carving them.

It is not clear whether Ortega worked alone, with family members, or maintained a *taller,* or workshop. Although a nephew asserted that the artist did not have a helper, Wroth suggests the possibility of a workshop under Ortega's direction. Two related groups of *bultos* from the Mora area have been identified that share many of the stylistic characteristics of

Ortega's work, but appear to have been made by other carvers.

In 1907, after his wife's death, Ortega left his home in La Cueva to take up residence with his children in Mora, New Mexico. Although he lived for another 34 years, he did not carve any more *bultos.*

See also **Bultos; Santeros; Santos.**

BIBLIOGRAPHY

Boyd, E. *Popular Arts of Spanish New Mexico.* Santa Fe, N. Mex., 1974.

Wroth, William. *Images of Penitence, Images of Mercy: Southwestern Santos of the Late Nineteenth Century.* Norman, Okla., 1991.

GERARD C. WERTKIN

OTTO, DANIEL (c. 1770–c. 1820) was the most talented of the four sons of Johann Henrich Otto (1733–c. 1800), one of the Pennsylvania Germans' seminal fraktur artists, who took up his father's art along with his brothers. Born in Lebanon County, Pennsylvania, Daniel's work surpassed his brothers' with the intensity of his colors and the striking nature of his designs. He followed his schoolmaster-father's move from Schaefferstown, Lebanon County, to St. Peter's Church, overlooking the junction of the Mahanoy and Schwaben Creeks in Mahanoy Township, Northumberland County, Pennsylvania, where he began to draw frakturs as well as fill in printed examples. Daniel eventually moved to Brush Valley, Miles Township, in Center County, Pennsylvania, where he remained until he crossed the mountains to the south and settled at Aaronsburg in Haines Township, Center County. As his name is crossed off the Aaronsburg tax list in 1821, he may have moved elsewhere subsequently. During much of this time in the area he was a schoolmaster, an occupation for which no taxes were paid unless the teacher owned land. Daniel later married and had a large family.

Daniel Otto's fraktur was inspired by his father's work. Known for the flat tulips (like those brought from Europe by early settlers and still found growing wild in Pennsylvania) that identified his body of work before his name was discovered, Otto also drew elaborate figures of parrots, long-necked birds, mermen and mermaids, and alligators to decorate his frakturs. He also drew pairs of lions facing each other, typical of the Pennsylvania Germans, who usually paired lions or unicorns together. For his certificate forms he designed an assortment of compartments that provided space for the text, unlike his father's forms, which provided only a straightforward record of birth

and baptism. His palette of brilliant ochre and yellow makes his work among the most striking of fraktur to be discovered. Daniel Otto died in Haines Township in Center County.

See also **Fraktur; German American Folk Art; Johann Henrich Otto; Pennsylvania German Folk Art; Religious Folk Art.**

BIBLIOGRAPHY

Weiser, Frederick S., and Bryding Adams Henly. "Daniel Otto: the 'Flat Tulip' Artist." *Antiques,* vol. 103 (1986): 504–509.

FREDERICK S. WEISER

OTTO, JOHANN HENRICH (1733–c. 1800) was one of the first people to make fraktur birth certificates in Pennsylvania. Born in Swartzerden, near Pfeffelbach, Germany, Otto arrived in America aboard the ship *Edinburgh* on October 2, 1753. He married Anna Catharine Dauterich, and they had children who were born in Lancaster and Montgomery Counties.

Otto advertised his services as a weaver in 1755. He served in the American Revolution between 1777 and 1780. He appears to have taught at the parochial schools of several Reformed Protestant churches, between about 1769 and 1779, at Schaefferstown, Pennsylvania. He moved to Mahanoy Township, Northumberland County, and probably taught at St. Peter's Lutheran and Reformed Church there.

Otto's earliest pieces of fraktur, produced in the 1760s, are completely hand-drawn, very detailed, and colorful. By 1784 he had baptism certificates printed at the press of the Ephrata Cloister in Pennsylvania, which were decorated with woodblocks of birds he may have designed. The text of these certificates begins with a record of the child, including the names of the parents, date of birth, date of baptism, and the name of the officiating clergyman. The longer text of these certificates appears to be a justification of infant baptism among Otto's Mennonite neighbors, who generally disapproved of the practice.

Otto published a variety of broadsides that featured Adam and Eve, as well as spiritual mazes, bookplates, and presentation frakturs. For many years, the figures of birds on his certificates were copied over and over again by other fraktur makers, either by hand or in printed form, as was the style of his text. His sons Jacob, William, Daniel, and Conrad all produced fraktur, as did Conrad's son Peter. Otto died in Mahanoy Township, Northumberland County, Pennsylvania.

See also **Fraktur; German American Folk Art; Johann Conrad Gilbert; Pennsylvania German Folk Art; Religious Folk Art.**

BIBLIOGRAPHY

Hollander, Stacy C., et al. *American Radiance: The Ralph Esmerian Gift to the American Folk Art Museum.* New York, 2001.

FREDERICK S. WEISER

OUTSIDER ART, the term coined by an editor at Studio Vista, the London publisher of the book *Outsider Art* (1972) by Roger Cardinal, was originally intended to serve as a palatable English equivalent for the French expression *Art brut.* Anglophones tend to associate *brut* with "brutal," when in fact it is properly translated as "raw," "unadulterated," "pure and simple," "untainted," or "without alloy." The phenomenon of self-taught art in the twentieth century has been traced predominantly through a European context, first acknowledging the importance of the German psychiatrist and aesthetician Hans Prinzhorn (1886–1933), whose *Artistry of the Mentally Ill* (1922; translated 1972) represented a definitive overview of Psychotic Art (as it has subsequently been called): that is, artwork spontaneously produced by persons in the grip of extreme mental disorders. The theories of the French collector and avant-garde artist Jean Dubuffet (1901–1985), however, whose 1945 coinage of *art brut* encompasses artistic sources that extend some way beyond the strictly psychopathological, connected outsider art to avant-garde painting first in Europe and then in America.

As a category, *Art brut* admits a great diversity of formats: drawings, paintings, calligraphies, embroideries, carvings, and assemblages, not to mention large-scale environmental installations (also known as "visionary environments" or "outsider architecture"). As an artistic label, it denotes works that possess thematic and compositional qualities of marked idiosyncrasy, originality, and intensity, and that, above all, are produced by untutored individuals whose engagement with orthodox culture and the conventional art world is minimal.

Dubuffet's collecting activities began in 1945, when he visited psychiatric hospitals in Switzerland and acquired drawings by the inmates Adolf Wölfli (1864–1930), Aloïse Corbaz (1886–1964), and Heinrich Anton Müller (1869-1930). His passion for the eccentric mannerisms of institutionalized psychotics at first attracted the support of the surrealist poet André Breton; but Dubuffet insisted on widening his orbit, turning his attention both to mediumistic art—that is, work produced, typically in a trance state, by

The Big Attic Interior. James Castle; n.d. Soot and saliva on found paper; 9 × 13½ inches.
Collection American Folk Art Museum, New York. Promised gift of Thomas Isenberg,
p12.2000.2.

adepts of spiritualism or other, non-aligned visionaries—and to art produced by culturally alienated individuals, a loose category that includes recluses, convicts, and other social misfits and victims. It should be noted that a high proportion of women artists (who were of marginalized status to begin with), including Corbaz, Madge Gill (1882–1961), and Jeanne Tripier (1869–1944), found their way into Dubuffet's *Art brut* canon. By the 1950s, Dubuffet had worked up his original intuitions into a complex doctrine, whereby conditions such as madness, incarceration, emotional trauma, or plain "orneriness" were to be seen as the facilitating conditions for acts of startling originality that entirely lacked the imprint of conventional culture. As an artist, Dubuffet prized work that gave imaginative expression to the individual's creative being, as it were, his or her inner world. And although he chose to seek out work produced—against the odds—by the marginalized and the underprivileged, it was emphatically *not* in order to further any scientific inquiry or charitable endeavor. Dubuffet was first and foremost concerned with art.

Having been housed in private premises for decades, Dubuffet's Collection de l'Art Brut enjoyed a more or less underground reputation until 1976, when it was finally established as a public museum in Lausanne, Switzerland. To this day, fresh discoveries continue to enhance its core collection, which by 2002 included work by American "outsiders" such as Henry Darger (1892–1973), Theodore Gordon (1924–), Dwight Mackintosh (1906–1999), Martín Ramírez (1895–1963), and Bill Traylor (1854–1949). During the 1980s these works inspired a number of other European collectors, including the Aracine Collection, based at Lille, France; the Musgrave-Kinley Collection, housed in Dublin; the Arnulf Rainer Collection, in Vienna; and the Éternod-Mermod Collection, in Lausanne. In 1995 the Humanitarian Center in Moscow styled itself as the first "Outsider Art Museum" in Russia. Despite being misapplied by some, the English term "outsider art" has been largely accepted across Europe as synonymous with *Art brut*.

In 1951 Dubuffet delivered a notorious lecture in Chicago titled "Anticultural Positions," in which he

voiced his fundamental dissent from what he saw to be the flawed principles of the Western cultural project. By 1968 he had sharpened his critique, publishing *Asphyxiating Culture* (translated in 1988) as an attack on the conservative values of beauty, harmony, and clarity. Elsewhere, his earnest and compelling critical studies of the artists in his collection introduced a scale of (more or less) intuitive evaluation, articulated in adjectives like "intense," "challenging," "compelling," "disturbing," "savage," and "violent." Partisans of this nonconformist aesthetic came to appreciate the distinctive aura of works that resist easy assimilation, remaining provocative and unsettling, bristling with energy and enigma, and generally demanding attention without being the least bit "pretty" or conventionally seductive. It may indeed be that Outsider Art is best identified by a quality of strangeness that resembles a perverse denial of communication. Certainly, it is this "spikiness" (in the extreme, a sign of quasi-autistic self-absorption) that differentiates it from traditional Peasant Art or Naive Art, both of which tend to foster an untroubled relationship with their audience.

Whereas, in the United States, the general territory of folk art had long since been explored and mapped by connoisseurs, collectors, and art dealers, the 1980s and 1990s saw a remarkable sharpening of interest in the more idiosyncratic modes of self-taught art associated with the role and status of the "outsider." The emergence of commercial galleries and public museums specifically concerned with such work, the establishment in 1993 of an annual Outsider Art Fair in New York, and the launching in Chicago of a magazine called *The Outsider* in 1996 are but a few signs of this accelerating enthusiasm. If it is the case that the concept of an "outsider art" remains problematic for some, there is nonetheless no doubt that the incidence of authentic Outsider Art in American collections remains noticeably high.

A recurrent vexation is that, more or less inadvertently, the very popularity of Outsider Art has nourished several misconceptions and misapplications of the term, so that, within the United States, the narrow and largely European understanding of the term has been stretched to the point of including work that it would be far more meaningful to label as Naive Art or, simply, Contemporary Folk Art. Moreover, the term is too often laxly assimilated to dozens of other modes of marginal artmaking, including graffiti; artwork produced by convicts, the homeless, or the socially dislocated; pictures produced with the encouragement of art therapists; Sunday painting; "fantastic" art made by amateurs; urban popular art from the Third World, and so forth. Still, it should be acknowledged that, in principle, there is no reason why authentic Outsider Art should not occasionally surface within just such contexts as these, and Dubuffet himself toyed with the idea that even academic painters might at some point in their lives jettison all their acquired skills and start again from scratch, tapping an uncontaminated source of independent inspiration. As an art and historical category, Outsider Art is really only useful as a means to register difference; if it is invoked carelessly or overgenerously, and without regard to the criteria outlined above, it forfeits its sharpness and comes to signify a catchall miscellany.

It must be acknowledged, as well, when seeking authoritative definitions, that controversies and confusions are also historical facts. Specialists in the field are well aware of the tendency to quarrel over criteria, while the impulse to dream up enticing new terms remains symptomatic of many approaches to self-taught art. By 2002 Outsider Art had seen three decades of service both as a banner and as a red rag. Attracted to the idea of creative individualism, a number of American enthusiasts have brandished the term to register a tactical distance from traditional folk art, which they perceive to be outdated and suggestive of the stereotyped, the unadventurous, or the merely decorative. Overzealous dealers and ambitious amateurs have sometimes carelessly promoted the term, as if to insist that outsider status is a commodity for all to share. Again, still others have sensed an inherent quirkiness about the term "outsider" (perhaps half-remembering Albert Camus' fictive portrait of an existential misfit in *L'étranger*), and have cautiously reverted to less combative expressions, such as "contemporary folk art," "visionary art," or "self-taught art" (the plain phrase favored by Sidney Janis in his 1940 book, *They Taught Themselves*). Historians of African American art and art practices, moreover, have long been suspicious of a formula that might seem to suggest an inferior and marginal mode of expression—an art relegated to the "outside" of white culture—and these arguments have been similarly linked to the critical examination of what modern art historians in the first half of the twentieth century termed "primitivism." No doubt Dubuffet would have ruled them right, for his stubbornly enforced criteria would have allowed no overlap between, on the one hand, those plentiful examples of folk art that appeal to communal experience and the sharing of values, and, on the other hand, those secretive, self-oriented expressions that characterize *Art brut*.

353

By the turn of the century, Dubuffet's dream of isolating *Art brut* as a priceless rarity had begun to seem farfetched. Certainly the notion of an autonomous creative impulse, untouched by cultural tradition or artistic precedent, has been exposed as more of a utopian ideal than a practical possibility. For all that the self-reliant autodidact is allegedly nourished by an autonomous fund of inspiration, close study of the art of the Swiss Adolf Wölfli or the Mexican Martin Ramirez has revealed an abundance of cultural echoes, emanating from their native folk culture as well as the wider world of transnational popular culture. Given that the twentieth century has seen the globalization of image transmission via newspapers, television, and cinema, it seems less and less plausible to suppose that an individual might be in a position to make a drawing dramatically different from or unmediated by other cultural and historical representations. Scholars today recognize that any given art is inseparable from its specific cultural and historical context.

Nevertheless, there is still a case for acknowledging the pertinence of "outsider art" as a technical term appropriate to the identification of a discrete category of artists. Despite the objections, it does appear that a relatively small number of self-taught creators exhibit distinctive qualities of intensity and individualism that mark them as "exceptional cases" worthy of special critical attention and admiration. Americans such as Henry Darger, Martin Ramirez, Bill Traylor, and Joseph Yoakum (1886–1972) have considerable international reputations; and, within the United States, there is growing respect for the achievements of other singular figures, including Eddie Arning (1898–1993), James Castle (1899–1977), Charles A. Dellschau (1830–1923), Minnie Evans (1892–1987), Frank Albert Jones (1900–1969), Achilles Rizzoli (1896–1981), and

Henry Speller (1900–1997), each the inventor of a startling visual system born of a singular mental scheme. None of these artists had any academic instruction; none ever worked on commission; none belonged to any group, school, or movement. Instead, each exerted a self-assured and impeccably idiosyncratic capacity for expression: each may be said to have projected a rich and compelling creative realm, a visionary world often violently at odds with the real one. The paradoxical implication of their being classified within Outsider Art is that each represents a fascinating exception and a powerful reminder never to trust in sweeping generalizations.

See also **Minnie Adkins; Eddie Arning; James Castle; Henry Darger; Charles A. Dellschau; Environments, Folk; Theodore Gordon; Frank Albert Jones; Dwight Mackintosh; Prison Art; Martín Ramírez; Achilles Rizzoli; Henry Speller; Bill Traylor; Visionary Art; Joseph Yoakum.**

BIBLIOGRAPHY

Cardinal, Roger. *Toward an Outsider Aesthetic in the Artist Outsider: Creativity and the Boundaries of Culture.* Washington, D.C., and London, 1994.

Danchin, Laurent, and Martine Lusardy. *Art Outsider et Folk Art des Collections de Chicago/Outsider and Folk Art: The Chicago Collections.* Paris, 1998.

Maizels, John. *Raw Creation: Outsider Art and Beyond.* London, 2000.

Peiry, Lucienne. *Art Brut: The Origins of Outsider Art.* Paris, 2001.

Rhodes, Colin. *Outsider Art: Spontaneous Alternatives.* London and New York, 2000.

Thévoz, Michel. *Art Brut.* London and New York, 1976.

ROGER CARDINAL

OVERMANTELS: *SEE* FIREBOARDS AND OVERMANTELS.

PAINTED FURNITURE: *SEE* FURNITURE, PAINTED AND DECORATED.

PAINTED TINWARE: *SEE* TINWARE, PAINTED.

PAINTING, AMERICAN FOLK is a broad term that comprises a wide variety of mediums and techniques practiced by both amateur and professional artists from the colonial period to the present. American folk painting has developed largely in tandem with and parallel to other streams of American art, while embracing a wide segment of American society rather than elite consumer circles. Throughout the history of folk painting in America, techniques and imagery have responded to both traditional and fashionable trends, as well as historical art movements (albeit often through secondary sources), technological innovations, aesthetic changes, and cultural influences that have determined the direction of American art.

An appreciation of American folk painting can be traced to the early decades of the twentieth century, at a point when Modernism coincided with the Colonial Revival movement. The sense of linearity and abstraction that is often associated with American folk painting resonated with the work of Modernists such as Charles Sheeler (1883–1965). Through artists like Sheeler, and their circle of patrons, dealers, and museums, an awareness of folk painting traditions in America reached ever-widening audiences.

In the most limited consideration of the term, American folk painting might include only those two-dimensional forms that fall within the fine arts canon, notably portraiture, landscapes, and still-lifes. In its wider and more commonly accepted interpretation, however, the term, as it is applied to artworks created before the twentieth century, also refers to a variety of painted embellishments (architectural elements, such as interior wall murals, and furniture, boxes, and tinware) as well as to other decorative arts, and to

specific genres such as theorem painting, ship portraits, architectural portraits, panorama painting, monochromatic painting, family records, fraktur, and Shaker drawings; the term additionally applies to village views, calligraphic exercises, fancy painting, and tinsel painting, among many other genres.

One of the distinguishing factors between folk and academic painters is the means by which they came to create art, and the ways in which they have gained their expertise. Some inherited artistic traditions are passed down through generations or within specific communities, such as the fraktur art of the Pennsylvania Germans or the *retablos* of the Hispanic Southwest. The famous Quaker artist Edward Hicks (1780–1849) was trained as a carriage and sign painter before turning his talents to powerful visions of the *Peaceable Kingdom*. A few American folk painters enjoyed brief periods of study with academically trained artists. Erastus Salisbury Field (1805–1900), for instance, apprenticed for a short time in New York with Samuel F.B. Morse (1791–1872) before returning to New England, where he painted portraits and, later, historical and religious allegories. Many folk artists, however, did not receive any formal training and instead attained their skills through years of experience. Still others, such as the Shaker sisters who transcribed inspired gift drawings, produced religious paintings that emerged from their particular belief systems.

The primary form of painting in the colonial period was portraiture, which developed in two distinct styles. The earliest portraits followed a European court tradition in their flat, medieval style, with a Mannerist formality and emphasis on ornamentation and material trappings rather than realistic spatial relationships, proportions, and perspectives. The artists who began to arrive in the United States at the beginning of the eighteenth century brought with them a knowledge of the precepts of the Renaissance,

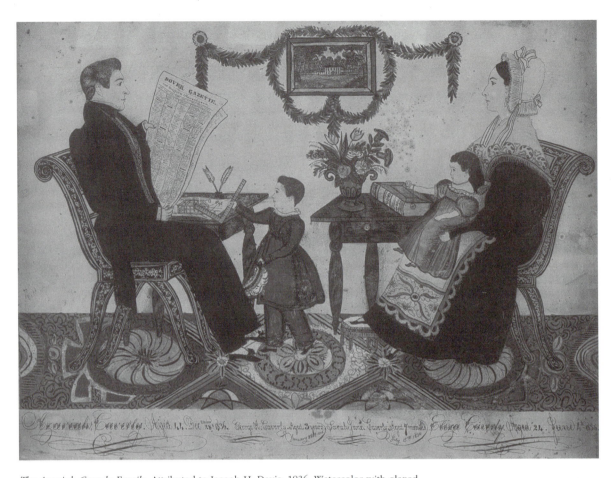

The Azariah Caverly Family. Attributed to Joseph H. Davis; 1836. Watercolor with glazed highlights, pencil and ink on wove paper; 10¹⁵/₁₆ × 14¹⁵/₁₆ inches; N-61.61. Collection Fenimore Art Museum, Cooperstown, New York. © New York State Historical Association, Cooperstown, New York.
Photo courtesy Richard Walker.

and hence a more naturalistic style strongly influenced by European mezzotints of the early eighteenth century with a new interest in true-to-life representations in an identifiably American setting. The tension between these two visual approaches persisted in American folk portraiture through the middle of the nineteenth century, when photography largely replaced the need for painted portraits.

By the early eighteenth century, but especially after the American Revolutionary War, interior architectural forms such as fireboards, overmantels, doors, and walls began to receive decorative treatments. This was in part a response to the cultivation of properties, construction of permanent homes, and the growing economic stability of an increasing middle class. Embellishments could be simple and traditional images, such as urns of flowers, but more ambitious

artists presented landscape views or architectural scenes. Occasionally, these interior forms depicted the very home or property in which the painting was situated, such as the 1732–1733 *Van Bergen Overmantel,* which presents one of the earliest views of the Dutch New York landscape. More typically, however, the decorations combined local scenery with romantic views gleaned from European prints. Itinerant decorative painters like Rufus Porter (1792–1884) devised timesaving methods for such interior decorations, thereby standardizing the representations while also contributing toward regional preferences.

As landscape painting developed, it continued to portray personal properties, but it also responded to larger themes introduced by artists such as Thomas Cole (1801–1848), whose paintings of the American wilderness disseminated the notion of the sublime to

356

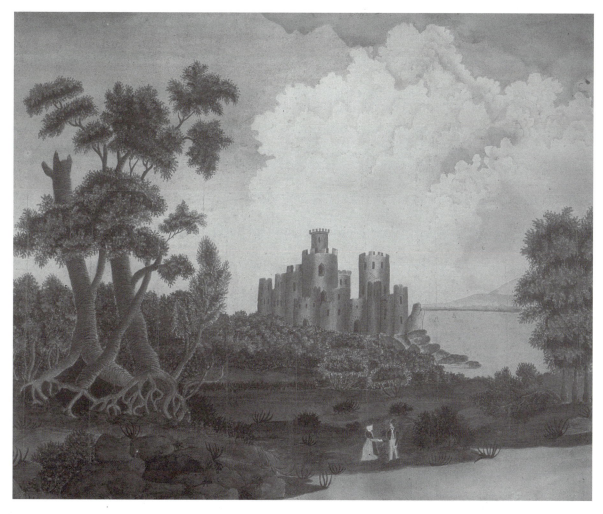

Romantic Landscape, vicinity of Sturbridge, Massachusetts. Artist unknown; c. 1830–1850.
Collection American Folk Art Museum, New York, 1983.29.3.
Photo courtesy Gavin Ashworth.

a wide audience. Metaphorical landscapes appeared in oils, marble dust drawings, and other mediums, with dramatic juxtapositions of man and nature. Following the American Civil War, a radical shift in perspective resulted in a new type of vista, from a bird's-eye view, with landscapes, farmscapes, cityscapes, and industrial complexes rendered with maplike precision. These realistic depictions replaced the lofty allegorical scenes, but an element of Romanticism still tinged the work of artists such as Jurgan Frederick Huge (1809–1878), whose composite landscapes were amalgams of exotic scenery with identifiable American locales and a healthy dose of anecdotal detail and activity. By the last quarter of the nineteenth century, the publication of centennial histories, as towns throughout the United States reached their

one-hundred-year birthdays, gave rise to a multitude of house portraits based on the aesthetic of the line lithographs that illustrated these same volumes. German immigrant artist Fritz Vogt (1841–1900), for instance, made more than 200 meticulous graphite and colored pencil representations of farmsteads, residences, and businesses in five counties of western New York during the ten-year period before his death. Vogt offered his clients an opportunity to have their properties recorded in the manner of the lithograph, with identifying legends written below the rendering, but in the most beneficial light through the manipulation of perspective and placement of structures.

From the late eighteenth century through the middle of the nineteenth century, a range of ornamental

arts was taught to and practiced by young women as part of their education. Religious subjects, mourning pieces, and flower painting were common themes that were provided for students to copy, trace, or design on paper, silk, velvet, textiles, and furniture. Originally, such exercises might have been executed in needlework. As watercolors became more widely available, however, the medium began to augment and ultimately replaced the expensive silk threads. While some of the older subjects passed from favor, flower imagery endured and adapted over time, from simple botanical representations to elaborate compositions of fruit and flowers painted with the aid of stencils, to reverse paintings on glass decorated with reflective foils applied using a technique known as tinsel painting. Outside the school environment, the taste for flower painting developed into formal compositions of bountiful still-life arrangements that came to be called "dining room pictures." By the turn of the twentieth century, this type of ornamental painting was satirized by artists such as Henry Church Jr. (1836–1908), whose *The Monkey Picture* interjected the mischievous animal wreaking havoc with the carefully arranged fruits and flowers. Most functional aspects of American folk painting had by now declined or been replaced with commercially produced goods. Nostalgic views of old-fashioned scenes presaged the memory paintings of transitional artists such as Anna Mary Robertson "Grandma" Moses (1860–1961), while idiosyncratic visions superseded adherence to convention.

Memory painters proliferated during the first half of the twentieth century. Contemporary folk painters like Grandma Moses and Horace Pippin (1888–1946) seemed to embody a sense of nostalgia and a desire to record history. Like earlier folk painters, landscape, portraiture, and genre scenes were still the dominant subject matter for these early-twentieth-century artists. Often, a lack of technical proficiency, especially in the sense of perspective, charmed fans of folk painters at this time. Montgomery, Alabama, artist Bill Traylor (1854–1949) used simple forms and a limited palette to create marvelously complex compositions. Painting for only three years when he was already in his eighties, Traylor created approximately 1,500 works, each recording aspects of his community and culture.

The aesthetic space between Moses' quaint canvases and Traylor's stark, Modernist-like images illustrate the great variety and diversity in contemporary folk painting. Painting during this time is more personalized, more idiosyncratic, and often more psychologically revealing. In fact, artists working in the second half of the twentieth century to the beginning of the twenty-first are so diverse and individualistic that the term folk is rarely used any longer. Moreover, "folk" painting is heard less frequently than "self-taught," "vernacular," "outsider," or "visionary." While culture is as evident as ever in contemporary expressions in paint, few students in art describe it as folk painting. Still, contemporary artists like Southerner Howard Finster (1915–2001) have continued to depict their religious convictions, while artists like Thornton Dial (1928–) illustrate social conditions in America, and secretive painters such as Henry Darger (1892–1973) appropriate popular culture in singular paintings. It is the very same idiosyncratic voice and distinct visual vocabulary of each artist that has invited new terminology into the discourse. The use of found objects and available materials continues to determine the variety of forms and mediums as well as the inventive techniques that self-taught and vernacular artists employ. For these reasons and others, one is more inclined to describe contemporary self-taught artists and their work as vernacular or visionary, rather than folk.

See also **African American Folk Art (Vernacular Art); Boxes; Calligraphy and Calligraphic Drawings; Henry Church Jr.; Henry Darger; Decoration; Thornton Dial; Family Records; Erastus Salisbury Field; Howard Finster; Fireboards and Overmantels; Fraktur; Furniture, Painted and Decorated; German American Folk Art; Edward Hicks; Jurgan Frederick Huge; Painting, Landscape; Painting, Memory; Painting, Theorem; Maritime Folk Art; Anna Mary Robertson "Grandma" Moses; Outsider Art; Pennsylvania German Folk Art; Horace Pippin; Rufus Porter; Religious Folk Art; Retablos; Shaker Drawings; Shakers; Painting, Still-life; Tinware; Bill Traylor.**

BIBLIOGRAPHY

Bishop, Robert. *Folk Painters of America*. New York, 1979.

Black, Mary, and Jean Lipman. *American Folk Painting*. New York, 1966.

Chotner, Deborah, et al. *American Naïve Paintings: The Collections of the National Gallery of Art Systematic Catalogue*. Washington, D.C., 1992.

Ebert, John, and Katherine Ebert. *American Folk Painters*. New York, 1975.

Hollander, Stacy C., et al. *American Anthem: Masterworks from the Collection of the American Folk Art Museum*. New York, 2001.

Lipman, Jean, and Tom Armstrong, eds. *American Folk Painters of Three Centuries*. New York, 1980.

Lipman, Jean, et al. *Five Star Folk Art: One Hundred American Masterpieces*. New York, 1990.

———. *Young America: A Folk Art History.* New York, 1986.

Longhauser, Elsa, and Harald Szeemann. *Self-Taught Artists of the Twentieth Century: An American Anthology.* San Francisco, 1998.

Rumford, Beatrix T., ed. *American Folk Portraits: Paintings and Drawings from the Abby Aldrich Rockefeller Folk Art Center.* Boston, 1981.

———. *American Folk Paintings: Paintings and Drawings Other Than Portraits from the Abby Aldrich Rockefeller Folk Art Center.* Boston, 1988.

STACY C. HOLLANDER AND BROOKE DAVIS ANDERSON

PAINTING, LANDSCAPE is a broad and diverse category of American folk art that spans the full range of American history, geography, and culture. Practiced in a wide variety of styles and forms, landscape painting offers insight into the complex relationship between human subjects and the natural environment. At times the category of landscape painting overlaps with those of genre and history painting. There is also a strong relationship between this category and architectural ornamentation. Owing to the importance of the landscape painting in American fine art, and the popularization of this topic in print media, folk landscape painting bears a closer resemblance to its academic counterpart than many other categories of folk art.

Many of the earliest folk landscapes appeared in the form of decoration on interior architectural elements. Landscape painting had been an important component of room decoration in late seventeenth and early eighteenth century England, and it was brought to America by English artists. This form of ornamentation consisted of landscapes in oil on canvas or wood, often set into the paneling above a fireplace (hence the term "overmantel") or inserted into the fireplace opening as a fireboard. A significant body of work exists as landscape scenery painted in oil directly onto plaster walls. The primary sources for imagery for this early work were European engravings of idealized landscapes, widely available in eighteenth-century America, and imported European (mainly French) scenic wallpaper.

A large number of itinerant painters of landscape overmantels worked in New England during the eighteenth and early nineteenth centuries. There was, for example, a large group of decorators working in central Massachusetts, and significant bodies of work in and around Boston and Salem. The most important practitioners of landscape decoration at this time were Michele Felice Corné (c. 1752–1845) and Winthrop Chandler (1747–1790). Corné emigrated from Naples to Salem 1799, and his scenic work in Salem included "chimney pieces" (overmantels) of the Pilgrims' landing at Plymouth and the launching of the Essex, both executed for the Salem East Indian Marine Society in 1804. Corné also worked in Boston by 1810 and Newport, Rhode Island, by 1822. Chandler worked in rural Connecticut and Worcester, Massachusetts, as a portrait and landscape painter, among other crafts, and left a small but significant group of decorative overmantels featuring generalized townscapes.

The painting of scenic wall murals, another form of folk landscape painting, has a long history in western culture, dating from the hunting scenes in prehistoric caves and the many murals of pharonic Egypt and classical Greece and Rome. In the Middle Ages, noble families hung large woven tapestries depicting historical and mythological scenes on their walls for decoration as well as insulation. By the eighteenth century, printed papers were made that continued the tradition of scenic views on interior walls and became extremely popular. In the United States, scenic wallpaper had to be imported from England or France. It was relatively expensive and difficult to obtain. A number of folk artists in New England and New York were quick to respond to the fashion and produced handpainted landscapes in competition with imported wallpaper. These include Corné, Rufus Porter (1792–1884), Jonathan D. Poor, Orison Wood (1811–1842), and William Price. The style flourished in the 1820s and 1830. As tastes changed, many murals were covered later with wallpaper, only to be discovered by later generations.

The largest number by far of scenic wall murals painted in the northeastern United States in the early nineteenth century was done by Rufus Porter and his followers. Porter was one of the most influential folk artists of all time, and his writings transformed, and largely created, a folk landscape style. His seminal book *A Select Collection of Valuable and Curious Arts and Interesting Experiments* (1825) included a section on wall painting, and his essays from the 1840s on various types of paintings broadened the audience for his ideas. Porter is credited with several innovations in folk landscape paintings: he encouraged the use of stencils in landscapes as an efficient and practical way of adding detail; he advocated painting a generalized rather than specific landscape scene; and he pioneered the use of camera obscura, a method used to project images on a wall, as a means of reducing images for miniature landscape painting. Porter's practical decorative approach was very popular and widely practiced by his followers, who included his son S.T. Porter and his nephew Jonathan D. Poor. His writings influenced many other artists

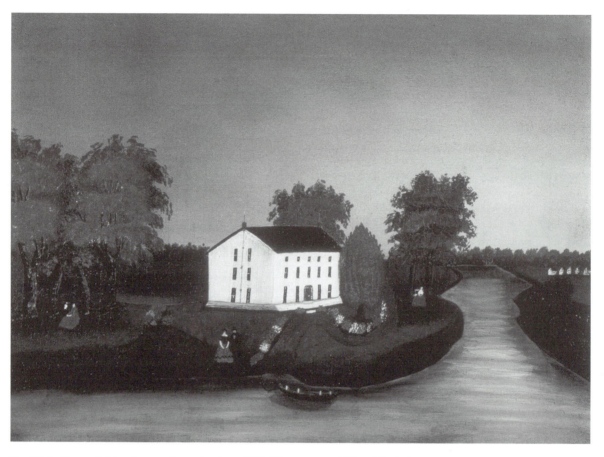

The White House. Artist unknown; Pennsylvania, c. 1855. Oil on canvas; 12¼ × 17¼ inches.
Collection American Folk Art Museum, New York, 1992.10.14.
Photo courtesy Helga Photo Studio.

such as Orison Wood and William Price to work in the Porter style.

Folk landscape painters also made extensive use of published prints as sources for their imagery. A favorite source for mid-nineteenth century folk artists was Nathaniel Parker Willis' *American Scenery*, published in 1840 with engravings of well known landmarks drawn by the English artist William Henry Bartlett. Folk artists such as Thomas Chambers rendered many images from *American Scenery* in a lively, decorative folk style. In supplying inexpensive paintings of the American landscape to a middle-class market, folk artists did much to foster popular taste for American scenes.

These folk artists also expanded the range of mediums for executing landscapes. One popular medium, marble dust painting, was particularly well suited to romantic landscape imagery. First called "Grecian painting" by the English artist B.F. Candee, and later called "monochromatic painting" by the

American artist and teacher Silas Wood Jr., marble dust painting was executed on an artist's board that was painted white and coated with marble dust sifted through fine muslin. When dry, this created a rough, dark surface that the artist could scrape away with leather or a knife to create strongly contrasting light and dark areas. This art form was very popular in female seminaries, where young women utilized prints found in popular magazines or books as source material. The dark, shimmering effect of marble dust painting lent itself well to moody landscapes from Gothic literature depicting castles, ruins, and bodies of water by moonlight.

In many cases, folk artists who were better known for their portrait paintings created significant landscapes as well. For example, William Matthew Prior (1806–1873) was a highly successful portraitist in Maine and Boston, Massachusetts, yet painted numerous landscapes in the 1850s. Some of Prior's landscapes are generalized renditions of such subjects as

lake scenes, while others depict national landmarks such as Washington's tomb at Mount Vernon, derived from popular prints. It is significant that Prior turned increasingly to landscape painting after the development of popular photographic techniques such as the daguerreotype captured most of the portrait business. Another portrait painter, central New York State artist Henry H. Walton, painted bird's-eye views of towns near Ithaca as well as in the Corning area of New York's southern tier.

A number of important nineteenth-century folk artists created townscapes with significant landscape elements. For example, Joseph H. Hidley (1830–1872) painted meticulously detailed scenes of his village, Poestenkill, New York, from different angles and at different times of the year. In these works, Hidley shows not only his ability to accurately depict buildings and human activity, but also his skill at placing the village and people within a convincing and beautiful landscape of rolling hills and pastures. Similarly, Charles Hoffmann's and John Rasmussen's paintings of the Pennsylvania almshouses include the surrounding landscape in decorative vignettes on the margins of the paintings. Paul Seifert's Wisconsin farmscapes from the 1880s capture an agricultural landscape that emphasizes harmony between people and the land.

Landscape painting continued to be a major painting subject well into the twentieth century. Its premiere practitioner was Anna Mary Robertson "Grandma" Moses (1860–1961). Grandma Moses painted as a child but it was not until she was in her seventies that she began painting her now famous memory paintings. Her works, although influenced by prints, newspapers, and magazines, are based mostly upon her own experiences as the wife of a farmer in upstate New York. It was Grandma Moses who mastered the stylistic and compositional device of setting her depictions of human activity within an expansive landscape. Moses' paintings often have a high horizon line to afford the viewer a bird's-eye view of the surroundings. In this manner Grandma Moses expressed her love of nature and emphasized the importance of the environment to a rural farming community. She gained immense popularity in the 1940s because of her depictions of a presumably less complex, happier era in American history. Consequently, Moses inspired a generation of folk painters to depict their memories in much the same manner as she did, thus creating a whole school of folk painting based upon the landscape.

Working in a style reminiscent of Grandma Moses, the Southern folk artists Queena Stovall (1887–1980) and Mattie Lou O'Kelley (1908–) documented the rural communities in which they lived in the mid- and late twentieth century. Stovall's paintings of farm life in western Virginia nearly universally include the surrounding Blue Ridge Mountains as well as the valleys and hollows in which the people lived and worked. O'Kelley painted the Georgia countryside using bright colors and a pointillistic technique using small dots of pure color that at a distance appear to form shapes and areas of tone, and including the same rich detail of people and places remembered as Moses and Stovall. Significantly, all three of these folk memory painters began to paint in retirement, after a long working life.

Another noteworthy twentieth-century folk artist who mainly painted landscapes, Joseph Yoakum (c. 1886–1972), is a much more mysterious character. Yoakum sold his landscapes out of a shop window in Chicago, Illinois, and claimed that the works represented the immense scope of his journeys in life. Working in pen, pencil, pastels, and watercolor on paper, Yoakum created vibrant and stylized renditions of exotic landscapes in the American west, South America, and Antarctica, among other regions. He identified each scene in neatly written inscriptions and often dated the pieces with a date stamp.

The extent to which landscape has captured the imagination of American folk artists is evident in the persistence of the subject through the full chronological range of American folk art, from the itinerant decorative painters of the seventeenth century to the isolated, "outsider" artists of the twentieth. Images of the land played a major role both in expressing national values and a local sense of place.

See also **Almshouse Painters; Architecture, Vernacular; Thomas Chambers; Winthrop Chandler; Michele Felice Corné; Decoration; Fireboards and Overmantels; Joseph H. Hidley; Anna Mary Robertson "Grandma" Moses; Mattie Lou O'Kelly; Outsider Art; Painting, Memory; Rufus Porter; William Matthew Prior; Queena Stovall; Henry H. Walton; Joseph Yoakum.**

BIBLIOGRAPHY

Lipman, Jean. *Rufus Porter, Yankee Pioneer.* New York, 1968.

Little, Nina Fletcher. *American Decorative Wall Painting, 1700–1850.* Sturbridge, Mass., 1952.

Rumford, Beatrix T., ed. *American Folk Paintings: Paintings and Drawings Other Than Portraits from the Abby Aldrich Rockefeller Folk Art Center.* Boston, 1988.

PAUL S. D'AMBROSIO

PAINTING, MEMORY emerged as a distinct category of folk art in the last two decades of the twentieth century, despite a long history of vernacular image-making aimed at preserving cherished memories that might otherwise lapse into oblivion. In late eighteenth century America, the vogue of "memorial paintings" or "mourning pictures" testifies to the widespread urge to temper the ache of loss through well-crafted commemorations of the recently dead. Typically executed in watercolor or needlework and tied to conventional formats, these homemade images rely on a limited range of melancholy motifs, such as tombs, weeping willows, and female mourners clad in classical garb. The styles of gravestone carving likewise draw upon a fixed repertoire of winged cherubs, doves, a finger pointing to the heavens, and the like. Interestingly, these grief-inspired modes of memorializing almost never sought to capture a physical likeness of the deceased, although a somewhat morbid cult of death portraiture in the medium of photography arose after the mid-nineteenth century.

In the early days of American settlement, pioneers who had accomplished the arduous task of establishing a viable homestead would sometimes commission an itinerant limner to create a painted record of their property. Painstakingly rendered in a naive, literalistic manner, and often enumerating livestock and family members alongside the farm buildings, such "inventory paintings" represent a statement of pride in one's hard-earned possessions and reflect a desire to achieve permanence through visible evidence. Throughout the nineteenth century, other folk art genres serviced the same cult of the emblematic image, whereby vague surges of nostalgic feeling could be marshaled and converted into stable and cogent forms of expression, thereby staving off the all too human tendency to erase the past. One such genre was "history painting," whose simple task was to provide a visual record of public events, whether recent or remote; by keeping track of essential facts in the collective memory, it also functioned as support to civic pride. *Burning of Old South Church, Bath, Maine* (c. 1854) by John Hilling (1822–1894), for instance, is an emotive image capturing a violent event in a small community's very recent past. Other examples of history painting include the countless amateur renderings of the more distant military feats of Gen. George Washington, reverently retrieved, so to speak, from the deep pool of national remembrance.

Once the term "memory painting" entered modern parlance, it was as if it tacitly confirmed a continuity between those earlier commemorative genres and the projects of more recent folk artists. The term's immediate application arose from the recognition that a significant number of elderly female autodidacts had been cultivating more or less the same memory-inspired themes. Of these women, the paradigmatic figure was the most celebrated of all twentieth-century folk artists, Anna Mary Robertson Moses, commonly known as Grandma Moses (1860–1961). Moses was a countrywoman who spent most of her life on a farm in upstate New York; it was not until her seventies, a few years after her husband's death, that she devoted herself fully to her painting. Moses based her work upon a rich fount of personal and communal reminiscence, occasionally exploiting popular prints or press cuttings as templates for her festive commemorations. Her representations of harvesting, maple syrup gathering, and Christmas celebrations were executed in a deft style that communicates the illusion that farm life in her beloved Hoosick Valley had never been less than a perfect idyll. Her remembered landscapes are steeped in the charmed hues of nostalgic reminiscence, and are often punctuated by deliberately archaic references, such as staging coaches and horse-drawn plows. Moses' pastoral vision gained in popularity what it lacked in realism, for her topography is never truly accurate, nor does she acknowledge large areas of experience, such as accidents and suffering; from her pictures, one might think she had never attended a funeral, although she is not afraid to paint a thunderstorm or a menacing snowfall.

The congenial example of Grandma Moses shows how memory painting diverges from history painting, in that it tends not to reconstitute an actual past but to fabricate a mythic yesteryear, a selective, even rose-tinted artifice that seems impervious to change. There are indications that the nationwide popularity of Moses' images after 1945 is in part explicable by the Cold War (1946–1990), a time when American patriotism hankered for positive images of the homeland. Moses' folkloric idealizations may offend the historian yet still delight the art lover, for her landscapes epitomize the virtues of the best of naive art in their intricacies of detail and their quasi-impressionistic subtleties of hue. With such art, the criterion of factual accuracy is superseded by that of formal integrity.

A list of outstanding exponents of memory painting might include such names as Grandma Moses, Clara McDonald Williamson, dubbed "Aunt Clara" (1875–1976), Fannie Lou Spelce (1908–1998), Minnie Smith Reinhardt (1898–?), and Mattie Lou O'Kelley (1908–1997); with Esther Hamerman (1886–1977), Nan Phelps (1904–1990), and Jessie DuBose Rhoads (1900–1972) also deserving of mention. These artists

are far from constituting a formal group or school, yet they tend to share similar biographies and thematic material. They were all elderly white countrywomen, typically widows, who were devoted to the gentle delineation of private and public recollections, and occasionally of single incidents, as with Williamson's poignant *The Day the Bosque Froze Over* (1953), but more often they documented routine or seasonal events, as with Minnie Reinhardt's many tableaux of her family making molasses in the fall. An instinctive allegiance to a friendly, luminous topography is manifested in their stock views of farmland and rolling hills; and although individuals appear in family or village groups, solo portraits are the exception. These memory painters, usually from large families, seem less interested in autobiographical escapades and more in those fixed landmarks, collective rituals, and daily chores that nurture community identity. Moses herself was born as early as 1860, while the others were born a generation or more later than she was; none emerged as active artists, however, until after World War II. Thus the precious memory traces that they recover and restore through their picture-making date back to the first two or three decades of the twentieth century, when rural folkways were already beginning to be overtaken by industrialization and urbanization. This explains why their work is so deeply nostalgic, for it often evokes traditions and situations that in reality have been obliterated.

If this "classic" grouping reflects a common understanding of the term "memory painting," a strong case can also be made for its wider application. For one thing, the no less nostalgic or idealized landscapes of Joseph Pickett (1848–1918), Harold Osman Kelly (1884–1955), and Nick Engelbert (1882–1962) testify to the arbitrariness of the definition as restricted by gender. Further, there seems to be no reason not to apply the term to art that, resisting the temptation to prettify the past, turns an honest and unblinking eye upon remembered scenes. Picture-making in this more austere vein adds a wider orbit to memory painting, showing it to be capable not only of mediating facts but also of voicing a concern with social and, indeed, political issues. For example, the imagery of Tella Kitchen (1902–1988) is comparable to that of Grandma Moses' insofar as its frame of reference is the artist's rural locality and its folk life. On the other hand, Kitchen places more emphasis on contemporary events, as witnessed in such storytelling pictures as *When the Fred Buck Livery Stable Burned* (1976), in which she foregrounds the keenness of local inhabitants to tackle the crisis together, and to help lead the horses to safety. The fact that Kitchen succeeded

her husband as mayor of her Ohio town is indicative of her solidarity with her neighbors, reinforcing her vocation as guardian of local memories. An artist working at an earlier period but in a similar vein was the Swedish immigrant Olof Krans (1838–1916), who in old age consulted his memories, and a stock of ancient photographs, to re-create the life of a religious colony at Bishop Hill in Illinois, where he had lived as a teenager. Though attractive to the eye, Krans's masterly orchestrations of communal planting and harvesting are scenes of regimented toil that none would relish revisiting in actuality.

There are, of course, other examples of artists whose range of recollection encompasses painful memories; many are to be found in the context of African American folk art or vernacular art. Certain late paintings of Horace Pippin's (1888–1946) cut to the quick in their documentation of poverty-stricken family life in the rural South, while the Louisiana artist Clementine Hunter (c. 1886–1988) has an esteemed reputation as the chronicler of plantation life on the Melrose Estate of the 1900s. Thanks to her unabashed deployment of bright paints in simplified configurations, Hunter's evocations of an all but forgotten yesteryear evince a surface sweetness; yet her depictions of cotton picking, sugarcane harvesting, hog slaughtering, and laundering, not to mention funerals and wakes, indicate that, here at least, memory painting does not shy away from the realities of hard work and death. The glimpses of rural Alabama painted by Bernice Sims (1926–) are imbued with the sense of physical toil and the material privations of an underprivileged black community. Produced near the end of his long life, the jaunty sketches of Bill Traylor's (1854–1949) represent a cascade of memory traces concerning the Alabama plantation on which he had been born into slavery. In contrast to the industrious literalism of much memory painting, Traylor's style is sparse but full of caricature and humor, yet it also communicates a serious and persuasive sense of authentic folk reminiscence.

A further extension of the canon would involve rejecting the widespread assumption that memory painting is exclusively rural. There is any number of self-taught artists for whom the past of cities represents a rich source of inspiration. The elderly Jacob Kass (1910–2000) painted aerial views of the Brooklyn suburbs of his youth, squeezing the details of busy market stalls and shops into the narrow confines of a handsaw, his eccentric choice of support. Another native New Yorker, Vestie Davis (1903–1978) specialized in portrayals of crowds, such as the pleasure-seekers on Coney Island in the 1930s. That

Davis, like Krans, drew on old photographs confirms an attachment to those telling details that inject poignancy into bygone scenes. Yet another New Yorker, Ralph Fasanella (1914–1997) produced a considerable body of work based upon memories dating from his childhood in an immigrant neighborhood in Greenwich Village. As a union activist, Fasanella placed his art in the service of working class interests and values. His city is painstakingly authenticated by the naming of buildings and streets, while his exposure of sweatshops, factories, tenements, reform schools, and penurious interiors are a revelation on a par with the politically tinged documentary work of professional photographers like Jacob Riis (1849–1914) and Lewis Hine (1874–1940).

It is clear that it would be pointless to expect memory painting to tabulate only absolutely authenticated past occurrences. Self-taught artists are hardly ever committed to an ideal of objectivity, even though some make claims about the reliability of their memory. Whether the genre is understood in the restricted sense exemplified by Grandma Moses, or whether it is understood in an expanded sense that embraces work by males, non-whites, and city-dwellers, not to mention social activists, the essential ingredient of such art is the fervor with which it summons up the past, breathes life into long-vanished scenes, and, thanks to the intimacy and intensity of its focus, instills meanings that are inevitably non-objective. If it is acceptable to allow some flexibility to the concept, it would seem sensible, nevertheless, to consider memory painting as typically an art of elderly creators who draw upon decades of absorbed experience. Theirs tends, moreover, to be a selective and nostalgic vision rather than an all-retentive and dispassionate one. In this sense, memory painting may be said to operate by the standard of poetic truth, a standard that acknowledges the relevance of emotion. True, there is always the danger of its slipping into complacent sentimentality and kitsch. Yet, at its best, memory painting opens up the prospect of events that, tenderly or trenchantly rendered, hint at the tacit mutuality of human experience.

See also **African American Folk Art (Vernacular Art); Vestie Davis; Ralph Fasanella; Gravestone Carving; Esther Hamerman; Clementine Hunter; Jacob Kass; Tella Kitchen; Olof Krans; Anna Mary Robertson "Grandma" Moses; Mourning Art; Mattie Lou O'Kelley; Painting, American Folk; Nan Phelps; Photography, Vernacular; Joseph Pickett; Pictures, Needlework; Horace Pippin; Fannie Lou Spelce; Bill Traylor.**

BIBLIOGRAPHY

Adele, Lynne. *Spirited Journeys: Self-Taught Texas Artists of the Twentieth Century*. Austin, Tex., 1997.

Bishop, Robert. *Folk Art: Painting, Sculpture, and Country Objects*. New York, 1983.

Bishop, Robert, and Jacqueline M. Atkins. *Folk Art in American Life*. New York, 1995.

Johnson, Jay, and William C. Ketchum Jr. *American Folk Art of the Twentieth Century*. New York, 1983.

Kallir, Jane. *Grandma Moses in the Twenty-first Century*. Alexandria, Va., 2001.

Rhodes, Lynette I. *American Folk Art: From the Traditional to the Naïve*. Cleveland, Ohio, 1978.

Russell, Charles, ed. *Self-Taught Art: The Culture and Aesthetics of American Vernacular Art*. Jackson, Miss., 2001.

Vlach, John Michael. *Plain Painters: Making Sense of American Folk Art*. Washington, D.C., 1988.

Watson, Patrick. *Fasanella's City*. New York, 1973.

Wilson, James L. *Clementine Hunter: American Folk Artist*. Gretna, La., 1990.

Zug, Charles G. III, ed. *Five North Carolina Folk Artists*. Chapel Hill, N.C., 1986.

ROGER CARDINAL

PAINTING, STILL-LIFE is a centuries-old tradition of visually representing arrangements of inanimate objects, both manmade and natural. Examples from antiquity often appeared on walls and mosaics, and were mimetic, that is, imitating life and intended to fool the eye. By the seventeenth century, realistic depictions of actual–size objects from daily life had become closely associated with Dutch artists, whose word *stilleven* was adopted into English as "still-life."

The earliest American still-life may be *Fruit Piece* (c. 1765), painted by Matthew Pratt (1734–1805), but it was the Peale family who were the most ardent proponents of academic still-life painting in America. In 1795 the initial Columbianum exhibition organized by Charles Willson Peale (1741–1827) in Philadelphia included several examples, but the type of formal composition the Peales advocated did not gain favor until the middle of the nineteenth century. This was a demonstration, in part, of the persistence of the low regard in which the genre had been held by the powerful French Academy. As a result, some of the earliest American still-life imagery occurs as symbolic vignettes within more acceptable categories, such as portraiture. The first such painting in the American colonies may be the 1680 self-portrait by Capt. Thomas Smith, whose hand rests on a skull in a type of still-life called *vanitas,* which evokes a sense of the brevity of life on earth. Bowls of fruit or urns of flowers in female portraits were references to beauty or fertility. By the nineteenth century still-life elements in portraits more often referred to real associ-

ations, such as orchards or related indicators of wealth.

In the folk art genre, still-life painting first flourished early in the eighteenth century on interior architectural forms. Urns of flowers proliferated on doors, overmantels, fireboards, wood paneling, and furniture, followed by arrangements of shells, flowers, and fruit. By the turn of the nineteenth century, the influx of botanical prints, books, herbals, and gardeners' manuals, such as Robert Furber's *The Flower Garden Displayed* (London, 1732), inspired botanical imagery in a variety of arts. Some of these publications explicitly indicated that their illustrations provided useful models for artistic endeavors. Furber states, for instance, that the plates included in his volume are "Very Useful, not only for the Curious in Gardening, but the Prints likewise for Painters, Carvers, Japanners, etc., also for the ladies, as Patterns for Working, and painting in Water-Colours or Furniture. . . ." Additionally, instruction manuals specifically for the art of fruit and flower painting started to become available about the same time.

The Federal-period taste for silk embroideries of baskets of fruit or flowers gave way to a technique known as theorem painting. Typically rendered in watercolor on velvet, theorem painting (also known as Poonah painting) was widely taught at female academies from about 1820 to 1840. Still-lifes of fruit and flowers were accomplished with the aid of hollow-cut stencils, or theorems; some examples required multiple stencils to build up the final composition. The distinctive shading associated with this form resulted from the application of color by means of pouncing against the sharp inner edge of the stencil, and working gently toward the center. In addition to designs provided by teachers or copied from books, lithographic prints of fruits and flowers were also widely distributed by companies such as Kellogg & Comstock, and Currier & Ives.

When theorem painting waned toward the middle of the century, it was largely replaced by "tinsel painting," a technique of reverse painting on glass characterized by the application of foil behind unpainted areas. Tinsel painting was popular from the mid-1830s through about 1890, and the most common images were of floral wreaths and vases of flowers. After the mid-nineteenth century, another type of still-life emerged, which art historian William H. Gerdts calls "the mid-century aesthetic of profusion and overabundance." These "dining room pictures," as they came to be known, showed bountiful displays of fruit spilling onto a dining table. The sense of satisfaction suggested by these images was often extended to the "plenty" of America itself through landscape window views that provided a larger national context for individual well-being.

By the turn of the twentieth century, the still-life genre was so well established and understood by the general public that it became the object of amused satire for artists such as Henry Church Jr. (1836–1908), who painted *The Monkey Picture,* a still-life with fruit and two monkeys, about 1895–1890. Indeed, the genre has continued to inspire contemporary commentary in the work of self-taught artists, demonstrating the endurance of notions of abundance, as well as the depth of meaning found through the still-life idiom.

See also **Joseph Goodhue Chandler; Henry Church Jr.; Decoration; Fireboards and Overmantels; Furniture, Painted and Decorated; Sybil Gibson; Painting, Landscape; Painting, Theorem; Pictures, Needlework; Reverse-Glass Painting.**

BIBLIOGRAPHY

Brindle, John V., and Sally Secrist. *American Cornucopia: Nineteenth-Century Still-Lifes and Studies.* Pittsburgh, Pa., 1976.

Chotner, Deborah, et al. *American Naïve Paintings: The Collections of the National Gallery of Art Systematic Catalogue.* Washington, D.C., and Cambridge, England, 1992.

Gerdts, William H. *Painters of the Humble Truth: Masterpieces of American Still-Life, 1801–1939.* Columbia, Mo., 1981.

Rumford, Beatrix T., ed. *American Folk Paintings: Paintings and Drawings Other Than Portraits from the Abby Aldrich Rockefeller Folk Art Center.* Boston, 1988.

Wilmerding, John. *An American Perspective: Nineteenth-Century Art from the Collection of Jo Ann and Julian Ganz Jr.* Washington, D.C., 1981.

STACY C. HOLLANDER

PAINTING, THEOREM is a technique in which artists use stencils in applying paint to paper, fabric, or other materials. The term "theorem," first used in an 1830 text, *Theoremetical System of Painting, or Modern Plan, Fully Explained in Six Lessons and Illustrated with Eight Engravings by which a Child of Tender Years Can Be Taught This Sublime Art in One Week,* refers to the stencils used in the process, and not to the painting itself. Theorem painting has also been referred to as Indian tint-work, formula painting, or Chinese painting, and occasionally as Oriental tinting or Poonah work (a style of painting named for its origin in Poona or Pune, India, and popular in England in the nineteenth century, in which thick, opaque and unmodulated color is applied to thin paper, to produce flower and bird motifs in imitation of Oriental work). These latter two terms, however,

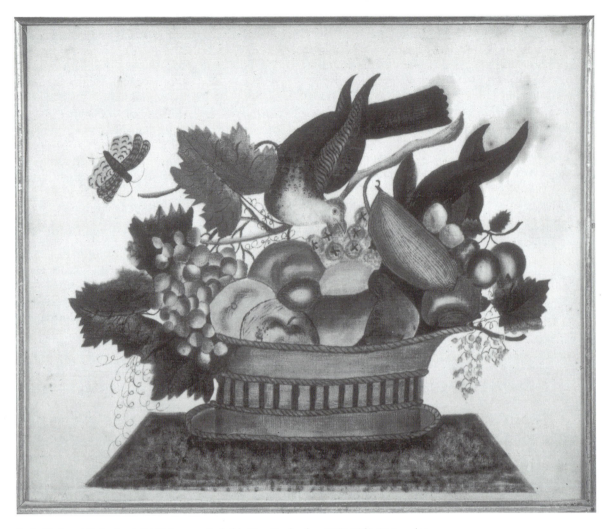

Fruit, Bird, and Butterfly. Artist Unknown. Probably New England, c. 1825–1840. Watercolor on white velvet; 15⅜ × 18¾ inches. Collection American Folk Art Museum, New York, 1984.13.1.
Photo courtesy Helga Photo Studio.

refer respectively to stenciling with watercolors on paper or stencil work on silk.

The origins of stencil painting are not fully known, although stencils were recorded as being used for decoration in the Far East in the eighth century. Eighteenth-century trade with China introduced this style of decoration to the west via painted ceramics and lacquerware, and the style quickly became popular. British and European craftsmen soon developed stenciling methods in imitation of the oriental work, and the technique began to be applied to many different media, including paper, fabric, and wood in addition to ceramics and tinware.

Americans knew of stencil painting from both the oriental import ware as well as from British and European pieces, and it became as admired in the United States as in England and on the Continent. Theorem painting began to be taught in America as early as 1800, and it was added to the curricula of some girls' schools as early as 1812. By the 1820s it had become one of most lauded types of painting for women, schoolgirls, and housewives alike, and teachers who specialized in theorem painting found ready audiences for the subject.

Part of the appeal of theorem painting lay most likely in its decorative versatility. It could be used to

create bright and lively compositions for framing, and then, the same stencils might be used to decorate tabletops and storage boxes, tinware, textiles, and even walls. Women who became extremely proficient in theorem painting could not only embellish their domestic interiors, but they also could often supplement the family income through employment in workshops producing tinware, chairs, and clock faces, many of which used painted stencil decoration on their products.

Theorem painting required considerable skill. It was not mechanistic work, as the artist had to compose a variety of stencil patterns into pleasing arrangements and then make careful use of color and shading to achieve the desired naturalistic effect in the final product. Fruit and flowers in endless combination formed the core iconography for theorem painting. The stenciled compositions might be leavened by the free-hand addition of bowls, silverware, tables, chairs, drapery, birds, and butterflies, with delicate details added with a fine brush. The stencils were usually made of oiled, waxed, or varnished paper which could be cut at home or by professionals. Decks of "drawing" cards carrying theorem designs could also be purchased, and mid-nineteenth century ladies' magazines occasionally included stencils for women to copy along with instructions for their use. The wide availability of stencil designs through the mass media and other commercial outlets explains why common elements can be found in theorem work from different geographic regions.

Both oil paints and watercolors were used in theorem work, with the choice of paint depending largely on the material to which it was to be applied as well as the end effect desired. Velvet was a popular choice for theorem painting, as it gave a depth and surface texture to the finished product that was desirable; it was, in fact, so much in vogue that this type of work became known to many as "velvet painting." Velvet was an especially well-liked choice when theorems were used in the decoration of clothing, such as handbags or scarves. Theorems were also used on cotton and muslin to create vivid and patterned furnishings such as bedspreads and curtains.

Theorem painting in America remained popular until about 1860, when new technologies allowed for the inexpensive production of art prints, printed textiles, and decorated furniture that appealed to a broad segment of society. Industrialization eventually led to theorem painting's relative rarity, as the number of practitioners began to dwindle. Because of its versatility, however, theorem painting did not disappear as did some other popular arts of the nineteenth century, such as needlework pictures and mourning pictures, but rather remained a practical and practiced art, albeit on a smaller scale. Today, theorem painting still has a dedicated group of decorative and folk art admirers and practitioners who not only help to expand the contemporary public's appreciation of nineteenth-century theorem art but who also enjoy the practice of the art.

See also **Boxes; Chairs; Furniture, Painted and Decorated; Metalwork; Mourning Art; Painting, American Folk; Painting, Still-life; Pictures, Needlework; Tinware, Painted.**

BIBLIOGRAPHY

Baer, Shirley S., and M. Jeanne Gearin, eds. *Decorative Arts: 18th and 19th Century: The Research and Writings of Shirley Spaulding DeVoe.* New York, 1999.
Finn, Matthew D. *Theoremetical System of Painting.* New York, 1830; reprinted, 1998.
Lefko, Linda Carter, and Barbara Knickerbocker. *The Art of Theorem Painting.* New York, 1994.

JACQUELINE M. ATKINS

PANORAMA PAINTING: *SEE* FOLK PAINTING.

PAPERCUTTING, a multicultural folk art that is still widely practiced, was brought to America in the seventeenth to twentieth centuries, first by colonists, and then by immigrants, who introduced their various traditions. In early America, papercutting was an accessible and inexpensive way to bring art and design into domestic life. Family portraits, religious images called devotionals, and home decorations could be produced using simple tools: embroidery scissors or sharpened penknives, paper, and wheat paste.

Silhouettes, based on French papercutting, were popular in America during the mid-eighteenth to mid-nineteenth centuries. Itinerant silhouette cutters, many who supplemented their incomes as portrait and landscape painters, traveled from town to town capturing a quick and accurate likeness of their sitters for posterity, at an affordable price. Some notable silhouette artisans included Martha Anne Honeywell (1787–1848), who was born in Lempster, New Hampshire, without hands and who cut profiles by holding scissors in her teeth and paper with her toes; Augustin Edouart (1789–1861), born in France, who worked in American cities for ten years, cutting approximately 10,000 silhouettes; and William Henry Brown (1808–1859), born in Charleston, South Carolina, whose reputation for producing accurate likenesses was renowned. The development of photography, which could more accurately and quickly capture a sitter's

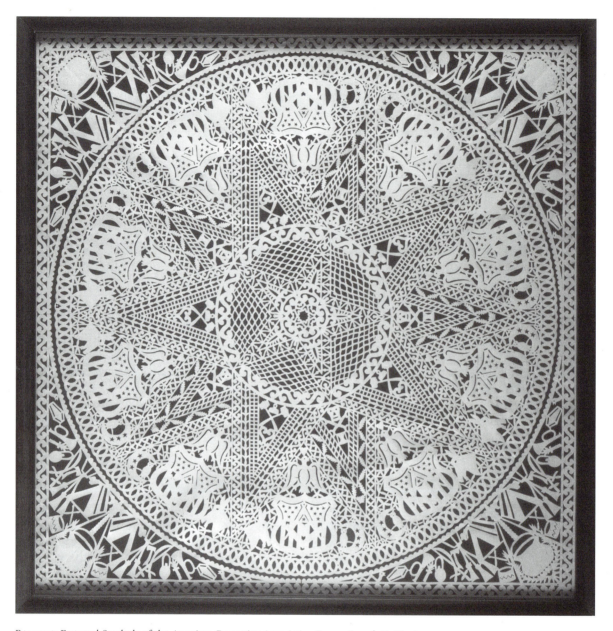

Papercut: Fraternal Symbols of the American Protective Association Paper. Joseph G. Heuts (maker's dates unknown). Probably Pennsylvania, 1919; 28½ × 28½ inches. © Collection American Folk Art Museum, New York, 1985.40.1.

image, in the 1830s eventually minimized the importance of silhouette art.

Scherenschnitte (cut-paper design produced by folding paper and usually symmetrical) was brought to the United States by German and Swiss immigrants. They were used to embellish legal documents, since individual cutting styles were difficult to replicate. Individual styles also illuminated hand-cut valentines as expressions of personal affection. In Pennsylvania,

especially in Lancaster County, many papercutters used *Scherenschnitte* images of hearts, tulips and other flowers, birds, and intricate lace-like borders, combined with painted images, and fraktur (decorative folk art drawings using calligraphy) to illustrate documents such as birth and marriage certificates.

Polish *wycinanki* are also symmetrical, cut-paper designs used for decorative purposes, made with layers of brightly colored papers. Common subjects in-

cluded pictorial images of rural life, including depictions of roosters, flowers, birds, chevrons, eggs, and genre scenes. Two distinctive styles of Polish *wycinanki* were popular: *leluje,* a symmetrical, single-folded cutting showing a central tree, and usually a pair of birds, among other images, and *gwiazda,* circular cuttings with multiple folds so the patterns of chevrons and flowers were repeated eight or more times. In mid-nineteenth century America, *wycinanki* was an inexpensive way for Polish immigrants to provide lively decorations for Christmas and Easter. *Wycinanki* remains a bold and colorful addition to Polish festivals in America where concentrations of Polish Americans live, such as in or near Chicago, New York City, upstate New York, and Connecticut.

Mexican *papel picado* banners (lacey papercuttings based on a grid of squares and punched with sharp marks hammered through layers of colored papers) were incorporated into the culture of the southwestern states in the early to mid-nineteenth century. *Papel picado* banners were strung together across streets on Fiesta (a celebration in San Antonio, Texas) and decorated home altars for Day of the Dead celebrations to remember family ancestors. In American communities with a strong Mexican or Latino heritage, these papercuttings are used to mark All Saints' Day and All Souls' Day (respectively, November 1 and November 2).

Origami, the Japanese art of folded paper and cut paper images of dragons, bonsai trees, water gardens, fish, flowers, animals, and folk tales, were introduced by Asian immigrants when they arrived at the east and west coasts of the United States in the mid-nineteenth century, and also by importers of exotic oriental artifacts. Today, animal-shaped, folded-papers, and cut-paper wall banners of garden images are used as decoration and gifts for Chinese New Year and other festivals celebrated by various Asian American groups, including those from China, Japan, and Korea. Delicate papercut designs were used, as they had been for centuries in Asia, as patterns for fabric and porcelains. Papercuttings of twelve animals associated with the Chinese lunar calendar were used to produce a series of twelve postage stamps designed by Chinese American Clarence Lee (1935–) to commemorate the Chinese New Year and issued from 1992 to 2004 by the United States Postal Service.

Jewish papercuttings traditionally cut to the text of the Old Testament and the Torah, were among the first forms of Jewish American folk art, with the earliest examples dating from about 1850. Jewish papercutting continues to be a rich and spiritual folk art in Jewish American communities. Elaborate compositions incorporating Hebrew text; stars of David; menorahs, a seven-armed candelabra; and the Tablets of the Law have religious, symbolic meanings. *Ketubbot,* marriage contracts stating the responsibilities and duties of marriage to the bride and groom, and illuminated with an intricate, papercut border, and *mizraḥim,* circular cuttings hung on the eastern wall in homes or community buildings to indicate the proper direction for prayer according to Jewish tradition, are common forms of Jewish papercuttings utilizing familiar symbols.

Today, papercutting in America is a vibrant and actively practiced folk art. Many papercutters in America continue to follow traditional forms of papercutting. Ruth Grabner (1927–) of New Jersey cuts silhouettes at school and church fairs, and Anne Leslie (1931–) of Virginia cuts silhouettes while demonstrating her skills in eighteenth century costume at traditional art fairs. Among the papercutters who cut traditional *scherenschnitte,* Marie-Helene Grabman (1950–) of Michigan cuts American themes in her European styled cuttings, Claudia Hopf (1935–) of Maine adds dimension to her papercuttings with watercolors, and Mary Lou Harris (1934–) of Pennsylvania combines calligraphy with papercutting. Roma Starczewska (1935–) of Virginia produces traditional Polish *wycinanki,* while Elzieta Kaleta (1946–) of New Mexico has blended her traditional Polish papercutting skills with motifs from the southwestern United States. Kathleen Trenchard (1948–) of Texas punches *papel picado* banners for Day of the Dead and Fiesta celebrations, and Karen Shain Schloss (1952–) of Pennsylvania makes Jewish papercuttings, especially *ketubbot.* Other American papercutters have creatively introduced independent themes into papercutting folk art to produce individual results. Suzi Zimmerer (1953–) of New Mexico produces black paper equestrian papercuttings, Sr. Clarice Steinfeldt, S.D.S. (1928–) of Wisconsin cuts ecclesiastic papercuttings of First Communion, Holy Days, and religious stories such as Noah's Ark, and Paul Beal (1928–) of Pennsylvania works with trees, forests, and deer images to make his papercuttings.

See also **Asian American Folk Art; Eastern European American Folk Art; Fraktur; German American Folk Art; Martha Anne Honeywell; Jewish Folk Art.**

BIBLIOGRAPHY

Benneck, Katrina. "Symbol in Folk Art." *FIRSTCUT,* vol. 13, no. 3 (summer 2000): 12–13.

Goodpasture, Beatrice. "Dia de los Muertos, Honoring Those Gone, But Not Forgotten." *FIRSTCUT*, vol. 13, no. 1 (winter 2000): 9–11.

Guyton, William Lehman, Mary B. Guyton, and James M. Koenig. *A Basic Guide to Identifying and Evaluating American Silhouettes*. Annville, Pa., 1990.

———. "Chinese New Year Stamps." *FIRSTCUT*, vol. 12, no. 1 (winter 1999): 12.

———. "Year of the Tiger–Commemorative Stamp (Lunar New Year Series)." *FIRSTCUT*, vol. 11, no. 1 (winter 1998): 9.

Harris, Sukey, ed. "Stamps." *FIRSTCUT*, vol. 13, no. 1 (winter 2000): 14.

Rich, Chris. *The Book of Paper Cutting: A Complete Guide to All the Techniques with More Than 100 Project Ideas*. New York, 1993.

Rosin, Nancy. "Devotional: Precursor of the Valentine." *FIRSTCUT*, vol. 13, no. 1 (winter 2000): 17.

Shadur, Yehudit, and Joseph Shadur. *Jewish Papercuts—A History and Guide*. Jerusalem, Israel, 1994.

———. *Traditional Jewish Papercuts: An Inner World of Art and Symbol*. Lebanon, N.H., 2002.

Shemetulskis, Richard. "Chinese New Year." *FIRSTCUT*, vol. 14, no. 1 (winter 2001): 12–13.

Temko, Florence. *Chinese Paper Cuts*. San Francisco, 1982.

Throckmorton, Sue. "Two Traditions. A Comparison of Polish Jewish and Polish Peasant Papercutting." *FIRSTCUT*, vol. 15, no. 2 (spring 2002): 10–12.

Trenchard, Kathleen. *Mexican Papercutting—Simple Techniques for Creating Colorful Cut-Paper Projects*. New York, 1999.

ANGELA MOHR

PARK, LINTON (1826–1906) was the creator of an acknowledged masterpiece of American primitive painting. His *Flax Scutching Bee* (1885) is one of the most exhibited and reproduced of all American folk paintings, because of both its undeniably pleasing aesthetic qualities and its colorful documentation of frontier life.

Park was a product of that frontier, born and raised in Marion (now Marion Center), a town laid out by his father, a surveyor, in Indiana County, west central Pennsylvania. Linton was the youngest of nine children. He never married, but was a beloved uncle to forty-nine nieces and nephews and became a well-known local character. As a boy he helped in the gristmill and tanyard that his father built, and as a young man he worked in the lumber industry. Four of the scenes he painted document aspects of logging trees and floating them down the Susquehanna River. In the 1850s he lived in the Pennsylvania towns of Lancaster, Altoona, and Marietta. He was in Washington, D.C. in 1863 and, according to family legend, assisted in the decoration of the Capitol. As a member of the 2nd Regiment, District of Columbia, Volunteer Infantry, in 1864, he served on the burial detail of the presidential guard. This experience may have helped to inspire two melancholy images of the war's consequences that he painted some thirty years later.

By 1868 he had returned to Marion, where he painted signs and carriages, opened a planing mill with a brother, and made picture frames. A clever inventor, he patented several devices, including a vegetable chopper (Park was a lifelong vegetarian), a device for cleaning featherbeds, and a type of ventilating window blind for which he won a prize at the Philadelphia Centennial (1876). It seems he did not do any paintings in oil until the last decades of his life. In 1904, the creamery that he had begun to use as a studio burned to the ground. Park spent most of the next two years in the Soldiers and Sailors Home in Erie, Pennsylvania, until his death on September 17, 1906.

There are just thirteen identified works by Park, six of which appear to be painted on bed ticking. It is not known where the artist obtained his paints, but it has been suggested that he may have ground and mixed his own pigments. His colors are remarkably vivid. He also had a reasonable command of both linear and atmospheric perspective. Although his grasp of anatomy was rudimentary, his work displays a strong sense of action and animation. *Flax Scutching Bee* is an energetic, flowing frieze of humorous vignettes and characterizations. This creative, eccentric artist was clearly a keen observer of the life around him.

See also **Painting, American Folk.**

BIBLIOGRAPHY

Griffith, J. Neal. *Linton Park: American Primitive*. Indiana, Pa., 1982.

Smith, Jean. "Linton Park, Pennsylvania Painter." *Antiques*, vol. 120, no. 5 (November 1981): 1203–1209.

DEBORAH CHOTNER

PARKER, CHARLES W. (1864–1932), self-proclaimed "Amusement King" and "Colonel," was founder and owner of companies producing carousel and carnival equipment, variously known as C.W. Parker Company, Parker Carnival Supply Co., and C.W. Parker Amusement Co. He is credited with hiring and training artisans who responded to his vision by carving, painting, and decorating carousel animals known for their forms, lines, fluidity, and adornments.

In 1882 Parker's carnival career was born when he invested in shooting gallery equipment. Ten years later, he purchased a secondhand portable carousel and, with two partners, began touring the carousel in towns in the Midwest. He soon bought out his partners, however, and began producing his own carousels and carnival equipment as Parker Carnival Supply Co. By 1902 Parker had his first traveling carnival

on the road, and in 1903 he added another that traveled by rail.

By 1906, under the name C.W. Parker Amusement Co., there were four Parker traveling shows. From a factory near his home in Abilene, Kansas, he was supplying the market with shooting galleries, carved wagon show fronts, concession banners, band organs, and railroad cars. The carnivals traveled from the Dakotas to Texas and from Chicago to the Rocky Mountains. Parker hired the young Dwight D. Eisenhower as a sander of carousel animals in his Abilene factory, which was just across the tracks from the Eisenhower home.

By 1911 the Parker family and the business moved to Leavenworth, Kansas, to a two-story factory building disguised to appear as having six stories. Production included dragon chariots and cabs, often depicting battles between dragons and pythons. Parker is best known for his carousel horses with their fancy trappings, such as large faceted and cabochon jewels, as well as their naturally flowing manes and their aggressive, stretched-out galloping positions. The four fully extended legs of the horses, drawn close to the body, expressed speed and flight, while also permitting easier stacking and transportation.

The entrepreneur insisted upon the title "Colonel" Parker, just one example of his flair for promotion, which was generally flamboyant and exaggerated. His advertisements pictured the Colonel and his family and stressed the wholesomeness of the carnival visit. When Parker died, his son assumed leadership of the family business.

See also **Carousel Art; Circus Art.**

BIBLIOGRAPHY

Dinger, Charlotte. *Art of the Carousel.* Green Village, N.J., 1983.
Fraley, Tobin. *The Carousel Animal.* Berkeley, Calif., 1987.
Fried, Frederick. *A Pictorial History of the Carousel.* New York, 1964.
Manns, William. *Painted Ponies.* Millwood, N.Y., 1986.

WILLIAM F. BROOKS JR.

PARTRIDGE, JOSEPH (1792–c. 1832), a painter, was born in England, although he was living in Nova Scotia by September 1, 1817. His first advertisement in the *Halifax Journal* announced that he intended to open a drawing school. His earliest known watercolor, *Man and Woman on a Sofa,* is signed and dated August 1817. Two other early watercolors are his painting of the *National School at Halifax, Nova Scotia,* painted about 1818, and a signed self-portrait of 1819.

After 1819, Partridge moved to New England, in the United States. The 1821 Boston city directory lists him as a miniature painter but no paintings from this period are known. From December 1821 through 1823, Partridge advertised in Providence, Rhode Island newspapers, indicating that he would instruct in painting and that he could paint portraits and miniatures of living or dead subjects.

Editorials in the *Providence Gazette* praised his paintings and recommended that manufacturers utilize his talents. At least one took this advice, using a lithograph based on a Partridge watercolor. Of Partridge's many renderings of Providence's buildings and streets, the location of only one of the subjects, *President Street, The First Baptist Meeting House and Adjoining Buildings* (1822) is now known.

Partridge's portraits of 1822 through 1823 include the 1822 miniature on ivory of the *Rev. Stephen Gano,* the watercolor on paper of the *Rev. Adam Clarke,* and the watercolors on paper of *Moses Brown.* Brown would not sit for a portrait, and Partridge did a sketch without his knowledge, producing three watercolors, the most fully developed one initialed and dated 1823.

Nevertheless, Partridge clearly found it difficult to earn a sufficient wage by his painting. On December 23, 1823, and again one month later, the Providence overseer of the poor authorized payment "for a load of wood for Partridge the Portrait Painter he being very poor and family suffering." On February 2, 1824 the town council decreed that he leave the state. He moved to Taunton, Massachusetts, and then to Boston, where, on May 15, 1825, he painted the signed and dated portrait of *Joseph Chapman.*

On August 26, 1825 he enlisted in the United States Marine Corps. During his three years aboard ship sailing in the Mediterranean, he painted about twenty-one watercolors of places he visited and the natives he saw. Partridge was discharged from service on October 18, 1830. Given that the 1834 Boston city directory lists his wife as a widow, he died sometime between his discharge and late 1834.

His paintings are in the collections of major museums such as the Rhode Island Historical Society and the Mariners' Museum, Newport News, Virginia, and in private collections.

See also **Miniatures; Painting, American Folk; Painting, Landscape.**

BIBLIOGRAPHY

Kern, Arthur, and Sybil. "Joseph Partridge, Painter." *The Magazine Antiques,* vol. 126, no. 3 (September 1984): 582–589.

ARTHUR AND SYBIL KERN

PARTRIDGE, NEHEMIAH (1683–c. 1737) is best known for his many New York portraits, but unlike many other limners or painters of this period, he was raised and trained in New England. Born in Portsmouth, New Hampshire, he was the son of Colonel William and Mary (Brown) Partridge. His father was a prosperous merchant and leading provincial official, acting variously at times as judge, treasurer, and lieutenant governor. By 1712 Partridge was selling all types of paint in Boston, and advertised his skill as a limner capable of producing "all sorts of painting, and all sorts of [clock] dials . . . at reasonable rates." It is believed he was trained as a "japanner"—a decorator and painter of furniture in the Chinese and Japanese manner—a skill that others in Boston also practiced at the time. This may have inspired his change of career to a limner. Partridge may have received encouragement from Jacob Wendell, an Albany merchant living in Boston, to seek patrons in Albany, where no other limner had yet visited.

In 1718 Partridge arrived in New York City, and began receiving commissions for portraits; but that city was already benefiting from the artistic talents of the Duyckinck family of limners, as well as from John Watson in nearby Perth Amboy, New Jersey. So he went to Albany, and he agreed to a trade with Evert Wendell, Jacob Wendell's cousin, of three portraits plus ten pounds sterling for a horse. Evert Wendell, a well-connected merchant, mill owner, and attorney, and related to many families in Albany, recorded this transaction in his daybook, thus establishing by name "Nehemiah Peartridge [*sic*]" as the limner of three family portraits known today. This record has also made possible the attribution of more than eighty other portraits and one scripture history painting to Partridge, most from the Albany area. Many of his portraits are inscribed "*Aetatis Suae*" (the time in which a person lives), and give the age of the sitter and the year the portrait was painted. This inspired a temporary name for the artist of this group of portraits as the "Aetatis Suae Limner," until art historian Mary Black discovered the Wendell transaction.

Partridge remained active in Albany until 1721, and then tried his prospects in Newport, Rhode Island, and in Jamestown and Williamsburg, Virginia, before returning to Albany in 1724, leaving behind a trail of portraits. The last year he is known to have painted portraits in Albany, or anywhere else, is 1725. He then returned to Boston, where he remained for the rest of his life.

Partridge's portraits show the influence of English mezzotint prototypes in the poses of his sitters. Depending on the patron's ambition or wealth, he would paint plain or elaborate backgrounds, which at times contained incongruous Renaissance architecture. Partridge worked out a manner of painting that allowed for quick execution, in which the image was laid out on a single layer of paint rather than being built up in blended layers. Over time, this dark ground layer has bled through the thinly painted areas of the image in many of Partridge's portraits, creating heightened contrasts not originally intended, especially in the faces.

See also **Mary Childs Black; Gerardus Duyckinck; John Watson.**

BIBLIOGRAPHY

Belknap, Waldron Phoenix. *American Colonial Painting: Materials for a History.* Cambridge, Mass., 1959.

Black, Mary C. "The Case of Red and Green Birds." *Arts in Virginia,* vol. 3 (1963): 2–9.

———. "The Case Reviewed." *Arts in Virginia,* vol. 10 (1969): 12–18.

———. "Contributions Toward a History of Early-Eighteenth-Century New York Portraiture: Identification of the Aetatis Suae and Wendell Limners." *American Art Journal,* vol. 12 (1980): 4–31.

———. "Early Colonial Painting of the New York Province," *Remembrance of Patria: Dutch Arts and Culture in Colonial America, 1609–1776.* Albany, N.Y., 1988.

———. "Pieter Vanderlyn and Other Limners of the Upper Hudson," *American Painting to 1776, A Reappraisal.* Charlottesville, Va., 1971.

———. "Remembrances of the Dutch Homeland in Early New York Provincial Painting," *Dutch Arts and Culture in Colonial America.* Albany, N.Y., 1987.

———. *Rivers, Bowery, Mill, and Beaver.* New York, 1974.

Flexner, James Thomas. *First Flowers of Our Wilderness: American Painting, the Colonial Period.* New York, 1969.

MacFarland, Janet R. "The Wendell Family Portraits." *The Art Quarterly,* vol. XXV, no. 4 (winter 1962): 385–392.

Piwonka, Ruth, and Roderic H. Blackburn. *A Remnant in the Wilderness: New York Dutch Scripture History Painting of the Early Eighteenth Century.* Albany, N.Y., 1980.

RODERIC H. BLACKBURN

PASTEL: *SEE* JOHN S. BLUNT; CHARLES HUTSON; HENRIETTA JOHNSTON; SARAH PERKINS.

PATETE, ELIODORO (1874–1953) was an Italian woodcarver who journeyed to America by ship in 1901 and 1909, settling in New York and West Virginia. While working in the coal mines, he carved in his spare time, primarily works with a religious theme in the stylized European folk art tradition. He offered his carvings for sale or as gifts to local churches.

Within the American folk art community Patete is celebrated as the carver of *Seated Liberty,* made famous by a 1938 rendering by Elizabeth Moutal (dates

unknown) for the *Index of American Design,* a New Deal federal art project begun in 1935 by the Works Progress Administration that published a visual archive of 1,900 American folk art pieces, ranging from quilts and weathervanes to stoneware and carousel animals. The index is the largest compendium of American folk art yet published. Patete's *Seated Liberty* was also reproduced in American folk art publications of the 1940s and 1950s, and again in the 1970s. There was a resurgence of interest in his work in publications from 2001 to 2002. Patete died in 1953 at his home in Vastogirardi, Molise province, Italy, where by day he farmed and by night carved religious folk figures for his family, neighbors, and local churches.

See also **Carousel Art; Pottery, Folk; Quilts; Religious Folk Art; Sculpture, Folk; Weathervanes.**

BIBLIOGRAPHY

Cahill, Holger. *Emblems of Unity and Freedom: The Index of American Design.* New York, 1942.

Christensen, Edwin O. *Early American Woodcarving.* Cleveland, Ohio and New York, 1952.

———. *The Index of American Design.* New York and Washington, D.C., 1950.

Clayton, Virginia Tuttle. *Drawing on America's Past: Folk Art, Modernism, and the Index of American Design.* Washington, D.C., 2002.

Hornung, Clarence P. *Treasury of American Design: A Pictorial Survey of Popular Folk Arts Based upon Watercolor Renderings in the Index of American Design, at the National Gallery of Art.* New York, 1972.

Horwitz, Elinor Lander. *The Bird, the Banner, and Uncle Sam: Images of America in Folk and Popular Art.* Philadelphia, and New York, 1976.

Joyce, Henry, and Sloane Stephens. *American Folk Art at the Shelburne Museum.* Shelburne, Vt., 2001.

Lipman, Jean. *American Folk Art in Wood, Metal, and Stone.* Meriden, Conn., 1948.

WILLIAM F. BROOKS JR.

PATTON, EARNEST (1931–) has been carving since the 1960s. His body of work is quite extensive, considering that he continued his work as a subsistence farmer and drove a school bus for many years to support his large family. A native of Wolfe County, Kentucky, Patton worked almost exclusively with his pocketknife, and his carvings have highly refined, smooth surfaces. While some similarities exist between Patton's work and that of Edgar Tolson (1904–1984), the range of each artist's work differs considerably. Patton carved biblical subjects, such as Adam and Eve with a snake in a tree, but he also portrayed scenes from local life, such as hog killing and coon hunting, figures from pop culture, such as the Lone Ranger, and graceful animal forms. His human faces are all the same, with a fixed gaze, such as a mother giving birth with a completely blank facial expression, reflective perhaps of the stoic, private world Patton inhabits. Patton is important for his creative vision, his exquisite craftsmanship, and the breadth of his subject matter.

See also **Sculpture, Folk; Edgar Tolson.**

BIBLIOGRAPHY

Yelen, Alice Rae. *Passionate Visions of the American South.* New Orleans, La., 1993.

ADRIAN SWAIN

PAYNE LIMNER (active 1780–1803), an unidentified artist of rare pictorial records documenting citizens of the young United States of America, portrayed residents of Richmond, Virginia, and surrounding Henrico and Goochland Counties in the years following the American Revolutionary War. The paintings ascribed to the artist comprise ten likenesses of members of the Archibald Payne Sr. family of "New Market," the family homestead in Goochland County, and three additional canvases of other relations. With no knowledge of the artist's identity other than this body of work, the name "Payne Limner" has been assigned due to the large number of canvases depicting this single family.

Archibald Payne Sr. and his wife Martha Spotswood Dandridge, granddaughter of Royal Governor Alexander Spotswood and sister-in-law to Virginia's revolutionary firebrand Patrick Henry, were prominent members of Virginia's elite. In about 1790, the couple commissioned the Payne Limner to execute likenesses of themselves and their children. These compositions reveal several hallmarks of the artist's style. Canvases were prepared with white pigment applied in large crescent-shaped arches, and the artist's preliminary drawing was executed in red. Male subjects are portrayed outdoors, in rural Goochland county scenery, taking part in rural activities such as hunting with bows and arrows, or guns, or as in Archibald Payne Sr.'s example, standing beside his plow, with wheat and haystacks nearby. Children, also portrayed outside, hold pets and play sports, while women are depicted indoors, wearing black necklaces and holding books and fans. Faces are flushed, with dark lines drawn between lips, arms are attenuated, hands appear chubby and devoid of skeletal definition. Several skillfully rendered stick-pins worn by the sitters suggest the artist also had some working knowledge of calligraphy.

Among the Payne Limner's most significant compositions, the group portrait depicting Archibald Sr.'s children, Alexander Spotswood and John Robert Dandridge, is remarkable for its monumental size (it measures 53″ x 69″) and for its full-length portrayal of an African American in the role of nursemaid to the youthful John. Alexander shows off his newly won game trophy, a small bird he recently felled with his bow and arrows. John, barely able to stand without assistance, is supported by his nursemaid as he expresses admiration for his brother's accomplishment. By including her to the right of the composition, the Payne Limner has presented a rare visual record of an African American female slave's interaction with her charge, in addition to conveying information about the garments worn by household servants.

See also **Calligraphy and Calligraphic Drawings; Painting, American Folk.**

BIBLIOGRAPHY

Lyon, Elizabeth Thompson. "The Payne Limner," M.A. Thesis, Virginia Commonwealth University, Richmond, Va., 1981.

CHARLOTTE EMANS MOORE

PECK, SHELDON (1797–1868) was born in Cornwall, Vermont, the son of a farmer and blacksmith. He began painting portraits of his family and neighbors in the Cornwall area by his middle twenties. His early work bears a strong resemblance to portraits that William Jennys (active 1795–1806) had painted in nearby Middlebury, Vermont, a generation earlier. Peck may have studied Jennys' portraits to learn the rudiments of painting. Also like Jennys', Peck's Vermont likenesses exhibit assured drawing, sharp delineation of highlight and shadow to suggest the contours of the face, subtle coloration, stiff poses, and dour expressions. The severe countenances that recur in Peck's work seem uncharitable to modern eyes. Yet such images were deemed fitting in a culture that carefully codified the rules of deportment and propriety, and sitters expected their portraits to show their diligence, prosperity, and status as effectively as they captured their likenesses.

Peck moved his young family from Vermont to Jordan in Onondaga County, New York, in 1828. Located along the recently opened Erie Canal, Jordan was well situated to put Peck in contact with the constant flow of canal traffic and potential sitters. There, Peck continued to paint mostly half-length portraits on wood panels as he had in Vermont, but now he more often included accessories such as jewelry, paint-decorated side chairs, and swags of drapery to increase his work's decorative appeal.

In 1835, Peck moved to Chicago for several months before moving yet again 25 miles west to the settlement of Babcock's Grove (now Lombard), Illinois, where he built a home and farm and continued painting portraits, traveling as far as the St. Louis area in search of commissions. About 1845 he introduced a dramatic departure from his previous work with a series of large, ambitious oil-on-canvas portraits of people who lived in and around nearby Aurora, Illinois. These original and inventive compositions appear to have been part of an effort to compete with the widespread popularity of the daguerreotype. Utilizing a horizontal format, bright colors, multiple full-length figures standing and sitting in stage-like settings with tables on which are vases of flowers and Bibles, as well as *trompe l'oeil* mahogany frames painted directly on the canvas, these paintings have few precedents in American folk portraiture.

No portraits painted by Peck after 1849 have been located to date, indicating that he could no longer compete with photography. During the 1850s he worked as an ornamental painter, probably painting signs, banners, and furniture from a studio he operated in Chicago.

See also **William Jennys.**

BIBLIOGRAPHY

Balazs, Marianne, "Sheldon Peck." *The Magazine Antiques*, vol. 108 (August 1975): 273–284.
Hollander, Stacy C., et al. *American Radiance: The Ralph Esmerian Gift to the American Folk Art Museum*. New York, 2000.

RICHARD MILLER

PECKHAM, ROBERT (1785–1877) was a Massachusetts portrait painter with a special sensitivity toward children that is evident in the detailed canvases he painted, primarily during the 1830s and 1840s. Peckham was born in Petersham, Massachusetts. In 1813 he married Ruth Sawyer of Bolton, Massachusetts, and by 1821 they had moved with their growing family to Westminster, Massachusetts. Peckham was a man of conscience and a strict temperance advocate and became deacon of the First Congregational Church in Westminster in 1828. He was also a staunch abolitionist and opened his house for anti-slavery lectures; it has been speculated that his home was a stop on the Underground Railroad, the secret organization that helped enslaved laborers flee the Southern United States to Canada or other "safe" places before the abolition of slavery. Peckham's anti-slavery beliefs

caused a rift in his church that resulted in his resigning his post as deacon after fourteen years; he was officially excommunicated in 1850. Peckham moved his family to Worcester, Massachusetts, but returned to Westminster in 1862, and was reinstated in the church.

Peckham is one of the few portrait painters in the folk genre known to have received instruction from an academic artist. From January through April of 1809 he studied with Ethan Allen Greenwood (1779–1866). Later that year he painted his earliest known work, the head and torso portrait of his friend James Humphreys Jr. In 1815 he advertised with his brother Samuel H. Peckham in the *Hampshire Gazette*: "House, Sign, and Ornamental Painting. Also Gilding, Glazing, and Varnishing." By 1817 he painted an ambitious canvas on a small scale (measuring 27 by 32 inches) of 16 members of the combined Peckham and Sawyer families. These early canvases have muted palettes, which is different in spirit from his brilliant portraits of the 1830s and 1840s, which feature children centrally located and surrounded by toys and interior details. Bright clothes, patterned carpets, grain-painted tables, and other elements lend animation to portraits such as *The Raymond Children*, *The Hobby Horse*, *Rosa Heywood*, and *Charles L. Eaton and his Sister*; this fact has led some scholars to question whether Peckham is indeed the artist of both groups of paintings. In addition, these portraits of "doll-like" children invariably have a pronounced delineation of the temples that is not seen in Peckham's portraits of adults, save that of the *Mrs. William Cowee* portrait.

The Farwell Children, painted about 1841, provides the transition between these portraits and the earlier works. It features five children in a circular composition wearing bright clothes, but they are set against a dusky background typical of Peckham's early documented work. This family portrait also continues a practice of posthumous portraiture that Peckham engaged in as early as the 1820s. The most striking example is the painting Peckham completed of his sister-in-law's family, *The Children of Oliver Adams*. Painted in 1831, a family record hanging on the wall in the painting lists that same year as the one in which one of the children portrayed died.

Robert Peckham first gained contemporary notice for his landscape *Westminster Village in 1831*. Less familiar today are paintings such as *The Woes of Liquor (Intemperance),* signed "*R. Peckham/Pinxet,*" and *The Happy Abstemious Family (Temperance),* which further illustrate the artist's firm support of the temperance movement. Though a religious man and

strict in his beliefs, Peckham is remembered as having "mingled much humanity with his piety," an apt description of the artist who advertised himself as a "delineator of the human face divine."

See also **Ethan Allen Greenwood; Painting, Landscape.**

BIBLIOGRAPHY

D'Ambrosio, Paul S., and Charlotte Emans. *Folk Art's Many Faces: Portraits in the New York State Historical Association.* Cooperstown, N.Y., 1987.

Johnson, Dale T. "Deacon Robert Peckham: 'Delineator of the 'Human Face Divine.'" *The American Art Journal,* vol. 11, no. 1 (January 1979): 27–36.

Krashes, David. "Robert Peckham: Unsung Rural Master." *Folk Art,* vol. 21, no. 1 (spring 1996): 38–45.

Luckey, Laura C. "The Portraits of Robert Peckham." *The Magazine Antiques,* vol. 134, no. 3 (September 1988): 550–557.

STACY C. HOLLANDER

PENNIMAN, JOHN RITTO (1782–1841), portraitist, ornamental artist, and draftsman, worked principally in the Boston, Massachusetts area and in Baltimore, Maryland, during the early nineteenth century. Born in 1782, he was the son of Elias Penniman and Anna Jenks of Milford, Massachusetts. At about age eleven, he apprenticed as a decorative painter, since his earliest known signed work is a painted clock dial dated 1793. At this time, he experimented with easel painting, executing a self-portrait in miniature, a scene depicting a family group dated 1798, and a landscape of Meeting House Hill in Roxbury, Massachusetts, from 1799, among other images.

Although Penniman painted portraits throughout most of his career, he principally secured income through his considerable skills in decorative painting. In 1803, he opened a shop on the same street in Roxbury as clockmaker Simon Willard (1753–1848) and across from John Doggett (1780–1857), a looking-glass and frame maker, gilder, and carver. Penniman provided supplementary ornamental services to these men, such as decorating the faces on Willard's clocks, painting Doggett's shop sign, and designing cabinetmaker labels.

In 1805, he married Susanna (or Susan) Bartlett, with whom he had four children. During this year, he moved his operation to Boston's South End, where he remained for the next twenty-one years. A member of St. John's Masonic Lodge, Penniman is credited with decorating the interior of Boston's Masonic Hall, then located in the Old State House, a collaborative effort with famed architect Alexander Parris (1780–1852). In addition to creating trade cards, advertisements,

membership certificates, Masonic ritualpaintings, theatrical backdrops, and book illustrations, Penniman generated designs for Staffordshire earthenware potters, worked for the Pendleton Lithographic Press in Boston, and in 1823 won the competition to design the seal for the city of Boston, an image still in use today. His artistic influence extended also to teaching, having had several students within his circle, among them Charles Codman (1800–1842), Nathan Negus (1801–1825), Moses A. Swett (c. 1805–1837), and Alvan Fisher (1792–1863).

Plagued with financial difficulties, in 1829 Penniman was committed to South Boston's House of Industry, a poorhouse. During the early 1830s, he moved to West Brookfield, where he executed at least seven known compositions of friends and relatives. The watercolor on paper portrait of little Ann Elizabeth Crehore is among his most pleasing likenesses from this period. Penniman died in 1841 in Baltimore, Maryland, where he had moved a few years earlier to be near his son.

See also **Decoration; Fraternal Societies; Freemasonry; Miniatures; Painting, American Folk; Painting, Landscape; Pottery, Folk; Trade Signs.**

BIBLIOGRAPHY

Andrews, Carol Damon. "John Ritto Penniman (1782–1841), an Ingenious New England Artist." *The Magazine Antiques*, vol. 120 (July 1981): 147–69.

Moore, William D. "American Masonic Ritual Paintings," *Folk Art*, vol. 24 (winter 1999–2000): 59–65.

CHARLOTTE EMANS MOORE

PENNSYLVANIA GERMAN FOLK ART originated in the period between the end of the Thirty Years War in 1648 and the rise of nineteenth-century industrialization, when the peasant population of Germanic central Europe developed a modest disposable income and a taste for non-essential, decorative objects. By copying the designs found on luxurious objects in cheaper materials or more readily available media, the populace developed the objects and works today categorized as folk art. Pottery replaced silver, softer woods replaced harder ones, drawings on paper replaced oils on canvas. The transition by media often simplified the object. By adapting materials based on his circumstances, a peasant craftsman working in a village in Germany, Austria, Switzerland, Italy, or the Alsace and Tyrol regions in France and Italy, respectively (where German language and culture prevailed) could create decorative objects or art. Regional costume was the first form of this culture to be recognized by scholars, but eventually furniture, textiles, and architecture were also studied.

During this same period, a large number of Germans immigrated to the United States, primarily to Pennsylvania. The beginning of this migration is generally dated to 1683, when Francis David Pastorius brought some Germans to Philadelphia, creating the Germantown settlement. A rumor spread among Germans in 1709 that Queen Anne would pay for their trip to the New World, and thus they made their way to England, only to learn upon their arrival that this was not the case. The following year they were shipped to New York, and eventually large numbers of them moved to Pennsylvania. When William Penn himself appeared in the Palatinate of Germany and invited Germans to his colony of Pennsylvania, the numbers increased. Initially a great number of Mennonites went to Pennsylvania, to escape the disapproval they met in their homeland for their religious practices. Eventually, economic factors drew German immigrants to America as well, for land was cheap and plentiful in the colonies. By the late 1720s, the waves of German immigrants led the provincial government to require an oath of fidelity from the new arrivals. By 1750, large sections of Pennsylvania were populated almost exclusively by farmers and craftsmen of German stock. The American Revolution impeded the flow of Germans, but the definitive end of this phase of German immigration to the United States is traced to the War of 1812.

These immigrants developed a new form of German culture in their adopted home. They continued (some still do today), to speak a German dialect called Pennsylvania German or Pennsylvania Dutch (as "Dutch" was a common English term for "German" in the eighteenth century). They developed a cuisine based on German cooking, with some adaptations to English tastes. Their preferred style of architecture changed from Germanic peasant cottages to fine Georgian homes. They gradually abandoned the traditional German floor chest in favor of an English chest of drawers. Nevertheless, as these changes took place, German immigrants managed to preserve, and even intensify, the desire to embellish what they made in imitation of fine objects found among the upper classes.

Folk costume disappeared at an early date (although it was retained by the Amish) among the Pennsylvanian Germans, but embroidered patterns on shirts, aprons, and kerchiefs, as well as sheets, pillowcases, and towels, survived. Furniture was painted in vibrant colors and marked with owners' names. Prosaic objects such as dough scrapers, wa-

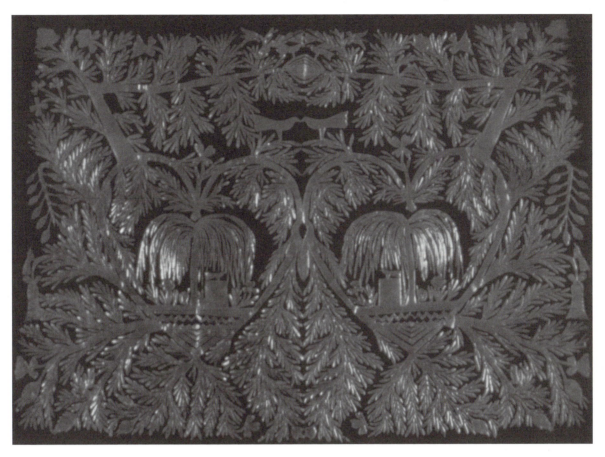

Scherenschnitte (cut-paper design). Artist unknown; Pennsylvania, c. 1850–1875. Gilded and cut paper. © Esto.

tering cans, cooking implements, and coffee pots were decorated by cut out, punchwork or inlay designs. Butter was stamped with flourishes such as tulips, eagles, or hearts. Christmas cookies were cut in hundreds of shapes, while Easter cheese was made in a mold in the shape of a heart. Pottery bore sgrafitto designs scratched into the surface and accompanied by a witty epigram. Baptismal certificates and gravestones were embellished with distinctive designs. Pennsylvania was a colorful world with churches nicknamed the Red, the White, the Yellow, and the Blue Church.

Whereas the fine furniture made for wealthy households in Europe was crafted of hard woods and often decorated with inlay, peasant craftsmen contented themselves with plentiful and fast growing soft woods. These needed paint as a simple protection for their surface, and that paint often substituted for the inlayed designs by adding flowers, birds, townscapes, and unicorns, together with owners' names and dates,

to the surface of a chest. When chests of drawers began to replace box-like, inefficient storage containers, craftsmen painted the drawers much as they had painted the chests. Other pieces of furniture were decorated in imitation of grained woods by using rags, feathers, or other objects on wet paint. Still other pieces were polychromed. The discovery in Pennsylvania of the black walnut tree, a wood that can be finished handsomely and relatively easily, balanced the colorful painted furniture with handsome dark pieces marked by a beautiful simple grain.

Whereas English homes were often cluttered with furniture, Pennsylvania German houses were characterized by the presence of just a few useful pieces. In a family's *Stube* (stove room), one corner held the iron stove with its decorated plates (fired in another room and therefore flame, smoke, and dirt free), while the opposite corner had benches built into the two walls. There was also a bench along the family's table, a bench against the other long wall, and a

stately chair (the *Daadi Stuhl*) at the head of the table. In the corner above was a shelf for the family's Bible and other books. Nearly every home had a clock and case so placed that it could be seen from the kitchen. A large wardrobe, called in the dialect a *Gleeder Schonk*, was present to hold clothing not hung on peg hooks in the master bedroom downstairs, or in the rooms for family and hired help above.

Bedrooms were functional. In addition to the master bed, a trundle bed, and a cradle accommodated smaller children, and either here or in a hall upstairs there was a chest for bed linens. The bed had wooden pillow guards at each side at the head. People slept on a pile of pillows, nearly in a sitting position. They were covered at night by woven blankets until quilts became popular, due to the English influence. Most beds had curtains—sometimes made of blue-resist, a cloth impregnated with matter which would not take die when dipped into a vat—to provide both privacy and warmth.

A Pennsylvania German dining table usually had a stretcher across the bottom and two drawers of disparate size, one for knives and forks and another for tablecloths. Either here or in the kitchen a cupboard with shelves for dishes and racks for spoons, an open area for pies, and drawers for sewing baskets could be found.

The kitchen was a long room, extending from the front to the back of the house. The main door of the house usually opened onto the kitchen. It contained work tables, a large dough box (for preparing the weekly dough for bread and pastry) and shelves for various cooking utensils. Baskets were needed to gather eggs, potatoes, and berries, as well as to store various commodities. They held the bread dough as it rose, and were placed on the hearth on Christmas Eve for the Christ Child to fill with gifts for the children. On a shelf outside, woven baskets were home to the bees who provided honey, which was used in baking.

Sewing baskets were filled with pins, needles, buttons, tapes, and homemade strips of cloth to be used as ties. A sampler often resided there, too, and the loom for the tape, sometimes magnificently decorated, was generally found nearby. Saltboxes, spice chests, and painted boxes for Sunday's bonnet or the family's valuable papers had a niche somewhere in the house as well. Pottery bowls, pie plates, cheese strainers, platters, and plant containers were kept in the kitchen cupboard. Along the fireplace hung long cooking utensils, some of the finest decorated with etched or inlaid designs. A muslin bag hung at the head of the attic steps held the family's collection of cookie cutters for Christmastime, when great quanti-

ties of rolled and cut-out cookies were baked. In one community, the most unusual and singular cookie cutters were placed in the windows facing the street, so that neighboring children could see and be impressed by the designs. A wise tinsmith made cutters with as many protruding parts as possible, as children loved to bite them off first. Elephants, the devil, birds, rabbits, horses, and all sorts of objects were outlined in tin for Christmas baking.

Pennsylvania German homes rarely had rugs or window curtains (wood shutters substituted for the latter). However, any textiles the household did own were often its most valuable possessions. Each represented many hours of work, from planting and harvesting the fibers to weaving the cloth and sewing the object. Every table invariably had a tablecloth, some of them embroidered, others fitted with a drawn-work panel, and still more adorned with stripes of pattern-woven linen. The door between the *Stube* and the kitchen frequently had an embroidered towel hanging on it, not for use but for decoration (in the nineteenth century, these were moved to the door of the guest room). A towel was usually decorated with red threads and had drawn-work panels; the door on which it hung was often painted blue to provide contrast. The same designs were sometimes stitched into sheets and pillowcases, especially those laid out on guest beds; they were also sewn into clothing. Woven woolen coverlets provided rich colors for beds. After the invention of the jacquard loom, they bore the owner's and the maker's names.

When Pennsylvania German girls learned about quilting from their English neighbors, bright, polychromed bedcovers with matching pillowcases appeared. Scraps of cloth in the household were made into pincushions, seed bags, potholders, and dresser scarves. Even hand-knit stockings and mittens were colorfully decorated.

Hardly a family existed in the Pennsylvania Dutch countryside which did not have some fraktur. The printed forms, numbering nearly one thousand, made it possible for anyone to have a birth and baptismal record if they belonged to the Lutheran and Reformed churches, which probably constituted 90 percent of the population.

The graveyards of southeastern Pennsylvania are full of markers, erected through the 1830s, that were carved by hand with folk designs. They often contain text about the deceased, some scripture or a hymn verse, and decorations similar to those found on fraktur. The view of death presented on Pennsylvania German tombstones is rarely maudlin or despairing; angels are often depicted as smiling, and one epitaph

asks, who can cry for this man, who is laughing with the angels. Some tombstones are carefully inlaid, with essentially the same composition used occasionally on furniture. Some were even painted with several colors.

Such objects and architectural styles are grouped together by the designation Pennsylvania German folk art. Simple products crafted by farmers and village craftsmen were made more attractive and individual by painted, carved, forged, or thrown designs. There is no definitive evidence that a decorated piece cost more than an unadorned one, and few estate inventories include any references to objects as being especially decorated, which suggests that embellished wares were taken for granted and not elevated as works of art. More than one decorated blanket chest found its way to the barn for practical use. Paint obliterated names and dates. Finely made textiles were subject to the casual abuse of everyday life. Neatly and colorfully penned birth records were placed in the coffin with the owner just before burial.

It is a marvel that any objects from this period were still preserved when Henry Chapman Mercer, the founder of the Mercer Museum in Doylestown, Pennsylvania, began to examine Bucks County in the 1890s, or when Henry Francis du Pont began collecting folk art for his home at Winterthur in the 1920s. Cornelius Weygandt and Wallace Nutting, and *The Magazine Antiques*, began publicizing Pennsylvania German objects in the 1920s. Meanwhile, a dealer named Joe Kindig in York and another named Hattie Brunner in Reinholds (both in Pennsylvania) helped shape museum collections.

Scholars followed the collectors. Frances Lichten's *Folk Arts of Rural Pennsylvania* (1946) was an early attempt to portray the distinctive style of Pennsylvania German folk art through a variety of examples. Donald A. Shelley's *The Fraktur—Writings or Illuminated Manuscripts of the Pennsylvania Germans* (1961) summarized and extended what was known of fraktur to date. John Jacob Stoudt issued essentially the same volume under different titles between 1938 and 1966, espousing a heavily religious view of its meaning. Even earlier, Edwin Atlee Barber had published a book about the gaudiest Pennsylvania German pottery, *The Tulip Ware of the Pennsylvania German Potters* (1903). Articles appeared generally emphasizing this folk art in idealistic, romanticized terms, often failing to situate the objects in a wider economic context.

Meanwhile, both private and museum collections grew. Chief among these was du Pont's at Winterthur in Delaware. Titus Geesey presented most of his collection to the Philadelphia Museum of Art. Local museums (the county historical societies from Gettysburg to West Chester) were heir to the accumulation from a variety of estates. The Philadelphia Public Library bought several large collections of fraktur and combined them in their rare books department on Logan Square. Under Donald Shelley's direction, the Henry Ford Museum in Dearborn Michigan obtained a selection of Pennsylvania German objects. Meticulous studies had yet to be carried out, but the groundwork had been laid for such analyses simply by the grouping of representative samples.

From 1966 to 1991, the Pennsylvania German Society made such academic work available to its members. Monroe H. Fabian's *The Pennsylvania German Decorated Chest* (1970) was an important study. Frederick S. Weiser and Howell Heaney published a two-volume catalogue, *The Pennsylvania German Fraktur of the Free Library of Philadelphia* in 1976 and 1977. In 1985, Ellen J. Gehret presented *This Is the Way I Pass My Time*, about the embroidered hand towels once popular, especially among Mennonites, and in 1991 Charles and Tandy Hersh produced *Samplers of the Pennsylvania Germans*. Since then, many publications have specialized in particular articles or objects, greatly expanding what we know about these objects.

The prediction of some dealers that Pennsylvania German folk art would command astounding figures came true, as several large private collections were dispersed through large New York auction houses. The gift promised by Ralph Esmerian to the American Folk Art Museum in Manhattan, and a large segment of the collection at the Abby Aldrich Rockefeller Folk Art Center in Colonial Williamsburg, have lent Pennsylvania German folk art a national reputation.

See also **Abby Aldrich Rockefeller Folk Art Museum; American Folk Art Museum; Amish Quilts and Folk Art; Architecture, Vernacular; Baskets and Basketry; Boxes; Christmas Decorations; Coverlets; Decoration; Henry Francis du Pont; Ralph Esmerian; Fraktur; Furniture, Painted and Decorated; German American Folk Art; Gravestone Carving; Henry Chapman Mercer; Philadelphia Museum of Art; Pottery, Folk; Quilts; Winterthur Museum; Woodenware.**

BIBLIOGRAPHY

Barber, Edwin Atlee. *The Tulip Ware of the Pennsylvania German Potters*. Philadelphia, 1903.

Fabian, Monroe H. *The Pennsylvania German Decorated Chest*. New York, 1970.

Garvan, Beatrice B. *The Pennsylvania German Collection.* Philadelphia, 1982.

Gehret, Ellen J. *This Is the Way I Pass My Time.* Kutztown, Pa., 1985.

Hersh, Charles, and Tandy Hersh. *Samplers of the Pennsylvania Germans.* Birdsboro, Pa., 1991.

Hollander, Stacy C. *American Radiance.* New York, 2001.

Lichten, Frances. *Folk Arts of Rural Pennsylvania.* New York, 1946.

Shelley, Donald A. *The Fraktur—Writings or Illuminated Manuscripts of the Pennsylvania Germans.* Allentown, Pa., 1961.

Swank, Scott T. *Arts of the Pennsylvania Germans.* New York, 1983.

Weiser, Frederick S., and Howell Heaney. *The Pennsylvania German Fraktur of the Free Library of Philadelphia.* Philadelphia, 1976 (vol. 1), 1977 (vol. 2).

FREDERICK S. WEISER

PERATES, JOHN W. (1895–1970) brought a family tradition of fine craftsmanship with him to Portland, Maine, when he emigrated from Amphikleia, Greece, in 1912. Heir to five generations of artisan woodcarvers, he used the skills taught to him by his grandfather to carve a massive altar and altar screen for Holy Trinity Greek Orthodox Church in Portland. He also carved and painted a series of icons for the church. Despite his grounding in tradition, however, his work was assertively individualistic. The church's conservative parish council relegated his unconventional icons to storage in the basement of the building.

According to family lore, Perates was a serious child, reading biblical and liturgical texts and visiting the small churches of Amphikleia and other villages near Delphi to study their Byzantine icons and relief carving. This local but intensive exposure to Greek culture and his apprenticeship under his grandfather, who also taught him to read and write, were his only formal education. His skills developed early in his life; as an eight-year-old boy, he built himself a working tricycle. Between 1908 and 1912, although still very young, he is supposed to have received commissions to make icons, but none of this work is thought to survive. He developed a lifelong practice of Bible study.

After he settled in Portland, Perates obtained employment as a cabinetmaker with J.F. Crockett Company. When that company ceased operation in the 1930s, he established his own business—under the name J.H. Pratt—making reproductions of antique furniture, as well as repairing, finishing, and upholstering furniture. At about the same time, the local Greek Orthodox church commissioned him to create a bishop's throne for the anticipated visit of a church prelate; the resulting work was 14 feet high, with a traditional reeded dome and carved grapevines and olive leaves as decorative elements. The throne, unlike his later work, was accepted by the church officials and installed. In 1938, perhaps as a result of the success of this endeavor and the satisfaction that it brought him, Perates began work on an elaborate octagonal pulpit, a project that occupied his time for sixteen years. Carved of walnut and cherry, the pulpit was embellished with icons depicting the four Evangelists and the early fathers of the Greek church.

The artist's masterwork is undoubtedly his monumental 16½-foot-high altar and altar screen, containing thirty-nine tiered relief panels in wood, each with an intricately carved and varnished icon, representations in relief and in the round of more than 200 angels, and six candlesticks, fashioned into the figures of angels. Among the woods represented in this impressive work are South American ironwood, walnut, and pumpkin pine; some of these woods were donated by interested friends, including a Roman Catholic priest. The artist was involved, almost obsessively, in the creation of this work over a period of many years.

Although the altar is his masterwork, Perates's individual icons are more widely known. Each is carved in relief and varnished; most are painted with rich and opulent colors. In the tradition of Byzantine iconography, these saintly figures, which are presented with their customary attributes, are highly stylized, frontal, and direct, but they share a power and a boldness that are less typical of conventional imagery. Impassive and otherworldly, they reflect their maker's deep spirituality.

Perates did not live long enough to see his lifework appreciated, although the local press showed interest in him from time to time. Within four years after his death, however, the Cincinnati Art Museum had organized a one-person exhibition devoted to his icons, an affirmation of their contribution to American culture.

See also **Religious Folk Art; Sculpture, Folk.**

BIBLIOGRAPHY

Macht, Carol, and Michael Hall. *John Perates: Twentieth Century American Icons.* Cincinnati, Ohio, 1974.

GERARD C. WERTKIN

PERKINS, SARAH (1771–1831) was a sensitive portraitist whose authorship of a significant body of work in pastel and oil was not recognized until 128 years after her death. She was born into the prominent Plainfield, Connecticut, family of Dr. Elisha and Sarah Douglas Perkins, the fourth of their ten children.

In 1959, art historian William Lamson Warren identified Sarah as the young pastelist who had produced a group of Perkins family portraits when he discovered an inscription on the back of a likeness of her

second cousin, the Reverend Nathan Perkins of Hartford, Connecticut. Written by his granddaughter Julie Seymour (1804–1886), the inscription stated, "*This portrait, and the accompanying one of his wife, were taken in 1790, in colored crayons, by Miss Sarah Perkins, at nineteen years of age, while on a visit to the family.*"

An overview of the approximately 35 pastels that are attributable to Sarah Perkins reflects a rapidly developing level of skill and assurance as she mastered her medium. Two years before Sarah Perkins was identified by William L. Warren, another art historian, Nina Fletcher Little (1903–1993), had isolated a group of six oil paintings that were stylistically related to one another. Included in this group were the large and complex portraits of a Dr. and Mrs. Beardsley. As no evidence existed regarding the identity of the artist, Little introduced the artist as the "Beardsley Limner" when she published her findings in the *Connecticut Historical Society Bulletin* in 1957.

Christine Skeele Schloss expanded the oeuvre of the Beardsley Limner by recognizing eight more portraits, and in 1972 the growing body of work was exhibited at the Abby Aldrich Rockefeller Folk Art Center in Williamsburg, Virginia. By 2003 three more works had been attributed to the limner, bringing the total output to 17 oil portraits.

In 1984, art historians Colleen Cowles Heslip and Helen Hill Kellogg published the results of research that was prompted by their recognition of the fact that there were stunning stylistic parallels between the pastels of Sarah Perkins and the accomplished but anonymous oil portraits. They concluded that there was indeed compelling evidence indicating that the talented young pastelist and the elusive Beardsley Limner were almost certainly the same artist, and today Sarah Perkins is finally credited for being a much more versatile and significant artist than had been previously realized.

See also **Abby Aldrich Rockefeller Folk Art Museum; Nina Fletcher Little; Painting, American Folk.**

BIBLIOGRAPHY

Heslip, Colleen Cowles, and Helen Kellogg. "The Beardsley Limner Identified as Sarah Perkins." *The Magazine Antiques*, vol. 126, no. 3 (September 1984): 548–565.

Heslip, Colleen, and Charlotte Emans Moore. "A Window into Collecting American Folk Art: The Edward Duff Balkan Collection at Princeton." *The Art Museum* (1999): 50–52.

Jones, Karen M. "Collectors Notes." *The Magazine Antiques*, vol. 113, no. 6 (June 1978): 1244, 1246.

Lipman, Jean, and Tom Armstrong, eds. *American Folk Painters of Three Centuries.* New York, 1980.

Little, Nina Fletcher. "Little Known Connecticut Artists: 1790–1810." *Connecticut Historical Society Bulletin*, vol. 22, no. 4 (October 1957): 99-100, 105–106, 114–117.

Rumford, Beatrix T., ed. *American Folk Portraits: Paintings and Drawings from the Abby Aldrich Rochefeller Folk Art Center.* Boston, 1981.

Schloss, Christin Skeeles. *The Beardsley Limner and Some Contemporaries: Post-Revolutionary Portraiture in New England: 1785–1805.* Williamsburg, Va., 1972.

———. "The Beardsley Limner." *The Magazine Antiques*, vol. 103, no. 3 (March 1973): 533–538.

Warren, William Lamson. "Connecticut Pastels: 1775–1829." *Connecticut Historical Society Bulletin*, vol. 25, no. 4 (October 1959): 101–107.

Woodward, Richard B. *American Folk Painting from the Collection of Mr. and Mrs. William E. Wilshire III.* Richmond, Va., 1977.

HELEN KELLOGG

PERSON, LEROY (1907–1985) was a wood-carver who spent his life in the small rural community where he had grown up in a family of African American sharecroppers: Occhineechee Neck, on the edge of a swamp in northeastern North Carolina. He had little formal education and remained functionally illiterate throughout his life. In his adult years he earned a living by working in a sawmill, until he took early retirement owing to a severe case of asthma. To occupy his time after retiring, he developed a singular chip style of wood carving that he initially applied to his small wood-frame house, incising the lintels and the frames of its doors and windows with decorative patterns and imagery. He then carved a number of wood slabs that he used to construct a fence around his small yard, surmounting them with silver-painted hieroglyphic signs. Unfortunately for later admirers of his work, his embellishment of his house and yard was not appreciated by his family, and before his work reached an audience outside his community, he removed the fence and his hand-carved architectural details and disposed of them.

Soon afterward, in the mid-1970s, a neighbor who noticed a box of scrap lumber that Person had saved to burn as firewood suggested that he instead carve these wood blocks into objects that might be used as teaching devices for the blind. Although none of his works were ever used for that purpose, Person began covering flat boards with incised patterns and images like those that had previously ornamented his house, and he also started carving small figural objects in the round that he then grouped to create tableaux. Among the favored subjects that he rendered in his distinctively stylized manner were birds, snakes, aquatic life-forms, vegetation, and tools (for which he used his own tools as stencils). Like traditional wood sculpture from sub-Saharan Africa, to which it has

often been compared, his work has extensive dense geometric patterning.

He also made desks, cabinets, and chairs that he called thrones from some of the wood scraps he carved. People who acquired Person's furniture sometimes painted the pieces, but he himself colored most of these works with bright-hued wax crayons.

Person found his inspiration primarily in nature, on television, and in his dreams. A highly prolific artist, he took up drawing late in his life, while he was hospitalized during one of his more serious bouts of asthma.

See also Architecture, Vernacular; Furniture, Painted and Decorated; Sculpture, Folk.

BIBLIOGRAPHY

Arnett, Paul, and William Arnett, eds *Souls Grown Deep: African-American Vernacular Art of the South*, vol. 2. Atlanta, Ga., 2001.

Manley, Roger. *Signs and Wonders: Outsider Art Inside North Carolina*. Raleigh, N.C., 1989.

Manley, Roger, and Tom Patterson. *Southern Visionary Folk Artists*. Winston-Salem, N.C., 1985.

TOM PATTERSON

PETERMAN, DANIEL (1797–1871), a third-generation American who was born and died in Shrewsbury Township, York County, Pennsylvania, made quantities of fraktur for children born in the mid-nineteenth century in York County. Most of the pieces he produced are similar in format. The text is bordered by two female figures that are sometimes given first names; a variety of flowers and birds usually completed the page. Peterman generally signed his work and sometimes indicated the place where he was living. When hand-milled paper could no longer be obtained, Peterman used commercial ruled sheets. He made fraktur well into the 1860s.

Peterman was a schoolmaster in the Lutheran or Reformed churches in York County, perhaps for a time at the Jerusalem, or Fissel's, Church. He was a member of the Reformed church, was married, and had a number of children. For his family, he made elaborate records in which he portrayed many objects—everything from sailing vessels to pianos. The baptismal record he produced for a nephew named for him is decorated with a market house, chickens for sale, and a dog chasing after one chicken. Occasionally, he included figures of Adam and Eve on a fraktur certificate, and he made drawings of courting couples, probably for close friends or relatives. His colors are bright and arresting.

See also Fraktur; German American Folk Art; Pennsylvania German Folk Art; Religious Folk Art.

FREDERICK S. WEISER

PETERSON, OSCAR: *SEE* FISH DECOYS.

PHELPS, NAN (1904–1990) was a memory painter who first gained recognition in the 1940s. Her early portraits of family members, characterized by restrained brushwork and documentary impulse, recall nineteenth-century folk portraiture. Phelps's later work, especially her scenes of everyday pleasures like baseball games, employ looser brushstrokes and a more expressive use of color.

Although Phelps enjoyed drawing as a child, she did not begin to paint until she had escaped the hardships of her early life in London, Kentucky. Responsible for the care of her brothers and sisters, Phelps was forced to drop out of school after completing the eighth grade. She married an abusive man but, after three years, fled with her two children to Hamilton, Ohio, where she met her second husband, Bob Phelps. In the 1930s, Phelps enrolled in a correspondence course in design. Purchasing oil paints from the Sears and Roebuck catalog, Phelps began to create paintings in a naive style and sent a painting to the Cincinnati Art Museum. Although the museum at first doubted that a local housewife had created the painting, it exhibited three of Phelps's paintings after she had proved herself in classes at the Cincinnati Art Academy.

Devoted to her artmaking, Phelps asked advice of Dorothy Miller, a curator at the Museum of Modern Art in New York City. Miller referred Phelps to the Galerie St. Etienne, whose director, Otto Kallir, had promoted the career of Anna Mary Robertson Moses, better known as Grandma Moses. Kallir exhibited Phelps's paintings, as did several other New York galleries.

See also Anna Mary Robertson "Grandma" Moses; Painting, American Folk; Painting, Memory.

BIBLIOGRAPHY

Kallir, Jane. *The Folk Art Tradition: Naïve Painting in Europe and the United States*. New York, 1981.

CHERYL RIVERS

PHILADELPHIA MUSEUM OF ART, one of the largest and most important museums in the United States, is a legacy of the great Centennial Exposition of 1876. It was originally established as the Pennsylvania Mu-

seum School of Industrial Arts in Philadelphia; its emphasis gradually expanded from industrial arts to include fine and decorative arts of Europe and Japan and then American art through gifts of the Wilstach Collection of Paintings, the Bloomfield Moore Collection of Decorative Arts, and the Pall and Tyndale Collection of Porcelain. In 1928 the museum opened its current home, a grand Neoclassic temple with wings embracing an open court designed by Horace Trumbauer (1868–1938) and his chief designer Julian Abele (1881-1950) and the architectural firm of Zantzinger, Borie, and Medary. Throughout the twentieth century the extensive holdings of the museum grew to more than 300,000 objects that include masterpieces in every medium of art in four major areas: Asian, European, American, and Modern and Contemporary Art.

An interest in folk art began early in the museum's history, during the directorship of Edwin Atlee Barber (1851–1916) between 1907 and 1916. His comprehensive research on the history of ceramics encouraged the museum's acquisition of important examples from Mexican Talavera pottery to Pennsylvania German redware to contemporary porcelain.

The museum's folk art collection of 23,000 objects includes examples of eighteenth- and nineteenth-century American, Pennsylvania German, and Shaker works; folk ceramics; metalwork; and works on paper. The museum's outstanding examples of American folk art include Pennsylvania German painted chests, redware ceramics, textiles, fraktur, *Noah's Ark* by Edward Hicks (1780–1849), and the Zieget Collection of Shaker furniture and other objects. Important folk art exhibitions have been "The Pennsylvania Germans: A Celebration of Their Arts 1683–1850" (1982), "From Pieces Here to Pieces Joined: American Appliquéd Quilts" (1989), and "Community Fabric: African American Quilts and Folk Art" (1994).

In 2002, the museum established the Center for American Art, dedicated to the study of the artistic and cultural heritage of the United States, particularly of the Philadelphia area, through lectures, programs, symposia, fellowships, publications, and research. The museum schedules fifteen to twenty special exhibitions each year and produces numerous catalogs and research publications in relation to its ongoing programs.

See also **African American Folk Art (Vernacular Art); Fraktur; German American Folk Art; Edward Hicks; Metalwork; Papercutting; Pennsylvania German Folk Art; Quilts; Quilts, African American; Redware; Shaker Drawings; Shaker Furniture; Shakers.**

BIBLIOGRAPHY

Blum, Dilys, and Jack L. Lindsey. "Nineteenth Century Appliqué Quilts." *Philadelphia Museum of Art Bulletin*, vol. 85, no. 363–364 (fall 1989): 1–47.
Garvan, Beatrice B. *The Pennsylvania German Collection.* Philadelphia, 1982.

DEBORAH LYTTLE ASH

PHILLIPS, AMMI (1788–1865) was a skilled and prolific portrait painter whose biblical name, meaning "my people," was a prescient indication of the legacy he was to leave of friends and neighbors living primarily in the border areas of Connecticut, Massachusetts, and New York. His long career and significant number of extant paintings provide a unique opportunity to assess broad changes in popular taste over time, as well as one artist's ability to meet those changes. That Phillips was successful in his efforts for more than fifty years is suggested by the fact that several distinct bodies of work, once ascribed to the "Border Limner," the "Kent Limner," and other unidentified artists, were demonstrated in 1959 by Barbara and Lawrence Holdridge to have been the production of a single artist: Ammi Phillips, working at different points in his career. One clue to his endurance lies in the early and only known advertisements that Phillips placed, in 1809 and 1810, when he was working in Pittsfield, Massachusetts. In these notices, the young artist asserts that he will portray his clients with "perfect shadows and elegantly dressed in the prevailing fashions of the day," a promise that Phillips kept for the next five decades.

Phillips came to the attention of the modern art world in 1924, when eight seemingly identical portraits, which were part of the legacy of Kent, Connecticut, families, were exhibited at a summer fair in that town. The portraits' artist, dubbed the Kent Limner thereafter, was widely admired by modernist artists who recognized in his portraits a reductive and abstract approach that resonated with their own work. The portraits coincidently gave rise to the popular and persistent myth that folk painters completed "stock bodies" for their paintings during the winter months, and traveled during the warmer times of the year painting individual portraits onto those bodies.

Phillips was born in Colebrook, Connecticut, in 1788. His art training, if any, is not known, but it has been speculated that the spare aesthetic of his portraits may have been influenced by the work of Connecticut artist Reuben Moulthrop (1763–1814), who painted Phillips' namesake, the Reverend Ammi Ru-

hamah Robbins, in nearby Norfolk. Phillips was also almost certainly aware of a Massachusetts artist, James Brown (active 1806–1808), whose 1808 full-length portrait of *Laura Hall* appears to have been the direct model for Phillips' 1811 portrait of *Pluma Amelia Barstow.* Although Phillips was listed in his father's household in the 1810 census, he was already painting in the Berkshires in Massachusetts, and advertising his "extensive experience." As no portraits from this earliest period have yet been identified, his competence must be gauged from portraits of 1811 and 1812. Based upon these examples, Phillips' skills at this point were rudimentary, yet many stylistic traits were already established: almond-shaped eyes, generous, off-center mouths, heavy outlining, few props, and plain backgrounds. Following his marriage in 1813 to Laura Brockway of Schodack, New York, Phillips was working in New York State, where he painted masterful portraits of *Harriet Campbell* and *Harriet Leavens.* Executed just a few years later than *Pluma Amelia Barstow,* the young women are similar in pose, but the dark palette of the Barstow portrait and the gangly awkwardness of the sitter have been translated into ethereal visions of tensile strength and delicate beauty in the shimmering, pearly hues of the Romantic age. Color fields now delineate the floor and walls, and a few key props balance the horizontal and vertical planes of the composition.

The luminous Romanticism of these portraits yields to an increasing realism by the end of the 1820s, reverberating with the sensibilities of the Jacksonian age. In 1830 Phillips' wife died, and he remarried shortly thereafter. The purposeful portraits of the ensuing so-called Kent years are codified depictions of men sitting formally in stenciled or grained chairs, wearing dark suits, and holding newspapers or books in their hands, and women leaning forward from the waist, their solemn faces perched on long, graceful necks. The canvases are studies in dark and light, mass and composition. Brilliant colors and translucent skin tones emerge dramatically from velvety backgrounds, focusing attention on the sitter. The iconic *Girl in Red Dress with Cat and Dog,* painted during this period, is one of a small but significant group of portraits of young children wearing similar red dresses with a dog by their feet. The portrait was included in "The Flowering of American Folk Art, 1776–1876," the seminal exhibition presented by the Whitney Museum of American Art in 1974, and more recently was reproduced as a United States postal stamp (1997–1998).

In 1840 Phillips painted a millwright from Somers, New York, and inscribed the reverse with his own name, the name and age of the sitter, and the year he painted the portrait. Because it was painted in a style similar to the Kent Limner's, *George Sunderland* became the Rosetta stone by which Barbara and Lawrence Holdridge were able to match names, signatures, and distinctive characteristics from the "Border" years, before 1820, to the "Kent" portraits of 1829 to 1838. By this time, Phillips was vying with photographic portraits, and he once again adapted his style to a new aesthetic. His portraits after 1840 reflect the rich, saturated colors of the Victorian age, as well as the staged aspect of the studio photograph. They also become more sculptural, in response to the "true to life" aspect of photography.

Sometime before 1860, Phillips moved back to the Berkshires, and is listed in the census as a resident of Curtisville (now Interlaken, near Stockbridge). By the time of his death, Phillips had painted hundreds, possibly thousands, of portraits, and had ventured as far north as Ticonderoga, New York, in the Adirondacks, and as far south as Bedford, in Westchester County, New York. In 1965 the Holdridges organized the first exhibition to present the full range of Phillips' oeuvre for the Connecticut Historical Society, and had identified 219 portraits. More than six hundred remarkable paintings, created between 1811 and 1862, are now attributed to Ammi Phillips, perfectly reflecting the prevailing fashions of the day and the people who wore them.

See also **James Brown; Reuben Moulthrop; Painting, American Folk.**

BIBLIOGRAPHY

Black, Mary. "Ammi Phillips: The Country Painter's Method." *The Clarion,* vol. 11, no. 1 (winter 1986): 32–37.

Chotner, Deborah, et al. *American Naïve Paintings: The Collections of the National Gallery of Art Systematic Catalogue.* Washington, D.C., 1992.

Heslip, Colleen Cowles. *Between the Rivers: Itinerant Painters from the Connecticut to the Hudson.* Williamstown, Mass., 1990.

Holdridge, Barbara C., and Lawrence B. Holdridge. *Ammi Phillips: Portrait Painter, 1788–1865.* New York, 1969.

———. "Ammi Phillips, 1788–1865." *The Connecticut Historical Society Bulletin,* vol. 30, no. 4 (October 1965): 97–145.

Hollander, Stacy C., and Howard P. Fertig. *Revisiting Ammi Phillips: Fifty Years of American Portraiture.* New York, 1994.

Rumford, Beatrix T., ed. *American Folk Portraits: Paintings and Drawings from the Abby Aldrich Rockefeller Folk Art Center.* Boston, 1981.

STACY C. HOLLANDER

PHOTOGRAPHY, VERNACULAR is a category that encompasses a wide variety of photographic forms and artifacts, from early studio portraits to technical illustrations to news photographs to amateur snap-

shots. Since its invention in 1839, photography has flourished at the crossroads of art and science. Among its earliest practitioners were chemists, silversmiths, watchmakers, tinkers, opticians, and engravers who were attracted by the artistic and commercial potential of the new medium. With the invention of the Kodak camera in 1888, these professionals and serious amateurs were joined by an even greater number of casual snapshooters, and since then photography has become the most ubiquitous form of popular visual expression.

Although photography was first invented and patented in France and England, it had spread throughout the United States by the early 1850s. Hundreds of commercial portrait studios sprang up in major cities, and itinerant photographers roamed the countryside with cameras and portable darkrooms in tow. The daguerreotype—a one-of-a-kind image on a highly polished copper plate coated with light-sensitive silver crystals—was the most common photographic process of the day. Priced at twenty-five cents to a dollar each, daguerreotypes allowed an unprecedented number of people from all social strata to commission portraits of themselves and their families. Even less expensive was the tintype, a similar process using thinly pressed iron rather than silvered copper. The low cost and relative ease of producing a photographic likeness forced many American miniature painters either to close shop or to take up the new medium.

Most daguerreotype portraits present the sitter in a standardized three-quarter-length pose against a plain, dark background; but at their best these images have an astonishing sense of three-dimensionality, uncanny detail, and a penetrating directness. Finished daguerreotypes were protected under glass in velvet-lined cases, often decorated with raised geometric or floral motifs. Intimate in scale, with a highly reflective surface, the daguerreotype portrait was meant to be held in the hand and treasured as a sentimental keepsake.

Another form of vernacular photography that captured the popular imagination in mid-nineteenth-century America was the stereograph, two nearly identical images mounted side by side on a stiff card, which were viewed through a stereoscope to produce a startling illusion of three-dimensionality. The stereoscope, a device based on the principles of binocular vision, had first appeared in the 1830s, with geometric drawings used to create an illusion of depth. By the early 1840s, photographs had replaced drawings, and within a decade collecting stereographs had become a rage throughout the world. Publishers began to specialize in the mass production and distribution of stereographs, flooding the market with views of every conceivable subject: landscapes, street scenes, foreign locales, tourist attractions, monuments, battlefields, and scenes of contemporary events, as well as pornography. In the late nineteenth century, the stereoscope filled much the same role as television in the twentieth, providing entertainment, education, diversion, and visual gratification. Entire evenings were spent viewing and trading stereographs, and it was said that no parlor in America was without a stereoscope.

By far the most significant event in the history of vernacular photography was the introduction of the Kodak Number 1 camera in 1888. Invented and marketed by George Eastman, a former bank clerk from Rochester, New York, the Kodak was a simple box camera that came loaded with a 100-exposure roll of film. When the roll was finished, the entire machine was sent back to the factory in Rochester, where it was reloaded and returned to the customer while the first roll was being processed. Although the Kodak was made possible by technical advances in the development of roll film and small, fixed-focus cameras, Eastman's real genius lay in his marketing strategy. By simplifying the apparatus and even processing the film for the consumer, he made photography accessible to millions of casual amateurs who had no particular professional training, technical expertise, or aesthetic credentials. To underscore the ease of the Kodak system, Eastman launched an advertising campaign featuring women and children operating the camera, and he coined the memorable slogan: "You press the button, we do the rest."

Within a few years of the introduction of the Kodak, snapshot photography became a national craze. Various forms of the word "Kodak" (kodaking, kodakers, kodakery) entered common American speech, and amateur "camera fiends" formed clubs and published magazines to share their enthusiasm. By 1898, just ten years after the first Kodak was introduced, one photography journal estimated that over 1.5 million roll-film cameras had reached the hands of amateur shutterbugs.

The great majority of early snapshots were made for personal reasons: to commemorate important events (weddings, graduations, parades); to document travels and seaside holidays; to record parties, picnics, or simple family get-togethers; to capture the appearance of children, pets, cars, and houses. The earliest Kodak photographs were printed in a circular format, but later models produced a rectangular image, usually printed small enough to be held in the

385

palm of the hand. Most snapshots produced between the 1890s and the 1950s were destined for placement in the family album, itself an important form of vernacular expression. The compilers of family albums often arranged the photographs in narrative sequences, providing factual captions along with witty commentary; some albums contain artfully elaborate collages of cut-and-pasted photographs and text, often combining personal snapshots with commercial images clipped from magazines.

During the first decade of the twentieth century, a number of serious amateur photographers reacted to the snapshot craze by forming organizations dedicated to promoting photography as a fine art rather than a popular pastime or a commercial pursuit. The most prominent of these organizations in the United States was Photo-Secession, founded in 1902 by the photographer, publisher, and galleryist Alfred Stieglitz. To the pictorialist photographers associated with the Photo-Secession movement, snapshot photography lacked the aesthetic sensibility and technical expertise necessary to qualify as fine art. In an article published in the magazine *Photographic Topics* in 1909, Stieglitz warned casual amateurs not to take themselves too seriously: "Don't believe you became an artist the instant you received a gift Kodak on Xmas morning." By staking out a position in opposition to both amateur and commercial photographers, Stieglitz and his compatriots succeeded in winning a place for photography in the hallowed halls of high art.

However, only a few decades later photographers such as Walker Evans, uncomfortable with the preciousness of much art photography of the day, began to reconsider snapshots, documentary photographs, and turn-of-the-century penny picture postcards, recognizing these unassuming pictures as forms of homegrown American folk art. In his own photographs of the 1930s, Evans aspired to the straightforward matter-of-factness and quiet lyricism of these vernacular traditions, training his lens on small-town main streets and roadside scenes in the rural American South.

By the 1950s, a number of younger photographers such as Robert Frank and William Klein had begun to embrace the formal energy, spontaneity, and immediacy of the snapshot and to bring these qualities to their own work. Grainy and blurred, with tilted horizons and erratic framing, their photographs managed to capture the movement and chaos of modern urban life in visual form. In the mid-1960s, the idea of a "snapshot aesthetic" began to gain currency in art photography circles. Photographers like Lee Fried-

lander and Garry Winogrand prowled the streets of New York with handheld cameras, producing images that seemed random, accidental, and caught on the fly. The majority of art photographers working in this mode used black-and-white film, but in the early 1970s photographers such as William Eggleston and Stephen Shore incorporated the saturated hues of early color snapshots into their work.

Among the most influential champions of the vernacular tradition in photography was John Szarkowski, curator of photography at the Museum of Modern Art in New York. In a seminal book and exhibition, *The Photographer's Eye* (1966), Szarkowski examined the essential characteristics of the medium by placing photographs by well-known art photographers alongside commercial studio portraits, newspaper pictures, and snapshots. This book was followed by a number of other compilations of photography, including Michael Lesy's *Wisconsin Death Trip* (1973), Larry Sultan and Mike Mandel's *Evidence* (1977), and Barbara P. Norfleet's *The Champion Pig: Great Moments in Everyday Life* (1979), which recontextualized images culled from rural newspaper offices, police files, insurance adjusters, and small-town portrait studios. Filled with visually arresting images by unknown amateur or commercial photographers, these books achieved cult status among artists and collectors and contributed to a growing interest in collecting the anonymous vernacular photographs that often surfaced at flea markets, estate sales, and auctions.

By the late 1990s, vernacular photography, and in particular anonymous snapshots from the late nineteenth century and the early twentieth, found a place on the walls of major American art museums. In 1998 the San Francisco Museum of Modern Art organized the exhibition "Snapshots: The Photography of Everyday Life, 1888 to the Present"; and in 2000 the Metropolitan Museum of Art presented "Other Pictures: Anonymous Photographs from the Thomas Walther Collection." Both exhibitions featured numerous photographs that, through some technical error—a tilted horizon, an amputated head, a looming shadow, or an inadvertent double exposure—achieved a strange and unexpected visual charm. Removed from their original context in the family album, these anonymous vernacular photographs take on new meanings, inviting interpretation as a uniquely modern form of American folk art.

BIBLIOGRAPHY

Bourdieu, Pierre. *Photography: A Middle-Brow Art*. Stanford, Calif., 1990.

Coe, Brian, and Paul Gates. *The Snapshot Photograph: The Rise of Popular Photography, 1888–1939*. London, 1977.

Collins, Douglas. *The Story of Kodak*. New York, 1990.

Fineman, Mia. *Other Pictures: Anonymous Photographs from the Thomas Walther Collection*. Santa Fe, N. Mex., 2000.

Nickel, Douglas. *Snapshots: The Photography of Everyday Life, 1888 to the Present*. San Francisco, 1998.

Szarkowski, John. *The Photographer's Eye*. New York, 1966.

MIA FINEMAN

PICKETT, JOSEPH (1848–1918) was one of the first twentieth-century self-taught artists to be recognized by the writer and curator Holger Cahill and is still regarded as one of the century's outstanding artists. His only surviving works are three attributed paintings, a possible fourth, and at least one drawing in colored pencil on paper, called *The Old and the New*.

Pickett's paintings record something of the history and landscape of his own small town: New Hope, Pennsylvania, just over the bridge from Lambertville, New Jersey. From the beginning of the twentieth century, this area with its splendid scenery—wooded hills along the banks of the Delaware River, an old canal, mills, and farmland—attracted artists and photographers.

Pickett's father, Edward, had come to New Hope in 1840 to repair canal locks and became a canal boat builder. Pickett worked with his father and learned carpentry from him but practiced it only briefly. Instead, Pickett traveled with carnivals and fairs and ran concessions such as cane racks, knife boards, and shooting galleries. He ran a successful rifle concession at picnic grounds at nearby Neshaminy Falls, where prosperous Philadelphians went on Sunday outings. Pickett may have met his future wife, Emily (whose birth name is unknown) at Neshaminy. They were married in the mid-1890s, settled in New Hope, and opened a grocery and general store there, on Mechanic Street. The store sign, "Pickett," showed a landscape with a large tree; it was perhaps a backdrop scene Pickett had painted for his shooting gallery. In 1912, Pickett moved the store to Bridge Street, near the railroad station and the canal, and applied his carpentry skills to build an addition for living quarters.

From the time of his marriage until the year he died, Pickett painted in the back room of his store. At first he used house paint; later, he worked in oil on canvas. His method was slow and labor-intensive. He would often spend years on a single painting in order to get the desired texture, sometimes mixing sand and shells with pigment for a particular effect. His style is characterized by this build-up of texture to simulate topography, concrete, the bark of trees, and struc-

tures such as a railroad trestle; and by a flattened arbitrary perspective, liberties with scale, and bright colors.

Pickett honored George Washington in two of his paintings. In *Washington under the Council Tree* (1890–1918), the general is shown on horseback under a legendary chestnut tree with a 22-foot trunk, at York and Trenton Roads; according to local folklore, this was where Washington planned his surprise attack on the Hessian army at Trenton. However, Pickett was not much concerned with historical accuracy. In *Coryell's Ferry* (1890–1918), Washington, shown on the crest of a hill, is a tiny figure peering through a telescope, while his horse waits off to one side in midground. This event actually took place in the winter of 1776, when the Continental troops were camped at the ferry crossing, but Pickett's landscape is lush and green, with swaying trees, as if in spring.

Pickett also documented Manchester Valley, where the railroad came to the town of New Hope, changing the bucolic landscape forever. According to Cahill and Gauthier, Pickett shows a remarkable sense of design and craftsmanship "of a very inventive kind" in *Manchester Valley* and is "one of the most authentic and important of the masters of folk and popular art."

In 1918, Pickett sent one of his paintings to an annual exhibition sponsored by the Pennsylvania Academy of Fine Arts. It was rejected but nevertheless received the votes of three jurors—the artists William L. Lathrop, Robert Henri, and Robert Spencer.

When Pickett died, his wife tried to sell his paintings at an auction. The high bids were a mere dollar each, so she herself bought the paintings and donated the masterpiece, *Manchester Valley*, to New Hope High School. Lloyd Ney, an artist in New Hope, saw the two paintings of George Washington at the Worthington Brothers' Garage, which then stood on the site of Pickett's old store on Bridge Street. Ney paid fifteen dollars for the two but traded them to a local art dealer, R. Moore Price, for fifty dollars' worth of frames.

Paintings by Pickett are in the permanent collections of three museums. *Washington under the Council Tree, Coryell's Ferry, Pennsylvania* is in the Newark Museum (New Jersey); *Coryell's Ferry, 1776* is in the Whitney Museum of American Art (New York); and *Manchester Valley* is in the Museum of Modern Art (New York).

See also **Holger Cahill; Painting, American Folk.**

BIBLIOGRAPHY

Cahill, Holger, and Maximilien Gauthier. *Masters of Popular Painting: Modern Primitives of Europe and America.* New York, 1938.

Janis, Sydney. *They Taught Themselves: American Primitive Painters of the Twentieth Century.* New York, 1942.

Lipman, Jean, and Tom Armstrong, eds. *American Folk Painters of Three Centuries.* New York, 1980.

Museum of Modern Art. *American Folk Art: The Art of the Common Man 1750–1900.* New York, 1932.

Newark Museum. *American Primitives.* Newark, N.J., 1930.

LEE KOGAN

PICTURES, NEEDLEWORK are pictorial images embroidered in silk or wool onto a ground fabric, usually silk or linen. Often framed for display, they could also be used as covers for small wooden cabinets or decorative fire screens. Like samplers, needlework pictures were an important part of the education of young women of means in both Europe and America in the seventeenth, eighteenth, and early nineteenth centuries.

The archaeological record indicates that pictorial embroidery was worked from very early times in many parts of the world. Examples have been found in China and Peru that date from the second century BCE. One of the most famous of the early European examples is the Bayeux Tapestry, an embroidered wall hanging that depicts the Norman conquest of Britain, worked by professional embroiderers about 1070. In the Middle Ages, pictorial needlework was used to embellish ecclesiastical vestments, high-quality wall hangings, and other furnishings, clothing, and domestic textiles. During the seventeenth century, needlework pictures began to be framed for display, a tradition that was brought to America. The earliest known American example is a set of pictorial needlework covers for a small cabinet that are said to have been worked sometime between 1655 and 1685 by the daughters of John Leverett, governor of Massachusetts.

The vast majority of European and American needlework pictures from the eighteenth and early nineteenth centuries were worked by schoolgirls. Needlework, along with music, drawing, and painting, was taught as a skill. In most cases the designs were copied from engravings and other printed sources. Some of these were published specifically as needlework patterns; for example, a map of Europe published in *Lady's Magazine* was copied and worked by Philadelphia schoolgirl Ann Smith in 1787. Scholars have been searching for print sources for other needlework pictures since the 1930s, but many remain unknown. At times a number of designs from various printed sources would be combined, often without changes to the relative sizes of the patterns, so that unusual proportions might be the result; for example, enormous floral sprigs might be placed beside smaller human figures.

There is evidence that some designs were drawn or copied by needlework teachers, and that some girls were taught to draw and copy needlework designs themselves. A rare drawing book owned by Ann Flower of Philadelphia has survived from the mid-eighteenth century. It contains needlework designs, pictures of her home and family, and copies of botanical illustrations. Other less skillful young women commissioned local artists to draw needlework patterns for them; an example of a design for whitework survives, inscribed "*Drawn for Miss H. McIntire*" and initialed "*I.C.*" In fact, a number of professional artists have been identified who drew needlework designs for young women to work, among them Samuel Folwell (1764–1813), who worked in Philadelphia, and the portrait painter John Johnston (1753–1818), who worked in Boston.

So many American needlework pictures survive from the mid-eighteenth century that regional styles and characteristics, and at times particular schools, can be identified. By the 1740s Boston artists were known for their pastoral canvaswork pictures, worked primarily in wool on linen canvas in a small, diagonal stitch, known as a tent stitch, which covers the crossing of the warp and weft of the ground linen, and which today is known as needlepoint. This group is often referred to as "Fishing Lady pictures," despite the fact that not all of them depict a woman fishing. They closely follow a model for pastoral canvaswork pictures established in England in the early eighteenth century. At about the same time, a group of needlework pictures that look very different but that employed the same embroidery technique have been identified as from Norwich, Connecticut. These depict Bible stories or other narratives, illustrated with figures in contemporary dress. In the 1730s a group of silkwork pictures was made by girls attending the school operated by Elizabeth Marsh (1683–1741) and her daughter, Ann (1717–1797). These pieces were worked in silk thread on a silk ground using primarily a flat stitch, an American version of a satin stitch, intended to save on expensive silk thread.

The height of popularity for needlework pictures worked in silk on a silk ground was from about 1790 to the 1830s; this coincided with a period of growth in the number of female academies in the United States. The eighteenth–century European and American predilection for heightened sentimentality provided subjects for many needlework pictures. At least three

silkwork pictures depicting Maria, the heroine of Laurence Stern's novel *A Sentimental Journey,* survive. Mourning pictures became phenomenally popular in America following the death of George Washington in 1799, many of them copied directly from the memorial prints that were also prevalent at the time. In 1817 Elizabeth Lane worked a needlework picture copied directly from an engraving by Samuel Seymour titled *In Memory of General Washington and His Lady,* published by John Savage in Philadelphia in 1804 and 1814. Biblical, allegorical, and historical subjects were also widely popular at this time.

Some needlework pictures were not only copied from engravings but were worked specifically to look like the prints from which they were taken. These were known as "printwork," and were worked in black silk thread on a white silk ground with the intention of looking exactly like an engraved print. A group of printwork mourning pictures depicting a church flanked by monuments and gravestones has been identified as originating from Albany, New York. In another example, attributed to Margarietta Beeckman, even the signature of the engraver has been copied and embroidered. Other printwork pictures incorporate washes of watercolor, mimicking the practice of adding painted color to engravings. Many early-nineteenth-century pictures combined both painted and embroidered elements, often incorporating chenille thread, a fuzzy silk thread that resembles a caterpillar. A number of professional artists have been identified who would draw needlework designs for young women to work and then fill in the painted elements after the needlework was completed, including Samuel Folwell and John Johnston, mentioned previously, and John Robert (1769–1803) of Portland, Maine.

More than three hundred needlework schools and instructors have been identified, many from their advertisements in newspapers of the eighteenth and early nineteenth centuries. American needlework scholars, particularly Betty Ring, have been working for more than 20 years to link surviving needlework to these schools. Only a few outstanding examples can be mentioned here. Elizabeth Murray (1726–1785) was a well-respected teacher in mid-eighteenth century Boston. Not only did she teach the daughters of important men, such as Faith Trumbull, daughter of Gov. Jonathan Trumbull of Connecticut, but Murray also is known to have encouraged young women, such as Jannette Day, who became a needlework teacher, to be financially independent by going into business for themselves as shopkeepers and teachers. Mary Balch (1762–1831) opened a school in Providence, Rhode Island, in the 1780s, and continued to teach until about 1826. In 1821 records show that 113 students, primarily girls but including some young boys as well, attended her school. The previously mentioned Elizabeth Marsh and daughter Ann were the premier teachers of needlework in Philadelphia from 1725 until about 1792, and their students included many daughters of the Quaker elite of that city, who worked fine samplers as well as silkwork pictures. From stylistic similarities across the region we can surmise that their needlework was influential throughout the Delaware Valley.

Farther south, Elizabeth Ann Seton (1774–1821), the first American saint, canonized in 1975, founded Saint Joseph's Academy in Emmitsburg, Maryland, in 1810. The majority of the silkwork pictures produced at the academy were made after 1820 and through the 1830s. The school itself survived until 1972. Examples of needlework from Southern schools are rare, despite the groundbreaking research of Kimberly Smith Ivey in Virginia and Jan Hiester and Kathleen Staples in Charleston, South Carolina. Scholars such as Sue Studebaker have extended what is known about needlework pictures and their makers westward to Ohio, where she also lives.

By the mid-nineteenth century, needlework lost its importance in the educational curriculum for girls; needlework pictures continued to be made, however, outside of the academies, particularly with a technique known generally as "Berlin woolwork." Worked in cross-stitch using wool thread, sometimes with silk highlights, these pictures are less skillfully executed than examples of silkwork from the earlier Federal period (1790–1815). Commercial patterns from which to make these pictures were widely available, often illustrating popular scenes from contemporary novels or narrative poems. Other patterns depicted important American political figures. Many examples exist of needlework pictures depicting George Washington, copied from a portrait by John Trumbull, and Henry Clay (1799–1852), a political figure whose widespread popularity rivaled America's first president, copied from a portrait by John Naegle.

The revival of finely worked embroidery in the late nineteenth century was heavily influenced by English examples shown at the Royal School of Art Needlework, at the Philadelphia Centennial Exhibition in 1876. Teachers from the Royal School were brought to America to teach the all-but-forgotten techniques to adults rather than schoolgirls. Although a great deal of the embroidery of this period was created for clothing and furnishings, some late nineteenth century needlework pictures were often worked as cop-

ies of seventeenth- and eighteenth-century still-life paintings.

The handicraft revival, closely associated with the Arts and Crafts movement (1870–1920), newly inspired many women to embroider pictorial work. Some examples were copied from American needlework pictures from the past, but the working of original designs was also developed during the early twentieth century. Designers like Erica Wilson, who trained at the Royal School of Needlework, marketed contemporary designs for needlework throughout the 1960s and 1970s. Many needleworkers began to use both traditional and modern techniques, including machine embroidery, as a medium to express their own creativity as artists, instead of the more traditional mediums of painting and sculpture. It is no coincidence that this period also marked a rise in the collecting of needlework pictures, as well as an increase in their historic and monetary values.

See also **John Johnston; Mourning Art; Painting, Still-life; Painting, Theorem; Samplers, Needlework.**

BIBLIOGRAPHY

Hiester, Jan, and Kathleen Staples. *This Have I Done: Samplers and Embroideries from Charleston and the Low Country.* Greenville and Charleston, S.C., 2001.

Ivey, Kimberly Smith. *In the Neatest Manner: The Making of the Virginia Sampler Tradition.* Williamsburg, Va., 1997.

Richter, Paula Bradstreet. *Painted with Thread: The Art of American Embroidery.* Salem, Mass., 2000.

Ring, Betty. *Girlhood Embroidery: American Samplers and Pictorial Needlework, 1650–1850.* New York, 1993.

Studebaker, Sue. *Ohio Is My Dwelling Place: Schoolgirl Embroideries, 1800–1850.* Athens, Ohio, 2002.

Swan, Susan Burrows. *Plain and Fancy: American Women and Their Needlework, 1650–1850.* Austin, Tex., 1995.

Synge, Lanto. *Art of Embroidery: History of Style and Technique.* Woodbridge, England, 2001.

LINDA EATON

PIERCE, ELIJAH (1892–1984) made carved relief panels that are frequently characterized as visual sermons and narrative tableaux. Pierce was born to an African American farming family in Baldwyn, Mississippi, and began carving as a child—mostly images of animals on tree trunks and some walking sticks that recall southern whittling traditions. Pierce's turbulent youth included work as a barber's assistant, religious conversion to the Baptist faith, false arrest for murdering a white man, and living as an itinerant throughout the South and Midwest. In 1920 he received a lay preacher's license from Mount Zion Baptist Church in Baldwyn. Three years later he settled in Columbus, Ohio, where he established himself as a successful barber, respected church leader, and acclaimed folk artist.

Around 1932, after carving a small elephant, Pierce renewed his interest in working with wood. His talent and ambition progressed quickly. During the 1930s and 1940s, Pierce took up itinerant preaching, using the monumental *Book of Wood* (Columbus Museum of Art), which he completed around 1932, and other carvings as teaching devices at tent revivals, churches, and fairs throughout the South and Midwest as well as in his house in Columbus. In 1967 his carvings attracted their first newspaper coverage; this gave him his first opportunity, a year later, to display his work as folk art and prompted him to set aside part of his barber shop as a gallery and studio in 1969.

In his ministry and his art, Pierce called on the tradition of African American evangelical preaching, which incorporates popular storytelling, especially folk variations on scriptural stories and parables. He considered his ability to see forms and subjects in wood as God's gift of divination, and he frequently described his carvings as sermons and messages. His interpretations of biblical events and characters—Noah's ark, the crucifixion, Adam and Eve, Jonah and the fish—are the most didactic expression of his desire to convey spiritual insight.

Other significant relief carvings are his secular parables on the human condition, addressing everything from the vices of drinking, smoking, and gambling to the fleeting nature of time and earthly existence. Many panels reveal Pierce's talent for social and political commentary, which focused largely on the American experience, especially that of African Americans. Slavery, emancipation, justice, civil rights, community leadership, and corruption are major themes, sometimes illustrated as portraits of Lincoln, Martin Luther King, the Kennedy brothers, and Richard Nixon. Other carvings are overtly autobiographical, depicting, for example, his birthplace, religious conversion, freemasonry, and love of sports.

Most of Pierce's works are shallow bas-relief panels, vertical or horizontal in orientation, that average 24 by 30 inches. He composed these panels in two distinctive ways. The first type of composition presents a centralized image or event in great detail. The second type pieces together vignettes and inscriptions that suggest the tradition of prophetic biblical charts. Both approaches invite the viewer to read the compositions as narratives. The balance of Pierce's carvings are small freestanding efforts that favor subjects such as animals and scenes of daily life, as well as several elaborate walking sticks. His modest means

dictated the use of common materials such as house paint and glitter to embellish the carvings, and his bold use of color endows the works with a sense of drama.

Although Pierce's works were done primarily to enhance his community-oriented ministry, they reflect a confident visual artistry that has attracted the attention of collectors, dealers, curators, and artists involved in championing contemporary folk art since the 1960s. Numerous one-person and group exhibitions and publications have established his significance as a modern interpreter of African American religion and culture, and as one of the country's most important twentieth-century folk artists. In 1982, his work was featured in the nationally touring exhibition "Black Folk Art in America, 1930–1980," and he also received the prestigious National Heritage Fellowship from the National Endowment for the Arts and the Distinguished Humanitarian Arts Award from the Ohio Arts Council. In 1983, the Elijah Pierce Art Gallery became a National Historic Site in the National Register of Historic Places. In 1985, the Columbus Museum of Art established the most extensive public collection of Pierce's art with its acquisition of more than 100 works and archival materials from his estate. Pierce's carvings are also well represented in other major public collections in the United States.

See also **African American Folk Art (Venacular Art); Religious Folk Art; Sculpture, Folk.**

BIBLIOGRAPHY

Columbus Museum of Art. *Elijah Pierce, Woodcarver.* Columbus, Ohio, 1992.

Hartigan, Lynda Roscoe, "Elijah Pierce and James Hampton: One Good Book Begets Another." *Folk Art,* vol. 19 (summer 1994): 52–57.

LYNDA ROSCOE HARTIGAN

PINNEY, EUNICE (1770–1849) created sensitive and refined watercolors that have been admired by folk art scholars and enthusiasts since the 1940s. Pinney was born in Simsbury, Connecticut, to Elisha Griswold and Eunice Viets Griswold. Her parents came from prominent local families. She apparently had an extensive education and was considered in her own time to be very well-read and influential in her community. Pinney's first marriage, to Oliver Holcomb of Granby, Connecticut, produced two children, Oliver Hector and Sophia. In 1797, sometime after Holcomb's death, she married Butler Pinney of Windsor, Connecticut, and had three more children: Norman, Emeline Minerva, and Viets Griswold. The Pinneys

may have lived in Windsor or Simsbury, as the artist is mentioned as living in the latter village in 1844.

Pinney began to paint in watercolor, ink, and pencil on paper about 1805 and continued until at least 1826, the date of the last known extant work. Much of her subject matter reflects her interest in classic literature and poetry, including scenes from Goethe's *Sorrows of Werther,* Homer's *Iliad,* and Robert Burns's "The Cotter's Saturday Night." She is also known for her mourning pictures and scenes of everyday life; Pinney probably used print sources for much of her work.

Pinney's painting style was dominated by a strong sense of design—solid forms with sure-handed, bold draftsmanship and bright colors. She frequently emphasized visual patterns in the repetition of decorative shapes on floor coverings, costumes, drapery, or trees. Pinney also used ink and pencil to delineate facial features and other small details. Her use of published sources, particularly eighteenth-century English prints, can be seen in the painted oval framing device she often employed, and in the late-eighteenth-century costumes worn by her figures.

See also **Painting, American Folk.**

BIBLIOGRAPHY

Lipman, Jean. "Eunice Pinney, An Early Connecticut Watercolorist." *The Art Quarterly,* vol. 6, no. 3 (summer 1943): 213–221.

Lipman, Jean, and Tom Armstrong, eds. *American Folk Painters of Three Centuries.* New York, 1980.

Rumford, Beatrix T., ed. *American Folk Paintings: Paintings and Drawings Other Than Portraits from the Abby Aldrich Rockefeller Folk Art Center.* Boston, 1988.

PAUL S. D'AMBROSIO

PIPPIN, HORACE (1888–1946), an African American painter, was one of the foremost self–taught artists of the twentieth century. A descendant of former slaves, Pippin was born in West Chester, Pennsylvania, a small town near Philadelphia. Raised in Goshen, New York, he settled in West Chester as an adult. Pippin saw active duty in France during World War I as a member of the famous 369th Regiment of African American troops. Shot in the shoulder by a German sniper in 1917, he subsequently rekindled his boyhood interest in art when he taught himself to paint as therapy for his injury. In 1938 the Museum of Modern Art's exhibition, "Masters of Popular Painting," included four Pippin paintings following his inclusion in a West Chester group show. Championed by Robert Carlin, his Philadelphia dealer, and by the Philadelphia collector Dr. Albert Barnes, Pippin's talents soon garnered a national audience. In an essay ac-

companying Pippin's 1947 memorial exhibition, the Howard University scholar Alain Locke called him "a real and rare genius, combining folk quality with artistic maturity so uniquely as almost to defy classification."

Pippin had his first New York solo exhibition in 1940. Early critics, eager to honor American achievement with favorable comparisons to well-known European artists, awarded Pippin the accolade of "The American Rousseau," as they had with the Pittsburgh painter, John Kane (1860–1934). Pippin died of a stroke at age fifty-eight, only nine years after he had first come to prominence. His small oeuvre, numbering fewer than 140 paintings and drawings, includes self-portraits and portraits of those whom he loved or admired; still-lifes; richly detailed memory pictures of black family life at the turn of the century; sportsmen in outdoor settings; firsthand depictions of black soldiers in combat; and protests against social injustice.

The shrapnel wounds in his right shoulder restricted Pippin's range of motion. Right-handed, he used his left hand to brace his weaker limb. He preferred to work on small-scale compositions. In the 1920s Pippin whittled decorative picture frames and jewelry boxes, now lost. His first paintings were on wood, for which he employed a combination of etched lines and brushed-in color. Pippin devised a technique of burning on the outlines of images with a hot iron poker from the stove. He worked on the flat surfaces of wooden shingles, as well as on panels cut from the spare leaves of oak extension tables. His first painting on canvas, *End of the War: Starting Home* (1930–1933), depicted German soldiers surrendering to troops of the 369th Regiment. Its decorated frame, carved with images of war matériel, is unique in Pippin's work.

A master of design, Pippin adroitly allowed the graining and tonality of his wood panels to read as integral parts of the overall composition. In his early work, *Winter Scene,* Pippin refrained from painting inside the incised outlines of trees and a log cabin, thus rendering the supporting surface and the image magically as one. The visual punning of the coloration of wood and dark skin is realized to haunting effect in *The Whipping* (1941), a powerful indictment of the abuses of slavery. Several Pippin paintings address the history of abolition. His grandmother's eyewitness account of the 1859 hanging of the antislavery activist John Brown, for example, provided the basis for a 1942 painting that depicted her as the sole African American onlooker, staring out at the viewer on this historic occasion. Pippin's *Holy Mountain* series, painted during World War II, adapted the

biblical prophecy of Isaiah for a vision of future peace.

Whether Horace Pippin depicted domestic interiors or the natural environment, he was acutely sensitive to his surroundings. His painted patchwork quilts, for example, often reflect an African American aesthetic. Pippin was also attentive to seasonal changes, cloud patterns, and circadian light rhythms. Dawn-reddened horizons and crimson-stained twilights often appear in his landscapes, such as *Duck Shooting* (1941), *Cabin in the Cotton III* (1944), and *Temptation of Saint Anthony* (1946). Once, when describing the influence of his war experience on his later work as a painter, he wrote, "I can never forget the suffering, and I will never forget the sunsets. I came home with all of it in my mind." Pippin's last completed painting is *Man on a Bench* (1946), a meditative portrayal of an older African American that is widely regarded as a spiritual self-portrait.

See also **African American Folk Art (Vernacular Art); John S. Kane; Painting, Memory; Quilts, African American.**

BIBLIOGRAPHY

Barnes, Albert. *Horace Pippin Exhibition.* Philadelphia, 1940.

Bearden, Romare. *Horace Pippin.* Washington, D.C., 1976.

Locke, Alain. *Horace Pippin Memorial Exhibition.* Philadelphia, 1947.

Rodman, Selden. *Horace Pippin: A Negro Painter in America.* New York, 1947.

Stein, Judith E., et al. *I Tell My Heart: The Art of Horace Pippin.* New York, 1993.

JUDITH E. STEIN

PLACARDS: *SEE* TRADE SIGNS.

POLITICAL FOLK ART is art made by individuals who use their crafts to applaud or protest their government's actions. The figure of Uncle Sam riding a bicycle, a whirligig in the collection of the American Folk Art Museum, bears a flag marked on one side with the colors of the United States, on the other with those of neighboring Canada. It is hard to imagine a clearer expression of international amity. On the other hand, the Tammany Bank, a cast iron figure that slyly slips coins into its pocket, clearly reflects a dubious aspect of the American political process. Both views, hopeful and cynical, pervade the field of political folk art.

Key figures or archetypes such as Liberty, Uncle Sam, the Bald Eagle, and the American national flag appear consistently in the folk vernacular, changing form or costume, perhaps, but always retaining iconic status. Thus, Liberty first appeared in the guise of an

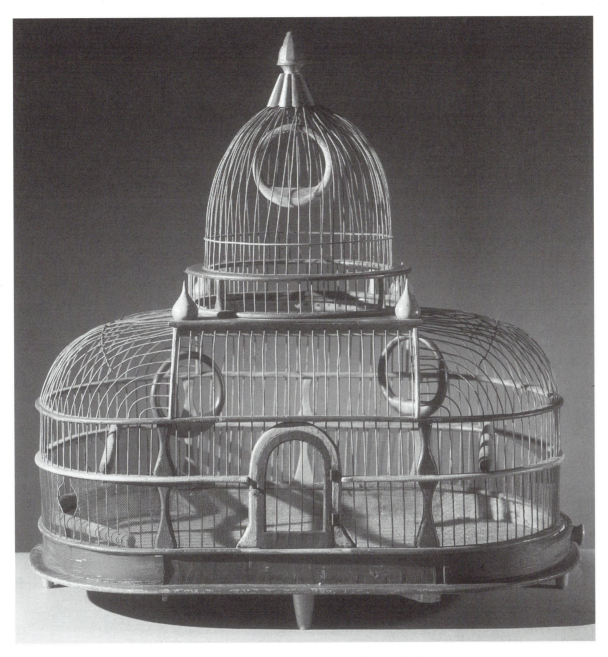

Red, White, and Blue Bird Cage in the shape of the United States Capitol Building. Probably produced for the Centennial celebration in 1876. Painted and carved wood and metal; 29 L × 17 W × 29 H inches.
Photo courtesy Allan Katz Americana, Woodbridge, Connecticut.

Indian Queen—a warlike figure in feathered headdress reflecting the European vision of Native Americans—but then her image gradually metamorphosed into a classical Greek goddess clad in a flowing gown and bearing various allegorical symbols such as the torch, book of wisdom, spear, and Liberty Cap.

In a similar manner the image of Uncle Sam transformed from Brother Jonathan, a rural trickster and sage, who, in his ability to outsmart seemingly more sophisticated opponents, symbolized the American Revolutionary War soldier. The Brother Jonathan character appeared in illustrations wearing a top hat,

long-tailed coat, and striped pants. During the War of 1812, Sam Wilson, a jovial Troy, New York, meat packer who had a contract to deliver beef to the United States Army became known as "Uncle Sam." In due course, writers and cartoonists attired the Uncle Sam figure in Brother Jonathan's clothing. Since then, Uncle Sam has appeared in the guise of trade signs, whirligigs, weathervanes, and countless toys.

The conclusion of the American Revolutionary War (c. 1775–1782) inspired feelings of patriotism and national unity that were reflected in the popular culture for decades thereafter. Folk painters, many of them itinerants who were equally skillful (or not) at painting portraits, tavern signs, coaches, and kitchen floors, found themselves called upon to constantly recreate the patriotic motifs; while carvers of tobacconists' figures and ship's figureheads found patriotic emblems among their best sellers. It was a time when every home boasted some sort of representation of George Washington on its walls, be it a commercially manufactured print or a reverse painting on glass by William Matthew Prior (1806–1873). Eagles crowned the majority of American municipal buildings, and the weary or thirsty traveler found his or her way at nightfall to the Liberty Bell or Lincoln Tavern, guided by a carved and painted sign that called upon the patriot to tarry. A carved wood bird cage, painted red, white, and blue and built in the form of the United States Capitol building, was probably created for the Centennial celebration of 1876; it is a whimsical nod to the grand edifice (begun in 1792 and completed in 1865).

Today political issues tend to be more fragmented and complex. Yet, the patriotic fervor that inspired the folk symbols of the nineteenth and early twentieth centuries has survived. Carved and painted mailboxes in the form of figures of Uncle Sam were inspired by the 1976 American Bicentennial celebrations, as were paintings of the American flag—raised in protest of the terror attack of September 11, 2001—that adorn and decorate both public and private walls, gates, doors, and signs.

The term political folk art also has a more specific meaning, however, relating to the numerous artifacts produced in the course of the American political process, that is, through the campaigns and candidates that have left their mark on American democratic society. Some of the most sought after political folk art relates to presidential campaigns (there is little interest in lesser contests) and to the victorious candidates, and in particular, George Washington, Abraham Lincoln, Theodore and Franklin D. Roosevelt,

and John F. Kennedy have captured the public imagination. This interest extends beyond the artifacts of campaign, election, and service in office, to those memorializing the historic figure, especially if he died in office. Mourning items include not only the theorem paintings and needleworks picturing Liberty or Columbia at the tomb of George Washington, but also late nineteenth-century plates bearing transfer decorated likenesses in black of the martyred presidents James A. Garfield and William McKinley.

Objects relating to quixotic causes and third party movements comprise another category of political folk art. A great groundswell was felt in the 1800s with the rise of the religious-inspired temperance movement, a protest against the perceived evils of alcohol consumption that produced individual crusaders such as the hatchet-wielding, Midwestern reformer Carry Nation (Carry Amelia Moore, 1846–1911) and, eventually in the 1920s, nationwide legal Prohibition. A vast amount of material exists from this era, as well as from the related Women's Rights Movement, that from its nascence in an 1848 convention at Seneca Falls, New York, to passage of the Nineteenth Amendment in 1920, struggled tirelessly for the female vote. Other common sources of historical material included the Abolitionist Movement against slavery, the struggles of organized labor for union rights and the eight-hour workday, and even the detritus left by such right-wing groups as the Ku Klux Klan.

Folk art related to election campaigns comprises another category of political folk art. From the 1820s, when electioneering as we know it began until the early twentieth century, presidential campaigns were intense public events featuring nighttime parades, stump speeches, and noisy gatherings of the party faithful. Precisely because there was no electronic media, it was necessary to employ a variety of materials and devices to publicize the candidate. Campaign banners of silk, linen, or cotton, for example, announced the candidates and their party affiliation, often with a captivating slogan such as "Freedom and Equality," and a patriotic symbol, such as the eagle. Many of these were handmade with painted or stenciled decoration, and are recognized as a form of folk painting. Every political party headquarters sported an oblong headquarters banner that was most often displayed in the front window, while parade banners graced festive marches. Parade banners were constructed of heavier material than was generally used for window banners, and were hung from long wooden shafts embellished with gilt cord, and brass or silvered tassels. Another folk art item used in parades, the flag banner,

consisted of a candidate's name, picture, and slogan superimposed upon a variation of the national flag. As these banners essentially "defaced" the venerated image of the American flag, these were banned around 1900 and surviving examples are rare.

Parades and rallies produced other kinds of political memorabilia. Before the invention of electricity, nighttime marches required lighting; thus the torchlight and lantern provided both illumination and candidate advertising. Torchlights, which looked a bit like tin cans mounted on poles, were fueled by coal oil or kerosene and were borne aloft during the march. Most were rather ordinary looking, such as those in the shape of top hats, roosters, sheep, axes, or even human busts. Campaign lanterns had carrying handles and glass sides upon which were pasted color prints of the candidates so that they might be seen in the glow of candle or oil light.

Canes and umbrellas were also popular in the nineteenth-century marches. The former featured handles carved or cast in the form of a candidate's bust, a party image such as the donkey, or even a horn to be tooted while on parade. Umbrellas might also have effigy handles, and the silk or oilcloth covering would usually be stenciled with party slogans. Moreover, noisemakers in the form of whistles, rattles, and ratchets, whose harsh sounds were well calculated to plague an opposing candidate's speech, are today widely collected. And, as almost every political participant was generally male, and a smoker, pipes were cast in the shape of the party symbol or the visage of the party's current frontrunner or favorite. Alcohol, too, could be a potent ally of the candidate, and from the 1820s until the early twentieth century, when laws were passed limiting drinking at the polling place, it was common practice to hand out free pints of liquor to prospective voters. Appropriately enough the booze was often contained in a glass bottle or flask embossed on one side with the candidate's image, on the other with an eagle, flag, or bust of George Washington, providing a sort of national recommendation for the office seeker.

Representations of death tended to be ritualized in the past, and the death of a president or other important public figure was typically the subject of a range of mourning or funerary memorabilia. The death of George Washington occasioned the manufacture of mourning rings, buttons, and tiny paintings to be placed inside lockets or brooches. The English potters, never ones to allow international animosity to stand in the way of a fast pound, flooded the American market with earthenware plates and pitchers with transfer printed images of the great man and slogans such as "Father of His Country." For decades after the event, schoolgirls from Maine to Ohio laboriously created mourning pictures featuring Washington's tomb and, usually, a group of mourners, typically clad in Roman togas. More unique versions might feature Native Americans, or luminaries such as Lafayette. By the late nineteenth century, folk artists were producing sandpaper or graphite paintings illustrating Washington's home and tomb at Mount Vernon, Virginia.

Other American presidents have been memorialized as well. Abraham Lincoln, recognized as both a heroic and tragic figure, has been the subject of many paintings and carvings and is a particular favorite of African American folk artists. Other politicians, some of them all but forgotten today, appear in the world of antiques. Benjamin Franklin's image can be found on the form of a Rockingham Toby pitcher made at the United States Pottery in Bennington, Vermont, around 1850. While Franklin's reputation in America is secure in the cultural memory primarily for his maxims and experiments with electricity than for his political role, his companions in clay, Zachary Taylor, United States president from 1848 to 1852, and John Stark, the American Revolutionary War general, are hardly blips on the cultural radar screen.

Whatever the cause they promoted, be it Prohibition, suffrage, or labor equity, political rebels were usually in the minority, and their ideas were often suppressed. In the process of disseminating their messages, reformers and political activists often had to generate a vast amount of propaganda including leaflets, tracts, song sheets, badges, ribbons, and posters. The temperance movement, for example, took as its symbol an ax of the sort Carry Nation purportedly used to break up saloons. Brooches and lapel pins in this form were made of everything from silver to pot metal. The opposition countered with equally collectible memorabilia such as the buttons proclaiming "WE WANT BEER" and "NO BEER NO WORK."

Some of the most remarkable protest memorabilia was generated by the Women's Rights Movement at the latter quarter of the nineteenth century. The cartoons issued in the popular press in opposition to the suffragists often mocked and portrayed women as wearing pants, holding political office, and serving in the military while their husbands cared for children and scrubbed floors. A rare object from this period is a statuette depicting the African American former slave, preacher and abolitionist Sojourner Truth, clad in her underwear, holding both a club and a sign proclaiming "Votes for Women."

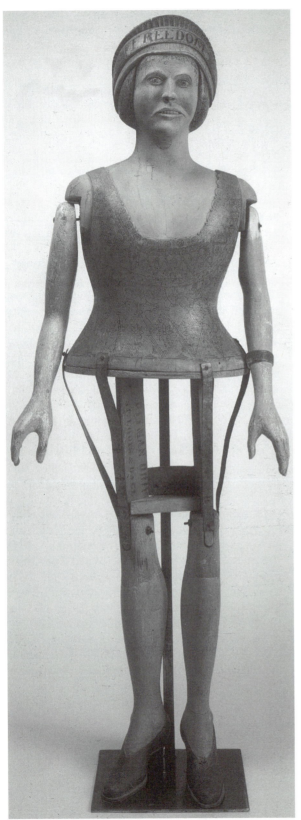

Another suffragette figure, titled "Miss Freedom" (maker unknown, c. 1910), features a fully formed trunk and partially formed legs that were likely draped in a red, white, and blue fabric skirt. The figure is carved in wood and decorated with a technique called pyrography or wood burning, a popular hobby practiced by women at the turn of the century. Historians speculate that Miss Freedom was probably used at locations where signatures were gathered to promote women's rights issues or used on parade floats at similar events or venues.

The Labor movement and the drive to unionize industrial America has also produced a vast amount of collectible material, although nothing that rivals the production of the folk artist and labor organizer, Ralph Fasanella (1914–1997). Fasanella's poignant and dramatic depictions of working-class misery in paintings remain unequaled and hang in major American museums. Union badges and the banners (often homemade) carried in protest marches, and posters such as the ones produced by the United Farm Workers are also highly prized today. Like all movement memorabilia, these capture the history of an ongoing struggle for equality. Other artists whose folk art is politically inspired include Ulysses Davis and Erastus Salisbury Field, among others. Group projects such as the AIDS Quilt also serve as remembrance and political statement.

See also **Banks, Mechanical; Canes; Ralph Fasanella; Flags; Holidays; Maritime Folk Art; Mourning Art; Painting, American Folk; Painting, Theorem; Pictures, Needlework; William Matthew Prior; Charles Peale Polk; Reverse-Glass Painting; Sandpaper Paintings; Trade Signs; Weathervanes; Whirligigs.**

BIBLIOGRAPHY

Fox, Nancy Jo. *Liberties with Liberty.* New York, 1985.
Ketchum, William C. *All-American: Folk Art and Crafts.* New York, 1986.
Klamkin, Marian. *American Patriotic and Political China.* New York, 1973.
Sullivan, Edmund B. *Collecting Political Americana.* New York, 1980.

WILLIAM C. KETCHUM

Suffragette Figure "Miss Freedom." Maker unknown; c. 1910; 69 × 21 × 14 inches.
Photo courtesy Allan Katz, Americana, Woodbridge, Connecticut.

POLK, CHARLES PEALE (1767–1822) was a major nonacademic painter who produced more than 150 portraits. Born in Annapolis, Maryland, he was orphaned during the American Revolutionary War and was raised by his uncle, the noted artist Charles Willson Peale (1741–1827), who educated him as a painter. Polk's artistic career began in Philadelphia about 1785, at the time of his marriage to Ruth Ellison, but by 1791 he had moved his family to Baltimore. Polk remained there for five years before moving west, to Frederick, Maryland.

During the next five years, as an itinerant painter in western Maryland and the northern Shenandoah Valley, Polk developed his mature style. Abandoning academic traditions, his distinctive style emerged, combining a heightened palette and electric highlights with an exaggerated attenuation of the human form. His portraits of *Isaac Hite*, *Eleanor Conway Hite and James Madison Hite*; *James Madison Sr.*; and *Eleanor Conway Madison*, painted in 1799, are his acknowledged masterpieces, demonstrating his accomplished manner of revealing more about the sitter than merely a physical likeness. Polk usually depicted sitters with objects and in settings telling about their family relationships, business dealings, or political beliefs. Isaac Hite's portrait, for example, declares support of the Republican Party and Thomas Jefferson's candidacy for president by inclusion of a newspaper known for its Republican views.

To further reinforce Hite's political ideals Polk was commissioned to portray Jefferson himself. He arrived at Monticello with a letter of introduction from James Madison, Hite's brother-in-law, and during November 1799 painted a portrait that was to become the source of at least five replicas. Plagued by a shortage of portrait commissions, Polk relied for income upon the sale of such replicas, not just of Jefferson but also of George Washington, a portrait he derived from images produced by his uncles Charles Willson Peale and James Peale.

Fleeing financial problems and political disagreements, Polk moved to Washington, D.C., in 1801, seeking a government appointment as a clerk in the United States Treasury Department. Through 1816 he painted occasional portraits of Washington residents, and also began working in *verre egolmisé,* a type of reverse painting with gold leaf on glass. Notable among his sitters are James Madison and Albert Gallatin, both portraits dating from about 1802 to 1803. Two years after his third marriage, to Ellen Ball Downman, Polk moved with his family to a farm in Richmond County, Virginia, where the artist spent the last two years of his life and probably continued to paint, as his estate records included painting supplies.

See also **Political Folk Art; Reverse-Glass Painting.**

BIBLIOGRAPHY

Miller, Lillian B. *The Peale Family: Creation of a Legacy, 1770–1870.* New York, 1996.

Simmons, Linda C. *Charles Peale Polk (1767–1822), A Limner and His Likenesses.* Washington, D.C., 1981.

LINDA CROCKER SIMMONS

PORTER, RUFUS (1792–1884) was a nineteenth-century painter, inventor, fiddler, teacher, journalist, and publisher whose active mind and diverse interests seemed to exemplify the American spirit of entrepreneurship, progress, and improvement. Porter was fascinated by time and labor-saving approaches in all his endeavors, whether it was the construction of a camera obscura to enable him to take profiles in fifteen minutes, or the design of a passenger "flying ship" that could travel up to one hundred miles per hour. Today he is recognized for establishing an influential style of landscape painting on walls that appears in almost two hundred interiors throughout New England, but Porter remained relatively obscure as an artist in his own lifetime. A lengthy obituary and biographical sketch that was published in the September 6, 1884, issue of *Scientific American,* a publication he founded in 1845, remained the only source of information about the artist until 1940, when his life and achievements attracted the interest of scholar and collector Jean Lipman (1909–1998). Her work revealed Porter as an early American visionary whose restless and inquisitive spirit anticipated the increasing tempo and innovations of the modern world.

Porter was born in West Boxford, Massachusetts, and moved with his family to Flintwood (now Baldwin), Maine, in 1801. After farming, playing the fiddle, and apprenticing briefly with his brother as a shoemaker, he walked to Portland, Maine, in 1810, thereby starting a pattern of itinerancy that was to become a lifetime hallmark of his character and movements. In Portland, Porter found work as a house and sign painter, learning many of the decorative techniques that he later applied to wall painting, but his activities ranged from playing the fife for military companies, and the violin for dancing parties, to teaching drumming and drum painting, painting gunboats and sleighs, and joining the Portland Light Infantry. From 1815, when he married, until about 1840, Porter worked as an itinerant artist, and began painting portraits first in New Haven, Connecticut,

and then throughout New England and as far south as Virginia. There are no records for the years between 1817 and 1819, a period when he may have joined the crew of a trading ship bound for the Pacific Northwest and Hawaii.

About 1819 Porter produced a handbill that outlined the types of portraits he offered and their associated costs. Beneath a woodblock print in the style of a typical portrait are listed: cut profiles, watercolor profiles, watercolor full-face portraits, and miniatures on ivory, the prices ranging from twenty cents to eight dollars. On the basis of two family portraits painted about the same time, a group of at least fifty watercolor portraits are now attributed to Porter. Most are half-length poses with a distinctive treatment of outlined eyes and ears and stippled facial modeling. Although he offered full-face portraits in this early handbill, known examples date from about 1830–1835.

Porter once again traveled through New England beginning in 1824, and this was the year he began to paint walls in a combination of freehand and stenciling. Some of his early work may have been completed in partnership with Moses Eaton Jr. (1796–1886), a prolific decorative painter known for his stenciled designs. Later, Porter also worked with his nephew, Jonathan D. Poor, and with his own son, Stephen Twombley Porter. In 1825 Porter published the first of five editions of *A Select Collection of Approved, Genuine, Secret, and Modern Receipts, For the Preparation and Execution of Various Valuable and Curious Arts,* a book of instructions on a variety of decorative-art techniques, including a precise system of landscape painting on walls based on scale, perspective, color, and detail. In a departure from the taste for imported wallpapers picturing exotic foreign climes, Porter was instead a proponent of the American scene, and simplified his designs to essential elements, with the suggestion that "in finishing up scenery, it is neither necessary nor expedient, in all cases, to imitate nature." His instructions were intended to enable even an amateur painter to complete the "four walls of a parlor in five hours," and create a nuanced landscape in four planes receding into the distance.

Wall painting remained Porter's primary occupation until the 1840s, when he founded and published *New York Mechanic, American Mechanic,* and *Scientific American.* Until his death in 1884, Porter's attention was focused on promoting his plans for "aerial navigation" and other mechanical inventions, many of which promoted improved methods of transport.

See also **Jean Lipman; Miniatures; Painting, American Folk; Painting, Landscape; Papercutting.**

BIBLIOGRAPHY

Brown, Ann Eckert. *American Wall Stenciling, 1790–1840.* Lebanon, N.H., 2003.

Lipman, Jean. "Rufus Porter, Yankee Wall Painter." *Art in America,* vol. 38, no. 3 (October 1950): 133–200.

———. *Rufus Porter, Yankee Pioneer.* New York, 1969; revised, 1980.

Lipman, Jean, and Tom Armstrong, eds. *American Folk Painters of Three Centuries.* New York, 1980.

Little, Nina Fletcher. *American Decorative Wall Painting, 1700–1850.* New York, 1989.

Rumford, Beatrix T., ed. *American Folk Portraits: Paintings and Drawings from the Abby Aldrich Rockefeller Folk Art Center.* Boston, 1981.

STACY C. HOLLANDER

PORTRAIT PAINTING: *SEE* ABBY ALDRICH ROCKEFELLER FOLK ART MUSEUM; EZRA AMES; ZEDEKIAH BELKNAP; JOSEPH BLACKBURN; MACEPTAW BOGUN; JOHN BRADLEY; JOHN BREWSTER JR.; SAMUEL BROADBENT; JOSEPH GOODHUE CHANDLER; WINTHROP CHANDLER; JUSTUS DALEE; JOSEPH H. DAVIS; WILLIAM DERING; RALPH EARL; JAMES SANFORD ELLSWORTH; J. EVANS; JONATHAN FISHER; IRA CHAFEE GOODELL; ETHAN ALLEN GREENWOOD; JAMES GUILD; JOHN VALENTINE HAIDT; RUFUS HATHAWAY; RICHARD JENNYS; WILLIAM JENNYS; SAMUEL JORDAN; WILLIAM W. KENNEDY; JACOB MAENTEL; MINIATURES; REUBEN MOULTHROP; NEW WHALING MUSEUM; ROBERT PECKHAM; AMMI PHILLIPS; POLITICAL FOLK ART; RUFUS PORTER; JOHN SMIBERT; STILL-LIFE PAINTING; HENRY WALTON; ISAAC AUGUSTUS WETHERBY.

PORTZLINE, FRANCIS CHARLES (1771–1857) was a fraktur artist who came from Solingen in Germany, settled in Franklin Township, York County, Pennsylvania, about 1800, and opened a general store. The account book of the store still exists, and is held by his descendants. He married Sabina Heiges, a local woman, and he probably taught in the school at the Franklin Church.

In 1804, he became a naturalized citizen in York County, and in 1812, he sold his land in York County, and moved to Perry County. A few years later he moved to Snyder County, where he would live for the rest of his life. Portzline ran a small farm while continuing to teach. He made many baptismal records for local children, frequently marked by border decorations of animals in bright colors. He used both Ger-

man and English in his work. Several fraktur certificates he designed, primarily for his own children, have been found.

See also **Fraktur; German American Folk Art; Pennsylvania German Folk Art; Religious Folk Art.**

BIBLIOGRAPHY

Hubbert, Ruthann. "Francis Portzline (1771–1857)." *Snyder County Historical Society Bulletin* (1982).

FREDERICK WEISER

POTTERY, FOLK in the broadest sense, is any ware made by hand and intended for utilitarian use. Stoneware and redware, certainly, fall within the category, as do certain types of yellowware, Rockingham, spongeware, spatterware, and sewer tile ware. Folk pottery is studied and evaluated for the aesthetics of both form and decoration or design.

Sewer tile ware best manifests the folk artist's persistent creativity in the face of adverse personal or economic circumstances. By the end of the nineteenth century, traditional potteries were closing all over the northeastern United States, driven out of business by a combination of new materials and competition from mechanized midwestern factories. Many displaced craftspeople found employment in shops that produced sewer, drainage, and roofing tile. The clay mixture used in this manufacture (sometimes earthenware, stoneware, or both) was coarse and fired to an unattractive reddish brown. However, it was all that the displaced potters had, and with it they created a vast array of folk sculpture. Made on the worker's own time and intended for personal use or as gifts, these pieces were primarily hand-modeled or formed with crude molds. A pressed-glass goblet, for example, was utilized to create a similar form in tile clay.

The range of sculptural forms found in folk pottery is wide-ranging. Animals, including lions, cats, dogs, and sheep, and a multitude of birds, ranging from doves and eagles to every imaginable denizen of the farmyard, appear, as do turtles, frogs, and fish. Some of these forms had a function as doorstops or bookends; but most were made for the sheer pleasure of creativity. More mundane forms included ashtrays, small boxes, and a variety of hand-thrown or molded pitchers, the latter sometimes embellished with sprig-molded flowers or masks. While most sewer tile ware is unidentifiable, some pieces bear a maker's name and, perhaps, that of the factory in which he or she

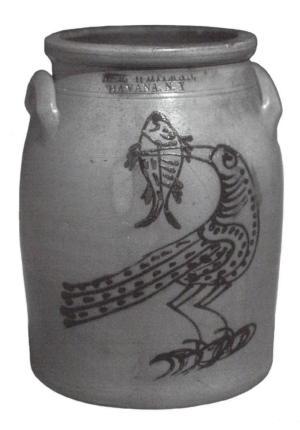

Open mouth jar with handles depicting bird with fish. Made by J. Hartman, Havana, New York; c. 1885. Cobalt blue slip cup decorated pottery.
Photo courtesy Allan Katz, Americana, Woodbridge, Connecticut.

worked. Most of the factories were located in western New York, Pennsylvania, Ohio, and Michigan.

Commercial potteries from the 1830s produced yellowware, a highly fired ceramic body most familiar in the form of banded mixing bowls. Most of this ware was mold-formed, and the craftsperson might add slip decoration to the edges or surfaces. Bowls, covered crocks, jars, saltshakers, and other vessels were typically decorated with blue, white, green, or brown bands in various combinations, with stenciled flowers or geometric devices, or with the sponged blue or green patterns called mocha. Mocha-decorated ware, the majority of which produced in England yet widely collected in the United States, shows the greatest design creativity. Colored slip was dripped or sponged onto a white ground in patterns (no two alike) referred to by such fanciful names as "seaweed," "tree," or "worm."

Figural yellowware is rather uncommon. Toby pitchers in the form of the fat, smiling *bon vivant* are

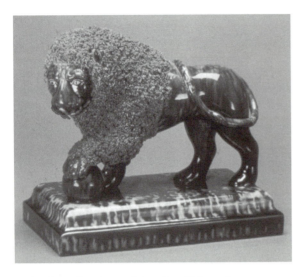

Rockingham glazed mantelpiece lion. Maker unknown; Bennington, Vermont, c. 1840–1850. Glazed yellowware. © Esto. Photo courtesy Schecter Lee.

sometimes seen, as are small dogs and lions. In addition, there are various food molds, the interiors of which are molded in the form of corncobs, sheaves of wheat, and grapes or other fruits and vegetables. Less often encountered are rabbit, lion, and fish forms.

Yellow firing clay was also decorated with a dripped or sponged brown glaze, referred to as Rockingham, and a much wider variety of figural pieces appear in this guise. Rockingham ware was made from Baltimore to Cincinnati throughout much of the nineteenth century; but it was at the United States Pottery in Bennington, Vermont, that potters were given the greatest creative license and turned out the most remarkable examples.

Mantelpiece figures, based on Staffordshire examples, were cast in molds and then hand-embellished with decorative details, such as the tiny baskets of porcelain flowers that poodles (a Victorian favorite) carried in their mouths. Other figures included pairs of male and female deer, lions, and cows; today large versions of these figures are quite collectible and valuable. Another group of favorites included the tall, full-length Toby bottles used for liquor storage. There were also myriad Toby mugs, pitchers, and covered snuff jars. The Bennington potters possessed a sense of humor as well. Whiskey flasks in the shape of books were embossed with such revealing names as "Hermit's Delight" and "Suffering and Death," while others were made in the shape of boots or shoes.

Bennington craftsmen turned out sets of miniature dishware for children, while at other shops dolls'

heads were popular products. Rockingham-glazed penny banks could take any form, from the standard acorn to a chest of drawers, a rustic cottage, or even a bust of thrifty old Uncle Sam.

As the nineteenth century waned, the Rockingham finish gradually fell out of favor, to be replaced by a cruder, more rustic pottery known as spongeware. This form consisted of a yellowware or stoneware body that was decorated in a contrasting color applied by sponging or daubing. Stoneware examples were typically sponged in blue after being dipped in a white Bristol slip. Yellow-bodied pieces were sponged in brown, green, red, blue, or in combinations of colors. While decoration could consist of little more than random daubs, creative decorators might apply floral patterns or patterns that resembled chicken wire. Occasionally, this might be accompanied with slip bands similar to those seen on yellowware bowls, or with such gilding as was often applied to Victorian dishwares.

Though spongeware was made in large factories, such as the Western Stoneware Company of Monmouth, Illinois, or the Redwing Pottery of Redwing, Minnesota, it was not mass-produced in the contemporary sense. Employees had substantial leeway in regard to decorative techniques. Few pieces look alike, and all bear the mark of individual whimsy. The best-known figural pieces are banks in the shape of pigs. These come in various finishes, including blue on white, red on white, green and brown on yellow. A substantial number of miniature utilitarian items, such as crocks, jugs, and water coolers also exist. The fact that some of these bear company names suggests that they might have served as salesmen's samples or advertising pieces.

Because a white earthenware body with a clear glaze provides an ideal surface for decoration, it is hardly surprising that some of the most appealing folk decoration is found in this medium. In the 1830s English potters began to produce an inexpensive ware decorated with powdered pigments, often applied using a peppershaker, by sponging, or using feathers or brushes. When fired, the polychrome finish had a speckled or spattered surface, hence the term "spatterware." Stencils were also used in decoration, and it was customary to leave an unpainted reserve in the center or on the side of a piece, in which a small picture was drawn.

Spatterware was made in a few American potteries, chiefly in New Jersey, Pennsylvania, and Maryland, but the majority of the ware so eagerly collected today came from England. It appears to have initially been most popular with German immigrants. City folk

and farmers in Pennsylvania, Virginia, and New Jersey bought it in quantity for use as their everyday tableware (it was never produced in the form of utilitarian items like crocks and jugs), keeping potters busy until the fashion passed in the 1870s.

All spatterware was individually hand-decorated to create unique pieces. There were some popular patterns, however, and decorators from different firms would produce plates, bowls, cups, and saucers that were often quite similar in appearance. Among the more common examples is "Wigwam," which features several peaked structures with what looks very much like a pair of smokestacks; the "Castle" pattern, with its representation of a tower; "Windmill" and "Two Men on a Raft," which resemble their pattern names.

Redware and stoneware, for which there are separate entries in this encyclopedia, are particularly apt examples of the potter's role as folk artist. Both were primarily wheel-thrown forms of pottery, and decoration was largely individually inspired. The redware maker focused on glazes, either using a white slip against the reddish body color to produce abstract floral or geometric designs as well as quaint sayings, such as "Money Wanted" or "Good Enough for Rich Folks," or by dripping and sponging contrasting black, green, or yellow glazes in polychrome patterns.

Prior to 1830 many stoneware potters incised designs, such as flowers, birds, and ships, onto the bodies of their wares, and then filled these with cobalt blue to highlight the decorated areas. Those potters who could afford them employed wood or metal stamps to impress similar designs. Then, with changes in body form that made for a larger surface on which to work, and the appearance of artists trained in calligraphic drawing, potters turned to freehand brushed or slip-cup designs. Surviving examples from this period provide a virtual gallery of ceramic folk art. There are the famous bathing beauties and circus performers from the Fulper Pottery of New Jersey; wonderful flowers from the Burgers of Rochester, New York; and the houses and deer from Bennington's Norton kiln in Vermont. These as well as many others from Maine to Missouri marked the zenith of painting on ceramics.

See also **Dolls; Doorstops; Jugs, Face; Pennsylvania German Folk Art; Miniatures; Political Folk Art; Redware; Sewer Tiles; Stoneware.**

BIBLIOGRAPHY

Adamson, Jack. *Illustrated Handbook of Ohio Sewer Pipe Folk Art.* Zoar, Ohio, 1973.
Barret, Richard Carter. *Bennington Pottery and Porcelain.* New York, 1963.
Ketchum, William C. *American Country Pottery, Yellowware, and Spongeware.* New York, 1987.
Robacker, Earl F., and Ada Robacker. *Spatterware and Sponge: Hardy Perennials of Ceramics.* New York, 1978.

WILLIAM C. KETCHUM

POWDER HORNS, the horns in which troops carried powder for their flintlock rifles and muskets, are among the most sought-after accoutrements of modern weaponry. As early as the fifteenth century, gunsmiths discovered that cow horns could be shaped to provide a useful receptacle in which gunpowder could be kept safe and dry. Cow or ox horn was boiled, so the inner core could be removed, leaving a hard shell-like tube. The larger end was fitted with a round wooden block held in place by pegs, while the smaller end from which the powder was poured was closed by a cork or a brass nozzle with a spring clip. In addition to the standard size black powder horn, craftsmen also produced much smaller horns for storage of the priming powder used in a gun's flash pan, and very large supply horns which held up to five pounds of powder.

The standard size horns carried by every hunter and soldier are the focus of most collectors, for these were often carved or etched, while the horn was still soft, with scrimshaw names, dates, maps, and even scenes of hunts or battles in which the owner had participated. So popular were these personalized powder horns that during the French and Indian War and the American Revolutionary War, a few engravers such as Jacob Gay of Massachusetts were able to earn a substantial sum decorating horns for their comrades in arms. These designs featured patriotic themes like "Liberty" emblazoned with a portrait of Washington or Lafayette or representations of the forts, locales, or military engagements that the owner might have visited or participated in. The museum at historic Fort Ticonderoga, in New York State, has an important collection of horns relating to the battles fought during the eighteenth century in the Lake George/Lake Champlain area.

Authentic examples of such powder horns are valuable, so it is hardly surprising that a substantial number of counterfeits exist. Knowledgeable collectors recognize fake powder horns by a lack of the telltale signs of age, as well as inaccuracy of recorded dates, localities, and costumes. Few authentic

period horns remain on the market. Most are held in museums or private collections.

See also **Scrimshaw.**

BIBLIOGRAPHY

Bowman, H.W. *Antique Guns.* Greenwich, Conn., 1953.
Patterson, Jerry. *Antiques of Sport.* New York, 1975.
Wilkinson, Frederick. *Collecting Military Antiques.* New York, 1976.

WILLIAM C. KETCHUM

POWERS, ASAHEL LYNDE (1813–1843), a portrait painter of Vermont and New York, was born in Springfield, Vermont, the eldest son of seven children. His earliest known portrait, dated 1831, indicates that he had developed his signature painting style by the age of eighteen. From 1835 to 1837, Powers entered into a business partnership with a Mr. Rice, probably the bookseller, writer, and publisher Daniel Rice of Springfield. The nature of the partner-

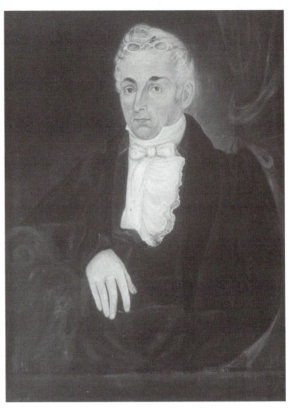

Mr. Jacob Farrar. Asahel Power; 1832. Oil on canvas; 34⅝ × 24⅔ inches. The Bertram K. Little and Nina Fletcher Little Collection auction at Sotheby's 6612, October 21 and 22, 1994.
Photo courtesy Sotheby's, New York.

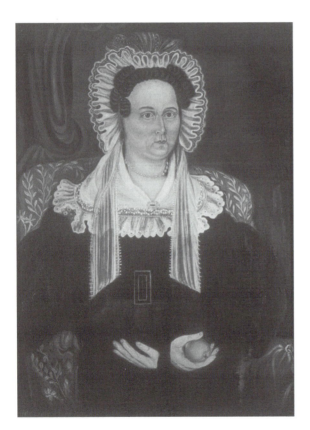

Mrs. Jacob Farrar. Asahel Powers; 1833. Oil on canvas; 33¼ × 24¾ inches. The Bertram K. Little and Nina Fletcher Little Collection auction at Sotheby's 6612, October 21 and 11, 1994.
Photo courtesy Sotheby's, New York.

ship is not known, although several portraits from this period are inscribed "Powers & Rice." Powers moved to New York State in 1839 and painted in Franklin and Clinton counties. He moved with his parents to Olney, Richland County, Illinois, in 1841, seemingly leaving a wife, Elizabeth M. Powers, behind in New York. It is not known whether Powers pursued painting in Illinois, as no portraits of his from this period are extant. Powers died in Illinois.

Powers's extant body of work numbers more than seventy likenesses. These are painted in a style marked by flowing, swirling lines; crisp black outlines; and multiple perspective. Adult subjects are often shown close to the picture plane, in half-length or three-quarter-length poses. Children are often depicted in full-length poses. Powers painted in oil on wood panel until the mid-1830s, when he began working in oil on canvas. His early portraits have vibrant, decorative lines of paint in the background, vaguely resembling drapery. Subsequent works, in

the late 1830s, are increasingly naturalistic and subdued, probably influenced by the realism of photography.

See also **Painting, American Folk.**

BIBLIOGRAPHY

D'Ambrosio, Paul S., and Charlotte Emans. *Folk Art's Many Faces: Portraits in the New York State Historical Association.* Cooperstown, N.Y., 1987.

Rumford, Beatrix T., ed. *American Folk Portraits: Paintings and Drawings from the Abby Aldrich Rockefeller Folk Art Center.* Boston, 1981.

PAUL S. D'AMBROSIO

POWERS, HARRIET (1837–1911), born a slave on a Georgia plantation, died long before her two known quilts came to embody the African American narrative quilting tradition. Now recognized as a master of story-quilt design, Powers spent her early years working on a plantation, where she may have learned her sewing skills from the plantation mistress. She created her highly original and visually compelling quilts using an appliqué technique with strong similarities to the appliqué work of the Fon people of Dahomey, West Africa, a style she possibly learned from other slaves. Although she could not read or write, Powers was nevertheless an effective storyteller through her vivid depictions in needle and thread of biblical stories she had heard and local events she knew of or had experienced.

Powers displayed her first story quilt, comprising eleven panels of biblical stories, at a cotton fair in Athens, Georgia, in 1886, where it was seen by a white woman, Oneita Virginia "Jennie" Smith, then head of the art department at the Lucy Cobb Institute. Smith immediately offered to buy the quilt, but Powers initially was unwilling to part with it. In 1891, however, when Powers and her family were in financial difficulty, she offered it to Smith for ten dollars. Smith told her she could only afford five, and Powers, after consultation with her husband, Armstead, agreed to sell it. She then gave Smith detailed oral descriptions of each of the quilt's panels, which begin with her depiction of the Garden of Eden and end with a Nativity scene.

Smith entered Powers' *Bible Quilt,* as it is now known, in the 1895 Cotton States and International Exposition in Atlanta, where it caught the attention of several faculty wives from Atlanta University. They commissioned a second narrative quilt from Powers as a gift for the Reverend Charles Cuthbert Hall, president of the Union Theological Seminary and longtime chairman of the board of trustees of Atlanta University, and it was presented to him in 1898. The fifteen panels in this quilt also illustrate biblical stories (Noah and the Great Flood) as well as events that occurred during Powers' lifetime (such as "Cold Thursday," in February 1895, when temperatures in Georgia fell below zero), and unusual incidents she had heard about, such as the "Night of Falling Stars" in 1833 that convinced many observers that Judgment Day had come (the event is now known to have been a Leonid meteor storm). The explanations for this quilt, written on pieces of cardboard and assumed to have been dictated by Powers, include remarkably accurate descriptions of these natural phenomena.

Today the *Bible Quilt* is preserved at the Smithsonian Institution in Washington, D.C., and the quilt commissioned for Reverend Hall is at the Museum of Fine Arts in Boston. They are not only powerful exemplars of the African American story quilt tradition but also extraordinary visual expressions of a vibrant oral history.

See also **African American Folk Art (Vernacular Art); Quilts; Quilts, African American; Religious Folk Art.**

BIBLIOGRAPHY

Fry, Gladys-Marie. *Stitched from the Soul: Slave Quilts of the Ante-Bellum South.* New York, 1990.

Lyons, Mary E. *Stitching Stars: The Story Quilts of Harriet Powers.* New York, 1993.

Perry, Regina. *Harriet Powers's Bible Quilts.* New York, 1994.

JACQUELINE M. ATKINS

PRESSMAN, MEICHEL (1864–1953) began painting in watercolor late in his long life, drawing upon themes from the Hebrew Bible and Jewish tradition and lore, and recording memories of his early years. He was born in Galicia, then a province of the Austro-Hungarian Empire, and spent his early years as a farm laborer. Early in the twentieth century, Pressman immigrated to America during a period of mass emigration from the Jewish *shtetlach* (villages) of Eastern Europe. He found employment in New York as a pants presser.

Pressman began painting almost by accident. After he retired, he found a box of crayons at home and began to draw. He was then eighty-four years of age. Within a year or two, his paintings were being shown at a New York gallery. As is frequently the case among artists who come to their creative expression late in life, Pressman's paintings are narrative in character. He relates successive elements of the story he is telling in separate but undivided vignettes, often placing one above the other. His figures, rendered stiffly,

generally share the same space at the front of the picture plane.

Among the subjects of Pressman's colorful and well-composed paintings are memories of a *seder* (the ritual Passover meal) in the town of his boyhood; the biblical account of the binding of Isaac; and the Holocaust. Pressman painted for only five years, from 1948 until his death in New York at the age of eighty-nine. Nevertheless, he left a vibrant record of a lost world and of traditions that continue to animate Jewish life to this day.

See also **Jewish Folk Art; Painting, Memory; Religious Folk Art.**

BIBLIOGRAPHY

Kleeblatt, Norman L., and Gerard C. Wertkin. *The Jewish Heritage in American Folk Art*. New York, 1984.

GERARD C. WERTKIN

PRIOR, WILLIAM MATTHEW (1806–1873) is an intriguing figure among nineteenth-century painters, both for his business practices and for his personal beliefs. He was a fervent follower of the Adventist leader William Miller, who predicted that the Second Coming of Christ would occur between 1843 and 1844. Prior was also an adherent of spiritualism and offered portraits after the death of the subject, painted from what he termed "spirit effect." He executed some of the nineteenth century's most respectful portraits of free men and women of color, suggesting that he held abolitionist leanings or beliefs. Prior worked primarily between the 1820s and 1860s, and his professional career exemplifies a shift in painted portraiture from luxury items to mass consumer goods. He successfully rode the wave and subsequent decline of popular demand for such commissions, producing large numbers of reductive portraits in oil or gouache on academy board that cost very little, as well as near-academic canvases that displayed his technical skills and represented a greater expenditure of time and money. Prior was born into a seafaring family in Bath, Maine. His father, Matthew, and brother, Barker, were both lost at sea in 1815, an event memorialized in a watercolor mourning piece by his sister, Jane Otis Prior (1803–?). Prior apparently did not follow the maritime trades; instead, he was trained as an ornamental painter. Advertisements in the *Maine Inquirer* from 1827 through 1831 detail the types of projects he undertook during this period, from re-japanning tea trays and tin waiters in a "tasty style" to restoring oil portraits. By 1823, however, he was painting portraits. His self-portrait of 1825 shows a confidence and academic ambition that belie his young age but support the idea that he may have received some training about 1824 in the studio of the artist Charles Codman (1800–1842) in Portland. He was an artist of aspirations who obtained permission from the Boston Athenaeum to copy a famous portrait of George Washington by Gilbert Stuart (1755–1828). In 1828, Prior married Rosamond Hamblin; that alliance united him with a large family of artisans whose fortunes and movements remained tied to his own for decades to come.

The earliest indication that Prior would adapt his painting style to the means of a client was contained in his advertisement of February 28, 1828, which stated: "Side views and profiles of children at reduced prices." A few years later, he began marketing different styles of portraiture depending on the client's wishes or ability to pay. Oil portraits in an academic manner with facial modeling ranged from $10 to $25. He advertised in the *Maine Inquirer* in 1831: "Persons wishing for a flat picture can have a likeness without shade or shadow at one quarter price." The label attached to the back of Prior's portrait *Nat Todd*, painted about 1848, demonstrates the extent to which he would ultimately take this approach: "PORTRAITS / PAINTED IN THIS STYLE! / Done in about an hour's sitting. / Price 2,92, including Frame, Glass, & c. / Please call at Trenton Street / East Boston / WM. M. PRIOR." Just a few years earlier, William W. Kennedy (1818–after 1870) had offered similar portraits in New Bedford as "a new style," perhaps suggesting a broader shift in taste as the daguerreotype (invented in 1839) became a widely available means of obtaining an inexpensive photographic likeness. This workshop or standardized approach allowed effective portraits to be painted predictably and expeditiously but contributed to contemporary criticism that such "staring likenesses" captured only the outward form, not the inner spirit.

Another consequence has been the present-day confusion in trying to distinguish among unsigned portraits produced by William Matthew Prior, his in-laws Sturtevant J. Hamblin (active 1837–1856) and George G. Hartwell (1815-1901), and William W. Kennedy. The works by these interrelated artists are now considered under the general appellation Prior-Hamblin School. Among these, Prior's paintings are distinctive for their consistently painterly yet crisp style, quick spontaneous brushwork, rich saturated colors, and freshness. Emblematic of Prior's approach is his 1853 portrait of *The Ward Children* in which the two young subjects are situated against a dark, flat background, allowing their faces, hands, and details

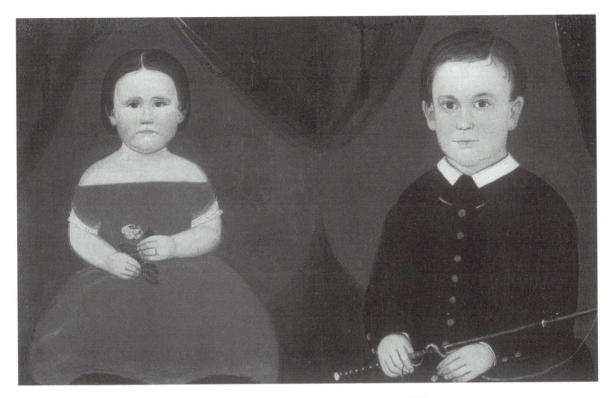

The Ward Children. William Matthew Prior; 1853. Oil on canvas laid on board; 20¾ × 35¾ inches. The Bertram K. Little and Nina Fletcher Little Collection auction at Sotheby's 6899, October 19, 1996.
Photo courtesy Sotheby's, New York.

of costume to stand out. While paintings such as *The Ward Children, Baby in Blue* (c. 1845, National Gallery of Art, Washington, D.C.) and *Isaac Josiah and William Mulford Hand* (c. 1845, Fine Arts Museums of San Francisco) share a similar taste for smooth, finished likenesses, in other works, Prior was quick to adapt his style to suit his subject and his client. Prior may have adapted some of the techniques of ornamental painting, as many passages are painted wet-on-wet and exhibit brush strokes like those used to decorate tinware.

Sometime between 1831 and 1834, Prior moved with his growing family to Portland, Maine, where he began a pattern of living with or near his Hamblin relatives. By 1841, the Prior and Hamblin families had moved together to Boston, where they lived in the home of Nathaniel Hamblin. In 1846, however, the Priors and their large family were established in their own home at 36 Trenton Street, which Prior dubbed the "Painting Garret." The number of portraits that have survived from this period attest to Prior's popularity despite the advent of photography, but he continued to travel throughout New England and as far

south as Baltimore in search of commissions, sometimes accompanied by one of his sons. It was during the 1850s that Prior began to paint "fancy" pictures of Mount Vernon and Washington's tomb, ice skaters on ponds, romantic landscapes, and moonlit scenes. He also applied his earlier experience of reverse painting on glass clock dials to create portraits in this technique of George and Martha Washington, Abraham Lincoln, and other historical figures.

As early as 1838, Prior had offered posthumous portraiture, when he painted *Arobine Sewall* after death from "cast relief." During the 1850s and 1860s he continued and even advertised this practice, but now by "spirit effect," a gift he claimed he had received after his conversion to Millerism. In 1840, Prior probably saw William Miller preach during a major convocation in Casco, Maine. He and his brother-in-law Joseph G. Hamblin became zealous converts, and Prior wrote at least two, possibly three, books on the subject, even after Miller's predictions failed to eventuate. In the first of these books Prior mentions painting a chronological chart illustrating Miller's calculations, and he is thought to be the artist of the

405

brooding portrait of Miller painted about 1850. In 1865 Prior used his visionary ability to paint his own deceased brother, Barker.

Throughout his career Prior ground his own pigments, prepared his own canvases, and even made many of his own frames. Advertisements as well as informative labels and inscriptions on the reverse side of paintings shed light on his marketing practices as they developed. His activities indicate an active, engaged life; and his entrepreneurial approach helped to democratize the art of portrait painting, bringing likenesses, both staring and otherwise, within reach of all those who desired them.

See also **Adventist Chronological Charts; Sturtevant J. Hamblin; William W. Kennedy; Mourning Art; Museum of Fine Arts, Boston; Reverse-Glass Painting; Visionary Art.**

BIBLIOGRAPHY

Chotner, Deborah. *American Naïve Paintings: The Collections of the National Gallery of Art Systematic Catalogue.* Washington, D.C., 1992

D'Ambrosio, Paul S., and Charlotte Emans. *Folk Art's Many Faces: Portraits in the New York State Historical Association.* Cooperstown, N.Y., 1987.

Johnston, Patricia. "William Matthew Prior, Itinerant Portrait Painter." *Early American Life,* vol. 10, no. 3 (June 1979): 20–23, 66.

Little, Nina Fletcher. "William M. Prior, Traveling Artist, and His In-laws, the Painting Hamblens." *Antiques: The Magazine,* vol. 53, no. 1 (January 1948): 44–48.

———. "William Matthew Prior and Some of His Contemporaries." *Maine Antique Digest,* vol. 4, no. 3 (April 1976): 19a–21a.

Lyman, Grace Adams. "William M. Prior: The 'Painting Garret' Artist." *Antiques: The Magazine,* vol. 26, no. 5 (November 1934): 180.

Rumford, Beatrix T., ed. *American Folk Portraits: Paintings and Drawings from the Abby Aldrich Rockefeller Folk Art Center.* Boston, 1981.

STACY C. HOLLANDER

PRISBREY, TRESSA ("Grandma") (1896–1988) built from bottles the buildings known as Bottle Village, in San Fernando Valley, California. She spent her early childhood in rural Minnesota. In 1908 her family moved from her birthplace near the town of Wells to a homestead near Minot, North Dakota. Four years later, when she was fifteen, she married Theodore Grinolds, a man of questionable reputation. Many years later she said she was essentially "sold" to Grinolds by her father. She bore Grinolds seven children over the next fifteen to twenty years, but in the late 1920s or early 1930s she left him, taking some of her children with her. Grinolds died soon afterward. In the years that followed she lost many of her siblings, and all but one of her children, to tragic circumstances.

During the 1930s Prisbrey worked as a waitress at a restaurant in Minot, where she sometimes played piano for customers. She also became active in state politics. She began a lifelong habit of collecting pencils after two North Dakota governors gave her commemorative pencils. She spent the World War II years in Seattle, Washington, where she worked assembling parts for the Boeing Corporation. In 1950 she moved to a small community then known as Santa Susanna, in the northwestern part of California's San Fernando Valley, and built a cement-block house where she briefly lived.

In 1954, in Santa Susanna, she met and married Al Prisbrey, a construction worker. With the proceeds from the sale of her house, they bought a 45-by-275-foot lot, and moved a trailer onto it. Soon afterward, she began making regular trips to a nearby garbage dump to collect the bottles that she came to be known for using as art materials. She used some of them to build a thirty-foot-high outdoor wall. Prisbrey next completed a small bottle-walled building where she housed her pencil collection—which, in her estimation, numbered up to 17,000. The wall and the "Pencil House" were the first of thirteen buildings and nine additional structures she eventually built on the site, including a 500-foot, bottle-and-concrete fence that surrounded it. Constructed between 1955 and 1963, these small buildings housed her additional collections of dolls, books, unusual bottles, and other artifacts. Prisbrey spent much of her time in her remaining years maintaining and embellishing the site, and it became a popular tourist attraction. Prisbrey delighted in entertaining visitors until the last few years of her life, when her health began to fail. She died in San Francisco in 1988.

See also **Environments, Folk.**

BIBLIOGRAPHY

Greenfield, Verni, "Tressa Prisbrey: More Than Money," *Raw Vision,* no. 4 (spring 1991): 46–51.

Naives and Visionaries. [exhibition catalog] New York, 1974.

Rosen, Seymour. *In Celebration of Ourselves.* San Francisco, 1979.

TOM PATTERSON

PRISON ART is the creative expression of artists whose work arises from their experience of incarceration. Few of these artists have had significant experience with art before their imprisonment; in fact, many prison artists come from backgrounds that do not encourage artmaking. However, faced with long

hours of inactivity, separation from friends and family, and the frustrations and tensions of prison life, many inmates find that artmaking offers diversion and a sense of accomplishment. In the last quarter of the nineteenth century and first decades of the twentieth century, some prisons, spurred by a prison reform movement, established woodworking shops where inmates produced boxes and furniture embellished with marquety. Some contemporary prison systems, finding that recreational programs create improved working and living conditions, have established art studios directed by professional teachers who introduce fine art techniques and materials. However, most artists who take up artmaking in prison either learn from other prisoners or develop highly personal strategies for self-expression.

Limited both by prison rules and inmates' needs to keep their innermost thoughts to themselves, much prison art is made with strict regard for convention. Since access to art supplies is also limited, prison artists make do with material at hand. Many prisoners learn to weave boxes, handbags, picture frames, and crosses from folded cigarette packages or gum wrappers and stitch their creations together with dental floss. Others create drawings that employ a standard repertoire of stereotypical images. Pinups of beautiful women abound, as do drawings of expensive cars and motorcycles. Watchtowers, chain link fences, lengths of chain, cement block walls, barred windows, and hourglasses or clocks present both the psychological and objective reality of the prisoner, while drawings with hearts, roses, cartoon figures, palm trees, and symbols of religious faith may express dreams of life outside or serve as love tokens for friends and family. Using this conventional prison imagery as well as the conventions of flash art, tattoo artists manage to offer their services to fellow inmates despite official discouragement. Accomplished artists who win the respect of fellow inmates and supervisory personnel can trade artwork for money or commissary coupons. The most prestigious artists are the portraitists who copy snapshots of family members or magazine illustrations of celebrities. Hand-made greeting cards and decorated envelopes are also sources of income for some artists.

A small number of prison artists whose work moves beyond the commonplace also attract art world recognition. *Paños,* ink or colored pencil drawings on handkerchiefs made by Mexican-American prisoners, appeal to art dealers and collectors who regard these works as true contemporary folk art that articulates communal identity. The best *paño* artists combine standard prison imagery; the traditional symbols of Catholic faith; and the politicized imagery of the Chicano movement, including Aztec warriors and heroes of the Mexican revolution, to exhort Mexican-Americans to resist the pull of poverty and racism in order to regain the glory of a mythic past. *Paño* art, characterized by compulsive patterning and confrontational imagery, succeeds, in part, through its rejection of middle-class aesthetics.

Idiosyncratic approaches to artmaking have brought recognition to another small group of artists. One of the few female prison artists of note is Inez Nathaniel Walker (c. 1911–1990), who began drawing while in the Bedford Hills Correctional Facility in New York. Her richly patterned drawing of nattily dressed African American men and women who toast each other, engage in conversation, and embrace are found in many private and museum collections. Frank Jones (1900–1969), imprisoned for several decades in Texas, is known for his drawings of maniacally smiling "haints" or ghosts, sometimes trapped but sometimes bursting out of "Devil Houses" that contain cell-like rooms. Like Jones, Henry Ray Clark (1936–) created his first drawings of powerful female figures and faraway planets during stints in Texas prisons. Herbert Singleton (1945–) is often considered a prison artist, although he has not been allowed to make his relief-carved tableaus of African American life while incarcerated. Ray Materson's (1954–) tiny embroideries, narratives of drug addiction, prison life, spiritual renewal, and baseball, that are stitched from threads unraveled from socks, have brought him the attention of collectors and significant earnings. Though most prison artists give up artmaking once released, Materson continues to work as an artist.

See also **Outsider Art; Tattoo.**

BIBLIOGRAPHY

Brandreth, Gyles. *Created in Captivity.* London, 1972.

Kornfeld, Phyllis. *Cellblock Visions: Prison Art in America.* Princeton, N.J., 1997.

Prinzhorn, Hans. *Bildernei der Gefangenen: Studie zur bildnerischen Gestaltung Unbegabter.* Berlin, Germany, 1926.

CHERYL RIVERS

PRY, LAMONT ALFRED ("Old Ironsides") (1921–1987) painted lively works that feature aircraft and the circus, though it is not clear that he was ever personally involved with circuses. From about 1968,

when he entered the Carbon County Home for the Aged (Laurytown, Pennsylvania) until his health began to decline in the late 1970s, he completed about 150 works.

Pry, who had previously carved wooden airplanes and circus wagons, now used flat house paint, enamel, metallic radiator paint, and poster paint on cardboard. Many of his works are segmented vignettes interspersed with text. For example, he executed *Ringling Brothers Barnum and Bailey Circus* (1970–1975) using bright, unmixed colors in a flat compartmentalized style that reflects the circus's three separate rings. "Susy"—his real or imagined ideal woman—appears in the zebra act and as a tightrope walker, a human cannonball, and a magician's assistant who is sawn in half.

Pry was part of the artist and collector Sterling Strauser's circle, which included artists such as Justin McCarthy, Jack Savitsky, Victor Joseph Gatto, and Charlie Dieter. In 1974, Peter Pfeiffer, the custodian of the Carbon County Home, which was about to be razed, asked Strauser to evaluate some paintings by Pry in the boiler room. Strauser bought some of them; then, over the years, he bought more and helped Pry enter local county fairs.

Pry was born in Mauch Chunk (now Jim Thorpe), Pennsylvania, the son of a coal miner. In 1941 he enlisted in the United States Army Air Corps. He was injured in a crash on a reconnaissance mission and was nicknamed "Old Ironsides" during his recovery at a hospital in Bolling, Pensylvania. In 1943 he returned to Mauch Chunk, working first in the civil service and then as an orderly at a hospital in Gettysburg. He said that there he met the head nurse, Susan Maury, who appears in many of his pictures, sometimes as Mrs. Susan Pry; but no Susan Maury has ever been found. Pry married his first wife, Virginia Logan, in the early 1940s. They were divorced, and he married Myrtle Binder in 1947; after her death he lived in two county homes: first the one in Laurytown, and then one in Weatherly. Pry was remembered (by Betty Smith, an administrator at the time of this writing) as alert and well dressed; he wore a large cross on a long chain and frequently used the chapel to preach, whether or not listeners were present.

See also Victor Joseph Gatto; Jack Savitsky; Sterling Strauser.

BIBLIOGRAPHY

Johnson, Jay, and William C. Ketchum Jr. *American Folk Art of the Twentieth Century.* New York, 1983.

Rosenak, Chuck, and Jan Rosenak. *Museum of American Folk Art Encyclopedia of Twentieth-Century American Folk Art and Artists.* New York, 1990.

Trechsel, Gail, ed. *Pictured in My Mind: Contemporary American Self Taught Art from the Museum of Art.* Birmingham, Ala., 1995.

LEE KOGAN

PUNDERSON, PRUDENCE ROSSITER (1758–1784) was a Preston, Connecticut, artist who stitched unique needlework pictures during the American Revolutionary War. The Connecticut Historical Society is the repository for her letters, poetry, and drawings, as well as the artist's known body of work, consisting of thirteen needlework pictures stitched with crimped silk floss on satin.

Punderson was the first of eight children of Ebenezer Punderson (an avowed Tory supporter of the British) and Prudence Geer Punderson. All holdings of the family were confiscated in 1778. The family fled to Long Island, where the comfortable existence they had known in Connecticut turned into a life of hardship, terror, and poverty during the American Revolution. Forced to engage in domestic work to survive, Punderson overcame many personal trials and a serious illness in 1780, which threatened her ability to work with her needle.

Twelve of Punderson's works are lively and imaginative individual portrayals of Christ's Apostles, inspired by print sources. Her most celebrated work, however, is the iconic *The First, Second and Last Scene of Mortality,* which depicts two perspectives on eighteenth-century America not usually found in needlework. Punderson's picture reveals the brevity of the life expectancy for women and provides a rare view of a home interior, c. 1775. Most commonly called the *Mortality Picture,* it is a self-portrait stitched with precise detail. The direct gaze of the sitter draws the viewer into her parlor, which is furnished with familiar objects: a Chippendale side chair and mirror, a framed needlework picture, a tripod table with ball-and-claw feet, and a woven and fringed checkerboard carpet. Prudence Punderson sits at a table which holds a ruler, compass, inkwell, and fabric square, drawing a pattern for her needlework. At her left lies a baby in a bonneted cradle, being rocked by a black nursemaid, which raises questions regarding slavery in Connecticut. At her right a coffin with the initials "PP" sits atop a drop-leaf table. The mirror is covered with white cloth, as was customary for funerals held at home. *The First, Second and Last Scene of Mortality* by Prudence Punderson is both an im-

portant work of folk art and a social document of American history.

At war's end, Punderson's prophetic needlework became a reality. She married Timothy Wells Rossiter on October 20, 1783. Their daughter Sophia was born on July 18, 1784, and Punderson died September 16, 1784, at age 26. She is buried in the Maple Cemetery in Berlin, Connecticut.

See also **Pictures, Needlework.**

BIBLIOGRAPHY

Ash, Deborah Lyttle. "The Needlework Pictures of Prudence Punderson." Folk Art Institute, Museum of American Folk Art, New York, 1998.

Punderson, Prudence. *Papers.* Connecticut Historical Society. Hartford, Conn.

Dewhurst, C. Kurt, Betty MacDowell, and Marsha MacDowell. *Artists in Aprons: Folk Art by American Women.* New York, 1979.

Ginsburg, Cora. "Textiles in the Connecticut Historical Society." *The Magazine Antiques,* vol. 107, no. 4 (April 1975): 772–775.

DEBORAH LYTTLE ASH

QUAKERS (RELIGIOUS SOCIETY OF FRIENDS):
SEE RELIGIOUS FOLK ART.

QUILTS are perhaps the best-known form of American textile art. Quiltmaking is rooted in a utilitarian past, but it has spawned such a wide-ranging creative exploration in design that it is not incorrect to call it, as some have, "the Great American Art." The traditional quilt is composed of three layers and is often described as a "sandwich": two layers of fabric (a top and bottom) with a layer of filling in between. The filling, or batting, may be of any of a variety of materials—cotton, wool, silk, feathers, and down have all been used, although quilters today prefer synthetic batting—and of any thickness. The layers are held together by decorative stitching (quilting) or by knots tied through the layers at spaced intervals. If knots are used, the end product is usually called a comforter rather than a quilt, but, like quilts, comforters can be ornamental as well as functional. The type of filling and the thickness (or thinness) of the fabric used for the outer layers, and the quilting itself, all combine to determine both the warmth and the decorative value of the quilt.

Quilting as a technique dates back thousands of years and probably originated in Asia. It became known as early as the eleventh century in Europe during the Crusades, when it was learned that the Saracens wore several thick layers of fabric stitched together as protection under their armor. The technique offered warmth as well as protection, and it began to be used in bedcovers as well as for various forms of clothing, such as petticoats, linings, and overcoats. A quilting tradition seems to have been well established in Europe by the late fourteenth century. A whitework Sicilian quilt from 1395 is one of the earliest known quilts and is a tour de force of quilting, embroidery, and stuffed work.

The earliest references to quilts in America are found in estate and household inventories from the late seventeenth century. Some of the references may have been to quilted petticoats rather than bedcovers, but whether clothing or bedding, these early quilts were most likely British imports ordered by wealthy families. Quilts in this period were hardly ubiquitous, as bed rugs, blankets, and other coverlets formed the bulk of bedcovers used. Quilts were instead highly valued items that only the wealthy could afford, and they often served a major decorative role in the dressing of American beds in eighteenth- and nineteenth-century homes. Many of these quilts were made of glazed wool or silk in a whole-cloth format and finished with elaborate quilting patterns. The early appliquéd and pieced quilts used a medallion design—a pattern also seen in the quilting on whole-cloth quilts—in which the central image, or "medallion," is framed by successive borders, or were composed of pieced hexagons that formed a variety of "honeycomb" patterns. The oldest surviving American quilt, dated 1704, is made of pieced triangles in a medallion format.

Quilted bedcovers are generally divided into three main groups: whole-cloth quilts, appliquéd quilts, and pieced quilts. The term "patchwork" can refer to either appliquéd or pieced quilts; it is, however, more accurate to refer to appliquéd or pieced *tops* rather than quilts, as the backs are usually whole-cloth rather than patchwork, but the term "quilt" is now standard usage and shall be used here. Several theories have been advanced toward establishing pieced quilts as the predecessors of appliquéd examples, but equally valid theories have been used to show that appliquéd quilts predate pieced ones. It is possible that both types developed more or less contemporaneously and have coexisted through the years.

Whole-cloth quilts are made of lengths of the same fabric stitched together to form the desired size. The

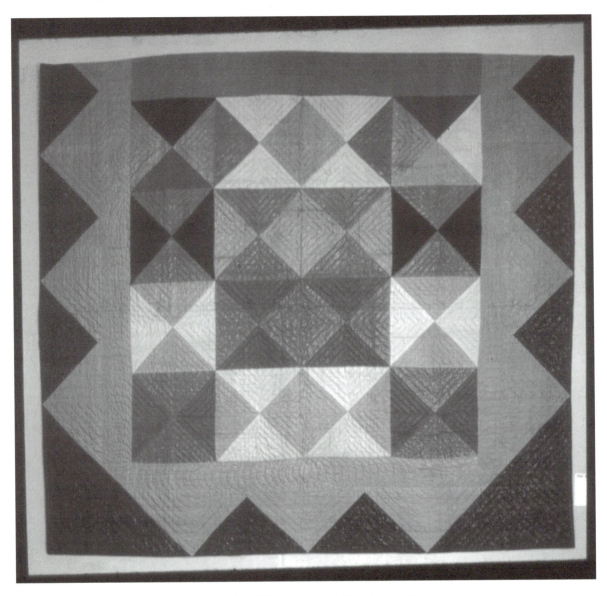

Harlequin Medallion Quilt. Artist unknown; c. 1800–1820; New England. Glazed wool; 87 ×
96 inches. Collection American Folk Art Museum, New York. Gift of Cyril Irwin Nelson in
loving memory of his grandparents John Williams and Sophie Anna Macy, 1984.33.1.

cloth used for the top is generally of better quality
than that used for the back, and the layers are held
together with extensive ornate stitching. Calimanco, a
worsted wool dyed in deep, rich colors and then
glazed, was an early favorite for whole-cloth quilts as
the glazed surface was ideal for showcasing the fine
stitching that formed the many complex quilting pat-
terns used. In the late eighteenth century printed
textiles were also used to create whole-cloth quilts.
Brightly patterned and glazed chintzes from India and
England were popular textiles for this purpose, as

were the well-known *toiles de Jouy*. Also favored—
although expensive—were whole-cloth quilts made
from palampores, the block-printed and over-painted
cotton fabrics from the East Indies that featured spec-
tacular "Tree of Life" and floral designs.

By the nineteenth century, all-white whole-cloth
quilts had become popular, especially as trousseau or
wedding gifts. The plain white ground proved an
effective backdrop for ornate decorative stitching,
embroidery, candlewicking, or stuffed work (also
known as *trapunto*). In stuffed work, designs were

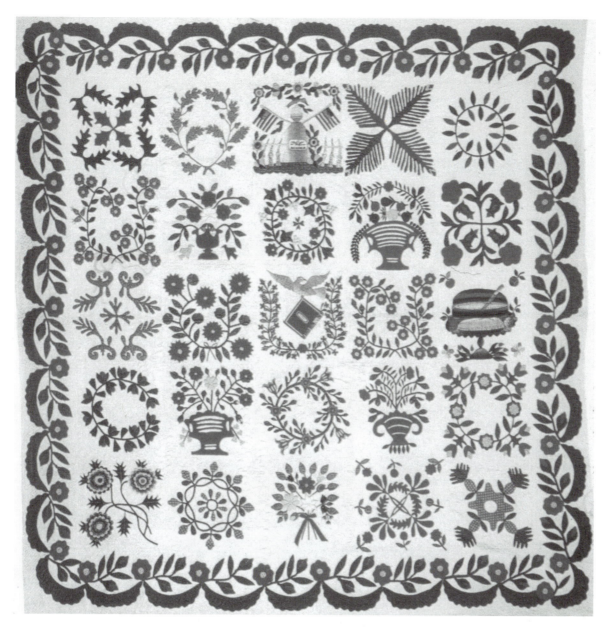

Baltimore Album Quilt. Mary E. Johnson; 1853. Pieced and appliquéd cotton; 105 × 105 inches. The Bertram K. Little and Nina Fletcher Little Collection auction at Sotheby's 6899, October 19, 1996.
Photo courtesy Sotheby's, New York.

first outlined with quilting stitches, then cotton wadding was pushed through the coarse backing of the quilt with a long needle, making the quilted design stand out in high relief against the background and giving it a strong sculptural effect that adds greatly to the ornamental quality of the quilt. The makers of these quilts, known as whitework, frequently employed more than one of the techniques noted.

Appliqué quilts are made of pieces of fabric cut into various shapes and sewn, or appliquéd, to a ground fabric to form a design. Because this technique involves cutout fabrics stitched to a ground fabric, thus creating a double layer, appliquéd quilts are more costly to make. The blank spaces between the appliquéd designs provide ideal areas to showcase elaborate quilting and stuffed work in decorative

patterns, and skilled quilters make full use of it. A good example of appliqué is *broderie perse* (Persian embroidery), also called cut-out chintz, a technique in which the images of flowers, birds, animals, and foliage are cut from pieces of printed chintz, arranged in a Central Medallion format, then stitched to a white or off-white ground fabric. By the late eighteenth century, cut-out chintz quilts had become so popular that textile manufacturers and designers began to print fabrics specifically intended for use in making them. John Hewson (active 1790–1815) of Philadelphia, Pennsylvania, is among the best known of those who produced such printed panels, and his textiles were widely used in *broderie perse* quilts. Some of these elegant pieces were not true quilts (that is, a textile "sandwich" of top, bottom, and filling held together with stitching) but instead lightweight unquilted bedspreads.

Appliqué quilts were especially popular along the Atlantic seaboard, from South Carolina north to New Jersey, and Baltimore Album quilts, made in and around Baltimore, Maryland, from 1846 to 1852, give further testimony to this popularity. The Baltimore Album quilts share an elaborate and identifiable style; rather than the medallion style favored in *broderie perse*, they are made in a block style, with each block having a different appliquéd design—hence the idea of "album." The best of these quilt blocks, many of which were commissioned by wealthy ladies who signed their own names to the pieces, are thought to have been designed by Achsah Goodwin Wilkins (1775–1854) and possibly made by Mary Evans (1829–1916). She may have been a designer who also sold blocks to clients. Baltimore Album quilts were stylish showpieces in which the creative took precedence over the functional, and many were no doubt intended as presentation pieces. Although the Album remained a popular format, to some extent they were replaced in the 1850s by the fashionable red, green, and white floral appliqué quilts of that period.

Pieced quilts are made from pieces of cloth cut into geometric shapes and sewn together in a predetermined design that might encompass the whole of the top or a series of repetitive pieced blocks sewn together. Because of their geometric composition, most pieced quilts are abstract and graphic; appliqué is usually pictorial or representational in style, although it may also employ abstract images.

Pieced quilts were time-consuming but economical in times when fabric was scarce as well as expensive. Initially pieced quilts were probably fashioned from remnants; wealthy women could purchase fabric for the elaborate *broderie perse* quilts of the late eigh-teenth century, but it was not until mechanized production lowered the cost of textiles and made them more widely available in the nineteenth century that most quilters could buy fabric for the sole purpose of cutting it up and reconstructing it. Templates were used to cut the pieces needed for a quilt accurately, and often thousands of such pieces were needed. They were then sewn together, usually according to a preplanned design, to form a patterned top. The recycled scraps that often appear in these quilts yield their own story, telling both of necessity and the history of a woman's life, as a favorite dress, a special occasion, or a remnant of a deceased relative's favorite fabric are recalled. Pieced quilts were, for the most part, considered utilitarian and represented the everyday bedcover. Appliquéd quilts, because of the extra work and expense involved, represented "best" coverings, yet it is clear that quilt makers spent no little time and effort in making their pieced quilts as attractive as possible, with care and forethought going into the choice of pattern and the placement of colors. The designs of many pieced quilts are bold and dramatic, their surfaces visually invigorating, their makers having succeeded in creating warmth for both the body and the mind.

Two of the most popular patterns for pieced quilts are the Log Cabin and the Crazy. Both allow for a wide variation of design, and both are still widely used by quilters today. The Log Cabin pattern blossomed in popularity just after the close of the American Civil War and it is a particularly graphic example of the quilter's art. The organization of the "logs" (rectangular strips of fabric stacked stepwise) in blocks and the arrangement of color in both logs and blocks can dramatically change the look of a piece, giving the possibility of a single large design or a series of smaller ones. Designs carry the evocative names of Barn Raising, Pineapple, Windmill Blades, Courthouse Steps, Streak o' Lightning, and Sunshine and Shadow and are only a few of the many possible variations using the Log Cabin technique.

Crazy quilts, composed of pieces sewn together in a random fashion, were most popular as ornamental couch throws in fashionable late-nineteenth-century parlors rather than as bedcovers. They generally include scraps of silk, satin, and velvet, many of which were adorned with painted images or embroidery; the opulent character of these quilts was further emphasized by elaborate embroidery stitches used to overlay the seams that joined the pieces. Crazy quilts are usually tied or "tufted" rather than quilted, as the variety of materials used and supplemental decorations make them difficult candidates for quilting.

There are several theories regarding the origin of the term "Crazy." One of them is purely descriptive and relates to the seemingly random combination of irregularly shaped pieces of fabric and often-excessive embroidery that made up these creations. Another holds that the style was inspired by the Japanese exhibition at the Philadelphia Centennial Exposition of 1876, where a screen ornamented with painted and embroidered patches of material and pottery with "crazed" finishes could be seen. The fad for Crazy quilts reached a peak during the last quarter of the nineteenth century and almost every household seemed to have one, either in the preferred silks, satins, and velvets, or in more prosaic wool or cotton made with remnants from the scrap bag.

There are thousands of quilt patterns, both for appliqué and pieced quilts, and many patterns have more than one name attached to them. Just as designs were modified through generations, so too did names change along with women's conceptual and social frameworks. A pattern known by one name in the east might evolve to a totally different one on the western frontier. Thus, Prince's Feather became Princess Feather, then Ostrich Plume and California Plume; Jacob's Ladder became Stepping Stones, then Underground Railroad, and later, Trail of the Covered Wagon. It was not until after the middle of the nineteenth century that names and patterns began to be standardized via women's magazines and, in the twentieth century, newspaper columns. While new pieced patterns have appeared throughout the history of American quilting, many appliqué patterns were set in the 1840s and 1850s and few others developed until the early twentieth century, when Marie D. Webster (1859–1956), a banker's wife from Indiana, designed a group of appliqué quilts that marked a definitive break with the past in terms of color, fabric, composition, and construction. Her simple yet sophisticated large-scale appliqué designs took elements from both the Arts and Crafts and Art Nouveau movements, and her use of light, clear colors and modulated pastels (made possible by technological advances in textile dyes) reflected contemporary trends in interior decoration. In 1915, Webster wrote *Quilts, Their Story and How to Make Them,* the first book to be devoted to the history and practice of quiltmaking and a seminal, if romanticized, publication. She was the first quilt designer to gain a national reputation; the demand for her patterns was so great that she started her own mail-order company to supply them. In all, Webster designed some thirty-three quilts; they are still looked on as icons for the century.

Once a quilt top was completed, it was combined with an inner lining or batting and a backing and mounted on a quilting frame that securely held the three layers and prevented them from shifting during quilting. The quilting pattern was usually "marked" on the quilt top as a guide for stitching. Sometimes this difficult task was done freehand, but more often pattern templates and chalk, pencil, or ink that could later be washed out were used to trace the design on the fabric. Some women preferred to prick the design into the fabric with a pin or needle, and then to hide the guide holes with quilting stitches.

Fine stitches and an intricate quilting pattern have always been considered among the most important elements of a good quilt. Many women chose to do their own quilting, but others looked to friends and neighbors for help in completing their quilts and held quilting "bees," gatherings that combined the social with the functional. These events could take many forms, from an impromptu get-together, to large-scale affairs that involved much of the neighborhood, and were accompanied by refreshments and entertainment. Quilting bees, a uniquely American invention, are representative of the communal aspect of American quilting that played such a strong part in women's social lives.

Communal work on quilts went beyond helping one woman complete her quilt, however. In the 1840s and 1850s group-made quilts were extremely popular and made for many reasons: friendship, weddings, coming of age, births, birthdays and anniversaries, departures, family reunions, the desire to honor someone in the community, deaths, and fundraising. Some were made by families, some by church groups, others by people who only came together to carry out a project for the larger community. These quilts, known variously as album, signature, autograph, friendship, or presentation quilts, were composed of blocks made by individuals who would then gather together to join the separate blocks together. The blocks were often signed by the makers or by other family or group members, sometimes with names only, sometimes with elaborate statements of friendship or remembrance, religious inscriptions, or popular adages. Although there were some regional differences in friendship quilts (single-pattern block quilts were favored in the Northeast, for example, while ornate album types, such as the Baltimore Album style, were popular in the mid-Atlantic region and the South), by the late nineteenth century almost any type of quilt, even Crazy quilts, were used for this purpose.

Fundraisers, a variation on the signature quilt, began to appear in the second half of the nineteenth century. Women's church or school groups often made them, as sewing was a favorite and effective means of raising revenue. In some cases, those who donated money to the fundraising effort would have their name included on the quilt; in others, a donation entitled the contributor to a chance to win the quilt in a raffle.

The mid-nineteenth century also saw the beginning of both group-made and individually produced quilts that served as expressions of patriotism, preferences, and political beliefs, and as celebrations of, or demand for, reform and change. Sooner or later almost all famous people, popular heroes, and significant historical events (war, peace, politics, elections, temperance, suffrage, emancipation, the environment, centennials, civil rights, assassinations, concentration camps, AIDS, and, most recently, the events of September 11, 2001) are represented in quilts. The history of quilts is not only embedded in our culture—the history of our culture is also embedded in quilts.

Following the Colonial Revival of the 1920s and 1930s, interest in quilting waned except in very rural areas, and it was not until the 1970s that the exhibition "Abstract Design in American Quilts" at the Whitney Museum of Art in New York and the Bicentennial galvanized women (and some men) to take up quilting once more. They also inspired a group of women artists with interests in "women's work" to revitalize quilting by taking it in a new direction, that of the "art" quilt.

Today, quilting is a many-faceted activity and flourishing art. Many women still make traditional quilts for function and decoration, but others move in different directions, sometimes using the past as inspiration and sometimes following new pathways in the development of style and technique. In the new vocabulary of quilt design, departures from the traditional quilt form (that is, a rectangle or a square) become the norm; an increasing number of quilts are designed to be seen on a wall rather than a bed. At the same time, there has been a slow but growing recognition by the broader art, design, and museum communities of the quilt as art rather than simply as an embellished functional object for the home.

Quiltmaking has continuously been influenced and informed by many different factors. Several American groups with strong religious, ethnic, or cultural characteristics, namely the Amish, African Americans, Hawaiians, and Native Americans, have created their own particular versions of the quilting tradition, often with far-reaching effects. The visually austere geometric designs, dramatic color juxtapositions, and superb workmanship associated with Amish quilts, for example, have struck a resonating chord in the larger quilt community and broadened the horizons of many non-Amish quiltmakers. The pieced quilts made by Amish quilters are distinctively designed and have their own unique palettes and quilting motifs, although styles vary depending on whether they are made in Pennsylvania or the Midwest. The Pennsylvania Amish have tended to produce quilts that are more conservative in design, use abstract patterns, and are made primarily of wool. The sparser Amish population in the Midwest put Amish needlewomen in closer contact with their "English," or non-Amish, neighbors and thus they are subject to more outside influences; though solid colors and geometric patterns still prevailed, their quilt designs reflect a greater diversity and complexity and the preferred fabric became cotton rather than wool.

In contrast to the restrained style seen in Amish quilts, African American quilts show an abundance of pattern. Designs are bold, rhythmic, and often asymmetrical; colors are bright, with vibrant contrasts, and multiple patterning may occur in any one quilt. Pictorial narratives also form an important idiom in African American quilts.

Some scholars believe there is a characteristic and identifiable African American quilt design tradition that encompasses textile traits common to many west and central African cultures, centered on the use of strong colors, asymmetry, multiple patterning, large-scale motifs, strip piecing, and improvisation. They see contemporary African American quilts as an expression of African art traditions passed down through the generations. Others point out the great diversity of quilts made over the last two centuries by African Americans and maintain that contemporary quilts tell only a part of the story. These scholars take issue with the dichotomization of quiltmaking into an "African American" tradition and a "European American" tradition. Rather than seeing African American quilts as distinct from the mainstream of quiltmaking in America, this group sees them as significant contributors over time to that mainstream. They argue for a quilt history that emphasizes inclusion rather than exclusion, an idea that encompasses both similarities to and differences from "traditional" quilts and also recognizes that quilts may be as diverse as their makers. The two points of view need not be viewed as mutually exclusive but rather as highlighting the hybridity that is so much a part of the history of quilts. Today, many African American quiltmakers are ex-

ploring their African heritage and incorporating African themes, images, motifs, and textiles in their work, thus making their own contributions to the contemporary quilt environment.

Hawaiian quilting was well established by the beginning of the twentieth century and encompasses several design genres. Hawaiian women learned to quilt from the wives of missionaries from New England in the 1820s. Though they learned both pieced work and appliqué, by the 1870s they had adapted appliqué techniques to create a uniquely Hawaiian mode of expression. The classic Hawaiian quilt design is a large, bold, curvilinear appliqué pattern that covers much of the surface of the quilt, and the symmetrical design is cut from only one piece of fabric. Many of the quilts use only two colors, usually a light ground with the pattern in a darker but strongly contrasting color. Solid colors were used originally, but today's quilts use prints as well; contrast, however, remains important. The works are quilted with "echo" stitching that follows the outline of the design. These unique Hawaiian creations are thought to have grown out of the complex freehand designs used to decorate native *tapa* cloth, and, as quilting developed, the *tapa* designs were first incorporated and then modified. Hawaiian quiltmakers always give their designs names, and they frequently reflect a relationship with nature, history, mythology, or dreams. Ownership is important; a design is never copied without permission, although mainland quilters often try to emulate them.

A second type of Hawaiian quilt popular in the late nineteenth and early twentieth centuries is, perhaps, just as unique. This group, known as flag quilts, or *Ku'u Hae Aloha ("My Beloved Flag")*, reflects a patriotic origin. Hawaiians were forbidden to fly their national flag after an 1893 American-backed coup against the Hawaiian Queen Liliuokalani, so Hawaiian patriots incorporated the flag design, as well as other symbols of the ruling family, into their quilts.

The islands have produced a number of outstanding master quilters, some of native Hawaiian ancestry, others mainlanders who now make Hawaii their home. They have all been influential in passing on the quilt tradition in Hawaii as well as in expanding its scope. As elsewhere, quilting in Hawaii is primarily a woman's art, but in recent years some men have entered the field and gained recognition.

Women in Native American communities learned quiltmaking in the latter part of the nineteenth century from missionaries and educators in schools established by religious groups or government schools on reservations, where quilting was one of the domestic arts taught in home economic classes. Although quiltmaking was a new medium for all Native American groups, it was quickly adopted, and by the beginning of the twentieth century quilts were being made in many communities.

Native American women initially used designs common to the European American quilt tradition, but soon incorporated their own cultural heritage. The morning star (Venus, the brightest object in the sky just before dawn) holds great symbolic meaning for many groups, especially those of the Great Plains, and was a motif used in many media. The traditional Lone Star (or Star of Bethlehem) quilt design lent itself well to this imagery and was in use in quilts made by Plains women by the early twentieth century. Since the mid-twentieth century, the star design (called Morning Star or Northern Star by some groups) has been a favorite of many Native American quilters as well as an integral part of a number of reinvented traditions. Star quilts, for example, play a major part in ceremonies honoring high school sports (especially basketball) as well as in ceremonies marking significant rites of passage, such as naming ceremonies, memorial feasts, graduations, weddings, or funerals, and women may spend much of the year preparing quilts for the ceremonies.

Although variations on the Star design are among the most popular, Native American quilters create quilts along a broad design spectrum, including ones that use motifs from traditional crafts such as beadwork, basketry, sand painting, and weaving. The design tradition has thus expanded across media and ensured the survival of some motifs that might otherwise have been lost. In this way, Native American groups have made quilting very much their own.

These groups mentioned above are not the only ones influenced by, and influencing, American quilting. The quilting revival that started in America in the late twentieth century has spread worldwide, reinvigorating the tradition in countries where it had lain dormant and becoming assimilated into the art/craft traditions of others. Nowhere has this happened to a greater extent than in Japan, where American-style quilting was taken up with great enthusiasm. In a comparatively brief period, Japanese women absorbed the essence of American quilting and gave it their own cultural flavor. Today, just as American quilters were once inspired by what they saw in the Japanese Pavilion at the Centennial Exposition, they now find inspiration in the work done by Japanese quilt artists. The exchange has become mutually reinforcing, resulting in a melding of ideas that has enhanced the work of quilters in these two countries as well as around the world.

See also **African American Folk Art (Vernacular Art); Amish Quilts and Folk Arts; Asian American Folk Art; Coverlets; International Quilt Study Center; Museum of the American Quilter's Society; Native American Folk Art; New England Quilt Museum; Quilts, African American; San José Museum of Quilts and Textiles.**

BIBLIOGRAPHY

Allen, Gloria Seaman. *First Flowerings: Early Virginia Quilts.* Washington, D.C., 1987.

Atkins, Jacqueline M. *Shared Threads: Communal Quilting Yesterday and Today.* New York, 1994.

Benberry, Cuesta. *Always There: The African American Presence in American Quilts.* Louisville, Ky., 1992.

Brackman, Barbara. *Clues in the Calico: A Guide to Identifying and Dating Antique Quilts.* McLean, Va., 1989.

Christopherson, Katy. *The Political and Campaign Quilt.* Frankfort, Ky., 1984.

Ferrero, Pat, et al. *Hearts and Hands: The Influence of Women and Quilts in American Society.* San Francisco, 1987.

Holstein, Jonathan. *The Pieced Quilt: An American Design Tradition.* Boston, 1982.

Houck, Carter, ed. *The Quilt Encyclopedia.* New York, 1991.

Imami-Paydar, Niloo. *American Quilt Renaissance: Three Women Who Influenced Quiltmaking in the Early 20th Century.* Tokyo, Japan, 1997.

Katzenberg, Dena S. *Baltimore Album Quilts.* Baltimore, Md., 1981.

Kiracofe, Roderick. *The American Quilt: A History of Cloth and Comfort 1750–1950.* New York, 1993.

Kirkham, Pat, ed. *Women Designers in the USA: 1900–2000.* New Haven, Conn., and London, 2000.

Lipsett, Linda Otto. *Remember Me: Women and Their Friendship Quilts.* San Francisco, 1985.

Mainardi, Patricia. "Quilts: The Great American Art." *The Feminist Art Journal,* vol. 2, no. 1 (winter 1973): 1, 18–23.

McMorris, Penny. *Crazy Quilts.* New York, 1984.

McMorris, Penny, and Michael Kile. *The Art Quilt.* Lincolnwood, Ill., 1996.

Orlofsky, Patsy, and Myron Orlofsky. *Quilts in America.* New York, 1992.

Peck, Amelia. *American Quilts and Coverlets in the Metropolitan Museum of Art.* New York, 1990.

Safford, Carleton L., and Robert Bishop. *America's Quilts and Coverlets.* New York, 1972.

Shaw, Robert. *Quilts: A Living Tradition.* New York, 1995.

———. *The Art Quilt.* New York, 1999.

Wahlman, Maude Southwell. *Signs and Symbols: African Images in African-American Quilts.* New York, 1992.

Warren, Elizabeth V., and Sharon L. Eisenstat. *Glorious American Quilts: The Quilt Collection of the Museum of American Folk Art.* New York, 1996.

Webster, Marie D. *Quilts, Their Story and How to Make Them.* 1915; new edition, Santa Barbara, Calif., 1990.

Weissman, Judith Reiter, and Wendy Lavitt. *Labours of Love: America's Textiles and Needlework, 1650–1930.* New York, 1987.

Woodard, Thomas K. and Blanche Greenstein. *Twentieth-Century Quilts: 1900–1950.* New York, 1988.

JACQUELINE M. ATKINS

QUILTS, AFRICAN AMERICAN have been made by African American women for generations, but it is only in recent years that African American quilts as a separate genre have begun to be widely recognized. Although many slaves came to America from Africa, beginning as early as the seventeenth century, with indigenous textile knowledge and skills, quilting was not a craft with roots in Africa. Enslaved black women in America were taught to quilt by their white mistresses, and the quilts they created initially reflected the patterns and tastes of their masters. Some slaves also made quilts for their own families, from leftover sewing scraps and discarded clothing, but extant examples of quilts produced by and for slaves are extremely rare. Many of the early post-Civil War African American quilts were also primarily utilitarian, and, like the pre-Civil War examples, few survive today because of the heavy use they received. Thus it is difficult to gain a broad picture of what both pre- and early post-Civil War African American quilts may have been like in regard to technique, aesthetic design, and fabrics used, although most of the examples known from these years are based on traditional mainstream (European-American) patterns.

Some of these quilts, however, do display elements that several scholars believe illustrate the existence of an identifiable African American quilt design tradition that encompasses decorative textile characteristics common to many West and Central African cultures. These characteristics (the use of strong and bold colors, asymmetrical configurations, multiple patterning, large-scale shapes and motifs, strip piecing, and improvisations on standard patterns) are thought to have come to America with slaves from those regions, then gradually to have been incorporated into their quilting aesthetic, and finally passed down through the generations to create a uniquely African American quilting tradition. These scholars note that corollaries also exist between some African American narrative quilts and the appliqué tradition of the Fon people of Dahomey and the Yoruba people of Nigeria, West Africa, peoples and areas from which many of the slaves brought to America originated.

Another group of quilt historians, however, see this approach as too narrowly focused and based on too small a sample of idiosyncratic quilts, most of which date from the early to mid-twentieth century, as so few verifiably documented, earlier African American quilts can be found today. Moreover, these scholars contend that there is no typical African American quilt tradition, but rather view African American quilts as representing a diverse body of work that has been influenced by the many factors that make up the

African American experience, from slavery to the civil rights movement to a desire to celebrate origins by consciously incorporating African components in their work. These two points of view are not necessarily contradictory, however, and can instead serve to highlight the cultural fusion that is so much a part of contemporary quilting.

Nevertheless, there is no doubt that many of the African American quilts made since the early twentieth century do indeed embrace the characteristics noted above, whether consciously or not, and these characteristics impart a highly distinctive look to these quilts. The use of improvisation, for example, in which the overriding visual impact is that of an informal arrangement without the geometric compartmentalization that characterizes many quilts, has led to striking reinterpretations of such traditional patterns as the Log Cabin, Star, and Snail's Trail, while the use of multiple patterning has served to override the symmetry and conformity of many conventional quilt formats. Using these elements as guiding principles for the quilt design allows for the construction of a unique piece, yet one that also adheres to a recognizable tradition while still allowing for a strong sense of ownership and creativity.

Pictorial narrative also forms an important idiom within the African American quilting tradition, and has been used by many quilters over the years as a way to tell the stories important to them. Harriet Powers' (1837–1911) quilts of the late nineteenth century, with their many blocks that represent both biblical stories and local events, are excellent examples of this style. It has also been used effectively by contemporary artists, such as Faith Ringgold (1930–), in a manner that explores contemporary experiences and issues within the context of African American life. Not all narrative quilts are necessarily pictorial. Some are based on text, and make use of scripture or even single words like "Freedom" to make dramatic statements about strong beliefs and societal concerns.

Though the question of the influence of African textile traditions on quilting remains an open issue among scholars, many African American quiltmakers today are consciously exploring their African heritage, and incorporating African themes, images, motifs, and textiles in their work. Some have gained a national reputation for their innovative design work using these elements, while still others use an African aesthetic as the source of inspiration simply for their own personal satisfaction and pleasure. African American quilters as a whole remain an eclectic and independent group, with a broad repertoire of design, from African to traditional European-American, from which to draw. Through their work, they have made a powerful and exciting contribution to the broader quilt scene.

See also **African American Folk Art (Vernacular Art); Harriet Powers; Quilts.**

BIBLIOGRAPHY

Benberry, Cuesta. *Always There: The African American Presence in American Quilts.* Louisville, Ky., 1992.

Fry, Gladys Marie. *Stitched from the Soul: Slave Quilts from the Anti-Bellum South.* New York, 1990.

Kirkham, Pat, ed. *Women Designers in the USA: 1900–2000.* New Haven, Conn., and London, 2000.

Leon, Eli. *Models in the Mind: African Prototypes in American Patchwork.* Winston-Salem, N.C., 1992.

Mazloomi, Carol. *Spirits of the Cloth: Contemporary African American Quilts.* New York, 1998.

Shaw, Robert. *Quilts: A Living Tradition.* New York, 1995.

Wahlman, Maude Southwell. *Signs and Symbols: African Images in African American Quilts.* New York, 1993.

JACQUELINE M. ATKINS

RADOSLOVICH, MATTEO (1882–1972) created an environment filled with sculptures he produced in his backyard in West New York, New Jersey. He was born in the town of Lussinpiccolo, on the small island of Lussin in the Adriatic Sea that became a part of the former Yugoslavia. His father and uncle were builders of small boats and Radoslovich learned ship carpentry from them. In 1914 at the outbreak of World War I, he immigrated to the United States. With his skills he readily found a job at the Todd Shipyards in Hoboken, New Jersey. He worked there until his retirement at age sixty-five in 1947.

Like so many folk artists, he began his creative career upon his retirement. He built a lively environment in his 20-by-40 foot backyard. Radoslovich worked on his outdoor sculpture garden for the remaining twenty-five years of his life. He began by making wind driven whirligigs using propellers. His first painted wood sculptures were of a man chopping wood and a woman washing. He went on to make clowns, birds, dancing girls, a man riding a pig, and dogs that chased each other. He intended that the backyard be experienced as an overall carnival. With the wind blowing there was an exciting sense of color and motion. He used wood, metal, glass, cloth, and other found objects to make his sculptures. Over the years he kept his environment repaired and painted. Little was written about his creation and he was relatively unknown. There were thirty-nine objects in the garden when he died. Most were acquired by Leo and Dorothy Rabkin, noted folk art collectors, who donated them to the American Folk Art Museum.

See also **American Folk Art Museum; Environments, Folk; Sculpture, Folk; Whirligigs.**

BIBLIOGRAPHY

Museum of American Folk Art. *A Time to Reap: Late Blooming Folk Artists.* South Orange, N.J., 1985.

Rosenak, Chuck, and Jan Rosenak. *Museum of American Folk Art Encyclopedia of Twentieth-Century American Folk Art and Artists.* New York, 1990.

JOHN HOOD

RAMÍREZ, MARTÍN (1895–1963) was a Mexican-born laborer who stopped talking in 1915 and was found homeless in Los Angeles, California, fifteen years later. Subsequently, he was diagnosed as "paranoid schizophrenic, deteriorated" by the staff of the DeWitt state mental hospital in Auburn, California, and was committed to that hospital for the rest of his life. He began to make drawings in 1948, and from then until about 1960 he produced more than 300 works. These were saved by Dr. Tarmo Pasto, an artist and psychologist who taught abnormal psychology at Sacramento State University and used Ramírez's drawings as teaching aids. Through the artist Jim Nutt, who mounted the first exhibition of Ramírez's work at the university's art gallery, the drawings entered the art market in 1973.

Ramírez's works are often impressive in size and always impressive in scale. He preferred to work in pencil, colored pencil, crayons, and occasionally tempera, on scraps of paper that he glued together using potato or wheat starch and saliva to create large, irregular sheets measuring up to 110 inches in one dimension. Some of his works combine drawing with collages of pictures from magazines that, along with Mexican folk art and religious art, are among the more readily identifiable sources of his work. His masked deer, fantastic architectural spaces, and undulating topography are sometimes held to illustrate Jung's theory of "archetypal" images, showing the intuitive ability of certain self-taught artists to tap the iconography that many cultures share. Other viewers have compared Ramírez's work to art it is unlikely he ever saw, or have inquired earnestly into the psychological underpinnings of his art. But Ramírez's art does not yield easily to analysis. His iconography can

be simultaneously familiar and strange, and it is made even more unsettling by his seductive, virtuosic ability to manipulate line and volume.

Among Ramírez's recurring motifs is a train entering or emerging from a tunnel made of a row of inverted U-shape, closely spaced lines that often climb precipitously up the sheet. The sexual implications of the train and tunnel are unavoidable, as when Ramírez combines a drawing of a speeding train with a magazine photograph of a beautiful young woman. The formal power of these provocative designs, with their unrelenting patterns and repetitions, is enough to hold one's attention. Moreover, because Ramírez spent most of his adult life mute and confined to a mental institution, these images may have provided him with a means to participate in life experiences that he was otherwise denied. When considered in this context, the eloquence of the train and tunnel drawings is as affecting as it is private.

Another favored image is the armed horseman. These figures have been called banditos, but they more likely depict the *Zapatistos* who fought with Francisco Villa and Emiliano Zapata against the Mexican government between 1910 and 1917. The fighter figures—mounted on agitated horses, wearing sombreros, bandoliers across their chests, and aiming cocked revolvers—are often placed in confined, proscenium-enclosed spaces. The year that Ramírez arrived in the United States is unknown, but his interest in the *Zapatisto* suggests that he may have had more than a passing familiarity with Mexico's revolutionary struggle. Whether Ramírez had been one of these peasant soldiers, and if his psychological trauma was triggered by his experiences as a participant in that brutal conflict, remains to be answered.

Drawings depicting enormous Madonnas, reminiscent of the ubiquitous Our Lady of Guadalupe, suggest that Ramírez was familiar with Mexican folk art and religious art. But unlike the popular image of Our Lady of Guadalupe, standing on a crescent moon, Ramírez's Madonnas dominate the globes on which they stand. Ramírez's Madonnas seem to radiate not benevolence but malevolence. If, indeed, he intended to transform the Madonna from a giver of life to a destroyer, he may have been projecting his views of religion, women, his culture, and his past; and this would offer further evidence of the basis of his mental instability. Another work, featuring a violin-playing skeleton, recalls the plaster skeletons and piles of edible sugar skulls that are a part of the celebrations for Mexico's Day of the Dead. Clearly, Ramírez retained recollections of his cultural heritage that he

modified, adapted, and placed in often new and unsettling contexts.

A fuller understanding of Ramírez's art is complicated by his mental turmoil and the lack of information about his early life. His scrupulous preservation of his drawings shows their vital importance to him and perhaps indicates that he intended his art to be preserved as privileged glimpses into his private world from the world outside.

See also **Outsider Art.**

BIBLIOGRAPHY

The Heart of Creation: The Art of Martin Ramirez. [exhibition catalog] Philadelphia, 1985.

Longhauser, Elsa. *Self-Taught Artists of the Twentieth Century: An American Anthology.* New York, 1998.

RICHARD MILLER

RASMUSSEN, JOHN: *SEE* ALMSHOUSE PAINTERS.

READING ARTIST, THE (fl. c. 1845–1850), who has not yet been identified, painted watercolor portraits on paper of thirty-five residents of Berks and Lebanon counties in Pennsylvania. He identified his subjects (most of whom have German names), using embellished broken Gothic script inked in a margin below each portrait. A black inked single or double outline framed the portrait on all sides. The artist often dated the portrait and included information about the subject's birth and baptism. In some portraits he inscribed other details: for instance, the portrait of Isaac Hottenstein notes that the subject was a lieutenant colonel of the First Regiment, Second Brigade, Sixth Division.

The Reading Artist developed a formula and many variations, but in several works he attempted a more realistic portrayal. The subjects of full-length portraits are standing or seated; subjects of three-quarter-length portraits are seated. The sitter's chair may be painted decoratively. Outdoor settings often have landscape elements—stone houses, fences, churches, a sky with billowy clouds, and foliage. For indoor portraits the sitter is often placed near a multipaned window with draperies; and other elements, such as patterned wallpaper or carpeting, may be included. Seated figures generally fold their hands, but some hold a book or newspaper; Joseph Kintzel, for instance, holds the *Redinger Adler* ("*Reading Eagle*"). Several families are depicted in individual pendant portraits, facing each other in the same setting; children are sometimes paired in a single work. Dr. George Horting and Katherine Horting are seated

outdoors near a picket fence in the pendant format; their children, Klara Anna and Henry, are paired near a stone wall in one drawing. In general, the artist makes his subjects' faces broad and their feet very small. Occasionally, as in four portraits of the Hunsicker-Brechbill family, the artist provided a grain-painted pasteboard frame with a hook that he had devised himself. He favored green and the primary colors.

One scholar, Don Walters, has noted similar stippled foliage by the Reading Artist and by Jacob Maentel, who worked in Berks County at the same time. Walters also notes a clue to the identity of the Reading Artist: a portrait of David Kistler (1845) inscribed "F. Bischoff pixt I[?]hverish [or possibly Invenit]." But although there was an artist in Reading named Frederick Christopher Bischoff, he died in 1835.

Portraits by the Reading Artist are at the American Folk Art Museum and the Fenimore House Museum, Cooperstown, New York.

See also **Jacob Maentel; Pennsylvania German Folk Art.**

BIBLIOGRAPHY

D'Ambrosio, Paul S., and Charlotte M. Emans. *Folk Art's Many Faces: Portraits in the New York State Historical Association.* Cooperstown: N.Y., 1987.

Hollander, Stacy C. *American Radiance: The Ralph Esmerian Gift to the American Folk Art Museum.* New York: 2000.

LEE KOGAN

REDWARE, or red earthenwares, are among the most common types of domestic ceramics produced throughout the histories of most of the world's diverse ceramic traditions. Both utilitarian and decorative wares employing the traditional materials and techniques of the redware potter continue to be made today worldwide. While most clay types vary widely from region to region in their specific chemical compositions and physical properties, the clay bodies employed in the production of red earthenwares tend to be composed from basic and plentiful, naturally occurring, common clay deposits, fine in particulate, with high content of both silicaceous and red iron glacial clays. Redware clays require a relatively low firing temperature, as low as 1,800 degrees Fahrenheit to produce durable, lightweight wares, that made their firing compatible for even the most primitive, rudimentary kilns. Typically, redware clay bodies remained porous after firing, but were often made more durable and watertight with the addition of simple silica based, lead glazes, that vitrified at similar low firing temperatures.

A wide range of both utilitarian and glazed, decorative domestic red earthenware forms were produced by American potters from the earliest colonial period. These traditional potters used a relatively limited range of traditional methods in forming and decorating their wares. The potter's wheel was the most common forming method, although early immigrant English and Germanic potters working in America adopted the use of molds to produce both pressed and slip–molded forms. Simple hand thrown, slab-built or molded forms could be augmented with surface decoration formed by appliqués or impressed designs, or more commonly through the application of trailed slip-decoration, or incised patterns. Liquefied clay, or "slip," usually yellow or white, could be colored with metal oxides to produce greens, blacks, browns, or blues. This slip could be brushed or applied by pouring or trailing it over a form using a small pouring cup fitted with one or more quill spouts. When poured, the slip cup produced a fine line or lines of slip across the surface of the form. The surface of the form could also be coated evenly with clay slip of one color and, once dried, scratched through to reveal the contrasting colored red clay of the form underneath. This technique allowed for precise drawn figural motifs and dates, inscriptions, and could be further elaborated with colored metallic oxides applied as dry powders or slips. The finished decoration usually received a final clear glaze coating composed most often of red lead, flint, and finely ground silica rich clay.

Most utilitarian and decorated red earthenwares such as these received only one firing in a wood fired kiln that could require several days to reach its desired temperature. The up-draft kilns used in Pennsylvania, Maryland, New York, and New England varied in form and construction, following the potter's individual preferences and accumulated knowledge of proper air flow, temperature, burning, and cooling time. Careful familiarity with the firing process was required to prevent the wares from exploding, warping, or melting, and to achieve the desired colors brought out from the slips and glazes during the process.

The work of the redware potter was most often combined with other seasonal work, and was placed into the agricultural calendar when the craft's necessary labors could be best accommodated. Local potteries were often operated by a single master potter, who may have been assisted by an apprentice potter, journeymen, or trained family members, depending on the size of the operation. Most smaller, rural potteries were able to supply only the demand in their

DWARE

immediate vicinity, and few of their products were retailed outside the local markets of nearby towns. A master potter often passed down their operation from father to son or through intermarriage, preserving not only their marketing position within the community but often the preferred techniques, decorations, and forms of the ceramics they produced. The confidence of these early folk potters, and the central place redware served for their community, is perhaps best expressed by an inscription found on a number of surviving redware plates; "From the earth with sense the potter makes everything."

See also **German American Folk Art; Pennsylvania German Folk Art; Pottery, Folk.**

IBLIOGRAPHY

arvan, Beatrice B. *The Pennsylvania German Collection*. Philadelphia, 1982.

Stradling, Diana, and J. Garrison, ed. *The Art of the Potter: Redware and Stoneware*. New York, 1977.

JACK L. LINDSEY

REED, ERNEST ("Popeye") (1919–1985), an Ohioan, was an unusual and versatile carver of wood and stone who said, "I'd like to carve until I die, right up to that last minute." Over some fifty years, he created thousands of small works including arrowheads, ducks, geese, birds, snakes, necklaces, bracelets, and clay pipes. He also carved more than 200 larger figures—life-size Native Americans; classical, mythological, and biblical figures; gods and goddesses; sphinxes—as well as some bas-relief plaques.

Reed was of Irish and Native American descent; his grandfather, a coal miner, had emigrated from Ireland to America in the 1880s. His great-uncles were furniture makers, though Reed did not remember seeing much of their work as a child. His father worked on the railroad; his mother was a member of the Little Turtle tribe of Miami. As a schoolboy, Reed would often sneak a penknife into the classroom so that he could carve during the day. He first worked in wood; he preferred hardwood, such as walnut, and might inlay mother-of-pearl for details. During the Depression, he sold his work at flea markets and at his home on Route 35. His first stone carving was a bowl, made from local material. Flint, soft native sandstone, and limestone were plentiful in the hills of southern Ohio, around Jackson and Limerick. His basic tools were a mallet and chisels. He often used "modified" tools, such as a drill made from motor parts; added grooves to a chisel to get a special effect, such as the texture of hair; or used a stag horn to incise fine lines.

Reed and his wife, Iona, lived in a 150-year-old log cabin near Jackson; after their divorce in 1964 he moved to an improvised tepee, then to a mobile home where his table, candle stand, and lamp were individually carved and embellished. The shelves were full of his sculptures and artifacts he would sell at flea markets: necklaces and bracelets of elk horn, flint, and slate. He owned art books, encyclopedias, and illustrated magazines, but when asked whether he was inspired by these, he said, "Hell, no. I use them to rest my knees on."

Reed's sculptures are at the American Folk Art Museum and the Milwaukee Art Museum. He had a show at the Equator Folk Art Gallery in New York (1980), but until recently his reputation was mostly regional. In 2002, there was a surge of interest in Reed's art.

IBLIOGRAPHY

arrett, Didi. *Muffled Voices*. New York, 1986.

"Equator Exhibits Works of 'Popeye' Reed." *Antiques and Arts Weekly*, vol. 17 (November 1981).

Guggenheim, Richard. "Popeye: It's Folk, but Is It Art?" *Ohio Antiques Review* (September 1980): 53–54.

Rosenak, Chuck, and Jan Rosenak. *Museum of American Folk Art Encyclopedia of Twentieth-Century American Folk Art and Artists*. New York, 1990.

LEE KOGAN

REED, POLLY ANNE (Jane) (1818–1881) is recognized as one of the most accomplished Shaker artists. Her meticulous drawings contain a wide array of symbolic figures, and her compositions are notable for their harmony and balance and for her delicate use of watercolor. Reed entered the United Society of Believers, known as Shakers, as a child of seven years and rose steadily through the ranks of the Shaker leadership to become a member of the central ministry in New Lebanon, New York, the highest authority in the religious community.

Reed was born in Fairfield, a hamlet in central New York state. She chose to accompany Elder Calvin Green, a Shaker leader from New Lebanon, when he returned home after having visited her family as a missionary in 1825. The tale of her youthful conversion to the Shaker faith was well known within the society and even entered American popular literature; her story is related in Kate Douglas Wiggin's *Susanna and Sue*, a novel published in 1909 with illustrations by Alice Barber Stephens and N.C. Wyeth. Reed entered the First Order of the Church, the most important of New Lebanon's Shaker "families," in December 1825.

During much of her life as a Shaker, Polly Anne Reed was a "tailoress," in keeping with the principle

4

that even the leaders of the society should be involved in hand labor, and she was celebrated as "a great worker with her hands." Her facility with needle and thread clearly had an impact on her drawings. She was educated entirely within the society and also served as a schoolteacher for the Shaker children at New Lebanon. Other Shakers remarked on her exquisite handwriting. In *Shakerism: Its Meaning and Message* (1904), by two Shaker leaders, Anna White and Leila S. Taylor, she is remembered for her "penmanship and map drawing" and "other work of like character." Reed was often called on to act as a scribe; she penned many beautiful manuscript hymnbooks using Shaker "letteral notation," a system for recording music invented by the Shakers.

During the "era of manifestations," or "mother's work" (1837–1859), a period in Shaker history characterized by widespread visionary experiences, Reed was one of a small group of Shakers, mostly women, who created "gift drawings." Approximately fifty of her drawings are extant; many of them are small heart or leaf cutouts dominated by textual elements. Of her surviving drawings, half a dozen are fully developed works of art, which combine painstaking calligraphy with representations of doves, flowers, and fanciful objects. One of her most impressive works, *A Present from Mother Ann to Mary H*[*azard*], is in the collection of the Abby Aldrich Rockefeller Folk Art Center; others are at the Western Reserve Historical Society, the American Folk Art Museum, and other museums.

In her obituary in the society's monthly publication, *The Shaker Manifesto*, Reed was remembered as a "woman of most excellent and ingenious faculties; a finished scholar; a beautiful speaker, and a most loveable associate."

See also **Sarah Bates; Hannah Cohoon; Shaker Drawings; Shakers.**

BIBLIOGRAPHY

Patterson, Daniel W. *Gift Drawing and Gift Song: A Study of Two Forms of Shaker Inspiration.* Sabbathday Lake, Maine, 1983.

GERARD C. WERTKIN

REGISTERS: *SEE* FAMILY RECORDS OR REGISTERS.

RELIGIOUS FOLK ART is a form of material culture meant to sustain ritual and ceremonial practices, to communicate doctrine, to convey adherence to belief systems, and to express spiritual ideas, visions, or feelings. Not every religious sect or denomination in America has produced a significant body of folk art. Indeed, some groups follow a doctrine that frowns on, or even forbids, any emphasis on decoration. For some religious groups, such as Muslims and Spanish Colonial Catholics, almost all of their material culture bears the stamp of their religious persuasions, whereas for other religious groups, such as Christian Scientists and Lutherans, only a small portion of their material culture reflects their doctrine. In some of the major utopian experiments and sectarian movements, such as Mormons, Zoarites, and Harmonists, artists are known for expressions that reflect a collective religious cultural identity, yet do not serve a clear-cut role in religious documentation or ritual. In such cases, however, these member-artists provide important visual data about the beliefs, practices, and cultural history of their particular religious community. Yet all religious groups, even those that profess a plain style of living, such as the Shakers, Mennonites, and Amish, surround themselves with distinctive cultural and artistic materials and images that reflect their religious philosophy. Whether in the physical layout of the place of worship, the fashion of dress worn by church or temple members, or in the materials produced for use in religious ceremonies, cultural artifacts and art objects provide evidence of the belief system of a particular religious group.

Beginning with the earliest cultural objects or artifacts of America's indigenous peoples, it has been clear that much of the country's art has been produced in support of, or in response to, deeply held belief systems. In most indigenous Native American tribal languages, there is no term or word for "art" to distinguish it from other societal functions; artistic constructions or embellishment simply convey a unity between object and spirit, between the present world and that of the ancestors. While the forms, materials, and designs of the arts produced by members of hundreds of distinct tribal groups vary considerably, there is remarkable consistency in the values and belief systems those works represent. Creation stories, the mythic and supernatural power of four-legged and winged animals, and the spiritual connection between natural resources and the creator have been expressed through nearly all indigenous Native American art, from the early rock drawings, architecture, and tools, to the traditional peyote sticks, pow wow regalia, and abstract acrylic paintings and stone sculptures made today.

Although belief-imbued art was pervasive among Native American peoples, within some tribes the expression was particularly powerful. For instance, Northwest Coast art includes dramatic depictions of supernatural birds and animals in carved and painted totem poles, masks, canoes, containers; embroidered

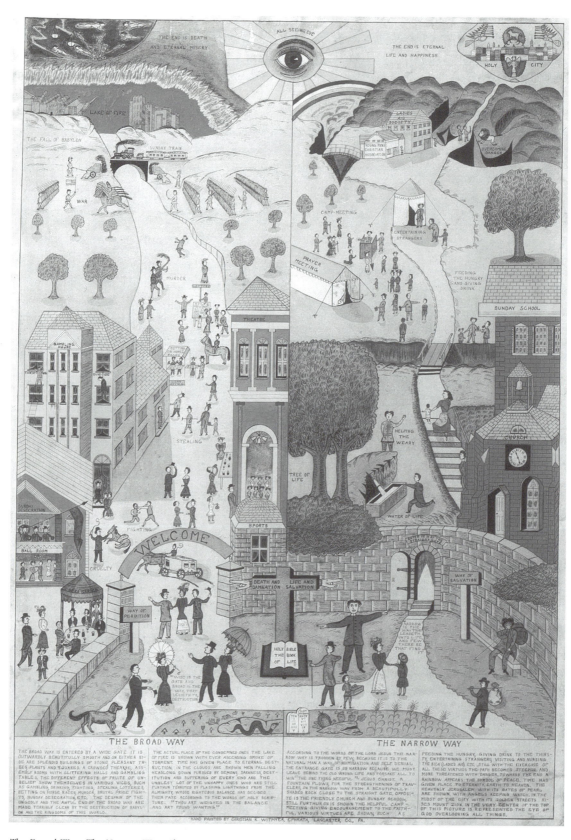

The Broad Way, The Narrow Way. Christian K. Witmyer; Ephrata, Lancaster County, Pennsylvania, c. 1870–1890. Drawing on paper, colored pencil, paint; 33 × 24 inches. Photo courtesy Allan Katz Americana, Woodbridge, Connecticut.

and woven, and button-embellished clothing; and in the massive murals painted on communal buildings. Likewise, the "Underground Panther" and "Thunderbird," spiritual beings important to Great Lakes Native cosmology, are often represented in beadwork, carvings, paintings, quilting, embroidery, weaving, and quillwork of Ojibway, Odawa, HoChunk, and other tribes in the Great Lakes basis. Hopis work graphic representations of revered corn and rain into designs on kachinas (dolls representing ancestor spirits), woven blankets, quilts, baskets, pottery, and clothing.

Certain forms have been repeated within traditional Native American expressive arts and, by the beginning of the twenty-first century, certain forms, such as the circle and medicine wheel, had become pan-Indian symbols representing unity among American Indians, unity with Mother Earth, and the Native American way of life.

The exploration, conquest, and colonization of North America by western Europeans had, of course, dramatic impacts on indigenous religious practices. The early, mostly Catholic missionaries (who were predominantly French in the north and Spanish in the south), and the later waves of immigrants of mostly Christian backgrounds, had an immediate and lasting impact on all of the tribal religions with which they came in contact. In some cases, traditional Native American religious and artistic practices were fused with western beliefs and practices. But, more typically, traditional beliefs and ways of life were discouraged or even banned. Many Native American tribes, rejecting the efforts of white missionaries to convert them, practiced their religious convictions in seclusion. Native people, in direct reaction to the pressure by dominant culture to impose belief systems on them, spawned some religious rites, such as the Ghost Dance of the Plains Indians. Despite the widespread assault on the folk religious beliefs of Native Americans, many of their religious practices have been maintained essentially intact through the last few centuries. Contact with other cultures and access to new technologies and materials did, however, impact changes in the material culture of Native peoples who incorporated the new ideas, materials, and processes into their work if and when it was appropriate. Thus, at the same time some traditions remained intact, others were transformed, and still others, entirely new, were initiated.

As the United States became colonized and settled, each immigrant group brought its own set of cultural traditions and the religious fabric in this country grew even more textured. Some immigrants transported their homeland religion with them and, when able to join previous immigrants from their country, formed enclaves where the immigrant's ethnic and religious identity was synonymous. Some immigrants found community, not in immigrants from their own countries, but in immigrants of their own faith. For other immigrants, particular religious customs became only privately observed within small circles of families or communities of believers. Some immigrants have adopted the material aspects of the prevalent religious beliefs of a community into their own secular or religious traditions. By doing so, they have been able to blend more easily into their new communities.

In other situations, immigrant religious practices became the foundation for when national holidays, like Christmas or Easter, are observed or for massive, mostly secular events such as St. Patrick's Day parades and celebrations. Some immigrants adopted the material aspects of the prevalent religious beliefs of a community, thereby often more easily blending into their new community. From the celebrations of saints' days, to the form and symbolism incorporated into grave markers, immigrant ethnic groups have managed to leave the stamp of their heritage on the visual and material life of their American communities. Whether it is the *casa templos* (house temples) of the adherents of Afro-Cuban Santería religion in New York, the *mojos* (amulets) of the Haitian Vodou religion in New Orleans and Miami, the *altarcitos* (home altars) of Mexican Catholics in San Antonio and Santa Fe, or the paper offerings for spirits made by Laotian-Hmong animists in Minneapolis, the material culture of America's religious groups is as varied as its people.

By the end of the nineteenth century, not only had most of the major religious groups been introduced into the United States, but religious life had experienced a number of significant changes: an increase in the use of evangelistic methods; major shifts in the memberships of major denominations; the strengthening of the role of women in fostering and maintaining religious activity; the organization of missionary and benevolent societies, the establishment of religion-based colleges and seminaries; the use of mass-distribution and communication technologies; the establishment of utopian and sectarian societies; and the continued influx of immigrant groups.

Each one of these changes had profound impacts on traditional religious folk art forms and functions; in fact, the types of religious objects, their manner of production, and their functions were as varied as the religious communities of which they were a part. Whether the material culture served an overt function within a religious context or simply reflected a reli-

gious view of life, it has been evident that religious folk art has been an integral part of the growth and maintenance of religious life in America.

Although many groups have contributed to the religious complexion of the United States, a few groups are worth special mention because of the volume, strength, or uniqueness of their religious material culture in American history.

In the Southwest, the importation of the Catholic religion of the Spanish colonialists laid the groundwork for the development of a distinctive New Mexican religious art. The religious objects brought by the colonists were quickly augmented and then almost wholly replaced by the work of local artisans. Beginning in the 1750s, local artists combined the imagery and designs in past religious objects, with local designs and materials to create powerful objects that supported this regional stronghold of Catholicism. Produced within a religious framework that was both timeless and universal, New Mexican religious folk artists created a local form that mirrored communal and personal Catholic views of God. One of the most distinctive traditions from this region is the carved, wooden death cart, in which a skeletal figure of *La Muerte* (Death), is shown with a bow and arrow. The carts are pulled by *Penitentes,* members of lay religious groups among the Catholics of the southwest, in Lenten processions.

One of the most pervasive folk art forms in the New Mexican Catholic tradition, however, is *santos.* The term *santo* in Spanish is both a noun (a "holy person" or "holy subject"), and an adjective simply meaning "holy." Although the term *santos* has been widely applied to an assortment of Catholic religious objects, more definitive terms are also used: *retablos* ("painted on wood") and *bultos* ("carved in wood"). Although used to decorate or furnish local churches, *santos* are made primarily as personal devotional aids. The New Mexican *santos* are characterized by their fusion of Spanish and New World decorative motifs and a focus on depicting a limited, locally-favored selection of saints. Outstanding New Mexican *santeros* have included José Rafael Aragon (1826–1855) of Cordova, José Benito Ortega (1880s–1907) of Mora, José Dolores Lopez (1868–1937) of Cordova, and National Heritage Awardees George T. Lopez (1900–1993) of Cordova, and Ramón José López of Santa Fe. The number of *santeros* has, at times, dwindled over the years but, by the end of the twentieth century, there had been a resurgence of interest in *santos*, both for personal religious use as well as a secular, decorative art.

Among the first colonists in the northeast in the seventeenth century were Puritans, anti-Catholic members of the Anglican Church of England, who believed that the New World offered the religious freedom they needed to achieve more aggressive church reforms than they could affect in England. Although many equate Puritanism with an ascetic life, a Puritan aesthetic was very intricately interwoven into the fabric of their religious and cultural lives. Though largely based on adherence to a "plain style" (a term that characterized the style of sermons given by some of the most noted Puritan clergy), the imagery of the folk art expression of Puritan New England is filled with depictions of man, nature, and poetic symbolism. The art served both to reinforce the restraint and order that the Puritans' morphology of conversion imposed on their lives as well as to educate others. A Puritan conceived beauty as pure and abstract order, with an emphasis on serving a higher purpose. The adaptability of Puritan doctrines and attitudes, including those toward artistic expression, have been well documented by twentieth-century cultural historians and have had a lasting effect on art making and art criticism in America.

The most central manifestation of the "plain style" aesthetic in Puritan communal life was the meetinghouse, a place for both sacred and secular activities. Unlike the highly decorated and sculpture-filled churches built to serve Catholic worshipers, the Puritan meetinghouse had few embellishments, although a carved or painted archangel Gabriel or cherub sometimes hung above the pulpit.

Much has been written on the subject of Puritan tombstones as a folk expression of religious convictions. The Puritan burial grounds, like the churchyards of England, were usually placed next to the meetinghouses. The earliest stones of these burial grounds had little or no ornamentation, but the late seventeenth century brought a flowering of visual expression in the handiwork of isolated rural stone carvers. The carved wood, slate, shale, and granite grave markers, carrying three basic design elements, have provided scholars with important clues to the development of religious life of the New England region. The earliest image, dating from circa 1680, is the winged death-head, that was replaced by the winged cherub in the eighteenth century. By the end of the eighteenth century, the primary design used was the willow tree overhanging an urn on a pedestal. These changes in design parallel the decline of orthodox Puritanism and the advent of the great mid-eighteenth century religious revival movements, including a rise in evangelism (especially camp meet-

ings), the establishment and growth of missionary work, and the strengthening of women's roles in religious work.

Before the rise of the seminaries for adolescent girls that appeared in the early nineteenth century, most young women learned their basic needle skills at home or at dame schools, boarding schools at which women were trained in all of the skills considered necessary to run a household. In addition to being influenced by biblical scripture in their choice of iconography, eighteenth-century women artists, such as Prudence Punderson (Rossiter) (1758–1784), Susan Smith (1783–c. 1853), and Mary Bulman (active c. 1754) were inspired to create works that documented their religious life. Numerous examples of needlework samplers depicted the parish church, or carried such textual testimonies of their faith and piety as "Lord Guide My Hands," or "Let Virtue Be a Guide to Thee." These needlework exercises, undertaken as a labor of religious devotion and demonstration of domestic skill, were placed in the homes of the makers, where they entreated others to maintain their spiritual values.

Most of the early eighteenth century settlers in Pennsylvania were Germans, and a distinctive Germanic culture arose in that state. Immigrants bound by shared Old World language, ethnicity, and religion developed forms of material culture that were overwhelmingly produced for a Lutheran and Reformed clientele living in a relatively small region; although borrowing from multiple design sources, that culture reflected values of form and function that were accepted by both locals and by outsiders as defining that community. Potters, weavers, quilters, fraktur artists, furniture makers, barn builders, and many other artists found full and part-time employment making work that is recognized as Pennsylvania German.

Among the first religious folk art forms produced by Pennsylvania Germans were stove plates for five-sided stoves, some of which date from as early as the 1740s. A majority of the scenes are representations of Old and New Testament passages, including Adam and Eve, David and Goliath, the Wedding at Cana, and the Miracle of the Oil, with the figures dressed in typical eighteenth century costumes. When the designs of the stoves moved from representational scenes to folk motifs such as angels, tulips, hearts, unicorns, and six-pointed stars, the stove plates retained their religious orientation, for the motifs embodied a religious symbolism rooted in medieval Christian art.

There are many ways in which the arts play an important role in Jewish life. The construction of a *Sukkah*, the decoration of a Torah binder, and the cutting of a paper message are all examples of the way in which art is expressed in the Jewish experience. Two twentieth-century artists, Harry Lieberman (1877–1983) of Great Neck, New York, and Malcah Zeldis (1931–) have drawn extensively on their Jewish life experiences in their work.

A group of approximately thirty-eight scriptural paintings were executed for Dutch, Walloon, and Huguenot homes in New York State's Hudson Valley during the eighteenth century, and are tangible evidence of Dutch-European religious values brought to New Netherlands as early as the mid-seventeenth century. The paintings were based largely on prints found in Dutch Bibles imported in the early part of the eighteenth century, but they may also have been influenced by the prints that decorated the walls of Dutch homes.

African American religious history consists of a complicated process that blended African customs and beliefs into mostly European American and partly indigenous religious institutions. By responding to the tensions inherent in continued oppression, the resulting mixture of African American religious customs has become both distinctive and more difficult to analyze. The blend of African motifs with American religious institutions has produced an array of distinctive artifacts, including quilts, gravesite decorations, churches, church furnishings, and pottery.

The Shaker movement was brought to America in 1774 by Mother Ann Lee (1736–1784) who had been influenced by Jane and James Wardley in England. The material culture of the Shaker order was in perfect harmony with its religious purpose. Shakers stressed orderliness and a usefulness that infused every aspect of the environment they created, including their gardens, barns, homes, furniture, and dress. Objects made for use by the order, as well as those made for the secular world, were governed by a set of strict principles. While most Shaker art was plain and subdued in both style and color, there was one area in which both color and ornamentation played key roles: the inspirational drawings and paintings created by a few members of the sect. First produced in the so-called Era of Manifestations beginning in 1839, these pictorial records of spiritual revelations grew in scope until around 1859. Usually rendered in ink and watercolor on paper, these images were filled

with brightly colored and highly decorated clothes, foods, ornaments, flowers, and musical instruments. It is almost as if the very objects that Shakers were denied in the temporal life were revealed to them as existing in the heavenly life.

The Zoarites, a self-sufficient company of almost three hundred Separatists (individuals who left the established Lutheran Church in the pursuit of creating a religious community bereft of ceremony), settled in Zoar, Ohio. There they developed a distinctive body of material culture—including stoves, furnaces, tinware, quilts, and coverlets—retaining traditional German styles and motifs, such as the Star of Bethlehem, rooted in medieval Christian symbolism. Anchoring the community's settlement was a magnificent garden, laid out in a design to symbolize New Jerusalem as described in the twenty-first chapter of Revelation.

Mormonism also encouraged the use of a variety of symbols to strengthen the identification with this religious movement. Some of the symbols were consciously created to augment church theology; others were popular motifs simply adopted by Mormons as part of the symbolic language of the church, today headquartered in Salt Lake City, Utah. Clasped hands, the all-seeing eye, the horn of plenty, and the beehive were all motifs adopted as institutional symbols of the mid-nineteenth century Church of Jesus Christ of Latter-day Saints (the official name for the Mormon Church), and has continued into the beginning of the twenty-first century.

The religious movement known as Moravianism, or the Moravian Church, had its center in Bohemia and Moravia, neighboring provinces in what would later become Czechoslovakia (today the Czech Republic). Moravians immigrated to North America as early as the mid-eighteenth century, settling primarily in Georgia, North Carolina, and Pennsylvania (in Bethlehem and Lititz). There the settlers became known especially for their tile work. The Moravian Star, first produced in Germany about 1850, is usually displayed on porches or in windows during the Christmas season. One of the earliest American artists to paint religious subjects was Moravian artist John Valentine Haidt (1700–1780).

The link between quilting and church work was well established by the nineteenth century and flourished particularly in rural communities and among members of certain religious groups. The women of certain conservative denominations, notably the Amish and Mennonite orders, have gained a marked reputation for their quilting. Emigrating from Swiss-German roots, they repudiated worldliness and the materiality they associated with other communities.

Quilts provided a means of personal expression that did not run counter to their conservative religious doctrine, or *Ordnung*, the regulations of faith prescribed for each church. In a culture otherwise noted for its somber colors, Amish women expertly used color (in sometimes startling combinations) generally in simple patterns to reflect the spiritual orientation of their society.

Thousands of women have also effectively used quilts to support religion-based causes. Some were made to simply give away to missionary or church-related activities; others were used to raise money, through auctions, raffles, or subscriptions, whereby each person paid a small sum to have their name inked or embroidered on to the quilt top. Mennonite women have been particularly active in fundraising through the quilt auctions regularly held by the Mennonite Relief Committees at several locations in the country. Some Mennonite women annually donate several hand-made quilts to more than one auction.

The design of the quilt itself sometimes incorporated patterns, motifs, and images based on religious texts and practices. The vital role that religion played in women's lives has been reflected in their choice of patterns for pieced quilts with such names as Jacob's Ladder, Crown of Thorns, Hosanna, Joseph's Coat, David and Goliath, Job's Tears, Forbidden Fruit, and numerous variations of the Star of Bethlehem and the Cross. Quaker women gave religious names to all their quilt patterns, for instance, changing an ordinary Bears Foot into The Right Hand of True Friendship. Quilts created by appliquéing scraps of fabric onto a supporting background provides a means of creating more expressive images. Either pieced blocks or the entire surface of the quilt is used to depict biblical scenes or religious symbols, such as the popular Tree of Life. In the late twentieth century, quiltmakers began to make "stained glass" quilts, often copying the windows of famous cathedrals.

Quakerism, also known as the Religious Society of Friends, is a religious movement started in mid-seventeenth century England with the intent of reforming the established practices of the Anglican Church. Known for its emphasis on worshiping in silence, religious tolerance, and pacifism, Quakerism was established in North America by the late seventeenth century. Although Quakers were not generally well known for distinctive religious arts, a Quaker preacher, Edward Hicks (1780–1849) of Bucks County, Pennsylvania, is considered one of America's greatest nineteenth century folk artists. He is best known for his more than sixty renditions of *The Peaceable Kingdom*, loosely based on text from the

Book of Isaiah. The painted renditions of this Biblical passage, repeated and refined over Hicks' lifetime, are works considered among the masterpieces of American folk art.

The religious art and culture produced by American folk artists since colonial times have spanned a broad range of subject matter. Some are governed by the aesthetic traditions of particular religious or ethnic groups, and others are simply the individual expressions of an artist about their own religious convictions. The variety of subjects and themes treated by American folk artists from the seventeenth to the twentieth century have included work based on scriptural or traditional texts, with certain subjects particularly popular among Christian folk artists: the great heroes of the Old Testament, such as Job, Jonah, Noah, and Moses; the Garden of Eden; Noah's Ark; Daniel in the Lion's Den; and the birth, baptism, and crucifixion of Jesus. Also popular have been the representations of religious life, such as prayer meetings, baptisms, weddings, funeral rites, and depictions of churches and the clergy. Folk artists, especially those from rural areas, have provided invaluable records of American religious life through their renderings of these scenes. Lastly, visionary or symbolic work includes artists' private visions or personal concepts of spiritual truth as well as those works based on traditional symbolic imagery.

A careful examination of iconographical patterns in America's religious material folk culture clearly reveals both continuity and change in choice and treatment of theme. The modifications, deletions, and additions that characterize these patterns have stemmed from a variety of cultural factors: changing views of America's destiny; social and economic upheavals; events in political and religious history; declining reliance on print sources coupled with greater interest in religious life; the introduction of other religious traditions, aesthetic forms, iconographical sources, and viewpoints with the continuing arrival of diverse ethnic groups; and the rise of Protestant fundamentalism.

Among contemporary visual expressions of religious convictions, there are many that bridge the gap between material that has commonly been accepted as folk art and that that has been defined as popular art. Numerous examples of religious expression in contemporary forms may be seen in public places, especially along roadsides or even on moving vehicles. Signboards, graffiti, bumper stickers, personalized license plates, and painted messages on cars and trucks are some of the modern means through which many Americans give witness to their faith. Worship environments have also been created, both as reflec-

tions of the makers' faith and as places where the weary motorist may find spiritual regeneration. Wayside chapels, shrines, grottoes, and religious gardens offer opportunities for private prayer or meditation. Whether deemed folk or popular art, these works are striking manifestations of the creative spirit and religious convictions of their makers.

See also **African American Folk Art (Vernacular Art); Amish Quilts and Folk Art; José Rafael Aragón; Asian American Folk Art; Bultos; Christmas Decorations; Coverlets; Death Carts; Dutch Scripture History Painting; Eastern European American Folk Art; Environments, Folk; Father Paul Dobberstein; German American Folk Art; Gravestone Carving; Edward Hicks; Hmong Arts; Holidays; Jewish Folk Art; Harry Lieberman; George T. López; José Dolores López; Ramón José López; Native American Folk Art; José Benito Ortega; Papercutting; Pennsylvania German Folk Art; Pictures, Needlework; Quilts; Quilts, African American; Retablos; Samplers, Needlework; Santería; Santos; Shaker Drawings; Shaker Furniture; Shakers; Trade Signs; Vodou Art; Visionary Art; Malcah Zeldis.**

BIBLIOGRAPHY

Coe, Ralph. *Sacred Circles: Two Thousand Years of North American Indian Art.* London, 1976.

Dewhurst, C. Kurt, and Betty MacDowell. *Reflections of Faith: Religious Folk Art in America.* New York, 1982.

Swank, Scott T., et al. *Arts of the Pennsylvania Germans.* New York, 1983.

Weigle, Marta, ed. *Hispanic Arts and Ethnohistory in the Southwest.* Santa Fe, N. Mex., 1983.

MARSHA MACDOWELL

REMMEY FAMILY POTTERS of New York City, Baltimore, and Philadelphia hold the record for longevity among American stoneware potters. Around 1735, John Remmey, a German potter, established a kiln in the Chambers Street area of Manhattan. His shop was close to that of his countrymen and, at times, business associates, the Crolius family. These families, related through marriage, dominated the New York City stoneware industry until well after 1800.

John Remmey, progenitor of the clan, remained in control until 1762, when he turned the business over to his son John, who operated it until 1792. Unlike the Crolius family, the Remmeys appear to have remained in Manhattan during the British occupation. In due course, John II relinquished control to his sons, Henry and John III. The former is known for a small stoneware flask at the Smithsonian Institution which is

inscribed "R./Made by Henry/Remmey/at New York/ June 18, 1789." In 1800, Henry assigned his interest in the New York City shop, then located next door to the Crolius kiln on Cross Street, to his brother and left the state. John III continued the business until around 1820.

Stoneware from the Remmey kiln is similar to that of the Crolius factory both in form and decoration. Pieces typically bear incised floral devices filled in cobalt blue. The only mark used is "J.REMMEY/MAN-HATTAN WELLS/N.YORK" or a variant of that stamp. In general Remmey ware is rather crude, and no highly decorated pieces are known.

Henry Remmey appears to have gone to New Jersey, and from there to Baltimore, where by 1817 he was running a shop in conjunction with a merchant named Myers. Rare examples from this period are impressed, "H.REMMEY/BALTIMORE." Remmey remained active in Baltimore until 1829, but in the interim (1827) his son, Henry II, had purchased an interest in a Philadelphia pottery.

The Philadelphia firm thrived and was run by its founder until 1859, and thereafter by his son, Richard Clinton Remmey, until the 1880s. The father's mark, "HENRY REMMEY/STONEWARE/PHILADELPHIA," is rare, but Richard's stoneware, marked simply "RCR" within a cartouche is quite common. Even the earliest Remmey wares from Baltimore are decorated with free hand brush strokes, and the Philadelphia examples show the rolling blue floral designs so typical of Pennsylvania stoneware.

See also **Crolius Family Potters; Pottery, Folk; Stoneware.**

BIBLIOGRAPHY

Clement, Arthur W. *Our Pioneer Potters.* New York, 1947.
Ketchum, William C. Jr. *American Stoneware.* New York, 1991.
———. *Potters and Potteries of New York State, 1650–1900,* Syracuse, N.Y., 1987.

<div align="right">WILLIAM C. KETCHUM</div>

RENDÓN, ENRIQUE (1923–1987) was a *santero,* or maker of religious images, known for his integrity in maintaining an individual artistic style without commercial considerations. His unwillingness to compromise his artistic vision by duplicating the formulaic historical images that many collectors preferred earned him a reputation as a maverick artist; ultimately, this reputation brought many collectors to his door.

Rendón was born in Monero, New Mexico, a coal mining community just south of the Colorado border.

His family often spent summers in the apple-growing village of Velarde, New Mexico, and moved there permanently in the 1940s. From the age of seventeen, Rendón worked in coal mines in Colorado and Utah; he then held jobs at Los Alamos National Laboratory, with the railroad, and as a custodian in the Velarde elementary school. Local legend has it that Rendón spontaneously decided to try wood carving one day while pruning an apple tree. Whatever his motivation, Rendón created his own versions of the wooden and plastic *santos* (saints) housed in the village church and *morada* (meeting house), where he and fellow members of the *penitente* brotherhood gathered for prayer.

Rendón used a handsaw, pocketknife, and chisels to carve aspen and cottonwood *bultos*—three-dimensional sculptures of saints—from the traditional family of Catholic images. He also created bark bas-relief *retablos*: altar screens whose semiround form deviated from traditional flat wooden paintings. But instead of the intensely somber and often bloody saints that were part of the *santero* tradition, Rendón's *bultos* reflected his lighthearted personality and optimistic religious faith.

Rendón's polychrome carvings, generally standing less than 20 inches high, wore wide smiles and frequently held their arms outstretched in a gesture of welcome. Rendón used watercolors or acrylics to create bright garments, then adorned them with plastic rosaries, religious medals, and artificial flowers, as well as key chains and other mail-order trinkets. For additional narrative inspiration, he read Marvel comic books about the saints. His works casually combined familiar elements of age-old tradition and modern popular culture. Each figure bore the artist's trademark: large, round, protruding black eyes with whites clearly emphasized beneath a border of long, dark lashes. His highly individual approach, far from diminishing his religious intent, underscored his singular expression of faith.

For Rendón, carving was a solitary pursuit in that he largely avoided the marketplace. On the occasions when he did sell his work, he did so from the comfort of his own home, leaving it to potential customers to come to him. Nonetheless, by the time of his death many of his carvings were in major public and private collections as examples of one man's steadfast belief that an artist's vision is solely his own.

See also **Bultos; Religious Folk Art; Retablos; Santeros.**

BIBLIOGRAPHY

Kalb, Laurie Beth. *Crafting Devotions: Tradition in New Mexico Santos.* Albuquerque, N. Mex., 1994.

CARMELLA PADILLA

RETABLOS in New Mexico are Catholic devotional panel paintings of saints and holy persons. The most common meaning of the Spanish term *retablo* is altar screen or reredos. The English term "retable" is its cognate; both terms derive from the Latin *retro-tabulum*, meaning a shelf or structure for images behind the altar table. The *retablo* or altar screen is an assemblage of paintings, either painted directly on it or attached to it, sometimes with niches for pieces of sculpture. However, in Mexican and New Mexican usage the term *retablo* has also come to mean an individual panel painting. The term is used in colonial documents, such as estate inventories listing personal possessions, often described as *pinturas de retablo* or *santos de retablo.* Such images are distinguished from *pinturas en lienzo* (or simply *lienzos*), which are paintings on canvas. The New Mexican *retablo*, then, is a religious painting on a wood panel.

In eighteenth- and nineteenth-century New Mexico, panels were cut from ponderosa pine logs and painstakingly shaped with adzes and chisels. The surface of the panel was then covered with a finely ground gesso mixed with wheat paste for binder. The gesso served to fill in surface imperfections and provided a smooth ground for painting. In the eighteenth century, oil paints imported in small quantities from Mexico were used to paint *retablos.* By the early nineteenth century, in the cases of both *retablos* and *bultos* (polychrome wood sculptures), *santeros* (the carvers and painters of figures of saints) began using water-based paints that they prepared themselves from plant and mineral sources, some local and some imported. Red was prepared from cinnabar, iron oxide, and cochineal, among other sources. Yellow was usually made from plants such as rabbit bush (*chamisa*). Blue was usually prepared from imported indigo. Brown came from local iron oxides, and black from carbon. White was achieved by leaving the gesso ground exposed. In the early 1800s wool weaving was a major New Mexican industry, and imported cochineal, indigo, and local plant dyes were all available to the *santeros* from weavers who used them for dyeing yarns. The paint technology of the early 1800s combined traditional European methods with those used by Pueblo Indians in the Southwest who painted wall surfaces and wooden ceremonial objects, as well as cotton fabric and hides. After a *retablo* was finished, it was usually coated with a protective varnish

Retablo, San Juan. Artist unknown; New Mexico, c. 1840–1860. Oil, gesso on cottonwood panel. © Esto.

of pine resin. This surface darkens with age, so that now the original brilliant colors used by the artist are often hidden.

The earliest Catholic paintings in New Mexico in the seventeenth and early eighteenth centuries were either *lienzos* imported from Mexico, or paintings on deer, elk, and buffalo hides. By the second half of the eighteenth century local artists were painting wood *retablos* in a provincial academic style that drew heavily on Mexican Baroque prototypes. Most surviving examples are painted over a red bole ground in sparsely applied oils, suggesting the scarcity of the imported oil paints. There are two main styles from this period. One has been attributed to the explorer and cartographer Bernardo Miera y Pacheco (1714–1785) who came to New Mexico in 1754 and the other to the Franciscan friar Andrés García who served in New Mexico missions from 1749 to 1779. Neither attribution has firm evidence to support it. A third artist referred to as "The Eighteenth-Century Novice" produced a large group of oil-painted *retablos* in the

1780s and 1790s in an even cruder style still beholden to Baroque prototypes.

Works by the Laguna Santero and his workshop (c. 1795–c. 1810) represent the transition from Baroque models to a pure folk art and the beginning of a period of florescence in the art of the *santero* in New Mexico. The Laguna Santero worked in water-based paints as did the artists who followed him, such as Molleno (active c. 1815–1845), José Aragón (active 1820–c. 1835), José Rafael Aragón (active c. 1796–1862), the Santo Niño Santero (active c. 1830–c. 1850), the Truchas Master (active c. 1780–c. 1840), the Quill-Pen Santero (active c. 1830–c. 1850), and the Arroyo Hondo Painter (active c. 1825–c. 1840). Due to the easy availability of commercial color prints from the eastern United States, in the late 1800s the making of *retablos* quickly began to die out. The few artists working after this date produced small and usually inept pieces painted in commercial oil paints. The one exception was José de Gracia Gonzales (c. 1832–1901), an immigrant from Mexico who painted *retablos* and altar screens in northern New Mexico and southern Colorado in the provincial Neo-Classic style then prevalent in northern Mexico.

In the revival of Hispanic folk arts in the 1920s and 1930s there were few *retablo* painters, the one prominent exception being Juan Sanchez (1901–1969) who worked on the Federal Art Project in New Mexico in the late 1930s. However, in the revival that began in the 1970s and continues into the twenty-first century, many fine *retablo* painters working in a variety of styles and media have emerged.

See also **José Aragón; José Rafael Aragón; Bultos; Laguna Santero; Molleno; Religious Folk Art; Santeros; Santo Niño Santero; Truchas Master.**

BIBLIOGRAPHY

Boyd, E. *Popular Arts of Spanish New Mexico.* Santa Fe, N. Mex., 1974.

Wroth, William. *Christian Images in Hispanic New Mexico.* Colorado Springs, Colo., 1982.

———. *Images of Penance, Images of Mercy: Southwestern Santos in the Late Nineteenth Century,* Norman, Ind. and London, 1991.

WILLIAM WROTH

REVERSE-GLASS PAINTING, the technique of painting a picture on the reverse or underside of a piece of glass, forms an interesting and little-known chapter in the world of folk art. The foreground of the work is literally painted in reverse, and then the opaque background is laid over the detailed areas. Bits of tin or gold foil or mother-of-pearl may be glued to the glass as part of the composition. When complete, the work is viewed through the glass that both protects the painted surface and complements the shimmering, exotic quality of the image.

This technique was introduced in the United States in late eighteenth century and not widely practiced until the 1830s, although it was long known in other parts of the world. Thirteenth century Italian artists, following Near Eastern models, etched religious designs on gilt-covered glass, and by the 1400s, translucent paints had largely replaced the gold. However, the use of gilt in combination with colored pigments continued, coming to be referred to as *verre églomisé* for the French frame-maker Jean-Baptiste Glomy (1711–1786), who employed it in creating decorative borders for the glass under which period prints were mounted. Today, the term is commonly used to denominate reverse-glass paintings, typically mirror tablets, which are primarily or completely gold in color.

The popularity of reverse-glass painting increased during the seventeenth and eighteenth centuries, with artisans in Germany and other central European countries embracing the technique. Images remained almost exclusively religious, with Italian and Spanish craftsmen favoring depictions of saints or of miraculous occurrences. Even today, churches in southern Europe exhibit *ex voto,* reverse paintings illustrating instances where divine intervention has spared the life or health of a believer who, in gratitude, has had the event memorialized in art.

Such a popular technique could not remain confined to religious subject matter. Late in the eighteenth century, English and French artists began to introduce secular subjects. Painted in translucent colors embellished with gold leaf or silver foil, these works were attractive and stylish, but were also produced inexpensively enough to make them available to a wide audience. Subject matter ranged from classical floral compositions, portraits of royalty and historic figures, to landscapes and representations of great events—categories that in large part were to continue to define the field.

Perhaps the most popular of these secular images were representations of actors, actresses, and dancers and the works in which they starred. Developing in the early 1800s as an offshoot of the woodblock prints and engravings of the same subjects, which were sold plain for a penny or in color for two pence, the paintings captured popular imagination and love for entertainment, much as the Japanese *yukiyo,* or "floating world," prints had.

While the earliest American reference to reverse-glass painting is a 1787 drawing master's advertisement referring to his ability to teach "painting on

glass," it does not appear that the art was widely practiced in the United States until at least the 1830s. One of the problems in dating or even assigning a country of origin to these works is their almost total anonymity. Their creators, professional or amateur, rarely ever signed their names. Nor is subject matter always a reliable indication of national origin. Among the earliest examples thought to be American are scenes of sea battles dating to the American Revolutionary War and the War of 1812. Since these paintings, usually found on the tablets of mirrors or clocks, typically depict those combats in which the American vessel emerged victorious, one would naturally assume an indigenous origin. However, it is generally agreed that many of these were done in England for export to the United States, thus snatching economic victory from the jaws of military defeat.

There are, however, some nineteenth century paintings on glass which can be traced to known American painters. The well-documented folk artist, William Matthew Prior (1806–1873), is known for numerous reverse painted portraits of George and Martha Washington; and, he advertised in the April 5, 1831 issue of the *Maine Inquirer* that he did "enameling on glass tablets for looking glasses and time pieces."

By the 1840s there was sufficient American interest in the technique that it was being taught at young women's boarding schools. Within a few years instructions were appearing in magazines such as *Godey's Lady's Book,* and it was even possible to obtain by mail kits containing stencils with which to construct theorem-like reverse paintings. Designs were often floral baskets or wreaths of flowers, the latter with an empty central reserve in which to place the portrait of a usually deceased loved one.

It was during the Victorian era that gold and silver foil and mother-of-pearl, largely absent from earlier American works, reappeared in profusion. So common were such materials in late nineteenth-century paintings that some refer to the entire field as "tinsel painting." This term, however, is inaccurate, since some of the finest examples, such as the sea battles and Prior's work, do not contain this material.

Under the tireless hands of the Victorians, reverse-glass painting also stepped out of the traditional picture frame to serve other purposes. Among the most popular items among contemporary collectors are reverse painted checkerboards. Table tops also were embellished with painted glass inserts as were serving trays, jewel boxes, and other delicate items. And, with the gradual disappearance of textile samplers and family genealogies, the task of historical documenta-tion fell to the family artist whose painted tree-of-life would be adorned with tin types of family members, living and dead. There were even pseudo stained glass windows for churches whose congregations could not afford stained glass.

While baskets, wreaths and other floral configurations were an important category of Victorian reverse glass painting, there was a second area which, in a sense, documented architecture and events of the period. There is, at the Museum of the City of New York, a reverse painted representation of the New York Crystal Palace, a famous exhibition hall which once stood on the site of the present New York Public Library. If this work was done at the time when the building was standing in the 1850s, it is a very early example of its type.

During the late nineteenth and early twentieth centuries, a large number of reverse-glass paintings were produced which featured important or popular American views. These consist of buildings and locations, the latter primarily of tourist sites. Pictures of the Capitol building, Mount Vernon, the New York City Hall and such unlikely edifices as the Treasury Building and the National Archives were produced. Important monuments such as the Washington and Lincoln memorials and Grant's Tomb are also found. All these exist in multiples with variation in techniques, but the subject matter was sufficiently common as to suggest that they were taken from period prints.

A second broad category includes tourist spots such as Lake George in the Adirondack Mountains, hotels in such places as Florida or New Hampshire's White Mountains, Gulf Coast scenes, and popular seaside resorts. All these were obviously produced for sale in quantity, quite possibly at the very places depicted. And yet, we know absolutely nothing about them. The presence of European scenes raises the interesting possibility that all this work is of foreign origin.

The third category, that of events, also makes it clear that the reverse-glass painting technique did not die out in the nineteenth century, but extended well into the twentieth century. There is a group of three well-known views of the Statue of Liberty and New York Harbor. In the first, sailing ships ply the waters about the monument. In the second, sidewheel steamers appear, and in the final version the predominant vessels are warships of the United States' Great White Fleet which cruised around the world in 1906.

A further indication of twentieth century origin is the series of four different views of the sinking of the liner *Titanic.* This event, though tragic, becomes almost humorous in one version, where the liner lies

athwart an iceberg so large that it is clear that any captain running into it would be guilty of the grossest negligence. But, of course, what is important here is the date. The Titanic went down in 1912, indicating that the production of historic reverse-glass paintings lasted at least until then.

There is much yet to be learned about the origin of reverse-glass paintings, especially the later examples. They remain inexpensive relative to the price of comparable folk art on canvas or paper, and thus offer great opportunity for the beginning or impecunious collector. Also, since so many later paintings were produced in multiples, one can usually find an example in good condition. This is important because flaking paint on reverse-glass paintings is difficult and expensive to repair and broken glass cannot be restored.

See also **Milton Bond; Gameboards; Maritime Folk Art; William Matthew Prior.**

BIBLIOGRAPHY

Holden, Madeline. *Tinsel Painting: Authentic Antique Techniques.* New Hampshire, 1947.
Karmason, Marilyn G. "Shimmering and Brilliant: American Victorian Tinsel Paintings," *The Clarion*, vol. 16, no. 4. (winter 1991–92): 73–79.

WILLIAM C. KETCHUM

RING, BARUCH ZVI (c. 1872–1927) served his community as a *sofer stam* (in Hebrew, "scribe"), meticulously inscribing scrolls of the Torah and other sacred texts required for the practice of the Jewish faith. He was also an expert in papercutting, a traditional Jewish folk art that he and other immigrants brought to the United States from Europe. Ring's papercuts combine elegant Hebrew inscriptions in ink with decorative motifs and religious symbols in cutwork and watercolor. He occasionally used metallic paints, crayon and colored pencil, as well. Although the imagery in Ring's work is drawn principally from the conventions of Jewish iconography (lions, eagles, crowns), scholars Joseph and Yehudit Shadur have demonstrated that he was influenced by American design. The artist, who was also known as Bernard Ring, was descended from a rabbinical family; he apparently prepared for a rabbinical career himself.

Aside from some recorded family memories, little is known about Ring's life. Soon after 1900, he settled in Rochester, New York, having left his home in Wojscje or Vishaya, Poland. In 1904, his wife and five children passed through Ellis Island on their way to join him. The family name was then Ringjanski. Although the details of his education are uncertain, it is apparent that he received instruction in Hebrew calligraphy. He earned a living as a scribe in Rochester, supplementing his income by training boys for their bar mitzvah. Of Ring's extant papercuts, several are *yortsayt* (in Yiddish, "year time," the anniversary of a death) plaques, which provide a record of the dates when family members died so that memorial prayers could be recited each year on the anniversary of the event, in accordance with Jewish custom.

Ring's exacting papercuts are notable for their skillful composition and technical precision. Although he created within the conventions of his faith, he brought a robust originality and a keen imagination to his work. His papercuts are dated from 1904 to 1917, near the end of the brief flowering of this traditional art form in America. In the last quarter of the twentieth century, another generation of artists, inspired in part by Ring and his contemporaries, began to revive the practice.

See also **Calligraphy and Calligraphic Drawings; Jewish Folk Art; Papercutting.**

BIBLIOGRAPHY

Kleeblatt, Norman L., and Gerard C. Wertkin, *The Jewish Heritage in American Folk Art.* New York, 1984.
Shadur, Joseph, and Yehudit. *Traditional Jewish Papercuts: An Inner World of Art and Symbol.* Hanover, N.H., 2002.

GERARD C. WERTKIN

RIZZOLI, ACHILLES G. (1896–1981) was born into a family of Swiss-Italian immigrants, and spent his life in the San Francisco Bay area. When he was nineteen his father deserted him and his mother, and was not heard from again until his suicide twenty years later. Rizzoli continued to live with his mother until her death in the mid- to late 1930s. In the meantime, he spent twenty-four years intensively studying architecture and related subjects, and then found a job at an architectural firm, where he worked until his death.

After his mother's death, Rizzoli remained in the house they had shared, devoting his spare time to a project for which he eventually filled 2,400 pages with poetry, prose, and elaborately detailed, text-augmented drawings of fantastic architecture that hybridizes a variety of styles.

Rizzoli, a devout Christian, titled this work *Amte's Celestial Extravaganza*, and wrote of it as the concluding book of the Bible. He claimed that its contents were revealed to him in heavenly visions, and that it was a collaboration with the spirits of the Italian artists and architects, Michelangelo, Leonardo da Vinci, Donato Bramante, and others. He named the supervisor of their efforts as *Rechi Tacteur*, or *Miss*

Amte, which translated from Latin means "Architecture Made to Entertain," thus making it clear why he gave this title to this work.

See also **Outsider Art.**

BIBLIOGRAPHY

Self-Taught Artists of the Twentieth Century: An American Anthology. [exhibition catalog] New York, 1998.
Hernandez, Jo Farb, et al. *A.G. Rizzoli: Architect of Magnificent Visions.* New York, 1997.
MacGregor, John, "A.G. Rizzoli: The Architecture of Hallucination." *Raw Vision*, vol. 6 (summer 1992): 52–55.

TOM PATTERSON

ROBB, SAMUEL ANDERSON (1851–1928) was a prominent wood carver and the owner of a successful wood carving store in New York City, well known for its shop figures, especially cigar store Indians. Robb's father, Peter, was a ship's carpenter; Robb's mother, Elizabeth, was a relative of Jacob Anderson (1810–1855), a ship's carver in New York. The folk art historian Frederick Fried (1908–1994) interviewed Samuel Robb's daughter Elizabeth, who was able to provide important biographical details. In 1872, Robb studied at the Free Night School of Science and Art at Cooper Union in New York City; between 1867 and 1875 he was periodically enrolled in studio art courses at the National Academy of Design. Before opening his own shop at 195 Canal Street in New York City, he is thought to have apprenticed for several years in the late 1860s with Thomas V. Brooks (1828–1895), a well-known carver in both New York and Chicago; and to have worked for William Demuth (1835–1911), whose company manufactured and distributed tobacco-related paraphernalia. Robb carved Indian shop figures for Demuth; from these figures, zinc castings were made for metal figures of Indians distributed nationally to tobacco shops.

The art historian Ralph Sessions reviewed the *Products of Industry Schedules of the Federal Census* for 1880 and found that Robb's large shop had ten employees, including the talented carvers Thomas J. White (1825–1902), Robb's brother Charles Robb (1855–1904), and his son Clarence Robb (1878–1956). Robb's shop moved to 114 Center Street in New York City in 1888 and remained there until its closing in 1903.

Some traditional shop figures by Robb reflected the popular culture of the day: these included *Captain Jinks*, based on a song of 1860; *Puck*, based on a widely read satirical magazine; firemen; and baseball players. Robb incised his name on many of the carvings. Records provided by his daughter reveal that smaller shop figures were also carved in Robb's store: wooden molars to hang from a second-floor dentist's office, wooden feet with bunions to be mounted in a chiropodist's window, and wooden knives and forks to promote a cutlery shop.

When the popularity of shop figures declined, Robb executed commissioned carvings of circus wagons from the Sebastian Wagon Company for Barnum and Bailey. One of the last carvings done by Robb, in 1923, was a figure of Santa Claus for his daughter.

See also **Thomas V. Brooks, Circus Art; William Demuth; Frederick Fried; Shop Figures.**

BIBLIOGRAPHY

Fried, Frederick. *Artists in Wood: American Carvers of Cigar-Store Indians, Show Figures, and Circus Wagons.* New York, 1970.

WILLIAM F. BROOKS JR.

ROBERTSON, ROYAL (1936–1997) decorated his house with hundreds of signs, drawings, calendars, and shrines that reflected his experience and imagination. His animated drawings of futuristic landscapes, fantastic architecture, UFOs, battles of good and evil, and heroes and superheroes filled every inch of the interior and exterior surface of the house. His subjects were based on his torment over his failed marriage to Adell Brent, his interest in science fiction and the occult, and biblical exhortations. Robertson considered himself a prophet and transcribed recurrent dreams and visions to paper.

In his writings, which are less well known than his art, Robertson chronicled his visionary journeys. Later, he used these texts in his drawings and on the signs that dotted his environment: "God's the Bible St. Zechariah Ch. 14 text 13/St. Mark Ch. 13 V13 V17 V20." . . . "The Wrath of God." "Whore Adell Proverbs Ch. 6 Vs 26 to 29." Robertson's millennial concerns were expressed as personal anguish: in one sign, "The End of the World St. Luke Ch. 21–26" was paired with "All Adulterous After His Neighbor Wifes Isaiah Ch. 13."

Robertson was born in Baldwin, Louisiana. He traveled west for about three years and worked as a field hand and sign painter before returning to Louisiana to help his mother. He married and had many children. When his wife left after their marriage deteriorated, his fury toward women dominated his pronouncements for a time—women's "treachery" was the source of all men's problems. He was ambivalent toward his wife, simultaneously adoring and hating her. According to the gallery owner Bruce Webb,

Robertson's children claimed that Robertson, not Adell, was at fault in their marital discord.

Robertson's drawings show his talent as a sign painter in the organized graphic layout, the clearly lettered accompanying text, and the immediacy of the messages. The artist often drew on both sides of the paper. He used poster paper, paperboard, crayons, Magic Markers, tempera, and oil paint. Webb, who visited the artist many times, noted several Bibles and copies of *Fate Magazine* with colorful, graphic covers that may have inspired Robertson's aesthetic sensibility.

In 1992, Hurricane Andrew destroyed Robertson's house and singular environment; but with assistance from his friend Warren Lowe (the collector who discovered his work) and from federal disaster relief agencies, Robertson acquired a prefabricated house that he embellished with repainted and reinstalled protective signs and new creations. He lived independently until his death from a heart attack.

See also **Peter Besharo; Charles August Albert Dellschau; Ken Grimes.**

BIBLIOGRAPHY

Allamel, Frederic. "Contemporary Apocryphal Writings: Royal Robertson's Contributions to the Scriptures. *Raw Vision*, vol. 13 (winter 1995–1996): 52–57.

Baking in the Sun: Visionary Images from the South. Lafayette, La., 1987.

Patterson, Tom. *Not By Luck: Self-Taught Artists in the American South.* New Milford, N.J., 26–28. (Essay.)

Rosenak, Chuck, and Jan Rosenak. *Museum of American Folk Art Encyclopedia of Twentieth-Century American Folk Art and Artists.* New York, 1990.

LEE KOGAN

ROCKEFELLER, ABBY ALDRICH (1874–1948), a founder of the Museum of Modern Art (MoMA), was a prominent collector of modern art and American folk art. Her collection of folk art, donated to Colonial Williamsburg in 1939, forms the basis of the collection of the Abby Aldrich Rockefeller Folk Art Museum, opened in Williamsburg, Virginia, in 1957. Rockefeller prized American folk art as a record of middle-class tastes and aspirations and as a vibrant expression of the American spirit.

The daughter of Nelson Aldrich, who served as senator from Rhode Island from 1881 to 1911, Abby Rockefeller was brought up in Providence and Washington, D.C. After her graduation in 1893 from Miss Abbott's School for Girls, in Providence, Rockefeller made several trips to Europe, where she cultivated an interest in art. In 1901, she married John D. Rockefeller Jr., son of the founder of Standard Oil. Early in their marriage, Rockefeller and her husband both began to collect art.

While the young couple made a few purchases together, their tastes diverged, for the most part. With a strict Baptist upbringing and respect for tradition, Mr. Rockefeller appreciated the craftsmanship of Chinese ceramics, Persian carpets, and medieval art. His delight in his medieval collection, which included the celebrated *Unicorn Tapestries,* led to his donation of land to and underwriting of the Cloisters, established by the Metropolitan Museum in 1938 to house its medieval European collections of architecture and painting. Rockefeller was frankly disturbed by the modern art his wife began to bring into their home, and as a result the allowance he gave her was quite modest in relation to the fortune he controlled. Mrs. Rockefeller, however, made her limited funds work to her advantage. Though she missed the opportunity to buy large masterworks, the strong collection of prints and small paintings by European and American artists she built during the 1920s and 1930s demonstrated her consistency and discrimination. She put her high aesthetic standards to good use when, along with Mary Quinn Sullivan and Lillie Bliss, she organized a committee to establish the MoMA. Rockefeller's organizational skills were instrumental in the new institution's success. She was the museum's devoted supporter for the rest of her life, serving for many years as a trustee and encouraging the museum to broaden its horizons, as she did in promoting the establishment of a film library in 1935. During the 1930s and 1940s, she donated much of her collection, including 1,600 prints, to the museum.

Rockefeller was equally devoted to her collection of American folk art. First introduced to folk art by Edith Gregor Halpert (1900–1970), a dealer who, like Rockefeller, was particularly drawn to the young modernists whose work often depicted American scenes. Already cognizant of such groups as Der Blaue Reiter and Die Brücke, which were attracted to the works of peasants and children, Rockefeller immediately grasped the shared aesthetics of folk art and modernism: abstraction of form, idiosyncratic use of perspective, and bold colors. Like other early enthusiasts, she was delighted to find in folk art precedents for American modernism. Rockefeller formed a productive relationship with Halpert and Holger Cahill (1887–1960), Halpert's advisor, who had organized the first major exhibitions of folk art at the Newark Museum in 1930 and 1931. Halpert and Cahill went on forays to New England, looking for works that would meet Rockefeller's exacting standards, and Rockefeller's collection soon included theorem paint-

ings, fraktur, weathervanes, memorial pictures, and embroideries as well as paintings by Sarah Perkins (1771–1831) also known as the Beardsley Limner, Edward Hicks (1780–1849), Erastus Salisbury Field (1805–1900), Ammi Phillips (1788–1865), and numerous unknown painters. Convinced that folk art was not just a New England phenomenon, in 1935 Rockefeller sent Cahill to the South, where he discovered *The Old Plantation,* a depiction of slaves dancing that has continued to fascinate scholars. With only one exception, all the works in Cahill's landmark exhibition, "American Folk Art: The Art of the Common Man in America, 1750–1900," organized for MoMA in 1932, were drawn from Rockefeller's collection.

Realizing that her collection of folk art deserved public display, in 1939 Rockefeller donated it to Colonial Williamsburg, whose restoration was supported by her husband. The collection, primarily of nineteenth-century New England works, did not fit well within the restored colonial city. Thus, in 1953 John D. Rockefeller Jr. presented Colonial Williamsburg with the funding to construct a museum outside the historic area, in memory of his wife. Works collected by Abby Aldrich Rockefeller remain among the masterpieces of American folk art.

See also **Abby Aldrich Rockefeller Folk Art Museum; Holger Cahill; Erastus Salisbury Field; Edith Gregor Halpert; Edward Hicks; Sara Perkins; Ammi Phillips.**

BIBLIOGRAPHY

Chase, Mary Ellen. *Abby Aldrich Rockefeller.* New York, 1950.
Goldstein, Malcolm. *Landscape with Figures: A History of Art Dealing in the United States.* New York, 2000.
Kert, Bernice. *Abby Aldrich Rockefeller: The Woman in the Family.* New York, 1993.
Little, Nina Fletcher. *The Abby Aldrich Rockefeller Folk Art Collection: A Descriptive Catalog.* Williamsburg, Va., 1957.
Rumford, Beatrix T., ed. *American Folk Painting: Paintings and Drawings Other than Portraits from the Collection of the Abby Aldrich Rockefeller Folk Art Center.* New York, 1988.

CHERYL RIVERS

RODIA, SIMON (or Sam) (c. 1875–1965), built one of America's most spectacular and enigmatic visionary constructions, the Watts Towers. Comprised of three enormous, thin-ribbed spires, one nearly 100 feet tall, they rise from an elaborate garden on a triangular lot adjacent to the remains of his house at 1765 107th Street East in the Watts section of Los Angeles. Made of cement-covered steel rod s are encrusted with a colorful mosaic of sea shells and debris, including broken bottles, tiles, and plates, Rodia's towers are

the most dramatic element of his creation. The construction also features ornamental garden structures built in a similar form, several smaller spires, a gazebo, planters, a fountain, and a mosaic boat. Built between the mid-1920s and 1954, the site is enclosed by a scalloped wall with mosaic and bas-relief designs. Overall, it resembles a ship, with the exterior walls coming to a point to form the bow, with the towers rising like masts from the middle.

Rodia, whose original given name was Sabato, was born into a family of landed peasants about 1875 near Naples, Italy. He immigrated to the United States around the age of fourteen, migrated west, and worked as a laborer, chiefly in construction. He apparently settled in Watts in the early 1920s, and soon thereafter began work on the towers. By all accounts, Rodia spoke little and did not explain the motivation for his work, beyond saying "I had it in my mind to do something big, and I did." Recent scholarship suggests that Rodia's creation was made to resemble the towers and ships built annually to celebrate the feast day of an Italian saint in Nola, a town near Rodia's childhood home. Other accounts propose that Rodia might have been hoping to demonstrate prowess at construction, or to give dramatic evidence of his sobriety; Rodia told a writer for *The New Yorker* that he started building the towers after he quit drinking. Rodia also admired explorers, whom he may have wanted to commemorate or emulate. There are frequent reports that he called the small boat found at the apex of his garden the ship of Marco Polo or the ship of Columbus, and the three main towers Nina, Pinta, and Santa Maria.

In 1954, Rodia gave the title for the Towers to a neighbor and moved away. In 1959, the city of Los Angeles attempted to demolish them, but they were saved through the efforts of a volunteer committee. They are now listed on the National Register of Historic Places, owned by the State of California, and administered by the Los Angeles Department of Cultural Affairs.

See also **Environments, Folk.**

BIBLIOGRAPHY

Posen, I. Sheldon, and Daniel Franklin Ward. "Watts Towers and the Giglio Tradition," *Library of Congress Folklife Annual* (1985): 143–57.
Trillin, Calvin. "A Reporter at Large: I Know I Want to Do Something," *The New Yorker,* vol. 41 (May 29, 1965): 72–120.
Whiteson, Leon. *The Watts Towers of Los Angeles.* Oakville, Canada, 1989.

JOHN BEARDSLEY

ROGERS, JUANITA (1934–1985) was an enigmatic African American artist who spent her life in southern Alabama. She recounted late in her life that she was born in a place called Indian, but her father said she was actually born in Tintop, Alabama. He also insisted that he and his late wife were her real parents, contrary to her allegation that they had adopted her when she was five, following the deaths of her birth parents.

In the early 1970s Rogers and her husband, Sol Huffman, moved into a two-room cabin in a pasture near the rural community of Snowdoun, where she would spend the rest of her life. They had no children, and Huffman died in 1980, leaving her without financial support. She devoted much of her time, especially after his death, to making figural sculptures from mud and clay, into which she intermixed animal bones, glass shards, cinders, Spanish moss, and coffee grounds. Most of these raw, earthen pieces take the form of fantastic human/animal hybrids with exaggerated features, missing heads, and other idiosyncratic facets. She claimed to produce these works at the behest of someone named "Stonefish," or "Stoneface," of whom there is no other record.

In the years after Huffman's death, Anton Haardt, the first collector of Rogers' art, encouraged her to draw, and she produced a parallel body of cartoonish, ink and watercolor drawings before dying of complications from an abdominal tumor.

See also **African American Folk Art (Vernacular Art); Sculpture, Folk.**

BIBLIOGRAPHY

Arnett, Paul, and William Armett, eds. *Souls Grown Deep: African-American Vernacular Art of the South,* vol. 1. Atlanta, Ga., 2000.

Patterson, Tom. *Ashe: Improvisation and Recycling in African-American Visionary Art.* Winston-Salem, N.C., 1993.

Yelen, Alice Rae. *Passionate Visions of the American South: Self-Taught Artists from 1940 to the Present.* New Orleans, La., 1993.

TOM PATTERSON

ROMANIAN AMERICAN FOLK ART: *SEE* EASTERN EUROPEAN AMERICAN FOLK ART.

ROSEMALING is a type of decorative painting that flourished in Norway during the eighteenth and nineteenth centuries, and then enjoyed a resurgence in the twentieth century in Norway and the United States. Characterized by stylized floral and plant motifs, sometimes incorporating symbolic figures and pictures, the form emerged most strongly in Norway's south central districts of Hallingdal and Telemark, as rural residents blended their Viking design heritage with colorful and flamboyant Baroque, Regency, and Rococo styles from Europe. Glass windows, stoves with chimneys, and milled planks used to construct walls and floors, adopted during the 1700s, provided lighter, brighter home interiors, and appropriate surfaces for decorating. As Norway's economy improved in the late 1700s, with increased lumbering, fishing, and trade with Europe, south central Norwegians commissioned rosemaling on walls, ceilings, moldings, rafters, furniture, and significant household utensils. Men with the talent to paint decoratively, often of small means, embraced the demand and source of income, and a competitive crop of independent itinerant professional rosemalers emerged, spreading the art form and desire for it into adjacent regions in Norway. By 1800, regionally distinctive painting styles had evolved, notably an asymmetrical C-scroll with tendrils in Telemark that has become emblematic of rosemaling and Norwegian and Norwegian-American identity.

The tradition waned in the mid-1800s as significant Norwegian immigration to the United States began. Many rosemalers emigrated, but only a few practiced their skills as virtuosos or as painters of implements and signs. But many immigrants remained familiar with rosemaling from the decorated trunks they brought with them, which often held small, *rosemaled* heirlooms. During the last decades of the nineteenth century, Romantic nationalism in Norway revived many folk arts, including rosemaling. Later immigrants, especially from a peak period during the first decade of the twentieth century, were familiar with this revival, and sometimes the revived skills. They joined older first- and second-generation immigrant populations in America in paying greater attention to their heritage.

The "father of American Rosemaling," Per Lysne (1880–1947), immigrated from Sogn, Norway, to the upper Midwest of the United States in 1906, the heart of Norwegian-American settlement during the mid-1800s. The son of a decorative painter, Lysne learned to paint in Norway during the native arts revival of the late 1800s. Working as a wagon-striper in Stoughton, Wisconsin, he branched out during the Great Depression (1929–1939), painting floral decorations in home interiors, on furniture, and on small items, such as plates. His work rode the wave of American interest in decorative folk painting in the 1930s, sold impressively, and caught the attention of Norwegian-Americans. Inspired by his work and rosemaling used to decorate heirlooms in their Norwegian-American communities, women like Ethel Kvalheim and Vi Thode of Stoughton, Wisconsin, and Elma and

Thelma Olsen of Elkhorn, Wisconsin, emulated his work and fueled the rosemaling movement in the 1940s, 1950s, and 1960s. Eager to learn techniques, patterns, and more about their ethnic heritage, they sought sources in the United States and Norway, shared their findings, and created a strong demand for classes and publications on the subject. Under the directorship of Marion Nelson, Vesterheim, a Norwegian-American museum begun in 1877 in Decorah, Iowa, became involved in 1967 by sponsoring a national exhibition of rosemaling produced by Americans. It also held workshops led by Norwegian rosemaler, Sigmund Aarseth. Vesterheim has since continued the successful workshops and annual exhibit, and expanded its support to the other Norwegian folk arts of weaving, woodcarving, and knife-making.

Early workshop teachers Aarseth, Nils Ellingsgard, and Bergljot Lunde are credited with introducing, respectively, codified Telemark, Hallingdal, and Rogaland styles that soon eclipsed the earlier work of American rosemalers. Vesterheim's juried exhibitions and workshops promoted revived Norwegian traditions, and encouraged sophistication in design and technique. A gold medal award system for exceptional American rosemalers reshaped American rosemaling's aesthetics and practice, restored a creative dynamic strongly versed in the older design heritage, and supported the development of accomplished virtuoso painters who have explored varied styles, fashioned American versions, and steered the art form's course into the twenty-first century.

In contrast to Norway's past tradition, in the United States women, for the most part, have pursued rosemaling, serving clients from similar middle class socioeconomic circumstances. Most widely practiced in the upper Midwest of the United States, rosemaling there has functioned as a social hobby that connects friends and neighbors and promotes a community identity that acknowledges a strong Norwegian-American component, but honors the region's tradition of ethnic pluralism. While the most industrious and proficient painters of varied ethnicities have sought gold medals and sometimes turned their "rosemaling fever" into an avocation like the early Norwegian painters did, their number is dwarfed by thousands who practice the skill for personal and community reasons, creating symbolic badges of ethnicity, community, or region for their homes, families, local businesses, and public buildings. In tandem, men (often from rosemalers' families) have spawned lively businesses producing traditional woodenware for rosemaling. Linked across Norwegian and Norwegian-American communities regionally, nationally, and internationally, the networks of rosemalers and supporters are, like the design heritage they perpetuate, vital, spirited, intertwined, and deeply-rooted.

See also **Decoration; Scandinavian American Folk Art.**

BIBLIOGRAPHY

Ellingsgard, Nils. *Norwegian Rose Painting.* Oslo, Norway, 1988.
———. *Norwegian Rose Painting in America.* Decorah, Iowa, 1993.
Fahden, Pamela, ed. *Norwegian Rosemaling in America.* Minneapolis, Minn., 1986.
Hauglid, Roar, ed. *Native Art of Norway.* New York, 1967.
Martin, Philip. *Rosemaling in the Upper Midwest: A Story of Region and Revival.* Mount Horeb, Wisc., 1989.
Miller, Margaret A., and Sigmund Aarseth. *Norwegian Rosemaling: Decorative Painting on Wood.* New York, 1974.
Nelson, Marion J., ed. *Norwegian Folk Art: The Migration of a Tradition.* New York, 1995.
Quimby, Ian M.G., and Scott T. Swank, ed. *Perspectives on American Folk Art.* New York, 1980.
Siporin, Steve, ed. *American Folk Masters: The National Heritage Fellows.* New York, 1992.
Stewart, Janice S. *The Folk Arts of Norway.* New York, 1972.
Whyte, Bertha Kitchell. *Craftsmen of Wisconsin.* Racine, Wisc., 1971.

JANET C. GILMORE

ROWE, NELLIE MAE (1900–1982) was a prolific doll maker, sculptor, and painter whose work reveals her humor, imagination, common sense, and deep spiritual faith. Her sense of color and design and her skillful variation of selected forms appeal to the senses and the emotions.

Rowe was born in Fayetteville, Georgia. Her father, Sam Williams, was an expert basket maker; her mother, Luella Swanson, a singer of gospel hymns, made quilts. As a child, Rowe used the family's laundry to make dolls, marking their features with pencil, pen, or crayon. However, she worked as a domestic all her life and was unable to devote much time to art until 1945, when her second husband died and she could concentrate on her "playhouse," as she described her environment and her artistic activity. She began to decorate her house and yard with drawings and objects she collected. She made dolls, many of which were life-size, and small sculptures of people, animals, and other creatures, usually molded from chewing gum. These were often embellished with marbles, shells, and plastic ornaments.

Rowe drew and painted on a variety of surfaces: plastic refrigerator trays, discarded bits of wood, wallpaper books. She preferred to work in pencil, pen, felt-tipped pens, or tempera on paper and cardboard. Her subjects came from her southern roots. Slavery,

for example, is acknowledged in *I Will Take You to the Market*, in which a nude woman sits huddled with her arms crossed in an attempt to shield her upper body. Rowe also called on her own memories of picking cotton and going to church, but she transcended the ordinary by tapping into her dreams and her vivid imagination. In some of her work she recalled stories of "haints" (ghosts) from her childhood, and she filled her paintings and drawings with strange creatures: figures that are half cow and half women fly through the sky, and figures that are half owl and half women inhabit the forest. Fish appear everywhere in her works, although rarely in the water.

Rowe used bright colors, and she varied repeated shapes rhythmically to create well-balanced, organic compositions. Her images are often accompanied by text that enhances their expressive power. Toward the end of her life, she often used recurrent motifs. She herself appears in many of her paintings and drawings disguised as a bird, cow, seductress, or dog. She used the figure of the dog metaphorically when she was painfully ill near the end of her life, to help her prepare for her "final journey."

In 1983 Linda Connelly made a film about Rowe, *Nellie's Playhouse*.

See also **African American Folk Art (Vernacular Art); Painting, American Folk.**

BIBLIOGRAPHY

Alexander, Judith. *Nellie Mae Rowe: Visionary Artist, 1900–1982*. Atlanta, Ga., 1983.

Kogan, Lee. "Nellie Mae Rowe." *Folk Art*, vol. 23, no. 4 (winter 1998–1999): 40–46.

———. *Ninety-Nine and a Half Won't Do: The Art of the Nellie Mae Rowe*. New York, 1998.

Livingston, Jane, and John Beardsley. *Black Folk Art in America: 1930–1980*. Washington, D.C., 1982.

Longhauser, Elsa, and Harald Szeemann. *Self-Taught Artists of the Twentieth Century: An American Anthology*. San Francisco, and New York, 1998.

Rosenak, Chuck, and Jan Rosenak. *Museum of American Folk Art Encyclopedia of Twentieth-Century American Folk Art and Artists*. New York, 1990.

Wadsworth, Anna. *Missing Pieces: Georgia Folk Art: 1770–1976*. Atlanta, Ga., 1976.

Yelen, Alice Rae. *Passionate Visions of the American South: Self-Taught Artists from 1940 to the Present*. New Orleans, La., 1993.

LEE KOGAN

ROWLEY, REUBEN (active 1825–1836), an itinerant miniature and portrait painter, is believed to have worked in central New York State in the 1820s and in Boston, Massachusetts in the mid-1830s. Despite contradictory surname spellings, the Reuben Roulery who painted in New York State and who was known as the teacher of the artist Philip Hewins (1806–1850) is thought to be the same person as the Reuben Rowley listed in the Boston city directories of 1834 and 1838. Records of exhibiting artists at the Boston Athenaeum for 1834, 1835, and 1836 include Rowley, both as a portrait and a still life exhibitor. Further complicating identification is the portrait *Dr. John Safford and Family* of Watertown New York, that once carried the name *"R. Rowley"* on the back of the canvas, later obscured when relined. The portrait captures the well-dressed family of casual demeanor and with gentle faces standing, perhaps pausing during a country walk, under the spreading limbs of several trees. Their costumes and adornments are painstakingly detailed, while the bucolic setting is more abstractly rendered.

Only two signed pairs of Rowley portraits are known to exist. The first pair is of *Colonel and Mrs. Richard Juliand*, signed "No By R,Rowley, 1826" and the second pair is of *Lucas Cushing* and *Chloe Cushing*. The figures are painted in a sculptural style, severe in countenance, and their costumes are executed with great detailing, highlighting the jewelry, hairstyle, and lace of the sitters. There are several other extant portraits attributed to Reuben Rowley that include the *Safford Family* portrait, one of *Sally Hayes Bostwick*, and a portrait pair of *Elijah Rathbone* and *Eliza Betts Rathbone*. A miniature portrait of *Alvin Chase Bradley* has been attributed to Reuben, and another miniature portrait, of *Dr. Morgan* with the stamp "Reuben Rowley, Portrait and Miniature Portrait Painter" on the white fabric inside the portrait case was reproduced in the August 1925 issue of *The Magazine Antiques*. Rowley is also known to have painted watercolors on ivory.

See also **Miniatures; Painting, American Folk; Painting, Still-life.**

BIBLIOGRAPHY

Barons, Richard I. *The Folk Tradition: Early Arts and Crafts of the Susquehanna Valley*. Binghamton, N.Y., 1982.

Chotner, Deborah. *American Naïve Paintings*. Washington, D.C., 1992.

Jones, Agnes Halsey. *Rediscovered Painters of Upstate New York*. Utica, N.Y., 1958.

Muller, Nancy C. *Paintings and Drawings at the Shelburne Museum*. Shelburne, Vt., 1976.

WILLIAM F. BROOKS JR.

RUDY, DURS, SR. (1766–1843) and **DURS RUDY JR.** (1789–1850), a father and son, were artists in the Pennsylvania German "fraktur" tradition. Because of similarities in the work attributed to the father and

son, uncertainty exists as to which of the two artists is responsible for specific compositions. The Rudy family arrived in the United States aboard *The Commerce* in 1803, disembarking in Philadelphia. Durs Rudy Sr. was Swiss in origin; his son was born in Baden. According to long-standing family tradition, the younger Durs Rudy, a tavern owner, shopkeeper, and organist at Neff's Church, North Whitehall Township in Lehigh County, was an artist who sketched and painted the local countryside. It is to him that the most ambitious of the Rudy frakturs have been attributed. However, according to the scholar Frederick S. Weiser, the elder Rudy, probably a schoolteacher and shopkeeper in Lehigh County, was the more skilled artist and penman of the two.

Most recorded frakturs associated with the Rudys fall into one of two principal categories. The first is *taufscheine* (birth and baptismal records). Rendered expertly in a distinctive German hand with impressive initial letters, these frakturs are rather formal certificates, reminiscent of European examples. Framing the text of many of the frakturs in this category is a distinguishing pair of columns with transom, decorated in a restrained fashion with small flowers and other elements.

The second category consists of fully developed drawings rendered in brilliant watercolors. Generally based on biblical narrative and presented either separately, in a series, or in several known examples, as metamorphoses, they are colorful, spirited, and immensely appealing works of art. In these drawings imagery, rather than text, is the dominating element.

In seeking to distinguish between the two artists, it is tempting to assign one format to the father and the other to the son. However, the use of the distinguishing columns and crosspiece to frame the textual portions of the *taufscheine* is a common feature of several of the biblical drawings as well. Other stylistic similarities also appear, including the occasional use of a related group of architectural elements in both categories. While several of the *taufscheine* contain more refined and carefully drawn calligraphy than the frakturs of the later group, the style of writing is remarkably consistent throughout the Rudys' work. It may be possible that father and son worked closely together or even collaborated on some frakturs. Until a dated example is found that is clearly outside the possible working life of either artist, or some other form of documentation appears, positive identification will remain difficult.

As is common in other frakturs of the era, the Rudys' figures are presented anachronistically, in the dress of the late eighteenth century rather than in that of the period described. Generally drawn in profile in ink, these figures characteristically have large, square jaws.

See also **Fraktur.**

BIBLIOGRAPHY

Shelley, Donald A. *The Fraktur-Writings or Illuminated Manuscripts of the Pennsylvania Germans.* Allentown, Pa., 1961.

Wertkin, Gerard C. "The Watercolors of Durs Rudy: New Discoveries in Fraktur." *Folk Art*, vol. 18 (summer 1993): 33–39.

GERARD C. WERTKIN

RUGS, beautiful, soft under foot, and a protection against cold drafts in winter, would have seemed a necessity in the colonial home; yet they were rare in Europe until the 1700s and rarer still in America, where only the wealthy could afford the luxury of imported floor coverings. Most people made do with bare wooden floors, sometimes covered with clean sand, rush matting, or painted canvas floorcloths.

Sand, preferably white beach sand, was sprinkled in a thin layer over the floor and then carefully swept into decorative patterns: wavy lines, swirls, and a sort of herringbone design. Sand did keep things clean, but of course these designs lasted only until the first person crossed the floor. Rush matting, which might last for weeks before it needed to be replaced, was a better solution. Still better was the canvas floorcloth: it was sturdy, was easily cleaned, and could be painted to resemble an expensive imported Axminster or Brussels carpet. Floorcloths remained popular into the mid-nineteenth century. By then, however, American ingenuity had devised several other floor coverings.

Among the earliest and most common of these were braided rag rugs and carpets. Since they could be made of old rags, used clothing, or unneeded yarn, they became the standard floor covering for people of modest means. Women collected fabric scraps, cut them into long strands, and then wove or plaited them into a thick cord or strand which was wrapped around itself with each new band being sewn to the previous one. Because of the way they were made, braided rag rugs tended to be round or oval, though some oblong ones are found. They also are usually fairly small (3 by 5 feet or less), as larger rugs would tend to pull apart with use.

Rag carpets were larger and were woven on a loom. Rags were cut into long strips that were sewn together end to end and then woven into sections about 3 feet wide. These might be used indepen-

dently as hall or stair runners. Several sections sewn together at the edges could make a room-size carpet.

Braided rag rugs and carpets were inexpensive and useful to their makers, but what now attracts us is their appearance—their bright colors and appealing patterns. Braided rugs were usually sewn in concentric circles of contrasting hues; carpets were woven in colorful stripes or checkered patterns. Both types have survived in quantity and are also still being made today.

During the first half of the nineteenth century, the yarn-sewn rug was popular among people with more time and, perhaps, more money for materials. This was made by sewing two-ply woolen yarn through a loosely woven backing, usually made of coarse linen. A continuous or running stitch was used, with loops on the rug's surface following the pattern drawn on the backing to create the design. These loops were then usually clipped off to make a pile. These brightly colored rugs (measuring usually no more than 2 by 4 feet) look like hooked rugs. However, the reverse side of a hooked rug almost mirrors the front, whereas the back of a yarn-sewn rug is mostly bare, showing only small yarn stitches separated by expanses of raw fabric. The decorative designs on yarn-sewn rugs are usually pictorial or floral. Animals, houses, and baskets of flowers are often shown. Geometric patterns, however, are uncommon. These rugs were fragile, and so only a tiny portion of what was surely a large output has survived. Chief among the surviving examples are hearth rugs, which covered the fireplace hearth during seasons when the fire was not kindled.

At about the time when yarn-sewn rugs were going out of style, another home-crafted floor covering appeared: the shirred rug. This development coincided with the emerging industrial system. Cotton mills and other fabric factories generated a great deal of coarse textile scrap. These remnants (unlike yarn) were too bulky to be sewn through a backing, so the strips were crumpled up into what came to be called "caterpillars" and were sewn directly onto the fabric. Sometimes referred to as chenille shiring, this technique was used to produce typically small square or rectangular rugs with floral designs. One exception is a 12 by 10 foot carpet showing a large colonial house set in a fenced garden.

There were several variations of shirred rugs, all of which involved essentially appliqué techniques. In pleated shirring, cloth strips were folded and sewn to the backing in tightly spaced ribbons. From close up, the surface looked somewhat like the sides of an accordion. Bias shirring involved cutting thin strips of cloth on the bias, then folding them lengthwise and stitching them to the backing so that the raw, cut edges extended upward. These were tightly sewn, one against the other, forming a soft pile. For variety, the fabric might be sewn in squares or circles rather than in straight lines. Called patch shirring, this technique was favored by Shaker rug makers.

Shirred rugs, like yarn-sewn rugs, may be mistaken for hooked rugs; once again, though, the backing is the distinguishing characteristic. As with yarn-sewn rugs, the backs of shirred floor coverings are mostly bare, showing simply a pattern of stitch work rather than the fully developed image found on the reverse of a hooked rug. Relatively few collectors are fortunate enough to own a shirred rug. The sewn construction is fragile: once the thread breaks, the piece unravels and, unless skillfully repaired, is lost.

The appliqué technique was used differently in the so-called table rugs of the late nineteenth century. These pieces were used to cover tables, couch backs, and pianos and as small scatter rugs and are now usually called "penny rugs." They had as a base a round, oval, hexagonal, or octagonal piece of woolen fabric. Onto this were sewn two or three layered circles, often with crimped edges, as well as, in some cases, other cutouts such as flowers or animals. The penny-size decorations were outlined with a buttonhole stitch and secured to the foundation with a cross-stitch, creating a pleasing pattern. Such rugs were often enhanced by the addition of a border composed of tongue-shape flaps, also embroidered and decorated. Penny rugs were made in some quantity and remain common. However, since most were made of wool, they are susceptible to damage by moths.

Another, quite different form is the needlework rug, a product of the late 1800s. Both crocheting and knitting techniques might be used to create these floor coverings, which were visually appealing but, owing to their soft bodies, uncertain underfoot. One variation—referred to, because of its appearance, as a "shaggy" or "fluff" mat—was made by cutting fabric into small strips and then knitting them together with string or heavy thread. The Amish, however, often combined knitting with braiding to create rugs with braided borders surrounding figural interior patterns; this was an easier technique than braiding alone.

One characteristic of nineteenth-century handmade floor covering is its eclecticism. Rug crafters, who were usually but not always women, did not hesitate to use several techniques or materials in the same piece. In Maine, one often sees rugs braided around a fragment of old ingrain carpet or a central

hooked panel. Table or penny rugs were invariably embroidered, and they are related to the crazy quilts that were being made during the same period. The appliqué technique was used wherever a flat surface allowed, and various forms of needlework were freely mixed to suit the designer's fancy.

Fortunately, except for certain rare examples, the various rug forms are still relatively easy to track down. Collectors prize signed or dated pieces particularly, but these are uncommon. Not only were most makers too modest to identify themselves, but the construction or material of many floor coverings did not lend itself to such notation.

See also **Hooked Rugs.**

BIBLIOGRAPHY

Montgomery, Florence. *Textiles in America, 1650–1870,* New York, 1984.
———. *The Needle Arts: A Social History of American Needlework,* New York, 1990.
Weissman, Judith Reiter, and Wendy Lavitt. *Labors of Love: America's Textiles and Needlework, 1650–1930.* New York, 1987.

WILLIAM C. KETCHUM

RULEY, ELLIS (1882–1959), a talented African American artist, was a recorder of personal dreams of heroism, peace, beauty, freedom, and harmony in nature. He painted sixty-four known pictures, using images from popular culture as metaphors. Many of the themes of his pictures also contain encoded autobiographical references. Ruley's masterpiece, *Adam and Eve,* with its psychological overtones, depicts a world that, on the surface at least, holds promise that man and animal can co-exist harmoniously.

Ruley's paintings encompass smiling women in exotic settings; people at leisure, swimming, boating, or enjoying a luau; heroic cowboys; and landscapes with lush foliage reminiscent of the dense, exotic greenery of the French painter Henri Rousseau. While Ruley longed for a peaceful and harmonious ideal, danger often lurked near the surface of his paintings. A grinning, bathing figure is about to drown; a reclining nude is stalked by a lion; a crouching animal hiding behind some craggy rocks is threatened by figures with guns. Popular culture was essential to Ruley's art, and he freely appropriated images from sources such as *LIFE* magazine and *National Geographic,* filtering the images through his experiential lens.

The son of a runaway slave, Ruley was born and attended school in Norwich, Connecticut. He married Wilhelmina Fox, his second wife, in 1924 and joined the local Union Baptist Church. Family and local residents remembered that he worked as a laborer most of his life and was employed by area contractors until the late 1920s, when he retired following a truck accident. In time, the interracial couple experienced hostility in their all-white neighborhood. In 1959, Ruley died in unexplained circumstances, according to California art collector Glenn Smith.

While Ruley's earliest works, produced about 1939, were colorful window screens, he soon began to paint easel-sized pictures using oil-based house paint on poster board or Masonite, to which he applied varnish for a lustrous finish. He added his signature to many of his paintings, using one and sometimes two rubber stamps. Ruley's flattened forms were outlined in pencil and filled in with color. He often used decorative patterning to enhance details, such as leaves and blossoms. His autumnal brown, green, and gold palette alternated with an occasional monochromatic one.

Ruley received minor artistic recognition during his lifetime. The director of Norwich's Slater Museum, Joe Gualtieri, who taught at the Norwich Free Academy in the early 1950s, remembered that Ruley brought paintings to him for evaluation. Recognizing his talent, Gualtieri encouraged Ruley to participate in the town's art fair, and in 1952 Ruley was featured in a one-man exhibition in Norwich. In 1993, the San Diego Museum of Art organized the traveling exhibition, "Discovering Ellis Ruley," with a national tour.

BIBLIOGRAPHY

Hollander, Stacy, and Lee Kogan. "Filtered Images: The Art of Ellis Ruley," in *Discovering Ellis Ruley: The Story of an American Outsider Artists,* edited by Glenn Robert Smith. New York, 1993.

LEE KOGAN

RUSH, WILLIAM (1756–1833) was the son of a Philadelphia ship carpenter and the first native born American sculptor to successfully make the transition from craftsman to artist. Apprenticed to a carver, Rush's talent was considered superior to his master's, and he opened his own carving shop at about the age of seventeen. After serving in the Revolutionary War, Rush's shop offered portrait busts in wood and terra cotta, figureheads, sculpture for architecture, tobacconist figures, and carved eagles.

Rush's preeminence as a figurehead carver was established when he received a commission to design figureheads for the U.S. Navy's first six frigates, built between 1790 and 1812. He broke with American tradition by innovating a full-length pose inspired by figureheads he observed on French frigates in Philadelphia. The figureheads he designed assumed a striding pose, which gave them a singularly assertive demeanor, and influenced ships' carvers internationally.

One of Philadelphia's most celebrated artists, Rush was also involved in numerous civic projects. He served on Philadelphia's Watering Committee, which supervised the affairs of the Fairmount Water Works. One of the organizers of the Pennsylvania Academy of Fine Arts, Rush was one of only two professional artists elected to its board (along with Charles Willson Peale [1741–1827]). In 1810 Rush became the first president of the Society of Artists, which included the painters Thomas Sully (1783–1872) and Rembrandt Peale (1778–1860) among its members.

Rush's authoritative, painted pine, allegorical figures promoted the Neoclassical ideal in public sculpture, despite his lack of direct access to European models. He advocated working from the living model, enabling him to more successfully emulate European Neoclassicism. The practice also invited criticism, however, when Philadelphians reproached his fountain sculpture *Water Nymph and Bittern* for revealing the female form beneath its draped, "wet" garb.

In 1808, Rush created monumental figures of *Comedy and Tragedy* for Benjamin Henry Latrobe's (1764–1820) New Theatre on Chestnut Street. When the building burned in 1820, the sculptures were placed into niches in the facade of William Strickland's (1788–1854) Chestnut Street Theater. Rush produced three allegorical sculptures carved for various buildings at the Water Works: *Allegory of the Schuylkill River* in 1809, and, with his son and partner John (1782–1853), *The Schuylkill Chained* and *The Schuylkill Freed* in 1825. His eight-foot-high figures *Mercy and Justice*, completed for an unrealized architectural project, were placed on top of the Grand Civic Arch designed by Strickland and built to honor Marquis Marie Joseph de Lafayette (1757–1834) upon his visit to Philadelphia during his 1824 tour of the United States.

See also **Maritime Folk Art; Sculpture, Folk; Ship Figureheads; Shop Figures.**

BIBLIOGRAPHY

Craven, Wayne. *Two Hundred Years of American Sculpture*. New York, 1976.
Philadelphia: Three Centuries of American Art. [exhibition catalog] Philadelphia, 1976.

RICHARD MILLER

RUSSIAN AMERICAN FOLK ART: *SEE* EASTERN EUROPEAN AMERICAN FOLK ART.

RYDER, DAVID, who was active around the year 1848, painted an agreeable portrait of Arabella Sparrow in oil on canvas that well deserved its reproduction on the cover of the book *American Folk Portraits: Paintings and Drawings from the Abby Aldrich Rockefeller Folk Art Center* (1981). This work has many of the characteristic elements of nineteenth-century folk portraiture. The featured subject is a young child who is is seated amid colorful flowers and foliage and is holding a sprig of strawberries. The surrounding trees, vines, and flowers support the sense of growth and represent a perfect environment in which little Arabella Sparrow will be able to develop. The background shows a spacious farm surrounded by a landscape: there is a white farmhouse, and both people and animals are present in the middle ground, enhancing the mood of tranquillity and productivity. An imposing white Neoclassic column in the foreground frames the picture and lends stability and elegance to the setting; and the vines in front of this column soften any severity that the solid columnar mass might otherwise impose. A large area of open blue sky in the landscape background supports the idea that the child's future is filled with limitless possibilities. The portrait itself may be understood today as a symbol for an America that was filled with promise for the future. As William Cullen Bryant wrote in "To a Poet" (1863), "Seekest thou in living lays/To limn the beauty of earth and sky/Before thine inner gaze/Let all that beauty in clear vision lie."

A note that was written years later by the sitter, by then a mature woman, was attached to the portrait. It identified the sitter as Arabella "Lois" Sparrow Southworth and the artist as David Ryder, of Rochester, Massachusetts; it also gave the date, 1848. The writer of the note added that the portrait had been painted from life, and that the strawberries had been put in her hand "to keep me quiet." The details of the landscape were evidently painted later. The sitter, who had been born in 1845, spent her entire life in Middleboro, Massachusetts; she married Rodney J. Southworth in 1866 and became a local vocalist. No information about the artist is known beyond his identity, except that Ryder may have been an ornamental painter rather than a portrait painter by vocation.

See also **Abby Aldrich Rockefeller Folk Art Museum; Painting, American Folk.**

BIBLIOGRAPHY

Rumford, Beatrix T., general ed. *American Folk Portraits: Paintings and Drawings from the Abby Aldrich Rockefeller Folk Art Center*. Boston, 1981.

LEE KOGAN

Photo © Esto.

Produced in vast numbers throughout the United States and Britain in the nineteenth century, spongeware kitchen and tableware pieces were prized for their durability and style. Spongeware was a decorative technique applied to stoneware or earthenware: a sponge is dipped in pigment and applied to the clay surface to create stylized patterns. Yellow-bodied pieces were sponged in brown, green, red, blue, or in combination (*Covered Bean Pot with Handle*, maker unknown, midwestern, c. 1880–1910, *left*). Pieces such as the *Pitcher and Bowl* (unknown maker, Ohio, c. 1875–1900, *below*) were sponged in blue after being dipped in a white Bristol slip. Although spongeware was produced in large factories, the potters were able to apply one-of-a-kind patterns that kept the originality of their work alive during a time when industrialization threatened to make folk pottery obsolete.

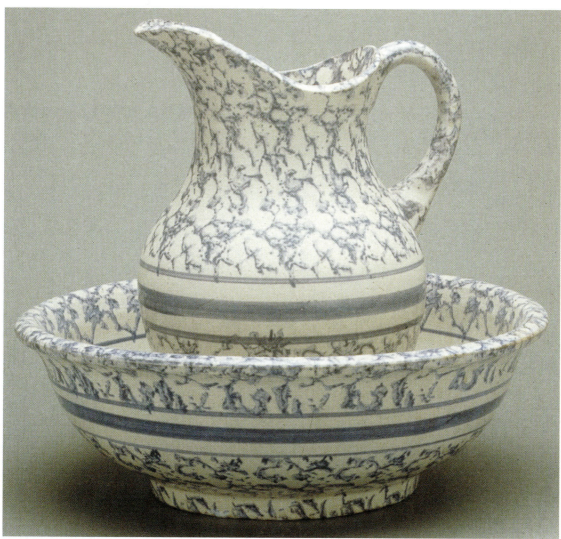

Photo © Esto.

PLATE 33

Objects such as the *Uncle Sam Riding a Bicycle Whirligig* (c. 1880–1920, *right*) and the *Flag Gate* (c. 1876, *below*) reflect the groundswell of American patriotism at the time of the nation's centennial. The ubiquitous Uncle Sam icon (based on one Sam Wilson, a meat packer from Troy, New York, who supplied meat to the United States Army during the War of 1812) found a legacy as an image on trade signs, toys, and weathervanes. This whirligig, made by an unidentified artist, probably New York State, of painted wood and metal, measures 37 × 55½ × 11 inches. Originating in Antwerp, Jefferson County, New York, the painted wooden *Flag Gate*, with additions of iron and brass, has thirty-seven white stars on one side and thirty-eight on the other (the thirty-eighth state, Colorado, entered the Union in 1876). Its stripes are shown as if rippling in a breeze; it measures 39½ × 57 × 3¾ inches.

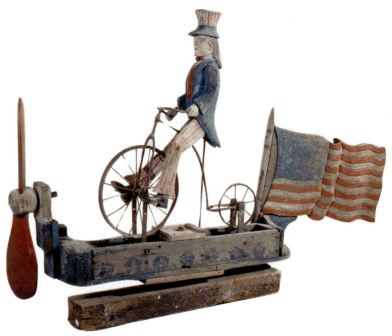

Collection American Folk Art Museum, New York.
Promised bequest of Dorothea and Leo Rabkin, Pl2.1981.6.

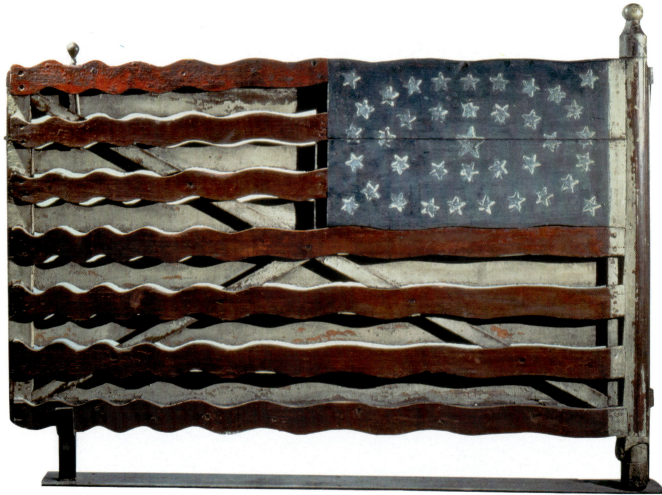

Collection American Folk Art Museum, New York. Gift of Herbert Waide Hemphill Jr., 1962.1.1.

PLATE 34

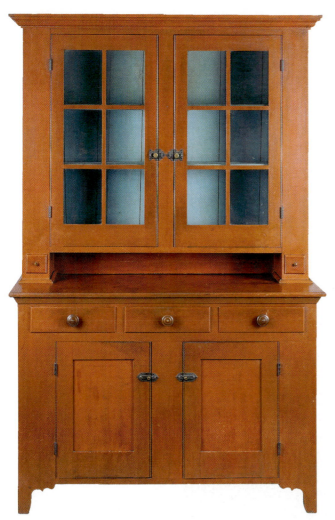

Photo courtesy Allan Katz, Americana, Woodbridge, Connecticut.

Furniture design traditions in America are as eclectic as their many-faceted sources, ranging from English-inspired Federal Era pieces (c. 1790–1825) to the minimalist Shaker aesthetic that flowered in New York, Pennsylvania, and Ohio (c. 1790–1900). The *Two-Piece Stepback Cupboard* (Wayne County, Ohio, c. 1850, *left*), attributed to Mennonite craftsmen, was handmade of poplar and originally painted with colorful blue and tomato red paint. The distinctive Mennonite furniture of the northern plains states exhibited faux grains, often overlaid with delicate floral patterns. This cupboard includes a pie shelf for cooling and storing. It measures 82½ × 55½ × 20¾ inches.

Purportedly carved for display at the Centennial Exposition of 1876 in Philadelphia—this elaborately carved *Center Hall Table* with leather inserts (maker unknown, 38 × 26 × 33½ inches, *right*)—boasts eighteen relief birds, eight horses, two eagles, and one mermaid figure among an intricate carving program that also includes over twenty-four United States shields. The piece melds European Rococo style with uniquely American symbolism.

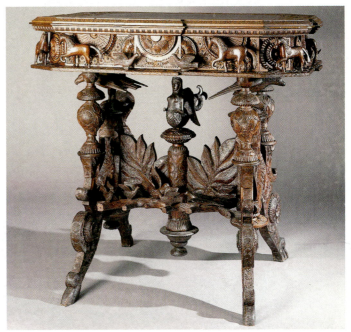

Photo courtesy Allan Katz, Americana, Woodbridge, Connecticut.

PLATE 35

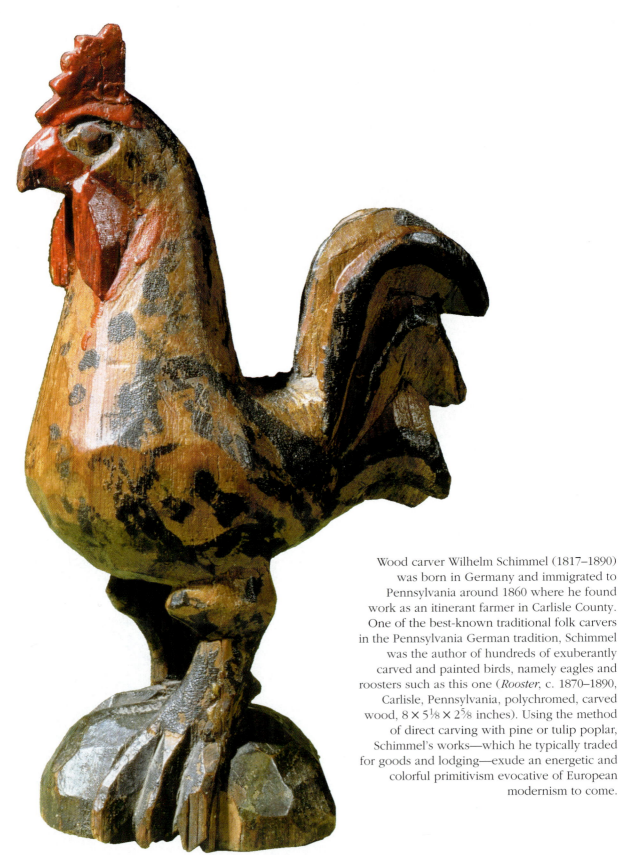

Wood carver Wilhelm Schimmel (1817–1890)
was born in Germany and immigrated to
Pennsylvania around 1860 where he found
work as an itinerant farmer in Carlisle County.
One of the best-known traditional folk carvers
in the Pennsylvania German tradition, Schimmel
was the author of hundreds of exuberantly
carved and painted birds, namely eagles and
roosters such as this one (*Rooster*, c. 1870–1890,
Carlisle, Pennsylvania, polychromed, carved
wood, 8 × 5⅛ × 2⅝ inches). Using the method
of direct carving with pine or tulip poplar,
Schimmel's works—which he typically traded
for goods and lodging—exude an energetic and
colorful primitivism evocative of European
modernism to come.

Collection American Folk Art Museum, New York, 1990.26.1. © Helga Photo Studio.

PLATE 36

Photo courtesy Andy Clausen.

Photo courtesy Allan Katz, Americana, Woodbridge, Connecticut.

Photo courtesy Allan Katz, Americana, Woodbridge, Connecticut.

Industrialization and urbanization at the *fin-de-siècle* contributed to a burgeoning leisure class and a market for indulgences. Toys, circus figures, and gameboards are well represented in American folk arts of the late nineteenth century. Prior to the age of the phonograph and radio, two-sided gameboards such as *"The Sociable Snake"* were popular (*upper left*). The Victorians invented "Halma" games, such as this one, in the 1880s; the objective was to progressively move all the pieces from one side of the board to the opposite. This gameboard, by an unknown maker, was made in New England, c. 1885, of polychrome wood. Other artisanally crafted objects include the *Swan Sled* (maker unknown, carved and painted wood with iron runners, New York, circa 1890, 49 × 32 × 16 inches, *left*); and the calliope figures (*Girls in Circus Costumes*, maker unknown, c. 1880, *upper right*). Carved of wood and painted blue and gold, these musical figures stand 33½ inches tall and have mechanical arms that strike a tambourine.

PLATE 37

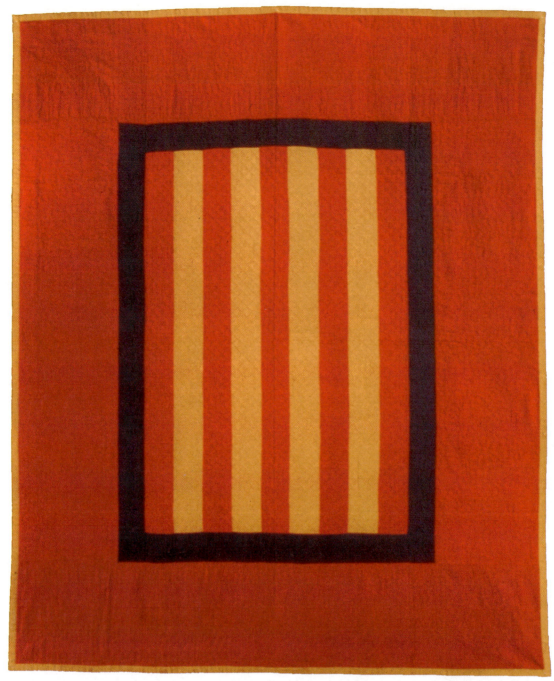

Collection American Folk Art Museum, New York. Gift of Mr. and Mrs. William B. Wigton, 1984.2532.

The Amish people left Rheinish Palatinate, Alsace, and Switzerland first for Holland and other parts of Europe and America during the eighteenth century as a result of persecution for their religious beliefs. Many settled in the rich farmlands of Berks and Lancaster Counties of Pennsylvania where they were welcomed by followers of William Penn (1644–1712), a staunch believer in the principles of liberty and equality for all, set down by the American founders. Amish quilt design may be seen as a product of the religious values and outlook of the community. Colors are often quite bold, solid fabric is used, and designs are geometric and abstract. The patterns of the *Bars Quilt* (*above*), produced in wool by an unknown artist from Lancaster County, Pennsylvania, c. 1910 to 1920, and measuring 87¼ × 72½ inches, continue to be used to design quilts in the Amish community today.

PLATE 38

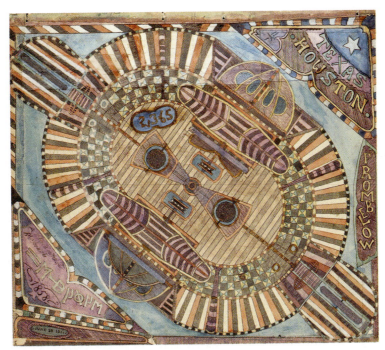

Photo courtesy Webb Gallery, Waxahachie, Texas.

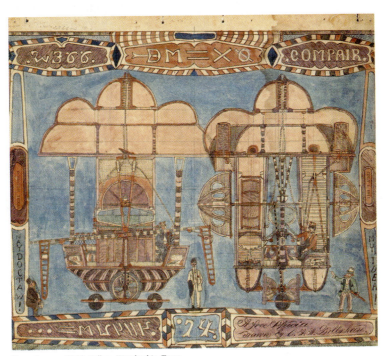

Photo Courtesy Webb Gallery, Waxahachie, Texas.

Painted and collaged nearly fifty years before the golden age of the Wright Brothers' first motor-powered flight at Kitty Hawk, North Carolina, Charles August Albert Dellschau's obsessively detailed picture books of fantastical flying machines (that he began around 1900) stand as exemplary works of outsider art. Dellschau, a Texas butcher, seems to have produced at a rate of about a page a day, a remarkable feat considering the intricacy of his narrative compositions. Recurring motifs included UFOs and alien figures, politics, and contemporary images of Houston culled from newspaper clippings and photographs. These recto and verso pages (*Compair*, 1911, ink, watercolor on newsprint), made in Houston, Texas, measure 20 × 25 inches.

PLATE 39

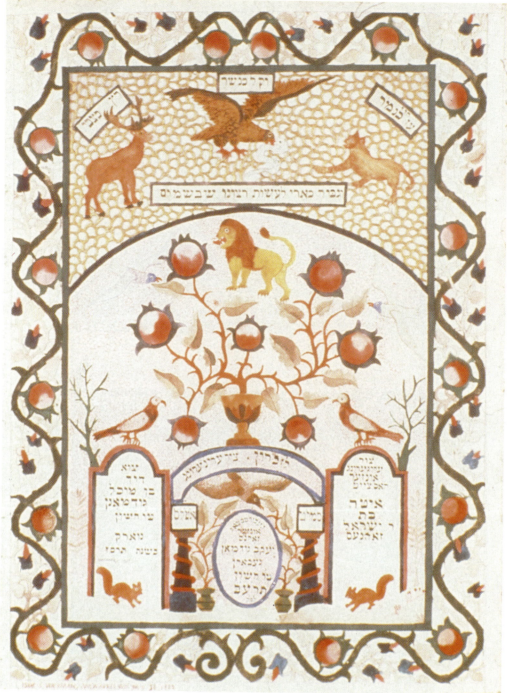

Private Collection.

Fraktur pieces such as birth and marriage certificates were also common among Jewish communities and were stylistically similar to their Christian counterparts. In the Jewish faith, however, iconography was less prevalent and when images were drawn and painted they closely illustrated the text. Among the most commonly used ornamental figures, for example, are the four animals referred to in Avot, or the Ethics of the Fathers, a popular Jewish text: "Be as strong as a leopard, light as an eagle, swift as a deer and brave as a lion to do the will of our Father in heaven" (Ethics of the Fathers, 5:23). This family record, by Issac S. Wachman, was made in Milwaukee, Wisconsin, signed July 30, 1922. It is ink and watercolor on paper and measures 24 × 18 inches.

PLATE 40

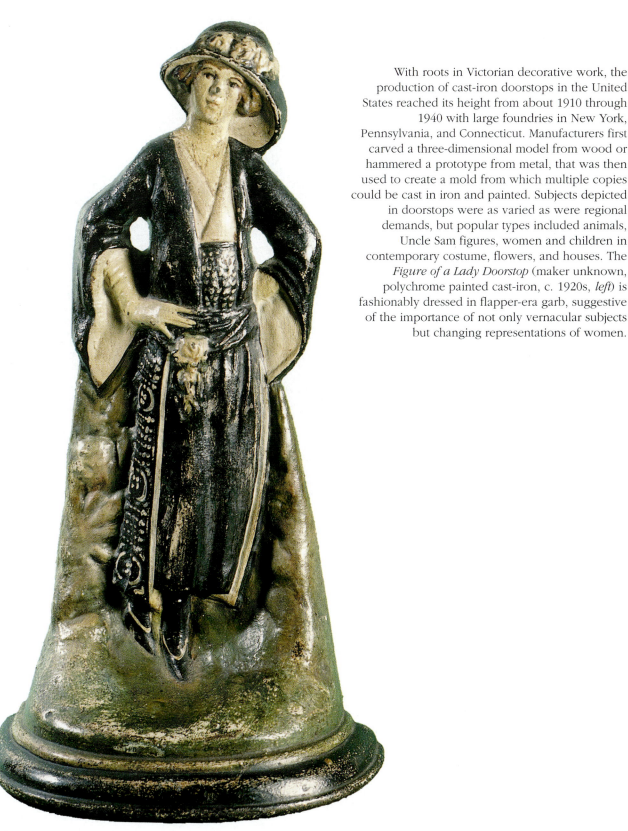

With roots in Victorian decorative work, the production of cast-iron doorstops in the United States reached its height from about 1910 through 1940 with large foundries in New York, Pennsylvania, and Connecticut. Manufacturers first carved a three-dimensional model from wood or hammered a prototype from metal, that was then used to create a mold from which multiple copies could be cast in iron and painted. Subjects depicted in doorstops were as varied as were regional demands, but popular types included animals, Uncle Sam figures, women and children in contemporary costume, flowers, and houses. The *Figure of a Lady Doorstop* (maker unknown, polychrome painted cast-iron, c. 1920s, *left*) is fashionably dressed in flapper-era garb, suggestive of the importance of not only vernacular subjects but changing representations of women.

Photo © Esto.

PLATE 41

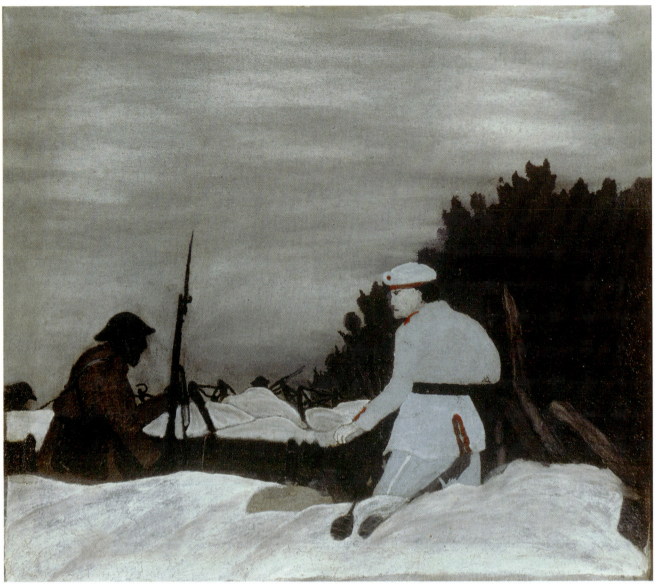

Collection American Folk Art Museum, New York. Gift of Patricia L. and Maurice C. Thompson Jr., 1999.25.1.

One of the foremost naïve painters in the United States, Horace Pippin (1888–1946) of West Chester, Pennsylvania, described himself as a realist; his complex work melds genre painting, African American history, and memory. Pippin joined the United States Army in 1917, enlisting in the all-black Fifteenth Regiment of the New York National Guard. The regiment fought on the front lines under French command due to concerns about integration. Ten years later Pippin began drawing and painting images from World War I from memory. *Outpost Raid: Champagne Sector* (1931, oil on fabric, 18 × 21 inches, *above*) is one of his earliest works. The artist's natural talent for composition, color, and pattern is evident in this moody and moving painting. On the right, a German soldier in uniform and beret stands beside a sentry box; on the left an American soldier who appears to be in French uniform emerges, lending credence to the belief that he might be a member of Pippin's regiment.

PLATE 42

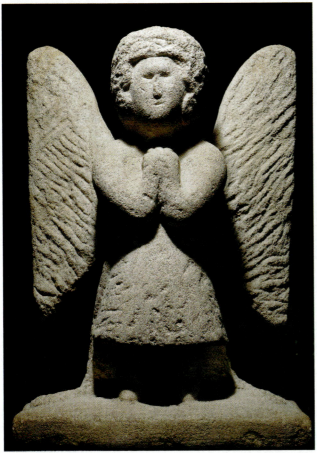
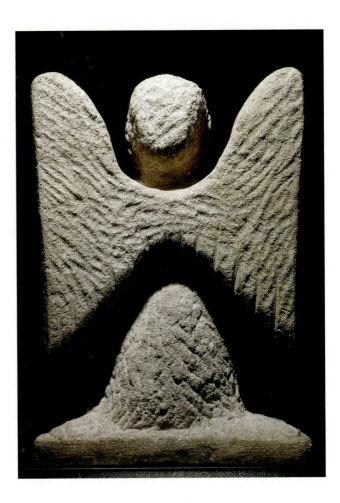

Private Collection.
Photo courtesy Ricco Maresca Gallery, New York.

The son of freed slaves from plantations in Davidson County, Tennessee, William Edmondson (1874–1951) has come to be known as one of America's foremost self-taught sculptors. In 1931 he opened a gravestone carving business serving mainly African American members of the Nashville community. Using a hammer and railroad spikes that he modified into chisels, Edmondson carved from limestone that he found in nearby quarries. A member of the United Primitive Baptist Church, his work was influenced by fundamentalist ideals. Edmondson's visionary work incorporates religious iconography including angels, doves, rams, Eve, Noah, and other biblical characters (*Angel*, c. 1932–1937, limestone, 18¼ × 13¼ × 7 inches, *above, front and back*). However, he also treated vernacular subjects such as Eleanor Roosevelt and black prizefighter Jack Johnson. His crudely detailed, abstract direct carvings share aesthetic qualities with European and American modernist sculpture.

PLATE 43

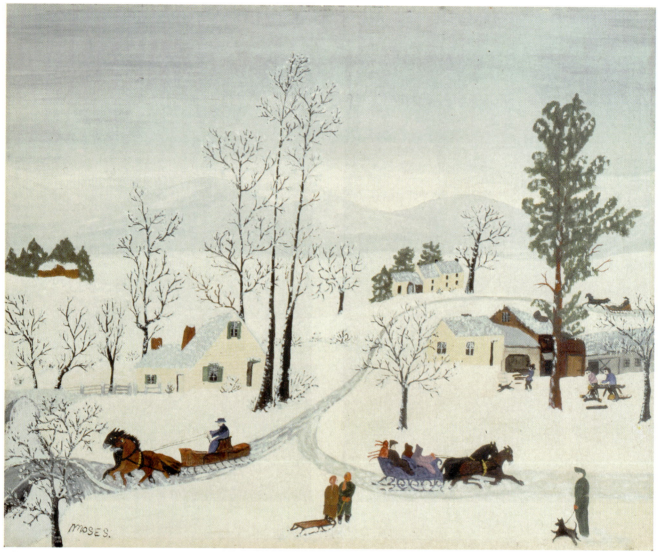

Collection American Folk Art Museum, New York. Gift of Galerie St. Etienne, New York, in memory of Otto Kallir, 1983.10.1. © 1969 (renewed 1997), Grandma Moses Properties Co., New York.

A paradigmatic figure of twentieth-century memory painting as well as an autodidact, Anna Mary Robertson "Grandma" Moses (1860–1961) memorialized a time and place untarnished by modernity. Born and raised in upstate New York, the daughter and wife of farmers, Moses began painting in her late sixties. Her pastoral vision and rural genre scenes generated a nationwide popularity and veneration that spoke to the postwar culture's desire for nostalgia, not unlike that of commercial artist Norman Rockwell (1894–1978). Moses drew upon remembered stories and images as well as popular prints, illustrations, and a scrapbook of collected motifs. In *Dividing of the Ways* (1947, oil on Masonite, 16 × 20 inches, *above*), the artist presents a winter rural scene with a remarkably able sense of composition, perspective, and naturalistic color.

PLATE 44

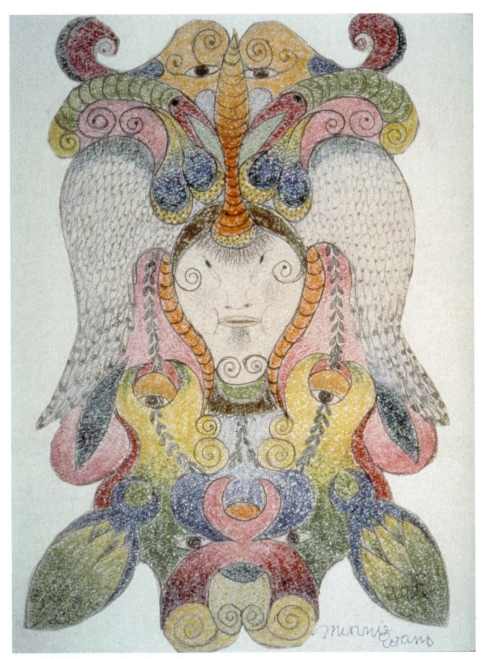

Photo courtesy Luise Ross Gallery, New York.

The work of visionary artist Minnie Evans (1892–1987) is the product of a woman who painted not for recognition or artistry, but because she claimed to have received a message from God. Evans worked for twenty-six years as a gatekeeper of a botanical garden near Wilmington, North Carolina—a lush environment that might have influenced her Edenic imagery. The source of her mixed media drawings—dreams and visions—is manifest in mythological and fantastical plant and animal forms, and Evans's work is closely tied to ancestral beliefs and psychic phenomena. The central motif is a vaguely human or animal face surrounded by foliate and rainbow-like patterns, often with multiple pairs of eyes, which she associated with the omniscience of God. Evans offered few explanations for her complex iconography, and historians cannot account for its resemblances to Caribbean, Chinese, East Indian, and Western elements of color and design. *Untitled (Face with White Wings)* (ink, pencil, crayon on paper, 12 × 9 inches, *above*) was executed in North Carolina around 1948.

PLATE 45

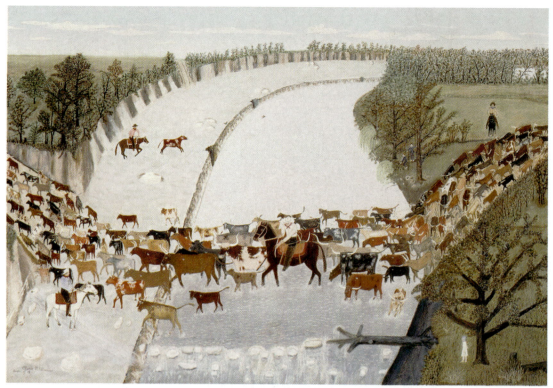

Collection American Folk Art Museum, New York, 1972.2.1.

Both Clara M. Williamson's *Get Along Little Dogies* (1945, oil on canvas, 26¾ × 39¾ inches, *top*) and Elijah Pierce's *Seeking Gold in the West* (c. 1950, carved and polychromed wood, 12 × 24½ inches, *bottom*) are depictions of narrative history based on memory. Williamson's autobiographical painting of herding longhorn cattle across the Texas river (the artist is depicted as a girl in the bottom right-hand corner) is a mosaic-like pattern of delicately modulated color harmonies. Although it was composed from memory, the picture suggests a vivid sense of observation. Pierce, a lay minister raised in the evangelical African American tradition, created a series of shallow bas-relief panels that he described as sermons or teaching tools. This particular panel—vividly painted in hues of yellow, red, blue, and brown—perhaps reflected the artist's own migration from his birthplace in Mississippi to Columbus, Ohio, where he owned his own barbershop.

PLATE 46

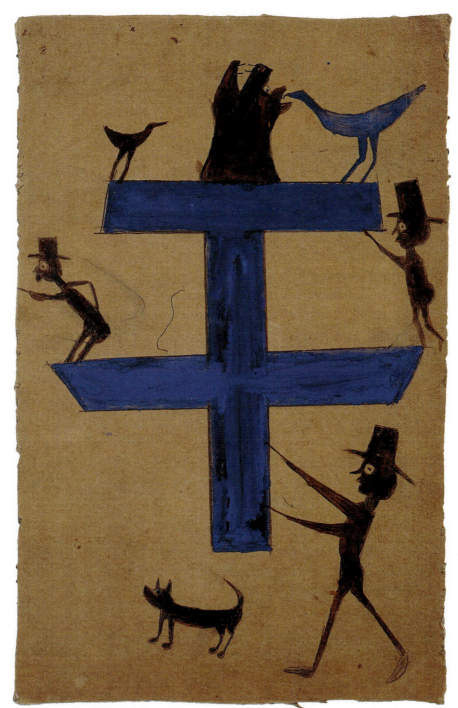

Photo courtesy Carl Hammer Gallery, Chicago, Illinois.

The work of Bill Traylor (1856–1949) remains the mysterious output of one of America's most celebrated outsider artists. A former slave, illiterate, and homeless on the streets of Montgomery, Alabama, in the years preceding World War II, Traylor existed on the periphery of mainstream culture. He did not begin painting until the age of eighty and produced 1,800 drawings using pencils, crayons, inks, and paper. Traylor rarely spoke explicitly about his abstract compositions, most of which revolve around a visual vocabulary of geometric shapes, iconic stick-like figures, crude animals (dogs, snakes, birds), and various combinations of these (*Construction with People and Animals*, c. 1939–1943, tempera, pencil on found cardboard, 12½ × 8 inches, *above*).

PLATE 47

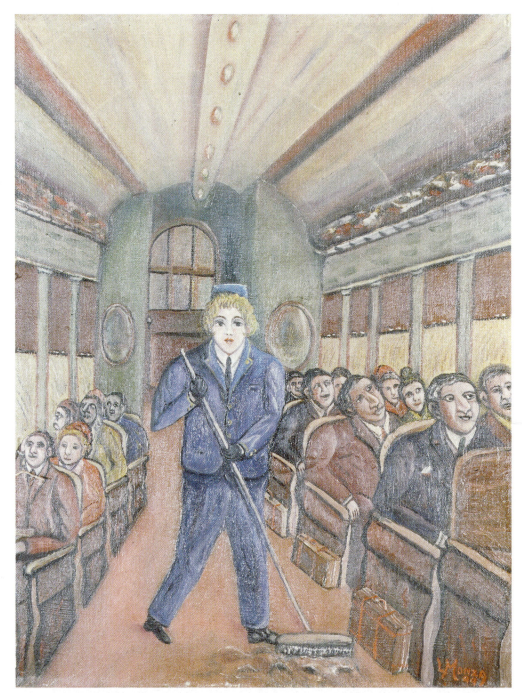

Photo courtesy Luise Ross Gallery, New York.

A stylistically versatile self-taught artist who worked in oils, printmaking, sculpture, and drawing, Italian-born Louis Monza possessed a highly personal and unique vision that eschews stylistic categories. Witnessing the final years of the Mexican Revolution (1915–1917) and service in the United States Army (1917–1919) left Monza a confirmed pacifist. He used his artwork as narrative and social commentary, attacking the abuses of the press, international governments, and industrialization. Although his themes were often political, his images might be fantastic and otherworldly, often with references to sexuality and mythology. *A Woman Sweeper on the Train* (1944, oil on canvas, 17 × 13 inches) reveals Monza's power of observation. Here a relatively prosaic scene of work is imbued with a psychological moodiness reinforced by its skewed spatial perspective.

PLATE 48

SAILORS' VALENTINES are ensembles of small sea-shells of various colors, mounted on an octagonal wooden backboard in a mosaic-like arrangement, and enclosed in a frame of mahogany or cedar, with a glass top. Typically, they vary in diameter from about eight to twenty inches (twenty to fifty centimeters). The mosaic is usually a geometric, floral, or heart motif, often accompanied by a sentimental motto or slogan (hence the appellation "valentine"), but seldom including any pictorial or figural content. Sailors' valentines are often double, consisting of two octagonal framed mosaics hinged together, so that they can be closed, with the glass panels facing one another on the inside, and the wooden backboards forming a protective box on the outside. This also enables double valentines to be displayed standing, like hinged double frames for photographs. Contrary to popular belief, sailors' valentines were customarily produced *for* sailors, rather than *by* sailors, primarily on Barbados, in the West Indies, where valentine-making was a cottage industry that began perhaps as early as 1830, and flourished during the second half of the nineteenth century. Barbados was a popular port-of-call for homeward-bound British and American merchant ships and South Sea whalers; most sailors' valentines of known provenance have associations with Barbados. Typical mottoes include "REMEMBER ME" and "GIFT FROM A FRIEND," but "GIFT FROM BARBADOS" also appears; the backs of some bear paper labels from curiosity shops in Kingstown, and an inventory identifying thirty-five species of seashells found in sailors' valentines corroborates their probable Barbadian origin. Several important examples. However, are well documented as having come from elsewhere: notably, a large double octagon with floral motif, purchased in June 1870 at St. Helena, in the South Atlantic, by whaleman Henry M. Hall of the New Bedford *Wave*. Variations include mosaics with *carte de visite* or postcard photographs, and others with personal names or external inscriptions. Other objects incorporating seashell mosaics are also referred to as sailors' valentines, such as small boxes and cases encrusted with shells. Another example often included in the category of sailors' valentines is a late Victorian genre of British sea-resort souvenirs consisting of a picture—usually a small colored lithograph of nautical interest, such as lifesaving heroine Grace Darling rescuing crewmen from a shipwreck in 1838—surrounded by a frame of seashells, surmounted by a glass plate or dome, sometimes including small starfish and other nautical bits, the whole usually circular, rectangular, or star-shaped.

See also **Maritime Folk Art.**

BIBLIOGRAPHY

John Fondas, *Sailors' Valentines*. New York, 2002.
Williams, Susan R. *A Gift from a Friend: Sailors' Valentines from the Strong Museum*. [exhibition catalog] Rochester, N.Y., 1988.

STUART M. FRANK

SAMPLERS, NEEDLEWORK, pieces of cloth, usually linen, embellished with letters, numbers, and/or embroidered motifs and designs, and worked in silk, crewel wool, or sometimes cotton thread, were made by young girls in Europe, from the sixteenth century, and probably before, as part of their education. This tradition was brought to America, where samplers were worked by schoolgirls all across the country from the seventeenth century until the mid-nineteenth century. In their simplest form, they were used to teach young women to mark and repair household linens. Decorative samplers, however, were intended to be displayed as evidence of the maker's skill with her needle.

The earliest known American example of a sampler—rows or bands of traditional designs as well as verse worked in cross-stitch using silk thread on a linen ground—was created by Loara Standish, who

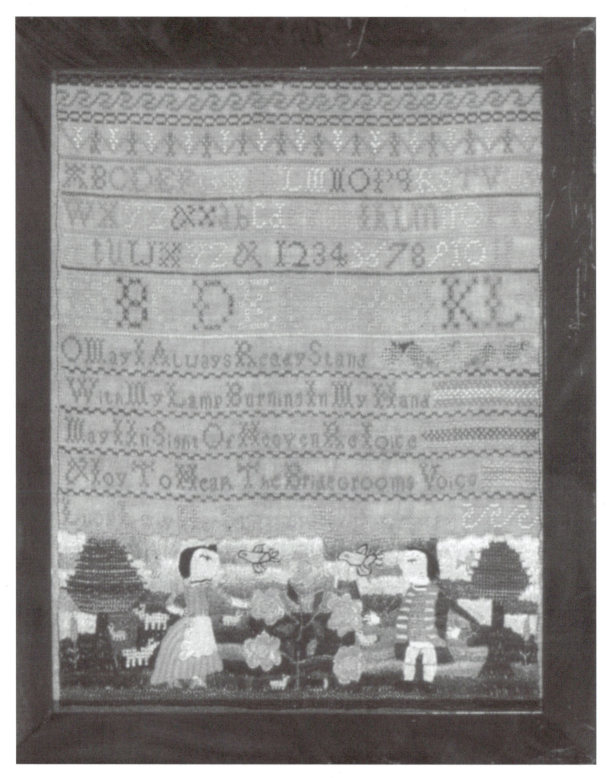

Lucy Low Sampler. Lucy Low (1764–1842). Danvers, Essex County, Massachusetts, 1776. Silk on linen. 14½ × 11⅜ inches. Collection American Folk Art Museum, New York. Promised Gift of Ralph Esmerian, P1.2002.285.

lived in Duxbury, Massachusetts in the 1640s. Samplers were most often produced at day and boarding schools, although some were worked at home. The patterns and designs were provided by the instructor and rarely reflected the individual creativity of the maker. The vocabulary of sampler motifs was international and often conventional. Motifs found in many nineteenth-century samplers, such as a vase of flowers, can be traced back to printed patterns or copybooks of the early seventeenth century. Other motifs were specific to particular places; for example, many American samplers include depictions of important buildings from the towns in which they were made.

A "marking" sampler, consisting of one or more series of alphabets and numerals worked in cross-stitch and sometimes including the maker's name and date of completion, would be the first that a young girl, sometimes only four or five years of age, would undertake. The girl would probably make more than one marking sampler, each subsequently increasing in its complexity of technique and design.

"Darning" samplers, a form of "plain" sewing whose purpose was to teach young women how to invisibly repair various types of household textiles, were also produced. In the seventeenth and eighteenth centuries, textiles were relatively expensive, and the value of household textiles and clothing could represent a large portion of a person's wealth. Thus the ability to repair these valuable belongings was considered an important skill. Sometimes also known as "needle weaving," darning stitches imitated woven and sometimes knitted patterns, to mend tears and holes in clothing as well as bed and table linens. While primarily functional, some darning samplers include the types of embroidered designs found in the more decorative samplers, and may have been intended for display.

In the eighteenth and early nineteenth centuries, young women whose parents could afford to continue their needlework education would make fancy samplers that might include alphabets, numerals, and verses, as well as elaborate borders, patterned bands, and pictorial elements, often mounted and framed for display. Needlework pictures were also part of a young girl's primary education. As such, what usually distinguishes a sampler from a needlework picture is the presence of alphabets, numerals, or verses. Other forms of samplers include map samplers and genealogical samplers.

Because the formats and designs were determined by the instructor, distinct regional styles developed, and recent scholarship has concentrated on the identification of these styles, as well as on the attribution of groups of samplers to specific schools and women's academies. Samplers were rarely worked precisely to match a particular design, but individual schools and regional preferences can be identified through comparisons of proportion, technique, and motifs.

The earliest identified stylistic groups are found in large, urban areas. A group of samplers that depict Adam and Eve have been identified as from Boston, in the 1720s, and, although the shape and composition of this group changed somewhat, the style is recognizable into the 1740s. In Philadelphia, a group of samplers worked at the school operated by Elizabeth Marsh (1683–1741) and her daughter, Ann (1717–1797), have been identified. During the 1720s this group consisted of "band" samplers, with traditional floral bands and simple borders, but another group worked at the same school has also been recognized. This group dates from the 1750s to the 1790s, and is square in format, with verses and floral sprigs worked in separate compartments and surrounded by a wide, decorative border.

Perhaps the purest form of the needlework sampler, as well as the rarest of American examples, is the "spot" sampler, consisting of a piece of cloth on which various embroidery techniques and designs were practiced. Spot samplers, usually produced anonymously, were intended to be kept as a record of designs and techniques. A few American spot samplers that were made with brightly colored Berlin wools worked in geometric patterns have survived from the second half of the nineteenth century. These were probably made by an adult as practice for stitches to be used to make various fancywork projects that were fashionable at the time, such as embroidered slippers, cushions, or table covers, and did not require the level of skill and practice that earlier samplers did.

The importance of samplers in women's education diminished after the development of indelible ink in the 1820s, and the practice almost completely vanished by the 1850s. In the early twentieth century, American women again began to make samplers, but rather than as schoolgirl exercises many of these were designed and worked by adults as both a conscious revival of past practices and as expressions of the makers' creativity.

See also **Pictures, Needlework.**

BIBLIOGRAPHY

Richter, Paula Bradstreet. *Painted with Thread: The Art of American Embroidery*. Salem, Mass., 2000.

Ring, Betty. *Girlhood Embroidery: American Samplers and Pictorial Needlework, 1650–1850*. New York, 1993.

Swan, Susan Burrows. *Plain and Fancy: American Women and Their Needlework, 1650–1850*. Austin, Tex., 1995.

LINDA EATON

SAN JOSÉ MUSEUM OF QUILTS AND TEXTILES, founded in 1977 as the American Museum of Quilts and Textiles by the Santa Clara Quilt Association, is recognized today as the first and oldest museum in the United States to focus specifically on the art of the quilt. The museum was a program of the Santa Clara Quilt Association until 1986, when it was incorporated as a nonprofit public-benefit museum and began to be administered under the direction of a community-based board of trustees. In 1998 the board voted to change the name of the museum so that it could compete more effectively for local public monies. It now receives funding from public sources such as the city of San José and the California Arts Council as well as from various foundations and private individuals.

A founding precept of the museum was that "textile art transcends cultural, ethnic, and age boundaries and encompasses traditional as well as contemporary forms." The museum's mission today is to promote the art, craft, and history of quilts and textiles; and its exhibits and programs are designed to give the public an expanded appreciation of quilts and textiles as art and to provide a better understanding of quilts and textiles as objects of material culture that not only reflect the lives of their makers and cultural traditions but also serve as important historical documents.

The museum collection comprises some 350 objects, gathered through donation and purchase. Included are 220 nineteenth- and twentieth-century quilts and 130 recently acquired ethnic textiles such as Japanese kimono, Mexican *huipils*, Indonesian batiks, Bedouin tunics, and embroidered East Indian garments. The East Indian pieces were assembled by the quilt artist Yvonne Porcella, who had used them as inspiration for the art she created in the 1980s. The museum's exhibitions are drawn from its own collection as well as from contemporary and historical quilts and textiles from around the world. The museum also maintains a reference library on quilt and textile history that is open to researchers and others with interests in this subject. It also has an active public programming component, offering workshops and lectures by experts for adults, and primary school educational programs that supplement the California school system's second-grade mathematics and language arts curriculum and fifth-grade history curriculum.

See also **Quilts.**

JACQUELINE M. ATKINS

SANCHEZ, MARIO (1908–) created polychromed wood bas-reliefs depicting Cuban-Americans in El Barrio de Gato, Cayo Hueso, an enclave in Key West, Florida, where he was born. At age twelve, Sanchez observed street life from his shoe shine stand next to his father's coffee shop. Over the years, he had many jobs, including one as custodian at the Art and Historical Society, and was exposed to local artists and artists sent to Key West by the Works Progress Administration during the depression.

Sanchez first made kites and carved fish and mermaids from driftwood. His polychromed carvings began as pencil sketches on grocery bags, transferred to wood with carbon paper. He used wood chisels, a mallet, broken glass and a razor blade to sharpen outlines, inexpensive paintbrushes, oil paint, and castor oil as a thinner. His detailed horizontal scenes, frontal and flattened with no spatial perspective, often took months to complete. In the 1990s he made dyptychs reflecting cultural changes: cigar makers—the Gato brothers—working at home, then a cigar factory; a dairyman selling milk from a cow on the street, then the modern truck of Magnolia's dairy; a fish peddler, Tomasita, with a cart and then a shop.

Sanchez's carvings are at the Tampa Museum of Art, Fort Lauderdale Museum of Art, and Fenimore Art Museum (Cooperstown, New York). In 1995, the state Folklife Festival commissioned Sanchez to carve the symbol for Florida's sesquicentennial.

See also **Sculpture, Folk.**

BIBLIOGRAPHY

Frank, Nance. *Mario Sanchez Before and After*. Key West, Fla., 1997.

Proby, Katherine Hall. *Mario Sanchez: Painter of Key West Memories*. Key West, Fla., 1981.

Rosenak, Chuck, and Jan Rosenak. *Museum of American Folk Art Encyclopedia of American Folk Art and Artists*. New York, 1990.

Rothermel, Barbara. "'I Paint What I Remember': The Art of Mario Sanchez." *Folk Art*, vol. 21 (fall 1996): 42–48.

LEE KOGAN

SANDPAPER PAINTINGS are drawings in charcoal or pastel, coated with marble dust to give a sandpaper-like appearance with sparkle and texture. Sandpaper paintings were most popular and most widely produced and marketed during the mid-nineteenth cen-

tury. They usually depicted American landscapes and historical events; these scenes were often copied from prints of the period, but the sandpaper paintings surpassed the prints in vitality, boldness, and singleness of expression. In the mid-ninteteeth century, alternative, though less popular, names were also applied to sandpaper paintings: "Grecian painting," "monochromatic painting," "monochromatic drawing," and others. Langdale prefers the term "sandpaper drawings," arguing that "the majority of the works are done in black and white and the media used are primarily drawing materials."

The accessibility of sandpaper painting is evident in this description, from an article in the *Montgomery* (Alabama) *Journal* in the 1840s: "It is within the power of any person, old or young, or ordinary capacity, to acquire this art in such perfection as to be able to produce a picture, that shall almost rival a Mezzotint in its mellowness, beauty, and delicacy." The form was heavily promoted by itinerants, especially Silas Wood Jr. (1816–1885), who traveled widely and encouraged the residents of targeted towns to attend his open lectures on the fine arts, view his traveling "Gallery of Original Painting," subscribe to his series of lessons, and purchase his sandpaper painting materials. The form was also promoted by B.F. Gandee's book *The Artist or, Young Ladies' Instructor in Ornamental Painting, Drawing, Etc.*, published in 1835 in both London and New York.

Sandpaper painting was also taught in the many local academies and seminaries in America in the 1850s. Holton and Holton reviewed published materials and curricula and found that while young ladies produced the preponderance of sandpaper paintings, this art was practiced by "boys and girls, men and women, amateurs and professionals." According to Holton and Holton, the acclaimed American artist Albert Bierstadt (1830–1902) was an instructor in this medium and won several competitions. Another recognized American artist, Thomas Almond Ayres (c. 1816–1858), used sandpaper paintings for his illustrations of the growth of California and the development of San Francisco. Holton and Holton describe the process of sandpaper painting as follows: "[A] drawing board was coated with white paint and, when not quite dry, pulverized marble was sifted through fine muslin to coat the entire surface. . . . The artist then applied charcoal (or less frequently, pastel) in stick and powder form, creating the basic shapes of the intended image. To achieve soft lighting and definition, the artist carefully left areas of the painting untouched or gradually removed charcoal with an eraser or a piece of leather. To create sharp details and contrasts, the artist scraped away the charcoal with a knife."

BIBLIOGRAPHY

Elliott, Melvin. "Drawings on Sandpaper." *Spinning Wheel* (July–August 1974): 18–20.

Flexner, James Thomas. "Monochromatic Drawing: A Forgotten Branch of American Art." *Magazine of Art*, vol. 38, no. 2 (February 1945): 62–65.

———. "Moonlit Mysteries." *Art and Antiques* (September 1988): 95–97, 136.

Holton, Randall, and Tanya Holton. "Sandpaper Paintings of American Scenes." *The Magazine Antiques*, vol. 150 (September 1996): 56–365.

Langdale, Shelley R. "The Enchantment of the Lake: The Origin and Iconography of a Nineteenth-Century Sandpaper Drawing." *Folk Art*, vol. 23, no. 4 (winter 1998–1999): 52–63.

Lowrey, Bates. *Looking for Leonardo: Naïve and Folk Art Object Found in America by Bates and Isabel Lowrey*. Iowa, 1993.

WILLIAM F. BROOKS JR.

SANTERÍA. The arts of the Afro-Cuban Santería and Ifá religious practices gain their significance within the setting of altar assemblages and ritual performances. These sacred arts carry symbolic and functional value, but they are also evaluated and appreciated by participants in ceremonies for their appropriateness and beauty. Santería arts express meanings that refer to the gods; at the same time, the very creation of these sacred arts is considered an act of devotion.

Santería arts, given the migration of Cubans throughout North, Central, and South America, Western Europe and Russia, as well as the ongoing initiation into Santería and Ifá of multitudes of visitors to Cuba, are found throughout the world, mostly in ethnically-diverse coastal cities. Throughout the United States, Cubans have initiated Americans of all stripes, especially African-Americans and members of all of the Latino groups. As a result, Santería arts are seen in *botánicas* (urban religious goods outlets) and make up the altars of "house-temples" (*casa-templos*) in all of New York City's boroughs, in the New Jersey towns lining the Hudson River in the north, and around Atlantic City and Camden in the south. On the Atlantic seaboard, from Boston through Philadelphia to South Florida, on the Gulf Coast, from New Orleans to Houston, in all of California's major coastal cities, in Seattle, and in Detroit, Chicago, and Gary, Indiana, Santería arts are also found.

Soperas, literally "soup tureens," are used to contain the deepest secrets of the *orishas* (deities) of the African Yoruba-Lukumí pantheon ("Santería" being the name applied to this traditional Yoruban religion

in Cuba). Afro-Cuban remodelings of Yoruba *orisha* pots made of clay, calabash, or wood, include bisque-fired and painted terracotta dishes and lidded water pots (*tinajas*), iron cauldrons, lathe-turned cedar containers, and soup tureens made of fine porcelain or its imitations.

The *orishas'* fundamental secrets consist of consecrated stones, which are carefully chosen for their smoothness, fecund roundness, particular natural colors, and quantities that are appropriate to each *orisha*. Lidded vessels containing stones reiterate the Yoruba idea of the cosmos as a lidded calabash, where stones recall the earth and the heads of individuals: in other words, seats of unmatched stability and creative agency, respectively. Stones within lidded vessels embody the *orishas' ashé*, or spiritual power of command—that is, power drawn from raw, living sources in the natural world (the sun, fire, lightning, rivers and oceans, the land, and its flora and fauna), and contained and controlled within shrines for human benefit. *Herramientas* are miniature "tools" of metal or wood that are kept in the vessels with the stones. They enable the *orisha* to perform particular kinds of spiritual work. They represent what an *orisha* does in its transformation of the world and human lives.

Attributes iconographically appropriate to particular *orishas* are arranged in groups on and around the *soperas* (containers of *ashé*) in the domestic shrine cabinet (*canastillero*), a type of armoire. They include objects made in a range of media, such as intricate sashes of multiple bead strands (*collares de mazo*), dance wands, fly whisks, fans, axes, machetes, and hooked staffs. These attributes are worn or carried by the *orishas* when they make themselves present in semi-public events, such as when the newly initiated are presented to the community in public celebration, appearing dressed in the *orisha's* sacred clothes under a canopied throne with the appropriate dance wand in hand. During drumming events, the *orishas* make themselves present through spirit possession, in which they "mount" (possess) their priests. As living embodiments of the *orishas*, mounted priests are changed into their respective *orishas'* clothes, and then dance and perform healing.

All *orisha* objects achieve their appropriateness through patterns of color and number, their particular materials, and iconographic elaboration in the form of symbols. Given the *orishas'* status as "kings," "queens," and deified "warriors," their attributes require prodigious beadwork and luxurious fabrics, though objects for the warriors, such as Eleguá and Ogún, as well as *orishas* of the earth (Babalú Ayé and Orisha Oko), receive natural and rustic treatment. For example, Yemayá, the mother of the world, seen in the vast oceans that embrace the land, receives beadwork attributes in blue and white, typically in the form of round- and teardrop-shaped fans, which are associated with salt water, coolness, fecundity, and oscillating movements. Her lead tools, which are, appropriately, resistant to corrosion, include oars, ships' wheels, anchors, propellers, and miniature suns and moons. These refer to the life-giving maritime vocations of the sea and Yemayá's wide ranging relationships with the heavens. Shangó, the archetypal king of the African Oyo-Yoruba empire, and *orisha* of thunder, fire, and "problems," lives in a cedar vessel atop his permanent throne, an hour glass-shaped mortar. In Cuba, cedar, a wood that is reddish in color and from a tall, hard tree, is thought to have masculine properties. Shango's mortar form refers to his thunderous *batá* drums, royal castle tower, and phallus "lightning rod," as well as the procreative mortar and pestle technology itself, which transforms nature or natural substances, such as grains and herbs, into life-giving nourishment. Shangó's mortar serves as an initiatory seat and orienting *axis mundi* upon which new priests are consecrated. Shangó's dance wand, often placed upright upon his head, is a beaded or painted double thunder ax in red and white, that refers to the fiery celts he hurls from heaven, the problems he creates for his enemies, and the problems he carries away from his followers. If red signifies Shangó's raw fire, white marks his submission to and control by the authority of his father, Obatalá, the pure and calm arch-*orisha* of the pantheon, who creates and rules all "heads," the seats of individual agency and intelligence that nevertheless, must give way to the authority of elders through demonstrations of deference and respect. Obatalá carries a stately white fly whisk, wears white garments, and is associated with such calming and healing substances as white cocoa butter, cotton, and white chalk; in contrast, Shangó is offered red palm oil as are other *orishas* of action and war, such as Eleguá, Ogún, and Oyá.

Honorific regalia of beadwork sashes and attributes adorn the *soperas* and complete the costume ensembles worn by the *orishas'* earthly representatives, the priests (*olorishas, iyalorishas, babalorishas*), who carry the *orishas' ashé* in their heads and bodies.

When newly consecrated initiates to Santería are first presented to the community in a public celebration called the "*Día del Medio*" (Middle Day) and when elder priests are mounted by their respective

orishas in "drummings," they dress in regal garments of satin (*ropa de santo*, or sacred clothes), that are adorned with cowrie shells, metallic braid, and lace. Yemayá's ensemble is a flowing, layered, blue, puff-shouldered gown made in an eighteenth-century aristocratic style, often with appliqués of nautical imagery in white and silver. Shangó wears a loose, belted, red jacket with accents of white and gold fastened military style at the side of the chest, and a skirt of six hanging lappets appliquéd with his thunder axes. All of the *orisha* kings, queens, and warriors wear satin and braid on festival occasions. In Cuba, this aesthetic of luxury in clothes and festival altars derives from the baroque splendor of the churches, and the sartorial display of both the white nobility and the royal rulers of the African *cabildos* (clubs or societies) during the colonial period. Although all of the *orishas'* share in the royal aesthetic, their head gear, dance wands, and thrones nonetheless register their contrasting vocations. For example, Yemayá and Shangó wear the shell- and bead-encrusted royal crowns appropriate to the king's palace. The archetypal warriors, Eleguá, Ogún, and Oshosi, wear the sombreros of outdoorsmen, farmers, soldiers, and hunters. They carry the animal skin provision bags of itinerants, wield the more rustic implements of work and war—hooked wood staffs, machetes, bows and arrows—and make their thrones not with Shangó's refined mortar, but with heavy stones or tree trunks.

Throne installations built for priestly initiations, drummings given to honor a particular *orisha*, and other semi-public festivals, such as the "birthday" (*cumpleaños*) or anniversary of a priest's initiation, dramatically mark these differences. For example, *orishas* of the royal palace repose under resplendent canopies in the *orishas'* counterpointed colors made in satin, lace, velvet, and chiffon. Stunning square blazons of satin or silk, accented with sequins, cowries, and embroidery, called *paños*, adorn the throne's curtained space, and cover the *orishas' soperas*. In contrast, the warrior's thrones, built from fresh green boughs stapled to wood and wire frames, recall the improvised, natural shelters of hunters or soldiers on campaign.

Thrones and domestic *orisha* cabinets are sacred assemblages built around the powerful core of the deities' secrets. They are points of spiritual orientation and portals for sacred communication. Through prayer, offerings, and, occasionally, drummings, priests sacrifice something in order to transform their lives, a practice known as "making *ebó*." Since offerings vary greatly and consist of ingredients that the *orishas* "prefer," the making of *ebó* can include art-

work, such as lovingly made dance wands, *paños*, bead sashes, and thrones. Indeed, cloth typically functions in Santería as a spiritually cleansing medium, and in the context of the throne, it protects vulnerable new initiates from intrusive or malevolent influences. Therefore, Santería spirituality is embodied in and through art making. Objects based on *orisha* iconography, including color and representational design, express and identify spiritual forces. At the same time, art making, a conscientious act of creation for the *orishas*, in a word, a gift, is, in itself, a devotional act.

In Cuba, *babalawos*, the diviners of the Ifá oracle, who work with the *orisha* Orunmila (also called Orula), have practiced for at least 175 years. The tray (*atepón* or *tablero*) and other divining equipment of *babalawos* mark the difference between what has been identified by scholars as "Santería" since the late 1930s (more properly called Lukumí or La Regla de Ocha) and La Regla de Ifá (the Order of Ifá). Master carvers have produced cedar and mahogany trays that are sixteen inches in diameter, along with multifarious sculptural and functional figures, tools, masks, and *batá* drums, at least since *babalawos* entered the Afro-Cuban oral history around the mid-1830s. Although they are not always elaborately decorated in sculptural low relief, as Yoruba trays are, Afro-Cuban examples are typically incised at the four cardinal points with a cross, a skull, the sun, and the moon (north, south, east, and west, respectively), and decorated with floral designs in gold leaf.

Carvers also fashion statuettes in cedar and other hard woods, called *aworán* (from the Yoruba for "image"), which represent Osain, Shangó, Olokun, the multifarious Eshús (the counterpart of Eleguá) associated with particular *odus* (signs) of Ifá, as well as the tools of the *babalawos'* Olokun and Oro liturgies. These forms include Janus figures called *modubela* (Eshú); half male, half female figures called *meyisos* (for Olokun and Oro); a disfigured one-eyed, one-armed, one-legged figure (representing the herbalist Osain after his cataclysmic battle with the warrior-king Shangó); and the latter, as a fierce-looking male warrior-king with a thunder axe sprouting from his head. Between seven and nine inches tall, these figures feature capped cavities upon their heads so they can be "charged" with secret herbal ingredients (*carga*). Unlike artwork intended for display, they remain unpainted or unvarnished so that they can "eat" sacrificial offerings.

Masters known among Havana *babalawos*, such as Shangó priest Juan Arrencívia, make the tools carried by special *orishas* and other powers. These include

the royal head of Olokun, which is fashioned in cedar in the style of ancient, bronze Ifè-Yoruba heads, and this *orisha's* nine miniature masks representing ancestors (*egun*). Equally mysterious are the "tools" of the *babalawo's* Oro liturgy. Arrencívia makes bull-roarers that consist of a small flat cedar tablet, often shaped like a fish, which is gyrated on a cord, producing a whirring sound, a practice recalling those of the Yorùbá Oro Society of important judicial function.

Like the objects dedicated to the *orishas*, the arts of Ifá also come in ensembles and are used in concert with the complex Ifá liturgy. The Ifá divination tray is accompanied by a fly whisk (*iruke*) signifying Orunmila's authority, a deer horn divination tapper (*irofá*) to invoke the ancestors who will contribute their wisdom to the divination session, and a small brush (*brocha*) to spread divination dust (*yefá*) over the surface of the tray, in which the *babalawo* marks the *odus* of Ifá. The fly whisk, tapper, and brush are beaded in Orunmila's colors, yellow and green. The wood tools of Olokun are contained in a huge, deep, terracotta water vessel that is encrusted with shells containing secret medicines. And the carved wood figurines, *aworán*, are incorporated into larger assemblages, as they are set into clay dishes with cement, adorned with cowries, and added to altars.

See also **Religious Folk Art; Vodou Art.**

BIBLIOGRAPHY

Barnes, Sandra, ed. *Africa's Ogun: Old World and New.* Bloomington, Ind., 1989.

Bascom, William. *Shango in the New World.* Austin, Tex., 1972.

Brown, David H. *Santería Enthroned: Art, Ritual, and Innovation in an Afro-Cuban Religion.* Chicago, 2003.

———. "Thrones of the Orichas: Afro-Cuban Altars in New York, New Jersey and Havana." *African Arts*, vol. 26, no. 4 (October 1993): 44–59, 85–87.

Flores-Peña, Ysamur, and Evanchuck, Roberta J. *Speaking without a Voice: Santería Garments and Altars.* Jackson, Miss., 1994.

Lindsay, Arturo, ed. *Santería Aesthetics in Contemporary Latin American Art.* Washington, D.C., 1996.

Mason, John. *Olóòkun: Owner of Rivers and Seas.* Brooklyn, N.Y., 1996.

Mason, Michael. *Living Santería: Rituals and Experiences in an Afro-Cuban Religion.* Washington, D.C., 2002.

Thompson, Robert Farris. *Flash of the Spirit: African and Afro-American Art and Philosophy.* New York, 1983.

DAVID H. BROWN

SANTEROS are makers of images of saints, known in New Mexico as *santos*. The Spanish term *santero* has several meanings, the primary one being the person who takes care of an altar or sanctuary. In colonial and nineteenth-century Mexican and New Mexican documents the term is not used for an artist; rather, the most common terms are *imaginero*, *maestro de arte* (or *de pintar*, of painting; or *de tallar*, of carving), *escultor* (sculptor), and *pintor* (painter). Only after about 1925 did the term *santero* as a maker of images of saints become current in New Mexico, perhaps in part through the influence of Anglo-American collectors and writers.

The art of the *santero* flourished in New Mexico from about 1750 to 1900. During this period *santeros* developed a distinctive folk style of both painting and sculpture that in many ways ignored academic conventions of the time and harked back to the spiritualized hieratic art of the Middle Ages. In New Mexico the *santeros* were often itinerant, making images for churches, brotherhood meeting houses (*moradas*), and families throughout a region near their home. They made new pieces but also retouched, restored, and sometimes completely repainted older pieces. Like the monastic painter of the Middle Ages, the *santero*, because he made sacred images, was expected to be a virtuous man. This idea was expressed by an Hispanic elder interviewed in 1940, who stated that the *santero* often was also the *rezador*, the most respected lay spiritual leader of the community. The art of the *santero* was a communal art based on traditional norms inherited from the long European Catholic tradition. In this the *santero* was markedly different from many eastern American folk painters and sculptors whose work tended to be more idiosyncratic.

In the seventeenth century the mission churches of New Mexico were furnished with sculpture, paintings, and altar screens imported from Mexico. Early inventories show many imported works, as well as numerous engravings on paper, all of which served as inspiration for the later *santeros*. However, even at this early date there is evidence that local artists, probably Indians working under the direction of a friar, made pieces for the churches. Some missions without imported altar screens had decorations and even images painted directly on the walls of the sanctuary by local artists; others had individual paintings on canvas or hide. The earliest surviving paintings from New Mexico are a series of works on deer, elk, and buffalo hides made in the late seventeenth century and the early eighteenth. However, it is not certain that they were actually painted in New Mexico; they may have been painted in mission establishments in Mexico and sent north for the New Mexican churches.

By the mid-eighteenth century New Mexico was no longer so well supplied by the Franciscan establishments in Mexico; the threat of incursions by nomadic Native Americans had been greatly reduced; and the Hispanic population had begun to increase, with the founding of many outlying communities in areas formerly vulnerable to attack. These factors combined to create a demand for more locally made religious art. Churches that were built in new Hispanic communities did not receive the same attention as the Native American missions had received in the previous century. The detailed inventories of New Mexican churches made by Father Francisco Atenacio Domínguez in 1776 contain, along with imported objects, many locally made pieces of sculpture and paintings. Soon after this time the first folk *santeros* began to work. The extensive work of the Laguna Santero (done from c. 1795–c. 1808) began a move away from academic art and provided inspiration for succeeding *santeros*, such as Molleno (active c. 1815–1845), José Aragón (active c. 1820–c. 1835), José Rafael Aragón (c. 1796–1862), the Santo Niño Santero (active c. 1830–c. 1850), the Truchas Master (active c. 1780–c. 1840), the Quill-Pen Santero (active c. 1830–c. 1850), the Arroyo Hondo Painter (active c. 1825–c. 1840), and the Arroyo Hondo Carver (active c. 1830–c. 1850).

After 1850, owing to the easy availability of color prints and polychrome plaster-cast sculpture from commercial sources in the eastern United States, the art of the *santero* began to die out. However, a number of carvers continued to make large pieces for lay brotherhoods into the early 1900s.

In the 1920s a revival of painting and carving began, but the work was made primarily for sale to outsiders. Since the 1970s a new revival has been more culturally based, and *santeros* and *santeras* produce pieces in both traditional and innovative styles. It is likely that in the nineteenth century and earlier, because of the traditional gender-based division of labor, few women made *santos*. Surviving documentary evidence provides only the names of men as *santeros*. Since the 1970s, however, a number of *santeras* have emerged who produce excellent work in both painting and sculpture.

See also **José Aragón; José Rafael Aragón; Arroyo Hondo Carver; Bultos; Death Carts; Juan Miguel Herrera; Laguna Santero; Molleno; Religious Folk Art; Retablos; Santo Niño Santero; Truchas Master.**

BIBLIOGRAPHY

Boyd, E. *Popular Arts of Spanish New Mexico.* Santa Fe, N. Mex., 1974.

Wroth, William. *Christian Images in Hispanic New Mexico.* Colorado Springs, Colo., 1982.

———. *Images of Penance, Images of Mercy: Southwestern Santos in the Late Nineteenth Century.* Norman, Okla., and London, 1991.

WILLIAM WROTH

SANTO NIÑO SANTERO (fl. c. 1830–c. 1860) was a painter and sculptor of religious images in northern New Mexico. His name derives from the large number of images of the Christ Child (Santo Niño) attributed to him. His identity is not known, but it is likely that he was José Manuel Benavides, who was a woodworker and sculptor associated with the *santero*—or painter and carver of figures of saints—José Rafael Aragón. Benavides is mentioned in 1842 in an accounting document from the church of Santa Cruz de la Cañada as receiving payment for altar screen images and for a *bulto*, or polychrome wooden statue of Christ crucified, which is still in the church and has been identified as being in the style of the Santo Niño Santero. This artist worked in or near the villages of Santa Cruz and Cordova and most likely worked for a time with Aragón, who may have been his teacher. A few surviving *retablos* (altar screens) show characteristics of both artists. However, the Santo Niño Santero soon developed his own distinctive style. His paintings are notable for their simplicity and abstract backgrounds. They have little of the space-filling decoration used by Aragón, and the simplified central figure often seems to float naively in an undefined background. The Santo Niño Santero did not paint narrative scenes but specialized in small devotional images of the more popular saints and holy persons in New Mexico, such as San Miguel, San Ramón Nonato, and Nuestra Señora de los Dolores.

A series of sculptures is also attributed to this artist. Decorative motifs and colors used in his paintings, including an unusual brown micaceous paint, are also found on a number of small finely done *bultos*. The only other New Mexican *santero* to use this paint was José Rafael Aragón, and some of the sculptural pieces also have carved details in the style of Aragón, suggesting that the two artists worked together in the same workshop. These skillfully done pieces are similar to but surpass the sculptural work of Aragón in their delicate modeling, harmonious proportions, and attention to detail. They are closer to naturalism than those of Aragón yet still portray idealized human

types. This body of work stands out as the finest in skill and technique among nineteenth-century New Mexican folk artists. A few derivative pieces of both painting and sculpture exist, suggesting that the Santo Niño Santero probably had a small workshop or a family member helping him.

See also **José Rafael Aragón; Bultos; Retablos; Santeros.**

BIBLIOGRAPHY

Boyd, E. *Popular Arts of Spanish New Mexico.* Santa Fe, N. Mex., 1974.

Esquibel, José Antonio, and Charles Carrillo. "Confirming the Identity of the Santo Niño Santero: José Manuel Benavides, Escultor, c. 1798–1852." *Tradición Revista* (fall 2002): 48–58.

Vedder, Alan C. "Establishing a *Retablo-Bulto* Connection." *El Palacio*, vol. 68 (1961): 83–86.

Wroth, William. *Christian Images in Hispanic New Mexico.* Colorado Springs, Colo., 1982.

WILLIAM WROTH

SANTOS: *SEE* BULTOS; RETABLOS; SANTEROS.

SARLE, CORA HELENA (1867–1956), a member of the Shaker community at Canterbury, New Hampshire, was a landscape and decorative painter for much of her adult life, the quiet village and its natural environment being her invariable subject. Sarle's best known paintings are postcard-size studies of Canterbury's 1792 Shaker meetinghouse that were intended for sale in the community's store, but she also created more ambitious, larger-scale works, often as gifts. Resourceful and creative, she painted on canvas, Masonite, paper, board, and on all sorts of small objects (including Band-Aid boxes), using oils or watercolors as her medium. For many years she maintained a studio in the village's Sisters' Shop.

Born in North Scituate, Massachusetts, Sarle entered the Shaker community in 1882 at the age of fifteen, when the community was enjoying a late nineteenth century flowering under such leaders as Elder Henry C. Blinn (1825–1905) and Eldress Dorothy A. Durgin (1825–1898). With Blinn as her mentor and guide, she created two botanical journals in 1886 to 1887, rendering the wild plants and flowers of the village and its woods and fields in delicate watercolors. Although she was untrained as an artist, these studies are remarkably skillful and well composed. With Blinn's notes about the habitat and properties of each illustrated plant, the botanical journals were published in a facsimile edition in 1997.

About 1920, Sarle began to decorate utilitarian objects (ceiling light globes, an umbrella stand, boxes and other objects) for use within the Shaker village. By then, earlier Shaker scruples against ornamentation had long been relaxed, and it was possible to introduce floral and landscape painting into a Shaker environment without violating community norms. Sarle—who was known by her second name (Helena)—was also a gifted musician, singing as a member of Canterbury's "Qui Vive Quartette," that performed publicly in New England in the late nineteenth and early twentieth centuries, and playing the cornet in the community's orchestra.

See also **Architecture, Vernacular; Henry Blinn; Painting, Landscape; Shaker Drawings; Shakers.**

BIBLIOGRAPHY

Kirk, John T. *The Shaker World: Art, Life, Belief.* New York, 1997.

Sarle, Cora Helena. *A Shaker Sister's Drawings: Wild Plants Illustrated by Cora Helena Sarle.* New York, 1997.

Swank, Scott T. *Shaker Life, Art and Architecture.* New York, 1999.

GERARD C. WERTKIN

SAVERY, REBECCA SCATTERGOOD (1770–1855) is associated with six quilts produced between c. 1827 and c. 1852. The daughter of John and Elizabeth Head Scattergood, her family had moved to Philadelphia in the late seventeenth century. Her father-in-law, William Savery (d. 1787) was apprenticed to the chair maker, Solomon Fussell, and eventually made high style chairs. Her husband Thomas Savery (1751–1819) became one of the premier cabinet makers of Philadelphia. Raised in an atmosphere of well-made and beautiful furnishings, Savery and her husband were active members of the Philadelphia Yearly Meeting of the Society of Friends.

It is assumed that Savery conformed to the social practices of her generation of Quaker women, and sewing was high on the list activities. As pieced, quilted bed coverings became the decorative needlework of choice in the second quarter of the nineteenth century, Quaker women participated in the trend. Three of the six quilts attributed to or associated with Savery are made in the Sunburst pattern, and three are Friendship quilts, made by a group of women. All utilize English roller printed cotton fabrics and wool batting. There are 175 names inked on the Friendship quilts, along with extraordinary inked drawings.

None of the quilts bear signatures, but one quilt in the collection of the Philadelphia Museum of Art car-

ries a hand-lettered cloth tag stating that it was "Made for mother by my great-grandmother, Rebecca Scattergood Savery, 1839." Another quilt at the Winterthur Museum has a similar tag and family provenance. The two quilts now in the collection of the American Folk Art Museum were discovered in 1979 in a wardrobe formerly belonging to one of Savery's great-great granddaughters. Another quilt, still in Savery family hands, has a clear provenance connecting it to the family. The sixth quilt, sold at auction in the 1990s to an owner that is unknown, lacks a firm genealogical trail, but its construction, materials, and appearing on the quilt names suggest that it belongs in the pantheon of Savery quilts.

See also **American Folk Art Museum; Chairs; Furniture, Painted and Decorated; Philadelphia Museum of Art; Pictures, Needlework; Quilts; Religious Folk Art; Samplers, Needlework; Winterthur Museum.**

BIBLIOGRAPHY

Forman, Benno M. "Delaware Valley 'Crookt Foot' and Slat Back Chairs: The Fussell—Slavery Connection," *Winterthur Portfolio*, vol. 15, no. 1 (1980): 41–64.

Savery, Addison Hutton, and Francis Richards Taylor. *A Genealogy and Brief Biography of the Savery Family of Philadelphia*. Philadelphia, 1911.

Sherman, Mimi. "A Fabric of One Family: A Saga of Discovery." *The Clarion* (spring 1989).

MIMI SHERMAN

SAVITSKY, JACK (1910–1991) worked as a miner for more than thirty years in eastern Pennsylvania. This experience is reflected in his paintings and drawings of trains, coal mines, the men and boys who worked in the mines, and the surrounding landscape. Though Savitsky's drawings and paintings depict repetitive and backbreaking activities, his lively representations emphasize a communal work experience in the mines, rather than one full of drudgery and hopelessness. Religion and patriotism are also among Savitsky's predominant themes.

Savitsky was born in New Philadelphia, Pennsylvania, to immigrant parents from Russia and Poland who settled in the mining area of eastern Pennsylvania in the late nineteenth century. At age twelve, when he completed the sixth grade, he found full-time work, like his father, in the mines at the Kaska Colliery near Pottsville, Pennsylvania. Starting as a slate picker, he became a contract miner in the 1940s and continued to work in No. 9 Colliery in Coalville, Pennsylvania, until the mine closed in 1959. Inter-

ested in art from his childhood years, he had little time to paint, nor was he encouraged to develop his interest. But during the 1940s, while he continued to work in the mines, he began to moonlight as a sign painter and painter of barroom murals.

When Savitsky left the mines, he was suffering from black lung disease and emphysema. Accustomed to working hard all his life, he started to paint, at the suggestion of his son, to help with his restlessness during his retirement. He used pencil, marking pens, pen and ink, charcoal, colored pencils, and pastels to make thousands of drawings, and he used oils and acrylic paints on canvas, board, and Masonite to produce about eight hundred paintings in sizes which ranged from a few inches to four feet. He recycled cardboard and cut up cereal boxes for some of his smaller drawings.

Savitsky's earliest works are not signed, but when he began signing his work, often only with his last name, he unintentionally made it difficult to date his works, because he usually added his signature long after the work was completed. Sterling Strauser, who represented Savitsky for many years, remembered that when Savitsky was hospitalized in 1973, he vowed that if he survived, he would sign his works with his signature followed by three dots representing "the Holy Trinity." Many of his later works bear this signature.

Savitsky's work changed over the years, from a representational style in his early murals to a flat cartoon-like style, with little attention paid to shading in his later work. His pictures demonstrate confident draftsmanship, flattened perspective, and formal abstraction within a representational framework. His paint application is generally smooth, but occasionally it is deeply textured to create movement and depth, and to enhance the mood of his subject. Thick paint applied with a palette knife is often effectively applied in the sky and the ground areas. He outlined his shapes before filling them with bright, pure color, and in some of his more complex compositions he added decorative, pictorial borders filled with images of houses, churches, animals, or miners. His paintings are lively and their interest is enhanced by a rhythmic repetition of images. Among his more intriguing works are several sensitive self-portraits of the artist as a miner. His later works, while incorporating his distinctive repetitiveness, are somewhat decorative in their impact.

In a major painting, *Sunrise*, Savitsky paints a townscape at daybreak. Twenty-six identical dwellings are laid out in a horizontal row, bounded on

each side by larger buildings, with a church at one end and a school at the other. In the foreground, a symmetrical band of grass sways toward a central axis, providing a walkway for a ribbon-like procession of figures in profile—men, women, children, even dogs—following a man in a horse-drawn wagon. A textured, golden sun at the horizon line with radiating, patterned rays occupies three-quarters of the compositional space. Savitsky's description on the back of the painting sheds light on his life of routine, and that of his fellow miners: "Sunrise in the coal region/I went to school/ I went to work/And on payday, I went and got drunk."

Savitsky's paintings provide an authentic record of an important era of social history in the United States, and of the lives of the miners who formed an essential part of the American working class in the early twentieth century. They also document the experience of immigrants and the importance of community life to people starting new lives in America.

See also **Painting, American Folk; Sterling Strauser.**

BIBLIOGRAPHY

Hemphill, Herbert W. Jr., and Julia Weissman. *Twentieth Century American Folk Art and Artists.* New York, 1974.

Hollander, Stacy C., and Brooke Davis Anderson. *American Anthem: Masterworks from the American Folk Art Museum.* New York, 2002.

Rosenak, Chuck, and Jan Rosenak. *Museum of American Folk Art Encyclopedia of Twentieth Century American Folk Art and Artists.* New York, 1990.

LEE KOGAN

SCANDINAVIAN AMERICAN FOLK ART

SCANDINAVIAN AMERICAN FOLK ART is the art produced by immigrants from the Scandinavia countries of Sweden, Norway, Denmark, Finland, and Iceland. In general, folk art objects created in the Scandinavian tradition are decorated items used in the home and on the farm, rather than art objects made for purely aesthetic reasons. Rosemaling, decorative painting used for furniture, trunks, or other wooden household objects; woodcarving; textiles; embroidery; and birch bark and straw work are the main categories of folk art, produced in the Scandinavian tradition in the United States Objects produced during the various periods of Scandinavian immigration to the United States are also included under the umbrella category of Scandinavian American folk art.

Immigration from the Scandinavian countries began when the Swedish government sent some of its citizens to North America to establish a colony, the New Sweden settlement in Delaware, in 1638. Although New Sweden existed until only 1655, when the colony was taken over by the Dutch, many of the original Swedish settlers, as well as their descendants, retained their language and important aspects of their native culture. Perhaps the most significant and lasting handwork tradition attributable to those New Sweden colonizers was their introduction to North America of their technique for constructing log cabins, which centered on the use of horizontally-placed logs with notched corners.

Large-scale emigration from Scandinavia did not begin until the 1800s, by which time population explosions had occurred in Denmark, Finland, Norway, and Sweden, due in large part to improved medical conditions and the introduction of the potato. The result was an economic crisis that forced millions of people to immigrate to America, viewed by the settlers as a land of unlimited opportunity.

During the 1800s the number of immigrants leaving the Scandinavian countries for North America swelled from a trickle to a river. By 1930, 1.3 million people had emigrated from Sweden. Norway, with approximately 850,000 immigrants, lost a larger percentage of its population than any other country in Europe except for Ireland. Nearly 350,000 emigrated from Denmark, 275,000 from Finland, and a far smaller number left Iceland.

Upon settling in the United States, many Scandinavians, especially Finns, Norwegians, and Swedes, settled in rural areas of the upper Midwest. Those settling in areas with generous natural wood supplies retained many of the traditional artistic practices of their homeland. The creation of pieces of wooden kitchenware, for instance, continued in an essentially unbroken tradition. Many textile techniques, including weaving, felting (the making of felt), knitting, and embroidery also continued.

Once in the New World, where land was readily available, large numbers of Swedes and Norwegians became farmers. Agriculture had been their mainstay in Scandinavia as well. The focus on farming by the Scandinavian immigrants resulted in the abandonment of many craft, handwork and folk art traditions, especially those practiced by men. Paint brushes and carving tools were laid aside, never to be picked up again. A far smaller percentage of Danish immigrants became farmers, choosing instead employment in towns or urban areas. They too, often abandoned whatever handwork traditions they brought with them, since they no longer had access to the raw materials necessary for the production of their native

crafts. Many Finnish immigrants settled in Michigan and northern Minnesota, affording them ready access to forests, their prime source of craft material.

Handwork and folk art traditions fared best among women, especially those who lived in rural, predominantly Scandinavian American communities. Most of the textile activities such as knitting, weaving, crocheting, tatting, and embroidery were passed from one generation to the next, even as Scandinavians became more and more Americanized with each generation.

Some first-generation immigrants returned to folk art activities after they retired, because during their working years they did not have time for hobbies or leisure activities. They did not pursue Scandinavian folk art and handcraft for economic necessity, as they had done in Europe, or in their early years in the United States; this involvement with craft, however, provided a meaningful connection with their countries and cultures of origin.

By the end of World War II, the Americanization of most Scandinavian immigrants was essentially complete. Fewer and fewer retained the ability to speak a Scandinavian language, and many of the handwork and folk art traditions that the immigrants had brought with them, had been lost as well. In the 1960s, many Scandinavian Americans (now third and fourth generation Americans) became increasingly interested in their ethnic and cultural roots. Since most were now a generation or more removed from those Scandinavian language-speaking members of their families, these Americans had to turn to non-Scandinavian language-dependent courses to learn various handwork and folk art techniques. Pursuing a course in rosemaling, for instance, was not dependent on a proficiency in the Norwegian language, yet rosemaling provided a window into one cultural aspect of their Norwegian ancestry. Folk art courses provided a valuable link for Scandinavian Americans to the heritage and culture of the past.

There were, of course, some first- or second-generation immigrants who still worked in a Scandinavian craft traditions that they learned before immigrating to the United States, or that they have learned in America directly from someone who had immigrated. Three such traditional artists have been named National Heritage Fellows by the National Endowment for the Arts for their contributions to the continuation of traditional arts: Leif Melgaard, a Norwegian American woodcarver from Minneapolis was named a fellow in 1985; Ethel Kvalheim, a Norwegian

American rosemaler from Stoughton, Wisconsin, in 1989; and Nadjeschda Overgaard, a Danish American needleworker from Kimballton, Iowa, in 1998.

Museums and cultural centers such as Vesterheim, the Norwegian-American Museum in Decorah, Iowa, and the American Swedish Institute in Minneapolis, began to offer courses in a wide variety of folk art and handwork techniques. Woodcarving, weaving, felting, decorative painting, knife-making, knitting, embroidery, and straw weaving all became non-language-dependent avenues of discovery for Scandinavian Americans.

With only rare exceptions, in the early years of these courses teachers were typically recruited directly from Scandinavia. Rosemalers, carvers, woodworkers, blacksmiths, and textile artists who served as instructors in the 1960s and 1970s often required English-language translators during their courses, resulting in the feeling among Scandinavian American course participants that they were receiving a very authentic cultural and artistic experience.

Within just a few years, however, course instructors began to emerge from the ranks of the Scandinavian American communities themselves. Having learned directly from Scandinavian artists, the new generation of teachers pursued a variety of cultural and artistic paths. Some insisted on remaining as faithful as possible to the original styles they had learned, while others began to combine elements of Scandinavian styles with impulses drawn from other artistic and ethnic traditions.

Adaptation, modification, and evolution were inevitable. For instance, some woodcarvers in America chose to carve Norwegian acanthus-style work, a type of decorative relief carving introduced in Norway in about 1700, using butternut or walnut, rather than pine or birch, that would have been used in Norway. Use of the darker-colored, and in the case of walnut, harder wood, resulted in a slightly different aesthetic. Some decorative painters began to use acrylic paint, rather than the original oil paint, in their work. In Scandinavia, as well as in America, some artists began to use synthetic fabrics instead of the traditional wool or linen.

Towns and cities that still retained some of the ethnic flavor of the original settlers began to organize events, such as ethnic festivals, that celebrated their heritage. Many communities in the upper Midwest observed their centennial anniversaries in the 1960s

and 1970s, providing appropriate opportunities to commemorate and celebrate their founders, as well as aspects of their founders' traditional culture.

Decorah's Nordic Fest, for instance, began in the late 1960s, and has been an annual event ever since. The festival features a wide range of demonstrations of traditional Norwegian and Norwegian American folk art and handwork such as rosemaling, woodcarving, and weaving, and it attracts handwork enthusiasts and visitors from all over North America. Ethnic festivals throughout the country have revitalized interest in all aspects of Scandinavian culture, including handcraft and folk art traditions.

Ironically, at the same time that some of the Scandinavian folk arts were increasing in popularity in the U.S., they were fading into obscurity in Scandinavia. Many Scandinavian American craftsmen have been invited to teach their handwork techniques in Scandinavia, so that the seeds of these folk art traditions may be re-sown in the countries of their origin.

See also **Rosemaling.**

BIBLIOGRAPHY

Nelson, Marion J., ed. *Norwegian Folk Art: The Migration of a Tradition.* New York, 1996.

Stewart, Janice. *The Folk Arts of Norway.* Rhinelander, Wisc., 1999.

Widbom, Mats, ed. *Swedish Folk Art: All Tradition is Change.* New York, 1995.

HARLEY REFSAL

SCHERENSCHNITTE: *SEE* PAPERCUTTING.

SCHIMMEL, WILHELM (1817–1890), an itinerant wood carver who traveled and worked during the late nineteenth century within the traditional Pennsylvania German and Anglo-Irish agrarian communities near Carlisle, Pennsylvania, has become one of the most prolific and widely recognized traditional folk carvers of the region. Born in Germany near Hesse-Darmstadt, Schimmel immigrated to Pennsylvania around 1860 and gained employment as an itinerant farm worker from several of the Germanic families settled along the Conodoguinet Creek west of Carlisle. By all accounts irascible, unpredictable in temperament, and prone to excessive drink, Schimmel was also remembered as gentle and often nurturing to children, and indeed valued for his useful woodworking skills as a repairman and carver. Befriended and supported within this close-knit farming community, Schimmel knew where he would be allowed to scavenge for the wood scarps to produce his carvings, and

who might buy or trade food, drink, or overnight lodging for his carvings.

Whether as a result of his unusual character and unruly appearance, a charitable act to support a troubled soul, or a genuine appreciation for their bright aesthetic character, his boldly carved and brightly painted eagles, animals, and other figures were acquired and preserved widely within his community. Saloons and taverns he frequented often displayed numerous examples of his work, traded for spirits or food, and other residents regularly bought his figures for ten to twenty-five cents, or accepted them in return for a night's lodging in a wash house or barn.

Carving indigenous pine or tulip poplar using only a common folding pocketknife, Schimmel shaped his figures confidently and directly. His largest works were often eagles, poised with outspread wings, that demonstrate his combined skills as a woodworker and carver, and the overall character of his style. Schimmel's larger eagle figures utilize a central body, head and tail section into which separate carved wings have been mortised, tenoned and glued in place. The feathers are depicted by deep angular cuts, layered to suggest distinct, individual feathers on the front face but more simplified by deeply cut, crosshatched lines on the reverse. Deeply cut angular notches and crosshatched lines further delineate the body, neck and tail sections. Once carved and assembled, Schimmel usually applied an overall priming of thin white plaster that filled the areas around joints and smoothed the surface for painting. The pigments used to further ornament the figure, usually greens, reds, whites, yellows, and black are most often common household paints, remnant or left over colors Schimmel most likely gained from his sympathetic, supportive neighbors and hosts.

See also **Sculpture, Folk; Pennsylvania German Folk Art.**

BIBLIOGRAPHY

Bishop, Robert. *American Folk Sculpture.* New York, 1974.

Lipman, Jean, and Alice Winchester. *The Flowering of American Folk Art 1776–1876.* New York, 1974.

JACK L. LINDSEY

SCHMIDT, CLARENCE (1897–1978) created a remarkable environment in Woodstock, New York: architectural structures, walkways, terraces, walls, a roof garden, shrines, grottoes. In the 1960s and 1970s his grand undertakings, often-changing combinations of disparate castoff materials, caught the attention of

artists interested in assemblage and were praised by celebrities such as Joan Baez and Bob Dylan.

Schmidt was born in Astoria, Queens, New York. He worked briefly as a plasterer, his father's trade. He married in 1928 but later separated from his wife; they had one son, Michael, who became a sculptor. At age thirty-one, a turning point in his life, Clarence Schmidt acquired from a relative the property in Woodstock, 5 acres on Ohayo Mountain facing the Ashokan reservoir. His first construction there was *Journey's End*, a one-room cabin embedded with cracked glass. In 1948–1960 he built into the side of the mountain the *House of Mirrors*, a seven-story complex with walkways, projections, a facade of window sashes, and a tree at its core. Near the upper access road, Schmidt made a path leading to the house, a roof garden, a conglomeration of old bicycle and automobile parts, bedsteads, and a profusion of mirrors. Schmidt found or was given many of his materials, but he also bought rubber face masks, hands, and feet that he incorported in shrine-like assemblages. His shrines and grottoes included memorials to presidents Washington and Kennedy. His interiors were embellished with picture postcards, dolls, animal heads, plastic flowers, beads, fragments of glass and mirrors, and Christmas lights. Walls were covered with aluminum foil or aluminium paint.

A fire destroyed the *House of Mirrors* in 1968; Schmidt then built *Mark II*, a three-room house on a platform on top of a Studebaker station wagon. He nailed foil-wrapped tree branches to its wooden walls; nearby, he coated young trees with aluminum paint and made winding pathways of chipped blue stone.

Schmidt had his detractors, some of whom considered his work an eyesore and vandalized it. In 1971, after a second fire, he left the mountain.

Once, Schmidt told a friend, Beryl Sokolov, that he had thought about building as early as age seven and had built a small retreat at age eight. He said that his "meditating" moved him to "the point of dedicating myself to the betterment of life and human nature as much as I can. In the advent of doing this I suffered many hardships. Wonderful thing to think I can live and enjoy this now."

See also **Environments, Folk; Outsider Art.**

BIBLIOGRAPHY

Cardinal, Roger. *Outsider Art*. New York and Washington, D.C., 1972.

Lipke, William C., and Gregg Blasdel. *Clarence Schmidt*. Burlington, Vt., 1975.

———. *Naives and Visionaries*. New York.

Melville, Robert. "One Man and His Mountain." *New York Times Magazine*, vol. 23 (February 1975): 50–52.

Lee Kogan

SCHOLL, JOHN (1827–1916) is remembered for his unique wooden constructions, several of them large and freestanding, incorporating elements of Victorian house trimming. Other works have snowflake forms. Scholl also created assemblages, reminiscent of German folk toys, and small whimsies sometimes called whittlers' puzzles, which the artist called "finials." Forty-two of his forty-five known sculptures survive.

Scholl was a carpenter and farmer. Like many other folk artists, he turned to art in his later years, though his family remembered that he had whittled wood earlier. According to Grier, whose research on this artist provided much biographical detail and Scholl's artistic chronology, whittlers' puzzles were his first works, and his larger constructions—such as *Snowflake on Stand*—are among his more mature works. *Snowflake* combines ornate flat cutouts of embellished circles arranged in a circular pattern with three-dimensional wooden balls on an elaborate stand whose shaft is composed of zigzag cutout elements.

Scholl was born in Württemberg, Germany, in 1827 and emigrated in 1853. He married Augusta Kuhlsmal, and they settled in Schuylkill County, Pennsylvania, a center of anthracite coal mining. Census records of 1860 for Silver Creek, Blythe Township, in Pennsylvania, another mining community, document Scholl as living there and record his occupation as carpenter. He became an American citizen in 1860.

By 1870, Scholl had moved to Germania, Pennsylvania, where he acquired a 25-acre tract of land northwest of the town. Census records of 1870 list his occupation as "house carpenter." Over the years, he more than tripled his landholdings; he operated half of his property as a farm with assistance from his wife, three sons, and two daughters. Scholl built a house on his property, embellishing it with fanciful trim, typical of mid- and late nineteenth-century domestic architecture. Decorative house ornaments—carved garlands, wooden snowflakes, crosses, and doves—resemble details in his sculptures. Designs for Scholl's decoration came from printed sources, pattern books, and catalogs that were inexpensive and widely distributed among people in the building trades.

After 1907, neighbors would visit Scholl's parlor to see his finished work. When Scholl established formal

viewing hours, the number of curious visitors increased: thousands of people came to take a guided tour and see his art. For fifteen years following Scholl's death, one of his sons continued the tradition.

The Scholl family retained possession of Scholl's art until 1967, when it was sold to Adele Earnest and Cordelia Hamilton, owners of a gallery in Stony Point, New York. Scholl's works were eventually dispersed to museums and private collections.

See also **Adele Earnest; Sculpture, Folk.**

BIBLIOGRAPHY

Grier, Catherine. *Celebrations in Wood: The Carvings of John Scholl 1827–1916.* Harrisburg, Pa., 1979–1980.

Rosenak, Chuck, and Jan Rosenak. *Museum of American Folk Art Encyclopedia of American Folk Art and Artists.* New York, 1991.

LEE KOGAN

SCHUMACHER, DANIEL (c. 1728–c. 1787), born in Hamburg, Germany, was a fraktur artist, and probably the first to use fraktur to keep records, rather than producing them merely as souvenirs of important events. Listed as a ship's passenger at Halifax, Nova Scotia, in 1751, his profession is documented as that of "candidate of theology." He had only a minimal education, and received no educational qualifications for the ministry. Nevertheless, he found Lutheran congregations in the Berks, Lehigh, and Northampton counties of Pennsylvania, looking for a minister, and settled into a long-term ministry. His work there was not without controversy, but the evidence is reasonably good that Schumacher was an effective, if irregular, member of his profession.

Lutheran clergy in Europe were required by law to keep ledgers of the pastoral acts they performed such as baptisms, confirmations, and marriages. In colonial Pennsylvania, however, it was the option of the pastor of a church as to whether records would be kept, and Schumacher did, adorning most of his records with decorations of flowers and angels. He kept a similar book of his own, from 1754 until 1773, and noted each child to whom he gave a certificate of baptism or confirmation. He was undoubtedly one of the first to do so. These documents have great genealogical value, but the records from this period also mark the start of the time baptismal records were the most common form of Pennsylvania German fraktur. In addition to angels and flowers, Schumacher's work portrays the eye of God and hearts, and every certificate bears his signature, as the presiding minister. The texts of the documents not only clearly state the factual information marking the pastoral event, but explain to the owner the meaning of the event that transpired in his or her life. The personal records Schumacher kept contain six drawings attempting to show Lutheran doctrine in a pictorial form. He also drew New Year greetings for his friends, as well as other drawings. He also composed poems that appear in his fraktur documents

Schumacher married, had a family, and owned a one-hundred-acre farm. He died in Weisenberg Township, Lehigh County, Pennsylvania.

See also **Fraktur; German American Folk Art; Johann Conrad Gilbert; Pennsylvania German Folk Art; Religious Folk Art.**

BIBLIOGRAPHY

Weiser, Frederick S. (trans. and ed.). *The Record Book of Daniel Schumacher 1754–1773.* Camden, Maine, 1994.

FREDERICK S. WEISER

SCHWENKFELDERS, members of a Protestant denomination that follows the teachings of Caspar Schwenckfeld von Ossig (1489–1561), came to Pennsylvania in several small migrations during the 1730s, seeking religious toleration. Although they were a comparatively small group within the much larger population of Pennsylvania Germans, they and their descendants made significant contributions to America's decorative and folk art heritage. They had come from Silesia, then at the eastern edge of German-speaking Europe. Some had been given refuge briefly in the Moravian community in eastern Saxony, but after seven years they were forced to find another haven. Most of the forty families that came to America settled on farmsteads within a 50-mile radius of Philadelphia. After meeting in homes for worship, prayer, and study, they established a school system for themselves and their neighbors in 1764. In the 1790s meetinghouses were built for worship. The Schwenkfelders were considered well educated for their time. Many were both farmers and craftspeople, and the sizes of their farms depended on the time they required for their crafts.

Immigrant Schwenkfelder craftsmen brought with them the techniques of traditional Germanic fabrication and design. Reverend Balzer Hoffman (1687–1775) brought the skills of weaving and writing in book hand, a style of fraktur lettering reminiscent of German typeface of the period. His immigrant son, Reverend Christopher Hoffman (1727–1804), became a pastor as well as a teacher, scrivener (maker of

handwritten copies of documents or books), fraktur artist, and bookbinder. This Schwenkfelder family was one of many that included gifted fraktur artists. The Heebner family of Worcester township, Montgomery County, Pennsylvania, proved to be a dynasty of fraktur artists, from Abraham Heebner (1760–1838) and his sister Susanna Heebner (1750–1818), also the son and daughter of a scrivener, to several of Abraham's sons and daughters. The tradition of fraktur writing continued for more than 100 years within this family. Members of the Kriebel families were also fraktur artists. Reverend David Kriebel (1787–1848) created some of the most vibrant and distinctive examples of this art form. His daughter Sarah Kriebel (1828–1908) became a fraktur and folk artist as well. Daniel Kriebel (1796–1855), a distant cousin, did fraktur work much in the Schwenkfelder style of David Kriebel. Additionally, many other Schwenkfelder families included major or minor contributors to the fraktur and folk art of southeastern Pennsylvania from the period after the American Revolution until about 1845.

Schwenkfelder needle arts are unique among the Pennsylvania Germans because they involved both traditional English and Pennsylvania German styles. Young women produced Germanic random-pattern samplers, with some designs that were uniquely Schwenkfelder and other motifs borrowed from their Mennonite neighbors. They decorated hand towels, like other Pennsylvania German girls; but unlike other girls raised in Germanic households, they crafted English-style pocketbooks and the formal symmetrical samplers and needlework pictures associated with English sewing schools. Their quilts were pieced or appliquéd with occasional regional variations of well-known designs such as the "Perkiomen Valley" pattern, a modification of the log cabin motif.

In decorating their blanket chests, Schwenkfelder cabinetmakers used traditional motifs, grain-painting, or sponging. Some dower chest decorations included the names and dates of their owners. The cabinetmaker and fraktur artist Balthasar Heydrick (1765–1846) decorated dower chests with fraktur-type letters and motifs. Numerous other decorated chests survive that were made for Schwenkfelder recipients by unknown makers and decorators. The organ builders John Krauss (1770–1819) and his brother Andrew (1771–1841) grain-painted some of their pipe organ cases in salmon and black.

Of all the work of Pennsylvania potters, the best-known is undoubtedly that by the Schwenkfelder George Hubener (1757–1828). His was a style of the Old World, with techniques, forms, glazes, and types of lettering and decoration that were traditionally Germanic. He was known for his sgraffito work and made both plates and hollowware.

Through the foresight and generosity of the Schwenkfelder community, a comprehensive collection of their written and material culture has been preserved in the Schwenkfelder Library and Heritage Center at Pennsburg, Pennsylvania.

See also **Decoration; Fraktur; Furniture, Painted and Decorated; Pennsylvania German Folk Art; Pictures, Needlework; Pottery, Folk; Quilts; Religious Folk Art; Samplers, Needlework.**

BIBLIOGRAPHY

Brecht, A.M., and Samuel Kriebel. *The Genealogical Record of the Shwenkfelder Families*. New York, 1923.

Bunner, Raymond J. *That Ingenious Business: Pennsylvania German Organ Builders*. Birdsboro, Pa., 1990.

Fabian, Monroe H. *The Pennsylvania-German Decorated Chest*. New York, 1978.

Garvan, Beatrice B. *The Pennsylvania German Collection*. Philadelphia, 1982.

Gerhard, E.S. "Schwenkfelder Craftsmen, Inventors, and Surveyors." *Schwenckfeldiana*, vol. 1, no. 5 (September 1945).

Hersh, Tandy, and Charles Hersh. *Samplers of the Pennsylvania Germans*. Birdsboro, Pa., 1991.

Hollander, Stacy C., et al. *American Radiance: The Ralph Esmerian Gift to the American Folk Art Museum*. New York, 2001.

Kriebel, Howard Wigner. *The Schwenkfelders in Pennsylvania: A Historical Sketch*. Lancaster, Pa., 1904.

Lipman, Jean, and Alice Winchester. *The Flowering of American Folk Art: 1776–1876*. New York, 1974.

Moyer, Dennis K. *The Colors of Goschenhoppen*. Pennsburg, Pa., 1996.

———. *Fraktur Writings and Folk Art Drawings of the Schwenkfelder Library Collection*. Kutztown, Pa., 1997.

Roan, Nancy, and Donald Roan. *Lest I Shall be Forgotten. Anecdotes and Traditions of Quilts*. Green Lane, Pa., 1993.

Schultz, Selina Gerhard. *Caspar Schwenckfeld von Ossig: Spiritual Interpreter of Christianity, Apostle of the Middle Way, Pioneer in Modern Religious Thought*. Norristown, Pa., 1946.

Shelley, Donald A. *The Fraktur-Writings or Illuminated Manuscripts of the Pennsylvania Germans*. Allentown, Pa., 1961.

Swank, Scott T. *Arts of the Pennsylvania Germans*. New York, 1983.

Weiser, Frederick S., and Howell J. Heaney. *The Pennsylvania German Fraktur of the Free Library of Philadelphia*, 2 vols. Breinigsville, Pa., 1976.

DENNIS K. MOYER

SCOTT, JUDITH (1943–) is an artist who has created a range of idiosyncratic, abstract sculptural works that, while certainly aesthetic and psychologically evocative, remain mysterious expressions of an artist who has little if any comprehension of what it means to be an "artist." Scott, who was born in Ohio

in 1943, is deaf and has Down's syndrome. Because she cannot hear nor speak, she has little understanding of language, and no intellectual conception of art as a practice or a history. Scott's sculptures are primarily vertical, fiber-wrapped stick bundles and fibrous cocoon shapes that, as many historians and critics have noted, resemble vegetative and corporeal forms. Each sculpture is the product of months of daily, almost compulsive, work that requires intense concentration and patience. Without knowing the intention of the artist, the viewer is nevertheless struck by the expressive power and beauty of the shapes, colors, and textures.

At age seven Scott was separated from her parents and twin sister, Joyce; diagnosed as noneducable, she was institutionalized for more than thirty-five years, until her sister succeeded in becoming her legal guardian and arranged for her release in 1986. Scott's enrollment in the Creative Growth Art Center in Oakland, California, a non-profit organization established in 1973 as the first independent visual arts center for severely disabled adults, enabled her to hone her highly subjective visual expression. During her first year at Creative Growth, Scott executed some unremarkable drawings and paintings; then, in 1987, after discovering fiber art materials Scott began creating the forceful three-dimensional works that have since been exhibited in national art centers and museums.

Scott salvages a found object from the environment—a broken electric fan, a key, or a tree branch—that will become the core of an elaborate structure that she wraps or knots with yarn, twine, wool, or rags, often sewing with a needle and thread. Her forms are generally tightly bound, with a solid structure, and yet exude a certain flux associated with cellular growth or unraveling. In her early work, a metal object or a small wood block would occasionally protrude from the center. The completed piece is much larger than the core object—in fact, as large as or larger than the artist herself; some of Scott's sculptures weigh several hundred pounds. Psychoanalytic critic and art historian John MacGregor has compared her process to one of metamorphosis; and indeed the

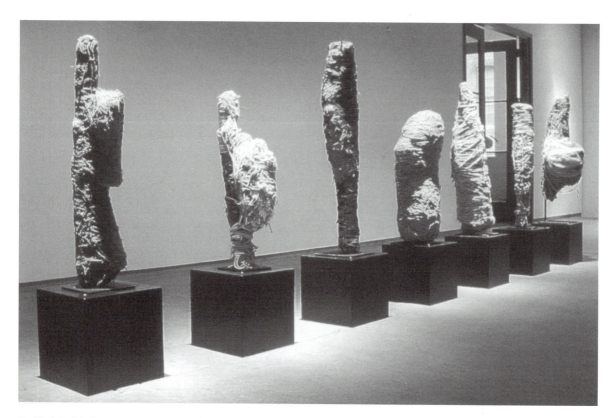

Untitled. Judith Scott; c. 1998. Yarn and found objects; 3 feet high.
Photo courtesy Ricco Maresca Gallery, New York.

cocoon-like objects she slavishly labors over are evocative of bodily transformation and regeneration.

Scott has completed approximately 160 works. Her fiber art sculptures have been exhibited in the United States, France, and Switzerland and are in the permanent collection of the American Folk Art Museum in New York, Milwaukee Art Museum, Collection d'Art Brut (Lausanne, Switzerland), and Aracine Musée d'Art Brut (Paris). She has had solo exhibitions at Intuit: The Center for Intuitive, and Outsider Art in Chicago, and the Shiseido Foundation in Tokyo. In 2001, she was honored by the Third Annual Professional Women's Luncheon (San Francisco) of the Down Syndrome League of the Greater Bay Area and the National Down Syndrome Society.

See also **Creative Growth Art Center; Intuit: The Center for Intuitive and Outsider Art; Dwight MacIntosh Outsider Art.**

BIBLIOGRAPHY

Cardinal, Roger. "'Metamorphosis: The Fiber Art of Judith Scott—The Outsider Artists and the Experience of Down's Syndrome' by John MacGregor." *Folk Art Messenger*, vol. 13, no. 2 (summer 1999): 16–17.

Liu, Marian. "Berkeley Dream Weaver Steps into Limelight." *Oakland Tribune*, vol. 23 (April 2001): "Cityside," 1, 8.

MacGregor, John. *Metamorphosis: The Fiber Art of Judith Scott—The Outsider Artists and the Experience of Down's Syndrome*. Oakland, Calif., 1999.

———. "Metamorphosis: The Fiber Art of Judith Scott." *Outsider*, vol. 5 (fall 2000): 10–18.

Smith, Barbara Lee. "Judith Scott: Finding a Voice." *Fiber Arts*, (summer 2001): 37–39.

LEE KOGAN

SCOTT, LORENZO (1934–) is a rarity among African American self-taught painters in that both the subject matter and style of his art have been influenced by the history of European painting, specifically the Renaissance and Baroque eras. Scott was born in West Point, Georgia, and moved with his large family to Atlanta soon after his birth. Inspired by his mother's drawings, at age five, he tried his own hand at this medium, and continued to draw into his adult years.

After a few scant years of formal education, Scott left Atlanta, and moved to New York for about two years in the late 1960s. While living in a Manhattan hotel and working service jobs, he nurtured his interest in art by visiting the Metropolitan Museum of Art and watching sidewalk painters at work in Greenwich Village. He began to paint around 1970, and thereafter returned to Atlanta.

Resettled in Atlanta, Scott supported himself as a construction worker and house painter, and became an occasional visitor to Atlanta's High Museum of Art. In the galleries he began making sketches from the classically influenced, illusionistic paintings of the Venetian and Florentine schools; he used these sketches as models for creating his own versions of these religious and history paintings. His denominational affiliation as a Southern Baptist did not prevent him from admiring, and in many cases emulating, the iconography and narratives of Roman Catholicism. Scott has painted numerous variations on themes including Adam and Eve, the Last Supper, the Madonna and Christ Child, the Deposition, the Baptism of Jesus, and the Raising of Lazarus among others. Scott's *Jesus Rose* [sic] *Lazarus from the Dead* (c. 1982) shares with its proto-Renaissance models a preference for jewel-toned local color, a flattened perspective, iconic and yet strikingly individual facial description, and the religious symbols typical of late-Medieval and early Renaissance art: burnished gold halos, the streaming light of the Holy Spirit, and a flowering fertile landscape.

As much as Scott admires the work of artists such as Giotto (c. 1267–1336), Leonardo da Vinci (1452–1519), and Paolo Veronese (1528–1588), he has remarked that his favorite painter is the American realist Norman Rockwell (1894–1978), best known for his *Saturday Evening Post* covers, which in and of themselves, have become some of the most iconic (and beloved) images of twentieth-century American material culture. Although Rockwell was an academically trained painter who gained tremendous commercial success, his entire body of work resonated with a sense of what historians might term a folk aesthetic, especially as it appealed to mass as opposed to avant-garde audiences eager for representations of ordinary life and experience. Perhaps what Scott responds to in Rockwell—as well as in Giotto or Leonardo—is the ability of the artist to communicate narrative regardless of stylistic or critical differences.

In addition to painting biblically inspired art, Scott also makes paintings that depict aspects of rural life or that comment on contemporary issues. He presented his early paintings in secondhand frames, but more recently he has come to prefer making his own frames, using an automobile body bonding compound and gold paint to simulate the look of Baroque gilding.

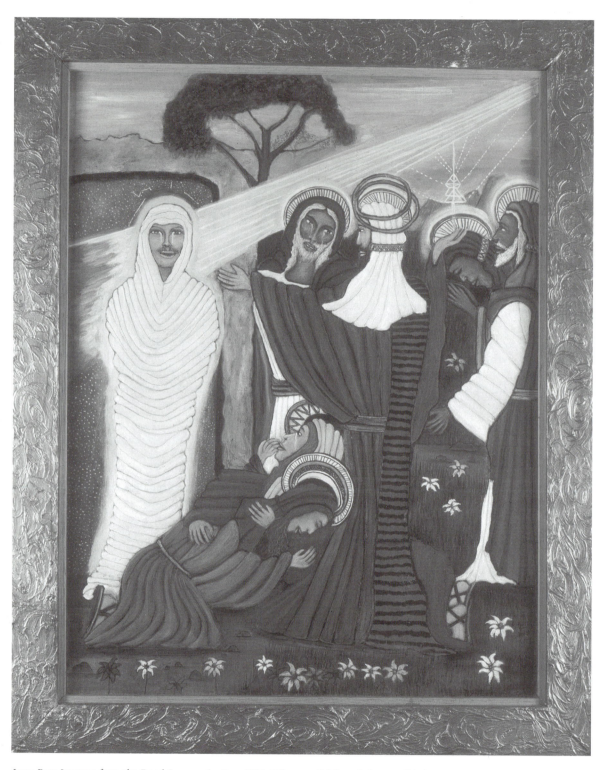

Jesus Rose Lazarus from the Dead; Lorenzo Scott; c. 1982. Oil on particleboard; frame: gilded with automobile repair paint on yellow pine; 52 × 43 inches. Collection American Folk Art Museum, New York. Gift of W. Marvin Clary, William H. Clary, Jane E. Hunecke, and Albert L. Hunecke Jr., 1991.35.1.
Photo courtesy Gavin Ashworth.

See also **African American Folk Art (Vernacular Art); Painting, American Folk.**

BIBLIOGRAPHY

Arnett, Paul, and William Arnett, eds. *Souls Grown Deep: African-American Vernacular Art of the South*, vol. 1. Atlanta, Ga., 2000.

Hunecke, Bert, and Mark Chepp. *An Unexpected Orthodoxy: The Paintings of Lorenzo Scott*. Springfield, Ohio, 1993.

TOM PATTERSON

SCRIMSHAW is an indigenous occupational art of whalers utilizing animal byproducts to produce practical implements and decorative objects, both for personal use and as gifts, often for their families back home. The etymology of "scrimshaw" is unknown, but its defining characteristics include not only the context in which it is made but its distinctive materials—sperm whale teeth, skeletal bone, baleen, and walrus tusks, often in combination with such other found materials as wood, seashell, tortoise shell, and bits of metal, ribbon, and cloth. Scrimshaw arose as a regular feature of the British and American whale fishery in the 1820s, became an occasional avocation for the men between voyages, and was adopted by whalers of other nations and by naval seamen and other mariners who had access to whale ivory and bone.

The varieties of scrimshaw production were many. According to Henry Cheever in *The Whale and His Captors* (1850), "whalemen busy themselves when making passages, and in the intervals of taking whales, in working up sperm whales' jaws and teeth and right whale bone into boxes, swifts, reels, canes, whips, folders, stamps, and all sorts of things, according to their ingenuity." Recent forensic studies corroborate Herman Melville's (1819–1891) claim in *Moby Dick* (1851) that although graving points, scalpels, ship carpentry saws, lathes, and other sophisticated micro-tools were occasionally employed, most of the carving and engraving was accomplished with ordinary sailors' knives. Melville also stressed variety and versatility in what by the early 1840s had evidently become a nearly universal practice on Yankee whaleships.

> Throughout the Pacific, and also in Nantucket, and New Bedford, and Sag Harbor, you will come across lively sketches of whales and whaling-scenes, graven by the fishermen themselves on Sperm Whale-teeth, and other like skrimshander articles, as the whalemen call the numerous little ingenious contrivances they elaborately carve out of the rough material, in their hours of ocean leisure. Some of them have little boxes of dentistical-looking implements, specially in-tended for the skrimshandering business. But, in general, they toil with their jack-knives alone; and, with that almost omnipotent tool of the sailor, they will turn you out anything you please, in the way of a mariner's fancy. (Melville, *Moby Dick*, 1851)

The prevailing pigment used in pictorial scrimshaw also came from the sailors' everyday environment. Simple lampblack (a suspension of carbon in oil, resulting from combustion), abundantly available from the shipboard tryworks where blubber was rendered into oil, served as the "pigment" for drawing. Other common pigments included sealing wax inlaid into incised grooves, commercially produced India or China inks, and home-brewed fruit and vegetable dyes.

Owing to surpluses in baleen production, baleen scrimshaw precursors appeared intermittently in Holland and Germany in the seventeenth and eighteenth centuries, but sperm-whale ivory and bone were not available until Americans undertook sperm whaling around 1712. However, whale teeth—similarly to baleen (a horny tooth-like substance found in the upper jaws of baleen whales)—became a valuable commodity that could be sold on the market to China traders for barter in the Pacific (notably at Fiji and Tonga), or could be bartered by the whalers themselves for provisions and services in Polynesian ports-of-call. It was only after Commodore David Porter's memoirs of his exploits in the American frigate *Essex* (1815) exposed the well-kept secret of the extraordinary value of whale teeth in Polynesia that a resulting surplus soon collapsed the market, making the teeth accessible to the fishermen. Accordingly, scrimshaw on whale ivory first appeared between 1817 and 1824.

This was a propitious windfall. With the opening of the Pacific whaling grounds in the 1790s, and with a post-Napoleonic resurgence of whaling, shipboard dynamics were changing dramatically. Voyages were extended for longer periods (by the 1840s the average was approximately forty months), vessels and crews grew larger to the point of chronic overstaffing (greater numbers of men were needed to hunt whales than actually to man the ship), and surplus leisure therefore was more oppressive. Scrimshaw was an avocational pursuit (along with reading, journal-keeping, drawing, poetry-writing, and music) that could fill the tedious intervals between passages or between whales, providing diversion for otherwise idle hands.

Scrimshaw was still being produced during the decline of the hand-whaling industry in the late nineteenth

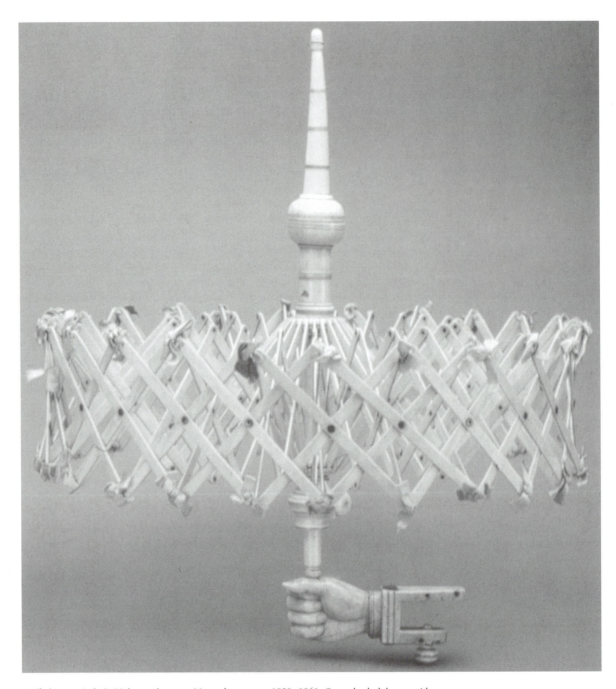

Swift (yarn winder). Maker unknown. Massachusetts, c. 1820–1860. Carved whalebone with engraved decorations. © Esto.

century, and the practice arose again, in somewhat degraded form, aboard the modern factory whaleships and shore stations of the twentieth century. Meanwhile, Native Alaskans and Canadian Inuit (with venerable ivory- and bone-carving traditions of their own) emulated Yankee scrimshaw to produce souvenirs. In the Azores, scrimshaw was integrated into the fabric of daily life ashore, and continues so today. But the vivacious fluorescence of Yankee scrimshaw within a single, sequestered occupational group in the nineteenth century render it uniquely articulate in imparting insights into the life and times of sea labor in the Age of Sail.

468

See also **Maritime Folk Art.**

BIBLIOGRAPHY

Flayderman, E. Norman. *Scrimshaw and Scrimshanders, Whales and Whalemen.* New Milford, Conn., 1972.

Frank, Stuart M. *Dictionary of Scrimshaw Artists*, Mystic, Conn., 1991.

————. *More Scrimshaw Artists.* Mystic, Conn., 1998.

————. "The Origins of Engraved Pictorial Scrimshaw." *The Magazine Antiques* (October 1992).

Malley, Richard C. *'Graven by the fishermen themselves': Scrimshaw in Mystic Seaport Museum,* Mystic. Conn., 1983.

STUART M. FRANK

SCULPTURE, FOLK is the term that is generally accepted to describe woodcarvings, metal constructions or assemblages, and other mixed media three-dimensional art works made by amateur artists or artisans with little or no conventional artistic training. Such folk sculpture is often for the artist's own pleasure or purposes rather than for a conventional art market or recognition. Folk sculpture therefore derived from artisanal—not aesthetic—traditions.

Sculpture was the first folk art practiced in America. The earliest English settlers, for example, possessed the manual skills required to build the necessary tools for daily living, including houses and furniture. Those who had woodworking skills, like the joiners who carved decorative designs on the facades of chests, could also make dolls and other playthings for their children or modest ornaments for their homes. Family gravestones, many of which feature winged angels and other pictorial symbols that were a part of these settlers' collective memory of England, comprise the earliest examples of public folk art. A familiarity with hand tools and the working of wood, metal, and stone by artisans and craftspersons allowed folk sculpture to flourish.

As the American economy transitioned from an agricultural to an industrial one with an emphasis on manufacturing, the number of persons whose livelihood depended on acquiring skills such as carpentry and carving diminished. Industrial processes did not require that an individual be able to fabricate a product from start to finish. Labor became compartmentalized and specialized. Nevertheless amateur craftspersons continued to make sculpture (both functional and non-functional) for their families and homes, thus demonstrating a strong interest in the creative tradition.

The formal qualities that distinguish folk sculpture from semi-academic or academic sculpture—as well as the level of training an artist may possess and still be considered a folk sculptor—is relatively subjective.

The kinds of works that have conventionally been considered and defined as "folk sculpture" include, among others, whittlings, ship figureheads, tobacconist and other shop figures, whirligigs, gravestones and grave ornaments, decoys, chalk figures, figural pottery, carousel and circus wagon figures, and weathervanes. Folk sculptors generally do not emulate prevailing academic styles nor do they make objects intended to appeal to elite collectors, that is, the mainstream art markets and institutions. In evaluating and understanding folk sculpture and the context in which it is made, historians have generally considered iconography to be the foremost defining characteristic.

One distinguishing feature of American culture and art is that it was formed by the contributions of many ethnic immigrant groups. Some of these groups steadfastly retained their ethnic identities and reflected them in the traditional sculpture they produced. Others responded to the other ethnic cultures they encountered in America by borrowing, discarding, or modifying their traditions and creating works of a hybrid nature. Examples of both approaches from the seventeenth century through the nineteenth century are numerous. German Americans, especially those who settled Pennsylvania, were more monolithic culturally, and they continued to make toys and decorative carvings that closely resembled objects that had been made in Germany for generations. Likewise, the Spanish who settled the American southwest retained their artistic traditions and practices, creating religious sculpture that is often difficult to distinguish from works created in Spain, Mexico, South America, or the Caribbean. In contrast, the folk sculpture produced within the African American community reveals a transition from tribal iconography to a distinctive melding of African and Anglo subjects, a metamorphosis that can be identified in the folk sculpture produced by many other ethnic groups in the twentieth century.

By the late nineteenth century, a tendency toward highly personal or expressionistic folk sculpture had emerged, and this approach has remained perhaps the dominant one throughout the twentieth century. One such example is the "Whimsy Bottle" depicting the vices of man, probably made circa 1910, by an unknown artist. The sculpture is comprised of three glass containers (a jug and two spheres) inside which the artist has placed tiny carved figures engaged in drinking, gambling, and fighting, respectively. This quirky and delightful sculpture functions as a playful reminder of earthly pleasures while at the same time suggesting moral lessons.

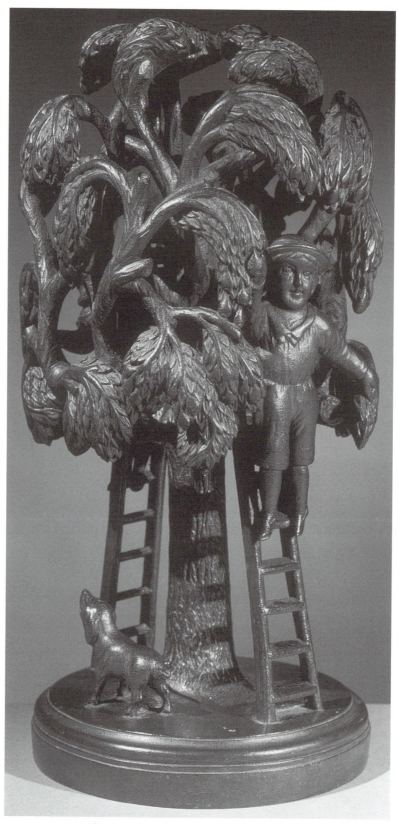

The Apple Pickers. Artist unknown; carved wood; Pennsylvania, c. 1890. 15½ × 8 inches.
Photo courtesy Allan Katz Americana, Woodbridge, Connecticut.

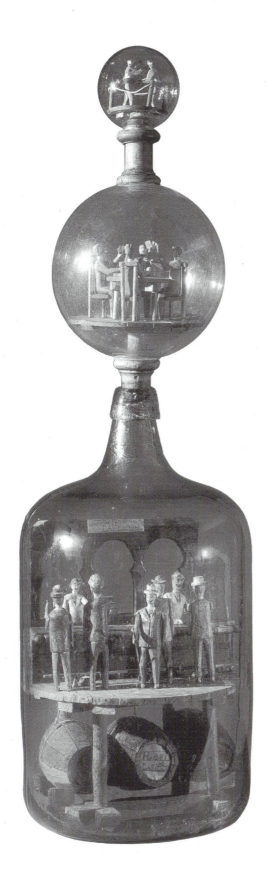

Another freestanding sculpture, dated around 1890 and probably carved in Pennsylvania, depicts two young apple pickers, standing on ladders, their dog watching from the base of the tree. This apparently non-functional decorative object (most likely a table-top sculpture) is not clearly aligned with any ethnic or regional traditions. By the twentieth century many folk sculptors were creating works that diverted from conventional ethnic traditions as well as popular iconography in favor of idiosyncratic subjects and forms. In many such works one finds an almost obsessive interest in complicated forms and mixed media, often found objects of an unorthodox nature. One explanation for the impetus of such work is the sheer personal delight the artist took in his or her imagination and ability to handle tools with authority. With the surge of industrialization and modernization came the perhaps inevitable isolation of the individual from the larger community, especially for the elderly, the disadvantaged or the infirm, an unfortunate cultural consequence that may partially explain the genesis of works that cannot easily be incorporated into a history of folk art style or iconography. Whether it be a seven-foot-tall cheval glass with a massive wooden frame painstakingly carved with writhing figures by David W. Fox (1851–c. 1941), or dozens of miniature chairs and abstract sculptures made of chicken bones by Eugene von Bruenchenhein (1910–1983), historians have been hard pressed to explain the origin of such works. Defining and analyzing these objects within a context of more familiar examples of sculptural expression can be equally difficult. Nonetheless it is through such challenging works that the depth and variety of American folk sculpture may be best appreciated.

See also **African American Folk Art (Vernacular Art); Carousel Art; Circus Art; Decoration; Decoys, Fish; Decoys, Wildfowl; Dolls; Environments, Folk; German American Folk Art; Gravestone Carving; Outsider Art; Pennsylvania German Folk Art; Religious Folk Art; Santeros; Ship Figureheads; Toys, Folk; Trade Figures; Weathervanes; Whirligigs; Woodenware.**

Whimsy Bottle (The Vices of Man). Artist unknown; c. 1910. Carved and polychrome painted wood, glass; 35 × 11½ × 11½ inches.
Photo courtesy Allan Katz Americana, Woodbridge, Connecticut.

BIBLIOGRAPHY

Hartigan, Lynda Roscoe. *Made with Passion*. Washington, D.C., 1990.

Ricco, Roger, and Frank Maresca. *American Primitive: Discoveries in Folk Sculpture*. New York, 1988.

RICHARD MILLER

SEARS, CLARA ENDICOTT (1863–1960), author and preservationist, established the Fruitlands Museums in Harvard, Massachusetts. Born into a family of wealth and privilege with deep New England roots, she built four museums on the grounds of "the Pergolas," her country estate on Prospect Hill in the rural Worcester County town. Assembled over several years following her initial purchase of land in 1910, the property commanded impressive views across the Nashua River valley to Mount Wachusett.

Among the properties acquired by Sears was the site of Fruitlands, the home of an 1843–1844 experiment in communal living that Amos Bronson Alcott (1799–1888) and other New England transcendentalists founded. Alcott's daughter, Louisa May Alcott (1832–1888), lived at Fruitlands. Her book *Transcendental Wild Oats* (1876) was based on her experiences in the short-lived "ideal" community. Sears arranged for the preservation of Fruitlands, opening its doors as a museum in 1914. The following year she published *Bronson Alcott's Fruitlands,* an account of the communal living experiment and its members.

The town of Harvard had been the site of a Shaker village since 1791, and Sears established friendships with Eldresses Annie Walker (1846–1912), Josephine Jilson (1851–1925), and other members of the dwindling religious community. A pioneer in the study of Shaker history and the collection and documentation of Shaker material culture, Sears was especially impressed by the spiritual traditions that the Believers maintained. With the cooperation of the Shakers, who had sufficient confidence in her to grant her access to the community's rare books and archives, she published *Gleanings from Old Shaker Journals* in 1916, two years before the old Shaker village closed its doors forever. Sears arranged to move one of the Shaker buildings to Prospect Hill, adjacent to the Fruitlands farmhouse, and installed within it a broad-based collection of furniture, crafts, and historical artifacts—the first museum devoted entirely to the Shaker heritage in the United States.

Sears was tied by family connection and personal conviction to the traditions of New England and the tales of its old ways. Among her fourteen fiction and non-fiction books, she chronicled the story of William Miller and the first Adventists in *Days of Delusion* (1924). The discovery of Indian arrowheads on Prospect Hill resulted in the building of a Native American collection and the creation in 1930 of an Indian museum on her property. Her important collection of early folk portraits not only prompted the publication of her trailblazing *Some American Primitives: A Study of New England Faces and Folk Portraits* (1941), but the establishment of a picture gallery on Prospect Hill, where she also exhibited her collection of Hudson River School paintings.

Remarkably creative to the end of her long life, Sears, who never married, closely supervised the growth and development of her museums. They stand today as monuments to her passionate commitment to the history and culture of New England and its intellectual, religious, and artistic heritage.

See also **Adventist Chronological Charts; Painting, American Folk; Shaker Furniture; Shakers.**

BIBLIOGRAPHY

Barton, Cynthia H. *History's Daughter: The Life of Clara Endicott Sears, Founder of Fruitlands Museums*. Harvard, Mass., 1988.

O'Brien, Harriet E. *Lost Utopias*. Boston, 1929.

Sears, Clara Endicott. *Some American Primitives: A Study of New England Faces and Folk Portraits*. Boston, 1941.

GERARD C. WERTKIN

SEIFERT, PAUL (1846–1921) is the only artist in the northern Midwest of the United States known to have worked as a painter of farm and house portraits (essentially landscapes that prominently featured one's home or farm). He was born in Dresden, Germany, in June of 1846, the son of a university professor, and was raised in an affluent household. Seifert attended university and is believed to have received a degree in civil engineering. He fled Germany in 1867 to escape the Austro-Prussian War and arrived in the United States, settling in Richland County, Wisconsin. Seifert befriended the German speaking Kraft family, and married their daughter, Elizabeth Ann Kraft, in 1868. The couple purchased land near Richland City and together nurtured a truck garden whose produce Paul marketed in nearby towns. They had four daughters.

Family records hold that Seifert learned taxidermy in his youth from a groundskeeper employed by his father. This may also explain the origin of Seifert's knowledge of horticulture that he applied to raising and selling flowers, fruits, and vegetables, and planting orchards. Beginning in the late 1870s, he began painting farm portraits on site in oil and watercolor for farmers in the Richland, Sauk, and Iowa counties

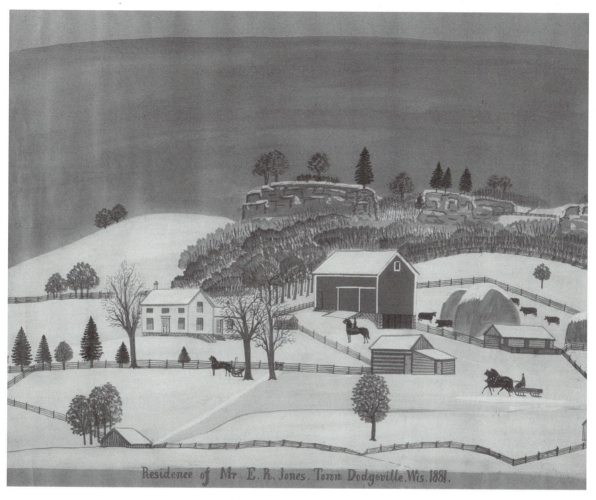

Residence of Mr. E. R. Jones. Town Dodgeville, Wis. 1881. Paul Seifert; 1881. Watercolor;
21½ × 27½ inches; N-222.61. Collection Fenimore Art Museum, Cooperstown, New York.
© New York State Historical Association, Cooperstown, New York

year round. He would pack a bag with paints and paper in search of farmers willing to pay $2.50 for a painting of their farmstead. Seifert made sketches on site, sometimes finishing a canvas in a day, but often returning home to finish the painting.

The farm and house portrait genre was a specialty particular to American artists of German descent in New York State, Pennsylvania, and Ohio. The precision with which Seifert rendered his farmsteads may have derived from his civil engineering training. The outlines of houses and outbuildings are drawn with pencil and a straightedge, and the materials used in their construction are identifiable. Seifert's colorful and varied palette manifests the local preference for the colors of houses, barns, and other farm structures with accurate details. The placement and scale of

these buildings in relation to one another, along with split rail fences that demarcate pastures, fields, orchards, and gardens, are carefully recorded. Hay scenes, horses and cattle grazing in pastures, figures on horseback, driving sleds, wagons, and, in one case, an automobile, give Seifert's paintings a sense of prosperity, order, and serenity. In one such example, *Residence of Mr. E. R. Jones. Town Dodgeville, Wis. 1881*, Seifert faithfully records Mr. Jones' property, including his house, barn, hay, and grazing cattle, using both opaque and transparent watercolors and a crisp linear style. Such a painting would have been proudly hung in the Jones home as a document of not only ownership but also of personal values.

The counties in which Seifert painted are noted for their scenic landscapes of steep, rocky bluffs, and

hills, limestone outcroppings along rivers, and fertile valleys. Seifert's paintings emphasize the natural beauty of the area, making them distinctive examples of the genre. In Seifert's work farms are situated on gently rolling bottomlands with the stylized, flowing contours of wooded hills or limestone bluffs in the background. Broad watercolor washes painted in a flattened arc often describe the sky, with scudding clouds sometimes painted in gold to suggest the reflected rays of the setting sun.

When demand for his farm portraits diminished or travel became increasingly difficult, Seifert opened a taxidermy studio and made pictures of castles on glass and oil paintings of churchyards.

See also **German American Folk Art; Painting, American Folk; Painting, Landscape.**

BIBLIOGRAPHY

Lipman, Jean, and Tom Armstrong, eds. *American Folk Painters of Three Centuries.* New York, 1980.

Rumford, Beatrix T., ed. *American Folk Paintings: Paintings and Drawings Other than Portraits From The Abby Aldrich Rockefeller Folk Art Center.* Boston, 1988.

RICHARD MILLER

SERBIAN AMERICAN FOLK ART: *SEE* EASTERN EUROPEAN AMERICAN FOLK ART.

SERL, JOHN (c. 1894–1993) was a painter who was born in Olean, New York, and spent his childhood touring the United States with his family, who were vaudeville entertainers. Due to their lifestyle, his schooling was sporadic. By the time he was ten he was performing onstage as a singer and dancer, often appearing onstage in the guise of a girl. He fled the United States for Canada for a brief time around the beginning of World War I (presumably to avoid conscription), but he was back in the country before the war ended.

In the 1930s Serl moved to Hollywood and began a career in the film industry. Drawing on his vaudeville experience, he earned a living by singing, dancing, playing minor film roles, and doing voice-overs for silent film stars whose speaking voices were ill-suited to cinema with sound. He also wrote several books and screenplays, fulfilling an early aspiration to a writing career. Nicknamed "Slats" by his peers, he traveled in a social and professional circle that included Howard Hughes and Hedda Hopper, who became a longtime friend.

When World War II broke out, Serl again fled the country—presumably to avoid military duty—and settled for a time in British Columbia, where he made his first attempts as a painter. Using a window shade and found pieces of wood or cloth as his surfaces, he painted a few landscapes, domestic interiors, and a small portrait of a boy who had recently died by drowning, but it was only later that he became more involved in painting and developed the distinctive, expressionistic style for which his work is known.

After the war, Serl returned to the United States and went to Texas, where he harvested crops and took other odd jobs, sometimes finding time to paint. By 1950 he was back in California, where he spent the 1950s in Laguna Beach, known as an artists' colony, and he devoted himself more wholeheartedly to painting, meanwhile supporting himself by working as a gardener and handyman. At the outset of the 1960s he moved into the barrio near the San Juan Capistrano mission and began cultivating an Edenic garden of fruit trees where chickens and dogs roamed freely about. He also began symbolically expressing his disdain for an increasingly commercialized, homogenized American society by routinely dressing as a monk and opening his home as a salon for fellow artists, intellectuals, writers and film-industry people, as well as a way-station for drifters and young hippies.

He moved in 1971 to Lake Elsinore, California, where a friend provided him with a rent-free house; he transformed the yard into yet another lush garden environment. He painted prolifically in his last two decades, during which his work gained widespread recognition and he attained celebrity status, making two appearances on national television, as Johnny Carson's guest on *The Tonight Show*. He died in his sleep, at home.

See also **Painting, American Folk.**

BIBLIOGRAPHY

Art Galleries of Ramapo College of New Jersey. *John Serl: Painter.* Mahwah, N.J., 1986.

Sellen, Betty Carol, and Cynthia Johanson. *Twentieth Century American Folk, Self Taught, and Outsider Art.* New York, 1993.

TOM PATTERSON

SEWER PIPE FOLK ART refers to objects made by sewer pipe factory workers after-hours, as gifts for friends and relatives or for the workers' own pleasure, from the same clay used for making sewer pipes. They fired them in the factory kilns, often contrary to company policy. The objects were usually cast from molds made by skilled workers, then embellished by hand. Animals, particularly lions, were popular subjects. Useful objects prevailed, such as ashtrays, can-

dlesticks, coin banks, doorstops, lamp bases, pipe stands, and planters, but some pieces were strictly decorative. Grave markers made of sewer pipe and inscribed by hand dot cemeteries across Ohio's clay belt. Although the names of several makers are known, most sewer pipe art is anonymous. An object's actual date and place of origin may be approximated from the nature of its glaze, and the color and texture of the unglazed clay on its underside. Nearly all pieces were produced between 1890 and 1950, mostly during the 1920s. Sewer pipe art was made across the Midwest, from western New York to Missouri, with Ohio as the largest producer. Made by untrained artists working in factory settings, sewer pipe art may be considered industrial folk art.

See also **Doorstops; Pottery, Folk.**

BIBLIOGRAPHY

Adamson, Jack E. *Illustrated Handbook of Ohio Sewer Pipe Folk Art.* Zoar, Ohio, 1973.

Dewhurst, Kurt C., and Marsha MacDowell. *Cast in Clay: The Folk Pottery of Grand Ledge, Michigan.* Lansing, Mich., 1980.

CAROL MILLSOM

SHAKER DRAWINGS, a form of visionary art, date from a period of about twenty years that began in 1837, during which an intense religious revival swept through the Shaker villages. During this period (known in Shaker history as the Era of Manifestations, or Mother's Work) some Shakers experienced trances, prophetic utterances, speaking in tongues, spirit communications, and other visionary experiences. These phenomena were recognized as "gifts" by the Shaker leadership, following the language of the New Testament: "Every good gift and every perfect gift is from above, and cometh down from the father of light" (James 1:17).

During the Era of Manifestations, thousands of gift messages and songs, among other phenomena, were believed by the Shakers to have been "received by inspiration" from deceased Shaker leaders or figures from sacred history. Those members of the community who received and transmitted these gifts were recognized as "instruments." Some talented Shakers, most of whom were women resident in the communities at New Lebanon, New York, and Hancock, Massachusetts, were inspired to create drawings as well. Far less common than other Shaker visionary expressions, a little more than two hundred drawings remain extant. Gift drawings, however, should be understood in the context of the oral and written gifts; all these forms share equivalent symbolic language

and imagery. They generally are intended for identified recipients and offer messages of encouragement, consolation, or exhortation. Spiritual presents, such as baskets of fruit or crowns, may also be bestowed.

Unlike the "automatic" writings or drawings of nineteenth-century spiritualism, Shaker drawings were not believed to be the work of spirits guiding the hand of a visionist or medium. Eldress M. Catherine Allen (1851–1922) of New Lebanon, a Shaker leader, referring to the exquisite drawings of Polly Ann (Jane) Reed (1818–1881) as "manifestation gifts," explained that the artist "did the work by dictation of the medium to whom the message & the vision were given." While some Shakers recorded, in written form or drawing, visions that they received themselves, even then the recording was rarely accomplished in a trance state or while "possessed." With the exception of certain gift communications in "unknown tongues," Shaker drawings were acknowledged to be the conscious act of their creators, the recording of a vision previously received. For this reason, the use of the term "spirit drawing," by which these visionary works previously were known, has declined in favor of "gift drawing," following the terminology suggested by the expert on Shaker drawings, Daniel W. Patterson.

It is difficult to assess the phenomena associated with the Era of Manifestations so many years after their occurrence. Too many intellectually gifted and devout Shakers are known to have participated in the visionary experiences of the period to dismiss them simply as pious fraud or delusion. Whatever the motivation of the "instruments," the historical record generally supports the sincerity of their own belief in the veracity of their gifts, although some participants later left the Shakers, and disavowed their belief in the phenomena. To the leadership of the United Society of Believers, as the Shakers were formally known, the meaning of the manifestations was clear: they were signs of the divine, a heavenly call for the Shakers to return to their founding principles after a period of encroaching worldliness and spiritual stagnation.

The earliest Shaker gift drawing is by Mary Hazard (1811–1899), a resident of the First Order of the Church, New Lebanon, perhaps the most important Shaker "family" of the period and home to a small group of accomplished artists who influenced one another's work. Dated November 28, 1839, the drawing depicts a leaf, with the words and music of a song written around its periphery in "letteral" notation, a form of musical notation invented by the Shakers. This drawing and a companion piece depicting the reverse of the leaf are the only extant drawings by

Hazard. They are illustrations in a small songbook in Hazard's hand, now in the collection of the Winterthur Museum.

On the basis of the surviving drawings, the most prolific Shaker artist was Polly Ann (Jane) Reed, also a member of the First Order of the Church, New Lebanon. All of her dated drawings were created between 1843 and 1854. They include a series of minute, double-sided heart-shaped cutouts, in which textual elements—messages of consolation from God the Father—dominate, and a small body of design elements is utilized. In addition, she is credited with creating other small but meticulous gifts, including a series of double-sided leaf-shaped drawings, a spiritual map, and several larger, more fully developed works in watercolor. Possessing an elegant, sure hand, she had the capacity to combine disparate elements into remarkably balanced and pleasing compositions, which seem to bear the influence of needlework samplers created by young women outside the Shaker communities.

Among the other artists in the First Order of the Church, Sarah Bates (1792–1881) is known for a series of "sacred rolls," complex gatherings of emblematic figures that appear to appropriate Masonic iconography, among other sources. Her work also incorporates representations of imaginative machinery. She worked closely with Reed, and their respective drawings are clearly related. Other First Order artists included Miranda Barber (1819–1871), Marilla Fairbanks (1806–1881), and Semantha Fairbanks (1804–1852).

Among the families at New Lebanon, gift drawings are also associated with the Second Order of the Church and the Second Family. Except for a handful of drawings from the Shaker villages at Watervliet, New York; Canterbury, New Hampshire; and North Union, Ohio, all other documented Shaker gift drawings originated in the Church Family at Hancock, Massachusetts, located just across the state border from New Lebanon. Unlike most New Lebanon gift drawings, a central element, frequently floral or arboreal in nature, dominates many of the Hancock examples. These are often reminiscent of quilt designs. Despite their insularity, the Shakers were not immune to influences from outside their villages. Not only were memories of the visual culture of the region retained, but new directions in design found their

way into Shaker communities through recent converts, publications, and the reports of those Shakers who were charged with doing business with the outside world.

Among the most accomplished artists among the Hancock Shakers were Hannah Cohoon (1788–1864) and Polly Collins (1801–1884). Cohoon's five extant drawings, dated between 1845 and 1856, are bold, highly stylized compositions dominated by trees and, in one example, by a basket of apples. Her 1854 composition, *The Tree of Life*, now in the collection of Hancock Shaker Village, is the best-known Shaker gift drawing and generally is considered the masterwork of the genre. Cohoon's drawings reflect the visual culture outside the Shaker communities: popular prints, quilt motifs, and needlework samplers. Although only five of her drawings survive, it is likely that she created others. After the Era of Manifestations came to an end in the late 1850s, the Shaker leadership was ambivalent about gift drawings. While some drawings were carefully stored or even exhibited, there is evidence that others were intentionally destroyed.

See also **Sarah Bates; Hannah Cohoon; Polly Collins; Fraternal Societies; Freemasonry; Quilts; Polly Ann Reed; Religious Folk Art; Samplers, Needlework; Shakers; Visionary Art; Winterthur Museum.**

BIBLIOGRAPHY

Patterson, Daniel W. *Gift Drawing and Gift Song: A Study of Two Forms of Shaker Inspiration.* Sabbathday Lake, Maine, 1983.
Promey, Sally M. *Spiritual Spectacles: Vision and Image in Mid-Nineteenth Century Shakerism.* Bloomington, Ind., 1993.

GERARD C. WERTKIN

SHAKER FURNITURE, with its highly regarded functional and aesthetic qualities, is the aspect of folk art for which the members of the United Society of Believers in Christ's Second Appearing, more commonly known as Shakers, are most widely renowned. They have had a presence in America since 1774, are highly accomplished in many disciplines, and have achieved much of great social and religious value. Shaker furniture is rooted in the basic tenets of their faith as taught by their founder Mother Ann Lee (1746–1784). The Shakers believed that the Second Coming of the

Rocking Chair. Unidentified Shaker maker. Mount Lebanon, New York, c. 1850–1875. Maple with woven tape seat; 45 × 24⅞ inches. Collection American Folk Art Museum, New York. Gift of Robert Bishop, 1990.25.29.

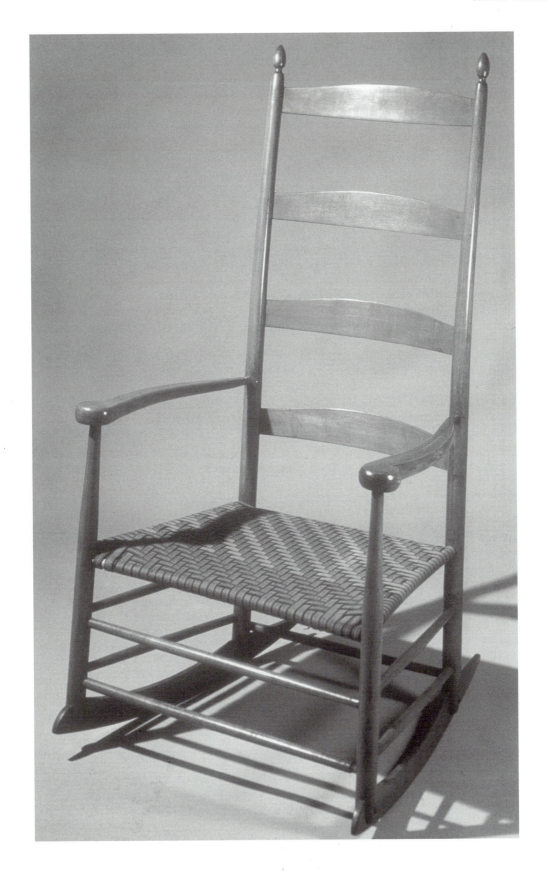

Christ spirit had already occurred through the work of Ann Lee, and that the Millennium had come, and with it the chance to live in heaven's kingdom on earth. Therefore, all labor was consecrated as worship. Sayings such as, "Do all your work as if you had a thousand years to live, and as you would if you knew you must die tomorrow," and "Hands to work, hearts to God," concisely express the attitude with which Shaker craftspeople approached their work.

During the late 1780s and early 1790s, the first Shaker communities were organized under the supervision of Father Joseph Meacham at New Lebanon, New York. At this time there did not exist a defined Shaker style of furniture, as most furnishings used in the communities were brought by the first converts. The research of scholars such as Edward Deming Andrews and Timothy D. Rieman has revealed that the Shakers at New Lebanon were producing their own chairs for sale as early as 1789. The classic Shaker chair is a stylistically refined example of the New England ladderback chair. Characterized by slender front and back posts devoid of excess turnings, a turned pommel or finial, and scribe marks to locate the slats (gradually arched towards the center and curved to accommodate the back), the Shaker chair is a radical departure from its thicker and more heavily turned predecessor. Shaker chairs came in a variety of forms, such as side chairs (with and without arms), rocking chairs (with and without arms), dining chairs, children's high chairs, and even wheel chairs.

All of these varieties were suited to a specific purpose of community life. Dining chairs were made to slide under the dining table to enable the floors to be efficiently swept after meals. The Shakers made seats for their chairs in cane, rush, splint, and woven wool or cotton cloth tape. Most of the Shaker communities have identifiably distinct shapes associated with the pommels that cap the rear posts of the chairs. Individual characteristics are also manifest in the shapes of slats, turnings of the front posts between the seat and arm of a rocker or side chair, the shape of the arms, as well as the form of the handholds. An almost entirely different type of Shaker chair was produced at Union Village, Ohio, during the early nineteenth century. This example has rear posts that are planed flat from just above the seat, gradually thinning the post to where it terminates in a "mule ear" instead of the typical pommel. Additionally, the Ohio chair has slats that are notched in a quarter circle from the post, with the depth of the notching increasing incrementally from the bottom to the top.

The Shakers produced chairs for use within their own communities, but also sold chairs to other Shaker and non-Shaker communities. The large scale commercial manufacture of Shaker chairs began in 1863, when the South Family at Mount Lebanon (formerly New Lebanon) was organized specifically for that purpose, and a factory was built and outfitted. Under the direction of Brother Robert Wagan (1833–1883), the South Family exhibited chairs at the 1876 Philadelphia Centennial Exhibition, where they were awarded a diploma and medal. The Shakers advertised chairs in printed catalogs in sizes 0, 1, 3, 4, 6, and 7; earlier catalogs included sizes 2 and 5. Various kinds of upholstery or tape could be had on side chairs and rockers, with or without arms, and featuring a shawl bar or the traditional pommels. The Shaker industry was quite successful, and they marketed their wares throughout the country, including merchants such as Marshall Field's in Chicago and the Herts Brothers in New York. In the wake of their success many imitators were spawned, inspiring the Shakers to mark their chairs with a gold decal on the inside of the rear post, signifying authenticity.

Wagan died of pneumonia in 1883, and with the overall Shaker population in marked decline, the chair industry began to gradually taper off by the early 1900s. A disastrous fire burned the five-story, stone chair factory on December 28, 1923. The business was restarted in a second factory that still stands at Mount Lebanon, but it never approached the volume of production achieved in the late nineteenth century. By the late 1940s, the last two Sisters involved in the industry died, bringing that chapter in Shaker history to a close.

The Shaker furniture that is showcased in museum villages across the United States, and that brings stunningly high prices at auction, was largely produced during the first half of the nineteenth century. Scholars regard this period of Shaker cabinetmaking as the "classic" period. Shaker cabinetmakers of the classical style employed many of the same forms as other cabinetmakers, such as blanket chests, chests of drawers, cupboards, side tables, candle stands, work counters, washstands, and beds. A number of characteristics, however, help to differentiate Shaker-made pieces.

Shaker craftsmen tended to strip away the excess ornamentation such as beadings, moldings, and turnings that were prominently displayed in early nineteenth-century furniture in general. The curvilinear fronts and neoclassical exuberance of Federal and Empire styles in American cabinetmaking are not found among Shaker craftsmanship. The Shakers favored clean, straight lines, and the reduction of forms to their essential properties. Shaker craftsmen em-

ployed subtle combinations of simple design elements, quarter round cornices and moldings, and simple cut feet. This does not mean that the Shakers sacrificed grace and beauty in their work; the finest elements of Shaker craftsmanship are to be admired in details hidden or considered mundane in other styles of cabinetmaking. Examples can be found in the slightly pillowed paneling on every cupboard door in the 1830 Brick Dwelling at Hancock, Massachusetts, or the hundreds of built-in drawers in the same building, each joined with dovetailed drawersides that taper in thickness from bottom to top.

The Shakers lived in large communal families that were organized within a religious hierarchy. Consequently, many pieces of furniture were designed and built for efficient use by large numbers of people. Examples of this functionality include large case pieces, such as one from New Lebanon, New York, which has three rows of seven drawers fitted under four cupboards. A piece of furniture built on this scale would only be practical for use by a communal family. Other examples in this vein include large trestle tables built for communal dining (some of which stretch to over twenty feet in length), and sewing stands with drawers facing in two directions for access by seamstresses working on opposite sides. Although individuality was to some degree discouraged or suppressed within the ranks of the Shakers, distinct traits can be identified in the work of cabinetmakers. Many indeed signed their work. Signed pieces of Shaker furniture have aided in the articulation of the differences in design and construction in the various communities, and have helped establish a chronology of workmanship.

Many surviving examples of Shaker furniture have been stripped of their original finishes or are entirely refinished. Pioneering paint research conducted by Susan Buck, and surviving examples of painted Shaker furniture, have revealed that the early nineteenth-century Shakers favored bright colors in finishing their furniture. Yellow ochre, red ochre, red lead, chrome yellow, chrome green, Venetian red, and less commonly, Prussian blue were commonly used. These pigments were bound in linseed oil to produce paint. Paint analysis of the interiors of Shaker buildings from Maine to Kentucky has revealed that the same pigments were favored in painting almost all exposed wooden surfaces, including the floors.

By the 1870s Shaker cabinetmakers were exploring Victorian forms of cabinetmaking. Although the Victorian-era products of Shaker craftsmen are stylistically similar to those of their counterparts during this period, the Shakers were decidedly more modest in their use of extravagant ornamentation.

See also **Edward Deming and Faith Andrews; Furniture, Painted and Decorated; Shakers.**

BIBLIOGRAPHY

Andrews, Edward Deming. *Religion in Wood*. Bloomington, Ind., 1966.

———. *Shaker Furniture: The Craftsmanship of an American Communal Sect*. New Haven, Conn., 1937.

Grant, Jerry V., and Douglas R. Allen. *Shaker Furniture Makers*. Hanover, N.H., 1989.

Kassay, John. *The Book of Shaker Furniture*. Amherst, Mass., 1980.

Muller, Charles R., and Timothy D. Rieman. *The Shaker Chair*. Winchester, Ohio, 1984.

Rieman, Timothy D., and Jean R. Burks. *The Complete Book of Shaker Furniture*. New York, 1993.

CHRISTIAN GOODWILLIE

SHAKERS are a small religious community that coalesced as a group in the mid-eighteenth century industrial boroughs of Lancashire, England; flourished in nineteenth-century America; and today are recognized for their distinctive traditions in art and design. Practicing celibacy, communal ownership of property, and pacifism, the Shakers established themselves in nineteen principal villages in New York, Massachusetts, Connecticut, New Hampshire, Maine, Ohio, Kentucky, and Indiana, as well as in several short-lived communities in those and other states. At first reviled by their neighbors, the Shakers in time were admired for their neat, efficient farms, the excellence of their craftsmanship, and the innovative technology and genius for invention that marked their history. Consisting of fewer than five thousand members at their height in the first half of the nineteenth century, the Shakers comprise only a handful of adherents today, all of whom live in a community located in Sabbathday Lake, Maine.

The Shakers trace their history to 1747, when worship meetings began to be held under the leadership of Jane and James Wardley, tailors in Bolton-on-the-Moors, near Manchester, England. Little is known, however, about the Wardleys or their immediate followers. Some sources assert that they were members of the Religious Society of Friends, or Quakers, who in turn had been influenced by the French Prophets, millenarians from southeastern France, and their English converts, but a direct connection between their faith and that of either movement is uncertain. In fact, the early Shakers did not articulate a fixed creed or doctrine. Rejecting the formal liturgical practices of the Church of England, they sought a freer, more personal expression of Christian faith. This took the

form of ecstatic, emotional gatherings for worship, during which the participants sang, shouted, and leaped for joy. It was from these unrestrained practices that the members of the group received their popular name.

In the spirit of English religious dissent that drew its adherents from the country's petty tradesmen, artisans, and laborers, the first Shakers were deeply affected by a sense of God's immanence in a lost and sinful world. As a consequence, they were drawn to millenarian prophecy and speculation about the Second Coming of Christ. Attracting few converts in England, the Shaker movement might have withered and died, but for the addition to its numbers in 1758 of Ann Lees (her surname was shortened to "Lee" in Shaker usage), the daughter of a Manchester blacksmith.

A member of the Church of England, Ann Lee (c. 1736–1784) not only became leader of the group, but she was so influential in the development of its belief system that she is recognized as the founder of the Shaker faith. Her birth, probably in Manchester, is not recorded, and its precise date has never been ascertained, although the tradition of the church holds it to be February 29, 1736. Her family was poor, and she suffered through a difficult childhood of factory labor, much like other English children of the working class. From her earliest years, she experienced a sense of spiritual longing. Among those whose teaching influenced her was George Whitefield, the Methodist preacher, and she is said to have attended his great outdoor meetings. It was with the Wardleys and their small conventicle, however, that Ann Lee found a spiritual home.

According to Shaker tradition, Ann Lee preferred not to marry. It was only in her twenty-sixth year (four years after she entered the Wardley society) that she acceded to the wishes of her family, and in 1762, she accepted the hand of Abraham Standerin (the name also appears as Stanley or Standley), a blacksmith like her father. The newlywed couple resided in the home of Lee's father in Manchester, among the tenements of Toad Lane. Four children were born to them, all of whom died early in their young lives.

Lee brought an invigorated sense of mission to the Wardley society. Because of the noisy exuberance of their worship, the Shakers attracted the hostility of their neighbors and the civil authorities; several Shakers, including Lee herself, were fined or imprisoned in the early 1770s for interrupting worship at Christ Church, Manchester. The Shakers believe that during Lee's confinement in the House of Correction, an old jail on the banks of the River Irwell, she had a profound visionary experience during which divine manifestations were presented to her view and the whole spiritual world was displayed before her. According to the Shaker account, when she was released from prison, Lee spoke to her followers about her vision and taught the necessity of celibacy to achieve a full Christian life. After a period of relative peace during which the Shakers worshiped at night in Manchester, and in nearby towns to avoid persecution, Mother Ann—as her followers now called her—led a small group of Shakers to the American colonies, following a "special revelation" that the faith would flourish there.

On August 6, 1774, Ann Lee and eight followers disembarked in New York, after a sea voyage that had begun the previous May in Liverpool. The *Mariah*, the vessel in which they traveled, was barely seaworthy. Among the many miraculous stories in the Shaker narrative is a tale of the *Mariah*'s deliverance from a great storm through the unshaken conviction of Ann Lee. Lee remained in New York for about two years, working as a laundress. Others, including her brother, William Lee (1739–1784), and her successor, James Whittaker (1750–1787), traveled up the Hudson River and were able to lease a tract of wooded land eight miles northwest of Albany, the site of the first Shaker community. After joining them in 1776, Lee undertook extensive preaching journeys with her companions in New York State and New England. Her pacifist message resulted in a confrontation with American authorities during the American Revolution; a small group of Shakers, including Lee, was jailed for several months in Poughkeepsie, New York. Nevertheless, Lee's message began to have an effect. By the time of her death in 1784, the groundwork had been laid for the organization of Shaker communities throughout the region and beyond.

Under Ann Lee's American-born successors, Father Joseph Meacham (1741–1796) and Mother Lucy Wright (1760–1821), Shaker communities were established between 1787 and 1810 at New Lebanon and Watervliet, New York; Hancock, Tyringham, Harvard and Shirley, Massachusetts; Enfield, Connecticut; Canterbury and Enfield, New Hampshire; Alfred and New Gloucester (Sabbathday Lake), Maine; Union Village and Watervliet, Ohio; South Union and Pleasant Hill, Kentucky; and West Union, Indiana. Three additional communities, North Union and Whitewater, Ohio, and Sodus Bay, New York, were established between 1822 and 1826.

In their self-contained villages, the members of the United Society of Believers in Christ's Second Appearing, as the Shakers were formally known, developed

a distinctive communal lifestyle. Women enjoyed equality with men in leadership and in other departments of community life, although work assignments tended to mirror the practices of the world outside the villages. This was but a practical application of the Shaker concept of Deity. Shaker theology recognizes the one God as Father and Mother rather than as a Trinity. Moreover, for some Shakers, Ann Lee herself represented the Second Coming of Christ, although others rejected this view. Community organization in the celibate society was based on the "family" unit, a group of Shakers who lived together, held their property in common, and shared joint social and economic interests. Unlike conventional families, Shaker families were not based on blood relationships or marriage. Consisting of a mere handful, to a hundred or more members, each family was governed by an elders' "lot" or order, consisting of two men and two women—a senior elder and eldress and their respective associates—who were responsible to the ministry of the "bishopric." All Shaker villages within a state, or otherwise located relatively near one another, constituted a bishopric and were governed by a ministry consisting of two elders and two eldresses. The bishopric ministries were, in turn, responsible to the central or "parent" ministry at New Lebanon, Columbia County, New York.

During much of the nineteenth century, each Shaker village had at least three families; the larger villages had eight or more. In each village, the "Church" or "Center" Family was the location of the meetinghouse, where all families worshipped together on Sunday. Families were often named on the basis of their geographical relationship to the Church (i.e., "North" Family), or the order of their founding (i.e., "Second" Family). In keeping with a tripartite system devised by Meacham, some families were "novitiate" or "gathering" families, which received inquirers from outside the community, and provided a means for instruction in the Shaker faith. Those who had advanced in the faith but still had ties to the world, or restraints limiting a full commitment to the church, lived in a "junior order." For those for whom a full consecration was possible, membership in a family "in church relation" and the execution of the "Church Covenant" signaled the intent to become a Shaker for life. Although the division of Shaker villages into families continued into the twentieth century, Meacham's system was not strictly in force by the mid-nineteenth century. Because each family was independent of the others, distinctive traditions developed in craftsmanship; it is possible, for example, to ascribe certain furniture forms to specific families.

Shaker theology and tradition stress simplicity, harmony, and perfection as goals of the spiritual life. This emphasis, which was reinforced by several compilations of rules in effect from time to time, had a direct impact on the development of the spare, elegant aesthetic that is associated with Shaker architecture and design. In seeking simplicity, Shaker master builders and craftsmen eschewed ornamentation of any kind. Shaker furniture, for example, is without decorative turnings, carvings or painting, but exacting in craftsmanship and purity of line. Although nineteenth-century Shakers proscribed decorative painting, the rich painted colors of their characteristic oval boxes demonstrate that color had an important place in Shaker life. The written rules and regulations, that helped order Shaker life during part of the nineteenth century, even specified the colors to be applied to various classes of buildings, inside and out, as well as to certain kinds of household furniture and other utilitarian objects. More often than not Shaker architecture and design represent a paring down of vernacular forms common to their region. Although the Shakers sought self-sufficiency and "separation from the world," they continued to be influenced by ideas emanating from the world outside the communities. Northeastern Shaker meetinghouses, each of which was built under the supervision of Brother Moses Johnson (1752–1842) of Enfield, New Hampshire, are based on the eighteenth-century gambrel-roofed dwelling houses of the Connecticut River Valley, without sign or symbol of any kind.

Unlike such religious communities as the Old Order Amish, with whom they are often compared, the Shakers have embraced progress in technology and science. Freed from care by their communal environment, members of the Society were encouraged to experiment. The result is a remarkable record of innovation and invention. Shakers are credited with inventing the flat broom, the clothespin and the circular saw. If these developments cannot be verified beyond a reasonable doubt, however, there are several dozen Shaker-patented inventions that underscore the Shakers' creative spirit, including an improved industrial washing machine, a tilting device for chairs, a harvesting machine, a grain separator, a chimney cap, cord clamps for windows; a folding stereopticon, and many others. The Round Stone Barn at Hancock Shaker Village in Berkshire County, Massachusetts was the first truly round barn built in North America, and its innovative qualities brought the Shakers widespread celebrity throughout the northeast when it was completed in 1826.

The Shaker villages attracted frequent comment from nineteenth-century utopian socialists and reformers, among them Karl Marx's collaborator, Friedrich Engels. While rejecting the Shakers' religious faith, they were impressed by their demonstration of the efficacy of communism. The Shakers were not only successful agriculturists, but they also grew, packaged and distributed garden seeds, produced a variety of medicinal herbal products, maintained a successful chair manufacturing business at the South Family, New Lebanon, New York, and manufactured many kinds of utilitarian woodenware, baskets, brooms, and brushes, among other products for home use and sale. In the late nineteenth and early twentieth centuries, when many more women than men comprised the Shaker communities, Shaker sisters produced poplar-ware fancy work, cloaks, knit goods, and other items for sale.

Shaker daily life was regular and orderly, with time for diversion and frequent rotation of jobs. The earlier ecstatic worship practices gave way in the nineteenth century to carefully choreographed dances and marches. The Shakers also developed an impressive tradition in religious folk hymnody. At least one Shaker song, the well-known "Simple Gifts," by Elder Joseph Brackett (1797–1882) of Sabbathday Lake, Maine, has entered American vernacular culture, having been used as a theme by Aaron Copland in his *Appalachian Spring*. Despite the regularity of Shakerism's daily rounds, an underlying receptiveness to visions and prophecy has remained a feature of life in the communities. Beginning in 1837 an intense religious revival swept through the Shaker villages that was reminiscent of the ecstatic and emotional manifestations common in the earliest years of the faith. During this period–known to Shaker history as the Era of Manifestations or Mother's Work, thousands of "gift" messages and songs were believed by the Shakers to have been received "by inspiration" from the spiritual realm through living instruments or mediums. Some gifted Shakers were inspired to create "gift" drawings during this period, as well. Continuing with varying degrees of emphasis from community to community until the late 1850s, the Era was characterized by elaborate worship practices and dance forms.

A slow but unremitting disintegration, which began to affect the Shaker communities following the American Civil War, accelerated with the advent of the twentieth century. Fewer and fewer adult converts entered the Society, and the Shakers began to rely on the young children who were left with them to fill the ranks of Believers. To be sure, Shaker life continued with remarkable robustness in two or three centers, but most of the surviving villages were places of quiet roads and near-empty dwelling houses and shops, where older Shakers seemed content to reflect upon events of earlier days, while the young grew restive in an environment no longer responsive to their needs. Only three villages survived into the second half of the twentieth century-Hancock, Massachusetts; Canterbury, New Hampshire; and Sabbathday Lake, Maine. Today only Sabbathday Lake remains as an active center of the Shaker faith.

See also **Edward Deming and Faith Andrews; Sarah Bates; Henry C. Blinn; Joshua Bussell; Polly Ann Reed; Cora Helena Sarle; Clara Endicott Sears; Shaker Drawings; Shaker Furniture.**

BIBLIOGRAPHY

Andrews, Edward Deming. *The People Called Shakers: A Search for the Perfect Society.* New York, 1953.

Kirk, John T. *The Shaker World: Art, Life, Belief.* New York, 1997.

Stein, Stephen J. *The Shaker Experience in America: A History of the United Society of Believers.* New Haven, Conn., 1992.

Wertkin, Gerard C. *The Four Seasons of Shaker Life: An Intimate Portrait of the Community at Sabbathday Lake.* New York, 1986.

GERARD C. WERTKIN

SHEFFIELD, ISAAC (1807–1845) was a painter of sea captains and their families. He was active in the whaling port of New London, Connecticut, during the 1830s and 1840s. According to the writer Joyce Hill, there are least two dozen works, some inscribed, that can safely be attributed to Sheffield and perhaps another dozen or more that may have been done by him.

The artist was the son of a shipmaster, Captain Isaac Sheffield, and his wife Betsy Sizer, of New London. Captain Sheffield also worked out of the ports of Stonington, Connecticut, and Sag Harbor, New York. Little is known about his training. City directories for New York list him as a painter of miniatures in 1828 and 1829. A Brooklyn directory for 1830 calls him a miniature and portrait painter. He appears to have returned to New London in 1830, upon the death of his father, and subsequently lived in the heart of that city's whaling district.

His portraits in oil on canvas or wood are a bit stiff and awkward in certain places, such as the hands of his male sitters. Yet they are fairly accomplished overall and he seems to have been able to capture a good likeness. His adult sitters are generally shown half-length, seated, and turned slightly, the gentlemen of pairs facing inward on the left and the ladies facing

inward on the right. Often the male sitters will hold an attribute of their profession, such as a telescope. Their vessels at sea are sometimes seen through the draped window behind them. The portrait of the *Connecticut Sea Captain* (1833), not only shows the captain's ship, but carefully depicts the operation in which the blubber of a whale is stripped.

Female sitters are depicted with close attention to their fine lace collars and to their impressive jewelry. The ladies generally have smooth, peach-colored complexions, pretty and regular features, and an exaggerated, triangular shape to their shoulders. The gentleman are similarly handsome, but with ruddier skin tones. Sheffield painted children as well, in full length. The best known of these works is the portrait of *James Francis Smith* (1837), who is depicted in the penguin-skin coat that was fashioned during a South Seas voyage with his father, Captain Franklin A. Smith, a famous sea captain.

By 1837 Sheffield offered his services as a painter of landscape, marine, and fancy paintings, but none no such works by him have yet been identified. Like his contemporaries Frederick Mayhew (1785–1854) of Martha's Vineyard and New Bedford, Massachusetts, and Orlando Hand Bears (1811–1851) of Sag Harbor, New York, Sheffield seems to have found plenty of work capturing for posterity the visages of the class of maritime adventurers flourishing in this era.

See also **Maritime Folk Art; Painting, American Folk.**

BIBLIOGRAPHY

Mayhew, Edgar. "Isaac Sheffield, Connecticut Limner." *Antiques*, vol. 84, no. 5 (November 1963): 589–591.

Hill, Joyce. "Cross Currents: Faces, Figureheads and Scrimshaw Fancies," *The Clarion* (spring/summer 1984): 25–32.

Deborah Chotner

SHELBURNE MUSEUM, THE was founded by Electra Havemeyer Webb (1888–1960), an idiosyncratic pioneer who was an important figure in American folk art. She was the only woman to have founded and endowed a major art and history museum in the United States. Although she inherited a love of collecting from her parents—Louisine (1855–1929) and Henry O. Havemeyer (1847–1907), who acquired fine Impressionist works—she had a distinctly different taste in art. Webb's passion to collect folk art began with her first purchase, a wooden cigar store figure from Connecticut, and continued for the rest of her life.

Electra Webb's wish to preserve America's heritage and display her rapidly growing collections was realized with the establishment of the Shelburne Museum in one building in 1947. Subsequently, between 1947 and 1960, the year of Webb's death, thirty nineteenth-century historic structures, predominantly from Vermont, with a few from New York and Massachussetts, were acquired and moved, usually in pieces to be reconstructed, to the 45-acre grounds of Shelburne. Examples include a meetinghouse, a covered bridge, a stone residence, a schoolhouse, and the steamboat *Ticonderoga*. Thirty-nine galleries and exhibition structures on the sprawling Shelburne property are filled with outstanding collections of fine and decorative arts, furniture, wood sculpture, tools, weather vanes, textiles, toys, dolls, vehicles, and paintings by artists such as William Matthew Prior (1806–1873), Martin Johnson Heade (1819–1904), Anna Mary Robertson "Grandma" Moses (1860–1961), Mary Cassatt (1824–1926), and Claude Monet (1840–1926).

Favorite exhibits include the Circus Building, with its circus posters and carousel figures; the Steamboat Ticonderoga, now a National Historic landmark; the Webb Memorial Building, containing Impressionist works and fine decorative arts from Webb's apartment in New York; the Stencil House, with its stenciled surfaces on walls, floors, and furniture; the Horseshoe Barn, which houses carriages and coaches; the Hat and Fragrance Textile Gallery, displaying coverlets, bedrugs, and fine needlework; the Blacksmith Shop; the Stagecoach Inn, displaying a collection of folk art sculpture; and the Bostwick perennial garden.

Shelburne is committed to sharing the collection of more than 150,000 objects of seventeenth- through twentieth-century Americana, art, architecture, and artifacts with the thousands who visit each year. The museum continues to retain the essence of Electra Webb, taking great care to keep her vision alive to provide education and enjoyment of the craftsmanship and ingenuity of American ancestors for generations to come.

See also **Architecture, Vernacular; Circus Art; Coverlets; Dolls; Toys, Folk; Furniture, Painted and Decorated; Hooked Rugs; Maritime Folk Art; Pictures, Needlework; William Matthew Prior; Quilts; Rugs; Samplers, Needlework; Shop Figures; Weathervanes; Electra Havermeyer Webb.**

BIBLIOGRAPHY

Curry, David P. *An American Sampler: Folk Art from the Shelburne Museum*. Washington, DC. 1987.

Shelburne Museum. *American Dreams, American Visions*. Shelburne, Vt., 2003.

DEBORAH LYTTLE ASH

SHELLEY, DONALD A.: *SEE* FRAKTUR.

SHIPS' FIGUREHEADS are carved wooden decorations usually representing real, mythological, or fantasy people or animals, attached to the bows of wooden ships. They served as a talisman for the ship, providing comfort to the sailors and intended ensure their safe return to their home port. As decorations they enhanced the beauty of the ship and often served as a pictorial or sculptural form for the name of the vessel.

While the proliferation and popularity of American ship figureheads reached their zenith in the early nineteenth century, ship decoration began with the advent of maritime vessels. Norsemen and the early Mediterranean people seem to be the earliest practitioners. They also have been traced to the locations of the islands of New Guinea, China, and India.

French figurehead carvers of the seventeenth century set the ideal for subsequent generations of all nations, especially England, Holland, Sweden, and Denmark. The French navy was founded in 1668 by Louis XIV's finance minister Jean-Baptiste Colbert who hired notable sculptors to execute ships' decoration. In search of expanded trade and bigger empires, naval activities (merchant ships and war ships) increased, as did shipbuilding and figurehead decoration. Over time the bow was either decorated with a single figurehead or a grouping of figures. Most wooden ships have sunk to the ocean floor where they have rotted, or they have succumbed to fire, but many ships' figureheads remain, as monuments to fallen sailors and memorials to past voyages.

Immigrant English ship carpenters initiated American ship carving in the early seventeenth century, but ship carving did not become a specialized trade until almost 1700. As in England, the lion was initially a popular figurehead, but lost its appeal in favor of images of horses and seahorses. Soon in vogue were individuals carved as figures, heralding the ship's name, the owner, his wife, or national heroes. British drawings of captured or sunk American vessels illustrate figureheads of Sir Walter Raleigh, who developed the first English settlements in America; John Hancock, president of the Continental Congress from 1775 to 1777; and Native Americans figures. United

States Customhouse files also record ship descriptions attesting to the popularity of the female figure. The artistic style corresponded to the fashion of the day, with the eighteenth century Baroque style of carving giving way in the next century to Neoclassicism, Romanticism, and Realism. As designs of ships changed, so did the styles of the figureheads.

Family ties and master-apprentice relationships were prevalent among the American carvers who primarily practiced their trade in Philadelphia, Boston, New York, and other East coast port cities. The best known and most competent early American ship figurehead carvers were William Rush (1756–1833) of Philadelphia, members of New England's Skillin family (active eighteenth century to early nineteenth century), Samuel McIntire (1757–1811) of Salem, Massachusetts, and Solomon Willard (1783–1861) of Boston, best known for his carving of President George Washington. The figurehead for the frigate *Constitution* (1797) was drawn by William Rush and executed by John Skillin (1745–1800). In writing to the naval constructor, Rush suggested that the figurehead for the *Constitution* be "represented by a Herculean figure, standing on the firm rock of independence, resting one hand on the fasces [a bundle of rods containing an ax with the blade projecting] . . . and the other hand presenting a scroll of paper, supposed to be the Constitution of America." A later figurehead added to the *Constitution* in 1848 represented the American hero and president, Andrew Jackson.

Pauline A. Pinckney, whose research is recorded in *American Figurehead and Their Carvers*, found that American figurehead carvers used accessible and abundant soft native pine for their figures. Carvers used either a single large block of pine for the body or smaller blocks, and carved individual body parts that were later fastened together using tongue and groove construction, and reinforced with brass or wooden pegs. The usual practice was for the apprentice to produce a rough-hewed figure from the wood and to leave the more exact detailing to the carver.

Elaborate decorations for both naval and merchant ships subsided from 1830 to 1850. The United States Navy economized and merchant shippers used less expensive and less weighty figurative busts. In 1850, with the arrival of clipper ships, a resurgence of ships' figureheads occurred, but since speed was the paramount consideration, figureheads of lesser weight and of a sleeker construction were required. A new generation of figurehead carvers accompanied the reign of the clipper ship, including the Fowle family of Boston (active 1813–1865), and the Dodge and

Anderson families of New York (both active in the mid-nineteenth century). Also active about 1850 were Joseph Wilson of Newburyport, Massachusetts, S.W. Gleason & Sons (later known as McIntyre & Gleason, that became Hastings and Gleason), and John W. Mason of Boston, Massachusetts; Portsmouth, New Hampshire; and Mystic, Connecticut. Boston and Baltimore had many prominent carvers. An economic depression of 1857, the Civil War, and the emergence of metal-hulled vessels brought an end to the era of the ship figurehead.

See also **Maritime Folk Art; William Rush; Sculpture, Folk; John and Simeon Skillin.**

BIBLIOGRAPHY

Brewington, M.V. *Shipcarvers of North America*. New York, 1972.
Norton, Peter. *Ships' Figureheads*. New York, 1976.
Pinckney, Pauline, A. *American Figureheads and Their Carvers*. Port Washington, New York, 1969.

WILLIAM F. BROOKS JR.

SHOP FIGURES are sculptural wooden or metal cast objects, usually figurative, used by commercial establishments to attract customers and to advertise services. Shop figures are also known as "trade figures" or "show figures." Originally carved by craftspersons from wood and later manufactured in metal from molds, shop figures flourished in the 1800s.

Many of the preeminent woodcarvers who created ships' figureheads also specialized in shop figures. Small, counter-size or tabletop wooden figures were popular before 1840. A stunning example is *Mercury* (1793), a commission of the John and Simeon Skillin Family workshop in Boston. This figure welcomed visitors to the post office on State Street in Boston from its perch above the door; it served as a locator for the post office and an advertisement of postal service, and it represented the speed with which posted letters would travel to their destinations. The carved image also suggested Mercury's characteristics—he was the fleet-footed messenger of the gods, as well as the god of commerce and patron of merchants and travelers.

A second iconic shop figure in Boston, *Lady With a Scarf*, was carved circa 1820 by Issac Fowle (1800–

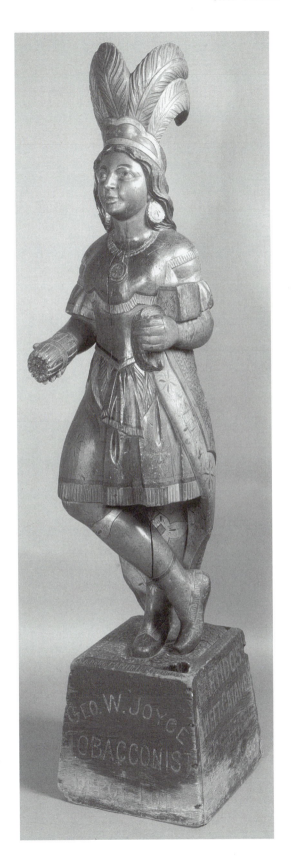

Tobacco Shop Trade Figure (The Cross Legged Princess). Signed: S.A. Robb, 114 Centre Street, NY. Carved and polychrome painted wood; 72 H × 15 W × 21 D inches. Photo courtesy Allan Katz, Americana, Woodbridge, Connecticut.

1832), formerly an apprentice in the Skillin workshop. The figure stood for years in front of the shop of its sculptor, attracting passersby as an example of Fowle's excellent craftsmanship in wood.

Perhaps the best known carver from this time period was William Rush (1756–1833) of Philadelphia, who is credited with setting the standard by which future wood-carvers were judged. His fellow carvers and their apprentices adopted Rush's designs and methods for their ships' figureheads and shop figures.

Shop figures were used to advertise many types of commercial establishments. A nautical shop or ship's chandler might have a carved sailor with spyglass in hand. A full-bodied turbaned Turk or Moor carved of wood was often used to promote a tea or coffee shop. The shop figure *The Little Admiral* stood at the entrance of the store of William Williams, a maker of mathematical instruments in Boston; earlier, it may have stood in front of the tavern that once occupied the same location. A figure of *Bacchus*, the god of wine, graced the entrance to an inn of the same name in Connecticut. In the mid-nineteenth century, shop figures lined the sidewalks of American villages, towns, and cities or functioned as sentries inside retail and wholesale shops and professional offices. The most popular shop figures, and those that have survived in the greatest quantity, are the cigar store figures, especially those representing Native Americans, better known as "cigar store Indians."

An article in the *New York Times* in 1890 reported on the popularity of shop figures, their carvers, and the carving methods. White pine was identified as the wood of choice, primarily because it was easily found in various lengths at spar yards. The master carver and his apprentices prepared, modeled, carved, finished, and painted the figures. Celebrated figural types included Native Americans, African Americans, Scottish Highlanders and "lassies," Chinese men and women, Turks, Sultans, soldiers, firemen, fancifully attired gentlemen and ladies, fur trappers, baseball players, Santa Clauses, Liberty (an allegorical female figure), Punch, Puck (the English folk figure and sprite from Shakespeare's *A Midsummer's Night Dream*), and a costumed female figure known as "Dolly Vardens." Although Native American and African American cigar store figures were widely popular, historians have since demonstrated that these figures reflected stereotypes of the late nineteenth century that today are understood as prejudicial or pejorative.

Samuel A. Robb and his apprentices were New York City's leading carvers of shop figures. One such tobacco shop figure signed "S.A. Robb," known as "The Cross Legged Princess," is incised with the shop owner's name: "Geo. W. Joyce, Tobacconist." Standing six feet tall and made of polychromed wood, Robb's figure wears the elaborate headdress and detailed costume that comprised the Native American typology of the day. Jacob Anderson (dates unknown), Charles J. Dodge (1806–1886), Thomas White (dates unknown), Tom Millard (dates unknown), John Cromwell (dates unknown), Nick Collins (dates unknown), and Thomas V. Brooks (1828–1895) were also known for their wooden shop figures. These men formed changing partnerships, initiated their sons in the craft (which was not, generally, considered an appropriate vocation for women), and located their shops in waterfront areas of cities where the shipbuilders had once been their primary customers. In New York City the shops were located in lower Manhattan on South Street, adjacent to the East River. Carvers' studios were also located in Baltimore, Philadelphia, Boston, Detroit, Chicago, Gloucester, Massachusetts, near the seaports of Maine, and elsewhere.

As electric signs, new forms of advertising and city ordinances addressing crowding on city streets lessened the demand for carved figures in the early twentieth century. Wood sculptors and their studios turned to other decorative woodcarving, adjusted to other media, or took up new professions.

See also **Thomas V. Brooks; William Demuth; Charles, J. Dodge; Maritime Folk Art; Samuel Anderson Robb; William Rush; Sculpture, Folk; Ships' Figureheads; John and Simeon Skillin.**

BIBLIOGRAPHY

Christensen, Erwin O. *Early American Woodcarving*. New York. 1952.
Fried, Fred, and Mary Fried. *America's Forgotten Folk Arts*. New York. 1978.

WILLIAM F. BROOKS JR.

SHOP SIGNS: *SEE* TRADE SIGNS.

SHOW FIGURES: *SEE* SHOP FIGURES.

SHRINES, a focus of popular devotional activity in the United States, often take the form of replicas of significant sites in the lives of Christ and early Christian saints; they are intended to provide a vivid religious experience for those unable to make the pil-

grimage to the Holy Land. Shrines come in many types: reliquaries, tombs, artificial caverns, reproductions of temples or churches, and Stations of the Cross. Such shrines were associated initially with the Franciscans, traditional guardians of sacred sites in the Middle East. They date back at least to the fifteenth century, when a Franciscan monk created a complex known as Sacro Monte at Varallo, in northern Italy: some forty chapels that tell the story of Jesus, set along a path that winds uphill to a replica of the Holy Sepulchre and the tomb of the Virgin Mary. While the Franciscans are responsible for the creation of important shrines in the United States—notably those of the Monastery Church at the Holy Land of America, Washington, D.C.—the practice of shrine building has spread broadly in America, especially among Catholics. For the most part, shrines are found in rural communities far from other ecclesiastical structures of any importance; they provide the faithful with a focus for pilgrimage and attract the curious, educating and perhaps converting them.

In the United States, grottoes have proved to be an especially prevalent form of shrine. Some of them are naturalistic; some borrow the forms of baroque church architecture. Most are made of concrete encrusted with stalactites, crystals, and other semiprecious natural materials. They recall the importance of caves in the life of Christ—many major sites in the Holy Land, such as the Church of the Nativity, Bethlehem, or the Church of the Holy Sepulchre, Jerusalem, are built over caves associated with Jesus. Moreover, the importance of caves has been reiterated throughout Christian history: some of the most popular pilgrimage sites in western Europe, such as Montserrat, Spain, and Lourdes, France, are associated with caves. The most familiar grotto shrines in the United States were built by German-born artist-priests in the upper Midwest; they include The Grotto of the Redemption, in West Bend, Iowa, built between 1912 and 1954 by Father Paul M. Dobberstein (1872–1954), and the Grotto of the Blessed Virgin, Dickeyville, Wisconsin, constructed in the 1920s by Father Mathias Wernerus (1873–1931). Grotto building is not only a Midwestern phenomenon, however: there is a splendid example at Saint Bernard Abbey, Cullman, Alabama, created in the early 1930s by a German-born lay brother, Joseph Zoetl (1878–1961). Neither is it entirely a German-American practice: a concrete cave shrine made in the 1940s by a Mexican-born artist, Dionicio Rodriguez (1891–1955), embellishes Memorial Park Cemetery, Memphis, Tennessee.

See also **Father Paul Dobberstein; Religious Folk Art; Mathias Wernerus; Joseph Zoetl.**

BIBLIOGRAPHY

Beardsley, John. *Gardens of Revelation.* New York, 1995.

Stone, Lisa, and Jim Zanzi. *Sacred Spaces and Other Places: A Guide to Grottos and Sculptural Environments in the Upper Midwest.* Chicago, 1993.

JOHN BEARDSLEY

SHUTE, RUTH WHITTIER (1803–1882) was part of a dynamic husband and wife team of itinerant folk portraitists. The enigmatic "R.W. and S.A. Shute" signature on a graphically arresting and uniquely intense group of oversized watercolor and mixed media pictures had aroused interest among folk art aficionados over thirty years, before research in the late 1970s identified R.W. as the Ruth Whittier who was born in Dover, New Hampshire, into a prosperous, middle class Quaker family. She was the eighth of Sarah Austin and Obadiah Whittier's nine children, and she was the first cousin of the celebrated poet and abolitionist John Greenleaf Whittier on her father's side, and his second cousin on her mother's.

On October 16, 1827, she married Dr. Samuel Addison Shute. The couple settled in Weare, New Hampshire, and within a year they were painting together. During this period, New England riverside communities were experiencing a burst of prosperity as textile mills were being established along their banks and young people were leaving nearby farms to take the jobs that were suddenly available. The Shutes found eager portrait patrons in this newly centralized and economically elevated population. Initially they were active in Lowell, Massachusetts, where many of their most noteworthy paintings of young mill workers were executed. Subsequently they traveled throughout northern New England and into upstate New York in an ongoing search for portrait commissions.

The young couple sought the business of prospective clients by setting up in regional hotels and announcing their presence in local newspapers. They worked in oil and watercolor and jointly signed examples in both media survive. The watercolors are particularly arresting with their backgrounds painted in translucent stripes and the depiction of the figure augmented by the use of additional artistic materials such as pastel, gouache, and collage. They carefully penciled the details of the facial features, achieving remarkably intense and expressive effects.

This high period is followed in 1834 by the disappearance of Samuel's name from the signatures and

the advertisements; he died in 1836. Undaunted by the social prohibitions of the times, Ruth persevered as a lone itinerant painter for four years. The watercolors of this period lack the inspiration and assurance of the earlier work, and she concentrated on portraits in pastel and oil. In 1840 she married Alpha Tarbell and moved to Kentucky, where she had two more daughters and continued to paint family portraits and allegories until the end of her life.

See also **Ralph Esmerian; Painting, American Folk; Dr. Samuel Addison Shute.**

BIBLIOGRAPHY

Hollander, Stacy C. *American Radiance: The Ralph Esmerian Gift to the American Folk Art Museum.* New York, 2001.

Kellogg, Helen. "Found: Two Lost American Painters." *Antiques World,* vol. 1, no. 2 (December 1978): 6–47.

Lipman, Jean, and Tom Armstrong, eds. *American Folk Painters of Three Centuries.* New York, 1980.

National Gallery of Art. *101 American Primitive Water Colors and Pastels from the Collection of Edgar William and Bernice Chrysler Garbisch.* Washington, D.C., 1966.

Rumford, Beatrix T., ed. *American Folk Portraits: Paintings and Drawings from the Abby Aldrich Rockefeller Folk Art Center.* Boston, 1981.

HELEN KELLOGG

SHUTE, DR. SAMUEL ADDISON (1803–1836) is celebrated as a member of a unique husband and wife team of itinerant folk painters whose work now hangs in major museums and private collections. Shute collaborated with his wife Ruth Whittier on a series of remarkable watercolor and oil portraits that were created as the couple traveled throughout rural Massachusetts, Vermont, New Hampshire, and upstate New York from the time they were twenty-four-year-old newlyweds until his early death at the age of thirty-two. During his boyhood, Shute's parents, Aaron and Betsy Poore Shute lived in Byfield, Massachusetts, and he attended the Governor Dummer Academy there, before going on to Dartmouth College where he studied medicine. Subsequently, according to *The History of Weare New Hampshire 1833–1888*, he was chosen to deliver East Weare's Fourth of July oration in 1827, and in 1828 he joined an effort to organize a new Masonic lodge. On March 24, 1829, the Shutes had a daughter, Adelaide Montgomery. She was born an invalid and she remained with her mother throughout her life.

A second daughter, Maria Antoinette, arrived on February 4, 1831, and lived only nine days. Her young father died five years later in Champlain, New York; he is buried beside her in Concord, New Hampshire.

Documentary evidence of Samuel Shute's artistic endeavors appears in several joint signatures on the backs of the collaborative portraits dated between February of 1832 and March of 1833. The wording of most of these inscriptions is: "Painted by R. W. and S. A. Shute," but, in an effort to isolate their individual contributions it is interesting to note that a few watercolors specify: "Drawn by R. W. Shute/ and/ Painted by S. A. Shute." Ruth continued to produce paintings long after she became a widow and subsequently remarried. The only example to date that verifies her husband's efforts as a solo artist is a family record for James Wilson and Lucinda Page and their one daughter and ten sons, signed and dated: "Samuel A. Shute/ Lowell Mafs. 30th March/ 1832." However, the jointly signed paintings are stylistically related to a large number of unsigned works from the tragically short but intensely prolific years when the couple worked together. It is this extraordinary body of work, characterized by graphic vitality and intense expressivity that assures the Shute team a very high standing among the most resourceful, inspired, and dynamic of American folk painters.

See also **Ralph Esmerian; Painting, American Folk; Ruth Whittier Shute.**

BIBLIOGRAPHY

Hollander, Stacy C. *American Radiance: The Ralph Esmerian Gift to the American Folk Art Museum.* New York, 2001.

Kellogg, Helen. "Found: Two Lost American Painters." *Antiques World,* vol. 1, no. 2 (December 1978): 36–47.

Lipman, Jean, and Tom Armstrong, eds. *American Folk Painters of Three Centuries.* New York, 1980.

National Gallery of Art. *101 American Primitive Water Colors and Pastels from the Collection of Edgar William and Bernice Chrysler Garbisch.* Washington, D.C., 1966.

Rumford, Beatrix T., ed. *American Folk Portraits: Paintings and Drawings from the Abby Aldrich Rockefeller Folk Art Center.* Boston, 1981.

The History of Weare, New Hampshire: 1835–1888. Weare, N.H., 1888.

HELEN KELLOGG

SIGN BOARDS: *SEE* TRADE SIGNS.

SILHOUETTES: *SEE* PAPERCUTTING.

SIMON, PAULINE (c. 1898–1976), was a Chicago artist who, following her unique vision, began painting at the age of seventy. She was born Pauline Hoherz in Minsk, Russia, and immigrated to the United States in 1909. Soon after arriving in Chicago, she was employed by a theatrical company to dress wigs. The position was short-lived, and within a year

she had married a dental student, Herman Simon. She worked in his dental office until his death in 1961. They lived on Chicago's south side, where they raised two daughters. Dr. Simon was a life member of the Art Institute of Chicago and Pauline Simon is said to have "avidly perused all the catalogs from the institute's exhibits." Following her husband's death, she enrolled in a four-week summer painting course at the Art Institute taught by Seymour Rosofsky (1924–1981). Frustrated by both the daily commute and her inability to grasp the rudiments, she visited the neighborhood Hyde Park Art Center, where she was encouraged by teacher and artist Don Baum (1922–).

His tutelage ignited a passion, and she painted until her death.

The majority of Simon's extant paintings are depictions of figures. Most canvases measure eighteen by twenty-four inches. Her primary subjects are playful individuals, abstractly represented in a decorative style. In an essay by Chicago art critic and author Michael Bonesteel on the occasion of a 1997 Simon retrospective of thirty paintings at Chicago's Intuit: The Center for Intuitive and Outsider Art, her paintings are described as filled with figures, "characterized by cartoon-like exaggeration, set against a flat picture plane. Her colors are vibrant, and she tends to favor reds, oranges, yellows, and pinks with green and blues for contrast. The thing that most distinguishes her work, however, is her wild use of patterning."

In a 1974 *Chicago Daily News* article, Simon commented on her artistic habits: "I spend a lot of time figuring out the colors. If I can't decide how to proceed, I stop and go to sleep for the night rather than waste time. I can't paint by electric light, I have to wait for the sunshine, especially to get the eyes just right." Whitney Halstead, art instructor at the School of the Art Institute of Chicago, on the occasion of a Simon retrospective of sixty-five works in 1974, wrote of the inhabitants of her paintings who "float weightless," and "without the ordinary limitations of anatomy, grow and extend themselves with delightful abandon."

See also **Intuit: The Center for Intuitive and Outsider Art; Outsider Art; Painting, American Folk.**

BIBLIOGRAPHY

Bonesteel, Michael. "The Perils of Being Pauline Simon: Revisiting the Art of an All-But-Forgotten Intuitive." *Outsider*, vol. 2, no. 1 (summer 1997): 6–8.

WILLIAM F. BROOKS JR.

SIMPSON, VOLLIS (1919–?) worked as a farmer, mechanic, and house-mover before he began building the outdoor environment of large-scale metal whirligigs for which he became widely known in the late 1980s and the 1990s. Simpson's collection of towering wind-powered constructions, reminiscent of a permanently installed carnival, is located near the small community of Lucama in eastern North Carolina. The site is a field alongside a pond at a five-points intersection of blacktop roads, on the farmland where Simpson was born and raised. Built from scrap heavy-equipment parts, industrial machinery, salvaged highway signs, and other brightly painted metal components, Simpson's whirligigs are among the largest and most structurally complex such creations on record. Each one has hundreds of moving parts and weighs several tons, and they range from 20 to 40 feet in height.

Simpson's interest in mechanics was initially spurred by the tractors and other farm equipment he and his family used to work their land during the 1920s and 1930s, when he was growing up. His fascination with airplanes, which are replicated in various scales in his whirligigs, stemmed from his four years in the United States Army Air Corps during World War II. After completing his military service, he returned to the family farm and went into business repairing tractors, pickup trucks, and the occasional car. He also began moving houses and other buildings, using special crane-equipped tow trucks and other gear that he designed and built from salvaged and hand-fabricated parts.

By the late 1960s, after more than twenty years of such work, Simpson had accumulated a vast number of spare parts and metal hardware left over from countless repair jobs, and he began using them to build the first of his big wind-driven contraptions. Then, with his ostensible retirement in the mid-1980s, he expanded on that initial creative statement. Disinclined to remain inactive, he went to work building more ambitious variations on the endlessly adaptable whirligig form, and by the early 1990s he had installed more than twenty of his monumental pieces in the field near his workshop. After being commissioned to contribute large, specially designed whirligigs to exhibitions at several art museums in the late 1980s, he started making much smaller, freestanding variations to satisfy an increasing demand from art collectors, who have visited him with increasing frequency since 1990.

See also **Environments, Folk; Whirligigs.**

BIBLIOGRAPHY

Manley, Roger. *Signs and Wonders: Outsider Art inside North Carolina*. Raleigh, N.C., 1989.

Patterson, Tom. *Not By Luck: Self-Taught Artists in the American South*. Milford, N.J., 1993.

TOM PATTERSON

SINGLETON, HERBERT (1945–) is an artist who powerfully depicts crime and violence in the African American ghetto of Algiers in New Orleans. He was the eldest of eight children; his family lived in two rooms. He completed only the sixth grade at school. He began carving at age seventeen, making walking canes that came to be known as "killer sticks" because a man was reputedly killed with one. He sold them for drugs, living a street life marked by gangs, pimps, and prostitutes. He was incarcerated for thirteen years at the infamous Angola Prison of Louisiana and has two scars from bullet wounds in his stomach.

Singleton's carvings are mainly bas-relief on found wood, often old oak and cypress doors. He paints them with bright enamel, and the subjects are often autobiographical. His *Club 27* is a carved and painted door, measuring 72 × 32 inches, and depicting a local club. Male and female prostitutes, framed by bloody knives, are positioned at the top, with patrons below drinking at the bar. In another panel of the same work is the figure of Big Hat Willie, a notorious pimp; he holds a killer stick and stands on the back of a woman. He is framed by figures injecting heroin. The bottom of the work is lined with skulls and dice. This powerful work is carefully incised and painted in bright colors. Its narrative shows the degraded world that Singleton experienced firsthand. Other works by depict subjects such as a funeral march in New Orleans; a lynching; a boy singled out as a dunce in a classroom setting; and a grocery store where Singleton worked. All these are permeated with vitality and emotion rendered in stark colors.

Singleton has also carved a number of works depicting Adam and Eve, and the Crucifixion, which are equally striking. His carving is done with hammer, chisel and pocket knife, after he has drawn the rough design on the wood.

See also African American Folk Art (Vernacular Art); Sculpture, Folk.

BIBLIOGRAPHY

Arnett, Paul and William, eds. *Souls Grown Deep*. vol. 1. Atlanta, Ga., 2000.

Sasser, Bill. "Herbert Singleton," *Raw Vision*, vol. 40, issue 40 (autumn 2002): 30–37.

Trechsel, Gail Andrews, ed. *Pictured in My Mind*. Birmingham, Ala., 1995.

JOHN HOOD

SKILLIN, JOHN (1745–1800) and **SIMEON SKILLIN JR.** (1756–1806) were sons of the patriarch of a prolific family of carvers, Simeon Skillin Sr. (1716–1778). Three of Simeon, Sr.'s five sons who lived to maturity, and two grandsons, became professional carvers. Simeon Sr. opened his carving shop in Boston about 1737. The Skillin shop was renowned from Salem to Philadelphia for producing highest-quality ship, decorative, and architectural carvings. John Skillin was apprenticed to his father, and Simeon Jr., in turn, most likely learned woodcarving from his father and older brother.

Beginning in 1777, John received commissions to make carvings for several ships being built in New London and Norwich, Connecticut, including the *Confederacy*. After its capture by the British, Skillin's carvings for the ship so impressed her captors that a drawing of them was made for the British Admiralty.

Shortly after the death of their father in 1778, John and Simeon Jr. formed a partnership. They opened a shop that was listed in the Boston directory for 1796 as being located on "Skillins Warf." John Skillin was so highly regarded by his fellow carvers that he was chosen to lead Boston carvers in parades celebrating the ratification of the United States Constitution in 1788 and Washington's visit to Boston a year later. In 1798, the Philadelphia sculptor Samuel Rush (1756–1833) recommended that John Skillin carve the figurehead *Hercules* after Rush's design for the U.S.S. *Constitution*.

The Skillins were also patronized by cabinetmakers, architects, and wealthy merchants who commissioned trade figures for their shops and ornamental carving for their houses. Salem merchant Elias Haskett Derby (1739–1799) hired Samuel McIntire (1757–1811) to design his summerhouse, for which McIntire also created the decorative relief carving. But Derby hired the Skillins to carve the figural garden pieces. Three of these, *Gardener*, *Plenty*, and *Pomona* survive, and the names of two others, *Hermit* and *Shepherdess*, are recorded. Derby's garden, with its summerhouse designed by McIntire and ornamented by the Skillin's sculptures created a remarkable and unique pastoral setting. In addition, the Skillins also carved three figures for a chest-on-chest ordered by Derby, carving for one of his ships, and the capitals on the pilasters of Derby's Salem mansion.

With John's death in 1800, Simeon Jr. continued the business. Several apprentices, including their

nephew Samuel (c. 1770–1816), had worked with the Skillin brothers during the 1790s, and it is likely that apprentices allowed the Skillin shop to continue in operation from John's death until Simeon Jr.'s death.

See also **Maritime Folk Art; Samuel McIntire; William Rush; Sculpture, Folk; Ships' Figureheads; Trade Figures.**

BIBLIOGRAPHY

Craven, Wayne. *Two Hundred Years of American Sculpture.* New York, 1976.
Lahvis, Sylvia Leistyna. "The Skillin Workshop." *The Magazine Antiques*, vol. 155 (March 1999): 442–451.

RICHARD MILLER

SKYLLAS, DROSSOS P. (1912–1973) executed, over a period of thirty years, thirty-eight paintings that combine meticulous realism with an undercurrent of surrealism. Although he was self-taught, Skyllas's works exhibit a high degree of technical proficiency and ingenuity. He began with pencil sketches that he then transferred to canvas. He preferred to work in oil, using deeply saturated jewel-like tones and eliminating any trace of brush work, creating a smooth surface. He often made his own brushes fine enough to execute the minute details he preferred. Skyllas's iconography, ranging from Greek Orthodox religious figures and icons to nudes, still-lifes, and landscapes is beautiful, but often disquieting.

Skyllas was born on the Greek island of Kalymnos where he was exposed to the Classical and Orthodox iconic traditions that inspired his later painting. He did not begin to paint until he after World War II, when he left Greece with his wife and settled in Chicago; his father, who owned a tobacco business, did not support Skyllas's desire to be an artist. Although he frequently visited the collections at the Art Institute of Chicago, Skyllas nurtured a style that was uniquely personal. He sought commissions but never sold any of his work—perhaps because he asked $25,000 to $35,000 per painting.

In *A Sunday Afternoon*, a mother and child in crimson are shown seated on a brick and tiled terrace; the backdrop is a vaguely Grecian looking, hilly city with a temple at its pinnacle. Bunches of grapes cascade from above the stoic sitters whose arresting faces are nearly identical and schematically rendered. The child wears a cross, perhaps a symbol of faithfulness, while her mother sits nearby, knitting, in a somewhat awkward pose. Although not wholly accurate, Skyllas's attempt at perspectival depth is relatively adroit for a self-taught painter. The canvas is

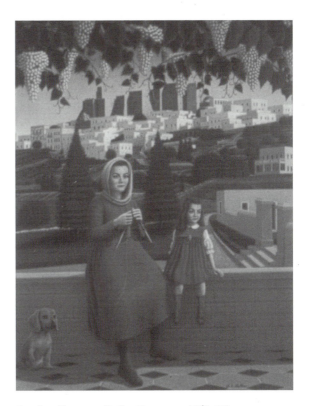

Sunday Afternoon; Skyllas Drossos; c. 1965. Oil on canvas; 46 × 36 inches.
Photo courtesy Phyllis Kind Gallery, New York.

bathed in an even, all-over light that enhances his use of pure, local colors including red, deep green, pale blue, and gold.

Although commercially unsuccessful, Skyllas remained determined. He advertised as a portrait painter specializing in "pure, realistic paintings" in a photographic style; moreover, he circulated a prospectus describing his desire to paint his version of the *Last Supper*, noting that he had prepared three large sketches and a smaller one with figures to be added when a sponsor came forward. If given the opportunity, he claimed, "I will create for you a *Last Supper*, equal only to those of the old master." Skyllas was religious, and this subject was his "sweetest dream"; as he wrote, "this invincible desire has grown as each year passes."

In 1974, William Bengston, a representative of the Phyllis Kind Gallery in Chicago, accidentally discovered Skyllas's paintings when he went to a police station to reclaim a wallet. One of the policemen there noticed Bengston's business card and invited him to look at the art of a friend (Skyllas) who had died the previous year. Museums and collectors have

since developed an appreciation for his work. His works are included in the American Folk Art Museum of New York and the Milwaukee Art Museum.

BIBLIOGRAPHY

Bihalji-Merin, Oto. *Encyclopedia of Naïve Painting.* Scranton, Pa., 1984.

Borum, Jenifer P. "The Work of Drossos P. Skyllas." *Folk Art,* vol. 19, no. 4 (winter 1994–95): 33–41.

Common Ground Uncommon Vision: The Michael and Julie Hall Collection of American Folk Art. Milwaukee, Wisc., 1993.

Johnson, Jay, and William Ketchum Jr. *American Folk Art of the Twentieth Century.* New York, 1983.

Maresca, Frank, and Roger Ricco. *American Self-Taught Artists: Paintings and Drawings by Outsider Artists.* New York, 1993

Rosenak, Chuck, and Jan Rosenak. *Museum of American Folk Art Encyclopedia of American Folk Art and Artists.* New York, 1990.

The Arts Club of Chicago. *Visions: Expressions beyond the Mainstream from Chicago Collections.* Chicago, 1990.

LEE KOGAN

SLOVAK AMERICAN FOLK ART: *SEE* EASTERN EUROPEAN AMERICAN FOLK ART.

SMIBERT, JOHN (1688–1751) was America's first academically trained painter. He was born in Edinburgh, Scotland, and was apprenticed to a house painter and worked as a plasterer before moving to London in 1709. Smibert painted coaches, then entered the academy of Sir Geoffrey Kneller, London's most influential artist. Smibert left for study in Italy in 1719, returned to London in 1722, and established a successful portrait studio in Covent Garden. In 1728 he accepted an invitation to join Bishop George Berkeley's mission to Bermuda, where Berkeley planned to organize a college and Smibert was to teach painting. Smibert sailed with Berkeley for Newport, Rhode Island, arriving there in 1729. When funding for Berkeley's college failed to materialize, Smibert settled permanently in Boston.

Smibert quickly established himself as Boston's leading artist. Along with a fashionable London portrait style that no other colonial painter could offer, Smibert brought a collection of artwork, including copies of works by Titian, Raphael, and Van Dyke that he had made in Florence and Rome on his grand tour. Displayed in Smibert's studio, these works gave many Bostonians their first exposure to the fine arts. Smibert's studio, the exhibits he organized, and the "color shop" he established, where he sold art materials and prints, became the center of Boston's fledgling artist community.

Smibert followed Kneller's formal, aristocratic Baroque portrait style, which emphasized the sitter's social standing more than his or her character. Smibert's poses avoided the stiffness that plagued the work of other colonial painters, and Smibert focused attention on the sitter without the distraction of unnecessary accessories. His portraits emphasize naturalism over idealization, reflecting not only his training but also his sitters' preference for likenesses that portrayed them as others saw them. Faces modeled with strong shadows, and solid volumetric forms, distinguish Smibert's work. Unlike some other colonial painters, Smibert occasionally localized a portrait by including an actual landscape in the background, rather than constructing a fanciful one.

Smibert began as an artisan, but his studies under Kneller, his grand tour of Italy, and his portrait work in London place him outside the folk tradition. His patrons were prominent Bostonians whose knowledge of portraiture was acquired from English Baroque mezzotints. Ironically, soon after Smibert's departure for the colonies, the Baroque style had begun to fall out of fashion in London, where it was replaced by the rococo. Thus, unknown to Smibert and his clientele, the new style of portraiture he had introduced to Boston was already outmoded.

See also **Painting, American Folk; Painting, Landscape.**

BIBLIOGRAPHY

Craven, Wayne. *Colonial American Portraiture.* Cambridge, Mass., 1986.

Sunders, Richard H., and Ellen G. Miles. *American Colonial Portraits, 1700–1776.* Washington, D.C., 1987.

RICHARD MILLER

SMITH, FRED (1886–1976) was a self-taught artist who created the Wisconsin Concrete Park, an environment of embellished concrete sculptures in Phillips, Wisconsin, between 1948 and 1964. Smith built over 200 sculptures and tableaux depicting people, animals, and events of local, national, and deeply personal significance. The Wisconsin Concrete Park is one of the country's notable folk art environments. It is linked to a regional tradition of creating sculptural and architectural environments of embellished concrete in the upper Midwest, established by two Catholic devotional grottoes in West Bend, Iowa, and Dickeyville, Wisconsin.

Born to German immigrants who settled in Ogema, Wisconsin, Smith had no formal schooling as a youth. He worked in lumber camps from his early teens until

1948, during which time he homesteaded 120 acres, married and raised five children, cultivated ginseng, created an ornamental rock garden, and built and operated his Rock Garden Tavern.

In 1948 Smith retired from the lumber camps, ostensibly due to severe arthritis. Despite this condition he was moved by an ambitious personal vision, which lead to building sculptures on a scale that surpassed mere yard decoration. The project began with an ornamented barbecue, followed by large-scale plaques of patriotic subjects, north woods motifs, and heroic depictions of Sacajawea and Sun yat-Sen. Smith later created three-dimensional sculptures, using armatures of steel pipe and wood, wrapped with wire and covered with mortar, and richly embellished with colored glass, mirror and other materials. The Wisconsin Concrete Park took the form of an ingenious historical narrative. Life size and larger-than-life tableaux depict the Native Americans who first occupied the region, lumberjacks who cleared the forests, and the "stump farmers" who cleared the land for farming. Sculptures depicting working people stand erect among an array of animals, including moose, elk, bear, deer, horses, oxen, dogs, and birds. A larger-than-life Paul Bunyan and Giant Muskie reflect local, north woods legends, and the tableau *From the Movie Ben Hur*, shows Smith's awareness of popular culture. Smith completed his last tableaux, the *Budweiser Clydesdale Team,* in 1964. He suffered a stroke shortly after, and spent the rest of his life in a nursing home. After Smith's death in 1976, the site was purchased by the Kohler Foundation, Inc. After restoration it was given as a gift to Price County. Preservation of the site has been ongoing since 1987.

See also **Environments, Folk.**

BIBLIOGRAPHY

Hemphill, Herbert W. Jr, and Julia Weissman. *20th Century Folk Art and Artists.* New York, 1974.

Hoos, Judith, and Gregg Blasdel. *Naives and Visionaries.* Minneapolis, Minn., 1974.

Stone, Lisa, and Jim Zanzi. *The Art of Fred Smith.* Phillips, Wisc., 1997.

———. *Sacred Spaces and Other Places: A Guide to the Grottos and Sculptural Environments in the Upper Midwest.* Chicago, 1993.

LISA STONE

SMITH, MARY TILLMAN (1904–1995) was an African American who painted wrenchingly expressionist human and animal subjects. She worked much of her life as a gardener, tenant farmer, and domestic servant. A hearing impairment diminished her verbal communication skills; for much her life she preferred to keep to herself. Relatives recalled her making pictures, including drawings in the soil, since she was a girl. As a young woman, she was briefly married to a sharecropper, but their relationship failed after her husband's landlord became upset at the effects of Smith's literacy and independent temperament on her spouse. Though she would never again marry, she later had a son with a man who bought a house for her just outside the town of Hazlehurst, Mississippi.

Using lengths of corrugated tin that she split with an ax, Smith built a series of intricate whitewashed fences that surrounded her manicured yard and delineated spaces within it. To the fence she attached paintings made on tin and wood—paintings of friends, neighbors, her pets, trees, and Jesus and other biblical themes. She also put up epigrammatic poetic signs that include legible sentences but also arcane, seemingly random or anagram-like collections of letters. Her property was also interspersed with painted minimal assemblages of wood, jugs, and found metal whose function was mysterious but evidently personal and religious.

Smith's painting style displays a kinship with both European art *brut* and the lyricism of the most successful abstract expressionist canvases. Like Bill Traylor and Jimmy Lee Sudduth, Smith was a master of formal economy, yet her highly charged brush strokes lead to altogether more visually confrontational effects. The direct figure-ground relationships in some of her paintings belie her penchant for subtly revising and augmenting her powerful initial marks; and she was an ingenious colorist, often deploying surprising combinations that bring warm backgrounds rushing forward as the cool foreground figures recede. She sometimes used only colors—green, brown, blue—of a similarly broken hue; these works all but disappear when reproduced in black and white.

Smith's written glosses—such as "My name is someone The Lord for me He no"— confirm not only the spiritual context of her work but also her self-consciousness about making art as a tablet for personal identity. Her property sat beneath a billboard beside a main road into Hazlehurst, and her work often seems to follow the formula of print advertising, with arresting images accompanied by slogans. She proclaimed her existence and her beliefs to local people and passersby. As one of her messages on a painting puts it, "Here I am don't you see me."

See also **African American Folk Art (Vernacular Art); Jimmy Lee Sudduth; Bill Traylor.**

BIBLIOGRAPHY

Arnett, William, and Paul Arnett. *Souls Grown Deep: African American Vernacular Art of the South,* vol. 2. Atlanta, Ga., 2001.

Maresca, Frank, and Roger Ricco. *American Self-Taught: Paintings and Drawings by Outsider Artists.* New York, 1991.

PAUL ARNETT

SMITH, ROYALL BREWSTER (1801–1855), is a folk artist important for his early nineteenth century portraits of residents living in a small area of Maine. In 1963 Smith was a relatively unknown artist with only seven known portraits. Thirty-six oil on canvas portraits, all painted between 1830 and 1837, are now attributed to him. Eight of these are signed, with attribution for the others made on the basis of stylistic characteristics. Six of the portraits are very large, the others measure about 30 by 25 inches. Twenty-three of the subjects, whose names are known, were neighbors, or related by marriage to each other or to members of the artist's family. Smith had no formal training but, living in and around Buxton, Maine, he was undoubtedly familiar with portraits by John Brewster (1766–1854) who was active in that area. Initially a painter of family records, Smith made the first of these about 1826, for Robert Davis of South Limington, Maine, related by marriage to his brother, Alexander. A second was for his own family.

The son of John and Elizabeth Smith, he was baptized in Buxton on December 14, 1801. In 1820 Buxton's officers appointed a guardian for his father, declaring him a spendthrift. About eight months later Elizabeth and her children moved to Limington. From then until October 1825, when he moved back to Buxton, Smith's health was poor and he was put under the care of his brother. He spent the years that followed as an itinerant painter traveling through the nearby towns. In 1838 he purchased a house in Gorham and there, on November 30, 1840, married Roxana Gowen of Shapleigh, Maine. Between 1840 and early 1843 he moved to Bangor, Maine, where the city directory lists him as a carpenter. Directories for 1846 through 1855, however, list him as a painter although there are no known portraits by him after 1837.

Royall Brewster Smith is buried in Bangor's Mount Hope Cemetery. His obituary indicates that he was "one of our most industrious and reliable mechanics." Had he been active in Bangor as a portrait painter this probably would have been mentioned in his obituary. His description as "mechanic" plus the directories listing as a painter, and the fact that his portraits often include grained furniture and lettering suggest that in the later years he worked at painting signs, furniture, and fire buckets.

See also **Painting, American Folk.**

BIBLIOGRAPHY

Kern, Arthur, and Sybil Kern. "Painted by Royall Brewster Smith." *The Clarion,* vol. 13, no. 2 (spring 1988): 48–55.

ARTHUR AND SYBIL KERN

SMITH, THOMAS (c. 1650–1691) is the only one of a dozen or so painters in seventeenth-century Boston for whom specific works can be identified with the artist. Distinguished as the painter of the earliest surviving self-portrait, Smith also portrayed members of his family, the military, and the merchant elite in Boston. His known works are six paintings, plus two others, lost or destroyed.

While the contemporary Freake-Gibbes-Mason Limner painted in a flat, linear style, Thomas Smith introduced light and shadow to set the faces and forms he painted convincingly in space. Smith's most famous work, his *Self-Portrait,* demonstrates a level of realism that was also new in Puritan portraiture, for he represented his age in his graying hair, heavy-set eyes, and lined, sagging flesh.

Smith included symbols and vignettes to convey biographical and sometimes allegorical messages. For example, his self-portrait contains a skull and a *memento mori* poem on the table in the foreground, and a naval battle scene in a window, perhaps a clue that he may have been a seaman. Smith's portrait of Major Thomas Savage includes a vignette that represents his role as a military leader in Boston, and Thomas Patteshall's portrait includes a seascape that identifies him as a prominent merchant.

Smith is primarily known by his paintings. The self-portrait is inscribed in monogram "TS" and the portrait of Thomas Savage is dated 1679. The others are attributed to Smith and given approximate dates based on those two benchmarks. Smith is also documented in the records of Harvard College for a payment made to him on June 2, 1680 for painting a copy of a portrait of the Puritan minister William Ames.

According to the Boston diarist Samuel Sewall, a Captain Thomas Smith died in that city November 8, 1688, and an inventory of his estate was made in 1691. While it is tempting to identify this Captain Smith with the mariner-artist, there were perhaps fourteen men who shared this name in seventeenth-century Boston, and several of those had careers as seamen.

See also **Freake-Gibbes-Mason Limner.**

BIBLIOGRAPHY

Dresser, Louisa. *XVII Century Painting in New England.* Worcester, Mass., 1935.
Fairbanks, Jonathan L., et al. *New England Begins: The Seventeenth Century.* Boston, Massachusetts, 1982.
Stein, Roger B. "Thomas Smith's Self-Portrait: Image/Text as Artifact." *Art Journal,* vol. 44, no. 4 (winter 1984): 316–27.

DAVID BRIGHAM

SMITHSONIAN AMERICAN ART MUSEUM is the world's largest, most inclusive institution dedicated to American art. The collection—over 39,000 artworks by almost 7,000 artists—encompasses three hundred years of artistic achievement which parallel and illustrate the nation's cultural development. The museum honors the country's artists through a vigorous acquisition agenda, exhibitions, publications (including the scholarly journal *American Art*), public programming, educational outreach, research fellowships, and online resources (AmericanArt.si.edu).

The first federal art collection, the museum began in 1829 as the National Institute, intended to preserve and display the products of man's creative genius in Washington, DC. The National Institute's artworks were transferred to the Smithsonian in the 1850s. Known as the National Collection of Fine Arts (1937–1980) and the National Museum of American Art (1980–2000), the museum changed its name to the Smithsonian American Art Museum in 2000 to emphasize its mission and relationship to the Smithsonian.

The collection represents major figures such as John Singleton Copley, Gilbert Stuart, Winslow Homer, John Singer Sargent, Mary Cassatt, Georgia O'Keeffe, Edward Hopper, Robert Rauschenberg, and Nam June Paik. The museum is also a pioneer in identifying, collecting, and exhibiting significant aspects of American art—work by African American and Latino artists, folk art, photography, art of the American West, modern realist art, and contemporary studio crafts—in a national arena.

The museum's first major folk art acquisition, in 1970, was James Hampton's visionary environment, *The Throne of the Third Heaven of the Nations Millennium General Assembly* (c. 1950–1964). Between 1986 and 1998 the museum acquired almost six hundred historical and modern works from Herbert W. Hemphill Jr.'s folk art collection, legendary for its adventuresome character and championship of contemporary self-taught artists. In 1997, acquiring more than two hundred works from the contemporary folk art collection of Chuck and Jan Rosenak—highly regarded for its African American, southern, and Navajo works—solidified the museum's national commitment to folk art.

See also **James Hampton; Herbert W. Hemphill Jr.**

BIBLIOGRAPHY

Hartigan, Lynda Roscoe. *Made with Passion: The Hemphill Folk Art Collection in the National Museum of American Art.* Washington, D.C., 1990.
National Museum of American Art. *The National Museum of American Art.* New York and Washington, D.C., 1995.
Patterson, Tom. *Contemporary Folk Art: Treasures from the Smithsonian American Art Museum.* New York, 2000.

LYNDA ROSCOE HARTIGAN

SOUTHEAST ASIAN FOLK ART: *SEE* ASIAN AMERICAN FOLK ART.

SPANGENBERG, JOHANNES ERNESTUS (1755–1814) was long known as the "Easton Bible artist" because he decorated a Bible owned by the German Reformed (now United Church of Christ) congregation in Easton, Pennsylvania. The frakturs he made were produced almost entirely for children who lived in or near the Easton and Greenwich Townships, Sussex County, New Jersey, across the Delaware River, as well as those living in Nockamixon, Pennsylvania. In addition to birth and baptismal records, Spangenberg drew ownership pages in ledgers for a number of people, and made a few statements of book ownership for individuals, as well as two Bibles for churches. He fought with several American units during the American Revolutionary War.

The distinguishing features of Spangenberg's work are the portraits he drew on a number of his certificates, many of them are carrying and playing musical instruments. Spangenberg was a Lutheran, and it was customary on special occasions in Lutheran congregations for a group of musicians to gather to accompany hymns or occasional music during worship. Spangenberg was bilingual; fraktur records he produced for the same child in some instances have been found in both English and German.

See also **Fraktur; German American Folk Art; Pennsylvania German Folk Art; Religious Folk Art.**

BIBLIOGRAPHY

Fabian, Monroe H. "The Easton Bible Artist Identified." *Pennsylvania Folklife,* vol. 22, no. 2 (1972): 2–14.

FREDERICK S. WEISER

SPARROW, SIMON (1925–2000) is best-known for his large assemblage works made primarily of recycled costume jewelry and glitter. He also did pastel drawings on paper.

Sparrow was born in North Carolina, where members of his family were sharecroppers. He moved north as a teenager, first to Philadelphia and then to New York, where he lived from 1943 to sometime in the late 1960s. He worked as a house painter there, and later in Wisconsin.

Having drawn since childhood, Sparrow turned to his mixed media masterpieces after he moved from New York City to Madison, Wisconsin. These assemblages were made of glitter, shells, marbles, buttons, Christmas ornaments, beads, jewelry, and other bric-a-brac; he used them as visual aids when he preached on the streets of Madison. Sparrow was entirely self-taught, but he was able to incorporate figures into his compositions very subtly: typically frontal, flat, and nearly abstract in form, the human or animal presence would seem to float in the artist's colorful, glittering surface. Sparrow also incorporated the frame into the composition; it too was often covered in found material and thus blended in with the overall encrusted surface.

BIBLIOGRAPHY

Cubbs, Joanne. *Religious Visionaries*. Sheboygan, Wisconsin, 1991.

Kogan, Lee. "Simon Sparrow, 1914–2000." *Folk Art*, vol. 26, no. 1 (spring 2001): 67.

Leach, Mark Richard. *Structure and Surface: Beads in Contemporary American Art*. Sheboygan, Wisc., 1990.

BROOKE DAVIS ANDERSON

SPELCE, FANNIE LOU (1908–1998) made some 500 paintings to "put those treasured images on canvas." Her work, which includes family portraits, idealizes rural life in the old Ozarks—cotton picking, camp meetings, country fairs, school days, squirrel hunts, family prayer, Christmas eve. *Quilting Bee* is filled with patterns and colors in the floor and window coverings, wallpaper, lace doilies, and antimacassars that enhance the vitality of the central quilt, where fourteen women are at work. Spelce's father is in a corner; her Aunt Lucy and two singers are at the piano.

Spelce was the eldest child of Florence and Hilary Arter Bennett; she lived in Dyer, Arkansas, until she entered nurses' training. She worked as a nurse for forty years and was on Michael DeBakey's team in Houston, Texas, in the early days of open heart surgery (1955–1959). She began painting as a hobby. In 1966, she enrolled in an art course at the Laguna Gloria Art Musem in Austin, Texas. After one session,

the instructor, Owen Cappleman, concluded that tutelage might interfere with Spelce's artistic expression and advised her to paint on her own.

Spelce worked in oils on canvas, using small brushes for intricate detail. Her hallmarks are bright color, patterning, flattened perspective, generalized lighting, and compositional balance. In 1972, Spelce had a solo exhibition at the Laguna Gloria Art Gallery.

BIBLIOGRAPHY

Adele, Lynne. "Fannie Lou Spelce 1908–1998." *Folk Art* (fall 1998), 35.

Kennedy Galleries, *Fannie Lou Spelce* (1972). New York.

Johnson, Jay, and William C. Ketchum. *American Folk Art of the Twentieth Century*. New York, 1983.

Parvin, Bob. "Painted Memories." *Texas Highways* (December 1977): 18–23 and cover.

Pirtle, Caleb. "Keep on Painting until the Memories Run Out." *Southern Living* (September 1976): 64–69.

See also **Painting, American Folk; Painting, Memory.**

LEE KOGAN

SPELLER, HENRY (1900–1997) created drawings that visualized the pain and the longing conveyed in his beloved Delta blues music. Born in the settlement of Panther Burn, near Rolling Fork in central Mississippi, and raised by his maternal grandmother, Speller dropped out of school at the age of twelve and helped support her when, after an altercation with a white employer, her husband was forced to flee the region. Speller grew up working on Delta farms and the levees of the Mississippi River, where he often drew pictures during lunch breaks. He left Mississippi for Memphis, Tennessee in 1939. There he worked in a succession of odd jobs as a junkman, a landscaper, a garbage collector, and a janitor, and lived within a few blocks of Beale Street, Memphis's musical hub. Speller was an accomplished blues musician who played with such American legends as Howlin' Wolf and Muddy Waters. According to his son William, Speller turned down offers to leave Memphis and play in professional bands. In the early 1960s he met Georgia Verges, who also loved to sing and to make pictures, and who became his third wife. They lived together in Memphis until her death in 1988. His art and health both declined within a few years of her death.

The imagery and insistent rhythms of the Delta blues flow through Speller's work, but his iconography also hints at the social, economic, and racial exclusions he observed throughout his life. His imagery was tethered to Memphis street life, as refracted

through his fantasies about a world he was never privileged to enter. His drawings, nearly always executed in pencil and marker on paper, are ordered like patchwork quilts and are undulating grid-like structures with saturated colors, frequently surrounded by wavy lines that resemble guitar strings and telegraph lines. Women, perhaps prostitutes, inhabit virtually all the compositions, where they are always depicted as having the time of their lives. The women are as powerful, erotic and fearsome as the subjects of a Bessie Smith song, yet Speller's women are also inaccessible; they inhabit hotels, riverboats, fancy houses, and other sites segregation placed off limits to Speller throughout his best years. Speller's reverence for these women rings clearest in works such as *Daisy Lewis Graduating,* where the high-toned threads transmute into a regal purple robe and mortarboard. As in the blues, the idea of transport—trains, boats, planes, cars, motorcycles—means freedom. But Henry Speller, who life's journey failed to take very far from the Delta, was never on board.

See also **African American Folk Art (Vernacular Art).**

BIBLIOGRAPHY

Arnett, Paul, and William Arnett. *Souls Grown Deep: African American Vernacular Art of the South, vol. 1.* Atlanta, Ga., 2000.
Rosenak, Chuck, and Jan Rosenak. *Museum of American Folk Art Encyclopedia of Twentieth-Century American Folk Art and Artists.* New York, 1991.

PAUL ARNETT

SPINNER, DAVID (1758–1811), of Milford Township, Bucks County, Pennsylvania, was a master redware potter who specialized in the complex art of sgrafitto decoration. While inexpensive utilitarian redware pottery was made throughout the eastern United States, nowhere was the craft more highly developed than Pennsylvania. Typically, taking the form of large pie plates, or jars, sgrafitto ware was created by coating the formed but unburned piece with an opaque tin based glaze, off-white in color. Before this was completely dry the craftsman would use a sharp pointed tool to sketch flowers or figures by scratching through the glaze to the contrasting red body. He might also then highlight the design in green, brown, or some other color before giving the plate a final coating of clear lead glaze and firing it.

Spinner, whose known dated work covers the period of 1801 to 1811, brought this technique to its highest level designing an array of figurative plates featuring various human and animal figures. Among his compositions are men and women in country finery; colonial soldiers, mounted or on foot; musicians; scenes of rural horse races; a proud female equestrian, "Lady Okle;" and even a unique composition entitled "Deer's Chase" in which by overlapping the edges of two plates, a scene of two horsemen is revealed, accompanied by dogs pursuing a deer. And, when Spinner infrequently made the flower decorated plates popular with most Pennsylvania potters, it was the fuchsia, rather than the ubiquitous tulip, that was found on his version.

It was not only its subject matter and superior draftsmanship that distinguished Spinner's work was from that of his fellow sgrafitto decorators. Unusually, despite his German-Swiss background, he signed his work in English (either "David Spinner/his Make" or "David Spinner Potter"), a rare thing in this predominantly Germanic area. The most extensive collection of his redware may be seen in the Pennsylvania German Collection at The Philadelphia Museum of Art.

See also **Pottery, Folk; Redware.**

BIBLIOGRAPHY

Barber, Edwin Atlee. *Tulip Ware of the Pennsylvania-German Potters.* New York, 1970.
Garvan, Beatrice B. *The Pennsylvania German Collection.* Philadelphia, 1982.
Ketchum, William C. *American Redware.* New York, 1991.

WILLIAM C. KETCHUM

SPITLER, JOHANNES (1774–1837) was a decorator of painted furniture in Shenandoah County, Virginia, in the late eighteenth and early nineteenth centuries. Spitler's decorated chests and tall case clocks were painted for his neighbors and relatives, who lived in a somewhat geographically and culturally isolated area known in the eighteenth century as Massanutten, near the present day Luray, Virginia.

While his painted designs generally evoke the Germanic and Swiss heritage of this settlement, his specific style is highly individualistic and diverse but easily recognized. His body of work is comprised of more than eighteen full-sized blanket chests and smaller storage boxes along with two important tall-case clocks. One of these clocks, now in the collection of the American Folk Art Museum, New York, was created in 1801 for Spitler's neighbor and relative by marriage, Jacob Strickler. The painting of this clock was customized with designs derived from fraktur script and drawings created by Strickler, whose duties as a Mennonite preacher included the teaching of penmanship. The significance of this visual communication between Spitler and Strickler can not be overstated, since it is rare proof of the presumed

influence of fraktur drawings on furniture decoration in German American decorative arts.

Spitler's vocabulary of motifs include pairs of ring-necked confrontal doves, large hearts (usually inverted), pinwheels, compass motifs, checkerboard, diamond, grid and candy-striped areas, stylized flowers and in one case a leaping stag. The outlines of the designs created with the aid of a compass or ruler were actually incised into the wood; in contrast to this overall precision, the application of the paint itself within these outlines was accomplished with broad, fluid, thick, somewhat haphazard strokes. Similarly, while Spitler's designs maintain a general sense of order and organic symmetry, some of his compositions achieve this order through a seemingly improbable balancing act of his standard motifs recombined in a unique visual construction.

When Spitler signed or inscribed his work he did so in an equally distinctive way: of the pieces that are signed, most are done so with a contraction of his initials, "j.SP." Typically "x's" are used to flank or separate the elements of the inscription; additionally, some pieces are numbered, but in a sequence that has yet to be logically explained. The palette of colors employed by Spitler consisted of lead white, red lead, Prussian blue and black; the ends of his blanket chests were sometimes "grained" with stylized circle or wave patterns. While it is not known if Spitler actually built the furniture he decorated there is an identifiable and consistent preference for: a distinctive foot profile, box locks (rather than grab locks), wrought iron strap hinges with an inverted triangular termination, dovetailed joinery and yellow pine as the primary wood.

Johannes Spitler moved to Fairfield County, Ohio, sometime between 1805 and 1809. He died there April 18, 1837. Although at least two Spitler chests have been found in Ohio, these pieces are undated and consequently it is unknown if Spitler continued his career as a furniture decorator after relocating there.

See also **Fraktur; Jacob Strickler.**

BIBLIOGRAPHY

Hollander, Stacy C. *American Radiance.* New York, 2001.

Walters, Donald R., "Johannes Spitler, Shenandoah County, Virginia, Furniture Decorator." *The Magazine Antiques,* vol. 108, no.4 (October 1975): 730–35.

DONALD R. WALTERS

STEVENS, JOHN (1646–1736) was a gravestone carver in Newport, Rhode Island, who began a local carving tradition that was carried on by his four sons and his grandson. Stevens was born in Thame, in Oxfordshire, England, and came to Boston in 1700. He married Mercy Rouse in Little Compton, Rhode Island, in 1701. Local records of 1705 indicate that he owned a house in Newport; it still stands at 30 Thames Street.

Stevens was a bricklayer and mason; and since Newport had no local gravestone carver, for twelve years, working in his backyard shop, he literally scratched out, from the hard local black slate, small gravestones with very crude skulls and side borders of geometric design. Around 1715, a gravestone carver from Boston who had a very dense Baroque style came to Newport. He taught Stevens how to use the mallet and chisel to carve in relief winged, knob-wigged, owl-eyed effigies and borders of leaves, gourds, and melons in the Boston manner.

At this time Stevens stopped using uppercase inscriptions and adopted italic lowercase lettering that flows rhythmically over the stone surface in extraordinary formations. He passed this inventive lettering on to his sons, but without his dancing italic, and they paid more attention paid to rules of good lettering. In his sixties and early seventies, Stevens began to create masterpieces of gravestone sculpture influenced by the Boston style, but his carvings—with their bulging eyes; fat wigs etched in swirling lines; flowing, feathered wings full of detail; and dense borders carved in deep relief—show greater abandon and are less refined than those of contemporary Boston carvers.

Stevens's four sons were taught to carve by their father and by the Boston master. Thus began a gravestone carving dynasty that continued for about 100 years. John (1702–1778), the eldest son, gave definition to an eighteenth-century rococo Narragansett Basin school of gravestone sculpture that was elegant and depended on precise chisel work. Another son, Philip (1706–1736), influenced the direction of gravestone sculpture in Connecticut and New Jersey. A third son, James (1708–1766), carved little, but one of his winged effigies is a marvel of eccentric American folk art, with wildly exaggerated design and chisel work. A fourth son, William (1710–1794), worked as a merchant on Long Wharf in Newport and shipped his work out, so that it can be found today in graveyards from Massachusetts to the Caribbean. John Stevens III (c. 1754–1817), the grandson who worked at the end of the eighteenth century, carved self-consciously Neoclassic stones that reflect Newport's prosperity and saintly aspirations yet never lose the quintessential Stevens qualities—naïveté and charm.

See also **Gravestone Carving; Old Stonecutter, The.**

BIBLIOGRAPHY

Luti, Vincent F. *Mallet and Chisel: Eighteenth Century Gravestone Carvers in Newport, Rhode Island.* Boston, 2002.

VINCENT F. LUTI

STEWARD, JOSEPH (1753–1822), resided principally in Hartford, Connecticut, where he worked as an artist, clergyman, and museum proprietor during the late eighteenth and early nineteenth centuries. A native of Upton, Massachusetts, Steward was the son of Joseph and Jane Wilson Steward. He graduated from Dartmouth College in Hanover, New Hampshire, in 1780, having chosen a career in the ministry. Steward subsequently gave up this religious calling due to a chronic illness that prevented him from accepting a full-time position, and instead turned to portrait painting. He died at the age of sixty-nine after a long illness.

Steward began work as an artist in Hampton, Connecticut, in 1788. Soon after, he and his wife Sarah Moseley, whom he married on May 31, 1789, moved to Hartford. During this period, the artist traveled extensively looking for portrait work throughout the Connecticut River Valley. Dartmouth College commissioned him to paint full-length likenesses of Eleazar Wheelock, its founder and first president, and John Phillips, its benefactor and trustee. Steward's use of a large-scale format (both paintings measure approximately 78 by 70 inches) is believed to be the result of study with famed Hartford artist Ralph Earl (c. 1785–1838), in addition to probably observing the work of John Trumbull (1756–1843) who was in this city in the fall of 1792. In turn, Steward taught the art of painting to several students, including John Brewster Jr. (1766–1854) and Samuel L. Waldo (1783–1861).

In addition to his portrait business, by 1797 Steward had opened a painting room and museum in the Connecticut State House. For the price of admission (twenty-five cents for adults and twelve-and-a-half cents for children), this center of enlightenment offered the public rare opportunities to view natural and artificial curiosities, to study over 350 feet of paintings, and to attend musical performances. In 1801, he advertised that visitors could see portraits of John Adams, president of the United States; Thomas Jefferson, the vice-president; scientist and statesman Benjamin Franklin; and Napoleon Bonaparte, first consul of the French Republic. Always eager to attract clients, in 1805 he added profiles cut with a physiognotrace to his list of amusements. By 1808, the museum had moved to larger quarters in Hartford to accomodate its expanded collections of over 1,000 articles, embracing stuffed animals, minerals, and sea shells, among other collections, that appealed to "strangers, and men of science and leisure." In time, Steward's Hartford Museum was recognized as the premier collection of its kind in New England and was considered second in the nation, behind only fellow artist, scientist, and museum proprietor Charles Wilson Peale's (1741–1827) establishment in Philadelphia.

See also **John Brewster Jr.; Ralph Earl; Painting, American Folk.**

BIBLIOGRAPHY

Harlow, Thompson R. "The Life and Trials of Joseph Steward." *Connecticut Historical Society Bulletin*, vol. 46 (October 1981): 97–126.
———. "The Versatile Joseph Steward, portrait painter and museum proprietor." *The Magazine Antiques* (January 1982): 303–307.
Heslip, Colleen Cowles. *Between the Rivers: Itinerant Painters from the Connecticut to the Hudson.* Williamstown, Mass., 1990.

CHARLOTTE EMANS MOORE

STOCK, JOSEPH WHITING (1815–1855) is one of the most thoroughly documented nineteenth-century folk painters, owing to the survival of his seventy-three-page journal describing his activities from 1832 to 1846. Stock was born in Springfield, Massachusetts, on January 30, 1815, the third of twelve children. At age eleven, he was crushed beneath an oxcart and left crippled. His physician, Dr. William Loring, encouraged him to paint, and he sought rudimentary training from the young portraitist and daguerreotypist Franklin White (active c. 1832–after 1849), who had been a student of the popular Boston portraitist Chester Harding (1792–1866). In 1834, Dr. James Swan of Springfield designed a wheelchair that gave Stock the freedom of movement he needed to pursue painting as a profession. Stock traveled throughout Western Massachusetts, Connecticut, and Rhode Island in the 1830s and 1840, painting likenesses of adults and children in oil on canvas and in miniature in oil on ivory. In 1844 he worked in partnership with his brother-in-law, Otis Cooley, to produce portraits and daguerreotypes. Stock traveled to upstate New York to the towns of Middletown and Port Jervis in 1852, where he went into partnership briefly with Salmon W. Corwin. He returned to Springfield in 1855 and died of tuberculosis in that year.

Stock's most appealing likenesses are his portraits of children, who frequently appear full-length in complex interior settings with their likenesses individualized by the inclusion of a variety of props and an occasional pet. The delicate facial expressions of the children, combined with lively colored and patterned

floor coverings, mark the best of these works. Stock often tilted the patterned floor in vertical perspective, giving his portraits a bold, decorative appearance. In addition to portraits, Stock indicated in his journal that he also executed landscapes, genre scenes, anatomical drawings, and window shades. His total output over the fourteen years covered by the journal was more than nine hundred works. Slightly less than one hundred have been located and attributed to him.

See also **Miniatures; Painting, American Folk.**

BIBLIOGRAPHY

D'Ambrosio, Paul S., and Charlotte Emans, *Folk Art's Many Faces: Portraits in the New York State Historical Association.* Cooperstown, N.Y., 1987.

Rumford, Beatrix T., ed. *American Folk Portraits: Paintings and Drawings from the Abby Aldrich Rockefeller Folk Art Center.* Boston, 1981.

Tomlinson, Juliette, ed. *The Paintings and the Journal of Joseph Whiting Stock.* Middletown, Conn., 1976.

PAUL S. D'AMBROSIO

STONE CARVING: *SEE* RAYMOND COINS; WILLIAM EDMONDSON; CONSUELO GONZALEZ AMEZCUA; GRAVESTONE CARVING; WILLIAM RUSH.

STONE, JOSEPH (1774–1818) was a watercolor painter from Framingham, Massachusetts, known primarily because of his portrait of Deborah Sampson. The remarkable behavior of Deborah Sampson is described in the title of her 1797 biography, . . .*Memoirs Of An American Young Lady; Whose Life and Character Are Peculiarly Distinguished—Being A Continental Soldier, For Nearly Three Years, In The Late American War,. . . She Performed The Duties of Every Department, Into Which She Was Called. . . And Preserved Her Chastity Inviolate, By The Most Artful Concealment Of Her Sex.* Her oil on paper portrait is inscribed "Drawn by Joseph Stone Framingham 1797." It depicts a young woman with two flags above, and a bird with outstretched wings and an American flag shield over its body below.

Two other paintings by Joseph Stone are known. Both are watercolor and ink on paper. One is inscribed "MINERVA or PALLAS/ Her Image. By Joseph Stone. Feb 25 1807" and depicts Minerva, the Roman goddess, or Pallas, as known in Greek mythology. She holds a shield on which is the figure of a head. This is based on the story that Minerva gave Perseus a shield to use when he cut off the head of Medusa; when Minerva was given the head, she put it on her shield. The other watercolor is inscribed along its lower border "VENUS. By her side Stand two Cupids,

and around her are The Three Graces, and/ after her follows the lovely beautiful Adonis/ Framingham. Feb 26, 1807/ By Joseph Stone."

Stone's three paintings show little evidence of training in the arts. They are flat, perspective and anatomy are poorly handled, and the faces of his subjects are similar. His style in rendering Deborah Sampson suggests that he may have supported himself primarily as a decorative painter of signs, fire buckets, and houses. He must have had some reputation as a painter, since he was the teacher of another Framingham folk artist, Warren Nixon (1793–1872).

Stone was the son of Isaac and Persis Howe Stone. He was born in Framingham on November 17, 1774, and lived there and later in nearby East Sudbury. The cause of his death on July 3, 1818, at 44 years of age is recorded as "fits."

See also **Warren Nixon; Painting, American Folk.**

BIBLIOGRAPHY

Kern, Arthur, and Sybil. "Joseph Stone and Warren Nixon of Framingham, Massachusetts," *The Magazine Antiques*, vol. 124, no. 3 (September 1983): 514–516.

ARTHUR AND SYBIL KERN

STONEWARE, a durable household pottery, became part of life in the American colonies. Moving from place to place, living in harsh and often difficult physical conditions, the early settlers required pottery that was functional, durable, and easy to transport without breakage. Importation and domestic manufacture of stoneware, a hard bodied ceramic that had been produced in Europe from at least the sixteenth century, fulfilled their needs. Immigrant potters from Germany and England established themselves as potters wherever suitable clay could be found. Stoneware was being made at Yorktown, Virginia, and in Philadelphia by 1720, in New York City by 1728, and in Boston as early as 1745. Though manufacturing methods have changed, the ware remains in production.

Early stoneware was primarily hand thrown on the potter's wheel, although some forms such as mugs and pitchers were cast in molds. Unlike porous red earthenware, baked stoneware did not require a sealing glaze. For aesthetic reasons, however, potters employed a variety of decorative glazes and finishes. Most common was the so-called salt glaze achieved by throwing rock salt into the kiln, which reached temperatures in excess of 1200 degrees centigrade, during firing. The salt bonded with the gray to brown ceramic body to create a glass-like pebbled surface now sometimes referred to as "Orange Peel." Potters

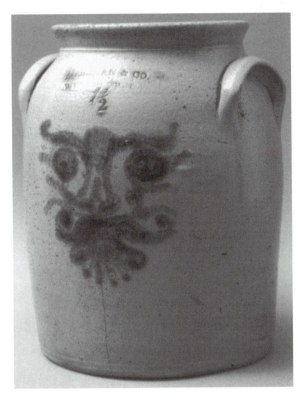

Salt-glazed stoneware jug with handles. Maker unknown;
Incised and blue-filled salt-glazed stoneware. © Esto.

working in the English tradition often dipped their ware in a brown, iron-based slip prior to salt glazing. By the late nineteenth century salt glazing had been largely replaced by use of heavy slip coatings, either a brown, referred to as "Albany Slip" or an opaque white termed "Bristol Slip." Most contemporary stoneware is still finished in this way.

Southern stoneware was glazed in yet another manner. As early as 1820, potters in the North and South Carolina began to employ a mixture of wood ash, clay, and sand to produce an alkaline glaze similar to what had been employed in Asia for generations. This dripped glaze was typically olive or brown in color but addition of slaked lime could produce a gray-green or yellowish hue, while further variations in color and texture could be achieved by adding salt, cinders, or ground glass. Though to some extent replaced by Albany Slip, alkaline glazes remain characteristic of Southern stoneware.

Its weight, which made it unsuitable for tableware, and its durability, which made it ideal for storage and shipment, determined stoneware's predominant forms. Jugs for wine or oil, pots and crocks for everything from cracked corn to baked cakes, preserve jars, water coolers, churns, pitchers, cuspidors, mugs, milk pans, bean pots, and flower pots are most common. Less common items include inkwells, children's banks, whistles and other toys, and figural forms such as mantelpiece ornaments based on Staffordshire examples and the now ubiquitous grotesque or face jugs made throughout the South.

Other than for surface color and, perhaps, the impressed name of the manufacturer, most stoneware was left undecorated. Immigrant potters, however, particularly those from the Rhineland area of Germany brought with them a strong decorative tradition that was manifest particularly in presentation or special order pieces and to a lesser extent throughout the general line of ware.

Three basic types of decoration are found on American stoneware: incised or impressed designs, free-hand painting, and stencil painting. The first, involves incising or scratching a naïve design, floral or pictorial, into the rubbery, hard clay prior to firing, and then filling this with cobalt blue or manganese brown to provide contrast. The results can be spectacular, but the process is time consuming and was largely abandoned by the 1830s. Impressed designs stamped into the soft clay with a cookie cutter-like device were easier to produce and required no special or artistic talent. But, one had to own the stamp. Most potters did not, so such pieces are uncommon. The use of stencils was another labor saving device, particularly popular in West Virginia and western Pennsylvania. Other, less generally employed methods of decoration included "sprigging," the application to the vessel of separately molded elements (again, limited by the availability of suitable molds) and hand-forming of figural pieces or decorative adjuncts.

Most early stoneware was produced in the northeastern and mid-Atlantic states with the industry gradually moving west into Ohio and Illinois after 1870. In the midwest it became highly industrialized with mechanized molding and assembly line methods replacing the earlier craft tradition. An exception, however, was the rural South where traditional methods and folk art decoration lingered well into the twentieth century.

See also **Crolius Family Potters; Dave the Potter; Jugs, Face; Lanier Meaders; Pottery, Folk; Remmey Family Potters.**

BIBLIOGRAPHY

Bivins, John Jr. *The Moravian Potters in North Carolina.* Chapel Hill, N.C., 1972.
Broderick, Warren and Bouck, William. *Pottery Works.* Madison, N.J., 1995.
Dearolf, Kenneth. *Wisconsin Folk Pottery.* Kenosha, Wisc., 1986.

Greer, Georgeanna H. *American Stoneware: The Art & Craft of Utilitarian Potters*. Exton, Pa., 1981.

Horne, Catherine W., ed. *Crossroads of Clay: The Southern Alkaline-Glazed Stoneware Tradition*. Columbia, S.C., 1990.

Ketchum, William C. *American Stoneware*. New York, 1991.

Osgood, Cornelius. *The Jug and Related Stoneware of Bennington*. Rutland, Vt., 1971.

Webster, Donald Blake. *Decorated Stoneware Pottery of North America*. Rutland, Vt., 1971.

WILLIAM C. KETCHUM

STOVALL, QUEENA (1887–1980) was a memory painter who left a detailed pictorial record of early twentieth-century country life in rural Virginia. Stovall was born Emma Serena Dillard in rural Amherst county, near Lynchburg, Virginia in 1887. She acquired the nickname "Queena" from childhood pronunciations of Serena. Queena Dillard attended high school, but left in her senior year to marry Brecheridge (Brach) Stovall, fourteen years her senior, in 1908. The couple had five sons and four daughters. Stovall lived most of her life in the Lynchburg area, raising children and tending to the household and farm. Her husband held various jobs as a traveling salesman that necessitated lengthy periods of separation from home and family. Stovall thus learned to be self-sufficient in raising her family and running the couple's farming operation. She was frugal and practical with household and farm chores, especially during the years of the Great Depression, yet still fostered a love of antique collecting and stylish fashions. Images of family, community, and ritual are all infused

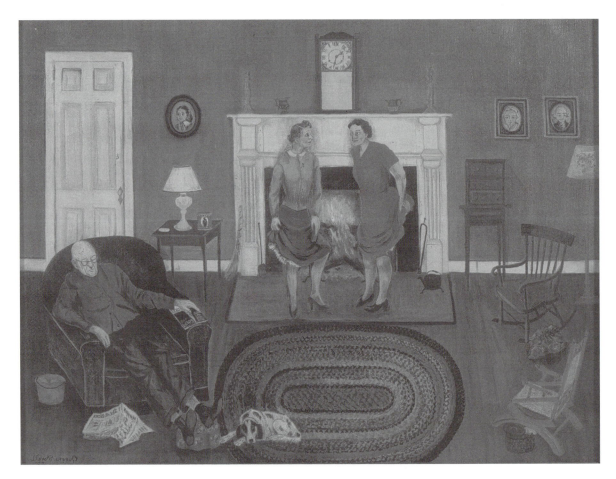

Fireside in Virginia; Queena Stovall; 1950. Oil on canvas; 24 × 18⅛; N-61.94. Collection Fenimore Art Museum, Cooperstown, New York. © New York State Historical Association, Cooperstown, New York.
Photo courtesy Richard Walker.

502

with an idiosyncratic eye for detail, autobiography, spirituality and African American life. Paintings such as *Fireside in Virginia, Family Prayers, Dressing Turkeys on the Farm,* and *Lawdy Lawdy, What'll I Do* evince Stovall's enduring interest in storytelling encapsulated with a tradition of narrative painting.

In 1949, when Stovall was sixty-two and a great-grandmother, her brother David Hugh suggested that she enroll in an art course at Randolph-Macon Women's College in Lynchburg. Her first painting, *Hog Killing,* impressed her instructor who encouraged here to continue painting. Within three years, Stovall earned a solo exhibition of her paintings at the Lynchburg Art Center. Her husband died in 1953, and Stovall continued to paint her memories and her neighbors and friends until her eyesight failed in 1968.

Stovall's oil on canvasses provide a detailed documentary of rural Southern life. She had a keen eye for the material culture of domestic and farm life, and often painted interiors that catalogued a myriad of household possessions and other objects with whimsical and descriptive detail. The daily activities of the people she knew—painted with the clarity as a diarist might record them—greatly enliven her works. Stovall's repertoire of subjects includes antique collectors at auction, funerals, baptisms, harvesting, butchering, and a wide variety of images depicting life on the farm. Although Stovall's memory and imagination provided much of the inspiration for her work, she did at times rely on newspaper and magazine photos. Queena Stovall's obituary in the *Lynchburg News & Advance* in June 1980 referred to her as "the Grandma Moses of Virginia."

See also **African American Folk Art (Vernacular Art); Painting, American Folk; Painting, Memory.**

BIBLIOGRAPHY

Jones, Louis C., and Agnes Halsey. *Queena Stovall: Artist of the Blue Ridge Piedmont.* Lynchburg, Va., 1974.

Wertherford, Claudine. *The Art of Queena Stovall: Images of Country Life.* Ann Arbor, Mich., 1986.

PAUL S. D'AMBROSIO

STRAUSER, STERLING (1907–1995) was a friend and patron of folk artists. He and his wife, Dorothy, discovered and promoted several folk artists, including Victor Joseph Gatto, Justin McCarthy, Jack Savitsky, Lamont Alfred Pry, and Charlie Dieter. Strauser was also interested in Vestie Davis, whose work he first saw at an outdoor exhibition in Greenwich Village in New York City. Strauser himself was an artist, represented by the Lyzon Gallery in Nashville, Tennessee; he had received some formal art instruction in school but was largely self-taught.

Strauser was born in Bloomsburg, Pennsylvania, the son of a railroader, and worked for thirty-two years at the International Boiler Works in East Stroudsburg. In 1928–1930 he supplemented his income as a picker for a local mailman, Jack Chamberlain, who often sold to Albert Barnes, Edith Gregor Halpert, and Edgar Garbisch. Strauser's appreciation for folk art began in 1935, on a visit to the John Law Robertson collection of folk art at the Everhart Museum in Scranton, Pennsylvania.

In 1942, Strauser, who was by then an inveterate collector, became intrigued by a picture and caption in a tabloid about an artist who painted jungle scenes. Strauser wrote to the artist; the correspondence marked the beginning of a long relationship with Gatto. Dorothy Strauser originally discovered Justin McCarthy's expressionisitic paintings in 1960 at an annual outdoor art fair in Stroudsburg; Sterling Strauser frequently likened McCarthy's art to that of Emil Nolde. Strauser was also close to Jack Savitsky, a retired coal miner whom he met in the early 1960s through Savitsky's son, Jack Savitt. Strauser constantly promoted these artists and was especially successful with regard to McCarthy and Savitsky.

In 1990, Strauser participated in a symposium accompanying the exhibition "The Cutting Edge: Twentieth Century American Folk Art" curated by Professor Barbara Cate and held of the Museum of American Folk Art (now the American Folk Art Museum) in New York. Also accompanying the exhibition was the book *Museum of American Folk Art Encyclopedia of American Folk Art and Artists* by Chuck Rosenak and Jan Rosenak, who dedicated it to the Strausers: "They taught us to see, and that seeing could be fun." In 1992, Strauser was an honored guest in conjunction with an exhibition of the art of John Peernock, at the Everhart Museum in Scranton. A retrospective called "Sterling Strauser: A Modernist Revisited," took place February 2000 at the Reading Museum of Art in Reading, Pennsylvania.

BIBLIOGRAPHY

Hartigan, Lynda. *Made with Passion.* Washington, D.C., and London: 1991.

Metzger, Robert. *Sterling Strauser: A Modernist Revisited.* Reading, Pa.

LEE KOGAN

STRENGE, CHRISTIAN (1757–1825) was a fraktur artist, and one of the many Germans who enlisted for

British service during the American Revolution. He arrived in America in 1776 from Altenhasungen, Hesse, Germany, but when his military unit was discharged from service in 1783, he had already deserted.

Strenge made his home in Lancaster County, in Hempfield township, Pennsylvania, where his first wife and infant daughter died. His second marriage produced five children. In the 1790s he moved to what became East Petersburg, Pennsylvania, where he began a career as a teacher and scrivener. He was made a justice of the peace in 1811.

Serving as a schoolmaster among Mennonites, he made fraktur according to their tastes, producing *Vorschriften* (writing samples), family records, Bible entries, bookplates, books of musical notation (which he had learned from the fraktur artist Johann Christian Alsdorff (1760–1838), and presentation pieces incorporating birds, hearts, and sayings. For his Lutheran and Reformed neighbors he made baptismal records. Among his grandest pieces are love letters, characterized by their circular shapes and complex texts, intended for a young man to give to a young woman. He also drew a representation of the Crucifixion. His choice of colors—bright orange and red predominate—makes his work attractive to the eye.

See also **Christian Alsdorff; Fraktur; German American Folk Art; Pennsylvania German Folk Art; Religious Folk Art.**

BIBLIOGRAPHY

Johnson, David R. "Christian Strenge, Fraktur Artist," *Der Reggeboge*, vol. 13 (July 1979): 1–24.

———. *Christian Strenge's Fraktur*. Lancaster, Pa., 1995.

FREDERICK S. WEISER

STRICKLER, JACOB (1770–1842) created a diverse body of fraktur writings and drawings in Virginia in the late eighteenth and early nineteenth centuries. Jacob Strickler was a descendant of one of the fifty-one German and Swiss Mennonite pioneers who, by 1733, had migrated from Lancaster County, Pennsylvania, to a relatively insulated region in Shenandoah County, Virginia, called Massanutten. Strickler's surviving body of work, ranging in date from 1787 to 1815, includes two *Geburtsscheine* (birth records); two *Vorschriften* (writing exercises); three uncolored trial designs; two major religious allegorical drawings; an elaborate *Zierschrift* (a sort of secular *Vorschrift*); and a small fraktur drawing, which, together with the *Zierschrift*, directly inspired motifs employed on a painted tall-case clock made for Strickler by his neighbor and relative, Johannes Spitler.

In addition to this rich range of visual evidence, other specimens of his script styles exist in his ink inscriptions in the margins and pages of books and German-language weekly newspapers, which survive in his preserved personal library. The nature of the book titles and inscribed notes in this library have led researchers to deduce that Strickler was a Mennonite preacher or parochial school leader. At least one *Vorschrift* bears the dedication "For Jacob Strickler. . ." and illustrates how, as a teacher of penmanship, he provided fraktur writing and drawing samples to be copied by students. While it is not known who may have instructed Strickler, certain specimens of his work show how he copied and personalized available models by more prolific and influential Pennsylvania fraktur artists, such as Daniel Schumacher (c. 1728–c. 1787).

The earliest dated recorded work by Strickler, from 1787, was done when he was only sixteen years old. However, it shows him already to be not only an accomplished penman, but also in possession of a distinctive personal vocabulary of motifs. Some typical and recurring elements include inverted hearts with flowers springing from their tips, decorative initials and script entwined with floral motifs, sawtooth patterns, and comma-shaped serifs on text and pictorial elements. Confident of his abilities, he boasts on an exuberantly and ambitiously embellished 1794 specimen: "the paper is my field and the pen is my plow. This is why I am so clever. The ink is my seed with which I write my name."

Farmer, preacher and folk artist, Jacob Strickler died on June 24, 1842 and was buried in the family cemetery on his property in what is now Page County, Virginia.

See also **Fraktur; Johannes Spitler.**

BIBLIOGRAPHY

Rumford, Beatrix T., ed. *American Folk Paintings*. Boston, 1988.

Walters, Donald R. "Jacob Strickler, Shenandoah County, Virginia, Fraktur Artist." *The Magazine Antiques* (September 1976): 536–543.

DONALD R. WALTERS

SUDDUTH, JIMMY LEE (1910–?) invented a painting process using mixtures of mud, earth, leaves, walnut hulls, ashes, burned hair, coffee grounds, berry juices, and other homemade pigments applied directly with his hands. His works are on subjects drawn from the world around him and from personal experience.

Sudduth grew up in the crossroads of Caines Ridge, Alabama, and spent most of his adult life

nearby, in the larger town of Fayette. He has described his mother, who was of Native American heritage, as a "medicine doctor," and recalls accompanying her on trips into the woods to collect herbs and other natural materials for remedies. At the age of nine, he made his first painting, on a tree. Although he loved to create art, it could not possibly support him financially, so he worked "wherever I could"—for example, on farms and at Alabama Power.

In the 1960s, while working as a gardener, Sudduth began to make paintings of the homes of his customers, some of whom bought his pictures (though few were hung with pride at the time). He received some national attention during the 1970s but did not paint full time until the 1980s, when his renown began to grow rapidly.

When Sudduth mixed his pigments with sugar and other binders, they became what he called "sweet mud" that he applied with his fingers to raw plywood boards prepared with a pencil drawing. Occasionally he would also add commercial paints. His small paintings are made up of of Zen-like smudges that cohere to the wood; the subjects are dogs (especially his own dog, Toto), squirrels, cows, horses, fowl, snakes, automobiles, alligators, bicyclists, Ferris wheels, flowers, wagons, cabins, and schematic gesturing human forms. He has also produced large, heavily crusted evocations of buildings and landmarks (such as the Washington Monument and the Statue of Liberty), and nearly life-size portraits and self-portraits. The large works, while typically less formally sinuous than the small, sketchy paintings, often have remarkable modulations of color, shading, and surface impasto. His iconography is usually gentle, although sometimes the presence of small manual workers in the foreground and the desolation of the buildings give a less sanguine dimension to the architectural grandeur.

The anecdotal and iconic images in his paintings mesh with his impromptu songs, performed to the accompaniment of his beloved blues harmonica. Sometimes nostalgic, sometimes whimsical, Sudduth's songs are populated by many of the same protagonists as his art and show a similar storyteller's talent for evocative, carefully chosen description.

See also **African American Folk Art (Vernacular Art).**

BIBLIOGRAPHY

Arnett, Paul, and William Arnett. *Souls Grown Deep: African American Vernacular Art of the South, vol. 1.* Atlanta, Ga., 2000.

Spriggs, Lynne, Joanne Cubbs, Lynda Roscoe Hartigan, and Susan Mitchell Crawley. *Let it Shine: Self-Taught Art from the T. Marshall Hahn Collection.* Atlanta, Ga., 2001.

PAUL ARNETT

SULLIVAN, PATRICK J. (1894–1967) was a painter. Born in Braddock, Pennsylvania, he was placed in an orphanage by his mother when he was two years old. He remained there until age fifteen, when he went to work at an iron mill. About 1911, he moved to Wheeling, West Virginia. After serving in the United States Army from 1916 to 1919, he worked as a house painter.

A self-taught artist, Sullivan created fifteen easel paintings between 1936 and 1964, never painting more than three canvases in a year, and completing only three paintings during the last twenty years of his life. Sullivan was a devout Catholic, a voracious reader, and deeply interested in philosophy. His faith inspired his earliest known painting, a copy of a portrait of a youthful Christ that he painted with house paint on a tea towel.

In 1936, Sullivan painted *Man's Procrastinating Pastime*, contrasting the positive aspects of human character with the constant attempts by people to hide their evil side. This was the first of the allegorical paintings that Sullivan continued to produce until 1959. It is fortunate that Sullivan wrote extensively about the meaning of many of these complex works, for his idiosyncratic, symbolic iconography would have been impenetrable otherwise. Other paintings were based on current events or inspired by the impending World War II, including his tribute to King Edward VIII upon abdicating the English throne for love; *The Fourth Dimension,* in which a figure on a barren, rocky planet contemplates the dizzying universe in a effort to comprehend the origin of creation; good and evil depicted in the form of World War II's Allied and Axis leaders; a canvas illustrating Sullivan's conviction that the first law of nature is love, not self-preservation; and other works emphasizing moral conflicts, the triumph of Christianity over atheism, and a work finished one week before the attack on Pearl Harbor illustrating his belief that artists should paint works to give people ". . . a feeling of tranquility which is sorely needed in today's emotionally upset world."

Sullivan's work was championed by the art dealer and collector Sidney Janis (1896–1989), and his work was included in major exhibitions in New York, Chicago, Los Angeles, and San Francisco during the late 1930s and early 1940s. Encouraged to become a professional artist by the attention his work received, Sullivan became discouraged, then embittered, when his paintings failed to sell. He worked as a washing machine salesman before returning to work in the steel mills as a laborer and watchman.

See also **Sidney Janis; Painting, American Folk.**

BIBLIOGRAPHY

Baker, Gary E. *Sullivan's Universe: The Art of Patrick J. Sullivan, Self-Taught West Virginia Painter*. Wheeling, W.Va., 1979.

Janis, Sidney, *They Taught Themselves: American Primitive Painters of the 20th Century*. New York, 1942.

RICHARD MILLER

SUSSEL-WASHINGTON ARTIST (active 1770s–1780s) is the name given to one of the most significant fraktur artists among the Pennsylvania Germans whose name remains unknown. The most important drawing by this artist, which was part of the collection of Arthur Sussel, was a drawing of George and Martha Washington, (which explains the designation by which this artist is known). Several dozen drawings, most of them baptismal greetings, have been identified as the work of the same artist.

Although the artist's name is unknown, there is still much that can be reported about him. The texts included with his pieces are identical to those used in European *Goettelbriefe* (souvenirs of baptism given by sponsors to the child). The imagery, especially the women in their "bee-bonnet" hats, is unlike anything seen in American fraktur. Although relatively few of the artist's works exist, they have come from the Berks, Lebanon, Dauphin, Lancaster, York and Schuylkill counties of Pennsylvania, and probably represent the work of a fraktur artist who traveled a great deal. This makes it difficult to assert his identity with any certainty.

In addition to baptismal records, he drew a variety of animals and figures of boys and girls. None of the pieces are signed or initialed. Some name the baptismal sponsors, tempting some experts to name the sponsors as the artist. Some include birds with cherries in their mouths, and another appears to have a background of wallpaper. The artist's drawings of people on horseback, including the portrait of the Washingtons, a portrait of the Princess of Sudbury, and his figures of Adam and Eve, are exceptionally fine in their execution. Sources for his design are unknown, but his animal figures had an impact on the fraktur of Johann Conrad Gilbert (1734–1812) of Schuylkill County, where the Sussel-Washington artist may have taught in the 1780s. Enough examples of his work exist filled in by another hand to suggest that he died leaving a supply of blank forms that were dispersed after his death.

See also **Fraktur; German American Folk Art; Johann Conrad Gilbert; Pennsylvania German Folk Art; Religious Folk Art.**

BIBLIOGRAPHY

Hollander, Stacy C. *American Radiance*. New York, 2001.

FREDERICK S. WEISER

SWEARINGEN, REVEREND JOHNNIE (1908–1993) painted religious subjects, secular scenes of life in his community, and pictures reflecting his ethnic identity and heritage. He was born in Campground Church, a rural African American community located outside Chapell Hill, in Washington county, Texas. Swearingen's expressionistic style imbues his paintings with a vibrant and restless energy. His earlier works were boldly outlined; later works were conceived more organically, as vignettes leading the viewer through the composition. Swearingen's preferred a colorful and intense palette; his forms were robust. He said, "I paint to make people happy. . . . It's a gift from God. I make pictures."

Swearingen was interested in art from about age twelve. He occasionally painted on the walls of his house, and some of his earliest works were done in shoe polish on cardboard; later he would often employ oil on Masonite or canvas.

Swearingen was raised in a family of sharecroppers, dividing his time between farming and school, where he completed the eighth grade. When he left Texas as a young man, he worked in the cotton fields and picked grapes; he also worked for the railroad, in construction, and, in San Pedro, California, as a longshoreman. His religious beliefs began to develop when he had his first revelation at age seven; but he claimed that in his teens the "devil got him (Adele, 1989)." In 1948, after a fifteen-year absence, Swearin-

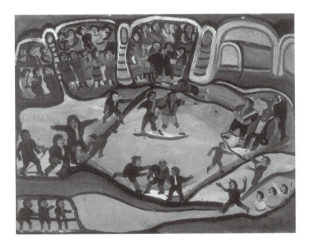

Untitled; Reverend Johnnie Swearingen; 1991. Acrylic on canvas; 48 × 36 inches. Collection of Stephanie and John Smither.

gen returned to Chapell Hill, Texas; he married (for the second time) in 1949 and settled in Brenham, Texas, where he worked as a tenant farmer. His interest in painting now became more serious, he often sold paintings from his pickup truck or in his front yard. He experienced a calling in 1962 that prompted him to take a correspondence course from the Lone Star Bible School. Swearingen was ordained in Huntsville, Texas, in 1965.

His paintings evolved as a kind of visual ministry, a narrative of his experiences and beliefs as a southern African American in the postwar era. At first, he would set up his paints and canvasses in front of a house, paint it, then ring the doorbell and try to sell the painting. He gathered an audience for both his ministry and his artwork when he painted and preached in the center of town.

Swearingen reworked biblical themes such as Noah's ark. *The Devil Got the Church on Wheels* was a favorite subject: a humorously malevolent devil attaches a motor scooter to a church on wheels, ready to whisk the congregation away. Recurrent secular themes include baseball pictures in which Swearingen might put himself on first base or all the bases, in order to heighten the action.

Around 1975 an antiques dealer in Houston, Gaye Hall, began to show Swearingen's work in her shop; Hall and her husband David Hickman organized an exhibition of self-taught Texas artists, "The Eyes of Texas," at the Lawndale Art Annex in Houston in 1980. During the 1980s Swearingen's work began to attract attention and patrons outside Texas including Louisiana, North Carolina, Washington, D.C., Chicago, Minneapolis, and New York.

Exhibitions of Swearingen's paintings include "I Make Pictures: Paintings by Reverend Johnnie Swearingen" at the University of Texas Institute of Texan Culture in San Antonio (1985) and a show at the African American Museum in Dallas, Texas (1990s). His work is at the Menil Collection (Houston) and Chapell Hill Historical Society in Texas.

See also **African American Folk Art (Vernacular Art); Religious Folk Art.**

BIBLIOGRAPHY

Adele, Lynne. *Black History/Black Vision: The Visionary Image in Texas.* Austin, Tex., 1989.

———. *Spirited Journeys: Self Taught Texas Artists of the Twentieth Century.* Austin, Tex., 1997.

Institute of Texan Culture at San Antonio. *"I Make Pictures": Paintings by Reverend Johnnie Swearingen.* San Antonio, Tex., 1985.

Rosenak, Chuck, and Jan Rosenak. *Museum of American Folk Art Encyclopedia of Twentieth-Century American Folk Art and Artists.* New York, 1990.

LEE KOGAN

TAPIA, LUIS (1950–) is a wood sculptor who defies accepted definitions of "tradition" in New Mexican art by creating colorful polychrome woodcarvings that honor centuries-old religious and social themes while transforming them into bold, often humorous commentaries on contemporary Hispanic life. Born in the tiny village of Agua Fria, just outside of Santa Fe, New Mexico, Tapia discovered his artistic motivations as a teen during the national Chicano movement of the late 1960s. The call for cultural awareness prompted Tapia to explore the artistry of his ancestors, who established a strong *santero* (a maker of religious images) tradition in the region beginning in 1598. Though he visited area museums to study traditional polychrome *santos* (saints), his first attempts at sculpting wood were in creating small-scale nudes. As his study into Spanish colonial art deepened, he began to make *bultos* (three-dimensional religious sculptures), *retablos* (religious images painted on wood), and even furniture.

Unsatisfied with merely duplicating old *santos*, Tapia expanded on traditional single-figure themes by sculpting multi-figured depictions of Old Testament subjects such as Noah's Ark and others. He shunned the then popular practice of making unpainted *santos*, and applied bright paints to his pine carvings. When homemade paints did not achieve the vivid colors he desired, he tried watercolors and egg tempera before finally opting for commercial acrylics. His use of paints underscored his belief that the old *santos*, while faded with age, were originally brightly painted. Tapia's theory, though disputed by some area scholars, influenced a revival of painted *santos*. Painted *santos* are now the standard among most *santeros,* though many prefer to mute their colors for an antique effect.

Though other artists followed Tapia's lead in creating painted works, none ventured into the broad conceptual realm of original ideas that distinguishes the artist's work as a contemporary visionary. Tapia's commentaries on modern religious, social, and political culture range from updated representations of saints, to serious examinations of crime and other social stigmas, to irreverent and humorous parodies of politics and everyday life. His meticulously carved and painted works employ familiar details of popular culture—such as cars, tattoos, golf courses, even one's weekly laundry—to encourage viewers to examine their own feelings about religion or politics, or to simply laugh and be entertained. Among Tapia's most popular images are his lowrider cars and life-sized "dashboard altar" installations, both of which explore religious themes within the context of contemporary car culture.

Tapia's work has been exhibited and acclaimed internationally by museums and private collectors. The artist has made hundreds of works, and both his single- and multi-figured images include complex architectural and conceptual environments that demand to be viewed fully in the round. The artist's subject matter and palette continue to expand into a truly limitless repertoire of profound and thought-provoking sculptures that transcend boundaries in culture and art.

See also **Bultos; Furniture, Painted and Decorated; Painting, American Folk; Religious Folk Art; Retablos; Santeros; Sculpture, Folk; Tattoo.**

BIBLIOGRAPHY

Adlmann, Jan, and Barbara McIntyre. *Contemporary Art in New Mexico.* Australia, 1996.

Beardsley, John, and Jane Livingston. *Hispanic Art in the United States: Thirty Contemporary Painters and Sculptors.* New York, 1987.

Kalb, Laurie Beth. *Crafting Devotions: Tradition in New Mexico Santos.* Albuquerque, N. Mex., 1994.

Keller, Gary D., and Mary Erickson. *Contemporary Chicana and Chicano Art: Artists, Works, Culture, and Education, Volume II.* Tempe, Ariz., 2002.

Owings-Dewey Fine Art. *Luis Tapia: ¡Ay Que Vida!*, Santa Fe, N. Mex., 2002.

Pierce, Donna, and Marta Weigle, eds. *Spanish New Mexico: The Spanish Colonial Arts Society Collection*. Santa Fe, N. Mex., 1996.

CARMELLA PADILLA

TATTOO, the marking of the skin with indelible inks in patterns and designs, had largely been a pastime of superstitious, ship-bound sailors and a scattering of port-town practitioners around the world. A maritime-related folk art in America, tattooing was revolutionized in 1892 when Samuel O'Reilly invented the electric tattoo machine in his Chatham Square, Bowery tattoo shop in New York City. He modified Thomas Edison's Electric Engraving Pen, changing the tube tip assembly to hold ink. His machine worked on a rotary-cam assembly principle that pushed the tattoo needle into the skin. New York tattoo artist Charlie Wagner, who was active between 1900 and 1952, and Bill Jones, active between 1930 and 1959, designed other tattoo machines based on O'Reilly's invention, although these used magnetic coils to create the pushing action of the needles. Wagner's and Jones's prototypes these became the standard tools of the trade. Other American tattoo innovators, such as Chicago's Owen Jensen, also designed successful tattoo machines.

A codified lexicon of tattoo designs developed from the late eighteenth to the early twentieth centuries based on conventional, and often Christian, life-affirming or magical marks tattooed by sailors on their skin to prevent mishaps associated with their dangerous profession. Because sailors lived on salt pork, the pig became a powerful symbol and many sailors had small images of pigs tattooed on the left instep as a charm to prevent drowning. Sailors often desired the image of a rooster tattooed on their right instep, a reference to the cock's crow that the angel Gabriel was supposed to have heard as the word of God. The sailors believed the crow symbol would enlist the deity's protection. Other images that would eventually become widely adopted and codified were associated with culturally masculine pursuits including maritime life, the American eagle, battle cannons, sailing ships framed with naked mermaids, and American flags with banners reading "Liberty." This particular iconography became a large part of the visual vocabulary of tattoo work throughout the United States. Tattooist "Sailor" Jerry Collins (1911–1973), of Honolulu, Hawaii, created some of the most elegant examples of American tattoo art using his natural flair for line and drafting ability. His provocative renderings of female pin-ups grew legendary among the sailors of the Pacific Fleet.

Before O'Reilly's machine innovation, the practice of tattooing by hand was typified by personalities such as Gus Wagner (1871–1941), who was born in Marietta, Ohio. He had become a merchant seaman in 1897, traveled the world for four years, and claimed to have learned the hand-tattooing technique from tribesmen in Java and Borneo. During his forty-year career as a tattooist, Wagner promoted himself as "The Most Artistically Marked Up Man In America." Men and women such as Wagner and his heavily tattooed wife Maud brought the practice of tattooing inland, away from the port-town settings. The Wagners traveled throughout America as tattooists, tattooed attractions, and circus performers. They worked in vaudeville houses, penny arcades, county fairs, and Wild West shows, exhibiting themselves to curious onlookers. Wagner's sales pitch was, "I've got a history of my life on my breast, a history of America on my back, a romance with the sea on each arm, the history of Japan on one leg, and the history of China on the other."

Modern tattooing, dating from the late nineteenth century, coalesced around the specialized culture of the electric tattoo machine and a standardized assortment of tattoo designs, referred to as "flash." The term flash was borrowed by tattooists from the jargon of carnival and circus sign painters and described graphic, eye-catching signage. Within the growing modernity and modernization of early twentieth-century America, the tattoo industry quickly adopted specialized knowledge and tools (including the electric tattoo machine) that would elevate tattooing to a modern profession from its humble, and often considered morally corrupt, origins. Specific cultural and artistic values developed around this particular body of knowledge and skills that focused on protecting the profession from "outsiders." Tattoo techniques were not openly discussed; the locations of sources of color pigments, needles, tattoo machines, and designs were generally kept secret.

New York City tattooist Lew Alberts, a wallpaper designer who was active as a tattooist about 1904, worked on Sands Street in Brooklyn, New York, at the main gate of the Brooklyn Navy Yard. He is credited with redesigning, standardizing, and improving the look of early tattoo art. Norfolk, Virginia, tattooist August "Cap" Coleman is also responsible for contributing to the changing appearance of early tattoo designs, in which many of the successful and workable designs were displayed on tattoo shop walls as prototypes from which customers could freely choose a

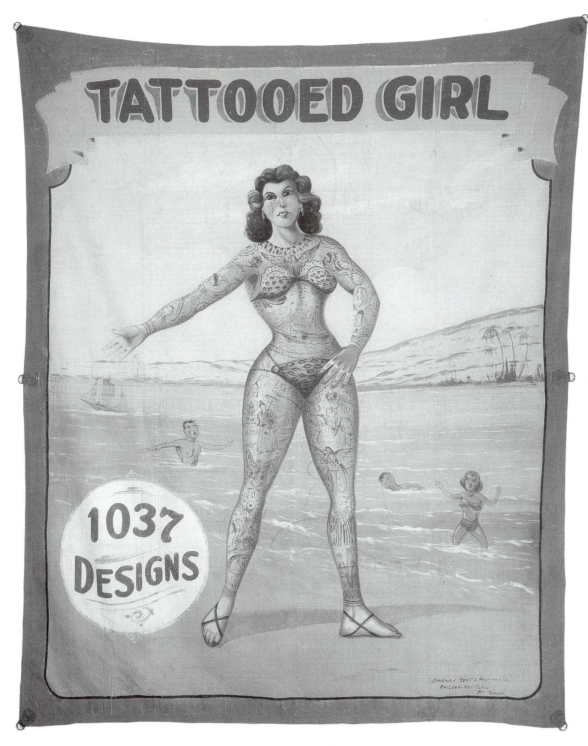

Tattooed Girl. Fred Johnson; c. 1940–1950. Paint on canvas; 141 × 116 inches. Private
Collection.
Photo courtesy Carl Hammer Gallery, Chicago.

design. Coleman's artistic ability established the measure of the standard American style of tattoo art. He transformed the idiosyncratic look of early machine-designed tattoos into more easily readable, open designs that stressed a heavy black outline and dynamic black shading techniques. The color palette of early tattooists was limited to carbon-, oxide-, and metallic-based black, as well as red and green pigments that were unreliable and faded quickly. When the colors on the painted flash display sheets or on the bodies of customers faded, the depth of Coleman's black shading preserved the integrity of the tattoo's design. Tattooists contemporary with Coleman praised his designs: "You can see what the design is from twenty-five feet away!" Sailors around the globe who traveled to the port city of Norfolk prized their Coleman tattoos.

The *Tattooed Girl*, painted by Fred Johnson, circa 1940–1950, for the O'Henry Tent and Awning Company of Chicago, Illinois, was most likely a banner advertising the seductive and illicit pleasures of tattooing, in this case a voluptuous woman in a bikini, her body covered with images including ships, eagles, dragons, horses and hearts. In the twenty-first century, tattooing has entered the cultural mainstream in America as a youth-based, popular art form. Surprisingly, the technology of tattoo machines has changed little over the last one hundred years, but tattoo artwork has changed dramatically and become specialized into style categories. Pigment technology has improved so that tattooists now have a limitless assortment of shades and colors from which to choose.

BIBLIOGRAPHY

Hardy, Donald Edward. *Sailor Jerry Collins: American Tattoo Master*. Honolulu, Hawaii, 1994.

Lucas, Don. *The Father of American Tattooing, Franklin Paul Rogers*. New Orleans, La., 1990.

McCabe, Michael. *Tattooing New York City: Style and Continuity in a Changing Art Form*. Atglen, Pa., 2001.

———. *New York City Tattoo: The Oral History of an Urban Art*. Honolulu, Hawaii, 1997.

Paul Rogers Tattoo Research Center, South Street Seaport Museum. *American Tattoo: The Art of Gus Wagner*. New York, 2000.

MICHAEL MCCABE

TAUFSCHEINE: *SEE* FRAKTUR.

TAVERN SIGNS: *SEE* TRADE SIGNS.

TAWANA, KEA (late 1930s–) built a monumental ark—98 feet long, 20 feet wide, three stories high, and weighing nearly 100 tons—on a vacant lot in the Central Ward of Newark, New Jersey. The ark was made mostly of wood, with metal, stained glass, old bottles, and other materials that she had gathered for more than ten years from abandoned residential buildings, factories, and a church; it was based on old boat manuals and on her own experience working in a shipyard in Brooklyn. According to John Beardsley, it had a hand-hewn keel and ribs joined by mortise and tenon, as well as a reinforced bulkhead with five waterproof sections in the hold.

Kea was born in Japan. Her American father, a civil engineer, died in a camp for displaced persons in San Diego; her Japanese mother was killed in an air raid in Tokyo. Tawana crossed the Pacific in 1947 on a transport ship that went through a typhoon—an ordeal that may have motivated her ark. At age twelve, she left one of the many foster homes she had been sent to; she spent the next years on her own. She settled in Newark in 1953 and began working in theater lighting, construction, and repair.

Construction of the ark began on August 8, 1982 and resulted in a legal tangle because she was working without a permit on land she did not own. When the New Community Corporation, an organization that provided housing in Newark, acquired the lot from the city, it accused her of violating the zoning and building codes. Tawana then moved the structure—single-handedly, using telephone poles and jacks—25 feet to an adjacent property, the parking lot of the Humanity Baptist Church at 235 Bergen Avenue, where it was welcomed; but the city again ordered her to demolish it. Tawana fought through the courts and the press; for a time, citizens' groups, art lovers, and New York newspapers came to her aid. Her lawyer argued that the ark, as a work of art, should be exempt from the zoning laws, and the case reached the New Jersey Superior Court. In September 1987, however, Tawana agreed to dismantle the ark, a process that she completed in the summer of 1988. The city continued to destroy other, smaller structures by Tawana; she remained in the neighborhood for a while, doing repair work, but eventually left the area.

See also **Environments, Folk.**

BIBLIOGRAPHY

Beardsley, John. *Gardens of Revelation*. New York, 1995.

Metz, Holly. *Two Arks, A Palace, Some Robots, and Mr. Freedom's Fabulous Fifty Acres: Grassroots Art in Twelve New Jersey Communities*. Newark, N.J., 1989.

Vergara, Camille. "Kea's Ark." *Folk Art Finder*, vol. 1.2, no. 3 (July–September): 13–17.

LEE KOGAN

TAYLOR, SARAH MARY (1916–) spent most of her life on plantations in the Mississippi Delta and learned to quilt by sewing on her mother's quilts. After she married in 1931 and left her mother's house, she began to make her own quilts. Taylor made pieced quilts for warmth until 1979, when she did *Man*, the first in a continuing series of appliqué quilts. It had nine blocks, each with a cutout image of a man. Like many contemporary quilt artists, Taylor tries to create original designs. To make her appliquéd quilts, she begins by cutting out paper shapes. Sometimes she draws figures freehand and copies pictures she has seen in newspapers, magazines, or catalogs. She selects and arranges her designs according to what she finds appealing, amusing, or important. She appliqués cut cloth figures onto squares until all her squares are filled with images. Then she pieces them together with vertical strips between them.

Taylor is very careful in her selection of colors: "I tries to match pieces up like I'd wear clothes. . . . I like to wear colors what's suitable to each other." Red is her favorite color, but she also likes blue and green. She tries to "match" colors by sewing one color next to another "that brings everything out."

Taylor rarely uses any of the quilts she makes. They are sold, given away to friends, or stored in one of the many closets in her rambling house. Making quilts is an artistic endeavor for Taylor: "When I be doing it, [I] be trying to see how pretty I can make it, just how I picture it in my mind." She does not quilt compulsively or continuously, but if she is inspired with an idea for a design in the middle of the night, she gets out of bed to draw it.

Taylor enjoys making appliquéd quilts and greatly prefers this technique to the traditional geometric piecing style she learned as a young woman. Appliqué offers her a flexible format for artistic and personal expression and seems to free up her visual memories of significant African American protective charms. Her *Mermaid* quilt illustrates two charm traditions: the Central African cloth charm that becomes a figure, here an appliquéd mermaid; and the small red square charm from West Africa, which becomes a *mojo,* an object believed to have magical powers. In this quilt Taylor juxtaposed an appliquéd blue hand over a pieced red square, the size, shape, and color of what is considered a protective *mojo* charm.

See also **Quilts; Quilts, African American; Voudou Art.**

BIBLIOGRAPHY

Wahlman, Maude. *Signs and Symbols: African Images in African American Quilts.* Atlanta, Ga., 2001.

MAUDE SOUTHWELL WAHLMAN

THOMAS, JAMES ("Son," "Son Ford") (1926–1993), was a renowned Delta bluesman whose unfired ceramic sculptures, like his country blues, were direct and uncompromising, but filled with wry humor and insight. Born into a musical household in Yazoo County, in western Mississippi, Thomas learned to play the guitar at age eight from his uncle, Joe Cooper. Cooper also taught him to sculpt the elastic "Gumbo clay" of the Yazoo hills. Even after Thomas relocated to Leland, near the Mississippi River, he went to Yazoo County to collect his clay. Thomas first made models of Ford tractors, which earned him the nickname "Son Ford." Then came animals like mules, horses, frogs, squirrels, and birds, all apparently charged with the symbolic valences of blues lyrics. His quails, for example, are thought by blues historian William Ferris to have reminded Thomas's audience of the Jim Crow stricture that only whites could hunt game birds. The sculptures were immediately popular with family and neighbors; he sometimes made more money from a single ceramic work than his grandparents earned in a week.

Thomas's blues singing also won respect in the community. While visiting his mother in Leland, he encountered a blues "jook joint" run by Shelby "Poppa Jazz" Brown. Soon Thomas was a regular weekend performer there. He also worked in a funeral home and as a gravedigger to pay the bills. He sculpted stylized human skulls to line the mantle of Brown's home and club. These skulls, whose connotations are so closely aligned with Thomas's clay medium, became his signature pieces. Often they were semi-hollow and lined with foil, and candles were placed inside to create a glow radiating from the skull's eyes, nostrils, and mouth. However, Thomas's portraits of the living, not the dead, complete the "blues" sensibility of his plastic arts. These heads or busts, slightly smaller than life size like the skulls, were embellished with wigs or artificial hair, paint, marble eyes, jewelry, glasses, and sometimes, genuine teeth. He called his sculptures "futures," and declared they were influenced by dreams, although his self-professed restlessness, loneliness of spirit, and deeply ironic outlook played their parts in his recondite empathy for his subjects. These highly individualized depictions, including the occasional self-portrait, stab at the desperation and pretence of human activities and, together with the skulls, create a forceful artistic

cycle about earthly vanity that inevitably ends in death. By the 1970s, Thomas had achieved acclaim as a singer and visual artist. He performed not only in the Delta, but throughout the United States and internationally.

See also **African American Folk Art (Vernacular Art).**

BIBLIOGRAPHY

Arnett, Paul, and William Arnett. *Souls Grown Deep: African American Vernacular Art of the South,* vol. 1. Atlanta, Ga., 2000.
Ferris, William. *James "Son" Thomas.* Las Cruces, N. Mex., 1985.
Livingston, Jane, and John Beardsley. *Black Folk Art in America, 1930–1980.* Washington, D.C., 1982.

PAUL ARNETT

THOMPSON, CEPHAS (1775–1856) was born in Middleboro, Massachusetts, where he was married in 1802. Thompson worked in New England and the South for nearly half a century, painting portraits in oil on panel or canvas, and at least one genre scene. His *Memorandum of Portraits,* an account of his painting activities, shows that the South, where he traveled annually during the winter, was particularly lucrative for him. He worked in Charleston in 1804 and advertised in a newspaper there that he would cut profiles with the aid of the "deliniating [sic] machine," a device he patented two years later. Thompson completed numerous commissions in Virginia, working in Alexandria in 1807, Richmond in 1807–1810, and Norfolk in 1811–1812. He painted in Philadelphia, was listed as a resident of Baltimore in 1804, traveled to New Orleans in December 1815, returned to Charleston in 1818–1819 and 1822, and worked in Savannah in 1817–1818. Thompson also painted in Bristol, Rhode Island; and his native Middleboro.

Thompson preferred to present a subject in three-quarter view, often seated on a stylish Neoclassic chair, looking at the viewer or at an unseen vista beyond the picture plane. His sitters' features are distinctive and individualized, suggesting that his works were reliable likenesses; the expressions are serene, offering little insight into personality. In his early works he used flat facial modeling, but his later portraits are more naturalistic, showing a more practiced hand. Typically, Thompson used a muted palette with subtle flesh tones, and he separated the figure from a background of dark, agitated clouds with lighter clouds behind the head. Occasionally he showed landscape backgrounds or placed the sitter in an interior with a window looking on the outside, books, and other domestic props.

Thompson's polished Neoclassic portraits of comfortable, fashionably dressed men, women, and children indicate that he had more than rudimentary training. Even his earliest works are well composed; the perspective is accurate; and there are few of the anatomical distortions often seen in the work of self-taught itinerants. His activity in larger cities shows that he sought the patronage of a prosperous urban clientele; in one instance he painted the portrait of the grandniece of a signer of the Declaration of Independence. These factors place his work outside folk art. Even though he did not achieve the lasting prominence of other portraitists working at the same time, Thompson nonetheless created elegant and appealing records of Americans living in the North and the South during the early federal period.

See also **Painting, American Folk.**

BIBLIOGRAPHY

American Folk Portraits: Paintings and Drawings from the Abby Aldrich Rockefeller Folk Art Center. Boston, 1981.
Gerdts, William H. *Art across America: The South and the Midwest.* New York, 1990.

RICHARD MILLER

TINWARE, PAINTED is the name given to the practical, lightweight tin wares made for use in the home in colonial America between 1750 and 1850. It was originally referred to as "flowered" "decorated" or "japanned" tin. It should not be confused with toleware, from the ancient French word "*taule,*" which was a heavy gauge ironware turned into trays and other utensils in eighteenth-century France.

Early in the eighteenth century, John Hanbury (1664–1734) of Pontypool, Wales invented rolling machines for the production of thin, black iron sheets that were then coated with tin from the plentiful mines of Cornwall in western England. By the early 1750s, these sheets were being shipped to colonial America where Scottish immigrant Edward Pattison (1721–1787) of Berlin, Connecticut, was the first to fashion the material into a unique and varied array of hand made implements for home use including trays, boxes, candlesticks, pots, pans, tea caddies, trunks, and canisters. Although heavy pewter, iron, and wood utensils were commonly used at this time, the new light weight, affordable, and rust proof tinware gained immediate acceptance. It was nicknamed "poor man's silver," because of its sheen when polished. The addition of painted decoration to the plain tin surface added enormously to its popularity. Use

was widespread throughout the United States until well after the middle of the nineteenth century.

Tinware production was a flourishing cottage industry in Connecticut by the first half of the nineteenth century. Account books and records of early families involved such as the Filleys, Upsons, Butlers, Norths, and Stevens have been most helpful in providing accurate details concerning techniques of manufacture and design. Widespread use occurred as tin shops were set up in outlying areas of New Jersey, Maine, New York, Pennsylvania, Ohio, and Louisiana. Peddler-driven wagons loaded with tinware, clocks and furniture traveled south and west on the rapidly growing system of roads and turnpikes across the land.

Major contributions were made by both men and women in the production of painted tinware. While men fashioned the objects, women painted them and, in several instances, women were the managers of the financial aspects of these businesses. Artists rarely signed their work, however, some styles and pieces have been attributed to particular young women through family tradition. The Butler sisters from Greenville, New York, had personal trademarks for their work. The diary of Candace Roberts of Bristol, Connecticut, is a rare and valuable document that provides a window into the social and working aspects of her life in Connecticut between 1800 and 1806. This young woman is only one of countless others who were "flowering upon tin" as they moved from shop to shop during the burgeoning years of tinware production.

Tinware was gaily painted with of fruits, flowers, urns, shells, cornucopias, birds, and multiple borders reflecting motifs seen on ceramics imported from England, France, and Holland. Research shows that styles of decorating and particular color palettes can be attributed to specific tinshops and regions of the country. Brush control was more important than artistic ability, and young women often learned on the job. Decorative styles varied from the spontaneous touch of an amateur to the refined techniques used by an experienced artisan. Light and quick strokes gave a spirited appearance. The more sophisticated techniques included japanning (a type of lacquering) and application of metallic gold, silver leaf, and bronze powders with the use of stencils that began to replace free-hand work by the fourth decade of the nineteenth century. Simultaneously these methods were also being employed to ornament the faces, glass tablets, and cases of clocks and other furniture forms produced at the time.

Interest in painted tinware was revived in the 1940s by Esther Stevens Brazer (1898–1945), the great-great-granddaughter of Maine tinmaker Zachariah Stevens (1778–1856). In 1947, the Historical Society of Early American Decoration (HSEAD) was formed in honor of her work; it is devoted to perpetuation of historical patterns and techniques of colonial painted tinware.

See also **Decoration; Furniture, Painted and Decorated.**

BIBLIOGRAPHY

Devoe, Shirley Spaulding. *The Tinsmiths of Connecticut.* Middletown, Conn., 1968.

Martin, Gina, and Lois Tucker. *American Painted Tinware: A Guide to Its Identification.* New York, 1997.

DEBORAH LYTTLE ASH

TOBACCONIST: *SEE* SHOP FIGURES.

TOLLIVER, MOSE (c. 1921–) is a significant American folk painter because of his sense of color and his rhythmic application of paint. This prolific self-taught African American artist captures the essence of his subjects, many of which relate to his life experience. Using unusual color variations and a minimalist style that relies strongly on abstraction, Tolliver places his images up front in the picture plane and establishes direct, intimate communication with the viewer.

Mose (or Moses) Earnest Tolliver was born in the Pike Road community, southeast of Montgomery, Alabama. His parents were tenant farmers; he was one of twelve children, and he attended school until age eight or nine. In the 1930s, during the Depression, Tolliver and his family moved to Montgomery, where he did lawn and garden maintenance, house painting, light carpentry, and plumbing. In the early 1940s, he married Willie Mae Thomas. He had thirteen children. Tolliver worked for McClendon's Furniture Company in Montgomery for nearly twenty-five years, until he was disabled in an accident and retired. In 1971, encouraged by the company owner's brother, who was an amateur painter, Tolliver began to paint trees, flowers, buses, turtles, birds, mules, real and imaginary people, and self-portraits. He has remarked that he "paints to keep his head together" and may do as many as a dozen pictures a day. Tolliver's early pictures, displayed on the outside of his house, attracted local patrons and, later, visitors from all over the world.

Tolliver uses a basic palette of two or three colors of house paint on plywood or Masonite. He works wet-on-wet—that is, he applies new paint to a surface layer of wet paint, so that his colors are blended directly. His forms are characterized by varied repetition and asymmetrical balance. He may show only one or two figures, but he sometimes presents a more complex narrative. His style is always lyrical, with a bold application of paint. Tolliver finishes each work by painting a frame around it; putting his signature, "M.T." or "Mose T.," in a corner; and nailing a soda can top to the back as a hanger.

Tolliver's work is based on his African American heritage, vernacular and popular culture, and his creative imagination. His sense of humor and "wickedness" are especially evident in what he calls his "nasty" pictures: erotic subjects presented frankly and amusingly. He sometimes alludes to the civil rights era, particularly in his paintings of buses, which recall the bus boycott in Montgomery in 1955.

See also **Painting, American Folk; Painting, Memory.**

BIBLIOGRAPHY

Arnett, Paul, and William Arnett, Eds. *Souls Grown Deep: Vernacular Art of the American South*, vol. 1. Atlanta, Ga., and New York, 2000.

Kogan, Lee. "Mose Tolliver." *Clarion*, vol. 18, no. 3: 44–52.

Rosenak, Chuck, and Jan Rosenak. *Museum of American Folk Art Encyclopedia of American Folk Art and Artists*. New York, 1991.

Tolliver, Mose, and Robert Elis. *Mose T's Slapout Family Album: Poems*. Montgomery, Ala., 2002.

LEE KOGAN

TOLSON, EDGAR (1904–1984) was a woodcarver, born into a poor, tenant-farming family of Scotch-Irish and German ancestry in the Appalachian hill country of Wolfe County, Kentucky, where he grew up. He began working with wood as a child, carving a series of utilitarian objects, a model locomotive, and crafting a mandolin. He attended a series of one-room schools, ending his formal education at eighteen, by which time he had finished the equivalent of the sixth grade. For a few more years Tolson lived with his parents and spent the summers helping them with farming chores and, in other seasons, working as a miner or hauling lumber to earn wages.

By the time he was twenty, Tolson had begun to preach at church meetings near his home, and in 1925 he married Lillie Smith, a farmer's daughter. They soon settled in adjoining Breathitt County, Kentucky, where she had grown up. To support their five children (a sixth child died in infancy), Tolson farmed and worked at railroad, carpentry, timbering, and sawmill jobs. During the late 1930s he helped build several schoolhouses for the federal Works Progress Administration (WPA), and he also crafted chairs that he sold to supplement his income. He continued to preach during those years, but by 1940 he began to experience an intense moral conflict between his religious devotion and his increasing interest in drinking and womanizing.

In 1941 Tolson was sentenced to two years in prison for deserting his family, and his wife divorced him. He was released from prison after serving half of his sentence. Unable to reconcile the morally conflicted, dual aspects of his personality, he abandoned preaching by the early 1960s. In 1942 Tolson married his second wife, Hulda Patton, who bore him sixteen children, and during the 1940s he made several stone carvings of animals and American Indians.

It was while recovering from a stroke he suffered in 1957 that Tolson began carving the small figural wood sculptures for which he would become widely known by the early 1970s. His most well-known pieces are tableaus illustrating the story of Adam's and Eve's temptation by the serpent and subsequent events narrated in the biblical book of Genesis. He began the latter, open-ended series sometime around 1967, after art professors at the University of Kentucky suggested the Garden of Eden theme to him.

See also **Musical Instruments; Religious Folk Art; Sculpture, Folk.**

BIBLIOGRAPHY

Ardery, Julia S. *The Temptation: Edgar Tolson and the Genesis of Twentieth-Century Folk Art*. Chapel Hill, N.C. and London, 1998.

Hall, Michael D., "You Make It with Your Mind," *The Clarion*, vol. 12 (spring-summer 1987): 36–43.

Hall, Michael D., and Rick Bell. *The Work of Edgar Tolson*. Lexington, Ky., 1970.

TOM PATTERSON

TOOMER, LUCINDA (1890–1983), the oldest daughter of seven children born to Orange and Sophie Stokes Hodrick, learned to sew and quilt when she was twelve years old. She was raised on her parents' farm in Georgia. Toomer said she learned to quilt when her mother would come into her room at night and "take her thimble and thump me in the head and wake me up and learn me how and I'm so glad she done it." When questioned about the great quantity of quilts she produced Lucinda replied: "I didn't make them to use. I just made them 'cause I know how." Mother and daughter quilted together until Lucinda married at the age of eighteen; as a wedding gift from

her mother, Toomer received the eight quilts she had made at home. In 1908, she married Jim Toomer, with whom she lived for "sixty-nine years, two months and a few days." The Toomers farmed peanuts and cotton on forty acres in southwestern Georgia. Their two children died in infancy.

Tomers's quilts became a consuming creative passion, and a substitute for children. She preferred to cut pieces in the morning, sorting them according to shape and color. She used scraps from her own sewing to make her quilts, and also purchased bags of scraps from local garment factories. She used strips to organize her patterns because "a strip divides so you can see plainer." Colors were important to her: "I get any color, you know, and I try to match with a different color . . . to make them work . . . see, that makes it show up." Red was her favorite color: "I put it where it will show up the pieces . . . red shows up in a quilt better than anything else . . . you can see red a long while." Visibility from a distance may be inherited from memories of the communicative function of West African textiles, meant to indicate the wearer's status, as well as the type of greeting, (formal or informal).

Toomer improvised, using patterns she learned from her mother or found in books and magazines. She did not duplicate the same pattern in successive quilt squares, but rather chose to create variations on a pattern. She won a National Heritage Fellowship in 1983.

See also **Quilts; Quilts, African American.**

BIBLIOGRAPHY

Wahlman, Maude. *Signs and Symbols: African Images in African American Quilts.* Atlanta, Ga., 2001.

MAUDE SOUTHWELL WAHLMAN

TOYS, FOLK in some form have existed for ages. Indeed, it is hard to imagine children without them. Ancient Egyptian children played with balls of wood or plaited reed, and their tombs contained crude mechanical animals. It was not until the eighteenth century, however, that a primitive toymaking industry developed, in the Nuremberg area of present-day Germany. In the American colonies, there was a strong prejudice against playthings, inspired by a harsh Calvinist philosophy that viewed children as miniature, flawed adults in need of instruction rather than recreation. Parents punished idle play and encouraged activities that instructed their offspring in piety and workaday habits.

By the eighteenth century, some families and educators saw toys as instructional devices. Boys were given tiny trade tools, including saws, hammers, rakes, shovels, and wheelbarrows, and were encouraged to emulate their toiling fathers; domestic chores were reserved for girls to mimic, with the miniature washtub, ironing board, and mixing bowl.

There also were toys that served no practical purpose other than improving dexterity; and the fact that many of these appear to have existed for hundreds, if not thousands, of years indicates that childhood play has long been a social norm. Among these ancient games are the hoop, the spinning top, *bilboquet* (cup and ball), and battledore (racket) and shuttlecock. A painting of the Brown children of Boston, done in the mid-nineteenth century, shows a girl with a hoop, while a top lies at the feet of a child portrayed in a canvas presently at the Shelburne Museum in Vermont.

Wooden hoops (trundled along the ground with a whiplike stick) and tops were easily constructed in the home or by a local craftsman and were popular playthings. Bilboquet was a game of skill involving a wooden ball and stick connected by a piece of string. A player tossed the ball into the air and then tried to catch it either in the cup at one end of his stick or by lodging the pointy end of the stick into a hole in the ball. Battledore and shuttlecock was a forerunner of today's badminton and was played in Asia as well as Europe.

More sedentary activities often involved crude mechanical toys. "Dancing Dan," a jointed doll that is activated by a long rod inserted in its back, is a simplified version of the richly carved and painted wooden Punch and Judy marionettes, whose ritual of spousal abuse has charmed audiences since the Middle Ages. Another ancient jointed string-operated toy is the "Jumping Jack." All these playthings have the virtue of movement, something remarkable to children in eras prior to the advent of clockwork and battery-operated toys, and they also allowed the creator some range for his or her creative impulses. Some early American examples reflect strong folk portraiture.

Another traditional group of handmade playthings includes pop-up toys. Best known is the jack-in-the-box. A head, usually of a clown, is mounted on a spring and concealed within a box with a hinged top. When the top is raised the figure bounds up to startle or amuse. Folk carvers have added some "interesting" variations to the theme. In one, a snakelike head armed with a sharp nail emerges, ready to puncture the unwary victim's finger. In another Pennsylvania-made version, probably intended as an adult toy, a

tiny carved body emerges from a coffin-shaped receptacle; it is a phallus.

There are also various balance toys. In this form, a carved wooden or ivory figure (usually human, though horses and other animals are known) balances atop a shaft, prevented from falling by a ball-like counterbalance. Related playthings include the pecking-chicken toys still carved in Central Europe and Russia. Wooden birds pegged to a small platform move and peck by the rotary action of a wooden ball, which is suspended pendulum-like beneath the platform and connected to each figure by guide strings.

Most folk toys are not animated but rely on form and color for appeal. Carved figures of birds, animals, and humans were found in ancient cultures, and they are the basis of the modern toy industry. Until the eighteenth century there were few commercially made playthings. The wealthy might commission a sculptor or other skilled craftsman to produce something to amuse their offspring; everyone else relied on Father's jackknife, file, and paintbrush.

In the early 1700s, merchants in Nuremberg, Germany, took advantage of these homegrown skills to establish a cottage industry, through which whole families spent their winter evenings turning out carved and painted figures that were then exported throughout Europe and North America. Though in a sense mass-produced, these carvings are considered folk art, far different from the factory-made metal and wood toys that were to inundate the world during the nineteenth century.

Skilled American carvers followed their own directions. Wilhelm Schimmel (1817–1890), who lived and worked in the Carlisle, Pennsylvania, area, is known for figures of birds, animals, and toy soldiers; his chip-carved style was widely followed. Other craftsmen produced their own versions of popular European toys, such as the Noah's ark with its menagerie of animals. Some of these beasts had tails or jaws that moved when a string was pulled. Snakes, carefully assembled from many jointed units, could wriggle realistically across the floor. An interesting Pennsylvania novelty was the bird tree, a tree branch on which was mounted numerous carved and brightly painted wooden birds.

Horses, which dominated transportation until the coming of the railroad and the combustion engine, were made in many forms. Small, brightly painted ones mounted on wheeled platforms served as pull toys, while larger rocking and hobbyhorses were found in almost every nursery. The hobbyhorse, a carved and painted wooden horse head mounted on a shaft, was known in ancient China, while rocking horses were used in the Middle Ages to familiarize boys with the mounts they would someday ride into battle.

The instructional nature of folk toys was also evident in the musical instruments produced for aspiring players. Some children born in the twentieth century can recall the poplar whistles their father carved for them. Larger whistle versions, crude flutes, and fifes, when joined by a hollow-log drum added a martial air to childish parades; wooden clackers, once used as signals by night watchmen, were calculated to disturb adult peace. But oldest of all is the "bull roarer," a bit of shaped wood attached to a string. Swinging it produces a rumbling sound, and ancient peoples believed it could bring rain because the noise sounded like thunder.

While most folk toys were made of wood, other materials were also utilized. Sailor fathers during their long voyages would use whale or walrus ivory, and they carved delicate rattles, tops, and balance toys for their offspring. A thousand years ago, Inuit craftsmen were using the same materials to shape game counters in the form of realistic-looking bears, seals, and birds. Today, all of these are rare and much sought after. Marbles, another ancient plaything, were usually shaped from stone or clay.

Pottery clay was also used by American manufacturers of inexpensive playthings. Potteries, especially in Pennsylvania, turned out quantities of miniature redware and stoneware jugs, crocks, plates, and pitchers as well as water whistles. The latter were hollow, pipelike figures, usually of birds, which gave off a melodious sound when filled with fluid and blown through. Potters produced a variety of decorated penny banks, designed to encourage saving. All of these items are now highly collectible, and slip-decorated miniature plates and platters are among the most desirable.

The ultimate folk toy was the dollhouse, which, with its tiny contents, captured the child's world in Lilliputian terms. The first dollhouses were called "cabinet houses," and were made for adult amusement in the seventeenth century. Within a hundred years they were being turned out all over Western Europe and in the American colonies. The earliest existent American example dates to about 1744.

Many homemade dollhouses were faithful reproductions of the buildings in which the young owners lived, or of historic edifices such as Mount Vernon or the White House. Furnishings, in some cases accurate representations of period pieces, were made of wood, metal, glass, or pottery. Individual rooms were also made, particularly the so-called Nuremberg

kitchens, in which tin and wooden stoves, cupboards, tables, and chairs accurately depicted a nineteenth-century scene.

Closely related to dollhouses are reproductions of stores and commercial offices. These were especially popular in England, where a butcher shop might have dozens of carved wood or composition hams, chops, and ribs hanging from the ceiling, while fancier cuts were displayed in a glass-fronted case. American versions featured familiar village locales, such as the blacksmith shop, the barber, or the milliner's, all capturing in miniature a life now past.

See also **Dolls; Mechanical Banks; Miniatures; Pottery, Folk; Redware; Wilhelm Schimmel; Shelburne Museum; Stoneware.**

BIBLIOGRAPHY

Brant, Sandra, and Elissa Cullman. *Small Folk: A Celebration of Childhood in America.* New York, 1980.

Daiken, Leslie. *Children's Toys Throughout the Ages.* London, 1963.

Ketchum, William C. *Toys and Games.* New York, 1981.

McClinton, Katharine Morrison. *Antiques of American Childhood.* New York, 1970.

WILLIAM C. KETCHUM

TRADE EMBLEMS: *SEE* TRADE SIGNS.

TRADE SIGNS, also known as trade emblems, sign boards, board signs, or shop signs, are made from any number of materials, primarily wood, to advertise a product or service. Before literacy was widespread, the trade sign often consisted only of symbols signifying the nature of the advertised business. Later, trade sign messages were contained in lettered words, sometimes accompanied by pictorial designs. To further attract consumer's attention, the symbol, the letters, and the pictures were regularly embellished with bright colors. The inveterate American folk art collector Nina Fletcher Little (1903–1993) had a fancy painter's sample board signed by E.F. Lincoln, Falmouth, in her collection, that colorfully demonstrated the lettering, flourishing, and monogramming—devices typically used by nineteenth-century ornamental painters.

Eighteenth- and nineteenth-century ephemeral paper broadsides and placards also fall under the heading of trade signs, but few survive. A sampling includes an engraved paper advertisement of about 1815 by Richard Brunton (d. 1832) that pictures a mail coach equipped with backless benches for nine to twelve passengers, a team of four horses, and a driver accompanied by the message *"Commercial Mail Stage, Thirty-nine Hours from Boston to New York."* Another paper advertisement that has survived, this

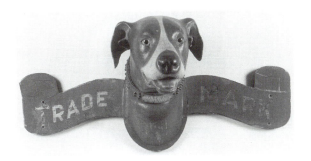

Paint store trade sign for A. L. Kieselbach Paint Store, 107 Smith Street, Brooklyn, New York. c. 1885. Carved and polychrome painted wood with leather and metal collar, glass eyes.
Photo courtesy Allan Katz, Americana, Woodbridge, Connecticut.

one from the *Salem* [Massachusetts] *Directory of 1851* is drawn in ink with gray wash and promotes James Emerton's Apothecary Shop picturing its three-story shop building with a carved classical bust mounted above the first floor outside corner and vertical lettering announcing *"DRUGS & MEDICINES."* A "cabinet card" circa 1890 features a female model holding a banner with the message *"Mrs. M.E. Tyler, Photographer,"* together with Mrs. Tyler's image. The model's full-length gown contains numerous portrait photographs.

Before the introduction of electric and neon signs, trade signs were crafted in wood and specialty shops, such as carriage shops, that had tradesmen and apprentices who painted on wood. Several well known eighteenth- and nineteenth-century craftsmen, portrait painters, genre and landscape artists began as sign painters. Paul Revere (1735–1818), the silversmith and American patriot, designed, crafted, and painted the sign for the Red Lion Inn in Boston. Edward Hicks (1780–1849) of Pennsylvania, known internationally for his *Peaceable Kingdom* paintings, trained as a sign painter. He excelled as an apprentice and later as the owner of his own shop. Technically and artistically proficient, Hicks developed expertise in color combinations, carpentry, lettering, spacing and knowledge of the diverse kinds of paints and grounds that were best suited to various materials, all skills required of an accomplished trade sign painter. Entries in account books maintained by Hicks list thirty-five lettered signs and tavern signs he produced between 1806 and 1833. He painted the Newtown Pennsylvania Library sign, with its center motif of Benjamin Franklin reading, and the signboard promoting Henry Vanhorn as a carpenter and joiner, with images of a coffin, a chest, and a cradle to indicate

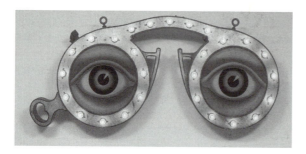

Optician's Trade Sign, W. Dodge. Maker unknown; American, c. 1870. Carved wood with polychrome paint, gilding, and smalt; iron hardware; 28 × 27 × 4½ inches.
Photo courtesy Allan Katz, Americana, Woodbridge, Connecticut.

service from birth to death. Also surviving are the two signs by Hicks, which stand at each side of the Delaware River, commemorating George Washington's historic crossing and marking the 1834 opening celebration of a new bridge. New England mural painter Rufus Porter (1792–1884) also trained as a sign painter. Nautical genre painter John Orne Johnson Frost (1852–1928) of Marblehead, Massachusetts, was a capable carpenter, and at the time of his death, a painted, wood six-foot codfish hung from the rafters of his studio.

Most trade sign makers and painters were self-taught and authorship remains unknown in many cases. The intricate and often humorous designs attest to their makers' artistic talents and woodworking skills. A French traveler, Moreau de St. Méry, during his 1793 to 1796 visit to America, wrote in his journal, *"There are artisans who make a specialty of painting remarkably beautiful signboards with backgrounds of different colors speckled with gold and silver."* Writing one hundred years later on July 3, 1892, a reporter from *The New York Times* described the abundance of diverse signs on the streets of New York City, identifying several sign painters who later gained fame as portrait and nautical painters, or who were affiliated with the Hudson River School. Matthew Pratt (1734–1805), a popular portrait artist, supplemented his income as a successful sign painter after the American Revolutionary War. Henry Mount Smith (1802–1841), known primarily as a painter of still life, studied sign painting as a young man, and by 1824 had his own sign painting business in New York City. Maritime painters Francis A. Silva (1835–1886) and Arthur Quarterly (1839–1886) were also accomplished sign painters, as were Hudson River artists Worthington Whittredge (1820–1910) and William Louis Sonntag (1822–1900), both natives of Cincinnati, Ohio.

Wooden trade signs typically reflected the abilities of trained, resourceful artisans who produced attractive designs and were skilled at molds, carving, and embellishments. Square or rectangular signs were plentiful, but shields, ovals, bells, and other cutouts were popular. Many signs were attached to building façades; others were hung at right angles to the building on which the advertised product was located and were visible to the public from both directions. These signs were lettered, pictorial, or a combination of both. Many signs were carved and painted in the round and hung from the appointed building or placed over the doorway. Trade signs were an integral and influential factor in shaping a town's appearance, especially along main streets in commercial districts. Considering the number of signs that lined the streets of America, few remain. The climate, insect infestation, fire, demolition, and stringent zoning codes led to the disappearance and destruction of most trade signs.

Many of the extant trade signs from the nineteenth century are maintained in public and private art collections. Taverns were numerous and varied samplings of tavern signs survive. A recently published survey indicates that between 1750 and 1850 there were 10,000 licensed food and lodging establishments in the state of Connecticut alone. Until the American Revolutionary War, early tavern signs incorporated popular British images, such as the lion. A sign by William Rice (1777–1847) produced in 1818, which advertised the Goodwin Tavern in Hartford, depicts a chained lion, perhaps signifying victory over England. A pictorial sign for the J. Carter Inn of Clinton, Connecticut, dated about 1815, pictures a soldier and a civilian sharing a dining table laden with a fowl and drink, while the reverse side illustrates a carriage transporting a man and woman. This is one of sixty-six tavern signs in the collection of the Connecticut Historical Society, which has the largest known collection of American tavern signs. The center oval of a three-part wooden sign advertising the D. Beemer Inn, dating from about 1820, incorporates Masonic symbols in its center oval. A more ambitious carving of the angel Gabriel of about 1815, hung outside the Angel Inn in Guilford, New York. A paint store trade sign made for A.L. Kieselbach Paint Store on Smith Street in Brooklyn, New York featured a carved dog's head, painted and embellished with glass eyes and a metal collar. Documents reveal that Mr. Kieselbach also owned a sign shop around the corner from the paint store, on Atlantic Avenue, and that it is likely that the trade sign—which immortalizes the Kieselbach's family

dog—was made in his neighboring shop. Holes in the dog's mouth indicate that a paint can probably hung from its mouth, and the studded metal collar is engraved with the family name and shop address.

A variety of designs depicted images of goods and services popular in nineteenth-century America: a sheaf of wheat for a baker, a pig for a butcher shop, a ram for a wool merchant, a circuit rider designating the home of an itinerant preacher, a whale for either a fish or whale oil shop, a violin for a music shop, the goddess of liberty feeding an eagle to designate the office of a justice of the peace, a cricket to promote a New Orleans brothel/dance hall, and a penknife for a cutlery store. *The New York Times*'s survey of New York trade signs in 1892 recorded other diverse images: fast-speeding messenger boys for the District Telegraph Company, the back view of a gentleman's high, starched collar for a laundry, a painter's palette for an artist materials store, a pyramid of painted barrels for a paint shop, a dummy camera for photographers, an oversized French horn or cello for a music shop, a gilded faucet for plumbing supplies, stuffed bears to announce a shop, and a "fiery dapple-gray steed" for a carriage and harness shop. In New York City both a toy manufacturer and V. Loewer's Gabrinus Brewery Co. featured trade signs with Santa Claus's image.

To ensure attention on busy streets, some signs were oversized. Extant examples include a watch, three feet in diameter; a high-wheeler bicycle with rider seven inches in height; and a revolver for a gunsmith shop. Frederick (1908–1994) and Mary Fried (1913–), folk art historians, reported that the largest known wooden sign in the United States in the 1890s was a 128-foot long wooden banner advertising the Mechanico Therapeutic Zander Institute of New York City.

In the case of the "Elephant Joe" Josephs (dates unknown) sign shop on Exchange Street in Buffalo, New York, the entire three-story building served as an advertisement, in which every exterior surface was covered with letters, pictorial images, cutouts, and framing devices, creating an amalgamation of signs that communicated the sign maker's craft, skill, as well as sense of humor. A reporter for the *Buffalo Advertiser* wrote that the shop evidenced "the strength and follies of the present day. A historian, a century hence, without any other source of information could read aright the riddle of the times from the designs which Joe Josephs has spread out so voluminously to the gaze of an admiring community." This observation hints at one of the significant aspects of trade signs, that is, their role in the development of America's nascent material culture, both visual and textual.

See also **Canes; Christmas Decorations; Freemasonry; Frederick Fried; John Orne Johnson Frost; Edward Hicks; Nina Fletcher Little; Maritime Folk Art; Painting, Landscape; Painting, Still-life; Rufus Porter.**

BIBLIOGRAPHY

Bishop, Robert, and Jacqueline Marx Atkins. *Folk Art in American Life.* New York, 1995.

Clayton, Virginia Tuttle. *Drawing on America's Past: Folk Art, Modernism, and the Index of American Design.* Washington, D.C., 2002.

Fried, Fred, and Mary Fried. *America's Forgotten Folk Arts.* New York, 1978.

Little, Nina Fletcher. *Little By Little: Six Decades of Collecting American Decorative Arts.* New York, 1984.

Lipman, Jean, and Tom Armstrong, eds. *American Folk Painters of Three Centuries.* New York, 1980.

Lipman, Jean, et al. *Young America: A Folk Art History.* New York, 1986.

Lipman, Jean, and Alice Winchester. *The Flowering of American Folk Art (1776–1876).* New York, 1974.

Lord, Priscilla Sawyer, and Daniel J. Foley. *The Folk Arts and Crafts of New England.* Radnor, Pa., 1975.

Rumford, Beatrix T., and Carolyn J. Weekley. *Treasures of American Folk Art from the Abby Aldrich Rockefeller Folk Art Center.* Boston, 1989.

WILLIAM F. BROOKS JR.

TRAMP ART, a tradition of carving and constructing three-dimensional objects from wood, was practiced generally from the 1880s to the 1930s in the United States. Sheets of wood were cut and shaped, usually into geometric patterns, then edge- or chip-carved (v-shaped notches were taken out of the wood usually with a pocket knife) and the sheets were attached to each other with glue or nails (similar to appliqué work) in pyramidal layers. While cedar cigar box-wood was by far the most popular material, wooden packing crates for soap, fruit, or starch were also used; the choice was usually the most readily available material.

Boxes and frames are the most frequently found pieces of tramp art because they were the easiest to make and the most useful. Small jewelry and dresser top boxes and sewing boxes were produced most often. Less common were wall pockets, wall boxes, comb cases, and doll-sized furniture. Equally rare were religious artifacts such as altars, crosses, and reliquaries. Full-sized pieces of furniture are even more unusual, although it appears that almost every known style of furniture was copied. The objects considered most fanciful include replicas of the Eiffel

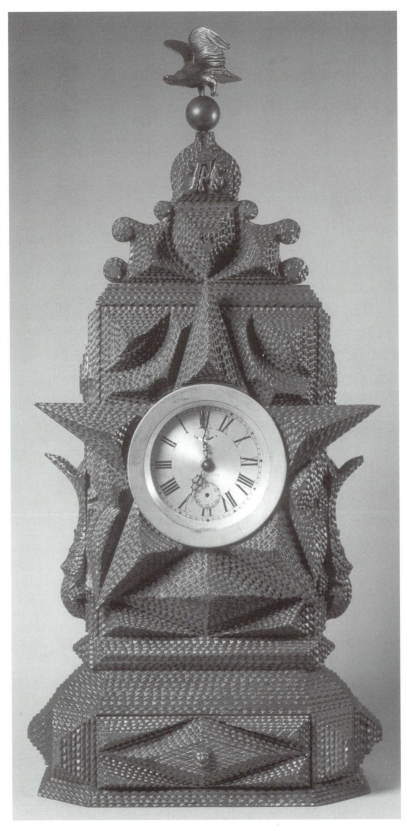

Tramp art clock. American; 1909. Carved and notched wood; 33½ × 16 inches.
Photo courtesy Allan Katz, Americana, Woodbridge, Connecticut.

Tower or Brooklyn Bridge; their novelty derives from their non-functional nature.

The method of layered and notched woodcarving used for tramp art developed from the chip-carving of the nineteenth century practiced in Northern Europe. In Germany and Scandinavia, *Wanderburschen*, wandering apprentices or journeymen, traveled the countryside working in their particular trades. Nineteenth-century American craftsmen or itinerant peddlers, such as blacksmiths, glass and furniture makers, and others worked in much the same way, walking great distances in search of work and a better life, particularly during difficult economic periods in the United States. The whittling and woodcarving they practiced during their free time was taught to those they encountered in their travels. Tramps, hobos, and other self-taught woodworkers taught the craft, passed from traveler to local resident, neighbor to neighbor, or father to son.

Even though a few pieces of tramp art are signed, little or nothing is known about the artists; most are anonymous. Pieces were valued for their utilitarian function; they were not collected unlike other types of folk art objects. Nonetheless, tens of thousands of pieces have survived, objects that are today prized by a growing number of collectors. In upstate New York, a group of artists who call themselves the Hermitage Artists have revived the old tradition and continue to make tramp art.

See also **Sculpture, Folk.**

BIBLIOGRAPHY

Fendelman, Helaine. *Tramp Art: An Itinerant's Folk Art.* New York, 1975.

Fendelman, Helaine, and Taylor, Jonathan. *Tramp Art: A Folk Art Phenomenon*, 1999.

Wallach, Clifford A., and Cornish, Michael. *Tramp Art, One Notch at a Time.* New York, 1998.

HELAINE FENDELMAN

TRAYLOR, BILL (1854–1949) was an African American artist born a slave on the cotton plantation owned by George Hartwell Traylor near Benton, Alabama. His earliest recollection was of Union troops burning and looting the Traylor plantation, which occurred on the same day the American Civil War ended. The 1870 census lists Traylor as a "farm laborer," aged seventeen. Traylor married, raised thirteen children, and became a sharecropper on the Traylor farm.

Traylor moved to nearby Montgomery, Alabama, at age 81 and worked in a shoe factory until rheumatism forced him to leave the job, walk with the aid of two canes, and to receive welfare relief. He lived behind a

Blue Wagon; Bill Traylor; c. 1939. Poster paint on cardboard; 14¼ × 22 inches.
Photo courtesy Fleisher/Ollman Gallery, Philadelphia.

funeral parlor and spent his days on the street in an African American section of Montgomery making drawings. In 1939, the same year that Traylor began to draw, artist Charles Shannon encountered him on the street. Shannon befriended Traylor, brought him artist's materials, and organized an exhibition of Traylor's works a year later.

Traylor drew on scrap cardboard with graphite pencils, colored pencils, crayons, and tempera. Using a straightedge to draw simple geometric forms, Traylor then elaborated these shapes into human and animal forms. The underlying abstract forms upon which his images are built, and his preference to contrast strong, often colorful shapes and forms with the compositional background, lie at the heart of his powerful works, and have encouraged comparisons of Traylor's drawings to modern art. Stylized, often contorted, human and animal figures, drawn singly and in groups, populate the drawings. His figurative compositions depict daily life: men and women drink, talk, fight, work, or engage in various communal activities. Snarling dogs, farm animals, coiled, and gaping snakes further reflect Traylor's life experiences. Other, more enigmatic narratives seem to derive from long forgotten folk tales or legends. Replete with forms, repetitions, and patterns that share a formalism with African art, Traylor's work, nonetheless, seems to stymie efforts to identify specific African sources.

He was born into and raised within a community of slaves, some of whom may well have lived in Africa and whose atavistic memories and stories might have been shared with Traylor, signaling the reference to fragments of remembered African culture. Traylor's significance, ultimately, may be that he bridged cultures through an intuitive ability to adapt the stories and traditions that were passed on to him and expressed through the art. The result is art that appears

familiar and commonplace, but may well contain embedded, and as yet undeciphered, references to Traylor's African heritage.

See also **African American Folk Art (Vernacular Art); Painting, American Folk; Painting, Memory.**

BIBLIOGRAPHY

Helfenstein, Josef, and Roman Kurzmeyer, eds. *Bill Traylor 1854–1949: Deep Blues*. New Haven, Conn., 1999.

Livingston, Jane, and John Beardsley. *Black Folk Art in America 1930-1980*. Washington, D.C., 1982.

RICHARD MILLER

TRUCHAS MASTER (working dates c. 1780–c. 1840) was a northern New Mexican *santero* (a carver and painter of figures/images of saints, or *santos*) named for two altar screens he painted in the church of Nuestra Señora del Rosario in the village of Truchas. He also painted a few other altar screens; numerous smaller *retablos* (devotional panel paintings); and he possibly made *bultos* (polychrome wood sculptures). His identity is not known, but he may have been Pedro Fresquis, a resident of Truchas who, in 1831, petitioned to be buried at El Santuario de Chimayó because he had worked on "various material projects" at Santa Cruz, Chimayó and Truchas. Whether these projects were *santos* is not known, and no other documentary evidence has been found to support this attribution.

The *retablos* of the Truchas Master are painted in a draftsman-like style, and many appear to be based upon prints of the period. His range of subjects is significantly larger than that of other New Mexican *santeros*, including many lesser known saints whose attributes he correctly rendered. Some of his pieces have prayers or inscriptions written on them in a clear hand, indicating that he was literate and probably had access to books and print sources. But the more academic nature of his subjects is in sharp contrast to his simple style. The figures and many decorative details are quickly and freely drawn, probably with a pen or fine brush and are painted in bright pure colors. His best paintings have a refreshingly spontaneous quality far removed from the naturalism of academic art.

The long span of working dates for the Truchas Master is based upon tree-ring dating of a series of his *retablos*. A number of them were done on boards from trees apparently cut in the 1780s and 1790s. However, it is not certain that he was actually working this early. He may well have painted on old boards cut many years before, and in fact at least two

of his paintings were done on boards salvaged from pieces of furniture. Also weakening the case for a long working career is the fact that his whole body of work is stylistically consistent. There are no appreciable differences between these possibly early pieces and those from the 1820s and 1830s, and thus no evidence of any development or change in his style or technique over a more than fifty-year period. It is perhaps more likely that he worked from about 1805 to 1840.

A few small *bultos* may have been made by him. They have stylistic details similar to those on his *retablos*. He also made a few gesso low reliefs. It appears that the Truchas Master had at least one follower who worked with less skill in a very similar style.

See also **Bultos; Retablos; Santeros.**

BIBLIOGRAPHY

Boyd, E. *Popular Arts of Spanish New Mexico*. Santa Fe, N. Mex., 1974.

Wroth, William. *Christian Images in Hispanic New Mexico*. Colorado Springs, Colo., 1982.

WILLIAM WROTH

TUTHILL, ABRAHAM GUGLIELMUS DOMINEY (1776–1843) was a painter of more than one hundred portraits. He was born on the northeastern tip of Long Island, at Oyster Pond (now Orient Point), New York. Although his Dominey relatives, early settlers of the area, were well-known for their fine cabinetmaking skills, Tuthill's talent was realized with the paintbrush. His earliest known portrait is that of the Long Island minister, Samuel Buell.

In 1799 Abraham Tuthill traveled to New York, and then to Philadelphia, to improve his artistic skills. He sought instruction from Gilbert Stuart (1755–1828), considered the father of American portraiture, who advised him to go abroad to study with Benjamin West (1738–1820), one of the first American painters to receive wide recognition in Europe. Tuthill's benefactor, from Shelter Island, New York, Colonial Sylvester Dering, financed his journey to Europe. Although details regarding the eight years he spent in England and France remain unknown, Tuthill did return to America a fine colorist, though without significant change to his style.

Tuthill spent the years from 1820 to 1843 as an itinerant portraitist in backcountry areas of the Vermont towns of Pomfret and Montpelier; in the upstate New York towns of Watertown, Plattsburgh, Sackets Harbor, Buffalo, Lockport, Rockport, Rochester, and Utica; in St. Clairsville and Cincinnati, Ohio; and in

Detroit, Michigan, a route made possible by the system of Champlain and Erie Canals completed in 1825. Thus, he avoided the competition in the East, where so many itinerant painters were working. Tuthill sought out commissions from prominent citizens who considered portraits evidence of cultural progress and wished to be portrayed as somber and proud Americans. His studies with Benjamin West certainly helped Tuthill secure commissions.

Tuthill generally painted three-quarter-length views of his sitters using rich shades of blue, red, green, and oyster white as well as delicately modulated grays and blacks. He painted distinctively formed hands with upturned fingers, and with forefingers extended and separated. Portraits of women are usually viewed from the right, men from the left.

Important works include a full-length portrait of DeWitt Clinton at the opening of the Erie Canal; portraits of two mayors of Buffalo, New York; portraits of Benjamin West painted from mezzotint sources; and the portrait of Deborah Eldridge, whom he married in 1825. Interestingly, she is represented as an artist who may possibly have assisted him in his portrait painting.

See also **Painting, American Folk.**

BIBLIOGRAPHY

Frankenstein, Alfred, and Arthur K.D. Healy. *Two Journeymen Painters.* Middlebury, Vt., 1950.

Tatham, David. *Abraham Tuthill: Portrait Painter in the Young Republic.* Watertown, N.Y., 1983.

DEBORAH LYTTLE ASH

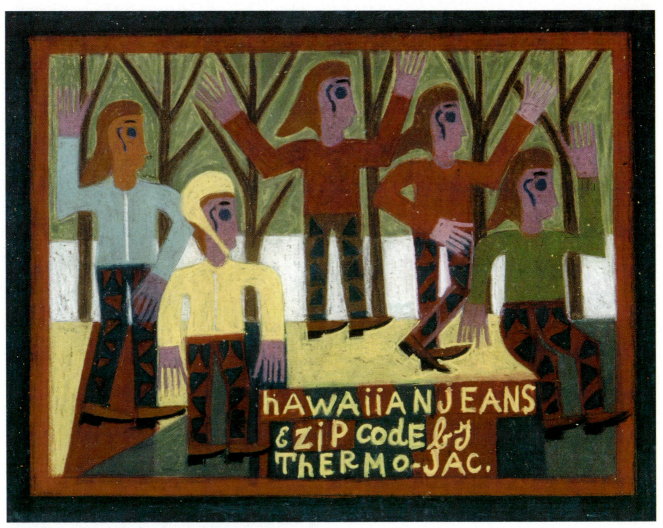

Photo courtesy Janet Fleisher Gallery, Philadelphia, Pennsylvania.

Eddie Arning began to draw as part of his therapy while confined to Austin State Hospital (Texas), where he was committed for schizophrenia for thirty years. Arning's early efforts comprised flattened, geometric birds, dogs, train cars, windmills, and airplanes using crayons on colored paper. Once he was moved to a nursing home facility in 1964, Arning's focus shifted to complex figural compositions, probably in relation to his treatment, which emphasized group socialization. He began using magazine advertisements from *Better Homes and Gardens* and *Readers' Digest* as source material, although he would freely transform the graphic images using his own reductive visual vocabulary with intense color juxtapositions and hierarchical forms. Arning's iconic figures feature "Egyptianizing" faces (in profile with frontal eyes). *Hawaiian Jeans* (c. 1965), made with Craypas on paper and measuring 19¾ × 25¾ inches, is such a work.

PLATE 49

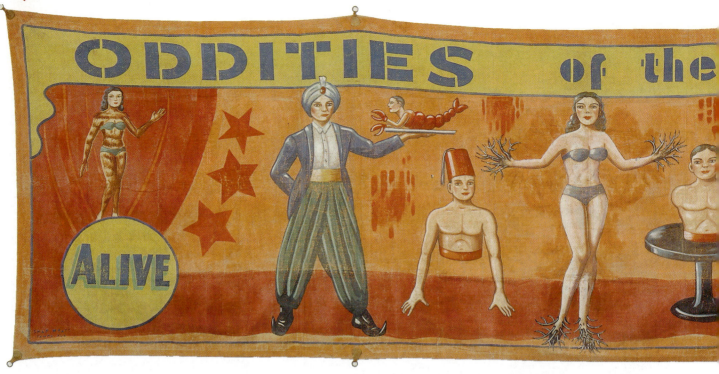

Private Collection.
Photo courtesy Carl Hammer Gallery, Chicago, Illinois.

Eugene Von Bruenchenhein (1910–1983) executed
thousands of photographs of his wife and muse
Marie Kalke throughout the 1940s to the 1960s, in
private and expressly not for an art market.
Untitled (Marie), made in his hometown of
Milwaukee, Wisconsin (date unknown, 2¾ × 4½
inches) shares affinities with not only avant-garde
Surrealism and that movement's passion for the
naked female form, but also Hollywood pinups of
the 1950s, an iconography that clearly influenced
Von Bruenchenhein's choice of poses. At once
idealized, erotic, and innocent, this work uses an
experimental montage technique to superimpose
images of Marie.

Photo courtesy Carl Hammer Gallery, Chicago, Illinois.

PLATE 50

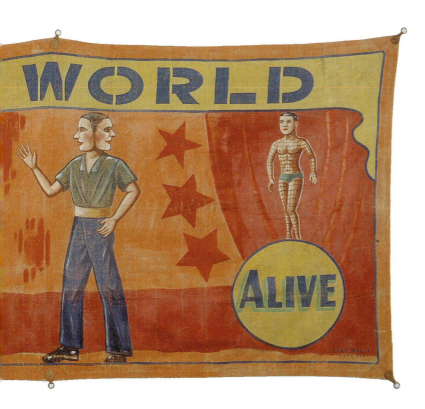

Each of the three works—the circus banner by Snap Wyatt (*left*), the photograph by Eugene Von Bruenchenhein (*bottom left*) and the bottle cap sculpture by Clarence and Grace Woolsey (*below*)—are fascinating examples of idiosyncrasy within the broad scheme of American folk art. Wyatt's *Oddities of the World* canvas (measuring 100 × 354 inches) derives from a category of commercial circus art seen in sideshows from the turn of the century to the 1950s that aimed to titillate and shock viewers with its animated images of freaks. In addition to the rubber man and the alligator girl, Wyatt (1905–1984) depicted a woman with tree branches for hands and feet, a man with a lobster body, and a two-headed man.

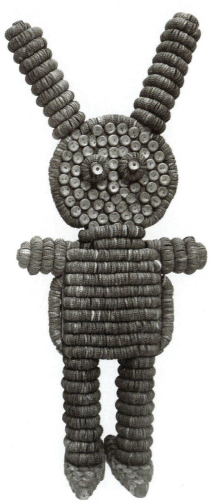

The origins of bottle cap art are uncertain, although figures, toys, and necklaces emerged in great numbers in the post-World War II era. Made largely by unknown artisans, bottle cap figures and their unorthodox materials were celebrations of kitsch. Figures such as the *Untitled* rabbit sculpture by Clarence (1929–1987) and Grace Woolsey (d. 1988), Iowa farmhands, were laboriously constructed with hundreds of thousands of caps, wood, paint, and wire. The piece measures 44 × 19 × 13 inches; the date is uncertain, although it is after 1961.

Collection of Eugenie and Lael Johnson.
Photo courtesy Intuit: The Center for Intuitive and Outsider Art, Chicago, Illinois.

PLATE 51

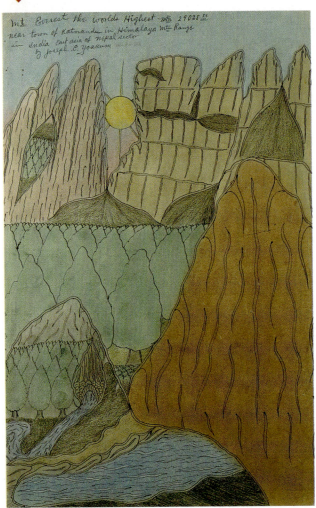

Mt. Everest, The World's Highest Mountain 29,028 Feet Near Town of Katmandu.
Photo courtesy Carl Hammer Gallery, Chicago, Illinois.

Joseph Yoakum (c. 1890–1972), born of Cherokee, Creek, and African American heritage, was a self-taught artist who devoted himself entirely to landscape. He produced some 2,000 works on paper in a Chicago storefront after retiring from the United States Army. Having traveled throughout the world as a sailor and stowaway, Yoakum's subjects include intricately linear topographies with the locations penned along the edge. *Mt. Everest, The World's Highest Mountain 29,028 Feet Near Town of Katmandu* (c. 1968, pen, colored pencil on paper, 19½ × 12¾ inches, *left*) is one such work that is most likely a combination of fantasy and remembered observations.

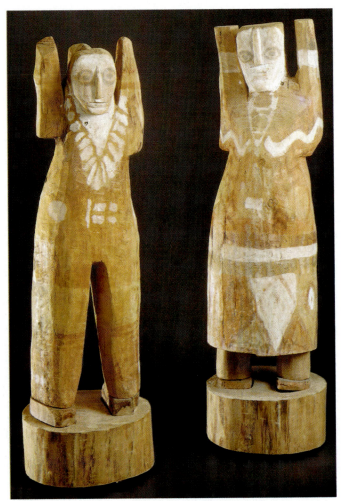

Folk art traditions are passed along generations within Native American families. One such artist whose son followed in his footsteps was Charlie Willeto (1897–1964), a pioneering Navajo visionary and medicine man whose so-called spirit figures embraced ceremonial influences as well as powerful abstract qualities. His *Two Figures* (c. 1960–1964), carved of wood and painted in the Nageezi area, New Mexico (*right*), raise their arms and hands in gestures reminiscent of the earth, sky, and wind gods depicted in sand paintings. The male figure measures 45 × 12 × 10 inches; the female measures 42 × 12 × 12 inches (excluding bases).

Collection of Stephanie and John Smither. Photo © Rick Gardner Photography, Houston.

PLATE 52

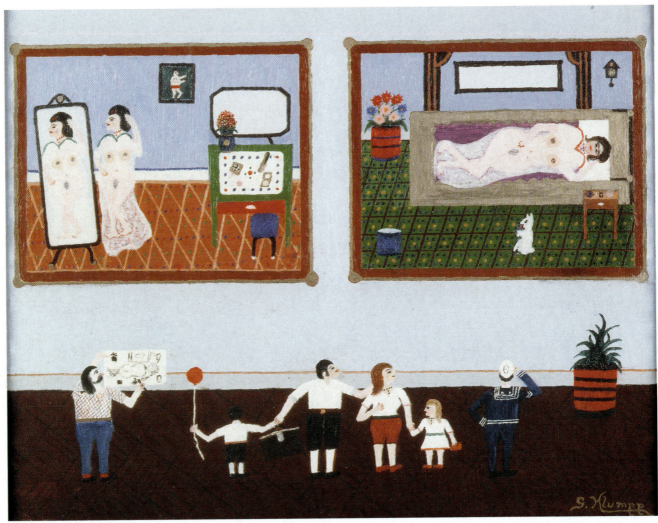

Collection American Folk Art Museum, New York, Gift of Mr. and Mrs. William Leffler, 1979.34.1.
Photo courtesy John Parnell.

This colorfully articulated, symmetrically ordered painting by German-born artist Gustav Klumpp (*The Art Gallery*, c. 1970, oil on canvas, 25½ × 19½ inches, *above*) is the idiosyncratic expression of a naïve artist whose interest in painting revolved around his desire to paint imaginary and fictive landscapes. Klumpp (1902–1980) worked as a linotype operator in the printing business and retired to Brooklyn, New York, where he first painted in the 1960s. This painting—with its flattened, local color and decorative patterning—shares the bold impact of graphic work. Klumpp reveals his interest not only in female nudes as subject matter for art, but the intricate contrast of interiors (in the two paintings) with the interior space of an imaginary art gallery.

PLATE 53

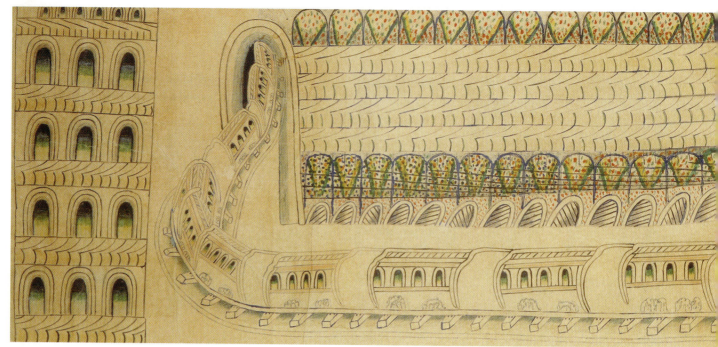

American Folk Art Museum, New York, Gift of Herbert Waide Hemphill Jr.

A union organizer who championed the working classes in the years following the Great Depression, Ralph Fasanella's (1914–1997) vibrant, complex compositions reflect his memories of immigrant life and culture in New York. In *Dress Shop* (1972, *bottom*) Fasanella articulates a dramatic and sweeping perspectival composition of the interior of a downtown dress shop and its environs. A brilliant critic of American politics, Fasanella included details that provide historical context; a plaque on the building reads "In Memory of the Triangle Shirt Workers," referring to the 1911 tragedy that killed 146 workers, mostly Jewish and Italian teenaged girls, and spurred the labor reform movement. The oil on canvas measures 45 × 92 inches.

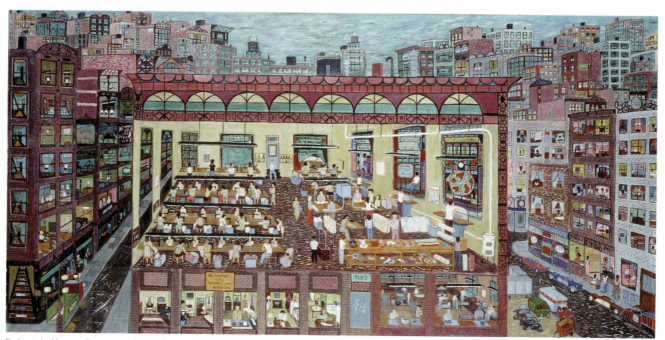

Fenimore Art Museum, Cooperstown, New York. © New York State Historical Association, Cooperstown, New York, N-3.83.
Photo courtesy Richard Walker.

PLATE 54

In contrast to Ralph Fasanella's historically specific work, Martin Ramirez (1895–1963), a Mexican-born laborer and paranoid schizophrenic confined to the DeWitt State mental hospital in Auburn, California, for the majority of his adult life, created spellbinding archetypal images in his drawings. *Train* (c. 1948–1960, pencil and crayon on pieced paper, 24 × 84½ inches, *left*) employs a rigidly structured composition with a train moving through a tunnel into deep space. Ramirez inexplicably stopped speaking around 1915 and according to psychological evaluations was unable to communicate with the outside world, making his beautiful and trancelike artworks, potent symbols of an interior self.

Josephus Farmer (1894–1989) learned woodcarving in his African American community of Tennessee as a child and went on to become a traveling evangelical preacher in St. Louis. In his carved and painted bas-reliefs Farmer combined biblical narrative with American history, often focusing on parables of slavery and emancipation. *Seven Wonders of the Ancient World* (c. 1970–1975, carved in redwood with enamel paint, in Milwaukee, Wisconsin, *below*) reveals the artist's use of source books including illustrated encyclopedias. The carving measures 30 × 50 inches.

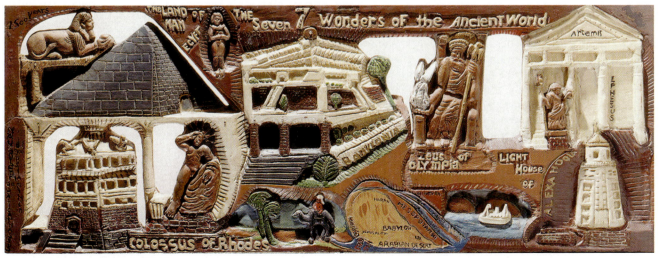

American Folk Art Museum, New York, 1990.1.4.
Photo courtesy Gavin Ashworth.

PLATE 55

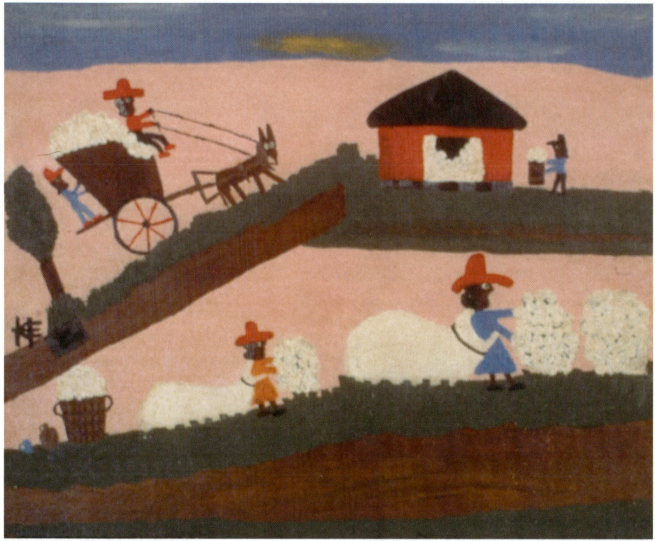

Photo courtesy Phyllis Kind Gallery, New York.

One of the most celebrated self-taught African American folk artists of the twentieth century, Clementine Hunter's (1886–1988) work depicted life on the plantation in Natchitoches, Louisiana, where she lived for nearly one hundred years. Hunter, who began to paint in her fifties, encouraged by a visitor to the plantation, completed over 4,000 works prior to her death. Her iconography ranged from scenes of labor, relaxation, and celebration to biblical subjects. *Picking Cotton* (1970, oil on Masonite, 17 × 20 inches, *above*) was painted from memory. Using a simplified composition of flat shapes and areas of color, Hunter disregards perspective, instead showing the landscape and sky in horizontal registers. Her body of work is an expressive historical document of an important era in American history.

PLATE 56

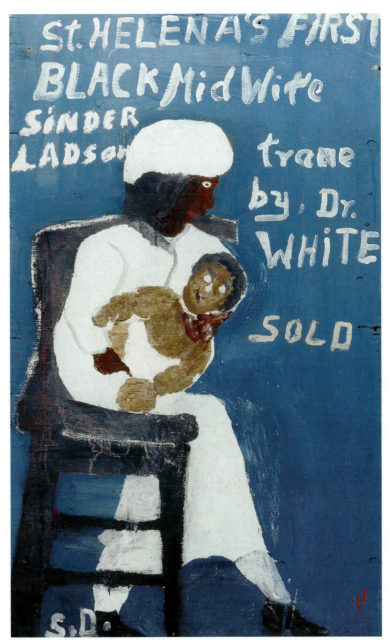

Collection of Gordon W. Bailey.

Thomas (Sam) Doyle (1906–1985) was born and spent his entire life on St. Helena, part of the Sea Islands off the coast of South Carolina, an area that remained an isolated enclave inhabited by the descendants of slaves well into the twentieth century. The residents still speak a unique West African-inflected language, called Gullah, and carry on cultural traditions that had African elements. Doyle created a series of portraits of local characters, such as his cousin, the island's first black midwife (*St. Helena's First Black Midwife*, c. 1980–1985, house paint on wood, 48 × 30 inches, *above*). In his crudely rendered paintings in enamel on tin or wood he incorporated significant aspects of St. Helena's history, often including text in the painting to identify the figures. Although he attended the vocational Penn School for black children established by northern white philanthropists, Doyle dropped out in the ninth grade to work as a clerk; later in life when given the opportunity to go to New York he declined, claiming to prefer Gullah life as he knew it. Nonetheless, he considered painting an important part of his life's vocation.

PLATE 57

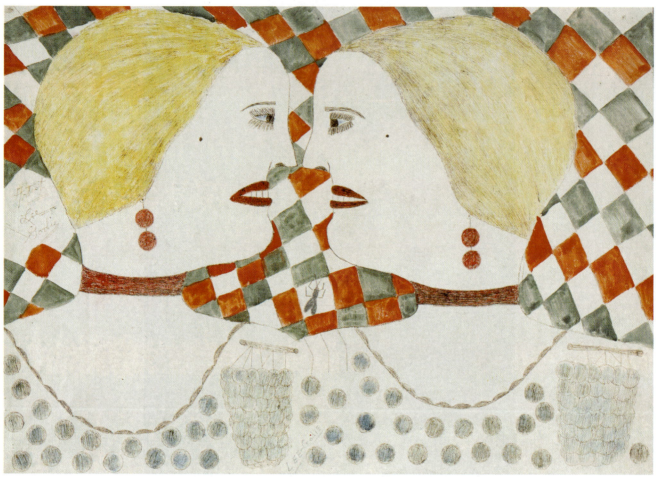

Photo courtesy Carl Hammer Gallery, Chicago.

A well-known Chicago outsider artist who self-fashioned an artistic identity as "Lee Godie, French Impressionist" for herself in the 1980s, Jamot Emily (Lee) Godie (1908–1994) began painting and drawing in the 1960s. The artist's difficult early circumstances (divorce, the death of a child, as well as financial impoverishment) are belied in her optimistic and colorful iconography: Hollywood-inspired portraits of beautiful men and women. Using crude materials (whatever was available) she created works such as *Girls* (1981, pen, crayon, watercolor on canvas, 36 × 25¼ inches, *above*). This drawing reveals a whimsical sense of linear description, geometric pattern, and flat interlocking shapes. Arguably one of the most accessible urban folk artists, Godie, who lived on the streets as a bag lady, received recognition at the end of her life.

PLATE **58**

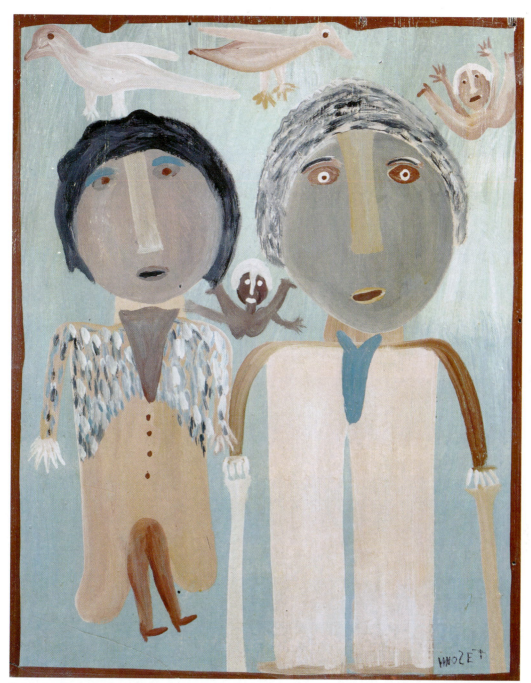

Photo courtesy The Arnett Collection.

The work of Mose Tolliver (c. 1921–) reflects a rich visual narrative of the life and experience of the African American artist who was born and raised in Montgomery, Alabama. Tolliver (who often signs his works "Mose T" or "M.T.") is part of the black vernacular folk art tradition, finding his subjects in personal history and storytelling. Using a variety of simple, sometimes crude materials Tolliver creates compositions that usually center upon a single figure such as an animal, person, car, snake, or dinosaur. *Me and Willie Mae* (a self-portrait with his wife), executed in 1987 with house paint and marker on wood, measures 31 × 24 inches. In the painting Tolliver depicts himself with the canes he required to ambulate following a serious work injury in the 1970s.

PLATE 59

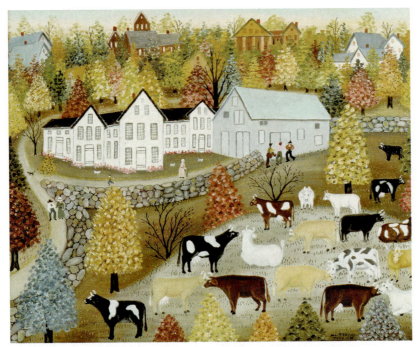

Collection American Folk Art Museum, New York, 1983.14.1. Photo © Shecter Lee.

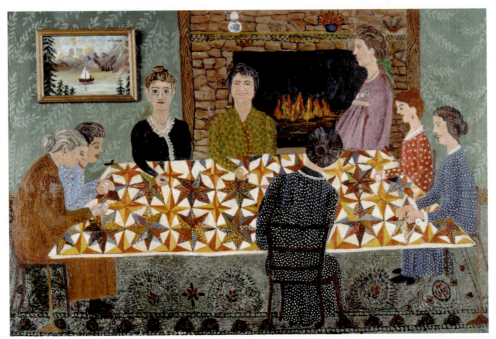

Collection American Folk Art Museum, New York, 1992.18.1. Photo © Gavin Ashworth.

Memory painting continued to be an important genre among folk artists in the South and the Midwest well into the twentieth century. *After the Dry Spell*, by Mattie Lou O'Kelley (c. 1975, Georgia, acrylic on canvas, *top*) and *Finishing the Quilt*, by Nan Phelps (1980, Hamilton, Ohio, oil on canvas, *bottom*) are two pictures that recall the artists' memories of rural idyllic life. Steeped in nostalgia and painted during a time when farming was in decline, O'Kelley's painting depicts a richly stippled landscape. It measures 24 × 32¼ inches. Phelps's painting visually mimics the appearance of stitched and appliquéd work with its intricate and colorful patterning on the walls, carpet, clothing, and the star quilt itself. The painting measures 28½ × 44¼ inches.

PLATE 60

Collection of Lee and Ed Kogan. Photo © Gavin Ashworth.

Untitled (City Hall) by William L. Hawkins (*left*) and *Friends of Wildlife II* by Philo Levi Willey (*below*) depict the streetscapes of the artists' home cities, Columbus, Ohio, and New Orleans, Louisiana, respectively. Their styles, however, are radically different. Hawkins (1916–1990) employs a flattened, frontal perspective; heavy black outlines and broad, juicy brushstrokes give the structure a sense of mass. Painted in 1984 with enamel on Masonite, the work measures $21\frac{1}{2} \times 37\frac{1}{2}$ inches. "Chief" Willey (1887–1980) painted animated, personal anecdotal scenes, which, typical of the nineteenth-century narrative traditions that are shaped by description as well as imagination. Willey employed a perspective that is both frontal and aerial in the same composition. Here chickens at a roadside farm are as large as the buildings. An oil on canvas, this work measures $35\frac{3}{4} \times 39\frac{7}{8}$ inches.

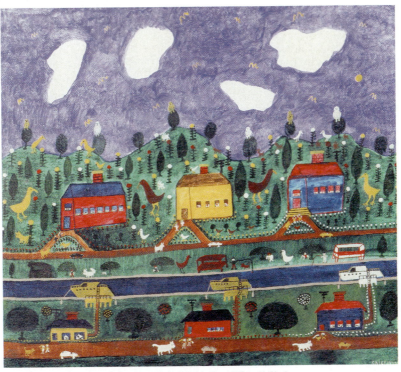

Collection American Folk Art Museum, New York, 1981.7.1. Photo © Terry McGinniss.

PLATE 61

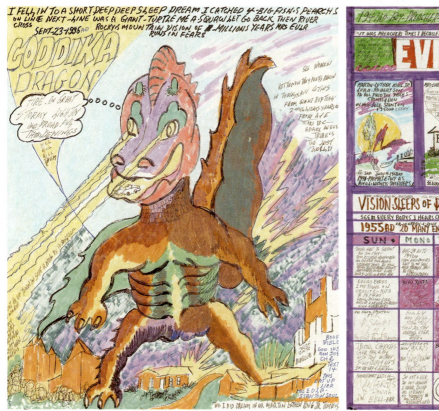
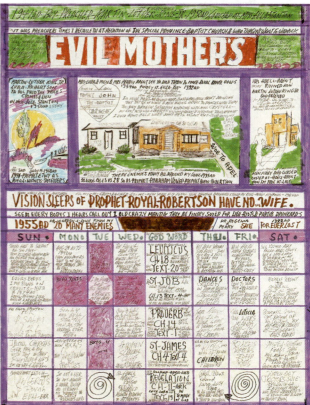

Collection Webb Gallery, Waxahachie, Texas.

The *Goddika Dragon* calendar (1995, recto and verso, *above*) is an expression of subjective torment by Royal Robertson (1936–1997), an artist who suffered from paranoid schizophrenia. Among folk painters (and the more recent term coined in the 1970s "outsider artists"), emotional and psychological maladies often give way to visionary works of art that transmute private thoughts, messages, and feelings. Robertson, a trained sign painter from Baldwin, Louisiana, scribbled and painted calendars, signs, and drawings with biblical exhortations and cryptic messages, many of which scorn women in general, and the artist's estranged wife Adell Brent, in particular. Each image, of ink and enamel on posterboard, measures 28 × 22 inches.

PLATE 62

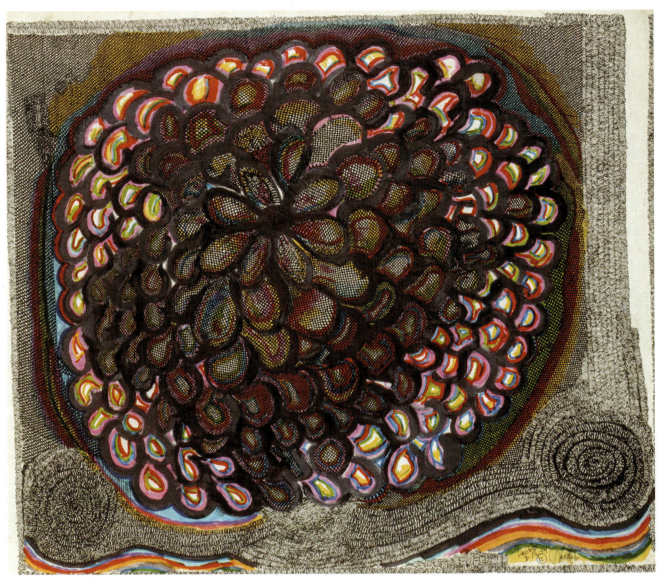

Collection Webb Gallery, Waxahachie, Texas.

Characterized by an intense preoccupation with self, alienation, obsession, and idiosyncrasy, the work of Hector Alonzo Benavides could be considered that of an outsider artist, that is an individual whose engagement with cultural norms and conventions is greatly impeded, if not terminated, often by a deficiency in language, lifestyle, or psychological health. Benavides (1952–), of Laredo, Texas, creates dizzying linear compositions of organic and geometric forms, usually with fine-point colored pens. The Catholic artist, who suffers from obsessive-compulsive disorder, equates the circles, squares, and triangles that make up his pulsating, abstract drawings with the Holy Trinity. This untitled work was made in 1994 with ballpoint pen; it measures 14 × 17 inches.

PLATE 63

Collection of the Artist.

Malcah Zeldis (1931–), born in the Bronx, New York, employs a complex iconography of celebrations, religious and biblical themes, fairy tales, and mythology. Although her work is laced with autobiography, Zeldis explores universal themes, transcending time and place. This reworking of Edward Hicks's *Peaceable Kingdom* from the prophet Isaiah, incorporates Jewish, Christian, and pagan imagery. Incorporating figures of different colors and creeds, Zeldis includes the sheep and the lion of the traditional version, along with a horned beast, a trumpet-wielding black man, and a girl in red holding a palette (perhaps the artist). Set against a backdrop of New York City, the *Peaceable Kingdom* (1999, oil on canvas, 30 × 40 inches) functions as a modern-day allegory for the biblical verse.

PLATE 64

UKRAINIAN AMERICAN FOLK ART: *SEE* EASTERN EUROPEAN AMERICAN FOLK ART.

UTICA ARTIST (active 1890s) is a name given to the artist of three sets of watercolors on paper, known since the 1930s, that included a rendering of the Utica Academy in New York, once thought to have been executed by a student or group of students from that institution. Through the discovery of a simply coded signature that substituted the following letter of the alphabet for each intended letter, the artist was identified as Laurence W. Ladd. The three sets of watercolors, each set a different size, depicted "exotic" scenes such as the circus, European travel, Biblical subjects, rail travel, natural wonders, and historical scenes. Ladd's artistic style included the heavy outlining of figures, exaggerated facial expressions and gestures, quickly rendered lines and cross-hatching to model forms, and a simple palette without color gradations. The images were strung together, illuminated, and viewed as a continuous whole as narrated panoramas for a popular audience. Some of Ladd's images are based on popular prints or other published sources. Although the individual watercolors are dispersed in public and private collections, Ladd's known body of work represents one of the few extant panoramas from nineteenth-century America.

See also **Painting, American Folk.**

BIBLIOGRAPHY

Karlins, Nancy F. *The Paper of the State.* New York, 1976.
Schweizer, Paul D., and Polowy, Barbara C. *Panoramas for the People.* Utica, N.Y., 1984.
Willard, Charlotte. "Panoramas, the First 'Movies,'" *Art in America,* vol. 47 (1959): 65–69.

PAUL S. D'AMBROSIO

VALDEZ, HORACIO (1929–1992) was revered as a master *santero* (a maker of religious images) among fellow *santeros* for creating detailed, powerful artworks that challenged them to raise the bar on quality in the carving arts. Valdez was raised in the tiny village of Dixon, New Mexico, an area steeped in the cultural and religious traditions of his Hispanic ancestors. A carpenter by trade, Valdez was frequently forced to leave home to find work but returned whenever possible.

Then, in 1974, a nearly fatal accident resulted in an injury that ended Valdez's carpentry career. That same year, friends invited Valdez to join a lay religious brotherhood commonly known as the *penitente* or the penitent ones, that met in an adobe *morada* or meeting house adorned with centuries old *bultos* (three-dimensional religious carvings) and *retablos* (religious paintings on wood). The experience had a profound effect on Valdez's life, prompting him to pick up a pocketknife and make copies of the saints. What started as a way to pass the time became his life's passion.

Valdez carved random chunks of aspen wood scattered around his mountain home, using scholarly books about New Mexican *santos* as a visual guide. Unsure of what paints to use, he followed a store clerk's advice and bought commercial acrylics, then taught himself how to paint. Valdez's use of commercial paints was a significant departure from the works of the early *santeros*, who created homemade paints from natural pigments. But Valdez's natural ability resulted in original images that, though based on old models, were refreshingly new. His *bultos* and *retablos* depicted the passionate stories of the saints through highly refined carving and painting techniques that would characterize Valdez as a master.

Valdez's art provided him with a necessary income and his work proved immediately popular in the marketplace. His first three carvings were purchased by the Taylor Museum in Colorado Springs, Colorado. Before his death, his works would be included in private and public collections internationally. Among his most popular images are eerie, large-scale death carts, skeletal images of death riding in rickety wooden carts traditionally used in *penitente* processions. Valdez's personal favorite was the Crucifixion, and he created hundreds during his career.

Valdez spent his artistic career carrying on the traditions of his ancestors, but he was also convinced that traditions change as times change. By producing polychrome *santos*, he gave an important nod to historical styles while allowing those styles to evolve through his own personal style. In doing so, Valdez has inspired new generations of New Mexican *santeros*.

See also **Bultos; Death Carts; Religious Folk Art; Retablos; Santeros; Sculpture, Folk.**

BIBLIOGRAPHY

Kalb, Laurie Beth. *Crafting Devotions: Tradition in New Mexico Santos*. Albuquerque, N. Mex., 1994.

Pierce, Donna, and Marta Weigle, eds. *Spanish New Mexico: The Spanish Colonial Arts Society Collection*. Santa Fe, N. Mex., 1996.

CARMELLA PADILLA

VAN MINIAN, JOHN (active 1791–1835) is recognized as the creator of a distinctive body of Pennsylvania German birth and baptismal records, marriage and family records, and decorated religious texts, but efforts of researchers to assemble even rudimentary information about his life and career have failed. Van Minian initially was identified as the maker of a birth record bearing his signature in the collection of the Abby Aldrich Rockefeller Folk Art Museum. His are among the most engaging and whimsical examples of fraktur in the tradition of the Pennsylvania Germans. Much of his work was undertaken for families in Berks and Montgomery Counties, Pennsylvania, and Baltimore County, Maryland, but he also produced a marriage and family record for a couple in Dorset, Vermont, dated 1826. His last dated work records the

birth in 1835 of Susannah Guysinger. Approximately twenty works by the artist are known.

Van Minian typically divided his compositions into carefully ruled and differentiated sections in which he placed figures of men (often peering through spy glasses) or women in profile, one or more highly stylized floral designs, or symbolic or patriotic elements, especially eagles, and a text in English or German. He generally wrote in an ornate Gothic-style calligraphy, but occasionally used a cursive script. His draftsmanship is precise and his application of watercolors is painstaking. Some examples of his work seem to bear the influence of the printed "angel-type" *Taufscheine* or birth and baptismal records that were widely available from printing establishments in Reading, Allentown, Harrisburg, Pennsylvania, and other places, and were distributed throughout the Pennsylvania German culture region. Traditional Pennsylvania German folk art often combines sacred and profane elements, a juxtaposition that is especially noteworthy in some examples of Van Minian's work.

See also **Abby Aldrich Rockefeller Folk Art Museum; Calligraphy and Calligraphic Drawings; Fraktur; Pennsylvania German Folk Art; Religious Folk Art.**

BIBLIOGRAPHY

Rumford, Beatrix T., ed. *American Folk Paintings: Paintings and Drawings Other Than Portraits from the Abby Aldrich Rockefeller Folk Art Center.* Boston, 1988.

GERARD C. WERTKIN

VANDERLYN, PIETER (c. 1682/1687–1778) was one of several limners painting portraits in New York in the period between Queen Anne's War and King George's War (1713–1744), a period of peace which inspired a flowering of vernacular art. He was an immigrant from the Netherlands, who came to New York by way of Curaçao, where he became a member of the Dutch Church in 1718 and married Geeritje van den Bergh, whose family had come from Albany, New York.

In 1719 a daughter was born, and her baptism was witnessed by Jacob Goelet and his wife. For Vanderlyn, Jacob Goelet provided important links to the Dutch Church as Goelet was its clerk, to artisans as Goelet's sons included a silversmith and the limner Raphael Goelet, and to the learned community because Goelet was a schoolteacher, a bookseller, and a stationer. Vanderlyn's daughter and wife died, however, and he moved to Kingston, New York.

That same year he married again, this time to Geertry Vas of Kingston, daughter of Petrus Vas, the widowed minister of the Dutch Church, who also remarried Elsie Rutgers Schuyler the same year, the widow of David Schuyler, a member of a distinguished Albany family. Elsie Vas had her portrait painted the next year by her new stepson-in-law, Pieter Vanderlyn—or so it was once thought. The diligent sleuthing of art historian Mary Black showed that the limner was actually Gerardus Duyckinck I of Manhattan, already known to her family by a portrait he had painted of her brother about 1722. There is no evidence that Vanderlyn began to paint until 1730.

Vanderlyn, his wife, and their first son Nicholas (who was also to become a painter) moved to Albany about 1724. The Vanderlyns had several more children in Albany, and entered into the community as church members. Vanderlyn was appointed the fire warden there in 1730. It is from this time and place that the first group of portraits by the distinct hand of the "Gansvoort" limner were identified. Art historian Mary Black found evidence pointing to Vanderlyn as the limner.

The majority of Vanderlyn's known portraits, over two dozen, are from the next decade in Vanderlyn's life in Kingston, New York, where he moved back with his family in 1733–1734. His portraits are distinctive in their linearity, flat modeling, and fidelity to contemporary costume details. Unlike other limners such as John Watson and Gerardus Duyckinck I, Vanderlyn tried to portray subjects as they were, avoiding backgrounds and costumes from contemporary prints. This naivety contributes to the "Americaness" of Vanderlyn's paintings, a quality his work shares with that of John Heaton, his contemporary and competitor in the Albany area.

See also **Mary Childs Black; Gerardus Duyckinck I; John Watson.**

BIBLIOGRAPHY

Belknap, Waldron Phoenix. *American Colonial Painting: Materials for a History.* Cambridge, Mass., 1959.
Black, Mary C. "Early Colonial Painting of the New York Province." *Remembrance of Patria: Dutch Arts and Culture in Colonial America, 1609–1776.* Albany, N.Y., 1988.
———. "The Gansevoort Limner." *The Magazine Antiques*, vol. 96 (1969): 738–744.
———. "Pieter Vanderlyn and Other Limners of the Upper Hudson." *American Painting to 1776, A Reappraisal.* Charlottesville, Va., 1971.
———. "Remembrances of the Dutch Homeland in Early New York Provincial Painting." *Dutch Arts and Cultural in Colonial America.* Albany, N.Y., 1987.
———. *Rivers, Bowery, Mill, and Beaver.* New York, 1974.
Blackburn, Roderic H., and Piwonka, Ruth. *Remembrance of Patria: Dutch Arts and Culture in Colonial America, 1609–1776.* Albany, N.Y., 1988.

Flexner, James Thomas. *First Flowers of Our Wilderness. American Painting, the Colonial Period.* New York, 1969.

RODERIC H. BLACKBURN

VERNACULAR ARCHITECTURE: *SEE* ARCHITECTURE, VERNACULAR.

VERNACULAR ART: *SEE* AFRICAN AMERICAN FOLK ART.

VERNACULAR PHOTOGRAPHY: *SEE* PHOTOGRAPHY, VERNACULAR.

VETERAN CANES: *SEE* CANES.

VISIONARY ART is art made by visionaries, people who experience vivid nocturnal dreams or waking apparitions, and who attribute these to a preternatural agency such as a divinity or a spirit, or to a sacred realm deemed either to lie outside the bounds of this earth or to be a transfigured version thereof. So-called "altered states," such as trance and ecstatic delirium, are intrinsic to the visionary process and are supposed to facilitate exceptional feats, including out-of-body traveling and the manifestation of clairvoyant and therapeutic powers. Although actual visions may last no more than a few minutes, they are typically described as involuntary and overwhelming, and they frequently instill a profound spiritual vocation.

Most world religions acknowledge the metaphysical value of such departures from the everyday perceptual norm. Certain creeds encourage extensive praying, fasting, or taking drugs in an effort to gain access to the sacred or numinous dimension. This is true, for example, of several native North American cultures; and the Aboriginal peoples of Australia cultivate "dreamings" that underpin a network of myths concerning the natural environment. Tribal peoples worldwide expect their shamans or priests to undertake entranced journeys outside their corporeal selves; these are articulated through dancing, chanting, and drumming, as well as elaborate costumes, carvings, tattoos, and painted images. Adepts of Tibetan Buddhism acknowledge the illuminating potential of near-death episodes and use ornate symmetrical images, or mandalas, to promote deep meditation.

It seems probable that the link between visionary experience and art is very ancient; some prehistorians have conjectured that it dates back to the cave art of the Upper Paleolithic. In historical times, the essential aim of sacred art has been to fix in visible form those transcendental scenes and epiphanies wherein collective belief is rooted. In the Bible, the Book of Revelation records a series of portentous visions that became a standard resource for Christian artists. In the twelfth century, the Catholic mystic Hildegard of Bingen (1098–1179) experienced lifelong visions of an apocalyptic and prophetic type; as an elderly abbess, she wrote down her visions while her nuns rendered them in pictorial form. (It is not thought that Hildegard herself made pictures.) Seventeenth-century witch trials, such as those held at Salem, Massachusetts, present evidence of supposed communication with nonterrestrial beings, especially the devil, although the rituals of witchcraft seem generally to have lacked an artistic component. The proto-Romantic English artist and poet William Blake (1757–1827) offers an outstanding example of visionary artistry, meshing word with image in such works as *Jerusalem*, which he illustrated himself. In 1819 Blake drew a set of *Visionary Heads* based on semi-induced hallucinations. The French poet Victor Hugo (1802–1885) cultivated uncanny doodling prompted by nocturnal apparitions; these arose out of séances he organized in 1853–1854 that involved "table-turning," the formalized invocation of otherworldly spirits. In nineteenth-century Europe, many Romantic artists and poets believed passionately that altered states nourish creativity; in the United States, academic painters within the orbit of Romanticism, such as Elihu Vedder (1836–1923), John La Farge (1835–1910), and Albert Pinkham Ryder (1847–1917), produced dreamlike landscapes that are often described as "visionary."

As regards the specific history of American folk art, works shaped by visionary experience may be traced to the Shaker culture of the early nineteenth century. The Shaker "era of manifestations" was characterized by trances, visions, oracular utterances, and other paranormal occurrences, and by the production of related artworks, especially "spirit drawings" (also known as "gift drawings"). Later on, the broader cult of spiritualism swept the country, fueled by the events of 1848—when, in a small town in New York State, the sisters Kate and Margaret Fox were said to have first communicated with a deceased person through table-rapping. Spiritualism, which was not a formal church, had a great appeal for women, who were drawn to a belief system that lacked a hierarchy and encouraged individuality. In becoming a medium, a woman could legitimize her intuitive faculties and exercise authority as a type of shaman in touch with supernatural forces. Thus, in the 1890s, the medium Leonora Piper (1857–1950) of Boston gained an international reputation for the uncanny messages she relayed from spirit guides in the "beyond." Immersed in spiritualism, the self-taught Ohion painter and

sculptor Henry Church Jr. (1836–1908), declared that he owed his entire output to discarnate spirits.

By the turn of the century, spiritualism was particularly rife in northern France, where the coal miner Augustin Lesage (1876–1954) was inspired to abandon his job and execute an astonishing series of ornamental paintings under the alleged mentorship of the Renaissance artist Leonardo da Vinci (1452–1519). In Britain, in the period just after World War I, when attempts to contact the dead were at their height, a housewife in London, Madge Gill (1882–1961), said she had been instructed by a spirit guide called Myrninerest to produce an immense output of "automatic drawings." Though not a spiritualist, the French domestic servant Séraphine Louis (1864–1942) said she was visited by angels, and she painted extravagant bouquets of unearthly flowers, evocative of a boundless mystic euphoria. Often such imagery seems to be less a deliberate transcription of a past vision than a direct "automatic" trace—comparable to the seismograph that mechanically records an earth tremor—of the palpitations of visionary ecstasy.

Without necessarily acknowledging these antecedents, partisans of American folk art have since the 1980s applied the term "visionary art" to a range of works that shun everyday experience in favor of awesome dreamscapes, resplendent utopias, and luxuriant paradises. As a subcategory of folk art, the term designates a creative orientation toward numinous or otherworldly material. Despite the fact that, in the American context, this frequently implies a concern with Christian and biblical themes, the term is not in principle restricted to any single faith, subject matter, or style.

Self-taught visionary artists responded essentially to individual vocation. Given that it is not uncommon for vernacular creators to claim a visionary origin for their art, such authentication by the person directly concerned could be said to represent the best justification for using the term. Typically, visionary artists refer to an influx of irresistible visual imagery, accompanied by some sort of inner voice instructing them to take up the artistic vocation. Their abrupt commitment to an unfamiliar activity often occurs late in life, as the result of an accident, a major psychological disturbance, or an unprecedented spiritual illumination.

Within the African American communities of the American South, the convergence of Protestant evangelism with an African spiritual inheritance provided the ideal ferment for visionary art, and the twentieth century saw the emergence of a canon of outstanding practitioners. Many self-taught visionaries are also self-proclaimed preachers, eager to exploit biblical themes such as the garden of Eden, the crucifixion, and the apocalypse. The paradigm of southern visionary art is the work of the street evangelist Sister Gertrude Morgan (1900–1980), who said that she started painting after receiving a vision from God; her depictions of angels in paradise are invariably accompanied by quotations from the scriptures, especially Revelation. Notably, Morgan insisted that her pictures were not art but essentially a vehicle for spreading the divine word. Comparable preacher-artists include the Reverend Johnnie Swearingen (1908–1993), who created biblical and rural scenes; and Eddie Kendrick (1928–1992), whose pictures derive from dream visions.

One of the outstanding exponents of visionary art is Minnie Evans (1892–1987), whose drawings dispose flowers, faces, and other figures in symmetrical patterns. The mysterious eyes that stare out from her gorgeous designs can be read as explicit reminders of the visionary character of the work. John Bunion Murray (1908–1988) was a diviner as well as a painter; he used to contemplate his secret calligraphy through a glass of water. Though his pictorial work is untypical of visionary art in being nonrepresentational, it was evidently linked to intense spiritual meditation and conduced to divinatory insights. In this respect, the visionary artwork functions as a device to promote metaphysical experience rather than simply document it.

Religious fervor equally underpins the work of Royal Robertson (1936–1997), who claimed to have made out-of-body trips to other planets. Robertson's profusion of painted signs rely heavily on biblical quotations. He once styled himself "Libra Patriarch Prophet Lord Archbishop Apostle Visionary Mystic Psychic Saint Royal Robertson"—an artistic manifesto in itself. A similar obsession with cosmic and religious themes informs the paintings of Peter Attie "Charlie" Besharo (1898–1960). The convict Frank Albert Jones (c. 1900–1969) was reported to have been visited by evil spirits or "haints" throughout his life, and his "devil house" drawings are said to be records of these visitations.

While visionary art is predominantly associated with African American communities, there are also a good many white practitioners, of whom the best-known is the Reverend Howard Finster (1916–2001). Finster, a Baptist preacher and self-styled "man of visions," insisted that his work originated in a vision he had in 1976, when God instructed him to make "sacred art." Beside a prolific output of paintings, light boxes, and assemblages, Finster created *Paradise Garden*, an environment of structures that he built himself, with walkways crammed with mosaics and handwritten "sermons in paint." Like Morgan's, Fin-

ster's avowed motive was to spread the lord's word through his art.

Within the field of visionary sculpture may be cited the carver Raymond Coins (1904–1998), a committed Primitive Baptist whose hallucinatory dreams inspired curious carvings in wood and stone. Ralph Griffin (1925–1992) fashioned figures out of tree roots dredged from a river, eliciting the hidden shapes of spirits by way of an idiosyncratic divinatory ritual. The outstanding folk sculptor William Edmondson (1870–1951) said that he became a stonemason as a result of a divine vision.

James Hampton (1909–1964) was a recluse who spent several years constructing an installation in a locked garage in Washington. This work, built of scrap wood and cardboard wrapped in gold and silver foil, bears enigmatic inscriptions and seems to have been intended as a material equivalent of the Old and New Testaments. Hampton is thought to have used this glittering shrine for private prayer, showing it to no one. Its title, *The Throne of the Third Heaven of the Nation's Millennium General Assembly*, is as eye-catching as the work itself and confirms its status as a grandiose, all-encompassing project of visionary cast. Though we cannot be sure that Hampton believed he had received literal visitations, his art is undeniably steeped in the atmosphere of the sacred.

Among the many mixed-media sites or "visionary environments" that have been tabulated in recent times may be mentioned *Totem Forest*, by the Texan Felix "Fox" Harris (1905–1985); and *Holy Ghost Park*, fashioned in Wisconsin by Father Mathias Wernerus (1873–1931). The latter represents a variation on the traditional shell grotto, its architecture of alcoves, shrines, and fountains being made up of concrete or cement surfaces encrusted with shells, broken glass, and semiprecious stones. Allusions to figures like the Virgin Mary and the apostles serve as points of anchorage within this prolix improvisation. It is possible that the technique of deploying many shimmering elements is integral to the visionary project, and that its bedazzling impact signals a convergence of spiritual and aesthetic impulses. The intention may be not just to convert the viewer to a religious creed but to offer a glimpse of the visionary event itself, an ecstatic experience configured through formal extravagance.

It is notable that the mission statement of the American Visionary Art Museum, which opened in Baltimore, Maryland, in 1995, promulgates a definition of visionary art barely distinguishable from outsider art, itself a somewhat exclusive category. Elsewhere, though, there are signs that the term "visionary art" is being ever more loosely applied, its superficial glamor hastening its haphazard distribution across a broad spectrum of self-taught artists. And yet a fantastic or flamboyant style alone falls short of being a sufficient criterion.

Admittedly, it is hard to prevent ill-considered usage, and indeed even the most rigorous criteria for visionary art are, as has been seen, rendered problematic by the technical difficulty of not always being able to ascertain whether a given work springs from authentic visionary experience. Thus the Texan painter Naomi Polk (1892–1984) produced pictures that are undeniably explicit about her fervent religious convictions; yet it does not necessarily follow that they document visions. Similarly, Perley M. Wentworth (whose dates are unknown; he was active in the twentieth century) painted extraterrestrial scenes that have a strong affinity with the ethereal spaces of much visionary art, although we have no evidence that he believed he was working with the collusion of invisible presences. Conversely, the term "visionary" has almost certainly been misapplied to the art of Joseph Yoakum (1890–1972). Granted, he did once refer to his art as a process of "spiritual unfoldment" (borrowing a phrase from Mary Baker Eddy, the founder of Christian Science), and he did claim that his first picture came to him in a dream. Yet his landscapes can just as plausibly be seen in terms of an imaginative response to geographical realities, and they seem to lack a sense of the numinous. One might also observe that Yoakum does not "preach" in his pictures, whereas it is arguably an indispensable characteristic of visionary art that it should seek to invoke some sort of sacred dimension.

See also **African American Folk Art (Vernacular Art); American Visionary Art Museum; Peter Attie Besharo; Henry Church Jr.; Raymond Coins; William Edmondson; Environments, Folk; Minnie Evans; Reverend Howard Finster; James Hampton; Frank Albert Jones; Sister Gertrude Morgan; John Bunion Murray; Outsider Art; Religious Folk Art; Shaker Drawings; Shaker Furniture; Shakers; Perley Wentworth; Mathias Wernerus; Joseph Yoakum.**

BIBLIOGRAPHY

Adele, Lynne. *Spirited Journeys: Self-Taught Texas Artists of the Twentieth Century.* Austin, Tex., 1997.

Beardsley, John. *Gardens of Revelation: Environments by Visionary Artists.* New York, London, and Paris, 1995.

Cardinal, Roger, and Martine Lusardy, eds. *Art spirite, médium-nique, et visionnaire: Messages d'outre-monde.* Paris, 1999.

Kemp, Kathy, and Keith Boyer. *Alabama's Visionary Folk Artists.* Birmingham, Ala., 1994.

Longhauser, Elsa, and Harald Szeemann. *Self-Taught Artists of the Twentieth Century: An American Anthology.* New York, 1998.

Maizels, John, and Deidi von Schaewen. *Fantasy Worlds.* Cologne, Germany, 1999.

Manley, Roger, and Mark Sloan. *Self-Made Worlds: Visionary Folk Art Environments.* New York, 1997.

Patterson, Tom. *Southern Visionary Folk Artists.* Winston-Salem, N.C., 1984.

Trechsel, Gail Andrews, ed. *Pictured in My Mind: Contemporary American Self-Taught Art.* Birmingham, Ala., 1995.

Yelen, Alice Rae. *Passionate Visions of the American South: Self-Taught Artists from 1940 to the Present.* New Orleans, La., 1993.

ROGER CARDINAL

VIVOLO, JOHN (1886–1987) began to carve people and animals from logs at age seventy-two; working in his basement studio, he completed about 400 pieces. He preferred themes from everyday life but also used fantasy. A signature piece, a man with outstretched arms riding a gaily-colored chicken, came entirely from Vivolo's imagination, according to Florence Laffal, who discovered his work at an antique show around 1974; she and her husband, Julius, befriended him and collected his work.

Among Vivolo's pieces are a seated man smoking a pipe, someone eating pasta, a nutcracker, a woman holding a baby, an astronaut, Adam and Eve, Theodore Roosevelt, Lyndon Johnson, Dolly Parton, a barbershop trio, rock stars, and a band of nine male musicians. Upon request, he carved a female band with a male drummer, explaining that the male drummer was included to "keep the peace since women always argued." He made whirligigs, stone castles, birdhouses that looked like igloos, planters, and a wishing well from wood, stone, mortar, metal, and other found materials. His whirligigs often depicted people at work—slaughtering a chicken or sawing logs, for example. His figures, which often have outstretched arms and disproportionately large heads, range from 14 to 36 inches high.

Vivolo's figures were roughly carved with an ax out of oak, birch, pine, or maple. His faces, which he began by using a compass, were carved more precisely with chisels and files. He sanded his finished carvings, using filler to prepare the surface for paint, and then used primer and several coats of latex or other paint. He first used monochromatic earth tones, then pastels, and then, in the 1970s, a brighter palette with details of metallic gold and silver.

Vivolo had immigrated at age fourteen from Accri, Italy. He worked in a coal mine in West Virginia; on a railroad construction crew in Maryland; in a bakery on the Lower East Side in Manhattan; in a butcher shop in Buffalo, New York; and at a series of construction jobs in Connecticut. His first house was destroyed by a fire and his second was condemned after a flood; in 1950 he completed a third home in a suburb of Hartford, where he spent his remaining years.

Vivolo did not achieve fame instantly. Two years after the Laffals met him, their son, Kenneth Laffal, wrote a book about Vivolo that caught the attention of the mass media. Although Vivolo did not seek buyers for what he called his "wooden children," he was willing to sell them.

BIBLIOGRAPHY

Laffal, Florence. "John Vivolo, Connecticut Folk Sculptor." *Folk Art Finder,* vol. 1, no. 1 (March–April 1980): 6.

Laffal, Kenneth. *Vivolo and His Wooden Children.* Essex, Conn., 1976.

Rosenak, Chuck, and Jan Rosenak. *Museum of American Folk Art Encyclopedia of Twentieth-Century American Folk Art and Artists.* New York, 1990.

LEE KOGAN

VODOU ART has become a vibrant part of the American folk art scene, as Haitians have established overseas communities in cities such as Boston, New Orleans, New York, and Miami. More than just a national religion, Vodou is the sum total of Haitian culture. Through Vodou perspectives, Haitians transform the visible world into objects of praise and wonder for invisible spirits. Most Vodou art invokes the *lwa,* the various spirits of Haiti's rich and complex pantheon, in compositions of oil, iron, wood, clay, tin, fabric, or mixed media. Following World War II, and the establishment of the cooperative *Centre d'Art* in Port-au-Prince, Haiti, by American expatriate DeWitt Peters, Vodou arts achieved a worldwide acclaim, epitomized in the observation of French critic André Malraux, "Haiti produces the finest popular art in the world."

Notable among this first generation of what soon became known as "the Haitian renaissance" was Hector Hyppolite (1894–1948), a self taught commercial painter whose oil canvases first revealed the faces and forms of the *lwa;* and Georges Liautaud (1899–1992), who wrought his own fantastic versions of the *lwa* out of steel from oil-drums. These early masters inspired successors like André Pierre, who describes his divine portraits as "songs on canvas," and Pierrot Barra, (c. 1941–1999) who sculpted his surreal visions of the *lwa* out of recycled materials. In the United States, the tradition is carried on by painters such as

Edouard Duval-Carrié who relocates the *lwa* on the beaches of Miami, and by mother-daughter conceptual artists Betye and Alison Saar, who merge Vodou icons with those of American pop culture.

There is a less celebrated category of folk art fabricated to serve rather than represent the *lwa*. This category includes drums and gourd rattles (*ason* and *maraca*) used to summon the *lwa*, and sequined bottles, satin-wrapped medicine paquets (*paket kongo*), and flags (*drapo*) used to channel their divine energies. Of these objects, only the *drapo* has become a commodity in the international folk art market. Inspired by military prototypes used during the Haitian Revolution (1791–1804), *drapo* have evolved during recent decades into elaborate sequined tapestries, comparable in design and function to the stained glass windows in Catholic churches. Their designs usually incorporate a *veve*, or cosmographic signature appropriate to the *lwa* being saluted, as well as the image of an alter-ego Catholic saint. The ensemble is bordered by a geometric motif, often the Kongo-derived diamond figures called "four moments of the sun." As flags have evolved into commercial commodities, designers such as Clotaire Bazile have established ateliers in both Miami and Port-au-Prince. Along with other modern flag artists like Silva Joseph and Yves Telemark, Bazile now stitches his initials in sequins onto his compositions.

Other objects, such as amulets, spirit repositories (*reposwa*) and magical operators (*wanga*) are constructed from plastic and cloth dolls, bottles, plaster saints' statues, rosaries, crucifixes, mirrors, bones, tinsel, or other found objects assembled according to an African aesthetic of accumulation and assemblage. This object list is necessarily provisional, since the *lwa* are notoriously fickle in taste and desire, and Haitians have little control over their import and export markets. Many of these same objects find their way into the amulets (*mojos*) of Hoodoo: the Kongo-inflected ritual magic practiced by African Americans in the Mississippi Delta and along the Gulf Coast. *Mojos* come in many forms: rabbits' feet, hairballs, and most notoriously, dolls stuck with pins (a ritual practice unknown in Haiti), and are a staple of "Voodoo" tourist shops from New Orleans to Memphis.

The most complete expression of Vodou art is the altar. Located in temples (*ounfo*), the basements of Brooklyn apartments, or the dashboard of taxis, altars consist of found objects, images, and offerings known to please divine tastes. Augmented through constant use, their aesthetic is improvisational. No altar is ever finished. Each has a particular identity, classified by the family of *lwa* it honors. Catholic icons tend to predominate on *Rada* altars, the spirits of which have all found correlates among the saints. Customary offerings include liquor, perfume and money. *Rada* altars are also repositories for ceramic *po têt* ("head pots") containing personal items of temple initiates; *govi*, containing the spiritual essence of ancestors and *lwa*; and pots for the *marasa*, the divine twins of the pantheon. There are fewer references to Catholicism on the *Petwo* altars, which salute the spirits of Kongo with *paket kongo*, divinatory devices, and many magical operators (*wanga*) wrapped in the strips of red and black cloth preferred by these hot and dark spirits. Although altars are composed of "found" objects, they are neither generic nor impersonal. Most express both idiosyncratic vision and the genius of the tradition.

See also **Religious Folk Art; Santería.**

BIBLIOGRAPHY

Cosentino, Donald, ed. *Sacred Arts of Haitian Vodou*. Los Angeles, 1995.

———. *Vodou Things: The Art of Pierrot Barra and Marie Cassaise*. Jackson, Miss., 1998.

Hurbon, Laennec. *Les Mysteres du Vaudou*. Paris, 1993.

Selden Rodman. *Where Art Is Joy*. New York, 1988.

DONALD J. COSENTINO

VOGT, FRITZ G. (c. 1841–1900) walked the turnpikes and dirt roads of five New York counties west of Albany between 1890 and 1900 creating more than two hundred distinctive architectural portraits featuring farms, homes, and businesses. Vogt was born in Germany in 1841, and emigrated to the United States probably in the summer of 1890. He arrived in New York State at about this same time, and executed several drawings in and around Sharon Springs, New York. Working in graphite on paper, he executed his house and farm portraits in a subdued, realistic manner at first, and gradually developed an exuberant style that featured multiple-point perspective, manipulations of scale, the use of color (from 1894), and a larger size of paper.

Through his ten-year drawing career, Vogt included an extraordinary amount of detail in his works while imbuing the subject with a romanticized sense of optimism and pride of place. Vogt's folk style allowed him to show more factual information to the viewer, by turning the sides of a building toward the viewer, or bringing distant structures closer to the picture plane. He made extensive use of a straight-edge, yet added numerous freehand embellishments such as animals, people, carriages, and architectural ornaments that reveal a distinct artistic talent.

Little is known of Vogt's life, but oral histories abound in local families. According to sources interviewed in the 1960s, Vogt was remembered as a short, smallish man with a quick step, yet slightly rotund, who wore five or six secondhand shirts and slept in the shelter of barns. He was apparently an accomplished violinist, organist, and singer. In addition to drawing, Vogt probably worked on area farms in the planting and harvesting seasons, as few drawings from early spring and early autumn have been documented.

Vogt was committed to the Montgomery County Almshouse in Fonda, New York, in 1898, undoubtedly suffering the effects of intemperance and rheumatoid arthritis. He was released briefly, and completed a few drawings in 1899 before re-entering the almshouse sometime after July of that year. On January 2, 1900 at 2 A.M., Vogt died of chronic rheumatism in the Montgomery County almshouse at the age of approximately fifty-eight years.

See also **Architecture, Vernacular; Painting, American Folk.**

BIBLIOGRAPHY

Scheuttle, Frank A. "Fritz G. Vogt: The Brookman's Corners Drawings," *New York Folklore Quarterly* (summer 1975): 57–74.

Hayes, W. Parker Jr., *Drawn Home: Fritz Vogt's Rural America.* Cooperstown, N.Y., 2002.

PAUL S. D'AMBROSIO

VON BRUENCHENHEIN, EUGENE (1910–1983) made and hung in his kitchen a gold-incised plaque reading: "Eugene Von Bruenchenhein/Freelance artist/Poet and Sculptor/Inovator [*sic*]/Arrow maker and plant man/Bone artifacts constructor/Photographer and Architect/Philosopher." He created thousands of works—paintings, sculpture, ceramics, photographs, writings, and musical instruments—devising a personal vocabulary, such as finger painting, for each form. His unorthodox materials included chicken and turkey bones used for small sculptural thrones and towers or his wife's hair used to make paintbrushes.

Von Bruenchenhein was born in 1910 in Marinette, Wisconsin. His stepmother, Elizabeth Mosley, who painted still lifes and wrote pamphlets on evolution and reincarnation, was his literary and artistic inspiration. He served in the army, then kept a greenhouse, worked for a florist, and worked in a bakery. In 1939 he met Marie K. Kalke and they married in 1943. For more than forty years, Von Bruenchenhein created visionary art secluded from the world except for a few family members and friends. After his death, Dan Nycz, a policeman who was trying to help the family financially, took some of Von Bruenchenhein's work to the Milwaukee Museum of Art, where the chief curator was greatly impressed by it.

Among Von Bruenchenhein's most compelling works are thousands of photographs, many hand-colored, that the artist took of his wife, who is often bare-breasted in a variety of classical and Hollywood-inflected poses. The photographs resemble the fantastical image worlds of Surrealism and one of that early twentieth century movement's most prevalent themes, that of the *femme-enfant*, the woman-child who is the artist's seductive muse. Von Bruenchenhein transforms the body of Marie by costumes and jewelry (such as a crown of spiky Christmas ornaments), though she may also be a playful companion in a sailor hat. Atmospheric effects are achieved by double exposures and intentional blurring.

Von Bruenchenhein's fragile, painted bone chairs and towers in gold, silver, and iridescent colors have subtly varied shapes, many suggesting floral forms. His ceramic low-fired painted vessels and crowns also tend to have leaf forms. His house was surrounded by large cast and painted concrete masks that seemed to have a protective function.

In 1954 he began painting a series of intense, raw abstract canvases, often associated with nuclear explosions. This and other motifs in Von Bruenchenhein's painting cross temporal and spatial boundaries, evoking underwater flora and fauna, bulging-eyed beasts and serpents, and fantasy architecture. For some years, he used objects such as sticks, combs, leaves, and wrinkled paper in his oil paintings on panel, which he carefully signed and dated. In his oil paintings, unlike his painted chairs and photographs, he used vibrant, pure, and often discordant color juxtapositions.

In 1984, the John Michael Kohler Arts Center in Sheboygen, Wisconsin, exhibited 250 works by Von Bruenchenhein. This center maintains a collection of his work and his archive of writings. Today Von Bruenchenhein's art is represented in major collections including those of the American Folk Art Museum in New York, the Milwaukee Art Museum, and the High Museum of Art, Atlanta.

See also **Sculpture, Folk; Visionary Art.**

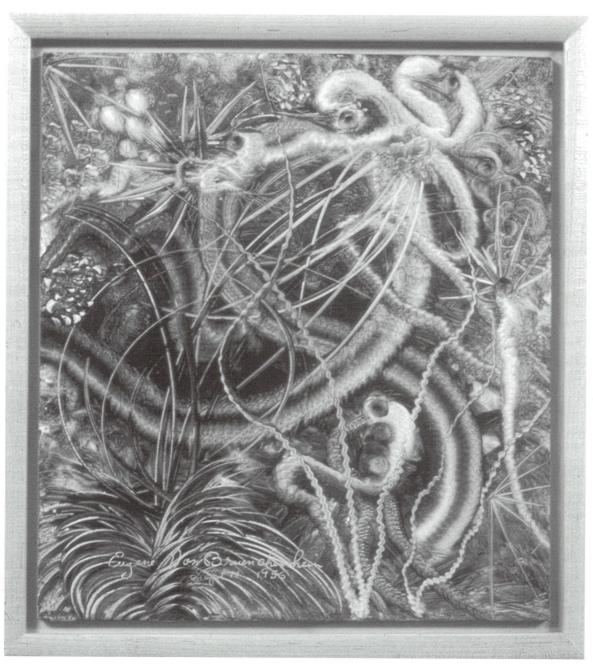

Untitled; Eugene Von Bruenchenhein; 1956. Oil on Masonite; 14½ × 13¾ inches. Photo courtesy Carl Hammer Gallery, Chicago.

BIBLIOGRAPHY

Cubbs, Joanne. *Eugene Von Bruenchenhein: Obsessive Visionary.* Sheboygen, Wisc., 1988.

Ebony, David. "Visionary in the Basement." *Art in America* (September 2001): 130–133.

Jacobs, Joseph. *A World of Their Own.* Newark, N.J., 1995.

Longhauser, Elsa, and Harald Szeemann. *Self-Taught Artists of the Twentieth Century: An American Anthology.* San Francisco, 1998.

Rosenak, Chuck, and Jan Rosenak. *Museum of American Folk Art Encyclopedia of American Folk Art and Artists.* New York, 1990.

Stone, Lisa. "Eugene Von Bruenchenhein." Chicago, 1990.

LEE KOGAN

VORSCHRIFTEN: *SEE* FRAKTUR.

WADSWORTH ATHENEUM, THE in Hartford, Connecticut, is the oldest continuously operated public art museum in the United States. Founded by Daniel Wadsworth in 1842, and opened in 1844, it originally housed a gallery of fine arts, the Connecticut Historical Society, and the Young Men's Institute (which later became the Hartford Public Library). Its early art collection included Wadsworth's gift of paintings commissioned from leading artists of the Hudson River School, the collection of the American Academy of Fine Arts acquired for the museum in 1844, as well as history paintings, portraits, and sculpture.

Twenty years later, the Watkinson Library of reference opened to the public in an addition to the Wadsworth building. In 1893 the renovated and expanded Atheneum reopened after the museum's first fundraising campaign. Elizabeth Hart Jarvis Colt, widow of the firearms manufacturer Samuel Colt, bequeathed her collection of paintings, decorative arts, and firearms to the museum in 1905, with funds to erect the Colt Memorial wing. Two years later, financier J. Pierpont Morgan proposed building another wing, the Junius Spencer Morgan Memorial, in memory of his father. The Colt and Morgan wings were opened separately in 1910. In 1917, J.P. Morgan Jr. presented the museum with over a thousand objects from his father's collections. A decade later Morgan gave the Atheneum the Wallace Nutting collection of seventeenth-century American furniture and decorative arts, the largest of its kind. With the appointment of A. Everett Austin Jr. as director in 1927, the Atheneum began to develop its large collection of European paintings and twentieth-century masterpieces. The performing arts were added to the museum's programs in 1934 with the building of the Samuel Putnam Avery Memorial wing, which included a fully equipped theater. Since that time, the Atheneum has continued to expand its collections and activities in many areas, including the establishment of the influ-ential MATRIX program of contemporary exhibitions in 1975; the acquisition of the Austin House in 1985, a National Historic Landmark; and the creation of a department of African American art in 1989.

The Wadsworth Atheneum has a representative collection of American folk art, including regional New England and Connecticut portraits by Ralph Earl, Simon Fitch, Joseph Steward, Joseph Whiting Stock, Ruth Whittier Shute, and Samuel Addison Shute, among many others. During the 1930s and 1940s, the museum acquired a number of private collections of maritime art, including models and paintings of ships, scrimshaw, portraits of sea captains, and whaling logs. Many of these objects have regional associations to ports on the Connecticut River. In addition, between 1957 and 1960, Edith Gregor Halpert, founder of the American Folk Art Gallery in New York, gave forty folk paintings and sculptures to the Wadsworth Atheneum ranging from works by well-known artists, such Edward Hicks and William Matthew Prior, to works by unidentified painters and sculptors. The collection of American decorative arts includes folk sculpture ranging from trade signs and cigar store Indians to decoys and weathervanes.

See also **Ralph Earl; Edith Gregor Halpert; Edward Hicks; Maritime Folk Art; William Matthew Prior; Scrimshaw; Ruth Whittier Shute; Samuel Addison Shute; Joseph Steward; Joseph Whiting Stock.**

BIBLIOGRAPHY

Ayres, Linda, ed. *The Spirit of Genius: Art at the Wadsworth Atheneum.* New York, 1992.

Kornhauser, Elizabeth Mankin, et al. *American Paintings Before 1945 in the Wadsworth Atheneum.* New Haven, Conn., and London, 1996.

Elizabeth Mankin Kornhauser

WAGAN, R.M. & CO.: *SEE* SHAKER FURNITURE.

WALKER, INEZ NATHANIEL (c. 1911–1990) created a large body of vivid, stylized portraits, which she began to make when she was serving a prison sentence for "criminally negligent homicide" in the Bedford Hills Correctional Facility in New York. She was incarcerated there from the late 1960s to 1972. Born in Sumter, South Carolina, Walker was orphaned by the age of twelve or thirteen and raised by a cousin. She had married and had four children by the time she was sixteen. In the 1930s Walker joined the African American migration north, settling in Philadelphia, and then moved to New York State in 1949, where she found work in a Fort Byron apple-processing plant.

Little is known of Walker's life for the next twenty years or so, or whether she was making drawings during this period. But in 1971, seventy-nine of her drawings were found by a local schoolteacher, Elizabeth Bailey. Impressed with their originality, meticulous attention to detail, and humor, Bailey purchased the drawings and showed them to art gallery owner Pat Parsons, who exhibited Walker's work for eight years. But from 1980, Parsons lost track of the artist. About a decade later, she discovered that Walker was living in a psychiatric hospital in Willard, New York. Parsons continued to represent the artist, buying about 200 of her works executed at Willard, until Walker's death there in 1990.

Walker's style changed over the years. Her first drawings were made on the backs of mimeographed prison newsletters. From 1972, Parsons supplied her with art materials: sketchpads, graphite, colored pencils, crayons, and felt-tipped markers. Her early portraits were executed as line drawings on plain backgrounds, with patterned areas added to delineate the features of her subjects. Many of her drawings are self-portraits, but she also drew generalized portraits of people. Most of her subjects are presented frontally or in profile close to the imaginary space of the picture plane, the window between the viewer and the picture's actual surface. Her frontal portraits exhibit an intense gaze, with the eyes staring directly at the viewer. Many of her self-portraits are reminiscent of those produced by the folk artist Mose Tolliver. Walker paid special attention to hairstyles (especially densely patterned "Afros" and permanent waves), hats, and clothing in her portrayals of women, and focused on the mustaches and the beards of her male subjects.

In time, the patterns in the form of parallel, converging, crossing, diagonal, and undulating lines, alternated with geometric forms such as dots, triangles, circles, and squares became more varied and dense within the linear figures she drew. In her later works, the patterns were less controlled, often extending beyond the outlined borders of the figures.

Walker's confident portraits affirm her identity as a woman, an African American, and an artist. Her oeuvre provided her with an expressive outlet during a time when she experienced loneliness and stress while leading a restrictive life in prison.

See also **Painting, American Folk; Prison Art; Mose Tolliver.**

BIBLIOGRAPHY

Beardsley, John, and Jane Livingston. *Black Folk Art in America, 1930–1980*. Washington, D.C., 1982.

Hollander, Stacy C., and Brooke Davis Anderson (co-curators). *American Anthem: Masterpieces from the American Folk Art Museum*. New York, 2002.

Kogan, Lee. "The More I Draw the Better I Get." *Folk Art Magazine*, vol. 22, no. 2 (summer 1997): 44–50.

LEE KOGAN

WALKING STICKS: *SEE* CANES.

WALTON, HENRY H. (1804–1865), portrait artist, landscapist, and lithographer, worked in his native Finger Lakes region of upstate New York, and subsequently in California during the early nineteenth century. Born in 1804, the artist was the son of Judge Henry Walton (1768–1844), the region's chief land owner and the developer of Saratoga Springs as a resort for therapeutic cures. Henry H. Walton's introduction to art has not been determined, however, he may have received some training in architectural draftsmanship. During the 1820s and 1830s, he worked as a lithographer, executing highly detailed and skillfully drawn town views of central New York for lithography firms such as Rawdon Clark & Co. of Albany and Pendleton's of Boston and New York. Many of these views—including the United States Hotel, Saratoga Springs, and Mrs. Ricord's Seminary at Geneva, Ontario County, New York—appeared as illustrations to guide books for the region and as supplementary material for other publications of the period.

From 1836 to 1851, Walton lived in the Finger Lakes. He resided primarily in Ithaca, but he also worked in Elmira, Big Flats, Addison, and Painted Post. In addition to making town views as engravings, and in watercolor and oil, he also executed beautiful, diminutive portraits in watercolor on paper, miniatures on ivory, and full size likenesses on canvas. A

fireman's parade banner that took three men to carry, a full-length portrait of politician Henry Clay, and a transparency of President William Henry Harrison also are ascribed to his hand. Walton often drew subjects in interior settings decorated with attributes of middle class status, as in his portrait of *Theodore Squires of Hector*. Men are posed at tables holding newspapers, letters, quill pens, and books, thus communicating their participation in professional circles. Women frequently are seated in chairs, holding small prayer books, handkerchiefs, or knitting implements, among other articles, suggesting their position as masters of their domestic life. In his portraits of children, the artist drew subjects in parlor settings where they stand on highly decorated, ornate floor coverings, holding hats, books, and flowers, or in outdoor views where boys and girls are seen in garden-like settings, or in front of sweeping vistas.

In 1851, Walton traveled to California, where he is believed to have joined others in search of gold. During this period, he executed at least two known scenes, a mining village in Grass Valley, and a portrait of *William D. Peck*, a miner from Rough and Ready, California. By 1857, he had retired with his wife Jane to Cassopolis, Michigan, where the artist died.

See also **Flags; Miniatures; Painting, Landscape.**

BIBLIOGRAPHY

D'Ambrosio, Paul S., and Emans, Charlotte M. *Folk Art's Many Faces: Portraits in the New York State Historical Association.* Cooperstown, N.Y., 1987.

Force, Albert W. "H. Walton—Limner, Lithographer, and Map Maker," *The Magazine Antiques*, vol. 82 (September 1962): 284–285.

Ithaca College Museum of Art. *Henry Walton: 19th Century American Artist.* Ithaca, N.Y., 1968.

CHARLOTTE EMANS MOORE

WARD, STEVE (1895–1976), and **LEMUEL WARD** ("Lem") (1896–1984), decoy carvers, were brothers from Crisfield, Maryland, on Chesapeake Bay. They specialized in working decoys early in their careers; later, they concentrated on decorative wildfowl. They had been taught by two locally respected decoy carvers: their father, L. Travis Ward Sr. (1863–1926); and a neighbor, Noah B. Sterling (1885–1954). The Ward brothers were actually barbers by trade; they took up carving between customers, and by the 1960s they were carving decoys full time. They called themselves "wildfowl counterfeiters in wood."

Lem Ward, who had a talent for painting, developed "rag painting" and was a master "scratch" painter. In rag painting, a decoy is first coated with lead; after it hardens, paint is applied with a rag, allowing the two colors to subtly blend. A scratch painter uses a nail or a piece of wood on the drying paint and applies a feather pattern. Lem Ward's color blending and patterning were forerunners of techniques used in the decorative birds, or "mantle birds," that occupied both carvers late in their careers.

The Wards produced decoys with every imaginable head and body position. Their neighbor R.H. Richardson has described their artistic progression—from large decoys with exaggerated painted feathers in the 1920s to their most productive period of streamlined, individualized, realistic feathering in the 1930s, culminating with their finest work in the 1950s, which was followed by their concentration on decorative carving in the 1960s. To honor their work, the Ward Museum of Wildfowl Art, an architecturally dramatic $4.7 million facility set on 4.2 acres overlooking a pond, was opened in 1992 in Salisbury, Maryland.

See also **Decoys, Wildfowl; Sculpture, Folk.**

BIBLIOGRAPHY

Engers, Joe, ed. *The Great Book of Wildfowl Decoys.* New York, 2001.

Earnest, Adele. *The Art of the Decoy.* New York, 1965.

———. *Folk Art in America: A Personal View.* Exton, Pa., 1984.

Richardson, R.H., ed. *Chesapeake Bay Decoys: The Men Who Made and Used Them.* Cambridge, Md., 1973.

WILLIAM F. BROOKS JR.

WARD, VELOX (1901–1994) is an artist who debunks the notion that memory painters always filter reality in order to idealize it: Ward intended to paint the nostalgia of by-gone days as he remembered them, but his stark, atmospheric pictures of life in East Texas in the early twentieth century diverge from idealized memories and tend more toward realism. Ward painted many outdoor scenes of people in their daily lives—butchering meat, ginning cotton, baling hay, sounding a dinner horn, napping on a porch. In his serene, spare landscapes he accentuated geometric perspective, depicting views into and through windows, doors, and breezeways. Even an interior view of a working sawmill opens out to show the deep space of a distant landscape.

Ward was born near Hopewell in Franklin County, East Texas. According to Margaret Vogel, it amused him to have been named after a German sewing machine that had a label reading "Speed and Accuracy." Ward left school to help support the family after the death of his father (a farmer who had failed in several business ventures) and thereafter worked at more than the usual variety of jobs because of restlessness as well as for

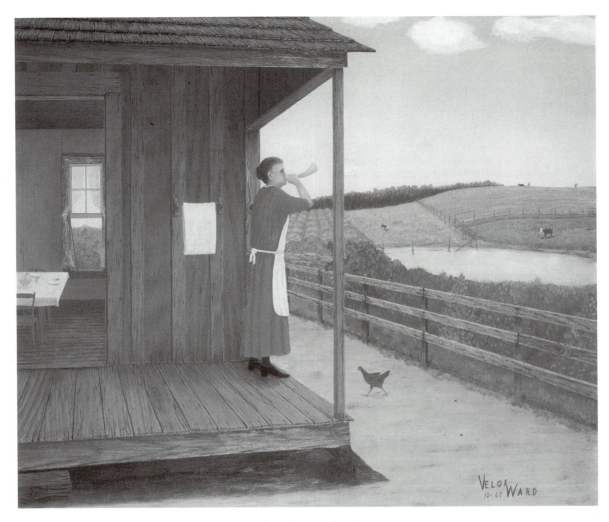

Mama Blows the Horn; Velox Ward; 1967. Oil on wood panel; 20 × 24 inches.
Photo courtesy Valley House Gallery, Dallas, Texas

economic reasons. He was, among other things, a farmer, machinist, salesman, plumber, cobbler, preacher, salesman, wrestler, and inventor.

Ward began to paint in 1960, when his three children asked him to paint a picture for each of them as a Christmas present. The experience was enjoyable for Ward, and he painted additional pictures that he hung in his shoe repair shop. People began to buy them, and eventually he was able to devote himself to painting full time. Donald and Margaret Vogel, who owned the Valley House Gallery in Texas, were impressed by his work and began to represent him.

Ward's ideas for his approximately 200 paintings in oil on canvas or Masonite (which are usually 20 by 24 inches) came from memory, imagination, and photographs. Each work took from three weeks to three

months to complete. For each composition, he would make paper cutouts of the major forms (he called these "cutout dolls"), then trace them onto the canvas or panel before beginning to paint. In works such as *Mama Blows the Horn* (1967), *Everybody Doesn't Work* (1964), *Girl with Hoop* (1964), and *The Unfinished House* (1968), Ward experiments with slightly irregular perspectival techniques, creating detailed linear compositions that seem to compress and expand space. A sense of realism is achieved through the smooth surfaces and diminished brush work, despite Ward's lack of technical training. The result is a carefully worked out composition that emphasizes abstract shapes and forms.

In 1972, Ward had a one-person exhibition at the Amon Carter Museum in Fort Worth, Texas that trav-

eled to the Wichita Falls Museum in Texas, the Dallas Museum of Fine Arts, and elsewhere.

See also **Painting, Memory.**

BIBLIOGRAPHY

Adele, Lynne. *Spirited Journeys: Self Taught Artists of the Twentieth Century.* Austin, Tex., 1997.
Rosenak, Chuck, and Jan Rosenak. *Museum of American Folk Art Encyclopedia of Twentieth Century American Folk Art and Artists.* New York, 1990.
Steinfeldt, Cecilia. *Texas Folk Art: One Hundred Fifty Years of the Southwestern Tradition.* Austin, Tex., 1981.
Vogel, Donald, and Margaret Vogel. *Velox Ward.* Fort Worth, Tex., 1972.

LEE KOGAN

WARE, THOMAS (1803–c. 1826) painted portraits of residents of the Pomfret-Woodstock area of Vermont. He was the son of Dr. Frederick Ware and Jemima Ware and a childhood friend of Benjamin Franklin Mason, whom he encouraged to draw when, at age nine, Mason was confined to bed following surgery. Later, after seeing the work of Abraham Tuttle, another portraitist in Pomfret, Ware and Mason both progressed to oil painting. The wherabouts of the early works by Ware are unknown.

During his short life, Ware produced at least forty-one portraits, of which two are known only from photographic reproductions in a book on Pomfret. Seven of the portraits are oil on canvas; the remainder are oil on wood panel. Most of them measure about 25 by 20 inches, except for a portrait of the Titus Hutchinson family that measures 30 by 124 inches. All but two of the portraits are bust-length, with the heads and bodies shown in three-quarter view. Female subjects usually face to the left and males to the right. The hands are not shown, except in a few instances when the subject holds an object such as eyeglasses or a book. The painting of the Hutchinson family, which is in the collection of the Woodstock Historical Society, is Ware's only group portrait.

Most of the portraits were painted between 1820 and 1823; one or two may have been done in 1824 or 1825. All the portraits, particularly those of female subjects, are strikingly similar: the subjects have wide-open eyes, large ears, large eyebrows, heavy shading along the line of the nose, and a deep depression in the midline of the upper lip. The young women characteristically wear a tortoiseshell comb in their hair and have prominent ringlets in front of their ears. As a rule, each portrait has a dark background, and the subject fills most of the panel. Ware's subjects are often identified by an inscription on the reverse of the

support, and many of the portraits are signed. The identity of thirty-five of the sitters is known, and thirty-one are from the Pomfret-Woodstock area.

Thomas Ware died at age twenty-three, unmarried, in Whitehall, New York, just across the state line from Vermont.

BIBLIOGRAPHY

Kern, Arthur, and Sybil Kern. "Thomas Ware: Vermont Portrait Painter." *Clarion* (winter 1983–1984): 36–45.
Ware, Emma Forbes. *Ware Genealogy: Robert Ware of Dedham, Massachusetts, 1642–1649, and His Lineal Descendants.* Boston, 1901.

ARTHUR AND SYBIL KERN

WARMACK, GREGORY (1948–) is a Chicago-born artist now living in Bethlehem, Pennsylvania. Warmack has always made art, although it was a violent attempted robbery that caused him to make a conscious choice to become a full-time, working artist. Shot in the stomach in 1978, Warmack fell into a coma and had visions of ancestral worlds and other civilizations. He renamed himself Mr. Imagination after this traumatic experience and has worked ever since in earnest and on a large scale. Working with any found material available to him, Warmack constructs totemic figures and imaginary animals of bottle caps, buttons, coins and wood. Industrial sandstone and plaster are materials used frequently by the artist. Mr. Imagination has boundless energy and is constantly turning his creative artistic powers into acts of good will that impact societal change. Whether it is his monumental public art grottoes, or his bottle cap and button sculptural trinkets, Mr. Imagination believes that his art is a gift to society. This prolific artist is constantly evolving his forms and modes of expression but he continually returns to the materials he has used from the beginning; bottle caps, sandstone, and found objects.

See also **Bottle Cap Art; Sculpture, Folk.**

BIBLIOGRAPHY

Patterson, Tom. *Artist and the Community: Mr. Imagination.* Winston-Salem, N.C., 1999.
———. *Reclamation and Transformation: Three Self-Taught Chicago Artists.* Chicago, 1994.

BROOKE DAVIS ANDERSON

WARNER, PECOLIA JACKSON (1901–1983), the ninth of eleven children, was trained by her mother, Katie Brant, in the skills that she used to support herself as a cook, housekeeper, nurse's aide and professional quilter. The family lived and worked on a plantation in the Mississippi Delta. Warner's mother was a college graduate and a school teacher who taught her children at home.

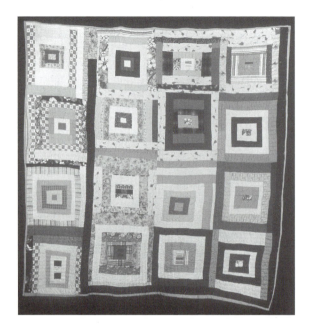

Pig Pen (Log Cabin Variation). Pecolia Warner; Yazoo City, Mississippi, 1982. Cotton (including muslin), linen, and synthetics, 79½ × 76½ inches. Collection American Folk Art Museum, New York. Gift of James and Maude Wahlman, 1991.32.3.

Warner said that she learned to make quilts by watching her mother: "I just be sitting side of her. I'd get the scissors and cut me out something, and be doing it just like I see her doing. And she bought me a little old thimble and a needle. That's the way I learned how to sew. From then on I'd be sewing and piecing and if I didn't do it right she'd pull it out and make me do it again." The first quilt top she pieced by herself was made of "strings," small rectangular scraps sewn into strips.

After living in New Orleans and Chicago, Warner returned to her native Mississippi in 1968. She always found time to make quilts, even while she cooked and cleaned for other people. Like many African American women of the south, Warner quilted as part of a enduring cultural tradition that valued the craft as a communal activity and a way to tell stories, passed down from mother to daughter, aunt to niece. Warner stated that she also sold most of the quilts she made, even if only for a small sum, and gave others away to friends. She quilted "to keep myself company, keep my mind occupied, I made quilts." Warner worked with many original colorful abstract patterns, never reproducing the patterns learned from her mother or those she saw in another quilts or in pattern books. She modified or improvised every pattern, making

each one her own. Warner claimed to have often dreamed of new patterns or created new ones based upon her experiences.

Warner was very particular about her colors and if she could not find a satisfactory color among her scraps, she would purchase material specifically for certain pieces. "When you cutting them little bitty pieces you got to study how to put them together, and you want them to hit just right," she explained.

In 1983 Warner was recognized for lifetime achievement in the visual arts by the Women's Caucus for Art (WCA), College Art Association, a national organization for artists, art historians, critics, museums, and art institutions.

See also **Quilts; Quilts, African American.**

BIBLIOGRAPHY

Ferris, William, ed. *Afro-American Folk Arts and Crafts*. Jackson, Miss., 1983.

Wahlman, Maude. *Signs and Symbols: African Images in African American Quilts*. Atlanta, Ga., 2001.

MAUDE SOUTHWELL WAHLMAN

WATERCOLORS: *SEE* JOHN S. BLUNT; SAMUEL BROADBENT; EMMA JANE CADY; JOSEPH H. DAVIS; EMILY EASTMAN; JAMES SANFORD ELLSWORTH; RALPH ESMERIAN; J. EVANS; ARUBA BROWNELL DEVOL FINCH; FURNITURE, PAINTED AND DECORATED; DEBORAH GOLDSMITH; JAMES GUILD; GUILFORD LIMNER; HEART IN HAND ARTIST; CHARLES HUTSON; MARITIME FOLK ART; LEWIS MILLER; MINIATURES; PAINTING, MEMORY; PAINTING, STILL-LIFE; PAINTING, THEOREMS; RUFUS PORTER; PAUL SEIFERT; RUTH WHITTIER SHUTE; SAMUEL ADDISON SHUTE; HENRY WALTON; MARY ANN WILSON.

WATERS, SUSAN C. (fl. 1845–1893), one of a few significant self-taught women painters in the nineteenth century, was for a while an itinerant portrait painter. Her career wazed and waned, but her ability to adapt to cultural currents allowed her to continue to live as an artist. When her husband, William C. Waters, became ill and she could no longer travel, she shifted to photography—which was then diminishing the demand for painted portraits—and took ambrotypes and daguerreotypes in a studio the couple opened. After 1866, she returned to painting, now doing realistic still lifes and animal, marine, and landscape pictures. Two of her paintings were shown at the Centennial Exposition in Philadelphia in 1876, and a newspaper story in 1886 likened Waters to Rosa Bonheur.

Susan Waters was born in Binghamton, New York; her family name was Moore. She attended a ladies' seminary in Friendville, Pennsylvania, where, according to Heslip, her talent at drawing was considered equal or superior to her instructor's. Her husband, a Hicksite Quaker, encouraged her painting, and she kept it up until the last few months of her life.

Waters' early portraits, rather than her more conventional later works, fit into the folk art canon. Waters did not advertise for commissions, but her itinerant work in southern New York State can be traced through signed and dated portraits of 1844 and 1845. She painted several bust-length adult portraits in 1844; some figures are shown with a column and softening drapery, and in some portraits a landscape is seen through a window. Her full-length children's portraits, set indoors and outside, are among her most detailed. Mary E. Kingman (1845), age three, wears a lacy collar, a loosely pleated dress, and pantaloons and is shown against a verdant landscape, holding a basket of fruit on her right arm and a leafy fruited sprig in her hand. Pets frequently appear with the children; large potted plants are included in paintings of adults and children.

Waters painted in oil on cotton, linen, or mattress ticking stretched and nailed to strainers or nonexpandable supports. Before painting, she would make a line drawing; she shaded faces with thin dark paint over flesh tones. On the back of her portraits, in large embellished handwriting, she wrote the name and age of each subject and signed her name.

An exhibition of Waters' paintings at the Longwood Fine Arts Center, Longwood College, Farmville, Virginia, traveled to the Arnot Art Museum in Elmira, New York in 1980.

See also **Painting, American Folk; Photography Vernacular.**

BIBLIOGRAPHY

Heslip, Colleen Cowles. *Mrs. Susan Waters: Nineteenth-Century Itinerant Painter.* Farmville, Va., 1979.

———. "Susan C, Waters." *Antiques: The Magazine*, vol. 115 (April 1979): 769–777.

Lee Kogan

WATSON, JOHN (1685–1768) was a portrait painter, or limner, who arrived in 1715 in Perth Amboy, New Jersey, from Scotland, where he had probably received training in portraiture. Little would be known of Watson's life as a limner if it were not that William Dunlap, also living in Perth Amboy, became the first chronicler of American art. Dunlap saw Watson's studio, with its portraits of "sages, heroes, and kings," some painted on shutter panels; and although Watson had by then died, the studio—and tales told by the townspeople—inspired Dunlap to write about the artist. In fact, Dunlap attributed his career as an art historian to this experience. Watson was described locally as a miser and usurer; Dunlap, mindful of the envy of those less successful, concluded that Watson had been a prudent investor and a prosperous merchant as well as a portrait painter. Dunlap wrote: "The story ran that old Watson painted many portraits and lent his money to those who employed him, thus procuring employment from those who could secure payment, and, according to English phraseology, patronized his patrons."

According to Dunlap, Watson returned to Europe to acquire a large collection of paintings. He brought to his new home in New Jersey "portraits, real or imaginary, of the kings of England and Scotland," to which he added his own creations. Judging by his eighty known paintings, Watson's works were nearly all portraits: some of kings, but mostly of colonial notables, who sought him out as the most fashionable portraitist of the 1720s and 1730s. Watson's large portraits, in oil on canvas, are colorful and appealingly delineated; they are patterned on mezzotint engravings rather than on the work of other limners. Thirty-six protraits are miniatures that were sketched quickly in wash and ink.

John Cooper, a limner and print dealer from London who sold dashingly rendered portraits of monarchs in Boston between 1714 and 1718, had arrived a few years earlier than Watson. Both artists were clearly pursuing the same market, and it served them well until the monarchy became unpopular during the American Revolution. Dunlap relates that late in Watson's life, when the war came and the artist—blind, deaf, and bedridden—was being cared for by his nephew and heir, his caretaker abandoned his paintings, leaving them to rebel soldiers to "delight in executing summary justice on the effigies of the Nimrods of the father-land."

When Dunlap wrote about Watson in the 1830s, he knew of no existing paintings attributable to this artist. However, a surviving notebook in which Watson listed some portraits he had done connected his name to paintings that had previously been attributed to the unidentified "Van Rensselaer" limner. The key portraits were those of Mr. and Mrs. Henderson, which stand today as elegant testaments to their creator's talent.

See also **Painting, American Folk.**

BIBLIOGRAPHY

Belknap, Waldron Phoenix. *American Colonial Painting: Materials for a History.* Cambridge, Mass., 1959.

Black, Mary C. "Early Colonial Painting of the New York Province." in *Remembrance of Patria: Dutch Arts and Culture in Colonial America, 1609–1776.* Albany, N.Y., 1988.

———. "Remembrances of the Dutch Homeland in Early New York Provincial Painting." In *Dutch Arts and Cultural in Colonial America: Proceedings of the Symposium, August 1986.* Albany, N.Y., 1987.

———. *Rivers, Bowery, Mill, and Beaver.* New York, 1974.

———. "Tracking Down John Watson." *American Arts and Antiques* (October 1979): 78–85.

RODERIC H. BLACKBURN

WEATHER COCKS: *SEE* WEATHERVANES.

WEATHERVANES have been displayed on buildings since ancient times to add novelty to the built environment and indicate the direction from which the wind was blowing. Commonly called "weather cocks" before the late nineteenth century, the term referred to the popularity of cocks that were placed on church spires as a reminder to the faithful of Saint Peter's denial of Christ in the Bible: "I tell you, Peter, the cock will not crow this day until you three times deny that you know me" (Luke 22:34). The practice spread from England and the Continent to North America, and cocks subsequently appeared on churches throughout eastern Canada and the United States. In the eighteenth century, weathervanes grew to be a commonly seen feature on public buildings in coastal cities. Sometimes the design was a reflection or acknowledgement of the local culture or economy, such as a codfish in a city where many relied on fishing for their livelihoods. The gilt grasshopper that has perched atop Boston's Faneuil Hall since 1742 symbolizes good luck and was an apt image for the city's central market where local farmers came to sell their produce.

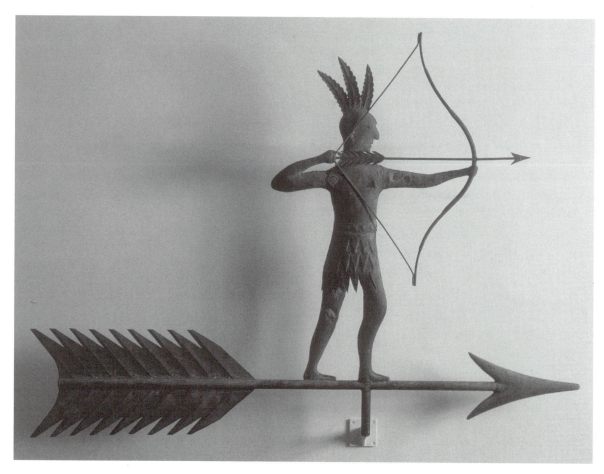

Mashamoquet Weathervane. New England, c. 1875; 43 × 60 inches.
Photo courtesy Allan Katz Americana, Woodbridge, Connecticut.

A weathervane's ability to indicate wind direction is the result of intentional imbalance. Moving the pivot point on which the vane rotates just forward of center allows the wind to push the back of the vane and turn the front into the wind. If the pivot point was located at the center, the wind would cause the vane to windmill. This simple fact allowed a farmer, for example, to rely upon a weathervane as simple weather forecasting tool, a vital necessity when one's survival could depend upon the contingencies of weather.

With the spread of agriculture throughout the east, the middle Atlantic region, and the Midwest, weathervanes depicting livestock proliferated. Images of roosters, cows, horses, sheep, and pigs were common, as were images of the Native Americans who had formerly occupied the land. The *Indian Weathervane of Mashamoquet* (New England, c. 1875) is one such example. Mashamoquet was the sachem (chief of a confederation of the Algonquian tribes of the North Atlantic coast) of the Mipmuk tribe. The vane originally adorned a building in Pomfret, Connecticut, adjacent to Mashamoquet State Park.

Homemade vanes could be constructed of boards cut to the correct silhouette and attached to one another with iron straps. Blacksmiths and farmers with metalworking skills could also cut a silhouette from sheet iron and reinforce the flexible metal with iron straps. Whether made of wood or iron, vanes were painted to provide some protection against inclement weather. The number of surviving examples of folk art weathervanes dating from the nineteenth and early twentieth century is remarkable and suggests that weathervanes were once nearly as common a sight in the countryside as barns themselves.

Technological changes introduced new images for weathervanes and altered methods of manufacture. Weathervanes depicting sailing vessels were as popular as images of fish in coastal cities and towns, and with the rise of the railroad, locomotive weathervanes became a common sight on railway stations. The interest in machine iconography continued into the twentieth century with the development of steam-powered tractors, automobiles, and airplanes, all of which were used as models for weathervanes.

It was but a matter of time before industrialization would be harnessed to make weathervanes that had formerly been fashioned completely by hand. In the early 1850s, the A.L. Jewell Co. of Waltham, Massachusetts, began marketing three-dimensional copper weathervanes that could be ordered from a catalog. These weathervanes were made from thin sheets of copper that were hammered into cast iron molds taken from the left and right side of a wooden pattern. Depending on the size of the weathervane, multiple molds could be used to make an animal's legs, neck, head, and tail. After hammering the copper sheets to conform to the molds, the copper pieces were removed, assembled, and soldered. As the century progressed, other manufacturers utilized this process, and the variety of weathervanes and sizes they offered was impressive. The process produced a naturalistic image that the majority of amateur weathervane makers could not achieve, since professional carvers made the wooden patterns. Other than the talent of the pattern carvers, little artistry was required to make weathervanes in this manner. Weathervanes became standardized in appearance, despite the wide range of designs available. That, coupled with the fact that molds from one company were acquired by a succession of other companies, makes identifying the makers of many commercially made weathervanes difficult.

See also **A.L. Jewell & Co., Shem Drowne; L.W. Cushing & Sons.**

BIBLIOGRAPHY

Bishop, Robert, and Patricia Coblentz, *A Gallery of American Weathervanes and Whirligigs.* New York, 1981.

Ricco, Roger, and Frannk Maresca. *American Primitive: Discoveries in Folk Sculpture.* New York, 1988.

RICHARD MILLER

WEBB, ELECTRA HAVEMEYER (1888–1960), art patron, pioneering collector of American folk art, and preservationist, was the founder of one of the most important repositories for Americana, architecture, and folk art in the United States. The Shelburne Museum—the institution Webb created in Shelburne, Vermont—is an indoor and outdoor museum that did not become static or never grew static. Before her death, Webb was adding twentieth-century objects to the already comprehensive aggregations of earlier art and artifacts. The Shelburne's inventories of textiles and vernacular sculpture have a depth, range, and quality found in few other collections, and they are considered the finest public holdings of their kind.

The youngest daughter of Henry and Louisine Elder Havemeyer (who assembled an unrivaled collection of Old Master and Impressionist paintings in the United States and became principal benefactors of the Metropolitan Museum of Art), Electra Havemeyer came by her passion for collecting through firsthand experience. While her parents focused on the treasures of Europe, the younger woman perceived art in

the rural antiques and carvings of her native country. In 1907, the eighteen-year-old Electra bought a cigar store Indian for $15 because it appealed to her as an aesthetic object. She was certainly the first collector of folk objects to declare immediately that what she bought was a work of art.

In 1910, Havemeyer married J. Watson Webb, a descendant of Cornelius Vanderbilt, and moved into a mansion in Syosset, New York, decorated by her mother and mother-in-law in a funereal taste she found stultifying. As an escape from this gloomy place, the newlyweds asked for and received a farmhouse on the Webb family's enormous country estate in Shelburne, Vermont, in 1913. Webb began filling her new retreat with rustic furniture and accessories that she picked up in second-hand stores and local auctions. The Webbs had five children; the needs of their growing family doubtless pushed them to sell the Syosset residence in 1920; a year later they moved to a house in Westbury, New York, which Webb unapologetically furnished to her own specifications. Through this activity, she learned an enormous amount and the pace of her acquisitions increased voraciously.

Webb was a collector and thought of herself as such, but she approached the field through household decor, long the traditional province of women. The introduction of folk art via the domestic realm and its associations with antiques is a constant in the lives of the first generation of women collectors of folk art, and it emerges as a natural avenue of expressing and broadening themselves. From the outset, Webb's strongest interests would be in amassing textiles, such as quilts, blankets, rugs, embroidered samplers, and bedcovers, as well as vernacular sculpture, most notably tobacconists' figures, weather vanes, whirligigs, decoys, carousel animals, and show signs. She acquired more than 400 quilts and nearly forty tobacconists' figures.

Webb founded the Shelburne Museum on the grounds of her Vermont property in 1947 as a home for the furniture, decorative arts, and folk art that she viewed as inimitable markers of American history and culture. With the museum underway, she also took the innovative step of augmenting the scope of the public collection by rescuing abandoned buildings and other historic structures in New York State and New England. Among the thirty-seven structures preserved were seven houses, an inn, a school, a jailhouse, a smithy, a meetinghouse, a covered bridge, a lighthouse, a general store, a railway station, and the S.S. *Ticonderoga*, a 220-foot side-wheel paddleboat that is the last extant example of its type.

When it opened to the public in 1952, the Shelburne Museum complex consisted of eleven buildings on twenty acres, but the collections were by no means complete. The Shelburne's array of decoys, for instance, grew in size and significance in 1952 when the museum acquired the collection of Joel Barber, the architect, artist, and carver whose book *Wild Fowl Decoys* (1934) identified decoys as an art form. Paintings were one of the last collections undertaken by Webb, and she did not live long enough to amass an encyclopedic collection. In this category of objects she was not a trailblazer; she followed the lead of the Karolik and Garbisch collections, and Maxim Karolik advised her on purchases of eighteenth- and nineteenth-century academic and folk paintings. Among the folk paintings in the Shelburne's permanent collection are portraits connected with William Matthew Prior and the Prior-Hamblen school, canvases by Erastus Salisbury Field, and studies of ships by John and James Bard.

See also **James and John Bard; Joel Barber; Decoys, Wildfowl; Erastus Salisbury Field; Edgar William and Bernice Chrysler Garbisch; Maxim Karolik; The Shelburne Museum.**

BIBLIOGRAPHY

Perry, David P. *An American Sampler: Folk Art from the Shelburne Museum.* Washington, D.C., 1987.

Garrett, Wendell. "Shelburne Museum." *The Magazine Antiques* (February 1988): 429–493.

AVIS BERMAN

WEINGARTNER, WALLRATH: *SEE* HARMONISTS.

WELLS, YVONNE (1940–), a schoolteacher from Tuscaloosa, Alabama, began to make quilts about 1979 without any training and with only a limited exposure to quilting in her childhood. She says, "I started quilting in 1979 after making a small wrap to be used by the fireplace. I had seen my mother quilt but did not help in making them. I taught myself and have had no formal training in quiltmaking. I consider myself a quilt artist and take pride in making big, bold, primitive, and unusual quilts."

The art dealer Robert Cargo notes that the colors, designs, techniques, and materials Wells uses reflect her independent spirit and her lively imagination. Her appliqué quilts display large, bold patterns, frequently of her own creation; unusual color combinations; and occasionally manufactured elements, such as socks, lace, and upholstery materials.

Growing recognition of her work has not affected her drive to satisfy herself first, rather than the public. The quilts are dense in meaning, and their visual impact is deliberately enhanced by the use of naive figures and strong colors. Wells says that she can always recognize the traditional quilters who come to see her quilts. "They sort of cringe. They fold their arms in front of them as if to protect themselves from the cold. When they come up to my work they think to themselves, 'God, what has happened here?'"

Her work is strongly influenced by Christian symbolism and her appliquéd quilts often depict Biblical themes, such as the Crucifixion. The little triangles included in some of her quilts are a personal trademark, and represent the Holy Trinity, but are referred to by the artist as "my little friends." Her use of the color purple symbolizes God's presence to her.

See also **Quilts; Quilts, African American.**

BIBLIOGRAPHY

Wahlman, Maude. *Signs and Symbols: African Images in African American Quilts.* Atlanta, Ga., 2001.

MAUDE SOUTHWELL WAHLMAN

WENDELL LIMNER: *SEE* JOHN HEATON.

WENTWORTH, PERLEY (P.M.) (fl. 1950s) left a few dozen works on paper, but virtually nothing is known of his life except that he was listed in telephone directories of Oakland, California, in 1955–1959. He may have been a night watchman—hence the initials P.M.—but a drawing with the name Perley suggests that this story is apocryphal. Wentworth's drawings were originally owned by Tarmo Pasto, who was also the first to own drawings by Martin Ramirez. The artist Jim Nutt acquired Wentworth's and Ramirez's drawings from Pasto around 1970 and later took many to the Phyllis Kind Gallery in Chicago.

Wentworth's drawings—visionary interplanetary landscapes with prophetic Christian references—are done in crayon, pencil, gouache, pastel, and charcoal on paper. Color on color and deliberate erasures blur some of the forms, enhancing the enigmatic, ambiguous, ethereal imagery. The artist takes the role of a prophet who can see beyond the earth into the cosmos: the sun, moon, and planets, and the face of God. His art is accompanied by Pentecostal texts. For example, in *Imagination by the Old Mill Temple in Bethsaida by the Sea of Galilee/Mark 8:22–25*, the passage cited, in which Jesus heals a blind man, symbolizes Wentworth's gift of "seeing" the vast universe at its creation and in apocalyptic moments; the picture shows a wall with a turret and paths leading through an archway to what is labeled "Sea of Galilee." Above the wall is the text "Objects from Sun Planet." In *Untitled* ("Rays of White on the/Cross"), we find "From the New World and Floating Clouds and Floating . . . Traveling Slowly from West to East/ 9:45 to 11:45 A.M.. The times may be when he began and finished the drawing. A small drawing, *Untitled* ("Moses—Tabernacle Foot of Mount Sinai"), depicts an amphitheater on huge feet; in the foreground, a bearded robed figure (perhaps Moses) stands next to a staff entwined by a long snake. Wentworth implies that the Hebrew tabernacle will eventually perish and only the converted will attain grace. Individual untitled drawings with the legend "(Imagination Mars— Full Moon) and (Imagination Jupiter = Planet)" are rendered as if the viewer is close to an aerial landing. Wentworth seems to have printed the word "imagination" on many of his drawings to assure viewers that he could distinguish the real from the unreal.

Wentworth's drawings are at the American Folk Art Museum, Intuit: The Center for Intuitive and Outsider Art, and the Smithsonian American Art Museum.

See also **Besharo, Peter.**

BIBLIOGRAPHY

Barrett, Didi. *Muffled Voices: Folk Artists in Contemporary America.* New York, 1986.

Hartigan, Lynda Roscoe. *Made with Passion: The Herbert Hemphill Folk Art Collection in the National Museum of American Art.* Washington, D.C., 1990.

Hollander, Stacy, and Brooke Anderson. *American Anthem: Masterpieces for the American Folk Art Museum.* New York, 2002.

Longhauser, Elsa, and Harald Szeemann. *Self Taught Artists of the Twentieth Century: An American Anthology.* San Francisco, 1998.

Pioneers in Paradise: Folk and Outsider Artists of the West Coast. Long Beach, Calif., 1984.

Rosenak, Chuck, and Jan Rosenak. *Museum of American Folk Art Encyclopedia of American Folk Art and Artists.* New York, 1990.

Tuchman, Maurice, and Carole Eliel. *Parallel Visions: Modern Artists and Outsider Art.* Princeton, N.J., 1992.

LEE KOGAN

WERNERUS, MATHIAS (1873–1931) was a Catholic priest who designed and built the Dickeyville Grotto on the grounds of the Holy Ghost Church in Dickeyville, Wisconsin, with the assistance of his parishioners, between 1920 and 1930. The Dickeyville Grotto was the second major grotto of elaborately embellished concrete built in the upper Midwest. The first was the Grotto of the Redemption in West Bend, Iowa, built by Father Paul Dobberstein between 1912 and 1954. The Dickeyville Grotto was a great source of local pride, and inspired people in the region, who

were untrained as artists or architects, to create similar environments, including Nick Engelbert's Grandview, the Paul and Matilda Wegner Grotto, and Mollie Jenson's Art Exhibit, all in Wisconsin, and others in and beyond the state. The radiating influence of Wernerus' work distinguished the region as a place replete with ambitious and original environments of embellished concrete, built within the context of home and garden, expressing individual creative visions and collective experiences.

Mathias H. Wernerus was born in 1873 in Kettenis, Germany (now Belgium). He studied in Europe and entered the St. Francis Seminary in Milwaukee, Wisconsin, in 1904, where he was ordained in 1907. In 1918 he became pastor of the Holy Ghost Church in Dickeyville, Wisconsin. Probably inspired by the Grotto of the Redemption, Wernerus engaged his parishioners in building projects that transformed a nondescript church into a glittering devotional landscape. His first artistic works were flower vases elaborately embellished with colored glass, made for a memorial group in the church's cemetery in 1920. In 1924 he began work on the Grotto of the Holy Eucharist, a concrete shrine richly embellished with colorful glass, shells, tile, and other materials. From 1925 to 1930 Wernerus and parishioners created a series of embellished grottos and shrines, including the Grotto of Christ the King and Mary His Mother, the Grotto of the Sacred Heart, and the Patriotism Shrine. Classical Roman architectural elements are nearly disguised by the rich encrustation of embellishment materials and the informal connection of the grottos and park spaces by walkways lined with embellished fences, punctuated with smaller decorative sculptures. The Dickeyville Grotto reflects popular religiousness and includes bold expressions of loyalty to church and state, an important sentiment for American Catholics at the time. It was formally dedicated on September 14, 1930. In February 1931, Wernerus died of pneumonia.

See also **Environments, Folk.**

BIBLIOGRAPHY

Beardsley, John. *Gardens of Revelation Environments by Visionary Artists.* New York, 1995.

Niles, Susan A. *Dickeyville Grotto: the Vision of Father Mathias Wernerus.* Jackson, Miss., 1997.

Stone, Lisa, and Jim Zanzi. *Sacred Spaces and Other Places: A Guide to the Grottos and Sculptural Environments in the Upper Midwest.* Chicago, 1993.

LISA STONE

WETHERBY, ISAAC AUGUSTUS (1819–1904) was a portrait painter whose activities and commissions were recorded in his detailed account books, which still exist. Weatherby was born in Providence, Rhode Island; his family relocated first to Massachusetts, and then to Maine. Wetherby (sometimes written as "Wetherbee") attended the Stow Massachusetts Academy and later the Bridgton Academy, near Norway, Maine. While in Maine, he learned to draw and paint.

He perfected his painting skills by producing portraits in New England communities, especially in Massachusetts and New Hampshire. His portraits were included in an exhibition at the Boston Athenaeum in 1842. Later in the 1840s, he traveled west as a portrait painter. An article in the Louisville, Kentucky *Dime* locates him there in 1844. Shortly thereafter, he is documented as living in Boston, where he married Catherine M. Thayer in February 1846, after painting her portrait.

Upon their return to Boston, his account books reflect that he painted numerous portraits of America's heroes, in particular a portrait of George Washington, using a Gilbert Stuart (1755–1828) painting as his guide.

Wetherby specialized also in the new daguerreotype photography. Investing in the necessary equipment, he moved to Tama County, Iowa and opened a photography studio. He also traveled to Illinois, where he made lithographs of political caricatures, and painted campaign banners. He was engaged to draw human heads and skulls by phrenologists traveling the countryside, body diagrams for "quack dispensers of patent medicines," and for temperance advocates. At the same time, he painted death portraits of adults and children from either the corpse or based on daguerreotypes.

His account books record that he produced his final two paintings in 1862 in Iowa City, Iowa. He lived another forty-two years, and died at age eighty-five. Extant portraits include one of abolitionist *John Brown*, the young girl *Mary Eliza Jenkins*, a self-portrait, and portraits of his wife, *Franklin Kimball*, and *Mrs. James Wilson*.

See also **Mourning Art; Photography, Vernacular.**

BIBLIOGRAPHY

Ford, Alice. *Pictorial Folk Art, New England and California.* New York, 1949.

Holloway, H.M. "Isaac Augustus Wetherby (1819–1904) and His Account Books." *New-York Historical Society Quarterly Bulletin,* vol. 25, no. 2 (April 1941): 55–69.

WILLIAM F. BROOKS JR.

WHEELER, CHARLES E. ("Shang") (1872–1949) was a wildfowl decoy and decorative carver. Born to a well-to-do Connecticut family, he left home at a young age to become a sailor. He returned to Connecticut, where his life's path took him from the halls of the Connecticut Senate to oyster inspections with the Connecticut State Game Commission. He was always an avid hunter, fisherman, and carver, as well as a competent cartoonist. Decoy expert Adele Earnest (1901–1993) described Wheeler as a "handsome man with a full mustache," a generous man who gave away, rather than sold, his decoys. His unusual nickname "Shang" was given to him by his classmates at Weston Military Institute of Nashville, Tennessee. Wheeler, a lanky teenager, six feet tall and as thin as a rail, drew the nickname from a combination of "landshang," one of the tallest breeds of chicken, and "chang," a sideshow giant with the P.T. Barnum circus.

Wheeler, along with decoy carvers Albert Laing (1811–1886) and Ben Holmes (1843–1912), formed the Stratford carving school, named for their neighboring town at the mouth of the Housatonic River along the Connecticut shore of Long Island Sound. Their decoys are assessed to be superior in selections of woods, construction of bodies, appearance, and riding ability. Wheeler and his Stratford associates specialized in black ducks, scaup, and scoters. In 1923 Wheeler was awarded a Silver Cup at the first Decoy Show held in the United States for a pair of mallards and his skill as a decoy maker and plumage painter; these mallards are now at the Shelburne Museum in Vermont. Characteristic of the Stratford school of decoys are overhanging breasts designed to over-ride slush ice, uniformly low heads, and detailed attention to the tails and to plumage painting. In addition, most of their birds were flat-bottomed and rigged with the body weight aft, which also served to raise the breast and permitted wider clearance over the slush ice.

Wheeler's decoy output was fewer than 500, testimony to the time and detail he spent on his carving and painting. Decoy bodies were often made of white-pine boards, one on top of the other, positioned to bring the seams above the water line and to hinder leakage. Some species required heavier material and he sometimes linked a very thick board to a thin bottom plank. He also fashioned both crude and sophisticated decoys from cork. These cork ducks often had tails made of other woods, as well as heads and necks positioned in sleep. Wheeler is also recognized as a carver of decorative mantle wildfowl.

See also **Joel Barber; Decoys, Wildfowl; Adele Earnest; Sculpture, Folk.**

BIBLIOGRAPHY

Barber, Joel. *Wild Fowl Decoys.* New York, 1954.

Earnest, Adele, *Folk Art in America: A Personal View.* Exton, Pa., 1984.

———. *The Art of the Decoy.* New York, 1965.

Mackey, William F. Jr. *American Bird Decoys,* New York, 1965.

Merkt, Dixon Macd., and Mark H. Lythe. *Shang, A Biography of Charles E. Wheeler.* Herber City, Utah, 1984.

WILLIAM F. BROOKS JR.

WHIRLIGIGS are wind-activated toys often made in the form of a three-dimensional carved figure with a pair of rotating propeller-like paddles in place of arms. Some whirligigs were mounted on the tops of buildings, but they were usually placed on a pole as a yard ornament and enjoyed close up whenever the wind was sufficiently strong to rotate the figure and activate the paddles. "Whirligig" is now generally applied to this type of construction, but in the nineteenth century, the word was used to denote any child's plaything, including pinwheels and similar toys that spun when held aloft by a running child. Nineteenth and early-twentieth century whirligigs were the product of individual craftspeople who applied their carving skill to making whirligigs for their delight or cottage businesses.

The most common materials used in the construction of earlier, single-figure whirligigs were carved and painted wood and metal. A wide range of forms were produced, but among the more popular were historical personages, military figures, and, in the twentieth century, policemen. Whirligigs depicting soldiers and policemen flailing wildly in the wind is a particularly amusing form of the American tradition of deflating authority.

A simpler whirligig design was one having a two-dimensional figure mounted on a horizontal base with a propeller on one end and a flat paddle on the other end. Easier to make than an articulated three-dimensional figures, this style was very popular because it offered makers a wider choice of ornamental possibilities. There is a hint of practicality in this design as well because the spinning propeller combines the entertaining movement of a whirligig, while the paddle end gives the whirligig the functionality of a weather vane.

By the early twentieth century, changes in technology began to affect the imagery found on whirligigs and the mechanism of their movement. Consequently, whirligigs depicting airplanes and automobiles began to appear with some frequency. Some

makers used their mechanical skills to construct elaborate whirligigs that could have one or more large propellers that activated a bewildering array of moving figures that were mechanized by a complicated series of cams and connecting rods. This innovative application of internal combustion engine parts to whirligigs made them, in essence, wind engines. It was a matter of time before some makers with welding and construction skills, and possibly inspired by windmills, pushed the whirligig form to its limits by building towering steel structures of whimsical design and having numerous spinning, rotating, and whirling elements.

See also **Sculpture, Folk; Toys, Folk; Weathervanes.**

BIBLIOGRAPHY

Bishop, Robert, and Patricia Coblentz. *A Gallery of American Weathervanes and Whirligigs.* New York, 1981.
Ricco, Roger, and Frank Maresca. *American Primitive: Discoveries in Folk Sculpture.* New York, 1988.

RICHARD MILLER

WIENER, ISIDOR ("Pop" or "Grandpa") (1886–1970) is remembered for his 200 or so brightly colored pictures of a wide variety of subjects and his small polychromed carvings of animals. He began to paint at sixty-five ("because I want to paint," he said) and was encouraged by his appreciative family. When Grandma Moses died, he called himself Grandpa Wiener, but he had signed his earlier work "I. Wiener." He was amused that people would pay for something that gave him so much pleasure; he enjoyed selling his work but would have created it even if there had been no buyers.

Wiener was born in the Bessarabian village of Durleshty in Russia and emigrated to America to escape religious persecution. He settled in New York City and worked at numerous jobs before opening a small grocery in the Bronx. When his wife died, their son Danny, a photographer, urged him to retire and, as a diversion, bought him a set of watercolors at a five- and ten-cent store.

Wiener found watercolors runny and switched to oil on canvas. He used a large brush for broad areas, but for detail he used small inexpensive brushes that he bought by the dozen. He felt that a palette knife made painting "too easy." He purchased Bocur and Grumbacher oils from Macy's and sprayed his finished paintings with Damar Varnish Spray and linseed oil. Wiener would work on several paintings simultaneously. He prepared preliminary sketches only when he was concerned with the proportions of a building; occasionally, he used photographs and pictures in magazines as sources.

Wiener's subjects were both religious and secular and included Noah and the ark, Daniel in the lion's den, the crossing of the Red Sea, and idealized flowers and trees. Wiener painted his own neighborhood, country villages, farms, mountains, bathing and boating scenes, a western cattle drive, a barroom, a version Claude Monet's *Terrace at Sainte Adresse*, a portrait of John Kennedy, and a Korean War battle. Even if a subject had a dark undercurrent, as in *The Witch in the Woods*, he used bright, cheerful colors. He favored generalized lighting, multiple perspectives, and abstracted forms, and he took liberties with scale. His figures are often wide-eyed and have disproportionately large heads.

Fifty-seven of his paintings were shown at Fenimore House Museum (1970); this exhibition traveled to the Albany Institute of Art and the American Folk Art Museum (New York, 1971).

BIBLIOGRAPHY

Bock, Joanne. "Grandpa Wiener: A Painter for Our Times." *Connoisseur* (November 1971): 204–207.
———. *Pop Wiener: Naïve Painter.* Massachusetts, 1974.
Frankenstein, Alfred. "Painted Memories: Folk Artists Are Back on the Scene." *Smithsonian* (February 1971): 28–35.
Rosenak, Chuck, and Jan Rosenak. *Museum of American Folk Art Encyclopedia of American Folk Art and Artists.* New York, 1990.

LEE KOGAN

WILDFOWL DECOYS: *SEE* DECOYS, WILDFOWL.

WILLETO, CHARLIE (1897–1964) made carved and painted figures of people and animals that are steeped in his Native American heritage, with its aesthetic ideal to achieve *hozo,* or harmony in nature. Although Willeto's expressive carved wooden figures are unconventional in medium and more idiosyncratic in nature than traditional Navajo weavings and silverwork, they are nonetheless deeply grounded in Navajo culture. They also offer some insight into the Navajo life view.

Willeto was born on a Navajo reservation near Ojo Encino, New Mexico, into his mother's Bitterwater clan and his father's Mud clan. After some formal education, he worked for a rancher as a sheepherder on the Jicarilla Apache Reservation. He was also a railroad worker, silversmith, moccasin maker, medicine man, and singer, or *hataali,* and he had knowledge of the "Windway," a five-day blessing chant that includes songs, prayers, the making of sandpaintings,

and other rituals. He married Elizabeth Betonie, a medicine woman whose parents were also practitioners of ritual and ceremony. They had four children, lived in a *hogan,* or mud hut, in a remote area west of the Nageezi trading post, and herded sheep.

Although some of Willeto's early carvings, especially his figures carved with snakes draped over their shoulders, may have had ceremonial functions, his motivation for carving is unknown. Traditionally, ritualistic figurines or dolls were stored away following their ceremonial use, and before the 1930s, it was taboo to carve figures for anything other than ritualistic purposes, a convention to which some Native American carvers remained loyal. Willeto took his figures to a local trading post, however, and used them to barter for groceries and other items. From 1961 to 1964 Willeto carved and painted more than four hundred works, ranging in size from about six inches to five feet in height. Although not often acknowledged, Willeto's wife was responsible for some of the fine painting of the figures, particularly among the early works.

Willeto used a knife for whittling smaller figures and for fine details, and an ax for the larger works that he carved from pine and cottonwood. His early figures were painted with delicate vegetable dyes that were also used in his wife's rugmaking. Later, he used house paint and brushes from Sears Roebuck that were purchased for him by the art collector Greg LaChapelle. LaChapelle was so impressed with the robust vitality of the figures that—along with Rex Arrowsmith, another collector—he purchased all of the Willeto carvings available.

Among other prototype subjects, Willeto painted male warrior figures with arrows in their hands, female weavers with their battens and combs, and the *vaquero,* or cowboy, wearing chaps. Of particular interest are Willeto's medicine men, spirit figures, and deities. Some wear horned caps, signifying power; masks; fur or spruce collars resembling beards; and bold, geometrically patterned clothing, incorporating rhythmic designs made up of triangles, rectangles, and zigzags. Many of the figures are carved with hands raised or sometimes bent at the elbow, gestures reminiscent of those of the earth, sky, wind, and other gods depicted in sandpaintings. All of the decorative detail in Willeto's figures is harmoniously balanced.

Willeto became the first Navajo folk artist to achieve national prominence when, in 1981, a large pair of his figures, part of a traveling exhibition of the Herbert Waide Hemphill Jr. Collection, were exhibited at the Milwaukee Art Museum. Since that first show, Willeto's carvings have been exhibited widely in the United States.

See also **Herbert W. Hemphill Jr.; Native American Folk Art; Sculpture, Folk.**

BIBLIOGRAPHY

Begay, Shabto, et al. *Collective Willeto: The Visionary Carvings of a Navajo Artist.* Santa Fe, N. Mex., 2002.
Carlano, Annie. *Vernacular Visionaries.* Santa Fe, N. Mex., 2003.
Patterson, Tom. *Contemporary Treasures from the Smithsonian American Art Museum.* Washington, D.C., 2000.
Rosenak, Chuck, and Jan Rosenak. *The People Speak: Navajo Folk Art.* Flagstaff, Ariz., 1994.

LEE KOGAN

WILLEY, PHILO LEVI ("Chief" Willey) (1887–1980), from Canaan, Connecticut, was a prolific artist who painted lively anecdotal works based on his own experiences, particularly in the area of New Orleans, where he settled in 1931. In fifteen years, he painted more than 1,800 pictures, including scenes of Mardi Gras, the zoo, Jackson Square, the Mississippi, and the suburbs of New Orleans. His exuberant work has elements of fantasy. Certain figures—a preacher bear, a palomino horse, and a man in red pants—appear and reappear in his paintings.

Willey's pictures typify folk narrative painting: representational, though highly abstract. In his early works, Willey painted in a characteristic flattened, nonperspectival style with watercolors, colored pencils, and crayons. Later, he preferred acrylic paint on canvas or Masonite. His paintings are often 16 by 20 inches, although some of them are larger. His compositional layout characteristically depicts two views—aerial and frontal—simultaneously. The compositions are layered with separated unmixed bands of color, such as green grass, blue water, and brown roads, that create the impression of a patchwork quilt. His vivid blue skies are filled with bright white clouds. Willey rendered landscapes in meticulous detail and with decorative patterning; houses, boats, animals, flowers, trees, and even people are often arranged in decorative rows. In *Friends of Wildlife,* guardian owls watch over treetops at the upper perimeter of the landscape. Willey takes liberties with scale: sometimes birds are larger than trees or cars.

Willey left the family farm at age twelve and traveled throughout the United States, doing various jobs; he was a lumberman, storekeeper, fireman, deckhand, and cowboy, and a wagon driver for the Barnum and Bailey circus. He boxed for a while and was a service manager for the Chevrolet division of General Motors in Saint Louis, Missouri. In the early 1930s,

Willey started work at the New Orleans Sewerage and Water Board; during his more than thirty years there, he became chief of security. He retired in 1965.

Willey was encouraged to paint by his second wife, Cecilia Seixas, who was also an artist. His first paintings were sold in Jackson Square, New Orleans, where he hung them from a fence. Robert Bishop, director of the Museum of American Folk Art in New York (now the American Folk Art Museum), recognized Willey's talent; and there was an exhibition of Willey's work at the State University of New York under the auspices of the Museum of American Folk Art.

Collections that hold Willey's paintings include those of the Museum of International Folk Art in Santa Fe, New Mexico, and the Fenimore Art Museum in Cooperstown, New York.

See also **American Folk Art Museum; Robert Bishop; Painting, Memory.**

BIBLIOGRAPHY

Rosenak, Chuck, and Jan Rosenak. *Museum of American Folk Art Encyclopedia of American Folk Art and Artists.* New York, 1990.

Trechsel, Gail, ed. *Pictured in My Mind: Contemporary American Self-Taught Art from the Collection of Dr. Kurt Gitter and Alice Yelen.* Jackson, Miss., 1995.

Yelen, Alice R., ed. *Passionate Visions of the American South: Self-Taught Artists from the 1940s to the Present.* Jackson, Miss., 1994.

LEE KOGAN

WILLIAMS, MICAH (c. 1782–1837) made pastel portraits that were appreciated by early collectors of American folk art long before he was identified as the artist. When Holger Cahill included portraits of Henry and Phoebe Ayres Mundy, owned by the New Jersey Historical Society, in his exhibition "American Primitives" at the Newark Museum (1930), Williams's work was listed as anonymous. Since then, twenty years of research by Mrs. Irwin F. Cortelyou has made a convincing case for attribution of approximately 120 pastel portraits and seven oil portraits, mostly of sitters in New Jersey, to Williams. Dorer, who has continued to do reseach on this artist, notes that in 1931, Edith Gregor Halpert, owner of the Downtown Gallery, sold Mrs. John D. Rockefeller two portraits by Williams which she herself found in Matawan, New Jersey.

Williams was born in Essex County and was a longtime resident of Middlesex County. According the the records of the First Presbyterian Church in New Brunswick, he married Margaret H. Priestly on Christmas eve, 1806. The couple had six children. A grand-daughter, Anna Morgan, recalled that the artist lived primarily in New Brunswick but also in New York, and that besides creating art he developed a technique for plating silver. Most of Williams's portraits were executed between 1818 and 1830, but the earliest was done in 1810 and the latest in 1835. Williams's art was praised by a critic in the Paterson *Chronicle* and the *Essex and Bergen Advertiser* April 16, 1823, who wrote that although Williams was self-taught, his work demonstrated "correctness of design and execution" and was "worth the patronage of an enlightened public."

According to family tradition, Williams prepared his own pastel crayons. His subjects—men, women, and children, among them many residents of Monmouth County—are occasionally seated or holding a book and are set in plain backgrounds. Williams's style is realistic. There is little modeling; the facial features, caps, collars, hair, and jewelry are detailed. Williams often backed the portraits and the stretchers with sheets from local newspaper.

For more than fifteen years, scholars have questioned whether all the portraits attributed to Williams are actually by him or by one or more other artists. Pastel portraits by James Van Dyck, an artist in Bergen County, are similar to those of Williams but are crisper and more modeled. Attributions are based on comparisons with a few signed examples from each artist's oeuvre, but the results are not always clear-cut.

See also **Pastel.**

BIBLIOGRAPHY

Cortelyou, Irwin. "Micah Williams: New Jersey Primitive Portrait Artist." *Monmouth Historian: Journal of the Monmouth County Historical Association* (spring 1974): 4–14.

Dorer, Nancy Tobin. "Micah Williams: A Recurring Quandary." *Folk Art Magazine* (winter 1993–1994): 41–46.

Hollander, Stacy, and Brooke Anderson. *American Anthem: Masterworks from the American Folk Art Museum.* New York, 2001.

LEE KOGAN

WILLIAMS, WILLIAM (1727–1791) was a native of Bristol, England, who worked as a portrait, ornamental, and theatrical backdrop painter and engraver; as a novelist; and as a drawing and music teacher during his nearly three decades living in the American colonies. By about age twenty, Williams, who had been a mariner, was shipwrecked off the Nicaraguan coast, settled in Philadelphia, and began painting portraits. He left Philadelphia for Jamaica in 1760, returned three years later, then moved to New York in 1769. Williams returned to Bristol in 1776 and died impov-

erished. Williams recorded painting 141 pictures; fourteen have been located.

Williams's artistic maturation occurred during the 1760s, the same decade as John Singleton Copley (1738–1815), but Williams could not claim the younger painter's natural gifts. He was probably self-taught; his portraits reflect the cultural distance between the colonies and England. His figures are somewhat rigid, and he emphasized clothing, props, and backgrounds. Devoting nearly equal attention to subject and background contributes to the provincial quality of his work, but the practice allowed Williams to indicate his sitters' social status and gender roles. The full-length portraits of William and Deborah Hall, son and daughter of a former partner of Benjamin Franklin, are good examples of Williams' mature style. William Hall faces the viewer directly wearing a self-assured expression, standing in a room filled with books, an ornate table, and a window looking out onto ships at sea that suggests his family's business interests. The portrait's linear drawing and elongated proportions demonstrate Williams' limitations, but the likeness successfully establishes William Hall as a wealthy and educated young man engaged in the world of ideas and mercantile pursuits. Fifteen-year-old Deborah, in contrast, wears a ravishing pink dress and stands in an enclosed formal garden picking a rose, a symbol of love. The rose and the circumscribed world Deborah Hall inhabits suggest the circumstances and lifestyle of a privileged eighteenth-century girl.

Lacking firsthand exposure to the latest developments in portraiture, Williams assimilated lessons gained by observing the work of predecessors and other painters. His sophisticated likenesses appealed to colonial America's mercantile aristocracy and influenced other artists. The crucial role Williams played in the development of an American art was underscored by Benjamin West (1738–1820) when he stated that Williams had been the principal influence on his decision to become an artist.

See also **Painting, American Folk.**

BIBLIOGRAPHY

Craven, Wayne. *Colonial American Portraiture*. Cambridge, England, 1986.

Saunders, Richard H., and Ellen G. Miles. *American Colonial Portraits, 1700–1776*, Washington, D.C., 1987.

RICHARD MILLER

WILLIAMSON, CLARA MACDONALD ("Aunt Clara") (1875–1976) depicted the rural town life that she remembered from her childhood in Iredell, a West Texas frontier community. Her more than 100 paintings include representations of cattle drives, square dances, cotton picking, planting, harvesting, camp meetings, and the town's first railroad.

Vogel and Vogel note Williamson's "restrained palette" and "close color harmonies," hallmarks of her style that give her painted panoramas atmospheric qualities transcending mere narrative. Iredell, Williamson's birthplace, was a cotton town and a stop on the old Chisolm Trail. In a signature autobiographical work, *Get Along Little Dogies*, a little girl, (the artist) stands under a tree watching Texas longhorn cattle, guided by cowboys, cross the Bosque River above waterfalls. The steady movement of the herd contrasts with the stillness of the stream; the blue-gray of the water is a backdrop for brown hues of the cattle; and the scene is framed by gently curving banks with grass and trees.

Williamson was the second of six children. She attended school when she could, but home chores and duties prevented her from getting the education she wanted. An opportunity to leave Iredell came when her uncle offered her a job in Waxahachie after becoming a county clerk. She returned to Iredell married, took care of her own children and her stepchildren, and worked in her husband's dry goods store. In 1920 the Williamsons moved to Dallas, where they also ran a store.

Williamson was interested in painting, but her husband believed that it was a waste of time. It was not until he died in 1943 that she began to paint. Williamson remembered that her mother had artistic inclinations and had pieced quilts, hooked rugs, and painted a picture. Williamson enrolled at the Dallas Museum School, and it was there that she met the painter and, later, gallery owner Donald Vogel. She once told Vogel, "I try to acomplish realism, truth, beauty, and some amusement in my pictures . . . and record my memories."

Williamson had a unique method: she would begin at the top of the canvas and work her way down as if "drawing a window shade"; she told Vogel that it was practical for her "not to get her hands into the paint." She worked mostly in oil on canvas but did some charcoal sketches and watercolors.

Williamson's paintings are in the Museum of Modern Art (New York), Dallas Museum of Fine Arts, Amon Carter Museum (Fort Worth, Texas), and Wichita Art Museum.

See also **Painting, Memory.**

BIBLIOGRAPHY

Adele, Lynne. *Spirited Journeys: Self Taught Artists of the Twentieth Century*. Austin, Tex., 1998.

Rosenak, Chuck, and Jan Rosenak. *Museum of American Folk Art Encyclopedia of American Folk Art and Artists*. New York, 1991.

Steinfeldt, Cecilia. *Texas Folk Art: One Hundred Fifty Years of the Southwestern Tradition*. Austin, Tex., 1981.

Vogel, Donald, and Margaret Vogel. *Aunt Clara: The Paintings of Clara McDonald Williamson*. Austin, Tex., 1966.

LEE KOGAN

WILLSON, MARY ANN (fl. c. 1800–c. 1830) is a singular figure in the canon of early nineteenth-century American art. Since the 1940s, when twenty of her idiosyncratic watercolors were discovered, Willson's work has resonated with the modern interest in abstraction and, more recently, with a heightened interest in visionary art. The watercolors were first exhibited in 1944 at the Harry Stone Gallery in New York. Jean Lipman, then editor of *Art in America*, wrote the catalog essay and printed in its entirety a letter handwritten about 1850 by an anonymous "Admirer of Art" whose legacy included the watercolors. This and a second letter, similar in content, now in the collection of the Vedder Library, Bronck Museum, in Coxsackie, New York, remain the most complete sources of biographical information about the artist.

The "Admirer of Art" wrote openly of Willson's "romantic attachment" to another woman, a Miss Brundage. According to this correspondent, the artist and her companion lived in Greenville, Greene County, New York, after having left an "Eastern" state, probably Connecticut. This rural community apparently embraced the two women: neighbors helped Miss Brundage cultivate the land and bought paintings from Willson. The pair are also mentioned in *Picturesque Catskills, Greene County* by R. Lionel De Lisser (1894). De Lisser describes Greene County and its significant citizens and states that the women had emigrated together from the "old country" to Connecticut, and from there to Greenville.

Willson may have made her own stains from berries, bricks, and other natural sources, using store-bought paint only occasionally. With these simple materials, she realized her artistic vision through broad areas of color (usually red, orange, green, and brown), nervous ink work, and decorative patterning. She relied on print sources for several of her watercolors, notably the series depicting the parable of the prodigal son (Luke 15:11–32), which transforms conventional engravings into apocalyptic scenes.

Among Willson's best-known works are *Mare-maid*, a figure combining the characteristics of a mermaid with attributes of an Amazon woman; and *Three Angel Heads*, which depicts female heads with wings floating in space. Four lines of verse are written in ink below the angels. In 1998, when the American Folk Art Museum in New York presented the exhibition "Mary Ann Willson: Artist Maid," these lines were identified as part of a Methodist hymn, "O Thou God of My Salvation," written by Thomas Olivers. The time when Willson and Brundage came to Greenville was marked by a religious fervor to which New York state was especially receptive, so religion may have been a factor in their move to Greene County. From Willson's depictions of clothing and other period details, we can surmise that the women lived there from about 1800 to 1825 or 1830.

Mary Ann Willson left Greene County shortly after the death of her companion; where she went is unknown, and she left no documentary trail. Ten watercolors from the original group of twenty, as well as the original letter, are now in the M. and M. Karolik Collection at the Museum of Fine Arts, Boston, the largest repository of her work.

See also **American Folk Art Museum; Maxim Karolik; Jean Lipman; Visionary Art.**

BIBLIOGRAPHY

Hollander, Stacy C. "May Ann Willson: Artist Maid." *Folk Art,* vol. 23, no. 2 (summer 1998): 20–23.

Karlins, N.F. "Mary Ann Willson." *The Magazine Antiques*, vol. 110, no. 5 (November 1976): 1040–1045.

Lipman, Jean. *Miss Willson's Watercolors*. New York, 1944.

Lipman, Jean, and Tom Armstrong, eds. *American Folk Painters of Three Centuries*. New York, 1980.

Lipman, Jean, and Alice Winchester, eds. *Primitive Painters in America 1750–1950*. Freeport, N.Y., 1971.

Ward, Gerald W.R., et al. *American Folk: Folk Art from the Collection of the Museum of Fine Arts, Boston*. Boston, 2001.

Rumford, Beatrix T., ed. *American Folk Paintings*. Boston, 1988.

STACY C. HOLLANDER

WINCHESTER, ALICE (1907–1996), the second editor of *The Magazine Antiques*, and a book editor, author, lecturer, and scholar, was one of the most influential spokespersons for the collecting fields of American antiques and folk art during her tenure at the magazine from 1939 until 1972. Born December 9, 1907 in Chicago, Illinois, she grew up in Concord, Massachusetts, the daughter of a clergyman. Educated at Smith College, she worked for a brief time at the Chase National Bank in New York City before joining the staff of *The Magazine Antiques* in the summer of 1930 as secretary to Homer Eaton Keyes, its founding editor. A year after Keyes's death in October 1938, Winchester was named editor in March 1939.

Winchester's monthly editorials and careful selection of articles put her at the forefront of the American antique-collecting public. She published groundbreaking research by leading furniture and decorative arts historians and curators including Joseph Downs, Charles F. Montgomery, Marshall B. Davison, Irving W. Lyon, and Helen Comstock. Many of these articles set a new standard for documentary investigation and formal analysis. She launched magazine features such as "Living with Antiques," featuring private dwellings and "History in Houses," reserved for buildings open to the public.

A catalyst for the early study, codification, and connoisseurship of American folk art, Winchester published documentary articles about individual folk artists, craftsmen, and regional schools written by Mabel M. Swan, Esther Stevens Brazer, E. Alfred Jones, Carl W. Dreppard, Jean Lipman, and Nina Fletcher Little. Winchester promoted the folk art collections being assembled in the newly formed museums of American furniture and decorative arts, devoting entire issues to Winterthur Museum, Colonial Williamsburg, Shelburne Museum, Greenfield Village, Henry Ford Museum, Mr. and Mrs. Flynt's preservation efforts at Historic Deerfield, and the restored outdoor Shaker museums at Hancock, Massachusetts, and Pleasant Hill, Kentucky. "Living with Antiques" featured the homes of the folk art collections of Bertram K. and Nina Fletcher Little, Mary Allis, Stewart Gregory, and Mr. and Mrs. Clarence W. Brazer, among others.

The May 1950 issue of *The Magazine Antiques* marked a seminal moment in the study of American folk art. This all-folk art issue ran the best of a symposium organized by Winchester entitled, "What is American Folk Art?" The differing opinions of thirteen specialists are recorded, resulting in the nearly universal adoption of the term "folk art." Other articles in this volume examined Norwegian and British folk art and the folk arts of the American Southwest.

Following her retirement from *Antiques*, Winchester published her research on the folk artist Jonathan Fisher in *Versatile Yankee: The Art of Jonathan Fisher* (1973). Her professional associations with Jean Lipman, the editor of *Art in America*, resulted in their co-authorship of *Primitive Painters in America, 1750–1950* (1950) and the seminal 1974 catalogue and exhibition, *The Flowering of American Folk Art, 1776–1876* in which she served as co-author of the catalogue and curator of the exhibition.

Among the many awards Winchester received during her lifetime were the Smith College Medal (1968) and the Henry Francis duPont Award for the Decorative Arts, given by Winterthur Museum, Garden and Library (1990). She was also the recipient of a number of honorary degrees. Alice Winchester died 9 December 1996, a month before the seventh-fifth anniversary edition of *The Magazine Antiques*.

See also **Abbey Aldrich Rockefeller Folk Art Museum; Mary Allis; Stewart Gregory; Jean Lipman; Nina Fletcher Little; Shelburne Museum; Winterthur Museum.**

BIBLIOGRAPHY

Garrett, Wendell. "Editorial." *The Magazine Antiques*, vol. 41, no. 2 (February 1997): 310–311.

Lipman, Jean, and Alice Winchester. *The Flowering of American Folk Art, 1776–1876*. New York, 1974.

Winchester, Alice, ed. *The Antiques Treasury of Furniture and Other Decorative Arts*. New York, 1959.

———, ed. *The Antiques Treasury of Furniture and Other Decorative Arts at Winterthur, Williamsburg, Sturbridge, Ford Museum, Cooperstown, Deerfield, Shelburne*. New York, 1959.

———. "Rediscovery: Parson Jonathan Fisher." *Art in America*, vol. 58, no. 6 (November-December 1970): 92–99.

———. *Versatile Yankee: The Art of Jonathan Fisher*. Princeton, N.J., 1973.

CYNTHIA VAN ALLEN SCHAFFNER

WINDMILL WEIGHTS, perhaps more than any other form of folk art, have come to be associated with the way of life of the pioneering American farmer. These cast iron objects, often in the shape of an animal or celestial body, not only served a utilitarian purpose, but also came to symbolize the submission of the prairie and the independent farmer's struggle for success in an often hostile climate.

When the first settlers pushed into the Great Plains (roughly the area from the Mississippi to the Rocky Mountains) they found fertile soil but little water. Lacking streams and adequate rainfall, they employed windmills to provide well water for crops. Windmills required a heavy weight at the end of the horizontal shaft that extends back from the wind wheel, both to balance the great weight of the wind vanes and to govern the speed of the windmill in varying winds. Any large lump of iron would have done the trick, but the manufacturers quickly recognized that an attractive form would be more appealing to customers and might also serve to advertise their products.

From the 1860s through the 1930s numerous foundries turned out a multitude of weights, weighing between ten and a hundred pounds each. Many took the form of farm animals. Roosters were especially popular, but cows, bulls, horses, and other beasts are found as well. Many of these became closely associated with a particular maker, such as the various

horse forms employed by Nebraska's Dempster Mill Manufacturing Company and the Elgin (Illinois) Windpower and Pump Company's rooster. Viewed from a distance across the flat land and recognizable to all, these became, in effect, trade signs.

Some of these weights were more popular than others, and in some cases customers had very specific objections to a particular form. For example, the Elgin Company introduced a squirrel-shaped weight, only to discover that farmers hated the crop-eating rodent. On another occasion, a crescent moon form with the open end down was altered so that ends faced up, as farmers complained that the former "wouldn't hold water" in time of drought.

The crescent moon was one of many non-livestock weight forms. Others included letters (often company initials), celestial bodies like stars, bells, lucky horseshoes, hearts, wagon wheels, shields, and spears, a patriotic eagle and, the buffalo, which the settlers had displaced from the plains.

Today weights are often found in polychrome hues. However, they were originally painted to match the windmills, most often in black, blue, red, or green. Many collectors prefer a dark rusted surface, which reflects many years of service on the windswept prairies.

See also **Metalwork.**

BIBLIOGRAPHY

Nidey, Rick, and Don Lawrence. *Windmill Weights*. Boise City, Okla., 1996.
Simpson, Milt. *Windmill Weights*. Newark, N.J., 1985.

WILLIAM C. KETCHUM

WINTERTHUR MUSEUM, founded in 1951 in Winterthur, Delaware, is a country estate, the former home of Henry Francis du Pont (1880–1969). It is most often thought of in connection with its high-style American furniture and decorative arts, but some of du Pont's earliest acquisitions reflect his abiding interest in American folk art.

Winterthur is filled with appealing objects, such as quilts, hooked rugs, redware, and earthenware; some even have their own rooms, such as the Spatterware Hall. Du Pont's aesthetics became more refined and his collecting accelerated in the 1920s, after he visited the collectors Electra Havemeyer Webb (1888–1960) in Shelburne, Vermont, and Henry Davis Sleeper (1878–1934) in Gloucester, Massachusetts.

Although its holdings include folk art from New England, Winterthur has the largest single collection of Pennsylvania German folk art. Du Pont wanted to demonstrate that items produced in the mid-Atlantic region could rival anything from New England. Fraktur, tinware, and pottery are displayed throughout the house and are featured in dedicated areas such as the Fraktur Room, the Pine Kitchen, and the End Shop, a restored dry goods store displaying an outstanding array of handmade wares that would have been available for sale in the eighteenth and nineteenth centuries. Hallways and alcoves throughout the museum hold wood carvings by Wilhelm Schimmel (1817–1890), painted blanket chests, and whimsical wrought iron. Several hand-painted interiors from historic buildings were painstakingly dismantled before the buildings were demolished, and were then reconstructed in the museum. The folk objects show the same emphasis on harmony of color, size, material, and proportion that can be seen in the more formal period rooms where the finest examples of American style and craftsmanship are displayed.

Many of the period rooms are dotted with works by some of America's best folk artists, including Edward Hicks (1780–1849) and Jacob Maentel (1778–1863). Painted furniture from the Mahantango (or Mahantongo) Valley shares space with the finest Philadelphia high chests. Household textiles made by girls are displayed beside the finest English textiles used in colonial revival bed hangings.

Unlike Winterthur's finer pieces that have been cleaned and in some cases restored to their original splendor, the folk art retains original surface and wear patterns. Winterthur's collection of more than 85,000 objects celebrates American craftsmanship in the fine decorative arts and in folk art.

See also **Henry Francis du Pont; Fraktur; Furniture, Painted and Decorated; Edward Hicks; Hooked Rugs; Jacob Maentel; Pennsylvania German Folk Art; Pictures, Needlework; Quilts; Redware; Samplers, Needlework; Wilhelm Schimmel; Tinware, Painted; Electra Havemeyer Webb.**

BIBLIOGRAPHY

Ames, Kenneth L. *Beyond Necessity: Art in the Folk Tradition.* Winterthur, Del., 1977.
Fiske, Betty, and Anne A. Verplank. "Vernacular Art at Winterthur." *The Magazine Antiques*, vol. 161, no. 1 (January 2002): 194–199.
Swank, Scott T. *Arts of the Pennsylvania Germans.* Winterthur, Del., 1983.

LAURA TILDEN

WOOD CARVING: *SEE* AFRICAN AMERICAN FOLK ART; JOHN HALEY BELLAMY; WILLIAM BOWMAN;

FREDERICK FRIED; RUFUS HATHAWAY; JEWISH FOLK ART; HENRY LEACH; SAMUEL MCINTIRE; MARITIME FOLK ART; CARL MCKENZIE; NOYES MUSEUM OF ART; WILLIAM RUSH; WOODENWARE.

WOODENWARE, which is also called *treen*, from the old English for "tree," refers to a variety of small objects sawed or carved from wood and utilized primarily within the household. Pipe boxes, candlesticks, and even washboards are considered woodenware by modern collectors.

The history of wooden utensils is reflected in both their necessity and preference in the home. The earliest American settlers and, for many years after, residents of isolated areas of the United States, used wood to make bowls, plates, and mugs for the table because of its practicality. Wood was an abundant material in much of the country; the forests were filled with trees ready to be cut and shaped. Similar pottery articles or those made from glass or tin were often not readily available or too expensive.

Native Americans employed pine, poplar, and the harder wood of the maple to manufacture household items. Northwest coast tribes, for example, made their wooden banquet dishes in the shapes of abstract frogs, bears, and other animals. They used fire and crude carving tools to form their woodenware, as did American settlers who introduced the foot- or water-powered lathe in the seventeenth century.

Woodenware objects would have eventually disappeared if lack of similar objects in other mediums had been the only reason those made from wood existed. Today, few homes are without some form of woodenware (salad bowls, wooden pepper grinder,

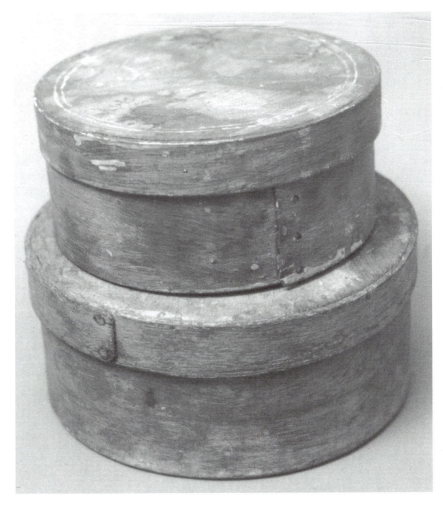

Pair of woodenware cheese boxes. New Jersey, c. 1850–1880. Paint over gesso on carved pinon wood. © Esto.

or rolling pins are popular examples), because the softness, luster, and utility of these objects has assured them a place in the modern household. Few contemporary examples, however, are handmade. In fact, by the mid-nineteenth century factories produced most woodenware. The 1883 catalog of New York City's L.H. Mace & Co., an important supplier of woodenware, illustrated hundreds of factory-produced, wooden items for the home.

Woodenware objects fall into several broad categories. Early tableware of the eighteenth century, including turned bowls, plates, and platters, or trenchers; hand-carved knives, forks, and spoons; salt containers; tankards; mugs; and carved pitchers called "noggins" are all objects sought by American woodenware collectors. Saw-cut and nailed boxes with carrying handles, designed to store cutlery, are prized items, while lathe-turned, covered sugar bowls, such as those made by Ohio's Pease family in the mid-1800s, were once found on every table. Late Victorian forms (c. 1870–1910), include napkin rings, small vases or urns, table mats, toothpick holders, and egg cups. Some of these, creatively hand-decorated with paint or inlay, bear the name of a scenic location, such as Saratoga Springs or Catskill Mountain House, where they were sold as tourist souvenirs.

Food preparation required a large number of utensils. Mortars and pestles were often made from durable *lignum vitae,* to withstand frequent use and wear and tear from grinding hard substances such as spices or cracked corn. Once ground, these were stored in eighteenth-century spice cabinets or, later (c. 1850–1900), in factory-made canisters. Large pine or maple bowls were common throughout the eighteenth and nineteenth centuries, both for chopping food items and for the "working" of butter with a flat, short-handled butter paddle. What was not chopped was sliced with a variety of iron-bladed, wooden-bodied vegetable slicers. Other wooden, labor-saving devices such as cherry pitters and apple corers were also produced. Home baking required a covered box for dough, the ubiquitous rolling pin, and a breadboard for rolling out the dough. A long-handled, shovel-like tool called a "peel," familiar from today's pizza parlors, was used to remove baked goods from the hot oven.

All sorts of storage receptacles were made partly of wood. Wooden "band boxes," primarily used for hats in the early 1800s, were covered with colorful wallpaper. Many types of nineteenth-century round or oval, covered boxes were made by bending flexible strips of steamed birch or maple into shape over a pine bottom. Best known are the popular Shaker-made examples from about 1850 to 1920. Tiny boxes were produced to hold medicine or herbs, while anything from butter to buttons could be found in the larger ones. Early nineteenth-century wall boxes were designed to preserve salt and other precious cooking ingredients, while tinfoil-lined caddies were made to hold a family's supply of tea.

There are innumerable other wooden forms made in the 1700s and 1800s, but most interesting and sought after are the decorated examples of woodenware. Boxes or bowls with an old paint surface, chip-carved spice cabinets, and carved or painted items which reflect the maker's affection for an object's recipient are examples of woodenware that draw the collector's eye. The eighteenth-century German settlers of Pennsylvania and North Carolina made particularly distinctive woodenware objects, painted with symbols from their homelands, such as starbursts and mythical birds, and notch-carved with surface decoration.

See also **Boxes; Butter Molds; Cake Prints; German American Folk Art; Native American Folk Art; Shakers.**

BIBLIOGRAPHY

Card, Devere A. *The Use of Burl in America.* Utica, N.Y., 1971.

Earle, Alice Morse. *Home Life in Colonial Days.* New York, 1898.

Gould, Mary Earle. *Early American Woodenware.* Rutland, Vt. 1962.

Ketchum, William C. *American Basketry and Woodenware.* New York, 1974.

Little, Nina Fletcher. *Country Arts in Early American Homes.* New York, 1975.

———. *Neat and Tidy: Boxes and Their Contents Used in Early American Households.* New York, 1980.

Phipps, Frances. *Colonial Kitchens, Their Furnishings and Their Gardens.* New York, 1972.

Pinto, Edward H. *Treen and Other Wooden Bygones.* London, 1969.

WILLIAM C. KETCHUM

WRITING SAMPLERS: *SEE* FRAKTUR.

YARD SHOW denotes one of the oldest and most dynamic visual traditions in black America, especially the South. The process of "working in the yard" or "dressing the yard" to create outdoor displays appears throughout black neighborhoods across the United States (and perhaps the rest of the black diaspora). Thousands of black homes are decorated with a seemingly unlimited assortment of materials: bottles, tires, secondhand housewares, real and artificial flowers, reflective objects, tools, garments, automobile parts, special plantings, wires and ropes, seats, stones and roots, as well as occasional hand-lettered signs. These yards have been the original display contexts for numerous surviving artworks, and have existed in some form since the nineteenth century. Many African-American vernacular artists—Nellie Mae Rowe, Lonnie Holley, David Butler, Charlie Lucas, Joe Light, Royal Robertson, Dilmus Hall, Mary Smith, Hawkins Bolden, Cleveland Turner, and Sam Doyle, among others—were recognized initially for their yard art environments.

The yard show's origins lie partly in the "make-do," improvisational, creative stance of a historically disenfranchised people, and partly in religious and metaphysical traditions traceable to African and Native American antecedents that also survive in other areas of African American culture. While yards decorated with found materials and artworks may be common to all the world's peoples, and especially prevalent among the marginalized, the "yard show" refers to a specific set of methods for treating ("dressing") the yard and home. The term "yard show" emerged from ideas proposed in the 1980s by African art historian Robert Farris Thompson and was codified by him in his 1993 book and exhibition *Face of the Gods: Art and Altars of Africa and the African Americas,* which posited the black yard as a displaced, personalized religious site or shrine whose terms inform much of the creative activities of black people in the diaspora.

The yards assume a wide range of forms, from spare arrangements of planters and rock formations to dense clusters of found objects interwoven among buildings and natural features such as trees. The uses of yard shows are equally diverse, from practical gardens and spaces designed for outside living in warm climates, to complex autobiographical statements about the maker's identity, in which materials assume symbolic meanings and relationships. In every event, yard shows become points of literal and figurative contact between the private and public spaces of a community, performing commemorative, honorific, spiritual, narrative, hortatory, and sometimes transgressive functions as a cultural discourse that evades neat pigeonholing as art, religion, landscape design, archive, or simply expedient storage.

See also **Hawkins Bolden; David Butler; Sam Doyle; Environments, Folk; Dilmus Hall; Lonnie Holley; Joe Light; Charlie Lucas; Nellie Mae Rowe; Mary Smith.**

BIBLIOGRAPHY

Arnett, William, and Paul Arnett, eds. *Souls Grown Deep: African American Vernacular Art of the South, vol. 2.* Atlanta, Ga., 2001.

Gundaker, Grey, ed. *Keep Your Head to the Sky: Interpreting African American Home Ground.* Charlottesville, Va., 1998.

Thompson, Robert Farris. *Face of the Gods: Art and Altars of Africa and the African Americas.* New York, 1993.

PAUL ARNETT

YOAKUM, JOSEPH (1890–1972) produced some 2,000 landscapes in colored pencil, graphite, pastel, chalk, watercolor, ink, ballpoint pen, and fiber-tip pen on paper. These stylized landscapes have captions identifying the place: his home town is shown in the sketch *This Is the Flooding of the Sock River through the Town of Ash Grove Missouri on July*

Fourth 1914; other works bear titles from all over the world—Wales, Italy, China, Russia, Africa, Asia, Antarctica. The topography serves the overall abstract presentation, in which rocks and clouds frequently take on human characteristics. Yoakum's landscapes are largely uninhabited by animals or people, but he did some portraits, including African Americans such as Chick Beamon, Althea Gibson, Bessie Smith, and Ethel Waters.

Yoakum was born in Ash Grove, Missouri (not in Window Rock, Arizona, as he claimed) and was of Cherokee, Creek, and African American extraction. He joined the Great Wallace Circus at age nine and was also associated with other circuses and entertainments. Yoakum's landscapes have been considered fantasies, but scholars now think he may have visited many places as an advance man for these circuses, and some of his subjects may have been inspired by the mythological, biblical, historical, and oriental elements of circus performances. Yoakum married; had five children; served in World War I; worked as a sailor, railroad porter, and custodian; and ran an ice cream business in Chicago.

Yoakum drew "all his life" but began to draw more seriously in the 1950s, when he retired. In 1965–1970 he started to work on a larger scale. In his storefront studio, he would complete a drawing every day or two. He sketched in pencil (freehand, except that he used a coin to draw the sun and a straightedge for houses), then went over the outlines with a pen. He wrote a title after a work was finished, and he signed and dated some works (although the authenticity of the dates is questionable). By 1965 he used pastel, colored pencils, and chalks sparingly, and he gradually abandoned watercolor.

Yoakum's art was first shown in a church near Chicago State College. His reputation was enhanced by the enthusiasm of artists from the School of the Art Institute of Chicago, such as Ray Yoshida, Whitney Halstead, Roger Brown, Jim Nutt, and Gladys Neilssen. Pennsylvania State University held an exhibit of Yoakum's drawings (1970). The Chicago Art Institute mounted the first major retrospective (1990s). Drawings by Yoakum are at the American Folk Art Museum, Chicago Art Institute, Milwaukee Museum of Art, and Smithsonian American Art Museum.

See also **Painting, Landscape; Seifert, Paul.**

BIBLIOGRAPHY

Animistic Landscapes: Joseph Yoakum Landscapes. Philadelphia, 1989.

De Passe, Derrel. *Traveling the Rainbow: The Life and Art of Joseph E. Yoakum.* Jackson, Miss., 2001.

Livingston, Jane, and John Beardsley. *Black Folk Art in America, 1930–1980.* Washington, D.C., 1981.

Longhauser, Elsa. *Self-Taught Artists of the Twentieth Century: An American Anthology.* San Francisco, 1990.

Rosenak, Chuck, and Jan Rosenak. *Museum of American Folk Art Encyclopedia of Twentieth-Century American Folk Art and Artists.* New York, 1990.

Tuchman, Maurice, and Carol Eliel. *Parallel Visions: Modern Artists and Outsider Art.* Princeton, N.J., 1992.

LEE KOGAN

ZAHN, ALBERT (1864–1963) carved birds to adorn the exterior of his house in Baileys Harbor, Door County, Wisconsin. Handcarved Hessian soldiers, patriarchal figures, angels, men, women, and more birds embellished the interior. At "Birds Park," as he called it (local people called it "Zahn's Birdhouse"), birds were mounted on the front columns, nailed to other parts of the house, and placed on pedestals. The people who came to see Birds Park, a popular tourist locale, often bought, for twenty-five cents to five dollars, the polychromed carvings Zahn was willing to sell.

Zahn was born in Pomerania in Germany in 1864. He came to America as a young man and eventually bought a dairy farm just outside Baileys Harbor. In 1924, he moved to Baileys Harbor, where he designed and, with his family's help, built a cement house. At this time he returned to wood carving, a craft that he had learned in Germany. According to his daughter, Evelyn Langohr, he carved birds to "trim" the house. He carved them during winter evenings, and his wife, Louise, then painted them in red, blue, black, and white, using a book to lend authenticity to the various species: blue jays, cardinals, canaries, hawks, and so on. Zahn also occasionally carved deer, lions, toy boats, and other figures. He used cedar, hand tools (jackknife, handsaw, and hatchet), and an awl to wire the wings. Over the years, he made thousands of carvings.

Zahn's work was influenced by his German heritage, his lively imagination, his Lutheran beliefs and practices, wild animals and birds, and the sea captains that figured in the history of Baileys Harbor. His most striking carvings include angels and the Hessian soldiers and patriarchs, with their unusual and complex geometric, pyramidal settings. Zahn called these structures "family trees" (Rosenak and Rosenak). According to Julia Guernsey of the Milwaukee Art Museum, Zahn's son Elmer said that the arranged figures may refer to a psalm of David (Psalms, 144:12–13).

When Zahn moved to Sturgeon Bay after his wife died in 1950, Birds Park remained unoccupied for a while. At the time of this writing, the current occupants hoped to buy back some of the artwork and restore the property to its former condition.

Zahn's carvings are in the collections of the Art Institute of Chicago, the Guggenheim Museum of Art in New York, and the Milwaukee Museum of Art.

See also **Sculpture, Folk.**

BIBLIOGRAPHY

Blei, Norbert. "Albert Zahn: The Man Who Carved Birds." In *Door Way*. Granite Falls, Minn., 1981.

Rosenak, Chuck, and Jan Rosenak. *Museum of American Folk Art Encyclopedia of American Folk Art and Artists*. New York, 1991.

LEE KOGAN

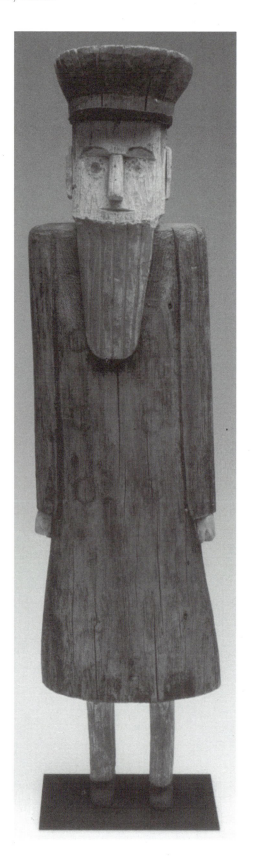

ZELDIS, DAVID (1952–) creates haunting graphite and colored pencil drawings that convey deep emotions, fears, and ideas. In his drawings, Zeldis portrays a variety of subjects including the desolate landscapes of other worlds. Devastation in a deserted subway station, remnants of buildings in a battle-scarred city, and a medieval dungeon all suggest imminent danger, alienation, isolation, and loneliness. Clocks as metaphors for past, present, and future time appear in many drawings. A Gothic-inspired iconography—rats, bats, roaches, skulls, flickering candles, and cobwebs—underscores a feeling of unrest. Games of chance such as roulette, featured in architectural settings, suggest life's unpredictability. Zeldis's intricate drawings, executed over hundreds of hours, also contain elements of mystery and seduction.

In *Homo Religio Dies* (1971), a finely drawn graphite work, Zeldis's composition is scattered with the remnants of some cryptic devestation, including a futuristic insect with a flaming phallus, a headless automaton, and another presumably dying figure with a surreal plant form sprouting from its head.

Occasionally he veers from surrealistic landscapes and architectural settings to draw a portrait of Abraham Lincoln, an arrangement of flawlessly colored seashells, a couple embracing on a beach, or a star-studded sky highlighting starfish, crab, conch, and scallops. These drawings suggest faith in life's possibilities, the potential to love, and the beauty of nature. Zeldis, who began drawing in the 1970s, has created over one hundred drawings to date. Figures and forms are schematically drawn and the skewed spatial perspective is suggestive of mood rather than place or time.

Son of the self-taught artist Malcah Zeldis and the writer Chaim Zeldis, the artist was born in Beersheba, Israel, moved to America when he was five, and studied photography at the School of Visual Arts in New York. Zeldis is also the author of a book of poetry, *Carmen and Her Parakeet*, and a science fiction novel, *The Time Sphere*. The Akron Museum of Art in Akron, Ohio mounted a one-person exhibition of his drawings in 2002.

See also **Outsider Art, Malcah Zeldis.**

Sea Captain. Albert Zahn; c. 1945. Carved and painted wood; 32 × 9 inches. Collection of John and Margaret Robson.

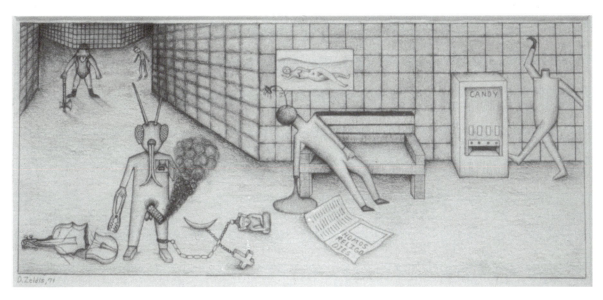

Homo Religio Dies; David Zeldis; 1971. Graphite on paper; 4½ × 10½ inches. Collection of the artist.

BIBLIOGRAPHY

Karlins, N. F. "Mindscapes of Fantasy." *Raw Vision Magazine*, vol. 18 (spring 1997): 42–43.

Kogan, Lee. "David Zeldis: Much Love to Bring/Our Imperfect Universe in His Creative Journey." *Fine Art*, vol. 24, no. 2 (2000): 68–69.

. LEE KOGAN

ZELDIS, MALCAH (1931–) is a self-taught painter whose parents emigrated from Russia. Born in New York in 1931, Zeldis is today widely known for her spirited paintings and works on paper. Zeldis depicts a broad range of iconography including Jewish, celebrations, religious and biblical themes, fairy tales, heroes and heroines, and scenes of everyday life. Despite the fact that her work is laced with autobiography, Zeldis's art often transcends time and place, and her energetic, lively narratives suggest a strong concern for human rights. She has portrayed the scenes from the Nazi Holocaust, Hiroshima, the massacre at My Lai, and the attack on the World Trade Center in 2001.

Zeldis was born the Bronx, New York in 1931; her given name was Mildred Brightman. The family moved to Detroit, where her father owned a window-cleaning company. He painted as a hobby and often took his children to the Detroit Institute of Art. In 1948, after graduating from high school, Mildred, who had strong Zionist leanings, went to live in the new state of Israel. There she married a writer, Hiram Zeldis, who was also from Detroit, and settled on a kibbutz (a cooperative farm) near Beersheba. The

Israeli artist Aaron Giladi visited the kibbutz, saw some of Zeldis's biblical paintings, and encouraged her to paint seriously. However, she did not do so until the 1970s, after she and her husband had resettled in New York, their children had grown up, they themselves had been divorced, and she had taken a college degree in education.

Zeldis paints in oil on canvas, Masonite, and cardboard, and in gouache on paper. She works quickly and does not mix colors, so as not to impede her creative momentum; as a result, her juxtaposed colors vibrate with an intense rhythm. Zeldis also paints on furniture and textiles and has made terracotta sculptures as well as assemblages from discarded objects. Her compositions are highly organized, often geometric, and frequently encompass complex narratives. The artist frequently paints in series, creating multiple canvases on a singular theme. *Miss Liberty* (1987), for example, includes images of Ludwig van Beethoven, Charlie Chaplin, Abraham Lincoln, Elvis Presley, Martin Luther King Jr., Nelson Mandela, Marilyn Monroe, and the pioneer folk art collector Herbert Waide Hemphill Jr., along with her own family members and friends, who surround the Statue of Liberty against a sky filled with exploding fireworks.

Other vernacular subjects include baseball, and Zeldis has painted scenes featuring Hank Greenburg, Joe Dimaggio, Orlando Hernandez ("El Duque"), and Derek Jeter and Bernie Williams of the New York Yankees. *Homage to Hank Greenburg* (oil on Maso-

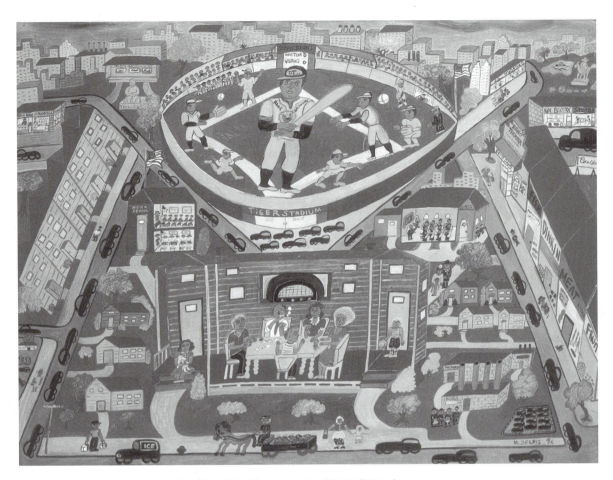

Homage to Hank Greenburg; Malcah Zeldis; 1991. Oil on Masonite; 37½ × 49½ inches; N-80.91. Collection of Fenimore Art Museum, Cooperstown, New York. © New York State Historical Association, Cooperstown, New York. Photo courtesy Richard Walker

nite, 1991) depicts the iconic baseball player (1933 to 1947) in Tiger Stadium, Detroit, Michigan. The brilliantly hued, symmetrical composition comprises a bird's eye view of the stadium and the surrounding city, including vignettes of the Alger School, the neighborhood synagogue, workers from the venerated Ford Plant, as well as a family playing cards and listening to the game on the radio. The intensely compressed perspective and meticulously rendered details exude a delightful rhythm and optimism characteristic of Zeldis's homage pictures.

Zeldis has had nine solo exhibitions including the American Folk Art Museum of New York and the Grey Art Gallery at New York University in 1988; an exhibition titled "To Anne with Love" was held at the Holocaust Memorial and Educational Center of Nassau County, New York, in 2000. Zeldis has also illustrated eight children's books.

See also **Painting, American Folk; David Zeldis.**

BIBLIOGRAPHY

Neimann, Henry. "Malcah Zeldis: Her Art." *Clarion*, vol. 13, no. 3 (summer 1988): 49, 52–53.

Rosenberg, Willa S. "Malcah Zeldis: Her Life." *Clarion*, vol. 13, no. 3 (summer 1988): 48, 50–51.

LEE KOGAN

ZOETL, JOSEPH (1878–1961), a lay brother at St. Bernard Abbey in Cullman, Alabama, was the creator of the Ave Maria Grotto, centerpiece of a garden that is filled with miniature replicas of all the important, and many of the lesser, churches of the Holy Land, Europe, and North America. Born in Bavaria, Germany, he was recruited at age fourteen by the Benedictine order for a new monastery they were establishing in Alabama; he arrived in Cullman in February

1892 with the hope of becoming a priest. Whether because of physical infirmities (he became severely hunchbacked as a young man) or because he was not an outstanding student, he did not attain the priesthood. Instead, he stayed on at St. Bernard Abbey as a lay brother, working in the kitchen and dining room and eventually, in 1912, becoming responsible for the Abbey power house, with its steam boilers and generators.

Soon after, Zoetl began building architectural replicas in tinted cement, basing his creations on images from post cards, travel brochures, and encyclopedias. In the early 1930s, he received permission from the Abbot to install his miniatures in an abandoned quarry on the monastery grounds. At the same time, he began work on a large central grotto, which rose to 27 feet at the apex and was built mostly of rock taken from the quarry. It was embellished on the interior with cement made to resemble stalactites, together with colored glass, shells, polished stones, and shattered marble salvaged from a nearby train wreck. The grotto contains sculptures of Our Lady of Prompt Succor, Saint Benedict, and Saint Scholastica; it was blessed as an oratory chapel by the bishop of Mobile, Alabama, on May 13, 1934. Zoetl's replicas are arrayed on stone ledges to either side of the grotto and are surrounded with perennials and flowering shrubs; those representing the shrines of the Holy Land are on the right, those of Europe and America are on the left. Outstanding elements include miniatures of the Cave of Gethsemane; the Benedictine Abbey church in Montserrat, Spain; the Pantheon; the Colosseum; and St. Peter's in Rome, its dome crafted over a birdcage and its columns cast in laboratory test tubes. Work on these miniatures continued without interruption almost until Brother Joseph's death in 1961. The Ave Maria Grotto was placed on the National Register of Historic Places in 1984.

See also **Environments, Folk; Shrines.**

BIBLIOGRAPHY

Beardsley, John. *Gardens of Revelation*. New York, 1995.
Morris, John. *Miniature Miracle: A Biography of Brother Joseph Zoetl, O. S. B.* Huntsville, Ala., 1991.

JOHN BEARDSLEY

INDEX

Page numbers in **boldface** indicate entry titles.

Plates 1–16: between pages 78 & 79; Plates 17–32: between pages 246 & 247

Plates 1–16: between pages 78 & 79; Plates 17–32: between pages 246 & 247

 Plates 1–16: between pages 78 & 79; Plates 17–32: between pages 246 & 247

Plates 1–16: between pages 78 & 79; Plates 17–32: between pages 246 & 247